II 1000 B.C.—1000 A.D. Unit of time: 100 years

1000 B.C.	900	800	700	600	500	400	300	200	100	1 A.D.	100	200	300	400	500	600	700	800	900	1000 A.D.

CENTRAL AND NORTH EUROPE
New Stone Age

GREECE

Carolingian

EUROPE
Middle Ages

Ottonian

ETRURIA

Iconoclastic Controversy

CHRISTIAN
Early Christian

Early
Byzantine

ROME

Late Byzantine

EGYPT

ISLAM

Persians Achaemenids Sassanians

Alexander the Great

INDIA Maurya—Shunga Andhra—Kushan *(Buddhist)* Gupta *(Buddhist)* Medieval *(Hindu)*

Buddha King Aśoka

CHINA | Chou, Early, Middle, & Late Han T'ang

JAPAN New Stone Age Iron Age begins Nara

AMERICAS Pre-Columbian

1000 B.C.— 1 A.D.

CONTINUED ON END PAPER INSIDE BACK COVER

HISTORY OF ART

A Survey of the Major Visual Arts

from the Dawn of History to the Present Day

H. W. JANSON

PROFESSOR OF FINE ARTS, NEW YORK UNIVERSITY

WITH DORA JANE JANSON

SECOND EDITION

HISTORY OF ART

A Survey of the Major Visual Arts

from the Dawn of History to the Present Day

HARRY N. ABRAMS, INC., PUBLISHERS, NEW YORK

Editor: Patricia Egan
Designers: Patrick Cunningham, Robin Fox

First Printing	*October, 1962*
Second Printing	*February, 1963*
Third Printing	*August, 1963*
Fourth Printing	*December, 1963*
Fifth Printing	*June, 1964*
Sixth Printing	*November, 1964*
Seventh Printing	*January, 1965*
Eighth Printing	*February, 1966*
Ninth Printing	*June, 1966*
Tenth Printing	*December, 1966*
Eleventh Printing	*May, 1967*
Twelfth Printing	*January, 1968*
Thirteenth Printing	*November, 1968*
REVISED AND ENLARGED IN 1969	
Fourteenth Printing	*July, 1969*
Fifteenth Printing	*October, 1970*
Sixteenth Printing	*July, 1971*
Seventeenth Printing	*December, 1971*
Eighteenth Printing	*February, 1973*
Nineteenth Printing	*December, 1973*
Twentieth Printing	*December, 1974*
SECOND EDITION 1977	
First Printing	*January, 1977*

Library of Congress Cataloging in Publication Data

Janson, Horst Woldemar, 1913–
 History of art. 2nd ed.

 Bibliography: p.
 Includes index.
 1. Art—History. I. Janson, Dora Jane,
1916– joint author. II. Title.
N5300.J3 1977b 709 76–27882
ISBN 0–8109–1052–7

Library of Congress Catalogue Card Number: 76–27882

NOTE ON THE PICTURE CAPTIONS

Unless otherwise noted, all paintings are in tempera on panel,
or oil on canvas, and all sculpture is of stone. Measurements are not given for objects
that are inherently large (architecture, architectural sculpture, wall painting), or small (manuscript
illuminations, drawings, prints). Height precedes width. A probable measuring error
of more than one per cent is indicated by "c." Dates are based on documentary evidence,
unless preceded by "c."

CONTENTS

PREFACE AND ACKNOWLEDGMENTS

The title of this book has a dual meaning: it refers both to the events that *make* the history of art, and to the scholarly discipline that deals with these events. Perhaps it is just as well that the record and its interpretation are thus designated by the same term. For the two cannot be separated, try as we may. There are no "plain facts" in the history of art—or in the history of anything else, for that matter; only degrees of plausibility. Every statement, no matter how fully documented, is subject to doubt, and remains a "fact" only so long as nobody questions it. To doubt what has been taken for granted, and to find a more plausible interpretation of the evidence, is every scholar's task. Nevertheless, there is always a large body of "facts" in any field of study; they are the sleeping dogs whose very inertness makes them landmarks on the scholarly terrain. Fortunately, only a minority of them can be aroused at the same time, otherwise we should lose our bearings; yet all are kept under surveillance to see which ones might be stirred into wakefulness and locomotion. It is these "facts" that fascinate the scholar. I believe they will also interest the general reader. In a survey such as this, the sleeping dogs are indispensable, but I have tried to emphasize that their condition is temporary, and to give the reader a fairly close look at some of the wakeful ones.

In an effort to keep my account as up to date as possible, I have made many changes of detail in every printing of the book since its publication in 1962. The revised edition of 1969 contained more of these, as well as a significant expansion of Part Four to take account of artistic developments during the 1960s. Other new features were the endpaper maps and the synoptic chronological charts, designed to correlate the history of art with important events and developments in other spheres of man's experience. In this Second Edition, each of the four main parts of the book has its own double-page map; 15 smaller maps are distributed over the chapter title pages. These, and a system of subheadings within the chapters, should make it easier for the reader to find his way through the book. The time charts, with illustrations added, now appear at the end of each of the four main parts of the book. The text includes a good deal of new material in the prehistoric chapter and those devoted to contemporary art. The reading list has been updated, a glossary has been added, and there is an instructive discussion of architectural plans and projections by David DeLong. The number of colorplates has been increased by 56 and the total is now 143.

I am under no illusion that my account is adequate in every respect. The history of art is too vast a field for anyone to encompass all of it with equal competence. If the shortcomings of my book remain within tolerable limits, this is due to the many friends and colleagues who have permitted me to tax their kindness with inquiries, requests for favors, or discussions of doubtful points. I am particularly indebted to Bernard Bothmer, Richard Ettinghausen, M. S. İpşiroğlu, Richard Krautheimer, Max Loehr, Wolfgang Lotz, Alexander Marshack, and Meyer Schapiro, who reviewed various aspects of the book and generously helped in securing photographic material. I must also record my gratitude to the American Academy in Rome, which made it possible for me, as art historian in residence during the spring of 1960, to write the chapters on ancient art under ideal conditions. Among those who contributed to the present edition, my thanks go to David DeLong for the essay on architectural drawings; to John O'Neill, who designed the illustrated time charts; to Robert Kaufmann for the reading list; to Ellen Grand for the index; to Grace Sowerwine for the glossary; and to Yoshiko Nihei for her valuable assistance in Tokyo. I should like also to acknowledge the admirable skill and patience of Robin Fox and Patrick Cunningham, who are responsible for the design and layout of the volume as a whole. Above all, however, I must record a huge debt of gratitude to Patricia Egan, whose indefatigable and devoted editorial labor has improved the book in countless ways ever since its initial publication.

H. W. J.

INTRODUCTION
The Artist and His Public

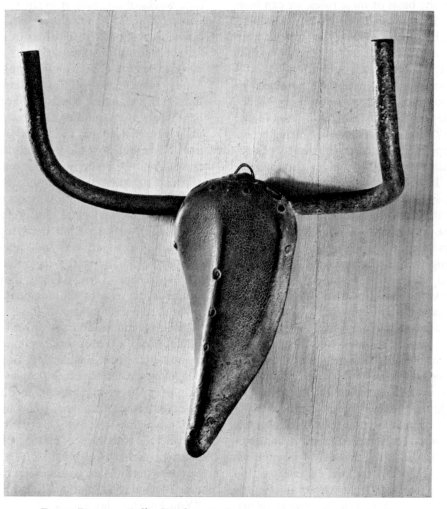

1. PABLO PICASSO. *Bull's Head.* 1943. Bronze cast of parts of a bicycle, height 16 ⅛". Galerie Louise Leiris, Paris

"Why is this supposed to be art?" How often have we heard this question asked—or asked it ourselves, perhaps—in front of one of the strange, disquieting works that we are likely to find nowadays in museums or art exhibitions. There usually is an undertone of exasperation, for the question implies that *we* don't think we are looking at a work of art, but that the experts—the critics, museum curators, art historians—must suppose it to be one, why else would they put it on public display? Clearly, their standards are very different from ours; we are at a loss to understand them and we wish they'd give us a few simple, clear-cut rules to go by. Then maybe we would learn to like what we see, we would know "why it is art." But the experts do not post exact rules, and the layman is apt to fall back upon his final line of defense: "Well, I don't know anything about art but I know what I like."

It is a formidable roadblock, this stock phrase, in the path of understanding between expert and layman. Until not so very long ago, there was no great need for the two to communicate with each other; the general public had little voice in matters of art and therefore could not chal-

lenge the judgment of the expert few. Today both sides are aware of the barrier between them (the barrier itself is nothing new, although it may be greater now than at certain times in the past) and of the need to level it. That is why books like this one are being written. Let us begin, then, by examining the roadblock and the various unspoken assumptions that buttress it. The most fateful among them, it seems to me, is the belief that there are, or ought to be, exact rules by which we can tell art from what is not art, and that, on the basis of these rules, we can then grade any given work according to its merits. Deciding what is art and evaluating a work of art are separate problems; if we had an absolute method for distinguishing art from non-art, this method would not necessarily enable us to measure quality. People have long been in the habit of compounding the two problems into one; quite often when they ask, "Why is it art?" they mean, "Why is it *good* art?" Yet, all systems for rating art so far proposed fall short of being completely satisfactory; we tend to agree with their authors only if they like the same things we do. If we do not share their taste, their system seems like a strait jacket to us. This brings us to another, more basic difficulty. In order to have any rating scale at all, we must be willing to assume that there are fixed, timeless values in art, that the true worth of a given work is a stable thing, independent of time and circumstance. Perhaps such values exist; we cannot be sure that they do not. We do know, however, that opinions about works of art keep changing, not only today but throughout the known course of history. Even the greatest classics have had their ups and downs, and the history of taste—which is part of the history of art—is a continuous process of discarding established values and rediscovering neglected ones. It would seem, therefore, that absolute qualities in art elude us, that we cannot escape viewing works of art in the context of time and circumstance, whether past or present. How indeed could it be otherwise, so long as art is still being created all around us, opening our eyes almost daily to new experiences and thus forcing us to adjust our sights? Perhaps, in the distant future, men will cease to produce works of art. It is not inconceivable, after all, that mankind may some day "outgrow" its need for art. When that happens, the history of art will have come to an end, and our descendants will then be in a better position to work out an enduring scale of artistic values—if the problem still interests them. Until that time, we had better admit that it is impossible to measure the merits of works of art as a scientist measures distances.

But if we must give up any hope of a trustworthy rating scale for artistic quality, can we not at least expect to find a reliable, objective way to tell art from non-art? Unfortunately, even this rather more modest goal proves so difficult as to be almost beyond our powers. Defining art is about as troublesome as defining a human being. Plato, it is said, tried to solve the latter problem by calling man "a featherless biped," whereupon Diogenes introduced a plucked rooster as "Plato's Man." Generalizations about art are, on the whole, equally easy to disprove. Even the most elementary statements turn out to have their pitfalls. Let us test, for instance, the simple claim that a work of art must be made by man, rather than by nature. This definition at least eliminates the confusion of treating as works of art phenomena such as flowers, sea shells, or sunsets. It is a far from sufficient definition, to be sure, since man makes many things other than works of art. Still, it might serve as a starting point. Our difficulties begin as soon as we ask, "What do we mean by making?" If, in order to simplify our problem, we concentrate on the visual arts, we might say that a work of art must be a tangible thing shaped by human hands. Now let us look at the striking *Bull's Head* by Picasso (fig. 1), which consists of nothing but the seat and handlebars of an old bicycle. How meaningful is our formula here? Of course the materials used by Picasso are man-made, but it would be absurd to insist that Picasso must share the credit with the manufacturer, since the seat and handlebars in themselves are not works of art. While we feel a certain jolt when we first recognize the ingredients of this visual pun, we also sense that it was a stroke of genius to put them together in this unique way, and we cannot very well deny that it is a work of art. Yet the handiwork—the mounting of the seat on the handlebars—is ridiculously simple. What is far from simple is the leap of the imagination by which Picasso recognized a bull's head in these unlikely objects; that, we feel, only he could have done. Clearly, then, we must be careful not to confuse the making of a work of art with manual skill or craftsmanship. Some works of art may demand a great deal of technical discipline; others do not. And even the most painstaking piece of craft does not deserve to be called a work of art unless it involves a leap of the imagination. But if this is true, are we not forced to conclude that the real making of the *Bull's Head* took place in the artist's mind? No, that is not so, either. Suppose that, instead of actually putting the two pieces together and showing them to us, Picasso merely told us, "You know, today I saw a bicycle seat and handlebars that looked just like a bull's head to me." Then there would be no work of art and his remark would not even strike us as an interesting bit of conversation. Moreover, Picasso himself would not feel the satisfaction of having created something on the basis of his leap of the imagination alone. Once he had conceived his visual pun, he could never be sure that it would really work unless he put it into effect.

Creativity

Thus the artist's hands, however modest the task they may have to perform, play an essential part in the creative process. Our *Bull's Head* is, of course, an ideally simple case, involving only one leap of the imagination and a single manual act in response to it—once the

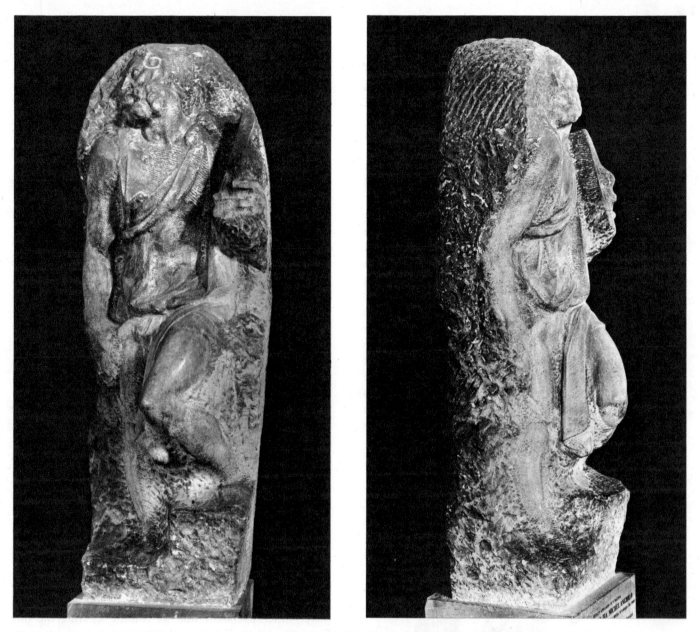

2, 3. MICHELANGELO. *St. Matthew*. 1506. Marble, height 8′ 11″. Academy, Florence

seat had been properly placed on the handlebars, the job was done. Ordinarily, artists do not work with ready-made parts but with materials that have little or no shape of their own; the creative process consists of a long series of leaps of the imagination and the artist's attempts to give them form by shaping the material accordingly. The hand tries to carry out the commands of the imagination and hopefully puts down a brush stroke, but the result may not be quite what had been expected, partly because all matter resists the human will, partly because the image in the artist's mind is constantly shifting and changing, so that the commands of the imagination cannot be very precise. In fact, the mental image begins to come into focus only as the artist "draws the line somewhere." That line then becomes part—the only fixed part—of the image; the rest of the image, as yet unborn, remains fluid. And each time the artist adds another line, a new leap of the imagination is needed to incorporate

that line into his ever-growing mental image. If the line cannot be incorporated, he discards it and puts down a new one. In this way, by a constant flow of impulses back and forth between his mind and the partly shaped material before him, he gradually defines more and more of the image, until at last all of it has been given visible form. Needless to say, artistic creation is too subtle and intimate an experience to permit an exact step-by-step description; only the artist himself can observe it fully, but he is so absorbed by it that he has great difficulty explaining it to us. Still, our metaphor of birth comes closer to the truth than would a description of the process in terms of a transfer or projection of the image from the artist's mind, for the making of a work of art is both joyous and painful, replete with surprises, and in no sense mechanical. We have, moreover, ample testimony that the artist himself tends to look upon his creation as a living thing. Thus, Michelangelo, who

has described the anguish and glory of the artist's experience more eloquently than anyone else, speaks of his "liberating the figure from the marble that imprisons it." We may translate this, I think, to mean that he started the process of carving a statue by trying to visualize a figure in the rough, rectilinear block as it came to him from the quarry. (At times he may even have done so while the marble was still part of the living rock; we know that he liked to go to the quarries and pick out his material on the spot.) It seems fair to assume that at first he did not see the figure any more clearly than one can see an unborn child inside the womb, but we may believe he could see isolated "signs of life" within the marble—a knee or an elbow pressing against the surface. In order to get a firmer grip on this dimly felt, fluid image, he was in the habit of making numerous drawings, and sometimes small models in wax or clay, before he dared to assault the "marble prison" itself, for that, he knew, was the final contest between him and his material. Once he started carving, every stroke of the chisel would commit him more and more to a specific conception of the figure hidden in the block, and the marble would permit him to free the figure whole only if his guess as to its shape was correct. Sometimes he did not guess well enough—the stone refused to give up some essential part of its pris-

4. *Thorn Puller (Spinario)*. Bronze, height 28 ³/₄″
Capitoline Museums, Rome

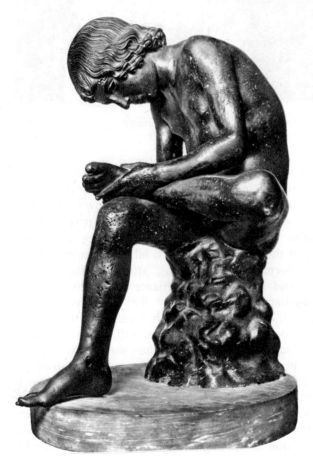

oner, and Michelangelo, defeated, left the work unfinished, as he did with his *St. Matthew* (figs. 2, 3), whose every gesture seems to record the vain struggle for liberation. Looking at the side view of the block (fig. 3), we may get some inkling of Michelangelo's difficulties here. But could he not have finished the statue in *some* fashion? Surely there is enough material left for that. Well, he probably could have, but perhaps not in the way he wanted, and in that case the defeat would have been even more stinging.

Clearly, then, the making of a work of art has little in common with what we ordinarily mean by "making." It is a strange and risky business in which the maker never quite knows what he is making until he has actually made it; or, to put it another way, it is a game of find-and-seek in which the seeker is not sure what he is looking for until he has found it. (In the *Bull's Head*, it is the bold "finding" that impresses us most, in the *St. Matthew*, the strenuous "seeking.") To the non-artist, it seems hard to believe that this uncertainty, this need-to-take-a-chance, should be the essence of the artist's work. For we all tend to think of "making" in terms of the craftsman or manufacturer who knows exactly what he wants to produce from the very outset, picks the tools best fitted to his task, and is sure of what he is doing at every step. Such "making" is a two-phase affair: first the craftsman makes a plan, then he acts on it. And because he—or his customer—has made all the important decisions in advance, he has to worry only about means, rather than ends, while he carries out his plan. There is thus little risk, but also little adventure, in his handiwork, which as a consequence tends to become routine. It may even be replaced by the mechanical labor of a machine. No machine, on the other hand, can replace the artist, for with him conception and execution go hand in hand and are so completely interdependent that he cannot separate the one from the other. Whereas the craftsman only attempts what he knows to be possible, the artist is always driven to attempt the impossible—or at least the improbable or unimaginable. Who, after all, would have imagined that a bull's head was hidden in the seat and handlebars of a bicycle until Picasso discovered it for us; did he not, almost literally, "make a silk purse out of a sow's ear"? No wonder the artist's way of working is so resistant to any set rules, while the craftsman's encourages standardization and regularity. We acknowledge this difference when we speak of the artist as *creating* instead of merely *making* something, although the word is being done to death by overuse nowadays, when every child and every lipstick manufacturer is labeled "creative."

Needless to say, there have always been many more craftsmen than artists among us, since our need for the familiar and expected far exceeds our capacity to absorb the original but often deeply unsettling experiences we get from works of art. The urge to penetrate unknown realms, to achieve something original, may be felt by every one of us now and then; to that extent, we can all

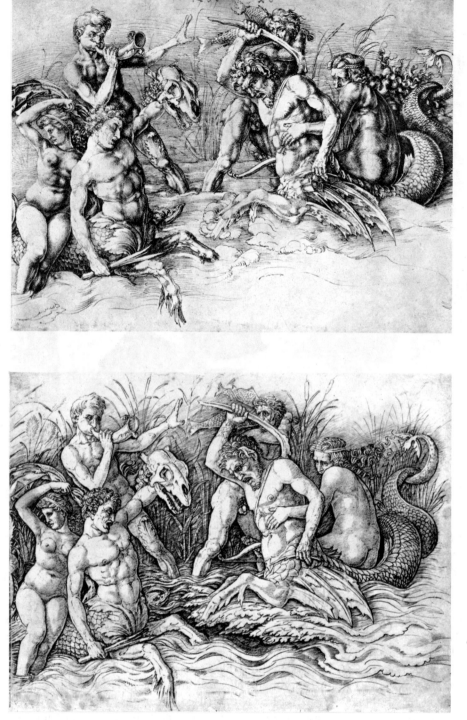

5. ALBRECHT DÜRER. *Battle of Sea Gods*. 1494.
Pen drawing, 11 3/8 × 15". Albertina, Vienna

6. ANDREA MANTEGNA. *Battle of Sea Gods*.
c. 1493. Engraving, 11 5/8 × 15 5/8".
The Metropolitan Museum of Art, New York
(Rogers Fund, 1920)

fancy ourselves potential artists—mute inglorious Miltons. What sets the real artist apart is not so much the desire to *seek*, but that mysterious ability to *find* which we call talent. We also speak of it as a "gift," implying that it is a sort of present from some higher power; or as "genius," a term which originally meant that a higher power—a kind of "good demon"—inhabits the artist's body and acts through him. All we can really say about talent is that it must not be confused with aptitude. Aptitude is what the craftsman needs; it means a better-than-average knack for doing something that any ordinary person can do. An aptitude is fairly constant and specific; it can be measured with some success by means of tests which permit us to predict future performance. Creative talent, on the other hand, seems utterly unpredictable; we can spot it only on the basis of *past* performance. And even past performance is not enough to assure us that a given artist will continue to produce on the same level: some artists reach a creative peak quite early in their careers and then "go dry," while others, after a slow and unpromising start, may achieve astonishingly original work in middle age or even later.

Originality

Originality, then, is what distinguishes art from craft.

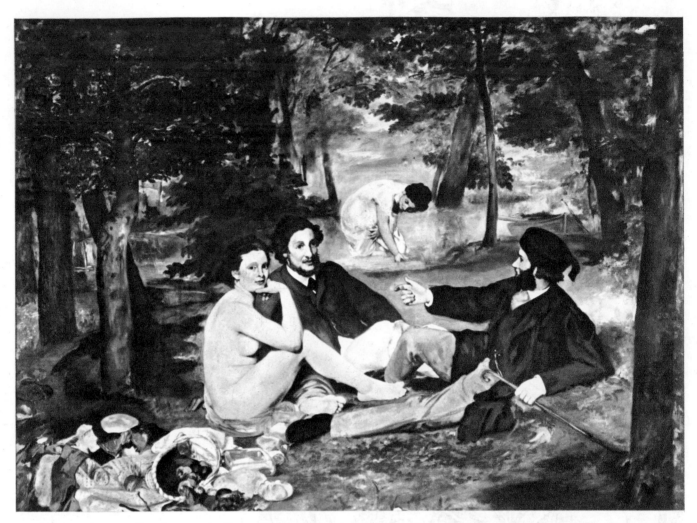

7. EDOUARD MANET. *Luncheon on the Grass (Le Déjeuner sur l'Herbe)*. 1863. Oil on canvas, 7' × 8' 10". The Louvre, Paris

We may say, therefore, that it is the yardstick of artistic greatness or importance. Unfortunately, it is also very hard to define; the usual synonyms—uniqueness, novelty, freshness—do not help us very much, and the dictionaries tell us only that an original work must not be a copy, reproduction, imitation, or translation. What they fail to point out is that originality is always relative: there is no such thing as a completely original work of art. Thus, if we want to rate works of art on an "originality scale" our problem does not lie in deciding whether or not a given work is original (the obvious copies and reproductions are for the most part easy enough to eliminate) but in establishing just exactly *how* original it is. To do that is not impossible. However, the difficulties besetting our task are so great that we cannot hope for more than tentative and incomplete answers. Which does not mean, of course, that we should not try; quite the contrary. For whatever the outcome of our labors in any particular case, we shall certainly learn a great deal about works of art in the process.

Let us look at a few of the baffling questions that come up when we investigate the problem of originality. The *Thorn Puller*, or *Spinario* (fig. 4), has long been one of the most renowned pieces of ancient bronze sculpture and enjoys considerable fame as a work of art even today—except among classical archaeologists who have studied it with care. They will point out that the head, which is cast separately and is of slightly different metal, does not match the rest: the planes of the face are far more severe than the soft, swelling forms of the body; and the hair, instead of falling forward, behaves as if the head were held upright. The head, therefore, must have been designed for another figure, probably a standing one, of the fifth century B.C., but the body could not have been conceived until more than a hundred years later. As soon as we become aware of this, our attitude toward the *Spinario* changes sharply: we no longer see it as a single, harmonious unit but as a somewhat incongruous combination of two ready-made pieces. And since the pieces are separate—though fragmentary—works of art in their own right (unlike the separate pieces, which are not works of art in themselves, in Picasso's *Bull's Head*), they cannot

grow together into a new whole that is more than the sum of its parts. Obviously, this graft is not much of a creative achievement. Hence we find it hard to believe that the very able artist who modeled the body should have been willing to countenance such a "marriage of convenience." The combination must be of a later date, presumably Roman rather than Greek. Perhaps the present head was substituted when the original head was damaged by accident? But are the head and body really authentic Greek fragments of the fifth and fourth century B.C., or could they be Roman copies or adaptations of such pieces? These questions may be settled eventually by comparison with other ancient bronzes of less uncertain origin, but even then the degree of artistic originality of the *Spinario* is likely to remain a highly problematic matter.

A straightforward copy can usually be recognized as such on internal evidence alone. If the copyist is merely a conscientious craftsman, rather than an artist, he will produce a work of craft; the execution will strike us as pedestrian and thus out of tune with the conception of the work. There are also likely to be small slip-ups and mistakes that can be spotted in much the same way as misprints in a text. But what if one great artist copies another? The drawing, *Battle of Sea Gods*, by Albrecht Dürer (fig. 5) is a case in point. An experienced eye will not only recognize it as a copy (because, while the "handwriting" is Dürer's, the design as a whole has a flavor distinctively different from that of the master's other output at that time), it will also be able to identify the source: the original must have been some work by Andrea Mantegna, a somewhat older Italian painter with a powerful artistic personality of his own. Dürer's drawing, of course, does not permit us to say with assurance what kind of work by Mantegna served as its model—it might have been a drawing, a painting, a print, possibly even a relief—or how faithful a copy it is. Yet it would be instructive to find this out, in order for us to gain a better

insight into the character of our drawing. The next step, therefore, is to check through the known works of Mantegna; if the same composition does not occur among them, we will have learned nothing new about the drawing but we may have added something to our knowledge of Mantegna, for in that event the Dürer drawing would be a valuable record of an otherwise unknown—and thus presumably lost—composition by the older master. It so happens that Dürer's model, a Mantegna engraving, has survived (fig. 6). As we compare the two, we are surprised to see that the drawing, although it follows Mantegna's design detail for detail, somehow retains the quality of an independent work of art as well. How can we resolve this paradox? Perhaps we may put it this way: in using the engraving as his model, Dürer did not really copy it in the accepted sense of that word, since he did not try to achieve the effect of a duplicate. He drew purely for his own instruction, which is to say that he looked at the engraving the way he would look at something in nature, transcribing it very accurately yet with his own inimitable rhythm of line. In other words, he was not in the least constrained or intimidated by the fact that his model, in this instance, was another work of art. Once we understand this, it becomes clear to us that Dürer's drawing *represents* (it does not *copy*) the engraving in the same way that other drawings represent a landscape or a living person, and that its artistic originality does not suffer thereby. Dürer here gives us a highly original view of Mantegna, a view that is uniquely Dürer's.

A relationship as close as this between two works of art is not as rare as one might think. Ordinarily, though, the link is less obvious. Edouard Manet's famous painting, *Luncheon on the Grass* (fig. 7), seemed so revolutionary a work when first exhibited almost a century ago that it caused a scandal, in part because the artist had dared to show an undressed young woman next to two fashionably clothed men. In real life such a party might indeed get

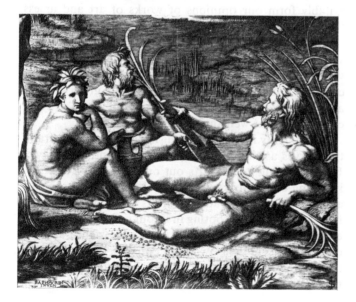

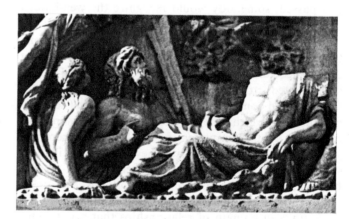

above: 8. *River Gods* (detail of Roman sarcophagus). 3rd century A.D. Villa Medici, Rome

left: 9. MARCANTONIO RAIMONDI, after RAPHAEL. *The Judgment of Paris* (detail). c. 1520. Engraving

10. Pablo Picasso with sketches after Manet's
Luncheon on the Grass. 1954
(Photograph copyright Alexander Liberman)

raided by the police, and people assumed that Manet had
intended to represent an actual event. Not until many
years later did an art historian discover the source of these
figures: a group of classical deities from an engraving
after Raphael (fig. 9). The relationship, so striking once
it has been pointed out to us, had escaped attention, for
Manet did not *copy* or *represent* the Raphael composition
—he merely *borrowed* its main outlines while translating
the figures into modern terms. Had his contemporaries
known of this, the *Luncheon* would have seemed a rather
less disreputable kind of outing to them, since now the
hallowed shade of Raphael could be seen to hover nearby
as a sort of chaperon. (Perhaps the artist meant to tease
the conservative public, hoping that after the initial shock
had passed, somebody would recognize the well-hidden
quotation behind his "scandalous" group.) For us, the
main effect of the comparison is to make the cool, formal
quality of Manet's figures even more conspicuous. But
does it decrease our respect for his originality? True, he
is "indebted" to Raphael; yet his way of bringing the
forgotten old composition back to life is in itself so origi-
nal and creative that he may be said to have more than
repaid his debt. As a matter of fact, Raphael's figures are
just as "derivative" as Manet's; they stem from still older
sources which lead us back to ancient Roman art and
beyond (compare the relief of *River Gods,* fig. 8).

Thus Manet, Raphael, and the Roman river gods form
three links in a chain of relationships that arises some-
where out of the dim and distant past and continues into
the future—for the *Luncheon on the Grass* has in turn
served as a source of more recent works of art (see fig. 10).
Nor is this an exceptional case. All works of art any-
where—yes, even such works as Picasso's *Bull's Head*—
are part of similar chains that link them to their predeces-
sors. If it is true that "no man is an island," the same can
be said of works of art. The sum total of these chains
makes a web in which every work of art occupies its own
specific place, and which we call *tradition.* Without tradi-
tion—the word means "that which has been handed down
to us"—no originality would be possible; it provides, as
it were, the firm platform from which the artist makes his
leap of the imagination. The place where he lands will
then become part of the web and serve as a point of de-
parture for further leaps. And for us, too, the web of
tradition is equally essential. Whether we are aware of it
or not, tradition is the framework within which we in-
evitably form our opinions of works of art and assess
their degree of originality. Let us not forget, however,
that such assessments must always remain incomplete and
subject to revision. For in order to arrive at a definitive
view, we should not only need to know *all* the different
chains of relationships that pass through a given work of
art, we should be able to survey the entire length of every
chain. And that we can never hope to achieve.

If originality is what distinguishes art from craft, tradi-
tion serves as the common meeting ground of the two.
Every budding artist starts out on the level of craft, by
imitating other works of art. In this way, he gradually
absorbs the artistic tradition of his time and place until
he has gained a firm footing in it. But only the truly gifted
ever leave that stage of traditional competence and be-
come creators in their own right. No one, after all, can be
taught how to create; he can only be taught how to go
through the motions of creating. If he has talent, he will

eventually achieve the real thing. What the apprentice or art student learns are skills and techniques—established ways of drawing, painting, carving, designing; established ways of *seeing*. And if he senses that his gifts are too modest for painting, sculpture, or architecture, he is likely to turn to one of the countless special fields known collectively as "applied art." There he can be fruitfully active on a more limited scale: he may become an illustrator, typographer, or interior decorator; he may design textile patterns, chinaware, furniture, clothing, or advertisements. All these pursuits stand somewhere between "pure" art and "mere" craft. They provide some scope for originality to their more ambitious practitioners, but the flow of creative endeavor is hemmed in by such factors as the cost and availability of materials or manufacturing processes, accepted notions of what is useful, fitting, or desirable; for the applied arts are more deeply enmeshed in our everyday lives and thus cater to a far wider public than do painting and sculpture. Their purpose, as the name suggests, is to beautify the useful—an important and honorable one, no doubt, but of a lesser order than that of art pure-and-simple. Nevertheless, we often find it difficult to maintain this distinction. Medieval painting, for instance, is to a large extent "applied," in the sense that it embellishes surfaces which serve another, practical purpose as well—walls, book pages, windows, furniture. The same may be said of much ancient and medieval sculpture. Greek vases, as we shall see, although technically pottery, are sometimes decorated by artists of very impressive ability. And in architecture the distinction breaks down altogether, since the design of every building, from country cottage to cathedral, reflects external limitations imposed upon it by the site, by cost factors, materials, technique, and by the practical purpose of the structure. (The only "pure" architecture is imaginary architecture.) Thus architecture is, almost by definition, an applied art, but it is also a major art (as against the others, which are often called the "minor arts").

Likes and Dislikes

It is now time to return to our troubled layman and his assumptions about art. He may be willing to grant, on the basis of our discussion so far, that art is indeed a complex and in many ways mysterious human activity about which even the experts can hope to offer only tentative and partial conclusions; but he is also likely to take this as confirming his own belief that "I don't know anything about art." Are there really people who know nothing about art? If we except small children and the victims of severe mental illness or deficiency, our answer must be no, for we cannot help knowing *something* about it, just as we all know something about politics and economics no matter how indifferent we may be to the issues of the day. Art is so much a part of the fabric of human living that we encounter it all the time, even if our con-

tacts with it are limited to magazine covers, advertising posters, war memorials, and the buildings where we live, work, and worship. Much of this art, to be sure, is pretty shoddy—art at third- and fourth-hand, worn out by endless repetition, representing the lowest common denominator of popular taste. Still, it is art of a sort; and since it is the only art most people ever experience, it molds their ideas on art in general. When they say, "I know what I like," they really mean, "I like what I know (and I reject whatever fails to match the things I am familiar with)"; such likes are not in truth theirs at all, for they have been imposed upon them by habit and circumstance, without any personal choice. To like what we know and to distrust what we do not know is an age-old human trait. We always tend to think of the past as "the good old days," while the future seems fraught with danger. But why should so many of us cherish the illusion of having made a personal choice in art when in actual fact we have not? I suspect there is another unspoken assumption here, which goes something like this: "Since art is such an 'unruly' subject that even the experts keep disagreeing with each other, my opinion is as good as theirs—it's all a matter of subjective preference. In fact, my opinion may be *better* than theirs, because as a layman I react to art in a direct, straightforward fashion, without having my view obstructed by a lot of complicated theories. There must be something wrong with a work of art if it takes an expert to appreciate it."

The Artist's Audience

Behind these mistaken conclusions we find a true and important premise—that works of art exist in order to be liked rather than to be debated. The artist does not create merely for his own satisfaction, but wants his work approved by others. In fact, the hope for approval is what makes him want to create in the first place, and the creative process is not completed until the work has found an audience. Here we have another paradox: the birth of a work of art is an intensely private experience (so much so that many artists can work only when completely alone and refuse to show their unfinished pieces to anyone), yet it must, as a final step, be shared by the public, in order for the birth to be successful. Perhaps we can resolve the paradox once we understand what the artist means by "public." He is concerned not with *the* public as a statistical entity but with his particular public, his audience; quality rather than quantity is what matters to him. At a minimum, this audience need consist of no more than one or two people whose opinion he values. If he can win them over by his work, he feels encouraged to go on; without them, he despairs of his calling. There have been some very great artists who had only such a minimum audience. They hardly ever sold any of their work or had an opportunity to display it in public, but they continued to create because of the moral support of a few faithful friends. These, of course, are rare cases. Ordi-

narily, artists also need patrons who will purchase their work, thus combining moral and financial support; from the artist's point of view, patrons are always "audience" rather than "customers." There is a vital difference between these last two terms. A customer buys the products of craftsmanship, he knows from previous experience what he will get and that he is going to like it—why else should he have established the custom of returning to the same source of supply? We think of him as "regular" and "satisfied." An audience, in contrast, merits such adjectives as critical, fickle, receptive, enthusiastic; it is uncommitted, free to accept or reject, so that anything placed before it is on trial—nobody knows in advance how the work will be received. Hence there is an emotional tension between artist and audience that has no counterpart in the relationship of craftsman and customer. It is this very tension, this sense of uncertainty and challenge, that the artist needs. He must feel that his work is able to overcome the resistance of the audience, otherwise he cannot be sure that what he has brought forth is a genuine creation, a work of art in fact as well as in intention. The more ambitious and original his work, the greater the tension, and the more triumphant his sense of release after the response of the audience has shown him that his leap of the imagination is successful. On a tiny scale we all have a similar experience when we happen to think up a joke: we have an irresistible urge to tell it to someone, for we can't be sure that it really *is* a joke until we find out whether it strikes others as funny, too. This analogy should not be pressed too far, but it does suggest why artists need an audience to "complete" their work.

The audience whose approval looms so large in the artist's mind is a limited and special one, not the general public: the merits of the artist's work can never be determined by a popularity contest. The size and composition of this primary audience vary a good deal with time and circumstance; its members may be other artists as well as patrons, friends, critics, and interested bystanders. The one qualification they all have in common is an informed love of works of art—an attitude at once discriminating and enthusiastic that lends particular weight to their judgments. They are, in a word, *experts,* people whose authority rests on experience rather than theoretical knowledge. And because experience, even within a limited field, varies from one individual to the other, it is only natural that they should at times disagree among themselves. Such disagreement often stimulates new insights; far from invalidating the experts' role, it shows, rather, how passionately they care about their subject, whether this be the art of their own time or of the past.

The active minority which we have termed the artist's primary audience draws its recruits from a much larger and more passive secondary audience, whose contact with works of art is less direct and continuous. This group, in turn, shades over into the vast numbers of those who believe they "don't know anything about art," the laymen pure-and-simple. What distinguishes the layman, as we have seen before, is not that he actually *is* pure and simple but that he likes to think of himself as being so. In reality, there is no sharp break, no difference in kind, between him and the expert, only a difference in degree. The road to expertness invites anyone with an open mind and a capacity to absorb new experiences. As we travel on it, as our understanding grows, we shall find ourselves liking a great many more things than we had thought possible at the start, yet at the same time we shall gradually acquire the courage of our own convictions, until— if we travel far enough—we know how to make a meaningful individual choice among works of art. By then, we shall have joined the active minority that participates directly in shaping the course of art in our time. And we shall be able to say, with some justice, that we know what we like.

Part One

THE ANCIENT WORLD

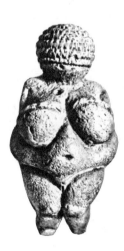

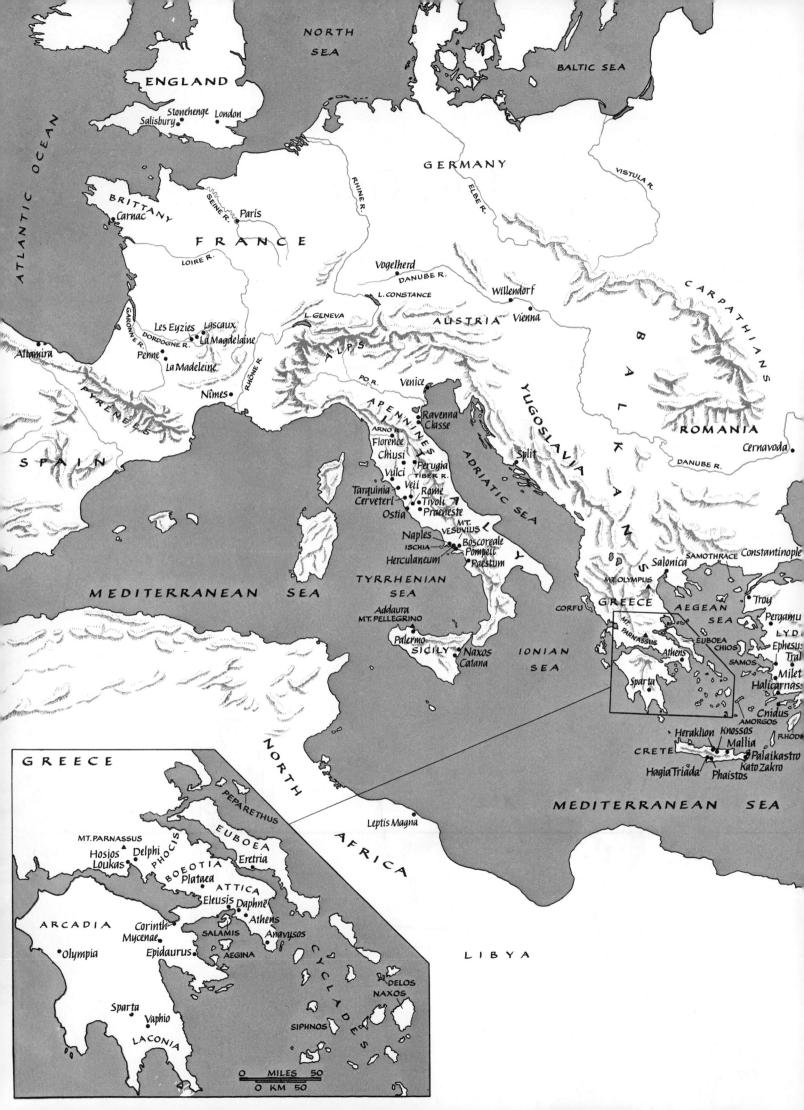

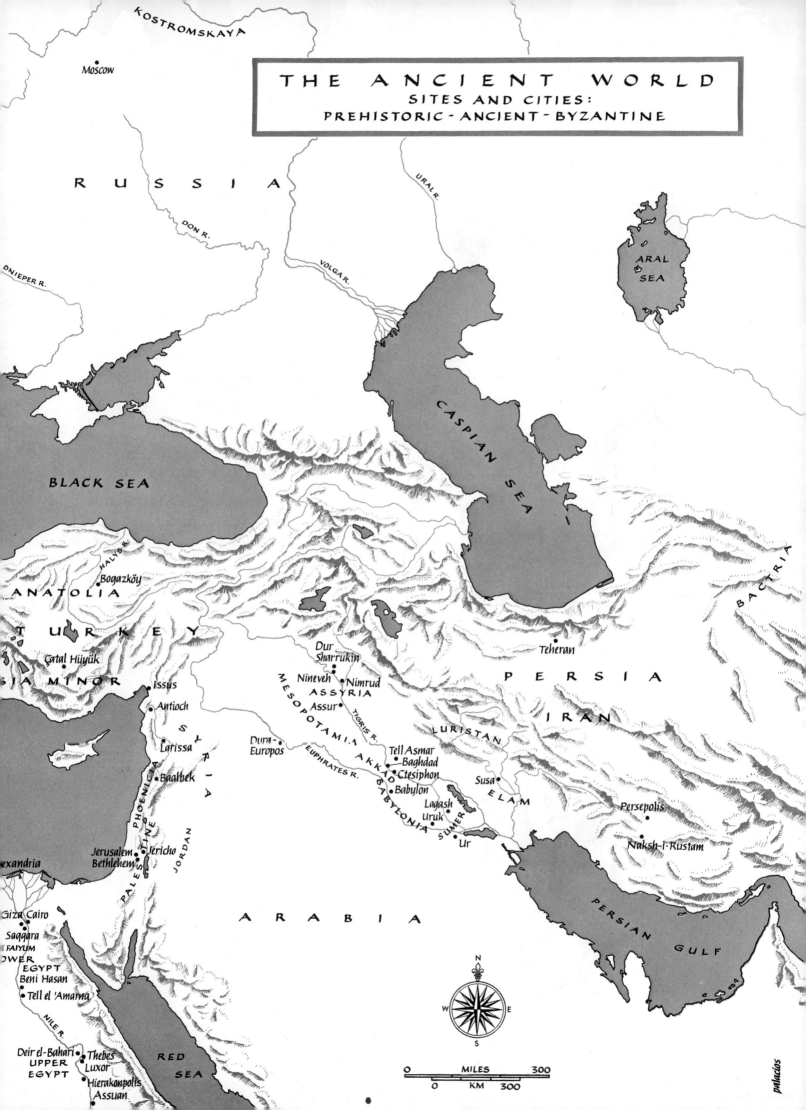

THE ANCIENT WORLD
SITES AND CITIES:
PREHISTORIC - ANCIENT - BYZANTINE

KOSTROMSKAYA

Moscow

RUSSIA

DON R.

DNIEPER R.

URAL R.

VOLGA R.

ARAL SEA

CASPIAN SEA

BLACK SEA

ANATOLIA

BACTRIA

Bogazköy

HALYS R.

TURKEY

Çatal Hüyük

A MINOR

Issus

Teheran

PERSIA

Dur Sharrukin

Nineveh • Nimrud

ASSYRIA

IRAN

Antioch

Assur

MESOPOTAMIA

TIGRIS R.

LURISTAN

Dura-Europos

Larissa

SYRIA

AKKAD

Tell Asmar
• Baghdad
Ctesiphon

Susa

Persepolis

Baalbek

EUPHRATES R.

BABYLON

Babylon

ELAM

PHOENICIA

Lagash
Uruk

SUMER

Naksh-i-Rustam

JORDAN

Jerusalem • Jericho
Bethlehem

Ur

PALESTINE

exandria

Giza Cairo

ARABIA

PERSIAN GULF

Saqqara

E FAIYUM

OWER
EGYPT

Beni Hasan

Tell el 'Amarna

N

W E

S

NILE R.

Deir el-Bahari • Thebes
UPPER
EGYPT Luxor

RED SEA

Hierakonpolis
Assuan

0 MILES 300

0 KM 300

palladdas

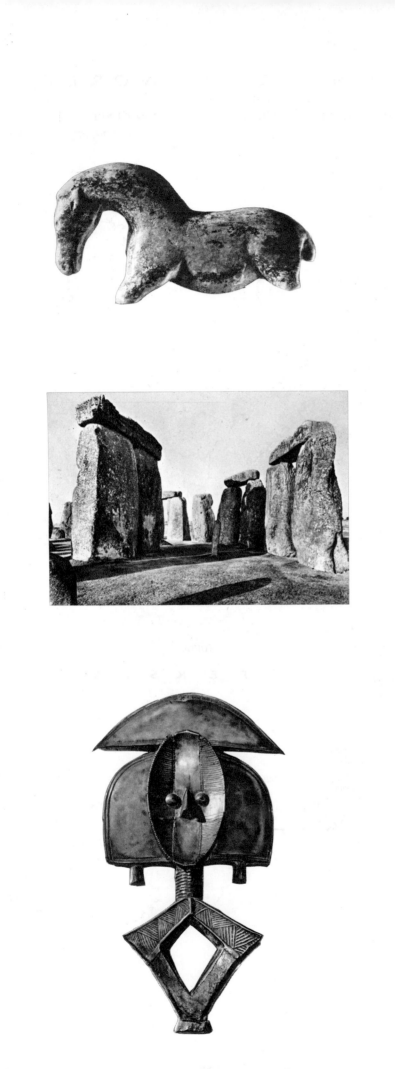

1

MAGIC AND RITUAL—
THE ART OF PREHISTORIC MAN

THE OLD STONE AGE

When did man start creating works of art? What prompted him to do so? What did these earliest works of art look like? Every history of art must begin with these questions —and with the admission that we cannot answer them. Our earliest ancestors began to walk the earth on two feet about four million years ago, but how they were using their hands remains unknown to us. More than two million years later we meet the earliest traces of man the toolmaker. He must have been *using* tools all along; after all, even apes will pick up a stick to knock down a banana, or a stone to throw at an enemy. The *making* of tools is a more complex matter. It demands first of all the ability to think of sticks or stones as "fruit knockers" or "bone crackers," not only when they are needed for such purposes but at other times as well. Once man was able to do that, he gradually discovered that some sticks or stones had a handier shape than others, and he put them aside for future use. He selected and "appointed" certain sticks or stones as tools because he had begun to connect *form* and *function*. The sticks, of course, have not survived, but a few of the stones have; they are large pebbles or chunks of rock that show the marks of repeated use for the same operation—whatever that may have been. The next step was for man to try chipping away at these tools-by-appointment so as to improve their shape. This is the first craft of which we have evidence, and with it we enter a phase of human development known as the Paleolithic, or Old Stone Age.

CAVE ART

It is during the last stage of the Paleolithic, which began about 35,000 years ago, that we meet the earliest works of art known to us. But these already show an assurance and refinement far removed from any humble beginnings. Unless we are to believe that they came into being in a single, sudden burst, as Athena is said to have sprung full-grown from the head of Zeus, we must assume that they were preceded by thousands of years of slow growth about which we know nothing at all. At that time the last Ice Age was drawing to a close in Europe (there had been at least three previous ones, alternating with periods of subtropical warmth, at intervals of about 25,000 years), and the climate between the Alps and Scandinavia resembled that of present-day Siberia or Alaska. Huge herds of reindeer and other large herbivores roamed the plains and valleys, preyed upon by the ferocious ancestors of today's lions and tigers—and by our own ancestors. These men liked to live in caves or in the shelter of overhanging rocks wherever they could find them. Many such sites have been discovered, mostly in Spain and in southwestern France; on the basis of differences among the tools and other remains found there, scholars have divided up the "cavemen" into several groups, each named after a characteristic site, and of these it is especially the so-called Aurignacians and Magdalenians who stand out

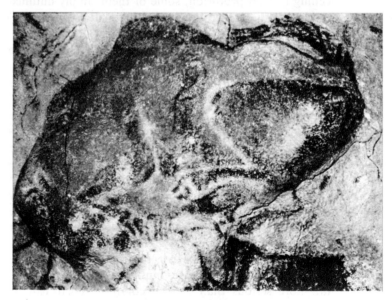

11. *Wounded Bison* (cave painting). c. 15,000–10,000 B.C. Altamira, Spain

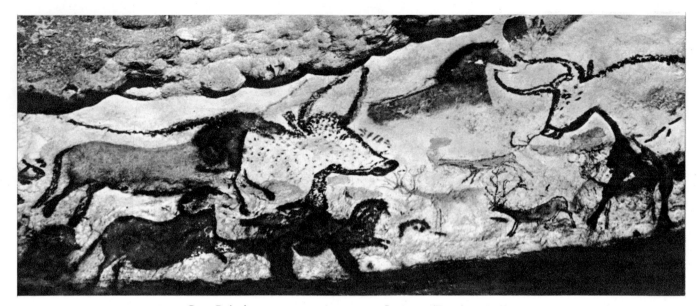

12. Cave Paintings. c. 15,000–10,000 B.C. Lascaux (Dordogne), France

for the gifted artists they produced and for the important role art must have played in their lives.

The most striking works of Paleolithic art are the images of animals, incised, painted, or sculptured, on the rock surfaces of caves, such as the wonderful *Wounded Bison* from the cave at Altamira in northern Spain (fig. 11). The dying animal has collapsed on the ground, its legs no longer able to carry the weight of the body, its head lowered in defense. What a vivid, lifelike picture it is! We are amazed not only by the keen observation, the assured, vigorous outlines, the subtly controlled shading that lends bulk and roundness to the forms, but even more perhaps by the power and dignity of this creature in its final agony. Equally impressive, if not quite as fine in detail, are the painted animals in the cave at Lascaux, in the Dordogne region of France (fig. 12, colorplate 1). Bison, deer, horses, and cattle race across walls and ceiling in wild profusion, some of them simply outlined in black, others filled in with bright earth colors, but all showing the same uncanny sense of life.

How did this extraordinary art develop? What purpose did it serve? And how did it happen to survive intact over so many thousands of years? The last question can be answered easily enough—for the pictures never occur near the mouth of a cave, where they would be open to easy view (and destruction) but only in the darkest recesses, as far from the entrance as possible. Some can be reached only by crawling on hands and knees, and the path is so intricate that one would soon be lost without an expert guide. The cave at Lascaux, characteristically enough, was discovered purely by chance in 1940 by some neighborhood boys whose dog had fallen into a hole that led to the underground chamber. Hidden away as they are in the bowels of the earth, to protect them from the casual intruder, these images must have served a purpose far more serious than mere decoration. There can be little doubt, in fact, that they were produced as part of a magic ritual, perhaps to ensure a successful hunt. We

gather this not only from their secret location and from the lines meant to represent spears or darts that are sometimes found pointing at the animals, but also from the peculiar, disorderly way the images are superimposed on one another (as in fig. 12). Apparently, the men of the Old Stone Age made no clear distinction between image and reality; by making a picture of an animal they meant to bring the animal itself within their grasp, and in "killing" the image they thought they had killed the animal's vital spirit. Hence a "dead" image lost its potency after the killing ritual had been performed, and could be disregarded when the spell had to be renewed. The magic worked, too, we may be sure; hunters whose courage was thus fortified were bound to be more successful when slaying these formidable beasts with their primitive weapons. Nor has the emotional basis of this kind of magic been lost even today. We carry snapshots of those we love in our wallets because this gives us a sense of their presence, and people have been known to tear up the photograph of someone they have come to hate.

Even so, there remains a good deal that puzzles us about the cave paintings. Why do they have to be in such inaccessible places? Couldn't the hunting magic they serve have been performed just as well out in the open? And why are they so marvelously lifelike? Would not the magic have been equally effective if the "killing" had been practiced upon less realistic images? We know of countless later instances of magic which require only the crudest and most schematic kind of representation, such as two crossed sticks for a human figure.

Perhaps we should regard the Magdalenian cave pictures as the final phase of a development that began as simple killing magic at a time when big game was plentiful but shifted its meaning when the animals became scarce (there is evidence that the big herds withdrew northward as the climate of Central Europe grew warmer). At Altamira and Lascaux, then, the main purpose may no longer have been to "kill" but to "make" ani-

mals—to increase their supply, perhaps through seasonal rituals repeated year after year. In some of the weapons associated with the animals (see colorplate 1) images of plants have recently been recognized. Could it be that the Magdalenians practiced their fertility magic in the bowels of the earth because they thought of the earth itself as a living thing from whose womb all other life springs? Such a notion is familiar to us from the cults of earth deities of later times; it is not impossible that its origin goes back to the Old Stone Age. If it does, it would help to explain the admirable realism of the cave paintings, for an artist who believes that he is actually "creating" an animal is more likely to strive for this quality than one who merely sets up an image for the kill. Some of the cave pictures even provide a clue to the origin of this tradition of fertility magic; in a good many instances, the shape of the animal seems to have been suggested by the natural formation of the rock, so that its body coincides with a bump or its contour follows a vein or crack as far as possible. We all know how our imagination sometimes makes us see all sorts of images in chance formations such as clouds or blots. A Stone Age hunter, his mind filled with thoughts of the big game on which he depended for survival, would have been even more likely to recognize such animals as he stared at the rock surfaces of his cave, and to attribute deep significance to his discovery. Perhaps at first he merely reinforced the outlines of such images with a charred stick from the fire, so that others, too, could see what he had found. It is tempting to think that those who proved particularly good at finding such images were given a special status as artist-magicians and relieved of the dangers of the real hunt so that they could perfect their image-hunting, until finally they learned how to make images with little or no aid

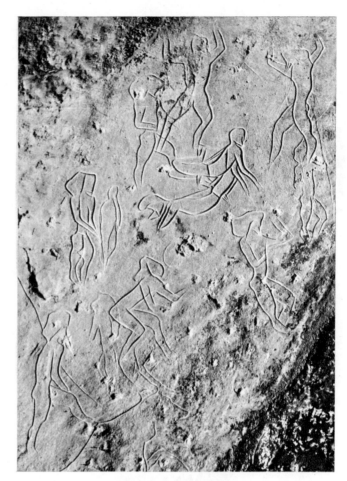

13. *Ritual Dance (?).*
c. 10,000 B.C.
Rock engraving, height of figures c. 10".
Cave of Addaura,
Monte Pellegrino (Palermo)

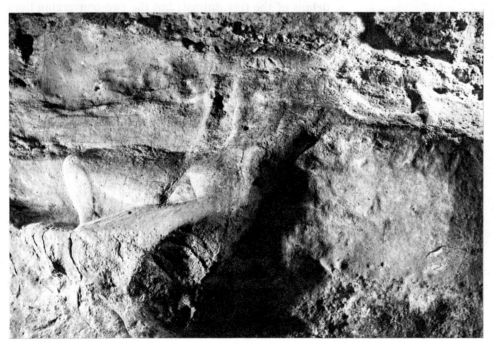

14. *Nude Woman.*
c. 15,000–10,000 B.C.
Rock carving, lifesize.
La Magdelaine Cave,
Penne (Tarn), France

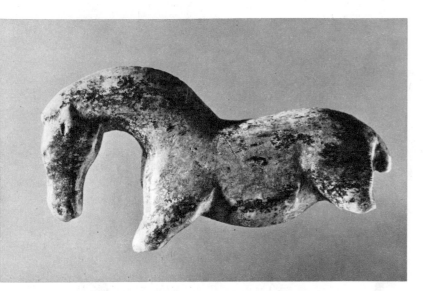

15. *Horse*, from Vogelherd cave. c. 28,000 B.C.
Mammoth ivory, length 2½". Private collection
(Photograph copyright Alexander Marshack)

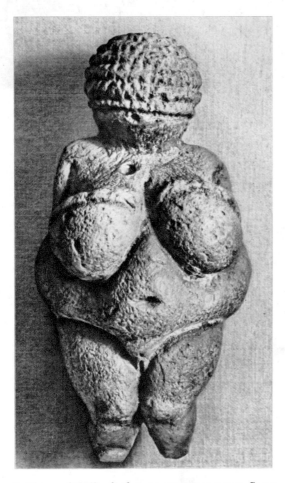

16. *Venus of Willendorf.* c. 25,000–20,000 B.C. Stone,
height 4⅜". Museum of Natural History, Vienna

from chance formations, though they continued to welcome such aid. A striking example of this process of creation is the remarkable *Nude Woman* from the La Magdelaine Cave at Penne (fig. 14), one of the rare instances of the human figure in Paleolithic art (apparently human fertility was a less pressing problem than animal fertility). The legs and torso have been carved from natural ledges of the rock in such a way that the shapes seem to emerge almost imperceptibly from the stone. The right arm is barely visible and the head appears to have been omitted altogether, for lack of "co-operation" on the part of the natural surface. What kind of ritual may have centered on this figure we can only guess. Yet the existence of cave rituals relating to both human and animal fertility would seem to be confirmed by a unique group of Paleolithic drawings recently discovered on the walls of the cave of Addaura near Palermo in Sicily (fig. 13). These images, incised into the rock with quick and sure lines, show human figures in dancelike movements, along with some animals; and here, as at Lascaux, we again find several separate layers of images superimposed on one another.

OBJECTS

Apart from large-scale cave art, the men of the Upper Paleolithic also produced small, hand-sized drawings and carvings in bone, horn, or stone, skillfully cut by means of flint tools. The earliest of these found so far are small figures of mammoth ivory from a cave in southwestern Germany, made 30,000 years ago. Even they, however, are already so accomplished that they must be the fruit of an artistic tradition many thousands of years old. The graceful, harmonious curves of the running horse (fig. 15) could hardly be improved upon by a more recent sculptor. Many years of handling have worn down some details of the tiny animal; but the two converging lines on the shoulder, indicating a dart or wound, were not part of the original design. In the end, then, this horse too has been "killed" or "sacrificed." Some of these carvings suggest that the objects may have originated with the recognition and elaboration of some chance resemblance. At an earlier stage, it seems, Stone Age men were content to collect pebbles (as well as less durable small specimens) in whose natural shape they saw something that rendered them "magic"; echoes of this approach can sometimes be felt in later, more fully worked pieces. Thus the so-called *Venus of Willendorf* in Austria (fig. 16), one of many such female fertility figurines, has a bulbous roundness of form that recalls an egg-shaped "sacred pebble"; her navel, the central point of the design, is a natural cavity in the stone. And the masterful *Bison* (fig. 17) of reindeer horn owes its compact, expressive outline in part to the contours of the palm-shaped piece of antler from which it was carved. It is not an unworthy companion to the splendid beasts at Altamira and Lascaux.

The art of the Old Stone Age in Europe as we know it

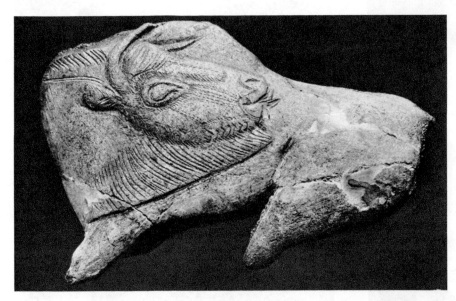

17. *Bison*, from La Madeleine
near Les Eyzies (Dordogne).
C. 15,000–10,000 B.C.
Reindeer horn, length 4″.
Museum of National Antiquities,
St.-Germain-en-Laye, France

today marks the highest achievements of a way of life that began to decline soon after. Adapted almost perfectly to the special conditions of the receding Ice Age, it could not survive beyond them. In other parts of the world, the Old Stone Age gave way to new developments between c. 10,000 and 5000 B.C., except for a few particularly inhospitable areas where the Old Stone Age way of life continued because there was nothing to challenge or disturb it. The Bushmen of South Africa and the aborigines of Australia are—or were, until very recently—the last remnants of this primeval phase of man's development. Even their art has decidedly Paleolithic features; the painting on tree bark from North Australia (fig. 18), while far less skillful than the cave pictures of Europe, shows a similar interest in movement and a keen observation of detail (including an "X-ray view" of the inner organs), only here it is kangaroos rather than bison on which the hunting magic is being worked.

FROM HUNTING TO HUSBANDRY: THE NEW STONE AGE

What brought the Old Stone Age to a close has been termed the Neolithic Revolution. And a revolution it was indeed, although its course extended over several thousand years. It began in the Near East sometime about 8000 B.C., when men made their first successful attempts to domesticate animals and food grains—one of the truly epoch-making achievements of human history. Paleolithic man had led the unsettled life of the hunter and food gatherer, reaping where nature sowed and thus at the mercy of forces which he could neither understand nor control. But now, having learned how to assure their food supply by their own efforts, men settled down in permanent village communities; a new discipline and order entered their lives. There is, then, a very basic

18. *A Spirit Man Spearing Kangaroos*, aboriginal painting from Western Arnhem Land, North Australia. c. 1900. Tree bark

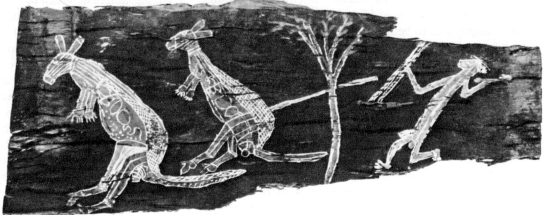

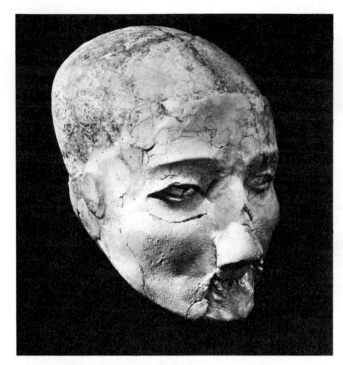

19. Neolithic Plastered Skull, from Jericho. c. 7000 B.C. Lifesize. Archaeological Museum, Amman, Jordan

right: 20. Early Neolithic Wall and Tower. c. 7000 B.C. Jericho, Jordan

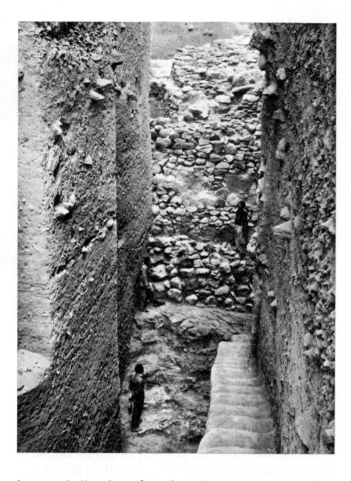

difference between the New Stone Age, or Neolithic, and the Old, despite the fact that men still depended on stone as the material of their main tools and weapons. The new mode of life brought forth a number of important new crafts and inventions long before the earliest appearance of metals: pottery, weaving and spinning, basic methods of architectural construction in wood, brick, and stone. We know all this from the tangible remains of Neolithic settlements that have been uncovered by excavation. Unfortunately, these remains tell us very little, as a rule, of the spiritual condition of Neolithic man; they include stone implements of ever greater technical refinement and beauty of shape, and an infinite variety of clay vessels covered with abstract ornamental patterns, but hardly anything comparable to the painting and sculpture of the Paleolithic. Yet the change-over from hunting to husbandry must have been accompanied by profound changes in man's view of himself and the world, and it seems impossible to believe that these did not find expression in art. There may be a vast chapter in the development of art here that is lost to us simply because Neolithic artists worked in wood or other impermanent materials. Or perhaps further excavations will help to fill the gap.

JERICHO; ÇATAL HÜYUK

A tantalizing glimpse of what lies in store for us is provided by the recent discoveries at prehistoric Jericho, which include a group of impressive sculptured heads dating from about 7000 B.C. (fig. 19). They are actual human skulls whose faces have been "reconstituted" in tinted plaster, with pieces of sea shell for the eyes. The subtlety and precision of the modeling, the fine gradation of planes and ridges, the feeling for the relationship of flesh and bone would be remarkable enough in themselves, quite apart from the amazingly early date. The features, moreover, do not conform to a single type; each has a strongly individual cast. Mysterious as they are, these Neolithic heads clearly point forward to Mesopotamian art (compare fig. 83); they are the first harbingers of a tradition of portraiture that will continue unbroken until the collapse of the Roman Empire. Unlike Paleolithic art, which had grown from the perception of chance images, the Jericho heads are not intended to "create" life but to perpetuate it beyond death by replacing the transient flesh with a more enduring substance. From the circumstances in which these heads were found we gather that they were displayed above ground while the rest of the body was buried beneath the floor of the house; most likely they belonged to venerated ancestors whose beneficent presence was thus assured. Paleolithic man, too, had buried his dead, but we do not know what ideas he associated with the grave: was death merely a return to the womb of mother earth, or did he have some conception of the beyond? The Jericho heads, on the other hand, suggest that Neolithic man believed in a spirit or soul, located in the head, which could survive the death of the body and assert its power over the fortunes of later generations, and thus had to be appeased or controlled. The preserved heads, apparently, were "spirit traps," designed

to keep the spirit in its original dwelling place. They thus express in visible form the sense of tradition, of family or clan continuity, that sets off the settled life of husbandry from the roving existence of the hunter. And Neolithic Jericho was a settled community of the most emphatic sort: the people who treasured the skulls of their forebears lived in stone houses with neat plaster floors, within a fortified town protected by walls and towers of rough but strong masonry construction (fig. 20). Yet, amazingly enough, they had no pottery; the technique of baking clay in a kiln, it seems, was not invented until later.

Since 1961, excavations at Çatal Hüyük in Anatolia have brought to light another Neolithic town, roughly a thousand years younger than Jericho. Its inhabitants lived in houses built of mud bricks and timber, clustered around open courtyards (fig. 21). There were no streets, since the houses had no doors; people apparently entered through the roof. The settlement included a number of religious shrines—the earliest found so far—and on their plaster-covered walls we encounter the earliest paintings on a man-made surface. Animal hunts, with tiny running figures surrounding huge bulls or stags (fig. 22, colorplate 2), evoke echoes of the Old Stone Age, an indication that the Neolithic Revolution must have been a recent event at the time. But the balance has already shifted; these hunts have the character of rituals honoring the male deity to whom the bull and stag were sacred, rather than of an everyday activity necessary for survival. Compared to the animals of the cave paintings, these at Çatal Hüyük are simplified and immobile; it is the hunters who are in energetic motion. Animals associated with female deities display an even more rigid discipline; the two symmetrically opposed leopards (fig. 23) are mirror images of each other, and another pair of leopards forms the sides of the throne of a fertility goddess (fig. 24), one of the

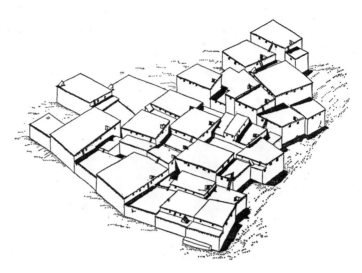

21. Houses and Shrines in terraces, Çatal Hüyük (schematic reconstruction of Level VI after Mellaart). c. 6000 B.C.

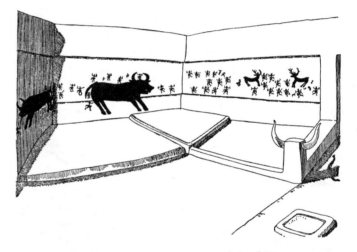

22. *Animal Hunt*, restoration of Main Room, Shrine A.III.1, Çatal Hüyük (after Mellaart). c. 6000 B.C.

23. *Twin Leopards*. Painted plaster relief, Shrine VI.A., Çatal Hüyük. c. 6000 B.C. 27 × 65"

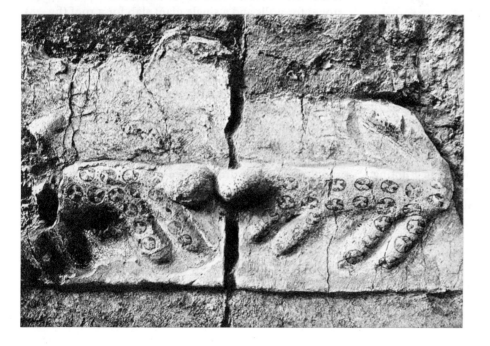

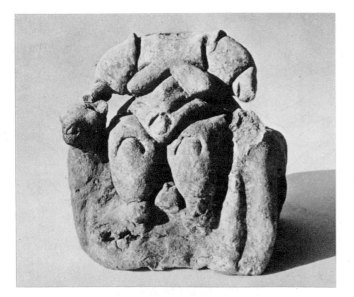

24. *Fertility Goddess,* from Shrine A.II.I,
Çatal Hüyük. c. 6000 B.C. Baked clay,
height 8″. Archaeological Museum, Ankara

25. *View of Town and Volcano,*
wall painting, Shrine VII. 14,
Çatal Hüyük. c. 6000 B.C.

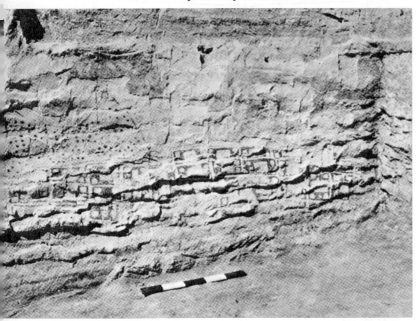

many baked clay statuettes that betray their descent from the *Venus of Willendorf* (compare fig. 16). Among the wall paintings at Çatal Hüyük, the most surprising one is a view of the town itself, with the twin cones of an erupting volcano above it (fig. 25). The densely packed rectangles of the houses are seen from above, while the mountain is shown in profile, its slope covered with dots representing blobs of lava. Such a volcano is still visible today from Çatal Hüyük. Its eruption must have been a terrifying event for the inhabitants; how could they have viewed it as other than a manifestation of the power of a deity? Nothing less could have brought forth this image, halfway between a map and a landscape.

NEOLITHIC EUROPE

While the Near East became the cradle of civilization (to be civilized, after all, means to live as a citizen, a town dweller), the Neolithic Revolution progressed at a very much slower pace in Europe. About 3000 B.C., Near Eastern influences began to spread to the northern shore of the Mediterranean. Baked clay figurines of fertility goddesses found in the Balkans, such as the very striking one from Cernavoda (figs. 26, 27), have their closest relatives in Asia Minor. What makes the Cernavoda Venus so memorable is the sculptor's ability to simplify the shapes of a woman's body and yet retain all its salient features (which, to him, did not include the face). The smoothly concave back sets off the ballooning convexity of the front—thighs, belly, arms, and breasts—in a way that would do honor to any twentieth-century sculptor.

North of the Alps, Near Eastern influence cannot be detected until a much later time. In Central and Northern Europe a sparse population continued to lead the simple tribal life of small village communities even after the introduction of bronze and iron, until a few hundred years before the birth of Christ. Thus Neolithic Europe never reached the level of social organization that produced the masonry architecture of Jericho or the dense urban community of Çatal Hüyük. Instead we find there monumental stone structures of a different kind, called megalithic because they consist of huge blocks or boulders placed upon each other without mortar. Their purpose was religious, rather than civic or utilitarian; apparently the sustained and co-ordinated effort they required could be compelled only by the authority of religious faith—a faith that almost literally demanded the moving of mountains. Even today these megalithic monuments have an awe-inspiring, superhuman air about them, as if they were the work of a forgotten race of giants. Some, known as dolmens, are tombs, "houses of the dead" with upright stones for walls and a single giant slab for a roof (fig. 28). Others, the so-called cromlechs, form the setting of religious observances. The one at Stonehenge in southern England (figs. 29, 30) consists of a great circle of evenly spaced uprights supporting horizontal slabs (lintels) and two inner circles similarly marked, with an altar-like stone at the center. The entire structure is oriented toward the exact point at which the sun rises on the day of the summer solstice, and therefore it must have served a sun-worshiping ritual. Whether a monument such as this should be termed architecture is a matter of definition: nowadays we tend to think of architecture in terms of enclosed interiors, yet we also have landscape architects, the designers of gardens, parks, and playgrounds; nor would we want to deny the status of architecture to open-air theaters or sports stadiums. Perhaps we ought to consult the ancient Greeks, who coined the term. To them, "archi-tecture" meant something higher than ordinary "tecture" (that is, "construction" or "building")—much as an archbishop ranks above a bishop or an archfiend

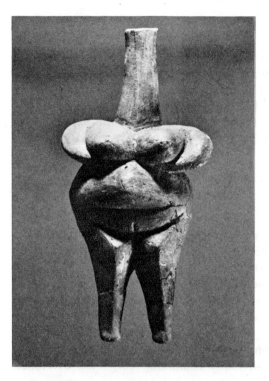
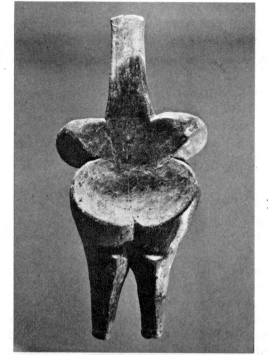

26, 27. *Fertility Goddess*,
from Cernavoda
(Romania). c. 5000 B.C.
Baked clay, height 6 ¼″.
National Museum, Bucharest
(Photographs copyright
Alexander Marshack)

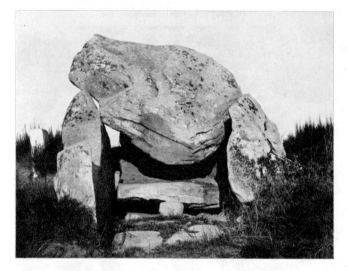
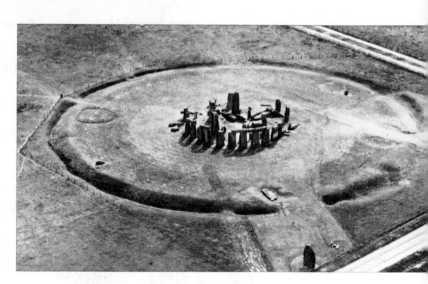

28. Dolmen. c. 1500 B.C. Carnac, Brittany

above and below: 29, 30. Stonehenge. c. 2000 B.C.
Diameter of circle 97′, height of stones above ground 13¹/₂′.
Salisbury Plain, Wiltshire, England

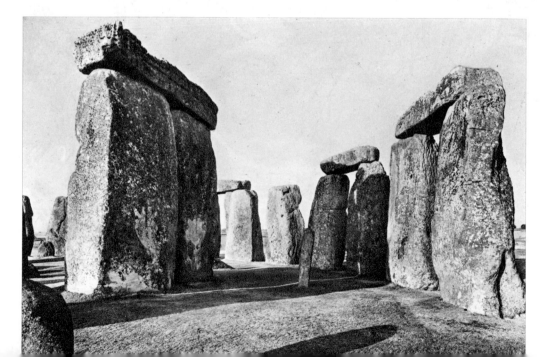

above a fiend—a structure distinguished from the merely practical, everyday kind by its scale, order, permanence, or solemnity of purpose. A Greek, therefore, would certainly have acknowledged Stonehenge as architecture. And we, too, shall have no difficulty in doing so once we understand that it is not necessary to *enclose* space in order to define or articulate it. If architecture is "the art of shaping space to human needs and aspirations," then Stonehenge more than meets the test.

NEOLITHIC AMERICA

Comparable to the megalithic monuments of Europe in terms of the effort involved is the "earth art" of the prehistoric Indians of North America, the so-called Mound Builders. The term is misleading, since these mounds vary greatly in shape and purpose as well as in date, ranging from about 2000 B.C. to the time of the white man's arrival. Of particular interest are the "effigy mounds" in the shape of animals—presumably the totems of the tribes that produced them. The most spectacular

is the Great Serpent Mound (fig. 31), a snake some 1400 feet long that slithers along the crest of a ridge by a small river in southern Ohio. The huge head, its center marked by a heap of stones that may once have been an altar, occupies the highest point. Evidently it was the natural formation of the terrain that inspired this extraordinary work of landscape architecture, as mysterious and moving in its way as Stonehenge.

PRIMITIVE ART

There are, as we have seen, a few human groups for whom the Old Stone Age lasted until the present day. Modern survivors of the Neolithic are far easier to find. They include all the so-called primitive societies of tropical Africa, the islands of the South Pacific, and the Americas. "Primitive" is a somewhat unfortunate word: it suggests —quite wrongly—that these societies represent the original condition of mankind, and has thus come to be burdened with many conflicting emotional overtones.

31. Great Serpent Mound, Adams County, Ohio. c. 300 B.C.–400 A.D. Length 1400'

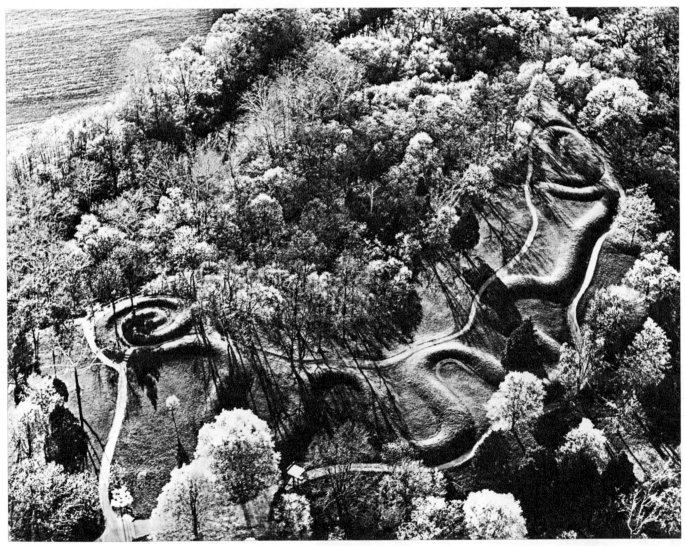

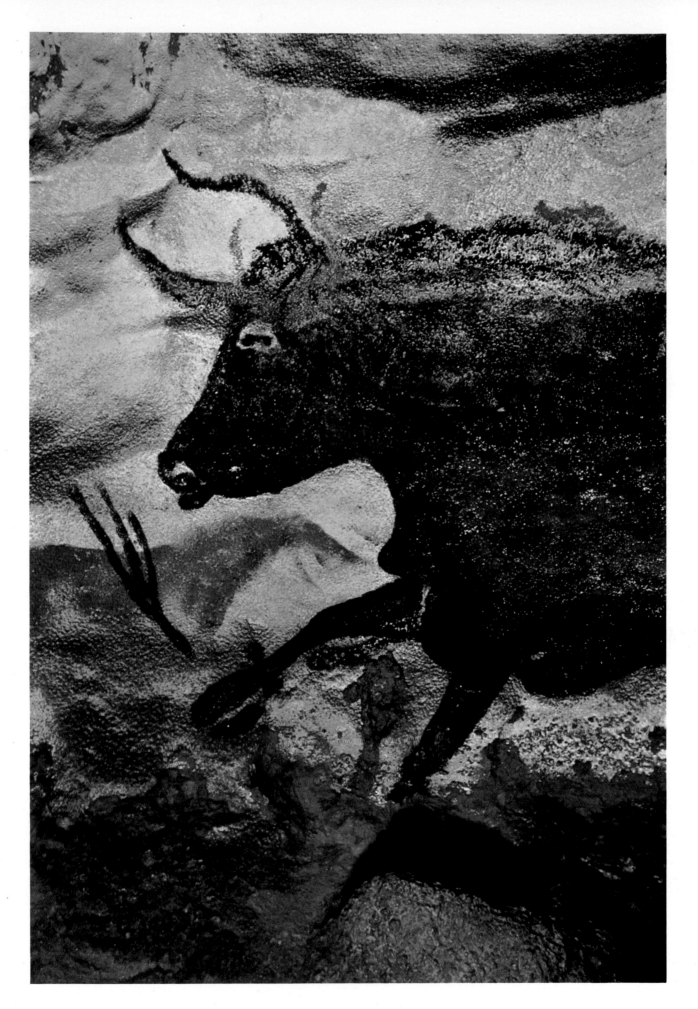

Colorplate I. PALEOLITHIC. *Black Bull*. Portion of Cave Painting.
15,000–10,000 B.C. Lascaux (Dordogne), France

Colorplate 2. NEOLITHIC. *Hunter* or *Dancer*.
Detail of Wall Painting in Main Room of Shrine A.III.1,
Çatal Hüyük. About 6000 B.C.

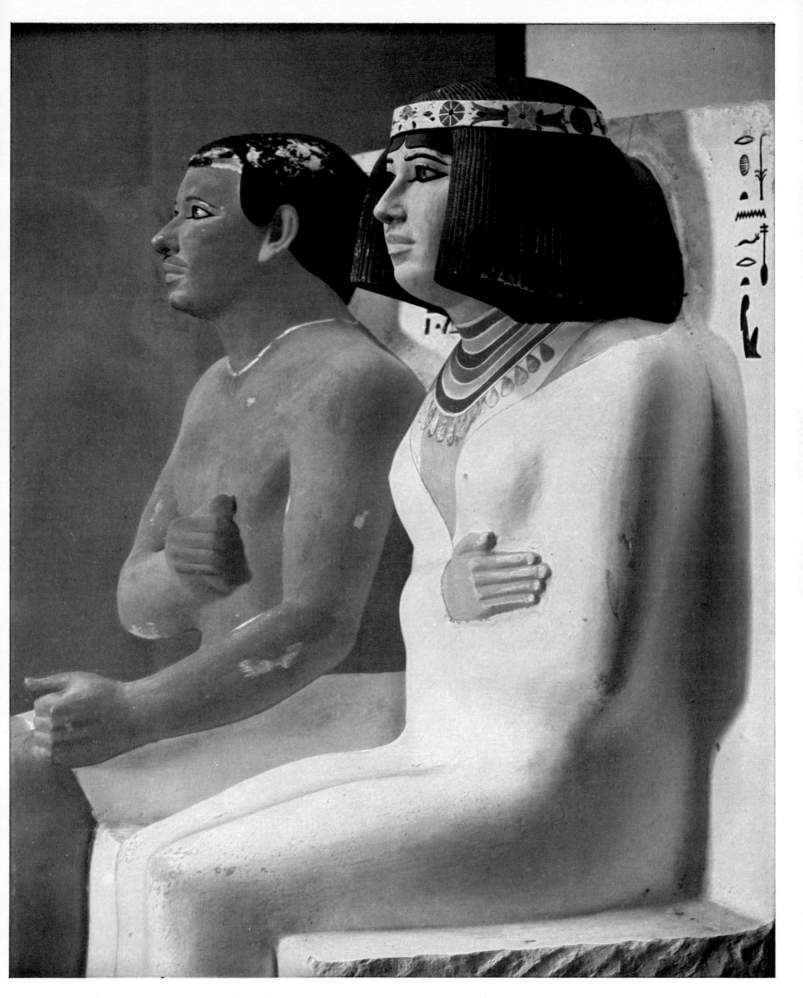

Colorplate 3. EGYPTIAN. *Prince Rahotep and His Wife Nofret*.
About 2580 B.C. Painted limestone, height 47¼″. Egyptian Museum, Cairo

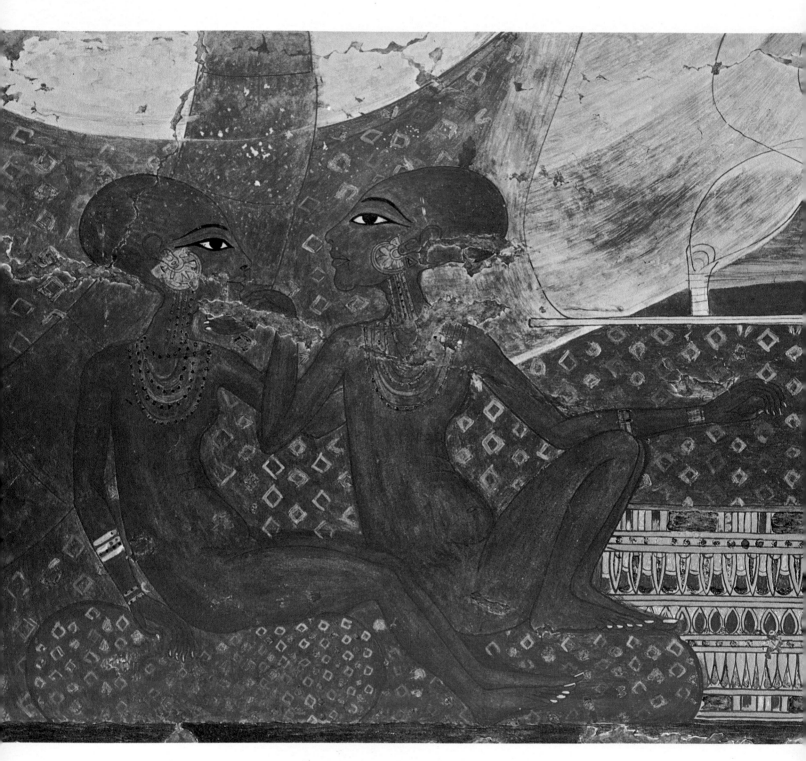

Colorplate 4. EGYPTIAN. *The Daughters of Akhenaten.*
Fragment of Wall Painting. c. 1360 B.C. 11 3/4 × 16″.
Oriental Institute, University of Chicago

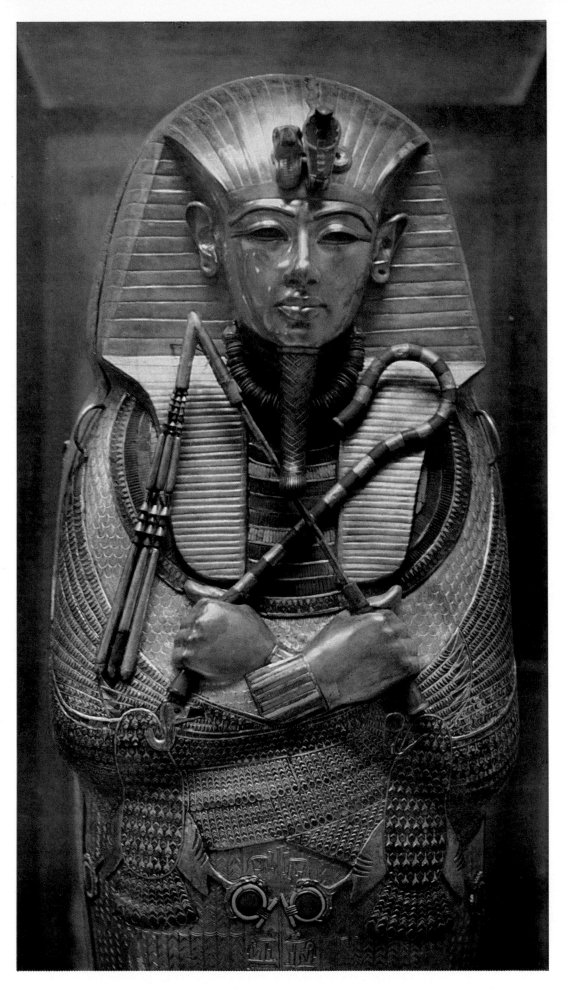

Colorplate 5. EGYPTIAN. Cover of the Coffin of Tutankhamen (portion).
About 1340 B.C. Gold (inlaid with enamel and semiprecious stones), height of whole 72 7/8″. Egyptian Museum, Cairo

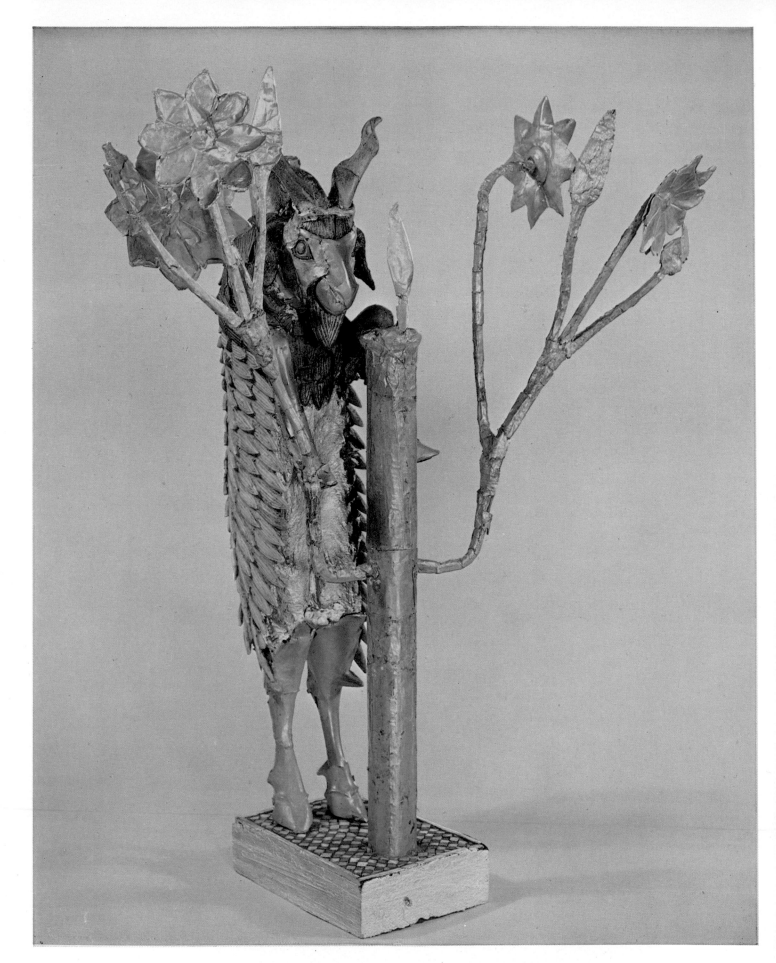

Colorplate 6. SUMERIAN. *Billy Goat and Tree* (offering stand), from Ur. About 2600 B.C.
Wood, gold, and lapis lazuli, height 20″. The University Museum, Philadelphia

Colorplate 7. NEO-BABYLONIAN. Ishtar Gate (restored), from Babylon. c. 575 B.C. ▶
Glazed brick. State Museums, Berlin (East)

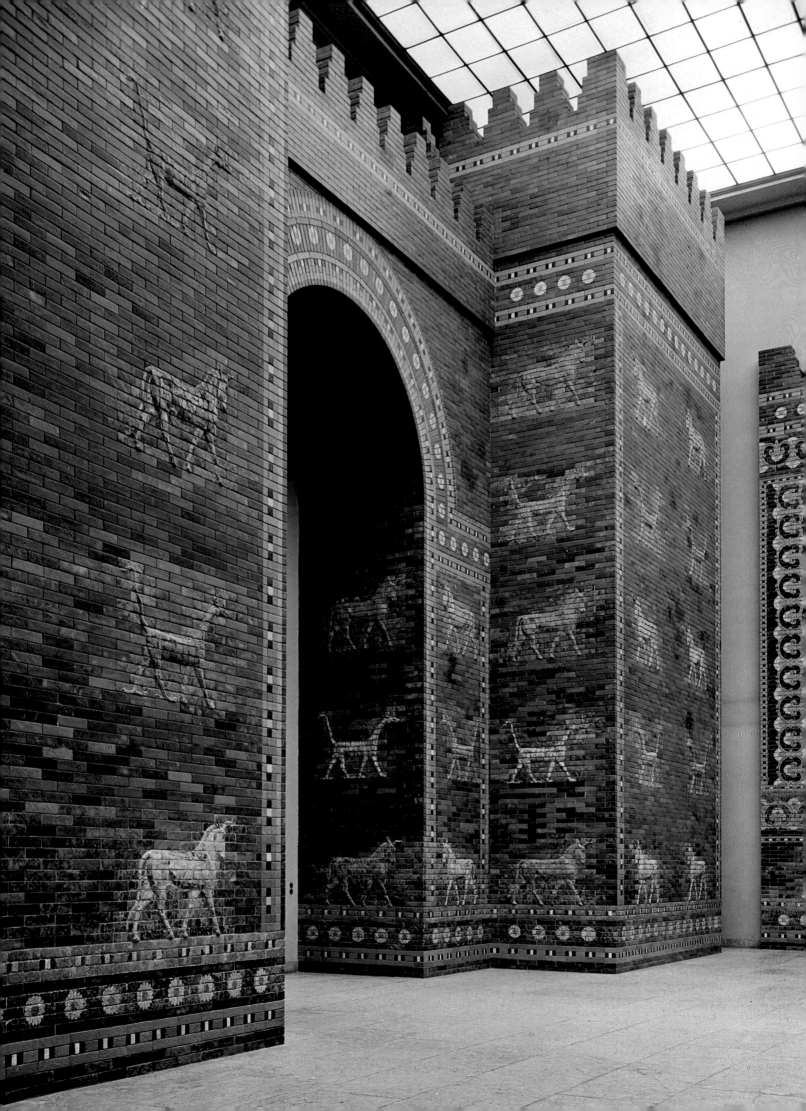

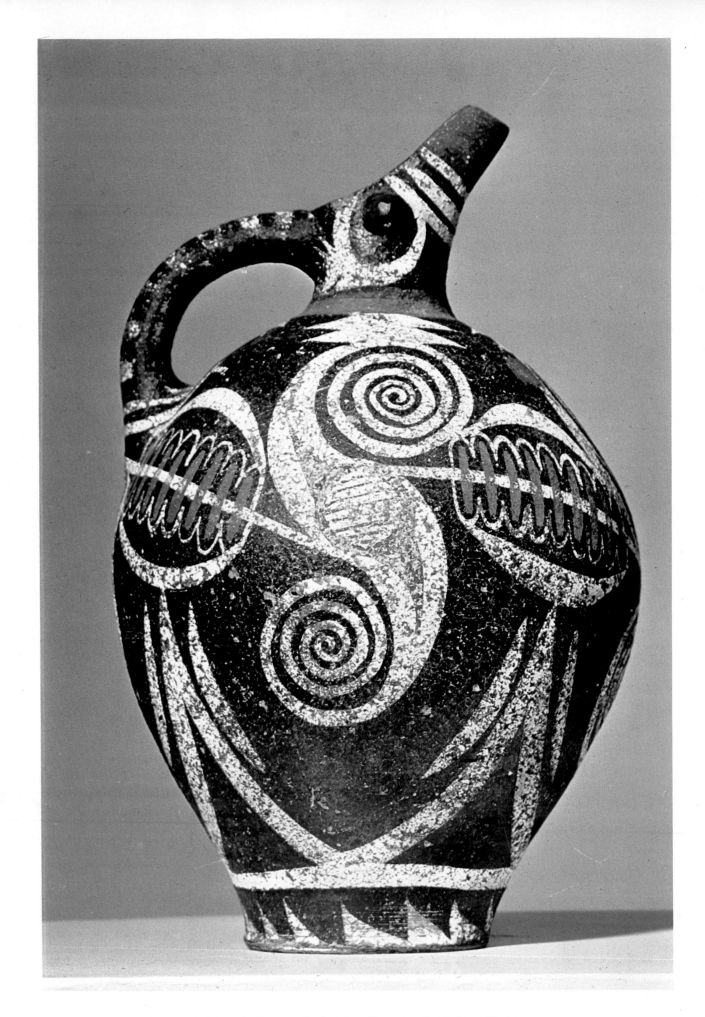

Colorplate 8. CRETAN. Beaked Jug (Kamares Style), from Phaistos.
About 1800 B.C. Height 10⁵/₈″. Museum, Heraklion, Crete

Still, no other single term will serve us better. Let us continue, then, to use primitive as a convenient label for a way of life that has passed through the Neolithic Revolution but shows no signs of evolving in the direction of the "historic" civilizations. What this means is that primitive societies are essentially rural and self-sufficient; their social and political units are the village and the tribe, rather than the city and the state; they perpetuate themselves by custom and tradition, without the aid of written records: hence they have little awareness of their own history. The entire pattern of primitive life is static rather than dynamic, without the inner drive for change and expansion that we take for granted in ours. Primitive societies tend to be strongly isolationist and defensive toward outsiders; they represent a stable but precarious balance of man and his environment, ill-equipped to survive contact with urban civilizations. Most of them have proved tragically helpless against encroachment by the West. Yet at the same time the cultural heritage of primitive man has enriched our own: his customs and beliefs, his folklore, and his music have been recorded by ethnologists, and primitive art is being avidly collected and admired throughout the Western world.

Ancestor Worship

The rewards of this concern with the world of primitive man have been manifold. Among them is a better understanding of the origins of our own culture in the Neolithic of the Near East and Europe. Though the materials on which we base our knowledge of primitive society and its ways are almost invariably of quite recent date—very few of them go back beyond the seventeenth century—they offer striking analogies with the Neolithic of the distant past; and, of course, they are infinitely richer. Thus the meaning of the cult of skulls at Jericho is illuminated by countless parallels in primitive art. The closest, astonishingly enough, is to be found in the Sepik River district of New Guinea, where until quite recently the skulls of ancestors (and of important enemies) were given features in much the same fashion, including the use of sea shells for eyes (fig. 32). And here we *know* that the purpose was to "trap" and thereby to gain power over the spirit of the dead. On the other hand, the Jericho cult probably differed from the New Guinea version in some significant respects, for the sculptured skulls from the Sepik River lack the delicate, realistic modeling of those from Jericho; the painted tribal pattern on the faces, rather than any actual portrait resemblance, establishes the identity of the deceased. Their unrelieved savagery of expression makes it hard for us to think of these heads as works of art, yet they embody the same belief as the splendid wood carvings of ancestral figures produced in that area, such as the one in figure 33. The entire design is centered on the head, with its intensely staring shell-eyes, while the body—as in primitive art generally—has been reduced to the role of a mere support. The limbs suggest the embryo position in

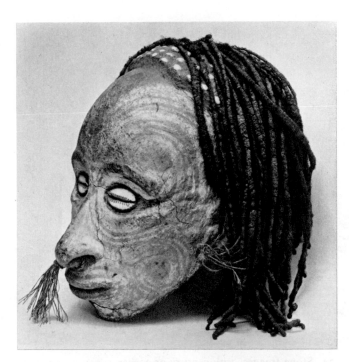

32. Plastered Skull, from the Sepik River, New Guinea. 19th century. British Museum, London

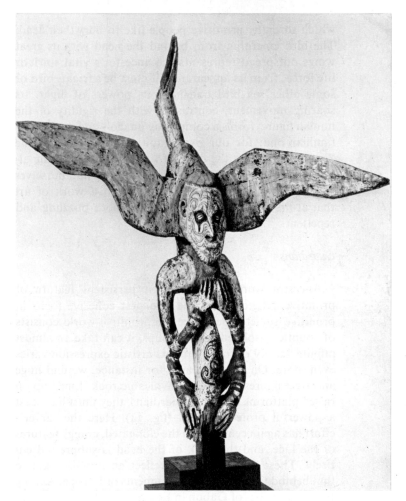

33. *Male Figure Surmounted by a Bird,* from the Sepik River, New Guinea. 19th–20th century. Wood, height 48″. Washington University Art Collection, St. Louis

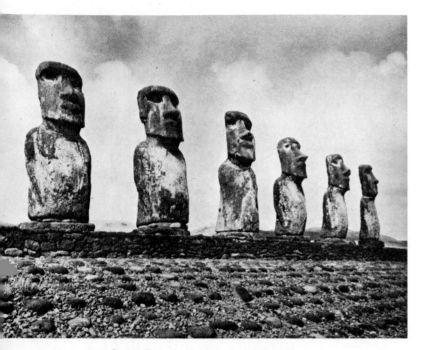

34. Stone Images. 17th century or earlier.
Height c. 30′. Akivi, Easter Island

which so many primitive people like to bury their dead. The bird emerging from behind the head with its great wings outspread represents the ancestor's vital spirit or life force; from its appearance, it must be a frigate bird or some other sea bird noted for its powers of flight. Its soaring movement, contrasted with the rigidity of the human figure, forms a compelling image—and a strangely familiar one: for our own tradition, too, includes the "soul bird," from the dove of the Holy Spirit to the albatross of the Ancient Mariner, so that we find ourselves responding, almost against our will, to a work of art that at first glance might seem to be both puzzling and repellent.

Guardians

Ancestor worship is the most persistent feature of primitive religions and the strongest cohesive force in primitive society, but since the primitive world consists of countless isolated tribal groups, it can take an almost infinite variety of forms, and its artistic expression varies even more. On Easter Island, for instance, we find huge ancestral figures carved from volcanic rock. Lined up on raised platforms like giant guardians, they must have cast a powerful protective spell (fig. 34). Here the carver's effort has again centered on the elongated, craggy features of the face, and the back of the head is suppressed entirely. These figures seem to reflect an impulse akin to that behind the megalithic monuments of Europe. Among the native tribes of Gabon in Equatorial Africa, the skulls of ancestors used to be collected in large containers that were protected by a carved guardian figure, a sort of com-

munal dwelling place of the ancestral spirits. Figure 35 shows such a guardian in the form traditional among the Bakota. This tribe, like a number of others along the west coast of Central Africa, was familiar with nonferrous metals to some extent, so that its artists were able to sheathe their guardian images in polished brass, thus endowing them with special importance. This figure is a remarkable example of the geometric abstraction which occurs, to a greater or lesser extent, throughout the realm of primitive art. Except for the head, the entire design has been flattened into a single plane; body and limbs are contracted to a hollow diamond shape, the headdress consists of two segments of circles. The face, in contrast, is a concave oval within which two spherical eyes and a pyramid-like nose nestle as they would in the center of a dish. The effect of the whole is extraordinarily calm, disciplined, and harmonious—a finely balanced sequence of shapes so unaggressive that one might almost mistake it for mere decoration. Surely this guardian could not have been meant to frighten anybody. Tribal secrets are not readily betrayed, hence the available accounts do not tell us very much about the exact significance of the Bakota guardians. It seems reasonable, however, to explain their extreme remoteness from nature—and the abstract tendency of primitive art generally—as an effort to convey the "otherness" of the spirit world, to divorce it as strictly as the artist's imagination would allow from the world of everyday appearances. Well and good—but how are we to account for the varying *degrees* of abstraction in primitive art? Must we assume that the more abstract its form, the more "spiritual" its meaning? If so, does the difference between the Bakota and Sepik River figures reflect an equally great difference in the kinds of ancestor worship from which they spring, or are there perhaps other factors to be taken into account as well?

As it happens, the Bakota guardians provide a good test for these assumptions. They have been collected in considerable numbers, and the differences among them are notable, even though they all clearly belong to a single type and must have been employed for exactly the same purpose. Our second specimen (fig. 36) is almost identical with the first, except for the head, which in comparison seems almost gruesomely realistic; its shape is strongly convex rather than concave, and every detail has an unmistakable representational meaning. This face, with its open mouth full of pointed teeth, is obviously designed to frighten. Here, we feel, is a guardian figure that does indeed live up to its function. Yet the members of the tribe failed to share our reaction, for they found the more abstract guardian figure equally acceptable. What, then, is the relation between the two? They were probably made at different times, but the interval could not have been more than a century or two, inasmuch as wooden sculpture does not survive for long under tropical conditions, and European travelers, so far as we know, did not begin to bring back any Bakota guardians until the eighteenth century. In any event, given the rigidly con-

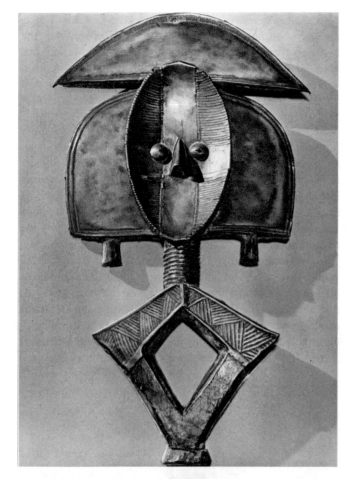

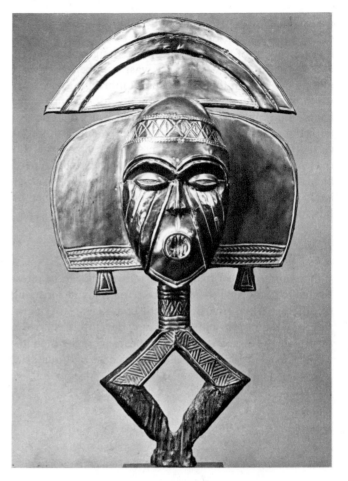

35. Guardian Figure, from the Bakota area, Gabon. 19th–20th century. Wood covered with brass, height 30". Musée Ethnographie, Geneva

36. Guardian Figure, from the Bakota area, Gabon. 19th–20th century. Wood covered with brass and copper, height 26 1/2". Collection Charles Ratton, Paris

servative nature of primitive society, we can hardly believe that the ancestor cult of the Bakota underwent any significant change during the time span that separates figure 35 from figure 36. Which of them came first, or—to put the question more cautiously—which represents the older, more nearly original version? Figure 36, surely, since we cannot imagine how its realistic features could have evolved from the spare geometry of figure 35. The line of development thus leads from figure 36 to figure 35, from representation to abstraction (we also have a good many intermediate examples). This change seems to have taken place while the religious meaning remained the same. Must we then credit the primitive artist and his public with an interest in abstraction for its own sake? That hardly sounds plausible. There is, I think, a far easier explanation: the increasingly abstract quality of the Bakota guardians resulted from endless repetition. We don't know how many such figures were in use at the same time, but the number must have been considerable, since each guardian presided over a container of not more than a dozen skulls. Their life expectancy being limited, they had to be replaced at frequent intervals, and the conservative temper of primitive society demanded

that every new guardian follow the pattern of its predecessor. Yet, as we know, no copy is ever completely faithful to its model; so long as he repeated the basic outlines of the traditional design, the Bakota carver enjoyed a certain latitude, for no two of the many surviving guardian figures have exactly the same facial structure. Maybe these slight variations were even expected of him, so as to distinguish the newly created guardian from the one it replaced. Any gesture or shape that is endlessly repeated tends to lose its original character—it becomes ground down, simplified, more abstract. We see a good example of this in the ideographs of Chinese writing, which started out as tiny pictures but before long lost all trace of their representational origin and became mere signs. The same kind of transformation, although not nearly as far-reaching, can be traced among the Bakota guardians: they grew simpler and more abstract, since this was the only direction in which they could develop. One might term what happened to them "abstraction by inbreeding." We have discussed the process at such length because it is a fundamental characteristic of Neolithic and primitive art, though we cannot often observe it as clearly as in the case of the Bakota figures. But let us be careful

not to take a negative view of this "inbreeding." It has its dangers, to be sure, but it also leads to the creation of an infinite variety of new and distinctive designs, both in art and in nature (as witness the vast number of breeds among dogs, all of them the result of inbreeding). Finally, we should note that "abstraction by inbreeding" does have its ultimate source in the primitive artist's concern with the otherness of the spirit world; for it is this concern that makes him repeat the same designs over and over again. After all, if he sets out to create a guardian of ancestral skulls, the only model he can use is another such guardian figure, and he cannot know whether he has succeeded unless the two resemble each other.

Rulers

The inbreeding of images in primitive art can be interrupted in two ways: there may be a forcible interbreeding of different tribal traditions as the consequence of migration or conquest, or conditions may develop that favor a return to the world of visible appearances. Such conditions prevailed for a time along the coast of Equatorial

Africa a few hundred miles northwest of Gabon. There, through contact with the historic civilizations of the Mediterranean, a number of native kingdoms arose, but none of them proved very enduring. A king, unlike a tribal chieftain, bases his authority on the claim that it has been given to him by supernatural forces; he rules "by the grace of God," embodying the divine will in his own person, or he may even assume the status of a deity himself. There are thus no inherent limits, ethnic, linguistic, or otherwise, to royal authority. Every king is, at least in theory, all-conquering. Hence his domain is not only larger and more complex than that of the tribal chief; he also has to exact far greater obedience from his subjects. He does so with the aid of a favored ruling elite, the aristocracy, to whom he delegates some of his authority. They enforce security and order among the rest of the population, which in return must support the aristocracy and the royal court by contributing a share of its goods and services. The institution of kingship, then, demands a society divided into classes, rather than the loose association of family or clan groups that makes up a tribe. It means the victory of the town over the countryside, and

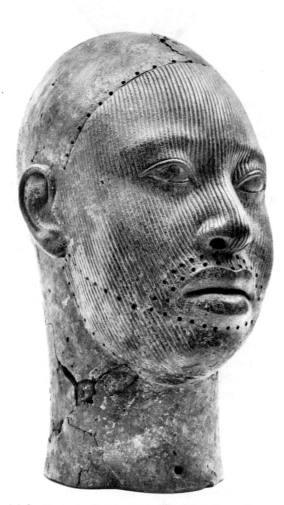

37. *Male Portrait Head*, from Ife, Nigeria. 12th century. Bronze, height 13 1/2". Collection the Oni of Ife

38. *Hornblower*, from Benin, Nigeria. Late 16th–early 18th century. Bronze, height 24 7/8". The Museum of Primitive Art, New York

thus runs counter to the rural tenor of primitive life. The African kingdoms never quite achieved this victory, so their instability is perhaps not surprising. The decisive factor may have been their failure to develop or adopt a system of writing. They existed, as it were, along the outer edge of the historic civilizations, and their rise and fall, therefore, are known to us only in dim and fragmentary fashion.

Artistically, the most impressive remains of these vanished native kingdoms are the portrait heads excavated at Ife, Nigeria, somewhat to the west of the lower course of the Niger River. Some are of terracotta; others, such as the splendid example in figure 37, of bronze. The casting technique, called the cire-perdue (lost-wax) process, surely had been imported from the Mediterranean, but it was used here with great skill: the actual modeling is done in wax over an earthen core, another layer of earth is firmly packed around the head, the whole is then heated to melt out the wax, and molten bronze is poured into the hollow form thus created. Even more astonishing than its technical refinement, however, is the subtle and assured realism of our Ife head. The features are thoroughly individual, yet so harmonious and noble in expression as to recall the classical art of Greece and Rome (see colorplate 14 and fig. 251). At the time this head was produced, the twelfth century A.D., nothing of comparable character can be found in Europe. Only the tribal scars on the face, and the holes for attaching hair and beard, relate it to primitive art elsewhere; these, and the purpose for which it was made: ancestor worship. Our head, together with its companions, must have formed part of a long series of portraits of dead rulers, and the use of real hair—probably hair taken from the person represented—strongly suggests that these heads were prepared as "traps" for the spirits of the deceased. But since the rulers each had individual importance, their spirits, unlike those of the tribal ancestors, could not be merged into an impersonal collective entity; in order to be an effective trap, every head had to be an authentic, clearly distinguishable portrait. It is possible, in fact, that these heads were made (if not of bronze, then at least of terracotta) while their subjects were still alive, and became spirit traps only after the ruler's death, through the addition of his hair. Clearly, each of these heads is unique and irreplaceable. It had to last forever, hence it was executed in laborious bronze rather than wood. It is no accident, then, that the Ife heads bear a closer resemblance to the Jericho skulls than to the ancestor figures of primitive art, for the rulers of Ife had indeed recaptured something of the urban quality of the Jericho ancestor cult.

The bronze technique of Ife was handed on to the kingdom of Benin, which arose in the same area and did not disappear until the early eighteenth century. In addition to ancestor heads, the artists of Benin produced a vast variety of works that had nothing to do with the spirit world but served to glorify the ruler and his court. The *Hornblower* (fig. 38) is a characteristic specimen of this

art for display. By the standards of primitive sculpture as a whole, it seems exceptionally realistic, but when measured against the art of Ife it betrays its close kinship with tribal wood carvings in the emphasis on the head and the geometric simplification of every detail.

Animism

That primitive man should prefer to think of the spirits of his ancestors collectively, as did the Bakota, rather than in terms of separate individuals, is not at all surprising in view of the curiously fluid nature of his religious beliefs. Such religious beliefs have been termed animism, for to the primitive mind a spirit exists in every living thing. He will feel that he must appease the spirit of a tree before he cuts it down but the spirit of any particular tree is also part of a collective "tree spirit" which in turn merges into a general "life spirit." Other spirits dwell in the earth, in rivers and lakes, in the rain, in sun and moon; still others demand to be appeased in order to promote fertility or cure disease. Their dwelling places may be given the shape of human figures, in which case

39. *Kneeling Woman*, from the Baluba area, Kinshasa, Zaïre. 19th–20th century. Wood, height 18 1/2". Royal Museum of Central Africa, Tervueren, Belgium

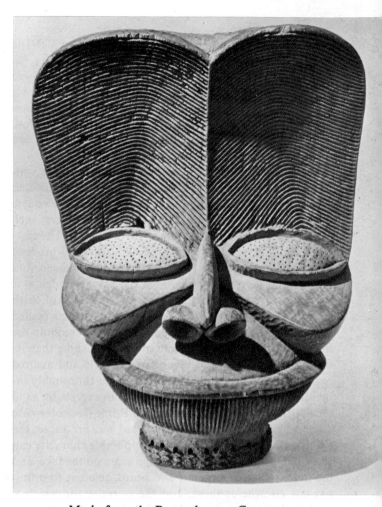

40. Mask, from Kippel, Lötschental, Switzerland.
19th century. Wood, height 18″.
Rietberg Museum, Zurich (E.v.d. Heydt Collection)

41. Mask, from the Bamenda area, Cameroon.
19th–20th century. Wood, height 26 1/2″.
Rietberg Museum, Zurich (E.v.d. Heydt Collection)

such spirits sometimes achieve enough of a stable identity to be viewed as rudimentary deities. This seems to be true of the very fine *Kneeling Woman* (fig. 39), produced by the Baluba tribe of the Congo region, though little is known about her ritual significance. The figure is among the gentlest and least abstract of all tribal carvings, and her trancelike expression, as well as the hollow bowl, suggests a ceremonial of incantation or divination.

Masks

In dealing with the spirit world, primitive man was not content to perform rituals or to present offerings before his spirit traps; he needed to act out his relations with the spirit world through dances and similar dramatic ceremonials in which he himself could temporarily assume the role of the spirit trap by disguising himself with elaborate masks and costumes. The origin of these dance rituals goes back as far as the Old Stone Age (see fig. 13), and there are indications that animal disguises were worn even then. In primitive society, the acting-out ceremonials assumed a vast variety of patterns and purposes; and the costumes, always with a mask as the cen-

tral feature, became correspondingly varied and elaborate. Nor has the fascination of the mask died out to this day. We still feel the thrill of a real change of identity when we wear one at Halloween or carnival time, and among the folk customs of the European peasantry there were, until recently, certain survivals of pre-Christian ceremonies in which the participants impersonated demons by means of carved masks of truly primitive character (see fig. 40). Masks form by far the richest chapter in primitive art; the proliferation of shapes, materials, and functions is almost limitless. Even the manner of wearing them varies surprisingly: some cover only the face, others the entire head; some rest on the shoulders; some may be worn above the head, attached to a headdress or atop a pole. There are masks of human faces, ranging from the realistic to the most fantastic, and animal masks or combinations of both in every conceivable form. There are also masks that are not made to be worn at all but to be displayed independently as images complete in themselves. The few samples reproduced here can convey no more than the faintest suggestion of the wealth of the available material. Their meaning, more often than not, is impossible to ascertain; the ceremonies which they

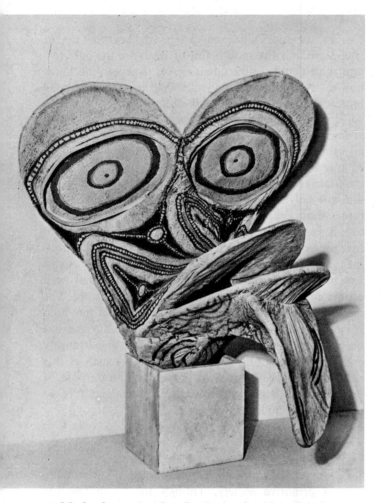

42. Mask, from the Gazelle Peninsula, New Britain.
19th–20th century. Bark cloth, height 18″.
Museo Nacional de Antropología, Mexico

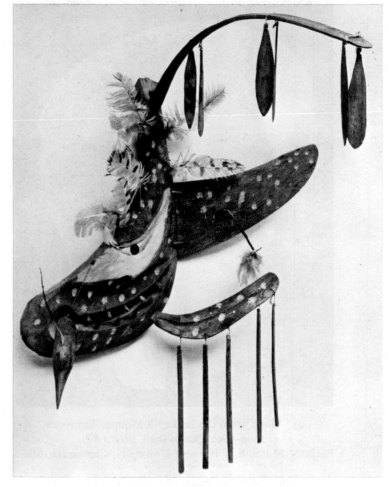

43. Mask (Eskimo), from southwest Alaska.
Early 20th century. Wood, height 22″.
Museum of the American Indian, Heye Foundation, New York

served usually had elements of secrecy that were jealously guarded from the uninitiated, especially if the performers themselves formed a secret society. This emphasis on the mysterious and spectacular not only heightened the dramatic impact of the ritual, it also permitted the makers of masks to strive for imaginative new effects, so that masks in general are less subject to traditional restrictions than other kinds of primitive sculpture.

African masks, such as the one in figure 41, are distinguished for symmetry of design and the precision and sharpness of their carving. In our example, the features of the human face have not been rearranged but restructured, so to speak, with the tremendous eyebrows rising above the rest like a protective canopy. The solidity of these shapes becomes strikingly evident as we turn to the fluid, ghostly features of the mask from the Gazelle Peninsula on the island of New Britain in the South Pacific, made of bark cloth over a bamboo frame (fig. 42). It is meant to represent an animal spirit, said to be a crocodile, and was worn in nocturnal ceremonies by dancers carrying snakes. Even stranger is the Eskimo mask from southwest Alaska (fig. 43), with its nonsymmetrical design of seemingly unrelated elements, especially the dangling

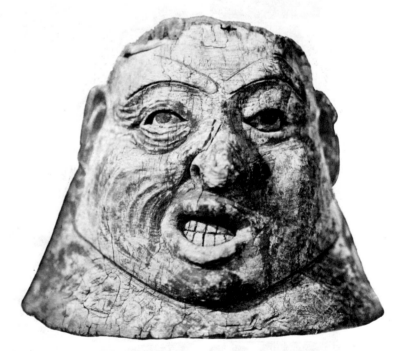

44. War Helmet (Tlingit), from southeast Alaska.
Early 19th century. Wood, height 12″.
The American Museum of Natural History, New York

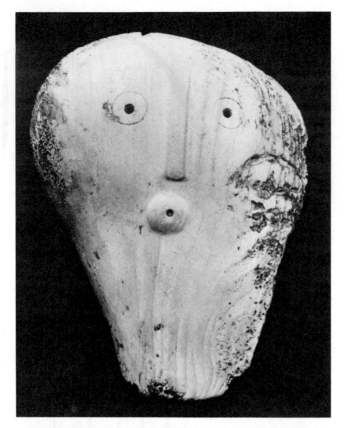

"leaves" or sticks attached to curved "branches." The single eye and the mouth full of teeth are the only recognizable details to the outsider, yet to those who know how to "read" this assembly of shapes it is the condensed representation of a tribal myth about a swan that drives white whales to the hunters. Such radical displacement of facial details is characteristic of Eskimo masks generally, though it is seldom carried as far as here. The wooden war helmet from southeast Alaska (fig. 44), in contrast, strikes us by its powerful realism, which may be due not only to the fact that this is a work of Indian rather than Eskimo origin, but also to its function. It, too, is a kind of mask, a second face intended to disconcert the enemy by its fierce expression. Our final specimen, one of the most fascinating of all, comes from an Indian burial mound in Tennessee (fig. 45). It has been estimated as being between 400 and 1000 years old. The material is a single large sea shell, whose rim has been smoothed and whose gently convex outer surface has been transformed into a face by simple but strangely evocative carving and drilling. Shell masks such as this seem to have been placed in graves for the purpose of providing the dead with a second, permanent face to trap his spirit underground.

45. Mask, from the Brakebill Mound, Tennessee.
c. 1000–1600. Ocean shell, height 8 5/8".
Peabody Museum of Harvard University, Cambridge, Mass.

46. *Lightning Snake, Wolf, and Thunder Bird on Killer Whale* (Nootka). c. 1850. Wood, 5' 8" × 8' 10".
The American Museum of Natural History, New York

Primitive Painting

Compared to sculpture, painting plays a subordinate role in primitive society. Though the technique was widely known, its use was restricted in most areas to the

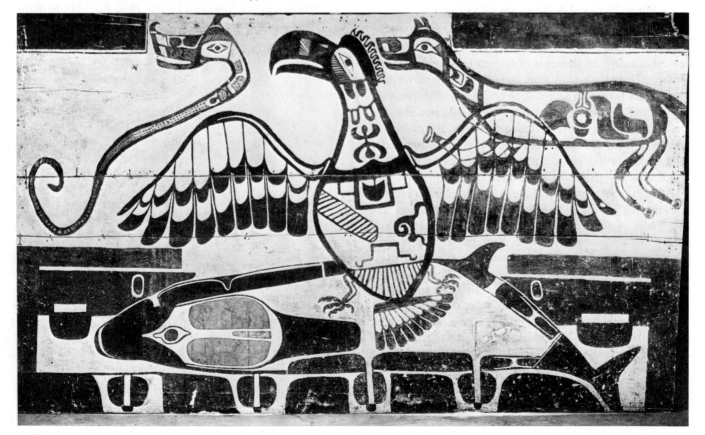

47. Sand Painting Ritual for a Sick Child (Navaho). Arizona

coloring of wood carvings or of the human body sometimes with intricate ornamental designs (see fig. 33). As an independent art, however, painting could establish itself only when exceptional conditions provided suitable surfaces. Thus the Nootka Indians on Vancouver Island, off the northwest coast of North America, developed fairly large wooden houses with walls of smooth boards which they liked to decorate with scenes of tribal legend. Figure 46 shows a section of such a wall, representing a thunder bird on a killer whale flanked by a lightning snake and a wolf. The animals are clearly recognizable but they do not form a meaningful scene unless we happen to know the context of the story. The owner of the house obviously did, so the painter's main concern was how to combine the four creatures into an effective pattern filling the area at his disposal. It is apparent that these animals, which play important parts in the tribal mythology, must have been represented countless times before; each of them is assembled in accordance with a well-established traditional formula made up of fixed ingredients—small, firmly outlined pieces of solid color that look as if they have been cut out separately and laid down one by one. The artist's pattern-consciousness goes so far that any overlapping of forms embarrasses him; where he cannot avoid it, he treats the bodies of the animals as transparent, so that the outline of the whale's back can be seen continuing right through the lower part of the bird's body, and the feathers of the right wing reveal the front legs of the wolf.

Formal and abstract as the Nootka wall painting may seem in comparison with the animals of the Paleolithic, it becomes downright realistic if we judge it by the standards of the sand painting visible in figure 47. That unique art grew up among the Indian tribes inhabiting the arid Southwest of the United States; its main practitioners today are the Navaho of Arizona. The technique, which demands considerable skill, consists of pouring powdered rock or earth of various colors on a flat bed of sand. Despite (or perhaps because of) the fact that they are impermanent and must be made fresh for each occasion that demands them, the designs are rigidly fixed by tradition; they can, indeed, be cited as a prime example of abstraction by inbreeding. The various compositions are rather like recipes, prescribed by the medicine man and "filled" under his supervision by the painter, for the main use of sand paintings is in ceremonies of healing. That these ceremonies are sessions of great emotional intensity on the part of both doctor and patient is well attested by our illustration. Such a close union—or even, at times, identity—of priest, healer, and artist may be difficult to understand in modern Western terms. (Or could it be that all these qualities are present, though not to an equal degree, in the personality and work of Sigmund Freud?) But for primitive man, trying to bend nature to his needs by magic and ritual, the three functions must have appeared as different aspects of a single process. And the success or failure of this process was to him quite literally a matter of life and death.

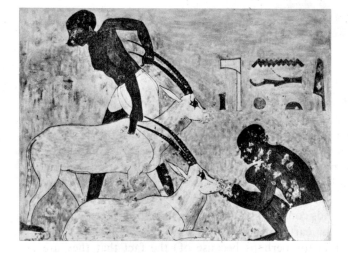

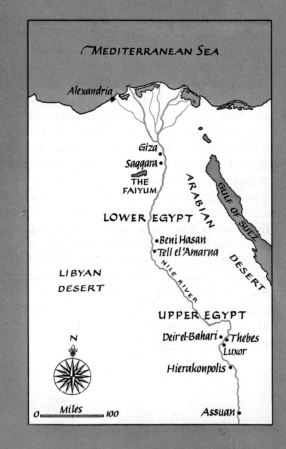

2

EGYPTIAN ART

History, we are often told, begins with the invention of writing, some 5000 years ago. It makes a convenient landmark, for the two events do coincide in a rough way, and the absence of written records is surely one of the key differences between prehistoric and historic societies. But as soon as we ask why this is so, we face some intriguing problems. First of all, how valid is the distinction between "prehistoric" and "historic"? Does it merely reflect a difference in our *knowledge* of the past? (Thanks to the invention of writing, we do know a great deal more about history than about prehistory.) Or was there a genuine change in the way things happened—or the kinds of things that happened—after "history" began? Obviously, prehistory was far from uneventful: the road from hunting to husbandry is a long and arduous one. Yet the changes in man's condition that mark this road, decisive though they are, seem incredibly slow-paced and gradual when measured against the events of the past 5000 years. The beginning of history, then, means a sudden increase in the speed of events, a shifting from low into high gear, as it were. And we shall see that it also means a change in the *kind* of events.

Perhaps it is merely a matter of perspective—things that are near to us loom larger—but I do not think so. For the problems and pressures faced by historic societies are very different from those that confronted Paleolithic or Neolithic man. Prehistory might be defined as that phase of human evolution during which man as a species learned how to maintain himself against a hostile environment; his achievements were responses to threats of physical extinction. With the domestication of animals and food plants, he had won a decisive victory in this battle, assuring his survival on this planet. But the Neolithic Revolution placed him on a level at which he might well have remained indefinitely; the forces of nature—at least during that geological era—would never again challenge him as they had Paleolithic man. And in many parts of the globe, as we saw in the previous chapter, man was content to stay on the "Neolithic plateau" of primitive society. In a few places, however, the Neolithic balance of man and nature was upset by a new threat, a threat posed not by nature but by man himself. The earliest monument to that threat is seen in the fortifications of Neolithic Jericho (see fig. 20), constructed almost 9000 years ago. What was the source of the human conflict that made them necessary? Competition for grazing land among tribes of herdsmen or for arable soil among farming communities? The basic cause, we suspect, was that the Neolithic Revolution had been too successful in this area, permitting the local population to grow beyond the available food supply. This situation might have been resolved in a number of ways: constant tribal warfare could have reduced the population; or the people could have united in larger and more disciplined social units for the sake of ambitious group efforts that no loosely organized tribal society would have been able to achieve. The fortifications at Jericho were an enterprise of this kind, requiring sustained and specialized labor over a long period. We do not know the outcome of the struggle in that region (future excavations may tell us how far the urbanizing process extended) but about 3000 years later similar conflicts, on a larger scale, arose in the Nile valley and that of the Tigris and Euphrates, and there these conflicts generated enough pressure to produce a new kind of society, very much more complex and efficient than had ever existed before.

It is at this point that we find the pace of events shifting into high gear. These societies quite literally *made* history; they not only brought forth "great men and great deeds"—the traditional definition of history—by demanding human effort on a new and larger scale, but they made these achievements *memorable*. (In order to be memorable, an event must be more than "worth remembering"; it must also be accomplished quickly enough to be grasped by human memory, and not spread over many centuries, as was the Neolithic Revolution.) From now on, first in Egypt and Mesopotamia, somewhat later in neighboring areas, as well as in the Indus valley and along the Yellow River in China, men were to live in a new, dynamic world, where their capacity to survive was challenged not by the forces of nature but by human forces—by tensions and conflicts arising either within society or as the result of competition between societies. These efforts to cope with his human environment have proved a far greater challenge to man than his earlier struggle with nature; they are the cause of the ever-quickening pace of events during the past 5000 years. The invention of writing was an early and indispensable accomplishment of the historic civilizations of Mesopotamia and Egypt. Without it, the growth we have known

48. *Men, Boats, and Animals.*
Wall Painting in Predynastic tomb.
c. 3200 B.C. Hierakonpolis

would have been impossible. We do not know the earliest phases of its development, but it must have taken several hundred years (between 3300 and 3000 B.C., roughly speaking, with Mesopotamia in the lead), after the new societies were already past their first stage. History was well under way by the time writing could be used to record historic events.

THE OLD KINGDOM

Egyptian civilization has long been regarded as the most rigid and conservative ever. Plato said that Egyptian art had not changed in 10,000 years. Perhaps "enduring" and "continuous" are better terms for it, although at first glance all Egyptian art between 3000 and 500 B.C. does tend to have a certain sameness. There is a kernel of truth in this: the basic pattern of Egyptian institutions, beliefs, and artistic ideas was formed during the first few centuries of that vast span of years and kept reasserting itself until the very end. We shall see, however, that as time went on this basic pattern went through ever more severe crises that challenged its ability to survive; had it been as inflexible as supposed, it would have succumbed long before it finally did. Egyptian art alternates between conservatism and innovation, but is never static. Some of its great achievements had a decisive influence on Greek and Roman art, and thus we can still feel ourselves linked to the Egypt of 5000 years ago by a continuous, living tradition.

The history of Egypt is divided into dynasties of rulers, in accordance with ancient Egyptian practice, beginning with the First Dynasty, shortly after 3000 B.C. (the dates of the earliest rulers are difficult to translate exactly into our calendar). The transition from prehistory to the First Dynasty is known as the predynastic period. The Old Kingdom forms the first major division after that, ending about 2155 B.C. with the overthrow of the Sixth

Dynasty. This method of counting historic time conveys at once the strong Egyptian sense of continuity and the overwhelming importance of the Pharaoh (king), who was not only the supreme ruler but a god. We have had occasion to mention the main features of kingship before (see page 44); the Pharaoh transcended them all, for his kingship was not a duty or privilege derived from a super-human source, but was absolute, divine. However absurd his status may seem to us, and however ineffective it was in practice at times of political disturbance, it remained the key feature of Egyptian civilization. For us it has particular importance because it very largely determined the character of Egyptian art. We do not know exactly the steps by which the early Pharaohs established their claim to divinity, but we know their historic achievements: molding the Nile valley from the first cataract at Assuan to the Delta into a single, effective state, and increasing its fertility by regulating the annual inundation of the river waters through dams and canals.

Of these vast public works nothing remains today, and very little has survived of ancient Egyptian palaces and cities. Our knowledge of Egyptian civilization rests almost entirely on the tombs and their contents. This is no accident, since these tombs were built to last forever. Yet we must not make the mistake of concluding that the Egyptians viewed life on this earth mainly as a road to the grave. Their preoccupation with the cult of the dead is a link with the Neolithic past, but the meaning they gave it was quite new and different: the dark fear of the spirits of the dead which dominates primitive ancestor cults seems entirely absent. Instead, the Egyptian attitude was that each man must provide for his own happy afterlife. He would equip his tomb as a kind of shadowy replica of his daily environment for his spirit, his *ka*, to enjoy, and would make sure that his *ka* had a body to dwell in (his own mummified corpse or, if that should be destroyed, a statue of himself). There is a curious blurring of the

sharp line between life and death here, and perhaps that was the essential impulse behind these mock households; a man who knew that after death his *ka* would enjoy the same pleasures he did, and who had provided these pleasures in advance by his own efforts, could look forward to an active and happy life without being haunted by fear of the great unknown. In a sense, then, the Egyptian tomb was a kind of life insurance, an investment in peace of mind. Such, at least, is the impression one gains of Old Kingdom tombs. Later on, the serenity of this concept of death was disturbed by a tendency to subdivide the spirit or soul into two or more separate identities, and by the introduction of a sort of judgment, a weighing of souls; and it is only then that we also find expressions of the fear of death.

An early stage in the development of Egyptian funerary customs—and of Egyptian art—can be seen in the fragment of a wall painting from Hierakonpolis (fig. 48). The design is still decidedly primitive in its character—an even scattering of forms over the entire surface. It is instructive to note, however, that the human and animal figures tend to become standardized, abbreviated "signs," almost as if they were on the verge of turning into hieroglyphics (such as we see in fig. 78). The large white shapes are boats; their significance here seems to be that of funeral barges or "vehicles of the soul," since that is their role in later tombs. The black and white figures above the topmost boat are mourning women, their arms spread out in a gesture of grief. For the rest, the picture does not appear to have any coherence as a scene nor any symbolic import; perhaps we ought to view it as an early attempt at those typical scenes of daily life that we meet several centuries later in Old Kingdom tombs (figs. 65, 66).

EGYPTIAN STYLE AND
THE PALETTE OF KING NARMER

At the time of the Hierakonpolis mural—about 3200 B.C.—Egypt was in process of learning the use of bronze tools. The country, we may assume, was ruled by a number of local sovereigns not too far removed from the status of tribal chiefs. The fight scenes between black-bodied and white-bodied men in the painting probably reflect local wars or raids. Out of these emerged two rival kingdoms, Upper and Lower Egypt. The struggle between them was ended when certain Upper Egyptian kings conquered Lower Egypt and combined the two realms. One of these was King Narmer, who appears on the strange but impressive object in figures 49 and 50, a ceremonial slate palette celebrating a victory over Lower Egypt (note the different crowns worn by the king). It, too, comes from Hierakonpolis, but otherwise it has little in common with the wall painting. In many ways, the Narmer palette can claim to be the oldest historic work of art we know: not only is it the earliest surviving image of a historic personage identified by name, but its character is clearly no longer primitive; in fact, it already shows most of the features of later Egyptian art. If only we had enough preserved material to trace step by step the evolution that led from the wall painting to this palette!

Let us first "read" the scenes on both sides. The fact that we are able to do so is another indication that we have left prehistoric art behind. For the meaning of these reliefs is made clear and explicit not only by means of hieroglyphic labels, but also through the use of a broad range of visual symbols conveying precise messages to the beholder, and—most important of all—through the

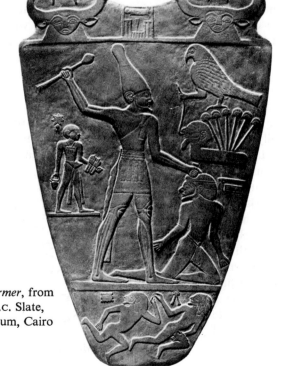
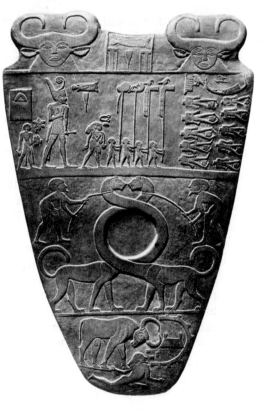

49, 50. *Palette of King Narmer*, from Hierakonpolis. c. 3000 B.C. Slate, height 25″. Egyptian Museum, Cairo

51. *Portrait Panel of Hesy-ra*, from Saqqara. c. 2660 B.C. Wood, height 45″. Egyptian Museum, Cairo

disciplined, rational orderliness of the design. In figure 49 Narmer has seized a fallen enemy by the hair and is about to slay him with his mace; two more defeated enemies are placed in the bottom compartment (the small rectangular shape next to the man on the left stands for a fortified town or citadel). Facing the king in the upper right we see a complex bit of picture writing: a falcon standing above a clump of papyrus plants holds a tether attached to a human head which "grows" from the same soil as the plants. This composite image actually repeats the main scene on a symbolic level; the head and papyrus plants stand for Lower Egypt, while the victorious falcon is Horus, the local god of Upper Egypt. The parallel is plain: Horus and Narmer are the same; a god triumphs over human foes. Hence, Narmer's gesture must not be taken as representing a real fight; the enemy is helpless from the very start, and the slaying is a ritual rather than a physical effort. We gather this from the fact that Narmer has taken off his sandals (the court official behind him carries them in his right hand), an indication that he is standing on holy ground. On the other side of the palette (fig. 50) he again appears barefoot, followed by the sandal

carrier, as he marches in solemn procession behind a group of standard-bearers to inspect the decapitated bodies of prisoners. (The same notion recurs in the Old Testament, apparently as the result of Egyptian influence, when the Lord commands Moses to remove his shoes before He appears to him in the burning bush.) The bottom compartment re-enacts the victory once again on a symbolic level, with the Pharaoh represented as a strong bull trampling an enemy and knocking down a citadel. (A bull's tail hanging down from his belt is shown in both images of Narmer; it was to remain a part of Pharaonic ceremonial garb for the next 3000 years.) Only the center section fails to convey an explicit meaning; the two long-necked beasts and their attendants have no identifying attributes and may well be a carry-over from earlier, purely ornamental palettes. In any event, they do not reappear in Egyptian art.

We have discussed these reliefs at such length because we must grasp their content in order to understand their formal qualities, their *style*. We have avoided this term until now and it is necessary to comment on it briefly before we proceed. *Style* is derived from *stilus*, the writing instrument of the ancient Romans; originally, it referred to distinctive ways of writing—the shape of the letters as well as the choice of words. Nowadays, however, style is used loosely to mean the distinctive way a thing is done in any field of human endeavor. It is simply a term of praise in most cases: "to have style" means to have distinction, to stand out. But something else is implied, too, which comes to the fore if we ask ourselves what we mean when we say that something "has no style." Such a thing, we feel, is not only undistinguished but also un-distinguishable; in other words, we do not know how to classify it, how to put it into its proper context, because it seems to be pointing in several directions at once. Of a thing that *has style*, then, we expect that it must not be inconsistent within itself, that it must have an inner coherence, or unity; a sense of wholeness, of being all of a piece. This is the quality we admire in things that have style, for it has a way of impressing itself upon us even if we do not know what particular *kind* of style is involved. In the visual arts, style means the particular way in which the forms that make up any given work of art are chosen and fitted together. To art historians the study of styles is of central importance; it not only enables them to find out, by means of careful analysis and comparison, when

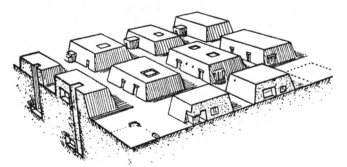

52. Group of Mastabas (after A. Badawy). 4th Dynasty

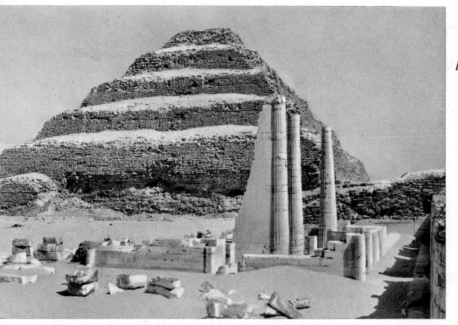

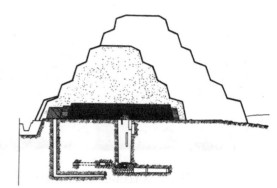

and where (and by whom) a given work was produced, but it also leads them to understand the artist's intention as expressed through the style of his work. This intention depends on both the artist's personality and the setting in which he lives and works. Accordingly, we speak of "period styles" if we are concerned with those features which distinguish, let us say, Egyptian art as a whole from Greek art. And within these broad period styles we in turn distinguish the styles of particular phases, such as the Old Kingdom; or, wherever it seems appropriate, we differentiate national or local styles within a period, until we arrive at the personal styles of individual artists. Even these may need to be subdivided further into the various phases of an artist's development. The extent to which we are able to do all this depends on how much internal coherence, how much of a sense of continuity, there is in the material we are dealing with. We find that the art of historic civilizations has a much more controlled, tightly knit kind of style than does prehistoric art. Which is not to say that prehistoric art cannot be analyzed in terms of style at all, but that the concept of style, which is based on the art of historic times, can be applied to it only in a limited sense. Hence it seemed best not to blunt the edge of this valuable tool by using it prematurely.

Let us now return to the Narmer palette. The new inner logic of its style becomes readily apparent in contrast to the predynastic wall painting. What strikes us first is its strong sense of order: the surface of the palette has been divided into horizontal bands (or registers), and each figure stands on a line or strip denoting the ground. The only exceptions are the attendants of the long-necked beasts, whose role seems mainly ornamental; the hieroglyphic signs, which belong to a different level of reality; and the dead enemies. The latter are seen from above, whereas the standing figures are seen from the side. Obviously, the modern notion of representing a scene as it would appear to a single observer at a single moment is as alien to the Egyptian artist as it had been to his Neo-

lithic predecessor; he strives for clarity, not illusion, and therefore he picks the most telling view in each case. But he imposes a strict rule on himself: when he changes his angle of vision, he must do so by 90 degrees, as if he were sighting along the edges of a cube. As a consequence, he acknowledges only three possible views: full face, strict profile, and vertically from above. Any intermediate position embarrasses him (note the oddly rubber-like figures of the fallen enemies: fig. 49, bottom). Moreover, he is faced with the fact that the standing human figure, unlike that of an animal, does not have a single main profile but two competing profiles, so that, for the sake of clarity, he must combine these views. His method of doing this—a method that was to survive unchanged for 2500 years—is clearly shown in the large figure of Narmer in figure 49: eye and shoulders in frontal view, head and legs in profile. Apparently this formula was worked out so as to show the Pharaoh (and all persons of significance who move in the penumbra of his divinity) in the most

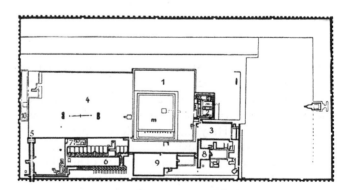

55. Plan of the Funerary District of
King Zoser, Saqqara (M. Hirmer after J. P. Lauer).
1) Pyramid (m = mastaba); 2) Funerary Temple;
3, 4, 6) Courts; 5) Entrance Hall;
7) Small Temple; 8) Court of North Palace;
9) Court of South Palace; 10) Southern Tomb

56. Papyrus Half-Columns, North Palace,
Funerary District of King Zoser, Saqqara

complete way possible. And since the scenes depict solemn and, as it were, timeless rituals, our artist did not have to concern himself with the fact that this method of representing the human body made almost any kind of movement or action practically impossible. In fact, the frozen quality of the image would seem especially suited to the divine nature of the Pharaoh; ordinary mortals *act*, he simply *is*. Whenever physical activity demanding any sort of effort or strain must be depicted, the Egyptian artist does not hesitate to abandon the composite view if necessary, for such activity is always performed by underlings whose dignity does not have to be preserved; thus, in our palette the two animal trainers and the four men carrying standards are shown in strict profile throughout (except for the eyes). The Egyptian style of representing the human figure, then, seems to have been created specifically for the purpose of conveying in visual form the majesty of the divine king; it must have originated among the artists working for the royal court. And it never lost its ceremonial, sacred flavor, even when, in later times, it had to serve other purposes as well.

THIRD DYNASTY

The full beauty of the style which we saw in the Narmer palette does not become apparent until about three centuries later, during the Third Dynasty, and especially under the reign of King Zoser, who was its greatest figure. From the tomb of Hesy-ra, one of Zoser's high officials, comes the masterly wooden relief (fig. 51) showing the deceased with the emblems of his rank. (These include writing materials, since the position of scribe was a highly honored one.) The view of the figure corresponds exactly to that of Narmer on the palette, but the proportions are far more balanced and harmonious, and the carving of the physical details shows keen observation as well as great delicacy of touch.

When we speak of the Egyptians' attitude toward death and afterlife as expressed in their tombs, we must be careful to make it clear that we do not mean the attitude of the average Egyptian but only that of the small aristocratic caste clustered around the royal court. The tombs of the members of this class of high officials (who were often relatives of the royal family) are usually found in the immediate neighborhood of the Pharaohs' tombs, and their shape and contents reflect, or are related to, the funerary monuments of the divine kings. We still have a great deal to learn about the origin and significance of Egyptian tombs, but there is reason to believe that the concept of afterlife we find in the so-called private tombs did not apply to ordinary mortals but only to the privileged few because of their association with the immortal Pharaohs. The standard form of these tombs was the mastaba, a squarish mound faced with brick or stone, above the burial chamber, which was deep underground and linked to the mound by a shaft (figs. 52, 54). Inside the mastaba is a chapel for offerings to the *ka* and a secret cubicle for the statue of the deceased. Royal mastabas grew to conspicuous size as early as the First Dynasty, and their exteriors could be elaborated to resemble a royal palace. During the Third Dynasty, they developed into step pyramids; the best known (and probably the first) is that of King Zoser (fig. 53), built over a traditional mastaba (see figs. 54, 55). The pyramid itself, unlike later examples, is a completely solid structure whose only purpose seems to have been to serve as a great landmark.

The modern imagination, enamored of "the silence of the pyramids," is apt to create a false picture of these monuments. They were not erected as isolated structures in the middle of the desert, but as part of vast funerary districts, with temples and other buildings which were the scene of great religious celebrations during the Pharaoh's lifetime as well as after. The most elaborate of these is the funerary district around the pyramid of Zoser: enough of its architecture has survived to make us understand why its creator, Imhotep, came to be deified in later Egyptian tradition. He is the first artist whose name has been recorded in history, and deservedly so, since his achievement is most impressive even today. Egyptian architecture had begun with structures made of mud bricks, wood, reeds, and other light materials. Imhotep used cut stone masonry, but his repertory of architectural forms still reflected shapes or devices developed for less enduring materials. Thus we find columns of several kinds—always "engaged" rather than freestanding—which echo the bundles of reeds or the wooden supports that used to be set into mud-brick walls in order to strengthen them. But the very fact that these members no longer had their original functional purpose made it possible for Imhotep and his fellow architects to redesign them so as to make them serve a new, *expressive* purpose. The notion that architectural forms can express anything may seem difficult to grasp at first; today we tend to assume that unless these forms have

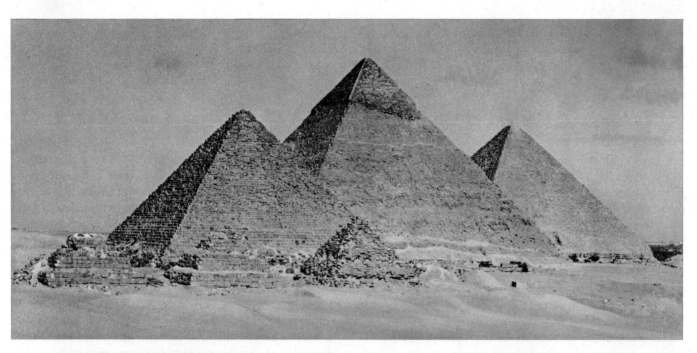

57. The Pyramids of Mycerinus (c. 2470 B.C.), Chefren (c. 2500 B.C.), and Cheops (c. 2530 B.C.), Giza

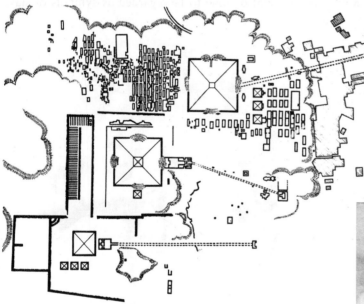

left: 58. Plan of the Pyramids at Giza

59. North-South Section of Pyramid of Cheops (after L. Borchardt)

a clear-cut structural service to perform (such as supporting or enclosing), they are mere surface decoration. But let us look at the slender, tapering fluted columns in figure 53, or the papyrus-shaped half-columns in figure 56: these do not simply decorate the walls to which they are attached, but interpret them and give them life, as it were. Their proportions, the feeling of strength or resilience they convey, their spacing, the degree to which they project, all share in this task. We shall learn more about their expressive role when we discuss Greek architecture, which took over the Egyptian stone column and developed it further. For the time being, let us note one additional factor that may enter into the design and use of such columns: announcing the symbolic purpose of the building. The papyrus half-columns in figure 56

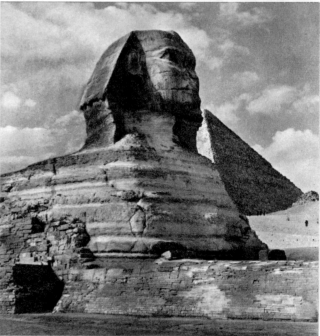

60. *The Great Sphinx.* c. 2500 B.C. Height 65'. Giza

are linked with Lower Egypt (compare the papyrus plants in fig. 49), hence they appear in the North Palace of Zoser's funerary district. The South Palace has columns of different shape, to evoke its association with Upper Egypt.

FOURTH DYNASTY

The development of the pyramid reaches its climax during the Fourth Dynasty in the famous triad of great pyramids at Giza (figs. 57, 58), all of them of the familiar, smooth-sided shape. They originally had an outer casing of carefully dressed stone, which has disappeared except near the top of the pyramid of Chefren. Each of the three differs slightly from the others in details of design and construction; the essential features are shown in the section of the earliest and largest, that of Cheops (fig. 59): the burial chamber is now near the center of the structure, rather than below ground as in the pyramid of Zoser. Clustered about the three great pyramids are several smaller ones and a large number of mastabas for members of the royal family and high officials, but the unified funerary district of Zoser has given way to a simpler arrangement; adjoining each of the great pyramids to the east is a funerary temple, from which a processional causeway leads to a second temple at a lower level, in the Nile valley, at a distance of about a third of a mile. Next to the valley temple of the second pyramid, that of Chefren, stands the Great Sphinx carved from the live rock (fig. 60), perhaps an even more impressive embodiment of divine kingship than the pyramids themselves. The royal head rising from the body of a lion towers to a height of 65 feet, and bore, in all probability, the features of Chefren (damage inflicted upon it during Islamic times has obscured the details of the face). Its awesome majesty is such that a thousand years later it could be regarded as an image of the sun-god.

Enterprises of this huge scale mark the high point of Pharaonic power. After the end of the Fourth Dynasty (less than two centuries after Zoser) they were never attempted again, although pyramids on a much more modest scale continued to be built. The world has always marveled at the sheer size of the great pyramids as well as at the technical accomplishment they represent; but they have also come to be regarded as symbols of slave

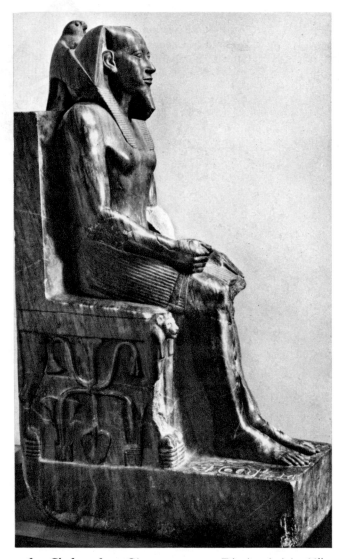

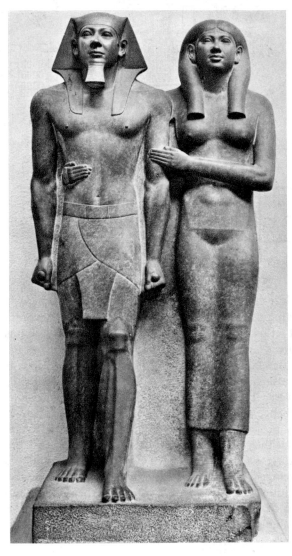

61. *Chefren*, from Giza. c. 2500 B.C. Diorite, height 66″. Egyptian Museum, Cairo

62. *Mycerinus and His Queen*, from Giza. c. 2470 B.C. Slate, height 56″. Museum of Fine Arts, Boston

63. *Bust of Prince Ankh-haf*, from Giza. c. 2520 B.C. Limestone, lifesize. Museum of Fine Arts, Boston

64. *Seated Scribe*, from Saqqara. c. 2400 B.C. Limestone, height 21". The Louvre, Paris

labor—thousands of men forced by cruel masters to serve the aggrandizement of absolute rulers. Such a picture may well be unjust: certain records have been preserved indicating that the labor was paid for, so that we are probably nearer the truth if we regard these monuments as vast public works providing economic security for a good part of the population.

Portraits

Apart from its architectural achievements, the chief glory of Egyptian art, during the Old Kingdom and later, is the portrait statues recovered from funerary temples and tombs. One of the finest is that of Chefren, from the valley temple of his pyramid (fig. 61). Carved of diorite, a stone of extreme hardness, it shows the king enthroned, with the falcon of the god Horus enfolding the back of the head with its wings (we encountered the association, in different form, on the Narmer palette, fig. 49). Here the Egyptian sculptor's "cubic" view of the human form appears in full force: clearly, the sculptor prepared the statue by drawing its front and side views on the faces of a rectangular block and then worked inward until these views met. The result is a figure almost overpowering in its three-dimensional firmness and immobility. Truly a magnificent vessel for the spirit! The body, well proportioned and powerfully built, is completely impersonal; only the face suggests some individual traits, as

will be seen if we compare it with that of Mycerinus (fig. 62), Chefren's successor and the builder of the third pyramid at Giza. Mycerinus, accompanied by his queen, is standing. Both have the left foot placed forward, yet there is no hint of a forward movement. Since the two are almost of the same height, they afford an interesting comparison of male and female beauty as interpreted by one of the finest of Old Kingdom sculptors, who knew not only how to contrast the structure of the two bodies but also how to emphasize the soft, swelling form of the queen through a thin and close-fitting gown. The sculptor who carved the statues of Prince Rahotep and his wife Nofret (colorplate 3) was less subtle in this respect. They owe their strikingly lifelike appearance to the vivid coloring, which they must have shared with other such statues but which has survived completely intact only in a few instances. The darker body color of the prince has no individual significance; it is the standard masculine complexion in Egyptian art. The eyes have been inlaid with shining quartz to make them look as alive as possible, and the portrait character of the faces is very pronounced.

Standing and seated figures comprise the basic repertory of Egyptian large-scale sculpture in the round. At the end of the Fourth Dynasty, a third pose was added, as symmetrical and immobile as the first two: that of the scribe squatting cross-legged on the ground. The finest of these scribes dates from the beginning of the Fifth

65. *Ti Watching a Hippopotamus Hunt*
(painted limestone relief). c. 2400 B.C.
Tomb of Ti, Saqqara

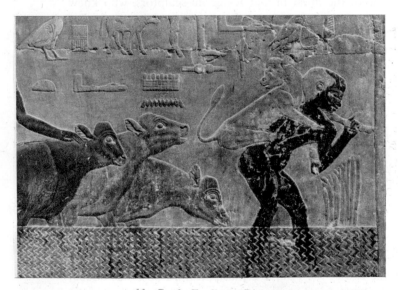

66. *Cattle Fording a River*
(detail of a painted limestone relief).
c. 2400 B.C. Tomb of Ti, Saqqara

Dynasty (fig. 64). The name of the sitter (in whose tomb at Saqqara the statue was found) is unknown, but we must not think of him as a lowly secretary waiting to take dictation; rather, the figure represents a high court official, a "master of sacred—and secret—letters," and the solid, incisive treatment of form bespeaks the dignity of his station (which in the beginning seems to have been restricted to the sons of Pharaohs). Our example stands out not only for the vividly alert expression of the face, but also for the individual handling of the torso, which records the somewhat flabby body of a man past middle age.

Another invention of Old Kingdom art was the portrait bust, a species of sculpture so familiar that we tend to take it for granted. Yet its origin is puzzling: was it simply an abbreviated statue, a cheaper substitute for a full-length figure? Or did it have a distinct purpose of its own, perhaps as a remote echo of the Neolithic custom of keeping the head of the deceased separate from the body (see page 28)? Be that as it may, the earliest of these busts (fig. 63) is also the finest—indeed, one of the great portraits of all time. In this noble head, we find a memorable image of the sitter's individual character as well as a most subtle differentiation between the solid, immutable shape of the skull and its soft, flexible covering of flesh.

Tomb Decoration

Before we leave the Old Kingdom, let us cast a brief glance at some of the scenes of daily life from the offering chambers of nonroyal tombs, such as that of the architectural overseer Ti at Saqqara. The hippopotamus hunt in figure 65 is of special interest to us because of its landscape setting. The background of the relief is formed by a papyrus thicket; the stems of the plants make a regular, rippling pattern that erupts in the top zone into an agitated scene of nesting birds menaced by small predators. The water in the bottom zone, marked by a zigzag pattern, is equally crowded with struggling hippopotamuses and fish. All these, as well as the hunters in the first boat, are acutely observed and full of action; only Ti himself, standing in the second boat, is immobile, as if he belonged to a different world. His pose is that of the funerary portrait reliefs and statues (compare fig. 51), and he towers above the other men, since he is more important than they. But his size also lifts him out of the context of the hunt—he neither directs nor supervises it, but simply observes. His passive role is characteristic of the representations of the deceased in all such scenes from the Old Kingdom. It seems to be a subtle way of conveying the fact that the body is dead but the spirit is alive and aware of the pleasures of this world, though the man can no longer participate in them directly. We should also note that these scenes of daily life do not represent the dead man's favorite pastimes; if they did, he

would be looking back, and such nostalgia is quite alien to the spirit of Old Kingdom tombs. It has been shown, in fact, that these scenes form a seasonal cycle, a sort of perpetual calendar of recurrent human activities for the spirit of the deceased to watch year in and year out. For the artist, on the other hand, these scenes offered a welcome opportunity to widen his powers of observation, so that in details we often find astounding bits of realism. Another relief from the tomb of Ti shows some cattle fording a river (fig. 66); one of the herders carries a newborn calf on his back, to keep it from drowning, and the frightened animal turns its head to look back at its mother, who answers with an equally anxious glance. Such sympathetic portrayal of an emotional relationship is as delightful as it is unexpected in Old Kingdom art. It will be some time before we encounter anything similar in the human realm. But eventually we shall even see the deceased abandoning his passive, timeless stance to participate in scenes of daily life.

THE MIDDLE KINGDOM

After the collapse of centralized Pharaonic power at the end of the Sixth Dynasty, Egypt entered a period of political disturbances and ill fortune that was to last almost 700 years. During most of this time, effective authority lay in the hands of local or regional overlords, who revived the old rivalry of North and South. Many dynasties followed one another in rapid succession, but only two, the Eleventh and Twelfth, are worthy of note. The latter constitute the Middle Kingdom (2134–1785 B.C.), when a series of able rulers managed to reassert themselves against the provincial nobility. However, the spell of divine kingship, having once been broken, never regained its old effectiveness, and the authority of the Middle Kingdom Pharaohs tended to be personal rather than institutional. Soon after the close of the Twelfth Dynasty, the weakened country was invaded by the Hyksos, a western Asiatic people of somewhat mysterious origin, who seized the Delta area and ruled it for 150 years until their expulsion by the princes of Thebes about 1570 B.C.

The unquiet spirit of the times is well reflected in Middle Kingdom art. We find it especially in the new type of royal portrait that marks the Twelfth Dynasty, such as the one in figure 67. There is a real sense of shock on first encountering this strangely modern face; the serene assurance of the Old Kingdom has given way to a brooding, troubled expression that bespeaks a new level of self-awareness. Deprived of its royal trappings, our fragment displays so uncompromising a realism, physical as well as psychological, that at first glance the link with the sculptural tradition of the past seems broken entirely. Here is another enduring achievement of Egyptian art, destined to live on in Roman portraiture and in the portraiture of the Renaissance. A loosening of established rules also makes itself felt in Middle Kingdom paint-

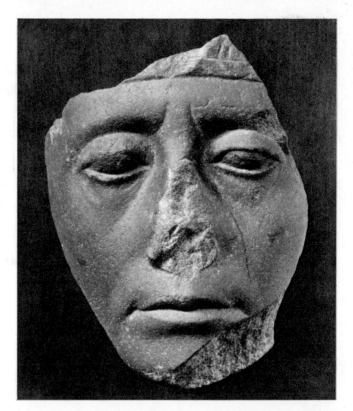

67. *Portrait of Sesostris III.* c. 1850 B.C.
Quartzite, height 6 1/2″. The Metropolitan Museum of Art, New York (Gift of Edward S. Harkness, 1926)

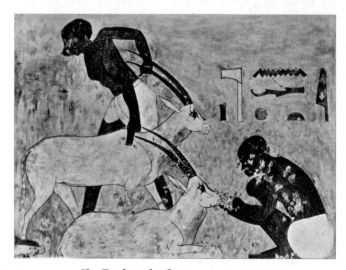

68. *Feeding the Oryxes.* c. 1920 B.C.
Tomb of Khnum-hotep, Beni Hasan

ing and relief, where it leads to all sorts of interesting departures from convention. They occur most conspicuously in the decoration of the tombs of local princes at Beni Hasan, which have survived destruction better than most Middle Kindom monuments because they are carved into the living rock. The mural *Feeding the Oryxes* (fig. 68) comes from one of these rock-cut tombs, that of Khnum-hotep. (As the emblem of the prince's domain, the oryx antelope seems to have been a sort of honored pet in his household.) According to the standards of Old Kingdom art, all the figures ought to share the same ground-line, or the second oryx and

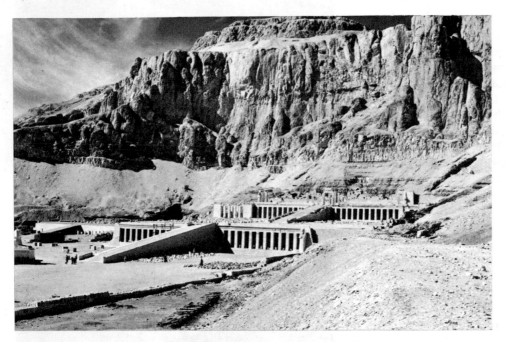

69. Funerary Temple of Hatshepsut, Deir el-Bahari. 18th Dynasty, c. 1480 B.C.

70. Plan of Funerary Temple of Queen Hatshepsut (after Lange)

its attendant ought to be placed above the first; instead, the painter has introduced a secondary ground-line only slightly higher than the primary one, and as a result the two groups are related in a way that closely approximates normal appearances. His interest in exploring spatial effects can also be seen in the awkward but quite bold foreshortening of the shoulders of the two attendants. If we cover up the hieroglyphic signs, which emphasize the flatness of the wall, we can "read" the forms in depth with surprising ease.

THE NEW KINGDOM

The five hundred years following the expulsion of the Hyksos, and comprising the Eighteenth, Nineteenth, and Twentieth Dynasties, represent the third Golden Age of Egypt. The country, once more united under strong and efficient kings, extended its frontiers far to the east, into Palestine and Syria (hence this period is also known as the Empire). During the climactic period of power and prosperity, between c. 1500 and the end of the reign of Ramesses III in 1162 B.C., tremendous architectural projects were carried out, centering on the region of the new capital, Thebes, while the royal tombs reached unequaled material splendor. The divine kingship of the Pharaohs was now asserted in a new way: by association with the god Amun, whose identity had been fused with that of the sun-god Ra, and who became the supreme deity, ruling the lesser gods much as the Pharaoh towered above the provincial nobility. But this very development produced an unexpected threat to royal authority; the priests

of Amun grew into a caste of such wealth and power that the king could maintain his position only with their consent. Amenhotep IV, the most remarkable figure of the Eighteenth Dynasty, tried to defeat them by proclaiming his faith in a single god, the sun disk Aten. He changed his name to Akhenaten, closed the Amun temples, and moved the capital to central Egypt, near the modern Tell el 'Amarna. His attempt to place himself at the head of a new monotheistic faith, however, did not outlast his reign (1365–1347 B.C.), and under his successors orthodoxy was speedily restored. During the long period of decline, after c. 1000 B.C., the country became increasingly priest-ridden, until, under Greek and Roman rule, Egyptian civilization came to an end in a welter of esoteric religious doctrines.

New Kingdom art covers a vast range of styles and quality, from rigid conservatism to brilliant inventiveness, from oppressively massive ostentation to the most delicate refinement. Like the art of Imperial Rome fifteen hundred years later, it is almost impossible to summarize in terms of a representative sampling. Different strands are interwoven into a fabric so complex that any choice of monuments is bound to seem arbitrary. All we can hope to accomplish is to convey some of the flavor of its variety.

ARCHITECTURE

Among the architectural enterprises that have survived from the early years of the New Kingdom, the outstanding one is the funerary temple of Queen Hatshepsut, built about 1480 B.C. against the rocky cliffs of Deir el-

Bahari (figs. 69, 70) and dedicated to Amun and several other deities. The worshiper is led toward the holy of holies—a small chamber driven deep into the rock—through three large courts on ascending levels, linked by ramps among long colonnades: a processional road reminiscent of those at Giza, but with the mountain instead of a pyramid at the end. It is this magnificent union of man-made and natural architecture—note how ramps and colonnades echo the shape of the cliff—that makes Hatshepsut's temple the rival of any of the Old Kingdom monuments.

The later rulers of the New Kingdom continued to build funerary temples, but an ever greater share of their architectural energies was devoted to huge imperial temples of Amun, the supreme god whom the reigning monarch traditionally claimed as his father. The temple at Luxor, across the Nile from Thebes, dedicated to Amun, his wife Mut, and their son Khonsu, was begun about 1390 B.C. by Amenhotep III but was extended and completed more than a century later. Its plan is characteristic of the general pattern of later Egyptian temples. The façade consists of two massive walls, with sloping sides, flanking the entrance; this unit is known as the gateway or pylon (fig. 71, far left), and leads to the court (fig. 72, A). The court, in our instance, is a parallelogram, because Ramesses II, who added it to the temple that had been planned under Amenhotep III, changed the axis of his court slightly, so as to conform with the direction of the Nile. We then enter a pillared hall, which brings us to the second court (fig. 72, B and C; fig. 71, center and right). On its far side we find another pillared hall. Beyond it, the temple proper begins: a series of symmetrically arranged halls and chapels shielding the holy of holies, a square room with four columns (fig. 72, extreme right). The entire sequence of courts, halls, and temple was enclosed by high walls that shut off the outside world. Except for the monumental façade, such a structure is designed to be experienced from within; ordinary worshipers were confined to the courts and could but marvel at the forest of columns that screened the dark recesses of the sanctuary. The columns had to be closely spaced, for they supported the stone lintels of the ceiling, and these had to be short to keep them from breaking under their own weight. Yet the architect has consciously ex-

71. Court and Pylon of Ramesses II (c. 1260 B.C.) and Colonnade and Court of Amenhotep III (c. 1390 B.C.). Temple of Amun-Mut-Khonsu, Luxor

72. Plan of the Temple of Amun-Mut-Khonsu, Luxor (after N. de Garis Davies)

73. Brick Storehouses, Mortuary Temple of
Ramesses II, West Thebes. c. 1260 B.C.

ploited this condition by making the columns far heavier than they need be. As a result, the beholder feels almost crushed by their sheer mass. The overawing effect is certainly impressive, but also rather vulgar when measured against the earlier masterpieces of Egyptian architecture. We need only compare the papyrus columns of the colonnade of Amenhotep III with their remote ancestors in Zoser's North Palace (fig. 56) in order to realize how little of the genius of Imhotep survives at Luxor.

The massive vastness of their tombs and temples makes us think that the Egyptians built mainly in stone. Yet, except where absolute durability was essential for religious reasons, they used sun-dried mud bricks, an infinitely cheaper and more convenient material. The achievements of Egyptian brick architecture have attracted little interest so far, and much of the work has been destroyed, but the few well-preserved structures, such as the storehouses attached to the mortuary temple of Ramesses II (fig. 73),

show a masterful command of brick building techniques. These barrel vaults, with a span of over 13 feet, anticipate the engineering skill of the Romans.

AKHENATEN; TUTANKHAMEN

Of the great projects built by Akhenaten hardly anything remains above ground. He must have been a revolutionary not only in his religious beliefs but in his artistic tastes as well, consciously fostering a new style and a new ideal of beauty in his choice of masters. The contrast with the past becomes strikingly evident if we compare a head in low relief from the Tomb of Ramose, done at the end of the reign of Amenhotep III (fig. 74), with a low-relief portrait of Akhenaten that is only about ten years later in date (fig. 75). The first one shows the traditional style at its best; the wonderful subtlety of the carving—the precision and refinement of its lines—makes the head of Akhenaten seem at first glance like a brutal caricature. And the latter work is indeed an extreme statement of the new ideal, with its oddly haggard features and overemphatic, undulating outlines. Still, we can perceive its kinship with the justly famous bust of Akhenaten's queen, Nofretete (fig. 76), one of the masterpieces of the "Akhenaten style." What distinguishes this style is not greater realism so much as a new sense of form that seeks to unfreeze the traditional immobility of Egyptian art; not only the contours but the plastic shapes, too, seem more pliable and relaxed, antigeometric, as it were. We find these qualities again in the delightful fragment of a wall painting showing the daughters of Akhenaten (colorplate 4). Their playful gestures and informal poses seem in defiance of all rules of Pharaonic dignity.

The old religious tradition was quickly restored after

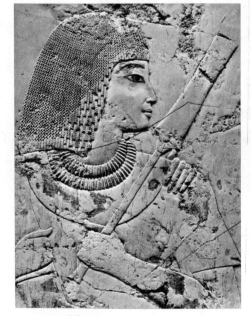

74. *The Brother of the Deceased*
(detail of a limestone relief).
c. 1375 B.C. Tomb of Ramose, Thebes

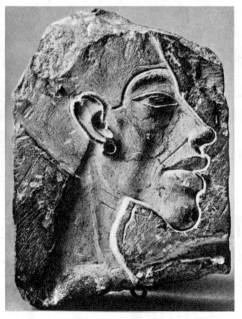

75. *Akhenaten (Amenhotep IV).*
c. 1360 B.C. Limestone,
height 3$^1$/$_8$". State Museums, Berlin

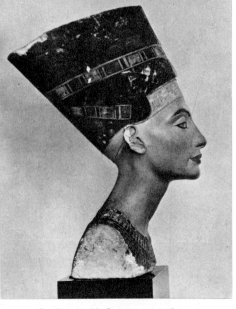

76. *Queen Nofretete.* c. 1360 B.C.
Limestone, height c. 20".
State Museums, Berlin

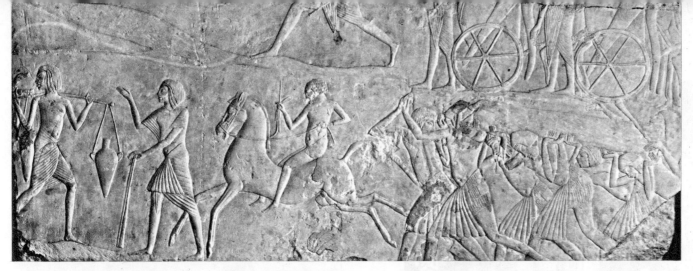

77. *Workmen Carrying a Beam,* from the Tomb of Horemheb, Saqqara. c. 1325 B.C. Museo Civico, Bologna

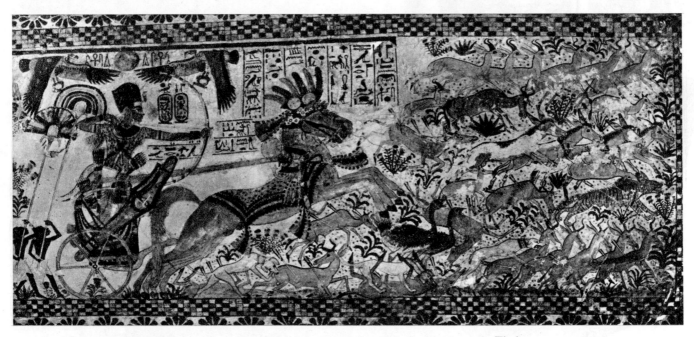

78. *Tutankhamen Hunting,* from a painted chest found in the king's tomb, Thebes. c. 1340 B.C.
Length of scene c. 20″. Egyptian Museum, Cairo

Akhenaten's death, but the artistic innovations he encouraged could be felt in Egyptian art for some time to come. The scene of workmen struggling with a heavy beam (fig. 77), from the tomb of Horemheb at Saqqara, shows a freedom and expressiveness that would have been unthinkable in earlier times. Even the face of Akhenaten's successor, Tutankhamen, as it appears on his gold coffin, betrays an echo of the Akhenaten style (colorplate 5). Tutankhamen, who died at the age of eighteen, owes his fame entirely to the accident that his is the only Pharaonic tomb discovered in our times with most of its contents undisturbed. The sheer material value of the tombs (Tutankhamen's gold coffin alone weighs 250 pounds) makes it understandable that grave robbing has been practiced in Egypt ever since the Old Kingdom. To us, the exquisite workmanship of the coffin, with the rich play of colored inlays against the polished gold surfaces, is even more impressive. As unique in its way as the gold coffin is a painted chest from the same tomb, showing the youthful king in battle and hunting scenes (fig. 78). These had been traditional subjects since the late years of the Old Kingdom, but here they are done with astonishing freshness, at least so far as the animals are concerned. While the king and his horse-drawn chariot remain frozen against the usual blank background filled with hieroglyphics, the same background in the right-hand half of the scene suddenly turns into a desert; the surface is covered with stippled dots to suggest sand, desert plants are strewn across it in considerable variety, and the animals stampede over it helterskelter, without any ground-lines to impede their flight. Here is an aspect of Egyptian painting that we rarely see on the walls of tombs; perhaps this lively scattering of forms against a landscape background existed only on the miniature scale of the scenes on Tutankhamen's chest and even there it became possible only as a result of the Akhenaten style. How these animals-in-landscape survived in later Egyptian painting we do not know, but they must have survived somehow, for their resemblance to Islamic miniatures done more than two thousand years later is far too striking to be ignored.

SUMERIAN ART
 AKKADIANS
 UR
 BABYLON

ASSYRIAN ART
 NEO-BABYLONIANS

PERSIAN ART
 ACHAEMENIDS
 SASSANIANS

3

THE ANCIENT NEAR EAST

SUMERIAN ART

It is an odd and astonishing fact that man should have
emerged into the light of history in two separate places
at just about the same time. Between 3500 and 3000 B.C.,
when Egypt was being united under Pharaonic rule, an-
other great civilization arose in Mesopotamia, the "land
between the rivers." And for close to 3000 years, the two
rival centers retained their distinct character, even though
they had contact with each other from their earliest be-
ginnings and their destinies were interwoven in many
ways. The pressures that forced the inhabitants of both
regions to abandon the pattern of Neolithic village life
may well have been the same (see fig. 20). But the valley
of the Tigris and Euphrates, unlike that of the Nile, is
not a narrow fertile strip protected by deserts on either
side; it resembles a wide, shallow trough with few natural
defenses, crisscrossed by two great rivers and their trib-
utaries, and easily encroached upon from any direction.
Thus the facts of geography tended to discourage the
idea of uniting the entire area under a single head. Rulers
who had this ambition did not appear, so far as we know,
until about a thousand years after the beginnings of
Mesopotamian civilization, and they succeeded in carry-
ing it out only for brief periods and at the cost of almost
continuous warfare. As a consequence, the political his-
tory of ancient Mesopotamia has no underlying theme of
the sort that divine kingship provides for Egypt; local
rivalries, foreign incursions, the sudden upsurge and
equally sudden collapse of military power—these are its
substance. Against such a disturbed background, the
continuity of cultural and artistic traditions seems all the
more remarkable. This common heritage is very largely
the creation of the founding fathers of Mesopotamian
civilization, whom we call Sumerians after the region of
Sumer, which they inhabited, near the confluence of the
Tigris and Euphrates.

The origin of the Sumerians remains obscure. Their
language is unrelated to any other known tongue. Some-
time before 4000 B.C., they came to southern Mesopo-
tamia from Persia, and there, within the next thousand
years, they founded a number of city-states and devel-
oped their distinctive form of writing in cuneiform
(wedge-shaped) characters on clay tablets. This transi-
tional phase, corresponding to the predynastic period in
Egypt, is called "protoliterate"; it leads to the early
dynastic period, from about 3000 to 2340 B.C. Unfortu-
nately, the tangible remains of Sumerian civilization are
extremely scanty compared to those of ancient Egypt;
stone being unavailable in Mesopotamia, the Sumerians
built only in mud brick and wood, so that almost nothing
is left of their architecture except the foundations. Nor
did they share the Egyptians' concern with the hereafter,
although some richly endowed tombs—in the shape of
vaulted chambers below ground—of the early dynastic
period have been found in the city of Ur. Our knowledge
of Sumerian civilization thus depends very largely on
chance fragments brought to light by excavation, includ-
ing vast numbers of inscribed clay tablets. Yet in recent
decades we have learned enough to form a general picture
of the achievements of this vigorous, inventive, and dis-
ciplined people.

Each Sumerian city-state had its own local god, who
was regarded as its "king" and owner. It also had a
human ruler, the steward of the divine sovereign, who led
the people in serving the deity. The local god, in return,
was expected to plead the cause of his subjects among his
fellow deities who controlled the forces of nature such as
wind and weather, water, fertility, and the heavenly bod-
ies. Nor was the idea of divine ownership treated as a
mere pious fiction; the god was quite literally believed to
own not only the territory of the city-state but also the
labor power of the population and its products. All these
were subject to his commands, transmitted to the people
by his human steward. The result was an economic sys-
tem that has been dubbed "theocratic socialism," a
planned society whose administrative center was the tem-
ple. It was the temple that controlled the pooling of labor
and resources for communal enterprises, such as the
building of dikes or irrigation ditches, and it collected and

79. The "White Temple" on Its Ziggurat,
Uruk (Warka). c. 3500–3000 B.C.

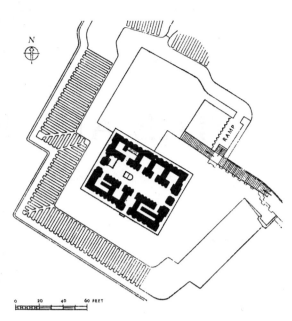

80. Plan of the "White Temple" on Its Ziggurat
(after H. Frankfort)

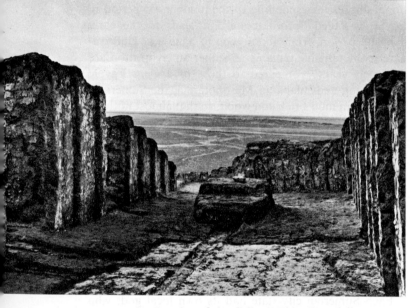

81. Interior of the Cella, "White Temple"

distributed a considerable part of the harvest. All this required the keeping of detailed written records. Hence we need not be surprised to find that the texts of early Sumerian inscriptions deal very largely with economic and administrative rather than religious matters, although writing was a priestly privilege.

Architecture

The dominant role of the temple as the center of both spiritual and physical existence is strikingly conveyed by the layout of Sumerian cities. The houses clustered about a sacred area that was a vast architectural complex embracing not only shrines but workshops, storehouses, and scribes' quarters as well. In their midst, on a raised platform, stood the temple of the local god. These platforms

soon reached the height of true man-made mountains, comparable to the pyramids of Egypt in the immensity of effort required and in their effect as great landmarks towering above the featureless plain. They are known as ziggurats. The most famous of them, the biblical Tower of Babel, has been completely destroyed, but a much earlier example, built shortly before 3000 B.C. and thus several centuries older than the first of the pyramids, survives at Warka, the site of the Sumerian city of Uruk (called Erech in the Bible). The mound, its sloping sides reinforced by solid brick masonry, rises to a height of 40 feet; stairs and ramps lead up to the platform on which stands the sanctuary, called the "White Temple" because of its whitewashed brick exterior (figs. 79, 80). Its heavy walls, articulated by regularly spaced projections and recesses, are sufficiently well preserved to suggest something of the original appearance of the structure. The main room, or cella (fig. 81), where sacrifices were offered before the statue of the god, is a narrow hall that runs the entire length of the temple and is flanked by a series of smaller chambers. But the main entrance to the cella is on the southwest side, rather than on the side facing the stairs or on one of the narrow sides of the temple, as one might expect. In order to understand the reason for this, we must view the ziggurat and temple as a whole: the entire complex is planned in such a way that the worshiper, starting at the bottom of the stairs on the east side, is forced to go around as many corners as possible before he reaches the cella. The processional path, in other words, resembles a sort of angular spiral. This "bent-axis approach" is a fundamental characteristic of

Mesopotamian religious architecture, in contrast to the straight single axis of Egyptian temples (see fig. 72). During the following 2500 years, it was elaborated into ever taller and more tower-like ziggurats rising in multiple stages. The one built by King Urnammu at Ur about 2500 B.C. (fig. 82) had three levels. Little is left of the upper two stages, but the bottom one, some 50 feet high, has survived fairly well, and its facing of brick has recently been restored. What was the impulse behind these structures? Certainly not the kind of pride attributed to the builders of the Tower of Babel in the Old Testament. They reflect, rather, the widespread belief that mountaintops are the dwelling places of the gods (we need only recall the Mount Olympus of the Greeks). In the plain of Sumer, men felt they could provide a fit residence for the deity only by creating artificial mountains of their own.

Sculpture

The image of the god to whom the "White Temple" was dedicated is lost—it was probably Anu, the god of the sky—but a splendid female head of white marble from the same period at Uruk (Warka) may well have belonged to another cult statue (fig. 83). The eyes and eyebrows were originally inlaid with colored materials, and the hair was covered with a "wig" of gold or copper. The rest of the figure, which must have been close to life size, probably consisted of wood. As an artistic achievement, this head is on the level of the finest works of Egyptian Old Kingdom sculpture. The softly swelling cheeks, the delicate curves of the lips, combined with the steady gaze of the huge eyes, create a balance of sensuousness and severity that seems worthy of any goddess.

It was the geometric and expressive aspects of the Uruk head, rather than the realistic ones, that survived in the stone sculpture of the early dynastic period, as seen in a group of figures from Tell Asmar (fig. 84) carved about five centuries later than the head. The tallest, about 30 inches high, represents Abu, the god of vegetation; the second largest, a mother goddess; the others, priests and worshipers. The two deities are distinguished from the rest not only by their size but by the larger diameter of the pupils of their eyes, although the eyes of all the figures are enormous. Their insistent stare is emphasized by colored inlays, which are still in place. The entire group must have stood in the cella of the Abu temple, the priests and worshipers confronting the two gods and communicating with them through their eyes. "Representation" here had a very direct meaning: the gods were believed to be present in their images, and the statues of the worshipers served as stand-ins for the persons they portrayed, offering prayers or transmitting messages to the deity in their stead. Yet none of them indicates any attempt to achieve a real likeness. The bodies as well as the faces are rigorously simplified and schematic, in order to avoid distracting attention from the eyes, the "windows of the soul." If the Egyptian sculptor's sense of form was es-

82. Ziggurat of King Urnammu, Ur. c. 2500 B.C.

sentially cubic, that of the Sumerian was based on the cone and cylinder. Arms and legs have the roundness of pipes, and the long skirts worn by all these figures are as smoothly curved as if they had been turned on a lathe. Even in later times, when Mesopotamian sculpture had acquired a far richer repertory of shapes, this quality asserted itself again and again.

The conic-cylindrical simplification of the Tell Asmar statues is characteristic of the carver, who works by cutting his forms out of a solid block. A far more flexible and realistic style prevails among the Sumerian sculpture that was made by addition rather than subtraction (that is, either modeled in soft materials for casting in bronze or put together by combining such varied substances as wood, gold leaf, and lapis lazuli). Some pieces of the latter kind, roughly contemporary with the Tell Asmar figures, have been found in the tombs at Ur which we had occasion to mention earlier. They include the fascinating object shown in colorplate 6, an offering stand in the shape of a billy goat rearing up against a flowering tree. The animal, marvelously alive and energetic, has an almost demonic power of expression as it gazes at us from between the branches of the symbolic tree. And well it might, for it is sacred to the god Tammuz and thus embodies the male principle in nature. Such an association of animals with deities is a carry-over from prehistoric times; we find it not only in Mesopotamia but in Egypt as well (see the falcon of Horus in figs. 49 and 61). What distinguishes the sacred animals of the Sumerians is the active part they play in mythology. Much of this lore, unfortunately, has not come down to us in written form, but tantalizing glimpses of it can be caught in pictorial representations such as those on an inlaid panel from a harp (fig. 85) that was recovered together with the offering stand at Ur. The hero embracing two human-

83. *Female Head*, from Uruk (Warka). C. 3500–3000 B.C. Marble, height 8″. The Iraq Museum, Baghdad

headed bulls in the top compartment was so popular a subject that its design has become a rigidly symmetrical, decorative formula; the other sections, however, show animals performing a variety of human tasks in surprisingly animated and precise fashion: the wolf and the lion carry food and drink to an unseen banquet, while the ass, bear, and deer provide musical entertainment (the bull-headed harp is the same type as the instrument to which the inlaid panel was attached). At the bottom, a scorpion-man and a goat carry some objects they have taken from a large vessel. The skillful artist who created these scenes was far less constrained by rules than his contemporaries in Egypt; even though he, too, places his figures on ground-lines, he is not afraid of overlapping forms or foreshortened shoulders. We must be careful, however, not to misinterpret his intention—what strikes the modern eye as delightfully humorous was probably meant to be viewed with perfect seriousness. If we only knew the context in which these actors play their roles! Nevertheless, we are entitled to regard them as the earliest known ancestors of the animal fable that flourished in the West from Aesop to La Fontaine. At least one of them, the ass with the harp, survived as a fixed image, and we encounter it almost 4000 years later in medieval sculpture.

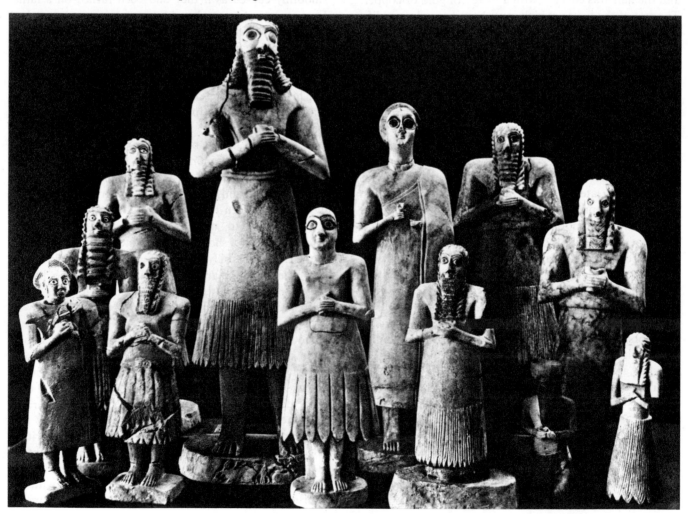

84. Statues, from the Abu Temple, Tell Asmar. C. 2700–2500 B.C. Marble, height of tallest figure c. 30″. The Iraq Museum, Baghdad, and The Oriental Institute, University of Chicago

85. Inlay on the Soundbox
of a Harp, from Ur.
c. 2600 B.C.
The University Museum,
Philadelphia

with incredible precision, yet without losing their organic character and becoming mere ornament. The complex technique of casting and chasing has been handled with an assurance that bespeaks true mastery. This head could hold its own in the company of the greatest works of any period.

Sargon's grandson, Naram-Sin, had himself and his victorious army immortalized in relief on a large stele (fig. 87)—an upright stone slab used as a marker—which owes its survival to the fact that at a later time it was carried off as booty to Susa, where modern archaeologists discovered it. Here rigid ground-lines have been discarded; we see the king's forces advancing among the trees on a mountainside. Above them, Naram-Sin alone stands triumphant, as the defeated enemy soldiers plead for mercy. He is as vigorously active as his men, but his size and his isolated position endow him with superhuman status. Moreover, he wears the horned crown hitherto reserved for the gods. Nothing appears above him except the mountaintop and the celestial bodies, his "good stars." This is the earliest known monument to the glory of a conqueror.

UR

The rule of the Akkadian kings came to an end when tribesmen from the northeast descended into the Meso-

AKKADIANS

Toward the end of the early dynastic period, the theocratic socialism of the Sumerian city-states began to decay. The local "stewards of the god" had in practice become reigning monarchs, and the more ambitious among them attempted to enlarge their domain by conquering their neighbors. At the same time, the Semitic inhabitants of northern Mesopotamia drifted south in ever larger numbers, until they outweighed the Sumerian stock in many places. They had adopted Sumerian civilization but were less bound to the tradition of the city-state. So it is perhaps not surprising that in Sargon of Akkad and his successors (2340–2180 B.C.) they produced the first Mesopotamian rulers who openly called themselves kings and proclaimed their ambition to rule the entire earth. Under these Akkadians, Sumerian art faced a new task—the personal glorification of the sovereign. The most impressive work of this kind that has survived is a magnificent royal portrait head in bronze from Nineveh (fig. 86). Despite the gouged-out eyes (once inlaid with precious materials), it remains a persuasive likeness, majestic and humanly moving at the same time. Equally admirable is the richness of the surfaces framing the face; the plaited hair and the finely curled strands of the beard are shaped

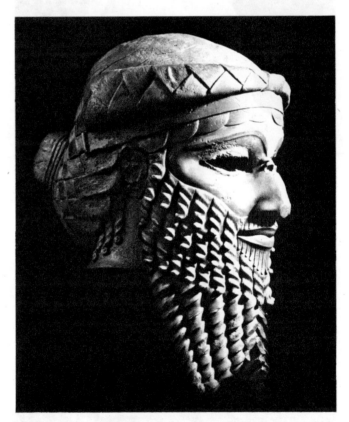

86. *Head of an Akkadian Ruler,* from Nineveh (Kuyunjik).
c. 2300–2200 B.C. Bronze, height 12".
The Iraq Museum, Baghdad

potamian plain and gained mastery of it for more than half a century. They were driven out in 2125 B.C. by the kings of Ur, who re-established a united realm that was to last a hundred years. During the period of foreign dominance, Lagash (the modern Telloh), one of the lesser Sumerian city-states, managed to retain local independence. Its ruler, Gudea, was careful to reserve the title of king for the city-god, whose cult he promoted by an ambitious rebuilding of his temple. Of this architectural enterprise nothing remains today, but Gudea also had numerous statues of himself placed in the shrines of Lagash, and some twenty examples, all obviously of the same general type, have been found so far. Carved of diorite, the extremely hard stone favored by Egyptian sculptors, they are much more ambitious works than their predecessors from Tell Asmar. Even Gudea, however devoted he was to the traditional pattern of the Sumerian city-state, seems to have inherited something of the sense

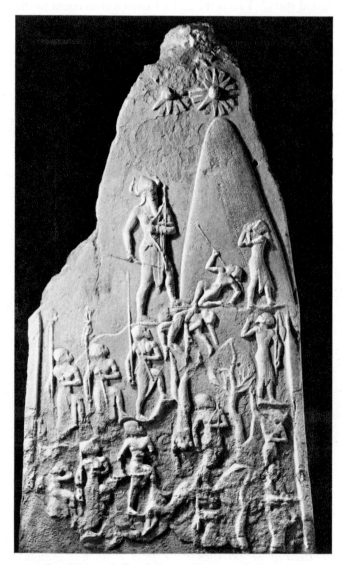

87. *Victory Stele of Naram-Sin.* c. 2300–2200 B.C. Stone, height 6′ 6″. The Louvre, Paris

of personal importance that we felt in the Akkadian kings, although he prided himself on his intimate relations with the gods rather than on secular power. His portrait head (fig. 89) appears far less distinctly individualized when compared with the Akkadian ruler, yet its fleshy roundness is far removed from the geometric simplicity of the Tell Asmar statues. The stone has been worked to a high and subtly accented finish, inviting a wonderful play of light upon the features. The seated statue (fig. 88) represents Gudea with an architectural plan on his lap (perhaps the enclosing wall of a temple district), which he is offering for the god's approval; there are six entrances framed by tower-like projections, and the walls show regularly spaced buttresses of the kind we saw in the "White Temple" at Uruk (Warka). The figure makes an instructive contrast with Egyptian statues such as those in figure 61 and colorplate 3—the Sumerian carver has rounded off all the corners to emphasize the cylindrical quality of the forms. Equally characteristic is the muscular tension in Gudea's bare arm and shoulder, compared with the passive, relaxed limbs of Egyptian statues.

BABYLON

The second millennium B.C. was a time of almost continuous turmoil in Mesopotamia. The ethnic upheaval that brought the Hyksos to Egypt had an even more disruptive effect on the valley of the Tigris and Euphrates. Central power by native rulers was exercised only between c. 1760 and 1600, when Babylon assumed the role formerly played by Akkad and Ur. Hammurabi, the founder of the Babylonian dynasty, is by far the greatest figure of the age: combining military prowess with a deep respect for Sumerian tradition, he saw himself as "the favorite shepherd" of the sun-god Shamash, whose mission it was "to cause justice to prevail in the land." Under him and his successors, Babylon became the cultural center of Sumer. The city was to retain this prestige for more than a thousand years after its political power had waned. Hammurabi's most memorable achievement is his law code, justly famous as the earliest uniform written body of laws and amazingly rational and humane in conception. He had it engraved on a tall diorite stele whose top shows Hammurabi confronting the sun-god (fig. 90). The ruler's right arm is raised in a speaking gesture, as if he were reporting his work of codification to the divine king. Although this scene was carved four centuries after the Gudea statues, it is strongly related to them in both style and technique. In fact, the relief here is so high that the two figures almost give the impression of statues sliced in half when we compare them with the pictorial treatment of the Naram-Sin stele. As a result, the sculptor has been able to render the eyes in the round, so that Hammurabi and Shamash gaze at each other with a force and directness unique in representations of this kind. They make us recall the statues from Tell Asmar, whose enormous eyes indicate an attempt to establish the same

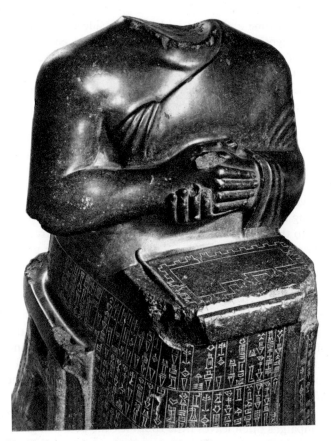

88. *Gudea with Architectural Plan*, from Lagash (Telloh).
c. 2150 B.C. Diorite, height 29″. The Louvre, Paris

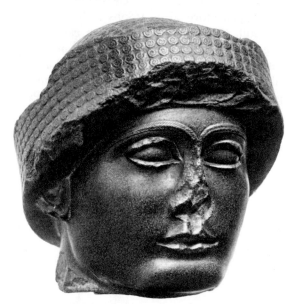

89. *Head of Gudea*, from Lagash (Telloh). c. 2150 B.C.
Diorite, height 9″. Museum of Fine Arts, Boston

90. Upper Part of Stele Inscribed with the Law Code of
Hammurabi. c. 1760 B.C. Diorite, height of stele c. 7′,
height of relief 28″. The Louvre, Paris

relationship between man and god in an earlier phase
of Sumerian civilization.

ASSYRIAN ART

The city-state of Assur on the upper course of the Tigris
owed its rise to power to a strange chain of events. During
the earlier half of the second millennium B.C., Asia Minor
had been invaded from the east by people of Indo-Euro-
pean language. One group, the Mitannians, created an
independent kingdom in Syria and northern Mesopo-
tamia, including Assur, while another, the Hittites, estab-
lished themselves farther north on the rocky plateau of
Anatolia. Their capital, near the present-day Turkish
village of Bogazköy, was protected by impressive fortifi-
cations built of large, roughly cut stones; the gates were
flanked by snarling lions or other guardian figures pro-
truding from the enormous blocks that formed the jambs
of the doorway (fig. 91). About 1360 B.C., the Hittites
attacked the Mitannians, who were allies of the Egyptians.
But the latter, because of the internal crisis provoked
by the religious reforms of Akhenaten (see pages 64–65),
could send no effective aid; the Mitannians were defeat-
ed and Assur regained its independence. Under a series
of able rulers, the Assyrian domain gradually expanded
until it embraced not only Mesopotamia proper but the
surrounding regions as well. At the height of its power,
between c. 1000 and 612 B.C., the Assyrian empire
stretched from the Sinai peninsula to Armenia; even
Lower Egypt was successfully invaded in 671 B.C.

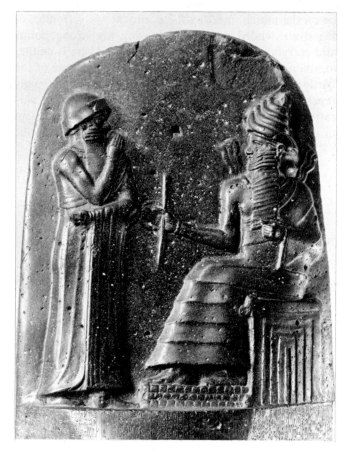

Palaces and Their Decoration

The Assyrians, it has been said, were to the Sumerians what the Romans were to the Greeks. Their civilization depended on the achievements of the south but reinterpreted them to fit its own distinctive character. Thus the temples and ziggurats they built were adapted from Sumerian models while the palaces of Assyrian kings grew to unprecedented size and magnificence. Only one of these, that of Sargon II at Dur Sharrukin (the modern Khorsabad), dating from the second half of the eighth century B.C., has been explored sufficiently to permit a reconstruction (fig. 92). It was surrounded by a citadel with turreted walls that shut it off from the rest of the town. Figure 93 shows one of the two gates of the citadel in process of excavation. Although the Assyrians, like the Sumerians, built in brick, they liked to line gateways and the lower walls of important interiors with great slabs of stone (which were less difficult to procure in northern Mesopotamia). These slabs were either decorated with low reliefs or, as in our case, elaborated into guardian demons that are an odd combination of relief and sculpture in the round. They must have been inspired by Hittite examples such as the lion gate at Bogazköy (fig. 91). Awesome in size and appearance, they were meant to impress the visitor with the power and majesty of the king. Inside the palace, the same impression was reinforced by long series of reliefs illustrating the conquests of the royal armies. Every campaign is described in detail, with inscriptions supplying further data. The Assyrian forces, relentlessly efficient, always seem to be on the march, meeting the enemy at every frontier of the overextended empire, destroying his strong points and carrying away booty and prisoners. There is neither drama nor heroism in these scenes—the outcome of the battle is never in doubt—and they are often depressingly repetitious. Yet, as the earliest large-scale efforts at narrative in the history of art, they represent an achievement of great importance. To describe the progress of specific events in time and space had been outside the scope of both Egyptian and Sumerian art; even the scene on the stele of Naram-Sin is symbolic rather than historic. The Assyrian artist thus has to develop an entirely new set of devices in order to cope with the problem of pictorial storytelling. If his results can hardly ever be called beautiful, they achieve their main purpose—to be clearly readable. This is certainly true of our example (fig. 94), from the Palace of Ashurbanipal at Nineveh (now Kuyunjik), which shows the sack of the Elamite city of Hamanu in the main register: Assyrian soldiers with pickaxes and crowbars are demolishing the fortifications—notice the falling timbers and bricks in mid-air—after they have set fire to the town itself; others are marching away from it, down a wooded hill, laden with booty. The latter group poses a particularly interesting problem in representation, for the road on which they walk widens visibly as it approaches the foreground, as if the artist had meant to render it in perspective, yet the same road also serves as a curved band that frames the marchers. An odd mixture of modes—but an effective device for linking foreground and background. Below the main scene, we observe the soldiers at camp, relaxing with food and drink, while one of them stands guard.

The mass of descriptive detail in the reliefs of military campaigns often leaves little room for the personal glorification of the king. This purpose is served more directly by another recurrent subject, the royal lion hunts. These were more in the nature of ceremonial combats than actual hunts: the animals were released from cages within a hollow square formed by troops with shields, for the king to kill. (Presumably, at a much earlier time, the hunting of lions in the field had been an important duty of Mesopotamian rulers as the "shepherds" of the communal flocks.) Here the Assyrian relief sculptor rises to his greatest heights; in figure 95, from the Palace of Ashurnasirpal II at Nimrud (Calah), the lion attacking the royal chariot from the rear is clearly the hero of the scene. Of magnificent strength and courage, the wounded

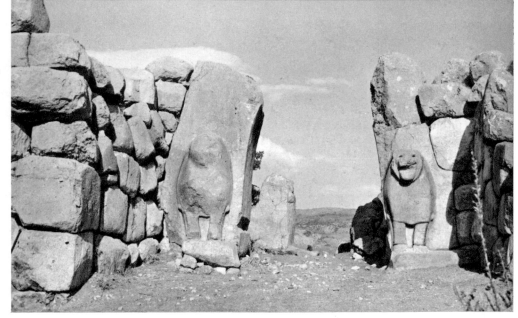

91. The Lion Gate, Bogazköy, Anatolia. c. 1400 B.C.

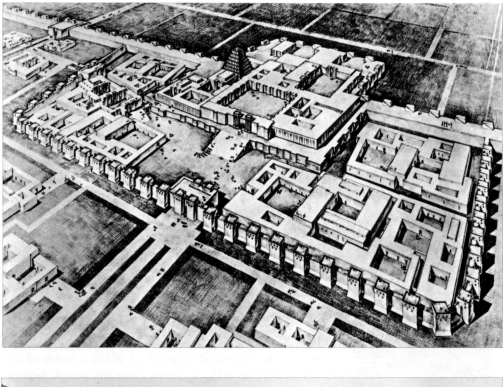

92. Citadel of Sargon II
at Dur Sharrukin
(Khorsabad). 742–706 B.C.
(reconstruction by Charles Altman)

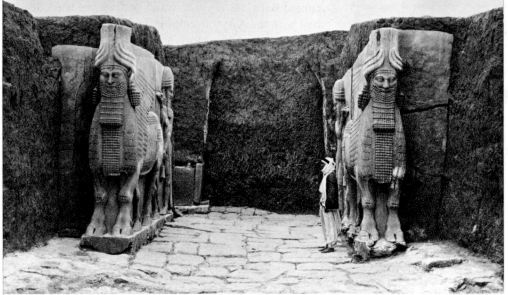

93. Gate of the Citadel of Sargon II
(during excavation)

animal seems to embody all the dramatic emotion that we miss in the pictorial accounts of war. The dying lion on the right is equally impressive in its agony. How differently the Egyptian artist (see fig. 77) had interpreted the same composition! We need only compare the horses—the Assyrian ones are less graceful but very much more energetic and alive as they flee from the attacking lion, their ears folded back in fear. The lion hunt reliefs from Nineveh, about two centuries later than those of Nimrud, are the finest of all. Despite the shallowness of the actual carving, the bodies have a greater sense of weight and volume because of the subtle gradations of the surface. Images such as the dying lioness (fig. 96) have an unforgettable tragic grandeur.

NEO-BABYLONIANS

The Assyrian empire came to an end when Nineveh fell before the combined onslaught of Medes and Scythians from the east. At that time the commander of the Assyrian army in southern Mesopotamia made himself king of Babylon; under him and his successors the ancient city had a final brief flowering between 612 and 539 B.C., before it was conquered by the Persians. The best known of these Neo-Babylonian rulers was Nebuchadnezzar, the builder of the Tower of Babel. That famous structure represented only one part of a very large architectural complex comparable to the citadel of Sargon II at Dur Sharrukin. Whereas the Assyrians had used carved stone

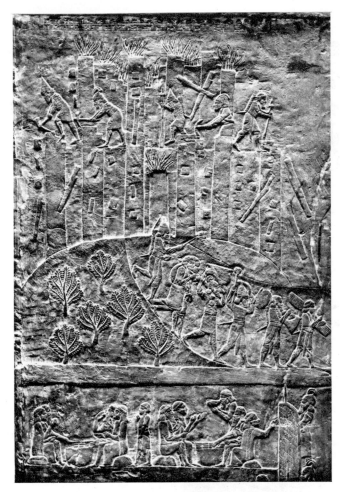

94. *The Sack of the City of Hamanu by Ashurbanipal,*
from Nineveh (Kuyunjik). c. 650 B.C.
Limestone, 36 × 24¹/₂″. British Museum, London

slabs, the Neo-Babylonians (who were farther removed from the sources of such slabs) substituted baked and glazed brick. This technique, too, had been developed in Assyria, but now it was used on a far larger scale, both for surface ornament and for architectural reliefs. Its very distinctive effect becomes evident if we compare the gate of Sargon's citadel (fig. 93) with the Ishtar Gate of Nebuchadnezzar's sacred precinct in Babylon, which has been rebuilt from the thousands of individual glazed bricks that covered its surface (colorplate 7). The stately procession of bulls, dragons, and other animals of molded brick within a framework of vividly colored ornamental bands has a grace and gaiety far removed from the ponderous guardian monsters of the Assyrians. Here, for the last time, we sense again that special genius of ancient Mesopotamian art for the portrayal of animals, which we noted in early dynastic times.

PERSIAN ART

Persia, the mountain-fringed high plateau to the east of Mesopotamia, takes its name from the people who occupied Babylon in 539 B.C. and became the heirs of what had been the Assyrian empire. Today the country is called Iran, which is the more suitable name, since the Persians, who put the area on the map of world history, were latecomers who had arrived on the scene only a few centuries before they began their epochal conquests. Inhabited continuously since prehistoric times, Iran always seems to have been a gateway for migratory tribes from the Asiatic steppes to the north as well as from India to the east. The new arrivals would settle down for a while, dominating or intermingling with the local population, until they in turn were forced to move on—to

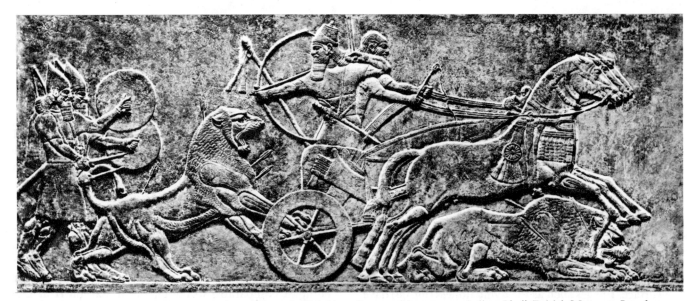

95. *Ashurnasirpal II Killing Lions,* from Nimrud (Calah). c. 850 B.C. Limestone, 3′ 3″ × 8′ 4″. British Museum, London

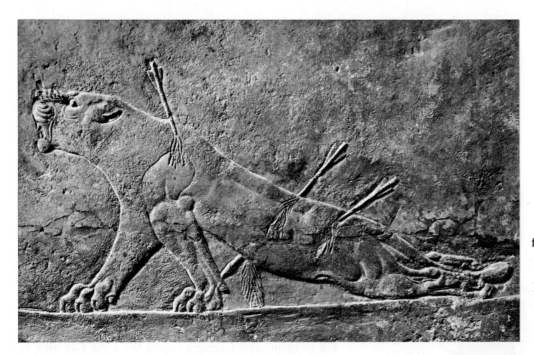

96. *Dying Lioness*, from Nineveh (Kuyunjik). c. 650 B.C. Limestone, height of figure 13³/₄″. British Museum, London

Mesopotamia, to Asia Minor, to southern Russia—by the next wave of migrants. These movements form a shadowy area of historical knowledge; all available information is vague and uncertain. Since nomadic tribes leave no permanent monuments or written records, we can trace their wanderings only by a careful study of the objects they buried with their dead. Such objects, of wood, bone, or metal, represent a distinct kind of portable art which we call the nomad's gear: weapons, bridles for horses, buckles, fibulas and other articles of adornment, cups, bowls, etc. They have been found over a vast area, from Siberia to Central Europe, from Iran to Scandinavia. They have in common not only a jewel-like concentration of ornamental design but also a repertory of forms known as the "animal style." And one of the sources of this animal style appears to be ancient Iran. Its main feature, as the name suggests, is the decorative use of animal motifs, in a rather abstract and imaginative manner. We find its earliest ancestors on the prehistoric painted pottery of western Iran, such as the fine beaker in figure 97, which shows an ibex (a wild mountain goat) reduced to a few sweeping curves, so that the body of the animal becomes a mere appendage of the huge horns. The racing hounds above the ibex are little more than horizontal streaks, and on closer inspection the striations below the rim turn out to be long-necked birds. In the historic art of Sumer, this style soon gave way to an interest in the organic unity of animal bodies (see colorplate 6 and fig. 85), but in Iran it survived despite the powerful influence of Mesopotamia. Several thousand years later, it reasserts itself in the small bronzes of the Luristan region, nomad's gear of a particularly resourceful kind. The pole top ornament (fig. 98) consists of a symmetrical pair of rearing ibexes, with vastly elongated necks and horns; originally, we suspect, they were pursued by a pair of lions, but the bodies of the latter have been absorbed into those of the ibexes, whose necks have been pulled out to

dragon-like slenderness. By and for whom the Luristan bronzes were produced remains something of a mystery. There can be little doubt, however, that they are somehow linked with the animal-style metalwork of the Asiatic steppes, such as the splendid Scythian gold stag from southern Russia, which is only slightly later in date (fig. 99). The animal's body here shows far less arbitrary distortion, and the smoothly curved sections divided by sharp ridges have no counterpart among Luristan bronzes, yet the way the antlers have been elaborated into an abstract openwork ornament betrays a similar feeling for form. Whether or not this typically Scythian piece re-

97. Painted Beaker, from Susa. c. 5000–4000 B.C. Height 11¹/₄″. The Louvre, Paris

98. Pole Top Ornament, from Luristan.
9th–7th century B.C. Bronze, height 7¹/₂″.
British Museum, London

flects Central Asiatic sources independent of the Iranian tradition, the Scythians surely learned a good deal from the bronze-casters of Luristan during their stay in Iran. They belonged to a group of nomadic Indo-European tribes, including the Medes and the Persians, that began to filter into the country soon after 1000 B.C. An alliance of Medes and Scythians, it will be recalled, had crushed Nineveh in 612 B.C. The Persians at that time were vassals of the Medes, but only sixty years later, under Cyrus the Great of the family of the Achaemenids, they reversed this situation.

ACHAEMENIDS

After conquering Babylon in 539 B.C., Cyrus assumed the title "King of Babylon" along with the ambitions of the Assyrian rulers. The empire he founded continued to expand under his successors; Egypt as well as Asia Minor fell to them, and Greece escaped the same fate only by the narrowest of margins. At its high tide, under Darius I and Xerxes (523–465 B.C.), the Persian empire was far larger than its Egyptian and Assyrian predecessors together. Moreover, this vast domain endured for two centuries—it was toppled by Alexander the Great in 331 B.C.—and during most of its life it was ruled both efficiently and humanely. For an obscure tribe of nomads to have achieved all this is little short of miraculous. Within a single generation, the Persians not only mastered the complex machinery of imperial administration but also evolved a monumental art of remarkable originality to express the grandeur of their rule.

Despite their genius for adaptation, the Persians re-

99. *Stag*, from Kostromskaya.
Scythian. 7th–6th century B.C.
Chased gold, height c. 12″.
Hermitage Museum, Leningrad

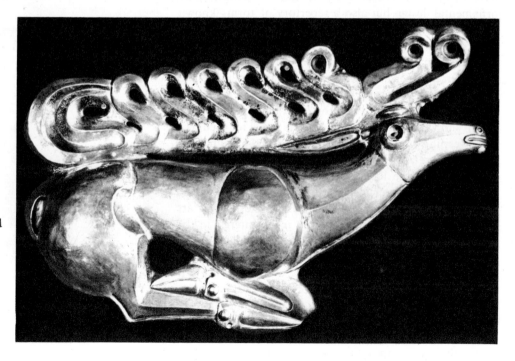

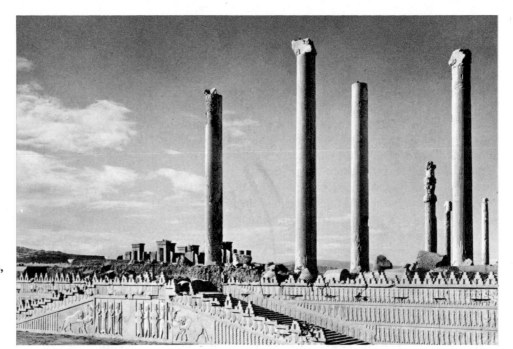

100. Audience Hall of Darius, Persepolis. c. 500 B.C.

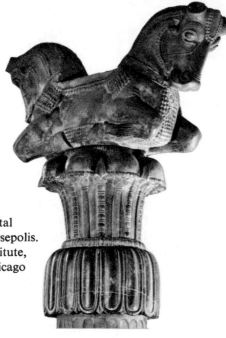

101. Bull Capital (restored), from Persepolis. The Oriental Institute, University of Chicago

tained their own religious belief derived from the prophecies of Zoroaster; this was a faith based on the dualism of Good and Evil, embodied in Ahuramazda (Light) and Ahriman (Darkness). Since the cult of Ahuramazda centered on fire altars in the open air, the Persians had no religious architecture. Their palaces, on the other hand, were huge and impressive structures. The most ambitious one, at Persepolis, was begun under Darius I in 518 B.C.; its general layout—a vast number of rooms, halls, and courts assembled on a raised platform—recalls the royal residences of Assyria (see fig. 92), and Assyrian traditions are the strongest single element throughout. Yet they do not determine the character of the building, for they have been combined with influences from every corner of the empire in such a way that the result is a new, uniquely Persian style. Thus, at Persepolis columns are used on a grand scale. The Audience Hall of Darius, a room 250 feet square, had a wooden ceiling supported by 36 columns 40 feet tall, a few of which are still standing (fig. 100). Such a massing of columns suggests Egyptian architecture (compare fig. 71), and Egyptian influence

102. *Darius and Xerxes Giving Audience.* c. 490 B.C. Limestone, height 8' 4''. Treasury, Persepolis

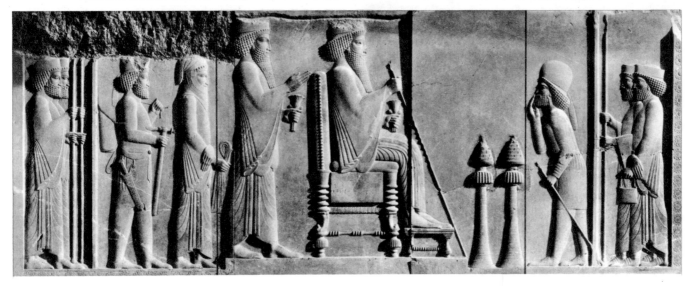

does indeed appear in the ornamental detail of the bases and capitals, but the slender, fluted shaft of the Persepolis columns is derived from the Ionian Greeks in Asia Minor, who are known to have furnished artists to the Persian court. Entirely without precedent in earlier architecture is the strange "cradle" for the beams of the ceiling, composed of the front parts of two bulls or similar creatures, that crowns the Persepolis columns (fig. 101); while the animals themselves are of Assyrian origin, the way they are combined suggests nothing so much as an enormously enlarged version of the pole top ornaments of Luristan. This seems to be the only instance of Persian architects drawing upon their native artistic heritage of nomad's gear.

The double stairway leading up to the Audience Hall is decorated with long rows of solemnly marching figures in relief (see fig. 100). Their repetitive, ceremonial character emphasizes a subservience to the architectural setting that is typical of all Persian sculpture. We find it even in scenes of special importance such as *Darius and Xerxes Giving Audience* (fig. 102); the expressive energy and narrative skill of Assyrian relief have been deliberately rejected. The style of these Persian carvings seems at first glance to be only a softer and more refined echo of the Mesopotamian tradition. Even here, however, we discover that the Assyrian-Babylonian heritage has been enriched in one important respect: there is no precedent in Near Eastern sculpture for the layers of overlapping

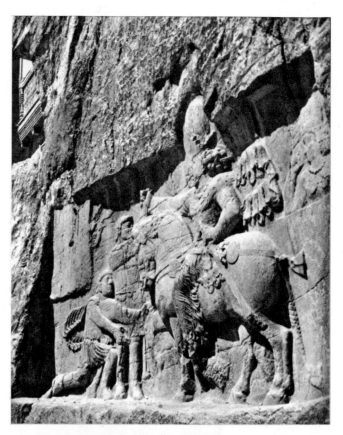

104. *Shapur I Triumphing over the Emperors Philippus the Arab and Valerian.* 260–272 A.D. Naksh-i-Rustam

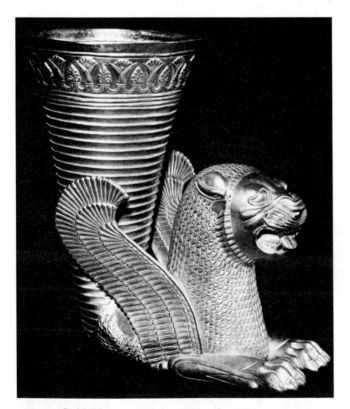

103. Gold Rhyton. Achaemenid, 5th–3rd century B.C.
Archaeological Museum, Teheran

garments, for the play of finely pleated folds such as we see in the Darius and Xerxes relief. Another surprising effect is the way the arms and shoulders of these figures press through the fabric of the draperies. These innovations stem from the Ionian Greeks, who had created them in the course of the sixth century B.C.

Persian art under the Achaemenids, then, is a remarkable synthesis of many diverse elements. Yet it lacked a capacity for growth; the style formulated under Darius I about 500 B.C. continued without significant change until the end of the empire. The main reason for this failure, it seems, was the Persians' preoccupation with decorative effects regardless of scale, a carry-over from their nomadic past which they never sloughed off. There is no essential difference between the bull capital of figure 101 and the fine goldsmith's work (fig. 103), textiles, and other portable art of Achaemenid Persia. The latter tradition, unlike that of monumental architecture and sculpture, somehow managed to survive the more than 500 years during which the Persian empire was under Greek and Roman domination, so that it could flower once more when Persia regained its independence and seized Mesopotamia from the Romans.

SASSANIANS

The rulers who accomplished this feat were of the house of the Sassanians; their greatest figure, Shapur I,

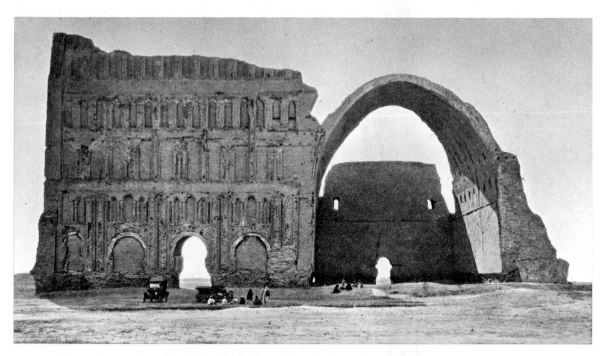

105. Palace of Shapur I, Ctesiphon. 242–272 A.D.

had the political and artistic ambitions of Darius. At Naksh-i-Rustam, the burial place of the Achaemenid kings not far from Persepolis, he commemorated his victory over two Roman emperors in an enormous relief hewn into the living rock (fig. 104). The formal source of this scene of triumph is a well-known composition in Roman sculpture—with the emperors in the role of the humiliated barbarians—but the flattening of the volumes and the ornamental elaboration of the draperies indicate a revival of Persian qualities. The two elements hold each other in balance, and that is what makes the relief so strangely impressive. A blending of Roman and Near Eastern elements can also be observed in Shapur's palace at Ctesiphon, near Babylon, with its enormous brick-vaulted audience hall (fig. 105); the blind arcades of the façade again show an emphasis on decorative surface pattern. But monumental art under Sassanian rule proved as incapable of further evolution as it had under the Achaemenids. Metalwork and textiles, on the other hand, continued to flourish. The chief glory of Sassanian art— and a direct echo of the ornamental tradition reaching back more than a thousand years to the Luristan bronzes —is its woven silks, such as the splendid sample in figure 106. They were copiously exported both to Constantinople and to the Christian West, and we shall see that their wealth of colors and patterns exerted an important stimulus upon the art of the Middle Ages. And since their manufacture was resumed after the Sassanian realm fell to the Arabs in the mid-seventh century, they provided an essential treasury of design motifs for Islamic art as well.

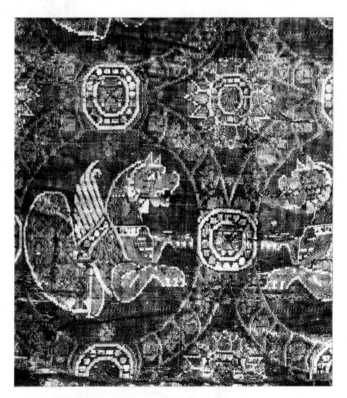

106. Woven Silk. Sassanian, c. 6th century A.D.
National Museum, Florence (Franchetti Collection)

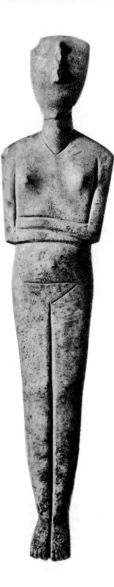

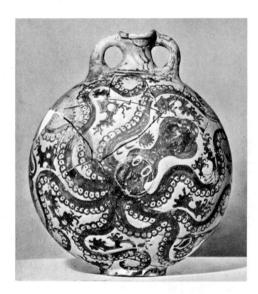

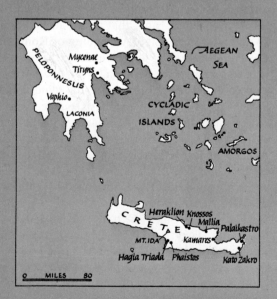

4

AEGEAN ART

If we sail from the Nile Delta northwestward across the Mediterranean, our first glimpse of Europe will be the eastern tip of Crete. Beyond it, we find a scattered group of small islands, the Cyclades, and, a little farther on, the mainland of Greece, facing the coast of Asia Minor across the Aegean Sea. To archaeologists, "Aegean" is not merely a geographical term; they have adopted it to designate the civilizations that flourished in this area during the third and second millenniums B.C., before the development of Greek civilization proper. There are three of these, closely interrelated yet distinct from each other: that of Crete, called Minoan after the legendary Cretan King Minos; that of the small islands north of Crete (Cycladic); and that of the Greek mainland (Helladic). Each of them has in turn been divided into three phases, Early, Middle, and Late, which correspond, very roughly, to the Old, Middle, and New Kingdom in Egypt. The most important remains, and the greatest artistic achievements, date from the latter part of the Middle and from the Late phase.

A hundred years ago, Aegean civilization was known to us only from Homer's account of the Trojan War in the *Iliad* and from Greek legends centering on Crete. The earliest excavations (by Heinrich Schliemann during the 1870s in Asia Minor and Greece, by Sir Arthur Evans in Crete shortly before 1900) were undertaken to test the factual core of these tales. Since then, a great amount of fascinating material has been brought to light—far more than the literary sources would lead us to expect—but our knowledge of Aegean civilization even now is very much more limited than our knowledge of Egypt or the ancient Near East. Unfortunately, our reading of the archaeological evidence has so far received almost no aid at all from the written records of the Aegeans. In Crete a system of writing was developed about 2000 B.C., and a late form of this Minoan script, called Linear B, which was in use about six centuries later both in Crete and on the Greek mainland, has recently been deciphered. The language of Linear B is Greek, yet this apparently was not the language for which Minoan script was

107. *Leaping Mountain Goat*, on a vase from the Palace at Kato Zakro. c. 1500 B.C. Limestone (originally covered with gold foil), length of goat c. 4″. Heraklion, Museum, Crete

used before the fifteenth century B.C., so that being able to read Linear B does not help us to understand the great mass of earlier Minoan inscriptions. Moreover, the Linear B texts are largely palace inventories and administrative records, which reveal very little about the history and religion of the people who composed them. We thus lack a great deal of the background knowledge necessary for an understanding of Aegean art. Its forms, although linked both to Egypt and the Near East on the one hand and to later Greek art on the other, are no mere transition between these two worlds; they have a haunting beauty of their own that belongs to neither. Among the many strange qualities of Aegean art, perhaps the most puzzling is its air of freshness and spontaneity, which makes us forget how little we know of its meaning.

108. Staircase, East Wing, Palace
of Minos, Knossos, Crete. c. 1500 B.C.

CYCLADIC ART

The people who inhabited the Cycladic islands between
about 2600 and 1100 B.C. have left hardly any trace apart
from their modest stone tombs. The things they buried
with their dead are remarkable in one respect only: they
include a large number of marble idols of a peculiarly
impressive kind. Almost all of them represent a standing
nude female figure with arms folded across the chest,
presumably the mother and fertility goddess known to
us from Asia Minor and the ancient Near East, whose
ancestry reaches far back to the Old Stone Age (see figs.
16, 26, 27). They also share a distinctive shape, which
at first glance recalls the angular, abstract qualities of
primitive sculpture: the flat, wedge shape of the body, the
strong, columnar neck, and the tilted, oval shield of the
face, featureless except for the long, ridgelike nose. With-
in this narrowly defined and stable type, however, the
Cycladic idols show wide variations in scale (from a few
inches to lifesize) as well as form. The best of them, such
as that in figure 109, have a disciplined refinement utterly
beyond the range of Paleolithic or primitive art. The
longer we study this piece, the more we come to realize
that its qualities can only be described as "elegance" and
"sophistication," however incongruous such terms may

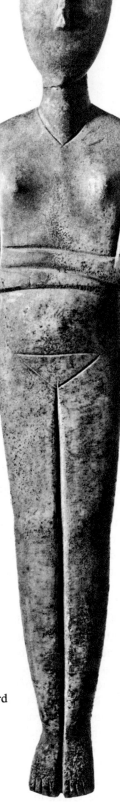

109. Idol, from Amorgos.
2500–1100 B.C.
Marble, height 30".
Ashmolean Museum, Oxford

seem in our context. What an extraordinary feeling for the organic structure of the body there is in the delicate curves of the outline, in the hints of convexity marking the knees and abdomen. Even if we discount its deceptively modern look, the figure seems a bold departure from anything we have seen before. There is no dearth of earlier fertility idols, but almost all of them betray their descent from the bulbous, heavy-bodied "Venus" figurines of the Old Stone Age; in fact, the earliest Cycladic idols, too, were of that type. What, then, made the Cycladic sculptors suppress the traditional fertility aspects of their female idols until they arrived at the lithe, "girlish" ideal of figure 109? Was there perhaps a radical change in the meaning and ritual purpose of these statues? We cannot even venture a guess to explain the mystery. Suffice it to say. that the Cycladic sculptors of the second millennium B.C. produced the oldest life-size figures of the female nude we know, and that for many hundreds of years they were the only ones to do so. In Greek art, we find very few nude female statues until the middle of the fourth century B.C., when Praxiteles and others began to create cult images of the nude Venus. It can hardly be coincidence that the most famous of these Venuses were made for sanctuaries on the Aegean islands or the coast of Asia Minor, the region where the Cycladic idols had flourished.

MINOAN ART

Minoan civilization is by far the richest, as well as the strangest, of the Aegean world. What sets it apart, not only from Egypt and the Near East but also from the Classical civilization of Greece, is a lack of continuity that appears to have deeper causes than archaeological accident. In surveying the main achievements of Minoan art, we cannot really speak of growth or development; they appear and disappear so abruptly that their fate must have been determined by external forces—

sudden violent changes affecting the entire island—about which we know little or nothing. Yet the character of Minoan art, which is gay, even playful, and full of rhythmic motion, conveys no hint of such threats.

ARCHITECTURE

The first of these unexpected shifts occurred about 2000 B.C. Until that time, during the eight centuries of the Early Minoan era, the Cretans had not advanced much beyond the Neolithic level of village life, even though they seem to have engaged in some overseas trade that brought them contact with Egypt. Then they created not only their own system of writing but an urban civilization as well, centering on several great palaces. At least three of them, Knossos, Phaistos, and Mallia, were built in short order. Hardly anything is left today of this sudden spurt of large-scale building activity, for the three palaces were all destroyed at the same time, about 1700 B.C.; after an interval of a hundred years, new and even larger structures began to appear on the same sites, only to suffer destruction, in their turn, about 1500 B.C. It is these "new" palaces that are our main source of information on Minoan architecture. The one at Knossos, called the Palace of Minos, was the most ambitious, covering a vast territory and composed of so many rooms that it survived in Greek legend as the labyrinth of the Minotaur. It has been carefully excavated and partly restored. We cannot recapture the appearance of the building as a whole, but we can assume that the exterior probably did not look impressive compared to Assyrian or Persian palaces (see figs. 92, 100). There was no striving for unified, monumental effect. The individual units are generally rather small and the ceilings low (figs. 108, 110), so that even those parts of the structure that were several stories high could not have seemed very tall. Nevertheless, the numerous porticoes, staircases, and air shafts must have given the palace a pleasantly open, airy quality; and some of the interiors, with their richly

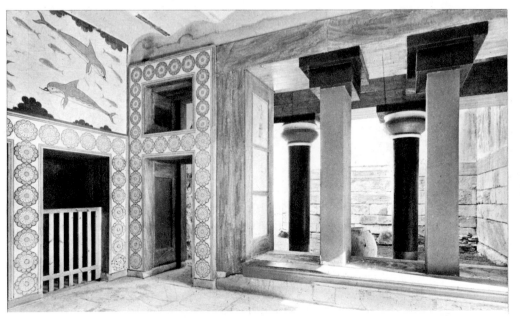

110. The Queen's Megaron, Palace of Minos, Knossos, Crete

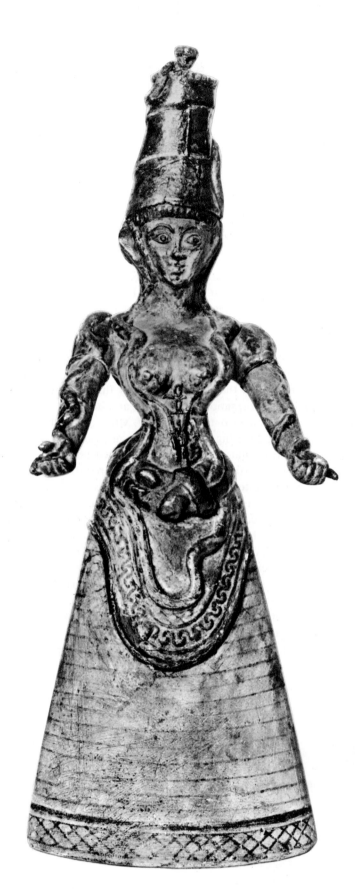

decorated walls, retain their atmosphere of intimate elegance to this very day. The masonry construction of Minoan palaces is excellent throughout, but the columns were always of wood. Although none have survived, their characteristic form (the smooth shaft tapering downward, topped by a wide, cushion-shaped capital) is known from representations in painting and sculpture. About the origins of this type of column, which in some contexts could also serve as a religious symbol, or about its possible links with Egyptian architecture, we can say nothing at all.

Who were the rulers that built these palaces? We do not know their names or deeds (except for the legendary Minos), but the archaeological evidence permits a few conjectures: they were not warrior princes, since no fortifications have been found anywhere in Minoan Crete and military subjects are almost unknown in Minoan art; nor is there any hint that they were sacred kings on the Egyptian or Mesopotamian model, although they may well have presided at religious festivals (the only parts of Minoan palaces that can be identified as places of worship are small chapels, suggesting that religious ceremonies took place out of doors). On the other hand, the many storerooms, workshops, and "offices" at Knossos indicate that the palace was not only a royal residence but a great center of administrative and commercial activity. Since shipping and trade formed an important part of Minoan economic life (to judge from

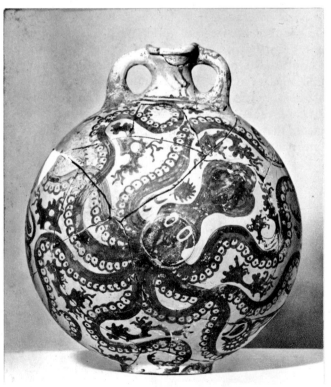

111. *Snake Goddess (Priestess?)*.
c. 1600 B.C. Terracotta, height 13½".
Museum, Heraklion, Crete

112. "Octopus Vase," from Palaikastro, Crete.
c. 1500 B.C. Height 11". Museum, Heraklion, Crete

elaborate harbor installations and from Cretan export articles found in Egypt and elsewhere), perhaps the king should be viewed as the head of a merchant aristocracy.

SCULPTURE

The religious life of Minoan Crete is even harder to define than the political or social order. It centered on certain sacred places, such as caves or groves, and its chief deity (or deities?) was female, akin to the mother and fertility goddesses we have encountered before. Since the Minoans had no temples, we are not surprised to find that they lacked large cult statues as well, but religious subjects in Minoan art are few in number and of uncertain significance even on a small scale. Two terracotta statuettes of c. 1600 B.C. from Knossos may represent the goddess in one of her several identities; one of them (fig. 111) shows her with three long snakes wound around her arms, body, and headdress. Their meaning would seem to be clear—in many ancient religions, snakes are associated with earth deities and male fertility, just as the bared breasts of our statuette suggest female fertility. But is she really a cult image? Her rigid, frontal stance would be equally fitting for a votive figure, and the snakes may represent a ritual of snake-handling rather than a divine attribute. Perhaps, then, our figure is a queen or priestess? She seems oddly lacking in awesomeness, and the emphasis on the costume endows her with a secular, "fashionable" air. Another paradox is the fact that Crete has few snakes, so that its snake cult was probably imported, not home-grown, yet no snake goddesses have so far been discovered outside Crete. Only the style of the statuette hints at a possible foreign source: the emphatically conical quality of the figure, the large eyes and heavy, arched eyebrows suggest a kinship —remote and indirect, perhaps through Asia Minor— with Mesopotamian art.

PAINTINGS; CERAMICS; RELIEFS

Our snake goddess dates from the beginning of the brief period, between 1600 and 1450 B.C., which produced almost everything we have of Minoan architecture, sculpture, and painting. After the catastrophe that had wiped out the earlier palaces, and a century of slow recovery, there was what seems to our eyes an explosive increase in wealth and an equally remarkable outpouring of creative energy. The most surprising aspect of this sudden efflorescence, however, is its great achievement in painting. At the time of the earlier palaces, between 2000 and 1700 B.C., Crete had developed a type of pottery famous for its technical perfection and its dynamic, swirling ornament (colorplate 8), but in no way preparing us for the "naturalistic" murals that covered the walls of the new palaces. Unfortunately, these paintings have survived only in small fragments, so that we hardly ever have a complete composition, let alone the design of an

entire wall. A great many of them were scenes from nature showing animals and birds among luxuriant vegetation, or the creatures of the sea. In the remarkable fragment in figure 113, we see a cat cautiously stalking a pheasant behind a bush. The flat forms, silhouetted against a background of solid color, recall Egyptian painting, and the acute observation of plants and animals also suggests Egyptian art. But if Minoan wall painting owes its origin to Egyptian influence, it betrays an attitude of mind, a sense of beauty very different from that of the Nile valley: instead of permanence and stability, we find a passion for rhythmic, undulating movement, and the forms themselves have an oddly weightless quality—they seem to float, or sway, in a world without gravity, as if the scene took place under water. Marine life (as seen in the fish and dolphin fresco in fig. 110) was a favorite subject of Minoan painting, and the marine feeling pervades everything else as well; we sense it even in the "Toreador Fresco," the largest and most dynamic Minoan mural recovered so far (colorplate 9; the darker patches are the original fragments on which the restoration is based). The conventional title should not mislead us: what we see here is not a bullfight but a ritual game in which the performers vault over the back of the animal. Two of the slim-waisted athletes are girls, differentiated (as in Egyptian art) mainly by their lighter skin color. That the bull was a sacred animal, and that bull-vaulting played an important role in Minoan religious life, is beyond doubt; scenes such as this still echo in the Greek legend of the youths and maidens sacrificed to the Minotaur. If we try, however, to "read" the fresco as a description of what actually went on during these performances, we find it strangely ambiguous. Do the three figures show successive phases of the same action? How did the youth in the center get onto the back of the bull, and in what direction is he moving? Scholars have even consulted rodeo experts without getting clear answers to these questions. All of which does not mean that the Minoan artist was deficient—it would be absurd to blame him for failing to accomplish what he never intended to do in the first place—but that fluid, effortless ease of movement was more important to him than factual precision or dramatic power. He has, as it were, idealized the ritual by stressing its harmonious, playful aspect to the point that the participants behave like dolphins gamboling in the sea.

The floating world of Minoan wall painting was an imaginative creation so rich and original that its influence can be felt throughout Minoan art during the era of the new palaces. In painted pottery, the abstract patterns of old (colorplate 8) gave way to a new repertory of designs drawn from plant and animal life. Some vessels are covered entirely with fish, shells, octopuses, etc., as if the ocean itself had been caught within them (fig. 112). Monumental sculpture, had there been any, might have retained its independence, but the small-scale works to which the Minoan sculptor was confined are often closely

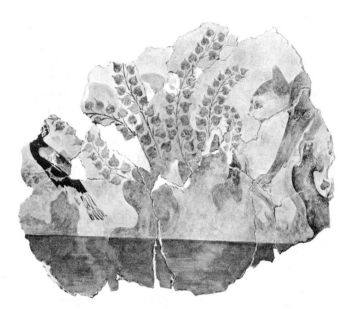

113. *Cat Stalking a Pheasant*, mural fragment, Hagia Triada. c. 1600–1580 B.C. Height 21″. Heraklion, Museum, Crete

114. *The Harvester Vase* (detail), from Hagia Triada. c. 1550–1500 B.C. Steatite, width 4¹/₂″. Heraklion, Museum, Crete

akin to the style of the murals; the splendidly observed mountain goat carved on a stone vase (fig. 107) leaps in the same "flying" movement as the bull of the "Toreador Fresco." These mountain goats, too, were sacred animals. Even more vivid is the relief on the so-called Harvester Vase (fig. 114; the lower part is lost): a procession of slim, muscular men, nude to the waist, carrying long-handled implements that look like a combination of scythe and rake. A harvest festival? Quite probably, although here again the lively rhythm of the composition takes precedence over descriptive clarity. Our view of the scene includes three singers led by a fourth who is swinging a sistrum (a rattle of Egyptian origin); they are bellowing with all their might, especially the "choir-master," whose chest is so distended that the ribs press

through the skin. What makes the entire relief so remarkable—in fact, unique—is its emphasis on physical strain, its energetic, raucous gaiety, which combines sharp observation with a consciously humorous intent. How many works of this sort, we wonder, did Minoan art produce? Only once have we met anything at all like it before: in the relief of workmen carrying a beam (fig. 77), carved almost two centuries later under the impact of the Akhenaten style. Is it possible that pieces similar to the Harvester Vase stimulated Egyptian artists during that brief but important period?

MYCENAEAN ART

Along the southeastern shores of the Greek mainland there existed during Late Helladic times (c. 1600–1100 B.C.) a number of settlements corresponding in many ways to those of Minoan Crete. They, too, were grouped around palaces. Their inhabitants have come to be called Mycenaeans, after Mycenae, the most important of these settlements. Since the works of art unearthed there by excavation often showed a strikingly Minoan character, the Mycenaeans were at first regarded as having come from Crete, but it is now agreed that they were the descendants of the earliest Greek tribes, who had entered the country soon after 2000 B.C.

Tombs and Their Contents

For some 400 years these people had led an inconspicuous pastoral existence in their new homeland; their modest tombs have yielded only simple pottery and a few bronze weapons. Toward 1600 B.C., however, they suddenly began to bury their dead in deep shaft graves and, a little later, in conical stone chambers, known as beehive tombs. This development reached its height toward 1300 B.C. in such impressive structures as the one shown in figures 115 and 116, built of concentric layers of precisely cut stone blocks. Its discoverer thought it far too ambitious for a tomb and gave it the misleading name "The Treasury of Atreus." Burial places as elaborate as this can be matched only in Egypt during the same period.

The Treasury of Atreus had been robbed of its contents long ago, but other Mycenaean tombs were found intact, and what they yielded up caused even greater surprise: alongside the royal dead were placed masks of gold or silver, presumably to cover their faces. If so, these masks were similar in purpose (if not in style) to the masks found in Pharaonic tombs of the Middle and New Kingdoms (compare colorplate 5). There was also a good deal of personal equipment—drinking vessels, jewelry, weapons—much of it gold and exquisite in workmanship. Some of these pieces, such as the magnificent gold vessel in the shape of a lion's head (fig.

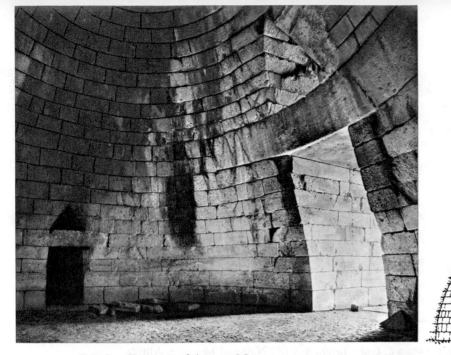

115. Interior, Treasury of Atreus, Mycenae. c. 1300–1250 B.C.

116. Section, Treasury of Atreus

117), show a boldly expressive style of smooth planes bounded by sharp ridges which suggests contact with the Near East, while others are so Minoan in flavor that they might be imports from Crete. Of the latter kind are the two famous gold cups from a tomb at Vaphio (figs. 118, 119); they must have been made about 1500 B.C., a few decades after the lion vessel, but where, for whom, and by whom? Here the problem "Minoan or Mycenaean?" becomes acute. The dispute is not as idle as it may seem, for it tests our ability to differentiate between the two neighboring cultures. It also forces us to consider every aspect of the cups: do we find anything in their style or content that is un-Minoan? Our first impulse, surely, is to note the similarity of the human figures to those on the Harvester Vase, and the similarity of the bulls to the animal in the "Toreador Fresco." On the other hand, we cannot overlook the fact that the men on the Vaphio cups are not engaged in the Cretan bull-vaulting game but in the far more mundane business of catching the animals on the range, a subject that does not occur in Minoan art, though we do find it in Mycenae. Once we realize this, we are also apt to notice that the design on the cups does not quite match the continuous rhythmic movement of Minoan compositions, and that the animals, for all their physical power, have the look of cattle rather than of sacred animals. It would seem, then, that the cups are a Mycenaean adaption of Minoan forms, either by a mainland artist or by a Cretan working for Mycenaean patrons.

In the sixteenth century B.C., Mycenae thus presents a strange picture: what appears to be an Egyptian influence on burial customs is combined with a strong artistic influence from Crete and with an extraordinary material wealth as expressed in the lavish use of gold. Did the Mycenaeans perhaps conquer the Minoans, causing the destruction of the "new" palaces there about 1500 B.C.? This idea has now been discarded; the new palaces, it seems, were destroyed by a natural catastrophe

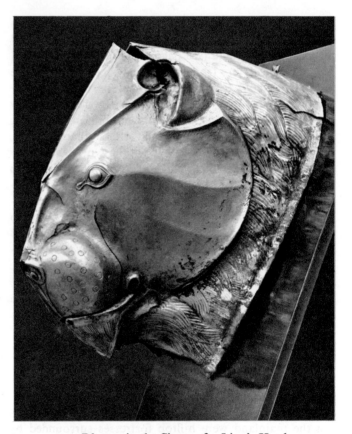

117. Rhyton in the Shape of a Lion's Head, from a shaft grave at Mycenae. c. 1550 B.C. Gold, height 8". National Museum, Athens

(earthquakes and tidal waves following the eruption of a volcano). In any event, it does not account for the puzzling connection with Egypt. What we need is a triangular explanation that involves the Mycenaeans with Crete as well as Egypt about a century before the destruction of the new palaces; and such a theory—fascinating and imaginative, if hard to confirm in detail—has been taking shape in recent years. It runs about as

118, 119. *The Vaphio Cups.* c. 1500 B.C. Gold, height 3–3½". National Museum, Athens

follows: between 1700 and 1580 B.C., the Egyptians were trying to rid themselves of the Hyksos, who had seized the Nile Delta (see page 61). For this they gained the aid of warriors from Mycenae, who returned home laden with gold (of which Egypt alone had an ample supply), and deeply impressed with Egyptian funerary customs. The Minoans, unmilitary but famous as sailors, ferried the Mycenaeans back and forth, so that they, too, had a new and closer contact with Egypt (which may help to account for their sudden prosperity toward 1600 B.C. as well as for the rapid development of naturalistic wall painting at that time). The close relations between Crete and Mycenae, once established, were to last a long time; toward 1400 B.C., when Linear B script began to appear, the Mycenaeans were the rulers of Crete, either by conquest or through dynastic marriage. In any event, their power rose as that of the Minoans declined; the great monuments of Mycenaean architecture were all built between 1400 and 1200 B.C.

Architecture

Apart from such details as the shape of the columns or decorative motifs of various sorts, Mycenaean architecture owes little to the Minoan tradition. The palaces on the mainland were hilltop fortresses surrounded by defensive walls of huge stone blocks, a type of construction quite unknown in Crete but similar to the Hittite fortifications at Bogazköy (see fig. 91). The Lion Gate at Mycenae (fig. 120) is the most impressive remnant of these massive ramparts, which inspired such awe in the Greeks of later times that they were regarded as the work of the Cyclopes (a mythical race of one-eyed giants). Even the Treasury of Atreus, although built of smaller and more precisely shaped blocks, has a Cyclopean lintel (see fig. 115). Another aspect of the Lion Gate foreign to the Minoan tradition is the great stone relief over the doorway. The two lions flanking a symbolic Minoan

column have the same grim, heraldic majesty as the golden lion's head we encountered in figure 117. Their function as guardians of the gate, their tense, muscular bodies, and their symmetrical design again suggest an influence from the ancient Near East. We may at this point recall the Trojan War, immortalized in Homer's *Iliad*, which brought the Mycenaeans to Asia Minor soon after 1200 B.C.; it seems likely, however, that they began to sally eastward across the Aegean, for trade or war, much earlier than that.

The center of the palace, at Mycenae and other mainland sites, was the royal audience hall, called the megaron. Only its plan is known for certain: a large rectangular room with a round hearth in the middle and four columns to support the roof beams (fig. 121). It was entered through a deep porch with two columns, and an antechamber. This design is in essence no more than an enlarged version of the simple houses of earlier generations; its ancestry can be traced back to Middle Helladic times. There must have been a rich decorative scheme of wall paintings and ornamental carvings to stress its dignity as the king's abode.

Sculpture

No trace has been found of Mycenaean temple architecture—if it ever existed. The palaces did, however, include modest shrines, as in Crete. What gods were worshiped there is a matter of dispute; Mycenaean religion surely included Minoan elements but also influences from Asia Minor, as well as deities of Greek origin inherited from their own forebears. But gods have an odd way of merging or exchanging their identities, so that the religious images in Mycenaean art are extremely hard to interpret. What, for instance, are we to make of the exquisite little ivory group (figs. 122, 123) unearthed at Mycenae in 1939? The style of the piece—its richly curved shapes and easy, flexible body movements—still echoes

Minoan art, but the subject is strange indeed. Two kneeling women, closely united, tend a single child; whose is he? The natural interpretation would be to regard the now headless figure as the mother, since the child clings to her arm and turns toward her; the second woman, whose left hand rests on the other's shoulder, would then be the grandmother. Such three-generation family groups are a well-known subject in Christian art, in which we often find St. Anne, the Virgin Mary, and the Infant Christ combined in similar fashion.

It is the memory of these later works that colors our view of the Mycenaean ivory. Yet we search in vain for a subject in ancient religion that fits our reading of the group. On the other hand, there is a very widespread myth about the divine child (his name varies from place to place) who is abandoned by his mother and reared by nymphs, goddesses, or even animals. We are thus forced to conclude—rather reluctantly—that our ivory in all likelihood shows a motherless child god with his nurses. The real mystery, however, lies deeper; it is the tender play of gestures, the intimate human feeling, that binds the three figures together. Nowhere in the entire range of ancient art before the Greeks do we find gods—or men, for that matter—expressing affection with such warmth and eloquence. Something quite basically new is reflected here, a familiar view of divine beings that makes even the Minoan snake goddess (fig. III) seem awesome and remote. Was this change of attitude, and the ability to express it in art, a Mycenaean achievement? Or did they inherit it from the Minoans? However that may be, our ivory group opens up a dimension of experience that had never been accessible to Egypt or Mesopotamia.

120. The Lion Gate, Mycenae. c. 1250 B.C.

121. Plan of a Mycenaean Megaron

122, 123. *Three Deities*, from Mycenae. c. 1500–1400 B.C. Ivory, height 3″. National Museum, Athens

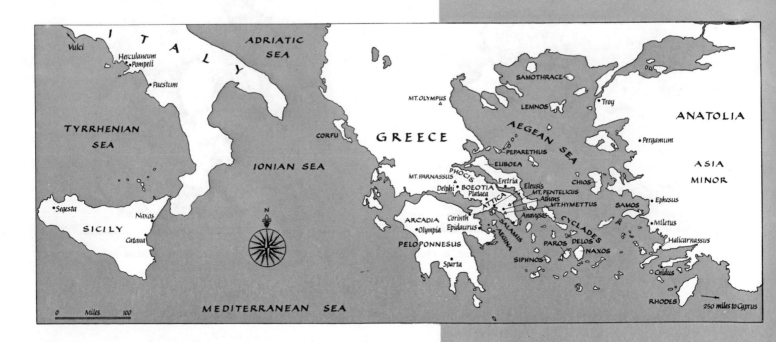

5

GREEK ART

The works of art we have come to know so far are like fascinating strangers: we approach them fully aware of their alien background and of the "language difficulties" they present. If it turns out that, after all, we can understand something of what they have to say, we are surprised and grateful. As soon as we reach the Greeks, our attitude undergoes a change: they are not strangers but relatives, we feel, older members of our own family whom we recognize immediately. A Greek temple will remind us at a glance of the First National Bank around the corner, a Greek statue will bring to mind countless other statues we have seen somewhere, a Greek coin will make us want to reach for the small change in our own pockets. But this air of familiarity is not an unmixed blessing. We would do well to keep in mind that the continuous tradition which links us with the Greeks is a handicap as well as an advantage. If we are to get an unhampered view of Greek architecture, we must take care not to be swayed by our memories of the First National Bank, and in judging Greek sculpture we had better forget its latter-day descendants in the public park.

Another complication peculiar to the study of Greek art arises from the fact that we have three separate, and sometimes conflicting, sources of information on the subject. There are, first of all, the monuments themselves, a reliable but often woefully inadequate source. Then we have various copies made in Roman times which tell us something about important Greek works that would otherwise be lost to us entirely. These copies, however, always pose a problem: some are of such high quality that we cannot be sure that they really *are* copies, others make us wonder how faithfully they follow their model (especially if we have several copies, all slightly different, of the same lost original). Finally, there are the literary sources. The Greeks were the first people in history to write at length about their own artists, and their accounts were eagerly collected by the Romans, who handed them down to us. From them we learn what the Greeks themselves considered their most important achievements in architecture, sculpture, and painting. This written testimony has helped us to identify some celebrated artists and monuments, but much of it deals with works of which no visible trace remains today, while other works, which do survive and which strike us as among the greatest masterpieces of their time, are not mentioned at all. To

reconcile the literary evidence with that of the copies and of the original monuments, and to weave these strands into a coherent picture of the development of Greek art, is a difficult task indeed, despite the vast amount of work that has been done since the beginnings of archaeological scholarship two hundred years ago.

Who were the Greeks? We have met some of them before—the Mycenaeans, who had come to Greece about 2000 B.C. Other Greek-speaking tribes entered the peninsula from the north, toward 1100 B.C., overwhelmed and absorbed the Mycenaean stock, and gradually spread to the Aegean islands and Asia Minor. It was these tribes who during the following centuries created the great civilization for which we now reserve the name Greek. We do not know how many separate tribal units there were in the beginning, but two main groups stand out: the Dorians, who settled mostly on the mainland, and the Ionians, who inhabited the Aegean islands and the nearby coast of Asia Minor and thus had closer contacts with the ancient Near East. Some centuries later, the Greeks also spread westward, founding important settlements in Sicily and southern Italy. Despite a strong sense of kinship based on language and common beliefs, and expressed in such traditions as the four great Panhellenic (all-Greek) festivals, the Greeks remained divided into many small, independent city-states. The pattern may be viewed as an echo of age-old tribal loyalties, as an inheritance from the Mycenaeans, or as a response to the geography of Greece, whose mountain ranges, narrow valleys, and jagged coastline would have made political unification difficult in any event. Perhaps all three factors reinforced one another. The intense rivalry of these states—military, political, and commercial—undoubtedly stimulated the growth of ideas and institutions. Our own thinking about government continues to make use of a number of key terms of Greek origin which reflect the evolution of the city-state: *monarchy, aristocracy, tyranny, democracy*, and, most important, *politics* (derived from *polites,* the citizen of the *polis* or city-state). In the end, however, the Greeks paid dearly for their inability to broaden the concept of the state beyond the local limits of the *polis*. The Peloponnesian War (431–404 B.C.), in which the Spartans and their allies defeated the Athenians, was a catastrophe from which Greece never recovered.

124. *Shipwreck,* drawing after a Geometric vase in the Museum at Ischia. 8th century B.C.

125. Dipylon Vase. 8th century B.C. Height 42¹/₂".
The Metropolitan Museum of Art, New York (Rogers Fund)

GEOMETRIC STYLE

The formative phase of Greek civilization embraces about four hundred years, from c. 1100 to 700 B.C. Of the first three centuries of this period we know very little, but after about 800 B.C. the Greeks rapidly emerge into the full light of history. The earliest specific dates that have come down to us are from that time: 776 B.C., the founding of the Olympic Games and the starting point of Greek chronology, as well as several slightly later dates recording the foundation of various cities. That time also saw the full development of the oldest characteristically Greek style in the fine arts, the so-called Geometric. We

know it only from painted pottery and small-scale sculpture (monumental architecture and sculpture in stone did not appear until the seventh century). At first the pottery had been decorated only with abstract designs—triangles, checkers, concentric circles—but toward 800 B.C. human and animal figures began to appear within the geometric framework, and in the most mature examples these figures could form elaborate scenes. Our specimen (fig. 125), from the Dipylon cemetery in Athens, belongs to a group of very large vases that served as grave monuments; its bottom has holes through which liquid offerings could filter down to the dead below. On the body of the vessel we see the deceased lying in state, flanked by figures with their arms raised in a gesture of mourning, and a funeral procession of chariots and warriors on foot. The most remarkable thing about this scene is that it contains no reference to an afterlife; its purpose is purely commemorative. Here lies a worthy man, it tells us, who was mourned by many and had a splendid funeral. Did the Greeks, then, have no conception of a hereafter? They did, but the realm of the dead to them was a colorless, ill-defined region where the souls, or "shades," led a feeble and passive existence without making any demands upon the living. When Odysseus, in the Homeric poem, conjures up the shade of Achilles, all the dead hero can do is mourn his own demise: "Speak not conciliatorily of death, Odysseus. I'd rather serve on earth the poorest man . . . than lord it over all the wasted dead." If the Greeks nevertheless marked and tended their graves, and even poured libations over them, they did so in a spirit of pious remembrance, rather than to satisfy the needs of the dead. Clearly, they had refused to adopt the elaborate burial customs of the Mycenaeans (see page 88). Nor is the Geometric style an outgrowth of the Mycenaean tradition but a fresh—and in some respects quite primitive—start. Given his limited repertory of shapes, the artist who painted our vase has achieved an astonishingly varied effect. The spacing of the bands, their width and density, show a rather subtle relationship to the structure of the vessel. His interest in representation, however, is as yet very limited: the figures or groups, repeated at regular intervals, are little more than another kind of ornament, part of the same over-all texture, so that their size varies in accordance with the area to be filled. Organic and geometric elements still coexist in the same field, and the distinction between them is often difficult: lozenges indicate legs, whether of a man, a chair, or a bier; circles with dots may or may not be human heads; and the chevrons, boxed triangles, etc., between the figures may be decorative or descriptive—we cannot tell. Much the same could be said of figure 124, a shipwreck scene from another Geometric vase which makes an instructive contrast with the Minoan view of marine life (see fig. 112); if it were not for the fact that the boat is upside down and that the biggest fish has seized the head of one of the men, we would read the design simply as a pattern, rather than as a disaster at sea. And what of the swastikas? Are

they ornamentalized starfish or abstract space fillers?

Geometric pottery has been found not only in Greece but in Italy and the Near East as well, a clear indication that Greek traders were well established throughout the eastern Mediterranean in the eighth century B.C. What is more, they had already adopted the Phoenician alphabet and reshaped it for their own use, as we know from the inscriptions on these same vases. The greatest Greek achievements of this era, however, are the two Homeric epics, the *Iliad* and the *Odyssey*. The scenes on Geometric vases contain barely a hint of the narrative power of these poems; if our knowledge of eighth-century Greece were based on the visual arts alone, we would inevitably think of it as a far simpler and more provincial society than the literary evidence suggests. There is a paradox here that needs to be resolved. Perhaps, at this particular time, Greek civilization was so language-minded that painting and sculpture played a less important role than they were to assume in the following centuries. In that event, the Geometric style may well have been something of an anachronism in the eighth century, a conservative tradition about to burst at the seams. In the shipwreck scene, its rigid order already seems in process of dissolution; representation and narrative demand greater scope than the style can provide. Toward 700 B.C., the dam finally bursts; new forms come flooding in, and Greek art enters another phase, which we call the Orientalizing style.

ORIENTALIZING STYLE

As its name implies, the new style reflects powerful influences from Egypt and the Near East, stimulated by

126. *The Blinding of Polyphemus* and *Gorgons* (Proto-Attic amphora). c. 675–650 B.C. Height 56″. Museum, Eleusis

127. Proto-Corinthian Perfume Vase. c. 650 B.C. Height 2″. The Louvre, Paris

128. PSIAX. *Herakles Strangling the Nemean Lion* (Attic black-figured amphora from Vulci; compare color-plate 10). c. 525 B.C. Height 19 ¹/₂″. Museo Civico, Brescia

increasing trade with these regions. Between c. 725 and 650 B.C., Greek art absorbed a host of Oriental motifs and ideas, and was profoundly transformed in the process. The change becomes very evident if we compare the large amphora (a two-handled storage jar) from Eleusis (fig. 126) with the Dipylon vase of a hundred years earlier. Geometric ornament has not disappeared altogether, but it is confined to the peripheral zones—the foot, the handles, and the lip; new, curvilinear motifs—such as spirals, interlacing bands, palmettes, and rosettes—are conspicuous everywhere; on the shoulder of the vessel we see a frieze of fighting animals, derived from the repertory of Near Eastern art. The major areas, however, are given over to narrative, which has become the dominant element. The figures have gained so much in size and descriptive precision that the decorative patterns scattered among them can no longer interfere with their actions; ornament of any sort now belongs to a separate and lesser realm, clearly distinguishable from that of representation. As a result, the blinding of the giant Polyphemus by Odysseus and his companions—the scene on the neck of the amphora—is enacted with memorable directness and dramatic force. If these men lack the beauty we expect of epic heroes, their movements have an expressive vigor that makes them seem thoroughly alive. The slaying of another monstrous creature is depicted on the body of the vase, the main part of which has been badly damaged, so that only two figures have survived intact; they are Gorgons, the sisters of the snake-haired, terrible-faced Medusa whom Perseus killed with the aid of the gods. Even here we notice an interest in the articulation of the body far beyond the limits of the Geometric style.

The Eleusis vase belongs to a group called Proto-Attic, the ancestors of the great tradition of vase painting that was soon to develop in Attica, the region around Athens. A second family of Orientalizing vases is known as Proto-Corinthian, since it points toward the later pottery production of Corinth. These vessels, noted for their spirited animal motifs, show particularly close links with the Near East. Some of them, such as the perfume vase in figure 127, are molded in the shape of animals. The enchanting little owl, "streamlined" to fit the palm of a lady's hand and yet so animated in pose and expression, helps us to understand why Greek pottery came to be in demand throughout the Mediterranean world.

ARCHAIC VASE PAINTING

The Orientalizing phase of Greek art was a period of experiment and transition, in contrast to the stable and consistent Geometric style. Once the new elements from the East had been fully assimilated, however, there emerged another style, as well defined as the Geometric but infinitely greater in range: the Archaic, which lasted from the later seventh century to about 480 B.C., the time

of the famous Greek victories over the Persians at Salamis and Plataea. During the Archaic period, we witness the unfolding of the artistic genius of Greece not only in vase painting but also in monumental architecture and sculpture. While Archaic art lacks the balance, the sense of perfection of the Classical style of the later fifth century, it has a freshness that gives it particularly strong appeal for the modern beholder. It is difficult to argue with those who regard it as the most vital phase in the development of Greek art.

Greek architecture and sculpture on a large scale must have begun to develop long before the mid-seventh century. Until that time, however, both were mainly of wood, and nothing of them has survived except the foundations of a few buildings. The desire to build and sculpt in stone, for the sake of permanence, was the most important new idea that entered Greece during the Orientalizing period. Moreover, the revolution in material and technique must have brought about decisive changes of style as well, so that we cannot safely reconstruct the appearance of the lost wooden temples or statues on the basis of later works. In vase painting, on the other hand, there was no such break in continuity. It thus seems best to deal with Archaic vases before we turn to sculpture. The few surviving monuments of Archaic architecture will be discussed in a separate section devoted to the development of Greek architecture as a whole (see pages 114–18).

The significance of Archaic vase painting is in some ways completely unique. Decorated pottery, however great its value as an archaeologist's tool, rarely enters into the mainstream of the history of art; we think of it, in general, as a craft or industry which by its very nature cannot rise above the level of a minor art. This is true even of Minoan vases, despite their exceptional beauty and technical refinement, and the same may be said of the vast bulk of Greek pottery. Yet if we study such pieces as the Dipylon vase or the amphora from Eleusis, impressive not only by virtue of their sheer size but as vehicles of pictorial effort, we cannot escape the feeling that they are among the most ambitious works of art of their day. There is no way to prove this, of course—far too much has been lost—but it seems obvious that these are objects of highly individual character, rather than routine ware produced in quantity according to set patterns. Archaic vases are generally a good deal smaller than their predecessors, since pottery vessels no longer served as grave monuments (which were now made of stone). Their painted decoration, however, shows a far greater emphasis on pictorial subjects (see fig. 128); scenes from mythology, legend, and everyday life appear in endless variety, and the artistic level is often very high indeed, especially among Athenian vases. How greatly the Greeks themselves valued the beauty of these vessels is evident from the fact that after the middle of the sixth century the finest vases frequently bear the signatures of the men who made them. This indicates not only that individual artists—potters as well as painters—took pride

129. EXEKIAS. *Dionysus in a Boat*
(interior of an Attic black-figured kylix). c. 540 B.C.
Diameter 12″. Staatliche Antikensammlungen, Munich

130. DOURIS. *Eos and Memnon*
(interior of an Attic red-figured kylix).
c. 490–480 B.C. Diameter 10½″. The Louvre, Paris

in their work, but also that they could become famous for their personal style. To us, such signatures in themselves do not mean a great deal; they are no more than convenient labels unless we know enough of an artist's work to gain some insight into his personality. And, remarkably enough, that is possible with a good many Archaic vase painters. Some of them have so distinctive a style that their artistic "handwriting" can be recognized even without the aid of a signature; and in a few cases we are lucky enough to have dozens (in one instance, over 200) of vases by the same hand, so that we can trace one master's development over a considerable period. Archaic vase painting thus introduces us to the first clearly defined personalities in the entire history of art. For while it is true that signatures occur in Archaic sculpture and architecture as well, they have not helped us to identify the personalities of individual masters.

Archaic Greek painting was, of course, not confined to vases. There were murals and panels, too. Although nothing has survived of them except a few poorly preserved fragments, we can form a fair idea of what they looked like from the wall paintings in Etruscan tombs of the same period (see fig. 201 and colorplate 15). How, we wonder, were these large-scale works related to the vase pictures? Did the vase painters follow the lead of their confreres, and if so, how closely does their output resemble the large-scale compositions they copied? We do not know—in fact, we cannot be sure that we have asked the right questions. One thing seems certain, however: *all* Archaic painting was essentially drawing filled in with solid, flat color; therefore the murals could not have been very different in appearance from the vase pictures, even if their range of pigments was less narrow. According to the literary sources, Greek wall painting did not come

into its own until after the Persian wars (c. 475–450 B.C.), through the gradual discovery of modeling and spatial depth. From that time on, vase painting became a lesser art, since depth and modeling were beyond its limited technical means; by the end of the fifth century, its decline was obvious. Characteristically enough, the signatures of most of the vase painters we know date from before the Persian wars. Afterward the habit slowly died out, along with the ambitions of the vase painters. The great age of vase painting, then, was the Archaic era. Until c. 475 B.C., the best vase painters enjoyed as much prestige as other artists. Their work was the small-scale counterpart of the murals of the period and, we may assume, similar in quality. Whether or not it directly reflects the lost wall paintings, it deserves to be viewed as a major achievement in its own right.

Black-Figure

The difference between Orientalizing and Archaic vase painting is one of artistic discipline. In the amphora from Eleusis (fig. 126), the figures are shown partly as solid silhouettes, partly in outline, or as a combination of both. Toward the end of the seventh century, Attic vase painters resolved these inconsistencies by adopting the "black-figured" style, which means that the entire design is silhouetted in black against the reddish clay; internal details are scratched in with a needle, and white and purple may be added on top of the black to make certain areas stand out. The virtues of this procedure, which favors a decorative, two-dimensional effect, are apparent in figure 129, a kylix (drinking cup) of c. 540 B.C. by Exekias. The slender, sharp-edged forms have a lacelike delicacy, yet also resilience and strength, so that the composition adapts itself to the circular surface without becoming

mere ornament. Dionysus reclines in his boat (the sail was once entirely white); it moves with the same ease as the dolphins, whose light forms are counterbalanced by the heavy clusters of grapes. But why is he at sea? What does the happy poetry of Exekias' image mean? According to a Homeric hymn, the god of wine had once been abducted by pirates, whereupon he caused vines to grow all over the ship and frightened his captors until they jumped overboard and were turned into dolphins. We see him here on his return journey (an event to be gratefully recalled by every Greek drinker), accompanied by seven dolphins and seven bunches of grapes for good luck.

If the spare elegance of Exekias seems to retain something of the spirit of Geometric pottery (see fig. 124 for an instructive comparison), the work of the slightly younger Psiax seems more akin to the forceful Orientalizing style of the blinding of Polyphemus in the Eleusis amphora. The scene of Herakles killing the lion, on an amphora attributed to Psiax (fig. 128 and colorplate 10), is all grimness and violence. The two heavy bodies are truly locked in combat, so that they almost grow together into a single, compact unit. Incised lines and subsidiary colors have been added with utmost economy in order to avoid breaking up the massive expanse of black. Yet Psiax succeeds to an extraordinary degree in conveying the three-dimensional quality of these figures; his knowledge of body structure, his ability to use foreshortening—note the way the abdomen and shoulders of Herakles are rendered!—seem little short of amazing when measured against anything we have seen before. Only in such details as the eye of Herakles do we still find the traditional combination of front and profile views.

Red-Figure

Psiax must have felt that the silhouette-like black-figured technique made the study of foreshortening unduly difficult, for in some of his vases he tried the reverse procedure, leaving the figures red and filling in the background. This red-figured technique gradually replaced the older method toward 500 B.C. Its advantages are well shown in colorplate 11, a kylix of c. 490–480 B.C. by an unknown master nicknamed the "Foundry Painter." The details of the Lapith and Centaur are now freely drawn with the brush, rather than laboriously incised, so the artist depends far less on the profile view than before; instead, he exploits the internal lines of communication that permit him to show boldly foreshortened and overlapping limbs, precise details of costume (note the pleated skirt), and interesting facial expressions. He is so fascinated by all these new effects that he has made the figures as large as he possibly could. They almost seem to burst from their circular frame, and a piece of the Lapith's helmet has actually been cut off. A similar striving for monumental effect, but with more harmonious results, may be seen in the *Eos and Memnon* by Douris (fig. 130), one of the masterpieces of late Archaic vase

painting. It shows the goddess of dawn holding the body of her son, who had been killed and despoiled of his armor by Achilles. In this moving evocation of grief, Greek art touches a mood that seems strangely prophetic of the Christian *Pietà*. And no less remarkable is the expressive freedom of the draughtsmanship; the lines are as flexible as if they had been done with a pen. Douris knows how to trace the contours of limbs beneath the drapery, how to contrast vigorous, dynamic outlines with thinner and more delicate secondary strokes, such as those indicating the anatomical details of Memnon's body. This vase also has a special interest because of its elaborate inscription, which includes the signatures of both painter and potter as well as a dedication ("Hermogenes is beautiful").

ARCHAIC SCULPTURE

The new motifs that distinguish the Orientalizing style from the Geometric—fighting animals, winged monsters, scenes of combat—had reached Greece mainly through the importation of ivory carvings and metalwork from Phoenicia or Syria which reflected Mesopotamian as well as Egyptian influences. Such objects have actually been found on Greek soil, so that we can regard this channel of transmission as well established. They do not help us, however, to explain the rise of monumental architecture and sculpture in stone about 650 B.C., which must have been based on acquaintance with Egyptian works that could be studied only on the spot. We know that small colonies of Greeks existed in Egypt at the time, but why, we wonder, did Greece suddenly develop a taste for monumentality, and how did her artists acquire so quickly the Egyptian mastery of stone carving? The mystery may never be cleared up, for the oldest surviving witnesses of Greek stone sculpture and architecture show that the Egyptian tradition had already been well assimilated and Hellenized, though their link with Egypt is still clearly visible.

Kouros and Kore

Let us consider two very early Greek statues, a female figure of c. 650–625 B.C. (fig. 131) and a nude youth of c. 600 B.C. (fig. 132), and compare them with their Egyptian predecessors (fig. 62). The similarities are certainly striking: we note the block-conscious, cubic character of all four statues, the slim, broad-shouldered silhouette of the male figures, the position of their arms, their clenched fists, the way they stand with the left leg forward, the emphatic rendering of the kneecaps. The formalized, wiglike treatment of the hair, the close-fitting garment of the female figure and her raised arm are further points of resemblance. Judged by Egyptian standards, the Archaic statues seem somewhat "primitive"—rigid, oversimplified, awkward, less close to nature. Whereas the Egyptian sculptor allows the legs and hips of the

131. *Female Figure.* c. 650 B.C.
Limestone, height 24¹/₂″.
The Louvre, Paris

132. *Standing Youth (Kouros).* c. 600 B.C. Marble,
height 6′ 1¹/₂″. The Metropolitan Museum of Art,
New York (Fletcher Fund, 1932)

female figure to press through the skirt, the Greek shows a solid, undifferentiated mass from which only the toes protrude. But the Greek statues also have virtues of their own that cannot be measured in Egyptian terms. First of all, they are truly free-standing—the earliest large stone images of the human form in the entire history of art of which this can be said. The Egyptian carver had never dared to liberate such figures completely from the stone; they remain immersed in it to some degree, as it were, so that the empty space between the legs, and between the arms and the torso (or between two figures in a double statue, as in fig. 62) always remains partly filled. There are never any holes in Egyptian stone figures. In that sense, they do not rank as sculpture in the round but as an extreme case of high relief. The Greek carver, on the contrary, does not mind holes in the least; he separates the arms from the torso and the legs from each other

(unless they are encased in a skirt), and goes to great lengths to cut away every bit of dead material (the only exceptions are the tiny bridges between the fists and the thighs of the nude youth). Apparently it is of the greatest importance to him that a statue consist only of stone that has representational meaning within an organic whole; the stone must be transformed, it cannot be permitted to remain inert, neutral matter. This is not, we must insist, a question of technique but of artistic intention. The act of liberation achieved in our two figures endows them with a spirit basically different from that of any of the Egyptian statues. While the latter seem becalmed by a spell that has released them from every strain for all time to come, the Greek images are tense, full of hidden life. The direct stare of their huge eyes offers the most telling contrast to the gentle, faraway gaze of the Egyptian figures.

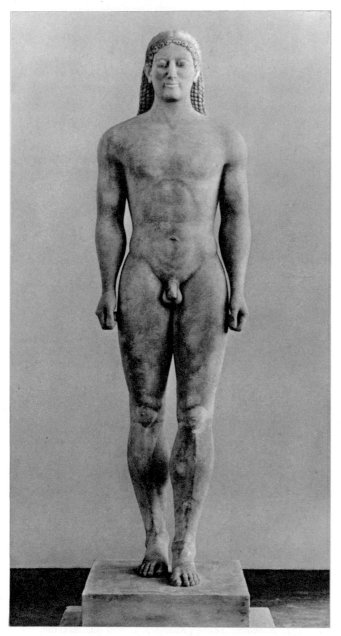

133. *Kroisos (Kouros from Anavysos)*. c. 525 B.C. Marble, height 6′ 4″. National Museum, Athens

Whom do they represent? We call the female statues by the general name of Kore (Maiden), the male ones by that of Kouros (Youth)—noncommittal terms that gloss over the difficulty of identifying them further. Nor can we explain why the Kouros is always nude while the Kore is clothed. Whatever the reason, both types were produced in large numbers throughout the Archaic era, and their general outlines remained extraordinarily stable. Some are inscribed with the names of artists ("So-and-so made me") or with dedications to various deities. These, then, were votive offerings; but whether they represent the donor, the deity, or a divinely favored person such as a victor in athletic games, remains uncertain in most cases. Others were placed on graves, yet they can be viewed as representations of the deceased only in the broadest (and completely impersonal) sense. This odd lack of differentiation seems part of the essential character of

these figures; they are neither gods nor men but something in between, an ideal of physical perfection and vitality shared by mortal and immortal alike, just as the heroes of the Homeric epics dwell in the realms of both history and mythology.

If the type of Kouros and Kore is narrowly circumscribed, its artistic interpretation shows the same inner dynamic we have traced in Archaic vase painting. The pace of this development becomes strikingly clear from a comparison of the Kouros of figure 132 with another carved some 75 years later (fig. 133) and identified by the inscription on its base as the funerary statue of Kroisos, who had died a hero's death in the front line of battle. Like all such figures, it was originally painted; traces of color can still be seen in the hair and the pupils of the eyes. Instead of the sharply contoured, abstract planes of the older statue, we now find swelling curves. The whole body displays a greater awareness of massive volumes, but also a new elasticity, and countless anatomical details are more functionally rendered than before. The style of the *Kroisos* thus corresponds exactly to that of Psiax's

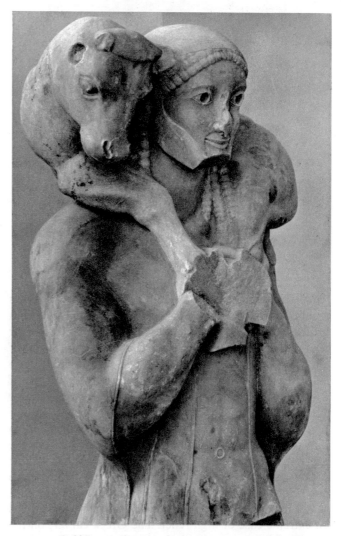

134. *Calf-Bearer* (upper portion). c. 570 B.C. Marble, height of entire statue 65″. Acropolis Museum, Athens

Herakles (colorplate 10); we witness the transition from black-figured to red-figured in sculptural terms. There are numerous statues from the middle years of the sixth century marking previous way stations along the same road, such as the magnificent *Calf-Bearer* of c. 570 B.C. (fig. 134), a votive figure representing the donor with the sacrificial animal he is offering to Athena. Needless to say, it is not a portrait, any more than the *Kroisos* is, but it shows a type: the beard indicates a man of mature years. The *Calf-Bearer* originally had the Kouros standing pose (the legs are badly damaged), and the body conforms to the Kouros ideal of physical perfection; its vigorous, compact forms are emphasized, rather than obscured, by the thin cloak, which fits them like a second skin, detaching itself only momentarily at the elbows. The face, effectively framed by the soft curve of the animal, no longer has the masklike quality of the early Kouros; the features have, as it were, caught up with the rest of the body in that they, too, are permitted a gesture, a movement expressive of life: the lips are drawn up in a smile. We must be careful not to impute any psychological meaning to this "Archaic smile," for the same radiant expression occurs throughout sixth-century Greek sculpture (even on the face of the

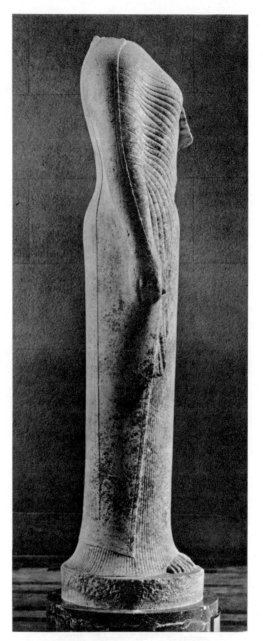

136. "*Hera*," from Samos. c. 570–560 B.C. Marble, height 6′ 4″. The Louvre, Paris

dead hero Kroisos). Only after 500 B.C. does it gradually fade out. One of the most famous instances of it is the wonderful *Rampin Head* (fig. 135), which probably belonged to the body of a horseman. Slightly later than the *Calf-Bearer*, it shows the black-figured phase of Archaic sculpture at its highest stage of refinement. Hair and beard have the appearance of richly textured beaded embroidery that sets off the subtly accented planes of the face.

The Kore type is somewhat more variable than that of the Kouros, although it follows the same pattern of development. A clothed figure by definition, it poses a different problem—how to relate body and drapery. It is also likely to reflect changing habits or local differences of dress. Thus, the impressive statue in figure 136, carved about the same time as the *Calf-Bearer*, does not represent a more evolved stage of the Kore in figure 131

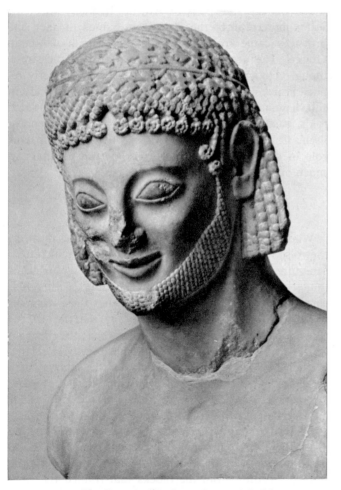

135. *The Rampin Head*. c. 560 B.C. Marble, height 11½″. The Louvre, Paris

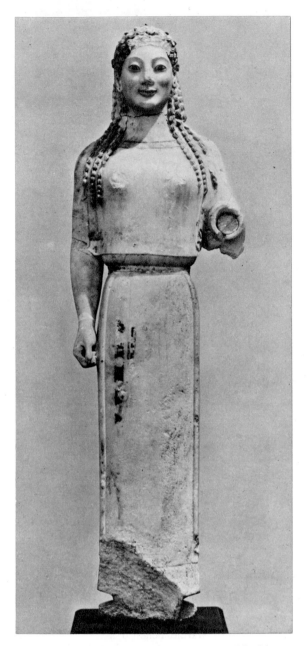

137. *Kore in Dorian Peplos.* c. 530 B.C. Marble,
height 48". Acropolis Museum, Athens

further (but never fully stopped) as it encounters the pro-
truding shapes of arms, hips, and torso. In the end, the
drapery, so completely architectonic up to the knee region,
turns into a second skin, the kind we have seen in the
Calf-Bearer.

The Kore of figure 137, in contrast, seems a linear
descendant of our first Kore, even though she was carved
a full century later. She, too, is blocklike rather than
columnar, with a strongly accented waist. The simplicity
of her garments, however, is new and sophisticated;
the heavy cloth forms a distinct, separate layer over the
body, covering but not concealing the solidly rounded
shapes beneath. And the left hand, which originally was
extended forward, proffering a votive gift of some sort,
must have given the statue a spatial quality quite beyond
the two earlier Kore figures we have discussed. Equally
new is the more organic treatment of the hair, which falls
over the shoulders in soft, curly strands, as compared
with the massive, rigid wig in figure 131. Most noteworthy
of all, perhaps, is the full, round face with its enchantingly
gay expression—a softer, more natural smile than any we
have seen hitherto. Here, as in the *Kroisos*, we sense the
approaching red-figured phase of Archaic art.

Our final Kore (colorplate 12), about a decade later,
has none of the severity of figure 137, though both were
found on the Acropolis of Athens. In many ways she
seems more akin to the *Hera* from Samos: in fact, she
probably came from Chios, another island of Ionian
Greece. The architectural grandeur of her ancestress,
though, has given way to an ornate, perhaps overly re-
fined grace. The garments still loop around the body in
soft diagonal curves, but the play of richly differentiated
folds, pleats, and textures has almost become an end in
itself. Color must have played a particularly important
role in such works, and we are fortunate that so
much of it survives in our example.

ARCHITECTURAL SCULPTURE

When the Greeks began to build their temples in stone,
they also fell heir to the age-old tradition of architectural
sculpture. The Egyptians had been covering the walls
(and even the columns) of their buildings with reliefs
since the time of the Old Kingdom, but these carvings
were so shallow (for example, figs. 65, 77) that they left the
continuity of the wall surface undisturbed; they had no
weight or volume of their own, so that they were related
to their architectural setting only in the same limited
sense as Egyptian wall paintings (with which they were,
in practice, interchangeable). This is also true of the reliefs
on Assyrian, Babylonian, and Persian buildings (for exam-
ple, figs. 95, 102). There existed, however, another kind
of architectural sculpture in the ancient Near East, origi-
nated, it seems, by the Hittites: the great guardian mon-
sters protruding from the blocks that framed the gate-
ways of fortresses or palaces (see figs. 91, 93). This tradi-
tion must have inspired, although perhaps indirectly, the

but an alternative approach to the same basic task. She
was found in the Temple of Hera on the island of Samos,
and may well have been an image of the goddess, because
of her great size as well as her extraordinary dignity. If
the earlier Kore echoes the planes of a rectangular slab,
the "*Hera*" seems like a column come to life. Instead of
clear-cut accents, such as the nipped-in waist in figure 131,
we find here a smooth, continuous flow of lines uniting
limbs and body. Yet the majestic effect of the statue de-
pends not so much on its abstract quality as on the way
the abstract form blossoms forth into the swelling soft-
ness of a living body. The great upward sweep of the
lower third of the figure gradually subdivides to reveal
several separate layers of garments, and its pace is slowed

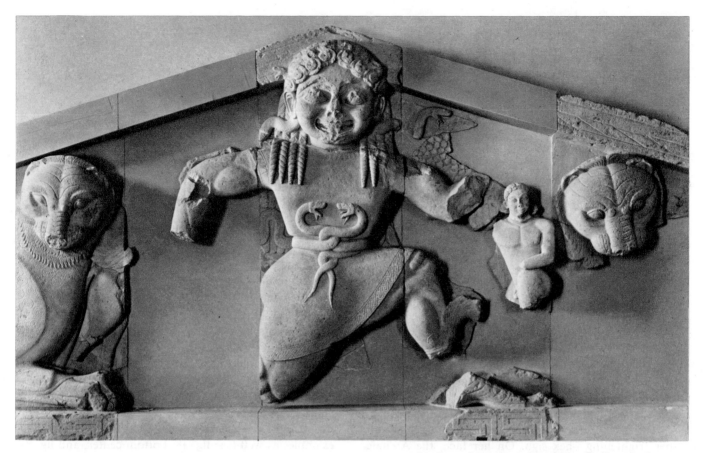

138. Central Portion of the West Pediment of
the Temple of Artemis at Corfu. c. 600–580 B.C.
Limestone, height 9′ 2″. Museum, Corfu

carving over the Lion Gate at Mycenae (see fig. 120). We must nevertheless note one important feature that distinguishes the Mycenaean guardian figures from their predecessors: although they are carved in high relief on a huge slab, this slab is thin and light compared to the enormously heavy, Cyclopean blocks around it. In building the gate, the Mycenaean architect left an empty triangular space above the lintel, for fear that the weight of the wall above would crush it, and then filled the hole with the comparatively lightweight relief panel. Here, then, we have a new kind of architectural sculpture—a work integrated with the structure yet also a separate entity rather than a modified wall surface or block. The Lion Gate relief is indeed the direct ancestor of Greek architectural sculpture, as will become evident when we compare it with the façade of the early Archaic Temple of Artemis on the island of Corfu, erected soon after 600 B.C. (figs. 138, 139). Here again the sculpture is confined to a zone that is framed by structural members but is itself structurally empty: the triangle between the horizontal ceiling and the sloping sides of the roof. This area, called the pediment, need not be filled in at all except to protect the wooden rafters behind it against moisture; it demands not a wall but merely a thin screen. And it is against this screen that the pedimental sculpture is displayed. Technically, these carvings are in high relief, like the guardian lions at Mycenae. Characteristically enough, however, the bodies are strongly undercut, so as

139. Reconstruction Drawing of the West Front of the
Temple of Artemis at Corfu (after Rodenwaldt)

to detach them from the background. Even at this early stage of development, the Greek sculptor wanted to assert the independence of his figures from their architectural setting. The head of the central figure actually overlaps the frame. Who is this frightening creature? Not Artemis, surely, although the temple was dedicated to that goddess. As a matter of fact, we have met her before:

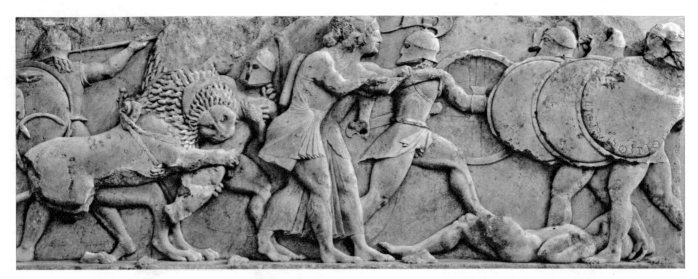

140. *Battle of the Gods and Giants*, from the north frieze of the Treasury of the Siphnians.
c. 530 B.C. Marble, height 26″. Museum, Delphi

she is a Gorgon, a descendant of those on the Eleusis amphora (fig. 126). Her purpose here was to serve as a guardian, along with the two huge lions, warding off evil from the temple and the sacred image of the goddess within. (The other pediment, of which only small fragments survive, had a similar figure.) She might be defined, therefore, as an extraordinarily monumental—and still rather frightening—hex sign. On her face, the Archaic

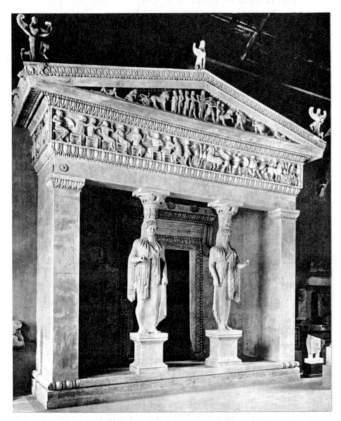

141. Reconstruction of the Façade of the Treasury of
the Siphnians in the Sanctuary of Apollo
at Delphi. Museum, Delphi

smile appears as a hideous grin; and to emphasize further how alive and real she is, she has been represented running, or rather flying, in a pinwheel stance that conveys movement without locomotion. The symmetrical, heraldic arrangement of the Gorgon and the two animals reflects an Oriental scheme which we know not only from the Lion Gate at Mycenae but from many earlier examples as well (see fig. 48, bottom center, and fig. 85, top). Because of its ornamental character, it fits the shape of the pediment to perfection. Yet the early Archaic designer was not content with that; he also wanted the pediment to contain narrative scenes; therefore he has added a number of smaller figures in the spaces left between or behind the huge main group. The design of the whole thus shows two conflicting purposes in uneasy balance. As we might expect, narrative will soon win out over heraldry.

Aside from the pediment, there were not many places that the Greeks deemed suitable for architectural sculpture. They might put free-standing figures—often of terracotta—above the ends and the center of the pediment, to break the severity of its outline. And they often placed reliefs in the zone immediately below the pediment. In Doric temples such as that at Corfu (fig. 139), this "frieze" consists of alternating triglyphs (blocks with three vertical markings) and metopes. The latter were originally the empty spaces between the ends of the ceiling beams; hence they, like the pediment, could be filled in with sculpture. In Ionic architecture, the triglyphs were omitted, and the frieze became what the term usually conveys to us, a continuous band of painted or sculptured decoration. The Ionians would also sometimes elaborate the columns of a porch into female statues—not a very surprising development in view of the columnar quality of the *Hera* from Samos. All these possibilities are combined in the Treasury (a miniature temple for storing votive gifts) erected at Delphi shortly before 525 B.C. by the inhabitants of the Ionian island Siphnos.

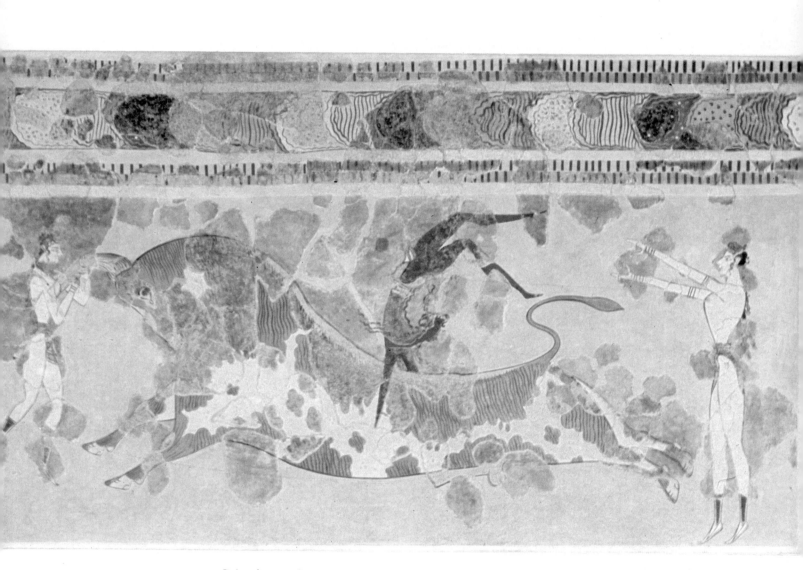

Colorplate 9. CRETAN. *"The Toreador Fresco."* About 1500 B.C.
Height about 24¹/₂″ (including upper border). Museum, Heraklion, Crete

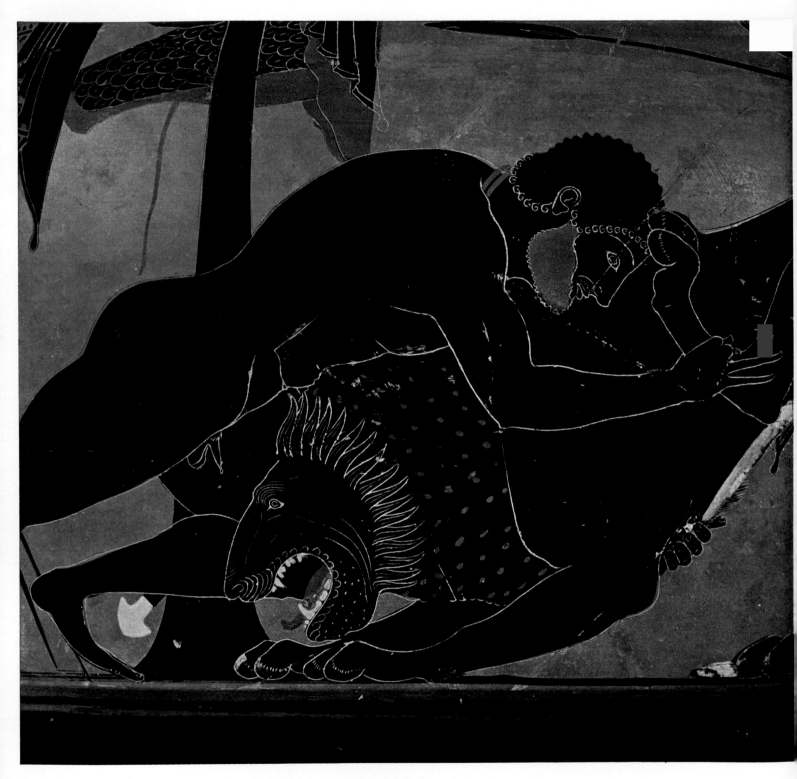

Colorplate 10. PSIAX. *Herakles Strangling the Nemean Lion*
(detail of Attic black-figured amphora from Vulci). About 525 B.C. Museo Civico, Brescia

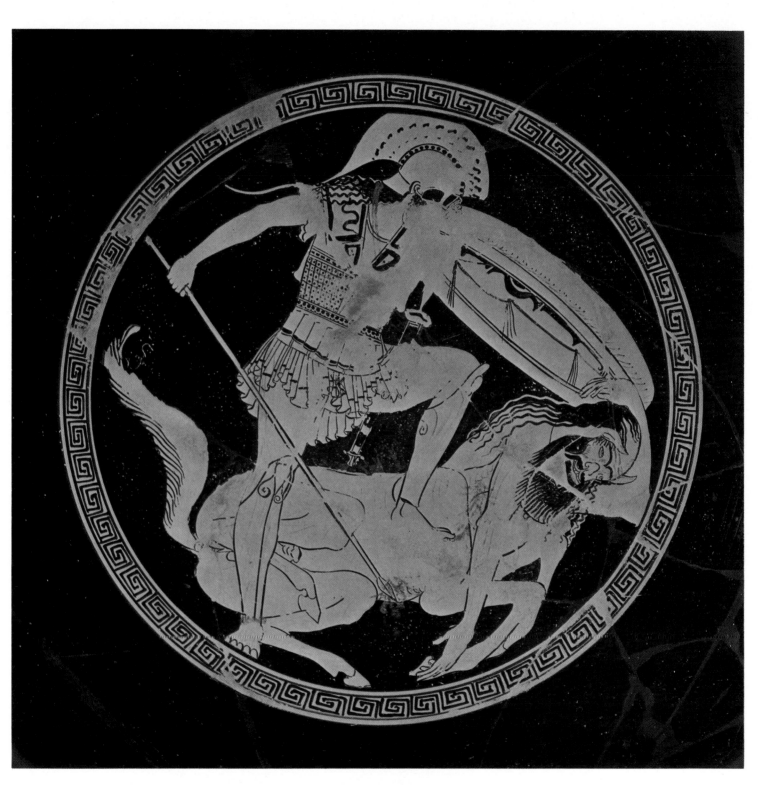

Colorplate 11. THE FOUNDRY PAINTER. *Lapith and Centaur* (interior of an Attic red-figured kylix).
About 490–480 B.C. Staatliche Antikensammlungen, Munich

Colorplate 12. GREEK. *Kore,* from Chios(?). About 520 B.C.
Marble, height 21 ⁷/₈″. Acropolis Museum, Athens

Colorplate 13. THE ACHILLES PAINTER. White-ground lekythos with *Mistress and Maid*.
Attic, about 440–430 B.C. Height 16″. Staatliche Antikensammlungen, Munich

Colorplate 14. GREEK. *Portrait Head,* from Delos.
About 80 B.C. Bronze, height 12 3/4". National Museum, Athens

Colorplate 15. ETRUSCAN. *Two Dancers* (detail of a wall painting).
About 480–470 B.C. Tomb of the Lionesses, Tarquinia

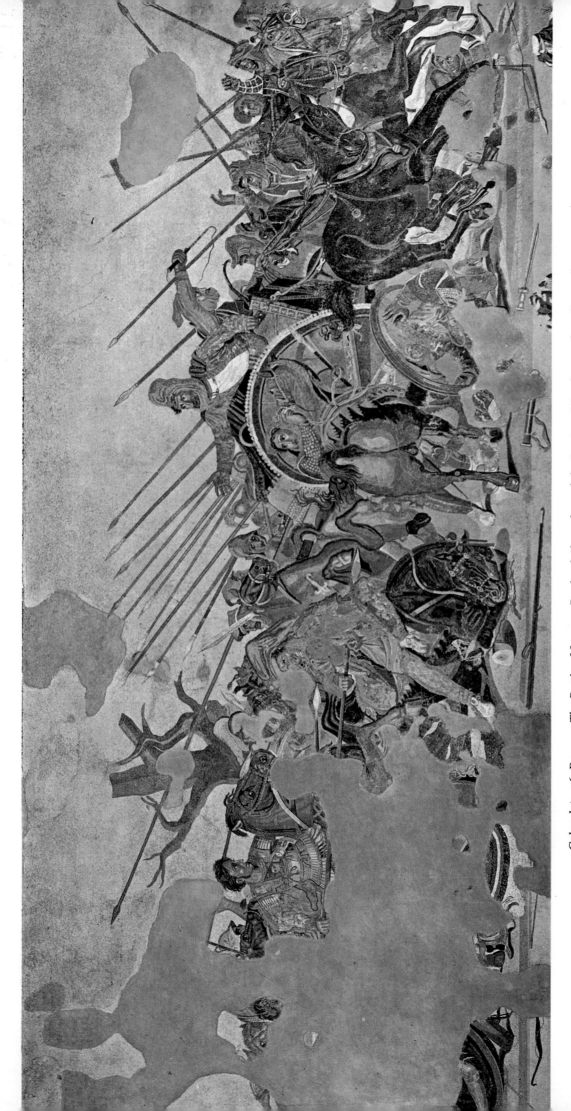

Colorplate 16. ROMAN. *The Battle of Issus* or *Battle of Alexander and the Persians*. Mosaic copy from Pompeii, 1st century B.C., of a Hellenistic painting. 8′ 11″ × 16′ 9¹⁄₂″. National Museum, Naples

142. Reconstruction Drawing of the East Pediment of
the Temple at Aegina (after Furtwängler)

Although the building itself is not standing any longer,
it has been convincingly reconstructed on the basis of the
preserved fragments (fig. 141). Of its lavish sculptural
décor, the most impressive part is the splendid frieze.
The detail reproduced here (fig. 140) shows part of the
battle of the Greek gods against the giants: on the ex-
treme left, two lions (who pull the chariot of Cybele) are
tearing apart an anguished giant; in front of them, Apollo
and Artemis advance together, shooting their arrows; a
dead giant, despoiled of his armor, lies at their feet, while
three others enter from the right. The high relief, with
its deep undercutting, recalls the Corfu pediment, but the
Siphnian sculptor has taken full advantage of the spatial
possibilities offered by this technique. He uses the pro-
jecting ledge at the bottom of the frieze as a stage on
which he can place his figures in depth. The arms and
legs of those nearest the beholder are carved completely
in the round; in the second and third layer, the forms be-
come shallower, yet even those farthest removed from us
are never permitted to merge with the background. The
result is a limited and condensed but very convincing space
that permits a dramatic relationship between the figures
such as we have never seen before in narrative reliefs.
Any comparison with older examples (such as figs. 66,
94, 114, 118) will show us that Archaic art has indeed
conquered a new dimension here, not only in the physical
but also in the expressive sense.

Meanwhile, in pedimental sculpture, relief has been

143. *Herakles*, from the east pediment of
the Temple at Aegina, c. 490 B.C.
Marble, height 31″. Glyptothek, Munich

144. *Dying Warrior*, from the east pediment of the Temple at Aegina. c. 490 B.C. Marble, length 72″. Glyptothek, Munich

abandoned altogether. Instead, we find separate statues placed side by side in complex dramatic sequences designed to fit the triangular frame. The most ambitious ensemble of this kind, that of the east pediment of the temple at Aegina, was created about 490 B.C., and thus brings us to the final stage in the evolution of Archaic sculpture. The figures were found in pieces on the ground and are now in the Glyptothek in Munich, stripped of their nineteenth-century restorations. The position of each within the pediment, however, can be determined almost exactly, since their height (but not their scale) varies with the sloping sides of the triangle (fig. 142). The center is accented by the standing goddess Athena, who calmly presides, as it were, over the battle between Greeks and Trojans that rages to either side of her in symmetrically diminishing fashion. The correspondence in the poses of the fighters on the two halves of the pediment makes for a balanced and orderly design, yet it also forces us to see the statues as elements in an ornamental pattern and thus robs them of their individuality to some extent. They speak most strongly to us when viewed one by one. Among the most impressive are the fallen warrior from the left-hand corner (fig. 144), and the kneeling Herakles—who once held a bronze bow—from the right-hand half (fig. 143); both are lean, muscular figures whose bodies seem marvelously functional and organic. That in itself, however, does not explain their great beauty, much as we may admire the artist's command of the human form in action. What really moves us is their nobility of spirit, whether in the agony of dying or in the act of killing. These men, we sense, are suffering—or carrying out—what fate has decreed, with tremendous dignity and resolve. And this communicates itself to us in the very feel of the magnificently firm shapes of which they are composed.

ARCHITECTURE

ORDERS AND PLANS

In architecture the Greek achievement has been identified since ancient Roman times with the creation of the three classic architectural orders, the Doric, Ionic, and Corinthian. Actually, there are only two, the Corinthian being a variant of the Ionic. The Doric (so named because its home is the Greek mainland) may well claim to be the basic order, since it is older and more sharply defined than the Ionic, which developed on the Aegean islands and the coast of Asia Minor. What do we mean by "architectural order"? By common agreement, the term is used for Greek architecture only (and its descendants); and rightly so, for none of the other architectural systems known to us produced anything like it. Perhaps the simplest way to make clear the unique character of the Greek orders is this: there is no such thing as "the

Egyptian temple" or "the Gothic church"—the individual buildings, however much they may have in common, are so varied that we cannot distill a generalized type from them—while "the Doric temple" is a real entity that inevitably forms in our minds as we examine the monuments themselves. We must be careful, of course, not to think of this abstraction as an ideal that permits us to measure the degree of perfection of any given Doric temple; it simply means that the elements of which a Doric temple is composed are extraordinarily constant in number, in kind, and in their relation to one another. As a result of this narrowly circumscribed repertory of forms, Doric temples all belong to the same clearly recognizable family, just as the Kouros statues do; like the Kouros statues, they show an internal consistency, a mutual adjustment of parts, that gives them a unique quality of wholeness and organic unity. The term Doric order refers to the standard parts, and their sequence, constituting the exterior of any Doric temple. Its general outlines are already familiar to us from the façade of the Temple of Artemis at Corfu (fig. 139): the diagram in figure 146 shows it in detail, along with the names of all the parts. To the nonspecialist, the detailed terminology may seem something of a nuisance, yet a good many of these terms have become part of our general architectural vocabulary, to remind us of the fact that analytical thinking, in architecture as in countless other fields, originated with the Greeks. Let us first note the three main divisions: the stepped platform, the columns, and the entablature (which includes everything that rests on the columns). The Doric column consists of: the shaft, marked by shallow vertical grooves known as flutes; the capital, which is made up of the flaring, cushion-like echinus, and a square tablet called the abacus. The entablature is the most complex of the three major units; it is subdivided into the architrave (a series of stone blocks directly supported by the columns), the frieze with its triglyphs and metopes, and the projecting cornice. On the long sides of the temple, the cornice is horizontal, while on the short sides (or façades), it is split open in such a way as to enclose the pediment between its upper and lower parts. The entire structure is built of stone blocks fitted together without mortar; they had to be shaped with extreme precision to achieve smooth joints. Where necessary, they were fastened together by means of metal dowels or cramps. Columns, with very rare exceptions, are composed of sections, called drums (clearly visible in fig. 148). The roof consisted of terracotta tiles supported by wooden rafters, and wooden beams were used for the ceiling; thus the threat of fire was constant.

The plans of Greek temples are not directly linked to the orders (which, as we have seen, concern the elevation only). They may vary according to the size of the building or regional preferences, but their basic features are so much alike that it is useful to study them from a generalized "typical" plan (fig. 145). The nucleus is the cella or naos (the room in which the image of the deity is

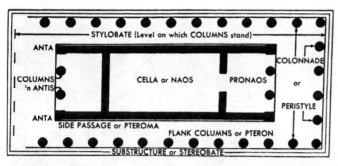

145. Ground Plan of a Typical Greek Temple (after Grinnell)

placed), and the porch (pronaos) with its two columns flanked by pilasters (antae). The Siphnian Treasury shows this minimal plan (see fig. 141). Often we find a second porch added behind the cella, to make the design more symmetrical. In the larger temples, this central unit is surrounded by a colonnade, called the peristyle, and the structure is then known as peripteral. The very largest temples of Ionian Greece may even have a double colonnade.

DORIC TEMPLES

How did the Doric temple originate? What factors shaped the rigid and precise vocabulary of the Doric order? This is an important and fascinating problem, which has occupied archaeologists for many years but which even now can be answered only in part, for we have hardly any remains from the time when the system was still in process of formation. The earliest stone temples known to us, such as that of Artemis at Corfu, show that the essential features of the Doric order were already well established soon after 600 B.C. How these features developed, individually and in combination, why they congealed into a system as rapidly as they seem to have done, remains a puzzle to which we have few reliable clues. The early Greek builders in stone apparently drew upon three distinct sources of inspiration: Egypt, Mycenae, and pre-Archaic Greek architecture in wood and mud-brick. The Mycenaean contribution is the most tangible, although probably not the most important, of these. The central unit of the Greek temple, the cella and pronaos, clearly derives from the megaron (see fig. 121), either through a continuous tradition or by way of revival. There is something oddly symbolic about the fact that the Mycenaean royal hall should have been converted into the dwelling place of the Greek gods; for the entire Mycenaean era had become part of Greek mythology, as attested by the Homeric epics, and the walls of the Mycenaean fortresses were believed to be the work of mythical giants, the Cyclopes. The religious awe the Greeks felt before these remains also helps us to understand the relationship between the Lion Gate relief at Mycenae and the sculptured pediments on Doric temples. Finally, the flaring, cushion-like capital of the Minoan-Mycenaean column is a good deal closer to the Doric echinus and abacus than is any Egyptian capital. The shaft of the Doric column, on the other hand, tapers

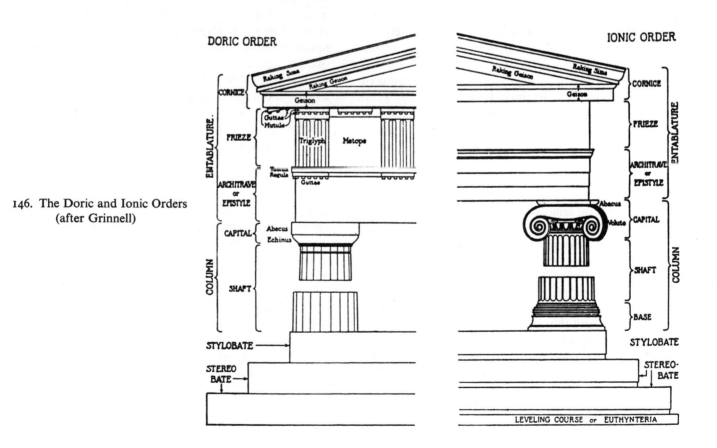

146. The Doric and Ionic Orders
(after Grinnell)

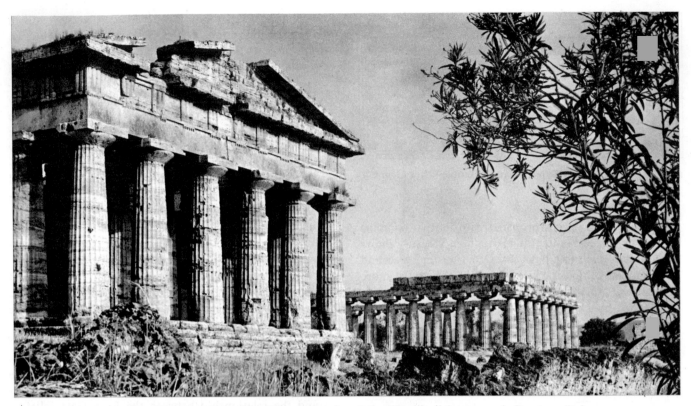

147. The "Temple of Poseidon" (c. 460 B.C.) and the "Basilica" (c. 550 B.C.), Paestum, Italy

upward, not downward as does the Minoan-Mycenaean column, and this definitely points to Egyptian influence. Perhaps we will recall now—with some surprise—the fluted columns (or rather half-columns) in the funerary district of Zoser at Saqqara (fig. 53), which closely approximate the Doric shaft more than 2000 years before its appearance in Greece. Moreover, the very notion that temples ought to be built of stone, and that they required large numbers of columns, must have come from Egypt. It is true, of course, that the Egyptian temple is designed to be experienced from the inside, while the Greek temple is arranged so that the impressive exterior matters most (few were allowed to enter the dimly lit cella, and religious ceremonies usually took place at altars erected out of doors, with the temple façade as a backdrop). But might a peripteral temple not be interpreted as the columned court of an Egyptian sanctuary turned inside out? The Greeks also must have acquired much of their stone-cutting and masonry technique from the Egyptians, along with architectural ornament and the knowledge of geometry they needed in order to lay out their temples and to fit the parts together. Yet we cannot say just how they went about all this, or exactly what they took over, technically and artistically, although there can be little doubt that they owed more to the Egyptians than to the Minoans or Mycenaeans. The problem becomes acute when we consider a third factor: to what extent can the Doric order be understood as a reflection of wooden structures? Those historians of architecture who believe that form follows function have pursued this line of approach at great length, especially in trying to explain the details of the entablature. Up to a point, their arguments carry conviction; it seems plausible to assume that at one time the triglyphs did mask the ends of wooden beams, and that the droplike markings known as guttae (see fig. 146) are the descendants of wooden pegs. The peculiar vertical subdivisions of the triglyphs are perhaps a bit more difficult to accept as an echo of three half-round logs. And when we come to the flutings of the column, our doubts continue to rise: were they really developed from adz marks on a tree trunk, or did the Greeks take them over ready-made from the "proto-Doric" stone columns of Egypt? As a further test of the functional theory, we would have to ask how the Egyptians came to put flutes in their columns. They, too, after all, had once had to translate architectural forms from impermanent materials into stone. Perhaps it was they who turned adz marks into flutes? But the predynastic Egyptians had so little timber that they seem to have used it only for ceilings; the rest of their buildings consisted of mud brick, fortified by bundles of reeds. And since the proto-Doric columns at Saqqara are not free-standing but are attached to walls, their flutings might represent a sort of abstract echo of bundles of reeds (there are also columns at Saqqara with convex rather than concave flutes which come a good deal closer to the notion of a bundle of thin staves). On the other hand, the Egyptians may have developed the habit of fluting

without reference to any earlier building techniques at all; perhaps they found it an effective way to disguise the horizontal joints between the drums and to stress the continuity of the shaft as a vertical unit. Even the Greeks did not flute the shafts of their columns drum by drum, but waited until the entire column was assembled and in position. Be that as it may, fluting certainly enhances the expressive character of the column: a fluted shaft looks stronger, more energetic and resilient, than a smooth one; and this, rather than its manner of origin, accounts for the persistence of the habit. Why then did we enter at such length into an argument that seems at best inconclusive? Mainly in order to suggest the complexity—and the limitations—of the technological approach to problems of architectural form. The question, always a thorny one, of how far stylistic features can be explained on a functional basis will face us again and again. Obviously, the history of architecture cannot be fully understood if we view it only as an evolution of style in the abstract, without considering the actual purposes of building or its technological basis. But we must likewise be prepared to accept the purely aesthetic impulse as a motivating force. At the very start, Doric architects certainly imitated in stone some features of wooden temples, if only because these features were deemed necessary in order to identify a building as a temple. When they enshrined them in the Doric order, however, they did not do so from blind conservatism or force of habit, but because the wooden forms had by now been so thoroughly transformed that they were an organic part of the stone structure.

Paestum

We must confront the problem of function once more when we consider the best-preserved sixth-century Doric temple, the so-called "Basilica" at Paestum in southern Italy (fig. 147, right; fig. 148), in relation to its neighbor, the so-called "Temple of Poseidon" (fig. 147, left), which was built almost a century later. Both are Doric, but we at once note striking differences in their proportions. The "Basilica" seems low and sprawling (and not only because so much of the entablature is missing), while the "Temple of Poseidon" looks tall and compact. Even the columns themselves are different: those of the older temple taper far more emphatically, their capitals are larger and more flaring. Why the difference? The peculiar shape of the columns of the "Basilica" (peculiar, that is, compared to fifth-century Doric) has been explained as being due to overcompensation: the architect, not yet fully familiar with the properties of stone as compared with wood, exaggerated the taper of the shaft for greater stability and enlarged the capitals so as to narrow the gaps to be spanned by the blocks of the architrave. Maybe so —but if we accept this interpretation in itself as sufficient to account for the design of these Archaic columns, do we not judge them by the standards of a later age? To

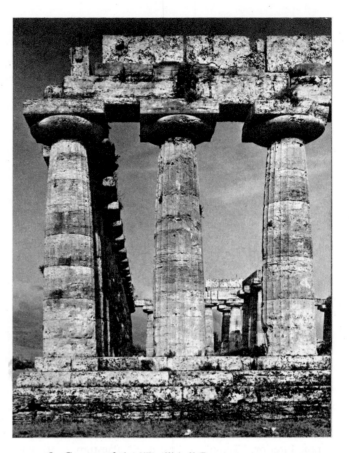

148. Corner of the "Basilica," Paestum. c. 550 B.C.

label them simply "primitive," or awkward, would be to disregard the particular expressive effect that is theirs— and theirs alone. The "Basilica's" columns seem to be more burdened by their load than those of the "Temple of Poseidon," so that the contrast between the supporting and the supported members of the order is dramatized rather than harmoniously balanced, as in the later building. Various factors contribute to this impression; the echinus of the "Basilica's" capitals is not only larger than its counterpart in the "Temple of Poseidon," it seems more elastic and hence more distended by the weight it carries, almost as if it were made of rubber. And the shafts not only show a more pronounced taper but also a particularly strong bulge or curve along the line of taper, so that they, too, convey a sense of elasticity and compression compared with the rigidly geometric blocks of the entablature. (This curve, called "entasis," is a basic feature of the Doric column; although it may be very slight, it endows the shaft with a "muscular" quality quite unknown in Egyptian or Minoan-Mycenaean columns.)

The "Temple of Poseidon" (figs. 147, 149–51)—it was probably dedicated to Hera—is among the best preserved of all Doric sanctuaries. Begun c. 475 B.C. and finished fifteen years later, it reflects the plan of the temple at Aegina. Of special interest are the interior supports of the cella ceiling (figs. 149–50), two rows of columns, each

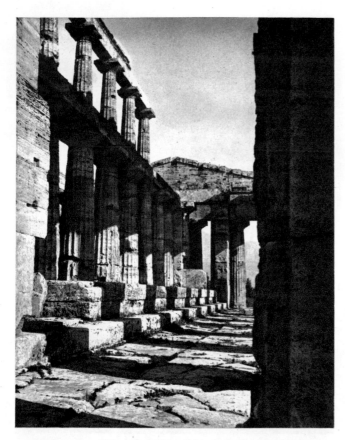

149. Interior, "Temple of Poseidon," Paestum. c. 460 B.C.

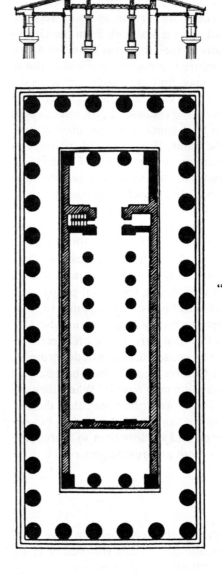

150, 151.
Transverse Section
and Plan of the
"Temple of Poseidon"
(after Hodge)

supporting a smaller set of columns in a way that makes the tapering seem continuous despite the architrave in between. Such two-story interiors had become a practical necessity for the cellas of the larger Doric temples of the fifth century.

Athens

In 480 B.C., shortly before their defeat, the Persians had destroyed the temples and statues on the Acropolis, the sacred hill above Athens which had been a fortified site since Mycenaean times. (For modern archaeologists, this disaster has turned out to be a blessing in disguise, since the debris, which was subsequently used as fill, has yielded many fine Archaic pieces, such as those in figures 134, 135, 137, and colorplate 12, which probably would not have survived otherwise.) The rebuilding of the Acropolis under the leadership of Pericles during the later fifth century, when Athens was at the height of her power, was the most ambitious enterprise in the history of Greek architecture, as well as its artistic climax. Individually and collectively, these structures represent the Classical phase of Greek art in full maturity. The greatest, and the only one whose completion was not cut short by the Peloponnesian War, is the Parthenon (figs. 152, 153) dedicated to the virginal Athena, the patron deity in whose honor Athens was named. Built of gleaming white marble on the most prominent site along the southern flank of the Acropolis, it dominates the entire city and the surrounding countryside, a brilliant landmark against the backdrop of mountains to the north of it. The history of the Parthenon is as extraordinary as its artistic significance—it is the only sanctuary we know that has served four different faiths in succession. The architects Ictinus and Callicrates erected it in 448–432 B.C., an amazingly brief span of time for a project of this size. In order to meet the huge expense of building the largest and most lavish temple on the Greek mainland, Pericles delved into funds collected from states allied with Athens for mutual defense against the Persians. He may have felt that the danger was no longer a real one, and that Athens, the chief victim and victor at the climax of the Persian war in 480–478 B.C., was justified in using the money to rebuild what the Persians had destroyed. His act did weaken the position of Athens, however (Thucydides openly reproached him for adorning the city "like a harlot with

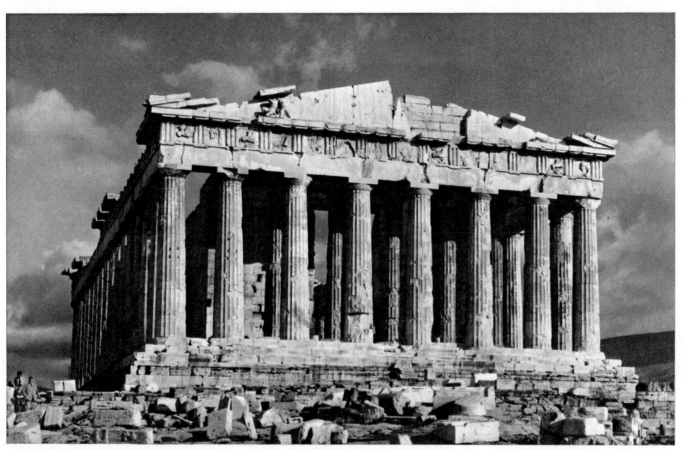

152. ICTINUS and CALLICRATES. The Parthenon (view from the west). 448–432 B.C. Acropolis, Athens

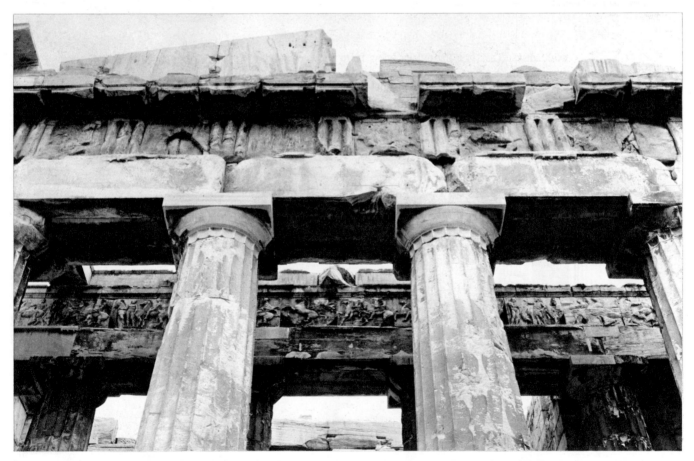

153. Frieze above the Western Entrance of the Cella of the Parthenon (see also fig. 174)

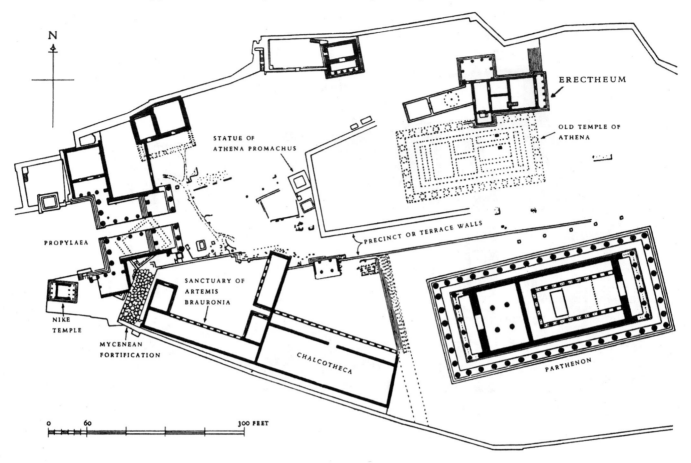

154. Plan of the Acropolis at Athens in 400 B.C. (after A. W. Lawrence)

ERECTHEUM

OLD TEMPLE OF
ATHENA

STATUE OF
ATHENA PROMACHUS

PRECINCT OR TERRACE WALLS

PROPYLAEA

SANCTUARY OF
ARTEMIS
BRAURONIA

NIKE
TEMPLE

MYCENEAN
FORTIFICATION

CHALCOTHECA

PARTHENON

0 60 300 FEET

155. MNESICLES. The Propylaea (view from the east). 437–432 B.C. Acropolis, Athens

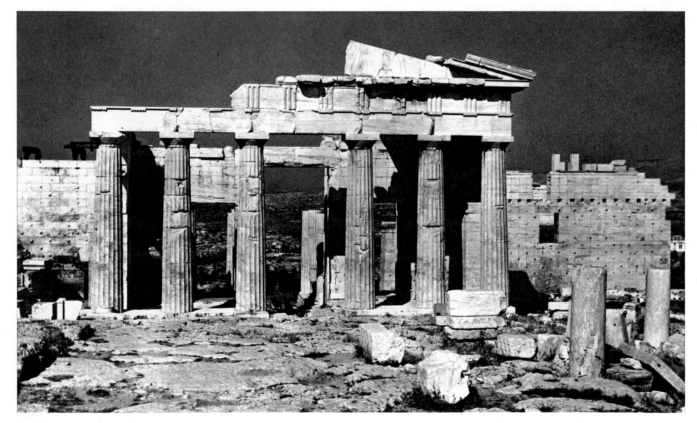

precious stones, statues and temples costing a thousand talents"), and contributed to the disastrous outcome of the Peloponnesian War. In Christian times, the Virgin Mary displaced the virginal Athena; the Parthenon became first a Byzantine church, then a Catholic cathedral, and finally, under Turkish rule, a mosque. It has been a ruin since 1687, when a store of gunpowder the Turks had put into the cella exploded during a siege. Much of the sculpture was removed during the years 1801–1803 by Lord Elgin. These Elgin Marbles are today the greatest treasure of the British Museum.

As the perfect embodiment of Classical Doric architecture, the Parthenon makes an instructive contrast with the "Temple of Poseidon" at Paestum. Despite its greater size, it seems far less massive. Rather, the dominant impression it creates is one of festive, balanced grace, within the austere scheme of the Doric order. This has been achieved by a general lightening and readjustment of the proportions: the entablature is lower in relation to its width and to the height of the columns, the cornice projects less, and the columns themselves are a good deal more slender, the tapering and entasis are less pronounced, and the capitals smaller and less flaring, while the spacing of the columns has become wider. Or we might say that the load carried by the columns has decreased, and as a consequence the supports can fulfill their task with a new sense of ease. The so-called "refinements," intentional departures from the strict geometric regularity of the design for aesthetic reasons, are another feature of the Classical Doric style that can be observed in the Parthenon better than anywhere else. Thus the stepped platform and the entablature are not absolutely straight but slightly buckled, so that the center is a bit higher than the ends; the columns lean inward, and the interval between the corner column and its neighbors is smaller than the standard interval adopted for the colonnade as a whole. A great deal has been written about these deviations from mechanical exactitude. That they are planned rather than accidental is beyond doubt, but why did the architects go to the enormous trouble of carrying them through? (Every capital of the colonnade is slightly distorted to fit the curving architrave!) They used to be regarded as optical corrections designed to produce the illusion of absolutely straight horizontals and verticals. Unfortunately, however, this functional explanation does not work: if it did, we should be unable to perceive the deviations except by careful measurement; yet the fact is that, though unobtrusive, they are visible to the naked eye, even in photographs such as our figure 152. Moreover, in temples that do not have these refinements, the columns do not give the appearance of leaning outward, nor do the horizontal lines look "dished." Plainly, then, the deviations were built into the Parthenon because they were thought to add to its beauty; they are a positive element that is meant to be noticed. And they do indeed contribute—in ways that are hard to define—to the integral, harmonious quality of the structure.

The cella of the Parthenon (see fig. 154) is unusually wide and somewhat shorter than in other temples, so as to accommodate a second room behind it. The pronaos and its counterpart at the western end have almost disappeared, but there is an extra row of columns in front of either entrance. The architrave above these columns is more Ionic than Doric, since it has no triglyphs

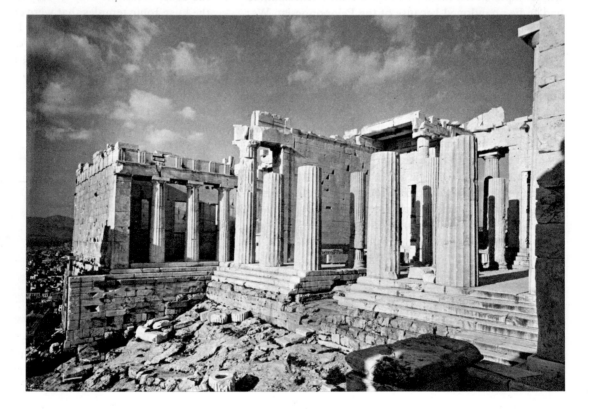

156. The Propylaea (with *pinakotheke*), Western Entrance

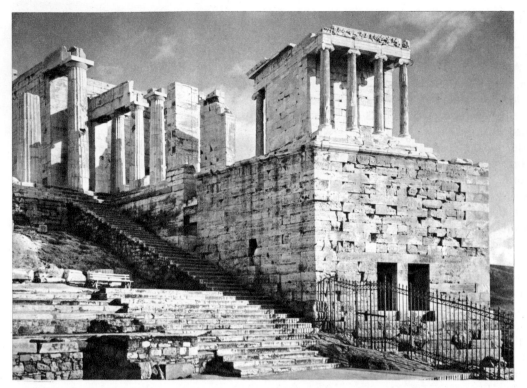

157. The Propylaea
(view from the west)
and the Temple of Athena Nike
(427–424 B.C.),
Acropolis, Athens

and metopes but a continuous sculptured frieze that encircles the entire cella (fig. 153).

Immediately after the completion of the Parthenon, Pericles commissioned another splendid and expensive edifice, the monumental entry gate at the western end of the Acropolis, called the Propylaea (see plan, fig. 154). It was begun in 437 B.C., under the architect Mnesicles, who completed the main part in five years; the remainder had to be abandoned because of the Peloponnesian War. Again the entire structure was built of marble, and included refinements comparable to those of the Parthenon. Its main fascination for us consists in the manner in which the elements of a Doric temple have here been adapted to another task, on an irregular and steeply rising site. Mnesicles has indeed acquitted himself nobly; his design not only fits the difficult terrain but also transforms it, so that a rude passage among rocks becomes a splendid overture to the sacred precinct on which it opens. Of the two porches (or façades) at either end, only the eastern one is in fair condition today (fig. 155); it resembles a Classical Doric temple front, except for the wide opening between the third and fourth columns. The western porch was flanked by two wings (figs. 156, 157). The one to the north, considerably larger than its companion, included a picture gallery (*pinakotheke*), the first known instance of a room especially designed for the display of paintings. Along the central roadway that passes through the Propylaea, we find two rows of columns which are Ionic rather than Doric. Apparently at that time the trend in Athenian architecture was toward using Ionic elements inside Doric structures (we recall the sculptured frieze of the Parthenon cella).

IONIC TEMPLES

Athens, with its strong Aegean orientation, had shown itself hospitable to the eastern Greek style of building from the mid-fifth century on, and the finest surviving examples of the Ionic order are to be found among the structures of the Acropolis. The previous development of the order is known only in very fragmentary fashion; of the huge Ionic temples that were erected in Archaic times on Samos and at Ephesus, little has survived except the plans. Its vocabulary, however, seems to have remained fairly fluid, with strong affinities to the Near East (figs. 100, 101), so that it did not really become an order in the strict sense until the Classical period. Even then it continued to be rather more flexible than the Doric order. Its

158. Aeolian Capital,
from Larissa. c. 600 B.C.
Archaeological Museum,
Istanbul

159. Corinthian Capital,
from the Tholos at
Epidaurus. c. 350 B.C.
Museum, Epidaurus

160. The Erechtheum (view from the east), 421–405 B.C., Acropolis, Athens

most striking feature is the Ionic column, which differs from the Doric not only in body but also, as it were, in spirit (see fig. 146). It rests on an ornately profiled base of its own; the shaft is more slender, and there is less tapering and entasis; the capital shows a large double scroll, or volute, between the echinus and abacus, which projects strongly beyond the width of the shaft. That these details add up to an entity very distinct from the Doric column becomes clear as soon as we turn from the diagram to an actual building (fig. 160). How shall we define it? The Ionic column is, of course, lighter and more graceful than its mainland cousin; it lacks the latter's muscular quality. Instead, it evokes the echo of a growing plant, of something like a formalized palm tree. And this vegetal analogy is not sheer fancy, for we have early ancestors, or relatives, of the Ionic capital that bear it out (fig. 158). If we were to pursue these plantlike columns all the way back to their point of origin, we would eventually find ourselves at Saqqara, where we not only encounter "proto-Doric" supports but the wonderfully graceful papyrus half-columns of figure 56, with their curved, flaring capitals. It may well be, then, that the Ionic column, too, had its ultimate source in Egypt, but instead of reaching Greece by sea, as we suppose the proto-Doric column did, it traveled a slow and tortuous path by land, through Syria and Asia Minor.

In pre-Classical times, the only Ionic structures on the Greek mainland had been the small treasuries built by eastern Greek states at Delphi in their regional styles (see fig. 141). Hence the Athenian architects who took up the Ionic order about 450 B.C. thought of it, at first, as suitable only for small temples of simple plan. Such a build-

ing is the little Temple of Athena Nike on the southern flank of the Propylaea (fig. 157), probably built 427–424 B.C. from a design prepared twenty years earlier by Callicrates. Larger and more complex is the Erechtheum (fig. 160; and plan, fig. 154), on the northern edge of the Acropolis opposite the Parthenon. It was erected 421–405 B.C., perhaps by Mnesicles, for, like the Propylaea, it is masterfully adapted to an irregular, sloping site. The area had various associations with the mythical founding of Athens, so that the Erechtheum was actually a "portmanteau" sanctuary with several religious functions. Its name derives from Erechtheus, a legendary king of Athens; the eastern room was dedicated to Athena Polias (Athena the city goddess); and it may also have covered the spot where a contest between Athena and Poseidon was believed to have taken place. (Apparently there were four rooms, in addition to a basement on the western side, but their exact purpose is under dispute.) Instead of a west façade, the Erechtheum has two porches attached to its flanks, a very large one facing north and a small one toward the Parthenon. The latter is the famous Porch of the Maidens, its roof supported by six female figures (caryatids) on a high parapet, instead of regular columns (compare fig. 141). One wonders whether these statues were the reason why a Turkish governor chose the building to house his harem two thousand years later. We cannot altogether blame him, for here the exquisite refinement of the Ionic order does indeed convey a feminine (though not effeminate) quality, compared with the masculinity of the Parthenon across the way. Apart from the caryatids, sculptural decoration on the Erechtheum was confined to the frieze (of which very little survives).

The pediments remained bare, perhaps for lack of funds at the end of the Peloponnesian War. However, the ornamental carving on the bases and capitals of the columns, and on the frames of doorways and windows, is extraordinarily delicate and rich; its cost, according to the accounts inscribed on the building, was higher than that of figure sculpture.

The Corinthian Capital

Such emphasis on ornament seems characteristic of the late fifth century. It was at this time that the Corinthian capital was invented, as an elaborate substitute for the Ionic; its shape is that of an inverted bell covered with the curly shoots and leaves of the acanthus plant, which seem to sprout from the top of the column shaft (fig. 159). At first, Corinthian capitals were used only for interiors. Not until a century later do we find them replacing Ionic capitals on the exterior. The earliest known instance is the Monument of Lysicrates in Athens (fig. 161), built

161. The Monument of Lysicrates, Athens. c. 334 B.C.

soon after 334 B.C. It is not really a building in the full sense of the term—the interior, though hollow, has no entrance—but an elaborate support for a tripod won by Lysicrates in a contest. The round structure, resting on a tall base, is a miniature version of a tholos, a type of circular building of which several earlier examples are known to have existed. The columns are engaged (set into the wall) rather than free-standing here, to make the monument more compact. Soon after, the Corinthian capital came to be employed on the exteriors of large buildings as well, and in Roman times it was the standard capital for almost any purpose.

Town Planning; Theaters

During the three centuries between the end of the Peloponnesian War and the Roman conquest, Greek architecture shows little further development. Even before the time of Alexander the Great, the largest volume of building activity was to be found in the Greek cities of Asia Minor. There we do encounter some structures of a new kind, often under Oriental influence, such as the huge Tomb of Mausolus at Halicarnassus (see figs. 178–80) or the Altar of Zeus at Pergamum (see figs. 188–90); town planning on a rectangular grid pattern, first introduced at Miletus in the mid-fifth century, assumed new importance, as did the municipal halls (stoas) lining the market places where the civic and commercial life of Greek towns was centered; private houses, too, became larger and more ornate than before. Yet the architectural vocabulary, aesthetically as well as technically, remained essentially that of the temples of the late fifth century. The basic repertory of Greek architecture was increased in one respect only: the open-air theater achieved a regular, defined shape. Before the fourth century, the auditorium had simply been a natural slope, preferably curved, equipped with stone benches; now the hillside was provided with concentric rows of seats, and with staircase-aisles at regular intervals, as at Epidaurus (figs. 162–63). At center is the orchestra, where most of the action took place. At the extreme right we see the remains of a hall-like building that formed the backdrop and supported the scenery.

LIMITATIONS

How are we to account for the fact that Greek architecture did not grow significantly beyond the stage it had reached at the time of the Peloponnesian War? After all, neither intellectual life nor the work of sculptors and painters shows any tendency toward staleness during the last three hundred years of Greek civilization. Are we perhaps misjudging her architectural achievements after 400 B.C.? Or were there inherent limitations that prevented Greek architecture from continuing the pace of development it had maintained in Archaic and Classical times? A number of such limitations come to mind: the concern with monumental exteriors at the expense of in-

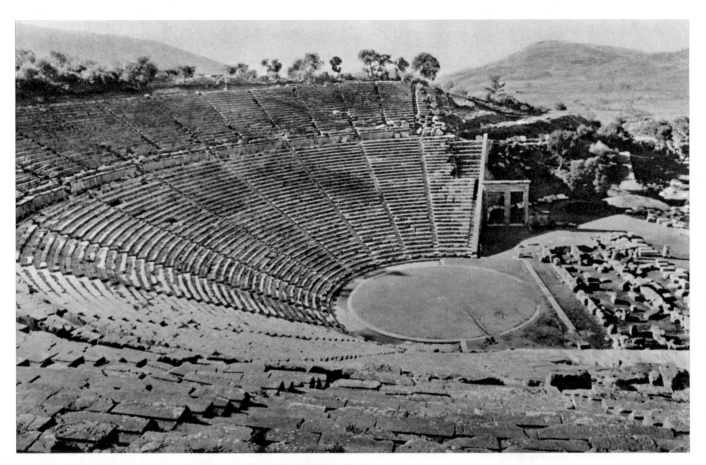

162. The Theater, Epidaurus. c. 350 B.C.

terior space; the concentration of effort on temples of one particular type; the lack of interest in any structural system more advanced than the post-and-lintel (uprights supporting horizontal beams). Until the late fifth century, these had all been positive advantages; without them, the great masterpieces of the Periclean age would have been unthinkable. But the possibilities of the traditional Doric temple were nearly exhausted by then, as indicated by the attention lavished on expensive refinements. What Greek architecture needed after the Peloponnesian War was a breakthrough, a revival of the experimental spirit of the seventh century, which would create an interest in new building materials, vaulting, and interior space. What prevented the breakthrough? Could it have been the architectural orders, or rather the cast of mind that produced them? The suspicion will not down that it was the very coherence and rigidity of these orders which made it impossible for Greek architects to depart from the established pattern. What had been their great strength in earlier days now became a tyranny. It remained for later ages to adapt the Greek orders to brick and concrete, to arched and vaulted construction, for such adaptation necessitated doing a certain amount of violence to the original character of the orders, and the Greeks, it seems, were incapable of that.

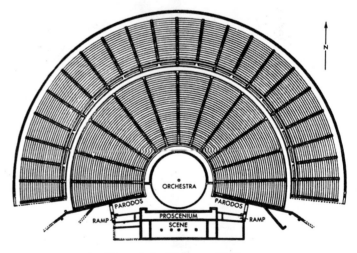

163. Plan of the Theater, Epidaurus
(after Picard-Cambridge)

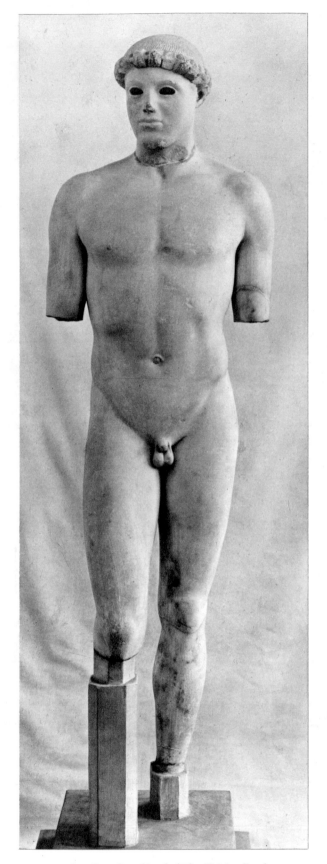

164. *Standing Youth (The Kritios Boy).*
c. 480 B.C. Marble, height 34".
Acropolis Museum, Athens

Among the statues excavated from the debris the Persians had left behind on the Acropolis, there is one Kouros (fig. 164) that stands apart from the rest. It must have been carved very shortly before the fateful year 480 B.C. This remarkable work, which some have attributed to the Athenian sculptor Kritios and which therefore has come to be known as the *Kritios Boy,* differs subtly but importantly from the Archaic Kouros figures we discussed above (figs. 132, 133): it is the first statue we know that *stands* in the full sense of the word. Of course, the earlier figures also stand, but only in the sense that they are in an upright position, and are not reclining, sitting, kneeling, or running; their stance is really an arrested walk, with the weight of the body resting evenly on both legs. The *Kritios Boy,* too, has one leg placed forward, yet we never doubt for an instant that he is standing still. Why this is so becomes evident when we compare the left and right half of his body, for we then discover that the strict symmetry of the Archaic Kouros has now given way to a calculated nonsymmetry: the knee of the forward leg is lower than the other, the right hip is thrust down and inward, the left hip up and outward; and if we trace the axis of the body, we realize that it is not a straight vertical line but a faint, S-like curve (or, to be exact, a reversed S-curve). Taken together, all these small departures from symmetry tell us that the weight of the body rests mainly on the left leg, and that the right leg plays the role of an elastic prop or buttress to make sure that the body keeps its balance. The *Kritios Boy,* then, not only stands; he stands at ease. And the artist has masterfully observed the balanced nonsymmetry of this relaxed, natural stance. To describe it, we use the Italian word *contrapposto* (counterpoise); the leg that carries the main weight is commonly called the engaged leg; the other, the free leg. These terms are a useful shorthand, for from now on we shall have frequent occasion to mention *contrapposto.* It was a very basic discovery. Only by learning how to represent the body at rest could the Greek sculptor gain the freedom to show it in motion. But is there not plenty of motion in Archaic art? There is indeed (see figs. 138, 140, 143–44), but somewhat mechanical and inflexible in kind; we read it from the poses without really feeling it. In the *Kritios Boy,* on the other hand, we sense for the first time not only a new repose but an animation of the body structure that evokes the experience we have of our own body. Life now suffuses the entire figure, hence the Archaic smile, the "sign of life," is no longer needed. It has given way to a serious, pensive expression characteristic of the early phase of Classical sculpture (or, as it is often called, the Severe Style).

The new articulation of the body that appears in the *Kritios Boy* was to reach its full development within half a century in the mature Classical style of the Periclean era. The most famous Kouros statue of that time, the *Doryphorus (Spear Bearer)* by Polyclitus (fig. 165), is known to

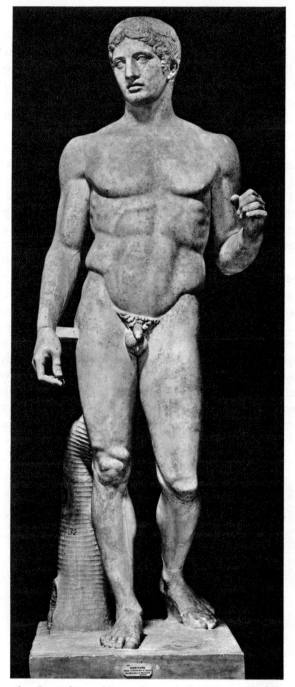

165. *Doryphorus (Spear Bearer).* Roman copy after
an original of c. 450–440 B.C. by Polyclitus. Marble,
height 6′ 6″. National Museum, Naples

us only through Roman copies whose hard, dry forms
convey little of the beauty of the original. Still, it makes
an instructive comparison with the *Kritios Boy*. The
contrapposto (with the engaged leg in the forward posi-
tion) has now become much more emphatic; the differ-
entiation between the left and right halves of the body can
be seen in every muscle, and the turn of the head, barely
hinted at in the *Kritios Boy*, is equally pronounced. This
studied poise, the precise, if overexplicit, anatomical de-
tail, and above all the harmonious proportions of the
figure, made the *Doryphorus* renowned as the standard
embodiment of the Classical ideal of human beauty. Ac-

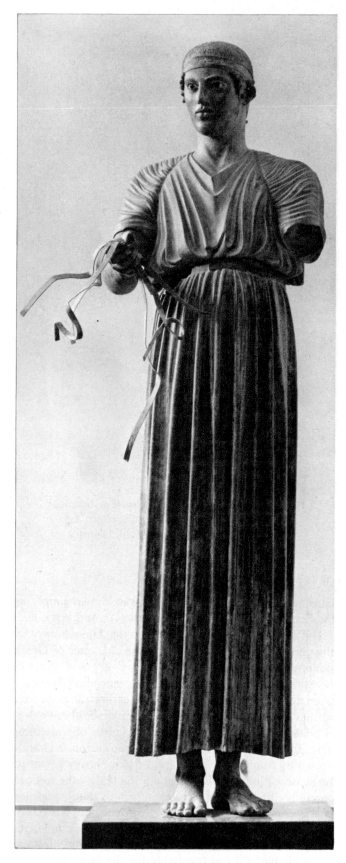

166. *Charioteer*, from the Sanctuary of Apollo
at Delphi. c. 470 B.C. Bronze, height 71″.
Museum, Delphi

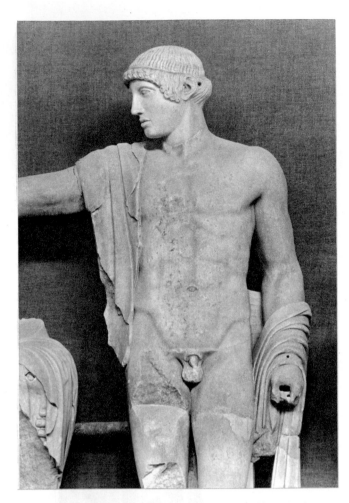

167. *Apollo* (portion), from the west pediment of
the Temple of Zeus at Olympia. c. 460 B.C.
Marble, over lifesize. Museum, Olympia

act upon it—the downward pull of gravity, the shape of the body underneath, and the belts or straps that constrict its flow. The face has the pensive, somewhat faraway look we saw in the *Kritios Boy*, but the color inlay of the eyes, fortunately preserved in this instance, as well as the slightly parted lips, give it a more animated expression. The bearing of the entire figure conveys the solemnity of the event commemorated, for chariot races and similar contests at that time were competitions for divine favor, not sporting events in the modern sense.

The greatest sculptural ensemble of the Severe Style is the pair of pediments of the Temple of Zeus at Olympia, carved c. 460 B.C. and now reassembled in the local museum. In the west pediment, the more mature of the two, we see the victory of the Lapiths over the Centaurs under the aegis of Apollo, who forms the center of the composition (fig. 167). His commanding figure is part of the drama and yet above it; the outstretched right arm and the strong turn of the head show his active intervention—he *wills* the victory but, as befits a god, does not physically help to achieve it. Nevertheless, there is a tenseness, a gathering of forces, in this powerful body that make its outward calm doubly impressive. The forms themselves are massive and simple, with soft contours and undulating, continuous surfaces. Apollo's glance is

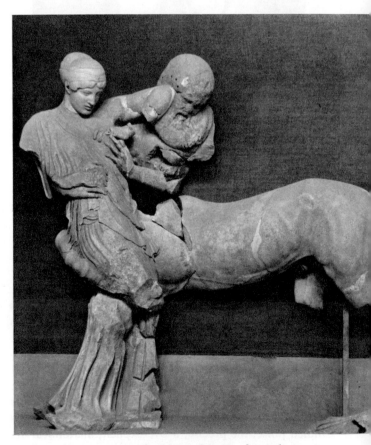

168. *Hippodamia Attacked by a Centaur*, from the west
pediment of the Temple of Zeus at Olympia. c. 460 B.C.
Marble, slightly over lifesize. Museum, Olympia

cording to one ancient writer, it was known simply as the Canon (rule, measure), so great was its authority.

But let us return to the Severe Style. The reason why this term was chosen to describe the character of Greek sculpture during the years between c. 480 and 450 B.C. becomes clear to us as we look at the splendid *Charioteer* from Delphi (fig. 166), one of the earliest large bronze statues in Greek art. It must have been made about a decade later than the *Kritios Boy*, as a votive offering after a race; the young victor originally stood on a chariot drawn by four horses. Despite the long, heavy garment, we sense a hint of *contrapposto* in the body—the feet are carefully differentiated so as to inform us that the left leg is the engaged one, and the shoulders and head turn slightly to the right. The garment is severely simple, yet compared with Archaic drapery the folds seem softer and more pliable; we feel (probably for the first time in the history of sculpture) that they reflect the behavior of real cloth. Not only the body but the drapery, too, has been transformed by a new understanding of functional relationships, so that every fold is shaped by the forces which

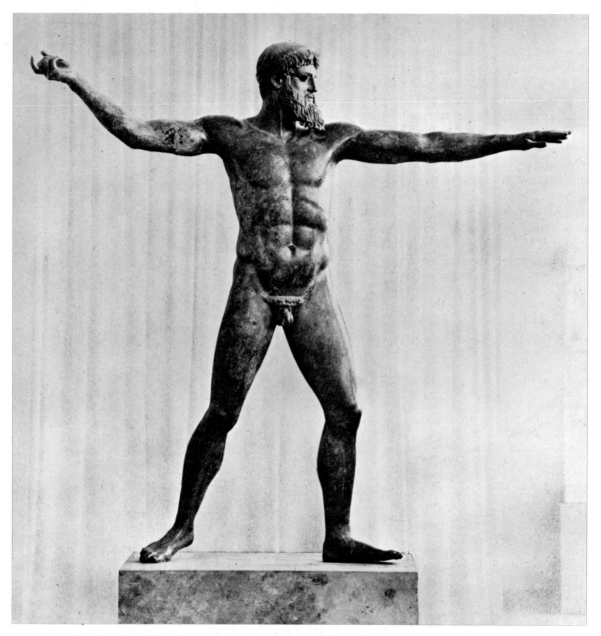

169. *Poseidon (Zeus?)*. c. 460–450 B.C. Bronze, height 6′ 10″. National Museum, Athens

directed at a Centaur who has seized Hippodamia, bride of the king of the Lapiths (fig. 168). Here we witness another achievement of the Severe Style: the passionate struggle is expressed not only through action and gesture but through the emotions mirrored in the faces—revulsion on the face of the girl, pain and desperate effort on that of the Centaur. Nor would an Archaic artist have known how to combine the two figures into a group so compact, so full of interlocking movements.

Strenuous action had already been explored in pedimental sculpture of the Late Archaic period (see figs. 143, 144). Such figures, however, although technically carved in the round, are not free-standing; they represent, rather, a kind of super-relief, since they are designed to be

seen against a background and from one direction only. To infuse the same freedom of movement into genuinely free-standing statues was a far greater challenge; not only did it run counter to an age-old tradition that denied mobility to these figures, but the unfreezing had to be done in such a way as to safeguard their all-around balance and self-sufficiency. The problem could not really be tackled until the concept of *contrapposto* had been established, but once this was done the solution no longer presented serious difficulties. Large, free-standing statues in motion are the most important achievement of the Severe Style. The finest figure of this kind was recovered from the sea near the coast of Greece some thirty years ago (fig. 169): a magnificent nude bronze Poseidon (or Zeus?),

almost seven feet tall, in the act of hurling his trident (or thunderbolt). The pose is that of an athlete, yet it does not strike us as the arrested phase of a continuous succession of movements but as an awe-inspiring gesture that reveals the power of the god. Hurling a weapon is a divine attribute here, rather than a specific performance aimed at a particular adversary. Some years after the *Poseidon*, about 450 B.C., Myron created his famous bronze statue of the *Discobolus (Discus Thrower)*, which came to enjoy a reputation comparable to that of the *Doryphorus*. Like the latter, it is known to us only from Roman copies (fig. 170). Here the problem of how to condense a sequence of movements into a single pose without freezing it is a very much more complex one, involving a violent twist of the torso in order to bring the action of the arms into the same plane as the action of

170. *Discobolus (Discus Thrower)*. Roman marble copy after a bronze original of c. 450 B.C. by Myron. Lifesize. Museo delle Terme, Rome

171. *Dying Niobid.* c. 450–440 B.C. Marble, height 59″. Museo delle Terme, Rome

the legs. We wonder whether the copy does not make the design seem harsher and less poised than it was in the original.

The *Discobolus* brings us to the threshold of the second half of the century, the era of the mature Classical style. The conquest of movement in the free-standing statue now exerted a liberating influence on pedimental sculpture as well, endowing it with a new spaciousness, fluidity, and balance. The *Dying Niobid* (fig. 171), a work of the 440s, was carved for the pediment of a Doric temple but is so richly three-dimensional, so self-contained, that we hardly suspect her original context. Niobe, according to legend, had humiliated the mother of Apollo and Artemis by boasting of her seven sons and seven daughters, whereupon the two gods killed all of Niobe's children. Our Niobid has been shot in the back while running; her strength broken, she sinks to the ground while trying to extract the fatal arrow. The violent movement of her arms has made her garment slip off; her nudity is thus a dramatic device, rather than a necessary part of the story. The artist's primary motive in devising it, however, was to display a beautiful female body in the kind of strenuous action hitherto reserved for the male nude. (The

Niobid is the earliest large female nude in Greek art.) Still, we must not misread the artist's intention: it was not a detached interest in the physical aspect of the event alone but the desire to unite motion and emotion and thus to make the beholder experience the suffering of this victim of a cruel fate. Looking at the face of the Niobid, we feel that here, for the first time, human feeling is expressed as eloquently in the features as in the rest of the figure. A brief glance backward at the wounded warrior from Aegina (fig. 144) will show us how very differently the agony of death had been conceived only half a century before. What separates the *Niobid* from the world of Archaic art is a quality summed up in the Greek word *pathos*, which means suffering, but particularly suffering conveyed with nobility and restraint so that it touches rather than horrifies us. Late Archaic art may approach it now and then, as in the Eos and Memnon group (fig. 130) yet the full force of *pathos* can be felt only in Classical works such as the *Niobid*. Perhaps, in order to measure the astonishing development we have witnessed since the beginnings of Greek monumental sculpture less than two centuries before, we ought to compare the *Niobid* with the earliest pedimental figure we came to know, the Gorgon from Corfu (fig. 138); and as we do so, we suddenly realize that these two, worlds apart as they may be, belong to the same artistic tradition, for the *Niobid,* too, shows the pinwheel stance, even though its meaning has been radically reinterpreted. Once we recognize the ancient origin of her pose, we understand better than before why the Niobid, despite her suffering, remains so monumentally self-contained.

Phidias and the Parthenon

The largest, as well as the greatest, body of Classical sculpture at our disposal consists of the remains of the plastic decoration of the Parthenon, most of them, unfortunately, in battered and fragmentary condition. The centers of both pediments are gone completely, and of the figures in the corners only those from the east pediment are sufficiently well preserved to convey something of the quality of the ensemble. They represent various deities, most in sitting or reclining poses, witnessing the birth of Athena from the head of Zeus (figs. 172, 173). Here, even more than in the case of the *Niobid,* we marvel at the spaciousness, the complete ease of movement of these statues. There is neither violence nor pathos in them, indeed no specific action of any kind, only a deeply felt poetry of being. We find it equally in the relaxed masculine body of Dionysus and in the soft fullness of the three goddesses, enveloped in thin drapery that seems to share the qualities of a liquid substance as it flows and eddies around the forms underneath. The figures are so freely conceived in depth that they create their own aura of space, as it were. How, we wonder, did they ever fit into the confined shape of a pediment? Might they not have looked a bit incongruous, as if they had been merely shelved there? The great master who designed them must have felt something of the sort, for the composition as a whole suggests that he refused to accept the triangular field as more than a purely physical limit. In the sharp angles at the corners, at the feet of Dionysus and the reclining goddesses, he has placed two horses' heads; they

172. *Dionysus,*
from the east pediment
of the Parthenon. c. 438–432 B.C.
Marble, over lifesize.
British Museum, London

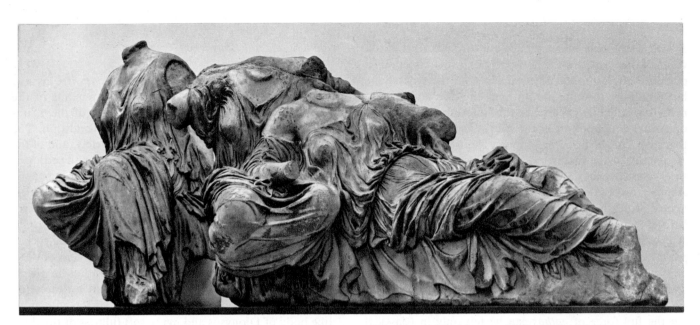

173. *Three Goddesses,* from the east pediment of the Parthenon. c. 438–432 B.C. Marble, over lifesize. British Museum, London

are meant to represent the chariots of the rising sun and the waning moon emerging into (and dipping below) the pedimental space, but visually the heads are merely two fragments arbitrarily cut off by the frame. Clearly, we are approaching the moment when the pediment will be rejected altogether as the focal point of Greek architectural sculpture.

The frieze of the Parthenon, a continuous band 525 feet long (fig. 153), shows a procession honoring Athena, in the presence of the other Olympic gods. It is of the same high rank as the pedimental sculptures. In a somewhat different way it, too, suffered from its subordination to the architectural setting, for it must have been poorly lit and difficult to see, placed as it was immediately below the ceiling. The depth of the carving and the concept of relief

are not radically different from the frieze of the Siphnian Treasury (see fig. 140), although the illusion of space and of rounded form is now achieved with sovereign ease. The most remarkable quality of the Parthenon frieze is the rhythmic grace of the design, particularly striking in the spirited movement of the groups of horsemen (fig. 174).

Who was responsible for this magnificent array of sculptures? They have long been associated with the name of Phidias, the chief overseer of all artistic enterprises sponsored by Pericles. According to ancient writers, Phidias was particularly famous for a huge ivory-and-gold statue of Athena he made for the cella of the Parthenon, a colossal Zeus in the same technique for the temple of that god in Olympia, and an equally large bronze statue of

174. *Horsemen,* from
the west frieze of the Parthenon.
c. 440 B.C. Marble, height 43″.
British Museum, London
(see also fig. 242)

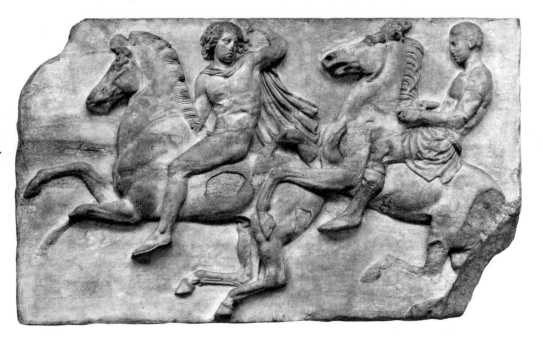

Athena that stood on the Acropolis facing the Propylaea. None of these survive, and small-scale representations of them in later times are utterly inadequate to convey anything of the artist's style. It is, in any event, hard to imagine that enormous statues of this sort, burdened with the requirements of cult images and the demands of a difficult technique, shared the vitality of the Elgin Marbles. The admiration they elicited could have been due in large part to their size, the preciousness of the materials, and the aura of religious awe surrounding them. Phidias' personality thus remains oddly intangible; he may have been a great genius, or simply a very able co-ordinator and supervisor. The term "Phidian style" used to describe the Parthenon sculptures is no more than a generic label, justified by its convenience but of questionable accuracy. Undoubtedly a large number of masters were involved, since the frieze and the two pediments were executed in less than ten years (c. 440–432 B.C.). The metopes, which we have omitted here, date from the 440s.

It is hardly surprising that the Phidian style should have dominated Athenian sculpture until the end of the fifth century and beyond, even though large-scale sculptural enterprises gradually came to a halt because of the Peloponnesian War. The last of these was the balustrade erected around the small temple of Athena Nike, c. 410–407 B.C. Like the Parthenon frieze, it shows a festive procession, but the participants are winged Nike figures (personifications of victory) rather than citizens of Athens. One Nike (fig. 175) is taking off her sandals, in conformity with an age-old tradition, indicating that she is about to step on holy ground (see page 54). Her wings—one open, the other closed—are effectively employed to help her keep her balance, so that she performs with consummate elegance of movement what is ordinarily a rather awkward act. Her figure is more strongly detached from the relief ground than are those on the Parthenon frieze, and her garments, with their deeply cut folds, cling to the body as if they were wet (we have seen an earlier phase of this treatment of drapery in the three goddesses of the Parthenon, fig. 173). "Phidian," too, and also from the last years of the century, is the beautiful *Grave Stele of Hegeso* (fig. 176). Memorials of this kind were produced in large numbers by Athenian sculptors, and their export must have helped to spread the Phidian style throughout the Greek world. Few of them, however, can match the harmonious design and the gentle melancholy of our example. The deceased is represented in a simple domestic scene; she has picked a necklace from the box held by the girl servant and seems to be contemplating it as if it were a keepsake. The delicacy of the carving can be seen especially well in the forms farthest removed from the beholder, such as the servant's left arm supporting the lid of the jewel box, or the veil behind Hegeso's right shoulder. Here the relief merges almost imperceptibly with the background, so that the ground no longer appears as a solid surface but assumes something of the transparency of empty space. This novel

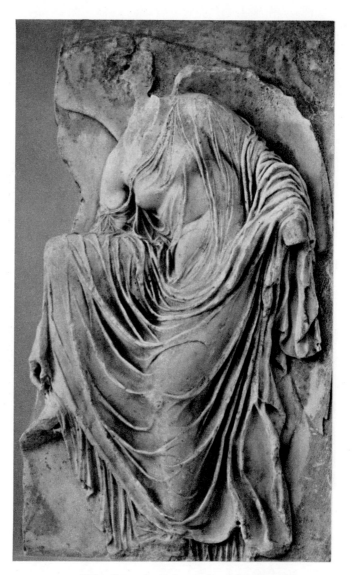

175. *Nike,* from the balustrade of the Temple of Athena Nike. c. 410–407 B.C. Marble, height 42″. Acropolis Museum, Athens

effect was probably inspired by the painters of the period, who, according to the literary sources, had achieved a great breakthrough in mastering illusionistic space.

CLASSICAL PAINTING

Unhappily, we have no murals or panels to verify this claim; and vase painting by its very nature could echo the new concept of pictorial space only in rudimentary fashion. Still, there are vessels that form an exception to this general rule; we find them mostly in a special class of vases, the lekythoi (oil jugs) used as funerary offerings. These had a white coating on which the painter could draw as freely, and with the same spatial effect, as his modern successor using pen and paper. The white ground,

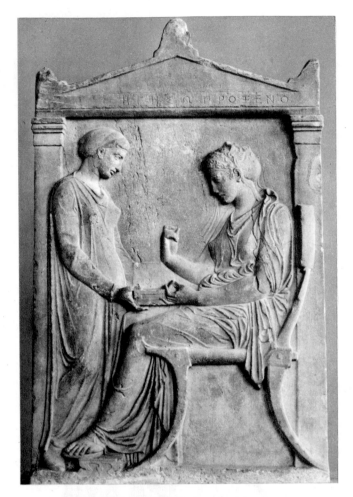

176. *Grave Stele of Hegeso.* c. 410–400 B.C.
Marble, height 59″. National Museum, Athens

others merge with one another or disappear into the white ground. However, we must not assume that the carver of the Hegeso Stele actually knew our lekythos; more likely, they both derive from a common ancestor, which may have been a marble stele like that of Hegeso but with a *painted* representation of the jewel-box scene.

Considering its artistic advantages, we might expect the white-ground technique to be more generally adopted. Such, however, was not the case. Instead, from the mid-fifth century on, the impact of monumental painting gradually transformed vase painting as a whole into a satellite art that tried to reproduce large-scale compositions in a kind of shorthand dictated by its own limited technique. The result, more often than not, was spotty and overcrowded. Even the finest examples suffer from this defect, as we can see in figure 177, which is taken from a vase produced in central Italy—probably by a Greek master—not very long after 400 B.C. It shows Thetis, who was about to bathe under a fountain, being abducted by Peleus as her two girl servants flee in panic. Our artist, the so-called Aurora Painter, has placed three of the figures on a rocky slope (the fourth, intended to be farther away, seems suspended in mid-air) in order to suggest the spatial setting of the scene; he even shows the fountain, in the shape of two pipes coming out of a rock in the upper right-hand corner. Yet the effect remains silhouette-like, because of the obtrusive black background. He has also tried to enlarge his color range: the body of Thetis has a lighter tint than the other figures, and some details have been added in white. This expedient, too, fails to solve his problem, since his medium does not permit him to shade or model. He thus must rely on creating a maximum of dramatic excitement to hold the scene together; and, being a spirited draughtsman, he almost succeeds. Still, it is a success at second hand, for the composition must have been inspired by a mural or panel picture. He is, as it were, battling for a lost cause; in another hundred years, vase painting was to disappear altogether.

SCULPTURE OF THE FOURTH CENTURY

There is, unfortunately, no single word, like Archaic or Classical, that we can use to designate the third phase in the development of Greek art, from c. 400 to the first century B.C. The seventy-five-year span between the end of the Peloponnesian War and the rise of Alexander the Great used to be labeled "Late Classical," the remaining two centuries and a half, "Hellenistic," a term meant to convey the spread of Greek civilization southeastward through Asia Minor to Mesopotamia, Egypt, and the borders of India. It was perhaps natural to expect that an event as world-shaking as the conquests of Alexander would also bring about an artistic revolution, but the history of style is not always in tune with political history,

in both cases, is treated as empty space from which the sketched forms seem to emerge—if the draughtsman knows how to achieve this. Not many lekythos painters were capable of bringing off the illusion. Foremost among them is the unknown artist, nicknamed the "Achilles Painter," who drew the woman in colorplate 13. Although some twenty-five years older than the Hegeso Stele, this vase shows exactly the same scene; here, too, a standing maidservant holds a box from which the deceased has just taken a piece of jewelry. There is the same mood of "Phidian" reverie, and even the chairs match almost exactly. This scene, then, was a standard subject for painted or sculptured memorials of young women. Our chief interest, however, is the masterly draughtsmanship; with a few lines, sure, fresh, and fluid, the artist not only creates a three-dimensional figure but reveals the body beneath the drapery as well. How does he manage to persuade us that these shapes exist in depth rather than merely on the surface of the vase? First of all, by his command of foreshortening. But the "internal dynamics" of the lines are equally important, their swelling and fading, which make some contours stand out boldly while

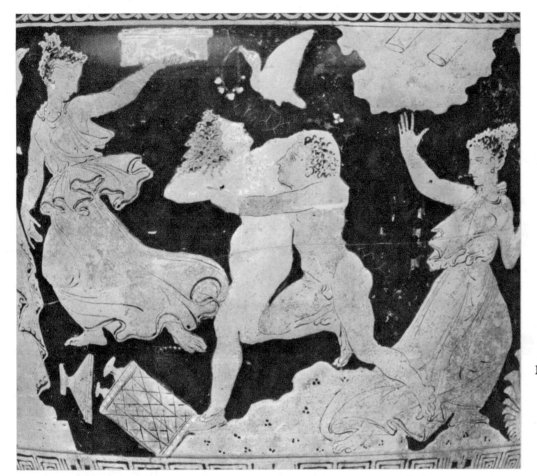

177. THE AURORA PAINTER.
Peleus and Thetis, detail of
a Faliscan vase. Early 4th century B.C.
Museo Nazionale di Villa Giulia, Rome

and we have come to realize that there was no decisive break in the tradition of Greek art at the end of the fourth century. The art of the Hellenistic era is the direct outgrowth of developments that occurred, not at the time of Alexander, but during the preceding fifty years. Here, then, is our dilemma: "Hellenistic" is a concept so closely linked with the political and cultural consequences of Alexander's conquests that we cannot very well extend it backward to the early fourth century, although there is wide agreement now that the art of the years 400–325 B.C. can be far better understood if we view it as pre-Hellenistic rather than as Late Classical. Until the right word is found and wins general acceptance, we shall have to make do with the existing terms as best we can, always keeping in mind the essential continuity of the "third phase" we are about to examine.

The Mausoleum and Scopas

The contrast between Classical and pre-Hellenistic is strikingly demonstrated by the only project of the fourth century that corresponds to the Parthenon in size and ambition. It is not a temple but a huge tomb—so huge, in fact, that its name, Mausoleum, has become a generic term for all outsized funerary monuments. It was erected

178. Reconstruction Drawing of the Mausoleum at Halicarnassus (after F. Krischen)

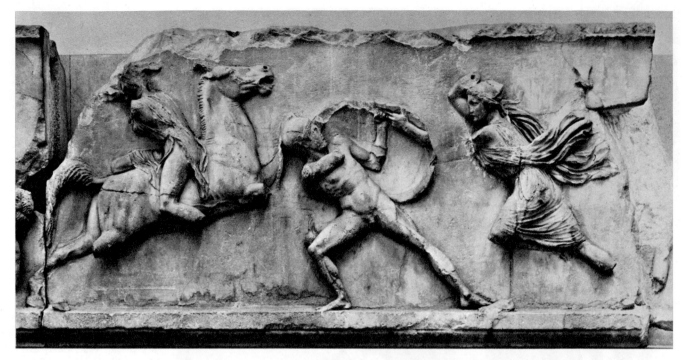

179. SCOPAS (?). *Battle of Greeks and Amazons,* from the east frieze of the Mausoleum, Halicarnassus.
359–351 B.C. Marble, height 35″. British Museum, London

at Halicarnassus in Asia Minor in the years just before
and after 350 by Mausolus, who ruled the area as a satrap
of the Persians, and by his widow Artemisia. The structure
itself is completely destroyed, but its dimensions and
general appearance can be reconstructed on the basis of
ancient descriptions and the fragments (including a good
deal of sculpture) excavated a hundred years ago. The
drawing in figure 178 does not pretend to be exact in
detail; it probably shows fewer statues than were actually
there. We do know, however, that the building rose in
three stages to a height of about 160 feet. A tall rectangu-
lar base 117 feet wide and 82 feet deep supported a col-
onnade of Ionic columns 40 feet tall, and above this rose
a pyramid crowned by a chariot with statues of the de-
ceased. The sculptural program consisted of three friezes
showing Lapiths battling Centaurs, Greeks fighting Ama-
zons, and chariot races; their combined length was twice
that of the Parthenon frieze. There were also rows of
carved guardian lions and an unknown number of large
statues, including portraits of the deceased and their an-
cestors. The commemorative and retrospective charac-
ter of the monument, based on the idea of human life as
a glorious struggle or chariot race, is entirely Greek, yet
we immediately notice the un-Greek way it has been
carried out. The huge size of the tomb, and more partic-
ularly the pyramid, derive from Egypt; they imply an
exaltation of the ruler far beyond ordinary human status.
His kinship with the gods may have been hinted at. Ap-
parently Mausolus took this view of himself as a divinely
ordained sovereign from the Persians, who in turn had

inherited it from the Assyrians and Egyptians, although
he seems to have wanted to glorify his individual per-
sonality as much as his high office. The structure embody-
ing these ambitions must have struck his contemporaries
as impressive and monstrous at the same time, with its
multiple friezes and the receding faces of a pyramid in
place of pediments above the colonnade.

According to ancient sources, the sculpture on each
of the four sides of the monument was entrusted to a
different master, chosen from among the best of the
time. Scopas, the most famous, did the main side, the
one to the east. His dynamic style has been recognized
in some portions of the Amazon frieze, such as the por-
tion in figure 179. The Parthenon tradition can still be felt
here, but there is also a decidedly un-Classical violence,
physical as well as emotional, conveyed through strained
movements and passionate facial expressions (deep-
set eyes are a hallmark of Scopas' style). As a conse-
quence, we no longer find the rhythmic flow of the Par-
thenon frieze; continuity and harmony have been sacri-
ficed so that each figure may have greater scope for
sweeping, impulsive gestures. Clearly, if we are to do
justice to this explosively energetic style we must not
judge it by Classical standards.

The "pre-Hellenistic" flavor is even more pronounced
in the portrait statue presumed to represent Mausolus
himself (fig. 180). The colossal figure must be the work
of a man younger than Scopas and even less encumbered
by Classical standards, probably Bryaxis, the master of
the north side. We know, through Roman copies, of some

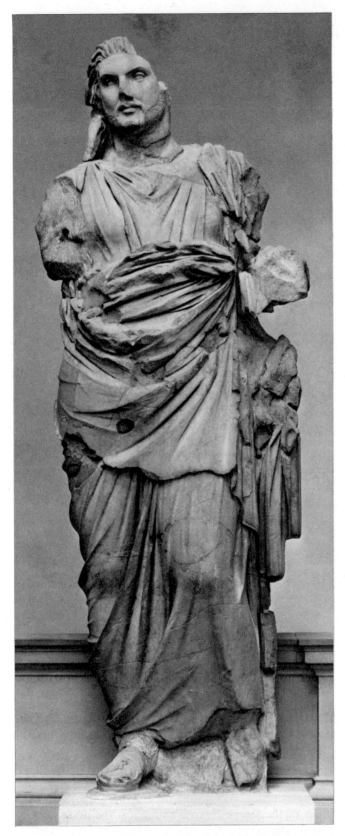

180. *"Mausolus,"* from the Mausoleum, Halicarnassus. 359–351 B.C. Marble, height 9′ 10″. British Museum, London

Greek portraits of Classical times, but they seem to represent types rather than individuals, whereas the *Mausolus* is both the earliest Greek portrait to have survived in the original and the first to show a clear-cut personal character. This very fact links it with the future rather than the past, for individual likenesses were to play an important part in Hellenistic times. Nor is it merely the head, with its heavy jaws and small, sensuous mouth, that records the sitter's appearance; the thick neck and the broad, fleshy body seem equally individual. The massiveness of the forms is further emphasized by the sharp-edged and stiff-textured drapery, which might be said to *encase,* rather than merely clothe, the body. The great volumes of folds across the abdomen and below the left arm seem designed for picturesque effect more than for functional clarity.

Praxiteles

Some of the features of the Mausoleum sculpture recur in other important works of the period. Foremost among these is the wonderful seated figure of Demeter from the temple of that goddess at Cnidus (fig. 181), a work only slightly later in date than the *Mausolus.* Here again the drapery, though more finely textured, has an impressive volume of its own; motifs such as the S-curve of folds across the chest form an effective counterpoint to the shape of the body beneath. The deep-set eyes gaze into the distance with an intensity that suggests the influence of Scopas. The modeling of the head, on the other hand, has a veiled softness that points to an altogether different source: Praxiteles, the master of feminine grace and sensuous evocation of flesh. As it happens, his most acclaimed statue, an Aphrodite, was likewise made for Cnidus, although probably some years later than the *Demeter.* But his reputation was well established even earlier, so that the unknown sculptor who carved the *Demeter* would have had no difficulty incorporating some Praxitelean qualities into his own work. The Cnidian Aphrodite by Praxiteles achieved such proverbial fame that she is often referred to in ancient literature as a synonym for absolute perfection. To what extent her renown was based on her beauty, or on the fact that she was (so far as we know) the first completely nude cult image of the goddess, is difficult to say; for the statue is known to us only through Roman copies that can be no more than pallid reflections of the original (fig. 182). She was to have countless descendants in Hellenistic and Roman art. A more faithful embodiment of Praxitelean beauty is the group of Hermes with the infant Bacchus at Olympia (fig. 183); it is of such high quality that it was long regarded as Praxiteles' own work. Today some scholars believe it to be a very fine Greek copy made some three centuries later. The dispute is of little consequence for us, except perhaps in one respect: it emphasizes the unfortunate fact that we do not have a

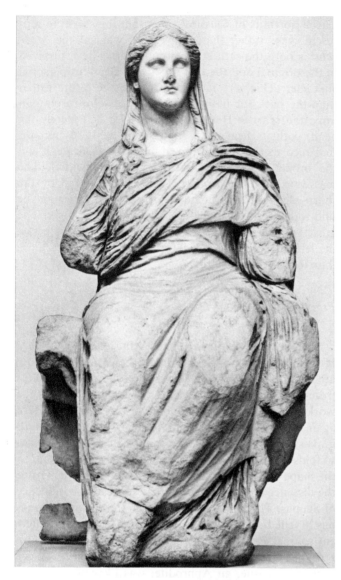

181. *Demeter,* from Cnidus.
c. 340–330 B.C. Marble, height 60″.
British Museum, London

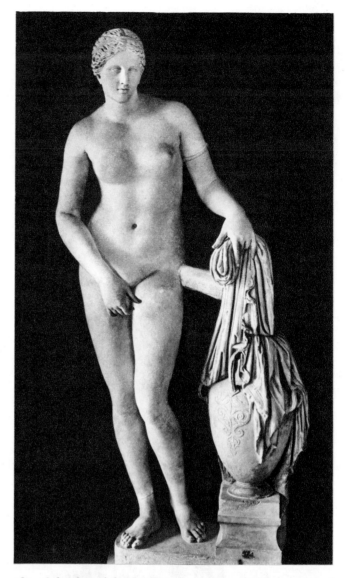

182. *Aphrodite of the Cnidians.* Roman copy after an original
of c. 330 B.C. by Praxiteles. Marble, height 6′ 8″.
Vatican Museums, Rome

single undisputed original by any of the famous sculptors of Greece. Nevertheless, the *Hermes* is the most completely Praxitelean statue we know. The lithe proportions, the sinuous curve of the torso, the play of gentle curves, the sense of complete relaxation (enhanced by the use of an outside support for the figure to lean against), all these agree well enough with the character of the Cnidian Aphrodite. We also find many refinements here that are ordinarily lost in a copy, such as the caressing treatment of the marble, the faint smile, the meltingly soft, "veiled" modeling of the features; even the hair, left comparatively rough for contrast, shares the silky feel of the rest of the work. The bland, lyrical charm of the *Hermes* makes it easy to believe that the Cnidian Aphrodite was the artist's most successful accomplishment.

The same qualities recur in many other statues, all of them Roman copies of Greek works in a more or less Praxitelean vein. The best-known—one is tempted to say the most notorious—is the *Apollo Belvedere* (fig. 184); it interests us less for its own sake than because of its tremendous popularity during the eighteenth and nineteenth centuries. Winckelmann, Goethe, and other champions of the Greek Revival thought it the perfect exemplar of classic beauty; plaster casts or reproductions of it were considered indispensable for all museums, art academies, or liberal arts colleges, and generations of students grew up in the belief that it embodied the essence of the Greek spirit. This enthusiasm tells us a good deal—not about the qualities of the *Apollo Belvedere* but about the character of the Greek Revival. Although

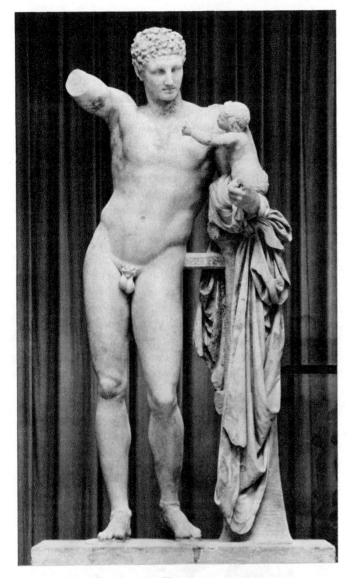

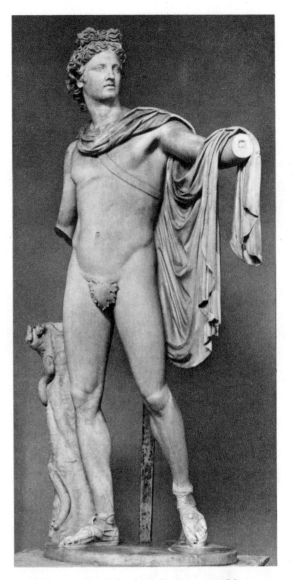

183. PRAXITELES. *Hermes.* c. 330–320 B.C.
(or copy?). Marble, height 7′ 1″.
Museum, Olympia

184. *The Apollo Belvedere.* Roman marble copy,
probably of a Greek original of the late 4th (or 1st)
century B.C. Height 7′ 4″. Vatican Museums, Rome

our own time takes a rather jaundiced view of the statue, we had better refrain from scoffing at the naïveté of our forefathers. Who knows whether the tide of taste may not turn some day? Let us not discount the possibility that the *Apollo Belvedere* may again hold a message for our grandchildren.

Lysippus

Besides Scopas and Praxiteles, there is yet another great name in pre-Hellenistic sculpture: Lysippus, whose long career may have begun as early as c. 370 and continued to the end of the century. The main features of his personal style, however, are more difficult to grasp than those of his two famous contemporaries, because

of the contradictory evidence of the Roman copies that are assumed to reproduce his work. Ancient authors praised him for replacing the canon of Polyclitus with a new set of proportions that produced a more slender body and a smaller head. His realism, too, was proverbial: he is said to have had no master other than nature itself. But these statements describe little more than a general trend toward the end of the fourth century. Certainly the proportions of Praxiteles' statues are Lysippic rather than "Polyclitan," nor could Lysippus have been the only artist of his time to conquer new aspects of reality. Even in the case of the *Apoxyomenos,* the statue most insistently linked with his name, the evidence is far from conclusive (fig. 185). It shows a young athlete cleaning himself with a scraper, a motif often represented in Greek

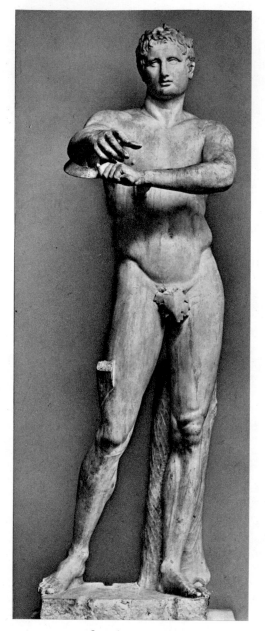

185. *Apoxyomenos (Scraper)*. Roman marble copy, probably after a bronze original of c. 330 B.C. by Lysippus. Height 6′ 9″. Vatican Museums, Rome

Of the artistic enterprises sponsored by Alexander the Great, such as the numerous portraits of the great conqueror by Lysippus, no direct evidence survives. In fact, we know very little of the development of Greek sculpture as a whole during the first hundred years of the Hellenistic era. Even after that, we have few fixed points of reference; of the large number of works at our disposal only a small fraction can be securely identified as to date and place of origin. Moreover, Greek sculpture was now being produced throughout a vast territory, and the interplay of local and international currents must have formed a complex pattern, a pattern of which we can trace only some isolated strands. One of these is represented by the bronze groups dedicated by Attalus I of Pergamum (a city in northwestern Asia Minor) between c. 240 and 200 B.C. to celebrate his victories over the Gauls. The Gauls were a Celtic tribe that had entered Asia Minor and kept raiding the Greek states there until Attalus forced them to settle down; we meet them a few centuries later as the Galatians in St. Paul's Epistle. The statues commemorating their defeat were reproduced in marble for the Romans (who may have had a special interest in them because of their troubles with Celtic tribes in northwestern Europe), and a number of these copies have sur-

186. *The Barberini Faun* (detail). Roman copy of a Greek original of c. 220 B.C. Marble, over lifesize. Glyptothek, Munich

art from Classical times on. Our version, of which only a single copy has turned up so far, is distinguished from all the others by the fact that the arms are horizontally extended in front of the body. This bold thrust into space, at the cost of obstructing the view of the torso, is a noteworthy feat, whether or not we credit it to Lysippus; it endows the figure with a new capacity for spontaneous three-dimensional movement. A similar freedom is suggested by the diagonal line of the free leg. Even the unruly hair reflects the new trend toward spontaneity.

187. *Dying Gaul*. Roman copy after
a bronze original of c. 230–220 B.C.
from Pergamum. Marble, lifesize.
Capitoline Museum, Rome

vived, including the famous *Dying Gaul* (fig. 187). The
sculptor who conceived the figure must have known the
Gauls well, for he has carefully rendered the ethnic type
in the facial structure and in the bristly shock of hair.
The torque around the neck is another characteristically
Celtic feature. Otherwise, however, the Gaul shares the
heroic nudity of Greek warriors, such as those on the
Aegina pediments (see fig. 144); and if his agony seems
infinitely more realistic in comparison, it still has consid-
erable dignity and *pathos*. Clearly, the Gauls were not
considered unworthy foes. "They knew how to die,
barbarians though they were," is the thought conveyed
by the statue. Yet we also sense something else, an animal
quality that had never before been part of the Greek
image of man. Death, as we witness it here, is a very con-
crete physical process: no longer able to move his legs,
the Gaul puts all his waning strength into his arms, as if
to prevent some tremendous invisible weight from crush-
ing him against the ground. A similar exploration of
uncontrolled bodily responses may be seen in the *Bar-
berini Faun* (fig. 186), which is probably a very fine Ro-
man copy after a Hellenistic work of the late third
century, contemporary with the *Dying Gaul*. A drunken
satyr is sprawled on a rock, asleep in the heavy-breathing,
unquiet manner of the inebriated. He is obviously dream-
ing, and the convulsive gesture of the right arm and
the troubled expression of the face betray the passionate,
disturbing nature of his dream. Here again we witness a
partial uncoupling of body and mind, no less persua-
sive than in the *Dying Gaul*.

Some decades later, we find a second sculptural style
flourishing at Pergamum. About 180 B.C., the son and
successor of Attalus I had a mighty altar erected on a
hill above the city to commemorate his father's victories.
Much of the sculptural decoration has been recovered by
excavation, and the entire west front of the altar has
been reconstructed in Berlin (fig. 188). It is an impressive
structure indeed. The altar proper occupies the center of
a rectangular court surrounded by an Ionic colonnade
which rises on a tall base about 100 feet square; a monu-
mental flight of stairs leads to the court on the west side
(fig. 189). Altar structures of such great size seem to have
been an Ionian tradition since Archaic times, but the
Pergamum Altar is the most elaborate of all, as well as
the only one of which considerable portions have sur-
vived. Its boldest feature is the great frieze covering the
base, 400 feet long and between 7 and 8 feet tall. The
huge figures, carved to such a depth that they are almost
detached from the background, have the scale and weight
of pedimental statues without the confining triangular
frame—a unique compound of two separate traditions
that represents a thundering climax in the development
of Greek architectural sculpture (fig. 190). The subject,
the battle of gods and giants, is a traditional one for Ionic
friezes; we saw it before on the Siphnian Treasury (com-
pare fig. 140). At Pergamum, however, it has a novel sig-
nificance, since the victory of the gods is meant to sym-
bolize the victories of Attalus I. Such a translation of
history into mythology had been an established device in
Greek art for a long time; victories over the Persians
were habitually represented in terms of Lapiths battling
Centaurs or Greeks fighting Amazons. But to place
Attalus I in analogy with the gods themselves implies an
exaltation of the ruler that is Oriental rather than Greek
in origin. Since the time of Mausolus, who may have
been the first to introduce it on Greek soil, the idea of
divine kingship had been adopted by Alexander the
Great and continued to flourish among the lesser sover-
eigns who divided his realm, such as the rulers of Per-
gamum. The carving of the frieze, though not very subtle

in detail, has tremendous dramatic force; the heavy, muscular bodies rushing at each other, the strong accents of light and dark, the beating wings and wind-blown garments, are almost overwhelming in their dynamism. A writhing movement pervades the entire design, down to the last lock of hair, linking the victors and the vanquished in a single continuous rhythm. It is this sense of unity that disciplines the physical and emotional violence of the struggle and thus keeps it—but just barely—from exploding its architectural frame.

Equally dramatic in its impact is another great victory monument of the early second century, the *Nike of Samothrace* (fig. 191). The goddess has just descended upon the prow of a ship; her great wings spread wide, she is still partly air-borne by the powerful head wind against which she advances. This invisible force of on-rushing air here becomes a tangible reality; it not only balances the forward movement of the figure but also shapes every fold of the wonderfully animated drapery. As a result, there is an active relationship—indeed, an interdependence—between the statue and the space that envelops it, such as we have never seen before. Nor shall we see it again for a long time to come. The *Nike of Samothrace* deserves her fame as the greatest masterpiece of Hellenistic sculpture.

Until the time of her discovery over a hundred years

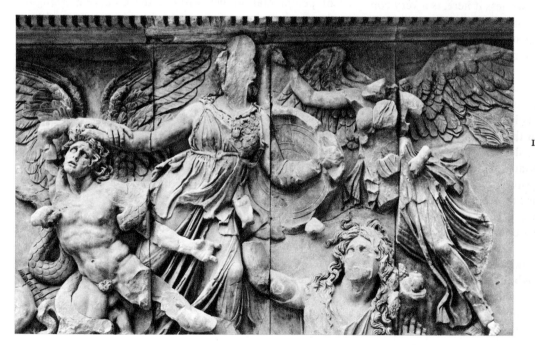

190. *Athena and Alcyoneus,*
from the east side
of the Great Frieze
of the Altar of Zeus
at Pergamum. c. 180 B.C.
Marble, height 7′ 6″.
State Museums, Berlin

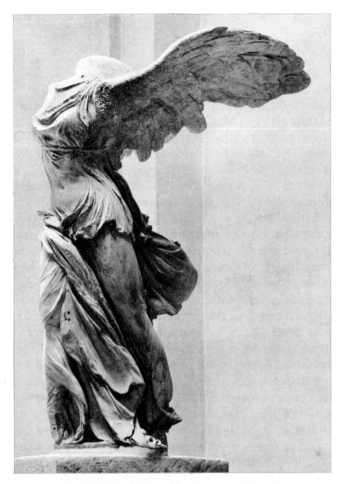

191. *Nike of Samothrace*. C. 200–190 B.C.
Marble, height 8'. The Louvre, Paris

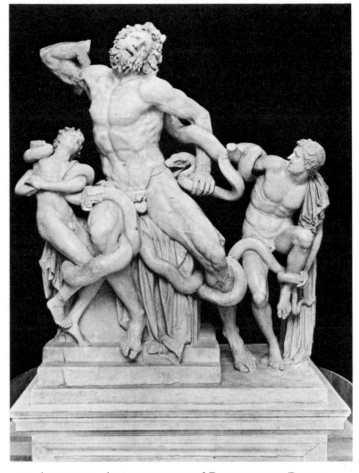

192. AGESANDER, ATHENODORUS, and POLYDORUS OF RHODES.
The Laocoön Group (present state, former restorations
removed). Late 2nd century B.C. Marble, height 7'.
Vatican Museums, Rome

ago, the most admired work of Hellenistic statuary had been a group showing the death of Laocoön and his two sons (fig. 192). It had been found in Rome as early as 1506 and had made a tremendous impression on Michelangelo and countless others. The history of its fame is rather like that of the *Apollo Belvedere;* the two were treated as complementary: the *Apollo* exemplifying harmonious beauty, the *Laocoön* sublime tragedy. Today we tend to find the pathos of the group somewhat calculated and rhetorical; its meticulous surface finish strikes us as a display of virtuoso technique. Yet, as a Greek original (according to ancient sources, by Agesander, Athenodorus, and Polydorus of Rhodes) it carries a good deal more conviction than the chilly *Apollo*. Its style, including the relief-like spread of the three figures, clearly descends from the Pergamum frieze, although its dynamism has now become uncomfortably self-conscious. On this basis we may assign it to the end of the second century. The Romans, we may assume, imported the group because the subject held a special meaning for them: the divine punishment meted out to Laocoön and his sons forewarned Aeneas of the fall of Troy and caused him to flee the city in time. Since Aeneas was believed to have come to Italy and to have been the ancestor of Romulus and Remus, the death of Laocoön could be viewed as the first link in a chain of events that ultimately led to the founding of Rome.

Portraiture, an important branch of Greek sculpture since the fourth century, continued to flourish in Hellenistic times. Its achievements, however, are known to us only indirectly for the most part, through Roman copies. One of the few originals is the very vivid bronze head from Delos, a work of the early first century B.C. (colorplate 14). It was not made as a bust but, in accordance with Greek custom, as part of a full-length statue. The identity of the sitter is unknown. Whoever he was, we get an intensely private view of him that immediately captures our interest. The fluid modeling of the somewhat flabby features, the uncertain, plaintive mouth, the unhappy eyes under furrowed brows, reveal an individual beset by doubts and anxieties, an extremely human, unheroic personality. There are echoes of Greek *pathos* in these features, but it is a pathos translated into psychological terms. Men of these particular character traits had surely existed earlier in the Greek world, just as they exist today. Yet it is significant that the inner complexity of such men could be conveyed by a work of art only when Greek independence, culturally as well as politically, was about to come to an end.

Before we leave Hellenistic sculpture, we must cast at

193. *Veiled Dancer.* c. 200 B.C.?
Bronze statuette, height 8½".
Collection Walter C. Baker, New York

We rarely think of coins as works of art, and the great majority of them do not encourage us to do so. The study of their history and development, known as numismatics, offers many rewards, but visual delight is the least of these. If many Greek coins form an exception to this general rule, it is not simply because they are the earliest (the idea of stamping metal pellets of standard weight with an identifying design originated in Ionian Greece sometime before 600 B.C.); after all, the first postage stamps were no more distinguished than their present-day descendants. The reason, rather, is the persistent individualism of Greek political life. Every city-state had its own coinage, adorned with its particular emblem, and the designs were changed at frequent intervals so as to take account of treaties, victories, or other occasions for local pride. As a consequence, the number of coins struck at any one time remained relatively small, while the number of coinages was large. The constant demand for new designs produced highly skilled specialists who took such pride in their work that they sometimes even signed it. Greek coins thus are not only an invaluable source of historical knowledge but an authentic expression of the changing Greek sense of form. Within their own compass, they illustrate the development of Greek sculpture from the sixth to the second century as faithfully as the larger works we have examined. And since they form a continuous series, with the place and date of almost every item well established, they reflect this development more fully in some respects than do the works of monumental art.

Characteristically enough, the finest coins of Archaic and Classical Greece were usually produced not by the most powerful states such as Athens, Corinth, or Sparta,

least a passing glance on another aspect of it, represented by the enchanting bronze statuette of a veiled dancer (fig. 193). She introduces us to the vast variety of small-scale works produced for private ownership. Such pieces were collected in much the same way as painted vases had been in earlier times; and, like vase pictures, they show a range of subject matter far broader than that of monumental sculpture. Besides the familiar mythological themes we encounter a wealth of everyday subjects: beggars, street entertainers, peasants, young ladies of fashion. The grotesque, the humorous, the picturesque—qualities that rarely enter into Greek monumental art—play a conspicuous role here. At their best, as in our example, these small figures have an imaginative freedom rarely matched on a larger scale. The bold spiral twist of the veiled dancer, reinforced by the diagonal folds of the drapery, creates a multiplicity of interesting views that practically forces the beholder to turn the statuette in his hands. No less extraordinary is the rich interplay of concave and convex forms, the intriguing contrast between the compact silhouette of the figure and the mobility of the body within. If we only knew when and where this little masterpiece was made!

194. *Winged God,* silver coin from Peparethus.
c. 500 B.C. Diameter 1½". British Museum, London

195. *Silenus,*
silver coin from Naxos.
c. 460 B.C. Diameter 1¹/₄″.
British Museum, London

196. *Apollo,*
silver coin from Catana.
c. 415–400 B.C. Diameter 1¹/₈″.
British Museum, London

197. *Alexander the Great
with Amun Horns,* four-drachma
silver coin issued by Lysimachus.
c. 300 B.C. Diameter 1¹/₈″.

but by the lesser ones along the periphery of the Greek world. Our first example (fig. 194), from the Aegean island of Peparethus, reflects the origin of coinage: a square die deeply embedded in a rather shapeless pellet, like an impression in sealing wax. The winged god, his pinwheel stance so perfectly adapted to the frame, is a summary-in-miniature of Archaic art, down to the ubiquitous smile. On the coin from Naxos in Sicily (fig. 195), almost half a century later, the die fills the entire area of the coin; the drinking Silenus fits it as tightly as if he were squatting inside a barrel. An astonishingly monumental figure, he shows the articulation and organic vitality of the Severe Style. Our third coin (fig. 196) was struck in the Sicilian town of Catana toward the end of the Peloponnesian War. It is signed with the name of its maker, Herakleidas, and it well deserves to be, for it is one of the true masterpieces of Greek coinage. Who would have thought it possible to endow the full-face view of a head in low relief with such plasticity! This radiant image of Apollo has all the swelling roundness of the mature Classical style. Its grandeur completely transcends the limitations of the tiny scale of a coin.

From the time of Alexander the Great onward, coins began to show profile portraits of rulers. The successors of Alexander at first put his features on their coins, to emphasize their link with the deified conqueror. Such a piece is shown in figure 197; Alexander here displays the horns identifying him with the ram-headed Egyptian god Amun. His "inspired" expression, conveyed by the half-open mouth and the upward glance of the eyes, is as characteristic of the emotionalism of Hellenistic art as the fluid modeling of the features and the agitated, snakelike hair. As a likeness, the head can have only the most tenuous relation to the way Alexander actually looked; yet this idealized image of the all-conquering genius projects the flavor of the new era more eloquently than do the large-scale portraits of Alexander. Once the

198. *Antimachus of Bactria,* silver coin. c. 185 B.C.
Diameter 1¹/₄″. British Museum, London

Hellenistic rulers started putting themselves on their coins, the likenesses became more individual. Perhaps the most astonishing of these (fig. 198) is the head of Antimachus of Bactria (present-day Afghanistan), which stands at the opposite end of the scale from the Alexander-Amun. Its mobile features show a man of sharp intelligence and wit, a bit skeptical perhaps about himself and others, and, in any event, without any desire for self-glorification. This penetratingly human portrait seems to point the way to the bronze head from Delos (colorplate 14) a hundred years later. It has no counterpart in the monumental sculpture of its own time, and thus helps to fill an important gap in our knowledge of Hellenistic portraiture.

6

ETRUSCAN ART

The Italian peninsula did not emerge into the light of history until fairly late. The bronze age came to an end there only in the eighth century B.C., about the time the earliest Greeks began to settle along the southern shores of Italy and in Sicily. Even earlier, if we are to believe the Classical Greek historian Herodotus, another great migration had taken place: the Etruscans had left their homeland of Lydia in Asia Minor and settled in the area between Florence and Rome which to this day is known as Tuscany, the country of the Tusci or Etrusci. Who were the Etruscans? Did they really come from Asia Minor? Strange as it may seem, Herodotus' claim is still the subject of lively debate among scholars. We know that the Etruscans borrowed their alphabet from the Greeks toward the end of the eighth century, but their language—of which our understanding is as yet very limited—has no kin among any known tongues. Culturally and artistically, the Etruscans are strongly linked with Asia Minor and the ancient Near East, yet they also show many traits for which no parallels can be found anywhere. Might they not, then, be a people whose presence on Italian soil goes back to the time before the Indo-European migrations of c. 2000–1200 B.C. which brought the Mycenaeans and the Dorian tribes to Greece and the ancestors of the Romans to Italy? If so, the sudden flowering of Etruscan civilization from about 700 B.C. onward could have resulted from a fusion of this prehistoric Italian stock with small but powerful groups of seafaring invaders from Lydia in the course of the eighth century. Interestingly enough, such a hypothesis comes very close to the legendary origin of Rome; the Romans believed that their city had been founded in 753 B.C. by the descendants of refugees from Troy (see page 143) in Asia Minor. Was this perhaps an Etruscan story which the Romans later made their own, along with a great many other things they took from their predecessors?

What the Etruscans themselves believed about their origin we do not know. The only Etruscan writings that have come down to us are brief funerary inscriptions and a few somewhat longer texts relating to religious ritual, though Roman authors tell us that a rich Etruscan literature once existed. We would, in fact, know practically nothing about the Etruscans at first hand were it not for their elaborate tombs, which the Romans did not molest when they destroyed or rebuilt Etruscan cities

and which therefore have survived intact until modern times. Italian bronze-age burials had been of the modest sort found elsewhere in prehistoric Europe: the remains of the deceased, contained in a pottery vessel or urn, were placed in a simple pit along with the equipment they required in afterlife (weapons for men, jewelry and household tools for women). In Mycenaean Greece, this primitive cult of the dead had been elaborated under Egyptian influence, as shown by the monumental beehive tombs. Something very similar happened eight centuries later in Tuscany. Toward 700 B.C., Etruscan tombs began to imitate, in stone, the interiors of actual dwellings, covered by great conical mounds of earth; they could be roofed by vaults or domes built of horizontal, overlapping courses of stone blocks, as was the Treasury of Atreus at Mycenae (see fig. 115). And at the same time, the pottery urns gradually took on human shape: the lid grew into the head of the deceased, and body markings appeared on the vessel itself, which could be placed on a sort of throne to indicate high rank (fig. 199). Alongside the modest beginnings of funerary sculpture, we find sudden evidence of great wealth in the form of exquisite goldsmith's work decorated with motifs familiar from the Orientalizing Greek vases of the same period, and intermingled with precious objects imported from the ancient Near East. The seventh and sixth centuries B.C. saw the Etruscans at the height of their power. Their cities rivaled those of the Greeks, their fleet dominated the western Mediterranean and protected a vast commercial empire competing with the Greeks and Phoenicians, and their territory extended as far as Naples in the south and the lower Po valley in the north. Rome itself was ruled by Etruscan kings for about a century, until the establishing of the Republic in 510 B.C. The kings threw the first defensive wall around the seven hills, drained the swampy plain of the Forum, and built the original temple on the Capitoline Hill, thus making a city out of what had been little more than a group of villages before. But the Etruscans, like the Greeks, never formed a unified nation; they were no more than a loose federation of individual city-states given to quarreling among themselves and slow to unite against a common enemy. During the fifth and fourth centuries, one Etruscan city after the other succumbed to the Romans; by the end of the third, all of them had lost their independ-

199. Human-Headed Cinerary Urn. c. 675–650 B.C.
Terracotta, height 25 1/2″. Etruscan Museum, Chiusi

ence, although many continued to prosper, if we are to judge by the richness of their tombs during the period of political decline.

TOMBS AND THEIR DECORATION

The flowering of Etruscan civilization thus coincides with the Archaic age in Greece. It was during this period, especially toward the end of the sixth and the early years of the fifth century, that Etruscan art showed its greatest vigor. Greek Archaic influence had displaced the Orientalizing tendencies—many of the finest Greek vases have been found in Etruscan tombs of that time—but Etruscan artists did not simply imitate their Hellenic models.

Working in a very different cultural setting, they retained their own clear-cut identity. One might expect to see the Etruscan cult of the dead wane under Greek influence, but that was by no means the case. On the contrary, the tombs and their equipment grew more elaborate as the capacities of the sculptor and painter expanded. The deceased themselves could now be represented full-length, reclining on the lids of sarcophagi shaped like couches, as if they were participants in a festive repast, an Archaic smile about their lips. The monumental example in figure 200 shows a husband and wife side by side, strangely gay and majestic at the same time. The entire work is of terracotta and was once painted in bright colors. The smoothly rounded, elastic forms betray the Etruscan sculptor's preference for modeling in soft materials, in contrast to the Greek love of stone carving; there is less formal discipline here but an extraordinary directness and vivacity. We do not know precisely what ideas the Archaic Etruscans held about man's afterlife. Effigies such as our reclining couple, which for the first time in history represent the deceased as thoroughly alive and enjoying themselves, suggest that they regarded the tomb as an abode not only for the body but for the soul as well (in contrast to the Egyptians, who thought of the soul as roaming freely and whose funerary sculpture therefore remained "inanimate"). Or perhaps the Etruscans believed that by filling the tomb with banquets, dancing, games, and similar pleasures they could induce the soul to stay put in the city of the dead and therefore not haunt the realm of the living. How else are we to understand the purpose of the wonderfully rich array of murals in these funerary chambers? Since nothing of the sort has survived in Greek territory, they are uniquely important, not only as an Etruscan achievement but also as a possible reflection of Greek wall painting. Perhaps the most as-

200. Sarcophagus, from Cerveteri.
c. 520 B.C. Terracotta, length 6′ 7″.
Museo Nazionale di Villa Giulia, Rome

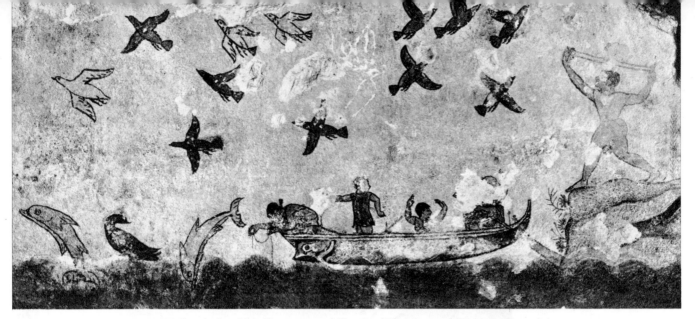

201. Wall painting (detail). c. 520 B.C. Tomb of Hunting and Fishing, Tarquinia

tonishing of them all is the great marine panorama of c. 520 B.C. in the Tomb of Hunting and Fishing at Tarquinia, of which figure 201 shows the best-preserved portion: a vast, continuous expanse of water and sky in which the fishermen, and the hunter with his slingshot, play only an incidental part. The free, rhythmic movement of birds and dolphins is strangely reminiscent of Minoan painting of a thousand years earlier (see fig. 110) but the weightless, floating quality of Cretan art is absent. We might also recall Exekias' *Dionysus in a Boat* (fig. 129) as the closest Greek counterpart to our scene. The differences here, however, are as revealing as the similarities, and one wonders if any Greek Archaic artist knew how to place man in a natural setting as effectively as the Etruscan painter did. Could the mural have been inspired by Egyptian scenes of hunting in the marshes, such as the one in figure 65? They seem the most convincing precedent for the general conception of our subject. If so, the Etruscan artist has brought the scene to life, just as the reclining couple in figure 200, has been brought to life compared with Egyptian funerary statues. A somewhat later example, from another tomb in Tarquinia (colorplate 15), shows a pair of ecstatic dancers; the passionate energy of their movements again strikes us as characteristically Etruscan rather than Greek in spirit. Of particular interest is the transparent garment of the woman, which lets the body shine through. In Greece, this differentiation appears only a few years earlier, in the final phase of Archaic vase painting. The contrasting body color of the two figures continues a practice introduced by the Egyptians more than two thousand years before (see colorplate 3).

During the fifth century, the Etruscan view of the hereafter must have become a good deal more complex and less festive. We notice the change immediately if we compare the group in figure 202, a cinerary container carved of soft local stone soon after 400 B.C., with its predecessor in figure 200. The woman now sits at the foot of the couch, but she is not the wife of the young man; her wings indicate that she is the demon of death, and the scroll in her left hand records the fate of the deceased. The young man is pointing to it as if to say, "Behold, my time has come." The thoughtful, melancholy air of the two figures may be due to some extent to the influence of Classical Greek art which pervades the style of our group. At the same time, however, a new mood of uncertainty and regret is reflected: man's destiny is in the hands of inexorable supernatural forces; death is the great divide rather than a continuation, albeit on a different plane, of life on earth. In later tombs, the demons of death gain an ever more fearful aspect; other, more terrifying demons enter the scene, often battling against benevolent spirits for possession of the soul of the deceased. One of these demons appears in the center of figure 203, a tomb of the third century B.C. at Cerveteri, richly decorated with stucco reliefs rather than paintings. The entire chamber, cut into the live rock, closely imitates the interior of a house, including the beams of the roof. The sturdy pilasters (note the capitals, which recall the Aeolian type from Asia Minor in fig. 158), as well as the wall surfaces between the niches, are covered with exact reproductions of weapons, armor, household implements, small domestic animals, and busts of the deceased. In such a setting, the snake-legged demon and his three-headed hound (whom we recognize as Cerberus, the guardian of the infernal regions) seem particularly disquieting.

TEMPLES AND THEIR DECORATION

Only the stone foundations of Etruscan temples have survived, since the buildings themselves were wooden. Apparently the Etruscans, although they were masters of masonry construction for other purposes, rejected for religious reasons the use of stone in temple architecture. The design of their sanctuaries bears a general resemblance to the simpler Greek temples but with several distinctive features, some of which were to be perpetuated by the Romans. The entire structure rests on a tall base,

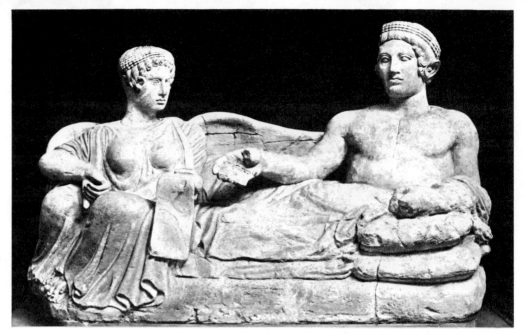

202. *Youth and Demon of Death* (cinerary container). Early 4th century B.C. Stone (pietra fetida), length 47″. Archaeological Museum, Florence

or podium, that is no wider than the cella and has steps only on the south side; these lead to a deep porch, supported by two rows of four columns each, and to the cella beyond. The cella is generally subdivided into three compartments, for Etruscan religion was dominated by a triad of gods, the predecessors of the Roman Juno, Jupiter, and Minerva. The Etruscan temple, then, must have been of a squat, squarish shape compared to the graceful Greek sanctuaries, and more closely linked with domestic architecture. Needless to say, it provided no place for stone sculpture; the plastic decoration usually consisted of terracotta plaques covering the architrave and the edges of the roof. Only after 400 B.C. do we occasionally find

large-scale terracotta groups designed to fill the pediment above the porch. We know, however, of one earlier attempt—and an astonishingly bold one—to find a place for monumental sculpture on the exterior of an Etruscan temple. The so-called Temple of Apollo at Veii, not very far north of Rome, a structure of standard type in every other respect, had four lifesize terracotta statues on the ridge of its roof, seen also in the reconstruction model (fig. 204). They formed a dramatic group of the sort we might expect in Greek pedimental sculpture: the contest of Hercules and Apollo for the sacred hind, in the presence of other deities. The best preserved of these figures, the *Apollo* (fig. 205), has long been acknowledged

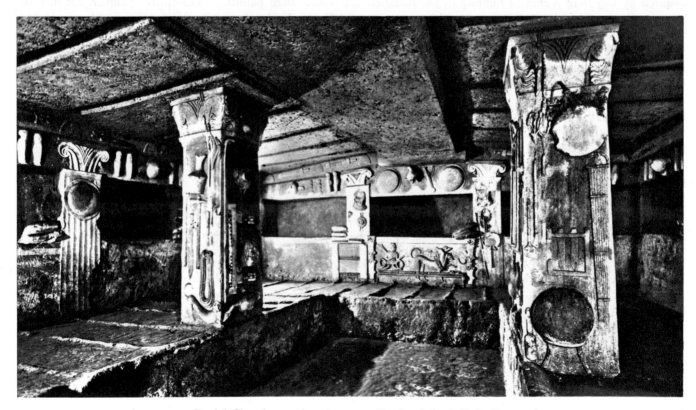

203. Burial Chamber. 3rd century B.C. Tomb of the Reliefs, Cerveteri

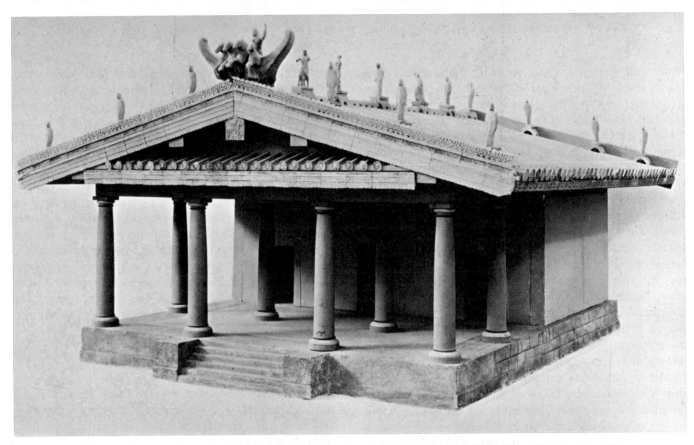

204. Reconstruction of an Etruscan Temple. Istituto di Etruscologia e Antichità Italiche, University of Rome

as the masterpiece of Etruscan Archaic sculpture. His massive body, completely revealed beneath the ornamental striations of the drapery; the sinewy, muscular legs; the hurried, purposeful stride—all these betray an expressive power that has no counterpart in free-standing Greek statues of the same date. That Veii was indeed a sculptural center at the end of the sixth century seems to be confirmed by the Roman tradition that the last of the Etruscan rulers of the city called on a master from Veii to make the terracotta image of Jupiter for the temple on the Capitoline Hill. This image has disappeared, but an even more famous symbol of Rome, the bronze figure of the she-wolf that nourished Romulus and Remus, is still in existence (fig. 206). The two babes are Renaissance additions, and the early history of the statue is obscure; some scholars, therefore, have even suspected it of being a medieval work. Nevertheless, it is almost surely an Etruscan Archaic original, for the wonderful ferocity of expression, the latent physical power of the body and legs have the same awesome quality we sense in the *Apollo* from Veii. In any event, the she-wolf as the totemic animal of Rome has the strongest links with Etruscan mythology, in which wolves seem to have played an important part from very early times.

PORTRAITURE AND METALWORK

The Etruscan concern with effigies of the deceased might lead us to expect an early interest in individual portraiture. Yet the features of such funerary images as those in figures 200 and 202 are entirely impersonal, and

205. *Apollo*, from Veii. c. 510 B.C. Terracotta, height 69". Museo Nazionale di Villa Giulia, Rome

it was only toward 300 B.C., under the influence of Greek portraiture, that individual likenesses began to appear in Etruscan sculpture. The finest of them are not funerary portraits, which tend to be rather crude and perfunctory, but the heads of bronze statues. That of a boy (fig. 207) is a real masterpiece of its kind; the firmness of the modeling lends a special poignancy to the sensitive mouth and the gentle, melancholy eyes. No less impressive is the very high quality of the casting and finishing, which bears out the ancient fame of the Etruscans as master craftsmen in metal. Their ability in this respect was of long standing, for the wealth of Etruria was founded on the exploitation of copper and iron deposits. From the sixth century on, they produced vast quantities of bronze statuettes, mirrors, and such, both for export and domestic consumption. The charm of these small pieces is well displayed by the engraved design on the back of a mirror done soon after 400 B.C. (fig. 208). Within an undulating wreath of vines, we see a winged old man, identified as Chalchas, examining a strange object. The draughtsmanship is so beautifully balanced and assured that we are tempted to assume that Classical Greek art was the direct source of inspiration. So far as the style of our piece is concerned, this may well be the case, but the subject is uniquely Etruscan, for the winged genius is gazing at the liver of a sacrificial animal. He exemplifies a practice that loomed as large in the lives of the Etruscans as the care of the dead: the search for omens or portents. The Etruscans believed that the will of the gods manifested itself through signs in the natural world, such as thunderstorms or the flight of birds, and that by reading them man could find out whether the gods smiled or frowned upon his enterprises. The priests who knew the secret language of these signs enjoyed enormous prestige; even the Romans were in the habit of consulting them before any major public or private event. Divination (as the Romans called the art of interpreting omens) can be traced back to ancient Mesopotamia—nor was the practice unknown in Greece—but the Etruscans carried it

further than any of their predecessors. They put especial trust in the livers of sacrificial animals, on which, they thought, the gods had inscribed the hoped-for divine message. In fact, they viewed the liver as a sort of microcosm, divided into regions that corresponded, in their mind, to the regions of the sky. Weird and irrational as they were, these practices became part of our cultural heritage, and echoes of them persist to this day. True, we no longer try to tell the future by watching the flight of birds or examining animal livers, but tea leaves and horoscopes are still "ominous" to many people; and we speak of auspicious events, that is, of events indicating a favorable future, unaware that "auspicious" originally referred to a favorable flight of birds. Perhaps we do not believe very seriously that four-leaf clovers bring good luck and black cats bad luck, yet a surprising number of us admit to being superstitious.

CITIES

According to Roman writers, the Etruscans were masters of architectural engineering, and of town planning and surveying. That the Romans learned a good deal from them can hardly be doubted, but exactly how much the Etruscans contributed to Roman architecture is difficult to say, since hardly anything of Etruscan or early Roman architecture remains standing above ground. Roman temples certainly retained many Etruscan features, and the atrium, the central hall of the Roman house (see fig. 230), likewise originated in Etruria. In town planning and surveying, too, the Etruscans have a good claim to priority over the Greeks. The original homeland of the Etruscans, Tuscany, was too hilly to encourage geometric schemes; however, when they colonized the flatlands south of Rome in the sixth century, they laid out their newly founded cities as a network of streets centering on the intersection of two main thoroughfares, the *cardo* (which ran north and south) and the *decumanus* (which ran east and west). The four quarters thus obtained could be further subdivided or expanded, according to need. This system, which the Romans adopted for the new cities they were to found throughout Italy, western Europe, and North Africa, may have been derived from the plan of Etruscan military camps. Yet it also seems to reflect the religious beliefs that made the Etruscans divide the sky into regions according to the points of the compass and place their temples along a north-south axis.

The Etruscans must also have taught the Romans how to build fortifications, bridges, drainage systems, and aqueducts, but very little remains of their vast enterprises in these fields. The only truly impressive surviving monument is the Porta Augusta in Perugia, a fortified city gate of the second century B.C. (fig. 209). The gate itself, recessed between two massive towers, is not a mere gateway but an architectural façade. The tall opening is spanned by a semicircular arch, framed by a molding;

206. *She-Wolf.* c. 500 B.C. Bronze, height 33 1/2".
Capitoline Museums, Rome

207. *Portrait of a Boy*. Early 3rd century B.C.
Bronze, height 9″. Archaeological Museum, Florence

208. Engraved Back of a Mirror.
c. 400 B.C. Bronze, diameter 6″.
Vatican Museums, Rome

above it is a balustrade of dwarf pilasters alternating with round shields, a pattern obviously derived from the triglyphs and metopes of the Doric frieze; it supports a second arched opening (now filled in) flanked by two larger pilasters. The arches here are true, which means they are constructed of wedge-shaped blocks, called voussoirs, pointing toward the center of the semicircular opening. Such an arch is strong and self-sustaining, in contrast to the "false" arch composed of horizontal courses of masonry or brickwork (as is the opening above the lintel of the Lion Gate at Mycenae, fig. 120). The true arch, and its extension, the barrel vault, had been discovered in Egypt as early as c. 2700 B.C., but the Egyptians had used it mainly in underground tomb structures and in utilitarian buildings (fig. 73), never in temples.

Apparently they thought it unsuited to monumental architecture. In Mesopotamia, the true arch was used for city gates (see fig. 92, colorplate 7) and perhaps elsewhere as well—to what extent we cannot determine for lack of preserved examples. The Greeks knew the principle from the fifth century on, but they confined the use of the true arch to underground structures or to simple gateways, refusing to combine it with the elements of the architectural orders. And herein lies the importance of the Porta Augusta: it is the first instance we know in which arches were integrated with the vocabulary of the Greek orders into a monumental whole. The Romans were to develop this combination in a thousand ways, but the merit of having invented it, of having made the arch respectable, seems to belong to the Etruscans.

209. Porta Augusta,
Perugia. 2nd century B.C.

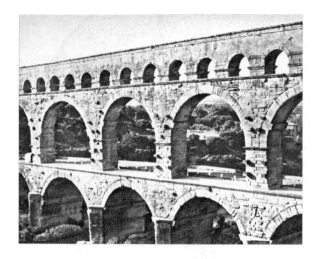

7

ROMAN ART

Among the civilizations of the ancient world, that of the Romans is far more accessible to us than any other. The growth of the Roman domain from city-state to Empire; its military and political struggles, its changing social structure, the development of its institutions; the public and private lives of its leading personalities—all these we can trace with a wealth of detail that never ceases to amaze us. Nor is this a matter of chance. The Romans themselves seem to have wanted it that way. Articulate and posterity-conscious, they have left us a vast literary legacy, from poetry and philosophy to humble inscriptions recording everyday events, and an equally huge mass of visible monuments that were scattered throughout their Empire, from England to the Persian Gulf, from Spain to Romania. Yet, paradoxically, there are few questions more embarrassing to the historian than "What is Roman art?" The Roman genius, so clearly recognizable in every other sphere of human activity, becomes

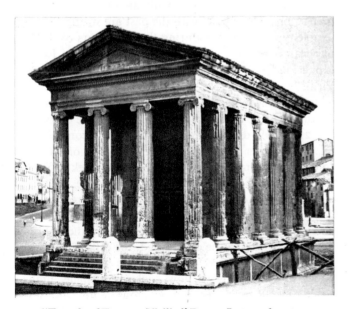

210. "Temple of Fortuna Virilis," Rome. Late 2nd century B.C.

oddly elusive when we ask whether there was a characteristic Roman style in the fine arts. Why is this so? The most obvious reason is the great admiration the Romans had for Greek art of every period and variety. Not only did they import originals of earlier date—Archaic, Classical, and Hellenistic—by the thousands, and have them copied in even greater numbers; their own production was clearly based on Greek sources, and many of their artists, from Republican times to the end of the Empire, were of Greek origin. Moreover, Roman authors show little concern with the art of their own time. They tell us a good deal about the development of Greek art as described in Greek writings on the subject, or they speak of artistic production during the early days of the Roman Republic, of which not a trace survives today, but rarely about contemporary works. While anecdotes or artists' names may be mentioned incidentally in other contexts, the Romans never developed a rich literature on the history, theory, and criticism of art such as had existed among the Greeks. Nor do we hear of Roman artists who enjoyed individual fame, although the great names of Greek art—Polyclitus, Phidias, Praxiteles, Lysippus, etc.—were praised as highly as ever.

One might well be tempted to conclude, therefore, that the Romans themselves looked upon the art of their time as being in decline compared with the great Greek past, whence all important creative impulses had come. This, indeed, was the prevalent attitude among scholars until not very long ago. Roman art, they claimed, is essentially Greek art in its final decadent phase—Greek art under Roman rule; there is no such thing as Roman style, there is only Roman subject matter. Yet the fact remains that, as a whole, the art produced under Roman auspices does look distinctly different from Greek art; otherwise our problem would not have arisen. If we insist on evaluating this difference by Greek standards, it will appear as a process of decay. If, on the other hand, we interpret it as expressing different, un-Greek intentions, we are likely to see it in a less negative light; and once we admit that art under the Romans had positive un-Greek qualities,

211. "Temple of the Sibyl," Tivoli. Early 1st century B.C.

212. Plan of the "Temple of the Sibyl," Tivoli

we cannot very well regard these innovations as belonging to the final phase of Greek art, no matter how many artists of Greek origin we may find in Roman records. Actually, the Greek names of these men do not signify much; most of the artists, it seems, were thoroughly "Romanized." The Empire was a cosmopolitan society in which national or regional traits were soon absorbed into the common all-Roman pattern set by the capital, the city of Rome. In any event, the great majority of Roman works of art are unsigned, and their makers, for all we know, may have come from any part of the far-flung Roman domain. But Roman society from the very start proved astonishingly tolerant of alien traditions; the all-Roman pattern had a way of accommodating them all, so long as they did not threaten the security of the state. The populations of newly conquered provinces were not forced into a uniform strait jacket but, rather, were put into a fairly low-temperature melting pot. Law and order, and a token reverence for the symbols of

Roman rule, were imposed on them; at the same time, however, their gods and sages were hospitably received in the capital, and eventually they themselves would be given the rights of citizenship. Roman civilization—and Roman art—thus acquired not only the Greek heritage but, to a lesser extent, that of the Etruscans and of Egypt and the Near East as well. All this made for an extraordinarily complex and open society, homogeneous and diverse at the same time. The sanctuary of Mithras accidentally unearthed a few years ago in the center of London offers a striking illustration of the cosmopolitan character of Roman society: the god is Persian in origin but he had long since become a Roman "citizen," and his sanctuary, thoroughly and uniquely Roman in form, can be matched by hundreds of others throughout the Empire.

Under such conditions, it would be little short of a miracle if Roman art were to show a consistent style such as we found in Egypt, or the clear-cut evolution that distinguishes the art of Greece. Its development—to the extent that we understand it today—might be likened to a counterpoint of divergent tendencies that may exist side by side, even within a single monument, and none of which ever emerges as overwhelmingly dominant. The "Romanness" of Roman art must be found in this complex pattern, rather than in a single and consistent quality of form.

ARCHITECTURE

If the autonomy of Roman sculpture and painting has been questioned, Roman architecture is a creative feat of such magnitude as to silence all doubts of this sort. Its growth, moreover, from the very start reflected a specifically Roman way of public and private life, so that whatever elements had been borrowed from Etruscans or Greeks were soon marked with an unmistakable Roman stamp. These links with the past are strongest in the temple types developed during the later years of the Republican period (510–60 B.C.), the heroic age of Roman expansion. The delightful small "Temple of Fortuna Virilis" (the name is sheer fancy, for the sanctuary seems to have been dedicated to the Roman god of harbors, Portunus) is the oldest well-preserved example of its kind (fig. 210). Built during the last years of the second century B.C., it suggests, in the elegant proportions of its Ionic columns and entablature, the wave of Greek influence that followed the Roman conquest of Greece. Still, it is no mere copy of a Greek temple, for we recognize a number of Etruscan elements: the high podium, the deep porch, and the wide cella, which engages the columns of the peristyle. On the other hand, the cella is no longer subdivided into three compartments as it had been under the Etruscans; it now encloses a single, unified space. The Romans needed spacious temple interiors, since they used them not only for the image of the deity

but also for the display of trophies (statues, weapons, etc.) brought back by their conquering armies. The "Temple of Fortuna Virilis" thus represents a well-integrated new type of temple designed for Roman requirements, not a haphazard cross of Etruscan and Greek elements. It was to have a long life; numerous examples of it, usually larger and with Corinthian columns, can be found as late as the second century A.D., both in Italy and in the provincial capitals of the Empire.

Another type of Republican temple is seen in the so-called Temple of the Sibyl at Tivoli (figs. 211, 212), erected a few decades later than the "Temple of Fortuna Virilis." It, too, was the result of the merging of two separate traditions. Its original ancestor was a structure in the center of Rome in which the sacred flame of the city was kept. This building at first had the shape of the traditional round peasant huts in the Roman countryside; later on it was redesigned in stone, under the influence of Greek structures of the tholos type (see page 124), and thus became the model for the round temples of late Republican times. Here again we find the high podium, with steps only opposite the entrance, and a graceful Greek-inspired exterior. As we look closely at the cella, however, we notice that while the door and window frames are of cut stone, the walls are built in a technique we have not encountered before. They are made of concrete—a mixture of mortar and gravel with rubble (that is, small pieces of building stone, brick, etc.), and, in this instance, faced with small, flat pieces of stone. This mode of construction had been invented in the Near East more than a thousand years earlier but had been used mainly for fortifications; it was the Romans who developed its potentialities until it became their chief building technique. Its advantages are obvious: strong, cheap, and flexible, it alone made possible the vast architectural enterprises that are still the chief mementos of "the grandeur that was Rome." The Romans knew how to hide the unattractive concrete surface behind a facing of brick, stone, or marble, or by covering it with smooth plaster. Today, this decorative skin has disappeared from the remains of most Roman buildings, leaving the concrete core exposed and thus depriving these ruins of the appeal that Greek ruins have for us. They speak to us in other ways, through massive size and boldness of conception.

The oldest monument in which these qualities are fully in evidence is the Sanctuary of Fortuna Primigenia at Palestrina, in the foothills of the Apennines east of Rome. Here, in what had once been an important Etruscan stronghold, a strange cult had been established since early times, dedicated to Fortuna (Fate) as a mother deity and combined with a famous oracle. The Roman sanctuary dates from the early first century B.C.; its size and shape were almost completely hidden by the medieval town that had been built over it, until a bombing attack in 1944 destroyed most of the later houses and thus laid bare the remains of the huge ancient temple precinct, which has been thoroughly explored during the past decade. A series of ramps and terraces (clearly visible in fig. 213) lead up to a great colonnaded court, from which we ascend, on a flight of steps arranged like the seats of a Greek theater, to the semicircular colonnade that crowned the entire structure (compare fig. 214). Arched openings, framed by engaged columns and entablatures, play an important part in the elevation, just as semicircular recesses do in the plan. One of the latter appears in our view of the lower terrace (fig. 215); it is covered by a barrel vault, another characteristic feature of the Roman architectural vocabulary. Except for the columns and architraves, all the surfaces now visible are of concrete, like the cella of the round temple at Tivoli, and it is indeed hard to imagine how a complex as vast as this could have been constructed otherwise. What makes the sanctuary of Palestrina so imposing, however, is not merely its scale but the superb way it fits the site. An entire hillside, comparable to the Acropolis of Athens in its commanding position, has been transformed and articulated so that the architectural forms seem to grow out of the rock, as if man had simply completed a design laid out by nature herself. Such a molding of great open spaces had never been possible—or even desired—in the Classical Greek world; the only comparable projects are found in Egypt (see the Temple of Hatshepsut, figs. 69, 70). Nor did it express the spirit of the Roman Republic. Significantly enough, the Palestrina sanctuary dates from the time of Sulla, whose absolute dictatorship (82–79 B.C.) marked the transition from Republican government to the one-man rule of Julius Caesar and his Imperial successors. Since Sulla had won a great victory against his enemies in the civil war at Palestrina, it is tempting to assume that he personally ordered the sanctuary built, both as a thanks offering to Fortuna and as a monument to his own fame. If so, the Palestrina complex may well have inspired Julius Caesar, who toward the end of his life sponsored a project planned on a similar scale in Rome itself: the Forum Julium, a great architecturally framed square adjoining the Temple of Venus Genetrix, the mythical ancestress of Caesar's family. Here the merging of religious cult and personal glory is even more overt. This Forum of Caesar set the pattern for all the later Imperial forums, which were linked to it by a common major axis (fig. 216), forming the most magnificent architectural sight of the Roman world. Unfortunately, nothing is left of the forums today but a stubbly field of ruins that conveys little of their original splendor.

SECULAR ARCHITECTURE

The arch and vault, which we encountered at Palestrina as an essential part of Roman monumental architecture, also formed the basis of construction projects such as sewers, bridges, and aqueducts, designed for efficiency rather than beauty. The first enterprises of this kind were built to serve the city of Rome as early as the end of the fourth century B.C.; only traces of them sur-

213. Sanctuary of Fortuna Primigenia, Praeneste (Palestrina). Early 1st century B.C.

214. Reconstruction Model
of the Sanctuary
of Fortuna Primigenia
at Praeneste (Palestrina).
Archaeological Museum,
Palestrina

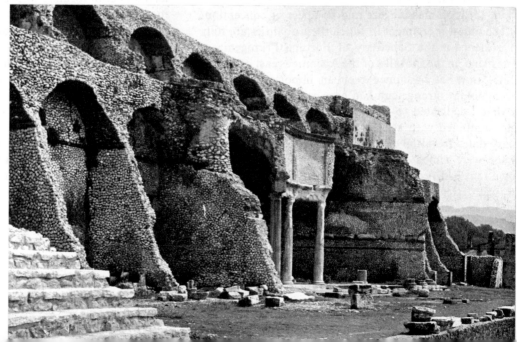

215. Lower Terraces,
Sanctuary of Fortuna Primigenia
at Praeneste (Palestrina)

vive today. There are, however, numerous others of later date throughout the Empire, such as the exceptionally well-preserved aqueduct at Nîmes in southern France known as the Pont du Gard (fig. 217). Its rugged, clean lines which span the wide valley are a tribute not only to the high quality of Roman engineering but also to the sense of order and permanence that inspired these efforts. The qualities we meet here impress us again in the Colosseum, the enormous amphitheater for gladiatorial games in the center of Rome (figs. 218–220). Completed in 80 A.D., it is, in terms of mass, one of the largest single buildings anywhere; when intact, it accommodated more than 50,000 spectators. The concrete core, with its miles of vaulted corridors and stairways, is a masterpiece of engineering efficiency to ensure the smooth flow of traffic to and from the arena. It utilizes both the familiar barrel vault and a more complex form, the groined vault (see fig. 220), which results from the interpenetration of two barrel vaults at right angles. The exterior, dignified and monumental, reflects the interior articulation of the structure but clothes and accentuates it in cut stone. There is a fine balance between vertical and horizontal elements in the framework of engaged columns and entablatures that contains the endless series of arches. The three Classical orders are superimposed according to their intrinsic "weight": Doric, the oldest and most severe, on the ground floor, followed by Ionic and Corinthian. The lightening of the proportions, however, is barely noticeable; the orders, in their Roman adaptation, are almost alike. Structurally, they have become ghosts, yet their aesthetic function continues unimpaired, for it is through them that this enormous façade becomes related to the human scale.

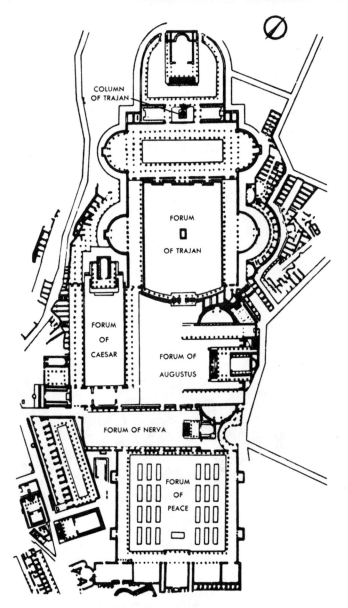

216. Plan of the Forums at Rome

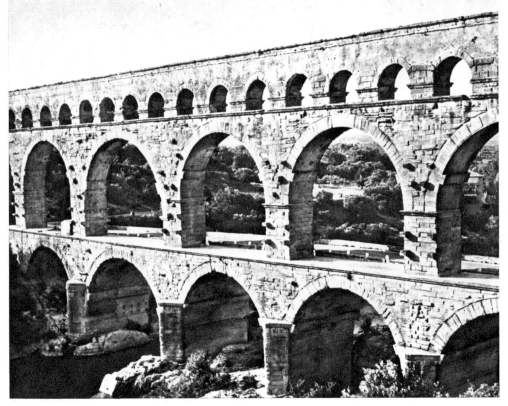

217. Pont du Gard, Nîmes. Early 1st century A.D.

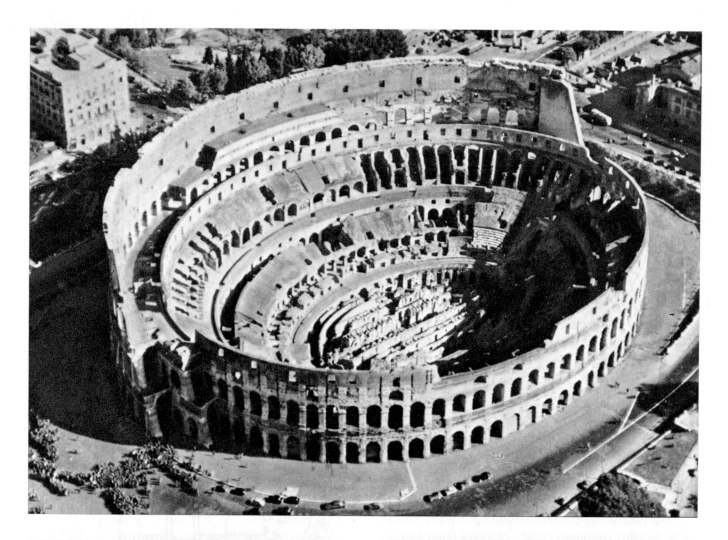

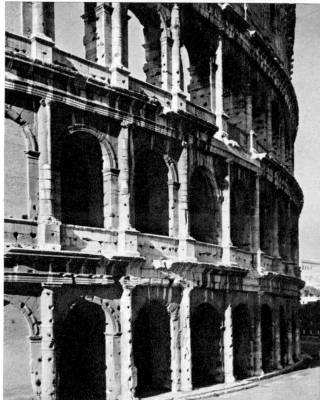

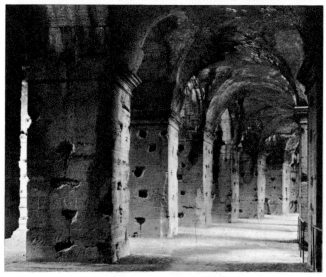

top: 218. The Colosseum (aerial view), Rome. 72–80 A.D.

left: 219. View of the Outer Wall of the Colosseum

above: 220. Interior, second floor, of the Colosseum

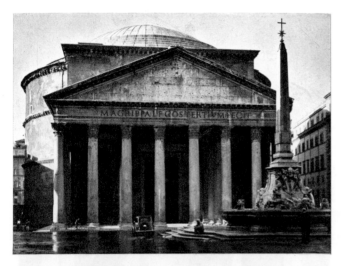

221. The Pantheon, Rome. 118–125 A.D.

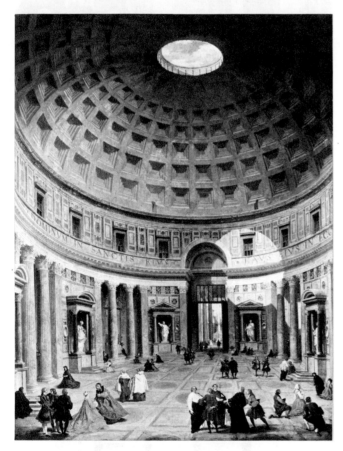

222. *The Interior of the Pantheon*, painting
by Giovanni Paolo Pannini. c. 1750.
National Gallery of Art, Washington, D.C. (Kress Collection)

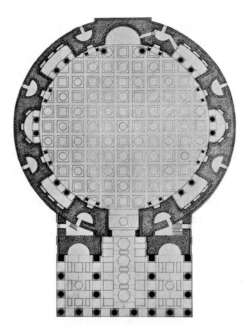

223. Plan of the Pantheon, Rome

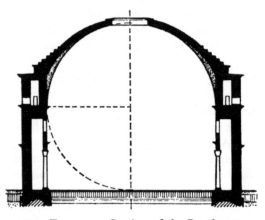

224. Transverse Section of the Pantheon

INTERIORS

Arches, vaults, and the use of concrete permitted the
Romans, for the first time in the history of architecture,
to create vast interior spaces. These were explored espe-
cially in the great baths, or thermae, which had become
important centers of social life in Imperial Rome. The
experience gained there could then be applied to other,
more traditional types of buildings, sometimes with rev-
olutionary results. Perhaps the most striking example of
this process is the famous Pantheon in Rome, a very large
round temple of the early second century A.D. whose
interior is the best preserved as well as the most impres-
sive of any surviving Roman structure (figs. 221–24).
There had been round temples long before that time, but
their shape, well represented by the "Temple of the Sibyl"
(figs. 211, 212), is so different from that of the Pantheon
that the latter could not possibly have been derived from
them. On the outside, the cella of the Pantheon appears

as an unadorned cylindrical drum, surmounted by a gently curved dome; the entrance is emphasized by a deep porch of the kind familiar to us from Roman temples of the standard type (see fig. 210). The junction of these two elements seems rather abrupt, but we must remember that we no longer see the building as it was meant to be seen. First of all, the level of the surrounding streets is a good deal higher than it was in antiquity, so that the steps leading up to the porch are submerged today; moreover, the porch was designed to form part of a rectangular, colonnaded forecourt, which must have had the effect of detaching it from the rotunda. So far as the cella is concerned, therefore, the architect apparently discounted the effect of the exterior, putting all the emphasis on the great domed space that opens before us with dramatic suddenness as we step through the entrance. The impact of this interior, awe-inspiring and harmonious at the same time, is impossible to convey in photographs; even the painting we have chosen (fig. 222) renders it only imperfectly. In any event, the effect is quite different from what the rather forbidding exterior would lead us to expect. The dome is not shallow, but is a true hemisphere; and the circular opening in its center admits an ample—and wonderfully even—flow of light. This "eye" is 143 feet above the floor, and that is also the diameter of the interior (fig. 224); dome and drum, being of equal height, are in exact balance. On the exterior, this balance could not be achieved, for the outward thrust of the dome had to be contained by making the base considerably heavier than the top (the thickness of the dome decreases from 20 feet to 6 feet). Another surprise are the niches, which show that the weight of the dome does not rest uniformly on the drum but is concentrated on eight "pillars." The niches, of course, are closed in back, but since they are screened by columns they give the effect of openings that lead to adjoining rooms and thus prevent us from feeling imprisoned inside the Pantheon. The columns, the colored marble paneling of the wall surfaces, and the floor remain essentially as they were in Roman times; the recessed coffers of the dome, too, are original, but the gilt that covered them has disappeared.

As its name suggests, the Pantheon was dedicated to "all the gods" or, more precisely, to the seven planetary gods (there are seven niches). It seems reasonable, therefore, to assume that the golden dome had a symbolic meaning, that it represented the Dome of Heaven. Yet this solemn and splendid structure grew from rather humble antecedents. The Roman architect Vitruvius, writing more than a century earlier, describes the domed steam chamber of a bathing establishment that anticipates (undoubtedly on a much smaller scale) the essential features of the Pantheon: a hemispherical dome, a proportional relationship of height and width, and the circular opening in the center (which could be closed by a bronze shutter on chains, to adjust the temperature of the steam room).

The Basilica of Constantine, of the early fourth century A.D., offers a similar example. Unlike other basilicas, of which we shall speak later, it derives its shape from the main hall of the public baths built by two previous emperors, Caracalla and Diocletian, but is built on an even vaster scale. It must have been the largest roofed interior in all of Rome. Today only the north aisle—three huge barrel-vaulted compartments—is still standing (fig. 225). The center tract, or nave, covered by three groined vaults (figs. 226, 227), rose a good deal higher. Since a groined

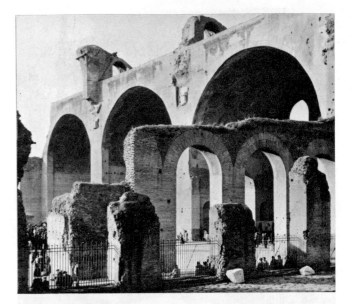

225. The Basilica of Constantine, Rome.
c. 310–320 A.D.

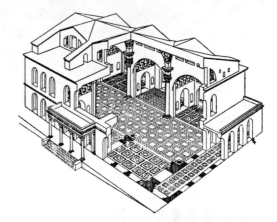

226. Reconstruction Drawing of the Basilica of Constantine (after Huelsen)

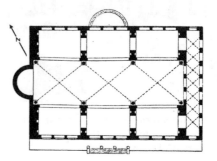

227. Plan of the Basilica of Constantine, Rome

vault resembles a canopy, with all the weight and thrust concentrated at the four corners, the upper walls of the nave (called the clerestory) could be pierced by large windows, so that the interior of the Basilica must have had a light and airy quality despite its enormous size. We shall meet its echoes in many later buildings, from churches to railway stations.

Basilicas, long halls serving a variety of civic purposes, had first been developed in Hellenistic Greece. Under the Romans, they became a standard feature of every major town, where one of their chief functions was to provide a dignified setting for the courts of law that dispensed justice in the name of the Emperor. Rome itself had a number of basilicas, but very little remains of them today. Those in the provinces have fared somewhat better. An outstanding one is that at Leptis Magna in North Africa (figs. 228, 229), which has most of the characteristics of the standard type. The long nave terminates in a semicircular niche, or apse, at either end; its walls rest on colonnades that give access to the side aisles. These are generally lower than the nave, to permit clerestory windows in the upper part of the nave wall. These basilicas had wooden ceilings instead of masonry vaults, for reasons of convenience and tradition rather than technical necessity. They were thus subject to destruction by fire; the one at Leptis Magna, sadly ruined though it is, counts among the best-preserved examples. The Basilica of Constantine in Rome was a daring attempt to create a novel, vaulted type, but the design seems to have met little public favor; it had no direct successors. Perhaps people felt that it lacked dignity, because of its obvious resemblance to the public baths. In any event, the Christian basilicas of the fourth century were modeled on the older, wooden-roofed type (see fig. 266). Not until seven hundred years later did vaulted basilican churches become common in western Europe.

DOMESTIC ARCHITECTURE

One of the delights in studying Roman architecture is that it includes not only great public edifices but also a vast variety of residential dwellings, from imperial palaces to the quarters of the urban poor. If we disregard the extremes of this scale, we are left with two basic types that account for most of the domestic architecture that has survived. The *domus* is a single-family house based on ancient Italic tradition. Its distinguishing feature is the atrium, a square or oblong central hall lighted by an opening in the roof, around which the other rooms are grouped. In Etruscan times, it had been a rural dwelling, but the Romans "citified" and elaborated it into the typical home of the well-to-do. Many examples of it, in various stages of development, have come to light at Herculaneum and Pompeii, the two famous towns near Naples that were buried under volcanic ash during an eruption of Mount Vesuvius in 79 A.D. Let us enter the so-called House of the Silver Wedding at Pompeii. The view in figure 230 is taken from the vestibule, along the main axis of the *domus*. Here the atrium has become a room of impressive size; the four Corinthian columns at the corners of the opening in the roof give it something of the quality of an enclosed court. There is a shallow basin in the center to catch the rain water (the roof slants inward). The atrium was the traditional place for keeping portrait images of the ancestors of the family. At its far end we see a recess, the *tablinum,* and beyond it the garden, surrounded by a colonnade, the peristyle. In addition to the chambers grouped around the atrium, there may be further rooms attached to the back of the house. The entire establishment is shut off from the street by windowless walls; obviously, privacy and self-sufficiency were important to the wealthy Roman.

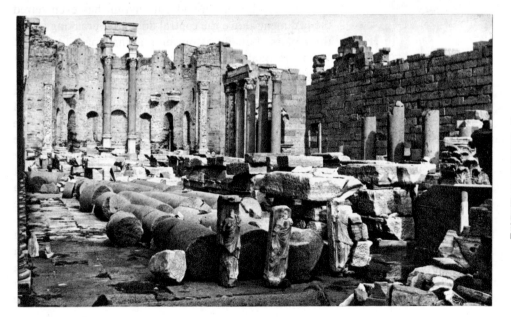

left: 228. Basilica, Leptis Magna, Libya. Early 3rd century A.D.

below: 229. Plan of the Basilica at Leptis Magna

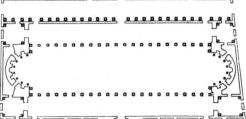

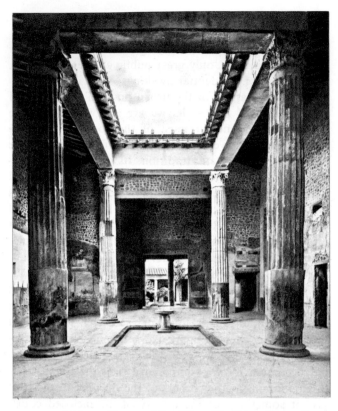

230. Atrium, House of the Silver Wedding, Pompeii. Early 1st century A.D.

231. Insula of the House of Diana, Ostia. c. 150 A.D.

Less elegant than the *domus*, and decidedly urban from the very start, is the insula, or city block, which we find mainly in Rome itself and in Ostia, the ancient port of Rome near the mouth of the Tiber. The insula anticipates many features of the modern apartment house; it is a large concrete-and-brick building (or a chain of such buildings) around a small central court, with shops and taverns open to the street on the ground floor and living quarters for numerous families above. Some insulae had as many as five stories, with balconies above the second floor (see fig. 231). The daily life of the craftsmen and shopkeepers who inhabited such an insula was oriented toward the street, as it still is to a large extent in modern Italy. The privacy of the *domus* was reserved for the minority that could afford it.

LATE ROMAN ARCHITECTURE

In discussing the new forms based on arched, vaulted, and domed construction, we have noted the Roman architect's continued allegiance to the Classical Greek orders. If he no longer relied on them in the structural sense, he remained faithful to their spirit, acknowledging the aesthetic authority of the post-and-lintel system as an organizing and articulating principle. Column, architrave, and pediment might be merely superimposed on a vaulted brick-and-concrete core, but their shape, as well as their relationship to each other, was still determined by the original grammar of the orders. This orthodox, reverential attitude toward the architectural vocabulary of the Greeks prevailed, generally speaking, from the Roman conquest of Greece until the end of the first century A.D. After that, we find increasing evidence of a contrary trend, of a taste for imaginative, "ungrammatical" transformations of the Greek vocabulary. Just when and where it began is still a matter of dispute; there is some evidence that it may go back to late Hellenistic times in the Near East. The tendency certainly was most pronounced in the Asiatic and African provinces of the Empire. A characteristic example is the Market Gate from Miletus, c. 160 A.D., now rebuilt in the State Museums, Berlin (fig. 232). One might call it a piece of display architecture, both in terms of its effect and of its ancestry, for the picturesque façade, with its alternating recesses and projections, derives from the architectural stage backgrounds of the Roman theater. The continuous in-and-out rhythm has even seized the pediment above the central doorway, breaking it into three parts. Equally astonishing is the small Temple of Venus at Baalbek, probably built in the early second century A.D. and refurbished in the third (figs. 233, 234). The convex curve of the cella is effectively counterbalanced by the concave niches and the scooped-out base and entablature, introducing a new play of forces into the conventional ingredients of the round temple (compare figs. 211, 212). By the late third century, unorthodox ideas such as these had become so well established that the traditional "grammar" of the Greek orders was in process of dissolution everywhere. In the peristyle of the Palace of Diocletian (fig. 235) at Split (Spalato), the architrave between the two center columns is curved, echoing the arch of the doorway below, and on the left we see an even more revolutionary device—a series of arches resting directly on columns. A few isolated instances of such an arcade can be found earlier, but it was only now on the

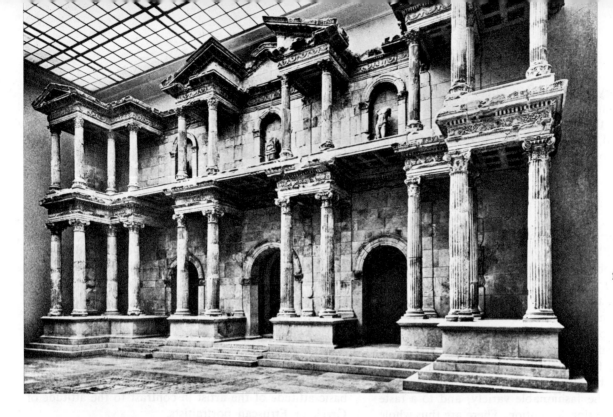

232. The Market Gate
from Miletus (restored).
c. 160 A.D.
State Museums, Berlin

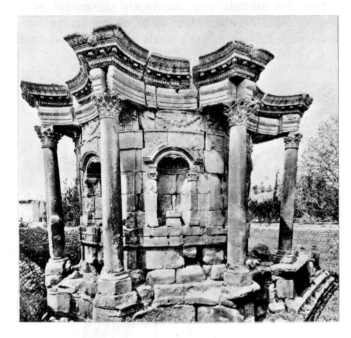

233, 234. View and Plan of the
Temple of Venus,
Baalbek (after Wiegand)

235. Peristyle, Palace of Diocletian,
Split, Yugoslavia. c. 300 A.D.

eve of the victory of Christianity, that the marriage of arch and column became fully legitimate. The union, indispensable to the future development of architecture, seems so natural to us that we can hardly understand why it was ever opposed.

SCULPTURE

The dispute over the question "Is there such a thing as a Roman style?" has centered largely on the field of sculpture, and for quite understandable reasons. Even if we discount the wholesale importing and copying of Greek originals, the reputation of the Romans as imitators seems borne out by vast quantities of works that are obviously—or at least probably—adaptions and variants of Greek models of every period. While the Roman demand for sculpture was tremendous, a good deal of it may be attributed to antiquarianism, both the learned and the fashionable variety, and to a taste for sumptuous interior decoration. There are thus whole categories of sculpture produced under Roman auspices that deserve to be classified as "deactivated" echoes of Greek creations, emptied of their former meaning and reduced to the status of highly refined works of craftsmanship. At times this attitude extended to Egyptian sculpture as well, creating a vogue for pseudo-Egyptian statuary. On the other hand, there can be no doubt that some kinds of sculpture had serious and important functions in ancient Rome. They represent the living sculptural tradition, in contradistinction to the antiquarian-decorative trend. We shall concern ourselves here mainly with those aspects of Roman sculpture that are most conspicuously rooted in Roman society: portraiture and narrative relief.

REPUBLICAN

We know from literary accounts that, from early Republican times on, meritorious political or military leaders were honored by having their statues put on public display. The habit was to continue until the end of the Empire a thousand years later. Its beginnings may well have derived from the Greek custom of placing votive statues of athletic victors and other important individuals in the precincts of such sanctuaries as Delphi and Olympia (see fig. 166). Unfortunately, the first four hundred years of this Roman tradition are a closed book to us; not a single Roman portrait has yet come to light that can be dated before the first century B.C. with any degree of confidence. How were those early statues related to Etruscan or Greek sculpture? Did they ever achieve any specifically Roman qualities? Were they individual likenesses in any sense, or were their subjects identified only by pose, costume, attributes, and inscriptions? Our sole clue in answer to these questions is the lifesize bronze statue of an official called *L'Arringatore*

(fig. 236), once assigned to the second century B.C. but now generally placed in the early years of the first. It comes from southern Etruscan territory and bears an Etruscan inscription which includes the name Aule Metele (Aulus Metellus in Latin), presumably the name of the person represented. He must have been a Roman, or at least a Roman-appointed official. The workmanship is evidently Etruscan, as indicated by the inscription, but the gesture, which denotes both address and salutation, recurs in hundreds of Roman statues of the same sort, and the costume, too, is Roman—an early kind of toga. One suspects, therefore, that our sculptor tried to conform to an established Roman type of portrait statue, not only in these externals but in style as well. For we find very little here of the Hellenistic flavor characteristic of the later Etruscan tradition. What makes the figure remarkable is its serious, prosaically factual quality, down to the neatly tied shoelaces. The term "uninspired" suggests itself, not as a criticism but as a way to describe the basic attitude of the artist in contrast to the attitude of Greek or Etruscan portraitists.

That this attitude was consciously striven for as a positive value becomes clear when we familiarize ourselves with Roman portrait heads of the years around

236. *Aulus Metellus (L'Arringatore)*. Early 1st century B.C. Bronze, height 71". Archaeological Museum, Florence

237. *Portrait of a Roman.* c. 80 B.C. Marble, lifesize.
Palazzo Torlonia, Rome

75 B.C., which show it in its most pronounced form. Apparently the creation of a monumental, unmistakably Roman portrait style was achieved only in the time of Sulla, when Roman architecture, too, came of age (see page 157). We see it at its most impressive perhaps in the features of the unknown Roman of figure 237, contemporary with the fine Hellenistic portrait from Delos in colorplate 14. A more telling contrast could hardly be imagined; both are extremely persuasive likenesses, yet they seem worlds apart. Whereas the Hellenistic head impresses us with its subtle grasp of the sitter's psychology, the Roman may strike us at first glance as nothing but a detailed record of facial topography—the sitter's character emerges only incidentally, as it were. And yet this is not really the case: the wrinkles are true to life, no doubt, but the carver has nevertheless treated them with a selective emphasis designed to bring out a specifically Roman personality—stern, rugged, iron-willed in its devotion to duty. It is a "father image" of frightening authority, and the minutely observed facial details are like individual biographical data that differentiate this father image from others. Its peculiar flavor reflects a Roman custom of considerable antiquity; at the death of the head of the family, a waxen image was made of his face, which was then preserved in a special shrine, or family altar. At funerals, these ancestral images were carried in the procession. We have seen the roots of this kind of ancestor worship in primitive societies (compare figs. 19, 32–37); the patrician families of Rome clung to it tenaciously, well into imperial times. The images were, of course, records rather than works of art, and because

of the perishability of wax they probably did not last more than a few decades. Thus the desire to have them duplicated in marble seems natural enough, yet the demand did not arise until the early first century B.C.; perhaps the patricians, feeling their traditional position of leadership endangered, wanted to make a greater public display of their ancestors, as a way of emphasizing their ancient lineage. That certainly is the purpose of the statue in figure 238, carved about half a century later than our previous example. It shows an unknown Roman holding two busts of his ancestors, presumably his father and grandfather. The work has little distinction, yet the "father-image" spirit can be felt even here. Needless to say, this quality was not present in the wax images themselves; it came to the fore when they were translated into marble, a process that not only made the ancestral images permanent but monumentalized them in the spiritual sense as well. Nevertheless, the marble heads retained the character of records, of visual documents, which means that they could be freely duplicated; what mattered was only the facial "text," not the "handwriting" of the artist who recorded it. The impressive head in figure 237 is itself a copy, made some fifty years later

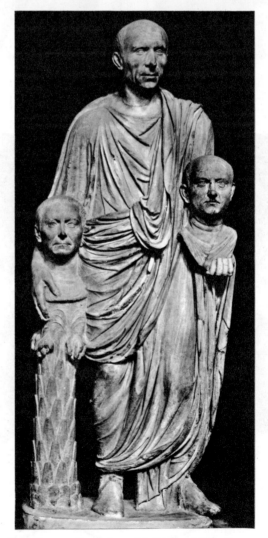

238. *A Roman Patrician with Busts of His Ancestors.*
c. 30 B.C. Marble, lifesize.
Capitoline Museums, Rome

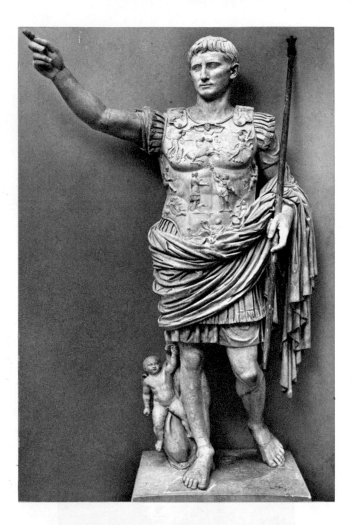

239, 240. Augustus of Primaporta. c. 20 B.C.
Marble, 6' 8". Vatican Museums, Rome

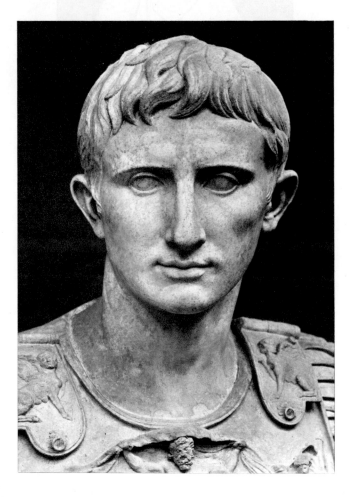

than the lost original, and so are the two ancestors in figure 238 (differences in style and in the shape of the bust indicate that the original of the head on the left is about thirty years older than that of its companion). Perhaps this Roman lack of feeling for the uniqueness of the original, understandable enough in the context of their ancestor cult, also helps to explain why they developed so voracious an appetite for copies of famous Greek statues.

IMPERIAL

As we approach the reign of the Emperor Augustus (27 B.C.–14 A.D.), we find a new trend in Roman portraiture that reaches its climax in the images of Augustus himself, as, for example, in the splendid statue from Primaporta (figs. 239, 240). At first glance, we may well be uncertain whether it represents a god or human being, and this doubt is entirely appropriate, for the figure is meant to be both. Here, on Roman soil, we meet a concept familiar to us from Egypt and the ancient Near East: that of the divine ruler. It had entered the Greek world in the fourth century (see fig. 180); Alexander the Great had made it his own, and so did his successors, who modeled themselves after him. The latter, in turn, transmitted it to Julius Caesar and the Roman emperors, who at first encouraged the worship of themselves only in the eastern provinces, where belief in a divine ruler was a long-established tradition. The idea of attributing superhuman stature to the emperor, and thus enhancing his authority, soon became official policy, and while Augustus did not carry it as far as his successors, the Primaporta statue clearly shows him enveloped in an air of divinity. Still, despite its heroic, idealized body, the statue has an unmistakably Roman flavor; the Emperor's gesture is familiar to us from the figure of Aulus Metellus, and the costume, including the rich allegorical program on the breastplate, has a concreteness of surface texture that conveys the actual touch of cloth, metal, and leather. The head, too, is idealized, or, better perhaps, "Hellenized"; small physiognomic details are suppressed, and the focusing of attention on the eyes gives it something of the "inspired" look we find in portraits of Alexander the Great (compare fig. 197). Nevertheless, the face is a definite likeness, elevated but clearly individual, as we can determine by comparison with the numerous other portraits of Augustus. Every Roman would have recognized it immediately, for he knew it from coins and countless other representations. In fact, the Emperor's image soon came to acquire the symbolic significance of a national flag. As a consequence of such mass production, artistic quality was rarely very high, except when portraits were produced under the ruler's direct patronage. That must have been true of the Primaporta statue, which was found in the villa of Augustus' wife, Livia.

Imperial art, however, was not confined to portraiture. The emperors also commemorated their outstanding

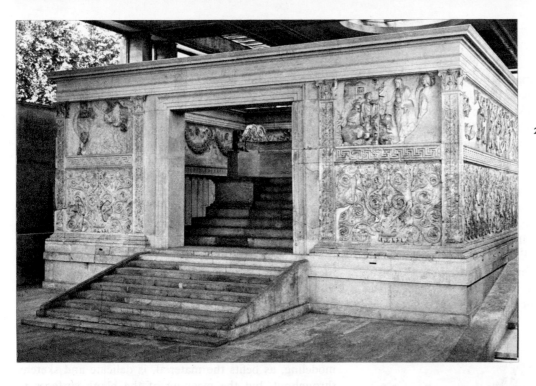

achievements in narrative reliefs on monumental altars, triumphal arches, and columns. Similar scenes are familiar to us from the ancient Near East (see figs. 87, 94, 102) but not from Greece. Historic events—that is, events which occurred only once, at a specific time and in a particular place—had not been dealt with in Classical Greek sculpture; if a victory over the Persians was to be commemorated, it would be represented indirectly, as a combat of Lapiths and Centaurs, or Greeks and Amazons—a mythical event outside any space-time context. Even in Hellenistic times, this attitude persisted, although not quite as absolutely; when the kings of Pergamum celebrated their victories over the Gauls, the latter were represented faithfully (see fig. 187) but in typical poses of defeat rather than in the framework of a particular battle. Greek painters, on the other hand, had depicted historic subjects such as the battle of Salamis as early as the mid-fifth century, although we do not know how specific these pictures were in detail. According to the Roman writer Pliny, Philoxenus of Eretria at the end of the fourth century painted the victory of Alexander the Great over Darius at Issus; an echo of that work may survive in a famous Pompeian mosaic (colorplate 16). In Rome, too, historic events had been depicted from the third century B.C. on; a victorious military leader would have his exploits painted on panels that were carried in his triumphal procession, or he would show such panels in public places. These pictures seem to have had the fleeting nature of posters advertising the hero's achievements. None have survived. Sometime during the late years of the Republic—we do not know exactly when—the temporary representations of such events began to assume more monumental and permanent form, no longer painted, but carved and attached to structures intended to last indefinitely. They were thus a ready tool for the glorification of imperial rule, and the emperors did not hesitate to use them on a large scale.

Ara Pacis; Arch of Titus

Since the leitmotif of his reign was peace, Augustus preferred to appear in his monuments as the "Prince of Peace" rather than as the all-conquering military hero. The most important of these monuments was the Ara Pacis (the Altar of Peace), voted by the Roman Senate in 13 B.C. and completed four years later. It is probably identical with the richly carved Augustan altar that bears this name today. (Parts of it had been found as early as the sixteenth century, but their reintegration was not achieved until 1938.) The entire structure (fig. 241) recalls the Pergamum Altar, though on a much smaller scale (compare figs. 188, 189). On the wall that screens the altar proper, a monumental frieze depicts allegorical and legendary scenes as well as a solemn procession led by the Emperor himself. Here the "Hellenic," Classicizing style we noted in the Primaporta statue reaches its fullest expression. It is instructive, therefore, to compare the Ara Pacis frieze (fig. 243) with that of the Parthenon (figs. 153, 242). Only a direct confrontation of the two will show how different they really are, despite all surface similarities. The Parthenon frieze belongs to an ideal, timeless world; it shows a procession that took place in the remote, mythic past, beyond living memory. What holds it together is the great formal rhythm of the ritual itself, not its variable particulars. On the Ara Pacis, in contrast, we see a procession in celebration of one particular recent event—probably the founding of the altar in 13 B.C.—idealized to evoke something of the solemn, timeless air that surrounds the Parthenon procession, yet filled with concrete details of a remembered event. The participants, at least so far as they belong to the imperial family, are meant to be identifiable as portraits, including those of children dressed in miniature togas but too young to grasp the significance of the occasion: note how the little boy in the center of our group is tugging

at the mantle of the young man in front of him while the somewhat older child to his left smilingly tells him to behave. The Roman artist also shows a greater concern with spatial depth than his Classical Greek predecessor; the softening of the relief background, which we first observed in the Stele of Hegeso (fig. 176), has been carried so far that the figures farthest removed from us seem partly immersed in the stone (such as the woman on the left whose face emerges behind the shoulder of the young mother in front of her). The same interest in space appears even more strongly in the allegorical panel in figure 245, showing Mother Earth as the embodiment of human, animal, and plant fertility, flanked by two personifications of winds. Here the figures are placed in a real landscape setting of rocks, water, and vegetation,

and the blank background clearly stands for the empty sky. Whether this pictorial treatment of space is a Hellenistic or Roman invention remains a matter of dispute. There can be no question, however, about the Hellenistic look of the three personifications, which thus represent not only a different level of reality but also a different —and less distinctly Roman—style from the imperial procession. The acanthus ornament on the pilasters and the lower part of the wall, on the other hand, has no counterpart in Greek art, although the acanthus motif as such derives from Greece. The plant forms are wonderfully graceful and alive, yet the design as a whole, with its emphasis on bilateral symmetry, never violates the discipline of surface decoration and thus serves as an effective foil for the spatially conceived reliefs above.

Much the same contrast of flatness and depth occurs in the stucco decoration of a Roman house, a casual but enchanting product of the Augustan era (fig. 244). The modeling, as befits the material, is delicate and sketchy throughout, but the meaning of the blank surfaces to which it is applied varies a great deal. On the bottom strip of our illustration, there are two winged genii with plant ornament; here depth is carefully eschewed, since this zone belongs to the framework. Above it, we see that which is being framed; it can only be described as a "picture painted in relief," an idyllic landscape of great charm and full of atmospheric depth, despite the fact that its space is merely suggested rather than clearly defined. The whole effect echoes that of painted room decorations (see fig. 259).

The spatial qualities of the Ara Pacis reliefs reached their most complete development in the two large narrative panels on the triumphal arch erected in 81 A.D. to commemorate the victories of the Emperor Titus. One

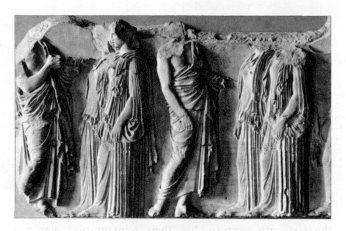

242. *Procession,* portion of east frieze, Parthenon. c. 440 B.C. Marble, height 43″. The Louvre, Paris

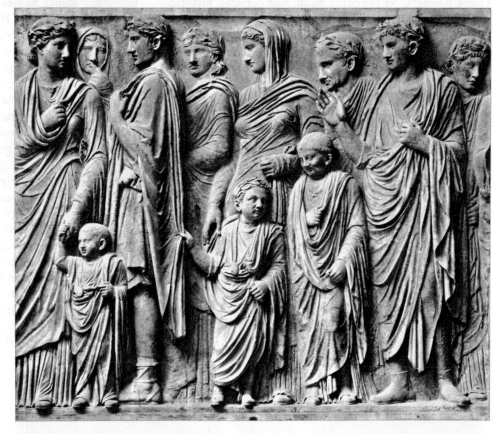

243. *Imperial Procession,* portion of the frieze of the Ara Pacis. Marble, height 63″

of them (fig. 246) shows part of the triumphal procession celebrating the conquest of Jerusalem; the booty displayed includes the seven-branched candlestick and other sacred objects. Despite the mutilated surface, the movement of a crowd of figures in depth still appears strikingly successful. On the right, the procession turns away from us and disappears through a triumphal arch placed obliquely to the background plane so that only the nearer half actually emerges from the background— a radical but effective device. The companion panel (fig. 247) avoids such experiments, although the number of layers of relief is equally great here. We also sense that its design has an oddly stationary quality, despite the fact that this is simply another part of the same procession. The difference must be due to the subject, which is the Emperor himself in his chariot, crowned by the winged Victory behind him. Apparently the sculptor's first concern was to display this set image, rather than to keep the procession moving. Once we try to read the imperial chariot and the surrounding figures in terms of real space, we become aware how strangely contradictory the spatial relationships are: the four horses, shown in strict profile view, move in a direction parallel to the bottom edge of the panel, but the chariot is not where it ought to be if they were really pulling it. Moreover, the bodies of the Emperor and of most of the other figures are represented in frontal view, rather than in profile. These seem to be fixed conventions for representing the triumphant Emperor, which our artist felt constrained to respect though they were in conflict with his desire to create the kind of consistent movement in space he achieved so well in figure 246.

Column of Trajan

That the purposes of imperial art, narrative or symbolic, were sometimes incompatible with a realistic treatment of space becomes fully evident in the Column of Trajan, erected in 106–113 A.D. to celebrate that emperor's victorious campaigns against the Dacians (the ancient inhabitants of Romania). Single, free-standing columns had been used as commemorative monuments from Hellenistic times on; their ultimate source may have been the obelisks of Egypt. The Column of Trajan is distinguished not only by its great height (125 feet, including the base) but by the continuous spiral band of relief covering its surface (fig. 248) and recounting, in epic breadth, the history of the Dacian wars. The Column was crowned by a statue of the Emperor (destroyed in the Middle Ages) and the base served as a burial chamber for his ashes. If we could unwind the relief band, we would find it to be 656 feet long, two-thirds the combined length of the three friezes of the Mausoleum at Halicarnassus and a good deal longer than the Parthenon frieze. In terms of the number of figures and the density of the narrative, however, our relief is by far the most ambitious frieze com-

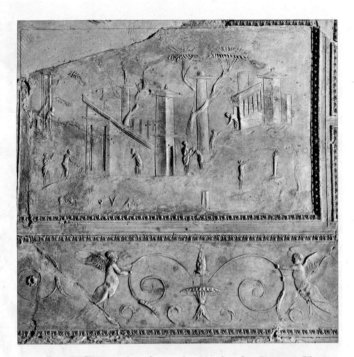

244. Stucco Decoration from the Vault of a Roman House. Late 1st century B.C. Museo delle Terme, Rome

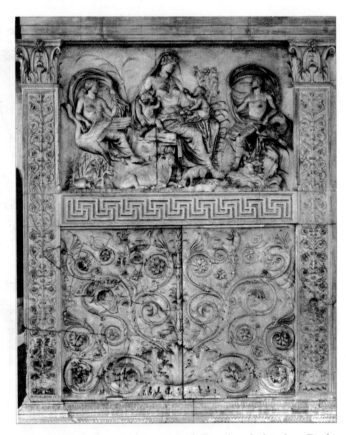

245. Allegorical and Ornamental Panels of the Ara Pacis

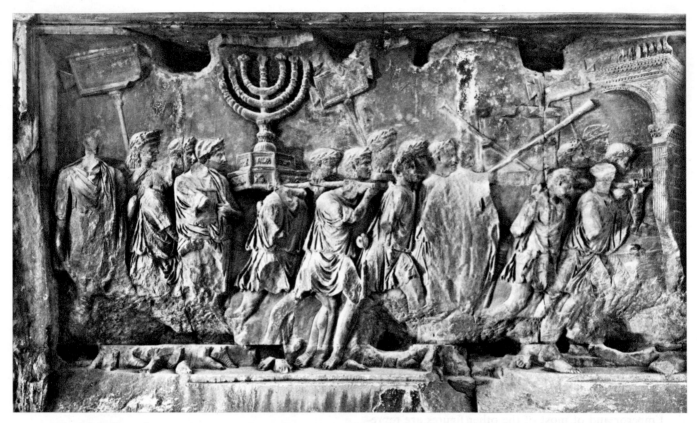

246. *Spoils from the Temple in Jerusalem,* relief in passageway, Arch of Titus, Rome. 81 A.D. Marble, height 7′ 10″

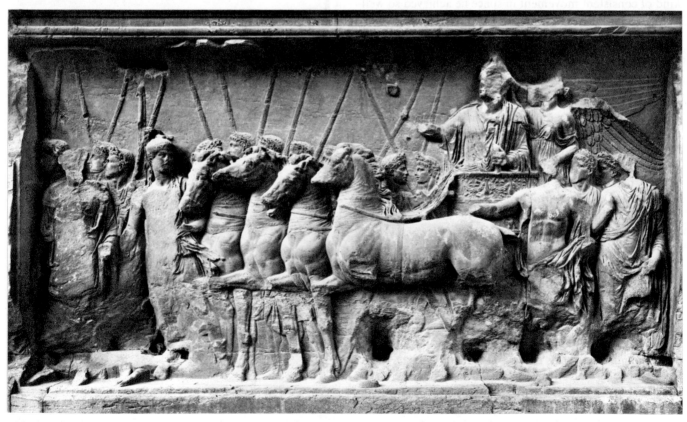

247. *Triumph of Titus,* relief in passageway, Arch of Titus

position attempted up to that time in the ancient world. It is also the most frustrating, for the beholder must "run around in circles like a circus horse" (to borrow the apt description of one scholar) if he wants to follow the narrative; once he gets above the fourth or fifth turn, he finds himself defeated by the wealth of detail unless he is equipped with field glasses. One wonders for whose benefit the elaborate pictorial account was intended. In Roman times, the monument formed the center of a small court flanked by public buildings at least two stories tall, but even that does not quite answer our question. Nor does it explain the evident success of our Column, which served as the model for several others of the same type. But let us take a closer look at the scenes visible in our illustration: in the center of the bottom strip, we see the upper part of a large river god representing the Danube; to the left, there are some river boats laden with supplies, and a Roman town on the rocky bank; to the right, the Roman army crosses the river on a pontoon bridge. The second strip shows Trajan addressing his soldiers (to the left) and the building of fortifications; the third, the construction of a garrison camp and bridge as Roman cavalry (on the right) sets out on a reconnaissance mission. In the fourth strip, Trajan's foot soldiers are crossing a mountain stream (center); on the right, the Emperor addresses his troops in front of a Dacian fortress. These scenes are a fair sampling; among the more than 150 separate episodes, actual combat occurs only rarely, while the geographic, logistic, and political aspects of the campaign receive detailed attention, much as they do in Julius Caesar's famous account of his conquest of Gaul. Only at one other time have we seen this matter-of-fact visualization of military operations—in Assyrian reliefs such as that in figure 94. Was there an indirect link between the two? And, if so, of what kind? The question is difficult to answer, especially since there are no extant copies of the Roman antecedents for our reliefs: the panels showing military conquests that were carried in triumphal processions (see page 169). At any rate, the spiral frieze on the Column of Trajan was a new and demanding framework for historic narrative which imposed a number of difficult conditions upon the sculptor: since there could be no clarifying inscriptions, the pictorial account had to be as explicit and self-sufficient as possible, which meant that the spatial setting of each episode had to be worked out with great care; visual continuity had to be preserved without destroying the inner coherence of the individual scenes; and the actual depth of the carving had to be much shallower than in reliefs such as those on the Arch of Titus, otherwise the shadows cast by the projecting parts would make the scenes unreadable from below. Our artist has solved these problems with conspicuous success, but at the cost of sacrificing all but the merest remnants of illusionistic spatial depth. Landscape and architecture are reduced to abbreviated "stage sets," and the ground on which the figures stand is tilted upward. All these devices had already been employed in Assyrian narrative reliefs; here

they asserted themselves once more, against the tradition of foreshortening and perspective space. In another two hundred years, they were to become dominant, and we shall find ourselves at the threshold of medieval art. In this respect, the relief band on the Column of Trajan is curiously prophetic of the end of one era and the beginning of the next.

Portraits

The Ara Pacis, the Arch of Titus, and the Column of Trajan are monuments of key importance for the art of Imperial Rome at the height of its power. To single out equally significant works among the portraits of the same period is very much more difficult; their production was vast, and the diversity of types and styles mirrors the ever more complex character of Roman society. If we regard the Republican ancestral image tradition and the Greek-inspired Augustus of Primaporta as opposite ends of the scale, we can find almost any variety of interbreeding between the two. The fine head of the Emperor Vespasian, of c. 75 A.D., is a case in point (fig. 250): he was the first

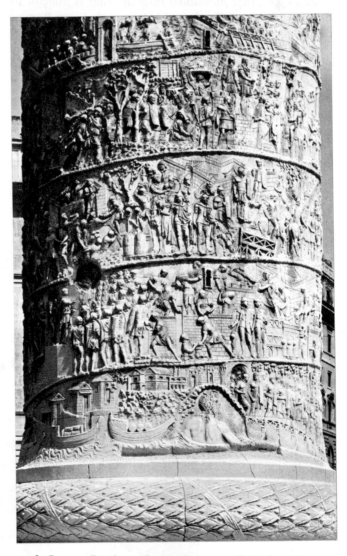

248. Lower Portion of the Column of Trajan, Rome. 106–113 A.D. Marble, height of relief band c. 50"

of the Flavian emperors, a military man who came to power after the Julio-Claudian (Augustan) line had died out and who must have viewed the idea of emperor worship with considerable skepticism. (When he was dying, he is reported to have said, "It seems I am about to become a god.") His humble origin and simple tastes may be reflected in the anti-Augustan, Republican flavor of his portrait. The soft, veiled quality of the carving, on the other hand, with its emphasis on the texture of skin and hair, is so Greek that it immediately recalls the seductive marble technique of Praxiteles and his school. A similar refinement can be felt in the surfaces of the slightly later bust of a lady (fig. 249), probably the subtlest portrait of a woman in all of Roman sculpture. The graceful tilt of the head and the glance of the large eyes convey a mood of gentle reverie; and how effectively the silky softness of skin and lips is set off by the corkscrew curls of the fashionable coiffure! The wonderful head of Trajan (fig. 251), of c. 100 A.D., is another masterpiece of portraiture. Its firm, rounded forms recall the Augustus of Primaporta, as does the commanding look of the eyes, dramatized by the strongly projecting brows. The face radiates a strange emotional intensity that is difficult to define—a kind of Greek *pathos* transmuted into Roman nobility of character.

Trajan still conformed to age-old Roman custom by being clean-shaven. His successors, in contrast, adopted the Greek fashion of wearing beards, as an outward sign of admiration for the Hellenic heritage. It is not surprising, therefore, to find a strong neo-Augustan, classicistic trend, often of a peculiarly cool, formal sort, in the sculpture of the second century A.D., especially during the reigns of Hadrian and Marcus Aurelius, both of them introspective men deeply interested in Greek philosophy. We can sense this quality in the equestrian bronze statue of Marcus Aurelius (fig. 252), which is remarkable not

only as the sole survivor of this class of monument but as one of the few Roman statues that remained on public view throughout the Middle Ages. The equestrian image of the Emperor, displaying him as the all-conquering lord of the earth, had been a firmly established tradition ever since Julius Caesar had permitted such a statue of himself to be erected in the Forum Julium. That of Marcus Aurelius, too, was meant to characterize the Emperor as ever victorious, for beneath the right front leg of the horse (according to medieval accounts) there once crouched a small figure of a bound barbarian chieftain. The wonderfully spirited and powerful horse expresses this martial spirit. But the Emperor himself, without weapons or armor, presents a picture of stoic detachment—a bringer of peace rather than a military hero. And so indeed he saw himself and his reign (161–180 A.D.).

It was the calm before the storm. The third century saw the Empire in almost perpetual crisis. Barbarians endangered its frontiers (see fig. 104) while internal conflicts undermined the authority of the imperial office. To hold the throne became a matter of naked force, succession by murder a regular habit; the "soldier emperors"—mercenaries from the outlying provinces of the realm—followed one another at brief intervals. The portraits of some of these men, such as Philippus the Arab (fig. 253; see fig. 104), who reigned from 244 to 249 A.D., are among the most powerful likenesses in all of art. Their facial realism is as uncompromising as that of Republican portraiture, but its aim is expressive rather than documentary: all the dark passions of the human mind—fear, suspicion, cruelty—suddenly stand revealed here, with a directness that is almost unbelievable. The face of Philippus mirrors all the violence of the time. Yet in a strange way it also moves us to pity; there is a psychological nakedness about it that recalls a brute creature doomed and cornered. Clearly, the agony of the Roman world

right: 249. *Portrait of a Lady*. c. 90 A.D. Marble, lifesize. Capitoline Museums, Rome

far right: 250. *Vespasian*. c. 75 A.D. Marble, lifesize. Museo delle Terme, Rome

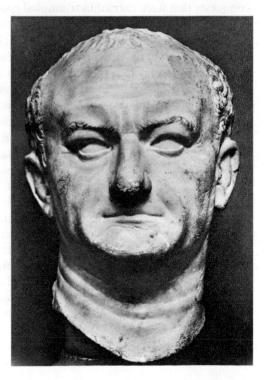

was not only physical but spiritual. That Roman art should have been able to create an image of man embodying this crisis is a tribute to its continued vitality. Let us note the new plastic means through which the impact of these portraits is achieved: we are struck, first of all, by the way expression centers on the eyes, which seem to gaze at some unseen but powerful threat. The engraved outline of the iris and the hollowed-out pupils, devices alien to earlier portraits, serve to fix the direction of the glance. The hair, too, is rendered in thoroughly un-Classical fashion as a close-fitting, textured cap; and the beard has been replaced by a peculiar unshaven look that results from roughing up the surfaces of the lower part of the face with short chisel strokes.

A somewhat later portrait, probably that of the late Greek philosopher Plotinus, suggests a different aspect of the third-century crisis (fig. 254). Plotinus' thinking—abstract, speculative, and strongly tinged with mysticism—marked a retreat from concern with the outer world that seems closer to the Middle Ages than to the Classical tradition of Greek philosophy. It sprang from the same mood which, on a more popular level, expressed itself in the spread of Oriental mystery cults throughout the Roman Empire. How trustworthy a likeness our head rep-

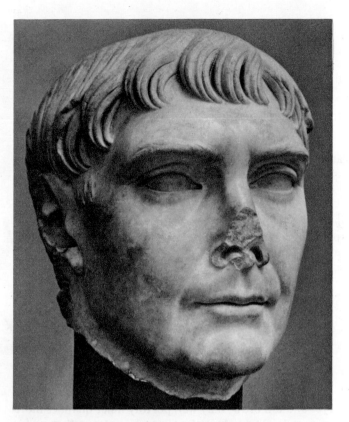

251. *Trajan.* c. 100 A.D. Marble, lifesize. Museum, Ostia

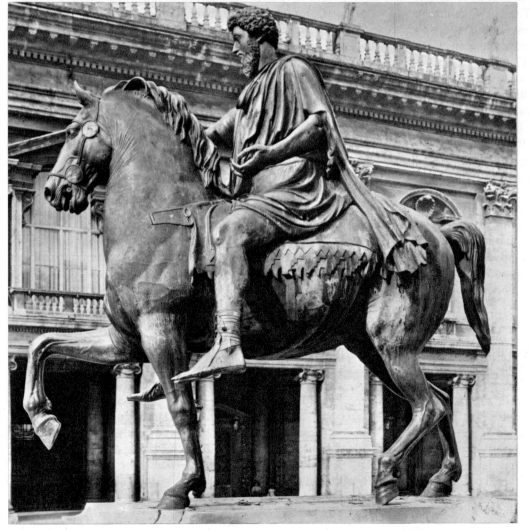

252. *Equestrian Statue of Marcus Aurelius.* 161–180 A.D. Bronze, over lifesize. Piazza del Campidoglio, Rome

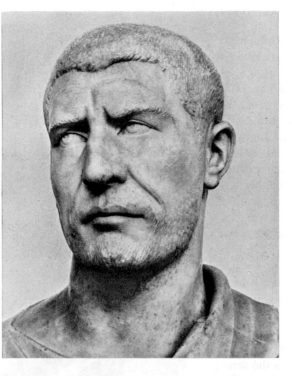

resents is hard to say; the ascetic features, the intense eyes and tall brow, may well portray inner qualities more accurately than outward appearance. According to his biographer, Plotinus was so contemptuous of the imperfections of the physical world that he refused to have any portrait made of himself. The body, he maintained, was an awkward enough likeness of the true, spiritual self; why then go to the bother of making an even more awkward "likeness of a likeness"?

Such a view presages the end of portraiture as we have known it so far. If a physical likeness is worthless, a portrait becomes meaningful only as a visible symbol of the spiritual self. It is in these terms that we must view the head of Constantine the Great, the first Christian Emperor and reorganizer of the Roman state (fig. 255). Originally, it belonged to a colossal statue which stood in the Basilica of Constantine. We may call it superhuman, not only because of its enormous size, but even more so perhaps as an image of imperial majesty. The huge, radiant eyes, the massive, immobile features do not tell us much about Constantine's actual appearance; they tell us a great deal about how he viewed himself and his exalted office.

Arch of Constantine

Constantine's conception of his role is clearly reflected in his triumphal arch (fig. 256), erected near the Colosseum 312–315 A.D. One of the largest and most elaborate of its kind, it is decorated for the most part with sculpture taken from earlier imperial monuments. This procedure has often been viewed as dictated by haste and by the poor condition of the sculptural workshops of Rome at that time. These may have been contributory factors, but there appears to be a conscious and carefully

considered plan behind the way the earlier pieces were chosen and employed. All of them come from a related group of monuments, those dedicated to Trajan, Hadrian, and Marcus Aurelius, and the portraits of these Emperors have been systematically reworked into likenesses of Constantine. Does this not convey Constantine's view of himself as the restorer of Roman glory, the legitimate successor of the "good emperors" of the second century? The arch also contains a number of reliefs made especially for it, however, such as the friezes above the lateral openings, and these show the new Constantinian style in full force. If we compare the medallions of figure 257, carved in Hadrian's time, with the relief immediately below them, the contrast is such that they seem to belong to two different worlds. The scene represents Constantine, after his entry into Rome in 312 A.D., addressing the Senate and the people from the rostrum in the Forum. The first thing we notice here is the avoidance of all the numerous devices developed since the fifth century B.C. for creating spatial depth; we find no oblique lines, no foreshortening, and only the barest ripple of movement in the listening crowds. The architecture has been flattened out against the relief background, which thus becomes a solid, impenetrable surface. The rostrum and the people on or beside it form a second, equally shallow layer—the second row of figures appears simply as a series of heads above those of the first. The figures themselves have an oddly doll-like quality: the heads are very large, while the bodies seem not only dwarfish (because of the thick, stubby legs) but also lacking in articulation. The mechanism of *contrapposto* has disappeared completely, so that these figures no longer stand freely and by their own muscular effort; rather, they seem to dangle from invisible strings. All the characteristics we have described so far are essentially negative, judged from the Classical

Colorplate 17. ROMAN. *The Laestrygonians Hurling Rocks at the Fleet of Odysseus*.
Wall Painting from a house on the Esquiline Hill. Late 1st century B.C. Museo Profano, The Vatican, Rome

Colorplate 18. ROMAN. *Peaches and Glass Jar*. Wall Painting from Herculaneum. About 50 A.D.
National Museum, Naples

Colorplate 19. ROMAN. *Scenes of a Dionysiac Mystery Cult*. Wall painting.
About 50 B.C. Villa of the Mysteries, Pompeii

Colorplate 20. EGYPTO-ROMAN. *Portrait of a Boy,*
from the Faiyum, Lower Egypt. 2nd century A.D.
Encaustic on panel, 13 × 7 1/4″.
The Metropolitan Museum of Art, New York
(Gift of Edward S. Harkness, 1918)

Colorplate 21. ROMAN. *The Consecration of the Tabernacle and Its Priests*, from the Assembly Hall of the Synagogue at Dura-Europos. 245–56 A.D. Mural, 4′ 8 1/4″ × 7′ 8 1/4″. National Museum, Damascus

Colorplate 22. BYZANTINE. Interior (view toward the apse),
Sant' Apollinare in Classe, Ravenna. 533–49 A.D.

Colorplate 23. BYZANTINE. Page with *Jacob Wrestling with the Angel*, from the *Vienna Genesis*.
Early 6th century A.D. 11 3/4 × 9 1/2″. National Library, Vienna

Colorplate 24. BYZANTINE. *Empress Theodora and Her Attendants*
(portion of a mosaic). About 547 A.D. San Vitale, Ravenna

point of view: they represent the loss of many hard-won gains—a throwback to earlier, more primitive levels of expression. Yet such an approach does not really advance our understanding of the new style. The Constantinian panel cannot be explained as the result of a lack of ability, for it is far too consistent within itself to be regarded as no more than a clumsy attempt to imitate earlier Roman reliefs. Nor can it be viewed as a return to Archaic art, since there is nothing in pre-Classical times that looks like it. No, the Constantinian sculptor must have had a positive new purpose of his own. Perhaps we can approach it best by stressing one dominant feature of our relief: its sense of self-sufficiency. The scene fills the available area, and fills it completely (note how all the background buildings are made to have the same height), but any suggestion that it continues beyond the frame is carefully avoided. It is as if our artist had asked himself, "How can I get *all* of this complicated ceremonial event into my panel?" In order to do so, he has imposed an abstract order upon the world of appearances: the middle third of the strip is given over to the rostrum with Constantine and his entourage, the rest to the listeners and the buildings that identify the Roman Forum as the scene of the action (they are all quite recognizable, even though their scale and proportions have been drastically adjusted). The symmetrical design also permits him to make clear the unique status of the Emperor. Constantine not only occupies the exact center; he is shown full-face (his head, unfortunately, has been knocked off), while all the other figures turn their heads toward him to express their dependent relationship. That the frontal pose is indeed a position of majesty reserved for sovereigns, human or divine, is nicely demonstrated by the seated figures at the corners of the rostrum, the only ones besides Constantine to face us directly: these figures are statues of emperors—the same "good emperors" we met elsewhere on the arch, Hadrian and Marcus Aurelius. Looked at in this way, our relief reveals itself as a bold and original creation. It is the harbinger of a new vision that will become basic to the development of Christian art.

PAINTING

The modern beholder, whether expert or amateur, is apt to find painting the most exciting as well as the most baffling aspect of art under Roman rule—exciting because it represents the only large body of ancient painting subsequent to the Etruscan murals and because much of it, having come to light only in modern times, has the charm of the unfamiliar; baffling because we know infinitely less about it than we do about Roman architecture or sculpture. The surviving material, with very few exceptions, is severely limited in range; almost all of it consists of wall paintings, and the great majority of these come from Pompeii, Herculaneum, and other settlements buried by the eruption of Mount Vesuvius in 79 A.D., or

from Rome and its environs. Their dates cover a span of less than two hundred years, from the end of the first century B.C. to the late first century A.D.; what happened before or after remains largely a matter of guesswork. And since we have no Classical Greek or Hellenistic wall paintings, the problem of singling out the Roman element as against the Greek is far more difficult than in sculpture or architecture.

GREEK SOURCES

That there was copying of Greek designs, that Greek paintings as well as painters were imported, nobody will dispute. But the number of instances in which this can be demonstrated is small indeed. Let us consider two of these. At an earlier point, we mentioned Pliny's reference to a Greek picture of the late fourth century B.C. representing the battle of Issus (see page 169). The same subject—or, at any rate, another battle of Alexander's war against the Persians—is shown in an exceptionally large and technically accomplished floor mosaic from a Pompeian house of the first century B.C. Colorplate 16 illustrates the center and right half, with Darius and the fleeing Persians, and the badly damaged left-hand portion, with the figure of Alexander. While there is no special reason to link this mosaic with Pliny's account, we can hardly doubt that it is a copy—and an astonishingly proficient one—of a Hellenistic painting. But a Hellenistic painting of what date? The crowding, the air of frantic excitement, the powerfully modeled and foreshortened forms, the precise cast shadows—when did all these qualities reach this particular stage of development? We do not know, for even the great frieze of Pergamum seems restrained in comparison. Our second instance is the very opposite of the first. A small marble panel from Herculaneum painted in a delicate, linear style, it shows a group of five women, two of them engaged in a game of knucklebones (fig. 258). An inscription tells us that Alexandros of Athens painted this. The style quite obviously recalls that of the late fifth century B.C. (compare the Attic white-ground lekythos in colorplate 13), yet the execution seems so much weaker than the conception that it must be a copy or, better perhaps, an imitation in the Classical manner, comparable to the copies or adaptations of Classical Greek statues manufactured for the Roman market. It belongs to a special class of "collector's items" that is no more representative of Roman painting as a whole than the Alexander mosaic. We wonder, moreover, whether anything as attenuated as this actually existed in Classical Athenian art. Was it perhaps a late "neo-Attic" invention meant to cater to the taste of a certain group of Roman connoisseurs?

ROMAN ILLUSIONISM

The earliest phase of Roman wall painting, known from a few examples of the second century B.C., does show a

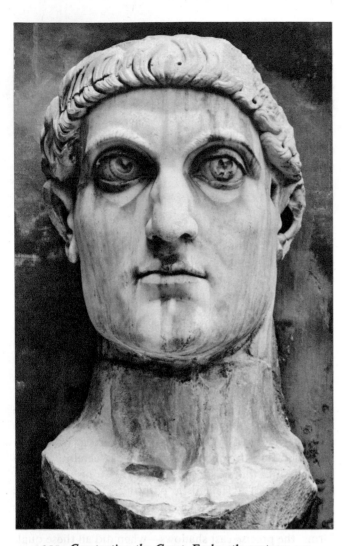

255. *Constantine the Great.* Early 4th century A.D.
Marble, height 8′. Capitoline Museums, Rome

256. The Arch of Constantine, Rome. 312–315 A.D.

257. Medallions (117–138 A.D.)
and Frieze (early 4th century),
Arch of Constantine

clear connection with the Hellenistic world, since it has also been found in the eastern Mediterranean. Unfortunately, it is not very informative for us, as it consists entirely of the imitation of colored marble paneling. About 100 B.C., this so-called First Style began to be displaced by a far more ambitious and elaborate style that sought to push back or open up the flat surface of the wall by means of illusionistic architectural perspectives and "window effects," including landscapes and figures. Three phases of this more elaborate style have been distinguished, known as the Second, Third, and Fourth Styles, but the differences between them are not always clear, and there seems to have been considerable overlapping in their sequence, so that we can largely disregard this classification here. The Fourth Style, which prevailed at the time of the eruption of Vesuvius in 79 A.D., is the most intricate of all; our example, a corner of the Ixion Room in the House of the Vettii at Pompeii (fig. 259), combines imitation marble paneling, conspicuously framed mythological scenes intended to give the effect of panel pictures set into the wall, and fantastic architectural vistas seen through make-believe windows. This architecture has a strangely unreal and picturesque quality that is believed to reflect the architectural backdrops of the theaters of the time; it often anticipates effects such as that of the Market Gate of Miletus (see fig. 232). The architectural vistas of the Second Style, as represented by our figure 260, are a good deal more substantial and thus provide a better measure of the illusionistic devices by which the Roman painter achieved these breakthroughs. He is clearly a master of modeling and surface textures; the forms framing the vista— the lustrous, richly decorated columns, the moldings, the mask at the top—have an extraordinary degree of three-dimensional reality. They effectively set off the distant view of buildings, which is flooded with light to convey a sense of free, open-air space. But as soon as we try to penetrate this architectural maze, we find ourselves lost; the individual structures cannot be disentangled from each other, their size and relationship are obscure. And we quickly realize that the Roman painter has no systematic grasp of spatial depth, that his perspective is haphazard and inconsistent within itself. Apparently he never intended us to enter the space he has created; like a promised land, it remains forever beyond us.

When landscape takes the place of architectural vistas, exact foreshortening becomes less important, and the virtues of the Roman painter's approach outweigh his limitations. This is strikingly demonstrated by the famous Odyssey Landscapes, a continuous stretch of landscape subdivided into eight compartments by a framework of pilasters. Each section illustrates an episode of the adventures of Odysseus (Ulysses). One of the adventures with the Laestrygonians is reproduced (colorplate 17). It has recently been cleaned, so that its colors stand out in all their original brilliance. The airy, bluish tones create a wonderful feeling of atmospheric, light-filled space that

envelops and binds together all the forms within this warm Mediterranean fairyland, where the human figures seem to play no more than an incidental role. Only upon further reflection do we realize how frail the illusion of coherence is even here: if we were to try mapping this landscape, we would find it just as ambiguous as the architectural perspective above. Its unity is not structural but poetic, like that of the stucco landscape in figure 244.

The Odyssey Landscapes form an instructive contrast with another approach to nature, which we know from the murals in a room of the Villa of Livia at Primaporta (fig. 261). Here the architectural framework has been dispensed with altogether; the entire wall is given over to a view of a delightful garden full of flowers, fruit trees, and birds. These charming details have the same tangible quality, the same concreteness of color and texture as the architectural framework of figure 260, and their apparent distance from the beholder is also about the same—they seem to be within arm's reach. At the bottom, there is a low trellis, beyond it a narrow strip of lawn with a tree in the center, then a low wall, and immediately after that the garden proper begins. Oddly enough, however, we cannot enter it; behind the front row of trees and flowers lies an opaque mass of greenery that shuts off our view as effectively as a dense hedge. This garden, then, is another promised land made only for looking. The wall has not really been opened up but merely pushed back a few feet and replaced by a wall of plants. It is this very limitation of spatial depth that endows our mural with its unusual degree of coherence. On a large scale, such restraint does not occur often in Roman mural decoration. We do find it, though, in the still lifes that sometimes make their appearance within the intricate architectural schemes. These usually take the form of make-believe niches or cupboards, so that the objects, which are often displayed on two levels, remain close to us. Our example (colorplate 18) is particularly noteworthy for the rendering of the translucent glass jar half-filled with water. The reflections are so acutely observed that we feel the painter must have copied them from an actual jar illuminated in just this way. But if we try to determine the source and direction of the light in the picture, we find that this cannot be done, because the shadows cast by the various objects are not consistent with each other. Nor do we have the impression that the jar stands in a stream of light; instead, the light seems to be imprisoned within the jar. Clearly, the Roman artist, despite his striving for illusionistic effects, is no more systematic in his approach to the behavior of light than in his handling of perspective. However sensuously real the details, his work nearly always lacks a basic unifying element in its overall structure. In the finest examples, this lack is amply compensated for by other qualities, so that our observation must not be regarded as condemning him to an inferior status. The absence of a consistent view of the visible world should be thought of, rather, as a fundamental barrier which differentiates Roman painting from

258. ALEXANDROS OF ATHENS.
The Knuckle-Bone Players. 1st century B.C.
Marble panel, 16 1/2 × 15″. National Museum, Naples

that of the Renaissance or of modern times.

The illusionistic tendencies that gained the upper hand in Roman murals during the first century B.C. may have been anticipated to some extent by Hellenistic painters, but in the form in which we know them they seem to be a specifically Roman development, as against the reproductive or imitative works we had examined before. Echoes of the latter persist in the mythological panels that occur like islands within an elaborate architectural framework (see fig. 259). While these scenes hardly ever give the impression of straightforward copies after Hel-

259. The Ixion Room, House of
the Vettii, Pompeii. 63–79 A.D.

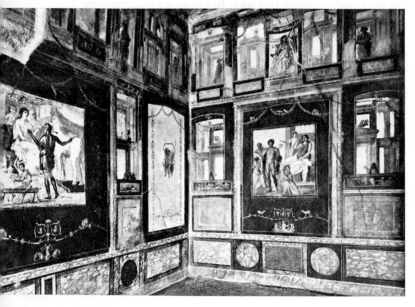

lenistic originals, they often have the somewhat disjointed character of compilations of motifs from various sources. A characteristic example is the picture of Hercules discovering the infant Telephus in Arcadia, from the Basilica at Herculaneum (fig. 262). What stamps it as the handiwork of a Roman painter is its oddly unstable style; almost everything here has the look of a "quotation," so that not only the forms, but even the brushwork varies from one figure to the next. Thus the personification of Arcadia, seated in the center, seems as cold, immobile, and tightly modeled as a statue, whereas Hercules, although his pose is equally statuesque, exhibits a broader and more luminous technique. Or compare the lion, painted in sketchy, agitated dabs, with the precise and graceful outlines of the doe. The sparkling highlights on the basket of fruit are derived from yet another source: they reflect still lifes such as in colorplate 18. And the mischievously smiling young Pan in the upper left-hand corner is composed of quick, feathery brush strokes that have a character all their own.

Villa of the Mysteries

There exists, however, one monument whose sweeping grandeur of design and coherence of style are unique in Roman painting: the great frieze in one of the rooms in the Villa of the Mysteries just outside Pompeii (colorplate 19 and fig. 263). Like the garden view from the Villa of Livia, it dates from the latter part of the first century B.C., when the Second Style was at its height. So far as the treatment of the wall space is concerned, the two works have more in common with each other than with the typical products of Second-Style mural decoration, for both of them are conceived in terms of rhythmic continuity and arm's-length depth. The artist who created the frieze in the Villa of the Mysteries has placed his figures on a narrow ledge of green against a regular pattern of red panels separated by strips of black, a kind of running stage on which they enact their strange and solemn ritual. Who are they, and what is the meaning of the cycle? Many details remain puzzling, but the program as a whole represents various aspects of the Dionysiac Mysteries, a semisecret cult of very ancient origin that had been brought to Italy from Greece. The sacred rites are performed in the presence of Dionysus and Ariadne, with their train of satyrs and sileni, so that human and mythical reality tend to merge into one. We sense this blending of the two spheres in the qualities all the figures have in common—their dignity of bearing and expression, the wonderful firmness of body and drapery, the rapt intensity with which they participate in the drama of the ritual. Many of the poses and gestures are taken from the repertory of Classical Greek art, yet they lack the studied and self-conscious quality we call classicism. An artist of exceptional greatness of vision has filled these forms with new life. Whatever his relation to the famous mas-

ters of Greek painting whose works are lost to us forever, he was their legitimate heir in the same sense that the finest Latin poets of the Augustan age were the legitimate heirs to the Greek poetic tradition.

Portraits

Portrait painting, according to Pliny, was an established custom in Republican Rome, serving the ancestor cult as did the portrait busts discussed earlier (see pages 166–67). None of these panels has survived, and the few portraits found on the walls of Roman houses in Pompeii may well derive from a different, a Hellenistic, tradition. The only coherent group of painted portraits at our disposal, strangely enough, comes from the Faiyum district in Lower Egypt. The earliest of them found so far seems to date from the second century A.D. We owe them to the survival—or revival—of an ancient Egyptian custom, that of attaching a portrait of the deceased to his wrapped, mummified body. Originally, these portraits had been sculptured (compare colorplate 5), but in Roman times they came to be replaced by painted ones such as the very fine and well-preserved wooden panel reproduced in colorplate 20. The amazing freshness of its colors is due to the fact that it was done in a technique of great durability called encaustic, which means that the pigments are suspended in hot wax. The mixture can be opaque and creamy, like oil paint, or thin and translucent. At their best, these portraits have an immediacy and sureness of touch that have rarely been surpassed; our dark-haired boy is as solid, sparkling, and lifelike a piece of reality as anyone might wish. The style of the picture—and it does have style, otherwise we could not tell it from a snapshot—becomes apparent only if we compare it with other Faiyum portraits. Since they were produced quickly and in large numbers, they tend to have many elements in common, such as the emphasis on the eyes, the placing of the highlights and shadows, the angle from which the face is seen. In the later examples, these conventional elements stiffen more and more into a fixed type, while in ours they merely furnish a flexible mold within which to cast the individual likeness. Whether to call this style Roman or Hellenistic is an idle question. We do know, however, that it was not confined to Egypt, since it can be linked with some portrait miniatures on glass apparently done in Italy during the third century A.D. The finest of them is the medallion shown in its actual size in figure 264. Its power of characterization, superior to that of any Faiyum portrait, represents the same climax of Roman portraiture that produced the marble bust of Philippus the Arab (see fig. 253).

EASTERN RELIGIONS

In discussing the crisis of the Roman world in the third century A.D. (see page 174), we mentioned, as characteristic of the mood of the times, the spread of Oriental

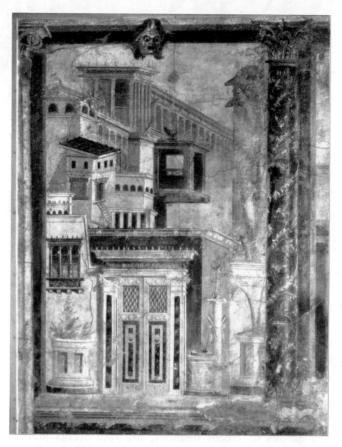

260. *Architectural View,* wall painting from a villa at Boscoreale, near Pompeii. 1st century B.C. The Metropolitan Museum of Art, New York (Rogers Fund, 1903)

mystery religions. They were of various origins—Egyptian, Persian, Semitic—and their early development naturally centered in their home territory, the southeastern provinces and border regions of the Roman Empire. Although based on traditions in effect long before the conquest of these ancient lands by Alexander the Great, the cults had been strongly influenced by Greek ideas during the Hellenistic period; it was, in fact, to this fusion of Oriental and Greek elements that they owed their vitality and appeal. The names of most of these cults, and their doctrines, are today remembered only by specialists, even though they were powerful rivals of Christianity during the early centuries of our era. In those days, the Near East was a vast religious and cultural melting pot where all the competing faiths, including Judaism, Christianity, Mithraism, Manichaeism, Gnosticism, and many others, tended to influence each other, so that they had an astonishing number of things in common, whatever their differences of origin, ritual, or nomenclature. Most of them shared such features as an emphasis on revealed truth, the hope of salvation, a chief prophet or messiah, the dichotomy of good and evil, a ritual of purification or initiation (baptism), and the duty to seek converts among the "unbelievers." The last and, in Near Eastern terms, the most successful product of this crossbreeding process was Islam, which still dominates the entire area to this day (see pages 225–27).

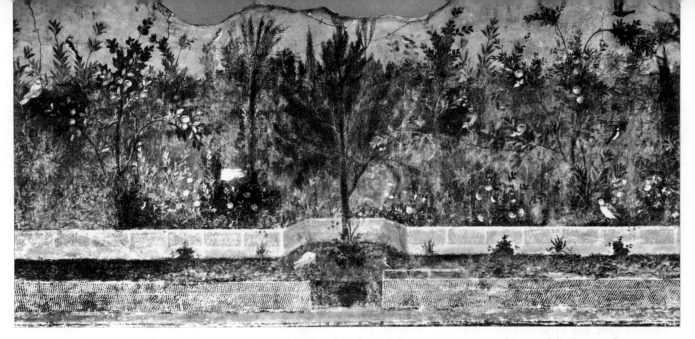

261. *View of a Garden,* wall painting from the Villa of Livia at Primaporta. c. 20 B.C. Museo delle Terme, Rome

The growth of the Graeco-Oriental religions under Roman rule is as yet very incompletely understood, since much of it was part of an underground movement which has left few tangible traces. Besides, the area where it took place has been a theater of war and destruction so many times that important discoveries, such as the Dead Sea Scrolls of recent memory, are rare events indeed. There is mounting evidence, however, that the new faiths also gave birth to a new style in art, and that this style, too, resulted from a fusion of Graeco-Roman and Oriental elements. The artists who struggled with the task of coining images to express the content of these faiths were not among the most gifted of their time; they were provincial craftsmen of modest ambition who drew upon whatever visual sources happened to be available to them, adapting, combining, and reshaping these as best they could. Their efforts are often clumsy, yet it is here that we find the beginnings of a tradition which was to become of basic importance for the development of medieval art.

Dura-Europos

The most telling illustrations of this new compound style have been found in the town of Dura-Europos on the upper Euphrates, a Roman frontier station that was captured by the resurgent Persians under Shapur I about 256 A.D. and abandoned by its population soon after. Its ruins have yielded the remains of sanctuaries of several religions, decorated with murals which all show essentially the same Graeco-Oriental character. The best preserved are those from the assembly hall of a synagogue, painted about 250 A.D.; of their numerous compartments, we illustrate the one representing the consecration of the tabernacle (colorplate 21). It is characteristic of the melting-pot conditions described before that even Judaism should have been affected by them. Momentarily, at least, the age-old injunction against images was relaxed so that the walls of the assembly hall could be covered with a richly detailed visual account of the history of the Chosen People and their Covenant with the Lord. The new attitude seems to have been linked with a tendency to change Judaism from a national to a universal faith by missionary activity among the non-Jewish population; interestingly enough, the inscriptions on the murals (such as the name Aaron in colorplate 21) are partly in Greek. In any event, we may be sure that the artists who designed these pictures faced an unaccustomed task, just as did the painters who worked for the earliest Christian communities; they had to cast into visible form what had hitherto been expressed only in words. How did they go about it? Let us take a closer look at our illustration: we can read the details—animals, human beings, buildings, cult objects—without trouble, but their relationship eludes us. There is no action, no story, only an assembly of forms and figures confronting us in the expectation that we will be able to establish the proper links between them. The frieze in the Villa of the Mysteries presents a similar difficulty—there, too, the beholder is supposed to know—yet it strikes us as very much less puzzling, for the figures have an eloquence of gesture and expression that makes them meaningful even though we may not understand the context of the scenes. If the synagogue painter fails to be equally persuasive, must we attribute this to his lack of competence, or are there other reasons as well? The question is rather like the one we faced when discussing the Constantinian relief of figure 257, which resembles the Dura-Europos mural in a number of ways. The synagogue painter exhibits the same sense of self-sufficiency, of condensation for the sake of completeness, but his subject is far more demanding: he had to represent a historical event of vast religious importance (the consecration of the tabernacle and its priests, which began the reconciliation of man and God) as described in detail in the Holy Scriptures, and he had to represent it in such a way as to suggest that it was also a timeless, recurrent ritual. Thus his picture is burdened with a wealth

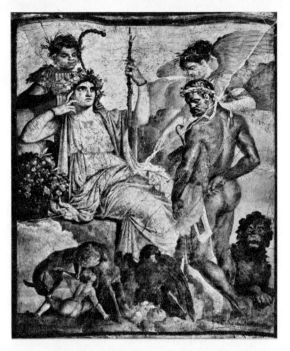

262. *Hercules and Telephus,* wall painting from
Herculaneum. c. 70 A.D. National Museum, Naples

263. Wall Painting Frieze. c. 50 B.C.
Villa of the Mysteries, Pompeii (detail of colorplate 19)

of significance far greater and more rigidly defined than
that of the Dionysiac frieze or the Constantinian relief.
Nor did he have a well-established tradition of Jewish
religious painting at his disposal to help him visualize
the tabernacle and the consecration ceremony. No won-
der he has fallen back on a sort of symbolic shorthand
composed of images borrowed from other, older tradi-
tions. The tabernacle itself, for instance, is shown as a
Classical temple, simply because our artist could not

imagine it, in accordance with the biblical description,
as a tentlike structure of poles and goat's-hair curtains.
The attendant and red heifer in the lower left-hand
corner are derived from Roman scenes of animal sacri-
fice, hence they show remnants of foreshortening not
found among the other figures. Other echoes of Roman
painting appear in the perspective view of the altar table
next to the figure of Aaron, in the perfunctory modeling
here and there, and in the rudimentary cast shadows
attached to some of the figures. Did the painter still
understand the purpose of these shadows? They seem
to be mere empty gestures, since the rest of the picture
betrays no awareness of either light or space in the Ro-
man sense. Even the occasional overlapping of forms
appears largely accidental. The sequence of things in
space is conveyed by other means: the seven-branched
candlestick, the two incense burners, the altar, and Aaron
are to be understood as behind, rather than on top of,
the crenelated wall that shields the precinct of the
tabernacle. Their size, however, is governed by their im-
portance, not by their position in space. Aaron, as the
principal figure, is not only larger than the attendants
but also more rigid and abstract. His costume, because
of its ritual significance, is diagramed in detail, at the
cost of obliterating the body underneath. The attendants,
on the other hand, still show a residue of mobility and
three-dimensional existence. Their garments, surprisingly
enough, are Persian, an indication not only of the odd
mixture of civilizations in this border area but of possible
artistic influences from Persia.

Our synagogue mural, then, combines—in none-too-
skillful fashion—a considerable variety of formal ele-
ments whose only common denominator is the religious
message of the whole. In the hands of a great artist, this
message might have been a stronger unifying force, but
even then the shapes and colors would have been no
more than a humble, imperfect simile of the spiritual
truth they were meant to serve. That, surely, was the
outlook of the authorities who supervised the execution
of the mural cycle and controlled its program. The essen-
tial quality of these pictures can no longer be understood
in the framework of ancient art; they express an attitude
that seems far closer to the Middle Ages. If we were to
sum up their purpose in a single phrase, we could hardly
do better than to quote a famous dictum justifying the
pictorial representation of Christian themes: *Quod legen-
tibus scriptura, hoc idiotis . . . pictura*—translated freely:
painting conveys the Word of God to the unlettered.

264. *Portrait of a Man.* c. 250 A.D.
Glass, diameter c. 2".
Archaeological Museum, Arezzo

8

EARLY CHRISTIAN
AND BYZANTINE ART

In 323 A.D. Constantine the Great made a fateful decision, the consequences of which are still felt today—he resolved to move the capital of the Roman Empire to the Greek town of Byzantium, which henceforth was to be known as Constantinople. Six years later, after an energetic building campaign, the transfer was officially completed. In taking this step, the Emperor acknowledged the growing strategic and economic importance of the eastern provinces (a development that had been going on for some time). The new capital also symbolized the new Christian basis of the Roman state, since it was in the heart of the most thoroughly Christianized region of the Empire. Constantine could hardly foresee that shifting the seat of imperial power would result in splitting the realm, yet within less than a hundred years the division had become an accomplished fact, even though the emperors at Constantinople did not relinquish their claim to the western provinces. The latter, ruled by western Roman emperors, soon fell prey to invading Germanic tribes—Visigoths, Vandals, Ostrogoths, Lombards. By the end of the sixth century, the last vestige of centralized authority had disappeared. The eastern, or Byzantine, Empire, in contrast, survived these onslaughts, and under Justinian (527–565) reached new power and stability. With the rise of Islam a hundred years later, the African and Near Eastern parts of the Empire were overrun by conquering Arab armies; in the eleventh century, the Turks occupied a large part of Asia Minor, while the last Byzantine possessions in the West (in southern Italy) fell to the Normans. Yet the Empire, with its domain reduced to the Balkans and Greece, held on until 1453, when the Turks finally conquered Constantinople itself.

The division of the Roman Empire soon led to a religious split as well. At the time of Constantine, the bishop of Rome, deriving his authority from St. Peter, was the acknowledged head, the pope, of the Christian Church. His claim to pre-eminence, however, soon came to be disputed by the patriarch of Constantinople, differences in doctrine began to develop, and eventually the division of Christendom into a Western, or Catholic, and an Eastern, or Orthodox, Church, became all but final. The differences between them went very deep: Roman Catholicism maintained its independence from imperial or any other state authority and became an international institution reflecting its character as the Universal Church, while the Orthodox Church was based on the union of spiritual and secular authority in the person of the emperor, who appointed the patriarch. It thus remained dependent on the power of the State, exacting a double allegiance from the faithful and sharing the vicissitudes of political power. We will recognize this pattern as the Christian adaptation of a very ancient heritage, the divine kingship of Egypt and the Near East; if the Byzantine emperors, unlike their pagan predecessors, could no longer claim the status of gods, they retained an equally unique and exalted role by placing themselves at the head of the Church as well as of the State. Nor did the tradition die with the fall of Constantinople. The tsars of Russia claimed the mantle of the Byzantine emperors, Moscow became "the third Rome," and the Russian Orthodox Church was as closely tied to the State as was its Byzantine parent body.

It is the religious even more than the political separation of East and West that makes it impossible to discuss the development of Christian art in the Roman Empire under a single heading. "Early Christian" does not, strictly speaking, designate a style; it refers, rather, to any work of art produced by or for Christians during the time prior to the splitting off of the Orthodox Church—or, roughly, the first five centuries of our era. "Byzantine art," on the other hand, designates not only the art of the Eastern Roman Empire but a specific quality of style as well. Since this style grew out of certain tendencies that can be traced back to the time of Constantine or even earlier, there is no sharp dividing line between Early Christian and Byzantine art. Thus the reign of Justinian has been termed the First Golden Age of Byzantine art, yet Justinian himself was a man of strongly western, Latin orientation who almost succeeded in reuniting the Constantinian domain; and the monuments he sponsored, especially those on Italian soil, may be viewed as either Early Christian or Byzantine, depending on which frame of reference we select. Soon after, it is true, the political and religious cleavage between East

265. Painted Ceiling. 4th century A.D.
Catacomb of SS. Pietro e Marcellino, Rome

and West became an artistic cleavage as well. In Western Europe, Celtic and Germanic peoples fell heir to the civilization of late antiquity, of which Early Christian art had been a part, and transformed it into that of the Middle Ages. The East, in contrast, experienced no such break; in the Byzantine Empire, late antiquity lived on, although the Greek and Oriental elements came increasingly to the fore at the expense of the Roman heritage. As a consequence, Byzantine civilization never became wholly medieval. "The Byzantines may have been senile," one historian has observed, "but they remained Greeks to the end." The same sense of tradition, of continuity with the past, determines the development of Byzantine art. We can understand it best, therefore, if we see it in the context of the final, Christian phase of antiquity rather than in the context of the Middle Ages.

EARLY CHRISTIAN ART

When and where the first Christian works of art were produced remains a matter of conjecture. Of the surviving monuments, none can be dated earlier than about 200 A.D.; therefore, we lack all direct knowledge of art in the service of Christianity before that time. In fact, there is little we know for certain about Christian art until we reach the reign of Constantine the Great, because the third century, too, is poorly represented. The painted decorations of the Roman catacombs, the underground burial places of the Christians, are the only sizable and coherent body of material, but these constitute merely one among various possible kinds of Christian art. Before Constantine, Rome was not yet the center of the faith; older and larger Christian communities existed in the great cities of North Africa and the Near East, such as Alexandria and Antioch. They had probably de-

veloped separate artistic traditions of their own. The extraordinary murals of the synagogue at Dura-Europos (see colorplate 21) suggest that paintings of a similarly orientalizing character may have decorated the walls of Christian places of worship in Syria and Palestine, since the earliest Christian congregations were formed by dissident members of the Jewish community. Alexandria, the home of a large and thoroughly Hellenized Jewish colony, during the first or the second century A.D. may have produced illustrations of the Old Testament in a style akin to that of Pompeian murals. We meet echoes of such scenes in Christian art later on, but we cannot be sure when or where they originated, or by what paths they entered the Christian tradition.

CATACOMBS

If the dearth of material from the eastern provinces of the Empire makes it difficult to judge the position of the catacomb paintings within the early development of Christian art, they nevertheless tell us a good deal about the spirit of the communities that sponsored them. The burial rite and the safeguarding of the tomb were of vital concern to the early Christian, whose faith rested on the hope of eternal life in paradise. The imagery of the catacombs, as can be seen in the painted ceiling in figure 265, clearly expresses this otherworldly outlook, although the forms are in essence still those of pre-Christian mural decoration. Thus we recognize the division of the ceiling into compartments as a late and highly simplified echo of the illusionistic architectural schemes in Pompeian painting; and the modeling of the figures, as well as the landscape settings, betray their descent from the same Roman idiom, which here, in the hands of an artist of very modest ability, has become debased by endless repetition. But the catacomb painter has used this traditional vocabulary to convey a new, symbolic content,

and the original meaning of the forms is of little interest to him. Even the geometric framework shares in this task, for the great circle suggests the Dome of Heaven, inscribed with the cross, the basic symbol of the faith. In the central medallion we see a youthful shepherd, with a sheep on his shoulders, in a pose that can be traced back as far as Greek Archaic art (compare fig. 134); he stands for Christ the Saviour, the Good Shepherd who gives His life for His sheep. The semicircular compartments tell the story of Jonah: on the left he is cast from the ship, on the right he emerges from the whale, and at the bottom he is safe again on dry land, meditating upon the mercy of the Lord. This Old Testament miracle, often juxtaposed with New Testament miracles, enjoyed immense favor in Early Christian art as proof of the Lord's power to rescue the faithful from the jaws of death. The standing figures represent members of the Church, with their hands raised in prayer, pleading for divine help. The entire scheme, though small in scale and unimpressive in execution, has a coherence and clarity that set it apart from its pagan ancestors as well as from the synagogue murals of Dura-Europos (see colorplate 21). It contains, if not the reality, at least the promise of a truly monumental new form (compare fig. 295).

ARCHITECTURE

Constantine's decision to make Christianity the state religion of the Roman Empire had a profound impact on Christian art. Until that time, congregations had been unable to meet for worship in public; services were held inconspicuously in the houses of the wealthier members. Now, almost overnight, an impressive architectural setting had to be created for the new official faith, so that the Church might be visible to all. Constantine himself devoted the full resources of his office to this task, and within a few years an astonishing number of large, im-

267. Reconstruction Drawing of Old St. Peter's, Rome (after Frazer)

268. Plan of
Old St. Peter's, Rome.
Begun c. 333 A.D.
(after Frazer)

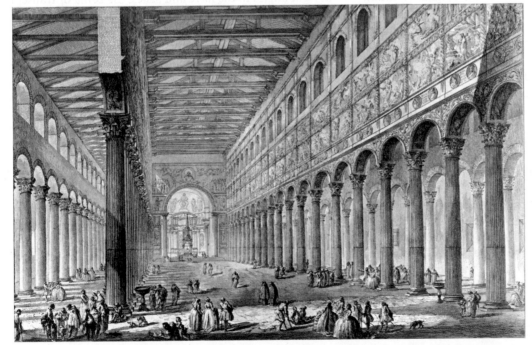

266. *Interior,*
St. Paul Outside the Walls,
Rome. Begun 386 A.D.
[Etching by G.B. Piranesi, 1749]

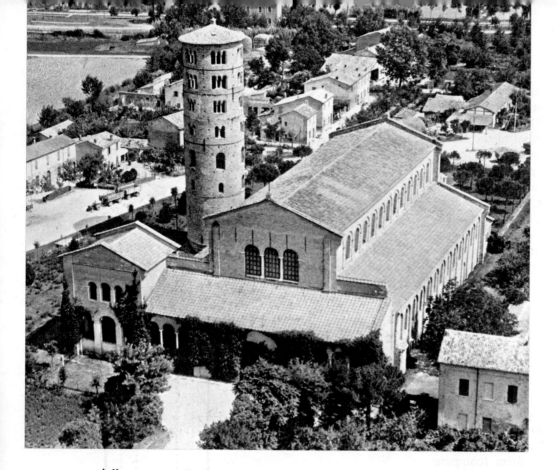

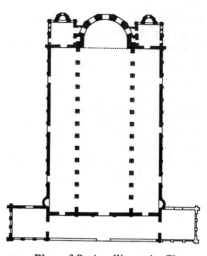

270. Plan of S. Apollinare in Classe,
Ravenna (after De Angelis d'Ossat)

269. S. Apollinare in Classe,
Ravenna. 533–549 A.D.

perially sponsored churches arose, not only in Rome but also in Constantinople, in the Holy Land, and at other important sites. These structures were a new type, now called the Early Christian basilica, that provided the basic model for the development of church architecture in western Europe. Unfortunately, none of them has survived in its original form, but the plan of the greatest Constantinian church, St. Peter's in Rome, is known with considerable accuracy (figs. 267, 268). For an impression of the interior, we must draw upon the slightly later basilica of St. Paul Outside the Walls, built on the same pattern, which remained essentially intact until it was wrecked by fire in 1823 (fig. 266). The Early Christian basilica, as exemplified in these two monuments, is a synthesis of assembly hall, temple, and private house. It also has the qualities of an original creation that cannot be wholly explained in terms of its sources. What it owes to the imperial basilicas of pagan times becomes obvious when we compare the plan of St. Peter's with that of the basilica at Leptis Magna, erected a hundred years earlier (fig. 229): the long nave flanked by aisles and lit by clerestory windows, the apse, the wooden roof, are familiar features of the earlier structure. The pagan basilica was indeed a uniquely suitable model for Constantinian churches, since it combined the spacious interior demanded by Christian ritual with imperial associations that proclaimed the privileged status of Christianity as the new State religion. But a church had to be more than an assembly hall; in addition to enclosing the community of the faithful, it was the sacred House of God, the Christian successor to the temples of old. In order to express this function, the design of the pagan basilica had to be given a new focus, the altar, which was

placed in front of the apse at the eastern end of the nave, and the entrances, which in pagan basilicas had usually been on the flanks, were shifted to the western end. The Christian basilica was thus oriented along a single, longitudinal axis that is curiously reminiscent of the layout of Egyptian temples (compare fig. 72). Before entering the church proper, we traverse a colonnaded court, the atrium (see page 163), the far side of which forms an entrance hall, the narthex. Only when we step through the nave portal do we gain the view presented in figure 266. The steady rhythm of the nave arcade pulls us toward the great arch at the eastern end (called the triumphal arch), which frames the altar and the vaulted apse beyond. As we come closer, we realize that the altar actually stands in a separate compartment of space placed at right angles to the nave and aisles, the bema or transept (in the lesser basilican churches, this feature is frequently omitted).

One essential aspect of Early Christian religious architecture has not yet emerged from our discussion: the contrast between exterior and interior. It is strikingly demonstrated in the sixth-century church of S. Apollinare in Classe near Ravenna, which still retains its original appearance for the most part. The plain brick exterior (figs. 269, 270) remains conspicuously unadorned; it is merely a shell whose shape reflects the interior space it encloses—the exact opposite of the Classical temple. (Our view, taken from the west, shows the narthex but not the atrium, which was torn down a long time ago; the round bell tower, or campanile, is a medieval addition.) This ascetic, antimonumental treatment of the exterior gives way to the utmost richness as we enter the church (colorplate 22). Here, having left the every-

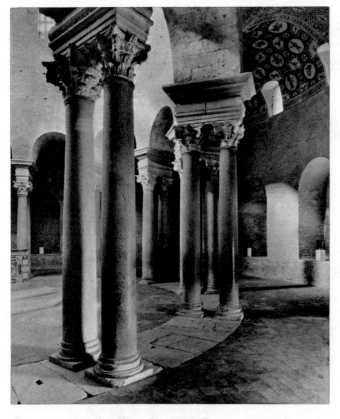

271. Interior, Sta. Costanza, Rome. c. 350 A.D.

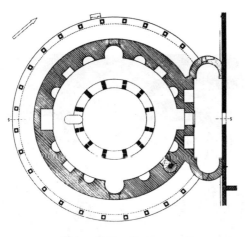

272. Plan of Sta. Costanza, Rome

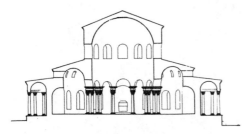

273. Section, Sta. Costanza, Rome

day world behind us, we find ourselves in a shimmering realm of light and color where precious marble surfaces and the brilliant glitter of mosaics evoke the spiritual splendor of the Kingdom of God.

Before dealing with these mosaic decorations at greater length, we must take note of another type of structure that entered the tradition of Christian architecture in Constantinian times: round or polygonal buildings crowned with a dome. They had been developed, we will recall, as part of the elaborate Roman baths; the design of the Pantheon was derived from that source (see page 162). Similar structures had been built to serve as monumental tombs, or mausoleums, by the pagan emperors. In the fourth century, this type of building is given a Christian meaning in the baptisteries (where the bath becomes a sacred rite) and funerary chapels linked with basilican churches. The finest surviving example is Sta. Costanza (figs. 271–73), the mausoleum of Constantine's daughter Constantia, originally attached to the (now ruined) Roman church of St. Agnes Outside the Walls. In contrast to its pagan predecessors, it shows a clear articulation of the interior space into a domed cylindrical core lit by clerestory windows—the counterpart of the nave of a basilican church—and a ring-shaped "aisle" or ambulatory covered by a barrel vault. Here again the mosaic decoration plays an essential part in setting the mood of the interior.

PAINTING; MOSAIC

The rapid growth of Christian architecture on a large scale must have had a well-nigh revolutionary effect on the development of Early Christian painting. All of a sudden, huge wall surfaces had to be covered with images worthy of their monumental framework. Who was equal to this challenge? Certainly not the humble artists who had decorated the catacombs with their limited stock of types and subjects. They were superseded by masters of greater ability, recruited, we may suppose, under imperial auspices, as were the architects of the new basilicas. Unfortunately, so little has survived of the decoration of fourth-century churches that its history cannot be traced in detail. Apparently, great pictorial cycles were spread over the nave walls, the triumphal arch, and the apse from the very start. These cycles must have drawn upon a great variety of earlier sources, reflecting the whole range of Graeco-Roman painting. The heritage of the past, however, was not only absorbed but transformed so as to make it fit its new environment, physical and spiritual. Out of this process, there emerged a great new art form, the Early Christian wall mosaic, which to a large extent replaced the older and cheaper technique of mural painting. Mosaics—designs composed of small pieces of colored material set in plaster—had been used by the Sumerians as early as the third millennium B.C. to embellish architectural surfaces. The Hellenistic Greeks and the Romans, employing small cubes of marble called

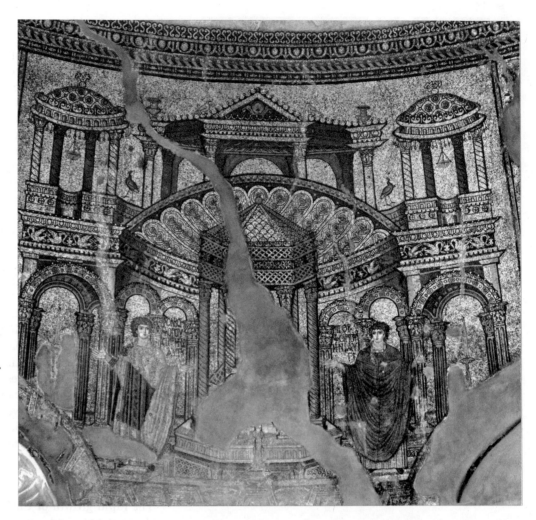

274. Dome Mosaic (detail).
Late 4th century A.D.
St. George, Salonica

tesserae, had refined the technique to the point that it could reproduce paintings, as in the *Battle of Issus* (see colorplate 16). Theirs were usually floor mosaics, however, and the color scale, although rich in gradations, lacked brilliance, since it was limited to the various kinds of colored marble found in nature. The Romans would also produce wall mosaics occasionally, but only for special purposes and on a limited scale. The vast and intricate wall mosaics of Early Christian art thus are essentially without precedent. The same is true of their material, for they consist of tesserae made of colored glass. These, too, were not entirely unknown to the Romans, yet their special virtues had never been exploited before; they offered colors of far greater range and intensity than marble tesserae, including gold, but lacked the fine gradations in tone necessary for imitating painted pictures. Moreover, the shiny (and slightly irregular) faces of glass tesserae act as tiny reflectors, so that the over-all effect is that of a glittering, immaterial screen rather than of a solid, continuous surface. All these qualities made glass mosaic the ideal complement of the new architectural aesthetic that confronts us in Early Christian basilicas. The guiding principle of Graeco-Roman architecture, we

275. *The Parting of Lot and Abraham* (mosaic). c. 430 A.D.
Sta. Maria Maggiore, Rome

recall, had been to express a balance of opposing forces, rather like the balance within the *contrapposto* of a Classical statue—a muscular, physical display of active and passive, supporting and supported members, whether these were structurally real or merely superimposed on a concrete core. Viewed in such terms, Early Christian architecture is strangely inexpressive, even antimonumental. The tangible, material structure has become subservient to the creation and definition of immaterial space; walls and vaults have the quality of weightless shells, their actual thickness and solidity hidden rather than emphasized as before. The brilliant color, the light-filled, transparent brightness of gold, the severe geometric order of the images in a mosaic complex such as that of S. Apollinare in Classe (colorplate 22) fit the spirit of these interiors to perfection. One might say, in fact, that Early Christian and Byzantine churches *demand* mosaics the way Greek temples demand architectural sculpture.

Roman mural painting had developed elaborate illusionistic devices in order to suggest a reality beyond the surface of the wall. Early Christian mosaics also denied the flatness of the wall surface, but for the purpose of achieving an "illusion of unreality," a luminous realm peopled by celestial beings or symbols. The difference in aim becomes particularly striking whenever these mosaics make use of the old formulas of spatial illusionism. Such is the case in figure 274, which shows a section of the magnificent dome mosaics from the church of St. George at Salonica, done at the end of the fourth century. Two saints, their hands raised in prayer, stand against a background that clearly betrays its descent from the perspective vistas of "stage architecture" in Pompeian painting; the foreshortening, to be sure, seems somewhat askew, but a surprising amount of it survives intact. Even so, the structure no longer seems real, for it lacks all physical substance: its body consists of the same gold as the background (other colors, mainly purple, blue, and green, are used only in the shaded portions and the ornament), so that the entire building becomes translucent. This is not a stage set but a piece of symbolic, otherworldly architecture meant to evoke such concepts as the Heavenly Jerusalem or the City of God.

In narrative scenes, too, we can watch the illusionistic tradition of ancient painting being transformed by the new content. Long sequences of them, selected from the Old and New Testaments, adorned the nave walls of Early Christian basilicas. *The Parting of Lot and Abraham* (fig. 275) is taken from the oldest surviving cycle of this kind, executed about 430 in the church of Sta. Maria Maggiore in Rome. Abraham, the boy Isaac, and the rest of his family occupy the left half of the composition; Lot and his clan, including his two small daughters, turn toward the city of Sodom on the right. The task of the artist who designed our panel is comparable to that faced by the sculptors of the Column of Trajan (see fig. 248): how to condense complex actions into a visual form that would permit them to be read at a distance. He has, in fact, employed many of the same "shorthand" devices, such as the abbreviative formulas for house, tree, and city, or the trick of showing a crowd of people as a "grape-cluster of heads" behind the foreground figures. But in the Trajanic reliefs, these devices could be used only to the extent that they were compatible with the realistic aim of the scenes, which re-create actual historic events. "Look, this is what happened in the Dacian wars," we are told. The mosaics in Sta. Maria Maggiore, on the other hand, depict the history of salvation; the reality they illustrate is the living word of the Scriptures (in our instance, Genesis 13), which is a *present* reality shared by artist and beholder alike, rather than something that happened only once in the space-and-time context of the external world. Our panel does not tell us, "This is what happened in Genesis 13" (we are expected to know that already), but "Behold the working of the Lord's will." Hence the artist need not clothe the scene with the concrete details of historic narrative; glances and gestures are becoming more important to him than dramatic movement or three-dimensional form. The symmetrical composition, with its cleavage in the center, makes clear the symbolic significance of this parting: the way of Abraham, which is that of righteousness and the Covenant, as against the way of Lot, destined for divine vengeance. And the contrasting fate of the two groups in further emphasized by the juxtaposition of Isaac and the daughters of Lot, whose future roles are thus called to mind.

ROLL, BOOK, AND ILLUSTRATION

From what source did the designers of narrative mosaic cycles such as that of Sta. Maria Maggiore derive their compositions? Were they the first to illustrate scenes from the Bible in extensive fashion? For certain subjects, they could have found models among the catacomb murals, but their most important prototypes may have come from illustrated manuscripts, especially of the Old Testament. As a scriptural religion, founded on the Word of God as revealed in Holy Writ, the early Christian Church must have sponsored the duplicating of the sacred text on a vast scale; and every copy of it was handled with a reverence quite unlike the treatment of any book in Graeco-Roman civilization. But when did these copies become works of pictorial art as well? And what did the earliest Bible illustrations look like? Books, unfortunately, are frail things; thus, their history in the ancient world is known to us largely from indirect evidence. It begins in Egypt—we do not know exactly when —with the discovery of a suitable material, paper-like but rather more brittle, made from the papyrus plant. Books of papyrus were in the form of rolls; they remained in use throughout antiquity. Not until late Hellenistic times did a better substance become available: parchment or vellum, thin, bleached animal hide, far more durable than papyrus. It was strong enough to be creased without

276. Miniature from the *Vatican Vergil*.
Early 5th century A.D. Vatican Library, Rome

breaking, and thus made possible the kind of bound book we know today, technically called a codex. Between the first and the fourth century A.D., the vellum codex gradually replaced the roll, whether vellum or papyrus. This technological change must have had an important effect on the growth of book illustration. As long as the roll form prevailed, illustrations seem to have been mostly line drawings, since layers of pigment would soon have cracked and come off in the process of rolling and unrolling; only the vellum codex permitted the use of rich colors, including gold, that was to make book illustration—or, as we usually say, illumination—the small-scale counterpart of murals, mosaics, and panel pictures. When, where, and at what pace the development of pictorial book illumination took place, whether biblical or classical subjects were primarily depicted, how much of a carry-over there might have been from roll to codex —all these are still unsettled problems. There can be little question, however, that the earliest illuminations, whether Christian, Jewish, or pagan, were done in a style strongly influenced by the illusionism of Hellenistic-Roman painting of the sort we meet at Pompeii. One of the oldest illustrated manuscripts preserved, the *Vatican Vergil*, probably executed in Italy about the time of the Sta. Maria Maggiore mosaics, reflects this tradition, although the quality of the miniatures is far from inspired (fig. 276); the picture, separated from the rest of the page by a heavy frame, has the effect of a window, and in the landscape we find remnants of deep space, perspective, and the play of light and shade.

The oldest illustrated Bible manuscripts so far discovered apparently belong to the early sixth century

(except for one fragment of five leaves that seems related to the *Vatican Vergil*); they, too, contain echoes of the Hellenistic-Roman style, in various stages of adaptation to religious narrative, often with a Near Eastern flavor that at times recalls the Dura-Europos murals (see colorplate 21). The most important example, the *Vienna Genesis*, is a far more striking work than the rather lame *Vergil*. Written in silver (now turned black) on purple vellum and adorned with brilliantly colored miniatures, it achieves a sumptuous effect not unlike that of the mosaics we have seen. Colorplate 23 shows a part of the story of Jacob; in the foreground, we see him wrestling with the angel and receiving the angel's benediction. The picture, then, does not show a single event but a whole sequence, strung out along a single U-shaped path, so that progression in space becomes progression in time. This method, known as continuous narration, has a complex—and much debated—history going back as far as ancient Egypt and Mesopotamia; its appearance in miniatures such as ours may reflect earlier illustrations made for books in roll form. (Our picture certainly looks like a frieze turned back upon itself.) For manuscript illustration, the continuous method offers the advantage of spatial economy; it permits the painter to pack a maximum of narrative content into the area at his disposal. Our artist apparently thought of his picture as a running account to be read like so many lines of text, rather than as a window demanding a frame. The painted forms are placed directly on the purple background that holds the letters, emphasizing the primary importance of the page as a unified field.

SCULPTURE

Compared to painting and architecture, sculpture played a secondary role in Early Christian art. The biblical prohibition of graven images was thought to apply with particular force to large cult statues, the idols worshiped in pagan temples, so that religious sculpture, in order to avoid the taint of idolatry, had to eschew life-size representations of the human figure. It thus developed from the very start in an antimonumental direction: away from the spatial depth and massive scale of Graeco-Roman sculpture toward shallow, small-scale forms and lacelike surface decoration. The earliest works of Christian sculpture are marble sarcophagi, which were produced from the middle of the third century on for the more important members of the Church. Before the time of Constantine, their decoration consisted mostly of the same limited repertory of themes familiar from catacomb murals—the Good Shepherd, Jonah and the Whale, and so forth—but within a framework borrowed from pagan sarcophagi. Not until a century later do we find a significantly broader range of subject matter and form. A key example for those years is the richly carved sarcophagus of Junius Bassus, a prefect of Rome, who died in 359 (figs. 277, 278). Its colonnaded front, divided into ten

277. Sarcophagus of Junius Bassus.
c. 359 A.D. Marble, 3′ 10 1/2″ × 8′.
Vatican Grottoes, Rome

278. *Christ Enthroned* (detail of fig. 277)

square compartments, shows a mixture of Old and New Testament scenes: in the upper row (left to right), the Sacrifice of Isaac, St. Peter Taken Prisoner, Christ Enthroned between SS. Peter and Paul, Christ before Pontius Pilate (two compartments); in the lower, the Misery of Job, the Fall of Man, Christ's Entry into Jerusalem, Daniel in the Lions' Den, and St. Paul Led to His Martyrdom. This choice, somewhat strange to the modern beholder, is highly characteristic of the early Christian way of thinking, which stresses the divine rather than the human na-

ture of Christ. Hence His suffering and death are merely hinted at; He appears before Pilate as a youthful, long-haired philosopher expounding the true wisdom (note the scroll), and the martyrdom of the two apostles is represented in the same discreet, nonviolent fashion. The two central scenes are devoted to Christ the King: as Ruler of the Universe He sits enthroned above the personification of the firmament, and as an earthly sovereign He enters Jerusalem in triumph. Adam and Eve, the original sinners, denote the burden of guilt redeemed by Christ, the Sacrifice of Isaac is the Old Testament prefiguration of Christ's sacrificial death, while Job and Daniel carry the same message as Jonah—they fortify man's hope of salvation.

When measured against the anti-Classical style of the frieze on the Arch of Constantine, carved almost half a century before (see fig. 257), the sarcophagus of Junius Bassus seems decidedly classicistic. The figures in their deeply recessed niches betray a conscious attempt to recapture the statuesque dignity of the Greek tradition. Yet beneath this superimposed quality we sense a basic kinship to the Constantinian style in the doll-like bodies, the large heads, the oddly becalmed, passive air of scenes calling for dramatic action. The events and personages confronting us are no longer intended to tell their own story, physically or emotionally, but to call to our minds a higher, symbolic meaning that binds them together. Classicizing tendencies of this sort seem to have been a recurrent phenomenon in Early Christian sculpture from the mid-fourth to the early sixth century. Their causes have been explained in various ways. On the one hand, during this period paganism still had many important adherents who may have fostered such revivals as a kind of rear-guard action; recent converts (such as Junius Bassus himself, who was baptized shortly before his death)

279. *Priestess of Bacchus* (leaf of a diptych). c. 390–400 A.D. Ivory, 11 ³/₄ × 5 ¹/₂″. Victoria & Albert Museum, London (Crown Copyright Reserved)

often retained a strong allegiance to the values of the past, artistic and otherwise; there were also important leaders of the Church who favored a reconciliation of Christianity with the heritage of Classical antiquity; and the imperial courts, too, both East and West, always remained aware of their institutional links with pre-Christian times, and could thus become centers for revivalist impulses. Whatever its roots in any given instance, classicism had its virtues in this age of transition, for it preserved—and thus helped to transmit to the future—a treasury of forms and an ideal of beauty that might have been irretrievably lost without it. All this holds true particularly for a class of objects whose artistic importance far exceeds their physical size: the ivory panels and other small-scale reliefs in precious materials. Designed for private ownership and meant to be enjoyed at close

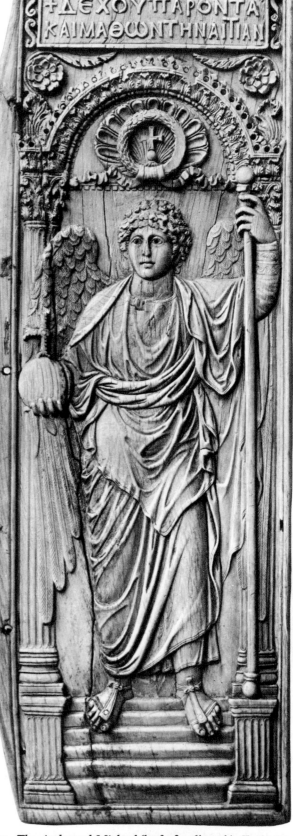

280. *The Archangel Michael* (leaf of a diptych). Early 6th century A.D. Ivory, 17 × 5 ¹/₂″. British Museum, London

281. *Portrait of Eutropios.* c. 450 A.D. Marble, height 12 ½".
Kunsthistorisches Museum, Vienna

range, they often mirror a collector's taste, a refined aesthetic sensibility not found among the large, official enterprises sponsored by Church or State. Such a piece is the ivory leaf (fig. 279) forming the right half of a hinged diptych that was carved about 390–400, probably on the occasion of a wedding among the Nicomachi and Symmachi, two aristocratic Roman families. Their conservative outlook is reflected not only in the pagan subject (a priestess of Bacchus and her assistant before an altar of Jupiter) but also in the design, which harks back to the era of Augustus (compare fig. 243). At first glance, we might well mistake it for a much earlier work, until we realize, from small spatial incongruities such as the priestess's right foot overlapping the frame, that these forms are quotations, reproduced with loving care but no longer fully understood. Significantly enough, the pagan theme did not prevent our panel from being incorporated into the shrine of a saint many centuries later; its cool perfection had an appeal for the Middle Ages as well. Our second ivory (fig. 280), done soon after 500 in the Eastern Roman Empire, shows a classicism that has become an eloquent vehicle of Christian content. The majestic archangel is clearly a descendant of the winged Victories of Graeco-Roman art, down to the richly articulated drapery. Yet the power he heralds is not of this world; nor does he inhabit an earthly space. The architectural niche against which he appears has lost all three-dimensional reality; its relationship to him is purely symbolic and ornamental, so that he seems to hover rather than to stand (notice the position of the feet on the steps). It is this disembodied quality, conveyed through classically harmonious forms, that gives him so compelling a presence.

If monumental statuary was discouraged by the Church, it retained, for a while at least, the patronage of the State.

Emperors, consuls, and high officials continued the old custom of erecting portrait statues of themselves in public places as late as the reign of Justinian, and sometimes later than that (the last recorded instance is in the late eighth century). Here, too, we find retrospective tendencies during the latter half of the fourth century and the early years of the fifth, with a revival of pre-Constantinian types and a renewed interest in individual characterization. From about 450 on, however, the outward likeness gives way to the image of a spiritual ideal, sometimes intensely expressive but increasingly impersonal; there were not to be any more portraits, in the Graeco-Roman sense of the term, for almost a thousand years to come. The process is strikingly exemplified by the head of Eutropios from Ephesus (fig. 281), one of the most memorable of its kind. It makes us think of the strangely sorrowful features of the "Plotinus" (fig. 254) and of the masklike colossal head of Constantine (fig. 255), but both of these have a physical concreteness that seems almost gross compared to the extreme attenuation of Eutropios. The face is frozen in visionary ecstasy, as if the sitter were a hermit saint; it looks, in fact, more like that of a specter than of a being of flesh and blood. The avoidance of solid volumes has been carried so far that the features are for the most part indicated only by thin ridges or shallow engraved lines. Their smooth curves emphasize the elongated oval of the head and thus reinforce its abstract, otherworldly character. Not only the individual person but the human body itself has ceased to be a tangible reality here; and with that the Greek tradition of sculpture in the round has reached the end of the road.

BYZANTINE ART

There is no clear-cut line of demarcation between Early Christian and Byzantine art. It could be argued that a Byzantine style (that is, a style associated with the imperial court of Constantinople) becomes discernible within Early Christian art as early as the beginning of the fifth century, soon after the effective division of the Empire. We have avoided making this distinction, for East Roman and West Roman—or, as some scholars prefer to call them, East and West Christian—characteristics are often difficult to separate before the sixth century. Until that time, both areas contributed to the development of Early Christian art, although the leadership tended to shift more and more to the East as the position of the West declined. During the reign of Justinian (527–565) this shift was completed; Constantinople not only reasserted its political dominance over the West but became the undisputed artistic capital as well. Justinian himself was an art patron on a scale unmatched since Constantine's day; the works he sponsored or promoted have an imperial grandeur that fully justifies the acclaim of those who have termed his era a golden age. They also display

282. Plan of S. Vitale, Ravenna

283. S. Vitale, Ravenna. 526–547 A.D.

284. Transverse Section of S. Vitale, Ravenna

285. Interior
(view from the apse),
S. Vitale, Ravenna

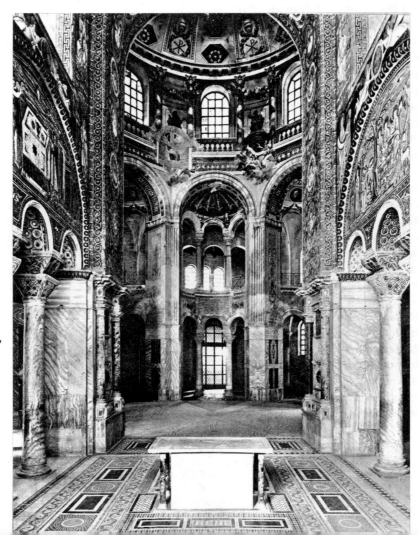

an inner coherence of style which links them more strongly with the future development of Byzantine art than with the art of the preceding centuries.

FIRST GOLDEN AGE: ARCHITECTURE AND DECORATION

Ironically enough, the richest array of monuments of the First Golden Age survives today not in Constantinople (where much has been destroyed) but on Italian soil, in Ravenna. That town, originally a naval station on the Adriatic, had become the capital of the Western Roman emperors in 402 and, at the end of the century, of Theodoric, king of the Ostrogoths, whose tastes were patterned after those of Constantinople. Under Justinian, Ravenna was the main stronghold of Byzantine rule in Italy. The most important church of that time, S. Vitale, built 526–547, represents a type derived mainly from Constantinople. We recognize its octagonal plan, with the domed central core (figs. 282–85), as a descendant of the mausoleum of Sta. Costanza in Rome (see figs. 271–73), but the intervening development seems to have taken place in the East, where domed churches of various kinds had been built during the previous century. Compared to Sta. Costanza, S. Vitale is both larger in scale and very much richer in its spatial effect; below the clerestory, the nave wall turns into a series of semicircular niches that penetrate into the aisle and thus link it to the nave in a new and intricate way. The aisle itself has been given a second story (the galleries were reserved for women). A new economy in the construction of the vaulting permits large windows on every level, which flood the interior with light. We find only the merest remnants of the longitudinal axis of the Early Christian basilica: a cross-vaulted compartment for the altar, backed by an apse, toward the east, and a narthex on the other side (its odd, non-symmetrical placement has never been fully accounted for). Remembering S. Apollinare in Classe, built at the same time on a straightforward basilican plan, we are particularly struck by the alien character of S. Vitale. How did it happen that the East favored a type of church building (as distinct from baptisteries and mausoleums) so radically different from the basilica and—from the Western point of view—so ill-adapted to Christian ritual? After all, had not the design of the basilica been backed by the authority of Constantine himself? Many different reasons have been suggested—practical, religious, political. All of them may be relevant, yet, if the truth be told, they fall short of a really persuasive explanation. In any event, from the time of Justinian domed, central-plan churches were to dominate the world of Orthodox Christianity as thoroughly as the basilican plan dominated the architecture of the medieval West. As for S. Vitale, its link with the Byzantine court is evidenced by the two famous mosaics flanking the altar (fig. 286 and colorplate 24), whose design must have come directly from the imperial workshop. Here Justinian and his Empress, Theodora, accompanied by officials, the local clergy, and ladies-in-waiting, attend the service as if this were a palace chapel. In these panels, executed shortly before the consecration of the church, we find an ideal of human beauty quite distinct from the squat, large-headed figures we had encountered in the art of the fourth and fifth centuries; occasionally (see figs. 274, 280, 281) we had caught a glimpse of this emerging new ideal, but only now do we see it complete: extraordinarily tall, slim figures, with tiny feet, small, almond-shaped faces dominated by the huge, staring eyes, and bodies that seem to be capable only of slow ceremonial gestures and the display of magnificently patterned costumes. Every hint of movement or change is carefully excluded—the dimensions of time and earthly space have given way to an eternal present amid the golden translucency of Heaven, and the solemn, frontal images seem to present a celestial rather than a secular court. This union of political and spiritual authority accurately reflects the "divine kingship" of the

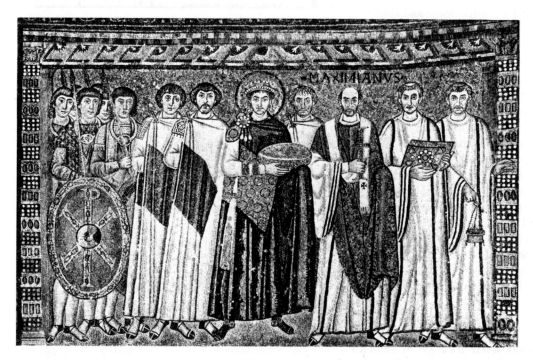

286. *Justinian and Attendants*
(mosaic).
c. 547 A.D. S. Vitale, Ravenna

Byzantine Emperor. We are, in fact, invited to see Justinian and Theodora as analogous to Christ and the Virgin: the hem of Theodora's mantle (not shown in our illustration) is conspicuously embroidered with the three Magi carrying their gifts to Mary and the newborn King, and Justinian is flanked by twelve companions—the imperial equivalent of the twelve apostles (six of them are soldiers, behind a shield with the monogram of Christ). If we turn from these mosaics to the interior space of the church, we discover that it, too, shares the quality of dematerialized, soaring slenderness that endows the figures with their air of mute exaltation. Justinian, Theodora, and their immediate neighbors were surely intended to be individual likenesses, and their features are indeed differentiated to a degree (those of the Archbishop, Maximianus, more so than the rest), but the ideal type has molded the faces as well as the bodies, so that they all have a curious family resemblance. We shall meet the same large dark eyes under curved brows, the same small mouths and long, narrow, slightly aquiline noses countless times from now on in Byzantine art.

Hagia Sophia

Among the surviving monuments of Justinian's reign in Constantinople, the most important by far is Hagia Sophia (the Church of Holy Wisdom), the architectural masterpiece of the age and one of the great creative triumphs of any age (figs. 287–91). Built in 532–37, it achieved such fame that the names of the architects, too, were remembered—Anthemius of Tralles and Isidorus of Miletus. After the Turkish conquest, it became a mosque (the four minarets were added at that time) and the mosaic decoration was largely hidden under whitewash. Some of the mosaics were uncovered in recent years (see colorplate 25), after the building was turned into a museum. The design of Hagia Sophia presents a unique combination of elements: it has the longitudinal axis of an Early Christian basilica, but the central feature of the nave is a square compartment crowned by a huge dome and abutted at either end by half-domes, so that the nave becomes a great oval. Attached to these half-domes are semicircular niches with open arcades, similar to those in S. Vitale; one might say, then, that the dome of Hagia Sophia has been inserted between the two halves of a central-plan church. The dome rests on four arches that carry its weight to the great piers at the corners of the square, so that the walls below the arches have no supporting function at all. The transition from the square formed by these arches to the circular rim of the dome is achieved by spherical triangles called pendentives; hence we speak of the entire unit as a dome on pendentives. This device permits the construction of taller, lighter, and more economical domes than the older method (as seen in the Pantheon, Sta. Costanza, and S. Vitale) of placing the dome on a round or polygonal base. Where or when the dome on pendentives was invented we do not

know; Hagia Sophia is the earliest example we have of its use on a monumental scale, and it must have been an example of epoch-making importance, for from now on the dome on pendentives became a basic feature of Byzantine architecture and, somewhat later, of Western architecture as well. There is, however, still another element that entered into the design of Hagia Sophia. The plan, the buttressing of the main piers, and the vast scale of the whole recall the Basilica of Constantine (figs. 225–27), the most ambitious achievement of imperial Roman vaulted architecture and the greatest monument associated with a ruler for whom Justinian had particular admiration. Hagia Sophia thus unites East and West, past and future, in a single overpowering synthesis. Its massive exterior, firmly planted upon the earth like a great mound, rises by stages to a height of 184 feet—41 feet higher than the Pantheon, and therefore the dome, although somewhat smaller (its diameter is 112 feet), stands out far more boldly. Once we are within, all sense of weight disappears, as if the material, solid aspects of the structure had been banished to the outside; nothing remains but an expanding space that inflates, like so many sails, the apsidal recesses, the pendentives, and the dome itself. Here the architectural aesthetic we saw taking shape in Early Christian architecture (see pages 196–97) has achieved a new, magnificent dimension. Even more than previously, light plays a key role: the dome seems to float—"like the radiant heavens," according to a contemporary descrip-

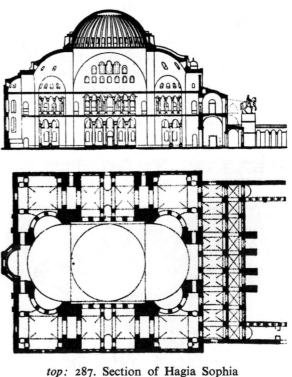

top: 287. Section of Hagia Sophia
(after Gurlitt)

above: 288. Plan of Hagia Sophia
(after v. Sybel)

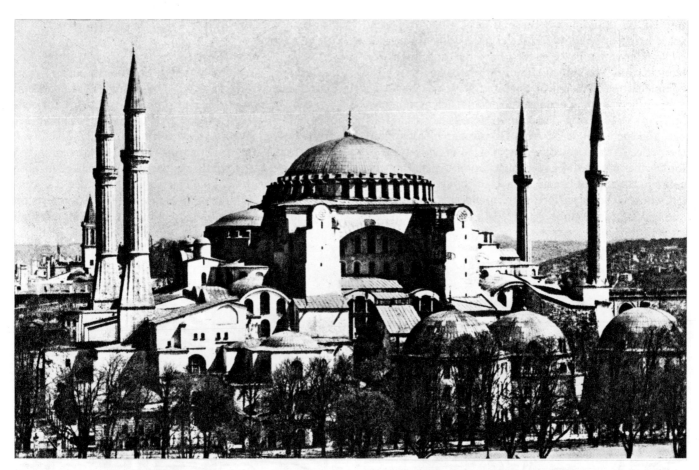

289. ANTHEMIUS OF TRALLES and ISIDORUS OF MILETUS. Hagia Sophia, Istanbul. 532–537 A.D.

290. Capital, Hagia Sophia

291. Interior, Hagia Sophia

tion of the building—because it rests upon a closely spaced ring of windows, and the nave walls are pierced by so many openings that they have the transparency of lace curtains. The golden glitter of the mosaics must have completed the "illusion of unreality." We can sense the new aesthetic even in ornamental details such as moldings and capitals (fig. 290). The motifs—scrolls, acanthus foliage, and such—all derive from Classical architecture, but their effect is radically different; instead of actively cushioning the impact of heavy weight upon the shaft of the column, the capital has become a sort of open-work basket whose delicate surface pattern conceals the strength and solidity of the stone.

SECOND GOLDEN AGE: ARCHITECTURE AND DECORATION

Byzantine architecture never produced another structure to match Hagia Sophia. The churches of the Second Golden Age (from the late ninth to the eleventh century) and after were modest in scale, and monastic rather than imperial in spirit. Their usual plan is that of a Greek cross (that is, a cross with arms of equal length) contained in a square, with a narthex added on one side and an apse (sometimes with flanking chapels) on the other. The central feature is a dome on a square base; it often rests on a cylindrical drum with tall windows, which raises it high

292. Churches of the Monastery of Hosios Loukas (St. Luke of Stiris), Greece. Early 11th century

293. Plan of Churches of the Monastery of Hosios Loukas, Greece (after Diehl)

294. Interior, Katholikon, Hosios Loukas

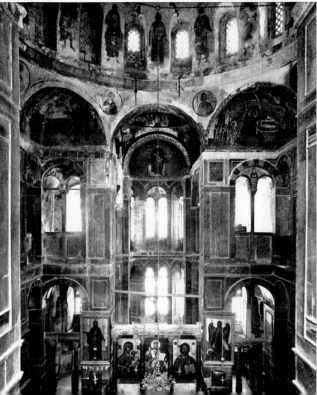

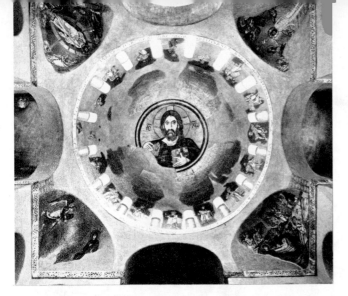

295. Dome Mosaics. 11th century. Monastery Church,
Daphnē, Greece

above the rest of the building, as in both churches of the
Monastery of Hosios Loukas in Greece (figs. 292, 293).
These also illustrate two other characteristics of later By-
zantine architecture: a tendency toward more ornate ex-
teriors, in contrast to the extreme severity we observed
earlier (compare fig. 283), and a preference for elongated
proportions. The full impact of this verticality, however,
strikes us only when we enter the church (fig. 294 shows
the interior of the Katholikon, which appears on the left
in figs. 292, 293). The tall, narrow space compartments
produce a sense of crowdedness, almost of compression,
which is dramatically relieved as we raise our glance to-
ward the luminous pool of space beneath the dome.
Figure 295 shows this view as it presents itself to us in the
Greek monastery church of Daphnē, where the pictorial
decoration of the dome is better preserved than in the
Katholikon of Hosios Loukas. Staring down from the
center of the dome is an awesome mosaic image of Christ
the Pantocrator (Ruler of the Universe) against a gold
background, its huge scale emphasized by the much
smaller figures of the sixteen Old Testament prophets
between the windows. In the corners, we see four scenes
revealing the divine and human natures of Christ—the
Annunciation (bottom left) followed in counterclockwise
order by the Birth, Baptism, and Transfiguration. The
entire cycle represents a theological program so perfectly
in harmony with the geometric relationship of the images
that we cannot say whether the architecture has been
shaped by the pictorial scheme or vice versa. A similarly
strict order governs the distribution of subjects through-
out the rest of the interior.

The largest and most lavishly decorated church of the
Second Golden Age surviving today is St. Mark's in Ven-
ice, begun in 1063. The Venetians had long been under
Byzantine sovereignty and remained artistically depend-
ent on the East long after they had become a political and
commercial power in their own right. St. Mark's, too,
shows the Greek-cross plan inscribed within a square, but
here each arm of the cross is emphasized by a dome of its
own (figs. 296, 297). These domes are not raised on drums;
instead, they have been encased in bulbous wooden hel-

mets covered by gilt copper sheeting and topped by
ornate lanterns, to make them appear taller and more
conspicuous at a distance. They make a splendid land-
mark for the seafarer. The spacious interior, famous for
its mosaics, shows that it was meant to receive the citizen-
ry of a large metropolis, and not just a small monastic
community as at Daphnē or Hosios Loukas. During the
Second Golden Age, Byzantine architecture also spread
to Russia, along with the Orthodox faith. There the basic
type of the Byzantine church underwent an amazing
transformation through the use of wood as a structural
material. The most famous product of this native trend is
the Cathedral of St. Basil adjoining the Kremlin in Mos-
cow (fig. 298). Built during the reign of Ivan the Terrible,
it seems as unmistakably Russian as that extraordinary
ruler. The domes, growing in limitless profusion, have
become fantastic tower-like structures whose vividly
patterned helmets may resemble anything from mush-
rooms and berries to Oriental turbans. These huge ice-
cream cones have the gay unreality of a fairy tale, yet
their total effect is oddly impressive. Keyed as they are to
the imagination of simple peasant folk (who must have
stared at them in open-mouthed wonder on their rare
visits to the capital), they nevertheless convey a sense of
the miraculous derived from the more austere miracles
of Byzantine architecture.

Iconoclasm and Revival

The development of Byzantine painting and sculpture
after the age of Justinian was disrupted by the Icono-
clastic Controversy, which began with an imperial edict
of 726 prohibiting religious images. It raged for more
than a hundred years, dividing the population into two
hostile groups. The image-destroyers (iconoclasts), led
by the emperor and supported mainly in the eastern
provinces of the realm, insisted on a literal interpretation
of the biblical ban against graven images as conducive to
idolatry; they wanted to restrict religious art to abstract
symbols and plant or animal forms. Their opponents, the
iconophiles, were led by the monks and centered in the
western provinces, where the imperial edict remained in-
effective for the most part. The roots of the conflict went
very deep: on the plane of theology they involved the
basic issue of the relationship of the human and divine in
the person of Christ, while socially and politically they
reflected a power struggle between State and Church. The
Controversy also marked the final break between Cathol-
icism and the Orthodox faith.

Had the edict been enforceable throughout the Empire,
it might well have dealt Byzantine religious art a fatal
blow. It did succeed in reducing the production of sacred
images very greatly, but failed to wipe it out altogether,
so that there was a fairly rapid recovery after the victory
of the iconophiles in 843. While we know little for certain
about how the Byzantine artistic tradition managed to
survive from the early eighth to the mid-ninth century,

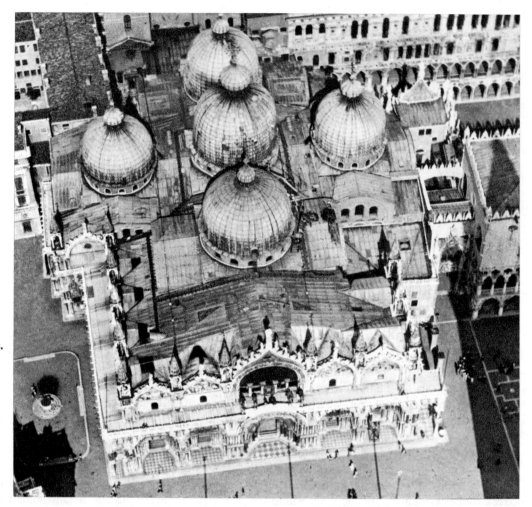

296. St. Mark's
(aerial view), Venice.
Begun 1063

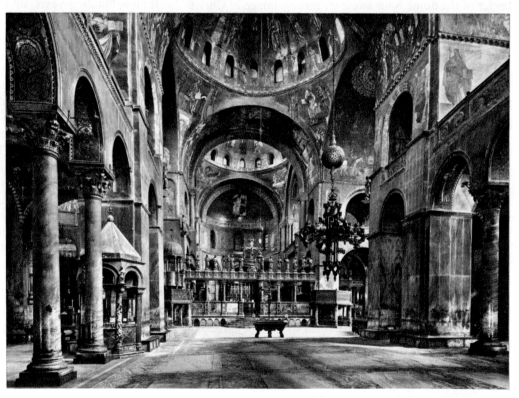

297. Interior,
St. Mark's, Venice

298. Cathedral of St. Basil, Moscow. 1554–60

Iconoclasm seems to have brought about a renewed interest in secular art, which was not affected by the ban. This may help to explain the astonishing reappearance of Late Classical motifs in the art of the Second Golden Age, as in *David Composing the Psalms* from the so-called *Paris Psalter* (colorplate 26). It was probably illuminated about 900, although the temptation to put it earlier is almost irresistible. Not only do we find a landscape here that recalls Pompeian murals; the figures, too, obviously derive from Classical models. David himself could well be mistaken for Orpheus charming the beasts with his music, and his companions prove even more surprising, since they are allegorical figures that have nothing to do with the Bible at all: the young woman next to David is Melody, the one coyly hiding behind a pillar is Echo, and the male figure with a tree trunk personifies the mountains of Bethlehem. The late date of the picture is evident only from certain qualities of style such as the abstract zigzag pattern of the drapery covering Melody's legs. Another fascinating reflection of an early source is the sequence of scenes from Genesis among the mosaics of St. Mark's in Venice (fig. 300), which must have been adapted from an Early Christian illuminated manuscript. The squat, large-headed figures recall the art of the fourth century, as does the classical young philosopher type representing the Lord (compare fig. 278), which had been long since replaced in general usage by the more familiar

bearded type (see fig. 295). Of particular interest is the scene in the upper right-hand corner. Ancient art had visualized the human soul as a tiny nude figure with butterfly wings; here this image reappears—or survives, rather—under Christian auspices as the spirit of life that the Lord breathes into Adam.

The *Paris Psalter* and the Genesis mosaics in St. Mark's betray an almost antiquarian enthusiasm for the traditions of Classical art. Such direct revivals, however, are extreme cases. The finest works of the Second Golden Age show a classicism that has been harmoniously merged with the spiritualized ideal of human beauty we encountered in the art of Justinian's reign. Among these, the *Crucifixion* mosaic at Daphnē (fig. 299) enjoys special fame. Its Classical qualities are more fundamental, and more deeply felt, than those of the *Paris Psalter,* yet also completely Christian: there is no attempt to re-create a realistic spatial setting, but the composition has a balance and clarity that are truly monumental as against the cluttered Pompeian landscape of the David miniature. Classical, too, is the statuesque dignity of the figures, which seem extraordinarily organic and graceful compared to those of the Justinian mosaic at S. Vitale (fig. 286). The most important aspect of their Classical heritage, however, is emotional rather than physical; it is the gentle *pathos* conveyed by their gestures and facial expressions, a restrained and noble suffering of the kind we first met in Greek art of the fifth century B.C. (see pages 130–31). Early Christian art had been devoid of this quality. Its view of Christ stressed the Saviour's divine wisdom and power, rather than his sacrificial death, so that the Crucifixion was depicted only rarely and in a notably unpathetic spirit. The image of the Pantocrator as we saw it on the sarcophagus of Junius Bassus and above the apse of S. Apollinare in Classe (fig. 278, colorplate 22) retained its importance throughout the Second Golden Age— the majestic dome mosaic at Daphnē stems from that tradition—but alongside it we now find a new emphasis on the Christ of the Passion. When and where this human interpretation of the Saviour made its first appearance, we cannot say for sure; it seems to have developed in the wake of the Iconoclastic Controversy. There are few examples of it earlier than the Daphnē *Crucifixion,* and none of them has as powerful an appeal to the emotions of the beholder. To have introduced this compassionate quality into sacred art was perhaps the greatest achievement of the Second Golden Age, even though its full possibilities were to be exploited not in Byzantium but in the medieval West at a later date. Yet Byzantine art, too, preserved and developed the human view of Christ in the centuries to come. The wonderful mosaic fragment from Hagia Sophia (colorplate 25), probably a work of the thirteenth century, no longer has the forbidding severity of the Daphnē *Pantocrator:* instead, we find an expression of gentle melancholy, along with a subtlety of modeling and color that perpetuates the best Classical tradition of the Second Golden Age.

299. *The Crucifixion* (mosaic).
11th century. Monastery Church, Daphnē

In 1204 Byzantium sustained an almost fatal defeat when the armies of the Fourth Crusade, instead of warring against the Turks, assaulted and took the city of Constantinople. For over half a century, the core of the Empire remained in Latin hands. Byzantium, however, survived even this catastrophe; in 1261, it once more regained its sovereignty, and the fourteenth century saw a last efflorescence of Byzantine painting, with a distinct and original flavor of its own, before the Turkish conquest in 1453. Because of the impoverished state of the greatly shrunken Empire, mural painting often took the place of mosaics, as in the recently uncovered wall decoration of a mortuary chapel attached to the Kariye Camii (the former Church of the Saviour in Chora) in Istanbul. From this impressive cycle of pictures, done about 1310–20, we reproduce the *Anastasis* (Greek for the Resurrection), in figure 301. The scene actually depicts the event just before the Resurrection—Christ's Descent into Limbo. Surrounded by a radiant gloriole, the Saviour has vanquished Satan and battered down the gates of Hell (note the bound Satan at His feet, in the midst of an incredible profusion of hardware) and is raising Adam and Eve from the dead. What amazes us about this central group is its dramatic force, a quality we would hardly expect to find on the basis of what we have seen of Byzantine art so far. Christ here moves with extraordinary physical energy, tearing Adam and Eve from their graves, so that they appear to fly through the air—a magnificently expressive image of divine triumph. Such dynamism had

300. Scenes from Genesis (mosaic).
c. 1200. St. Mark's, Venice

301. *Anastasis*, Fresco,
c. 1310–20. Kariye Camii
(Church of the Saviour in Chora),
Istanbul

been unknown in the earlier Byzantine tradition. Coming in the fourteenth century, it shows that 800 years after Justinian, Byzantine art still had its creative powers.

Icons

During the Iconoclastic Controversy, one of the chief arguments in favor of sacred images was the claim that Christ Himself had permitted St. Luke to paint His portrait, and that other portraits of Christ or of the Virgin had miraculously appeared on earth by divine fiat. These original, "true" sacred images were supposedly the source of the later, man-made ones. Such pictures, or icons, had developed in early Christian times out of Graeco-Roman portrait panels (such as colorplate 20). Little is known about their origins, for examples antedating the Iconoclastic Controversy are extremely scarce. Of the few discovered so far, perhaps the most important is the *Madonna* from Sta. Francesca Romana in Rome, brought to light some years ago by the cleaning of a much-repainted panel. Only the Virgin's face still shows the original surface in fair condition (fig. 302). Its link with Graeco-Roman portraiture is evident not only from the painting medium, which is encaustic (see page 189), a technique that went out of use after the Iconoclastic Controversy, but also from the fine gradations of light and shade. The forms themselves, however—the heart-shaped outline of the face, the tiny mouth, the long, narrow nose, the huge eyes under strongly arched brows—reflect an ideal of human beauty as spiritualized as that of the S. Vitale mosaics, while retaining a far higher degree of three-

302. *Madonna* (detail).
6th–7th century A.D. Encaustic on wood.
Sta. Francesca Romana, Rome

303. *Madonna Enthroned*. Late 13th century. Panel, 32 × 19 1/2″. National Gallery of Art, Washington, D.C. (Mellon Collection)

play of drapery folds, the tender melancholy of the Virgin's face, the elaborate, architectural perspective of the throne (which looks rather like a miniature replica of the Colosseum). But all these elements have become oddly abstract. The throne, despite its foreshortening, no longer functions as a three-dimensional object, and the highlights on the drapery resemble ornamental sunbursts, in strange contrast to the soft shading of hands and faces. The total effect is neither flat nor spatial but transparent, somewhat like that of a stained-glass window; the shapes look as if they were lit from behind. And this is almost literally true, for they are painted in a thin film on a highly reflecting gold surface that forms the highlights, the halos, and the background, so that even the shadows never seem wholly opaque. This all-pervading celestial radiance, we will recall, is a quality we first encountered in Early Christian mosaics. Panels such as ours, therefore, should be viewed as the aesthetic equivalent of mosaics on a smaller scale and not simply as the descendants of the ancient panel painting tradition. In fact, the most precious Byzantine icons are miniature mosaics done on panels, rather than paintings.

Along with the Orthodox faith, icon painting spread throughout the Balkans and Russia, where it continued to flourish even after the disappearance of the Byzantine Empire. The shifting of the creative impulses within this tradition to the outlying areas of the Orthodox world is signalized by the work of Andrei Rublev, the finest Russian icon painter and a great artist by any standard. Colorplate 27 shows his famous panel, *Old Testament Trinity,* done about 1410–20. (The title refers to the three angels who visited Abraham at Mamre.) Although parts of it are poorly preserved—most of the background has disappeared—the picture reveals a harmonious beauty of design and a depth of lyrical feeling that vie with the most Classical products of the Second Golden Age. Rublev must have been thoroughly acquainted with the best Byzantine art had to offer, either through contact with Greek painters in Russia or through a sojourn in Constantinople. The most individual element—and also the most distinctively Russian—is the color scale, brighter, more complex, and different in key from that of any Byzantine work. In the hands of a lesser master, such combinations as orange, vermilion, and turquoise might easily have assumed a primitive garishness of the sort we often encounter in folk art; here, the controlled intensity of these tones becomes an essential part of the composition.

SCULPTURE

Monumental sculpture, as we saw earlier, tended to disappear completely from the fifth century on. In Byzantine art, large-scale statuary died out with the last imperial portraits, and stone carving was confined almost entirely to architectural ornament (see fig. 290), while small-scale reliefs, especially in ivory and metal, contin-

dimensional solidity. What makes this image so singularly impressive is the geometric severity of the design, which endows the features with a monumental grandeur such as we never encounter again in Early Christian or Byzantine art. Where and when was it produced? In the sixth or seventh century, we must assume, but whether in Italy or the East we cannot say, for lack of comparable material. Be that as it may, it is a work of extraordinary power which makes us understand how men came to believe in the superhuman origin of sacred pictures.

Because of the veneration in which they were held, icons had to conform to strict formal rules, with fixed patterns repeated over and over again. As a consequence, the majority of them are more conspicuous for exacting craftsmanship than for artistic inventiveness. The *Madonna Enthroned* (fig. 303) is a work of this kind; although painted in the thirteenth century, it reflects a type several hundred years earlier. Echoes of the Classicism of the Second Golden Age abound: the graceful pose, the rich

304. *The Harbaville Triptych.*
Late 10th century. Ivory,
9 1/2 × 11". The Louvre, Paris

305. *The Sacrifice of Iphigenia*
(detail of ivory casket).
10th century.
Victoria & Albert Museum, London
(Crown Copyright Reserved)

ued to be produced throughout the Second Golden Age and beyond. Their extraordinary variety of content, style, and purpose is suggested by the two samples shown here, both of them dating from the tenth century. One is a triptych—a small portable altar shrine with two hinged wings—of the sort a high dignitary might carry for his private devotions while traveling (fig. 304); in the upper half of the center panel we see Christ Enthroned, flanked by St. John the Baptist and the Virgin—who plead for divine mercy on behalf of mankind—and five apostles below. The exquisite refinement of this icon-in-miniature recalls the style of the Daphnē *Crucifixion.* Our second panel, representing the Sacrifice of Iphigenia (fig. 305), belongs to an ivory casket meant for wedding gifts and, rather surprisingly, is decorated with scenes of Greek mythology. Even more than the miniatures of the *Paris Psalter,* it illustrates the antiquarian aspects of Byzantine classicism subsequent to the Iconoclastic Controversy, for the subject is that of a famous drama by Euripides; and our composition (which is curiously shallow, despite the deep undercutting of the relief) probably derives from an illustrated Euripides manuscript, rather than from a sculptural source. Though drained of all tragic emotion and reduced to a level of ornamental playfulness, these knobby little figures form a coherent visual quotation from ancient art. It was through channels such as this that the Graeco-Roman heritage entered the mainstream of Byzantine tradition.

ILLUSTRATED TIME CHART I

B.C. 7000

6000

4000

POLITICAL HISTORY, RELIGION

Sumerians settle in lower Mesopotamia
Predynastic period in Egypt; Menes unites
 Upper and Lower Egypt c. 3100

3000

Old Kingdom, Egypt (dynasties I–VI)
 c. 3100–2185
Divine Kingship of the Pharaoh
Early dynastic period, Sumer, c. 3000–2340;
 Akkadian kings 2340–2180; Gudea c. 2150
Theocratic socialism in Sumer

LITERATURE, SCIENCE, TECHNOLOC

Pictographic writing, Sumer, c. 3500
Wheeled carts, Sumer, c. 3500–3000
Sailboats in Egypt after c. 3500
Use of potter's wheel, Sumer, c. 3250

Hieroglyphic writing, Egypt, c. 3000
Cuneiform writing, Sumer, c. 2900
First bronze tools and weapons, Sumer
Plows drawn by oxen

2000

Middle Kingdom, Egypt, 2133–1786
Hammurabi founds Babylonian dynasty
 c. 1760
Code of Hammurabi c. 1760
Hittites conquer Babylon c. 1600
Flowering of Minoan civilization c. 1700–
 1500
New Kingdom, Egypt, c. 1580–1085
Monotheism of Akhenaten (r. 1372–1358)
Shang dynasty, China, c. 1500–1100
Dorians invade Greece c. 1100

Bronze tools and weapons in Egypt
Canal from Nile to Red Sea
Mathematics and astronomy flourish in
 Babylon under Hammurabi
Hittites employ iron tools and weapons
Hyksos bring horses and wheeled vehicles
 to Egypt c. 1725
China develops silk production c. 1500
Oldest Sanskrit literature (Vedas) in India
 c. 1500–1000

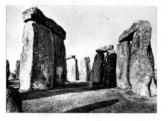

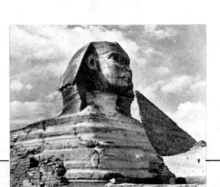

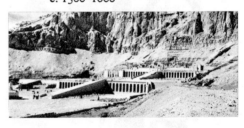

1000

Hebrews accept monotheism
Jerusalem capital of Palestine; rule of
 David; of Solomon (died 926)
Assyrian Empire c. 1000–612
Chou dynasty, China, 1027–256
Zoroaster (born c. 660)
Nebuchadnezzar destroys Jerusalem 586
Gautama Buddha (563–483)
Confucius (551–479)
Persians conquer Babylon 539; Egypt 525
Athenians expel Hippias, last of tyrants,
 and establish democracy 510
Romans revolt against Etruscans, set up
 republic 509

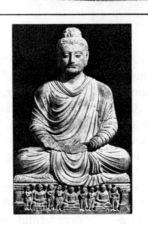

Phoenicians develop alphabetic writing c.
 1000; Greeks adopt it c. 800
Earliest iron tools and weapons in China
Ideographic writing in China
Sacred Hindu writings c. 800–600
First Olympic games 776
Homer (fl. c. 750–700)
Coinage invented in Lydia (Asia Minor)
 c. 700–650; soon adopted by Greeks
Thales of Miletus calculates solar eclipse
 585; Anaximander of Miletus designs
 geographic map and celestial globe c. 560
Aeschylus (525–456)
Pythagoras (fl. c. 520)

500

PAINTING, SCULPTURE, ARCHITECTURE

7000 B.C.

Fortifications, Jericho, Jordan

6000

Houses, Shrine, and Wall Painting, Çatal Hüyük

4000

Painted beaker, Susa
Female Head from Uruk
"White Temple" and ziggurat, Uruk
Mural, Hierakonpolis

3000

Palette of Narmer
Statues from Abu temple, Tell Asmar
Step pyramid and funerary district of Zoser,
 Saqqara, by Imhotep
Harp and offering stand from Ur
Rahotep and Nofret
Ankh-haf
Chefren from Giza
Pyramids at Giza
Idol from Amorgos
Ziggurat of King Urnammu
Tomb of Ti, Saqqara
Stele of Naram-Sin
Gudea statues from Lagash

2000

Tomb of Khnum-hotep, Beni Hasan
Sesostris III
Stonehenge
Stele of Hammurabi
Cat Stalking Pheasant, Hagia Triada
Snake goddess, Crete
"Toreador Fresco"
"Octopus Vase," Palaikastro
Harvester Vase from Hagia Triada
Vaphio Cups
Palace of Minos, Knossos, Crete
Funerary temple of Hatshepsut, Deir el-Bahari
Lion Gate, Bogazköy
Temple of Amun-Mut-Khonsu, Luxor
Daughters of Akhenaten
Akhenaten and Nofretete
Tomb of Tutankhamen
Treasure of Atreus, Mycenae
Lion Gate, Mycenae

1000

Dipylon vase
Citadel of Sargon II, Dur Sharrukin
Stag, Scythian
Proto-Attic amphora, Eleusis
Reliefs from Nimrud and Nineveh
Temple of Artemis, Corfu
Ishtar Gate, Babylon
"Hera" from Samos
"Basilica," Paestum
Kylix painted by Exekias
"Peplos Kore"
Treasury of the Siphnians, Delphi
Siphnian Treasury sculpture, Delphi
Kroisos
Tomb of Hunting and Fishing, Tarquinia
Kore from Chios
Sarcophagus from Cerveteri
Apollo from Veii

500

500

Persian Wars 499–478
Periclean Age in Athens c. 460–429
Peloponnesian War 431–404
Alexander the Great (356–323) occupies
 Egypt 333; defeats Persia 331; conquers
 Near East
Rome beats Carthage in First Punic War
 264–241; acquires Spain 201
King Asoka (272–232), India
Great Wall of China built 221–210

Travels of Herodotus c. 460–440
Sophocles (496–406)
Euripides (died 406)
Hippocrates (born 469)
Socrates (died 399)
Plato (427–347); founds Academy 386
Aristotle (384–322)
Theophrastus of Athens, botanist (fl. c. 300)
Euclid (fl. c. 300–280)
Archimedes (287–212)
Eratosthenes of Cyrene measures the globe
 c. 240

200

Han dynasty, China, 202 B.C.–220 A.D.
Rome dominates Asia Minor and Egypt;
 annexes Macedonia 147; destroys
 Carthage 146

Invention of paper, China
Carneades of Cyrene, head of Academy,
 visits Rome with a delegation of Greek
 philosophers 156

100

Julius Caesar dictator of Rome 49–44
Emperor Augustus (r. 27 B.C.–14 A.D.)

Golden Age of Roman literature: Cicero,
 Catullus, Vergil, Horace, Ovid
Vitruvius' *De architectura*
Earliest water mills

A.D. 1

Crucifixion of Jesus c. 30
Jewish rebellion against Rome 66–70;
 destruction of Jerusalem
Paul (died c. 65) spreads Christianity to
 Asia Minor and Greece

Pliny the Elder, *Natural History*
Invention of glass blowing
Tacitus, Seneca

100

Emperor Marcus Aurelius (r. 161–180)
Mahayana and Hinayana Buddhism

Ptolemy, astronomer (died 160)
Galen, physician and anatomist (died 201)

200

Shapur I (r. 242–272), Sassanian king of
 Persia
Persecution of Christians in Roman Empire
 250–302
Emperor Diocletian
Mithraism spreads in Roman Empire

Plotinus (died 270)

300

— 500

Palace, Persepolis
East pediment from Aegina
Lapith and Centaur, red-figured kylix
Tomb of Lionesses, Tarquinia
Charioteer, Delphi
Pediments, Olympia
"Temple of Poseidon," Paestum
Doryphorus by Polyclitus
Parthenon, Acropolis, Athens
Propylaea, Acropolis, Athens
Temple of Athena Nike, Acropolis, Athens
Erechtheum, Acropolis, Athens
Mausoleum, Halicarnassus
Theater, Epidaurus
Monument of Lysicrates, Athens
Aphrodite and *Hermes* by Praxiteles
Apoxyomenos by Lysippus

— 200

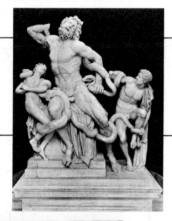

Nike of Samothrace
Pergamum Altar
Porta Augusta, Perugia
Laocoön Group
"Temple of Fortuna Virilis," Rome

— 100

Aulus Metellus
"Temple of the Sibyl," Tivoli
Sanctuary of Fortuna, Praeneste
Portrait head from Delos
Villa of the Mysteries, Pompeii
Painting by Alexandros of Athens
Forum of Caesar, Rome
Villa of Livia, Primaporta
Augustus of Primaporta
Odyssey Landscapes
Ara Pacis

— 1 A.D.

House of the Silver Wedding, Pompeii
House of the Vettii, Pompeii
Hercules and Telephus, Herculaneum
Colosseum, Rome
Vespasian
Arch of Titus

— 100

Column of Trajan
Pantheon, Rome
Insula of House of Diana, Ostia
Market Gate, Miletus
Equestrian statue of Marcus Aurelius
Portrait of a boy, Faiyum
Temple of Venus, Baalbek

— 200

Palace of Shapur I, Ctesiphon
Triumph of Shapur I, Naksh-i-Rustam
Basilica, Leptis Magna
Philippus the Arab
Synagogue, Dura-Europos

— 300

POLITICAL HISTORY, RELIGION	LITERATURE, SCIENCE, TECHNOLOGY	PAINTING, SCULPTURE, ARCHITECTURE

300

Christianity legalized by Edict of Milan 313; state religion 395
Emperor Constantine the Great (r. 324–337)
St. Augustine, St. Jerome
Roman Empire split into eastern and western branches 395

Palace of Diocletian, Split
Arch of Constantine, Rome
Colossal statue of Constantine
Basilica of Constantine, Rome
Old St. Peter's, Rome
Sta. Costanza, Rome
Sarcophagus of Junius Bassus
St. Paul's Outside the Walls, Rome
Catacomb of Santi Pietro e Marcellino, Rome
Dome mosaic, St. George, Salonica

400

Rome sacked by Visigoths 410
Split between eastern and western Churches begins 451
St. Patrick (died c. 461) founds Celtic Church in Ireland
Fall of Western Roman Empire 476
Theodoric founds Ostrogoth kingdom in Italy
"Golden Age" of Justinian 527–565
St. Benedict (died 543) founds Benedictine order
Lombard kingdom in north Italy 568

Invention of the stirrup in China
Silk cultivation brought to eastern Mediterranean from China

Mosaics, Sta. Maria Maggiore, Rome
Eutropios
Vatican Vergil
Mosaics, S. Apollinare in Classe and S. Vitale, Ravenna
S. Vitale, Ravenna
Hagia Sophia, Istanbul
Vienna Genesis
Archangel Michael, diptych

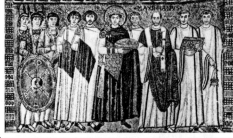

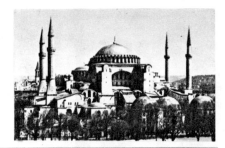

600

Mohammed (570–632); Hegira 622, beginning of Moslem chronology
Byzantium loses Near Eastern and African provinces to Moslems 642–732; to Seljuk Turks 1071
Iconoclastic controversy 726–843
T'ang dynasty, China, 623–908; Sung dynasty founded 906
Conversion of Russia to Orthodox Church c. 990

Koran 652

Madonna, Sta. Francesca Romana, Rome
St. Mark's, Venice
Harbaville Triptych
Monastery churches, Hosios Loukas
Mosaics, Daphnē

1200

Latin empire in Constantinople 1204–61
Mongols conquer China 1234–79; Ming dynasty founded 1368

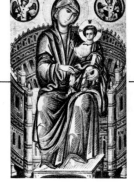

Mosaic, St. Mark's, Venice
Fresco, Kariye Camii, Istanbul
Madonna Enthroned, icon

1400

Constantinople conquered by Ottoman Turks 1453
Moscow becomes center of Orthodox Church after 1453

Old Testament Trinity by Andrei Rublev
Cathedral of St. Basil, Moscow

Part Two

THE MIDDLE AGES

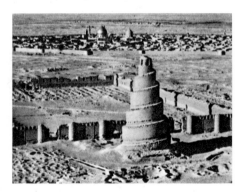

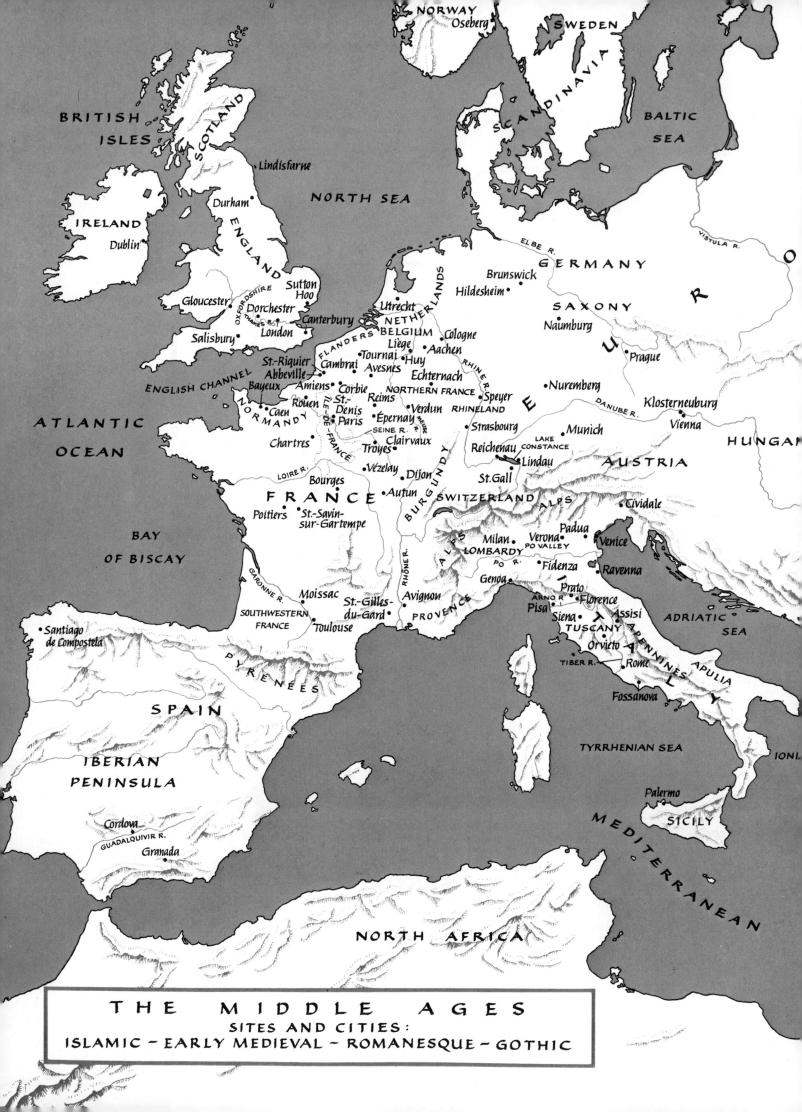

NORWAY
Oseberg
SWEDEN

BRITISH
ISLES
SCOTLAND
Lindisfarne
NORTH SEA
SCANDINAVIA
BALTIC
SEA

IRELAND
Durham
Dublin

ENGLAND
Sutton Hoo
Gloucester
Dorchester
OXFORDSHIRE
Salisbury
THAMES R.
London
Canterbury

Utrecht
NETHERLANDS
BELGIUM
FLANDERS
Liège
Tournai Huy
Cambrai
Avesnes
St.-Riquier
Abbeville
Amiens
Corbie
NORTHERN FRANCE
Bayeux
Rouen
St.-Denis
Reims
Caen
ÎLE-DE-FRANCE
Paris
Épernay
SEINE R.

ENGLISH CHANNEL
NORMANDY

GERMANY
Brunswick
Hildesheim
SAXONY
Naumburg
Prague
Nuremberg
Cologne
Aachen
Echternach
RHINE R.
Speyer
RHINELAND
Verdun
MEUSE
Strasbourg
Munich
Klosterneuburg
DANUBE R.
Vienna
HUNGARY
AUSTRIA

ATLANTIC
OCEAN

Chartres
Troyes
Clairvaux
Vézelay
Dijon
Bourges
Autun
FRANCE
Poitiers
St.-Savin-sur-Gartempe
LOIRE R.

Reichenau
LAKE CONSTANCE
Lindau
St.Gall
BURGUNDY
SWITZERLAND
ALPS
Cividale

BAY
OF BISCAY

Milan
LOMBARDY
Verona
PO VALLEY
Padua
Venice
Fidenza
Ravenna
Genoa
PO R.
Prato
ARNO R.
Florence
Pisa
Siena
Assisi
TUSCANY
ADRIATIC
SEA
Orvieto
APENNINES
TIBER R.
Rome
APULIA
Fossanova

Moissac
GARONNE R.
SOUTHWESTERN FRANCE
Toulouse
St.-Gilles-du-Gard
Avignon
PROVENCE
RHÔNE R.

Santiago de Compostela
PYRENEES

SPAIN
IBERIAN
PENINSULA
Cordova
GUADALQUIVIR R.
Granada

TYRRHENIAN SEA
IONI

Palermo
SICILY

MEDITERRANEAN

NORTH AFRICA

THE MIDDLE AGES
SITES AND CITIES:
ISLAMIC – EARLY MEDIEVAL – ROMANESQUE – GOTHIC

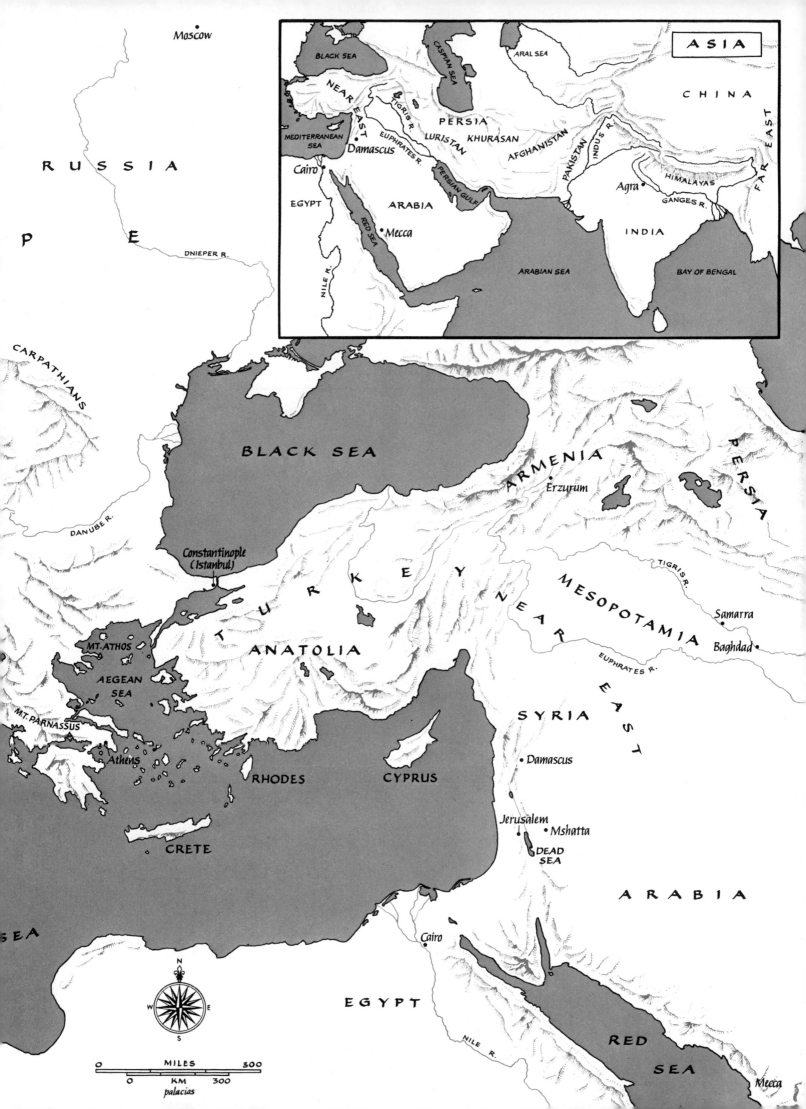

MILES 300

KM 300
palacias

INTRODUCTION

When we think of the great civilizations of our past, we tend to do so in terms of visible monuments that have come to symbolize the distinctive character of each: the pyramids of Egypt, the ziggurats of Babylon, the Parthenon of Athens, the Colosseum, Hagia Sophia. The Middle Ages, in such a review of climactic achievements, would be represented by a Gothic cathedral—Notre-Dame in Paris, perhaps, or Reims, or Canterbury. We have many to choose from, but whichever one we pick, it will be well north of the Alps, although in territory that formerly belonged to the Roman Empire. And if we were to spill a bucket of water in front of the cathedral of our choice, this water would eventually make its way to the English Channel, rather than to the Mediterranean. Here, then, we have the most important single fact about the Middle Ages: the center of gravity of European civilization has shifted to what had been the northern boundaries of the Roman world. The Mediterranean, for so many centuries the great highway of commercial and cultural exchange binding together all the lands along its shores, has become a barrier, a border zone.

We have already observed some of the events that paved the way for this shift—the removal of the imperial capital to Constantinople, the growing split between the Catholic and Orthodox faiths, the decay of the western half of the Roman Empire under the impact of invasions by Germanic tribes. Yet these tribes, once they had settled down in their new environment, accepted the framework of late Roman, Christian civilization, however imperfectly; the local kingdoms they founded—the Vandals in North Africa, the Visigoths in Spain, the Franks in Gaul, the Ostrogoths and Lombards in Italy—were Mediterranean-oriented, provincial states on the periphery of the Byzantine Empire, subject to the pull of its military, commercial, and cultural power. As late as 630, after the Byzantine armies had recovered Syria, Palestine, and Egypt from the Sassanid Persians, the reconquest of the lost western provinces remained a serious possibility. Ten years later, the chance had ceased to exist, for meanwhile a tremendous and completely unforeseen new force had made itself felt in the East: the Arabs, under the banner of Islam, were overrunning the Near Eastern and African provinces of Byzantium. By 732, within a century after the death of Mohammed, they had swallowed all of North Africa as well as Spain, and threatened to add southwestern France to their conquests.

It would be difficult to exaggerate the impact of the lightning-like advance of Islam upon the Christian world. The Byzantine Empire, deprived of its western Mediterranean bases, had to concentrate all its efforts on keeping Islam at bay in the East. Its impotence in the West (where it retained only a precarious foothold on Italian soil) left the European shore of the western Mediterranean, from the Pyrenees to Naples, exposed to Arabic raiders from North Africa or Spain. Western Europe was thus forced to develop its own resources, political, economic, and spiritual. The Church in Rome broke its last ties with the East and turned for support to the Germanic north, where the Frankish kingdom, under the energetic leadership of the Carolingian dynasty, rose to the status of imperial power during the eighth century. When the Pope, in the year 800, bestowed the title of emperor upon Charlemagne, he solemnized the new order of things by placing himself and all of Western Christianity under the protection of the king of the Franks and Lombards. He did not, however, subordinate himself to the newly created Catholic emperor, whose legitimacy depended on the pope, whereas hitherto it had been the other way around (the emperor in Constantinople had ratified the newly elected pope). This interdependent dualism of spiritual and political authority, of Church and State, was to distinguish the West from both the Orthodox East and the Islamic South. Its outward symbol was the fact that though the emperor had to be crowned in Rome, he did not reside there; Charlemagne built his capital at the center of his effective power, in Aachen, close to France, Germany, and the Netherlands on the present-day map of Europe.

Meanwhile, Islam had created a new civilization stretching from Spain in the west to the Indus Valley in the east, a civilization that reached its highest point far more rapidly than did that of the medieval West. Baghdad on the Tigris, the capital city of Charlemagne's great contemporary, Harun al-Rashid, rivaled the splendor of Byzantium. Islamic art, learning, and craftsmanship were to have a far-ranging influence on the European Middle Ages, from arabesque ornament, the manufacture of paper, and Arabic numerals to the transmission of Greek philosophy and science through the writings of Arabic scholars. (Our language records this debt in such words of Arabic origin as algebra and alcohol.) It is well, therefore, that we acquaint ourselves with some of the artistic achievements of Islam before we turn to medieval art in Western Europe.

ARCHITECTURE
 EASTERN ISLAMIC
 WESTERN ISLAMIC
 TURKISH

REPRESENTATION
 PERSIA

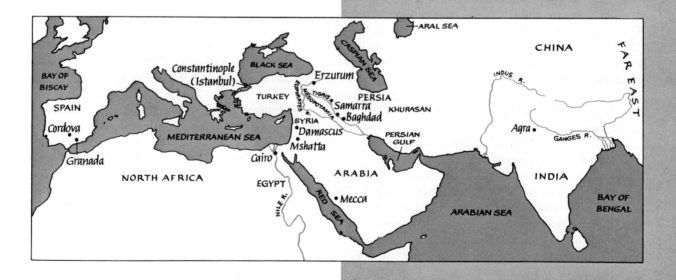

1

ISLAMIC ART

The incredible speed with which Islam spread throughout the Near East and North Africa remains one of the most astonishing phenomena in world history. In two generations, the new faith conquered a larger territory and greater numbers of believers than Christianity had in three centuries. How was it possible for a group of semi-civilized desert tribes suddenly to burst forth from the Arab peninsula and to impose their political and religious dominance on populations far superior to them in numbers, wealth, and cultural heritage? That they had the advantage of surprise, great fighting skill, and a fanatical will to win, that both Byzantine and Persian military power was at a low ebb, has been pointed out often enough; these favorable circumstances may help to account for the initial Arab successes but not for the enduring nature of their conquests. What had begun as a triumph of force soon turned into a spiritual triumph as Islam gained the allegiance of millions of converts. Clearly, the new faith must have satisfied the needs of vast multitudes of people more fully than any of the older religions of the Hellenized Orient.

Islam owes many of its essential elements to the Judaeo-Christian tradition. The word Islam means "submission"; Moslems are those who submit to the will of Allah, the one and all-powerful God, as revealed to Mohammed in the Koran, the sacred scriptures of Islam. The Koran often draws upon the contents of the Bible and counts the Old Testament prophets as well as Jesus among the predecessors of Mohammed. Its teachings include the concepts of the Last Judgment, of Heaven and Hell, of angels and devils. The ethical commands of Islam, too, are basically similar to those of Judaism and Christianity. On the other hand, there is no ritual demanding a priest-hood; every Moslem has equal access to Allah, and the observances required of him are simple: prayer at stated times of day (alone or in a mosque), almsgiving, fasting, and a pilgrimage to Mecca. All true believers, according to Mohammed, are brothers, members of one great community. During his lifetime, he was their leader not only in the religious sense but in all temporal affairs as well, so that he bequeathed to posterity a faith which was also a new pattern of society. The tradition of placing both religious and political leadership in the hands of a single ruler persisted after the Prophet's death; his successors were the caliphs, the deputies of Mohammed, whose claim to authority rested on their descent from the families of the Prophet or his early associates.

The unique quality of Islam—and the core of its tremendous appeal—is the blending of ethnic and universal elements. Like Christianity, it opened its ranks to everyone, stressing the brotherhood of the faithful before God, regardless of race or culture. Yet, like Judaism, it was also a national religion, firmly centered in Arabia. The Arab warriors under the early caliphs who set out to conquer the earth for Allah did not expect to convert the unbelievers to Islam; their aim was simply to rule, to enforce obedience to themselves as the servants of the One True God. Those who wanted to share this privileged status by joining Islam had to become Arabs-by-adoption: they not only had to learn Arabic in order to read the Koran (since Allah had chosen to speak in that language, his words must not be translated into lesser tongues), but also to adopt the social, legal, and political framework of the Moslem community. As a result, the Arabs, though few in numbers, were never in danger of being absorbed by the inhabitants of the regions they ruled. Instead, they absorbed the conquered populations, along with their cultural heritage, which they skillfully adapted to the requirements of Islam.

ARCHITECTURE

In art, this heritage encompassed the Early Christian-Byzantine style, with its echoes of Hellenistic and Roman forms, as well as the artistic traditions of Persia (see page 81). Pre-Islamic Arabia contributed nothing except the beautifully ornamental Arabic script; populated largely by nomadic tribes, it had no monumental architecture; and its sculptured images of local deities fell under Mohammed's ban against idolatry. Originally, Islam, like early Christianity, made no demands at all upon the visual arts. During the first fifty years after the death of the Prophet, the Moslem place of prayer could be a church taken over for the purpose, a Persian columned hall, or even a rectangular field surrounded by a fence or a ditch. The one element these improvised mosques had in common was the marking of the *qibla* (the direction to which Moslems turn in praying): the side

306. Landscape Mosaic. 715 A.D.
The Great Mosque, Damascus

facing toward Mecca had to be emphasized by a colonnade, or merely by placing the entrance on the opposite side. At the end of the seventh century, however, the Moslem rulers, now firmly established in the conquered domains, began to erect mosques and palaces on a large scale as visible symbols of their power, intended to outdo all pre-Islamic structures in size and splendor. These early monuments of Moslem architecture do not, for the most part, survive in their original form. What we know of their design and decoration shows that they were produced by craftsmen gathered from Egypt, Syria, Persia, and even Byzantium, who continued to practice the styles in which they had been trained. A distinctive Islamic tradition crystallized only in the course of the eighth century.

EASTERN ISLAMIC

Thus the Great Mosque at Damascus, built 706-715 within the enclosure of a Roman sanctuary, had its walls covered with wonderful glass mosaics of Byzantine origin. The surviving remnants, such as the section reproduced in figure 306, consist entirely of views of landscape and architecture framed by richly ornamented borders against a gold background. Nothing quite like them is known in Byzantine art, but their style obviously reflects an illusionism familiar to us from Pompeian painting. Apparently, ancient traditions persisted more strongly in the Near Eastern provinces of Byzantium than in Europe. Caliph al-Walid, who built the mosque, must have welcomed these Hellenistic-Roman motifs, so different from the symbolic and narrative content of Christian mosaics. A somewhat later Arabic author records that the country contained many churches "enchantingly fair and renowned for their splendor," and that the Great Mosque at Damascus was meant to keep the Moslems from being dazzled by them. The date of the huge desert

palace at Mshatta (in the present-day Kingdom of Jordan) has been much disputed; we can well understand why, for the style of the façade decoration (fig. 307) harks back to various pre-Islamic sources. According to the best available evidence, the palace was erected by one of al-Walid's successors, probably about 743. The lacelike carving and the character of the plant motifs are strongly reminiscent of Byzantine architectural ornament (compare fig. 290), and variations within the work indicate that it was done by craftsmen conscripted from several provinces of the former Byzantine domain in the Near East. There is also, however, a notable Persian element, evidenced by winged lions and similar mythical animals familiar from Sassanian textiles or metalwork (see fig. 106). On the other hand, the geometric framework of zigzags and rosettes, uniformly repeated over the entire width of the façade, suggests a taste for symmetrical abstract patterns characteristic of Moslem art.

A striking example of the architectural enterprises of the early caliphs, which were built on an immense scale at incredible speed, is the Great Mosque at Samarra (on the Tigris, northwest of Baghdad), built under al-Mutawakkil, 848-852. Only an aerial view (fig. 308) can suggest its vast dimensions, which make it the largest mosque in the world. The basic features of the plan (fig. 309) are typical of the mosques of this period: a rectangle, with its main axis pointing south to Mecca, encloses a court surrounded by aisles that run toward the *qibla* side, the center of which is marked by a small niche, the mihrab; on the opposite side we see the minaret, a tower from which the faithful were summoned to prayer by the cry of the muezzin. (This feature was derived from the towers of Early Christian churches in Syria, which may also have influenced the church towers of medieval Europe.) The floor area of the Great Mosque at Samarra is more than 45,000 square yards—almost ten acres, of which five and a half were covered by a wooden roof resting on

307. Portion of the Façade of the Palace at Mshatta (Jordan).
c. 743 A.D. Height of triangles 9 1/2'. State Museums, Berlin

308. Mosque of Mutawakkil (view from the north), Samarra, Iraq. 848–852 A.D.

309. Plan of the
Mosque of Mutawakkil
(after Creswell)

464 supports. These have all disappeared now, along with the mosaics that once covered the walls. The most spectacular aspect of the building is the minaret, linked with the mosque by a ramp. Its bold and unusual design, with a spiral staircase leading to the platform at the top, reflects the ziggurats of ancient Mesopotamia, such as the famed Tower of Babel (see pages 68–69), at that time still in a fair state of repair. Did al-Mutawakkil wish to announce to the world that the realm of the caliphs was heir to the empires of the ancient Near East?

WESTERN ISLAMIC

In order to gain some notion of the interior effect of the Great Mosque at Samarra, we must turn to the mosque at Cordova in Spain, begun in 786. Although converted to Christian use after the reconquest of the city in 1236, the structure retains its Islamic character. The plan (fig. 310) was originally designed as a simpler version of the type we came to know at Samarra, the aisles being confined to the *qibla* side. Half a century later, the mosque was enlarged by extending the length of these aisles; in 961–965 they were lengthened again, and twenty years later eight more aisles were added on the east side, since a river bank barred any further extension to the south. These successive stages illustrate the flexible nature of early mosque plans, which made it possible to quadruple the size of the sanctuary without departing from the original pattern. As we enter, a seemingly endless forest of columns confronts us, with nothing but the direction of the aisles to guide us toward the *qibla* side. The sanctuary was covered by a wooden roof (now replaced by vaults) resting on double arcades of remarkable and picturesque design (fig. 311). The lower arches are horseshoe-shaped, a form that sometimes occurs in Near Eastern buildings of pre-Islamic date but which Moslem architecture made peculiarly its own. They rise from short, slender columns of a kind familiar to us from

Roman and early Christian times. These columns, however, also support stone piers that carry a second tier of arches. Was this piggy-back arrangement a practical necessity because the architect who started building the mosque—apparently at maximum speed—had to utilize a set of too-short columns from some earlier structure? If so, he certainly has used the device to excellent advantage, for it produces an effect far lighter and airier than a system of single arches and supports could have achieved. A further elaboration of the same principle is found in the Capilla de Villaviciosa (fig. 312), a vaulted chamber to the north of the mihrab, which dates from the building campaign of 961–965. Here we meet lobed arches in three tiers, interlaced in such a way as to form a complex, ornamental screen. The vault is even more imaginative; eight slender arches, or ribs, cross each other above the square compartment, subdividing it into a network of cells. It is instructive to compare the spatial effect of the Mosque at Cordova with that of Byzantine architecture: in the latter, space always is treated as volume and has a clearly defined shape, while at Cordova its limits are purposely obscured, so that we experience it as something fluid, limitless, and mysterious. Even in the Capilla de Villaviciosa, the surfaces and cavities prevent us from perceiving walls or vaults as continuous surfaces; the space is like that of an open-work cage, screened off yet continuous with its surroundings.

This distinctively Moorish (North African and Spanish) style reaches its ultimate stage of refinement in the Alhambra Palace in Granada, the last Islamic stronghold on the Iberian peninsula during the late Middle Ages. Its richest portion, the Court of the Lions and the rooms around it, was built 1354–91 (fig. 313). The columns now have become slender as flower stalks; they support stilted arches of extravagantly complex shape, cut into walls that seem to consist of nothing but a gossamer-like web of ornament. On the interior surfaces (fig. 314) we find the same lacework of arabesque decoration, carried out in delicately colored stucco or tile—a limitless

310. Plan of the Mosque at Cordova,
showing successive enlargements
between 786 and 987 A.D. (after Marçais)

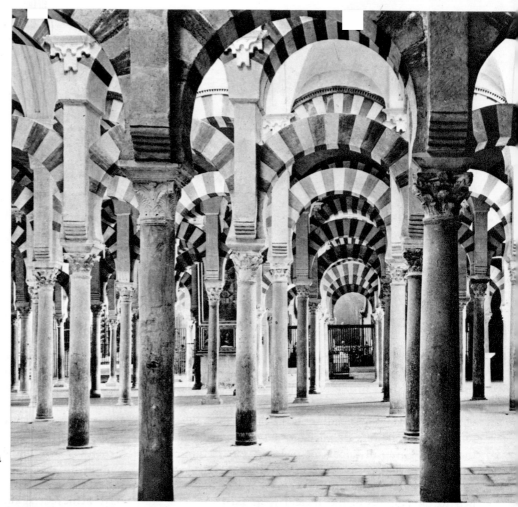

311. Interior of the Sanctuary
(view from the east), Mosque, Cordova

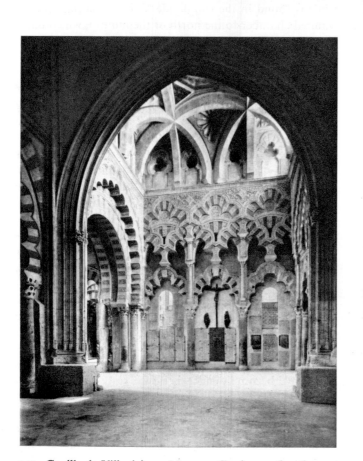

312. Capilla de Villaviciosa, Mosque, Cordova. 961–965 A.D.

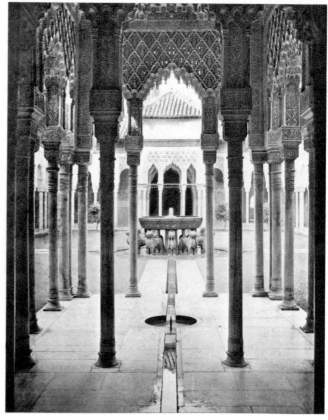

313. Court of the Lions, The Alhambra, Granada. 1354–91

variety of designs, including bands of inscriptions, yet disciplined by symmetry and rhythmic order. The effect is infinitely richer than that of the Mshatta façade, but in retrospect the two monuments, separated by six centuries and the entire expanse of the Mediterranean, appear clearly linked by the same basic sense of form. Moorish vaulting has gone through a similar process of evolution: the ribs of the Capilla de Villaviciosa have disappeared behind a honeycomb of ever-multiplying cells framed by tiny arches that hang like stalactites from the ceilings. Little wonder that the Alhambra is enshrined in the romantic imagination of the West as the visible counterpart of all the wonders of *The Thousand and One Nights*.

TURKISH

From the tenth century onward, the Seljuk Turks gradually advanced into the Near East, where they adopted Islam, seized control of most of Persia, Mesopotamia, Syria, and the Holy Land, and advanced against the Byzantine Empire in Asia Minor. They were followed in the thirteenth century by the Mongols of Genghis Khan—whose armies included the Mamelukes (a people related to the Turks)—and by the Ottoman Turks. The latter not only put an end to the Byzantine Empire by their capture of Constantinople in 1453, but occupied the entire Near East and Egypt as well, thus becoming

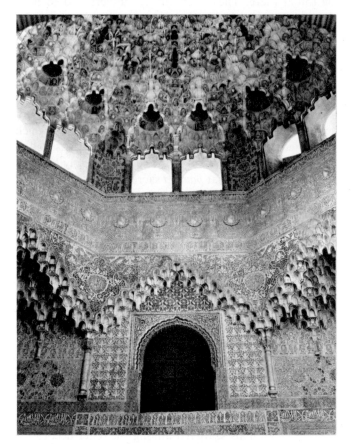

314. Stucco Decoration, Hall of the Two Sisters, The Alhambra, Granada

the most important power in the Moslem world. The growing weight of the Turkish element in Islamic civilization is reflected by the westward spread of a new type of mosque, the madrasah, which had been created in Persia under Seljuk domination in the eleventh century. One of the most imposing examples is the Madrasah of Sultan Hasan in Cairo, contemporary with the Alhambra but very different in spirit. Its main feature is a square court (fig. 315), with a fountain in the center. Opening onto each side of this court is a rectangular vaulted hall; that on the *qibla* side, larger than the other three, serves as the sanctuary. The monumental scale of these halls seems to echo the palace architecture of Sassanian Persia (see fig. 105), while the geometric clarity of the whole design, emphasized by the severe wall surfaces, is a Turkish contribution that we shall meet again later. It represents an attitude toward architectural space completely opposed to that of many-aisled Arabic mosques. Attached to the *qibla* side of the Madrasah of Sultan Hasan is the Sultan's mausoleum, a large cubic structure surmounted by a dome (fig. 316). Such funerary monuments had been unknown to early Islam; they were borrowed from the West (see page 197) in the ninth century and became especially popular among the Mameluke sultans of Egypt. The dome in our example betrays its descent from Byzantine domes. The most famous mausoleum of Islamic architecture is the Taj Mahal at Agra (fig. 317), built three centuries later by one of the Moslem rulers of India, Shah Jahan, as a memorial to his wife. He belonged to the Mogul dynasty, which had come from Persia, so that the basic similarity of the Taj Mahal and the mausoleum of Sultan Hasan is less surprising than it might seem at first glance. At the same time, such a comparison emphasizes the special qualities that make the Taj Mahal a masterpiece of its kind. The massiveness of the Cairo mausoleum, with its projecting cornice and firmly anchored dome, has given way to a weightless elegance not unlike that of the Alhambra. The white marble walls, broken by deep shadowy recesses, seem paper-thin, almost translucent, and the entire building gives the impression of barely touching the ground, as if it were suspended from the balloon-like dome. Its mood of poetic reverie is greatly enhanced by the setting; the long reflecting pool lined with dark green shrubs sets off the cool whiteness of the great pavilion in truly magnificent fashion.

The Turks, once they settled in Asia Minor, developed a third type of mosque by interbreeding the Seljuk madrasah and the domed Byzantine church. Among the earliest and most astonishing results of this process is the wooden dome of the Ulu Mosque at Erzurum (see fig. 638), which has successfully withstood the earthquakes common in that region. The Turks, therefore, were well prepared to appreciate the beauty of Hagia Sophia when they entered Constantinople. It impressed them so strongly that echoes of it appear in numerous mosques built in that city and elsewhere after 1453. One of the most im-

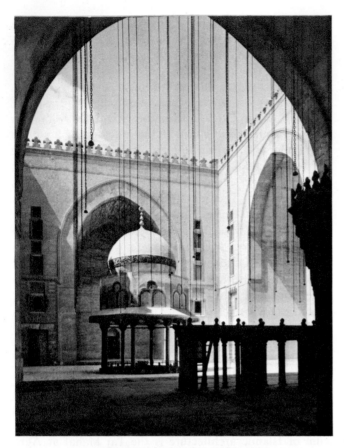

315. Court (view from the *qibla* side),
Madrasah of Sultan Hasan, Cairo. 1356–63

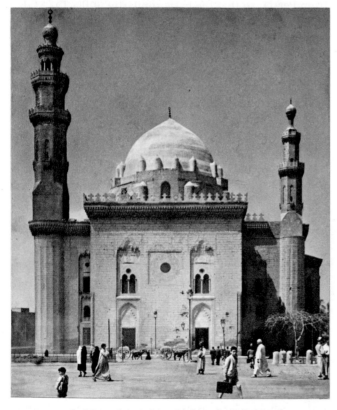

316. Mausoleum Attached to the Madrasah
of Sultan Hasan

pressive, that of Sultan Ahmed I, dates from 1609–16 (figs. 318–20). Its plan elaborates and regularizes the design of Hagia Sophia into a square, with the main dome abutted by four half-domes instead of two, and four smaller domes next to the minarets at the corners. The mounting sequence of these domes has been handled with marvelous logic and geometric precision, so that the exterior is far more harmonious than that of Hagia Sophia. Thus, the first half of the seventeenth century, which produced both the Taj Mahal and the Mosque of Ahmed I, marks the final flowering of Moslem architectural genius.

REPRESENTATION

Before we can enter into a discussion of Islamic painting and sculpture, we must understand the Moslem attitude toward representation. It has often been likened to that of the Byzantine iconoclasts, but there are significant differences. The Iconoclasts, we will recall, were opposed to sacred images (that is, images of religious personages) rather than to representation as such. Mohammed, too, condemned idolatry; one of his first acts after his triumphant return to Mecca in 630 was to take over the Kaaba, an age-old Arabic sanctuary, and to remove all the idols he found there. These were always understood to have been statues, and the Koran expressly places statues among the handiwork of Satan, while painting and representation in general are not mentioned. Mohammed's attitude toward painting seems to have been ambiguous. An early Arabic source informs us that in 630 the Kaaba also contained murals of religious (apparently biblical) subjects; the Prophet ordered them all to be destroyed, except for a picture of Mary with the Infant Jesus, which he protected with his own hands. This incident, as well as the lack of any discussion of the subject in early Moslem theology, suggests that *painted* sacred images never posed a serious problem to Mohammed and his immediate successors; since there was no pictorial tradition among the Arabs, Islamic religious painting could have been created only by borrowing from outside sources, and such a development was most unlikely as long as the authorities did not encourage it. They could afford to display indifference or even at times a certain tolerance toward the sacred pictures of other faiths. (Mohammed may have saved the Virgin and Child from destruction in order not to hurt the feelings of former Christians among his followers.) This passive iconoclasm did not prevent the Arabs from accepting the nonreligious representational art they found in the newly conquered territories. Statues of any sort they surely abominated, but Hellenistic landscapes could be introduced into mosques (see fig. 306) and Sassanian animals scattered among the relief decoration of the Mshatta façade (see fig. 307). The ruins of another palace, contemporary with Mshatta, have even yielded

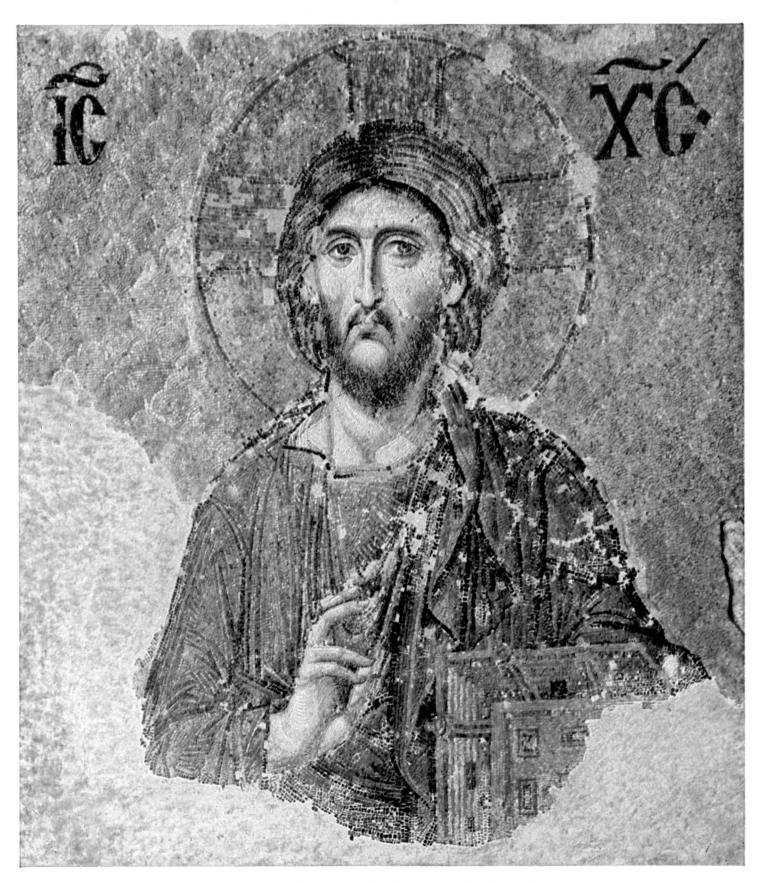

Colorplate 25. BYZANTINE. *Christ* (portion of a Deësis mosaic).
13th century. Hagia Sophia, Istanbul

Colorplate 26. BYZANTINE. *David Composing the Psalms*, from the *Paris Psalter*.
c. 900 A.D. 14¹⁄₈ × 10¹⁄₄″. Bibliothèque Nationale, Paris

Colorplate 27. ANDREI RUBLEV. *Old Testament Trinity*. About 1410–20.
Panel, 55¹/₂ × 44¹/₂″. Tretyakov Gallery, Moscow

Colorplate 28. ISLAMIC. *Summer Landscape,* from the *Album of the Conqueror (Sultan Mohammed II).*
Mongol, mid-14th century. Topkapu Palace Museum, Istanbul

Colorplate 29. PERSIAN. *The Ascension of Mohammed,*
from a Persian manuscript. 1539–43. British Library, London

Colorplate 30. ISLAMIC. Calligraphic Page, from the *Album of the Conqueror (Sultan Mohammed II)*.
Turkish (?), 15th century. Topkapu Palace Museum, Istanbul

Colorplate 31. ANGLO-IRISH. Cross Page, from the *Lindisfarne Gospels*.
About 700 A.D. 13$^{1}$/$_{2}$ × 9$^{3}$/$_{4}$″. British Library, London

Colorplate 32. ANGLO-IRISH. *Symbol of St. Mark,* from the *Echternach Gospels.*
About 700 A.D. Bibliothèque Nationale, Paris

317. Taj Mahal, Agra, India. 1630–48

fresco fragments with human figures. Only from about 800 on do we find strictures against representation as such in Moslem religious literature, perhaps under the influence of prominent Jewish converts. The chief argument now is not the danger of idolatry but of human presumption: in making images of living things, the artist usurps a creative act that is reserved to God alone, since only He can breathe a soul into living creatures.

Decorated Objects

Theoretically, therefore, human or animal figures of any kind were forbidden by Islamic law. Yet in actual practice the ban was fully effective only against large-scale representational art for public display. There seems to have been a widespread conviction, especially at the luxury-loving courts of the caliphs and other Moslem princes, that images of living things were harmless if they did not cast a shadow, if they were on a small scale, or applied to objects of daily use, such as rugs, fabrics, pottery. As a result, human and animal figures did survive in Islamic art, but they tended to become reduced to decorative motifs, intrinsically no more important than geometric or plant ornament. We must remember, too, that this tendency was an age-old tradition; among the peoples who shaped Moslem civilization, Arabs, Persians, Turks, and Mongols all shared a love of portable, richly decorated objects as the common heritage of their nomadic past (see page 77). Islam, then, merely reinforced a taste that was natural to them. When the techniques of the nomads' arts—rugmaking, metalwork, and leathercraft—merged with the vast repertory of forms and materials accumulated by the craftsmen of Egypt, the Near East, and the Graeco-Roman world, the decorative arts of Islam reached a level of sumptuousness never equaled before or since. The few samples illustrated here can convey only the faintest suggestion of their endless variety. Characteristically enough, a good many of the finest specimens are to be found in the churches and palaces of western Europe; whether acquired by trade, by gift, or as crusaders' booty, they were treasured throughout the Middle Ages as marvels of imaginative craftsmanship, and often imitated. Such a piece is the embroidered coronation cloak of the German emperors (fig. 322), made by Islamic artisans in Palermo for Roger II of Sicily in 1133–34, half a century after the Normans had captured that city from the Moslems (who had held it for 241 years). The symmetrical grouping of two lions attacking camels on either side of a symbolic tree of life is a motif whose ancestry goes back thousands of years in the ancient Near East (compare fig. 98); here, inscribed within quarter-circles and filled with various kinds of ornament, the animals have yielded their original fierceness to a splendid sense of pattern. It is the latter element that links them with the bronze creature made fifty years later in a very different part of the Moslem world, northeast Persia (fig. 321). This one certainly casts a shadow, and a sizable one at that, since it is almost three feet tall; it is, in fact, one of the largest pieces of free-standing sculpture in all of Islamic art. Yet to call it the statue of an animal hardly does justice to its peculiar character. It is primarily a vessel, a perforated incense burner whose shape approaches that of an animal; the representational aspect of the forms seems secondary and casual. We cannot tell what kind of beast this is meant to be; if only a part of it had survived, we might even be doubtful whether

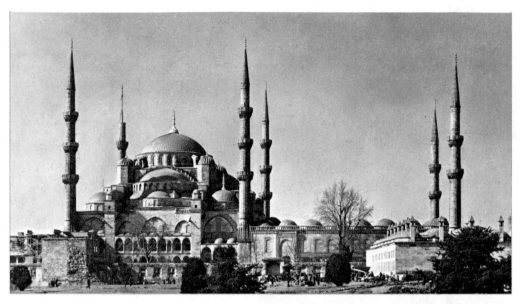

318. Mosque of Ahmed I, Istanbul. 1609–16

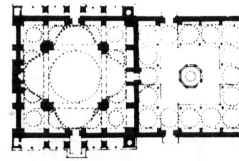

319. Plan of the Mosque of Ahmed I (after Ünsal)

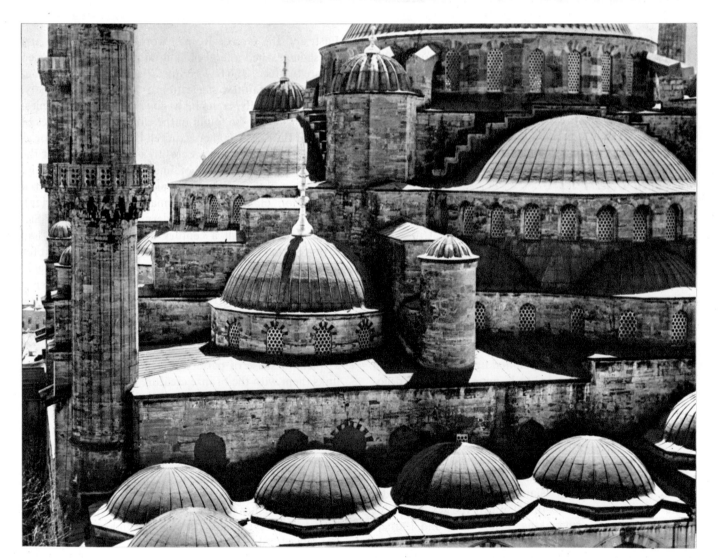

320. Detail, Mosque of Ahmed I

it represented anything at all, so abstract and ornamental is the handling of the body. The object becomes a "living creature" only while it is serving its proper function; filled with burning incense, breathing fire and smoke, our animal might well have seemed terrifyingly real to a naïve beholder. The Seljuk prince who owned it undoubtedly enjoyed the performance of this half-comic, half-demoniacal guardian monster, which he himself could "bring to life" whenever he wished.

Painting

The fate of painting in the Moslem world between the eighth and thirteenth centuries remains almost entirely unknown to us. So little has survived from the five hundred years following the Damascus mosaics that we should be tempted to assume the complete disappearance of pictorial expression under Islam if literary sources did not contain evidence to the contrary. Even so, it seems clear that the tradition of painting was kept alive, not by Moslems but by artists of other faiths. Byzantine masters were imported occasionally to work for Arab rulers, and the Oriental Christian churches that survived within the Islamic empire must have included many painters who were available to Moslem art patrons. But what kind of pictures could the Moslems have wanted? We may assume there was a more or less continuous demand for the illustration of scientific texts. The Arabs had inherited such manuscripts from the Byzantines in the Near East, and, being keenly interested in Greek science, they reproduced them in their own language. This meant that the illustrations had to be copied as well, since they formed an essential part of the content, whether they were ab-

stract diagrams or representational images (as in zoological, medical, or botanical treatises). Works of this sort are among the earliest Islamic illuminated manuscripts known so far, although none of them can be dated earlier than c. 1200. Our example (fig. 323) is from an Arabic translation, signed and dated 1224, of Dioscorides' *De Materia Medica;* it shows the Greek physician Erasis-

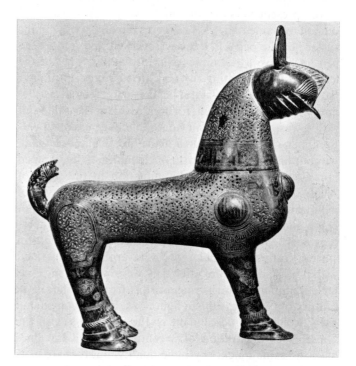

321. Incense Burner, from Khurasan, Iran. 1181–82. Bronze, height 33 1/2". The Metropolitan Museum of Art, New York (Rogers Fund, 1951)

322. Coronation Cloak of the German Emperors. 1133–34. Red silk and gold embroidery, width 11' 2". Kunsthistorisches Museum, Vienna

tratus reclining on a couch and discoursing with an assistant. (Both are equipped with halos, to indicate their venerability.) Interestingly enough, the scribe in this instance also did the illustration; or, rather, he copied it along with the text. The ultimate source of the picture must have been a late antique miniature with three-dimensional figures in a spatial setting, but it takes a real effort of the imagination to see remnants of these qualities in the present version, in which everything is flattened out and ornamentalized. The forms remain strictly on the surface of the page, like the script itself, and our artist's pen lines have a rhythmic assurance akin to that of the lettering. It is tempting to think that manuscript illumination found its way into Islamic art through scribes doubling as draughtsmen, for to a Moslem the calling of scribe was an ancient and honorable one; a skilled calligrapher might do pictures if the text demanded them, without having to feel that this incidental activity stamped him as a painter (and an abomination in the sight of Allah). Be that as it may, the calligrapher's style of pen-drawn illustrations, with or without the addition of color, soon made its appearance in secular Arabic literature such as the *Maqamat* of Hariri. These delightful stories, composed about 1100, were probably illustrated within a hundred years after they were written, since we have illuminated Hariri manuscripts from the thirteenth century on. The drawing in figure 324, from a copy dated 1323, is clearly a descendant of the style we saw in the Dioscorides illustration of a century before. The lines have the same quick, rhythmic quality, but they are handled very much more freely now, and with an extraordinary expressive power. Our artist's grasp of human character as he shows the response of the eleven men to the plea of the clever little rascal in the center, is so precise and witty that we must regard him as far more important than a mere copyist.

PERSIA

Arab merchants had been in touch with the Far East even before the advent of Islam, and occasional references to Chinese painters by early Moslem authors indicate that these contacts had brought about some acquaintance with the art of China. It was only after the Mongol invasion of the thirteenth century, however, that Chinese influence became an important factor in Islamic art. It can be felt most strongly in Persian illuminated manuscripts done under Mongol rule, from about 1300 on, such as the *Summer Landscape* in colorplate 28. More than three centuries earlier, under the Sung Dynasty, the painters of China had created a landscape art of great atmospheric depth, its mist-shrouded mountains and rushing streams embodying a poetic vision of untamed nature. Our Mongol painter must have known this tradition well; most of the essential elements recur in his own work, enhanced by a lively sense of color that made him stress the red and yellow of leaves turning in early fall. Did such landscapes reach medieval Europe? We do not know, but it may be more than coincidence that landscape painting in the West, which had been dormant since the end of Antiquity, began to revive just about this time (see figs. 453, 458).

The extent to which Chinese influence transformed the tradition of Islamic miniature painting is well demonstrated by the scene of two warriors fighting in a landscape (fig. 325): this is not a colored drawing but an ambitious pictorial composition that fills the entire page. The narrative to be illustrated has served merely as a point of departure for our artist; most of his effort is devoted to the setting, rather than to the action described in the text. He must have been a great admirer of Chinese landscapes, for the graceful and delicately shaded rocks, trees, and flowers of our picture clearly reflect their Far Eastern

323. *Erasistratus and an Assistant*, from an Arabic translation of Dioscorides' *De Materia Medica*. 1224. Smithsonian Institution, Freer Gallery of Art, Washington, D.C.

324. Pen Drawing in Red Ink, from a Hariri manuscript. Mesopotamian (?). 1323. British Museum, London

source. At the same time, the design has a decorative quality that is characteristically Islamic; in this respect, it seems more akin to the pattern of a Persian carpet than to the airy spaciousness of Chinese landscape painting.

Another important result of Far Eastern influence, it would seem, was the emergence of religious themes in Persian miniatures. The Mongol rulers, familiar with the rich tradition of Buddhist religious art in India and China, did not share their predecessors' horror at the very idea of pictures of Mohammed. In any event, scenes from the life of the Prophet do occur in Persian illuminated manuscripts from the early fourteenth century on. Since they had never been represented before, the artists who created them had to rely on both Christian and Buddhist art as their source of inspiration. The result was a curious mixture of elements, often far from well integrated. Only on rare occasions does Islamic religious painting rise to a level that bears comparison with the art of older faiths. Such a picture is the wonderful miniature, colorplate 29, showing Mohammed's ascension to paradise. In the Koran, we read that the Lord "caused His servant to make a journey by night . . . to the remote place of worship which We have encircled with blessings, that We might show him of Our signs." Later Moslem authors added elaborate details to this brief account: the ascent was made from Jerusalem, under the guidance of the angel Gabriel; Mohammed rose through the seven heavens, where he met his predecessors, including Adam, Abraham, Moses, and Jesus, before he was brought into the presence of Allah. The entire journey apparently was thought of as analogous to that of Elijah, who ascended to heaven in a fiery chariot. Mohammed, however, was said to have ridden a miraculous mount named *buraq,* "white, smaller than a mule and larger than an ass," and having a cheek—or a face—like that of a human being; some authors also gave it wings. We will recognize the ancestry of this beast: it derives from the winged, human-headed guardian monsters of ancient Mesopotamia (see fig. 93) and their kin, the sphinxes and centaurs, all of which had survived as ornamental motifs in the great melting pot of Islamic decorative art, where they lay dormant, as it were, until Moslem writers identified them with *buraq.* In our miniature, the wings are reduced to a ring of feathers around *buraq's* neck, so as not to interfere with the saddle. The animal follows Gabriel across a deep-blue, star-studded sky; below, among scattered clouds, there is a luminous celestial body, probably the moon. The Far Eastern elements in this poetic vision are striking. We find them in the flame-like golden halos behind Gabriel and Mohammed, a familiar feature of Buddhist art; in the curly, "intestinal" stylization of the clouds; in the costumes and facial types of the angels. Yet the composition as a whole—the agitated movement of the angelic servitors converging from all sides upon the Prophet—strongly recalls Christian art. Our miniature thus represents a true, and singularly felicitous, meeting of East and West.

325. *Two Warriors Fighting in a Landscape,* from a Persian manuscript. 1396. British Museum, London

Scenes such as this one occur in manuscripts of historical or literary works but not of the Koran. Even the Persians apparently did not dare to illustrate the Sacred Book directly, although—or perhaps because—illustrated copies of the Bible were not altogether unknown in the Moslem world. The Koran remained the calligraphers' domain, as it had been from the very beginning of Islam. In their hands, Arabic lettering became an amazingly flexible set of shapes, capable of an infinite variety of decorative elaborations, both geometric and curvilinear. At their best, these designs are masterpieces of the disciplined imagination that seem to anticipate, in a strange way, the abstract art of our own time. The page shown in colorplate 30, probably done by a Turkish calligrapher of the fifteenth century, renders the single word Allah. It is indeed a marvel of intricacy within a rigorous set of formal rules, sharing the qualities of a maze, of a rug pattern, and of certain nonobjective paintings. More than any other single object, it sums up the essence of Islamic art.

THE DARK AGES

CAROLINGIAN ART

ARCHITECTURE

MANUSCRIPTS AND BOOK COVERS

OTTONIAN ART

SCULPTURE

ARCHITECTURE

METALWORK

MANUSCRIPTS

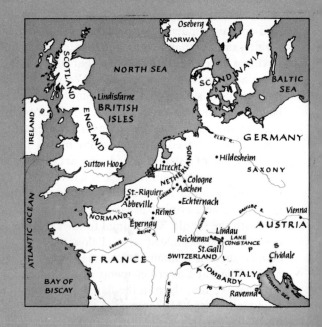

2

EARLY MEDIEVAL ART

THE DARK AGES

The labels we use for historical periods tend to be like the nicknames of people: once established, they are almost impossible to change, even though they may no longer be suitable. Those who coined the term "Middle Ages" thought of the entire thousand years from the fifth to the fifteenth century as an age of darkness, an empty interval between classical antiquity and its rebirth, the Renaissance in Italy. Since then, our view of the Middle Ages has changed completely; we no longer think of the period as "benighted" but as the "Age of Faith." With the spread of this new, positive conception, the idea of darkness has become confined more and more to the early part of the Middle Ages. A hundred years ago, the "Dark Ages" were generally thought to extend as far as the twelfth century; they have been shrinking steadily ever since, so that today the term covers no more than the 200-year interval between the death of Justinian and the reign of Charlemagne. Perhaps we ought to pare down the Dark Ages even further; for in the course of the century 650–750 A.D., as we have pointed out earlier, the center of gravity of European civilization shifted northward from the Mediterranean, and the economic, political, and spiritual framework of the Middle Ages began to take shape. We shall now see that the same period also gave rise to some important artistic achievements.

Germanic

The Germanic tribes that had entered western Europe from the east during the declining years of the Roman Empire, carried with them, in the form of nomads' gear, an ancient and widespread artistic tradition, the so-called animal style. We have encountered early examples of it in the Luristan bronzes of Iran and the Scythian gold ornaments from southern Russia (see pages 76–77 and figs. 98, 99). This style, with its combination of abstract and organic shapes, of formal discipline and imaginative freedom, became an important element in the Celtic-Germanic art of the Dark Ages, such as the gold-and-enamel purse cover (fig. 326) from the grave, at Sutton Hoo, of an East Anglian king who died between 625 and 633. On it are four pairs of symmetrical motifs: each has its own distinctive character, an indication that the motifs have been assembled from four different sources. One motif, the standing man between confronted animals, has a very long history indeed—we first saw it in Sumerian art more than three thousand years before. The eagles pouncing on ducks bring to mind similar pairings of carnivore-and-victim in Luristan bronzes. The design above them, on the other hand, is of more recent origin. It consists of fighting animals whose tails, legs, and jaws are elongated into bands forming a complex interlacing pattern. Interlacing bands as an ornamental device occur in Roman and Early Christian art, especially along the southern shore of the Mediterranean, but their combination with the animal style, as shown here, seems to be an invention of the Dark Ages, not much before the date of our purse cover.

Metalwork, in a variety of materials and techniques and often of exquisitely refined craftsmanship, had been the principal medium of the animal style. Such objects, small, durable, and eagerly sought after, account for the rapid diffusion of its repertory of forms. During the Dark Ages, however, these forms migrated not only in the geographic sense but also technically and artistically, into

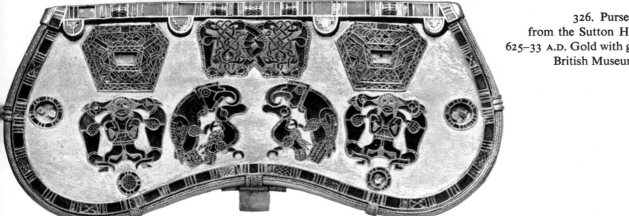

326. Purse Cover,
from the Sutton Hoo Ship-Burial.
625–33 A.D. Gold with garnets and enamels.
British Museum, London

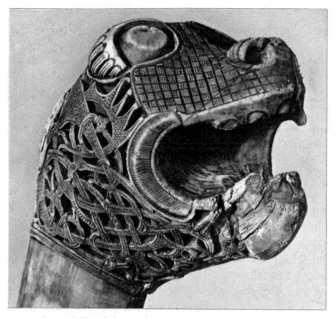

327. *Animal Head,* from the Oseberg Ship-Burial. c. 825 A.D. Wood, height c. 5″. University Museum of Antiquities, Oslo

wood, stone, and even manuscript illumination. Wooden specimens, as we might expect, have not survived in large numbers; most of them come from Scandinavia, where the animal style flourished longer than anywhere else. The splendid animal head in figure 327, of the early ninth century, is the terminal of a post that was found, along with much other equipment, in a buried Viking ship at Oseberg in southern Norway. Like the motifs on the Sutton Hoo purse cover, it shows a peculiarly composite quality: the basic shape of the head is surprisingly realistic, as are certain details (teeth, gums, nostrils), but the surface has been spun over with interlacing and geometric patterns that betray their derivation from metalwork. Snarling monsters such as this used to rise from the prows of Viking ships, endowing them with the character of mythical sea dragons.

Irish

This pagan Germanic version of the animal style is reflected in the earliest Christian works of art north of the Alps as well. In order to understand how they came to be produced, however, we must first acquaint ourselves with the important role played by the Irish, who, during the Dark Ages, assumed the spiritual and cultural leadership of western Europe. The period 600–800 A.D. deserves, in fact, to be called the Golden Age of Ireland. Unlike their English neighbors, the Irish had never been part of the Roman Empire; thus the missionaries who carried the Gospel to them from England in the fifth century found a Celtic society entirely barbarian by Roman standards. The Irish readily accepted Christianity, which brought them into contact with Mediterranean civilization, but without becoming Rome-oriented. Rather, they adapted what they had received in a spirit of vigorous

local independence. The institutional framework of the Roman Church, being essentially urban, was ill-suited to the rural character of Irish life. Irish Christians preferred to follow the example of the desert saints of Egypt and the Near East who had left the temptations of the city to seek spiritual perfection in the solitude of the wilderness. Groups of such hermits, sharing a common ideal of ascetic discipline, had founded the earliest monasteries. By the fifth century, monasteries had spread as far north as western Britain, but only in Ireland did monasticism take over the leadership of the Church from the bishops. Irish monasteries, unlike their Egyptian prototypes, soon became seats of learning and the arts; they also developed a missionary fervor that sent Irish monks to preach to the heathen and to found monasteries in northern Britain as well as on the European mainland, from Poitiers to Vienna. These Irishmen not only speeded the conversion to Christianity of Scotland, northern France, the Netherlands, and Germany; they also established the monastery as a cultural center throughout the European countryside. Although their Continental foundations were taken over before long by the monks of the Benedictine order, who were advancing north from Italy during the seventh and eighth centuries, Irish influence was to be felt within medieval civilization for several hundred years to come.

In order to spread the Gospel, the Irish monasteries had to produce copies of the Bible and other Christian books in large numbers. Their writing workshops (scriptoria) also became centers of artistic endeavor, for a manuscript containing the Word of God was looked upon as a sacred object whose visual beauty should reflect the importance of its contents. Irish monks must have known Early Christian illuminated manuscripts, but here again, as in so many other respects, they developed an independent tradition instead of simply copying their models. While pictures illustrating biblical events held little interest for them, they devoted great effort to decorative embellishment. The finest of these manuscripts belong to the Hiberno-Saxon style, combining Celtic and Germanic elements, which flourished in the monasteries founded by Irishmen in Saxon England. The Cross Page in the *Lindisfarne Gospels* (colorplate 31) is an imaginative creation of breath-taking complexity; the miniaturist, working with a jeweler's precision, has poured into the compartments of his geometric frame an animal interlace so dense and yet so full of controlled movement that the fighting beasts on the Sutton Hoo purse cover seem childishly simple in comparison. It is as if the world of paganism, embodied in these biting and clawing monsters, had suddenly been subdued by the superior authority of the Cross. In order to achieve this effect, our artist has had to impose an extremely severe discipline upon himself. His "rules of the game" demand, for instance, that organic and geometric shapes must be kept separate; that within the animal compartments every line must turn out to be part of an animal's body, if we take the trouble to trace it back to its point of origin. There are also rules,

too complex to go into here, concerning symmetry, mirror-image effects, and repetitions of shapes and colors. Only by working these out for ourselves by intense observation can we hope to enter into the spirit of this strange, mazelike world.

Of the representational images they found in Early Christian manuscripts, the Hiberno-Saxon illuminators generally retained only the symbols of the four evangelists, since these could be translated into their ornamental idiom without much difficulty. The lion of St. Mark in the *Echternach Gospels* (colorplate 32), sectioned and patterned like the enamel inlays of the Sutton Hoo purse cover, is animated by the same curvilinear sense of movement we saw in the animal interlaces of the previous illustration. Here again we marvel at the masterly balance between the shape of the animal and the geometric framework on which it has been superimposed (and which, in this instance, includes the inscription, *imago leonis*). The human figure, on the other hand, remained beyond the Celtic or Germanic artist's reach for a long time. The bronze plaque of the *Crucifixion* (fig. 328), probably made for a book cover, shows how helpless he was when faced

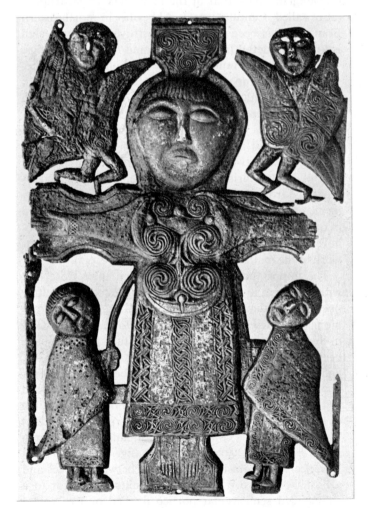

328. *Crucifixion* (from a book cover?). 8th century A.D. Bronze. National Museum of Ireland, Dublin

with the image of man. In his attempt to reproduce an Early Christian composition, he suffers from an utter inability to conceive of the human frame as an organic unit, so that the figure of Christ becomes disembodied in the most elementary sense: head, arms, and feet are separate elements attached to a central pattern of whorls, zigzags, and interlacing bands. Clearly, there is a wide gulf between the Celtic-Germanic and the Mediterranean traditions, a gulf that the Irish artist who modeled the *Crucifixion* did not know how to bridge.

Lombard

The situation was much the same in Continental Europe: we even find it among the Lombards in northern Italy. The Germanic stone carver who did the marble balustrade relief in the Cathedral Baptistery at Cividale (fig. 329) was just as perplexed as his Irish contemporaries by the problem of representation. His evangelists' symbols are strange creatures indeed; all four of them have the same spidery front legs, and their bodies consist of nothing but head, wings, and (except for the angel) a little spiral tail. Apparently he did not feel he was violating their integrity by forcing them into their circular frames in this Procrustean fashion. On the other hand, he had a well-developed sense of ornament; the panel as a whole, with its flat, symmetrical pattern, is an effective piece of decoration, rather like an embroidered cloth. He may, in fact, have derived his design in part from Oriental textiles (compare fig. 106).

CAROLINGIAN ART

The empire built by Charlemagne did not endure for long. His grandsons divided it into three parts, and proved incapable of effective rule even in these, so that political power reverted to the local nobility. The cultural achievements of his reign, in contrast, have proved far more lasting; this very page would look different without them, for it is printed in letters whose shape derives from the script in Carolingian manuscripts. The fact that these letters are known today as Roman rather than Carolingian recalls another aspect of the cultural reforms sponsored by Charlemagne: the collecting and copying of ancient Roman literature. The oldest surviving texts of a great many classical Latin authors are to be found in Carolingian manuscripts, which, until not very long ago, were mistakenly regarded as Roman, hence their lettering, too, was called Roman. This interest in preserving the classics was part of an ambitious attempt to restore ancient Roman civilization, along with the imperial title. Charlemagne himself took an active hand in this revival, through which he expected to implant the cultural traditions of a glorious past in the minds of the

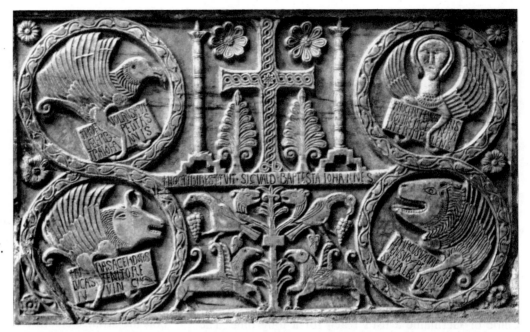

329. Balustrade Relief
Inscribed by the Patriarch Sigvald
(762–776 A.D.) and probably carved
c. 725–750 A.D. Marble, about 3 × 5'.
Cathedral Baptistery, Cividale, Italy

semibarbarian people of his realm. To an astonishing extent, he succeeded. Thus the "Carolingian revival" may be termed the first—and in some ways the most important—phase of a genuine fusion of the Celtic-Germanic spirit with that of the Mediterranean world.

ARCHITECTURE

The fine arts played an important role in Charlemagne's cultural program from the very start. On his visits to Italy, he had become familiar with the architectural monuments of the Constantinian era in Rome and with those of the reign of Justinian in Ravenna; his own capital at Aachen, he felt, must convey the majesty of empire through buildings of an equally impressive kind. His famous Palace Chapel (figs. 330–32) is, in fact, directly inspired by S. Vitale (compare figs. 282–85). To erect such a structure on Northern soil was a difficult undertaking; columns and bronze gratings had to be imported from Italy, and expert stonemasons must have been hard to find. The design, by Odo of Metz (probably the earliest architect north of the Alps known to us by name), is by no means a mere echo of S. Vitale but a vigorous reinterpretation, with piers and vaults of Roman massiveness and a geometric clarity of the spatial units very different from the fluid space of the earlier structure. Equally significant is Odo's scheme for the western entrance (now largely obscured by later additions and rebuilding); at S. Vitale, the entrance consists of a broad, semidetached narthex with twin stair turrets, at an odd angle to the main axis of the church, while at Aachen these elements have been molded into a tall, compact unit, in line with the main axis and closely attached to the chapel proper. This monumental entrance structure, or westwork (from the German *Westwerk*), which makes one of its first recorded appearances here, contains the germ of the two-tower façade familiar from

so many later medieval churches. An even more elaborate westwork formed part of the greatest basilican church of Carolingian times, that of the monastery of St.-Riquier (also called Centula), near Abbeville in northeastern France. It has been completely destroyed, but its design is known in detail from drawings and descriptions (figs. 333, 334). Several innovations in the church were to become of basic importance for the future: the westwork leads into a vaulted narthex which is in effect a western transept; the crossing (the area where the transept intersects the nave) was crowned by a tower, and the same feature recurred above the crossing of the eastern transept, again with two round stair towers. The apse, unlike that of Early Christian basilicas (compare fig. 268), is separated from the eastern transept by a square compartment, called the choir. St.-Riquier was widely imitated in other Carolingian monastery churches, but these, too, have been destroyed or rebuilt in later times (a fine westwork of the tenth century is shown in figure 342).

The importance of monasteries, and their close link with the imperial court, are vividly suggested by a unique document of the period, the large drawing of a plan for a monastery preserved in the Chapter Library at St. Gall in Switzerland (fig. 335). Its basic features seem to have been determined at a council held near Aachen in 816–17, and then this copy was sent to the abbot of St. Gall for his guidance in rebuilding the monastery. We may regard it, therefore, as a standard plan, to be modified according to local needs. (Figure 335 omits the explanatory titles.) The monastery is a complex, self-contained unit, occupying a rectangle c. 500 by 700 feet (fig. 336). The main entrance-way, from the west, passes between stables and a hostelry toward a gate which admits the visitor to a colonnaded semicircular portico flanked by two round towers, a sort of strung-out westwork that loomed impressively above the low outer buildings. It emphasizes the

church as the center of the monastic community. The church is a basilica, with a transept and choir in the east but an apse and altar at either end; the nave and aisles, containing numerous other altars, do not form a single continuous space but are subdivided into compartments by screens. There are numerous entrances: two beside the western apse, others on the north and south flanks. This entire arrangement reflects the functions of a monastery church, designed for the liturgical needs of the monks rather than for a lay congregation. Adjoining the church to the south is an arcaded cloister, around which are grouped the monks' dormitory (on the east side), a re-

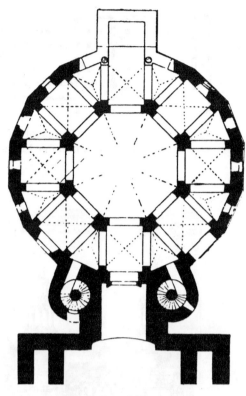

331. Restored Plan of the
Palace Chapel of Charlemagne

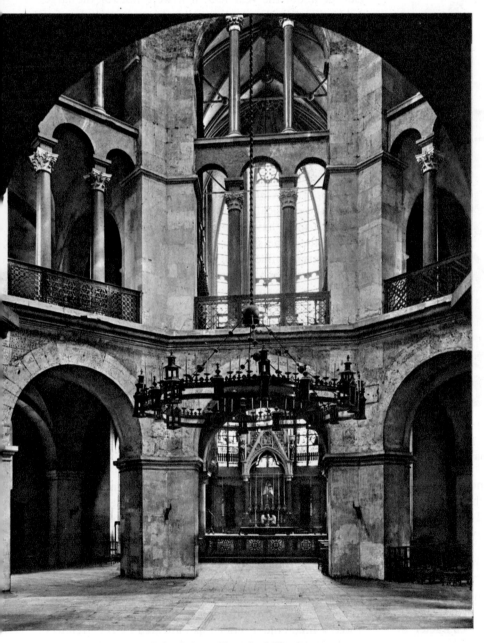

330. Interior of the Palace Chapel of Charlemagne,
Aachen. 792–805 A.D.

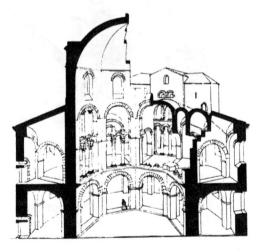

332. Axonometric Projection of
the Palace Chapel of Charlemagne
(after Kubach)

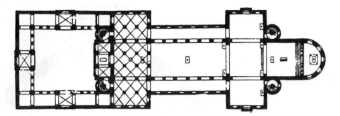

333. Plan of the Abbey Church of St.-Riquier, France.
Consecrated 799 A.D. (after Effmann, 1912)

334. Abbey Church of St.-Riquier, France
(engraved view by Petau, 1612, after
an 11th-century manuscript illumination)

fectory and kitchen (on the south side), and a cellar. The three large buildings north of the church are a guest-house, a school, and the abbot's house. To the east are the infirmary, a chapel and quarters for novices, the cemetery (marked by a large cross), a garden, and coops for chickens and geese. The south side is occupied by workshops, barns, and other service buildings. There is, needless to say, no monastery exactly like this anywhere—even in St. Gall the plan was not carried out as drawn—yet its layout conveys an excellent notion of the character of such establishments throughout the Middle Ages.

MANUSCRIPTS AND BOOK COVERS

We know from literary sources that Carolingian churches contained murals, mosaics, and relief sculpture, but these have disappeared almost entirely. Illuminated manuscripts, ivories, and goldsmiths' work, on the other hand, have survived in considerable numbers. They demonstrate the impact of the Carolingian revival even more strikingly than the architectural remains of the period. The former Imperial Treasury in Vienna contains a Gospel Book said to have been found in the tomb of Charlemagne and, in any event, closely linked with his court at Aachen. As we look at the picture of St. Matthew from that manuscript (fig. 337), we find it hard to believe that such a work could have been executed in northern Europe about the year 800: if it were not for the large golden halo, the Evangelist might almost be mistaken for a classical author's portrait like the one of Menander (fig. 338), painted at Pompeii almost eight centuries earlier. Whoever the artist was—Byzantine, Italian, or Frank—he shows himself fully conversant with the Roman tradition of painting, down to the acanthus ornament on the wide frame, which emphasizes the "window" aspect of the picture. The *St. Matthew* represents the most orthodox phase of the Carolingian revival; it is the visual counterpart of copying the text of a classical work of literature. Our next miniature, done two or three decades later for the *Gospel Book of Archbishop Ebbo of Reims* (fig. 339), shows the classical model translated into a Carolingian idiom. It must have been based on an evangelist's portrait of the same style as the *St. Matthew*, but now the entire picture is filled with a vibrant energy that sets everything into motion: the drapery swirls about the figure, the hills heave upward, the vegetation seems to be tossed about by a whirlwind, and even the acanthus pattern on the frame assumes a strange, flamelike character. The Evangelist himself has been transformed from a Roman author setting down his own thoughts into a man seized with the frenzy of divine inspiration, an instrument for recording the Word of God. His gaze is fixed, not upon his book but upon his symbol (the winged lion with a scroll), which acts as the transmitter of the Sacred Text. This dependence upon the Will of the Lord, so powerfully expressed here, marks the contrast between the classical and the medieval image of man. But the *means* of expression—the dynamism of line that distinguishes our miniature from its predecessor—recalls the passionate movement we found in the ornamentation of Irish manuscripts of the Dark Ages.

The Reims School also produced the most extraordinary of all Carolingian manuscripts, the *Utrecht Psalter* (fig. 340). It displays the style of the *Ebbo Gospels* in an even more energetic form, since the entire book is illustrated with pen drawings. Here again the artist has followed a much older model, as indicated by the architectural and landscape settings of the scenes and by the use

335, 336. *above:* Plan of a Monastery. c. 820 A.D. Chapter Library, St. Gall. *below:* Reconstruction Model (Walter Horn, 1965)

337. *St. Matthew*, from the *Gospel Book of Charlemagne.*
c. 800–810 A.D. Kunsthistorisches Museum, Vienna

338. *Portrait of Menander* (wall painting).
c. 70 A.D. House of Menander, Pompeii

339. *St. Mark,* from the *Gospel Book of Archbishop Ebbo of Reims.* 816–835 A.D. Municipal Library, Epernay, France

of Roman capital lettering, which had gone out of general use several centuries before. The wonderfully rhythmic quality of his draughtsmanship, however, gives these sketches a kind of emotional coherence that could not have been present in the earlier pictures. Without it, the drawings of the *Utrecht Psalter* would carry little conviction, for the poetic language of the Psalms does not lend itself to illustration in the same sense as the narrative portions of the Bible. The Psalms can be illustrated only by taking each phrase literally and then trying to visualize it in some way. Thus, at the top of our picture, we see the Lord reclining on a bed, flanked by pleading angels, an image based on the words, "Awake, why sleepest thou, O Lord?" On the left, the faithful crouch before the Temple, "for . . . our belly cleaveth unto the earth," and at the city gate in the foreground they are killed "as sheep for the slaughter." In the hands of a

MEA·QUAREMEREPPULIS ADDMQUILAETIFICAT CONFITEBORILLI·SALU
TIFIQUARETRISTISINCEDO· IUUENTUTEMMEAM IARFUULTUSMEIETDSMS
DUMADFLICITMEINIMICUS·

340. Illustration to Psalm 44, from the *Utrecht Psalter*. c. 820–832 A.D. University Library, Utrecht

pedestrian artist, this procedure could well turn into a wearisome charade; here, it has the force of a great drama.

The style of the Reims School can still be felt in the reliefs of the jeweled front cover of the *Lindau Gospels* (colorplate 33), a work of the third quarter of the ninth century. This masterpiece of the goldsmith's art shows how splendidly the Celtic-Germanic metalwork tradition of the Dark Ages adapted itself to the Carolingian revival. The clusters of semiprecious stones are not mounted directly on the gold ground but raised on claw feet or arcaded turrets, so that the light can penetrate beneath them, to bring out their full brilliance. Interestingly enough, the crucified Christ betrays no hint of pain or death; He seems to stand rather than to hang, His arms spread out in a solemn gesture. To endow Him with the signs of human suffering was not yet conceivable, even though the means were at hand, as we can see from the eloquent expressions of grief among the small figures in the adjoining compartments.

OTTONIAN ART

In 870, about the time when the *Lindau Gospels* cover was made, the remains of Charlemagne's empire were ruled by his two surviving grandsons: Charles the Bald, the West Frankish King, and Louis the German, the East Frankish King, whose domains corresponded rough-ly to the France and Germany of today. Their power was so weak, however, that continental Europe once again lay exposed to attack. In the south, the Moslems resumed their depredations, Slavs and Magyars advanced from the east, and Vikings from Scandinavia ravaged the north and west. These Norsemen (the ancestors of today's Danes and Norwegians) had been raiding Ireland and Britain by sea from the late eighth century on; now they invaded northwestern France as well, occupying the area that ever since has been called Normandy. Once established there, they soon adopted Christianity and Carolingian civilization, and, from 911 on, their leaders were recognized as dukes nominally subject to the authority of the king of France. During the eleventh century, the Normans assumed a role of great importance in shaping the political and cultural destiny of Europe, with William the Conqueror becoming King of England while other Norman nobles expelled the Arabs from Sicily and the Byzantines from South Italy. In Germany, meanwhile, after the death of the last Carolingian monarch in 911, the center of political power had shifted north to Saxony. The Saxon kings (919–1024) re-established an effective central government, and the greatest of them, Otto I, also revived the imperial ambitions of Charlemagne. After marrying the widow of a Lombard king, he extended his rule over most of Italy and had himself crowned emperor by the pope in 962. From then on the Holy Roman Empire was to be a German institution. Or perhaps we ought to call it a German dream, for Otto's successors never managed to consoli-

date their claim to sovereignty south of the Alps. Yet this claim had momentous consequences, since it led the German emperors into centuries of conflict with the papacy and local Italian rulers, linking North and South in a love-hate relationship whose echoes can be felt to the present day.

SCULPTURE

During the Ottonian period, from the mid-tenth century to the beginning of the eleventh, Germany was the leading nation of Europe, politically as well as artistically. German achievements in both areas began as revivals of Carolingian traditions but soon developed new and original traits. These are impressively brought home to us if we compare the Christ on the cover of the *Lindau Gospels* with the *Gero Crucifix* (fig. 341) in the cathedral at Cologne. The two works are separated by little more than a hundred years' interval, but the contrast

341. *The Gero Crucifix.* c. 975–1000 A.D. Wood, height 6′ 2″.
Cathedral, Cologne

between them suggests a far greater span. In the *Gero Crucifix* we meet an image of the crucified Saviour new to Western art: monumental in scale, carved in powerfully rounded forms, and filled with a deep concern for the sufferings of the Lord. Particularly striking is the forward bulge of the heavy body, which makes the physical strain on arms and shoulders seem almost unbearably real. The face, with its deeply incised, angular features, has turned into a mask of agony, from which all life has fled. How did the Ottonian sculptor arrive at this startlingly bold conception? We do not belittle his greatness by recalling that the compassionate view of Christ on the Cross had been created in Byzantine art of the Second Golden Age (see fig. 299) and that the *Gero Crucifix* clearly derives from that source. Nor need we be surprised that Byzantine influence should have been strong in Germany at that time, for Otto II had married a Byzantine princess, establishing a direct link between the two imperial courts. It remained for the Ottonian artist to translate the Byzantine image into large-scale sculptural terms and to replace its gentle pathos with an expressive realism that has been the main strength of German art ever since.

ARCHITECTURE

Cologne was closely connected with the imperial house through its Archbishop, Bruno, the brother of Otto I, who left a strong mark on the city through the numerous churches he built or rebuilt. His favorite among these, the Benedictine Abbey of St. Pantaleon, became his burial place as well as that of the wife of Otto II. Only the monumental westwork (fig. 342) has retained its original shape essentially unchanged until modern times; we recognize it as a massive and well-proportioned successor to Carolingian westworks, with the characteristic tower over the crossing of the western transept and a deep porch flanked by tall stair turrets. The most ambitious patron of architecture and art in the Ottonian age, however, judged in terms of surviving works, was Bernward, who, after having been one of the tutors of Otto III, became Bishop of Hildesheim. His chief monument there is another Benedictine abbey church, St. Michael's. The plan (fig. 343), with its two choirs and lateral entrances, recalls the monastery church of the St. Gall plan (fig. 335). But in St. Michael's the symmetry is carried much further: not only are there two identical transepts, with crossing towers and stair turrets (see St.-Riquier, figs. 333, 334), but the supports of the nave arcade, instead of being uniform, consist of pairs of columns separated by square piers. This alternating system divides the arcade into three equal units of three openings each; the first and third units are correlated with the entrances, thus echoing the axis of the transepts. Since, moreover, aisles and nave are unusually wide in relation to their length, Bernward's intention must have been to achieve

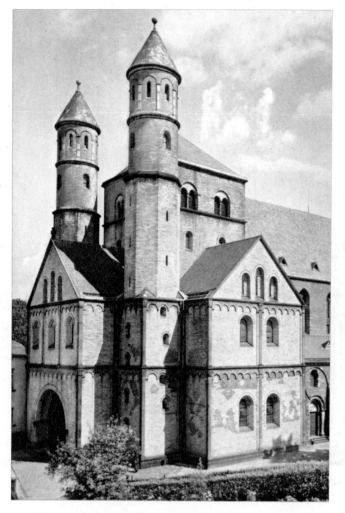

342. Westwork, St. Pantaleon, Cologne. Consecrated 980. A.D.

a harmonious balance between the longitudinal and transverse axes throughout the structure. The exterior, as well as the choirs, of Bernward's church have been disfigured by rebuilding, but the interior of the nave (figs. 344, 345), with its great expanse of wall space between arcade and clerestory, retained the majestic spatial feeling of the original design until the Second World War reduced it to ruins. (The capitals of the columns date from the twelfth century, the painted wooden ceiling from the thirteenth.) The Bernwardian western choir, as reconstructed in our plan on the basis of recent studies, is particularly interesting: its floor was raised above the level of the rest of the church, so as to accommodate a half-subterranean basement chapel, or crypt, apparently a special sanctuary of St. Michael, which could be entered both from the transept and from the west. The crypt was roofed by groined vaults resting on two rows of columns, and its walls were pierced by arched openings that linked it with the U-shaped corridor, or ambulatory, wrapped around it. This ambulatory must have been visible above ground, enriching the exterior of the western choir, since there were windows in its outer wall. Such crypts with ambulatories,

usually housing the venerated tomb of a saint, had been introduced into the repertory of Western church architecture during Carolingian times; the Bernwardian design stands out for its large scale and its carefully planned integration with the rest of the building.

METALWORK

How much importance Bernward himself attached to the crypt at St. Michael's can be gathered from the fact that he commissioned a pair of richly sculptured bronze doors which were probably meant for the two entrances leading from the transept to the ambulatory (they were finished in 1015, the year the crypt was consecrated). The idea may have come to him as a result of his visit to Rome, where he could see ancient Roman—and perhaps Byzantine—bronze doors. The Bernwardian doors, however, differ from their predecessors; they are divided into broad horizontal fields rather than vertical panels, and each field contains a biblical scene in high relief. Our detail (fig. 346) shows Adam and Eve after the Fall. Below it, in inlaid letters remarkable for their classical Roman character, is part of the dedicatory inscription, with the date and Bernward's name. In these figures we find nothing of the monumental spirit of the *Gero Crucifix*: they seem far smaller than they actually are, so that one might easily mistake them for a piece of goldsmiths' work such as the *Lindau Gospels* cover (compare colorplate 33). The entire composition must have been derived from an illuminated manuscript; the oddly stylized bits of vegetation have a good deal of the twisting, turning movement we recall from Irish miniatures. Yet the story is conveyed with splendid directness and expressive force. The accusing finger of the Lord, seen against a great void of blank surface, is the focal point of the drama; it points to a cringing Adam, who passes the blame to his mate, while she, in turn, passes it to the serpent at her feet.

MANUSCRIPTS

The same intensity of glance and gesture characterizes Ottonian manuscript painting, which blends Carolingian and Byzantine elements into a new style of extraordinary scope and power. The most important center of manuscript illumination at that time was the Reichenau monastery, on an island in the Lake of Constance. Perhaps its finest achievement—and one of the great masterpieces of medieval art—is the *Gospel Book of Otto III*, from which we reproduce two full-page miniatures (colorplate 34). The scene of Christ washing the feet of St. Peter contains notable echoes of ancient painting, transmitted through Byzantine art; the soft pastel hues of the background recall the illusionism of Graeco-Roman landscapes, and the architectural frame around Christ is a late descendant of such architectural perspectives as the mural from Boscoreale (see fig. 260). That these elements have been

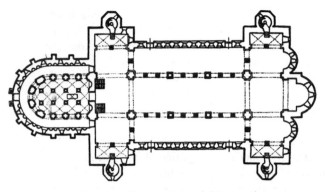

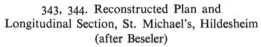

343, 344. Reconstructed Plan and
Longitudinal Section, St. Michael's, Hildesheim
(after Beseler)

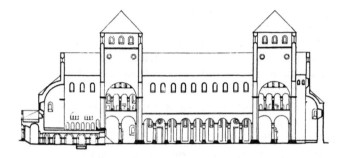

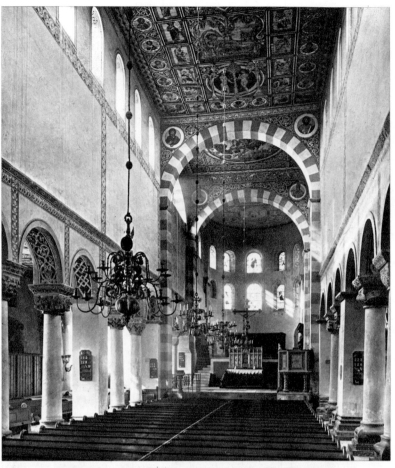

345. Interior (view toward the west, before World War II),
St. Michael's, Hildesheim

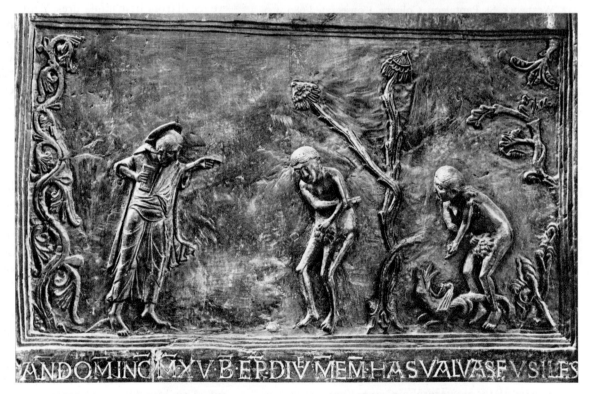

346. *Adam and Eve Reproached by the Lord,* from the Bronze Doors of Bishop Bernward for
St. Michael's. 1015. c. 23 × 43″. Hildesheim Cathedral

misunderstood by the Ottonian artist is obvious enough; but he has also put them to a new use, so that what was once an architectural vista now becomes the Heavenly City, the House of the Lord filled with golden celestial space as against the atmospheric earthly space without. The figures have undergone a similar transformation: in ancient art, this composition had been used to represent a doctor treating a patient. Now St. Peter takes the place of the sufferer, and Christ that of the physician (note that He is still the beardless young philosopher type here). As a consequence, the emphasis has shifted from physical to spiritual action, and this new kind of action is not only conveyed through glances and gestures, it also governs the scale of things: Christ and St. Peter, the most active figures, are larger than the rest; Christ's "active" arm is longer than His "passive" one; and the eight disciples who merely watch have been compressed into a tiny space, so that we see little more than their eyes and hands. The other miniature, the painting of St. Luke, is a symbolic image of overwhelming grandeur. Unlike his Carolingian predecessors, the Evangelist is no longer shown writing; his Gospel lies completed on his lap. Enthroned on two rainbows, he holds aloft a huge cluster of clouds from which tongues of light radiate in every direction. Within it we see his symbol, the ox, surrounded by five Old Testament prophets and an outer circle of angels. At the bottom, two lambs drink the life-giving waters that spring from beneath the Evangelist's feet. The key to the entire design is the inscription: *Fonte patrum ductas bos agnis elicit undas*— "From the source of the fathers the ox brings forth a flow of water for the lambs"—that is, St. Luke makes the prophets' message of salvation explicit for the faithful. The Ottonian artist has truly "illuminated" the meaning of this terse and enigmatic phrase by translating it into such compelling visual terms.

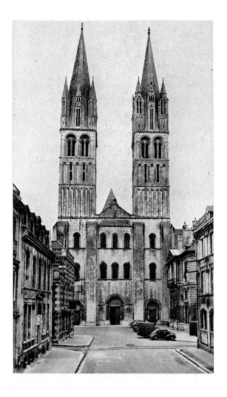

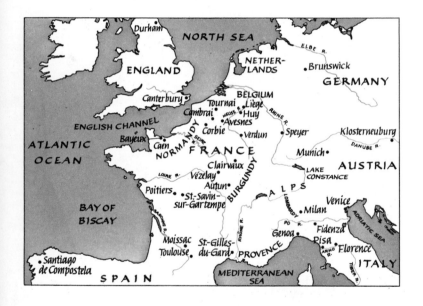

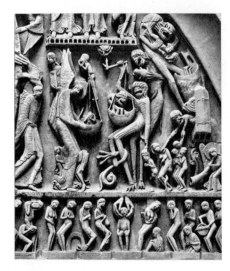

3

ROMANESQUE ART

Looking back over the ground we have covered in this book so far, a thoughtful reader will be struck by the fact that almost all of our chapter headings and subheadings might serve equally well for a general history of civilization. Some are based on technology (e.g., the Stone Age), others on geography, ethnology, religion; whatever the source, they have been borrowed from other fields, even though in our context they also designate artistic styles. There are only two important exceptions to this rule: Archaic and Classical are primarily terms of style; they refer to qualities of form rather than to the setting in which these forms were created. Why don't we have more terms of this sort? We do, as we shall see—but only for the art of the past 900 years. The men who first conceived the idea of viewing the history of art as an evolution of styles, started out with the conviction that art in the ancient world developed toward a single climax: Greek art from the age of Pericles to that of Alexander the Great. This style they called Classical (that is, perfect). Everything that came before was labeled Archaic, to indicate that it was still old-fashioned and tradition-bound, not-yet-Classical but striving in the right direction, while the style of post-Classical times did not deserve a special term since it had no positive qualities of its own, being merely an echo or a decadence of Classical art. The early historians of medieval art followed a similar pattern; to them, the great climax was the Gothic style, from the thirteenth century to the fifteenth. For whatever was not-yet-Gothic they adopted the label Romanesque. In doing so, they were thinking mainly of architecture; pre-Gothic churches, they noted, were round-arched, solid, and heavy (as against the pointed arches and the soaring lightness of Gothic structures), rather like the ancient Roman style of building, and the term Romanesque was meant to convey just that. In this sense, all of medieval art before 1200, insofar as it shows any link with the Mediterranean tradition, could be called Romanesque. Some scholars speak of medieval art before Charlemagne as pre-Romanesque, and of Carolingian and Ottonian as proto- or early Romanesque, and they are right to the extent that Romanesque art proper (that is, medieval art between c. 1050 and 1200) would be unthinkable without the contributions of these earlier styles. On the other hand, if we follow this practice we are likely to do less than justice to those qualities that make the art of the Dark Ages and of Carolingian and Ottonian times different from the Romanesque.

Carolingian art, we will recall, was brought into being by Charlemagne and his circle, as part of a conscious revival policy; even after his death, it remained strongly linked with the court. Ottonian art, too, had this imperial sponsorship, and a correspondingly narrow base. The Romanesque, in contrast, sprang up all over western Europe at about the same time; it consists of a large variety of regional styles, distinct yet closely related in many ways, and without a central source. In this respect, it resembles the art of the Dark Ages rather than the court styles that had preceded it, although it includes the Carolingian-Ottonian tradition along with a good many other, less clearly traceable ones, such as Late Classical, Early Christian, and Byzantine elements, some Islamic influence, and the Celtic-Germanic heritage. What welded all these different components into a coherent style during the second half of the eleventh century was not any single force but a variety of factors that made for a new burgeoning of vitality throughout the West. Christianity had at last triumphed everywhere in Europe; the Vikings, still largely pagan in the ninth and tenth centuries when their raids terrorized the British Isles and the Continent, had entered the Catholic fold, not only in Normandy but in Scandinavia as well; the Caliphate of Cordova had disintegrated in 1031 into many small Moslem states, opening the way for the reconquest of the Iberian peninsula; and the Magyars had settled down in Hungary. There was a growing spirit of religious enthusiasm, reflected in the greatly increased pilgrimage traffic to sacred sites and culminating, from 1095 on, in the crusades to liberate the Holy Land from Moslem rule. Equally important was the reopening of Mediterranean trade routes by the navies of Venice, Genoa, and Pisa; the revival of commerce and manufacturing; and the consequent growth of city life. During the turmoil of the early Middle Ages, the towns of the Western Roman Empire had shrunk greatly in size (the population of Rome, about one million in 300 A.D., fell to less than 50,000 at one point); some were deserted altogether. From the eleventh century on, they began to regain their former importance. New towns sprang up everywhere,

and an urban middle class of craftsmen and merchants established itself between the peasantry and the landed nobility as an important factor in medieval society. In many respects, then, western Europe between 1050 and 1200 became a great deal more "Roman-esque" than it had been since the sixth century, recapturing some of the international trade patterns, the urban quality, and the military strength of ancient imperial times. The central political authority was lacking, to be sure (even the Empire of Otto I did not extend much farther west than modern Germany does) but the central spiritual authority of the pope took its place to some extent as a unifying force. The international army that responded to Urban II's call for the First Crusade was more powerful than anything a secular ruler could have raised for the purpose.

ARCHITECTURE

The most conspicuous difference between Romanesque architecture and that of the preceding centuries is the amazing increase in building activity. An eleventh-century monk, Raoul Glaber, summed it up well when he triumphantly exclaimed that the world was putting on a "white mantle of churches." These churches were not only more numerous than those of the early Middle Ages, they were also generally larger, more richly articulated, and more "Roman-looking," for their naves now had vaults instead of wooden roofs, and their exteriors, unlike those of Early Christian, Byzantine, Carolingian, and Ottonian churches, were decorated with both architectural ornament and sculpture. Geographically, Romanesque monuments of the first importance are distributed over an area that might well have represented the world—the Catholic world, that is —to Raoul Glaber: from northern Spain to the Rhineland, from the Scottish-English border to central Italy. The richest crop, the greatest variety of regional types, and the most adventurous ideas are to be found in France. If we add to this group those destroyed or disfigured buildings whose original design is known to us through archaeological research, we have a wealth of architectural invention unparalleled by any previous era.

SOUTHWESTERN FRANCE

We begin our sampling—it cannot be more than that —with St.-Sernin, in the southern French town of Toulouse (figs. 347–50), one of a group of great churches of the "pilgrimage type," so called because they were built along the roads leading to the pilgrimage center of Santiago de Compostela in northwestern Spain. The plan immediately strikes us as very much more complex and more fully integrated than those of earlier structures such as St.-Riquier, or St. Michael's at Hildesheim (see figs. 333, 343). It is an emphatic Latin cross, with the center of

gravity at the eastern end. Clearly, this church was not designed to serve a monastic community only but (like Old St. Peter's in Rome) to accommodate large crowds of lay worshipers in its long nave and transept. The nave is flanked by two aisles on either side, the inner aisle continuing around the arms of the transept and the apse and thus forming a complete ambulatory circuit anchored to the two towers of the west façade. The ambulatory, we will recall, had developed as a feature of the crypts of earlier churches (as at St. Michael's); now it has emerged above ground and it is linked with the aisles of nave and transept, and enriched with apsidal chapels that seem to radiate from the apse and continue along the eastern face of the transept. (Apse, ambulatory, and radiating chapels form a unit known as the pilgrimage choir.) The plan also shows that the aisles of St.-Sernin are groin-vaulted throughout. This, in conjunction with the features already noted, imposes a high degree of regularity upon the entire design: the aisles are made up of square bays, which serve as a basic unit, or module, for the other dimensions, so that the nave and transept bays equal two such units, the crossing and the façade towers four units. On the exterior, this rich articulation is further enhanced by the different roof levels that set off the nave and transept against the inner and outer aisles, the apse, the ambulatory, and the radiating chapels; by the buttresses reinforcing the walls between the windows, so as to contain the outward thrust of the vaults; by the decorative framing of windows and portals; and by the great crossing tower (completed in Gothic times and taller than originally intended). The two façade towers, unfortunately, have remained stumps. As we enter the nave, we are impressed with its tall proportions, the architectural elaboration of the nave walls, and the dim, indirect lighting, all of which create a sensation very different from the ample and serene interior of St. Michael's, with its simple and clearly separated "blocks" of space (see figs. 344, 345). The contrast between these structures is such as to make the nave walls of St. Michael's look Early Christian (see fig. 266), while those of St.-Sernin seem more akin to structures such as the Colosseum (see fig. 219). The syntax of ancient Roman architecture—vaults, arches, engaged columns, and pilasters firmly knit together into a coherent order—has indeed been recaptured here to a remarkable degree; yet the forces whose interaction is expressed in the nave of St.-Sernin are no longer the physical, "muscular" forces of Graeco-Roman architecture but spiritual forces—spiritual forces of the kind we have seen governing the human body in Carolingian and Ottonian miniatures. The half-columns running the entire height of the nave wall would appear just as unnaturally drawn-out to an ancient Roman beholder as the arm of Christ in colorplate 34. They seem to be driven upward by some tremendous, unseen pressure, hastening to meet the transverse arches that subdivide the barrel vault of the nave. Their insistently repeated rhythm propels us

347. Plan of St.-Sernin, Toulouse. c. 1080–1120
(after Conant)

349. Axonometric Projection of Nave,
St.-Sernin, Toulouse (after Choisy)

348. St.-Sernin,
Toulouse (aerial view)

350. Nave and Choir, St.-Sernin, Toulouse

toward the eastern end of the church, with its light-filled apse and ambulatory (now obscured by a huge altar of later date). In thus describing our experience we do not, of course, mean to suggest that the architect consciously set out to achieve this effect. For him, beauty and engineering were inseparable. Vaulting the nave so as to eliminate the fire hazard of a wooden roof was not only a practical aim; it also challenged him to make the House of the Lord grander and more impressive. And since a vault becomes the more difficult to sustain the farther it is from the ground, he strained every resource to make the nave as tall as he dared. He had, however, to sacrifice the clerestory for safety's sake. Instead, he built galleries over the inner aisles, to abut the lateral pressure of the nave vault, hoping that enough light would filter through them into the central space. St.-Sernin serves to remind us that architecture, like politics, is "the art of the possible," and that its success, here as elsewhere, is measured by the degree to which the architect has explored the limits of what was possible to him under those particular circumstances, structurally and aesthetically.

BURGUNDY; WESTERN FRANCE

The builders of St.-Sernin would have been the first to admit that their answer to the problem of the nave vault was not a final one, impressive though it is in its own terms. The architects of Burgundy arrived at a more ele-

gant solution, as evidenced by the Cathedral of Autun (fig. 351), where the galleries are replaced by a blind arcade (called a triforium, since it often has three openings per bay) and a clerestory. What made this three-story elevation possible was the use of the pointed arch for the nave vault, which produced a thrust more nearly downward than outward. For reasons of harmony, the pointed arch also appears in the nave arcade (it had probably reached France from Islamic architecture, where it had been employed for some time). Autun, too, comes close to straining the limits of the possible, for the upper part of the nave wall shows a slight but perceptible outward lean under the pressure of the vault, a warning against any further attempts to increase the height of the clerestory or to enlarge the windows.

A third alternative, with virtues of its own, appears in the west of France, in such churches as that of St.-Savin-sur-Gartempe (fig. 352). The nave vault here lacks the reinforcing arches, since it was meant to offer a continuous surface for murals (see fig. 381 for this cycle, the finest of its kind). Its great weight rests directly on the nave arcade, which is supported by a majestic set of columns. Yet the nave is fairly well lit, for the two aisles are carried almost to the same height, and their outer walls have generously sized windows. At the eastern end of the nave, there is a pilgrimage choir—happily unobstructed in this case—beyond the crossing tower.

351. Nave Wall, Autun Cathedral. c. 1120–32

352. Choir (c. 1060–75) and Nave
(c. 1095–1115), St.-Savin-sur-Gartempe

The nave and aisles of "hall churches" are covered by a single roof, as at St.-Savin. The west façade, too, tends to be low and wide, and may become a richly sculptured screen. That of Notre-Dame-la-Grande at Poitiers (fig. 353), due west from St.-Savin, is particularly noteworthy in this respect, with its elaborately bordered arcades housing large seated or standing figures. A wide band of relief stretches across the façade on either side of the doorway, which is deeply recessed and framed by a series of arches resting on stumpy columns. Taller bundles of columns enhance the turrets, whose conical helmets match the height of the gable in the center (which rises above the actual height of the roof behind it). The sculptural program spread out over this entire area is a visual exposition of Christian doctrine that is a feast for the eyes as well as the mind.

NORMANDY AND ENGLAND

Further north, in Normandy, the west façade evolved in an entirely different direction. That of the abbey church of St.-Etienne at Caen (fig. 354), founded by William the Conqueror a year or two after his invasion of England, offers a striking contrast with Notre-Dame-la-Grande. Decoration is at a minimum, four huge buttresses divide

the front of the church into three vertical sections, and the vertical impetus continues triumphantly in the two splendid towers, whose height would be impressive enough even without the tall Early Gothic helmets. The interior is equally remarkable, but in order to understand its importance we must first turn to the extraordinary development of Anglo-Norman architecture in Britain during the last quarter of the eleventh century. Its most ambitious product is the Cathedral of Durham (figs. 355–57), just south of the Scottish border, begun in 1093. Though somewhat more austere in plan, it has a nave one-third wider than St.-Sernin's, and a greater over-all length (400 feet), which places it among the largest churches of medieval Europe. The nave may have been designed to be vaulted from the start; and the vault over its eastern end had been completed by 1107; the rest of the nave, following the same pattern, by 1130. This vault is of great interest, for it represents the earliest systematic use of a ribbed groined vault over a three-story nave, and thus marks a basic advance beyond the solution we saw at Autun. Looking at the plan, we see that the aisles consist of the usual groin-vaulted compartments closely approaching a square, while the bays of the nave, separated by strong transverse arches, are decidedly oblong and groin-vaulted in such a way that the ribs form a double-X design, dividing the vault into seven sections rather

353. West Façade, Notre-Dame-la-Grande, Poitiers.
Early 12th century

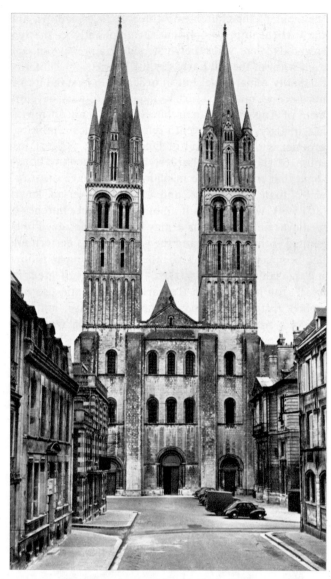

354. West Façade, St.-Etienne, Caen. Begun c. 1068

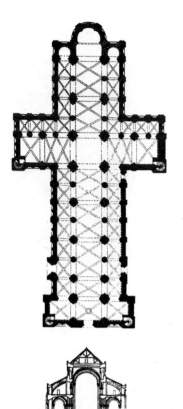

355, 356. Durham Cathedral. Plan and Transverse Section
(after Conant). 1093–1130

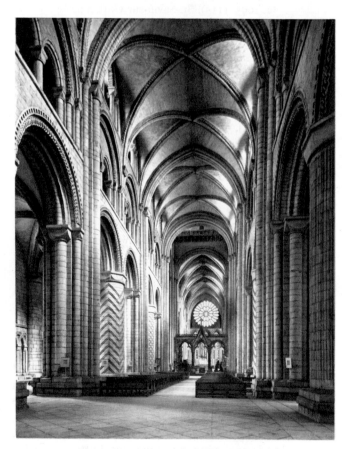

357. Nave (looking east), Durham Cathedral

than the conventional four. Since the nave bays are twice
as long as the aisle bays, the transverse arches occur only
at the odd-numbered piers of the nave arcade, and the
piers therefore alternate in size, the larger ones being of
compound shape (that is, bundles of column and pilaster
shafts attached to a square or oblong core), the others
cylindrical. Perhaps the easiest way to visualize the origin
of this peculiar system is to imagine that the architect
started out by designing a barrel-vaulted nave, with gal-
leries over the aisles, and without a clerestory, as at St.-
Sernin, but with the transverse reinforcing arches spaced
more widely. As he was doing so, he realized that he could
have a clerestory after all if the barrel vault of each nave
bay were intersected by two transverse barrel vaults of
oval shape; the result would be a pair of Siamese-twin
groined vaults, and the ends of the transverse barrel
vaults could become the clerestory, since the outward
thrust and the weight of the whole vault would be con-
centrated at six securely anchored points on the gallery

level. The ribs, of course, were necessary to provide a stable skeleton for the groined vault, so that the curved surfaces between them could be filled in with masonry of minimum thickness, thus reducing both weight and thrust. We do not know whether this ingenious scheme was actually invented at Durham, but it could not have been created much earlier, for it is still in an experimental stage; while the transverse arches at the crossing are round, those to the west of it are slightly pointed, indicating a continuous search for improvements in detail. Aesthetically, the nave at Durham is among the finest in all Romanesque architecture: the wonderful sturdiness of the alternating piers makes a splendid contrast with the dramatically lighted, sail-like surfaces of the vault.

Let us now return to the interior of St.-Etienne at Caen (fig. 358). The nave, it seems, had originally been planned with galleries and clerestory, and a wooden ceiling. After the experience of Durham, it became possible, in the early twelfth century, to build a groined nave vault instead, with only slight modifications of the wall design. But the bays of the nave here are approximately square, so that the double-X rib pattern could be replaced by a single X with an additional transverse rib (⊠), producing a groined vault of six sections instead of seven. These sexpartite vaults are no longer separated by heavy transverse arches but by simple ribs—another saving in weight which, besides, gives a stronger sense of continuity to the nave vault as a whole and makes for a less emphatic alternating system of piers. Compared to Durham, the nave of St.-Etienne creates an impression of graceful, airy lightness closely akin to the quality of the Gothic choir that was added in the thirteenth century. And structurally, too, we have here reached the point where Romanesque merges into Early Gothic.

LOMBARDY

At the time when the Normans and Anglo-Normans constructed their earliest ribbed groined nave vaults, the same problem was being explored in Lombardy, where ancient cities had once again grown large and prosperous. Lombard Romanesque architecture was both nourished and impeded by a continuous building tradition reaching back to Roman and Early Christian times and including the monuments of Ravenna. We sense this as we approach one of its most venerable and important structures, S. Ambrogio in Milan (figs. 359–61), on a site that had been occupied by a church since the fourth century. The present building was begun in the late eleventh century, except for the apse and southern tower, which date from the tenth. The brick exterior, though more ornate and far more monumental, recalls the proportions and the geometric simplicity of the Ravennate churches (compare figs. 269, 283). Upon entering the atrium, we are confronted by the severely handsome façade, with its deeply recessed arcades; just beyond it are two bell

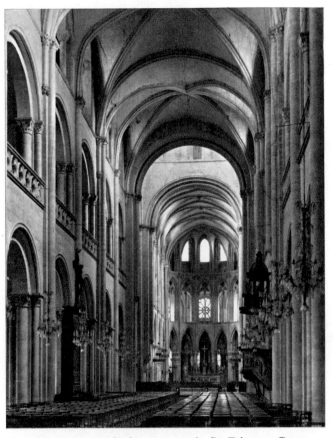

358. Nave (vaulted c. 1115–20), St.-Etienne, Caen

towers, separate structures just touching the outer walls of the church. We had seen a round tower of this kind—probably the earliest surviving example, of the ninth or tenth century—on the north side of S. Apollinare in Classe (fig. 269); most of its successors are square, but the tradition of the free-standing bell tower, or campanile, remained so strong in Italy that they hardly ever became an integral part of the church proper. The nave of S. Ambrogio, low and broad (it is some ten feet wider than that at Durham), consists of four square bays separated by strong transverse arches. There is no transept, but the easternmost nave bay carries an octagonal, domed crossing tower or lantern. This was an afterthought, and we can easily see why, for the nave has no clerestory and the windows of the lantern provide badly needed illumination. As at Durham or Caen, there is an alternating system of nave piers, since the length of each nave bay equals that of two aisle bays; the latter are groin-vaulted, like the first three of the nave bays, and support galleries. The nave vaults, however, differ significantly from their northern counterparts. Constructed of brick and rubble, in a technique reminiscent of Roman groined vaults such as those in the Basilica of Constantine, they are a good deal heavier; the diagonal ribs, moreover, form true half-circles (at Durham and Caen, they are flattened), so that the vaults rise to a point considerably above the transverse arches. This produces a domed effect and gives each

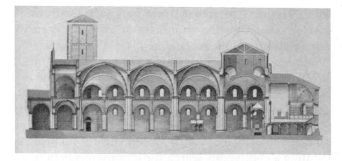

361. Longitudinal Section of S. Ambrogio, Milan

359. S. Ambrogio, Milan.
Late 11th and 12th centuries

bay the appearance of a separate entity, apart from further increasing the weight of the vault. On a smaller scale, the Milanese architect might have attempted a clerestory instead of galleries; but the span of the nave was determined by the width of the tenth-century apse, and he shared with his patrons a taste for ample interior proportions like those of Early Christian basilicas (compare colorplate 22) instead of striving for height and light as his Norman contemporaries did. Under these circumstances, he saw no reason to take risks by experimenting with more economical shapes and lighter construction, so that the ribbed groined vault in Lombardy remained conservative and never approached the proto-Gothic stage.

360. Interior, S. Ambrogio, Milan

German Romanesque architecture, centered in the Rhineland, was equally conservative, although its conservatism reflects the persistence of Carolingian-Ottonian rather than earlier traditions. Its finest achievement, the Imperial Cathedral of Speyer, begun about 1030, but not completed until more than a hundred years later, has a westwork (now sheathed by a modern reconstruction) and an equally monumental grouping of crossing tower and paired stair towers at the eastern end (fig. 362). The architectural detail derives from Lombardy, long a focus of German imperial ambitions (compare S. Ambrogio), but the tall proportions are northern, and the scale is so vast as to dwarf every other church of the period. The nave, one-third taller and wider than that of Đurham, has a generous clerestory, since it was planned for a wooden roof; in the early twelfth century, it was divided into square bays and covered with heavy, unribbed groined vaults akin to the Lombard rather than the Norman type.

The impressive eastern end of Speyer Cathedral is echoed in a number of churches of the Rhine Valley and the Low Countries. In the Cathedral of Tournai (fig. 363), it occurs twice, at either end of the transept—the most memorable massing of towers anywhere in Romanesque architecture. Originally, there were to have been four more: two at the west façade (later reduced to turrets) and two flanking the eastern apse (replaced by a huge Gothic choir). Such multiple towers had been firmly established in medieval church design north of the Alps

362. Speyer Cathedral
(from the east). Begun 1030

363. Tournai Cathedral.
Nave 1110–71,
transept and crossing c. 1165–1213

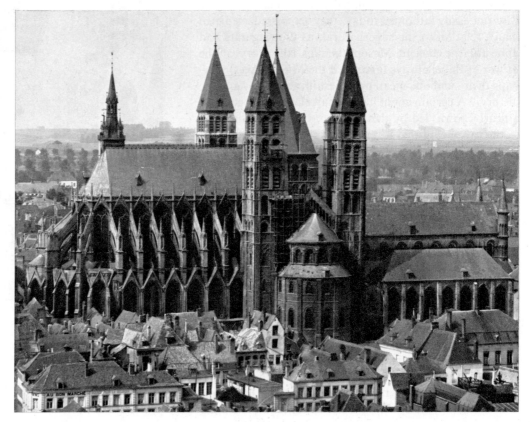

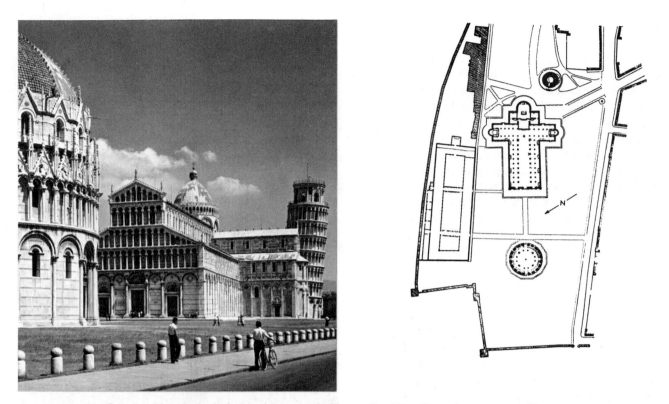

364, 365. Pisa Cathedral, Baptistery, and Campanile. View from the west, and Plan. 1053–1272

since the time of Charlemagne (see St.-Riquier, fig. 334), although few complete sets were ever finished and even fewer have survived. Whatever their practical functions (as stair towers, bell towers, or watchtowers), their popularity can hardly be accounted for on this basis. In a way not easily fathomed today, they expressed medieval man's relation to the supernatural, as the ziggurats had done for the ancient Mesopotamians (the story of the Tower of Babel always fascinated the Middle Ages). Perhaps their symbolic meaning is best illustrated by a "case history." A certain count had a quarrel with the people of a nearby town, led by their bishop. He finally laid siege to the town, captured it, and, to express his triumph and humiliate his enemies, he lopped the top off their cathedral tower. Evidently, loss of tower meant loss of face, towers being architectural symbols of strength, power, and authority.

TUSCANY

The most famous tower of all, however, owes its renown to an accident. It is the Leaning Tower of Pisa (or, more precisely, the campanile of Pisa Cathedral), which began to assume its present angle, because of poor foundations, even before completion (figs. 364, 365; note that its axis is slightly bent). The tower forms part of a magnificent ensemble on an open site north of the city that includes the Cathdral and the circular, domed Baptistery to the west of it. They represent the most ambitious monument of the Tuscan Romanesque, reflecting

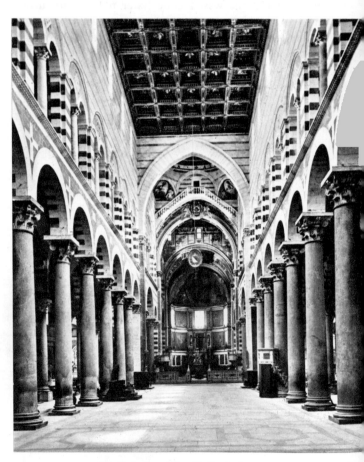

366. Interior, Pisa Cathedral

the wealth and pride of the city republic of Pisa. Far more than Lombardy, with its strong northward connections, Tuscany retained an awareness of its classical heritage throughout the Middle Ages. The plan of Pisa Cathedral is essentially that of an Early Christian basilica, elaborated into a Latin cross by the addition of two transept arms that resemble smaller basilicas in themselves, with apses of their own; the crossing is marked by a dome but the rest of the church is wooden-roofed except for the aisles (four in the nave, two in the transept arms), which have groined vaults. The interior (fig. 366) has somewhat taller proportions than an Early Christian basilica, because there are galleries over the aisles, as well as a clerestory, yet the splendid files of classical columns supporting the nave and aisle arcades inevitably recall such Roman structures as St. Paul Outside the Walls (see fig. 266). Pisa Cathedral and its companions are sheathed entirely in white marble inlaid with horizontal stripes and ornamental patterns in dark green marble. This practice, familiar from Imperial Roman times, survived (or was revived) only in central Italy during the Middle Ages. On the exteriors, it is combined with blind arcades and galleries, producing a lacelike richness of texture and color very different from the austerely simple Early Christian exteriors. But then the time had long passed when it

might be thought undesirable for a church to compete with the outward splendor of classical temples.

In Florence, which was to outstrip Pisa commercially and artistically, the greatest achievement of the Tuscan Romanesque is the Baptistery (fig. 367) opposite the west façade of the Cathedral, a domed octagonal structure of impressive size. Here the marble paneling follows severe geometric lines, and the blind arcades are extraordinarily classical in proportion and detail. The entire building, in fact, exudes so classical an air that the Florentines themselves came to believe, a few hundred years later, that it had originally been a temple of Mars. And even today the controversy over its date has not yet been settled to everyone's satisfaction. We shall have to return to this Baptistery a number of times, since it was destined to play an important role in the Renaissance.

SCULPTURE

The revival of monumental stone sculpture is even more astonishing than the architectural achievements of the Romanesque era, since neither Carolingian nor Ottonian art had shown any tendencies in this direction. Free-standing statues, we will recall, all but disappeared from Western art after the fifth century; stone relief survived only in the form of architectural ornament or surface decoration, with the depth of the carving reduced to a minimum. Thus the only continuous sculptural tradition in early medieval art was that of sculpture-in-miniature: small reliefs, and occcasional statuettes, in metal or ivory. Ottonian art, in works such as the bronze doors of Bishop Bernward (see fig. 346), had enlarged the scale of this tradition but not its spirit; and its truly large-scale sculptural efforts, represented by the impressive *Gero Crucifix* (fig. 341), were limited almost entirely to wood. What little stone carving there was in western Europe before the mid-eleventh century hardly went beyond the artistic and technical level of the Sigvald relief (fig. 329).

SOUTHWESTERN FRANCE

Fifty years later, the situation had changed dramatically. Just when and where the revival of stone sculpture began we cannot say with assurance, but if any one area has a claim to priority it is southwestern France and northern Spain, along the pilgrimage roads leading to Santiago de Compostela. The link with the pilgrimage traffic seems logical enough, for architectural sculpture, especially when applied to the exterior of a church, is meant to appeal to the lay worshiper rather than to the members of a closed monastic community. Like Romanesque architecture, the rapid development of stone sculpture between 1050 and 1100 reflects the growth of religious fervor among the lay population in the decades before the First Crusade. St.-Sernin at Toulouse contains several important examples probably carved about 1090,

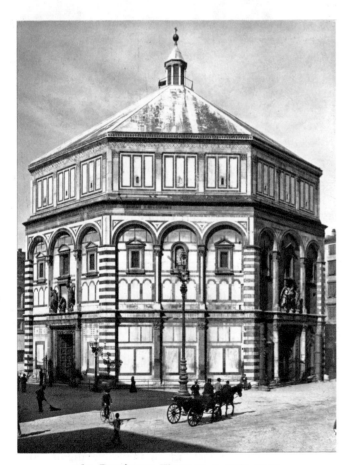

367. Baptistery, Florence. c. 1060–1150

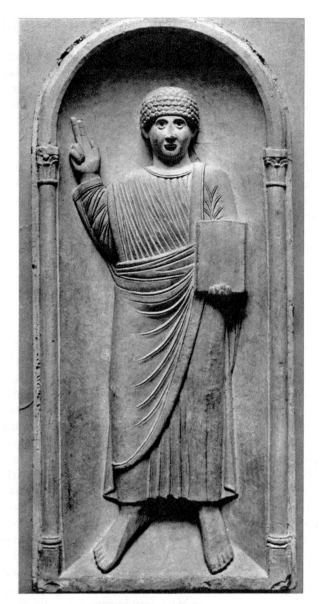

368. *Apostle*, c. 1090.
St.-Sernin, Toulouse

369. South Portal (portion), St.-Pierre,
Moissac. Early 12th century

including the *Apostle* in figure 368. This panel is now in the ambulatory; its original location remains uncertain—perhaps it decorated the front of an altar. Be that as it may, the figure (which is somewhat more than half lifesize), was not intended for viewing at close range only. Its impressive bulk and weight "carry" over a considerable distance. This emphasis on massive volume hints at what may well have been the main impulse behind the revival of large-scale sculpture: a stone-carved image, being tangible and three-dimensional, is far more "real" than a painted one. To the mind of a cleric, steeped in the abstractions of theology, this might seem irrelevant, or even dangerous. St. Bernard of Clairvaux, writing in 1127, denounced the sculptured decoration of churches as a vain folly and diversion that tempts us "to read in the marble rather than in our books." He was a voice not very much heeded, however; for the unsophisticated

layman, any large piece of sculpture inevitably had something of the quality of an idol, and it was this very fact that gave it such great appeal. But let us return to the *Apostle* from St.-Sernin. Where have we seen its like before? The solidity of the forms has a strongly classical air, indicating that our artist must have had a close look at late Roman sculpture (of which there are considerable remains in southern France). The design as a whole, on the other hand—the solemn frontality of the figure, its placement in the architectural frame—derives from a Byzantine source, in all likelihood an ivory panel descended from the *Archangel Michael* in figure 280. Yet in enlarging such a miniature, the carver of our relief has also reinflated it: the niche is a real cavity, the hair a round, close-fitting cap, the body severe and blocklike. Our *Apostle* has, in fact, much the same dignity and directness as the sculpture of Archaic Greece.

Another important early center of Romanesque sculpture was the abbey at Moissac, some distance north of Toulouse. The south portal of its church, carved a generation later than the *Apostle* from St.-Sernin, displays a richness of invention that would have made St. Bernard wince. In figure 369 we see the magnificent *trumeau* (the center post supporting the lintel) and the western jamb. Both have a scalloped profile—apparently a bit of Moorish influence (see fig. 312)—and the shafts of the half-columns applied to jambs and *trumeau* follow this scalloped pattern as if they had been squeezed from a giant pastry tube. Human and animal forms are treated with the same incredible flexibility, so that the spidery Prophet on the side of the *trumeau* seems perfectly adapted to his precarious perch (notice how he, too, has been fitted into the scalloped outline). He even remains free to cross his legs in a dancelike movement and to turn his head toward the interior of the church as he unfurls his scroll. But

what of the crossed lions that form a symmetrical zigzag on the face of the *trumeau*—do they have a meaning? So far as we know, they simply "animate" the shaft as the interlacing beasts of Irish miniatures (whose descendants they are) animate the compartments assigned to them. In manuscript illumination, this tradition had never died out; our sculptor has undoubtedly been influenced by it, just as the agitated movement of the Prophet has its ultimate origin in miniature painting (see fig. 379). The crossed lions, however, reflect another source as well; we find them in Persian metalwork (although not in this tower-like formation), whence they can be traced back to the confronted animals of ancient Near Eastern art (see figs. 85, 120). Yet we cannot fully account for their presence at Moissac in terms of their effectiveness as ornament. They belong to a vast family of savage or monstrous creatures in Romanesque art that retain their demoniacal vitality even though they are compelled—like our lions—to perform a supporting function. (Similar examples may be seen in figs. 370 and 374.) Their purpose is thus not merely decorative but expressive; they embody dark forces that have been domesticated into guardian figures or banished to a position that holds them fixed for all eternity, however much they may snarl in protest.

The portal proper at Moissac is preceded by a deep porch, with lavishly sculptured sides. On the east flank (fig. 370) we see, within the arcade, the *Annunciation* and *Visitation*, as well as the *Adoration of the Magi*. Other

370. East Flank, South Portal, St.-Pierre, Moissac
(the Angel of the *Annunciation*, bottom left, is modern)

371. *Last Judgment* (detail), west tympanum,
Autun Cathedral. c. 1130–35

372. *The Mission of the Apostles,* tympanum of the center portal of the narthex, Ste.-Madeleine, Vézelay. 1120–32

373. *Pig-Snouted Ethiopians,* portion of
tympanum, Ste.-Madeleine, Vézelay

events from the early life of Christ are shown on the frieze above. Here we find the same thin limbs, the same eloquent gestures we saw in the Prophet on the *trumeau* (note especially the wonderful play of hands in the *Visitation* and *Annunciation*); only the proportions of the bodies and the size of the figures vary with the architectural context. What matters is the vividness of the narrative, rather than consistency of treatment.

BURGUNDY

The tympanum (the lunette above the lintel) of the main portal of Romanesque churches is usually given over to a composition centered on the Enthroned Christ, most often the Apocalyptic Vision or the Last Judgment, the most awesome scene of Christian art. At Autun Cathedral, the latter subject has been visualized with singular expressive force. Our detail (fig. 371) shows part of the right half of the tympanum, with the weighing of the souls. At the bottom, the dead rise from their graves in fear and trembling; some are already beset by snakes or gripped by huge, clawlike hands. Above, their fate quite literally hangs in the balance, with devils yanking at one end of the scales and angels at the other. The saved souls cling like children to the hem of the angel's garment for protection, while the condemned are seized by grinning devils and cast into the mouth of Hell. These devils betray the same nightmarish imagination we observed in the Romanesque animal world; they are composite creatures, human in general outline but with spidery, bird-

like legs, furry thighs, tails, pointed ears, and enormous, savage mouths. But their violence, unlike that of the animal monsters, is unchecked; they enjoy themselves to the full in their grim occupation. No visitor, having "read in the marble" here (to speak with St. Bernard), could fail to enter the church in a chastened spirit.

Perhaps the most beautiful of all Romanesque tympanums is that of Vézelay, not far from Autun in Burgundy (fig. 372). Its subject, the Mission of the Apostles, had a special meaning for this age of crusades, since it proclaims the duty of every Christian to spread the Gospel to the ends of the earth. From the hands of the majestic ascending Christ we see the rays of the Holy Spirit pouring down upon the apostles, all of them equipped with copies of the Scriptures in token of their mission. The lintel and the compartments around the central group are filled with representatives of the heathen world, a veritable encyclopedia of medieval anthropology which includes all sorts of legendary races (fig. 373). On the archivolt (the arch framing the tympanum) we recognize the signs of the zodiac and the labors appropriate to every month of the year, to indicate that the preaching of the Faith is as unlimited in time as it is in space.

ROMANESQUE CLASSICISM: PROVENCE; ITALY

The portal sculpture at Moissac, Autun, and Vézelay, although varied in style, has many qualities in common: intense expression, unbridled fantasy, and a nervous agility of form that owes more to manuscript illumination and metalwork than to the sculptural tradition of antiquity. The *Apostle* from St.-Sernin, in contrast, had impressed us with its stoutly "Roman" flavor. The influence of classical monuments is particularly strong in the Provence, the coastal region of southeastern France

374. North Jamb, Center Portal, St.-Gilles-du-Gard. Second quarter of 12th century

375. BENEDETTO ANTELAMI. *King David.* c. 1180–90. West façade, Fidenza Cathedral

(which had been part of the Graeco-Roman world far longer than the rest of the country and is full of splendid Roman remains) as well as in Italy. Perhaps for this reason, the Romanesque style persisted longer in these areas than elsewhere. Looking at the center portal of the church at St.-Gilles-du-Gard (fig. 374), one of the great masterpieces of Romanesque art, we are struck immediately by the classical flavor of the architectural frame-

work, with its free-standing columns, meander patterns, and fleshy acanthus ornament. The two large statues, carved almost in the round, have a sense of weight and volume akin to that of the *Apostle* from St.-Sernin, although, being half a century later in date, they also display the richness of detail we have observed in the intervening monuments. They stand on brackets supported by crouching beasts of prey, and these, too, show a Roman massiveness, while the small figures on the base (Cain and Abel) recall the style of Moissac. The two statues at St.-Gilles are akin to the splendid figure of King David from the façade of Fidenza Cathedral in Lombardy (fig. 375), by Benedetto Antelami, the greatest sculptor of Italian Romanesque art. That we should know his name is not surprising in itself—artists' signatures are far from rare in Romanesque times; what makes Antelami exceptional is the fact that his work shows a considerable degree of individuality, so that, for the first time since the ancient Greeks, we can begin to speak (though with some hesitation) of a personal style. And his *David,* too, approaches the ideal of the self-sufficient statue more closely than any medieval work we have seen so far. The *Apostle* from St.-Sernin is one of a series of figures, all of them immutably fixed to their niches, while Antelami's *David* stands physically free and even shows an attempt to recapture the Classical *contrapposto.* To be sure, he would look awkward if placed on a pedestal in isolation; he *demands* the architectural framework for which he was made, but certainly to a far lesser extent than do the two statues at St.-Gilles. Nor is he subject to the group discipline of a series; his only companion

376. RENIER OF HUY. Baptismal Font. 1107–18. Bronze, height 25″. St.-Barthélemy, Liège

377. Lion Monument. 1166. Bronze, length c. 6′. Cathedral Square, Brunswick

is a second niche statue on the other side of the portal. An extraordinary achievement indeed, especially if we consider that not much more than a hundred years separate it from the beginnings of the sculptural revival.

THE MEUSE VALLEY; GERMANY

The emergence of distinct artistic personalities in the twelfth century is a phenomenon that is rarely acknowledged, perhaps because it contravenes the widespread assumption that all medieval art is anonymous. It does not happen very often, of course, but it is no less significant for all that. Antelami is not an isolated case; he cannot even claim to be the earliest. Nor is the revival of individuality confined to Italy. We also find it in one particular region of the north, in the valley of the Meuse River, which runs from northeastern France into Belgium and Holland. This region had been the home of the "Reims style" in Carolingian times (see figs. 339, 340 and colorplate 33), and the same awareness of classical sources pervades its art during the Romanesque period. Here again, then, interestingly enough, the revival of individuality is linked with the influence of ancient art, although this influence did not produce works on a monumental scale. "Mosan" Romanesque sculpture excelled in metalwork, such as the splendid baptismal font of 1107–1118 in Liège (fig. 376), which is also the masterpiece of the earliest among the individually known artists of the region, Renier of Huy. The vessel rests on twelve oxen (symbols of the twelve apostles), like Solomon's basin in the Temple at Jerusalem as described in the Bible. The reliefs make an instructive contrast with those of Bernward's doors (see fig. 346), since they are about the same height. Instead of the rough expressive power of the Ottonian panel, we find here a harmonious balance of design, a subtle control of the sculptured surfaces, and an understanding of organic structure that, in medieval terms, are amazingly classical. The figure seen from the back (beyond the tree on the left in our picture), with its graceful turning movement and Greek-looking drapery, might almost be mistaken for an ancient work.

The one monumental free-standing statue of Romanesque art—perhaps not the only one made, but the only one that has survived—is that of an animal, and in a secular rather than a religious context: the lifesized bronze lion on top of a tall shaft that Duke Henry the Lion of Saxony had placed in front of his palace at Brunswick in 1166 (fig. 377). The wonderfully ferocious beast (which, of course, personifies the Duke, or at least that aspect of his personality which earned him his nickname) reminds us in a curious way of the archaic bronze she-wolf of Rome (see fig. 206). Perhaps the resemblance is not entirely coincidental, since the she-wolf was on public view in Rome at that time and must have had a strong appeal for Romanesque artists. The more immediate relatives of the Brunswick Lion, however, are the countless bronze water ewers in the shape of lions, dragons,

378. Ewer, Mosan. c. 1130. Gilt bronze, height 7¼". Victoria & Albert Museum, London (Crown Copyright Reserved)

griffins, and such, that came into use in the twelfth century for the ritual washing of the priest's hands during Mass. These vessels—another instance of monsters doing menial service for the Lord—were of Near Eastern inspiration. The beguiling specimen reproduced in figure 378 still betrays its descent from the winged beasts of Persian art, transmitted to the West through trade with the Islamic world.

PAINTING

Unlike architecture and sculpture, Romanesque painting shows no sudden revolutionary developments that set it apart immediately from Carolingian or Ottonian. Nor does it look more "Roman" than Carolingian or Ottonian painting. This does not mean, however, that in the eleventh and twelfth centuries painting was any less important than it had been during the earlier Middle Ages; it merely emphasizes the greater continuity of the pictorial tradition, especially in manuscript illumination.

FRANCE

Nevertheless, soon after the year 1000 occur the beginnings of a painting style which corresponds to—and often anticipates—the monumental qualities of Romanesque sculpture. The new attitude is clearly evident in the *St. Mark* (fig. 379), from a Gospel Book probably done toward 1050 at the monastery of Corbie in northern France. The twisting and turning movement of the lines, which pervades not only the figure of the Evangelist but the

winged lion, the scroll, and the curtain, recalls Carolingian miniatures of the Reims School such as the *Ebbo Gospels* (see fig. 339), but this very resemblance helps to make us aware of the differences between the two works: in the Corbie manuscript, every trace of classical illusionism has disappeared; the fluid modeling of the Reims School, with its suggestion of light and space, has been replaced by firmly drawn contours filled in with bright, solid colors, so that the three-dimensional aspects of the picture are reduced to an overlapping of flat planes. Even Ottonian painting (see colorplate 34) seems oddly illusionistic in comparison. Yet by sacrificing the last remnants of modeling in terms of light and shade, the Romanesque artist has endowed his work with an abstract clarity and precision that had not been possible in Carolingian or Ottonian times; only now can we truly say that the representational, the symbolic, and the decorative elements of the design are knit together into a single, unified structure.

This style of rhythmic lines and planes eschews all effects that might be termed specifically pictorial—not only tonal values but the rendering of textures and highlights such as we still find in Ottonian painting, and because of this it gains a new universality of scale. The evangelists of the *Ebbo Gospels,* the drawings of the *Utrecht Psalter,* the miniatures in the *Gospel Book of Otto III* are made up of open, spontaneous flicks and dashes of brush or pen that have an intimate, handwritten flavor; they would look strange if copied on a larger scale or in another medium. The Corbie miniature, on the contrary, might be translated into a mural, a stained-glass window, a tapestry, or a relief panel without losing any of its essential qualities. We can see this if we compare it with the Vézelay tympanum (fig. 372),

379. *St. Mark,* from a Gospel Book produced at Corbie. c. 1025–50. Municipal Library, Amiens

380. *The Battle of Hastings,* detail of the *Bayeux Tapestry.* c. 1073–83. Wool embroidery on linen, height 20″. Town Hall, Bayeux

381. *The Building of the Tower of Babel* (detail of painting on the nave vault).
Early 12th century. St.-Savin-sur-Gartempe

where much the same pleated drapery patterns are rendered in sculptural terms; or with the so-called Bayeux Tapestry, an embroidered frieze 230 feet long illustrating William the Conqueror's invasion of England. In our detail (fig. 380), which shows the Battle of Hastings, the kinship to the style of the Corbie manuscript even extends to the somersaults of the falling horses, so strikingly like the pose of the lion in the miniature. Again we marvel at the ease with which the designer has integrated narrative and ornament: the main scene is enclosed by two border strips that perform their framing function equally well, although the upper one is purely decorative while the other consists of dead warriors and horses and thus forms part of the story.

Firm outlines and a strong sense of pattern are equally characteristic of Romanesque wall painting. *The Building of the Tower of Babel* (fig. 381) is taken from the most impressive surviving cycle, on the nave vault of the church at St.-Savin-sur-Gartempe (compare fig. 352). It is an intensely dramatic design, crowded with strenuous action; the Lord Himself, on the far left, participates directly in the narrative as He addresses the builders of the colossal structure. He is counterbalanced, on the right, by the giant Nimrod, the leader of the enterprise, who frantically hands blocks of stone to the masons atop the tower, so that the entire scene becomes a great test of strength between God and Man. The heavy dark contours, the emphatic play of gestures, make the composition eminently readable from a distance, yet these same qualities occur in the illuminated manuscripts of the region, which can be equally monumental despite their small scale.

THE CHANNEL REGION

While Romanesque painting, like architecture and sculpture, developed a wide variety of regional styles throughout western Europe, its greatest achievements emerged from the monastic scriptoria of northern France, Belgium, and southern England. The works produced in this area are so closely related in style that it is at times impossible to be sure on which side of the English Channel a given manuscript belongs. Thus the style of the wonderful miniature of St. John (colorplate 35), has been linked with both Cambrai and Canterbury. Here the abstract linear draughtsmanship of the Corbie manuscript has been enriched by Byzantine influence (note the ropelike loops of drapery, whose origin can be traced back to such works as fig. 280) but without losing its energetic rhythm. It is the precisely controlled dynamics of every contour, both in the main figure and in the frame, that unite the varied elements of the composition into a coherent whole. This quality of line still betrays its ultimate source, the Celtic-Germanic heritage; if we compare our miniature with the *Lindisfarne Gospels* (colorplate 31), we see how much the interlacing patterns of the Dark Ages have contributed to the design of the St. John page. The drapery folds, the clusters of floral ornament have an impulsive yet disciplined aliveness that echoes the intertwined snakelike monsters of the animal style, even though the foliage is derived from the classical acanthus and the human figures are based on Carolingian and Byzantine models. The unity of the entire page, however, is conveyed not only by the forms but by the content as well. The Evangelist "inhabits" the

frame in such a way that we could not remove him from it without cutting off his ink supply (proffered by the donor of the manuscript, Abbot Wedricus), his source of inspiration (the dove of the Holy Spirit in the hand of God), or his identifying symbol, the eagle. The other medallions, less directly linked with the main figure, show scenes from the life of St. John.

Soon after the middle of the twelfth century, an important change of style begins to make itself felt in Romanesque painting on either side of the English Channel. The *Portrait of a Physician* (fig. 382), from a medical manuscript of c. 1160, is surprisingly different from the St. John miniature, although it was produced in the same region. Instead of abstract patterns, we suddenly find lines that have regained the ability to describe three-dimensional shapes; the drapery folds no longer lead an ornamental life of their own but suggest the rounded volume of the body underneath; there is even a renewed interest in foreshortening. Here at last, then, we meet the pictorial counterpart of that classicism which we saw earlier in the Baptismal Font of Renier of Huy at Liège (see fig. 376). In fact, our miniature was probably done at Liège, too, and its sharp, deliberate lines look as if they had been engraved in metal, rather than drawn with pen or brush.

382. *Portrait of a Physician*, from a medical treatise.
c. 1160. British Museum, London

Nicholas of Verdun

That a new painting style should have originated in metalwork is perhaps less strange than it might seem at first glance, for its essential qualities are sculptural rather than pictorial; moreover, metalwork (which includes not only cast or embossed sculpture but also engraving, enameling, and goldsmithing) had been a highly developed art in the Meuse valley area since Carolingian times. Its greatest practitioner after Renier of Huy was Nicholas of Verdun, in whose work the classicizing, three-dimensional style of draughtsmanship reaches full maturity. The engraved and enameled plaques of the Klosterneuburg altar, which he completed in 1181 (fig. 383 shows one of them, *The Crossing of the Red Sea*), clearly belong to the same tradition as the Liège miniature, but the figures, clothed in rippling, "wet" draperies familiar to us from countless classical statues, have achieved so high a degree of organic body structure and freedom of movement that we tend to think of them as harbingers of Gothic art rather than as the final phase of the Romanesque. Whatever we choose to call it, the style of the Klosterneuburg altar was to have a profound impact upon both painting and sculpture during the next fifty years (see figs. 420, 421).

The astonishing humanity of Nicholas of Verdun's art must be understood against the background of a general reawakening of interest in man and the natural world throughout northwestern Europe. This attitude could express itself in various ways: as a new regard for classi-

383. NICHOLAS OF VERDUN. *The Crossing of the Red Sea.*
1181. Enamel on gold plaque, height 5 1/2".
Klosterneuburg Abbey, Austria

cal literature and mythology, an appreciation of the beauty of ancient works of art, or simply as a greater readiness to acknowledge the enjoyment of sensuous experience. The latter aspect is reflected particularly in such lighthearted poetry as the well-known *Carmina Burana,* composed during the later twelfth century and preserved in an illuminated manuscript of the early thirteenth. That a collection of verse devoted largely—and at times all too frankly—to the delights of nature, love, and drinking should have been embellished with illustrations is significant in itself. We are even more surprised, however, to find that one of the miniatures (colorplate 36), coupled with a poem praising spring, represents a landscape—the first, so far as we know, in Western art since late classical times. Echoes of ancient landscape painting, derived from Early Christian and Byzantine sources, can be found in Carolingian art (see figs. 339, 340), but only as a background subordinated to the human figure. Later on, these remnants had been reduced still further, even when the subject required a

landscape setting; the Garden of Eden on Bernward's doors (fig. 346) consists of nothing but a few strangely twisted stems and bits of foliage. Thus the *Carmina Burana* illustrator, called upon to depict the life of nature in springtime, must have found his task a rather perplexing one. He has solved it in the only way possible for him—by filling his page with a sort of anthology of Romanesque plant ornament, interspersed with birds and animals. The trees, vines, and flowers remain so abstract that we cannot identify a single species (the birds and animals, probably copied from a zoological treatise, are far more realistic), yet they have an uncanny vitality of their own that makes them seem to sprout and unfold as if the growth of an entire season were compressed into a few frantic moments. These giant seedlings convey the exuberance of spring, of stored energy suddenly released, far more intensely than any normal vegetation could. Our artist has created a fairytale landscape, but his enchanted world nevertheless evokes essential aspects of reality.

4

GOTHIC ART

Time and space, we have been taught, are interdependent. Yet we tend to think of history as the unfolding of events in time without sufficient awareness of their unfolding in space—we visualize it as a stack of chronological layers, or periods, each layer having a specific depth that corresponds to its duration. For the more remote past, where our sources of information are scanty, this simple image works reasonably well. It becomes less and less adequate as we draw closer to the present and our knowledge grows more precise. Thus we cannot define the Gothic era in terms of time alone; we must consider the changing surface area of the layer as well as its depth.

At the start, about 1150, this area was small indeed. It embraced only the province known as the Île-de-France (that is, Paris and vicinity), the royal domain of the French kings. A hundred years later, most of Europe had "gone Gothic," from Sicily to Iceland, with only a few Romanesque pockets left here and there; through the Crusaders, the new style had even been introduced to the Near East. About 1450, the Gothic area had begun to shrink—it no longer included Italy—and about 1550 it had disappeared almost entirely. The Gothic layer, then, has a rather complicated shape, its depth varying from close to 400 years in some places to a minimum of 150 in others. This shape, moreover, does not emerge with equal clarity in all the visual arts. The term Gothic was coined for architecture, and it is in architecture that the characteristics of the style are most easily recognized. Only during the past hundred years have we become accustomed to speak of Gothic sculpture and painting. There is, as we shall see, some uncertainty even today about the exact limits of the Gothic style in these fields. This evolution of our concept of Gothic art suggests the way the new style actually grew: it began with architecture, and for about a century—from c. 1150 to 1250, during the Age of the Great Cathedrals—architecture retained its dominant role. Gothic sculpture, at first severely architectural in spirit, tended to become less and less so after 1200; its greatest achievements are between the years 1220 and 1420. Painting, in turn, reached a climax of creative endeavor between 1300 and 1350 in central Italy. North of the Alps, it became the leading art from about 1400 on. We thus find, in surveying the Gothic era as a whole, a gradual shift of emphasis from architecture to painting or, better perhaps, from architectural to pictorial qualities (characteristically enough, Early Gothic sculpture and painting both reflect the discipline of their monumental setting, while Late Gothic architecture and sculpture strive for "picturesque" effects rather than clarity or firmness). Overlaying this broad pattern there is another one; international diffusion as against regional independence. Starting as a local development in the Île-de-France, Gothic art radiates from there to the rest of France and to all Europe, where it comes to be known as *opus modernum* or *francigenum* (modern or French work). In the course of the thirteenth century, the new style gradually loses its "imported" flavor; regional variety begins to reassert itself. Toward the middle of the fourteenth century, we notice a growing tendency for these regional achievements to influence each other until, about 1400, a surprisingly homogeneous "International Gothic" style prevails almost everywhere. Shortly thereafter, this unity breaks apart: Italy, with Florence in the lead, creates a radically new art, that of the Early Renaissance, while north of the Alps, Flanders assumes an equally commanding position in the development of Late Gothic painting and sculpture. A century later, finally, the Italian Renaissance becomes the basis of another international style. With this skeleton outline to guide us, we can now explore the unfolding of Gothic art in greater detail.

ARCHITECTURE

FRANCE: ST.-DENIS

We can pinpoint the origin of no previous style as exactly as that of Gothic. It was born between 1137 and 1144 in the rebuilding, by Abbot Suger, of the royal Abbey Church of St.-Denis just outside the city of Paris. If we are to understand how Gothic architecture happened to come into being at this particular spot, we must first acquaint ourselves with the special relationship between St.-Denis, Suger, and the French monarchy. The kings of France derived their claim to authority from the Carolingian tradition, although they belonged to the Capetian line (founded by Hugh Capet after the death

monarchy not only on the plane of practical politics but on that of "spiritual politics"; by investing the royal office with religious significance, by glorifying it as the strong right arm of justice, he sought to rally the nation behind the King. His architectural plans for the Abbey of St.-Denis must be understood in this context, for the church, founded in the late eighth century, enjoyed a dual prestige that made it ideally suitable for Suger's purpose: it was the shrine of the Apostle of France, the sacred protector of the realm, as well as the chief memorial of the Carolingian dynasty (both Charlemagne and his father, Pepin, had been consecrated kings there, and it was also the burial place of Charles Martel, Pepin, and Charles the Bald). Suger wanted to make the Abbey the spiritual center of France, a pilgrimage church to outshine the splendor of all the others, the focal point of religious as well as patriotic emotion. But in order to become the visible embodiment of such a goal, the old edifice had to be enlarged and rebuilt. The great Abbot himself has described the entire campaign in such eloquent detail that we know more about what he desired to achieve than we do about the final result, for the west façade and its sculpture are sadly mutilated today, and the choir, which Suger regarded as the most important part of the enterprise, retains its original appearance only in the ambulatory (figs. 384, 385). Looking at the plan, we recognize familiar elements of the Romanesque pilgrimage choir (compare fig. 347), with an arcaded apse surrounded by an ambulatory and radiating chapels. Yet these elements have been integrated in strikingly novel fashion; the chapels, instead of remaining separate entities, are merged so as to form, in effect, a second ambulatory, and ribbed groined vaulting based on the pointed arch is employed throughout (in the Romanesque pilgrimage choir, only the ambulatory had been groin-vaulted). As a result, the entire plan is held together by a new kind of geometric order: it consists of seven identical wedge-shaped units fanning out from the center of the apse. We experience this double ambulatory not as a series of separate compartments but as a continuous (though articulated) space, whose shape is outlined for us by the network of slender arches, ribs, and columns that sustains the vaults. What distinguishes this interior immediately from its predecessors is its lightness, in both senses; the architectural forms seem graceful, almost weightless as against the massive solidity of the Romanesque, and the windows have been enlarged to the point that they are no longer openings cut into a wall—they fill the entire wall area, so that they themselves become translucent walls. If we now examine the plan once more, we realize what makes this abundance of light possible. The outward pressure of the vaults is contained by heavy buttresses jutting out between the chapels (in the plan, they look like stubby black arrows pointing toward the center of the apse). The main weight of the masonry construction is concentrated there, visible only from the outside. No wonder, then, that the interior appears so

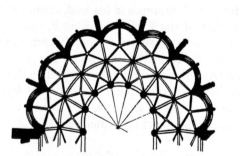

384, 385. Abbey Church of St.-Denis, Paris.
Ambulatory and Plan of Choir (after Gall). 1140–44

of the last Carolingian in 987). But their power was eclipsed by that of the nobles who, in theory, were their vassals; the only area they ruled directly was the Île-de-France, and they often found their authority challenged even there. Not until the early twelfth century did the royal power begin to expand; and Suger, as chief adviser to Louis VI, played a key role in this process. It was he who forged the alliance between the monarchy and the Church, which brought the bishops of France (and the cities under their authority) to the King's side, while the King, in turn, supported the papacy in its struggle against the German emperors. Suger, however, championed the

amazingly airy and weightless, since the heaviest members of the structural skeleton are beyond our view. The same impression would be even more striking if we could see Suger's choir in its entirety, for the upper part of the apse, rising above the double ambulatory, had very large, tall windows (the effect, from the nave, must have been similar to that of the somewhat later choir of Notre-Dame in Paris; see fig. 386).

In describing Suger's choir, we have also described the essentials of Gothic architecture. Yet none of the individual elements that entered into its design is really new; the pilgrimage choir plan, the pointed arch, the ribbed groined vault, are familiar to us from the various regional schools of the French (and Anglo-Norman) Romanesque, even though we never encounter them all combined in the same building until St.-Denis. The Île-de-France had failed to develop a Romanesque tradition of its own, so that Suger—as he himself tells us—had to bring together artisans from many different regions for his project. We must not conclude from this, however, that Gothic architecture originated as a mere synthesis of Romanesque traits. If it were no more than that, we would be hard pressed to explain the new spirit that strikes us so forcibly at St.-Denis: the emphasis on strict geometric planning and the quest for luminosity. Suger's account of the rebuilding of his church insistently stresses both of these as the highest values achieved in the new structure. "Harmony" (that is, the perfect relationship among parts in terms of mathematical proportions or ratios) is the source of all beauty, since it exemplifies the laws according to which divine reason has constructed the universe; the "miraculous" light flooding the choir through the "most sacred" windows becomes the Light Divine, a mystic revelation of the spirit of God.

This symbolic interpretation of light and of numerical harmony had been established for centuries in Christian thought. It derived from the writings of a fifth-century Greek theologian who, in the Middle Ages, was believed to have been Dionysius the Areopagite, an Athenian disciple of St. Paul. Through this identification, the works of this Pseudo-Dionysius came to be vested with great authority. In Carolingian France, however, Dionysius the disciple of St. Paul was identified both with the author of the Pseudo-Dionysian writings and with St. Denis, the Apostle of France and special protector of the realm. The revival of monarchic power during the early twelfth century gave new importance to the theology of the Pseudo-Dionysius, attributed to St. Denis and therefore regarded as France's very own. For Suger, the light-and-number symbolism of Dionysian thought must thus have had a particularly strong appeal. We can well understand why his own mind was steeped in it, and why he wanted to give it visible expression when he rebuilt the church of the royal patron saint. That he succeeded is proved not only by the inherent qualities of his choir design but also by its extraordinary impact; every visitor to St.-Denis, it seems, was overwhelmed by

Suger's achievement, and within a few decades the new style had spread far beyond the confines of the Île-de-France.

The how and why of his success are a good deal more difficult to explain. Here we encounter a controversy we have met several times before—that of form versus function. To the advocates of the functionalist approach, Gothic architecture has seemed the result of advances in architectural engineering, which made it possible to build more efficient vaults, to concentrate their thrust at a few critical points, and thus eliminate the solid walls of the Romanesque. Suger, they would argue, was fortunate in securing the services of an architect who evidently understood the principles of ribbed groined vaulting better than anybody else at that time. If the Abbot chose to interpret the resulting structure as symbolic of Dionysian theology, he was simply expressing his enthusiasm over it in the abstract language of the churchman; his account does not help us to understand the origin of the new style. It is perfectly true, of course, that the choir of St.-Denis is more rationally planned and constructed than any Romanesque church. The pointed arch (which can be "stretched" to reach any desired height regardless of the width of its base) has now become an integral part of the ribbed groined vault. As a result, these vaults are no longer restricted to square or near-square compartments; they have gained a flexibility that permits them to cover areas of almost any shape (such as the trapezoids and pentagons of the ambulatory). The buttressing of the vaults, too, is more fully understood than before. How could the theological ideas of Suger have led to these technical advances, unless we are willing to assume that he was a professionally trained architect? If we grant that he was not, can he claim any credit at all for the style of what he so proudly calls "his" new church? Perhaps the question poses a false alternative, somewhat like the conundrum of the chicken and the egg. The function of a church, after all, is not merely to enclose a maximum of space with a minimum of material; for the master who built the choir of St.-Denis under Suger's supervision, the technical problems of vaulting must have been inextricably bound up with considerations of form (that is, of beauty, harmony, fitness, etc.). As a matter of fact, his design includes various elements that *express* function without actually performing it, such as the slender shafts (called "responds") that seem to carry the weight of the vaults to the church floor. But in order to know what constituted beauty, harmony, and fitness, the medieval architect needed the guidance of ecclesiastical authority. Such guidance might be a simple directive to follow some established model or, in the case of a patron as actively concerned with architectural aesthetics as Suger, it might amount to full participation in the designing process. Thus Suger's desire to "build Dionysian theology" is likely to have been a decisive factor from the very beginning; it shaped his mental image of the kind of structure he wanted, we may assume, and determined

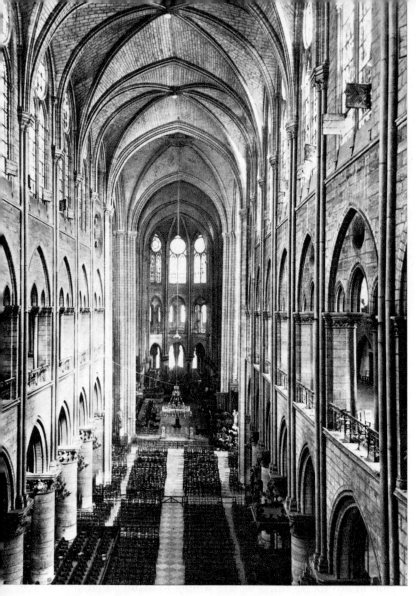

386. Nave and Choir, Notre-Dame, Paris. 1163–c. 1200

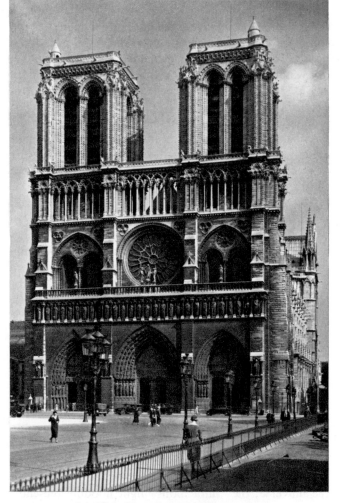

387. West Façade, Notre-Dame, Paris

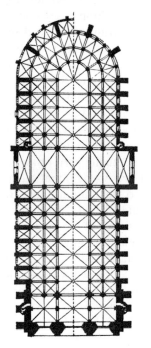

388. Plan of Notre-Dame, Paris. 1163–c. 1250

his choice of a master of Norman background as the chief architect. This man, a great artist, must have been singularly responsive to the Abbot's ideas and instructions. Between them, the two together created the Gothic style.

Paris

Although St.-Denis was an abbey, the future of Gothic architecture lay in the towns rather than in rural monastic communities. There had been a vigorous revival of urban life, we will recall, since the early eleventh century; this movement continued at an accelerated pace, and the growing weight of the cities made itself felt not only economically and politically but in countless other ways as well: bishops and the city clergy rose to new importance; cathedral schools and universities took the place of monasteries as centers of learning, while the artistic efforts of the age culminated in the great cathedrals. That of Notre-Dame ("Our Lady," the Virgin Mary) at Paris, begun in 1163, reflects the salient features of Suger's St.-Denis more directly than any other. The plan (fig. 387),

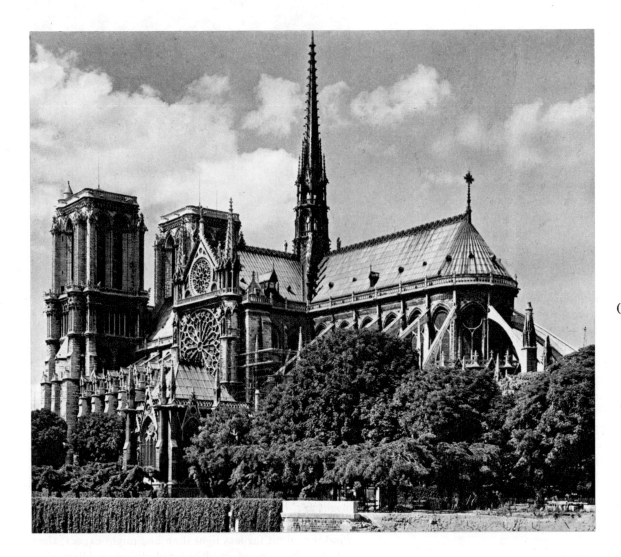

389. Notre-Dame
(view from the southeast),
Paris

with its emphasis on the longitudinal axis, is extraordinarily compact and unified as against that of major Romanesque churches; the double ambulatory of the choir continues directly into the aisles, and the stubby transept barely exceeds the width of the façade. In the interior (fig. 386) we still find echoes of the Norman Romanesque: sexpartite nave vaults over squarish bays, and galleries above the inner aisles. The columns of the nave arcade are another conservative feature. Yet the large clerestory windows, the lightness and slenderness of the forms, create an unmistakably Gothic effect (note how thin the nave walls are made to seem). Gothic, too, is the "verticalism" of the interior space. This depends less on the actual proportions of the nave—for some Romanesque naves are equally tall, relative to their width—than on the constant accenting of the verticals and on the soaring ease with which the sense of height is attained. Romanesque interiors (such as fig. 350), by contrast, emphasize the great effort required in supporting the weight of the vaults.

In Notre-Dame, as in Suger's choir, the buttresses (the "heavy bones" of the structural skeleton) are not visible from the inside. The plan shows them as massive blocks of masonry that stick out from the building like a row of teeth. Above the aisles, these piers turn into flying buttresses—arched bridges that reach upward to the critical spots between the clerestory windows where the outward thrust of the nave vault is concentrated (fig. 389). This method of anchoring vaults, a characteristic feature of Gothic architecture, certainly owed its origin to functional considerations. Even the flying buttress, however, soon became aesthetically important as well, and its shape could express support (apart from actually providing it) in a variety of ways, according to the designer's sense of style.

The most monumental aspect of the exterior of Notre-Dame is the west façade (fig. 388). Except for its sculpture, which suffered heavily during the French Revolution and is for the most part restored, it retains its original appearance. The design reflects the general disposition of the façade of St.-Denis, which in turn had been derived from Norman Romanesque façades such as that of St.-Etienne at Caen (see fig. 354). Comparing the latter with Notre-Dame, we note the persistence of

some basic features: the pier buttresses that reinforce the corners of the towers and divide the façade into three main parts; the placing of the portals; the three-story arrangement. The rich sculptural decoration, however, recalls the façades of the west of France (see fig. 353) and the elaborately carved portals of Burgundy. Much more important than these resemblances, however, are the qualities that distinguish the façade of Notre-Dame from its Romanesque ancestors. Foremost among these is the way all the details have been integrated into a wonderfully balanced and coherent whole; the meaning of Suger's emphasis on harmony, geometric order, and proportion becomes evident here even more strikingly than in St.-Denis itself. This formal discipline also embraces the sculpture, which is no longer permitted the spontaneous (and often uncontrolled) growth so characteristic of the Romanesque but has been assigned a precisely defined role within the architectural framework. At the same time, the cubic solidity of the façade of St.-Etienne at Caen has been transformed into its very opposite; lacelike arcades, huge portals and windows dissolve the continuity of the wall surfaces, so that the total effect approximates that of a weightless openwork screen. How rapidly this tendency advanced during the first half of the thirteenth century can be seen by comparing the west façade of Notre-Dame with the somewhat later façade of the south transept, visible in figure 389. In the former the rose window in the center is still deeply recessed and, as a result, the stone tracery that subdivides the opening is clearly set off against the surrounding wall surface; on the transept façade, in contrast, we can no longer distinguish the rose window from its frame—a single network of tracery covers the entire area.

Chartres; Amiens; Reims

Toward 1145 the Bishop of Chartres, who befriended Abbot Suger and shared his ideas, began to rebuild his cathedral in the new style. Fifty years later, all but the west façade of Chartres Cathedral was destroyed by fire (for the sculpture of the west portals, see figs. 417–18), and a second rebuilding took place between 1194 and 1220. It is the nave of the latter structure that appears in figure 390. Conceived one generation after the nave of Notre-Dame in Paris, it represents the first masterpiece of the mature, or High Gothic, style. The galleries have now been reduced to a narrow passageway within the thickness of the nave wall, screened by a triforium arcade; the openings of the nave arcade are taller and narrower; responds have been added to the columnar supports, so as to stress the continuity of the vertical lines; and the nave vault is no longer sexpartite. Alone among all major Gothic cathedrals, Chartres still retains most of its original stained-glass windows. The magic of its interior space, unforgettable to anyone who has experienced it on the spot, cannot be suggested by black-and-white photographs, which inevitably exaggerate the

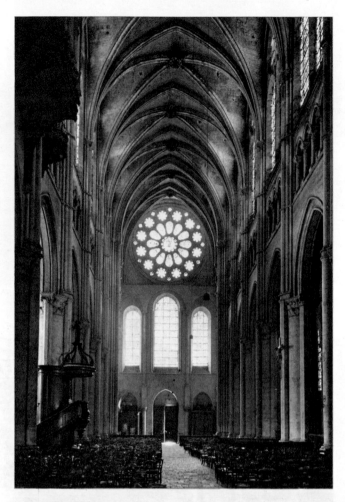

390. Nave toward west, Chartres Cathedral.
1194–1220 (see colorplate 37)

brightness of the windows and thus make them look like "holes" instead of "translucent walls." In reality, the windows admit far less light than one might expect; they act mainly as huge, multicolored diffusing filters that change the *quality* of ordinary daylight, endowing it with the poetic and symbolic values so highly praised by Abbot Suger. Our colorplate 37, which shows the northern nave wall illuminated by sunlight shining through the windows on the south side, conveys something of the wonderfully warm and vibrant effect that prompted Suger to describe his choir as filled with "miraculous" light.

The High Gothic style defined at Chartres reaches its climax a generation later in the interior of Amiens Cathedral (figs. 391–93). Breathtaking height has become the dominant aim, both technically and aesthetically; skeletal construction is carried to its most precarious limits. The inner logic of the system forcefully asserts itself in the shape of the vaults, taut and thin as membranes, and in the expanded window area, which now includes the triforium, so that the entire wall above the nave arcade becomes a clerestory. The same emphasis on verticality and translucency can be traced in the development of the High Gothic façade. The most famous of these, at Reims Cathedral (fig. 394), makes an instructive contrast with the west façade of Notre-Dame in Paris, even

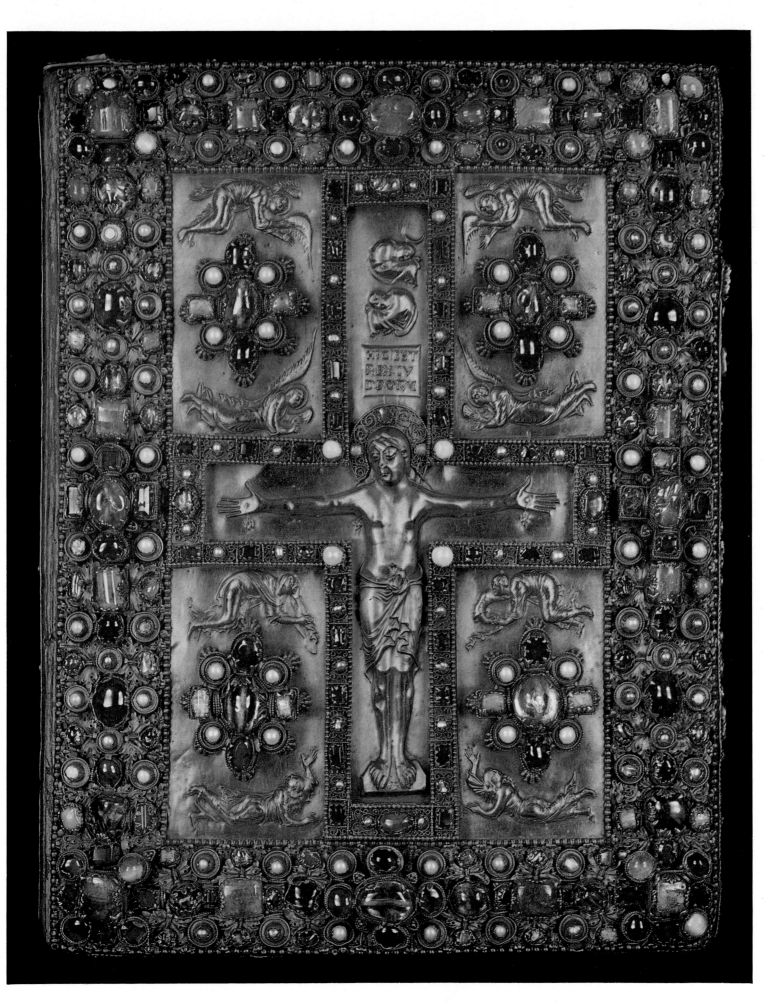

Colorplate 33. CAROLINGIAN. Upper Cover of the Binding of the *Lindau Gospels*. About 870 A.D.
Gold and jewels, 13³/₄ × 10¹/₂″. The Pierpont Morgan Library, New York

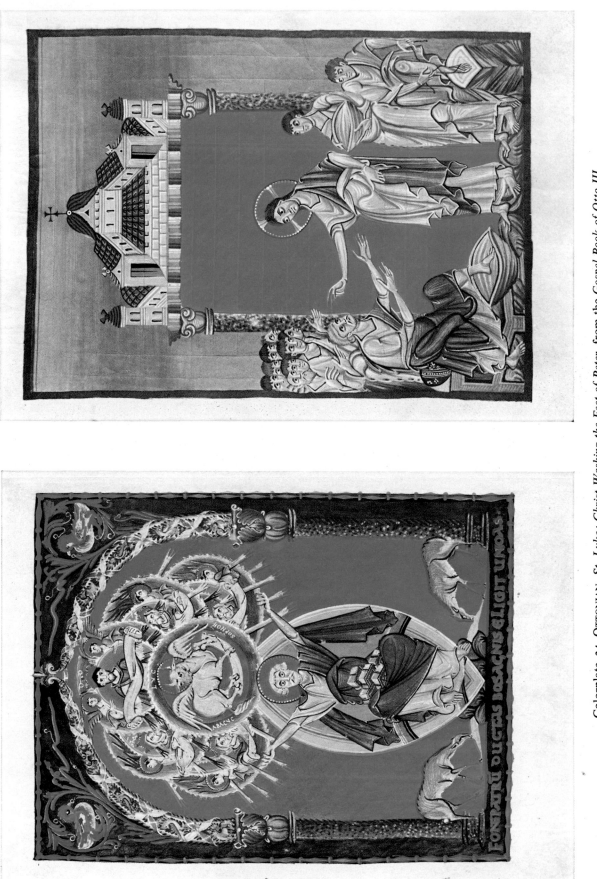

Colorplate 34. OTTONIAN. *St. Luke; Christ Washing the Feet of Peter*, from the *Gospel Book of Otto III*. About 1000. Bavarian State Library, Munich

Colorplate 35. ROMANESQUE. *St. John the Evangelist,*
from the *Gospel Book of Abbot Wedricus.* Shortly before 1147.
Société Archéologique, Avesnes, France

Colorplate 36. ROMANESQUE. Page with *Spring Landscape,*
from a manuscript of *Carmina Burana.* Early 13th century.
Bavarian State Library, Munich

Colorplate 37. GOTHIC. View of the North Clerestory Wall of
the Nave, Chartres Cathedral. 1194–1220

Colorplate 38. DUCCIO. *Christ Entering Jerusalem,* from back of *Maestà Altar.*
1308–11. Panel, 40 1/8 × 21 1/8″. Cathedral Museum, Siena

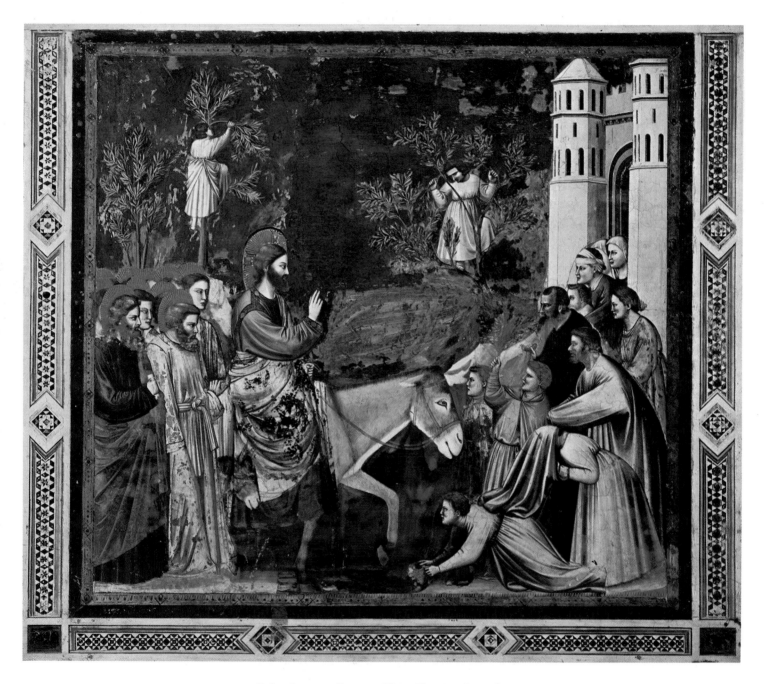

Colorplate 39. Giotto. *Christ Entering Jerusalem.*
1305–6. Fresco. Arena Chapel, Padua

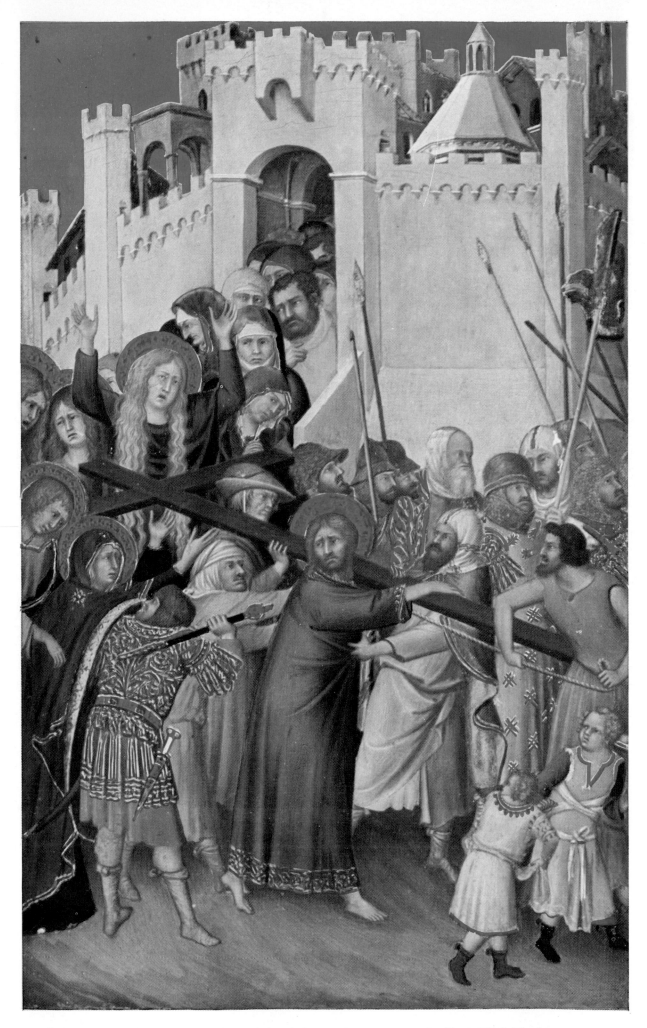

Colorplate 40. SIMONE MARTINI. *The Road to Calvary*. About 1340. Panel, 9⁷/₈ × 6¹/₈″. The Louvre, Paris

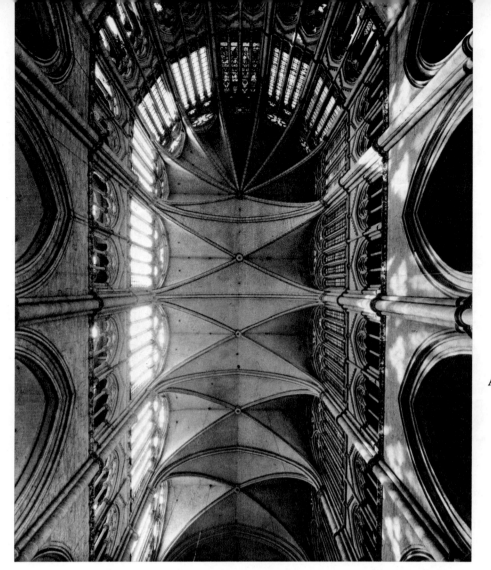

391. Choir Vault,
Amiens Cathedral. Begun 1220

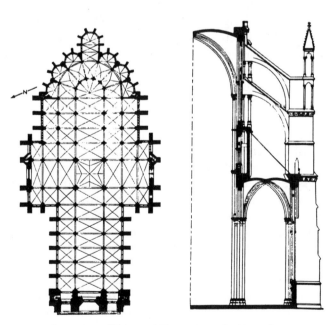

392, 393. Plan and Transverse Section of
Amiens Cathedral

though its basic design was conceived only about thirty years later. Many of the same elements are common to both (as the Coronation Cathedral of the kings of France, Reims was closely linked to Paris), but in the younger structure they have been reshaped into a very different ensemble. The portals, instead of being recessed, are projected forward as gabled porches, with windows in place of tympanums above the doorways; the gallery of royal statues, which in Paris forms an incisive horizontal between the first and second stories, has been raised until it merges with the third-story arcade; every detail except the rose window has become taller and narrower than before; and a multitude of pinnacles further accentuates the restless upward-pointing movement. The sculptural decoration, by far the most lavish of its kind (see pages 310–12), is no longer kept in clearly marked-off zones; it has now spread to so many hitherto unaccustomed perches, not only on the façade but on the flanks as well, that the exterior of the cathedral begins to look like a dovecote for statues.

Later Churches

The High Gothic cathedrals of France represent a concentrated expenditure of effort such as the world has

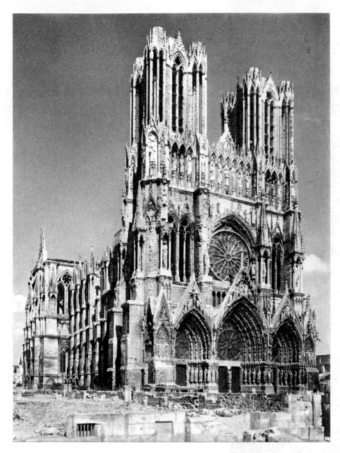

394. West Façade, Reims Cathedral. c. 1225–99

rarely seen before or since. They are truly national monuments, whose immense cost was borne by donations collected all over the country and from all classes of society—the tangible expression of that merging of religious and patriotic fervor which had been the goal of Abbot Suger. As we approach the second half of the thirteenth century, we sense that this wave of enthusiasm has passed its crest: work on the vast structures begun during the first half now proceeds at a slacker pace; new projects are fewer and generally on a far less ambitious scale; and the highly organized teams of masons and sculptors that had developed at the sites of the great cathedrals during the preceding decades gradually break up into smaller units. A characteristic church of the later years of the century, St.-Urbain in Troyes (figs. 395, 396), leaves no doubt that the "heroic age" of the Gothic style is past. Refinement of detail, rather than towering monumentality, has been the designer's chief concern; by eliminating the triforium and simplifying the plan, he has created a delicate cage of glass (in the choir, the windows begin ten feet above the floor), sustained by flying buttresses so thin as to be hardly noticeable. The same spiny, attenuated elegance can be felt in the architectural ornament. In some respects, St.-Urbain is prophetic of the Late, or Flamboyant, phase of Gothic architecture. The beginnings of Flamboyant Gothic do indeed seem to go back to the late thirteenth century, but its growth was delayed by the Hundred Years' War with England, so that we do not meet full-fledged examples of it until the early fifteenth. Its name, which means flamelike, refers to the undu-

lating patterns of curve and countercurve that are a prevalent feature of Late Gothic tracery, as at St.-Maclou in Rouen (fig. 397). Structurally, Flamboyant Gothic shows no significant developments of its own; what distinguishes St.-Maclou from such churches as St.-Urbain in Troyes is the luxuriant profusion of ornament. The architect has turned into a virtuoso who overlays the structural skeleton with a web of decoration so dense and fanciful as to obscure it almost completely. It becomes a fascinating game of hide-and-seek to locate the "bones" of the building within this picturesque tangle of lines.

Secular Architecture

Since our account of medieval architecture is mainly concerned with the development of style, we have until now confined our attention to religious structures, the most ambitious as well as the most representative efforts of the age. Secular building, to be sure, reflects the same general trends, but these are often obscured by the diversity of types, ranging from bridges and fortifications to royal palaces, from barns to town halls. Moreover, social, economic, and practical factors play a more important part here than in church design, so that the useful life of the buildings is apt to be much briefer and their chance of preservation correspondingly less. (Fortifications, indeed, are often made obsolete by even minor advances in the technology of warfare.) As a consequence, our knowledge of secular structures of the pre-Gothic Middle Ages remains extremely fragmentary, and most of the surviving examples from Gothic times belong to the latter half of the period. This fact, however, is not without significance; nonreligious architecture, both private and public, became far more elaborate during the fourteenth and fifteenth centuries than it had been before. The history of the Louvre in Paris provides a telling example: the original building, erected about 1200, followed the severely functional plan of the castles of that time—it consisted mainly of a stout tower, the donjon or keep, surrounded by a heavy wall. In the 1360s, King Charles V had it rebuilt as a sumptuous royal residence. Although this second Louvre, too, has now disappeared we know what it looked like from a fine miniature painted in the early fifteenth century (see colorplate 44). There is still a defensive outer wall, but the great structure behind it has far more the character of a palace than of a fortress. Symmetrically laid out around a square court, it provided comfortable quarters for the royal family and household (note the countless chimneys) as well as lavishly decorated halls for state occasions. (Fig. 460, another miniature from the same manuscript, conveys a good impression of such a hall.)

If the exterior of the second Louvre still has some of the forbidding qualities of a stronghold, the sides toward the court displayed a wealth of architectural ornament and sculpture. The same contrast appears in the house of Jacques Cœur in Bourges, dating from the

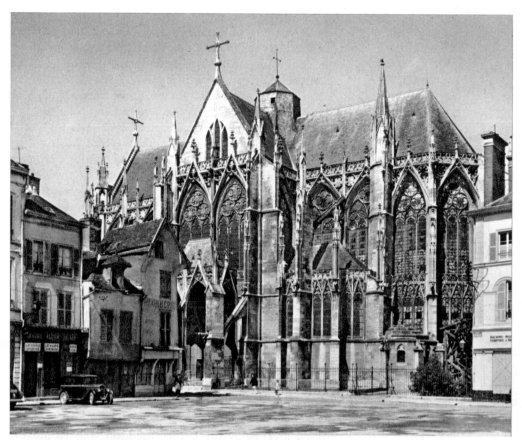

395. St.-Urbain, Troyes. 1261–75

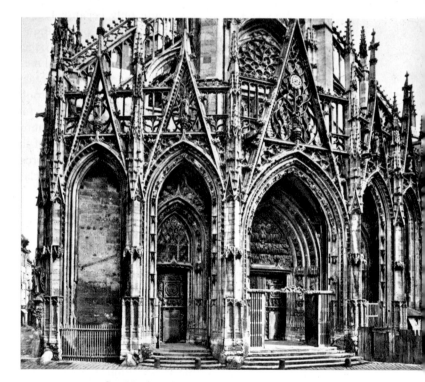

397. St.-Maclou, Rouen. Begun 1434

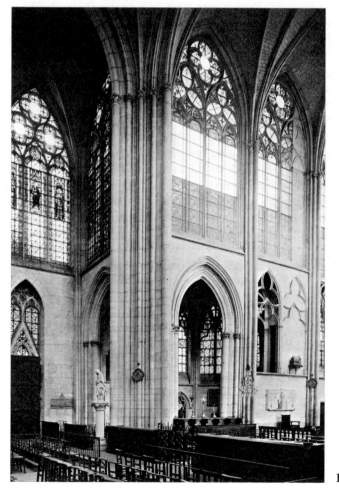

396. St.-Urbain, Troyes.
Interior toward northeast. 1261–75

398. Court, House of Jacques Coeur, Bourges. 1443–51

1440s. We speak of it as a house only because Jacques Cœur was a silversmith and merchant, rather than a nobleman. Since, however, he also was one of the richest men of his day, he could well afford an establishment obviously modeled on the mansions of the aristocracy. The courtyard (fig. 398), with its high-pitched roofs, its pinnacles and decorative carvings, suggests the picturesque qualities familiar to us from Flamboyant church architecture (fig. 397). That we should find an echo of the Louvre court in a merchant's residence is striking proof of the importance attained by the urban middle class during the later Middle Ages.

ENGLAND

Among the astonishing things about Gothic art is the enthusiastic response this "royal French style of the Paris region" evoked abroad. Even more remarkable was its ability to acclimate itself to a variety of local conditions—so much so, in fact, that the Gothic monuments of England and Germany have become objects of intense national pride in modern times, and critics in both countries have acclaimed Gothic as a peculiarly "native" style. How are we to account for the rapid spread of Gothic art? A number of factors might be cited, singly or in combination: the superior skill of French architects and stone carvers; the vast intellectual prestige of French centers of learning, such as the Cathedral School of Chartres and the University of Paris; and the influence of the Cistercians, the reformed monastic order founded by St. Bernard of Clairvaux. He, we recall, had violently denounced the flights of fancy of Romanesque sculpture. In conformity with his ascetic ideals, Cistercian abbey churches were a distinctive, severe type—decoration of any sort was held to a minimum, and a square choir took the place of apse, ambulatory, and radiating chapels. For that very reason, however, Cistercian architects put special emphasis on harmonious proportions and exact craftsmanship; and their "anti-Romanesque" outlook prompted them to adopt certain basic features of the Gothic style. During the latter half of the twelfth century, as the reform movement gathered momentum, this austere Cistercian Gothic came to be known throughout western Europe. Still, one wonders whether any of the explanations we have mentioned really go to the heart of the matter. The ultimate reason for the international victory of Gothic art seems to have been the extraordinary persuasive power of the style itself, its ability to kindle the imagination and to arouse religious feeling even among people far removed from the cultural climate of the Île-de-France.

That England should have proved particularly receptive to the new style is hardly surprising. Yet English Gothic did not grow directly from Anglo-Norman Romanesque but from the Gothic of the Île-de-France (introduced in 1175 by the French architect who rebuilt the choir of Canterbury Cathedral) and from that of the Cistercians. Within less than fifty years, it developed a well-defined character of its own, known as the Early English style, which dominated the second quarter of the thirteenth century. Although there was a great deal of building activity during those decades, it consisted mostly of additions to Anglo-Norman structures. A great many English cathedrals had been begun about the same time as Durham (see figs. 355–57) but remained unfinished; they were now completed or enlarged. As a consequence, we find few churches that are designed in the Early English style throughout. Among cathedrals, only Salisbury meets this requirement (figs. 399–401). Viewing the exterior, we realize immediately how different it is from its counterparts in France—and how futile it would be to judge it by French Gothic standards. Compactness and verticality have given way to a long, low, sprawling look (the great crossing tower, which provides a dramatic unifying accent, was built a century later than the rest and is much taller than originally planned). Since there is no straining after height, flying buttresses have been introduced only as an afterthought. Characteristically enough, the west façade has become a screen wall, wider than the church itself and stratified by emphatic horizontal bands of ornament and statuary, while the towers have shrunk to stubby turrets. The plan, with its strongly projecting double transept, retains the segmented quality of Romanesque structures; the square east end derives from Cistercian architecture. As we enter the nave, we recognize the same elements familiar to us from French interiors of the time, such as Chartres (see

399. Salisbury Cathedral. 1220–70

400. Plan of Salisbury Cathedral

fig. 390), but the English interpretation of these elements produces a very different total effect. As on the façade, the horizontal divisions are stressed at the expense of the vertical, so that we see the nave wall not as a succession of bays but as a continuous series of arches and supports. These supports, carved of dark marble, stand out against the rest of the interior—a method of stressing their special function that is one of the hallmarks of the Early English style. Another insular feature is the steep curve of the nave vault. The ribs ascend all the way from the triforium level, and the clerestory, as a result, gives the impression of being "tucked away" among the vaults. At Durham, more than a century earlier, the same treatment had been a technical necessity (compare fig. 357); now it has become a matter of style, thoroughly in keeping with the character of Early English Gothic as a whole. This character might be described as conservative in the positive sense: it accepts the French system but tones down its revolutionary aspects so as to maintain a strong sense of continuity with the Anglo-Norman past.

The contrast between the bold upward thrust of the crossing tower and the leisurely horizontal progression throughout the rest of Salisbury Cathedral suggests that English Gothic had developed in a new direction during the intervening hundred years. The change becomes very evident if we compare the interior of Salisbury with the choir of Gloucester Cathedral, built in the second quarter of the next century (fig. 402). This is a striking example of English Late Gothic, also called Perpendic-

401. Nave and Choir, Salisbury Cathedral

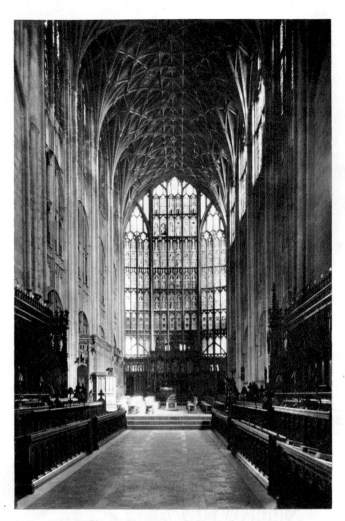

402. Choir, Gloucester Cathedral. 1332–57

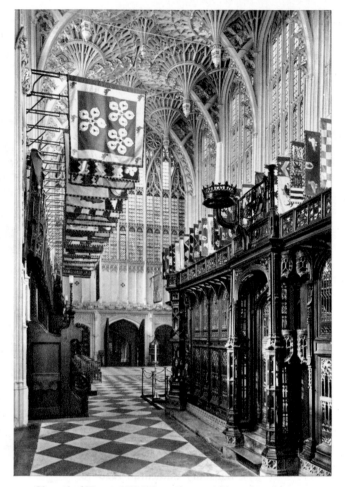

403. Chapel of Henry VII, Westminster Abbey, London. 1503–19

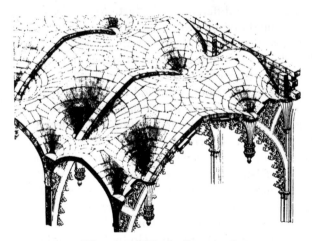

404. Diagram of Vault Construction,
Chapel of Henry VII, Westminster Abbey,
London. 1503–19

ular. The name certainly fits, since we now find the dominant vertical accent that is so conspicuously absent in the Early English style (note the responds running in an unbroken line from the vault to the floor). In this respect Perpendicular Gothic is much more akin to French sources, yet it includes so many features we have come to know as English that it would look very much out of place on the Continent. The repetition of small uniform tracery panels recalls the bands of statuary on the west façade at Salisbury; the plan simulates the square east end of earlier English churches; and the upward curve of the vault is as steep as in the nave of Salisbury. The ribs, on the other hand, have assumed an altogether new role—they have been multiplied until they form an ornamental network that screens the boundaries between the bays and thus makes the entire vault look like one continuous surface. This, in turn, has the effect of emphasizing the unity of the interior space. Such decorative elaboration of the "classic" quadripartite vault is characteristic of the Flamboyant style on the Continent as well, but the English started it earlier and carried it to greater lengths. The ultimate is reached in the amazing pendant vault of Henry VII's Chapel at Westminster Abbey, built in the early years of the sixteenth century (figs. 403, 404), with its lantern-like knobs hanging from con-

ical "fans." This fantastic scheme merges ribs and tracery patterns in a dazzling display of architectural pageantry.

GERMANY

In Germany, Gothic architecture took root a good deal more slowly than in England. Until the mid-thir-

teenth century, the Romanesque tradition, with its persistent Ottonian reminiscences, remained dominant, despite the growing acceptance of Early Gothic features. From about 1250 on, the High Gothic of the Île-de-France had a strong impact on the Rhineland; Cologne Cathedral (begun in 1248) represents an ambitious attempt to carry the full-fledged French system beyond the stage of Amiens. Significantly enough, however, the building remained a fragment until it was finally completed in modern times; nor did it have any successors. Far more characteristic of German Gothic is the development of the hall church, or *Hallenkirche*. Such churches—with aisles and nave of the same height—are familiar to us from Romanesque architecture (see fig. 352). For reasons not yet well understood, the type found particular favor on German soil, where its artistic possibilities were very fully explored. The large hall choir added in 1361–72 to the church of St. Sebald in Nuremberg (fig. 405) is one of many fine examples from central Germany. The space here has a fluidity and expansiveness that enfolds us as if we were standing under a huge canopy; there is no pressure, no directional command to prescribe our path. And the unbroken lines of the pillars, formed by bundles of shafts which gradually diverge as they turn into ribs, seem to echo the continuous movement that we feel in the space itself.

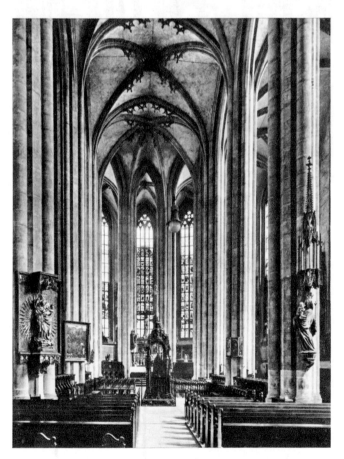

405. Choir, St. Sebald, Nuremberg. 1361–72

ITALY

Italian Gothic architecture stands apart from that of the rest of Europe. Judged by the formal criteria of the Île-de-France, most of it hardly deserves to be called Gothic at all. Yet it produced structures of singular beauty and impressiveness that cannot be understood as mere continuations of the local Romanesque. We must be careful, therefore, to avoid too rigid or technical a standard in approaching these monuments, lest we fail to do justice to their unique blend of Gothic qualities and Mediterranean tradition. It was the Cistercians, rather than the cathedral builders of the Île-de-France, who provided the chief exemplars on which Italian architects based their conception of the Gothic style. As early as the end of the twelfth century, Cistercian abbeys sprang up in both north and central Italy, their designs patterned directly after those of the French abbeys of the order. One of the finest, at Fossanova, some 60 miles south of Rome, was consecrated in 1208 (figs. 406, 407). Without knowing its location, we would be hard put to decide where to place it on a map—it might as well be Burgundian or English; the plan looks like a simplified version of Salisbury, and the finely proportioned interior bears a strong family resemblance to all Cistercian abbeys of the time. There are no façade towers, only a lantern over the crossing, as befits the Cistercian ideal of austerity. The groined vaults, although based on the pointed arch, have no diagonal ribs, the windows are small, and the architectural detail retains a good deal of Romanesque solidity, but the flavor of the whole is unmistakably Gothic nevertheless.

Churches such as the one at Fossanova made a deep impression upon the Franciscans, the monastic order founded by St. Francis of Assisi in the early thirteenth century. As mendicant friars dedicated to poverty, simplicity, and humility, they were the spiritual kin of St. Bernard, and the severe beauty of Cistercian Gothic must have seemed to them to express an ideal closely related to theirs. Be that as it may, their churches from the first reflected Cistercian influence and thus played a leading role in establishing Gothic architecture in Italy. Santa Croce in Florence, begun about a century after Fossanova, may well claim to be the greatest of all Franciscan structures (figs. 408, 409); it is also a masterpiece of Gothic architecture, even though it has wooden ceilings instead of groined vaults. There can be no doubt that this was a matter of deliberate choice, rather than of technical or economic necessity—a choice made not only on the basis of local practice (we recall the wooden ceilings of the Tuscan Romanesque) but also perhaps from a desire to evoke the simplicity of Early Christian basilicas and, in doing so, to link Franciscan poverty with the traditions of the early Church. The plan, too, combines Cistercian and Early Christian features. We note, however, that it shows no trace of the Gothic structural system, except for the groin-vaulted choir; the walls remain intact as

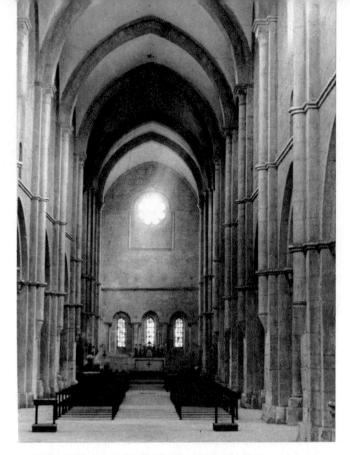

407. Nave and Choir, Abbey Church of Fossanova.
Consecrated 1208

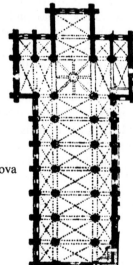

406. Plan of the
Abbey Church of Fossanova

inant role of light as forcefully as Abbot Suger's choir at St.-Denis. Judged in terms of its emotional impact, Sta. Croce is Gothic beyond doubt; it is also profoundly Franciscan—and Florentine—in the monumental simplicity of the means by which this impact has been achieved.

If in Sta. Croce the architect's main concern was an impressive interior, Florence Cathedral was planned as a monumental landmark towering above the entire city (figs. 410–12). The original design, by Arnolfo di Cambio, dating from 1296—about the time construction was begun at Sta. Croce—is not known in detail; although somewhat smaller than the present building, it probably

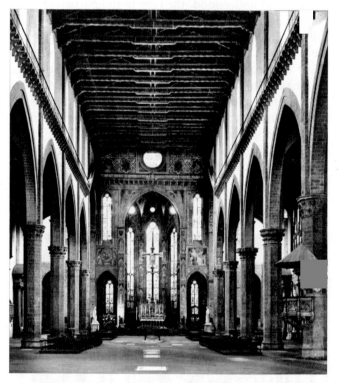

408. Nave and Choir, Sta. Croce, Florence. Begun c. 1295

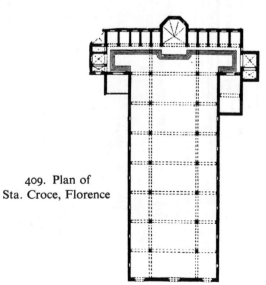

409. Plan of
Sta. Croce, Florence

continuous surfaces (indeed, Sta. Croce owes part of its fame to its wonderful murals) and, in contrast to Fossanova, there are no buttresses at all, since the wooden ceilings do not require them. Why, then, speak of Sta. Croce as Gothic? Surely the use of the pointed arch is not sufficient to justify the term? A glance at the interior will dispel our misgivings. For we sense immediately that this space creates an effect fundamentally different from that of either Early Christian or Romanesque architecture. The nave walls have the weightless, "transparent" quality we saw in northern Gothic churches, and the dramatic massing of windows at the eastern end conveys the dom-

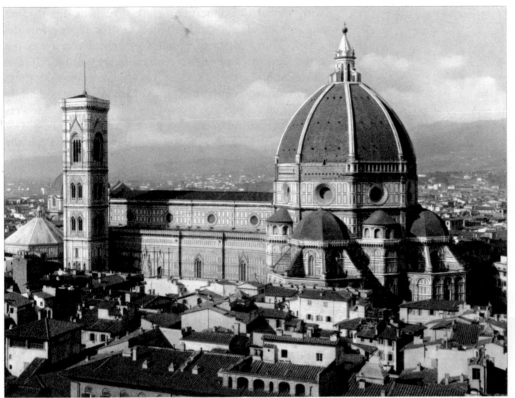

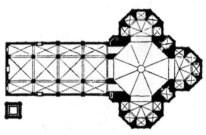

410. Florence Cathedral. Begun by Arnolfo di Cambio, 1296; dome by Filippo Brunelleschi, 1420–36

411. Plan of Florence Cathedral

showed the same basic features. The most striking of these is the great octagonal dome with its subsidiary half-domes, a motif ultimately of late Roman origin (see figs. 222, 223, 271–73). Arnolfo may have thought of it at first as an oversized dome above the crossing of nave and transept, but it soon grew into a huge central pool of space that makes the nave look like an afterthought. The actual building of the dome, and the details of its design, belong to the early fifteenth century. Apart from the windows and the doorways, there is nothing Gothic about the exterior of Florence Cathedral (flying buttresses to sustain the nave vault may have been planned but proved unnecessary). The solid walls, encrusted with geometric marble inlays, are a perfect match for the Romanesque Baptistery across the way (see fig. 367). Characteristically enough, a separate campanile takes the place of the façade towers familiar to us in northern Gothic churches. The interior, on the other hand, recalls Sta. Croce, even though the dominant impression is one of chill solemnity rather than lightness and grace. The ribbed groined vault of the nave rests directly on the huge nave arcade, producing an emphasis on width instead of height, and the architectural detail throughout has a massive solidity that seems more Romanesque than Gothic. Thus the unvaulted interior of Sta. Croce reflects the spirit of the new style more faithfully than does the Cathedral, which, on the basis of its structural system, ought to be the more Gothic of the two.

The west façade, so dramatic a feature in French cathedrals, never achieved the same importance in Italy. It

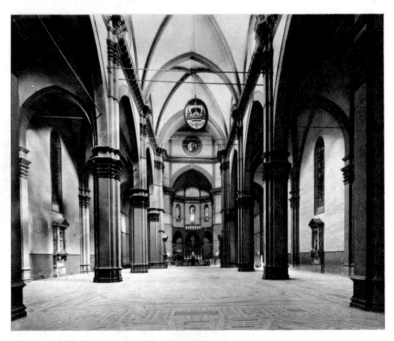

412. Nave and Choir, Florence Cathedral

is remarkable how few Italian Gothic façades were ever carried near completion before the onset of the Renaissance (those of Sta. Croce and Florence Cathedral are both modern). Among those that were, the finest is Orvieto Cathedral (fig. 413), designed in the main by Lorenzo Maitani. It makes an instructive comparison

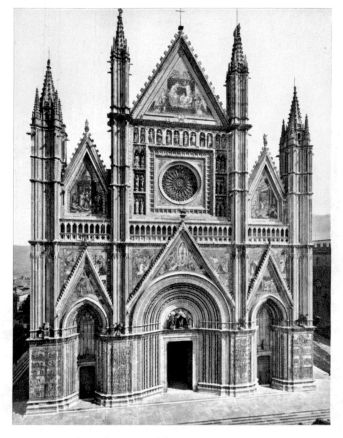

413. LORENZO MAITANI AND OTHERS.
Façade, Orvieto Cathedral. Begun c. 1310

with Tuscan Romanesque façades (such as fig. 364) on the one hand, and with French Gothic façades on the other. Many of its ingredients clearly derive from the latter source, and its screenlike lightness, too, is unmistakably Gothic. Yet we realize at once that these features have been superimposed on what is essentially a basilican façade like that of Pisa Cathedral; the towers are reduced to turrets so as not to compete in height or importance with the central gable, and, as at Pisa, the entire design has a strangely small-scale quality that has nothing to do with its actual size. This impression may strike us as somewhat paradoxical, for the Orvieto façade is less complex and more clearly articulated than that of (let us say) Reims Cathedral. But whereas at Reims the infinite richness of detail is subordinated to the grandly simple two-tower silhouette, the Orvieto façade lacks a dominant motif, so that the elements which compose it seem "assembled" rather than merged into a single whole. One somehow feels that the entire arrangement, beautifully balanced though it is, could be folded up or taken apart if the need arose. Except for the modest-sized rose window and the doorways, the Orvieto façade has no real openings, and large parts of it consist of framed sections of wall area. Yet we experience these not as solid, material surfaces but as translucent, since they are filled with brilliantly colored mosaics—an effect equivalent to Gothic stained glass in the North.

414. Milan Cathedral.
Begun 1386

By far the largest Gothic church on Italian soil, as well as the one most nearly comparable to Northern structures, is Milan Cathedral (fig. 414), begun in 1386. Its design was the subject of a famous dispute between the local architects and consulting experts from France and Germany. What they achieved can hardly be termed a genuine synthesis of Northern and Southern traditions; it strikes us, rather, as an uneasy—though ambitious—compromise, burdened with overly elaborate Late Gothic decoration but devoid of any unity of feeling. The façade in particular reveals its shortcomings very plainly if we compare it with that of Orvieto. Both are composed in much the same way, yet the earlier design has a jewel-like perfection while the later one strikes us as little more than a mechanical piling-up of detail.

Secular Architecture

The secular buildings of Gothic Italy convey as distinct a local flavor as the churches. There is nothing in the cities of northern Europe to match the impressive grimness of the Palazzo Vecchio (fig. 415), the town hall of Florence. Fortress-like structures such as this reflect the factional strife—among political parties, social classes, and prominent families—so characteristic of life

416. Ca' d'Oro, Venice. 1422–c. 1440

within the Italian city-states. The wealthy man's home (or *palazzo*, a term denoting any large urban house) was quite literally his castle, designed both to withstand armed assault and to proclaim the owner's importance. The Palazzo Vecchio, while larger and more elaborate, follows the same pattern. Behind its battlemented walls, the city government could feel well protected from the wrath of angry crowds. The tall tower not only symbolizes civic pride but has an eminently practical purpose; dominating the city as well as the surrounding countryside, it served as a lookout against enemies from without or within. Among Italian cities Venice alone was ruled by a merchant aristocracy so firmly established that internal disturbances were the exception rather than the rule. As a consequence, Venetian *palazzi,* unhampered by defensive requirements, developed into graceful, ornate structures such as the Ca' d'Oro (fig. 416). There is more than a touch of the Orient in the delicate lattice-work effect of this façade, even though most of the decorative vocabulary derives from the Late Gothic of northern Europe. Its rippling patterns, ideally designed to be seen against their own reflection in the water of the Grand Canal, have the same fairy-tale quality we recall from the exterior of St. Mark's (see fig. 296).

SCULPTURE

FRANCE

Although his story of the rebuilding of St.-Denis does not deal at length with the sculptural decoration of the

415. Palazzo Vecchio, Florence. Begun 1298

church, Abbot Suger must have attached considerable importance to this aspect of the enterprise. The three portals of his west façade were far larger and more richly carved than those of Norman Romanesque churches. Unhappily, their condition today is so poor that they do not tell us a great deal about Suger's ideas of the role of sculpture within the total context of the structure he had envisioned.

Chartres: West Portals

We may assume, however, that Suger's ideas had prepared the way for the admirable west portals of Chartres Cathedral (fig. 417), begun about 1145 under the influence of St.-Denis, but even more ambitious in conception. They probably represent the oldest full-fledged example of Early Gothic sculpture. Comparing them with Romanesque portals, we are impressed first of all with a new sense of order, as if all the figures had suddenly come to attention, conscious of their responsibility to the architectural framework. The dense crowding, the frantic movement of Romanesque sculpture have given way to an emphasis on symmetry and clarity; the figures on the lintels, archivolts, and tympanums are no longer entangled with each other but stand out as separate en-

tities, so that the entire design carries much farther than that of previous portals. Particularly striking in this respect is the novel treatment of the jambs (fig. 418), which are lined with tall figures attached to columns. Similarly elongated figures, we recall, had occurred on the jambs or *trumeaux* of Romanesque portals (see figs. 369, 374), but they had been conceived as reliefs carved into—or protruding from—the masonry of the doorway. The Chartres jamb figures, in contrast, are essentially statues, each with its own axis; they could, in theory at least, be detached from their supports. Here, then, we witness a development of truly revolutionary importance: the first basic step toward the reconquest of monumental sculpture in the round since the end of classical antiquity. Apparently, this step could be taken only by "borrowing" the rigid cylindrical shape of the column for the human figure, with the result that these statues seem more abstract than their Romanesque predecessors. Yet they will not retain their immobility and unnatural proportions for long; the very fact that they are round endows them with a more emphatic presence than anything in Romanesque sculpture, and their heads show a gentle, human quality that betokens the fundamentally realistic trend of Gothic sculpture. Realism is, of course, a relative term whose meaning varies greatly according

417. West Portals, Chartres Cathedral. c. 1145–70

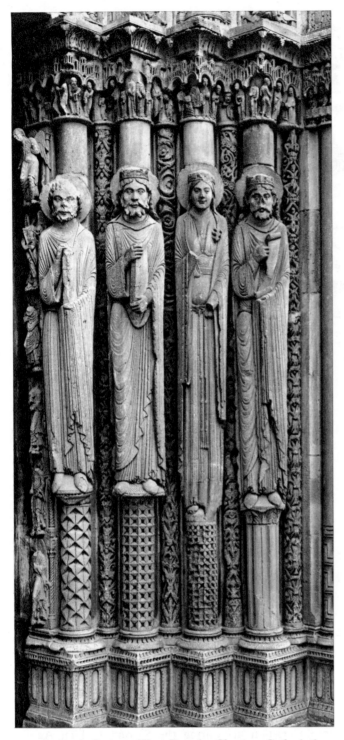

418. Jamb Statues, West Portals, Chartres Cathedral

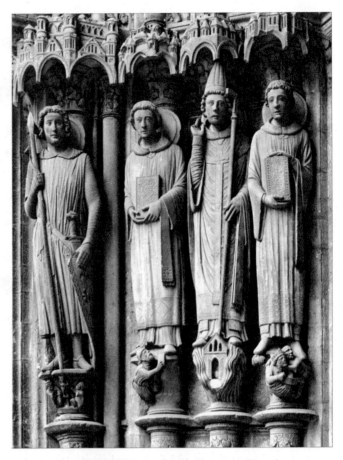

419. Jamb Statues, South Transept Portals,
Chartres Cathedral. c. 1215–20

to circumstances. On the Chartres west portals, it appears to spring from a reaction against the fantastic and demoniacal aspects of Romanesque art, a reaction that may be seen not only in the calm, solemn spirit of the figures and their increased physical bulk (compare the Christ of the center tympanum with that at Vézelay, fig. 372) but in the rational discipline of the symbolic program underlying the entire scheme. While the subtler

aspects of this program are accessible only to a mind fully conversant with the theology of the Chartres Cathedral School, its main elements are simple enough to be grasped by the man in the street. The jamb statues, a continuous sequence linking all three portals, represent the prophets, kings, and queens of the Bible; their purpose is both to acclaim the rulers of France as the spiritual descendants of Old Testament royalty and to stress the harmony of secular and spiritual rule, of priests (or bishops) and kings—an ideal insistently put forward by Abbot Suger. Christ Himself appears enthroned above the main doorway as Judge and Ruler of the Universe, flanked by the symbols of the four Evangelists, with the Apostles assembled below and the twenty-four Elders of the Apocalypse in the archivolts. The right-hand tympanum shows His incarnation—the Birth, the Presentation in the Temple, and the Infant Christ on the lap of the Virgin (who also stands for the Church)—while in the archivolts we see the personifications and representatives of the liberal arts: human wisdom paying homage to the divine wisdom of Christ. In the left-hand tympanum, finally, we see the timeless Heavenly Christ, the Christ of the Ascension, framed by the signs of the zodiac and their earthly counterparts, the labors of the twelve months—the ever-repeating cycle of the year.

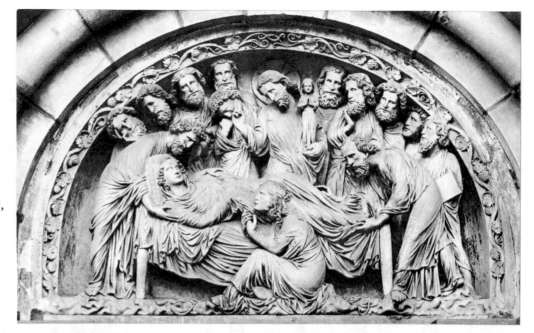

420. *Death of the Virgin,*
tympanum of the South Transept Portal,
Strasbourg Cathedral. c. 1220

Gothic Classicism

When Chartres Cathedral was rebuilt after the fire of 1195, the Royal Portals of the west façade must have seemed rather small and old-fashioned in relation to the rest of the new edifice. Perhaps for that reason, the two transept façades each received three large and lavishly carved portals preceded by deep porches. The jamb statues of these portals, such as the group shown in figure 419, represent an early phase of High Gothic sculpture. By now, the symbiosis of statue and column has begun to dissolve: the columns are quite literally put in the shade by the greater width of the figures, by the strongly projecting canopies above, and by the elaborately carved bases of the statues. In the three saints on the right, we still find echoes of the rigid cylindrical shape of Early Gothic jamb statues, but even here the heads are no longer strictly in line with the central axis of the body; and St. Theodore, the knight on the left, already stands at ease, in a semblance of Classical *contrapposto.* His feet rest on a horizontal platform, rather than on a sloping shelf as before, and the axis of his body, instead of being straight, describes a slight but perceptible S-curve. Even more astonishing is the abundance of precisely observed detail—the weapons, the texture of the tunic and chain mail—and, above all, the organic structure of the body. Not since imperial Roman times have we seen a figure as thoroughly alive as this. Yet the most impressive quality of the statue is not its realism; it is, rather, the serene, balanced image of man which this realism conveys. In this ideal portrait of the Christian Soldier, the spirit of the Crusades has been cast into its most elevated form.

The style of the *St. Theodore* could not have evolved directly from the elongated columnar statues of the Chartres west façade. It incorporates another, equally important tradition: the classicism of the Meuse valley, which we traced in an earlier chapter from Renier of Huy to Nicholas of Verdun (compare figs. 376, 382, 383). At the end of the twelfth century this trend, hitherto confined to metalwork and miniatures, began to appear in monumental stone sculpture as well, transforming it from Early Gothic to Classic High Gothic. The link with Nicholas of Verdun becomes strikingly evident in the *Death of the Virgin* (fig. 420), a tympanum from Strasbourg Cathedral contemporary with the Chartres transept portals; here the draperies, the facial types, the movements and gestures have a classical flavor that immediately recalls the Klosterneuburg altar (fig. 383). What marks it as Gothic rather than Romanesque, on the other hand, is the deeply felt tenderness pervading the entire scene. We sense a bond of shared emotion among the figures, an ability to communicate by glance and gesture such as we have never met before. This quality of *pathos,* too, has Classical roots—we recall its entering into Christian art during the Second Golden Age in Byzantium (see fig. 299). But how much warmer and more eloquent it is at Strasbourg than at Daphnē!

The climax of Gothic classicism is reached in some of the statues at Reims Cathedral, the most famous among them being the Visitation group (fig. 421, right). To have a pair of jamb figures enact a narrative scene such as this would have been unthinkable in Early Gothic sculpture; the fact that they can do so now shows how far the sustaining column has receded into the background. Characteristically enough, the S-curve, much more conspicuous than in the *St. Theodore,* dominates the side view as well as the front view, and the physical bulk of the

body is further emphasized by horizontal folds pulled across the abdomen. The relationship of the two women shows the same human warmth and sympathy we found in the Strasbourg tympanum, but their classicism is of a far more monumental kind; they remind us so forcibly of ancient Roman matrons (compare fig. 243) that we wonder if the artist could have been inspired directly by large-scale Roman sculpture. The influence of Nicholas of Verdun alone could hardly have produced such firmly rounded, solid volumes.

The vast scale of the sculptural program for Reims Cathedral had made it necessary to call upon the services of masters and workshops from various other building sites, and so we encounter several distinct styles among the Reims sculpture. Two of these styles, both clearly different from the classicism of the *Visitation*, appear in the Annunciation group (fig. 421, left). The Virgin exhibits a severe manner, with a rigidly vertical body axis and straight, tubular folds meeting at sharp angles, a style probably invented about 1220 by the sculptors of the west portals of Notre-Dame in Paris; from there it traveled to Reims as well as Amiens (see fig. 424, below). The angel, in contrast, is conspicuously graceful: we note

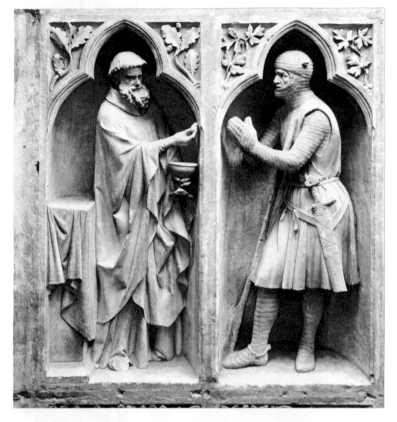

422. *Melchizedek and Abraham,* interior west wall, Reims Cathedral. After 1251

421. *Annunciation* and *Visitation,* West Portals, Reims Cathedral. c. 1225–45

the tiny, round face framed by curly locks, the emphatic smile, the strong S-curve of the slender body, the ample, richly accented drapery. This "elegant style," created around 1240 by Parisian masters working for the royal court, was to spread far and wide during the following decades; it soon became, in fact, the standard formula for High Gothic sculpture. We shall feel its effect for many years to come, not only in France but abroad. A characteristic instance is the fine group of Abraham and Melchizedek, carved shortly after the middle of the century for the interior west wall of Reims Cathedral (fig. 422). Abraham, in the costume of a medieval knight, still recalls the vigorous realism of the *St. Theodore* at Chartres; Melchizedek, however, shows clearly his descent from the angel of the Reims *Annunciation*—his hair and beard are even more elaborately curled, the draperies more lavishly ample, so that the body almost disappears among the rich play of folds. The deep recesses and sharply projecting ridges betray a new awareness of light-and-shadow effects that seems more pictorial than sculptural, and the same may be said of the way the figures are placed in their cavernous niches. A half-century later every trace of classicism has disappeared from Gothic sculpture. The human figure itself now becomes strangely cavernous and abstract. Thus the famous *Virgin of Paris* (fig. 423) in Notre-Dame Cathe-

423. *The Virgin of Paris.*
Early 14th century. Notre-Dame, Paris

When we look back over the century and a half that separates the *Virgin of Paris* from the Chartres west portals, we cannot help wondering what brought about this retreat from the realism of Early and Classic High Gothic sculptures. Despite the fact that the new style was backed by the royal court and thus had special authority, we find it hard to explain why attenuated elegance and calligraphic, smoothly flowing lines came to dominate Gothic art throughout northern Europe from about 1250 to 1400. It is clear, nevertheless, that the *Virgin of Paris* represents neither a return to the Romanesque nor a complete repudiation of the earlier realistic trend. Gothic realism had never been of the all-embracing, systematic sort: it had been a "realism of particulars," focused on specific details rather than on the over-all structure of the visible world. Its most characteristic products are not the classically oriented jamb statues and tympanum compositions of the early thirteenth century, but small-scale carvings such as the *Labors of the Months* in quatrefoil frames on the façade of Amiens Cathedral (fig. 424), with their delightful observation of everyday life. This intimate kind of realism survives even within the abstract formal framework of the *Virgin of Paris;* we see it in the Infant Christ, who appears here not as the Saviour-in-miniature austerely facing the beholder, but as a thoroughly human child playing with his mother's veil. Our statue thus retains an emotional appeal which links it to the Strasbourg *Death of the Virgin* and to the Reims *Visitation.* It is this appeal, not realism or classicism as such, that is the essence of Gothic art.

ENGLAND

The spread of Gothic sculpture beyond the borders of France began only toward 1200—the style of the Chartres west portals had hardly any echoes abroad—but, once under way, proceeded at an astonishingly rapid pace. England may well have led the way, as it did in evolving its own version of Gothic architecture. Unfortunately, so much English Gothic sculpture was destroyed during the Reformation that we can study its development only with difficulty. Our richest materials are the tombs, which did not arouse the iconoclastic zeal of anti-Catholics. They include a type, illustrated by the splendid example in figure 425, that has no counterpart on the other side of the Channel: it shows the deceased, not in quiet repose as does the vast majority of medieval tombs, but in violent action, a fallen hero, fighting to the last breath. According to an old tradition, these dramatic figures, whose agony so oddly recalls the *Dying Gaul* (see fig. 187), honor the memory of Crusaders who died in the struggle for the Holy Land. If so, they would, as the tombs of Christian Soldiers, carry a religious meaning that might help to account for their compelling expressive power. In any event, they are among the finest achievements of English Gothic sculpture.

dral consists largely of hollows, the projections having been reduced to the point where they are seen as lines rather than volumes. The statue is quite literally disembodied—its swaying stance no longer bears any relationship to the Classical *contrapposto.* Compared to such unearthly grace, the angel of the Reims *Annunciation* seems solid and tangible indeed, yet it contains the seed of the very qualities so strikingly expressed in the *Virgin of Paris.*

above: 424. *Signs of the Zodiac* and *Labors of the Months (July, August, September),* west façade, Amiens Cathedral. c. 1220–30

left: 425. Tomb of a Knight. c. 1260 Dorchester Abbey, Oxfordshire

GERMANY

In Germany, the growth of Gothic sculpture can be traced more easily. From the 1220s on, German masters trained in the sculptural workshops of the great French cathedrals transplanted the new style to their homeland, although German architecture at that time was still predominantly Romanesque. However, even after the middle of the century, Germany failed to emulate the vast statuary cycles of France. As a consequence, German Gothic sculpture tended to be less closely linked with its archi-

tectural setting (the finest work was often done for the interiors rather than the exteriors of churches) and this, in turn, permitted it to develop an individuality and expressive freedom greater than that of its French models. All these qualities are strikingly evident in the style of the Naumburg Master, an artist of real genius whose best-known work is the magnificent series of statues and reliefs he carved, about 1250–60, for Naumburg Cathedral. The *Crucifixion* (fig. 426) forms the central feature of the choir screen; enclosed by a deep, gabled porch, the three figures frame the opening that links the nave

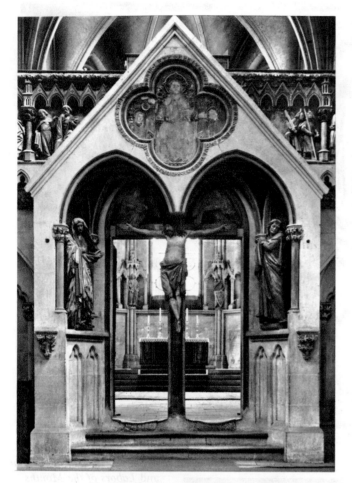

426. *Crucifixion,* on the choir screen,
Naumburg Cathedral. c. 1250–60

an instructive contrast with the *St. Theodore* at Chartres (see fig. 419).

Gothic sculpture, as we have come to know it so far, reflects a desire to endow the traditional themes of Christian art with an ever greater emotional appeal. Toward the end of the thirteenth century, this tendency gave rise to a new kind of religious imagery, designed to serve private devotion; it is often referred to by the German term *Andachtsbild,* since Germany played a leading part in its development. The most characteristic and widespread type of *Andachtsbild* was the *Pietà* (an Italian word derived from the Latin *pietas,* the root word for both "pity" and "piety"), a representation of the Virgin grieving over the dead Christ. No such scene occurs in the scriptural account of the Passion; it was invented, rather —we do not know exactly where or when—as a tragic counterpart to the familiar motif of the Madonna and Child. The example reproduced in figure 429 dates from the same period as the *Virgin of Paris;* like most such groups, it is carved of wood, with a vividly painted surface to enhance its impact. Realism here has become purely a vehicle of expression—the agonized faces, the blood-encrusted wounds of Christ that are enlarged and elaborated to an almost grotesque degree; and the bodies and limbs are of a puppet-like thinness and rigidity. The purpose of the work, clearly, is to arouse so overwhelming a sense of horror and pity that the beholder will identify his own feelings completely with those of the grief-stricken Mother of God.

THE INTERNATIONAL STYLE (NORTH)

At first glance, our *Pietà* would seem to have little in common with the *Virgin of Paris.* Yet they both share a lean, "deflated" quality of form that is the characteristic period flavor of Northern European art from the late thirteenth century to the mid-fourteenth. Only after 1350 do we again find an interest in weight and volume, coupled with a renewed impulse to explore tangible reality. The climax of this trend occurred around 1400, during the period of the so-called International Style (see also page 338), and its greatest exponent was Claus Sluter, a sculptor of Netherlandish origin working for the Duke of Burgundy at Dijon. The portal of the Chartreuse de Champmol (fig. 430), which he did in 1385–93, recalls the monumental statuary on thirteenth-century cathedral portals, but the figures have grown so large and expansive that they almost overpower their architectural framework. This effect is due not only to their size and the bold three-dimensionality of the carving, but also to the fact that the jamb statues (Duke Philip the Bold and his wife, accompanied by their patron saints) are turned toward the Madonna on the *trumeau,* so that the five figures form a single, coherent unit, like the Crucifixion group at Naumburg. In both instances, the sculptural composition has simply been superimposed—however skillfully—on the shape of the doorway,

with the sanctuary. Placing the group as he did (rather than above the screen, in accordance with the usual practice) our sculptor has brought the sacred subject down to earth both physically and emotionally: the suffering of Christ becomes a human reality because of the emphasis on the weight and volume of the Saviour's body, and Mary and John, pleading with the beholder, convey their grief more eloquently than ever before. The *pathos* of these figures is heroic and dramatic, as against the lyricism of the Strasbourg tympanum or the Reims *Visitation.* If the Classic Gothic sculpture of France evokes comparison with Phidias, the Naumburg Master might be termed the temperamental kin of Scopas. The same intensity of feeling dominates the Passion scenes, such as the *Kiss of Judas* (fig. 427), with its unforgettable contrast between the meekness of Christ and the violent, sword-wielding St. Peter. Finally there are, attached to the responds inside the choir, the statues of nobles associated with the founding of the cathedral, among them the famous pair, Ekkehard and Uta (fig. 428). Although these men and women were not of the artist's own time, so that he knew them only as names in a chronicle, he has given each of them a personality as distinctive and forceful as if he had portrayed them from life. They make

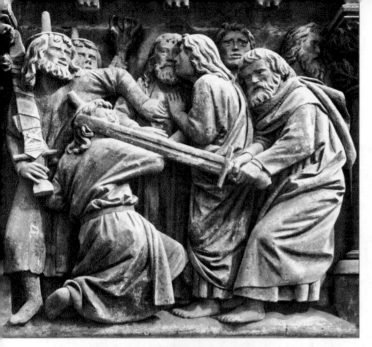

427. *The Kiss of Judas,* on the choir screen,
Naumburg Cathedral. c. 1250–60

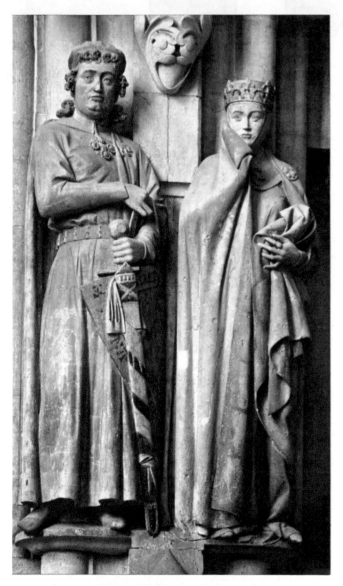

428. *Ekkehard and Uta,*
Naumburg Cathedral. c. 1250–60

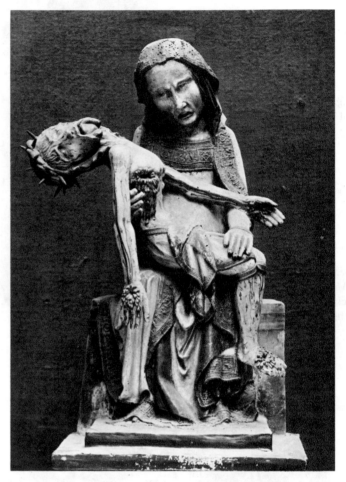

429. *Pietà.* Early 14th century.
Wood, height 34¹/₂″. Provinzialmuseum, Bonn

not developed from it as at Chartres, Notre-Dame, or
Reims. Significantly enough, the Champmol portal did
not pave the way for a revival of architectural sculpture;
it remained an isolated effort, and Sluter's other works
belong to a different category, which for lack of a better
term we must label church furniture (tombs, pulpits,
etc.), combining large-scale sculpture with a small-scale
architectural setting. The most impressive of these is the
Moses Well at the Chartreuse de Champmol (fig. 431), a
symbolic well surrounded by statues of Moses and other
Old Testament prophets and once surmounted by a cru-
cifix. The majestic Moses epitomizes the same quali-
ties we find in Sluter's portal statues; soft, lavishly draped
garments envelop the heavy-set body like an ample
shell, the swelling forms seem to reach out into the sur-
rounding space, determined to capture as much of it as
possible (note the outward curve of the scroll). In the
Isaiah, facing left in our illustration, these aspects of our
artist's style are less pronounced; what strikes us, rather,
is the precise and masterful realism of every detail, from

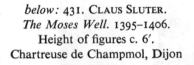

right: 430. CLAUS SLUTER.
Portal of the Chartreuse de Champmol,
Dijon. 1385–93

below: 431. CLAUS SLUTER.
The Moses Well. 1395–1406.
Height of figures c. 6′.
Chartreuse de Champmol, Dijon

the minutiae of the costume to the texture of the wrinkled skin. The head, unlike that of Moses, has all the individuality of a portrait. Nor is this impression deceiving, for the sculptural development that culminated in Claus Sluter had produced, from about 1350 on, the first genuine portraits since late antiquity. And Sluter himself has left us two splendid examples in the heads of the Duke and Duchess on the Chartreuse portal. It is this attachment to the tangible and specific that distinguishes his realism from that of the thirteenth century.

ITALY

We have left a discussion of Italian Gothic sculpture to the last, for here, too, as in Gothic architecture, Italy stands apart from the rest of Europe. The earliest Gothic sculpture on Italian soil was probably produced in the extreme south, in Apulia and Sicily, the domain of the German Emperor Frederick II, who employed Frenchmen and Germans along with native artists at his court. Of the works he sponsored little has survived, but there is evidence that his taste favored a strongly Classic style derived from the sculpture of the Chartres transept portals and the Visitation group at Reims. This style not only provided a fitting visual language for a ruler who saw himself as the heir of the Caesars of old; it also blended easily with the classical tendencies in Italian Romanesque sculpture (see above, page 276).

Nicola Pisano; Giovanni Pisano

Such was the background of Nicola Pisano, who came to Tuscany from southern Italy about 1250 (the year of

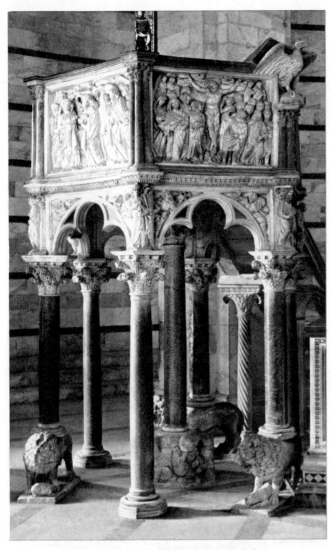

432. NICOLA PISANO. Marble Pulpit.
1259–60. Baptistery, Pisa

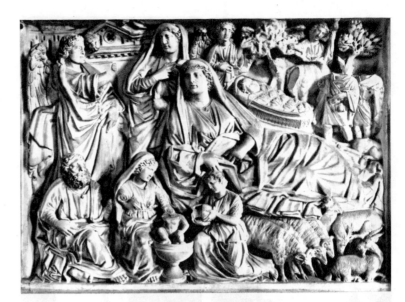

433. *The Nativity*, detail of
the Marble Pulpit, Baptistery, Pisa

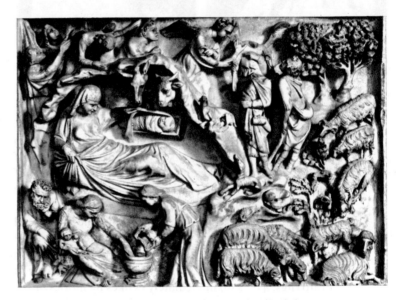

434. GIOVANNI PISANO. *The Nativity*, detail of the
Marble Pulpit. 1302–10. Pisa Cathedral

Frederick II's death). In 1260 he completed the marble pulpit in the Baptistery of Pisa Cathedral (fig. 432). His work has been well defined as that of "the greatest—and in a sense the last—of medieval classicists." In the Pisa Baptistery pulpit the classical flavor is indeed so strong, whether we look at the architectural framework or at the sculptured parts, that the Gothic elements are hard to detect at first glance. But we do find such elements in the design of the arches, in the shape of the capitals, and in the standing figures at the corners (which look like small-scale descendants of the jamb statues on French Gothic cathedrals). More striking, perhaps, is the Gothic quality of human feeling in the narrative scenes such as the *Nativity* (fig. 433). The dense crowding of figures, on the other hand, has no counterpart in northern Gothic sculpture (aside from the Nativity, the panel also shows the Annunciation and the shepherds in the fields receiving the glad tidings of the birth of Christ). This treatment of the relief as a shallow box filled almost to the bursting point with solid, convex shapes tells us that Nicola Pisano must have been thoroughly familiar with Roman sarcophagi (compare fig. 277).

Half a century later Nicola's son Giovanni, who was

an equally gifted sculptor, did a marble pulpit for Pisa Cathedral. It, too, includes a *Nativity* (fig. 434). Both panels have a good many things in common, as we might well expect, yet they also offer a sharp—and instructive—contrast. Giovanni's slender, swaying figures, with their smoothly flowing draperies, no longer recall classical antiquity nor the Visitation group at Reims; instead, they reflect the elegant style of the royal court at Paris that had become the standard Gothic formula during the later thirteenth century. And with this change there has come about a new treatment of relief: to Giovanni Pisano, space is as important as plastic form. The figures are no longer tightly packed to-

gether; they are now spaced far enough apart to let us see the landscape setting that contains them, and each figure has been allotted its own pocket of space. If Nicola's *Nativity* strikes us as essentially a sequence of bulging, rounded masses, Giovanni's appears to be made up mainly of cavities and shadows.

Giovanni Pisano, then, seems to follow the same trend toward "disembodiment" that we encountered north of the Alps around 1300. He does so, however, only within limits. Compared to the *Virgin of Paris,* his *Madonna* at Prato (figs. 435, 436) immediately evokes memories of Nicola's style. The three-dimensional firmness of the modeling is further emphasized by the strong turn of the head and the thrust-out left hip; we also note the heavy, buttress-like folds that anchor the figure to its base. Yet there can be no doubt that the Prato statue derives from a French prototype which must have been rather like the *Virgin of Paris.* (The back view, with its suggestion of "Gothic sway," reveals the connection more clearly than the front view.)

Church Façades; Tombs

The façades of Italian Gothic churches, we will recall, do not rival those of the French cathedrals as focal points of architectural and sculptural endeavor. The French Gothic portal, with its jamb statues and richly

carved tympanum, never found favor in the South. Instead, we often find a survival of Romanesque traditions of architectural sculpture, such as statues in niches or small-scale reliefs overlaying the wall surfaces (compare fig. 375). At Orvieto Cathedral, Lorenzo Maitani covered the wide pilasters between the portals with relief carvings of such lacelike delicacy that we become aware of them only if we see them at close range. The tortures of the damned from the *Last Judgment* on the southernmost pilaster (fig. 437) make an instructive comparison with similar scenes in Romanesque art (such as fig. 371): the hellish monsters are as vicious as ever, but the sinners now evoke compassion rather than sheer horror. Even here, then, we feel the spirit of human sympathy that distinguishes the Gothic from the Romanesque.

If Italian Gothic sculpture failed to emulate the vast sculptural programs of northern Europe, it excelled in the field which we have called church furniture, such as pulpits, screens, shrines, and tombs. Among the latter, the most remarkable perhaps is the monument of Can Grande della Scala, the lord of Verona. A tall structure built out-of-doors next to the church of Sta. Maria Antica,

it consists of a vaulted canopy housing the sarcophagus and surmounted by a truncated pyramid which in turn supports an equestrian statue of the deceased (fig. 438). The ruler, astride his richly caparisoned mount, is shown in full armor, sword in hand, as if he were standing on a windswept hill at the head of his troops; and, in a supreme display of self-confidence, he wears a broad grin. Clearly, this is no Christian Soldier, no crusading knight, no embodiment of the ideals of chivalry, but a frank glorification of power. Can Grande, remembered today mainly as the friend and protector of Dante, was indeed an extraordinary figure; although he held Verona as a fief from the German emperor, he styled himself "the Great Khan," thus asserting his claim to the absolute sovereignty of an Asiatic potentate. His free-standing equestrian statue—a form of monument traditionally reserved for emperors—conveys the same ambition in visual terms.

THE INTERNATIONAL STYLE (SOUTH)

During the later fourteenth century, northern Italy proved particularly hospitable to artistic influences from across the Alps, not only in architecture (see Milan Cathedral, fig. 414) but in sculpture as well. The apostles atop the choir screen of St. Mark's in Venice (fig. 439), carved by Jacobello and Pierpaolo dalle Masegne about 1394, reflect the trend toward greater realism and the renewed interest in weight and volume that culminated in the work of Claus Sluter, even though these qualities are not yet fully developed here. With the apostles from St. Mark's, we find ourselves on the threshold of the "International Style," which flourished throughout Western Europe between c. 1400 and 1420. Its foremost representative in Italian sculpture was a Florentine, Lorenzo Ghiberti, who as a youth must have had close contact with French art. We first encounter him in 1401–1402, when he won a competition for a pair of richly decorated bronze doors for the Baptistery in Florence. (It took him more than two decades to complete these doors, which fill the north portal of the building.) Each of the competing artists had to submit a trial relief, in a Gothic quatrefoil frame, representing the Sacrifice of Isaac. Ghiberti's panel (fig. 440) strikes us first of all with the perfection of its craftsmanship, which reflects his training as a goldsmith. The silky shimmer of the surfaces, the wealth of beautifully articulated detail, make it easy to understand why this entry was awarded the prize. If the composition seems somewhat lacking in dramatic force, that is as characteristic of Ghiberti's calm, lyrical temper as of the taste of the period, for the realism of the International Style did not extend to the realm of the emotions. The figures, in their softly draped, ample garments, retain an air of courtly elegance even when they enact scenes of violence. However much his work may owe to French influence, Ghiberti proves

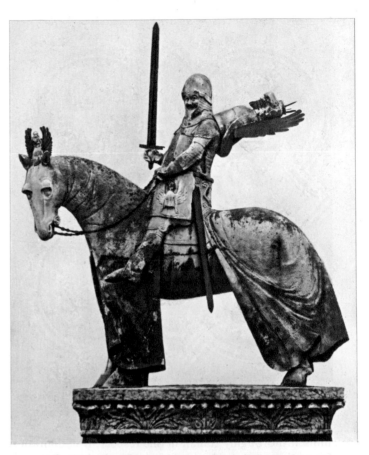

438. *Equestrian Statue of Can Grande della Scala,* from his tomb. 1330. Museum, Verona

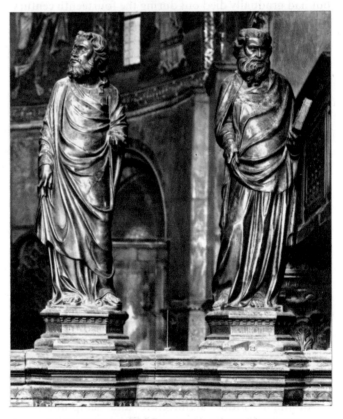

439. JACOBELLO and PIERPAOLO DALLE MASEGNE. *Apostles,* on the choir screen. 1394. Marble, height c. 53″. St. Mark's, Venice

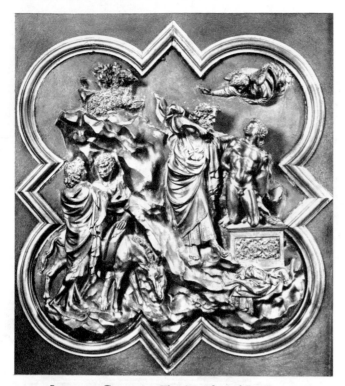

440. LORENZO GHIBERTI. *The Sacrifice of Isaac.* 1401–02.
Gilt bronze, 21 × 17″. National Museum, Florence

himself thoroughly Italian in one respect: his admiration for ancient sculpture, as evidenced by the beautiful nude torso of Isaac. Here our artist revives a tradition of classicism that had reached its highest point in Nicola Pisano but had gradually died out during the fourteenth century. But Ghiberti is also the heir of Giovanni Pisano. In the latter's *Nativity* panel (fig. 434) we noted a bold new emphasis on the spatial setting; the trial relief carries this same tendency a good deal further, achieving a far more natural sense of recession. For the first time since classical antiquity, we are made to experience the background of the panel not as a flat surface but as empty space from which the sculptured forms emerge toward the beholder (note particularly the angel in the upper right-hand corner). This "pictorial" quality relates Ghiberti's work to the painting of the International Style, where we find a similar concern with spatial depth and atmosphere (see below, page 338). While not a revolutionary himself, he prepares the ground for the great revolution that will mark the second decade of the fifteenth century in Florentine art and that we call the Early Renaissance.

PAINTING

FRANCE: STAINED GLASS; MANUSCRIPTS

Although Gothic architecture and sculpture began so dramatically at St.-Denis and Chartres, Gothic painting developed at a rather slow pace in its early stages. The new architectural style sponsored by Abbot Suger gave

birth to a new conception of monumental sculpture almost at once but did not demand any radical change of style in painting. Suger's account of the rebuilding of his church, to be sure, places a great deal of emphasis on the miraculous effect of stained-glass windows, whose "continuous light" flooded the interior. Stained glass was thus an integral element of Gothic architecture from the very beginning. Yet the technique of stained-glass painting had already been perfected in Romanesque times; the "many masters from different regions" whom Suger assembled to do the choir windows at St.-Denis may have faced a larger task and a more complex pictorial program than before, but the style of their designs remained Romanesque.

During the next half-century, as Gothic structures became ever more skeletal and clerestory windows grew to vast size, stained glass displaced manuscript illumination as the leading form of painting. Since the production of stained glass was so intimately linked with the great cathedral workshops, the designers came to be influenced more and more by architectural sculpture, and in this way, about the year 1200, arrived at a distinctively Gothic style of their own. The majestic *Habakkuk* (fig. 441) of Bourges Cathedral, one of a series of windows representing Old Testament prophets, is the direct kin of the jamb statues on the Chartres transept portals and of the Visitation group at Reims. All these works share a common ancestor, the classicizing style of Nicholas of Verdun (compare fig. 383), yet the *Habakkuk* resembles a statue projected onto a translucent screen rather than an enlarged figure from the enamel plaques of the Klosterneuburg altar. Examining one of the sections of the stained glass at close range (fig. 442), we realize that the window consists not of large panes but of hundreds of small pieces of tinted glass bound together by strips of lead. The maximum size of these pieces was severely limited by the primitive methods of medieval glass manufacture, so that the artist who created this window could not simply "paint on glass"; rather, he painted *with* glass, assembling his design, somewhat the way one would a mosaic or a jigsaw puzzle, out of odd-shaped fragments which he cut to fit the contours of the forms. Only the finer details, such as eyes, hair, and drapery folds, were added by actually painting—or, better perhaps, drawing—in black or gray on the glass surfaces. While this process encourages an abstract, ornamental style, it tends to resist any attempt to render three-dimensional effects. Yet in the hands of a great master the maze of lead strips could resolve itself into figures of the looming monumentality of our *Habakkuk*.

Apart from the peculiar demands of their medium, the stained-glass workers who filled the windows of the great Gothic cathedrals also had to face the difficulties arising from the enormous scale of their work. No Romanesque painter had ever been called upon to cover areas so vast —the *Habakkuk* window is more than 14 feet tall—or so firmly bound into an architectural framework. The task

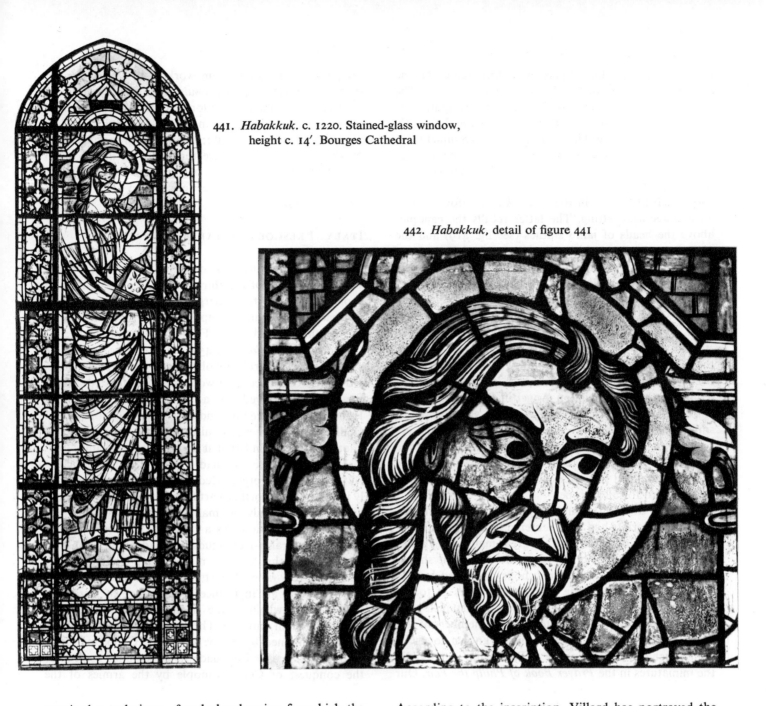

441. *Habakkuk.* c. 1220. Stained-glass window,
height c. 14'. Bourges Cathedral

442. *Habakkuk,* detail of figure 441

required a technique of orderly planning for which the medieval painting tradition could offer no precedent. Only architects and stone masons knew how to deal with this problem, and it was their methods that the stained-glass workers borrowed in mapping out their own compositions. Gothic architectural design, as we recall from our discussion of the choir of St.-Denis (see figs. 384, 385), is a system of geometric relationships; the same rules could be used to control the design of a stained-glass window, or even of an individual figure. We gain some insight into this procedure from the drawings in a notebook compiled about 1240 by the architect Villard de Honnecourt, such as the *Wheel of Fortune* (fig. 443). What we see here is not the final version of the design but the scaffolding of circles and triangles on which the image is to be constructed. The pervasiveness of these geometric schemes is well illustrated by another drawing from the same notebook, the *Front View of a Lion* (fig. 444).

According to the inscription, Villard has portrayed the animal from life, but a closer look at the figure will convince us that he was able to do so only after he had laid down a geometric pattern: a circle for the face (the dot between the eyes is its center) and a second, larger circle for the body. To Villard, then, drawing from life meant something far different from what it does to us—it meant filling in an abstract framework with details based on direct observation. If we now turn back once more to the firmly drawn, simplified outlines of the *Habakkuk,* we cannot help wondering to what extent they, too, reflect a geometric scaffolding of some sort.

The period 1200–50 might be termed the Golden Age of stained glass. After that, as architectural activity declined and the demand for stained glass began to slacken, manuscript illumination gradually recaptured its former position of leadership. By then, however, miniature painting had been thoroughly affected by the

influence of both stained glass and stone sculpture, the artistic pacemakers of the first half of the century. The resulting change of style is fully evident in figure 445, from a Psalter done about 1260 for King Louis IX (St. Louis) of France. The scene illustrates I Samuel 11:2, in which Nahash the Ammonite threatens the Jews at Jabesh. We notice first of all the careful symmetry of the framework, which consists of flat, ornamented panels very much like those in the *Habakkuk* window, and of an architectural setting. The latter recalls the canopies above the heads of jamb statues (see fig. 419) and the arched twin niches enclosing the relief of *Melchizedek and Abraham* at Reims (fig. 422). Against this emphatically two-dimensional background, the figures are "relieved" by smooth and skillful modeling. But their sculptural quality stops short at the outer contours, which are defined by heavy dark lines rather like the lead strips in stained-glass windows. The figures themselves show all the characteristics of the elegant style originated about twenty years before by the sculptors of the royal court (compare the Annunciation Angel in fig. 421 and Melchizedek in fig. 422): graceful gestures, swaying poses, smiling faces, neatly waved strands of hair. Of the expressive energy of Romanesque painting we find not the slightest trace. Instead, our miniature exemplifies the subtle and refined taste that made the court art of Paris the standard for all Europe.

Until the thirteenth century, the production of illuminated manuscripts had been centered in the scriptoria of monasteries. Now, along with a great many other activities once the special preserve of the monks, it shifted more and more to urban workshops organized by laymen, the ancestors of the publishing houses of today. Here again the workshops of sculptors and stained-glass painters may have set the pattern. Some members of this new, secular breed of illuminator are known to us by name, such as Master Honoré of Paris who, in 1295, did the miniatures in the *Prayer Book of Philip the Fair*. Our

sample (fig. 446) shows him working in a style derived from the *Psalter of St. Louis*. Significantly enough, however, the framework no longer dominates the composition; the figures have become larger, and their relief-like modeling is more emphatic; they are even permitted to overlap the frame, a device that helps to detach them from the flat pattern of the background and thus introduces a certain—though as yet very limited—spatial range into the picture.

ITALY: FRESCOES; ALTAR PANELS

We must now turn our attention to Italian painting, which at the end of the thirteenth century produced an explosion of creative energy as spectacular, and as far-reaching in its impact upon the future, as the rise of the Gothic cathedral in France. A single glance at Giotto's *Lamentation* (fig. 450) will convince us that we are faced with a truly revolutionary development here. How, we wonder, could a work of such intense dramatic power be conceived by a contemporary of Master Honoré? What were the conditions that made it possible? Oddly enough, as we inquire into the background of Giotto's art, we find that it arose from the same "old-fashioned" attitudes we had met in Italian Gothic architecture and sculpture. Medieval Italy, although strongly influenced by Northern art from Carolingian times on, nevertheless had always maintained close contact with Byzantine civilization. As a result, panel painting, mosaics, and murals—techniques that had never taken firm root north of the Alps—were kept alive on Italian soil; and at the very time when stained glass became the dominant pictorial art in France, a new wave of Byzantine influence overwhelmed the lingering Romanesque elements in Italian painting. There is a certain irony in the fact that this neo-Byzantine style (or "Greek manner," as the Italians called it) made its appearance soon after the conquest of Constantinople by the armies of the

right: 443. VILLARD DE HONNECOURT. *Wheel of Fortune.* c. 1240. Bibliothèque Nationale, Paris

far right:
444. VILLARD DE HONNECOURT. *Front View of a Lion.* c. 1240. Bibliothèque Nationale, Paris

445. *Nahash the Ammonite Threatening the Jews at Jabesh,* from the *Psalter of St. Louis.* c. 1260. Bibliothèque Nationale, Paris

446. MASTER HONORÉ. *David and Goliath,* from the *Prayer Book of Philip the Fair.* 1295. Bibliothèque Nationale, Paris

Fourth Crusade in 1204—one thinks of the way Greek art had once captured the taste of the victorious Romans of old. Be that as it may, the Greek manner prevailed almost till the end of the thirteenth century, so that Italian painters were able to absorb the Byzantine tradition far more thoroughly than ever before. During this same period, we recall, Italian architects and sculptors followed a very different course; untouched by the Greek manner, they were assimilating the Gothic style. Eventually, toward 1300, Gothic influence spilled over into painting as well, and it was the interaction of this element with the neo-Byzantine that produced the revolutionary new style of which Giotto is the greatest exponent.

Cimabue; Duccio

Among the painters of the Greek manner, the Florentine master Cimabue, who may have been Giotto's teacher, enjoyed particular fame. His impressive altar panel of the Madonna Enthroned (fig. 447) rivals the finest Byzantine icons or mosaics (compare fig. 303 and colorplate 25); what distinguishes it from them is mainly a greater severity of design and expression, which befits its huge size. Panels on such a monumental scale had never been attempted in the East. Equally un-Byzantine is the gabled shape of the picture, and the way the throne of inlaid wood seems to echo this shape. The geometric inlays—indeed, the architectural style of the throne—will remind us of the Baptistery in Florence (see fig. 367). Another *Madonna Enthroned* (fig. 448), painted a quarter of

a century later by Duccio of Siena for the main altar of Siena Cathedral, makes an instructive comparison with Cimabue's work. The Sienese honored this panel by calling it the *Maestà*—"majesty"—to identify the Virgin's role here as the Queen of Heaven surrounded by her celestial court of saints and angels. At first glance, the two pictures may seem much alike, since both follow the same basic scheme; yet the differences are important. They reflect not only two contrasting personalities and contrasting local tastes—the gentleness of Duccio is characteristic of Siena—but also the rapid evolution of style. In Duccio's hands the Greek manner has become unfrozen, as it were: the rigid, angular draperies have given way to an undulating softness, the abstract shading-in-reverse with lines of gold is reduced to a minimum, and the bodies, faces, and hands are beginning to swell with a subtle three-dimensional life. Clearly, the heritage of Hellenistic-Roman illusionism that had always been part of the Byzantine tradition, however dormant or submerged, is asserting itself once more. But there is also a half-hidden Gothic element here; we sense it in the fluency of the drapery folds, the appealing naturalness of the Infant Christ, and the tender glances by which the figures communicate with each other. The chief source of this Gothic influence must have been Giovanni Pisano, who spent the decade 1285–95 in Siena as the sculptor-architect in charge of the cathedral façade.

Apart from the *Madonna,* the *Maestà* includes many small compartments with scenes from the lives of Christ and the Virgin. In these panels, the most mature works

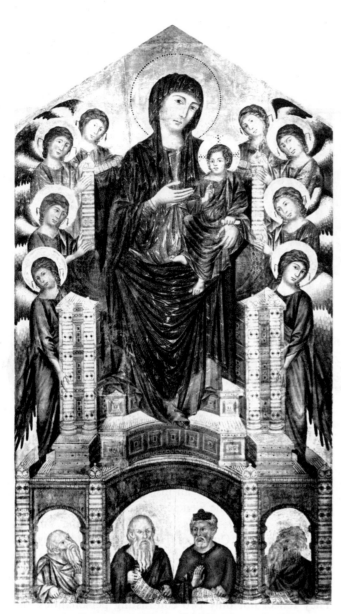

447. CIMABUE. *Madonna Enthroned.* c. 1280–90.
Panel, 12′ 7 1/2″ × 7′ 4″. Uffizi Gallery, Florence

of Duccio's career, the cross-fertilization of Gothic and
Byzantine elements has given rise to a development of
fundamental importance—a new kind of picture space.
The *Annunciation of the Death of the Virgin* (fig. 449)
shows us something we have never seen before in the
history of painting: two figures enclosed by an architec-
tural interior. Ancient painters (and their Byzantine suc-
cessors) had been quite unable to achieve this; their ar-
chitectural settings always stay *behind* the figures, so that
their indoor scenes tend to look as if they were taking
place in an open-air theater, on a stage without a roof.
Duccio's figures, in contrast, inhabit a space that is
created and defined by the architecture, as if the artist
had carved a niche into his panel. Perhaps we will rec-
ognize the origin of this spatial framework: it derives
from the architectural "housing" of Gothic sculpture
(compare especially figs. 422, 426). Northern Gothic
painters, too, had tried to reproduce these architectural
settings, but they could do so only by flattening them out
completely (as in the *Psalter of St. Louis,* fig. 445). The

Italian painters of Duccio's generation, on the other
hand, trained as they were in the Greek manner, had ac-
quired enough of the devices of Hellenistic-Roman illu-
sionism to let them render such a framework without
draining it of its three-dimensional qualities. Even in the
outdoor scenes on the back of the *Maestà,* such as *Christ
Entering Jerusalem* (colorplate 38), the architecture keeps
its space-creating function: the diagonal movement into
depth is conveyed not by the figures—which have the
same scale throughout—but by the walls on either side
of the road leading to the city, by the gate that frames
the welcoming crowd, and by the structures beyond.
Whatever the shortcomings of Duccio's perspective, his
architecture again demonstrates its capacity to contain
and enclose, and for that very reason strikes us as more
intelligible than similar vistas in ancient art (compare
fig. 260).

Giotto

As we turn from Duccio to Giotto, we meet an artist
of far bolder and more dramatic temper. Ten to fifteen
years younger, Giotto was less close to the Greek manner
from the start, despite his probable apprenticeship under
Cimabue. As a Florentine, he fell heir to Cimabue's sense
of monumental scale, which made him a wall painter by
instinct, rather than a panel painter. Of his surviving

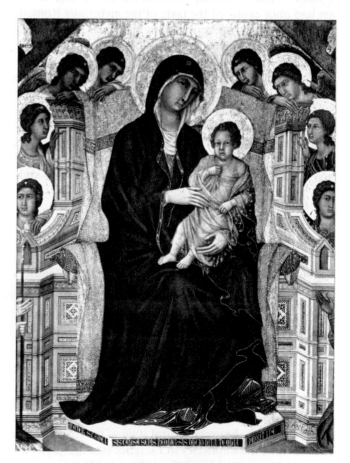

448. DUCCIO. *Madonna Enthroned,* center of
front panel of the *Maestà Altar.* 1308–11. Panel,
height 6′ 10 1/2″. Cathedral Museum, Siena

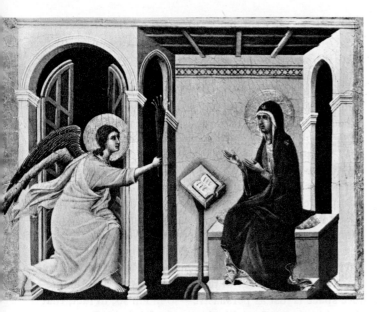

449. DUCCIO. *Annunciation of the Death of the Virgin,* from the *Maestà Altar*

murals, those in the Arena Chapel, Padua, done in 1305–6, are the best preserved as well as the most characteristic. They include many of the same subjects that we find on the reverse of Duccio's *Maestà,* such as *Christ Entering Jerusalem* (colorplate 39). The two versions have many elements in common, since they both ultimately derive from the same Byzantine source; but where Duccio has enriched the traditional scheme, spatially as well as in narrative detail, Giotto subjects it to a radical simplification. The action proceeds parallel to the picture plane; landscape, architecture, and figures have been reduced to the essential minimum. And the sober technique of fresco painting (watercolors applied to the freshly plastered wall), with its limited range and intensity of tones, further emphasizes the austere quality of Giotto, as against the jewel-like brilliance of Duccio's picture, which is executed in egg tempera on gold ground. (Colorplate 40, although of somewhat later date, may help us to visualize the sparkling colors of the *Maestà* panel.) Yet Giotto's work has by far the more powerful impact of the two; it makes us feel so close to the event that we have a sense of being participants rather than distant observers. How does the artist achieve this extraordinary effect? He does so, first of all, by having the entire scene take place in the foreground and—even more important—by presenting it in such a way that the beholder's eye-level falls within the lower half of the picture. Thus we can imagine ourselves standing on the same ground plane as the painted figures, while Duccio makes us survey the scene from above in bird's-eye perspective. The consequences of this choice of viewpoint are truly epoch-making; choice implies conscious awareness—in our case, awareness of a relationship in space between the beholder and the picture—and Giotto may well claim to be the first to have established such a relationship. Duccio, certainly, does not yet conceive his picture space as continuous with the beholder's space

(hence we have the sensation of vaguely floating above the scene, rather than of knowing where we stand), and even ancient painting at its most illusionistic provides no more than a pseudo-continuity in this respect (see the previous discussion of figs. 259–61). Giotto, on the other hand, tells us where we stand, and he also endows his forms with a three-dimensional reality so forceful that they seem as solid and tangible as sculpture in the round. With him it is the figures, rather than the architectural framework, that create the picture space. As a result, this space is more limited than Duccio's—its depth extends no further than the combined volumes of the overlapping bodies in the picture—but within its limits it is very much more persuasive. To his contemporaries, the tactile quality of Giotto's art must have seemed a near-miracle; it was this that made them praise him as equal, or even superior, to the greatest of the ancient painters, because his forms looked so lifelike that they could be mistaken for reality itself. Equally significant are the stories linking Giotto with the claim that painting is superior to sculpture—not an idle boast, as it turned out, for Giotto does indeed mark the start of what might be called "the era of painting" in Western art. The symbolic turning point is the year 1334, when he was appointed the head of the Florence Cathedral workshop, an honor and responsibility hitherto reserved for architects or sculptors.

Yet Giotto's aim was not simply to transplant Gothic statuary into painting. By creating a radically new kind of picture space, he had also sharpened his awareness of the picture surface. When we look at a work by Duccio (or his ancient and medieval predecessors) we tend to do so in installments, as it were; our glance travels from detail to detail at a leisurely pace until we have surveyed the entire area. Giotto, on the contrary, invites us to see the whole at one glance. His large, simple forms, the strong grouping of his figures, the limited depth of his "stage," all these factors help to endow his scenes with an inner coherence such as we have never found before. Notice how dramatically the massed verticals of the "block" of apostles on the left are contrasted with the upward slope formed by the welcoming crowd on the right; how Christ, alone in the center, bridges the gulf between the two groups. The more we study the composition, the more we come to realize its majestic firmness and clarity. But Giotto's achievement as a master of design does not fully emerge from any single work. Only if we compare a number of scenes from the Padua fresco cycle do we understand how perfectly the composition in each instance is attuned to the emotional content of the subject. Thus the artist has "rephrased" the traditional pattern of Christ's Entry into Jerusalem to stress the solemnity of the event as a triumphal procession of the Prince of Peace, while the tragic mood of the *Lamentation* (fig. 450) is brought home to us by the formal rhythm of the design as much as by the gestures and expressions of the participants. The very low center of gravity, the hunched, bending figures com-

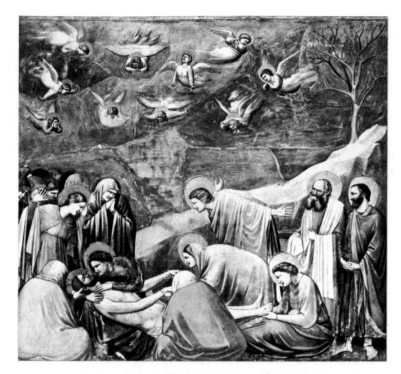

450. GIOTTO. *The Lamentation.* 1305–6.
Fresco. Arena Chapel, Padua

municate the somber quality of the scene and arouse our
compassion even before we have grasped the specific
meaning of the event depicted. With extraordinary bold-
ness, Giotto sets off the frozen grief of the human mourn-
ers against the frantic movement of the weeping angels
among the clouds, as if the figures on the ground were
restrained by their collective duty to maintain the stabil-
ity of the composition while the angels, small and weight-
less as birds, do not share this burden. Let us note, too,
how the impact of the drama is heightened by the severely
simple setting; the descending slope of the hill acts as a
unifying element and at the same time directs our glance
toward the heads of Christ and the Virgin, which are the
focal point of the scene. Even the tree has a twin func-
tion. Its barrenness and isolation suggest that all of
nature somehow shares in the Saviour's death, yet it
also invites us to ponder a more precise symbolic mes-
sage. For it alludes—as does Dante in a passage in the
Divine Comedy—to the Tree of Knowledge, which the sin
of Adam and Eve had caused to wither and which was
to be restored to life through the sacrificial death of Christ.

The art of Giotto is so daringly original that its sources
are far more difficult to trace than those of Duccio's style.
Apart from his Florentine background as represented by
the Greek manner of Cimabue, the young Giotto
seems to have been familiar with the neo-Byzantine
painters of Rome; in that city, he probably also became
acquainted with older monuments—Early Christian and
ancient Roman mural decoration. Classical sculpture,
too, left an impression on him. More fundamental than
any of these, however, was the influence of the Pisanos
—Nicola, and especially Giovanni—the founding fathers
of Italian Gothic sculpture. They were the chief inter-

mediaries through whom Giotto first came in contact
with the world of northern Gothic art. And the latter
remains the most important of all the elements that
entered into Giotto's style. Without the knowledge,
direct or indirect, of Northern works such as those illus-
trated in figure 420 or figure 427, he could never have
achieved the emotional impact of his *Lamentation*.

What we have said of the Padua frescoes applies
equally to the *Madonna Enthroned* (fig. 451), the most
important among the small number of panel paintings by
our master. Done about the same time as Duccio's
Maestà, it illustrates once again the difference between
Florence and Siena; its architectural severity clearly de-
rives from Cimabue (see fig. 447). The figures, however,
have the same overpowering sense of weight and volume
we saw in the frescoes in the Arena Chapel, and the pic-
ture space is just as persuasive—so much so, in fact, that
the golden haloes look like foreign bodies in it. Character-
istically enough, the throne, of a design based on Italian
Gothic architecture, has become a niche-like structure
that encloses the Madonna on three sides and thus
"insulates" her from the gold background. Its lavish
ornamentation includes one feature of special interest:

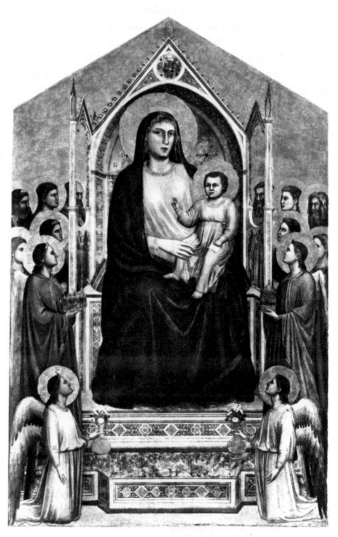

451. GIOTTO. *Madonna Enthroned.* c. 1310.
Panel, 10' 8" × 6' 8". Uffizi Gallery, Florence

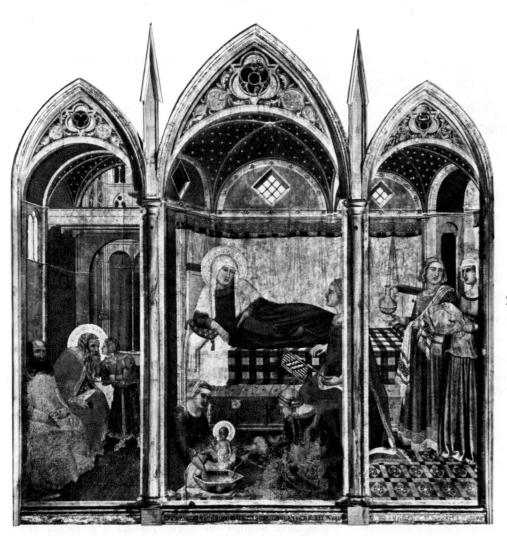

452. PIETRO LORENZETTI.
The Birth of the Virgin. 1342.
Panel, 6′ 1 1/2″ × 5′ 11 1/2″.
Cathedral Museum, Siena

the colored marble surfaces of the base and of the quatre-foil within the gable. Such make-believe stone textures had been highly developed by ancient painters (see figs. 259 and 260, and colorplate 19), but the tradition had died out in Early Christian times. Its sudden re-appearance here offers concrete evidence of Giotto's familiarity with whatever ancient murals could still be seen in medieval Rome.

Simone Martini; the Lorenzetti Brothers

There are few men in the entire history of art to equal the stature of Giotto as a radical innovator. His very greatness, however, tended to dwarf the next generation of Florentine painters, which produced only followers rather than new leaders. Their contemporaries in Siena were more fortunate in this respect, since Duccio never had the same overpowering impact. As a consequence, it was they, not the Florentines, who took the next decisive step in the development of Italian Gothic paint-ing. Simone Martini, who painted the tiny but intense *Road to Calvary* (colorplate 40) about 1340, may well claim to be the most distinguished of Duccio's disciples. He spent the last years of his life in Avignon, the town in southern France that served as the residence-in-exile of the popes during most of the fourteenth century. Our

panel, originally part of a small altar, was probably done there. In its sparkling colors, and especially in the archi-tectural background, it still echoes the art of Duccio (see colorplate 38). The vigorous modeling of the figures, on the other hand, as well as their dramatic gestures and expressions, betray the influence of Giotto. While Simone Martini is not much concerned with spatial clarity, he proves to be an extraordinarily acute observer; the sheer variety of costumes and physical types, the wealth of human incident, create a sense of down-to-earth reality very different from both the lyricism of Duccio and the grandeur of Giotto. This closeness to everyday life also appears in the work of the brothers Pietro and Ambrogio Lorenzetti, but on a more monumental scale and coupled with a keen interest in problems of space. The boldest spatial experiment is Pietro's triptych of 1342, *The Birth of the Virgin* (fig. 452), where the painted architec-ture has been correlated with the real architecture of the frame in such a way that the two are seen as a single system. Moreover, the vaulted chamber where the birth takes place occupies two panels—it continues unbroken behind the column that divides the center from the right wing. The left wing represents an anteroom which leads to a vast and only partially glimpsed architectural space suggesting the interior of a Gothic church. What Pietro Lorenzetti achieved here is the outcome of a develop-

453. AMBROGIO LORENZETTI. *Good Government in the Country*
(detail). 1338–40. Fresco (see colorplate 41,
Good Government in the City). Palazzo Pubblico, Siena

ment that began three decades earlier in the work of
Duccio (compare fig. 449), but only now does the picture
surface assume the quality of a transparent window
through which—not *on* which—we perceive the same
kind of space we know from daily experience. Yet Duccio's
work alone is not sufficient to explain Pietro's astonish-
ing breakthrough; it became possible, rather, through
a combination of the *architectural* picture space of Duc-
cio and the *sculptural* picture space of Giotto. The same
procedure enabled Ambrogio Lorenzetti, in his frescoes
of 1338–40 in the Siena city hall, to unfold a com-
prehensive view of the entire town before our eyes
(colorplate 41). Again we marvel at the distance that
separates this precisely articulated "portrait" of Siena
from Duccio's Jerusalem (see colorplate 38). Ambro-
gio's mural forms part of an elaborate allegorical pro-
gram depicting the contrast of good and bad govern-
ment; hence the artist, in order to show the life of a
well-ordered city-state, had to fill the streets and houses
with teeming activity. The gay and busy crowd gives
the architectural vista its striking reality by introducing
the human scale. On the right, beyond the margin of col-
orplate 41, the *Good Government* fresco provides a view
of the Sienese countryside, fringed by distant mountains.
It is a true landscape—the first since ancient Roman
times—full of sweeping depth yet distinguished from its
classical predecessors (such as colorplate 17) by an in-
grained orderliness, a domesticated air. Here the pres-
ence of man is not accidental; he has taken full posses-
sion of nature, terracing the hillsides with vineyards,
patterning the valleys with the geometry of fields and
pastures. In such a setting, Ambrogio observes the peas-
ants at their seasonal labors (fig. 453), recording a rural

Tuscan scene so characteristic that it has hardly changed
during the past six hundred years.

The Black Death; Traini

The first four decades of the fourteenth century in
Florence and Siena had been a period of political sta-
bility and economic expansion as well as of great artistic
achievement. In the 1340s both cities suffered a series of
catastrophes whose echoes were to be felt for many
years: banks and merchants went bankrupt by the score,
internal upheavals shook the government, there were
repeated crop failures, and in 1348 an epidemic of
bubonic plague, the Black Death, wiped out more
than half the urban population. The popular reaction to
these calamitous events was mixed. Many people
regarded them as signs of Divine wrath, warnings to a
sinful humanity to forsake the pleasures of this earth;
in such people the Black Death engendered a mood of
otherworldly exaltation. To others, such as the gay com-
pany in Boccaccio's *Decameron,* the fear of sudden
death merely intensified the desire to enjoy life while
there was yet time. These conflicting attitudes are reflect-
ed in a new pictorial theme, The Triumph of Death.
The most impressive version of this subject is an enor-
mous fresco in the Camposanto, the cemetery building
next to Pisa Cathedral. From this work, attributed to the
Pisan master Francesco Traini, we reproduce a partic-
ularly dramatic detail (fig. 454). The elegantly costumed
men and women on horseback have suddenly come
upon three decaying corpses in open coffins; even the
animals are terrified by the sight and smell of rotting
flesh. Only the hermit, having renounced all earthly
pleasures, calmly points out the lesson of the scene. But
will the living accept the lesson, or will they, like the
characters of Boccaccio, turn away from the shocking
spectacle more determined than ever to pursue their own
hedonistic ways? The artist's own sympathies seem
curiously divided; his style, far from being otherworldly,
recalls the realism of Ambrogio Lorenzetti, although the
forms are harsher and more expressive.

In a fire which occurred in 1944, Traini's fresco was
badly damaged and had to be detached from the wall in
order to save what was left of it. This procedure exposed
the first, rough coat of plaster underneath, on which the
artist had sketched out his composition (fig. 455). These
drawings, of the same size as the fresco itself, are done
in red, hence they are called *sinopie* (an Italian word
derived from ancient Sinope in Asia Minor, which was
famous as a source of brick-red earth pigment); amaz-
ingly free and sweeping, they reveal Traini's personal
style more directly than the painted version, which was
carried out with the aid of assistants. *Sinopie* also serve to
acquaint us with the standard technique of preparing
frescoes in the fourteenth century.

Traini still retains a strong link with the great masters
of the second quarter of the century. More characteristic

Colorplate 41. AMBROGIO LORENZETTI. *Good Government in the City.* 1338–40.
Fresco, width of entire wall 46′. Palazzo Pubblico, Siena

Colorplate 42. BOHEMIAN. *Death of the Virgin*. 1350–60.
Panel, 39 × 27³/₄″. Museum of Fine Arts, Boston

Colorplate 43. MELCHIOR BROEDERLAM. *The Presentation in the Temple and the Flight into Egypt.*
1394–99. Panel, 64 × 51″. Museum of Fine Arts, Dijon

Colorplate 44. THE LIMBOURG BROTHERS. *October,* from *Les Très Riches Heures du Duc de Berry.*
1413–16. Musée Condé, Chantilly, France

Colorplate 45. GENTILE DA FABRIANO. *The Adoration of the Magi.*
1423. Panel, 9′ 10⅛″ × 9′ 3″. Uffizi Gallery, Florence

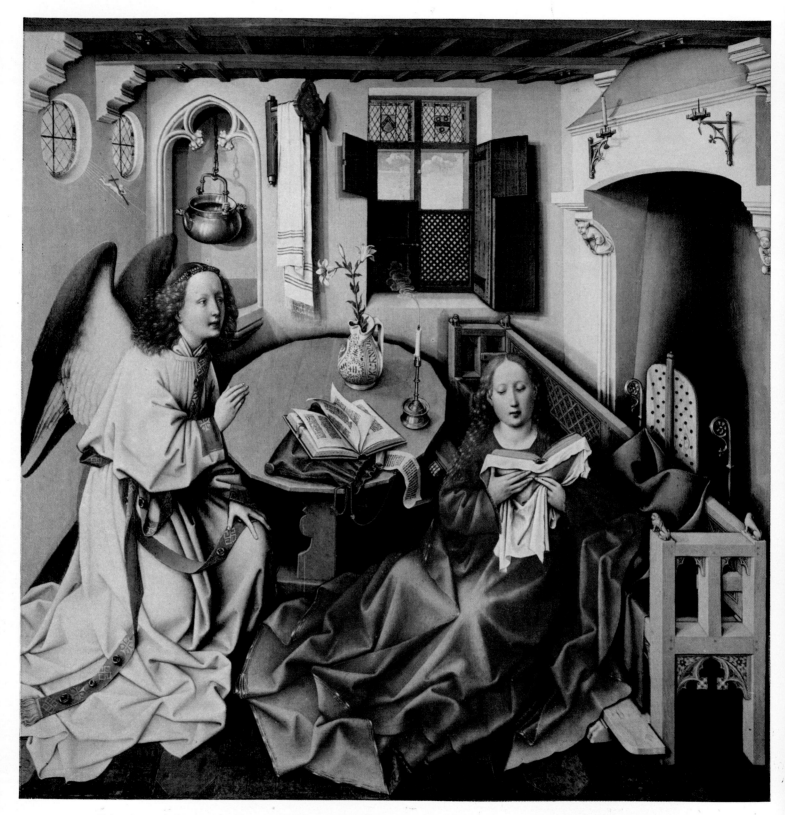

Colorplate 46. MASTER OF FLEMALLE (ROBERT CAMPIN?). *The Annunciation,* center panel of the *Merode Altarpiece.*
About 1425–28. Panel, 25¼ × 24⅞″. The Metropolitan Museum of Art, New York (The Cloisters Collection, Purchase)

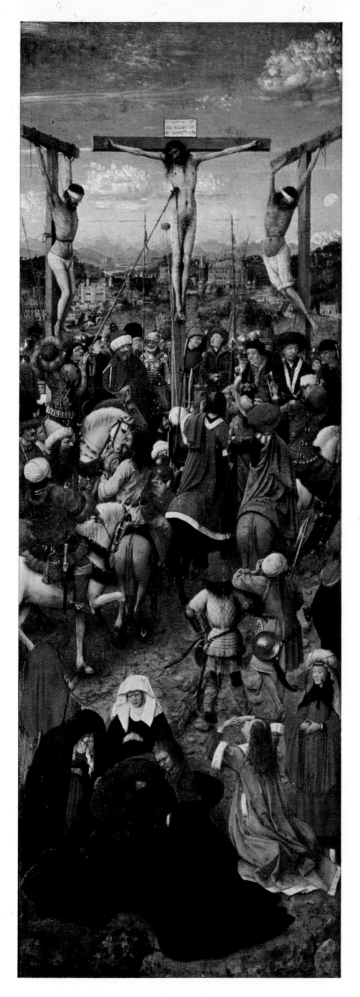 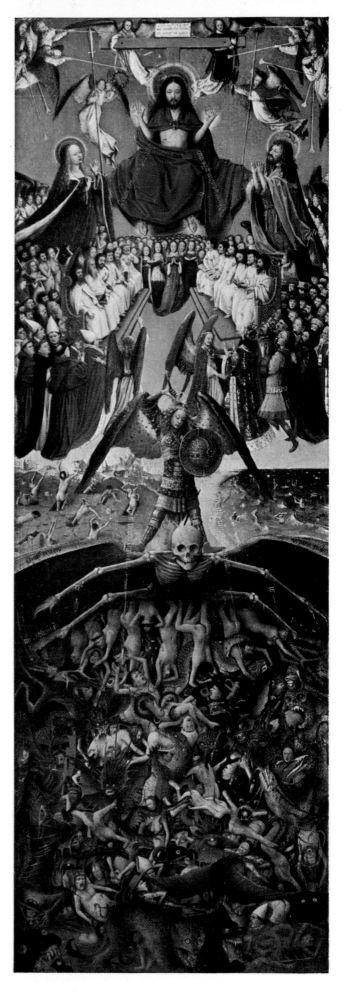

Colorplate 47. HUBERT and/or JAN VAN EYCK. *The Crucifixion; The Last Judgment.*
About 1420–25. Canvas transferred from panel, each panel 22 1/4 × 7 3/4".
The Metropolitan Museum of Art, New York (Fletcher Fund, 1933)

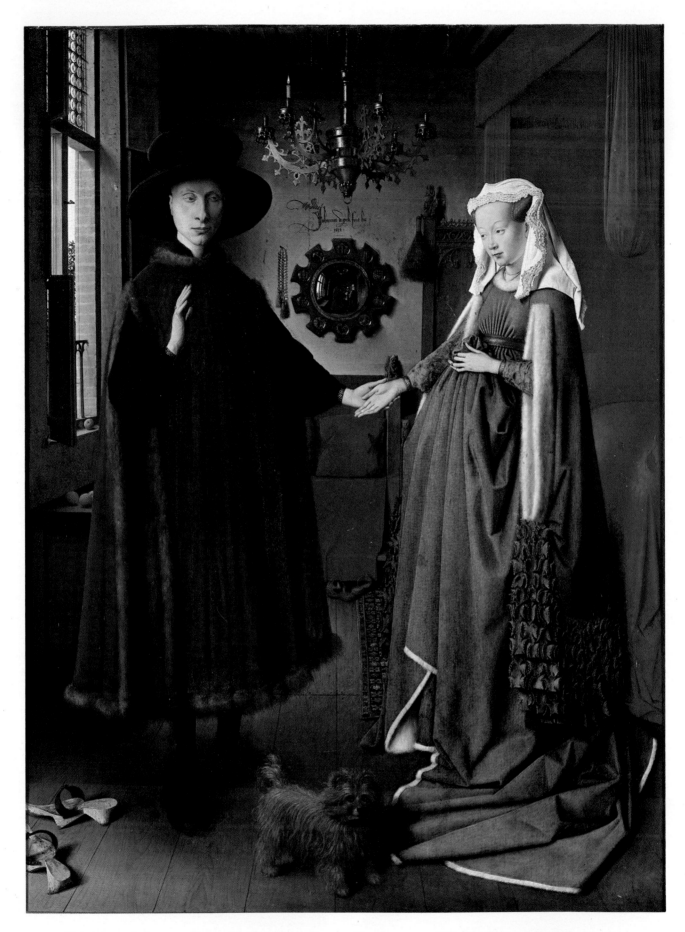

Colorplate 48. JAN VAN EYCK. *Wedding Portrait*. 1434. Panel, 33 × 22 1/2″. The National Gallery, London

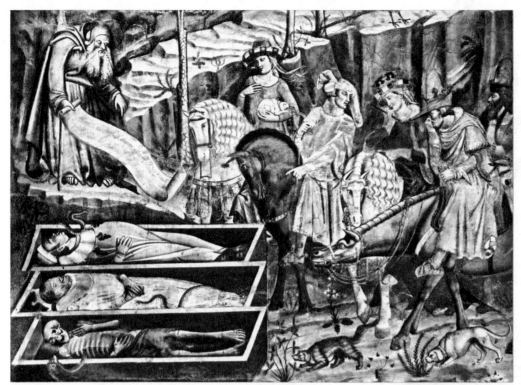

left: 454. FRANCESCO TRAINI.
The Triumph of Death (portion).
c. 1325–50. Fresco. Camposanto, Pisa

below: 455. FRANCESCO TRAINI.
"Sinopia" drawing for the
Triumph of Death (detail).
Camposanto, Pisa

of Tuscan painting after the Black Death are the artists who did not reach maturity until the 1350s. None of them can compare with the men whose work we have discussed; their style, in comparison, seems dry and formula-ridden. Yet they were capable, at their best, of expressing the somber mood of the time with memorable intensity. Giovanni da Milano's *Pietà* panel of 1365 (fig. 456) has all the emotional appeal of a German *Andachtsbild* (compare fig. 425), although the heritage of Giotto can be clearly felt even here.

NORTHERN GOTHIC

We are now in a position to turn once more to Gothic painting north of the Alps. What happened there during the latter half of the fourteenth century was determined in large measure by the influence of the great Italians. Some examples of this influence can be found even earlier, such as the *Annunciation* (fig. 457) from the private prayer book—called a "book of hours"—illuminated by Jean Pucelle in Paris about 1325–28 for Jeanne d'Evreux, queen of France. The style of the figures still recalls Master Honoré (see fig. 446) but the architectural interior clearly derives from Duccio (fig. 449). It had taken less than twenty years for the fame of the *Maestà* to spread from Tuscany to the Île-de-France. In taking over the new picture space, however, Jean Pucelle had to adapt it to the special character of a manuscript page, which lends itself far less readily than a panel to being treated as a "window." The Virgin's chamber no longer fills the entire picture surface; it has become an ethereal cage that floats on the blank parchment background (note the supporting angel on the right) like the rest of

the ornamental framework, so that the entire page forms a harmonious unit. As we explore the details of this framework, we realize that most of them have nothing to do with the religious purpose of the manuscript: the kneeling queen inside the initial D is surely meant to be Jeanne d'Evreux at her devotions, but who could be the man with the staff next to her? He seems to be listening to the lute player perched on the tendril above him. The

456. GIOVANNI DA MILANO. *Pietà*. 1365. Panel,
48 × 22 ³/₄". Academy, Florence

four figures at the bottom of the page are playing a game
of tag outdoors; a rabbit peers from its burrow beneath
the girl on the left, and among the foliage leading up to
the initial we find a monkey and a squirrel. These fanciful
marginal designs—or *drôleries*—are a characteristic fea-
ture of Northern Gothic manuscripts. They had originat-
ed more than a century before Jean Pucelle in the regions
along the English Channel, whence they spread to Paris
and all the other centers of Gothic art. Their subject
matter encompasses a vast range of motifs: fantasy,
fable, and grotesque humor, as well as acutely observed
scenes of everyday life, appear side by side with religious
themes. The essence of *drôlerie* is its playfulness, which
marks it as a special domain where the artist enjoys
almost unlimited freedom. It is this freedom, comparable
to the license traditionally claimed by the court jester,
that accounts for the wide appeal of *drôlerie* during the
later Middle Ages.

As we approach the middle years of the fourteenth
century, Italian influence becomes ever more important
in Northern Gothic painting. Sometimes this influence
was transmitted by Italian artists working on Northern
soil; an example is Simone Martini (see page 327). The
delightful frescoes with scenes of country life in the

Palace of the Popes at Avignon (fig. 458) were done by
one of his Italian followers, who must have been thor-
oughly familiar with the pioneer explorers of landscape
and deep space in Sienese painting. His work shows
many of the qualities we recall from the *Good Govern-
ment* fresco by Ambrogio Lorenzetti (see fig. 453). An-
other gateway of Italian influence was the city of Prague,
which in 1347 became the residence of Emperor Charles
IV and rapidly developed into an international cultural
center second only to Paris. The *Death of the Virgin*
(colorplate 42), by an unknown Bohemian painter of
about 1360, again brings to mind the achievements of
the great Sienese masters, although these were known to
our artist only at second or third hand. Its glowing rich-
ness of color recalls Simone Martini (compare color-
plate 40), and the carefully articulated architectural
interior betrays its descent from such works as Pietro
Lorenzetti's *Birth of the Virgin* (fig. 452), although it
lacks the spaciousness of its Italian models. Italian, too,
is the vigorous modeling of the heads and the overlap-
ping of the figures, which reinforces the three-dimen-
sional quality of the design but raises the awkward ques-
tion of what to do with the haloes. (Giotto, we will
remember, had faced the same problem in his *Madonna
Enthroned;* compare fig. 451.) Still, the Bohemian
master's picture is not a mere echo of Italian painting.
The gestures and facial expressions convey an intensity
of emotion that represents the finest heritage of Northern
Gothic art. In this respect, our panel is far more akin to
the *Death of the Virgin* at Strasbourg Cathedral (fig. 420)
than to any Italian work.

THE INTERNATIONAL STYLE

Toward the year 1400, the merging of Northern and
Italian traditions had given rise to a single dominant
style throughout western Europe. This International
Style was not confined to painting—we have used the
same term for the sculpture of the period—but painters
clearly played the main role in its development. Among
the most important was Melchior Broederlam, a Flem-
ing who worked for the court of the Duke of Burgundy
in Dijon. The panel shown in colorplate 43, one of a
pair of shutters for an altar shrine which he did in
1394–99, is really two pictures within a single frame; the
temple of the *Presentation* and the landscape of the
Flight into Egypt stand abruptly side by side, even
though the artist has made a half-hearted effort to per-
suade us that the landscape extends around the building.
Compared to Pietro and Ambrogio Lorenzetti, Broeder-
lam's picture space still strikes us as naïve in many
ways—the architecture looks like a doll's house, and the
details of the landscape are quite out of scale with the
figures. Yet the panel conveys a far stronger feeling of
depth than we have found in any previous Northern
work. The reason for this is the subtlety of the modeling;
the softly rounded shapes, the dark, velvety shadows

create a sense of light and air that more than makes up for any shortcomings of scale or perspective. The same soft, pictorial quality—a hallmark of the International Style—appears in the ample, loosely draped garments with their fluid curvilinear patterns of folds, which remind us of Sluter and Ghiberti (see figs. 431, 440). Our panel also exemplifies another characteristic of the International Style: its "realism of particulars," the same kind of realism we encountered first in Gothic sculpture (see fig. 424) and somewhat later among the marginal *drôleries* of manuscripts. We find it in the carefully rendered foliage and flowers, in the delightful donkey (obviously drawn from life), and in the rustic figure of St. Joseph, who looks and behaves like a simple peasant and thus helps to emphasize the delicate, aristocratic beauty of the Virgin. It is this painstaking concentration on detail that gives Broederlam's work the flavor of an enlarged miniature rather than of large-scale painting, even though the panel is more than five feet tall.

The Limbourg Brothers

That book illumination remained the leading form of painting in Northern Europe at the time of the International Style, despite the growing importance of panel painting, is well attested by the miniatures of the *Très Riches Heures du Duc de Berry*. Produced for the brother of the king of France, a man of far from admirable character but the most lavish art patron of his day, this luxurious book of hours represents the most advanced phase of the International Style. The artists were Pol de Limbourg and his two brothers, a group of Flemings

457. JEAN PUCELLE. *The Annunciation*, from the *Hours of Jeanne d'Evreux* (slightly enlarged). 1325–28. The Metropolitan Museum of Art, New York (The Cloisters Collection, Purchase, 1954)

458. Italian Follower of SIMONE MARTINI (MATTEO GIOVANNETTI?). *Scenes of Country Life* (detail). c. 1345. Fresco. Palace of the Popes, Avignon

left: 459. THE LIMBOURG BROTHERS. *February,* from *Les Très Riches Heures du Duc de Berry.* 1413–16. Musée Condé, Chantilly, France

below: 460. THE LIMBOURG BROTHERS. *January,* from *Les Très Riches Heures du Duc de Berry*

who, like Sluter and Broederlam, had settled in France. They must have visited Italy as well, for their work includes a great number of motifs and whole compositions borrowed from the great masters of Tuscany. The most remarkable pages of the *Très Riches Heures* are those of the calendar, with their elaborate depiction of the life of man and nature throughout the months of the year. Such cycles, originally consisting of twelve single figures each performing an appropriate seasonal activity, had long been an established tradition in medieval art (compare fig. 424). Jean Pucelle had enriched the margins of the calendar pages of his books of hours by emphasizing the changing aspects of nature in addition to the labors of the months. The Limbourg brothers, however, integrated all these elements into a series of panoramas of human life *in* nature. Thus the February miniature (fig. 459), the earliest snow landscape in the history of Western art, gives an enchantingly lyrical account of village life in the dead of winter, with the sheep huddled together in their fold, birds hungrily scratching in the barnyard, and a maid blowing on her frostbitten hands as she hurries to join her companions in the warm cottage (the front wall has been omitted for our benefit), while in the middle distance we see a villager cutting branches for firewood and another driving his laden donkey toward the houses among the hills. Here the promise of the Broederlam panel has been fulfilled, as it were: landscape, architectural interiors and exteriors are harmoniously united in deep, atmospheric space. Even such intangible, evanescent things as the frozen breath of the maid, the smoke curling from the chimney, and the clouds in the sky have become "paintable."

Our colorplate 44 shows the sowing of winter grain during the month of October. It is a bright, sunny day, and the foreground figures—for the first time since classical antiquity—cast visible shadows on the ground. Once more we marvel at the wealth of realistic detail such as the scarecrow in the middle distance or the footprints of the sower in the soil of the freshly plowed field. That sower is memorable in other ways as well; his tattered clothing, his unhappy mien, go beyond mere description. He is meant to be a pathetic figure, to arouse our awareness of the miserable lot of the peasantry in contrast to the life of the aristocracy, as symbolized by the splendid castle on the far bank of the river. (The castle, we will recall, is a "portrait" of the Gothic Louvre, the most lavish structure of its kind at that time; see page 298.)

Several of the calendar pages are devoted to the life of the nobility. The most interesting perhaps is the January picture, the only interior scene of the group, which shows the Duke of Berry at a banquet (fig. 460). He is seated next to a huge fireplace, with a screen to protect him and incidentally to act as a kind of secular halo that sets him off against the multitude of courtiers and attendants. His features, known to us also from other works

of the period, have all the distinctive qualities of a fine portrait, but the rest of the crowd—except for the youth and the cleric on the Duke's right—displays an odd lack of individuality. They are all of the same type, in face as well as stature: aristocratic mannequins whose superhuman slenderness brings to mind their feminine counterparts in the fashion magazines of our own day. They are differentiated only by the luxuriance and variety of their clothing. Surely the gulf between them and the melancholy peasant of the October miniature could not have been greater in real life than it appears in these pictures!

Gentile da Fabriano

From the courtly throng of the January page it is but a step to the three Magi and their train in the altarpiece by Gentile da Fabriano, the greatest Italian painter of the International Style (colorplate 45). The costumes here are as colorful, the draperies as ample and softly rounded, as in the North. The Holy Family on the left almost seems in danger of being overwhelmed by the gay and festive pageant pouring down upon it from the hills in the distance. Again we admire the marvelously well-observed animals, which now include not only the familiar ones but hunting leopards, camels, and monkeys. (Such creatures were eagerly collected by the princes of the period, many of whom kept private zoos.) The Oriental background of the Magi is further emphasized by the Mongolian facial cast of some of their companions. It is not these exotic touches, however, that mark our picture as the work of an Italian master but something else, a greater sense of weight, of physical substance, than we could hope to find among the Northern representatives of the International Style. Gentile, despite his love of fine detail, is obviously a painter used to working on a monumental scale, rather than a manuscript illuminator at heart. Yet he, too, commanded the delicate pictorial effects of a miniaturist, as we can see if we turn to the small panels decorating the base, or predella, of his altarpiece. In the *Nativity* (fig. 461) the new awareness of light that we first observed in the October page of the *Très Riches Heures*—light as an independent factor, separate from form and color—dominates the entire picture. Even though the main sources of illumination are the divine radiance of the newborn Child ("the light of the world") and of the angel bringing the glad tidings to the shepherds in the fields, their effect is as natural—note the strong cast shadows—as if the Virgin were kneeling by a campfire. The poetic intimacy of this night scene opens up a whole new world of artistic possibilities, possibilities that were not to be fully explored until two centuries later.

461. GENTILE DA FABRIANO. *The Nativity* (predella panel of the altarpiece shown in colorplate 45). 1423. 12 1/4 × 29 1/2". Uffizi Gallery, Florence

ILLUSTRATED TIME CHART II

600

Mohammed (570–632)

Omayyad caliphs (Damascus) 661–750

Moslems invade Spain 711–718; defeated by Franks, battle of Tours 732

Abbasid caliphate (Baghdad) begins 750

St. Boniface (died 755) converts Germans

Pepin the Short crowned king of Franks by St. Boniface 751, reconfirmed by Pope 754; conquers Ravenna and donates it to papacy 756; Pope becomes temporal ruler

Independent Moslem state established in Spain 756

Earliest cast iron in China

Porcelain invented in China c. 700

Paper-making introduced into Near East from China

Isidore of Seville (died 636)

The Venerable Bede (673–735)

Beowulf epic

Stirrup introduced into Western Europe

800

Charlemagne (r. 768–814) crowned Emperor of Romans by Pope 800; empire extends from northern Spain to western Germany and northern Italy

Treaty of Verdun 843, three-way split of Carolingian empire: France (Charles the Bald), Germany (Louis the German), Lorraine (Lothair)

Rhabanus Maurus (784–856)

Lorraine divided between Charles and Louis 870

Alfred the Great (r. 871–899?), Anglo-Saxon king of England

Earliest version of *1001 Nights*

Earliest documented church organ, Aachen, 822

Carolingian revival of Latin classics

Earliest printed book, China, 868

Horse collar adopted in Western Europe, makes horses efficient draft animals

900

Monastic order of Cluny founded 910

Normandy awarded to Vikings by king of France 911

Otto I (the Great) crowned emperor by Pope 962

Otto II (r. 973–983) defeated by Moslems in southern Italy

Ethelred the Unready (r. 978–1016) buys off Danish invaders of England

Hugh Capet (r. 987–996) founds Capetian dynasty in France

Earliest documented use of windmills, in Near East

Earliest application of water power to industry

1000

Normans arrive in Italy 1016; conquer Bari, last Byzantine stronghold, 1071; Sicily 1072–92

College of Cardinals formed to elect pope 1059

Reconquest of Spain from Moslems begins

William the Conqueror defeats Harold at Battle of Hastings 1066

Emperor Henry IV humiliated by Pope at Canossa 1077

First Crusade 1095–96

Cistercian order founded 1098

Leif Ericson sails to North America 1002

Avicenna (980–1037), chief medical authority for Middle Ages

Hariri (1054–1121)

Omar Khayyam (fl. c. 1100)

1100

600

Sutton Hoo ship-burial treasure
Lindisfarne Gospels
Echternach Gospels
Sigvald relief, Cividale Cathedral
Palace at Mshatta, Jordan
Mosque at Cordova
Abbey Church of St.-Riquier

800

Palace Chapel of Charlemagne, Aachen
Gospel Book of Charlemagne
Gospel Book of Ebbo of Reims
Utrecht Psalter
Monastery plan, St. Gall
Oseberg ship-burial
Mosque of Mutawakkil, Samarra, Iraq
Crucifixion relief, cover of Lindau Gospels

900

Gero Crucifix, Cologne Cathedral
St. Pantaleon, Cologne

1000

Gospel Book of Otto III
St. Michael's, Hildesheim
Bronze doors of Bernward, Hildesheim
Speyer Cathedral
Pisa Cathedral
Baptistery, Florence
St.-Etienne, Caen
Bayeux Tapestry
St.-Sernin, Toulouse
S. Ambrogio, Milan
Durham Cathedral

1100

Mediterranean made safe for commerce by Italian naval supremacy over Moslems

Rivalry of Guelfs (Duke Henry the Lion) and Hohenstaufen emperors in Germany

Kingdom of Naples and Sicily 1127

Louis the Fat of France (died 1137) strengthens monarchy

Portugal becomes independent 1143

Frederick Barbarossa (r. 1155–90) titles his realm "Holy Roman Empire," tries to assert his authority in Italy

King Henry II founds Plantagenet line in 1154

Rise of universities (Bologna, Paris, Oxford) based on faculties of law, medicine, theology

Peter Abelard (1079–1142)

Geoffrey of Monmouth (died 1154)

Use of the crossbow against Christians forbidden by the Church 1123

First flowering of vernacular literature (epics, fables, chansons de geste); age of the troubadours

Hildegard of Bingen (1098–1179)

Mined coal supplements use of charcoal as fuel

Earliest use of magnetic compass for navigation

Earliest documented windmill in Europe 1180

1200

Fourth Crusade (1202–4) conquers Constantinople

St. Dominic (1170–1221) founds Dominican order; Inquisition established to combat heresy

St. Francis of Assisi (died 1226)

Emperor Frederick II (1194–1250) neglects Germany, resides at Palermo

Magna Carta limits power of English kings 1215

Louis IX (St. Louis, r. 1226–70), king of France

Mongol invasion of Russia 1237

Nibelung epic c. 1205; flowering of minnesingers in Germany

Golden Legend by Jacobus de Voragine written 1266–83

St. Thomas Aquinas (died 1274)

Albertus Magnus (1193–1280)

Roger Bacon (1214–1292)

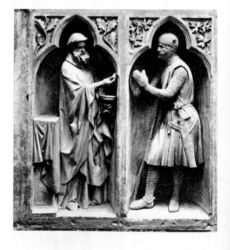

Alexander Nevski beats Teutonic Knights at Lake Peipus 1242

Edward I (r. 1272–1307) conquers Wales

Philip IV (the Fair, r. 1285–1314), king of France, humiliates Pope Boniface VI 1303

Moslems conquer Acre, last Christian stronghold in Holy Land, 1291

Dante Alighieri (1265–1321)

Marco Polo travels to China and India c. 1275–93

Arabic (actually Indian) numerals introduced in Europe

Spectacles invented c. 1286

First documented use of spinning wheel in Europe 1298

1300

Nave vault murals, St.-Savin-sur-Gartempe
South Portal, Moissac
Notre-Dame-la-Grande, Poitiers
Font, St.-Barthélemy, Liège, by Renier of Huy
Tournai Cathedral
Tympanum, center portal, Vézelay
Last Judgment tympanum, Autun
Coronation cloak of German emperors
Abbey Church of St.-Denis, Paris
Gospel Book of Wedricus
Portal sculpture, St.-Gilles-du-Gard
West portals, Chartres Cathedral
Notre-Dame, Paris
Lion monument, Brunswick
Klosterneuburg altar, by Nicholas of Verdun
Façade sculpture, Fidenza Cathedral, by Antelami
Chartres Cathedral
Abbey Church, Fossanova

Stained glass, Chartres Cathedral
Carmina Burana manuscript, Munich
Transept portals, Chartres Cathedral
Stained glass, Bourges Cathedral
South transept portal, Strasbourg Cathedral
Amiens Cathedral
West façade sculpture, Amiens Cathedral
Salisbury Cathedral
Illustrated Arabic Dioscorides
Reims Cathedral
Tomb of a Knight, Dorchester Abbey
Sketchbook of Villard de Honnecourt
Choir screen, Naumburg Cathedral
Interior west wall sculpture, Reims Cathedral
Pulpit, Baptistery, Pisa, by Nicola Pisano
St. Louis Psalter
St.-Urbain, Troyes
Madonna Enthroned, by Cimabue
Prayer Book of Philip the Fair, by Master Honoré
Sta. Croce, Florence
Florence Cathedral
Palazzo Vecchio, Florence

POLITICAL HISTORY, RELIGION	LITERATURE, SCIENCE, TECHNOLOGY	PAINTING, SCULPTURE, ARCHITECTURE

1300

Exile of papacy at Avignon 1309–76	First large-scale production of paper in Italy and Germany	Virgin of Paris, Notre Dame
Hundred Years' War between England and France begins 1337	First large-scale production of gunpowder; earliest known use of cannon 1326	Pisa Cathedral pulpit, by Giovanni Pisano
Black Death 1347–50	Earliest cast iron in Europe	Arena Chapel frescoes, Padua, by Giotto
Jacquerie revolt in France 1358	Master Eckhart (died 1327)	*Maestà* altar, Siena, by Duccio
St. Bridget of Sweden (1303–73)	William of Occam (c. 1300–1349)	Orvieto Cathedral
Russians defeat Mongols at Kulikovo 1380	*Canterbury Tales* by Chaucer c. 1387	Façade sculpture, Orvieto Cathedral
Wat Tyler uprising in England 1381		*Triumph of Death*, Pisa, by Traini
John Wycliffe (died 1384)		Hours of Jeanne d'Evreux, by Jean Pucelle

Equestrian statue of Can Grande, Verona
Choir, Gloucester Cathedral
Good and Bad Government frescoes, Siena, by Ambrogio Lorenzetti
Country Life frescoes, Avignon
Alhambra Palace, Granada
Madrasah of Sultan Hasan, Cairo
Choir, St. Sebald, Nuremberg
Portal of Chartreuse, Dijon, by Claus Sluter; Moses Well
Altar wings, Dijon, by Broederlam
Louvre of Charles V, Paris

1400

Teutonic Knights beaten by Poles and Lithu- anians at Tannenberg 1410		Trial relief for Baptistery doors, Florence, *Très Riches Heures du Duc de Berry*, by Limbourg brothers
Jan Hus burned at stake for heresy 1415	Gutenberg invents printing with movable type 1446–50	Ca' d'Oro, Venice
Great Papal Schism (since 1378) settled by election of Martin V at Council of Con- stance 1417; Pope returns to Rome	Earliest account of the sea-quadrant 1456	*Adoration of the Magi* altar, by Gentile da Fabriano

St.-Maclou, Rouen
House of Jacques Coeur, Bourges
Chapel of Henry VII, Westminster Abbey

Part Three

THE
RENAISSANCE

INTRODUCTION

In discussing the transition from classical antiquity to the Middles Ages, we were able to point to a great crisis—the rise of Islam—marking the separation between the two eras. No comparable event sets off the Middle Ages from the Renaissance. The fifteenth and sixteenth centuries, to be sure, witnessed far-reaching developments: the fall of Constantinople and the Turkish conquest of southeastern Europe; the journeys of exploration that led to the founding of overseas empires in the New World, in Africa and Asia, with the subsequent rivalry of Spain and England as the foremost colonial powers; the deep spiritual crisis of Reformation and Counter Reformation. But none of these events, however vast their effects, can be said to have produced the new era. By the time they happened, the Renaissance was well under way. Thus it is hardly surprising that the causes, the extent, and the significance of the Renaissance have long been a favorite subject of debate among historians, and that their opinions vary like those of the proverbial blind men trying to describe an elephant. Even if we disregard the minority of scholars who would deny the existence of the animal altogether, we are left with an extraordinary diversity of views on the Renaissance. Every branch of historic study has tended to develop its own image of the period. While these images overlap, they do not coincide, so that our concept of the Renaissance may vary as we focus on its fine arts, music, literature, philosophy, politics, economics, or science. Perhaps the only essential point on which most experts agree is that the Renaissance had begun when people realized they were no longer living in the Middle Ages.

This statement is not as simple-minded as it sounds; it brings out the undeniable fact that the Renaissance was the first period in history to be aware of its own existence and to coin a label for itself. (Those who believe that there was no such thing as the Renaissance admit this, but claim that the people who thought they were no longer living in the Middle Ages were deluded.) Medieval man did not think he belonged to an age distinct from classical antiquity; the past, to him, consisted simply of "B.C." and "A.D.," the era "under the Law" (that is, of the Old Testament) and the era "of Grace" (that is, after the birth of Christ). From his point of view, then, history was made in Heaven rather than on earth. The Renaissance, by contrast, divided the past not according to the Divine plan of salvation, but on the basis of human

achievements. It saw classical antiquity as the era when man had reached the peak of his creative powers, an era brought to a sudden end by the barbarian invasions that destroyed the Roman Empire. During the thousand-year interval of "darkness" which followed, little was accomplished, but now, at last, this "time in-between" or "Middle Age" had been superseded by a revival of all those arts and sciences which flourished in classical antiquity. The present, the "New Age," could thus be fittingly labeled a "rebirth"—*rinascità* in Italian (from the Latin *renasci*, to be reborn), *renaissance* in French and, by adoption, in English. The origin of this revolutionary view of history can be traced back to the 1330s in the writings of the Italian poet Petrarch, the first of the great men who made the Renaissance. Petrarch, however, thought of the new era mainly as a "revival of the classics," that is, limited to the restoration of Latin and Greek to their former purity and the return to the original texts of ancient authors. During the next two centuries, this concept of the rebirth of antiquity grew to embrace almost the entire range of cultural endeavor, including the visual arts. The latter, in fact, came to play a particularly important part in shaping the Renaissance, for reasons that we shall have to explore later.

That the new historic orientation—to which, let us remember, we owe our concepts of the Renaissance, the Middle Ages, and classical antiquity—should have had its start in the mind of one man is itself a telling comment on the new era. Petrarch's plea for a revival of antiquity is extraordinary not for his veneration of the ancients—classical revivals, we recall, had been far from unknown in the Middle Ages—but, rather, for the outlook, strangely modern for his time, that underlies his plea, revealing him to be both an individualist and a humanist. Individualism—a new self-awareness and self-assurance—enabled him to proclaim, against all established authority, his own conviction that the "age of faith" was actually an era of darkness, while the "benighted pagans" of antiquity really represented the most enlightened stage of history. Such readiness to question traditional beliefs and practices was to become profoundly characteristic of the Renaissance as a whole. Humanism, to Petrarch, meant a belief in the importance of what we still call "the humanities" or "humane letters" (rather than Divine letters, or the study of Scripture); that is, the pursuit of learning in languages, literature,

history, and philosophy for its own end, in a secular rather than a religious framework. Here again he set a pattern that proved to be most important, for the humanists, the new breed of scholar who followed him, became the intellectual leaders of the Renaissance.

We must not assume, however, that Petrarch and his successors wanted to revive classical antiquity lock, stock, and barrel. By interposing the concept of "a thousand years of darkness" between themselves and the ancients, they acknowledged—unlike the medieval classicists—that the Graeco-Roman world was irretrievably dead. Its glories could be revived only in the mind, by nostalgic and admiring contemplation across the barrier of the "dark ages," by rediscovering the full greatness of ancient achievements in art and thought, and by endeavoring to compete with these achievements on an ideal plane. The aim of the Renaissance was not to duplicate the works of antiquity but to equal and, if possible, to surpass them. In practice, this meant that the authority granted to the ancient models was far from unlimited. Writers strove to express themselves with Ciceronian eloquence and precision, but not necessarily in Latin. Architects continued to build the churches demanded by Christian ritual, not to duplicate pagan temples; but their churches were designed *all'antica*, "in the manner of the ancients," using an architectural vocabulary based on the study of classical structures. Renaissance

physicians admired the anatomical handbooks of the ancients, which they found very much more accurate than those of the Middle Ages, but they discovered discrepancies when they matched the hallowed authority of the classical texts against the direct experience of the dissection table, and learned to rely on the evidence of their own eyes. And the humanists, however great their enthusiasm for classical philosophy, did not become neo-pagans but went to great lengths trying to reconcile the heritage of the ancient thinkers with Christianity.

The men of the Renaissance, then, found themselves in the position of the legendary sorcerer's apprentice who set out to emulate his master's achievements and in the process released far greater energies than he had bargained for. But since their master was dead, rather than merely absent, they had to cope with these unfamiliar powers as best they could, until they became masters in their own right. This process of forced growth was replete with crises and tensions. The Renaissance must have been an uncomfortable, though intensely exciting, time to live in. Yet these very tensions—or so it appears in retrospect—called forth an outpouring of creative energy such as the world had never experienced before. It is a fundamental paradox that the desire to return to the classics, based on a rejection of the Middle Ages, brought to the new era not the rebirth of antiquity but the birth of Modern Man.

1

"LATE GOTHIC" PAINTING, SCULPTURE, AND THE GRAPHIC ARTS

RENAISSANCE vs. "LATE GOTHIC"

As we narrow our focus from the Renaissance as a whole to the Renaissance in the fine arts, we are faced with some questions that are still under debate: When did it start? Did it, like Gothic art, originate in a specific center, or in several places at the same time? Should we think of it as one new, coherent style, or as a new attitude that might be embodied in more than one style? "Renaissance-consciousness," we know, was an Italian idea, and there can be no doubt that Italy played the leading role in the development of Renaissance art, at least until the early sixteenth century. But when did this development get under way? So far as architecture and sculpture are concerned, modern scholarship agrees with the traditional view, first expressed more than five hundred years ago, that the Renaissance began soon after 1400. For painting, however, an even older tradition claims that the new era began with Giotto, who (as Boccaccio wrote about 1350) "restored to light this art which had been buried for many centuries." We cannot disregard such testimony, yet we hesitate to accept it at face value, for we must then assume that the Renaissance in painting dawned about 1300, a full generation before Petrarch. Nor did Giotto himself reject the past as an age of darkness; after all, the two chief sources of his own style were the Byzantine tradition and the influence of Northern Gothic. The artistic revolution he created from these elements does not necessarily place him in a new era, since revolutionary changes had occurred in medieval art before. Nor is it fair to credit this revolution to him alone, disregarding Duccio and the other great Sienese masters. Petrarch was well aware of the achievements of all these men—he wrote admiringly of both Giotto and Simone Martini—but he never claimed that they had restored to light what had been buried during the centuries of darkness. How, then, do we account for Boccaccio's statement? We must understand that Boccaccio, an ardent disciple of Petrarch, was chiefly concerned with advancing humanism in literature. In his defense of the status of poetry, he found it useful to draw analogies with painting—had not the ancients themselves proclaimed that the two arts were alike, in Horace's famous dictum, *ut pictura poesis*?—and to cast Giotto in the role of "the Petrarch of painting," taking advantage of his already legendary fame. Boccaccio's view of Giotto as a Renaissance artist is a bit of intellectual strategy, rather than a trustworthy reflection of Giotto's own attitude. Nevertheless, what he has to say interests us because he was the first to apply Petrarch's concept of "revival-after-the-dark-ages" to one of the visual arts (even though he did it somewhat prematurely), and for his way of describing Giotto's achievement. It was he who claimed that Giotto depicted every aspect of nature so truthfully that people often mistook his paintings for reality itself (see page 325). Here he implies that the revival of antiquity means for painters an uncompromising realism. And this, as we shall see, was to become a persistent theme in Renaissance thought, justifying the imitation of nature as part of the great movement "back to the classics" and tending to minimize the possible conflicts between these two aims.

Boccaccio, of course, was not in a position to know how many aspects of reality Giotto and his contemporaries had failed to investigate. These aspects, we recall, were explored by the painters of the International Style, although in somewhat tentative fashion.

FLEMISH PAINTING

To advance beyond Gothic realism required a second revolution, which began simultaneously and independently in Florence and in the Netherlands, about 1420. We have to think, therefore, of two events, both linked by a common aim—the conquest of the visible world—yet sharply separated in almost every other respect. The Florentine, or Southern, revolution was the more systematic and, in the long run, the more funda-

mental, since it included architecture and sculpture as well as painting; we call it the Early Renaissance. The same term is not generally applied to the new style that emerged in the North, in Flanders. We have, in fact, no satisfactory name to designate the Northern focus of the revolution, for art historians are still of two minds about its scope and significance in relation to the Renaissance movement as a whole. The customary label, "Late Gothic" (which we shall use, for the sake of convenience, with quotation marks to indicate its doubtful status), hardly does justice to the special character of Northern fifteenth-century painting. But it has some justification. It indicates, for instance, that the creators of the new style, unlike their Italian contemporaries, did not reject the International Style; rather, they took it as their point of departure, so that the break with the past was less abrupt in the North than in the South. "Late Gothic" also reminds us that fifteenth-century architecture outside Italy remained firmly rooted in the Gothic tradition. Whatever we choose to call the style of Northern painters of this time, their artistic environment was clearly "Late Gothic" (see pages 303, 328). How could they create a genuinely post-medieval style in such a setting, one wonders; would it not be more reasonable to regard their work, despite its great importance, as the final phase of Gothic painting? If we treat them here as the Northern counterpart of the Early Renaissance, we do so for several reasons. The great Flemish masters whose work we are about to examine had an impact that went far beyond their own region. In Italy they were as admired as the leading Italian artists of the period, and their intense realism had a conspicuous influence on Early Renaissance painting. (The Italians, we will recall, had

associated the exact imitation of nature in painting with a "return to the classics.") Italian Renaissance art, in contrast, made very little impression north of the Alps during the fifteenth century. To Italian eyes, then, "Late Gothic" painting appeared definitely post-medieval. Moreover, the situation of the Flemish painters had a close parallel in the field of music. After about 1420, the Netherlands produced a school of composers so revolutionary as to dominate the development of music throughout Europe for the next hundred years. How much the new style of these men was appreciated can be gathered from a contemporary source which states that "nothing worth listening to had been composed before their time." This remark, with its sweeping rejection of the "musical dark ages," links the attitude of the Flemish musicians with Italian "Renaissance-consciousness" (except for the absence of any reference to the revival of antiquity). We have no similar testimony concerning the new style of the Flemish painters, but from what we know of the impact of their work it seems likely that people felt "nothing worth looking at had been painted before their time."

The Master of Flémalle

The first phase—and perhaps the decisive one—of the pictorial revolution in Flanders is represented by an artist whose name we do not know for certain. We call him the Master of Flémalle (after the fragments of a large altar from Flémalle, now in the Staedel Institute, Frankfurt), although he was probably identical with Robert Campin, the foremost painter of Tournai, whose career we can trace in documents from 1406 to his death

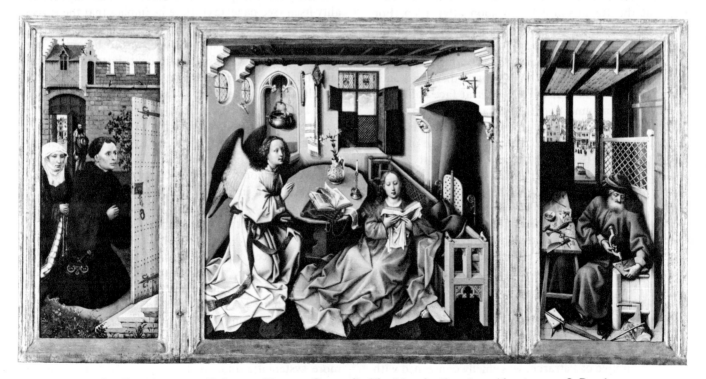

462. THE MASTER OF FLÉMALLE (ROBERT CAMPIN?). *The Merode Altarpiece*. About 1425–28. Panel,
center 25 1/4 × 24 7/8″, wings 25 3/8 × 10 7/8″ each.
The Metropolitan Museum of Art, New York (The Cloisters Collection, Purchase, 1957; see colorplate 46)

in 1444. Among his finest works is the *Merode Altarpiece* (fig. 462, colorplate 46), which he must have done soon after 1425. Comparing it with its nearest relatives, the Franco-Flemish pictures of the International Style (figs. 459, 460, colorplates 43, 44), we see that it belongs within that tradition; yet we also recognize in it a new pictorial experience. Here, for the first time, we have the sensation of actually looking *through* the surface of the panel into a spatial world that has all the essential qualities of everyday reality: unlimited depth, stability, continuity, and completeness. The painters of the International Style, even at their most adventurous, had never aimed at such consistency; their commitment to reality was far from absolute. The pictures they created have the enchanting quality of fairy tales where the scale and relationship of things can be shifted at will, where fact and fancy mingle without conflict. The Master of Flémalle, in contrast, has undertaken to tell the truth, the whole truth, and nothing but the truth. He does not yet do it with ease—his objects, overly foreshortened, tend to jostle each other in space. With a determination that seems almost obsessive, he endows every last detail with its maximum concreteness by defining every aspect: its individual shape and size; its color, material, surface textures; its degree of rigidity; and its way of responding to illumination. The artist even distinguishes between the diffused light producing soft shadows and delicate gradations of brightness, and the direct light entering through the two round windows; the latter accounts for the twin shadows sharply outlined in the upper part of the center panel, and for the twin reflections on the brass vessel and candlestick.

The *Merode Altarpiece*, in short, transports us with shocking abruptness from the aristocratic world of the International Style to the household of a Flemish burgher. The Master of Flémalle, whether or not we believe him to have been Robert Campin, was not a court painter, but a townsman catering to the tastes of such well-to-do fellow citizens as the two donors piously kneeling outside the Virgin's chamber. Characteristically, this is the earliest Annunciation in panel painting that occurs in a fully equipped domestic interior (for contrast, see figs. 449, 457), as well as the first to honor Joseph, the humble craftsman, by showing him at work next door. This bold departure from tradition forced upon our artist a problem no one had faced before: how to transfer supernatural events from symbolic settings to an everyday environment, without making them look either trivial or incongruous. He has met this challenge by the method known as "disguised symbolism," which means that almost any detail within the picture, however casual, may carry a symbolic message. Thus the rosebush, the violets and daisies in the left wing, and the lilies in the center panel, are flowers associated with the Virgin, the roses denoting her charity, the violets her humility, and the lilies her chastity; the shiny water basin and the towel on its rack are not merely ordinary household equipment

but further tributes to Mary as the "vessel most clean" and the "well of living waters." Perhaps the most intriguing symbol of this sort is the candle next to the vase of lilies. It was extinguished only moments ago, as we can tell from the glowing wick and the curl of smoke. But why, in broad daylight, had it been lit, and what made the flame go out? Has the divine radiance of the Lord's presence overcome the material light? Or did the flame of the candle itself represent the Divine light, now extinguished to show that God has become man, that in Christ "the Word was made flesh"?

Clearly, the entire wealth of medieval symbolism survives in our picture, but it is so completely immersed in the world of everyday appearances that we are often left to doubt whether a given detail demands symbolic interpretation. Observers had long wondered, for instance, about the little boxlike object on Joseph's workbench (and a similar one on the ledge outside the open window), until one scholar proposed to identify them as mousetraps intended to convey a specific theological message: according to St. Augustine, God had to appear on earth in human form so as to fool Satan—"the Cross of the Lord was the devil's mousetrap." Since explanations of this sort require much scholarly ingenuity, we tend to think of the *Merode Altarpiece* and similar pictures as embodying a special kind of puzzle. And so they often do, to the modern beholder, although they can be enjoyed apart from knowing all their symbolic content. But what about the patrons for whom these works were painted? Did they immediately grasp the meaning of every detail? They would have had no difficulty with such well-established symbols in our picture as the flowers. Let us grant, too, that they probably understood the significance of the water basin. The message of the extinguished candle and the mousetrap could not have been common knowledge even among the well-educated, however; for these two symbols—and from their incongruity we can hardly question that they *are* symbols—make their earliest appearance in the *Merode Altarpiece*. They must be unusual ones, for St. Joseph with the mousetrap has been found in only one other picture, and the recently extinguished candle does not recur elsewhere, so far as we know. Apparently, then, the Master of Flémalle introduced these symbols into the visual arts, yet hardly any artists adopted them despite his vast influence. But if the candle and the mousetrap were difficult to understand even in the fifteenth century, why are they in our picture at all? Did the patron (who may have been exceptionally erudite) tell the artist to put them in? Possibly, if this were the only case of its kind. Since, however, there are countless instances of equally subtle or obscure symbolism in "Late Gothic" painting, it seems more likely that the initiative came from the artists, rather than from their various patrons. We have reason to believe, therefore, that the Master of Flémalle was either a man of unusual learning himself, or had contact with the theologians and other scholars who

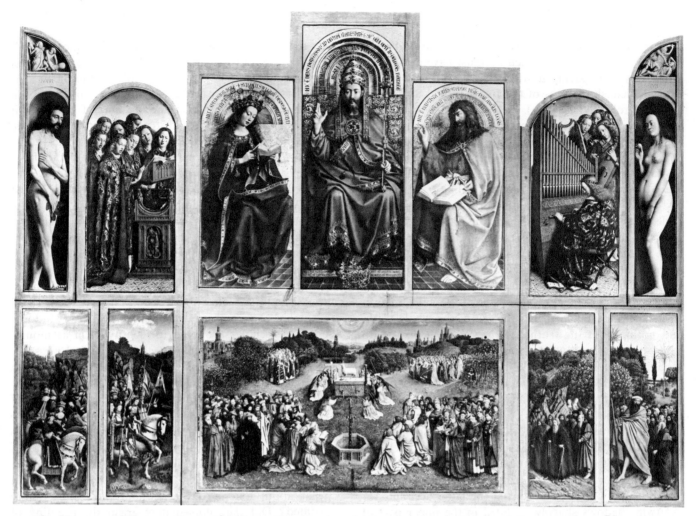

463. HUBERT and JAN VAN EYCK. *The Ghent Altarpiece* (open). Completed 1432. Panel, 11′3″ × 14′5″. St. Bavo, Ghent

could supply him with the references that suggested the symbolic meanings of things like the extinguished candle and the mousetrap. In other words, our artist did not merely continue the symbolic tradition of medieval art within the framework of the new realistic style; he expanded and enriched it by his own efforts. But why, we wonder, did he pursue simultaneously what we are accustomed to regard as two opposite goals, realism and symbolism? To him, apparently, the two were interdependent, rather than in conflict. We might say that he needed a growing symbolic repertory because it encouraged him to explore features of the visible world never represented before (such as a candle immediately after it has been blown out, or the interior of a carpenter's shop, needed as the setting for the mousetraps). For him to paint everyday reality, he had to "sanctify" it with a maximum of spiritual significance. This deeply reverential attitude toward the physical universe as a mirror of Divine truths helps us to understand why in the Merode panels the smallest and least conspicuous details are rendered with the same concentrated attention as the sacred figures; potentially at least, everything is a symbol and thus merits an equally exacting scrutiny. The disguised symbolism of the Master of Flémalle and his successors was not an external device grafted onto the new realistic style, but ingrained in the creative process. Their Italian contemporaries must have sensed this, for they praised both the miraculous realism and the "piety" of the Flemish masters.

If we compare our colorplate of the *Merode Annunciation* with those of earlier panel paintings (colorplates 40, 42, 43, 45), we see vividly that, all other differences aside, its distinctive tonality makes the Master of Flémalle's picture stand out among the rest. The jewel-like brightness of the older works, their patterns of brilliant hues and lavish use of gold, have given way to a color scheme far less decorative but much more flexible and differentiated. The subdued tints—muted greens, bluish or brownish grays—show a new subtlety, and the scale of intermediate shades is smoother and has a wider range. All these effects are essential to the realistic style of the Master of Flémalle; they were made possible by the use of oil, the medium he was among the first to exploit. The basic technique of medieval panel painting had been tempera, in which the finely ground pigments were mixed ("tempered") with diluted egg yolk. It produced a thin, tough, quick-drying coat admirably suited to the medieval taste for high-keyed, flat color surfaces. However, in tempera the different tones on the panel cannot be smoothly blended, and the continuous progression

metal. It was the Master of Flémalle and his contemporaries who discovered its artistic possibilities. Oil, a viscous, slow-drying medium, could produce a vast variety of effects, from thin, translucent films (called "glazes") to the thickest impasto (that is, a thick layer of creamy, heavy-bodied paint); the tones could also yield a continuous scale of hues, including rich, velvety dark shades previously unknown. Without oil, the Flemish masters' conquest of visible reality would have been much more limited. Thus, from the technical point of view, too, they deserve to be called the "fathers of modern painting," for oil has been the painter's basic medium ever since.

Jan van Eyck

Needless to say, the full range of effects made possible by oil was not discovered all at once, nor by any one man. The Master of Flémalle contributed less than Jan van Eyck, a somewhat younger and very much more famous artist, who was long credited with the actual

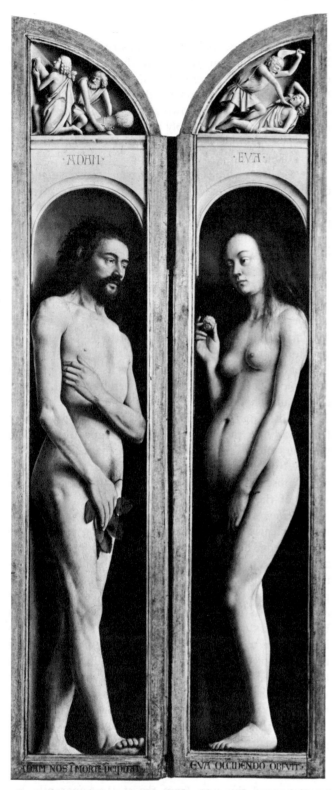

464. *Adam and Eve*, details of *The Ghent Altarpiece*, left and right wings

of values necessary for three-dimensional effects was difficult to achieve; also, the darks tended to look muddy and undifferentiated. For the Master of Flémalle these were serious drawbacks, which he overcame by substituting oil for the water-and-egg-yolk mixture. In a purely material sense oil was not unfamiliar to medieval artists, but it had been used only for special purposes, such as the coating of stone surfaces or painting on

465. *The Ghent Altarpiece* (closed)

"invention" of oil painting. About Jan's life and career we know a good deal; born about 1390, he worked in Holland from 1422 to 1424, in Lille from 1425 to 1429, and thereafter in Bruges, where he died in 1441. He was both a townsman and a court painter, highly esteemed by Duke Philip the Good of Burgundy, who occasionally sent him on confidential diplomatic errands. After 1432, we can follow Jan's career through a number of signed and dated pictures. The inscription on the frame of the great *Ghent Altarpiece* tells us that he completed it in that year, after it had been begun by his older brother, Hubert (figs. 463–65). Jan's earlier development, however, remains disputed; there are several "Eyckian" works, obviously older than the *Ghent Altarpiece,* that may have been painted by either of the two brothers. The most fascinating of these is a pair of panels showing the Crucifixion and the Last Judgment (colorplate 47). Scholars agree that their date is between 1420 and 1425, whichever brother, Jan or Hubert, was the author.

The style of the two panels has many qualities in common with that of the *Merode Altarpiece*—the all-embracing devotion to the visible world, the unlimited depth of space, the angular drapery folds, less graceful but far more realistic than the unbroken loops of the International Style. At the same time, however, the individual forms are not starkly tangible, like those characteristic of the Master of Flémalle, and seem less isolated, less "sculptural"; the sweeping sense of space is the result not so much of violent foreshortening as of subtle changes of light and color. If we inspect the *Crucifixion* panel slowly, from the foreground figures to the far-off city of Jerusalem and the snow-capped peaks beyond, we see a gradual decrease in the intensity of local colors and in the contrast of light and dark. Everything tends toward a uniform tint of light bluish gray, so that the farthest mountain range merges imperceptibly with the color of the sky. This optical phenomenon, which the Van Eycks were the first to utilize fully and systematically (the Limbourg Brothers had already been aware of it, as is seen in fig. 459), is known as "atmospheric perspective," since it results from the fact that the atmosphere is never wholly transparent. Even on the clearest day, the air between us and the things we are looking at acts as a hazy screen that interferes with our ability to see distant shapes clearly; as we approach the limit of visibility, it swallows them altogether. Atmospheric perspective is more fundamental to our perception of deep space than linear perspective, which records the diminution in the apparent size of objects as their distance from the observer increases. It is effective not only in faraway vistas; in our *Crucifixion* panel even the foreground seems enveloped in a delicate haze that softens contours, shadows, and colors, and thus the entire scene has a continuity and harmony quite beyond the pictorial range of the Master of Flémalle. How did the Van Eycks accomplish this effect? Their exact tech-

nical procedure is difficult to reconstruct, but there can be no question that they used the oil medium with extraordinary refinement. By alternating opaque and translucent layers of pigment, they were able to impart to their pictures a soft, glowing radiance of tone that has never been equaled, probably because it depends as much on their individual sensibility as it does on their skillful craftsmanship.

Viewed as a whole, the *Crucifixion* seems singularly devoid of drama, as if the scene had been gently becalmed by some magic spell. Only when we concentrate on the details do we become aware of the violent emotions in the faces of the crowd beneath the cross, and the restrained but profoundly touching grief of the Virgin Mary and her companions in the foreground. In the *Last Judgment* panel, this dual aspect of the Eyckian style takes the form of two extremes: above the horizon, all is order, symmetry, and calm, while below it—on earth and in the subterranean realm of Satan—the opposite condition prevails. The two states thus correspond to Heaven and Hell, contemplative bliss as against physical and emotional turbulence. The lower half, clearly, was the greater challenge to the artist's imaginative powers. The dead rising from their graves with frantic gestures of fear and hope, the damned being torn apart by devilish monsters more frightful than any we have seen before, all have the awesome reality of a nightmare, but a nightmare "observed" with the same infinite care as the natural world of the *Crucifixion* panel.

The *Ghent Altarpiece* (figs. 463–65), the greatest monument of early Flemish painting, presents problems so complex that our discussion must be limited to bare essentials. We have already mentioned the inscription informing us that the work, begun by Hubert, was completed by Jan in 1432. Since Hubert died in 1426, the altarpiece was presumably made in the seven-year span between 1425 and 1432. We may expect it, therefore, to introduce to us the next phase of the new style, following that of the pictures we have discussed so far. Although its basic form is a triptych—a central body with two hinged wings—each of the three units consists of four separate panels, and since, in addition, the wings are painted on both sides, the altarpiece has a total of twenty component parts of assorted shapes and sizes. The ensemble makes what has rightly been called a "super-altar," overwhelming but far from harmonious, which could not have been planned this way from the start. Apparently Jan took over a number of panels left unfinished by Hubert, completed them, added some of his own, and assembled them at the behest of the wealthy donor whose portrait we see on the outside of the altar. To reconstruct this train of events, and to determine each brother's share, is a fascinating but treacherous game. Suffice it to say that Hubert remains a somewhat shadowy figure; his style, overlaid with retouches by Jan, can probably be found in the four central panels, although these did not belong together originally. The upper three, whose huge figures

in the final arrangement crush the multitude of small ones below, were intended, it seems, to form a self-contained triptych: the Lord between the Virgin Mary and St. John the Baptist. The lower panel and the four flanking it probably formed a separate altarpiece, the Adoration of the Lamb, symbolizing Christ's sacrificial death. The two panels with music-making angels may have been planned by Hubert as a pair of organ shutters. If this set of conjectures is correct, the two tall, narrow panels showing Adam and Eve (fig. 464) are the only ones added by Jan to Hubert's stock. They certainly are the most daring of all: the earliest monumental nudes of Northern panel painting (hardly less than life-size), magnificently observed, and caressed by the most delicate play of light and shade. Their quiet dignity—and their prominent place in the altar—suggests that they should remind us not so much of Original Sin, as of man's creation in God's own image. Actual evil, by contrast, is represented in the small, violently expressive scenes above, which show the story of Cain and Abel. Still more extraordinary, however, is the fact that the Adam and Eve were designed specifically for their present positions in the ensemble. Acknowledging that they would really appear this way to the spectator whose eye-level is below the bottom of the panels, Jan van Eyck has depicted them in accordance with this abnormal viewpoint and thereby established a new, direct relationship between picture space and real space.

The outer surfaces of the two wings (fig. 465) were evidently planned by Jan as one coherent unit. Here, as we would normally expect, the largest figures are not above, but in the lower tier. The two St. Johns (painted in grays to simulate sculpture, like the scenes of Cain and Abel), the donor, and his wife, each in his separate niche, are the immediate kin of the Adam and Eve panels. The upper tier has two pairs of panels of different

width; the artist has made a virtue of this awkward necessity by combining all four into one interior. Such an effect, we recall, had first been created almost a century earlier (compare fig. 452), but Jan, not content with perspective devices alone, heightens the illusion by painting the shadows cast by the frames of the panels on the floor of the Virgin's chamber. Interestingly enough, this *Annunciation* resembles, in its homely detail, the *Merode Altarpiece,* thus providing a valuable link between the two great pioneers of Flemish realism.

Donors' portraits of splendid individuality occupy conspicuous positions in both the Merode and the Ghent altarpieces. A renewed interest in realistic portraiture had developed in the mid-fourteenth century, but until about 1420 its best achievements had been in sculpture (see fig. 430), the painters usually confining themselves to silhouette-like profile views (such as the portrait of the Duke of Berry in fig. 460). Not until the Master of Flémalle, the first artist since antiquity to have real command of a close-range view of the human face from a three-quarter angle, did the portrait play a major role in Northern painting. In addition to donors' portraits, we now begin to encounter in growing numbers small, independent likenesses whose peculiar intimacy suggests that they were treasured keepsakes, pictorial substitutes for the real presence of the sitter. One of the most fascinating is Jan van Eyck's *Man in a Red Turban* of 1433 (fig. 466), which may well be a self-portrait—the slight strain about the eyes seems to come from gazing into a mirror. The sitter is bathed in the same gentle, clear light as the Adam and Eve of the *Ghent Altarpiece;* every detail of shape and texture has been recorded with almost microscopic precision. Jan does not suppress the sitter's personality, yet this face, like all of Jan's portraits, remains a psychological puzzle. It might be described as "even-tempered" in the most

exact sense of the term, its character traits balanced against each other so perfectly that none can assert itself at the expense of the rest. As Jan was fully capable of expressing emotion (we need only recall the faces of the crowd in the *Crucifixion,* or the scenes of Cain and Abel in the *Ghent Altarpiece*), the stoic calm of his portraits surely reflects his conscious ideal of human character rather than his indifference or lack of insight.

The Flemish cities where the new style of painting flourished—Tournai, Ghent, Bruges—rivaled those of Italy as centers of international banking and trade. Their foreign residents included many Italian businessmen. For one of these, perhaps a member of the Arnolfini family, Jan van Eyck painted his remarkable *Wedding Portrait,* one of the major masterpieces of the period (colorplate 48). The young couple is solemnly exchanging marriage vows in the privacy of the bridal chamber. They seem to be quite alone, but as we scrutinize the mirror, conspicuously placed behind them, we discover in the reflection that two other persons have entered the room. One of them must be the artist, since the words above the mirror, in florid legal lettering, tell us that "Johannes de eyck fuit hic" (Jan van Eyck was here) in the year 1434. Jan's role, then, is that of a witness; the picture purports to show exactly what he saw and has the function of a pictorial marriage certificate. Yet the domestic setting, however persuasively realistic, is replete with disguised symbolism of the most subtle kind, conveying the sacramental nature of marriage. The single candle in the chandelier, burning in broad daylight, stands for the all-seeing Christ (note the Passion scenes of the mirror frame); the shoes which the couple has taken off remind us that they are standing on "holy ground" (for the origin of the theme refer to page 54); even the little dog is an emblem of marital faith, and the furnishings of the room invite similar interpretation. The natural world, as in the *Merode Altarpiece,* is made to contain the world of the spirit in such a way that the two actually become one.

Rogier van der Weyden

In the work of Jan van Eyck, the exploration of the reality made visible by light and color had reached a limit that was not to be surpassed for another two centuries. Rogier van der Weyden, the third great master of early Flemish painting, set himself a different though equally important task: to recapture, within the framework of the new style created by his predecessors, the emotional drama, the *pathos,* of the Gothic past. We can see this immediately in his early masterpiece, *The Descent from the Cross* (colorplate 49), which dates from about 1435, when the artist was in his mid-thirties. Here the modeling is sculpturally precise, with its brittle, angular drapery folds recalling the Master of Flémalle; and the soft half-shadows and rich, glowing colors show his knowledge of Jan van Eyck. Yet Rogier is far more than

a mere follower of the two older men; whatever he owes to them—and it is obviously a great deal—he uses for ends which are not theirs but his. The outward events (in this case, the lowering of Christ's body from the cross) concern him less than the world of human feeling; this *Descent,* judged for its expressive content, could well be called a *Lamentation.* The artistic ancestry of these grief-stricken gestures and faces is in sculpture rather than in painting—from the Strasbourg *Death of the Virgin* (fig. 420) and the Naumburg *Crucifixion* (fig. 426), to the Bonn *Pietà* (fig. 429) and Claus Sluter's *Moses Well* (fig. 430). It seems peculiarly fitting, therefore, that Rogier should have staged his scene in a shallow architectural niche or shrine, as if his figures were colored statues, not seen against a landscape background. This bold device gave him a double advantage in heightening the effect of this tragic event: it focused the beholder's entire attention on the foreground, and allowed him to mold the figures into a coherent, formal group. No wonder that Rogier's art, which has been well described as "at once physically barer and spiritually richer than Jan van Eyck's," set an example for countless other artists. When he died in 1464, after thirty years of unceasing activity as the foremost painter of Brussels, his influence was supreme in European painting north of the Alps. Its echoes continued to be discernible almost everywhere outside Italy until the end of the century, such was the authority of his style.

What is true of Rogier's religious works applies equally well to his portraits. The likeness of Francesco d'Este (fig. 467), an Italian nobleman resident at the Burgundian court, may strike us as less lifelike than Jan van Eyck's. Modeling is reduced to a minimum; much descriptive detail has been simplified or omitted altogether; the gracefully elongated forms of the body render an aristocratic ideal rather than the sitter's individual appearance. Yet this face, compared with that of the *Man in a Red Turban,* conveys a more vivid sense of character. Instead of striving for the psychologically "neutral" calm of Jan's portraits, Rogier interprets the human personality by suppressing some traits and emphasizing others. In consequence, he tells us more about the inner life of his sitters, less about their outward appearance.

Hugo van der Goes; Geertgen

Among the artists who followed Rogier van der Weyden, few succeeded in escaping from the great master's shadow. The most dynamic of these was Hugo van der Goes, an unhappy genius whose tragic end suggests an unstable personality peculiarly interesting to us today. After a spectacular rise to fame in the cosmopolitan atmosphere of Bruges, he decided in 1478, when he was about forty years of age, to enter a monastery as a lay brother; for some time he continued to paint, but increasing fits of depression drove him to the verge of suicide, and four years later he was dead. His most

468. HUGO VAN DER GOES. *The Portinari Altarpiece* (open). c. 1476. Panel, center 8′3¹/₂″ × 10′, wings 8′3¹/₂″ × 4′7¹/₂″ each. Uffizi Gallery, Florence

ambitious work, the huge altarpiece he completed about 1476 for Tommaso Portinari, is an awesome achievement (figs. 468, 469). While we need not search it for hints of Hugo's future mental illness, it nonetheless evokes a tense, explosive personality. Or is there no strain between the artist's devotion to the natural world (the wonderfully spacious and atmospheric landscape setting, and the wealth of precise realistic detail) and his concern with the supernatural? In the wings, for instance, the kneeling members of the Portinari family are dwarfed by their patron saints, whose gigantic size characterizes them as beings of a higher order, like Joseph, the Virgin Mary, and the shepherds of the *Nativity* in the center panel, who share the same huge scale. But these latter figures are not meant to be "larger-than-life," for their height is normal in relation to the architecture and to the ox and ass; the angels, which are drawn to the same scale as the donors, thus appear abnormally small. This variation of scale, although its symbolic and expressive purpose is clear, stands outside the logic of everyday experience affirmed in the environment the artist has provided for his figures. There is another striking contrast between the frantic excitement of the shepherds (fig. 469) and the ritual solemnity of all the other figures. These field hands, gazing in breathless wonder at the newborn Child, react to the dramatic miracle of the Nativity with a wide-eyed directness never attempted before. They aroused particular admiration in the Italian painters who saw the work after it arrived in Florence about 1480.

During the last quarter of the fifteenth century there were no painters in Flanders comparable to Hugo van der Goes, and the most original artists appeared further north, in Holland. To one of these, Geertgen tot Sint Jans of Haarlem, we owe the enchanting *Nativity* reproduced in figure 470, a picture as daring, in its quiet way, as the center panel of the *Portinari Altarpiece*. The idea of a nocturnal Nativity, illuminated mainly by radiance

469. *The Portinari Altarpiece*, detail of center panel

from the Christ Child, goes back to the International Style (see fig. 461), but Geertgen, applying the pictorial discoveries of Jan van Eyck, gives new, intense reality to the theme. The magic effect of his little panel is greatly enhanced by the smooth, simplified shapes that record the impact of light with striking clarity; the manger is a rectangular trough; the heads of the angels, the Infant, and the Virgin are as round as objects turned on a lathe.

Bosch

If Geertgen's uncluttered, "abstract" forms attract us specially today, another Dutch artist, Hieronymus

470. GEERTGEN TOT SINT JANS. *The Nativity*. c. 1490.
Panel, 13$^1/_2$ × 10″. The National Gallery, London
(Reproduced by courtesy of the Trustees)

Bosch, appeals to our interest in the world of dreams. Little is known about Bosch except that he spent his life in the provincial town of s'Hertogenbosch and that he died, an old man, in 1516. His work, full of weird and seemingly irrational imagery, has proved so difficult to interpret that much of it, despite the remarkable insights contributed by recent research, remains unsolved. We can readily understand this if we study the triptych known as *The Garden of Delights* (figs. 471, 472, color-plate 50), the richest and most puzzling of Bosch's pictures. Of the three panels, only the left one has a clearly recognizable subject: the Garden of Eden, wherein the Lord introduces Adam to the newly created Eve. The landscape, almost Eyckian in its airy vastness, is filled with animals, among them such exotic creatures as an elephant and a giraffe, and also hybrid monsters of odd and sinister kinds. Behind them, the distant rock formations are equally strange. The right wing, a nightmarish scene of burning ruins and fantastic instruments of torture, surely represents Hell. But what of the center? Here we see a landscape much like that of the Garden of Eden, populated with countless nude men and women performing a variety of peculiar actions: in the center, they parade around a circular basin on the backs of all sorts of beasts; many disport themselves in pools of water; most of them are closely linked with enormous birds, fruit, flowers, or marine animals. Only a few are

openly engaged in love-making, yet there can be no doubt that the delights in this "garden" are those of carnal desire, however oddly disguised. The birds, fruit, etc., are symbols or metaphors which Bosch uses to depict man's life on earth as an unending repetition of the Original Sin of Adam and Eve, whereby we are all doomed to be the prisoners of our appetites. Nowhere does he so much as hint at the possibility of Salvation; corruption, on the animal level at least had already asserted itself in the Garden of Eden before the Fall, and we are all destined for Hell, the Garden of Satan, with its grisly and refined instruments of torture. So profound is Bosch's pessimism—if we read the meaning of the triptych correctly—that some scholars have refused to take it at face value; the center panel, they claim, is really an unusual vision of Paradise according to the beliefs of a secret heretical sect to which Bosch supposedly belonged. While their view has few adherents, it does point up the fundamental ambiguity of the *Garden*: there is indeed an innocence, even a haunting poetic beauty, in this panorama of sinful mankind. Consciously, Bosch was a stern moralist who intended his pictures to be visual sermons, every detail packed with didactic meaning. Unconsciously, however, he must have been so enraptured by the sensuous appeal of the world of the flesh that the images he coined with such prodigality tend to celebrate what they are meant to condemn. That, surely, is the reason why *The Garden of Delights* still evokes so strong a response today, even though we no longer understand every word of the sermon.

FRENCH AND GERMAN PAINTING

We must now glance briefly at fifteenth-century art in the rest of Northern Europe. After about 1430, the new realism of the Flemish masters began to spread into France and Germany until, by the middle of the century, its influence was paramount from Spain to the Baltic. Among the countless artists (many of them still anonymous) who turned out provincial adaptations of Netherlandish painting, only a few were gifted enough to impress us today with a distinctive personality. One of the earliest and most original was Conrad Witz of Basel, whose altarpiece for Geneva Cathedral, painted in 1444, includes the remarkable panel shown in figure 473. To judge from the drapery, with its tubular folds and sharp, angular breaks, he must have had close contact with the Master of Flémalle. But the setting, rather than the figures, attracts our interest, and here the influence of the Van Eycks seems dominant. Witz, however, did not simply follow these great pioneers; an explorer himself, he knew more about the optical appearances of water than any other painter of his time (note especially the bottom of the lake in the foreground). The landscape, too, is an original venture, representing a specific part of the shore of the Lake of Geneva—the earliest landscape "portrait" that has come down to us.

471. HIERONYMUS BOSCH. *The Garden of Delights.* c. 1500. Panel, center 86¹/₂ × 76³/₄″,
wings 86¹/₂ × 38″ each. The Prado, Madrid (see colorplate 50)

472. *The Garden of Delights,* detail of right wing

In France, the painter Jean Fouquet, twenty-odd years younger than Witz, had the exceptional fortune, soon after he had completed his training, of a lengthy visit to Italy, about 1445. In consequence, his work represents a unique blend of Flemish and Early Renaissance elements, although it remains basically Northern. *Etienne Chevalier and St. Stephen* (fig. 474), painted about 1450 for the left wing of a diptych, shows his mastery as a portraitist (the head of the saint seems no less indi-

vidual than that of the donor); Italian influence can be seen in the style of the architecture and, less directly, in the statuesque solidity and weight of the two figures. The artist's self-portrait from about the same time also reflects his sojourn in the South (fig. 475); it is a tiny picture executed in gold on black enamel, which must have been inspired by a late Roman miniature like the one reproduced in figure 264. It revives a species of "portable" portrait that was to become immensely popular, especially in England, a century later. And it has the further distinction of being the earliest clearly identified self-portrait that is a separate painting, not an incidental part of a larger work. The style of the likeness is Flemish in origin, however, rather than ancient or Renaissance. In fact, the quality of the glance recalls Jan van Eyck's *Man in a Red Turban* (fig. 466) so strongly that one is tempted to cite it as evidence that Jan's picture, too, must be a self-portrait.

A Flemish style, influenced by Italian art, also characterizes the most famous of all French fifteenth-century pictures, *The Avignon Pietà* (fig. 476). As its name indicates, the panel comes from the extreme south of France. It was probably painted by an artist of that region, but the name of this important master is not recorded, and we know no other works by his hand. All we can say about his background is that he must have been thoroughly familiar with the art of Rogier van der Weyden, for the figure types and the expressive content of the *Avignon Pietà* could be derived from no other source. At the same time, the design, magnificently simple and stable, is Italian rather than Northern (we first saw these qualities in the art of Giotto). Southern,

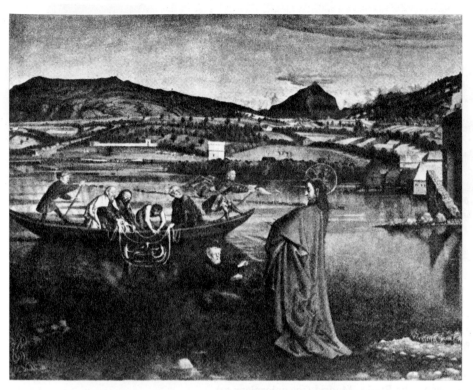

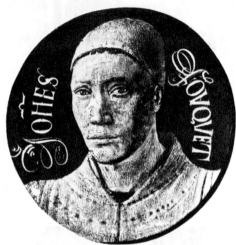

473. CONRAD WITZ.
The Miraculous Draught of Fishes.
1444. Panel, 51 × 61″.
Museum, Geneva

475. JEAN FOUQUET. *Self-Portrait.* c. 1450. Gold and
enamel on copper, diameter 3″. The Louvre, Paris

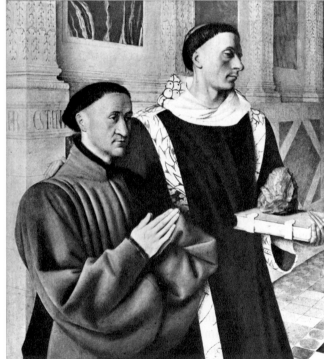

474. JEAN FOUQUET. *Etienne Chevalier and St. Stephen.*
c. 1450. Panel, 36¹/₂ × 33¹/₂″. State Museums, Berlin

too, is the bleak, featureless landscape emphasizing the
monumental isolation of the figures. The distant build-
ings behind the donor on the left have an unmistakably Is-
lamic flavor: did the artist mean to place the scene in an
authentic Near Eastern setting? However that may be, he
has created from these various features an unforgettable
image of heroic pathos.

LATE GOTHIC SCULPTURE

If we had to describe fifteenth-century art north of the
Alps in a single phrase, we might label it "the first cen-
tury of panel painting," for panel painting so dominated
the art of the period between 1420 and 1500 that its
standards apply to manuscript illumination and stained
glass and even, to a large extent, to sculpture. After the
later thirteenth century, we will recall, the emphasis had
shifted from architectural sculpture to the more intimate
scale of devotional images, tombs, pulpits, and the like.
Claus Sluter, whose art is so impressive in weight and
volume, had briefly recaptured the monumental spirit of
the High Gothic; but he had no real successors, although
echoes of his style can be felt in French art for the next
fifty years. What ended the International Style in the
sculpture of Northern Europe was the influence of the
Master of Flémalle and Rogier van der Weyden. The carv-
ers (who quite often were also painters) began to re-
produce in stone or wood the style of these artists, and
continued to do so, in essence, until about 1500. How
completely the aims of "Late Gothic" sculpture became
identified with those of painting may be seen in figures
477 and 478: the *Flying Angel* from a work of the Master
of Flémalle, about 1420, anticipates all the main features
of a carved angel by a fine German sculptor almost a

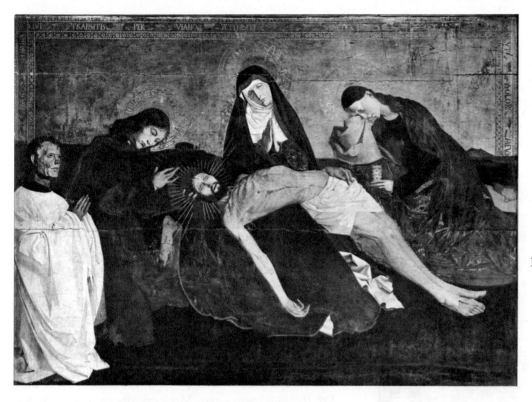

476. SOUTHERN FRENCH MASTER. *The Avignon Pietà.* c. 1470. Panel, 64 × 86″. The Louvre, Paris

century later. The most characteristic works of the "Late Gothic" carver are wooden altar shrines, often large in size and incredibly intricate in detail. Such shrines were especially popular in the Germanic countries. One of the richest examples is the *Coronation of the Virgin* (fig. 479) by the Tyrolean sculptor and painter Michael Pacher, in St. Wolfgang, Austria. Its lavishly gilt and colored forms make a dazzling spectacle as they emerge from the shadowy depth of the shrine under spiky Flamboyant canopies; we enjoy it—but in pictorial rather than plastic terms. We have no experience of volume, either positive or negative; the figures and setting seem to melt into a single pattern of agitated, twisting lines that permits only the heads to stand out as separate entities. If we compare this *Coronation* with Rogier's *Descent from the Cross* (col-

orplate 49), we realize that the latter, paradoxically, is a far more "sculptural" scene. Did Pacher, the "Late Gothic" sculptor, feel unable to compete with the painter's rendering of three-dimensional bodies and therefore choose to meet him in the pictorial realm, by extracting the maximum of drama from contrasts of light and shade? Pacher's own work seems to support this view: some years after completing the St. Wolfgang shrine he made another altarpiece, this time with a painted center (fig. 480). Again we see large figures under ornate canopies—the equivalent of a carved shrine—but now with far greater emphasis on space and volume. To say that Pacher is a painter when he sculpts, and a sculptor when he paints, is only a slight exaggeration: in this exchange, sculpture inevitably gets the short end of the bargain.

477. THE MASTER OF FLÉMALLE (ROBERT CAMPIN?). *Flying Angel,* detail of the *Entombment.* c. 1420 Panel. Collection Count Antoine Seilern, London

478. VEIT STOSZ. *Flying Angel,* detail of the *Annunciation.* 1518. St. Lorenz, Nuremberg

479. MICHAEL PACHER. *Coronation of the Virgin* (center portion of wooden shrine). 1471–81. Figures about lifesize. Parish church, St. Wolfgang, Austria

480. MICHAEL PACHER. *St. Augustine and St. Gregory,* center panel of the *Altarpiece of the Four Latin Fathers.* c. 1483. 81 × 77″. Pinakothek, Munich

PRINTING

At this point we must take note of another important event north of the Alps—the development of printing, for pictures as well as books. Our earliest printed books in the modern sense were produced in the Rhineland soon after 1450 (we are not certain whether Gutenberg deserves the priority long claimed for him). The new technique quickly spread all over Europe and developed into an industry that had a profound effect on Western civilization, ushering in the era of general literacy. Printed pictures, however, had hardly less importance, for without them, the printed book could not have replaced the work of the medieval scribe and illuminator so quickly and completely. The pictorial and the literary aspects of printing were, indeed, closely linked from the start. But where is the start? When, and by whom, was printing invented? The beginnings of the story—which will be told here in barest outline—lie in the ancient Near East five thousand years ago. Mechanically speaking, the Sumerians were the earliest "printers," for their relief impressions on clay from stone seals were carved with both pictures and inscriptions. From Mesopotamia, the use of seals spread to India and eventually to China. The Chinese applied ink to their seals in order to impress them on wood or silk, and, in the second century A.D., they invented paper. By the ninth century, they were printing pictures and books on paper from wooden blocks carved in relief, and two hundred years later they developed movable type. Some of the products of Chinese printing surely reached the medieval West—through the Arabs, the Mongols, or travelers such as Marco Polo—although we lack direct evidence. The technique of manufacturing paper, too, came to Europe from the East, and Chinese silk and porcelain were imported in small quantities from the fourteenth century on. Paper and printing from wood blocks were both known in the West during the later Middle Ages, but paper, as a cheap alternative to parchment, gained ground very slowly, while printing was used only for ornamental patterns on cloth. All the more astonishing is the development, beginning about 1400, that produced within the century a printing technology which was superior to that of the Far East and of far wider cultural importance. After 1500, in fact, no basic changes were made in this field until the Industrial Revolution.

WOODCUTS

The idea of printing pictorial designs from wood blocks onto paper seems to have originated in Northern Europe at the very end of the fourteenth century. Many of the oldest surviving examples of such prints, called woodcuts, are German, others are Flemish, and some

may be French; all show the familiar qualities of the International Style. The designs were probably furnished by painters or sculptors, but the actual carving of the wood blocks was done by the specially trained craftsmen who also produced wood blocks for textile prints. As a result, early woodcuts, such as the *St. Dorothy*, figure 481, have a flat, ornamental pattern; forms are defined by simple, heavy lines with little concern for three-dimensional effects (there is no hatching or shading). Since the outlined shapes were meant to be filled in with color, these prints often recall stained glass (compare fig. 442) more than the miniatures which they replaced. Despite their aesthetic appeal to modern eyes, fifteenth-century woodcuts were popular art, on a level that did not attract masters of high ability until shortly before 1500. A single wood block yielded thousands of copies, to be sold for a few pennies apiece, bringing the individual ownership of pictures within everyone's reach for the first time in our history. What people did with these prints is illustrated in figure 482, a detail from a Flemish *Annunciation* panel of about 1435, where a tattered woodcut of St. Christopher is pinned up above the mantel. Perhaps it is a hint at the Virgin's journey to Bethlehem

(St. Christopher is the patron of travelers), but this charmingly incongruous feature must also be understood as a disguised symbol of her humility, for only the poor would have such an object on their walls.

The St. Christopher woodcut has two lines of lettering—a short prayer, presumably—at the bottom. Inscriptions of this kind are often found among early woodcuts, the letters having been either added by hand or printed from the same block as the picture. Such woodcuts combining image and text were sometimes assembled into popular picture books, called "block books." But to carve lines of text in relief on a wooden block was a wearisome and particularly risky task—a single slip could ruin an entire page. Little wonder, then, that printers soon had the idea of putting each letter on its own small block. Wooden movable type carved by hand worked well for letters of large size but not for small ones; moreover, it was too expensive to use for printing long texts such as the Bible. By 1450, this problem had been solved through the introduction of metal type cast from molds, and the stage was set for book production as we know it today.

ENGRAVING

Whoever first thought of metal type probably had the aid of goldsmiths to work out the technical production problems. This is the more plausible since many goldsmiths, as engravers, had already entered the field of printmaking. An engraving, unlike a woodcut, is printed not from a raised design but from V-shaped grooves, cut

481. *St. Dorothy.* c. 1420. Woodcut.
Staatliche Graphische Sammlung, Munich

482. *Woodcut of St. Christopher,* detail from an *Annunciation* by Jacques Daret (?). c. 1435.
Royal Museums of Fine Arts, Brussels

483. MARTIN SCHONGAUER. *The Temptation of St. Anthony.*
c. 1480–90. Engraving. The Metropolitan Museum of Art,
New York (Rogers Fund, 1920)

into a metal plate (usually copper) with a steel tool
known as a burin. The technique of embellishing metal
surfaces with engraved pictures was developed in clas-
sical antiquity (see fig. 208) and continued to be prac-
ticed throughout the Middle Ages (see fig. 383; the en-
graved lines are filled in with enamel). Thus, no new skill
was required to engrave a plate that was to serve as the
"matrix" for a paper print; the subsequent printing was
done by rubbing ink into the grooves, wiping off the
surface of the plate, covering it with a damp sheet of
paper, and putting it through the press. The notion of
making an engraved print apparently came from the
desire for an alternative, more refined and flexible, to
woodcuts. (On a wood block, let us remember, lines are
ridges; hence the thinner they are, the more difficult to
carve.) Engravings appealed from the first to a smaller
and more sophisticated public. The oldest examples we
know, dating from about 1430, already show the in-
fluence of the great Flemish painters; their forms are
systematically modeled with fine hatched lines, and often
convincingly foreshortened. Nor do engravings share the
anonymity of early woodcuts: individual hands can be
distinguished almost from the beginning, dates and ini-
tials shortly appear, and most of the important engravers

of the last third of the fifteenth century are known to us
by name. Even though the early engravers were usually
goldsmiths by training, their prints are so closely linked
to local painting styles that we may determine their geo-
graphic origin far more easily than for woodcuts. Espe-
cially in the Upper Rhine region, we can trace a con-
tinuous tradition of fine engravers from the time of
Conrad Witz to the end of the century. The most ac-
complished of these is Martin Schongauer (c. 1430–91),
the first printmaker whom we also know as a painter,
and the first to gain international fame.

Schongauer; The Master of the Hausbuch

Schongauer might be called the Rogier van der Wey-
den of engraving. After learning the goldsmith's craft
in his father's shop, he must have spent considerable
time in Flanders, for he shows a thorough knowledge of
Rogier's art. His prints are replete with Rogierian motifs
and expressive devices, and reveal a deep temperamental
affinity to the great Fleming. Yet Schongauer had his
own impressive powers of invention; his finest engrav-
ings have a complexity of design, spatial depth, and

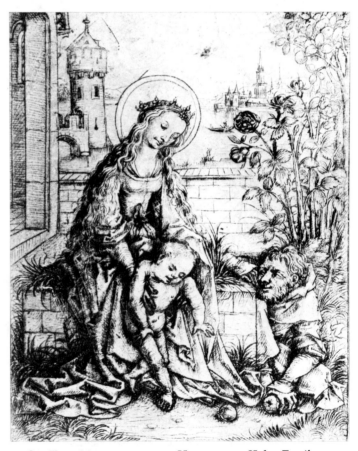

484. THE MASTER OF THE HAUSBUCH. *Holy Family.*
c. 1480–90. Drypoint. Rijksmuseum, Amsterdam

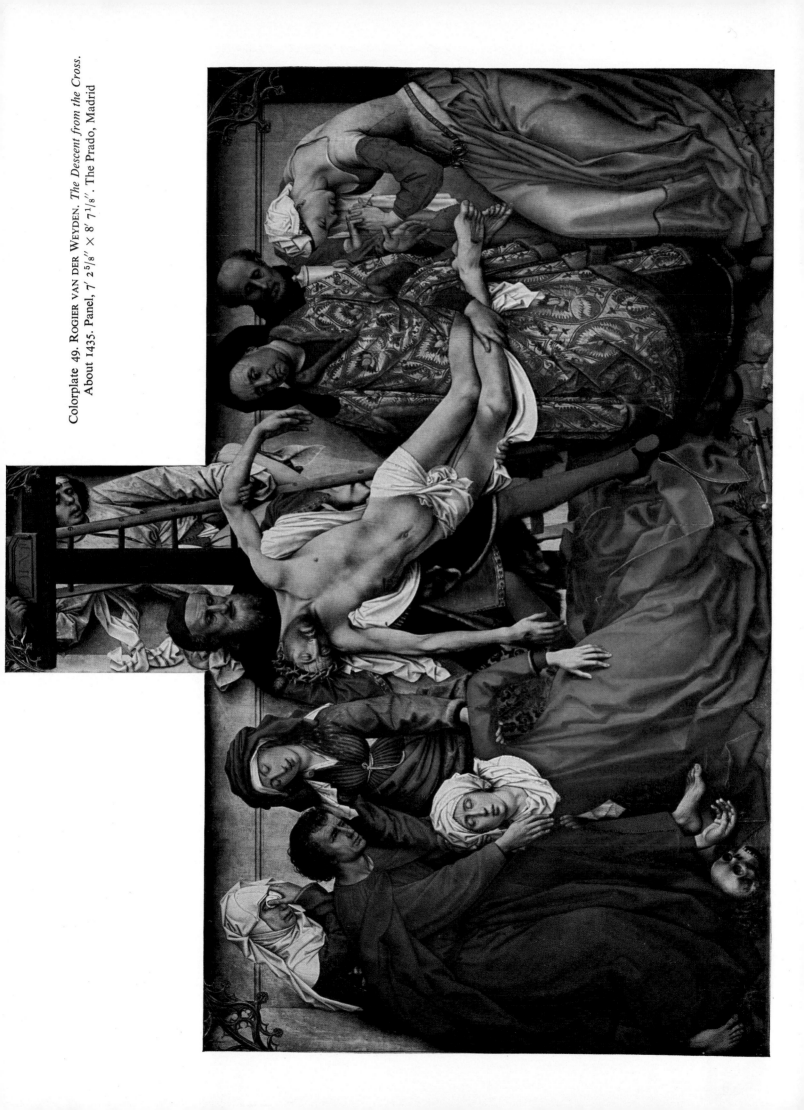

Colorplate 49. ROGIER VAN DER WEYDEN. *The Descent from the Cross.* About 1435. Panel, 7′ 2⁵/₈″ × 8′ 7¹/₈″. The Prado, Madrid

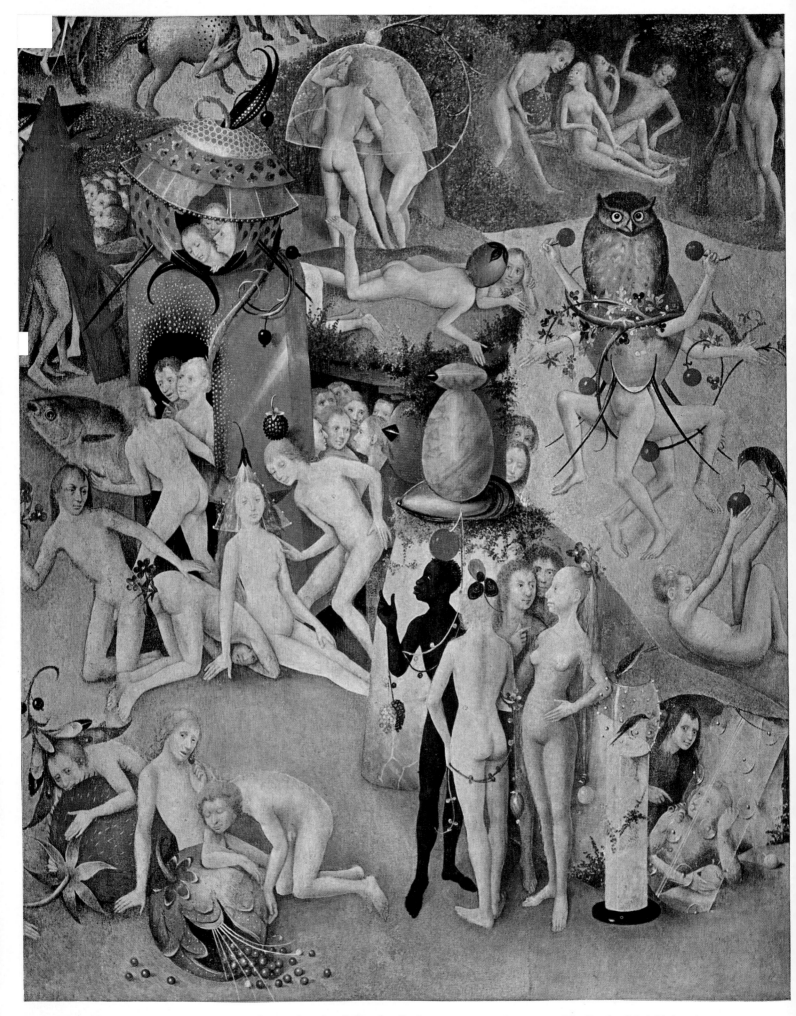

Colorplate 50. HIERONYMUS BOSCH. *The Garden of Delights,* detail of center panel. About 1500. The Prado, Madrid (see figure 471)

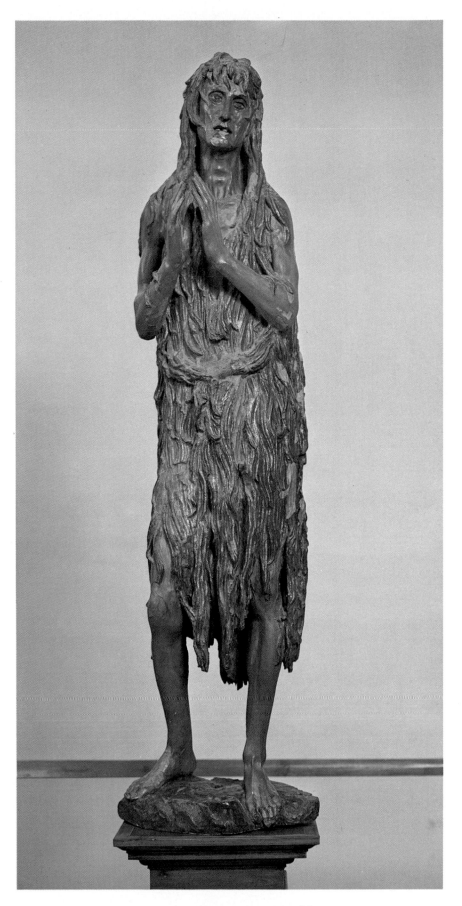

Colorplate 51. Donatello. *Mary Magdalen.* 1445–55.
Wood, partially gilded; height 6′ 2″. Cathedral Museum, Florence

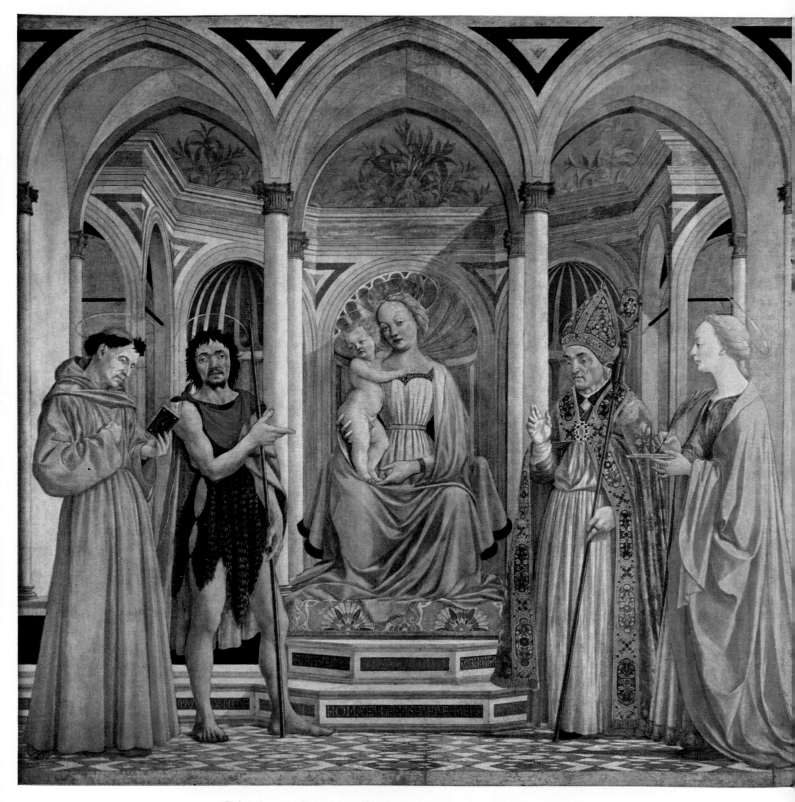

Colorplate 52. DOMENICO VENEZIANO. *Madonna and Child with Saints.*
About 1445. Panel, 6′ 7¹/₂″ × 6′ 11⁷/₈″. Uffizi Gallery, Florence

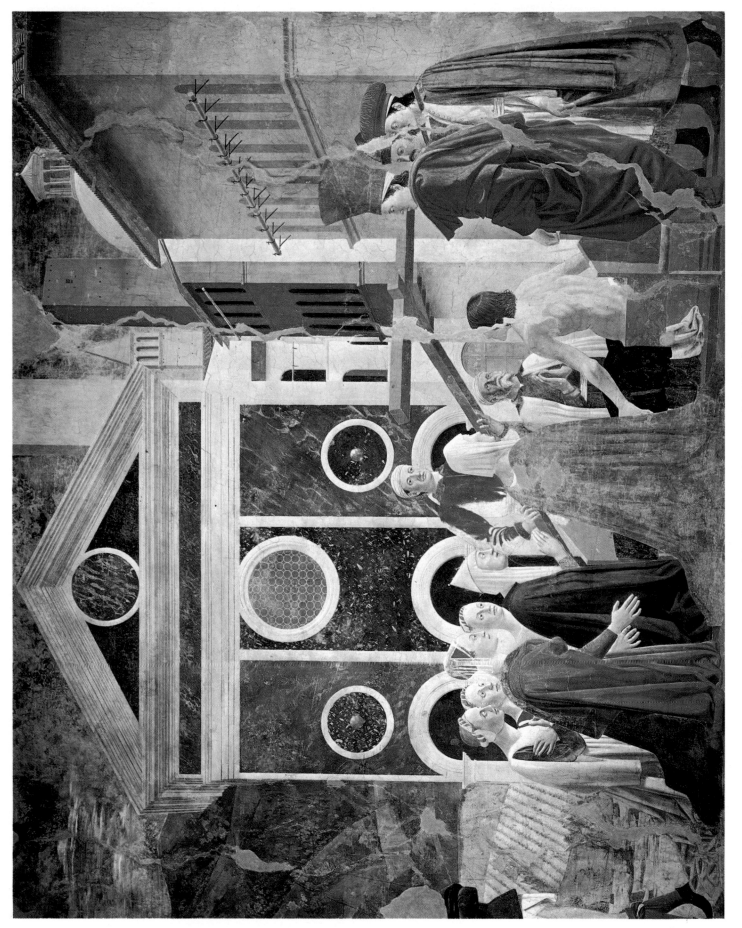

Colorplate 53. PIERO DELLA FRANCESCA. Portion of the *Discovery and Proving of the True Cross*. About 1460. Fresco. S. Francesco, Arezzo

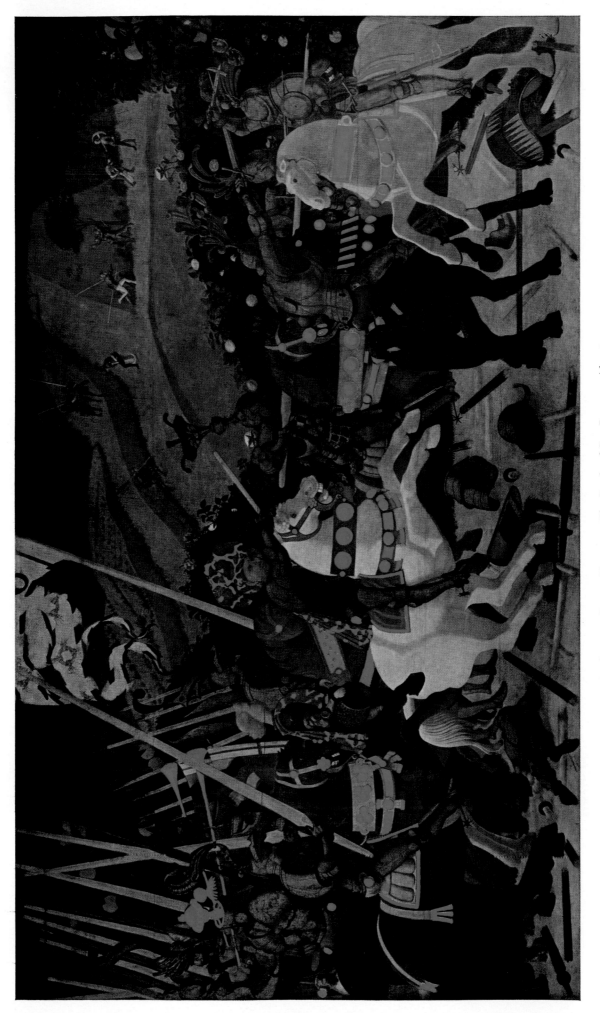

Colorplate 54. PAOLO UCCELLO. *The Battle of San Romano*. About 1455.
Panel, 6′ × 10′ 5³/₄″. The National Gallery, London (Reproduced by courtesy of the Trustees)

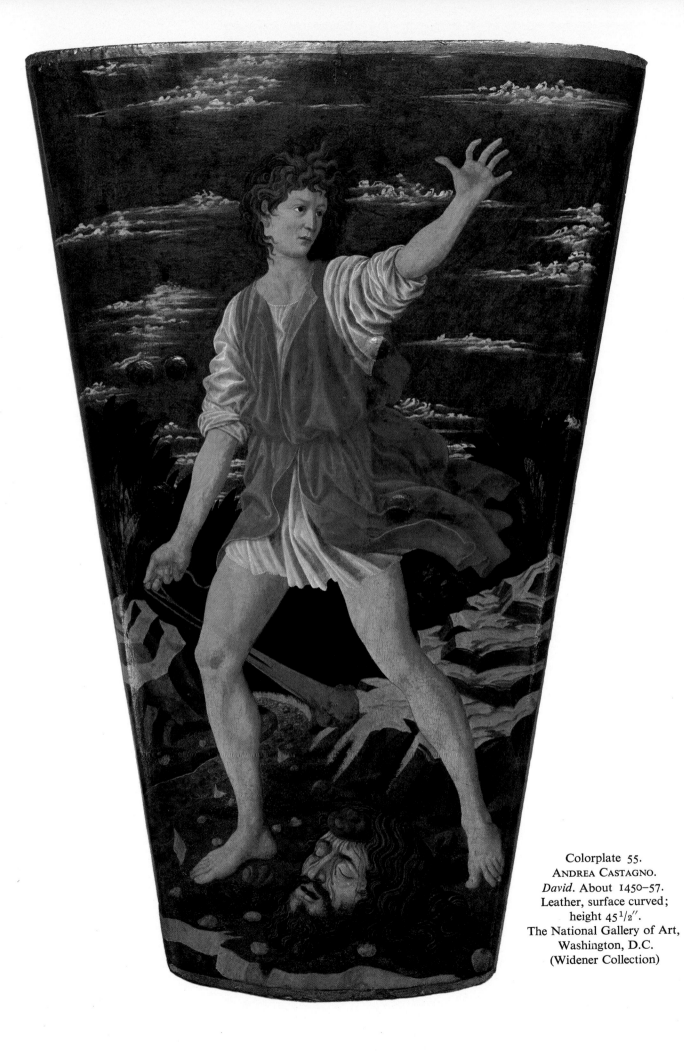

Colorplate 55.
ANDREA CASTAGNO.
David. About 1450–57.
Leather, surface curved;
height 45$\frac{1}{2}$″.
The National Gallery of Art,
Washington, D.C.
(Widener Collection)

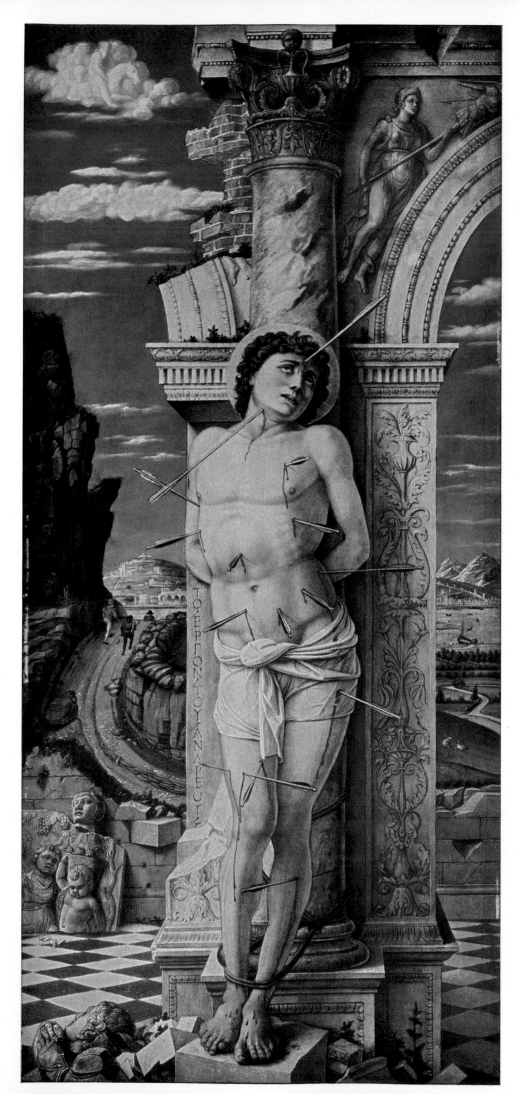

Colorplate 56. ANDREA MANTEGNA.
St. Sebastian. About 1455–60.
Panel, 26³/₄ × 11⁷/₈″.
Kunsthistorisches Museum, Vienna

richness of texture that make them fully equivalent to panel paintings, and lesser artists often found inspiration in them for large-scale pictures. *The Temptation of St. Anthony* (fig. 483), one of Schongauer's most famous works, masterfully combines savage expressiveness and formal precision, violent movement and ornamental stability. The longer we look at it, the more we marvel at its range of tonal values, the rhythmic beauty of the engraved line, and the artist's ability to render every conceivable surface—spiky, scaly, leathery, furry—merely by varying the burin's attack upon the plate. He was not to be surpassed by any later engraver in this respect.

For originality of conception and technique, Schongauer had only one rival among the printmakers of his time, the Master of the Hausbuch (so called after a book of drawings attributed to him). The very individual style of this artist, who was probably of Dutch origin, although he seems to have spent most of his career in the Rhineland, is the opposite of Schongauer's. His prints (such as the *Holy Family,* fig. 484) are small, intimate in mood,

and spontaneous, almost sketchy, in execution. Even his tools were different from the standard engraver's equipment; instead of submitting to the somewhat impersonal discipline demanded by the burin, the Master of the Hausbuch scratched his designs into the copperplate with a fine steel needle. This technique, known as "drypoint," permitted him to draw almost as freely as if he were working with a pen on a sheet of paper. The needle, of course, did not cut grooves as deep as those made by the burin, so that a drypoint plate was apt to wear out after yielding a mere handful of impressions, whereas an engraved plate lasted through hundreds of printings. But the drypoint technique preserved the artist's personal "handwriting," and permitted soft, atmospheric effects—velvety shadows, delicate, luminous distances—unattainable with the burin. The Master of the Hausbuch knew how to take full advantage of these possibilities. He was a pioneer in the use of a tool that was to become, a century and a half later, the supreme instrument of Rembrandt's graphic art.

FLORENCE: 1400–1450

 SCULPTURE

 ARCHITECTURE

 PAINTING

CENTRAL AND
NORTHERN ITALY: 1450–1500

 ARCHITECTURE

 SCULPTURE

 PAINTING

2

THE EARLY RENAISSANCE
IN ITALY

When we discussed the new style of painting that arose in Flanders about 1420, we avoided suggesting why this revolution took place at that particular time and in that particular area. This does not mean, however, that no explanation is possible. Unless we believe in sheer fate or chance, we find it difficult to place the entire burden of responsibility on the Master of Flémalle and the brothers Van Eyck; there must, we feel, be some link between their accomplishment and the social, political, and cultural setting in which they worked. But this link is as yet less apparent, and less well understood, than we might wish. Regarding the origins of Early Renaissance art, we are in a better position. Thanks to recent research, we have more insight into the special circumstances that help to explain why this style was born in Florence at the beginning of the fifteenth century, rather than elsewhere or at some other time.

In the years around 1400, Florence faced an acute threat to its independence. The powerful Duke of Milan, trying to bring all of Italy under his rule, had already subjugated the Lombard plain and most of the Central Italian city-states; Florence remained the only serious obstacle to his ambition. The city put up a vigorous and successful defense, on the military, diplomatic, and intellectual fronts. Of these three, the intellectual was by no means the least important; the Duke had much eloquent support as a new Caesar, bringing peace and order to the country, whereas Florence, in its turn, rallied public opinion by proclaiming itself the champion of freedom against unchecked tyranny. This propaganda war was waged on both sides by humanists, the heirs of Petrarch and Boccaccio, but the Florentines gave by far the better account of themselves. Their writings, such as Leonardo Bruni's *Praise of the City of Florence* (1420–3), give renewed focus to the Petrarchan ideal of a Rebirth of the Classics: the humanist, speaking as the citizen of a free republic, asks why, among all the states of Italy, Florence alone had been able to defy the superior power of Milan; he finds the answer in her institutions, her cultural achievements, her geographical situation, the spirit of her people, and her descent from the city-states of an-

cient Etruria. Does not Florence today, he concludes, assume the same role of political and intellectual leadership as that of Athens at the time of the Persian Wars? The patriotic pride, the call to greatness, implicit in this image of Florence as the "new Athens" must have aroused a deep response throughout the city, for just when the forces of Milan threatened to engulf them, the Florentines embarked upon an ambitious campaign to finish the great artistic enterprises begun a century before, at the time of Giotto. Following the competition of 1401–2 for the bronze doors of the Baptistery (see page 319), another extensive program continued the sculptural decoration of the Cathedral and other churches, while deliberations were resumed on how to build the dome of the Cathedral, the largest and most difficult project of all. The campaign lasted more than thirty years (it gradually petered out after the completion of the dome in 1436). Its total cost, although difficult to express in present-day financial terms, was comparable to the cost of rebuilding the Acropolis in Athens (page 118). The huge investment was itself not a guarantee of artistic quality but, motivated by such civic enthusiasm, it provided a splendid opportunity for the emergence of creative talent and the coining of a new style worthy of the "new Athens." And, from the start, the visual arts were considered essential to the resurgence of the Florentine spirit. They had been classed with the crafts, or "mechanical arts," throughout antiquity and the Middle Ages, and it cannot be chance that the first explicit statement claiming a place for them among the liberal arts occurs in the writings of the Florentine chronicler Filippo Villani, about 1400. A century later, this claim was to win general acceptance throughout the Western world. What does it imply? The liberal arts were defined by a tradition going back to Plato, and comprised the intellectual disciplines necessary for a gentleman's education —mathematics (including musical theory), dialectics, grammar, rhetoric, and philosophy; the fine arts were excluded because they were "handiwork" lacking a theoretical basis. Thus, when the artist gained admission to this select group, the nature of his work had to be

redefined: he was acknowledged as a man of ideas, rather than a mere manipulator of materials; and the work of art came to be viewed more and more as the visible record of his creative mind. This meant that works of art need not—indeed, should not—be judged by fixed standards of craftsmanship; soon everything that bore the imprint of a great master—drawings, sketches, fragments, unfinished pieces—was eagerly collected, regardless of its incompleteness. The artist's outlook, too, underwent certain changes. Now in the company of scholars and poets, he often became himself a man of learning and literary culture; he might write poems, an autobiography, or theoretical treatises. As another consequence of this new social status, artists tended to develop into one of two contrasting personality types: the man of the world, self-controlled, polished, at ease in aristocratic society; and the solitary genius, secretive, idiosyncratic, subject to fits of melancholy, and likely to be in conflict with his patrons. It is remarkable how soon this modern view of art and artists became a living reality in the Florence of the Early Renaissance.

FLORENCE: 1400–1450

SCULPTURE

This half of the fifteenth century became the heroic age of the Early Renaissance. Florentine art, dominated by the original creators of the new style, retained the undisputed leadership of the movement. To trace its beginnings, we must discuss sculpture first, for the sculptors had earlier and more plentiful opportunities than the architects and painters to meet the challenge of the "new Athens." The artistic campaign had opened with the competition for the Baptistery doors, and for some time it consisted mainly of sculptural projects. Ghiberti's trial relief, we recall, does not differ significantly from the International Gothic (see fig. 440); nor do the completed Baptistery doors, even though their execution took another twenty years. In the trial panel only Ghiberti's admiration for ancient art, evidenced by the torso of Isaac, can be linked with the classicism of the Florentine humanists around 1400. Similar instances occur in other Florentine sculpture at that time. But such "quotations" of ancient sculpture, isolated and small in scale, merely recapture what Nicola Pisano had done a century before (see fig. 433). A decade after the trial relief, we find that this limited medieval classicism has been surpassed by a somewhat younger artist, Nanni di Banco. The four saints, called the *Quattro Coronati* (fig. 485), which he made about 1410–14 for one of the niches on the exterior of the church of Or San Michele, demand to be compared not with Nicola Pisano but with the Reims *Visitation* (see fig. 421). The figures in both groups are approximately lifesize, yet Nanni's give the

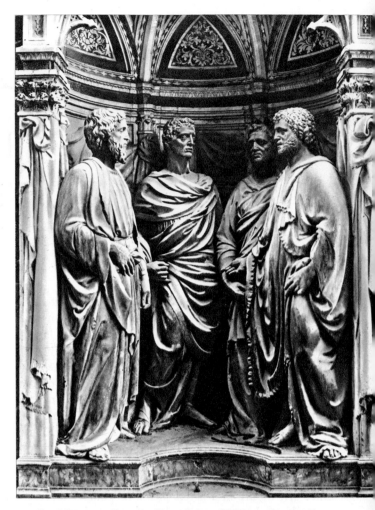

485. NANNI DI BANCO. *Four Saints (Quattro Coronati)*. c. 1410–14. Marble, about lifesize. Or San Michele, Florence

impression of being a good deal larger than those at Reims; their quality of mass and monumentality seems quite beyond the range of medieval sculpture, even though Nanni depended less directly on ancient models than had the Master of the Visitation or Nicola Pisano. Only the heads of the second and third of the *Coronati* recall specific examples of Roman sculpture—those memorable portrait heads of the third century A.D. (compare figs. 486 and 487). Nanni was obviously much impressed by their realism and their agonized expression. His ability to retain the essence of both these qualities indicates a new attitude toward ancient art, which unites classical form and content, no longer separating them as medieval classicists had done.

When Nanni carved the *Quattro Coronati*, he was still in his early thirties. He died in 1421, leaving almost finished a huge relief of the Assumption of the Virgin for the gable above the second north portal of Florence Cathedral. In figure 488, one of the flying angels that carry the Virgin heavenward, we see how rapidly—and surprisingly—Nanni's art had evolved during the interval. The style of this figure is remote from both the classicism of the *Coronati* and the International Gothic.

It recalls, instead, the flying angels of "Late Gothic" art such as that by the Master of Flémalle (fig. 477). Both artists, at the same time and independently, had discovered how to visualize air-borne figures persuasively: enveloping them in thin, loose draperies whose turbulent patterns and balloon-like bulges demonstrate the buoyant force of the wind. But the body of the Flemish angel tends to disappear among the folds, so that it seems essentially passive, whereas the body of Nanni's angel fills out the garments with its own vigorous action; this figure, we are convinced, propels itself, while its Northern counterpart merely floats.

Early Donatello

Comparing the two angels makes us see that Early Renaissance art, in contrast to "Late Gothic," sought an attitude toward the human body similar to that of classical antiquity. The man who did most to re-establish this attitude was Donatello, the greatest sculptor of his time. Born in 1386, several years after Nanni di Banco, he outlived Nanni by forty-five years. Among the "founding fathers" of the new style, he alone survived well past the middle of the century. Together with Nanni, Donatello spent the early part of his career working on commissions for the Cathedral and Or San Michele; they often faced the same artistic problems, yet the personalities of the two masters had little in common. Their different approaches are strikingly illustrated in Nanni's *Quattro Coronati* and Donatello's *St. Mark* (fig. 489): both are located in deep Gothic niches, but Nanni's figures cannot be divorced from their architectural setting and still seem attached, like jamb statues, to the pilasters behind them. The *St. Mark* no longer needs such

shelter; perfectly balanced and self-sustaining, he would lose nothing of his immense authority if he were deprived of his present enclosure. Here is the first statue since antiquity capable of standing by itself, or, to put it another way, the first statue to recapture the full meaning of the Classical *contrapposto*. (For a discussion of this

488. NANNI DI BANCO. *Flying Angel,* detail of *The Assumption.* c. 1420. Porta della Mandorla, Florence Cathedral

489. DONATELLO. *St. Mark.* 1411-13.
Marble, 7′ 9″. Or San Michele, Florence

490. DONATELLO. St. George Tabernacle.
c. 1415-17. Marble (the statue has been transferred to
the National Museum and replaced by a bronze copy),
height of statue 6′ 10″. Or San Michele, Florence

term, refer to page 126). In a performance that truly
marks an epoch, the young Donatello has mastered at
one stroke the central achievement of ancient sculpture.
He treats the human body as an articulated structure,
capable of movement, and its drapery as a separate and
secondary element, determined by the shapes underneath
rather than by patterns imposed from without. Unlike
the *Coronati,* the *St. Mark* looks as if he could take off
his clothes. And yet he is not at all classicistic; that is,
ancient motifs are not quoted as they are in Nanni's
figures. Perhaps "classic" is the right word for him
instead.

A few years later, about 1415-17, Donatello carved
another statue for Or San Michele, the famous *St. George*
(fig. 490). This niche is shallower than that of the *St.
Mark,* and the young warrior saint can actually protrude
from it slightly. Although encased in armor, his body
and limbs are not rigid but wonderfully elastic; his
stance, with the weight placed on the forward leg, con-
veys his readiness for combat (the right hand originally

held a lance or sword). The controlled energy of his body
is reflected in his eyes, which seem to scan the horizon
for the approaching enemy. He is the Christian Soldier
in his Early Renaissance version, spiritually akin to the
St. Theodore at Chartres (see fig. 419), but also the proud
defender of the "new Athens." Below his niche is a
relief panel showing the hero's best-known exploit, slay-
ing the dragon (fig. 491; the maiden on the right is the

left: 491. *St. George and the Dragon*, portion of relief below *St. George* (fig. 490). Marble, height 15³/₄"

below: 492. DONATELLO. *Prophet (Zuccone)*, on the campanile of the Cathedral. 1423–25. Marble, height 6'5". The original is now in the Cathedral Museum, Florence

captive princess whom the saint had come to liberate). Donatello has here produced another revolutionary work, devising a new kind of relief that is physically shallow (hence called *schiacciato,* "flattened-out") yet creates an illusion of infinite pictorial depth. This had already been achieved to some degree in certain Greek and Roman reliefs, and by Ghiberti (compare with figs. 176, 243–47, 440). But in all these cases, the actual carved depth is roughly proportional to the apparent depth of the space represented: the forms in the front plane are in very high relief, while those more distant become progressively lower, seemingly immersed in the background of the panel. Donatello discards this relationship; behind the figures, the amazing wind-swept landscape consists entirely of delicate surface modulations which cause the marble to catch light from varying angles. Thus every tiny ripple becomes endowed with a descriptive power infinitely greater than its real depth, and the chisel, like a painter's brush, becomes a tool for creating shades of light and dark. Yet Donatello cannot have borrowed his landscape from any painting, for no painter, at the time he did the St. George relief, had achieved so coherent and atmospheric a view of nature.

On the campanile of Florence Cathedral, when it was built in 1334–57, a row of tall Gothic niches had been designed for statues (barely visible above the rooftops in fig. 410). Half of these niches were still empty, and between 1416 and 1435 Donatello filled five of them. The most impressive statue of his series (fig. 492) is the unidentified prophet nicknamed *Zuccone* ("pumpkinhead"), made a dozen years after the *St. Mark.* The figure has long enjoyed special fame as a striking example of the master's realism, and there is no question that it is indeed realistic—far more so than any ancient statue or its nearest rivals, the prophets on the *Moses Well* (see fig. 431). But, we may ask, what *kind* of realism have we here? Donatello has not followed the conventional image of a prophet (a bearded old man in Oriental-looking costume, holding a large scroll); he has invented an

493. DONATELLO. *The Feast of Herod.* c. 1425.
Gilt bronze, 23¹/₂″ square. Baptismal Font, S. Giovanni,
Siena

494. LORENZO GHIBERTI. *The Story of Jacob and Esau,*
Panel of the "Gates of Paradise." c. 1435.
Gilt bronze, 31¹/₄″ square. Baptistery, Florence

entirely new type, and it is difficult to account for his impulse in terms of realism. Why did he not reinterpret the old image from a realistic point of view, as Claus Sluter had done? Donatello obviously felt that the established type was inadequate for his own conception of the subject, but how did he conceive it anew? Surely not by observing the people around him. More likely, he imagined the personalities of the prophets from what he had read about them in the Old Testament. He gained an impression, we may assume, of divinely inspired orators haranguing the multitude; and this, in turn, reminded him of the Roman orators he had seen in ancient sculpture. Hence the classical costume of the *Zuccone,* whose mantle falls from one shoulder like those of the toga-clad patricians in figures 238 and 243. Hence, also, the fascinating head, ugly yet noble, like Roman portraits of the third century A.D. (compare figs. 253, 254). To shape all these elements into a coherent whole was a revolutionary feat, an almost visible struggle. Donatello himself seems to have regarded the *Zuccone* as a particularly hard-won achievement; it is the first of his surviving works to carry his signature. He is said to have sworn "by the *Zuccone*" when he wanted to emphasize a statement, and to have shouted at the statue, during his work, "Speak, speak, or the plague take you!"

Ghiberti and Donatello

Donatello had learned the technique of bronze sculpture as a youth by working under Ghiberti on the Baptistery doors. Now, in the 1420s, he began to rival his former teacher in that medium. *The Feast of Herod* (fig. 493), which he made about 1425 for the baptismal font of S. Giovanni (the Baptistery of Siena Cathedral), shows the same exquisite surface finish as Ghiberti's panels (see fig. 440), but also an expressive power that we could expect only of the master of the *Zuccone.* By classical or medieval standards, the main scene is poorly composed: the focus of the drama (the executioner presenting the head of St. John to Herod) is far to the left; the dancing Salome and most of the spectators are massed on the right; the center remains empty. Yet we see at once why Donatello created this gaping hole: it conveys, more effectively than the witnesses' gestures and expressions, the impact of the shocking sight. Moreover, the centrifugal movement of the figures helps persuade us that the picture space does not end within the panel but continues indefinitely in every direction; that the frame is merely a window through which we see this particular segment of unlimited, continuous reality. The arched openings within the panel serve to frame additional segments of the same reality, luring us further into the depths of the palace. This architecture, with its round arches, its fluted columns and pilasters, is not Gothic but reflects the new style launched by Filippo Brunelleschi, whose architectural achievements will occupy us

soon. Brunelleschi also invented the system of linear perspective, and *The Feast of Herod* is probably the earliest surviving example of a picture space constructed by this method. The details of the method need not concern us here, beyond saying that the system is a geometric procedure for projecting space onto a plane, analogous to the way the lens of a photographic camera now projects a perspective image on the film. Its central feature is the vanishing point, toward which any set of parallel lines will seem to converge. If these lines are perpendicular to the picture plane, their vanishing point will be on the horizon, corresponding exactly to the position of the beholder's eye. Brunelleschi's discovery in itself was scientific rather than artistic, but it immediately became highly important to Early Renaissance artists because, unlike the perspective practices of the past, it was objective, precise, and rational (in fact, it soon became an argument for up-grading the fine arts into the liberal arts). While empirical methods could also yield striking results, mathematical perspective made it possible now to represent three-dimensional space on a flat surface in such a way that all the distances remained measurable—and this meant, in turn, that by reversing the procedure the plan could be derived from the perspective picture of a building. On the other hand, the scientific implications of the new perspective demanded that it be consistently applied, a requirement that artists could not always live up to, for practical as well as aesthetic reasons. Since the method presupposes that the beholder's eye occupies a fixed point in space, a per-

spective picture automatically tells us where we must stand to see it properly. Thus the artist who knows in advance that his work will be seen from above or below, rather than at ordinary eye-level, ought to make his perspective construction correspond to these conditions; but if these are so abnormal that he must foreshorten his entire design to an extreme degree, he may disregard them and assume instead an ideal beholder, normally located. Such is the case in *The Feast of Herod*: our eye should be on a line perpendicular to the center of the panel, but in the Baptistery we must crouch low to see it correctly, as the basin to which our relief is attached is only a few feet high. (For other problems raised by the use of scientific perspective, see page 393).

At the same time that Donatello designed *The Feast of Herod*, Ghiberti was commissioned to do another pair of bronze doors for the Baptistery in Florence. This second set, so beautiful that they were soon dubbed the "Gates of Paradise," is decorated with ten large reliefs in square frames (not twenty-eight small panels in quatrefoil frames, as on the earlier doors) and shows the artist's successful conversion, under the influence of Donatello and the other pioneers of the new style, to the Early Renaissance point of view. *The Story of Jacob and Esau* (fig. 494) may be instructively contrasted with *The Feast of Herod*. It is about a decade later, and its perspective construction is more easy and assured; Brunelleschi's discovery had meanwhile been formulated in writing by Leone Battista Alberti, the author of the first Renaissance treatise on painting and, later, an important

495. JACOPO DELLA QUERCIA. *The Creation of Adam.* c. 1430. Marble, 34$\frac{1}{2}$ × 27$\frac{1}{2}$". Main Portal, S. Petronio, Bologna

496. *Adam in Paradise,* detail of an ivory diptych. c. 400 A.D. National Museum, Florence

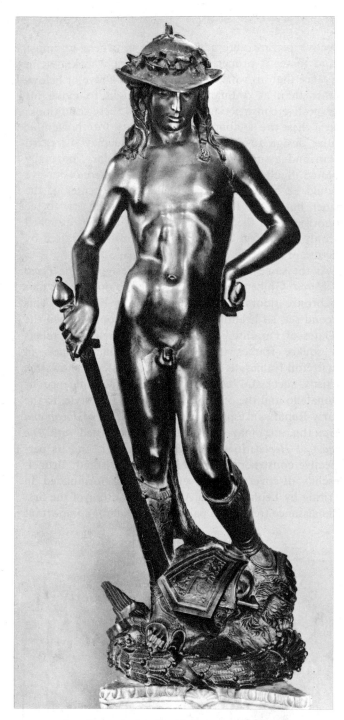

497. DONATELLO. *David.* c. 1430–32. Bronze,
height 62¼". National Museum, Florence

architect (see pages 399–401). The setting for Ghiberti's
narrative is a spacious hall, a fine example of Early
Renaissance architectural design reflecting the mature
art of Brunelleschi, while the figures still remind us, by
their gentle and graceful classicism, of the International
Gothic style.

Jacopo della Quercia and the Classical Nude

Outside Florence the only major sculptor at that time
was Jacopo della Quercia of Siena. Like Ghiberti, he
changed his style from Gothic to Early Renaissance in
mid-career, mainly through contact with Donatello. Had
he grown up in Florence, he might have been one of the
great leaders of the new movement from the start, but
his forcefully individual art remained outside the main
trend. It had no effect on Florentine art until the very
end of the century, when the young Michelangelo fell
under its spell. Michelangelo's admiration was aroused
by the scenes from Genesis framing the main portal of
the church of S. Petronio in Bologna, among them *The
Creation of Adam* (fig. 495). The relief mode of these
panels is conservative—Jacopo had little interest in pic-
torial depth—but the figures are daring and profoundly
impressive. The figure of Adam slowly rising from the
ground, as a statue brought to life might rise from its
mold, recaptures the heroic beauty of a classical athlete.
Here the nude body once again expresses the dignity and
power of man as it did in classical antiquity. Yet we
sense that man has not been freed from Original Sin.
Jacopo's Adam contains a hint of incipient conflict as he
faces the Lord; he will surely fall, but in pride of spirit
rather than as a hapless victim of the Evil One.

It is instructive to compare Jacopo's Adam with the
work that probably inspired it, an Adam in Paradise from
an Early Christian ivory diptych (fig. 496). The latter
figure represents a classicizing trend around 400 A.D.
(compare fig. 279), a final attempt to preserve the Greek
ideal of physical beauty within a Christian context.
Adam appears as the Perfect Man, divinely appointed to
"have dominion . . . over every living thing," but the
classic form has already become a formula, a mere shell.
And the classical nude entered the tradition of medieval
art in this desiccated condition. Whenever we meet the
unclothed body, from 800 to 1400, we may be sure that
it is derived, directly or indirectly, from a classical source,
no matter how unlikely this may seem (as in fig. 346).
We may also be sure—except for a few special cases—
that such nudity has a moral significance, whether nega-
tive (Adam and Eve, or sinners in Hell) or positive (the
nudity of the Christ of the Passion; of saints being
martyred or mortifying the flesh; of Fortitude in the
guise of Hercules). Finally, medieval nudes, even the
most accomplished, are devoid of that sensuous appeal
which we take for granted in every nude of classical
antiquity. Such appeal was purposely avoided rather
than unattainable, for to the medieval mind the physical
beauty of the ancient "idols," especially nude statues,
embodied the insidious attraction of paganism. The
fifteenth century rediscovered the sensuous beauty of the
unclothed body, but by way of two separate paths. The
Adam and Eve of Jan van Eyck (fig. 464), or the nudes
of Bosch (colorplate 50), have no precedent in either
ancient or medieval art; they are, indeed, not "nude," but
"naked"—people whose normal state is to be dressed
and who for specific reasons appear stripped of their
clothing. Jacopo della Quercia's Adam, on the other
hand, is clearly nude, in the full classical sense. So also

is Donatello's bronze *David* (fig. 497), an even more rev-olutionary achievement of Early Renaissance sculpture, the first lifesize nude statue since antiquity that is wholly free-standing. The Middle Ages would surely have con-demned it as an idol, and Donatello's contemporaries, too, must have felt uneasy about it; for many years it remained the only work of its kind. Why the artist chose to represent the young victor in this fashion is somewhat puzzling (the symbolic reasons that have been suggested are not very persuasive), especially since David wears rather ornate military boots and a hat. The early history of the figure is unknown, but there can be little doubt that it was made for a private patron and meant to be placed—perhaps in the center of a courtyard—where it would be visible from every side. While the David is, in a sense, partly dressed, we are less likely to wonder what happened to the rest of his costume than why he wears as much as he does. Nudity, clearly, is his natural state, although he resembles a classical statue only in his beautifully poised *contrapposto*. Donatello has chosen to model an adolescent boy, not a full-grown youth like the athletes of Greece, so that the skeletal structure here is less fully enveloped in swelling muscles; nor does he articulate the boy's torso according to the classical pat-tern (compare figs. 164, 165). If the figure nevertheless conveys a profoundly classical air, the reason lies beyond its anatomic perfection; as in ancient statues, the body speaks to us more eloquently than the face, which by Donatello's standards is strangely devoid of individuality.

Donatello: Padua and Later

Donatello was called to Padua in 1443 to produce the equestrian monument of Gattamelata, the recently de-ceased commander of the Venetian armies (fig. 498). This statue, the artist's largest free-standing work in bronze, still stands in its original position on a tall pedestal near the façade of the church dedicated to St. Anthony of Pad-ua. We already know its two chief precedents, the *Marcus Aurelius* in Rome (fig. 252) and the *Can Grande* in Ve-rona (fig. 438). Without directly imitating the former, the *Gattamelata* shares its material, its impressive scale, and its sense of balance and dignity; Donatello's horse, a heavy-set animal fit to carry a man in full armor, is so large that the rider must dominate it by his authority of command, rather than by physical force. The link with the *Can Grande*, though less obvious, is equally signifi-cant: both statues stand next to a church façade, both are memorials to the military prowess of the deceased. But the *Gattamelata*, in the new Renaissance fashion, is not part of a tomb; it was designed solely to immortalize the fame of a great soldier. Nor is it the self-glorifying statue of a sovereign, but a monument authorized by the Republic of Venice, in special honor of distinguished and faithful service. To this purpose, Donatello has coined an image that is a complete union of ideal and reality;

498. DONATELLO. *Equestrian Monument of Gattamelata.* 1445–50. Bronze, c. 11′ × 13′. Piazza del Santo, Padua

the general's armor combines modern construction with classical detail; the head is powerfully individual, and yet endowed with a truly Roman nobility of character.

When Donatello went home to Florence after a dec-ade's absence, he must have felt like a stranger. The political and spiritual climate had changed, and so had the taste of artists and public (see page 404). His subsequent works, between 1453 and 1466, stand apart from the dominant trend; perhaps that is why their fierce expressiveness and personal quality exceed any-thing the master had revealed before. The wooden *Mary Magdalen* (colorplate 51) seems so far from Renaissance ideals that at first we are tempted to see in her a return to such Gothic devotional images as the Bonn *Pietà* (fig. 429). But then we recall the intensity of the *Zuccone*, and we realize that the ravaged features of his *Mary Magdalen* betray an insight into religious experience not basically different from Donatello's earlier work. Far from being a retreat to the medieval past, the extreme individualism of his late style confirms Donatello's rep-

utation as the earliest "solitary genius" among Renaissance artists.

ARCHITECTURE: BRUNELLESCHI

Although he was its greatest and most daring master, Donatello had not created the Early Renaissance style in sculpture all by himself. The new architecture, on the other hand, did owe its existence to one man, Filippo Brunelleschi. Ten years older than Donatello, Brunelleschi had begun his career as a sculptor. After failing to win the competition of 1401–2 for the first Baptistery doors, he reportedly went to Rome with Donatello. He studied the architectural monuments of the ancients, and seems to have been the first to take exact measurements of these structures. His discovery of scientific perspective may well have grown out of his search for an accurate method of recording their appearance on paper. What

499. FILIPPO BRUNELLESCHI.
Plan of S. Lorenzo.
1421–69. Florence

else he did during this long "gestation period" we do not know, but in 1417–19 we again find him competing with Ghiberti, this time for the job of building the Cathedral dome (see figs. 410, 411). Its design had been established half a century earlier and could be altered only in details, but its vast size posed a difficult problem of construction. Brunelleschi's proposals, although contrary to all traditional practice, so impressed the authorities that this time he won out over his rival. Thus the dome deserves to be called the first work of post-medieval architecture, as an engineering feat if not for style. The technical details need not concern us here. Brunelleschi's main achievement was to build the dome in two separate shells that are ingeniously linked to reinforce each other, rather than in one solid mass. As the total weight of the structure was thereby lightened, he could dispense with the massive and costly wooden trusswork required by the older method of construction. Instead of having building materials carried up on ramps to the required level, he designed hoisting machines; his entire scheme reflects a bold, analytical mind, always discarding conventional solutions if better ones could be devised. This fresh approach distinguishes Brunelleschi from the Gothic stonemason-architects, with their time-honored procedures.

In 1419, while he was working out his final plans for the dome, Brunelleschi received his first opportunity to create buildings entirely of his own design. It came from the head of the Medici family, one of the leading merchants and bankers of Florence, who commissioned him to add a sacristy to the Romanesque church of San Lorenzo. His plans for this sacristy (which was to serve also as a burial chapel for the Medici) so impressed his patron that he was immediately asked to develop a new design for the entire church. The construction, begun in 1421, was often interrupted, so that the interior was not com-

500. FILIPPO BRUNELLESCHI.
S. Lorenzo. Florence

pleted until 1469, more than twenty years after the architect's death (the exterior remains unfinished to this day). Nevertheless, the building in its present form is essentially what Brunelleschi had envisioned about 1420, and thus represents the first full statement of his architectural aims (figs. 499, 500).

The plan may not seem very novel, at first glance. Its general arrangement recalls Cistercian Gothic churches (see fig. 406); the unvaulted nave and transept link it to Sta. Croce (see fig. 408). What distinguishes it is a new emphasis on symmetry and regularity. The entire design consists of square units: four large squares form the choir, the crossing, and the arms of the transept; four more are combined into the nave; other squares, one-fourth the size of the large units, make up the aisles and the chapels attached to the transept (the oblong chapels outside the aisles were not part of the original design). We notice, however, some small deviations from this scheme—the transept arms are slightly longer than they are wide, and the length of the nave is not four but four-and-a-half times its width. A few simple measurements will explain these apparent inconsistencies. Brunelleschi must have first decided to make the floor area of the choir equal to four of the small square units; the nave and transept were thus to be twice as wide as the aisles or chapels. But in fixing this system, he made no allowance for the inevitable thickness of the walls between these compartments, so that the transept arms have a width of two units, and a length of two units plus one wall-thickness; the nave is seven wall-thicknesses longer than, ideally speaking, it should be. In other words, Brunelleschi conceived S. Lorenzo as a grouping of abstract "space blocks," the larger ones being simple multiples of the standard unit. Once we understand this we realize how revolutionary he was, for his clearly defined, separate space compartments represent a radical departure from the Gothic architect's way of thinking.

The interior bears out our expectations. Cool, static order has replaced the emotional warmth, the flowing spatial movement of Gothic church interiors. San Lorenzo does not sweep us off our feet. It does not even draw us forward after we have entered it—we are quite content to remain near the door, for our view seems to take in the entire structure almost as if, from that vantage point, we were confronted with a particularly clear and convincing demonstration of scientific perspective (compare fig. 494). The total effect recalls the "old-fashioned" Tuscan Romanesque—such as Pisa Cathedral (fig. 366)—and Early Christian basilicas (compare fig. 266), for these monuments, to Brunelleschi, exemplified the church architecture of classical antiquity; they inspired his return to the use of the round arch and of columns, rather than piers, in the nave arcade. Yet these earlier buildings lack the transparent lightness, the wonderfully precise articulation of San Lorenzo. Unlike Brunelleschi's, their columns are larger and more closely spaced, tending to screen off the aisles from the nave. Only the arcade of the Florentine Baptistery is as gracefully proportioned as that of San Lorenzo, but it is a *blind* arcade, without any supporting function (see fig. 367; the Baptistery, we recall, was in Brunelleschi's day thought to have once been a classical temple). But Brunelleschi did not revive the architectural vocabulary of the ancients out of mere antiquarian enthusiasm. The very quality that attracted him to the component parts of classical architecture must have seemed, from the medieval point of view, their chief drawback: their inflexibility. A classical column, unlike a medieval column or pier, is strictly defined and self-sufficient, and its details and proportions can be varied only within narrow limits (the ancients thought of it as an organic structure comparable to the human body); the classical round arch, unlike any other arch (horseshoe, pointed, etc.), has only one possible shape, a semicircle; the classical architrave and the classical repertory of profiles and ornaments are all subject to similarly strict rules. Not that the classical vocabulary is completely inflexible—if it were, it could not have persisted from the seventh century B.C. to the fourth century A.D. in the ancient world—but the disciplined spirit of the Greek orders, which can be felt even in the most original Roman buildings, demands regularity and consistency, and discourages sudden, arbitrary departures from the norm. Without the aid of such a "standardized" vocabulary, Brunelleschi would have found it impossible to define the shape of his "space blocks" so convincingly. With remarkable logic, he emphasizes the edges or "seams" of the units without disrupting their rhythmic sequence. To single out a particularly noteworthy example, consider the vaulting of the aisles: the transverse arches rest on pilasters attached to the outer wall (corresponding to the columns of the nave arcade) but a continuous architrave intervenes between arch and pilaster, linking all the bays. We would expect these bays to be covered by groined vaults of the classical, unribbed type (see fig. 220); instead, we find a novel kind of vault, whose curved surface is formed from the upper part of a hemispherical dome (its radius equals half the diagonal of the square compartment). Avoiding the ribs and even the groins, Brunelleschi has created a "one-piece" vault, strikingly simple and geometrically regular, that makes of each bay a distinct unit.

At this point we may well ask: if the new architecture consists essentially of separate elements added together, be they spaces, columns, or vaults, how did Brunelleschi relate these elements to each other? What makes the interior of San Lorenzo seem so beautifully integrated? There is indeed a controlling principle that accounts for the harmonious, balanced character of his design: the secret of good architecture, Brunelleschi was convinced, lay in giving the "right" proportions—that is, proportional ratios expressed in simple whole numbers—to all the significant measurements of a building. The ancients had possessed this secret, he believed, and he tried to rediscover it by painstakingly surveying the remains of

their monuments. What he found, and how he applied his theory to his own designs, we do not know for sure. He may have been the first, though, to think out what would be explicitly stated a few decades later in Leone Battista Alberti's *Treatise on Architecture:* that the arithmetical ratios determining musical harmony must also govern architecture, for they recur throughout the universe and are thus divine in origin. Similar ideas, ultimately derived from the Greek philosopher Pythagoras, had been current during the Middle Ages (see page 285), but they had not before been expressed so radically, directly, and simply. When Gothic architects "borrowed" the ratios of musical theory, they did so with the aid of the theologians and far less consistently than their Renaissance successors. But even Brunelleschi's faith in the universal validity of harmonious proportions did not tell him how to allot these ratios to the parts of any given building. It left him many alternatives, and his choice among them was necessarily subjective. We may say, in fact, that the main reason S. Lorenzo strikes us as the product of a single great mind is Brunelleschi's individual "sense of proportion" which permeates every detail.

In the revival of classical forms, Renaissance architecture found a standard vocabulary; the theory of harmonious proportions provided it with the kind of syntax that had been mostly absent in medieval architecture. Lest this comparatively inflexible order be misinterpreted as an architectural impoverishment, we might carry our linguistic analogy a bit further. It is tempting to see a

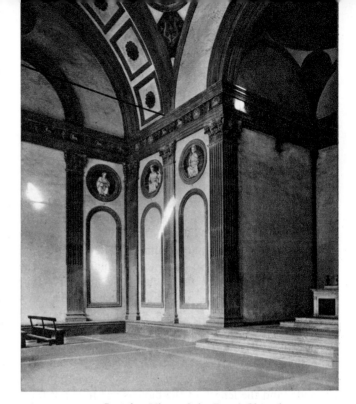

502. Interior View of the Pazzi Chapel

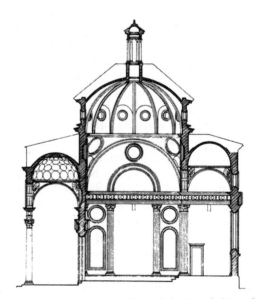

503. Longitudinal Section of the Pazzi Chapel

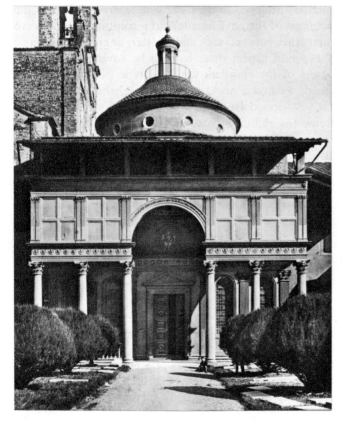

501. FILIPPO BRUNELLESCHI and others.
Pazzi Chapel. Begun 1430–33. Sta. Croce, Florence

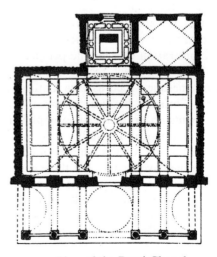

504. Plan of the Pazzi Chapel

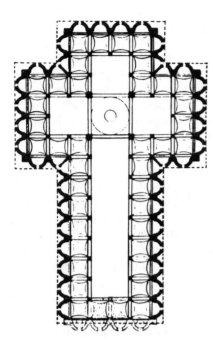

505. FILIPPO BRUNELLESCHI. Plan of S. Spirito.
Begun 1434–35. Florence

the portal behind, and draws attention to the dome. The plan (fig. 504) shows us that the interrupted architrave supports two barrel vaults, which in turn help to support a small dome above the central opening. Inside the chapel, we find the same motif on a larger scale—two barrel vaults flanking the dome—and a third small dome, like that over the entrance, above the square compartment housing the altar (figs. 502, 503). Interior surfaces are articulated much as in S. Lorenzo but their effect is

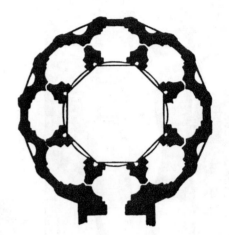

506. FILIPPO BRUNELLESCHI. Plan of Sta. Maria degli Angeli. 1434–37. Florence

parallel between the "un-classical" flexibility of medieval architecture, proliferating in regional styles, and the equally "un-classical" attitude at that time toward language, as evidenced by its barbarized Latin and the rapid growth of regional vernaculars, the ancestors of our modern Western tongues. The revival of Latin and Greek in the Renaissance did not stunt these languages; on the contrary, the classical influence made them so much more stable, precise, and articulate that Latin before long lost the dominant position it had maintained throughout the Middle Ages as the language of intellectual discourse. It is not by chance that today we can still read Renaissance literature in Italian, French, English, or German without much trouble, while texts of a century or two before can often be understood only by scholars. In a similar way, the revival of classical forms and proportions enabled Brunelleschi to transform the architectural "vernacular" of his region into a stable, precise, and articulate system. The new rationale underlying his buildings soon spread to the rest of Italy, and later to all of Northern Europe.

Among the surviving structures by Brunelleschi, not one exterior shows his original design unaltered by later hands. Recent research indicates that even the façade of the Pazzi Chapel (fig. 501) can no longer be regarded as an exception to this rule. The chapel was begun about 1430, but Brunelleschi (who died in 1446) could not have planned the façade in its present form. It dates from about 1460, and the top story remains incomplete. Nevertheless, it is a most original creation, totally unlike any medieval façade. A porch, reminiscent of the narthex of Early Christian churches (see fig. 268), precedes the chapel, making the façade seem to screen the main body of the structure. The central arch linking two sections of a classical colonnade is a prime innovation; it frames

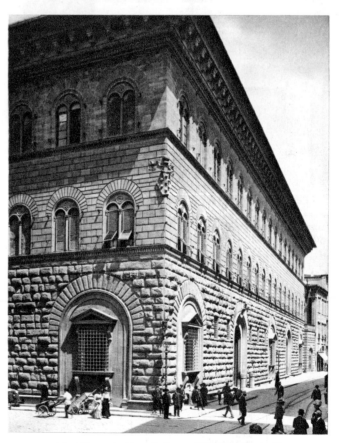

507. MICHELOZZO. Palazzo Medici-Riccardi.
Begun 1444. Florence

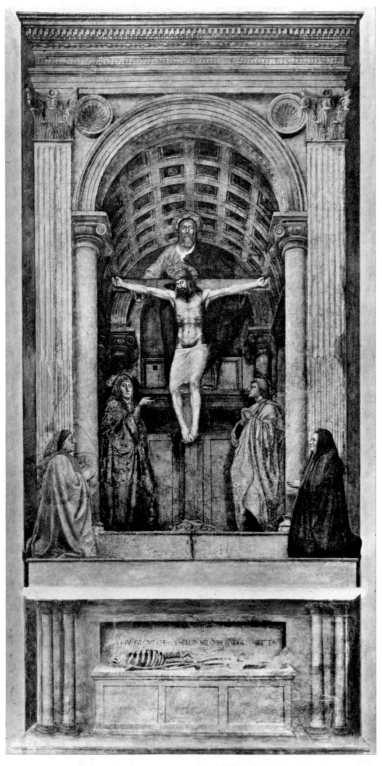

508. MASACCIO. *The Holy Trinity with the Virgin and St. John.* 1425. Fresco. Sta. Maria Novella, Florence

509. Ground Plan of *The Holy Trinity*

richer and more festive. Here we also find some sculpture: large roundels on the four pendentives of the central dome, with reliefs of the evangelists (one of them is partly visible in fig. 502), and on the walls, twelve smaller ones of the apostles. These reliefs, however, are not essential to the design of the chapel; Brunelleschi provided the frames, but he need not have intended them to be filled with sculpture—the medallions may very well have been planned "blind," like the recessed panels below them. In any case, the medieval interdependence of architecture and sculpture (never as strong in Italy as in Northern Europe) had ceased to exist. Donatello had liberated the statue from its setting, and Brunelleschi's conception of architecture as the visual counterpart of musical harmonies did not permit sculpture to play a role more weighty than the roundels in the Pazzi Chapel.

In the early 1430s, when the Cathedral dome was nearing completion, Brunelleschi's development as an architect entered a decisive new phase. His design for the church of S. Spirito (fig. 505) might be described as a perfected version of S. Lorenzo; all four arms of the cross are alike, the nave being distinguished from the others only by its greater length, the entire structure now enveloped by an unbroken sequence of aisles and chapels. These chapels are the most surprising feature of S. Spirito; Brunelleschi had always shunned the apsidal shape before, but now he used it to express more dynamically the relation between interior space and its boundaries (the wall seems to bulge under the outward pressure of the space). In the church of Sta. Maria degli Angeli, which Brunelleschi began about the same time as S. Spirito, this new tendency reaches its ultimate conclusion (fig. 506): a domed, central-plan church—the first of the Renaissance—inspired by the round and polygonal structures of Roman and early Christian times (compare figs. 221–24, 271–73, 282–85). Financial difficulties interfered with completing the project above the ground floor, and we cannot be sure of the design of the upper part, or even of some details in the plan. It is clear, nevertheless, that Brunelleschi here has recaptured the ancient Roman principle of the "sculptured" wall; the dome was to rest on eight heavy piers of complex shape, which belong to the same mass of masonry from which the eight chapels have been "excavated." Wall and space are both charged with energy, and the plan records the precarious balance of their pressures and counterpressures. As a conception, Sta. Maria degli Angeli was so far in advance of Brunelleschi's previous work that it must have utterly bewildered his contemporaries. It had, in fact, no echoes until the end of the century.

The massive "Roman" style of Sta. Maria degli Angeli may explain the great disappointment of Brunelleschi's final years: the rejection by his old patrons, the Medici, of his design for their new palace. The family had risen, since the 1420s, to such power that they were in practice, if not in theory, the rulers of Florence. For that very reason they thought it prudent to avoid any ostentation

which might antagonize the public. If Brunelleschi's plan for their palace followed the style of Sta. Maria degli Angeli, it probably had such imperial Roman magnificence that the Medici could not safely afford so grand an edifice. They awarded the commission to a younger and much less distinguished architect, Michelozzo; actual construction began in 1444, two years before Brunelleschi's death. Michelozzo's design (fig. 507) still recalls the fortress-like Florentine palaces of old (the windows on the ground floor were added by Michelangelo seventy-five years later), but the type has been transformed by Brunelleschian principles (compare fig. 415). The three stories are in a graded sequence, each complete in itself: the lowest is built of roughhewn, "rustic" masonry like the Palazzo Vecchio; the second of smooth-surfaced blocks with "rusticated" (that is, indented) joints; the surface of the third is unbroken. On top of the structure rests, like a lid, a strongly projecting cornice inspired by those of Roman temples, emphasizing the finality of the three stories.

PAINTING: MASACCIO

Although Early Renaissance painting did not appear until the early 1420s, a decade later than Donatello's *St. Mark* and some years after Brunelleschi's first designs for S. Lorenzo, its inception is the most extraordinary of all; this new style was launched, singlehanded, by a young genius named Masaccio, who was only twenty-one years old at the time (he had been born in 1401) and who died at the age of twenty-seven. The Early Renaissance

was already well established in sculpture and architecture by then, making Masaccio's task easier than it would have been otherwise; but his achievement remains stupendous, nevertheless. The earliest of his surviving works that can be dated fairly accurately is a fresco of 1425 in Sta. Maria Novella (fig. 508), showing the Holy Trinity accompanied by the Virgin, St. John the Evangelist, and two donors (members of the Lenzi family, whose tomb was recently discovered beneath the mural). The lowest section of the fresco, linked with this burial site, represents a skeleton lying on a sarcophagus, with the inscription (in Italian): "What you are, I once was; what I am, you will become." Here, as in the case of the *Merode Altarpiece,* we seem to plunge into a new environment; but Masaccio's world is a realm of monumental grandeur rather than the concrete everyday reality of the Master of Flémalle. It seems hard to believe that only two years before, in this city of Florence, Gentile da Fabriano had completed one of the masterpieces of the International Gothic (see colorplate 45). What the *Trinity* fresco brings to mind is not the style of the immediate past, but Giotto's art, with its sense of the large scale, its compositional severity and sculptural volume. Yet Masaccio's renewed allegiance to Giotto was only a starting point. For Giotto, body and drapery form a single unit, as if both had the same substance; Masaccio's figures, like Donatello's, are "clothed nudes," their drapery falling like real fabric. The setting, equally up-to-date, reveals a complete command of Brunelleschi's new architecture and of scientific perspective. This barrel-vaulted chamber is no mere niche, but a deep space wherein the figures could move freely if they wished. And—for the first time in history—we are given all the needed data to measure

510. MASACCIO. *The Tribute Money.* c. 1427. Fresco. Brancacci Chapel, Sta. Maria del Carmine, Florence

the depth of this painted interior. First we note that all the lines perpendicular to the picture plane converge upon a point below the foot of the cross, on the platform that supports the kneeling donors; to see the fresco properly, we must face this point, which is at normal eye-level, somewhat more than 5 feet above the floor of the church. The figures within the vaulted chamber are 5 feet tall, slightly less than lifesize, while the donors, who are closer to us, are fully lifesize. The exterior framework is therefore "lifesize," too, since it is directly behind the donors. The distance between the pilasters corresponds to the span of the barrel vault, and both are 7 feet; the circumference of the arc over this span measures 11 feet. That arc is subdivided by eight square coffers and nine ridges, the coffers being 1 foot wide and the ridges 4 inches. Applying these measurements to the length of the barrel vault (which consists of seven coffers—the nearest one is invisible behind the entrance arch) we find that the vaulted area is 9 feet deep. We can now draw a complete floor plan (fig. 509). A puzzling feature may be the place

of God the Father. His arms support the cross, close to the front plane, while His feet rest on a ledge attached to a wall. How far back is this surface? If it is the rear wall of the chamber, God would appear to be exempt from the laws of perspective. But in a universe ruled by reason, this cannot be so; hence Masaccio must have intended to locate the ledge directly behind the cross. The strong shadow that St. John casts on the wall beneath the ledge bears out our interpretation.

The largest group of Masaccio's works to come down to us are his frescoes in the Brancacci Chapel in Sta. Maria del Carmine. *The Tribute Money* (fig. 510) is the most renowned of these. It illustrates, by the age-old method known as "continuous narration" (see p. 278), the story in the Gospel of Matthew (17:24–27): in the center, Christ instructs Peter to catch a fish, whose mouth will contain the tribute money for the tax collector; on the far left, in the distance, Peter takes the coin from the fish's mouth; on the right, he gives it to the tax collector. Since the lower edge of the fresco is almost 14 feet above

right: 511. MASACCIO.
The Expulsion from Paradise.
c. 1427. Fresco.
Brancacci Chapel,
Sta. Maria del Carmine,
Florence

far right: 512. MASACCIO.
Madonna Enthroned. 1426.
Panel, 56 × 29″.
The National Gallery,
London (Reproduced by
courtesy of the Trustees)

the floor of the chapel, Masaccio could not here co-ordinate his perspective with our actual eye-level. Instead, he expects us to imagine that we are looking directly at the central vanishing point, which is located behind the head of Christ. Oddly enough, this feat is so easy that we take note of it only if we are in an analytical frame of mind. But then, pictorial illusion of any sort is always an imaginary experience; no matter how eager we are to believe in a picture, we never mistake it for reality itself, just as we are hardly in danger of confusing a statue with a living thing. If we could see the *Tribute Money* from the top of a suitable ladder, the painted surface would be more visible, of course, but the illusion of reality would not be markedly improved. This illusion depends to only a minor degree on Brunelleschian perspective; Masaccio's weapons here are exactly those employed by the Master of Flémalle and the Van Eycks—he controls the flow of light (which comes from the right, where the window of the chapel is actually located), and he uses atmospheric perspective in the subtly changing tones of the landscape. (We recall Donatello's "preview" of such a setting, a decade earlier, in his small relief of St. George; compare fig. 491.)

The figures in the *Tribute Money,* even more than those in the *Trinity* fresco, display Masaccio's ability to merge the weight and volume of Giotto's figures with the new functional view of body and drapery. All stand in beautifully balanced *contrapposto,* and close inspection reveals fine vertical lines scratched in the plaster by the artist, establishing the gravitational axis of each figure from the head to the heel of the engaged leg. This makes the figures rather static, however; the narrative is conveyed to us by intense glances and a few emphatic gestures, rather than by physical movement. But in another fresco of the Brancacci Chapel, *The Expulsion from Paradise* (fig. 511), Masaccio proves decisively his ability to display the human body in motion. The tall, narrow format leaves little room for a spatial setting; the gate of Paradise is only indicated, and in the background are a few shadowy, barren slopes. Yet the soft, atmospheric modeling, and especially the forward-moving angel, boldly foreshortened, suffice to convey a free, unlimited space. In conception this scene is clearly akin to Jacopo della Quercia's Bolognese reliefs (see fig. 495). Masaccio's grief-stricken Adam and Eve, though less dependent on ancient models, are equally striking exemplars of the beauty and power of the nude human form.

While he had a mural painter's temperament, Masaccio was equally versed in panel painting. His large polyptych, made in 1426 for the Carmelite church in Pisa, has since been dispersed among various collections. Its center panel shows a *Madonna Enthroned* (fig. 512), of the monumental Florentine type introduced by Cimabue and reshaped by Giotto (see figs. 447, 451), and may be instructively compared with its predecessors. The traditional elements—including the gold ground—are still present: a large, high-backed throne dominates the composition

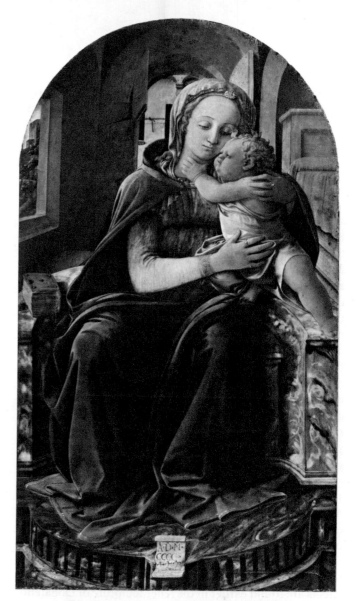

513. FRA FILIPPO LIPPI. *Madonna Enthroned.* 1437. Panel, 45 × 25 1/2". National Gallery, Rome

and on either side are adoring angels (here only two). The kneeling angels in Giotto's *Madonna* have become lute players, seated on the lowest step of the throne, and the Christ Child is no longer blessing us but eating a bunch of grapes (a symbolic act alluding to the Passion and the Eucharist, the grapes referring to wine, which represents the Saviour's blood). It is no surprise, after the *Trinity* fresco, that Masaccio replaces Giotto's ornate but frail Gothic throne with a solid and austere stone seat in the style of Brunelleschi, nor that he uses perspective expertly (note especially the two lutes). We are perhaps less prepared by the murals to find such delicacy and precision in painting the light on the surfaces. Within the picture, sunlight enters from the left—not the brilliant glare of noontime but the softer glow of the setting sun (some of the shadows on the throne permit us to determine its exact angle). There are consequently no harsh contrasts between light and shade; subtle half-shadows intervene, producing a rich scale of transitional hues. The light retains its full descriptive function, while acting as an

independent force that imposes a common tonality—and a common mood—upon all the forms it touches. Clearly, Masaccio's awareness of natural light as a pictorial factor matches that of his Flemish contemporaries, but he lacked their technical means to explore it so fully.

Fra Filippo Lippi; Fra Angelico

Masaccio's early death left a gap that was not filled for some time. Among his younger contemporaries only Fra Filippo Lippi (c. 1406–69) seems to have had close contact with him. Fra Filippo's earliest dated work, the *Madonna Enthroned* of 1437 (fig. 513), evokes Masaccio's earlier *Madonna* in several important ways—the lighting, the heavy throne, the massive three-dimensional figures, the drapery folds over the Virgin's legs. Nevertheless, the picture lacks Masaccio's monumentality and severity; in fact, it seems downright cluttered by comparison. The background is a domestic interior (note the Virgin's bed on the right), and the vividly patterned marble throne displays a prayer book and the scroll inscribed with the date. Such a quantity of realistic detail, as well as the rather undisciplined perspective, indicate an artistic temperament very different from Masaccio's; they also suggest that Fra Filippo must have seen Flemish paintings (perhaps during his visit to northeastern Italy in the mid-1430s). Finally, we must note another novel aspect of this *Madonna*: the painter's interest in movement, which is evident in the figures and, even more strikingly, in parts of the drapery (such as the curly, fluid edge of the Virgin's headdress and the curved folds of her mantle streaming to the left, accentuating her own turn to the right). These effects are found earlier in the relief sculpture of Donatello and Ghiberti—compare the dancing Salome in *The Feast of Herod* (fig. 493) and the maidens in the lower left-hand corner of *The Story of Jacob and Esau* (fig. 494). It is not surprising that these two artists should have so strongly affected Florentine painting in the decade after Masaccio's death. Age, experience, and prestige gave them authority unmatched by any painter then active in the city. Their influence, and that of the Flemish masters, modified Fra Filippo's early Masacciesque outlook in a particularly significant way, for Fra Filippo lived until 1469 and played a decisive role in setting the course of Florentine painting during the second half of the century.

If Fra Filippo depended more on Donatello than on Ghiberti, the opposite is true of his slightly older contemporary, Fra Angelico. He, too, was a monk ("Fra" means "Brother"), but, unlike Fra Filippo, he took his vows seriously and rose to a responsible position within his order. When, during the years 1437–52, the monastery of S. Marco in Florence was rebuilt, Fra Angelico embellished it with numerous frescoes. The large *Annunciation* (fig. 514) from this cycle has been dated about 1440 by some scholars, about 1450 by others—either date is plausible, for this artist, like Ghiberti, developed slowly and his style underwent no decisive changes during the 1440s. Fra Angelico preserves the very aspects of Masaccio—his dignity, directness, and spatial order—that Fra Filippo had rejected. But his figures, much as we may admire their lyrical tenderness, never achieve the physical and psychological self-assurance that characterizes the Early Renaissance image of man.

Domenico Veneziano

In 1439 a gifted painter from Venice, Domenico Veneziano, had settled in Florence. We can only guess at his

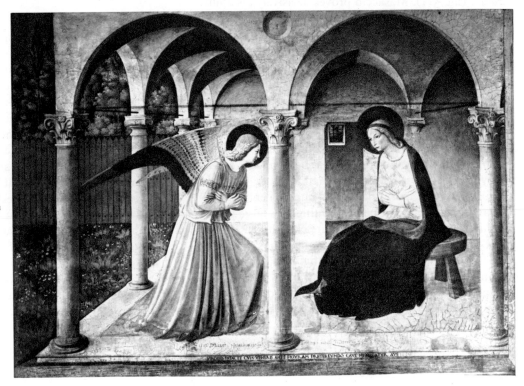

514. FRA ANGELICO. *The Annunciation.*
c. 1440–50. Fresco. S. Marco, Florence

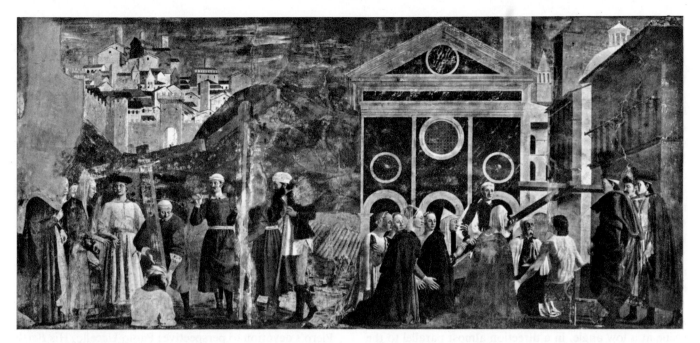

515. PIERO DELLA FRANCESCA. *The Discovery and Proving of the True Cross.* c. 1460. Fresco. S. Francesco, Arezzo

age (he was probably born about 1410), training, and previous work. He must, however, have been in sympathy with the spirit of Early Renaissance art, for he quickly became a thoroughgoing Florentine-by-choice, and a master of great importance in his new home. His *Madonna and Child with Saints* shown in colorplate 52 is one of the earliest examples of a new type of altar panel that was to prove tremendously popular from the mid-fifteenth century on, the so-called *Sacra Conversazione* ("sacred conversation"). The scheme includes an enthroned Madonna, framed by architecture, and flanked by saints who may converse with her, with the beholder, or among themselves. Looking at Domenico Veneziano's panel, we can understand the wide appeal of the *Sacra Conversazione.* The architecture and the space it defines are supremely clear and tangible, yet elevated above the everyday world; and the figures, while echoing the formal solemnity of their setting, are linked with each other and with us by a thoroughly human awareness. We are admitted to their presence, but they do not invite us to join them; like spectators in a theater, we are not allowed "on stage." (In Flemish painting, by contrast, the picture space seems a direct extension of the beholder's everyday environment; compare colorplate 46.) The basic elements of our panel were already present in Masaccio's *Trinity* fresco; Domenico Veneziano must have studied it carefully, for his St. John looks at us while pointing toward the Madonna, repeating the glance and gesture of Masaccio's Virgin. Domenico's perspective setting is worthy of the older master, although the slender proportions and colored inlays of his architecture are less severely Brunelleschian. His figures, too, are balanced and dignified like Masaccio's, but without the same weight and bulk. The slim, sinewy bodies of the male saints, with their highly individualized, expressive faces, show Donatello's influence (see fig. 492).

In his use of color, however, Domenico owes nothing to the great Florentine master; unlike Masaccio, he treats color as an integral part of his work, and the *Sacra Conversazione* is quite as remarkable for its color scheme as for its composition. The blond tonality, its harmony of pink, light green, and white set off by strategically placed spots of red, blue, and yellow, reconciles the decorative brightness of Gothic panel painting with the demands of perspective space and natural light. Ordinarily, a *Sacra Conversazione* is an indoor scene, but this one takes place in a kind of loggia flooded with sunlight streaming in from the right (note the cast shadow behind the Madonna). The surfaces of the architecture reflect the light so strongly that even the shadowed areas glow with color. Masaccio had achieved a similar quality of light in his *Madonna* of 1426 (which Domenico surely knew). In this *Sacra Conversazione,* the older master's discovery is applied to a far more complex set of forms, and integrated with Domenico's exquisite color sense. The influence of its distinctive tonality can be felt throughout Florentine painting of the second half of the century.

Piero della Francesca

When Domenico Veneziano settled in Florence, he had as an assistant a young man from southeastern Tuscany named Piero della Francesca, who became his most important disciple and one of the truly great artists of the Early Renaissance. Surprisingly enough, Piero left Florence after a few years, never to return. The Florentines seem to have regarded his work as somewhat provincial, and from their point of view they were right. Piero's style, even more strongly than Domenico's, reflected the aims of Masaccio; he retained this allegiance to the founding father of Italian Renaissance painting throughout his long career (he died in 1492), whereas Florentine

taste developed after 1450 in a different direction. Piero's most impressive achievement is the fresco cycle in the choir of S. Francesco in Arezzo, which he painted from about 1452 to 1459. Its many scenes represent the legend of the True Cross (that is, the origin and history of the cross used for Christ's crucifixion). The section seen in figure 515 and colorplate 53 shows the Empress Helena, the mother of Constantine the Great, discovering the True Cross and the two crosses of the thieves who died beside Christ (all three had been hidden by enemies of the Faith). On the left, they are being lifted out of the ground, and on the right, the True Cross is identified by its power to bring a dead youth back to life.

Piero's link with Domenico Veneziano is readily apparent from his colors. The tonality of this fresco, although less luminous than in Domenico's *Sacra Conversazione,* is similarly blond, evoking early morning sunlight in much the same way. Since the light enters the scene at a low angle, in a direction almost parallel to the picture plane, it serves both to define the three-dimensional character of every shape and to lend drama to the narrative. But Piero's figures have a harsh grandeur that recalls Masaccio, or even Giotto, more than Domenico. These men and women seem to belong to a lost heroic race, beautiful and strong—and silent. Their inner life is conveyed by glances and gestures, not by facial expressions. Above all, they have a gravity, both physical and emotional, that makes them seem kin to Greek sculpture of the Severe Style (figs. 167, 168). How did Piero arrive at these memorable images? Using his own testimony, we may say that they were born of his passion for perspective. More than any artist of his day, Piero believed in scientific perspective as the basis of painting; in a rigorously mathematical treatise—the first of its kind—he demonstrated how it applied to stereometric bodies and

architectural shapes, and to the human form. This mathematical outlook permeates all his work. When he drew a head, an arm, or a piece of drapery, he saw them as variations or compounds of spheres, cylinders, cones, cubes, and pyramids, endowing the visible world with some of the impersonal clarity and permanence of stereometric bodies. We may call him the earliest ancestor of the abstract artists of our own time, for they, too, work with systematic simplifications of natural forms. (The medieval artist, in contrast, had used the opposite procedure, building natural forms on geometric scaffoldings: fig. 443). It is not surprising that Piero's fame is greater today than ever before.

Uccello

In mid-fifteenth-century Florence there was only one painter who shared—and may have helped to inspire—Piero's devotion to perspective: Paolo Uccello. His *Battle of San Romano* (colorplate 54), painted about the same time as Piero's frescoes in Arezzo, shows an extreme preoccupation with stereometric shapes. The ground is covered with a gridlike design of discarded weapons and pieces of armor—a display of perspective studies neatly arranged to include one fallen soldier. The landscape, too, has been subjected to a process of stereometric abstraction, matching the foreground. Despite these strenuous efforts, however, the panel has none of the crystalline order and clarity of Piero della Francesca's work. In the hands of Uccello, perspective produces strangely disquieting, fantastic effects; what unites his picture is not its spatial construction but its surface pattern, decoratively reinforced by spots of brilliant color and the lavish use of gold. Born in 1397, Uccello had been trained in the Gothic style of painting; it was only

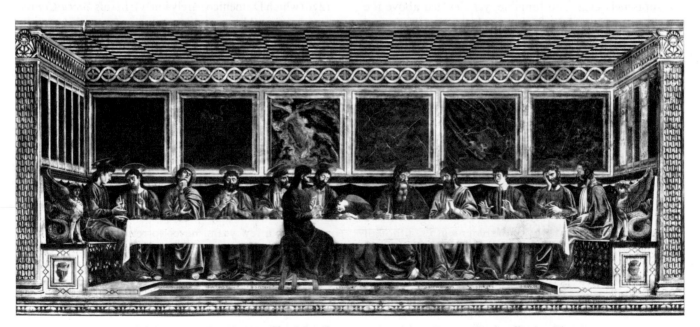

516. ANDREA DEL CASTAGNO. *The Last Supper.* c. 1445–50. Fresco. S. Apollonia, Florence

in the 1430s that he was "converted" to the Early Renaissance outlook by the new science of perspective. This he superimposed on his earlier style like a strait jacket. The result is a fascinating and highly unstable mixture. As we study this panel we realize that surface and space are more at war than the mounted soldiers, who get entangled with each other in all sorts of implausible ways.

Castagno

The third dimension held no difficulties, however, for Andrea del Castagno, the most gifted Florentine painter of Piero della Francesca's own generation (he was born about 1423). Less subtle but more forceful than Domenico Veneziano, Castagno recaptures something of Masaccio's monumentality in his *Last Supper* (fig. 516), one of the frescoes he painted in the refectory of the convent of S. Apollonia. The event is set in a richly paneled alcove designed as an extension of the real space of the refectory. As in medieval representations of the subject, Judas sits in isolation on the near side of the table, opposite Christ. The rigid symmetry of the architecture, emphasized by the colorful inlays, enforces a similar order among the figures and threatens to imprison them; there is so little communication among the apostles—only a glance here, a gesture there—that a brooding silence hovers over the scene. Castagno, too, must have felt confined by a scheme imposed on him by the rigid demands of both tradition and perspective, for he used a daringly original device to break the symmetry and focus the drama of the scene. Five of the six panels on the wall behind the table are filled with subdued varieties of colored marble, but above the heads of St. Peter, Judas, and Christ, the marble panel has a veining so garish and explosive that a bolt of lightning seems to descend on Judas' head. When Giotto revived the ancient technique of illusionistic marble textures, he hardly anticipated that it could hold such expressive significance.

Some five years after the *Last Supper,* between 1450 and 1457 (the year of his death), Castagno produced the remarkable *David* in colorplate 55. It is painted on a leather shield—to be used for display, not protection—and its owner probably wanted to convey an analogy between himself and the biblical hero, since David is here defiant as well as victorious. This figure differs fundamentally from the apostles of the *Last Supper.* Solid volume and statuesque immobility have given way to graceful movement, conveyed both by the pose and the wind-blown hair and drapery; the modeling of the earlier figures has been minimized, so that the David seems to be in relief rather than in the round, the forms now defined mainly by their outlines. This dynamic linear style has important virtues, but they are far from those of Masaccio. During the 1450s, the artistic climate of Florence changed greatly; Castagno's *David* is early evidence of the outlook that was to dominate the second half of the century.

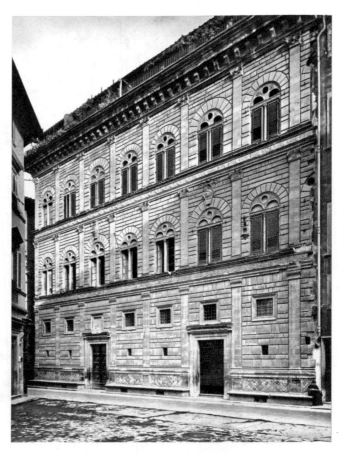

517. LEONE BATTISTA ALBERTI.
Palazzo Rucellai. 1446–51. Florence

CENTRAL AND NORTHERN ITALY: 1450–1500

As the founding fathers of Early Renaissance art and their immediate heirs disappeared one by one in the middle years of the century, a younger generation began to assert itself. At the same time, the seeds planted by Florentine masters in other regions of Italy—we recall Donatello's stay in Padua—were burgeoning; when some of these regions, notably the northeast, produced distinctive versions of the new style, Tuscany ceased to have the privileged position it had enjoyed before.

ARCHITECTURE: ALBERTI

In architecture, the death of Brunelleschi in 1446 brought to the fore Leone Battista Alberti (1404–72), whose career as a practicing architect had been long delayed, like Brunelleschi's own. Until he was forty, Alberti seems to have been interested in the fine arts only as an antiquarian and theorist; he studied the monuments of ancient Rome, composed the earliest Renaissance treatises on sculpture and painting, and began a third treatise, far more exhaustive than the other two, on architecture. After about 1430, he was close to the leading artists of his day (the treatise *On Painting* is dedicated to Brunelleschi and refers to "our dear friend" Donatello) and began to practice art as a dilettante; eventually

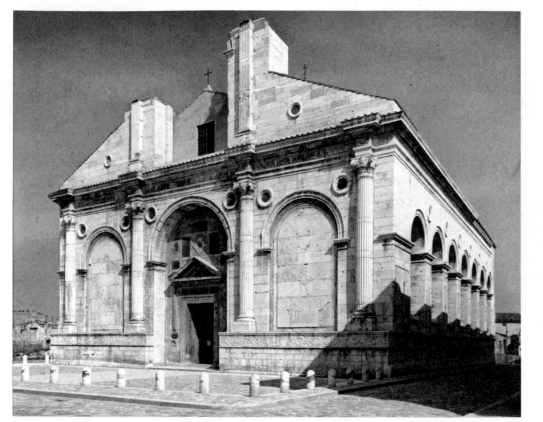

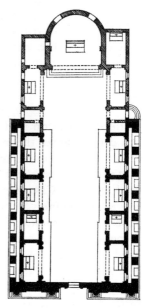

519. Plan of S. Francesco

518. LEONE BATTISTA ALBERTI. S. Francesco. Façade designed 1450. Rimini

he became a professional architect of outstanding ability. Highly educated in classical literature and philosophy, as an artist he exemplifies both the humanist and the man of the world.

The design for the Palazzo Rucellai (fig. 517) may be Alberti's critique of the slightly earlier Medici Palace (see fig. 507). Again we meet the heavy cornice and the three-story scheme, but the articulation of the façade is more strict and more self-consciously classical. It consists of three superimposed orders of pilasters, separated by wide architraves, in imitation of the Colosseum (see fig. 219). Yet Alberti's pilasters are so flat that they remain part of the wall, and the entire façade seems to be one surface on which the artist projects a linear diagram of the Colosseum exterior. If we are to grasp the logic of this curiously abstract and theoretical design, we must understand that Alberti has met here—perhaps for the first time—an issue which became fundamental to Renaissance architecture: how to apply a classical system of articulation to the exterior of a non-classical structure. Whether Brunelleschi ever coped with the same problem is difficult to say; only his exterior design for the Pazzi Chapel survives, too special a case to permit general conclusions. Alberti's solution acknowledges the primacy of the wall, reducing the classical system to a network of incised lines.

For his first church exterior Alberti tried a radically different alternative. Sigismondo Malatesta, lord of the town of Rimini, engaged him toward 1450 to turn the Gothic church of S. Francesco into a "temple of fame"

and a burial site for himself, his wife, and the humanists of his court. Alberti encased the older building in a Renaissance shell, the sides consisting of austere, deeply recessed niches, arched above and containing stone sarcophagi (figs. 518, 519). The façade has three similar niches, the larger one framing the central portal, the other two (now filled in) intended to receive the sarcophagi of Sigismondo and his wife. But these niches are flanked by columns, in a scheme clearly derived from the triumphal arches of ancient Rome (see fig. 256). Unlike the pilasters of the Palazzo Rucellai, these columns are not part of the wall; although partly imbedded in it, they project so strongly that we see them as separate entities. We notice, too, that they are set on separate blocks, rather than on the platform supporting the walls, and that they would have nothing to support if the entablature had not been made to project above each capital. These projections make the vertical divisions of the façade more conspicuous than the horizontal ones, and we expect each column to support some important feature of the upper story. Yet Alberti planned such a feature (an arched niche with a window and framed by pilasters) only above the portal; the second story fails to fulfill the promise of the first. Perhaps our artist would have modified this aspect of his design in the end, but the whole enterprise was never finished, and the great dome, projected as its crowning feature, was never built. If the classical system of the Palazzo Rucellai is in danger of being devoured by the wall, that of S. Francesco retains too much of its ancient Roman character to fit the shape of a basilican fa-

cade. (See, for contrast, the medieval approach to this task in fig. 364.)

Only toward the end of his career did Alberti find a fully satisfactory answer to his problem. In the majestic façade of S. Andrea at Mantua (fig. 520), designed in 1470, he has superimposed the triumphal arch motif—now with a huge center niche—upon a classical temple front, and projected this combination onto the wall. Significantly enough, he again uses flat pilasters that acknowledge the primacy of the wall surface but these pilasters, unlike those of the Palazzo Rucellai, are clearly differentiated from their surroundings. They are of two sizes; the larger ones are linked with the unbroken architrave and the strongly outlined pediment, and form what is known as a "colossal" order for all three stories of the façade wall, balancing exactly the horizontal and vertical impulses within the design. So intent was Alberti on stressing the inner cohesion of the façade that he made its height equal to its width, even though this height is appreciably lower than that of the nave of the church. Thus the upper portion of the west wall protrudes above the pediment. Since this part is behind the façade, it is relatively invisible from the street; Alberti's compromise is more disturbing in photographs, which must be taken from a point high above street level to avoid distortion. While the façade is thus physically distinct from the main body of the structure, artistically there is complete continuity with the interior of the church, where the same colossal order, the same proportions, and the same triumphal arch motif reappear on the nave walls (see the plan, fig. 521): the façade offers an exact "preview" of the interior. Comparing the plan with Brunelleschi's S. Spi-

rito (fig. 505), we are struck by its revolutionary compactness. Had the church been completed as planned, the difference would be even stronger, for Alberti's design had no transept, dome, or choir, only a nave terminating in an apse. The aisles are replaced by chapels alternately large and small, and there is no clerestory; the colossal pilasters and the arches of the large chapels support a barrel vault of impressive span (the nave is as wide as the façade). Alberti has here drawn upon his memories of the massive vaulted halls in ancient Roman baths and basilicas (compare fig. 225), yet he interprets his classical models as freely as in his façade design. They no longer embody an absolute authority that must be quoted literally, but serve as a valuable store of motifs to be utilized at will. With this sovereign attitude toward his sources, he was able to create a structure that truly deserves to be called a "Christian temple."

Central-plan Churches

Nevertheless, S. Andrea, which occupies the site of an older church (note the Gothic campanile next to the façade) with consequent limitations on the designer's freedom, does not conform to the ideal shape of sacred buildings defined in Alberti's treatise on architecture. There he explains that the plan of such structures should be either circular, or of a shape derived from the circle (square, hexagon, octagon, etc.), because the circle is the perfect as well as the most natural figure, and therefore a direct image of Divine reason. This argument rests, of course, on his faith in the God-given validity of mathematically determined proportions (discussed pp. 389–91),

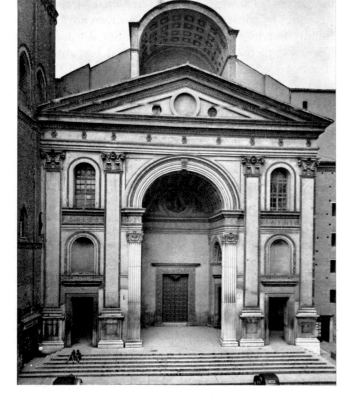

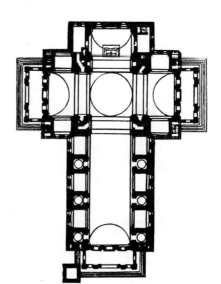

left: 520. LEONE BATTISTA ALBERTI. S. Andrea. Designed 1470. Mantua

below: 521. Plan of S. Andrea, Mantua (transept, dome, and choir are later additions)

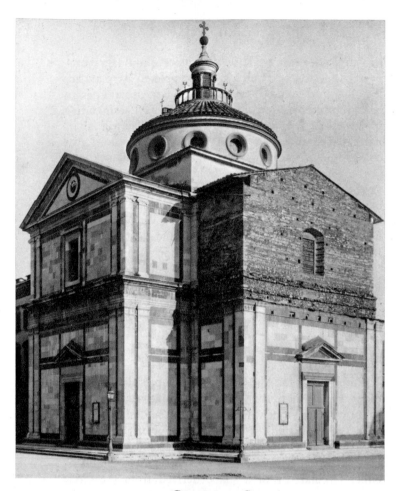

522. GIULIANO DA SANGALLO.
Sta. Maria delle Carceri. 1485. Prato

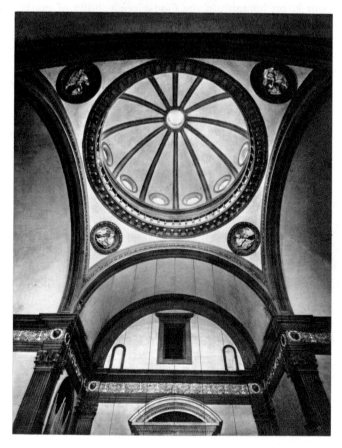

524. Interior, Sta. Maria delle Carceri, Prato

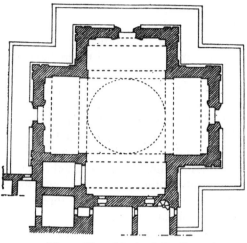

523. Plan of Sta. Maria delle Carceri

but how could he reconcile it with the historic evidence? After all, the standard form of both ancient temples and Christian churches was longitudinal. But, he reasons, the basilican church plan became traditional only because the early Christians worshiped in private Roman basilicas. Since pagan basilicas were associated with the dispensing of justice (which originates from God), he admits that their shape has some relationship to sacred architecture, but since they cannot rival the sublime beauty of the temple, their purpose is human rather than divine. In speaking of temples, Alberti arbitrarily disregarded the standard form and relied instead on the Pantheon (see figs. 221–24), the round temple at Tivoli (figs. 211, 212), and the domed mausoleums (which he mistook for temples). Moreover, he asked, had not the early Christians themselves acknowledged the sacred character of these structures by converting them to their own use? Here he could point to such monuments as Sta. Costanza (see figs. 271–73), the Pantheon (which had been used as a church ever since the early Middle Ages), and the Baptistery in Florence (supposedly a former temple of Mars).

Alberti's ideal church, then, demands a design so harmonious that it would be a revelation of divinity, and would arouse pious contemplation in the worshiper. It should stand alone, elevated above the surrounding everyday life, and light should enter through openings placed high, for only the sky should be seen through them. That such an isolated, central-plan structure was ill-adapted to the requirements of Catholic ritual made no difference to Alberti; a church, he believed, must be a visible embodiment of "divine proportion," and the central plan alone permitted attainment of this aim.

When Alberti formulated these ideas in his treatise, about 1450, he could have cited only Brunelleschi's revolutionary—and unfinished—Sta. Maria degli Angeli as a modern example of a central-plan church (see fig. 506). Toward the end of the century, after his treatise became

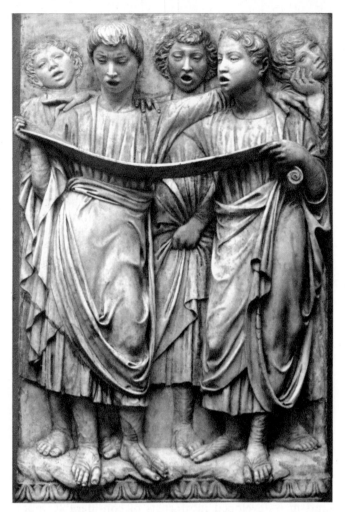

525. LUCA DELLA ROBBIA. *Singing Angels,* from the *Cantoria.* c. 1435. Marble, c. 38 × 24″. Cathedral Museum, Florence

el—but the basic shape of the structure conforms closely to Alberti's ideal. Except for the dome, the entire church would fit neatly inside a cube, since its height (up to the drum) equals its length and width. By cutting into the corners of this cube, as it were, Giuliano has formed a Greek cross (a plan he preferred for its symbolic value). The dimensions of the four arms stand in the simplest possible ratio to those of the cube: their length is one-half their width, their width one-half their height. The arms are barrel-vaulted, and the dome rests on these vaults, yet the dark ring of the drum does not quite touch the supporting arches, making the dome seem to hover, weightless, like the pendentive domes of Byzantine architecture (compare fig. 297). There can be no doubt that Giuliano wanted his dome to accord with the age-old tradition of the Dome of Heaven; the single round opening in the center and the twelve on the perimeter clearly refer to Christ and the apostles. Brunelleschi had anticipated this feature in the Pazzi Chapel, but Giuliano's dome, crowning a perfectly symmetrical structure, conveys its symbolic value far more strikingly.

Donatello left Florence for Padua in 1443; his ten-year absence had an effect similar to that of Brunleleschi's death. But whereas Alberti took Brunelleschi's place in architecture, there was no young sculptor of that stature to take Donatello's. The consequence of his absence was to bring into greater prominence the other sculptors remaining in the city. The new talents who appeared on the scene between 1443 and 1453 grew up under the influence of these men; it was they, rather than their elders, who brought about the changes Donatello must have seen with dismay upon his return.

Luca della Robbia

Ghiberti aside, the only significant sculptor in Florence after Donatello left was Luca della Robbia (1400–82). He had made his reputation in the 1430s with the marble reliefs of his *Cantoria,* or singers' pulpit, in the Cathedral. The panel reproduced here (fig. 525) shows the beguiling mixture of sweetness and gravity

widely known, the central-plan church gained general acceptance; between 1500 and 1525 it became a vogue reigning supreme in High Renaissance architecture. It is no mere coincidence that Sta. Maria delle Carceri in Prato (figs. 522–24), an early and distinguished example of this trend, was begun in 1485, the date of the first printed edition of Alberti's treatise. Its architect, Giuliano da Sangallo, must have been an admirer of Brunelleschi—many features of the design recall the Pazzi Chap-

526. LUCA DELLA ROBBIA. *Madonna and Angels.* c. 1460. Glazed terracotta, 63 × 87 1/2″. National Museum, Florence

standing statue, and the *Cantoria* remained his most ambitious achievement. For the rest of his long career, he devoted himself almost exclusively to sculpture in terracotta—a cheaper and less demanding medium than marble—which he covered with enamel-like glazes to mask its surface and make it impervious to weather. His finest works in this technique, such as the lunette in figure 526, have the charm of the *Cantoria* panels. The white glaze for the figures and the frame creates the impression of marble, with a deep blue for the background of the lunette. Other colors are confined almost entirely to the wreath of flowers. This tasteful restraint, however, lasted only while Luca was in active charge of his workshop. Later, the quality of the modeling deteriorated and the simple harmony of white and blue often gave way to an assortment of more vivid hues. At the end of the century, the Della Robbia shop had become a factory, turning out small Madonna panels and garish altarpieces for village churches by the score.

Because of Luca's almost complete withdrawal from the domain of marble carving, there was a real shortage of capable marble sculptors in the Florence of the 1440s. By the time Donatello returned, this gap had been filled by a group of men, most of them still in their twenties, from the little hill towns to the north and east of Florence. That region had long supplied the city with stonemasons and carvers; now, because the exceptional circumstances gave them special opportunities, the most gifted of these craftsmen developed into artists of considerable importance.

Bernardo Rossellino

Oldest of these, Bernardo Rossellino (1409–64) seems to have begun as a sculptor and architect in Arezzo. He established himself in Florence about 1436, but received no commissions of real consequence until some eight years later, when he was entrusted with the tomb of

527. BERNARDO ROSSELLINO. Tomb of
Leonardo Bruni. c. 1445–50. Marble, height 20′
(to top of arch). Sta. Croce, Florence

characteristic of all of Luca's work. Its style, we realize, has very little to do with Donatello; instead, it recalls the classicism of Nanni di Banco (see fig. 485), with whom Luca may have worked as a youth. We also sense a touch of Ghiberti here and there, as well as the powerful influence of classicistic Roman reliefs (such as fig. 243). But Luca, despite his great gifts, lacked a capacity for growth. He never, so far as we know, did a free-

528. ANTONIO ROSSELLINO. *Giovanni Chellini*. 1456.
Marble, height 20″. Victoria & Albert Museum, London

Leonardo Bruni (fig. 527). This great humanist and statesman had played a vital part in the city's affairs ever since the beginning of the century (see page 379). When he died in 1444, he received a grand funeral "in the manner of the ancients," and his monument, too, was probably ordered by the government. Since he had been born in Arezzo, however, his native town also wished to honor him, and its representatives may have helped to secure the commission for Bernardo, whom they knew from his earlier activity there. One wonders what chance Bernardo would have had if Donatello had been available.

Although the Bruni monument is not the earliest Renaissance tomb, nor even the earliest large-scale tomb of a humanist, it can claim to be the first memorial that fully expresses the spirit of the new era. Echoes of Bruni's funeral *all'antica* are everywhere: the deceased reclines on a bier supported by Roman eagles, his head wreathed in laurel and his hands enfolding his *History of Florence* rather than a prayer book—a fitting tribute to the man who, more than any other, had helped to establish the new historical perspective of the Florentine Early Renaissance. On the classically severe sarcophagus, two winged genii display an inscription very different from those on medieval tombs; instead of recording the name, rank, and age of the deceased and the date of his death, it refers only to his timeless accomplishments: "At Leonardo's passing, history grieves, eloquence is mute, and it is said that the Muses, Greek and Latin alike, cannot hold back their tears." The religious aspect of the tomb is confined to the lunette, where the Madonna is adored by angels. The entire monument may thus be viewed as an attempt to reconcile two contrasting attitudes toward death—the retrospective, commemorative one of the ancients (see pages 136–37), and the Christian concern with afterlife and salvation. Bernardo Rossellino's design is admirably suited to such a program, balancing architecture and sculpture within a compact, self-contained framework. Its dominant motif, the two pilasters supporting a round arch resting on a strongly accented architrave, suggests Alberti, who employed it repeatedly. It is derived from the entrance to the Pantheon (see fig. 211), which accounts for its use in church portals such as that of S. Andrea in Mantua (fig. 520). While Bernardo Rossellino may have adopted it for the Bruni tomb on purely aesthetic grounds, it is possible that he also meant to convey a symbolic meaning—the deceased on his bier, pausing at the gateway between one life and the next. Perhaps he even wanted us to associate the motif with the Pantheon, the "temple of the immortals" for pagans and Christians alike; once dedicated to all the gods of the Roman world, it had been rededicated to all the martyrs when it became a church, and in the High Renaissance it was to receive the remains of yet another breed of immortals—such famous artists as Raphael.

The sculptural style of the Bruni tomb is not easy to define, since its component parts vary a good deal in quality. Broadly speaking, it reflects the classicism of Ghiberti and Luca della Robbia; echoes of Donatello are few and indirect. Bernardo Rossellino surely employed assistants here, as he did in his subsequent commissions. During the later 1440s his workshop was the only training ground for ambitious young marble sculptors such as his very gifted brother Antonio (1427–79) and other members of the same generation. Their share in Bernardo's sculptural projects is hard to identify, however, for their personalities were not distinct until they began to work independently. Nor have we yet a clear conception of Bernardo's own style as a sculptor. In any event, all the tombs, tabernacles, and Madonna reliefs produced by the younger men between 1450 and 1480 have a common ancestor in the Bruni monument, whatever other elements we may discern in them.

The Portrait Bust

Since Bernardo Rossellino and his artistic descendants concentrated their efforts on sculptural ensembles of the kind we have labeled church furniture, free-standing statues are—with one or two possible exceptions—absent from their works. They produced only one form of large-scale sculpture in the round that was not intended for an architectural context—the marble portrait bust. The great Roman tradition of realistic portrait sculpture, we recall, had died out in late antiquity; its revival was long credited to Donatello (who certainly knew and admired Roman portraits, as we saw in the *Zuccone*), but the earliest examples we know all date from the 1450s, and none are by Donatello. It seems far more likely, therefore, that the Renaissance portrait bust originated among the younger marble sculptors from the circle of Bernardo Rossellino. The attractive example shown in figure 528 was carved in 1456 by Antonio Rossellino. It represents a highly esteemed Florentine physician, Giovanni Chellini, whose personality—at once sardonic and kindly—has been observed with extraordinary precision. Comparing it with Roman heads (such as figs. 237, 238, 249–55), we cannot say the resemblance is striking. In fact, these busts, however realistic they may seem at first, all seem idealized in some respect (not always physically) beside our Florentine doctor, who radiates an individuality far beyond any attained in ancient times. He is linked to his Roman predecessors only by the idea of portrait sculpture in the round as an effective—and enduring—substitute for the sitter's real presence. Stylistically, the ancestry of Antonio's bust is to be found among the heads of effigies such as that of Leonardo Bruni, for it was in tomb sculpture that realistic portraiture had first been revived, often with the aid of death masks. Although our piece was carved during the sitter's lifetime, its insistence on documenting every wrinkle makes it look like a death-mask portrait suddenly brought to life. Fortunately, Antonio Rossellino did not permit this preoccupation with the details of facial topography to diminish his concern with the sitter's qualities as a human being.

529. ANTONIO DEL POLLAIUOLO. *Hercules and Antaeus.*
c. 1475. Bronze, height 18" (with base).
National Museum, Florence

The popularity of portrait busts after about 1450 suggests a demand for works to be shown in the homes of individual art patrons. The collecting of sculpture, widely practiced in ancient times, apparently ceased during the Middle Ages; the taste of kings and feudal lords—those who could afford to collect for personal pleasure—ran to gems, jewelry, goldsmith's work, illuminated manuscripts, and precious fabrics. The habit was re-established in fifteenth-century Italy as an aspect of the "revival of antiquity." Humanists and artists first collected ancient sculpture, especially small bronzes (such as fig. 193), which were numerous and of convenient size; before long, contemporary artists began to cater to the spreading vogue, with portrait busts and with small bronzes of their own "in the manner of the ancients." A particularly fine piece of this kind (fig. 529) is by Antonio del Pollaiuolo (1431–98), who represents a sculptural style very different from that of the marble carvers we discussed before. Trained as a goldsmith and metalworker, probably in the Ghiberti workshop, he was deeply impressed by the late style of both Donatello and Castagno, as well as by ancient art. From these sources, he evolved the distinctive manner that appears in our *Hercules and Antaeus.* To create a free-standing group of two figures in violent struggle, even on a small scale, was a daring idea in itself; even more astonishing is the way Pollaiuolo has endowed his composition with a centrifugal impulse: limbs seem to radiate in every direction from a common center, and we see the full complexity of their movements only when we turn the statuette before our eyes. Despite its strenuous action, the group is in perfect balance. To stress the central axis, Pollaiuolo, as it were, grafted

530. ANTONIO DEL POLLAIUOLO.
Battle of Ten Naked Men
(engraving). c. 1465–70.
The Metropolitan Museum
of Art, New York
(Joseph Pulitzer Bequest, 1917)

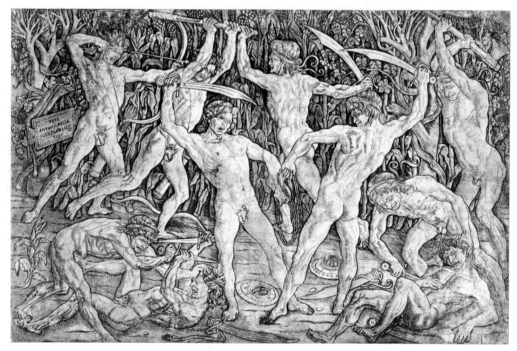

he found in certain types of ancient painted vases (compare fig. 177). But he realized that a full understanding of bodily movement demands a detailed knowledge of anatomy, down to the last muscle and sinew. While we do not know for sure, he may well have been the first artist to dissect human bodies for firsthand knowledge of their structure (a practice then uncommon even in medical schools). The ten naked men do indeed have an oddly "flayed" appearance, as if their skin had been stripped off to reveal the play of muscles underneath, and so, to a somewhat lesser degree, do the two figures of our statuette. Equally novel are their facial expressions, as strained as the bodily movements. We have already encountered contorted features in the work of Donatello and Masaccio (see figs. 493, 511, colorplate 51), but the anguish they convey does not arise from, or accompany, the extreme physical action of Pollaiuolo's struggling nudes. The importance of this integration of motion and emotion is strikingly evident in figure 531, which shows one of the mourners from a lifesize group of the Lamentation by Niccolò dell'Arca, about 1485–90. We know of

531. NICCOLO DELL'ARCA. *The Lamentation* (detail). c. 1485–90. Terracotta, lifesize. Sta. Maria della Vita, Bologna

the upper part of Antaeus onto the lower part of his adversary. There is no precedent for this design among earlier statuary groups of any size, ancient or Renaissance; our artist has simply given a third dimension to a composition from the field of drawing or painting. He himself was a painter and engraver as well as a bronze sculptor, and we know that about 1465 he did a large picture of Hercules and Antaeus, now lost, for the Medici Palace (our statuette also belonged to the Medici). Few of his paintings have survived, and only a single engraving, the *Battle of Ten Naked Men* (fig. 530). This print, however, is of great importance, since it represents Pollaiuolo's most elaborate pictorial design. Its subject—undoubtedly a classical one—has not yet been convincingly identified, but that matter is not so significant; the primary purpose of the engraving, obviously, was to display Pollaiuolo's mastery of the nude body in action. About 1465–70, when the print must have been produced, this was still a novel problem, and Pollaiuolo contributed more than any other master to its solution. An interest in movement, coupled with slender proportions and an emphasis on outline rather than on modeling, had been seen in Castagno's *David*, for example (colorplate 55), who in these respects is clearly the progenitor of the *Naked Men*. Pollaiuolo also drew upon the action poses

532. ANDREA DEL VERROCCHIO. *Putto with Dolphin*. c. 1470. Bronze, height 27″ (without base). Palazzo Vecchio, Florence

533. ANDREA DEL VERROCCHIO. *Equestrian Monument of Colleoni.* c. 1483–88. Bronze, height c. 13'. Campo SS. Giovanni e Paolo, Venice

Verrocchio (1435–88), the greatest sculptor of his day and the only one to share some of Donatello's range and ambition. A modeler as well as a carver—we have works of his in marble, terracotta, silver, and bronze—he combined elements from Antonio Rossellino and Antonio del Pollaiuolo into a unique synthesis. He was also a respected painter and the teacher of Leonardo da Vinci (something of a misfortune; ever since, he has inevitably suffered slighting comparisons). His most popular work in Florence, because of its location in the courtyard of the Palazzo Vecchio as well as its perennial charm, is the *Putto with Dolphin* (fig. 532). It was designed as the center of a fountain—the dolphin is spouting a jet of water, as if responding to the hug it has to endure—for one of the Medici villas near Florence. The term putto (plural, putti) designates one of the nude, winged children that often accompany more weighty subjects in ancient art; they personify spirits of various kinds (such as the spirit of love, in which case we call them cupids), usually in a gay and playful way. They were reintroduced during the Early Renaissance, both in their original identity and as child angels. The dolphin associates Verrocchio's *Putto* with the classical kind (compare the putto and dolphin in fig. 239). Artistically, however, he is closer to Pollaiuolo's *Hercules and Antaeus* than to ancient art, despite his larger size and greater sense of volume. Again the forms fly out in every direction from a central axis, but here the movement is graceful and continuous rather than jagged and broken; the stretched-out leg, the dolphin, and the arms and wings fit into an upward spiral, making the figure seem to revolve before our eyes.

By a strange coincidence, the crowning achievement of Verrocchio's career, as of Donatello's, was the bronze equestrian monument of a Venetian army commander: Bartolommeo Colleoni (fig. 533). In his will, Colleoni had requested such a statue and, by way of encouragement, had left a sizable fortune to the Republic of Venice. He obviously knew the Gattamelata monument and wanted to ensure the same honor for himself. Verrocchio, too, must have regarded Donatello's work as the prototype of his own statue. Yet he did not simply imitate his illustrious model; he reinterpreted the theme less subtly, perhaps, but no less impressively. The horse, graceful and spirited rather than robust and placid, is modeled with the same sense of anatomy-in-action that we saw in the nudes of Pollaiuolo; its thin hide reveals every vein, muscle, and sinew, in strong contrast with the rigid surfaces of the armored figure bestriding it. Since the horse is also smaller in relation to the rider than Gattamelata's, Colleoni looms in the saddle like the very embodiment of forceful dominance. Legs rigidly straight, one shoulder thrust forward, he surveys the scene before him with the utter concentration of Donatello's *St.George* (see fig. 490), but his lip is now contemptuously curled. Neither Gattamelata nor Colleoni is a portrait in the specific sense of the term; both project an idealization of the personality which each artist associated with success-

no direct link between that work and Pollaiuolo—Niccolò came from Apulia and spent most of his life in Bologna—yet it could not have been created without his influence. Again, the facial expression itself is not unprecedented, but coupled with the vehement forward rush, the movement of the entire figure overpowers us, as it does in the *Nike of Samothrace* (see fig. 191).

Verrocchio

Although Pollaiuolo, during the late years of his career, did two monumental bronze tombs for St. Peter's in Rome, he never had an opportunity to execute a large-scale free-standing statue. For such works we must turn to his slightly younger contemporary, Andrea del

ful leadership in war. If Gattamelata conveys steadfast purpose and nobility of character, Colleoni radiates an almost frightening sense of power. As an image of awesome self-assurance, he recalls the Can Grande (see fig. 438) rather than the Gattamelata monument. Perhaps Verrocchio visited the tomb of the Can Grande (who was well remembered in Florence as the patron of Dante), and decided to translate the wonderful arrogance of the statue into the style of his own day. In any case, Bartolommeo Colleoni got a great deal more than he had bargained for in his will.

PAINTING

Before we resume our discussion of Florentine painting, we must consider the growth of Early Renaissance art in Northern Italy. The International Style in painting and sculpture lingered there until the mid-century, and architecture retained a strongly Gothic flavor long after the adoption of a classical vocabulary. We shall disregard North Italian architecture and sculpture between 1450 and 1500, as there are hardly any achievements of major consequence in either field. Instead, we shall focus upon painting in Venice and its dependent territories, for during these same years a great tradition was born here that was to flourish for the next three centuries. The Republic of Venice, although more oligarchic, and unique in its eastward orientation, had many ties with Florence; it is not surprising, therefore, that she, rather than the Duchy of Milan, should have become the leading center of Early Renaissance art in Northern Italy.

Padua: Mantegna

Florentine masters had been carrying the new style to Venice and to the neighboring city of Padua since the 1420s. Fra Filippo Lippi, Uccello, and Castagno had all worked there at one time or another. Still more important was Donatello's ten-year sojourn. Their presence, however, evoked only rather timid local responses until, shortly before 1450, the young Andrea Mantegna emerged as an independent master. Born in 1431, he was first trained by a minor Paduan painter, but his early development was decisively shaped by the impressions he received from locally available Florentine works and—we may assume—by personal contact with Donatello. Next to Masaccio, Mantegna was the most important painter of the Early Renaissance. And he, too, was a precocious genius, fully capable at seventeen of executing commissions on his own. Within the next decade, he reached artistic maturity, and during the next half-century—he died at the age of seventy-five—he broadened the range of his art but never departed, in essence, from the style he had formulated in the 1450s. His greatest achievement of that time, the frescoes in the Church of

534. ANDREA MANTEGNA. *St. James Led to His Execution.*
c. 1455. Fresco. Ovetari Chapel,
Church of the Eremitani, Padua (destroyed 1944)

535. ANDREA MANTEGNA. *St. James Led to His Execution.*
c. 1455. Pen drawing, 6 1/8 × 9 1/4".
Collection G.M. Gathorne-Hardy,
Donnington Priory, Newbury, Berkshire, England

the Eremitani in Padua, was almost entirely destroyed by an accidental bomb explosion in 1944—a more grievous loss than the murals of the Camposanto of Pisa (see fig. 454). The scene we reproduce in figure 534, *St. James Led to His Execution,* is the most dramatic of the cycle, because of its daring "worm's-eye view" perspective, which is based on the beholder's actual eye-level (the central vanishing point is below the bottom of the picture, somewhat to the right of center). The architectural setting consequently looms large, as in Masaccio's *Trinity* fresco (see fig. 508). Its main feature, a huge triumphal arch, although not a copy of any specific Roman monument, looks so authentic in every detail that it might as well be. Here Mantegna's devotion to the visible remains of antiquity, almost like that of an archaeologist, shows his close association with the learned humanists at the University of Padua (who had the same reverence for every word of ancient literature). No Florentine painter or sculptor of the time could have transmitted such an attitude to him. The same desire for authenticity can be seen in the costumes of the Roman soldiers (compare fig. 239); it even extends to the use of "wet" drapery patterns, an invention of Classical Greek sculpture inherited by the Romans (see fig. 242). But the tense figures, lean and firmly constructed, and especially their dramatic interaction, clearly derive from Donatello. Mantegna's subject hardly demands this agitated staging: the saint, on the way to his execution, blesses a paralytic and commands him to walk. But the large crowd of bystanders, many of them expressing by glance and gesture how deeply the miracle has stirred them, generates an extraordinary emotional tension that erupts into real physical violence on the far right. The great spiral curl of the banner merely echoes the turbulence below. By rare good luck, a sketch for our fresco has survived (fig. 535), the earliest instance we know of a drawing that permits us to compare the preliminary and final versions of such a design. (Among the drawings by earlier masters, none, it seems, is related to a known picture in the same way.) This sketch differs from the *sinopie,* full-scale drawings on the wall (see fig. 455), in its tentative, unsettled quality; the composition has not yet taken full shape; still growing, as it were, the image in our drawing is "unfinished" both in conception and in the sense that the forms are set down in a quick, shorthand style. We note, for example, that here the perspective is closer to normal, indicating that the artist worked out the exact scheme only on the wall. Our drawing also offers proof of what we suspected in the case of Masaccio: that Early Renaissance artists actually conceived their compositions in terms of nude figures. The group on the right is still in that first stage, and in the others the outlines of the body show clearly beneath the costume. But the drawing is more than only a document; it is a work of art in its own right. The very quickness of its "handwriting" gives it an immediacy and rhythmic force that are necessarily lost in the fresco. Many of its essential qualities can still be felt

536. GIOVANNI BELLINI. *Madonna and Saints.* 1505. Panel, 16′ 5 1/2″ × 7′ 9″. S. Zaccaria, Venice

in the same master's engraving, *Battle of Sea Gods,* more than thirty years later (see fig. 6), although this print recalls the linear and expressive features of Pollaiuolo's *Battle of Ten Naked Men* as well.

On the evidence of these works, we would hardly expect Mantegna to be much concerned with light and color. The panel reproduced in colorplate 56, painted only a few years after the Paduan frescoes, proves that he was. In the foreground, to be sure, we find the familiar array of classical remains (including, this time, the artist's signature in Greek). The saint, too, looks more like a statue than a living body. But beyond we see a wonderfully atmospheric landscape and a deep blue sky dotted with the softest of white clouds. The entire scene is bathed in the warm radiance of late afternoon sunlight, which creates a gently melancholy mood, making the pathos of the dying saint doubly poignant. The background of our

panel would hardly be conceivable without the influence, direct or indirect, of the Van Eycks (compare colorplate 47, left). Some works of the great Flemish masters had surely reached Florence as well as Venice between 1430 and 1450, and must have been equally admired in both cities; but in Venice they had more immediate effect, evoking the interest in lyrical, light-filled landscapes that became an ingrained part of Venetian Renaissance painting.

Venice: Bellini

In the painting of Giovanni Bellini (c. 1431–1516), Mantegna's brother-in-law, we can trace the further growth of the Flemish tradition. Bellini was slow to mature; his finest pictures, such as *St. Francis in Ecstasy* (colorplate 57), date from the last decades of the century or later. The saint is here so small in comparison to the setting that he seems almost incidental, yet his mystic rapture before the beauty of the visible world sets our own response to the view that is spread out before us, ample and intimate at the same time. He has left his wooden pattens behind and stands barefoot on holy ground, like Moses in the Lord's presence (see page 54). Bellini's contours are less brittle than those of Mantegna, the colors are softer and the light more glowing, and he shares the tender regard of the great Flemings for every detail of nature. Unlike the Northerners, however, he can define the beholder's spatial relationship to the landscape—the rock formations of the foreground are structurally clear and firm, like architecture rendered by the rules of scientific perspective.

As the foremost painter of the city of Venice, Giovanni Bellini produced a number of formal altar panels of the *Sacra Conversazione* type. His compositional pattern is well exemplified by the latest—and most monumental—member of the series, the *Madonna and Saints* of 1505 in S. Zaccaria (fig. 536). Compared to Domenico Veneziano's *Sacra Conversazione* (colorplate 52), the architectural setting is a good deal simpler but no less impressive: we stand in the nave of a church, near the crossing (which is partly visible), with the apse filling almost the entire panel. The figures appear in front of the apse, however, under the great vaulted canopy of the crossing. The structure is not a real church, for its sides are open and the entire scene is flooded with gentle sunlight, just as Domenico Veneziano had placed his figures in a semi-outdoors setting. The Madonna's solid, high-backed throne and the music-making angel on its lowest step are derived (through many intermediaries, no doubt) from Masaccio's *Madonna* of 1426 (see fig. 512). What differentiates this altar immediately from its Florentine ancestors is not merely the ample spaciousness of the design but its wonderfully calm, meditative mood; instead of "conversation," we sense the figures' deep communion that makes all rhetorical gestures unnecessary. We shall encounter this quality again and again in Venetian paint-

ing; here, from the way the aged master has bathed the entire scene in a delicate aerial haze, we see it as through a diffusing filter of atmosphere. All harsh contrasts are eliminated, light and shadow blend in almost imperceptible gradations, and colors glow with a new richness and depth. In this magical moment, Giovanni Bellini becomes the true heir of the two greatest painters of the fifteenth century, uniting the Florentine grandeur of Masaccio with the Northern poetic intimacy of Jan van Eyck.

Florence: Botticelli

We now return once more to Florence. The trend forecast by Castagno's *David* substitutes energetic, graceful movement and agitated linear contours for the stable monumentality of the Masaccio style; its climax comes in the final quarter of the century, in the art of Sandro Botticelli (1444/5–1510). Trained by Fra Filippo Lippi—whose *Madonna* (fig. 513) already had undercurrents of linear movement—and strongly influenced by Pollaiuolo, Botticelli soon became the favorite painter of the so-called Medici circle, those patricians, literati, scholars, and poets surrounding Lorenzo the Magnificent, the head of the Medici family and, for all practical purposes, the ruler of the city. For one member of this group, Botticelli did *The Birth of Venus* (colorplate 58), probably his most famous picture. Its kinship with Pollaiuolo's *Battle of Ten Naked Men* is unmistakable: in both, the shallow modeling and the emphasis on outline produce an effect of low relief rather than of solid, three-dimensional shapes; in both we note a lack of concern with deep space—the ornamentalized thicket forms a screen behind the *Naked Men* much like the grove on the right-hand side of the *Venus*. But the differences are just as striking. Botticelli evidently does not share Pollaiuolo's passion for anatomy; his bodies are more attenuated, and drained of all weight and muscular power; they seem to float even when they touch the ground. All this seems to deny the basic values of the founding fathers of Early Renaissance art, yet the picture does not look medieval: the bodies, ethereal though they be, retain their voluptuousness; they are genuine nudes (see our discussion, page 386) enjoying full freedom of movement.

Neo-Platonism

To understand this paradox, we must consider the meaning of our picture, and the general use of classical subjects in Early Renaissance art. During the Middle Ages, classical form had become divorced from classical subject matter. Artists could only draw upon the ancient repertory of poses, gestures, expressions, etc., by changing the identity of their sources: philosophers became apostles, Orpheus turned into Adam, Hercules into Sam-

son. When medieval artists had occasion to represent the pagan gods, they based their pictures on literary descriptions rather than visual models. This was the situation, by and large, until the mid-fifteenth century. Only with Pollaiuolo—and Mantegna in Northern Italy—does classical form begin to rejoin classical content. Pollaiuolo's lost paintings of the Labors of Hercules (about 1465) mark the earliest instance—so far as we know—of large-scale subjects from classical mythology depicted in a style inspired by ancient monuments; and *The Birth of Venus* contains the first monumental image since Roman times of the nude goddess in a pose derived from classical statues of Venus (see fig. 182). Moreover, the subject of the picture is clearly meant to be serious, even solemn. How could such images be justified in a Christian civilization, without subjecting both artist and patron to the accusation of neopaganism? In the Middle Ages, classical myths had at times been interpreted didactically, however remote the analogy, as allegories of Christian precepts. Europa abducted by the bull, for instance, could be declared to signify the soul redeemed by Christ. But such pallid constructions were hardly an adequate excuse for reinvesting the pagan gods with their ancient beauty and strength. To fuse the Christian faith with ancient mythology, rather than merely relate them, required a more sophisticated argument. This was provided by the Neo-Platonic philosophers, whose foremost representative, Marsilio Ficino, enjoyed tremendous prestige during the later years of the fifteenth century and after. Ficino's thought, based as much on the mysticism of Plotinus (discussed page 175) as on the authentic works of Plato, was the very opposite of the orderly system of medieval scholasticism. He believed that the life of the universe, including that of man, was linked to God by a spiritual circuit continuously ascending and descending, so that all revelation, whether from the Bible, Plato, or classical myths, was one. Similarly, he proclaimed that beauty, love, and beatitude, being phases of this same circuit, were one. Thus Neo-Platonists could invoke the "celestial Venus" (that is, the nude Venus born of the sea, as in our picture) interchangeably with the Virgin Mary, as the source of "divine love" (meaning the cognition of divine beauty). This celestial Venus, according to Ficino, dwells purely in the sphere of Mind, while her twin, the ordinary Venus, engenders "human love." Once we understand that Botticelli's picture has this quasi-religious meaning, it seems less astonishing that the two wind gods on the left look so much like angels, and that the personification of Spring on the right, who welcomes Venus ashore, recalls the traditional relation of St. John to the Saviour in the Baptism of Christ (compare fig. 376). As baptism is a "rebirth in God," the birth of Venus evokes the hope for "rebirth" from which the Renaissance takes its name. Thanks to the fluidity of Neo-Platonic doctrine, the number of possible associations to be linked with our painting is almost limitless. All of them, however, like the celestial Venus herself, "dwell in the sphere

of Mind," and Botticelli's deity would hardly be a fit vessel for them if she were less ethereal.

Neo-Platonic philosophy and its expression in art were obviously too complex to become popular outside the select and highly educated circle of its devotees. In 1494, the suspicions of the man in the street were confirmed by the monk Girolamo Savonarola, an ardent advocate of religious reform, who gained a huge following with his sermons attacking the "cult of paganism" among the city's ruling circle. Botticelli himself became a follower of Savonarola and reportedly burned a number of his "pagan" pictures. In his last works—he seems to have stopped painting entirely after 1500—he returns to traditional religious themes but with no essential change in style.

Piero di Cosimo; Ghirlandaio

Colorplate 59, a panel by Botticelli's contemporary, Piero di Cosimo, illustrates a view of pagan mythology diametrically opposed to that of the Neo-Platonists. In-

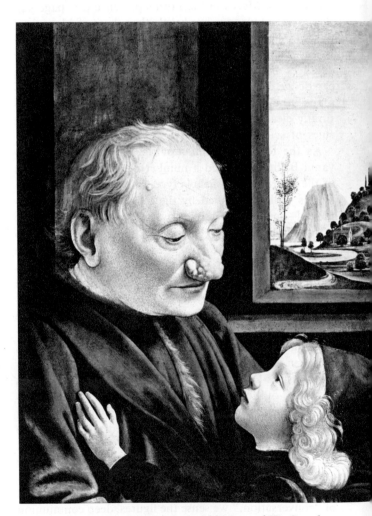

537. DOMENICO GHIRLANDAIO. *An Old Man and His Grandson.* c. 1480. Panel, 24 1/2 × 18". The Louvre, Paris

538. PIETRO PERUGINO. *The Delivery of the Keys.* 1482. Fresco. Sistine Chapel, The Vatican, Rome

stead of "spiritualizing" the pagan gods, it brings them down to earth as beings of flesh and blood. In this alternate theory, man had slowly risen from a barbaric state through the discoveries and inventions of a few exceptionally gifted individuals; gratefully remembered by posterity, these men were finally accorded the status of gods. St. Augustine subscribed to such a view (which can be traced back to Hellenistic times) without facing all of the implications expressed by ancient authors. The complete theory was not revived until the late fifteenth century: it postulates a gradual evolution of man from the animal level, which thus conflicts with the scriptural account of Creation. This could be glossed over, however, by making a gay idyl out of the achievements of these pagan "culture heroes," to avoid the impression of complete seriousness—exactly what Piero di Cosimo did in our picture. Its title, *The Discovery of Honey,* refers to the central episode, a group of satyrs busying themselves about an old willow tree. They have discovered a swarm of bees, and are making as much noise as possible with their pots and pans to induce the bees to cluster on one of the branches. The satyrs will then collect the honey, from which they will produce mead. Behind them, to the right, some of their companions are about to discover the source of another fermented beverage; they are climbing trees to collect wild grapes. Beyond is a barren rock, while on the left there are gentle hills and a town. This contrast does not imply that the satyrs are city dwellers; it merely juxtaposes civilization, the goal of the future, with untamed nature. Here the "culture hero" is, of course, Bacchus, who appears in the lower right-hand corner, a tipsy grin on his face, next to his lady-love, Ariadne. Despite their classical appearance, Bacchus and his companions do not in the least resemble the frenzied revelers of ancient mythology. They have an oddly domestic air, suggesting a fun-loving family clan on a picnic. The brilliant sunlight, the rich colors, and the far-ranging landscape make the scene a still more plausible extension of everyday reality. We can well believe that Piero di Cosimo, in contrast to Botticelli, admired the great Flemish realists, and this landscape would be inconceivable without the strong influence of the *Portinari Altarpiece* (compare fig. 468).

Not only Piero was receptive to the realism of the Flemings: Domenico Ghirlandaio, another contemporary of Botticelli, shared this attitude. Ghirlandaio's fres-

539. LUCA SIGNORELLI. *The Damned Cast into Hell.* 1499–1500. Fresco.
S. Brizio Chapel, Orvieto Cathedral

co cycles are so replete with portraits that they almost serve as family chronicles of the wealthy patricians who sponsored them. Among his most affecting individual portraits is the panel of an old man with his grandson (fig. 537). Lacking the pictorial delicacy of Flemish portraits, it nevertheless reflects their precise attention to surface texture and facial detail. But no Northern painter could have rendered like Ghirlandaio the tender human relationship between the little boy and his grandfather. Psychologically, our panel plainly bespeaks its Italian origin.

Urbino: Perugino; Signorelli

Rome, long neglected during the papal exile in Avignon, became once more, in the later fifteenth century, an important center of art patronage. As the papacy re-

gained its political power on Italian soil, the occupants of the Chair of St. Peter began to beautify both the Vatican and the city, in the conviction that the monuments of Christian Rome must outshine those of the pagan past. The most ambitious pictorial project of those years was the decoration of the walls of the Sistine Chapel about 1482. Among the artists who carried out this large cycle of Old and New Testament scenes we encounter most of the important painters of Central Italy, including Botticelli and Ghirlandaio, although the frescoes do not, on the whole, represent their most distinguished work. There is, however, one exception to this rule: *The Delivery of the Keys* (fig. 538) by Pietro Perugino must rank as his finest achievement. Born near Perugia in Umbria (the region southeast of Tuscany), Perugino maintained close ties with Florence. His early development had been decisively influenced by Verrocchio, as the statuesque balance and solidity of the figures in *The Delivery of the Keys* still suggest. The gravely symmetrical design con-

veys the special importance of the subject in this particular setting (the authority of St. Peter as the first pope—and that of all his successors—rests on his having received the keys to the Kingdom of Heaven from Christ Himself). A number of contemporaries, with powerfully individualized features, witness the solemn event. Equally striking is the vast expanse of the background, its two Roman triumphal arches (both modeled on the Arch of Constantine) flanking a domed structure in which we recognize the ideal church of Alberti's *Treatise on Architecture*. The spatial clarity, the mathematically exact perspective of this view, are the heritage of Piero della Francesca, who spent much of his later life working for Umbrian clients, notably the Duke of Urbino. And also from Urbino, shortly before 1500, Perugino received a pupil whose fame soon obscured his own—Raphael, the most classic master of the High Renaissance.

Luca Signorelli is linked to Perugino by a similar background, although his personality is infinitely more dramatic. Of provincial Tuscan origin, he had been a disciple of Piero della Francesca before coming to Florence in the 1470s. Like Perugino, Signorelli was strongly impressed by Verrocchio, but he also admired the energy, expressiveness, and anatomic precision of Pollaiuolo's nudes. Combining these influences with Piero's cubic solidity of form and mastery of perspective foreshortening, Signorelli achieved a style of epic grandeur that later made a lasting imprint upon the mind of Michelangelo. He reached the climax of his career just before 1500 with the four monumental frescoes, representing the end of the world, on the walls of the S. Brizio Chapel in Orvieto Cathedral—especially the most dynamic of these, *The Damned Cast into Hell* (fig. 539). What most strikes us is not Signorelli's use of the nude body as an expressive instrument—even though he far surpasses his predecessors in this respect—but the deep sense of tragedy that pervades the scene. Signorelli's Hell, the exact opposite of Bosch's (compare fig. 472), is illuminated by the full light of day, without nightmarish machines of torture or grotesque monsters. The damned retain their human dignity, and the devils, too, are humanized; even in Hell, the Renaissance faith in man does not lose its force.

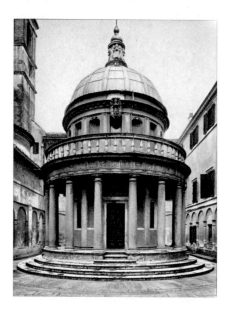

FLORENCE AND MILAN:
LEONARDO DA VINCI

ROME: BRAMANTE

FLORENCE AND ROME: MICHELANGELO

ROME: RAPHAEL

VENICE: GIORGIONE; TITIAN

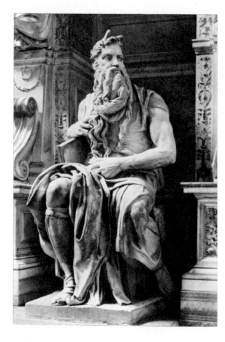

3

THE HIGH RENAISSANCE
IN ITALY

It used to be taken for granted that the High Renaissance followed upon the Early Renaissance as naturally and inevitably as noon follows morning. The great masters of the sixteenth century—Leonardo, Bramante, Michelangelo, Raphael, Giorgione, Titian—were thought to have shared the ideals of their predecessors, but to have expressed them so completely that their names became synonyms for perfection. They represented the climax, the classic phase, of Renaissance art, just as Phidias seemed to have brought the art of ancient Greece to its highest point. This view could also explain why these two classic phases were so short: if art is assumed to develop along the pattern of a ballistic curve, its highest point cannot be expected to last more than a moment.

Since the 1920s, art historians have come to realize the shortcomings of this scheme. When we apply it literally, the High Renaissance becomes so absurdly brief, for example, that we wonder whether it happened at all. Moreover, we hardly increase our understanding of the Early Renaissance if we regard it as a "not-yet-perfect High Renaissance," any more than an Archaic Greek statue can be satisfactorily viewed from a Phidian standpoint. Nor is it very useful to insist that the subsequent post-Classical phase, whether Hellenistic or "Late Renaissance," must be decadent. The image of the ballistic curve has now been abandoned, and we have gained a less assured, but also less arbitrary, estimate of what, for lack of another term, we still call the High Renaissance.

In some fundamental respects, we shall find that the High Renaissance was indeed the culmination of the Early Renaissance, while in others it represented a departure. Certainly the tendency to view the artist as a sovereign genius, rather than as a devoted craftsman, was never stronger than during the first half of the sixteenth century. Plato's concept of genius—the spirit entering into the poet that causes him to compose in a "divine frenzy"—had been broadened by Marsilio Ficino and his fellow Neo-Platonists to include the architect, the sculptor, and the painter. Men of genius were thought to be set apart from ordinary mortals by the divine inspiration guiding their efforts, and worthy of being called "divine," "immortal," and "creative" (before 1500,

creating, as distinct from *making,* was the privilege of God alone). This cult of genius had a profound effect on the artists of the High Renaissance. It spurred them to vast and ambitious goals, and prompted their awed patrons to support such enterprises. But since these ambitions often went beyond the humanly possible, they were apt to be frustrated by external as well as internal difficulties, leaving the artist with a sense of having been defeated by a malevolent fate. At the same time, the artist's faith in the divine origin of inspiration led him to rely on subjective, rather than objective, standards of truth and beauty. If Early Renaissance artists felt bound by what they believed to be universally valid rules, such as the numerical ratios of musical harmony and the laws of scientific perspective, their High Renaissance successors were less concerned with rational order than with visual effectiveness. They evolved a new drama and a new rhetoric to engage the emotions of the beholder, whether sanctioned or not by classical precedent. In fact, the works of the great High Renaissance masters immediately became classics in their own right, their authority equal to that of the most renowned monuments of antiquity. But here we encounter a contradiction: if the creations of genius are viewed as unique by definition, they cannot be successfully imitated by lesser men, however worthy they may seem of such imitation. Unlike the founding fathers of the Early Renaissance, the leading artists of the High Renaissance did not set the pace for a broadly based "period style" that could be practiced on every level of quality. The High Renaissance produced astonishingly few minor masters; it died with the men who had created it, or even before. Of the six great personalities mentioned above, only Michelangelo and Titian lived beyond 1520. External conditions after that date were undoubtedly less favorable to the High Renaissance style than those of the first two decades of the century. Yet the High Renaissance might well have ended soon even without the pressure of circumstances; its harmonious grandeur was inherently unstable, a balance of divergent qualities. Only these qualities, not the balance itself, could be transmitted to the artists who reached maturity after 1520. In pointing out the limited and pre-

carious nature of the High Renaissance we do not mean to deny its tremendous impact upon later art. For most of the next three hundred years, the great personalities of the early sixteenth century loomed so large that the achievements of their predecessors seemed to belong to a forgotten era. Even when the art of the fourteenth and fifteenth centuries was finally rediscovered, people still acknowledged the High Renaissance as the turning point, referring to all painters before Raphael as "the Primitives."

FLORENCE AND MILAN: LEONARDO DA VINCI

One of the strangest aspects of the High Renaissance—and one important reason why, within the limitations set forth above, it rightfully deserves to be called a period—is the fact that its key monuments were all produced between 1495 and 1520, despite the great differences in age of the men creating them. Bramante, the oldest, was born in 1444, Raphael in 1483, and Titian about 1488–90. Yet the distinction of being the earliest High Renaissance master belongs to Leonardo da Vinci, not to Bramante. Born in 1452 in the little Tuscan town of Vinci, Leonardo was trained by Verrocchio. Conditions in Florence must not have suited him; at the age of thirty he went to work for the Duke of Milan—as a military engineer, and only secondarily as an architect, sculptor, and painter—leaving behind unfinished the most ambitious work he had then begun, a large *Adoration of the Magi* for which he had made many preliminary studies. Its design shows a geometric order and a precisely constructed perspective space that recall Florentine painting in the wake of Masàccio, rather than the style prevailing about 1480. The most striking—and indeed revolutionary—aspect of the

panel is the way it is painted, although Leonardo had not even completed the underpainting. Our detail (fig. 540) is taken from the area to the right of center, which is more nearly finished than the rest; the forms seem to materialize softly and gradually, never quite detaching themselves from a dusky realm. Leonardo, unlike Pollaiuolo or Botticelli, thinks not of outlines, but of three-dimensional bodies made visible, in varying degrees, by the incidence of light. In the shadows, these shapes remain incomplete, their contours are merely implied. In this method of modeling (called *chiaroscuro,* "light-and-dark") the forms no longer stand abruptly side by side but partake of a new pictorial unity, the barriers between them having been partially broken down. And there is a comparable emotional continuity as well: the gestures and faces of the crowd convey with touching eloquence the reality of the miracle they have come to behold. We will recognize the influence of both Pollaiuolo and Verrocchio in the mobile expressiveness of these figures, but Leonardo may also have been impressed by the breathless shepherds in the *Portinari Altarpiece,* then newly installed in Florence (see fig. 469). Soon after arriving in Milan, Leonardo did *The Virgin of the Rocks* (fig. 541), another altar panel, which suggests what the *Adoration* would have looked like if it had been completed. Here the figures emerge from the semidarkness of the grotto, enveloped in a moisture-laden atmosphere that delicately veils their forms. This fine haze (called *sfumato*), more pronounced than similar effects in Flemish and Venetian painting, lends a peculiar warmth and intimacy to the scene. It also creates a remote, dreamlike quality, and makes the picture seem a poetic vision rather than an image of reality pure and simple. The subject—the infant St. John adoring the Infant Christ in the presence of the

540. LEONARDO DA VINCI.
Adoration of the Magi
(detail). 1481–82. Panel,
size of area shown c. 24 × 30".
Uffizi Gallery, Florence

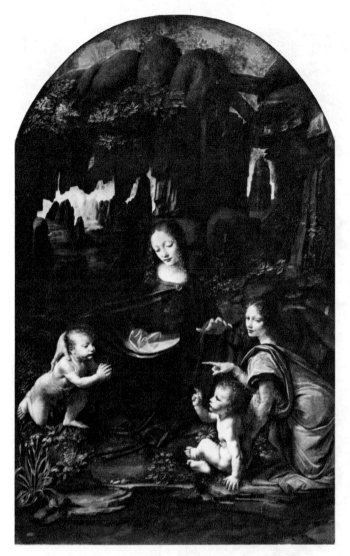

541. LEONARDO DA VINCI. *The Virgin of the Rocks.*
c. 1485. Panel, 75 × 43 ¹/₂". The Louvre, Paris

Virgin and an angel—is mysterious in many ways, without immediate precedent: the secluded, rocky setting, the pool in front, and the plant life, carefully chosen and exquisitely rendered, all hint at symbolic meanings that are somehow hard to define. And on what level, or levels, of significance are we to interpret the relationships among the four figures? Perhaps the key is the conjunction of gestures—protective, pointing, and blessing—toward the center of the group. However puzzling its content, few pictures cast a more enduring spell.

Despite their originality, the *Adoration* and the *Virgin of the Rocks* do not yet differ clearly, in conception, from the aims of the Early Renaissance. But Leonardo's *Last Supper,* later by a dozen years, has always been recognized as the first classic statement of the ideals of High Renaissance painting (fig. 542). Unhappily, the famous mural began to deteriorate a few years after its completion; the artist, dissatisfied with the limitations of the traditional fresco technique, experimented in an oil-tempera medium that did not adhere well to the wall. We thus need some effort to imagine its original splendor. Yet what remains is more than sufficient to account for

its tremendous impact. Viewing the composition as a whole, we are struck at once by its balanced stability; only afterward do we discover that this balance has been achieved by the reconciliation of competing, even conflicting, claims such as no previous artist had attempted. A comparison with Castagno's *Last Supper* (fig. 516), painted half a century before, is particularly instructive here: the spatial setting in both cases seems like an annex to the real interior of the refectory, but Castagno's architecture has a strangely oppressive effect on the figures while Leonardo's, despite its far greater depth, does not. The reason for this becomes clear when we realize that in the earlier work the perspective space has been conceived autonomously—it was there before the figures entered, and would equally suit another group of diners. Leonardo, in contrast, began with the figure composition, and the architecture had merely a supporting role from the start. The central vanishing point, which governs our view of the interior, is located behind the head of Christ in the exact middle of the picture, and thus becomes charged with symbolic significance. Equally plain is the symbolic function of the main opening in the back wall; its projecting pediment acts as the architectural equivalent of a halo. We thus tend to see the perspective framework of the scene almost entirely in relation to the figures, rather than as a pre-existing entity. How vital is this relationship we can easily test by covering the upper third of the picture: the composition then takes on the character of a frieze, the grouping of the apostles is less clear, and the calm triangular shape of Christ becomes merely passive, instead of acting as a physical and spiritual focus. The Saviour, presumably, has just spoken the fateful words, "One of you shall betray me," and the disciples are asking, "Lord, is it I?" We actually see nothing that contradicts this interpretation, but to view the scene as one particular moment in a psychological drama hardly does justice to Leonardo's intentions. These went well beyond a literal rendering of the biblical narrative, for he crowded together all the disciples on the far side of the table, in a space quite inadequate for so many diners. He clearly wanted to condense his subject physically by the compact, monumental grouping of the figures, and spiritually by presenting many levels of meaning at one time. Thus the gesture of Christ is one of submission to the Divine will, and of offering. It is a hint at Christ's main act at the Last Supper, the institution of the Eucharist ("And as they were eating, Jesus took bread . . . and gave it to the disciples, and said, Take and eat; this is my body. And he took the cup . . . saying, Drink ye all of it; for this is my blood . . ."). And the apostles do not merely react to these words; each of them reveals his own personality, his own relationship to the Saviour. (Note that Judas is no longer segregated from the rest; his dark, defiant profile sets him apart well enough.) They exemplify what the artist wrote in one of his notebooks, that the highest and most difficult aim of

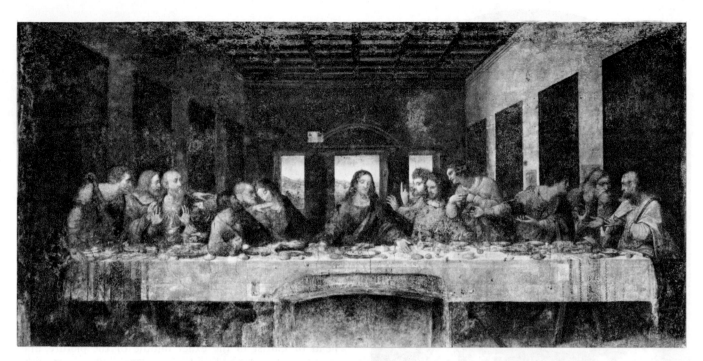

above: 542. LEONARDO DA VINCI.
The Last Supper. c. 1495–98. Mural.
Sta. Maria delle Grazie, Milan

543. PETER PAUL RUBENS.
Drawing after Leonardo's Cartoon
for "The Battle of Anghiari."
c. 1605. The Louvre, Paris

painting is to depict "the intention of man's soul" through gestures and movements of the limbs—a dictum not to be interpreted as referring to momentary emotional states but to man's inner life as a whole.

In 1499, the duchy of Milan fell to the French, and Leonardo, after brief trips to Mantua and Venice, returned to Florence. He must have found the cultural climate very different from his recollections of it; the Medici had been expelled, and the city was briefly a republic again, until their return. For a while, Leonardo seems to have been active mainly as an engineer and surveyor, but in 1503 the city commissioned him to do a mural for the council chamber of the Palazzo Vecchio, with some famous event from the history of Florence as its subject. Leonardo chose the Battle of Anghiari, where the Florentine forces had once defeated the Milanese army. He completed the cartoon (a full-scale drawing) and had just begun the mural itself when, in 1506, he returned once more to Milan at the request of the French, abandoning the commission. The cartoon for *The Battle of Anghiari* survived for more than a century, and enjoyed enormous fame. Today we know it only through Leonardo's preliminary sketches and through copies of the cartoon by later artists, notably a

splendid drawing by Peter Paul Rubens (fig. 543). Leonardo had started with the historical accounts of the engagement; as his plans crystallized, however, he abandoned factual accuracy and created a monumental group of soldiers on horseback that represent a condensed, timeless image of the spirit of battle, rather than any specific event. His concern with "the intention of man's soul"—in this case, a savage fury that has seized not only the men but the animals as well—is even more evident here than in the *Last Supper*. *The Battle of Anghiari* stands at the opposite end of the scale from Uccello's *Battle of San Romano* (colorplate 54), where nothing has been omitted except the fighting itself. Yet Leonardo's battle scene is not one of uncontrolled action; its dynamism is held in check by the hexagonal outline that stabilizes this seething mass. Once again, balance has been achieved by the reconciliation of competing claims.

While working on *The Battle of Anghiari,* Leonardo painted his most famous portrait, the *Mona Lisa* (fig. 544). The delicate *sfumato* already noted in the *Madonna of the Rocks* is here so perfected that it seemed miraculous to the artist's contemporaries. The forms are built from layers of glazes so gossamer-thin that the entire panel seems to glow with a gentle light from within. But the fame of the *Mona Lisa* comes not from this pictorial subtlety alone; even more intriguing is the psychological fascination of the sitter's personality. Why, among all the smiling faces ever painted, has this particular one been singled out as "mysterious"? Perhaps the reason is that, as a portrait, the picture does not fit our expectations. The features are too individual for Leonardo to have simply depicted an ideal type, yet the element of idealization is so strong that it blurs the sitter's character. Once again the artist has brought two opposites into harmonious balance. The smile, too, may be read in two ways: as the echo of a momentary mood, and as a timeless, symbolic expression (somewhat like the "Archaic smile" of the Greeks; see figures 134, 135, 137, and colorplate 12). Clearly, the Mona Lisa embodies a quality of maternal tenderness which was to Leonardo the essence of womanhood. Even the landscape in the background, composed mainly of rocks and water, suggests elemental generative forces.

In the later years of his life, Leonardo devoted himself more and more to his scientific interests. Art and science, we recall, were first united in Brunelleschi's discovery of systematic perspective; Leonardo's work is the climax of this trend. The artist, he believed, must know not only the rules of perspective but also all laws of nature, and the eye was to him the perfect instrument for gaining such knowledge. The extraordinary scope of his own inquiries is attested in the hundreds of drawings and notes which he hoped to incorporate into an encyclopedic set of treatises. How original he was as a scientist is still a matter of debate, but in one field his importance remains undisputed: he created the modern

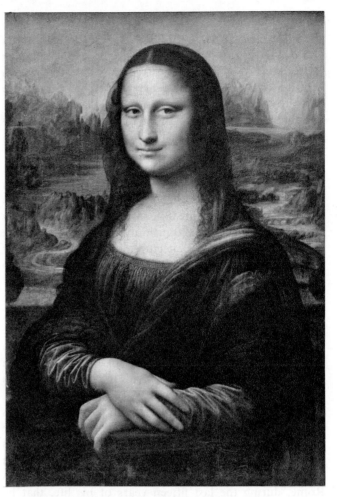

544. LEONARDO DA VINCI. *Mona Lisa.* c. 1503–05. Panel, 30 1/4 × 21". The Louvre, Paris

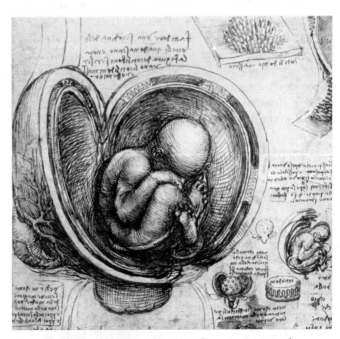

545. LEONARDO DA VINCI. *Embryo in the Womb.* c. 1510. Pen drawing. Royal Library, Windsor Castle (Crown Copyright Reserved)

scientific illustration, an essential tool for anatomists and biologists. A drawing such as the *Embryo in the Womb* (fig. 545) combines his own vivid observation with the analytic clarity of a diagram, or—to paraphrase Leonardo's own words—sight and insight.

Contemporary sources show that Leonardo was esteemed as an architect. Actual building seems to have concerned him less, however, than basic problems of structure and design. The numerous architectural projects in his drawings were intended, for the most part, to remain on paper. Yet these sketches, especially those of his Milanese period, have great historic importance, for only in them can we trace the transition from the Early to the High Renaissance in architecture. The domed, centrally planned churches of the type illustrated in figure 546 hold particular interest for us; the plan recalls Brunelleschi's Sta. Maria degli Angeli (see fig. 506) but the new relationship of the spatial units is more complex, while the exterior, with its cluster of domes, is more monumental than any Early Renaissance structure. In conception, this design stands halfway between the dome of Florence Cathedral and the most ambitious structure of the sixteenth century, the new church of St. Peter's in Rome (compare figs. 410, 549, 551). It gives evidence, too, of Leonardo's close contact, during the 1490s, with the architect Donato Bramante, who was then also working for the Duke of Milan. Bramante went to Rome after Milan fell to the French; it was in Rome, during the last fifteen years of his life, that he became the creator of High Renaissance architecture.

ROME: BRAMANTE

The new style is shown fully formed in Bramante's Tempietto at S. Pietro in Montorio (figs. 547, 548), designed soon after 1500. This chapel marks the site of St. Peter's crucifixion, and was planned to be surrounded by a circular, colonnaded courtyard. The Tempietto would then have appeared less isolated from its environment than it does today, for Bramante intended it to be set within a "molded" exterior space—a conception as bold

and novel as the design of the chapel itself. Its nickname, "little temple," seems well deserved: in the three-step platform, and the severe Doric order of the colonnade, Classical temple architecture is more directly recalled than in any fifteenth-century structure. Equally striking is Bramante's application of the "sculptured wall" principle, in the Tempietto itself and in the courtyard; not since Brunelleschi's Sta. Maria degli Angeli have we seen such deeply recessed niches, "excavated" from heavy masses of masonry. These cavities are counterbalanced by the convex shape of the dome and by strongly projecting moldings and cornices. As a result, the Tempietto has a monumental weight that belies its modest size.

The Tempietto is the earliest of the great achievements that made Rome the center of Italian art during the first quarter of the sixteenth century. Most of them belong to the decade 1503–13, the papacy of Julius II. It was he who decided to replace the old basilica of St. Peter's, which had long been in precarious condition, with a church so magnificent as to overshadow all the monuments of ancient imperial Rome. The task naturally fell to Bramante, the foremost architect in the city. His original design, of 1506, is known to us only from a plan (fig. 549), and from the medal commemorating the start of the building campaign (fig. 551) which shows the exterior in rather imprecise perspective. These are sufficient, however, to bear out the words Bramante reportedly used to define his aim: "I shall place the Pantheon on top of the Basilica of Constantine." To surpass the two most famous structures of Roman antiquity by a Christian edifice of unexampled grandeur—nothing less would have satisfied Julius II, a pontiff of vast ambition, who wanted to unite all Italy under his command and thus to gain a temporal power matching the spiritual authority of his office. Bramante's design is indeed of truly imperial magnificence: a huge dome, hemispherical like that of the Tempietto, crowns the crossing of the barrel-vaulted arms of a Greek cross, with four lesser domes and tall corner towers filling the angles. This plan fulfills all the demands laid down by Alberti for

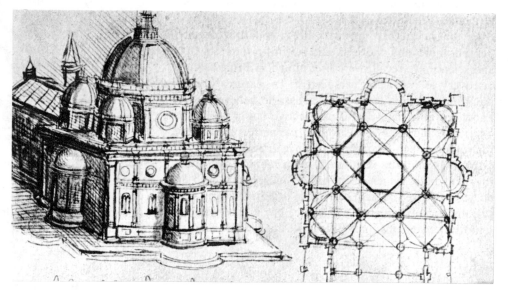

546. LEONARDO DA VINCI.
Project for a Church (Ms. B).
c. 1490. Pen drawing.
Bibliothèque de l'Arsenal, Paris

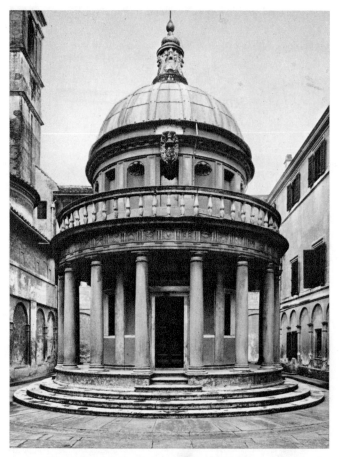

547. DONATO BRAMANTE. The Tempietto. 1502.
S. Pietro in Montorio, Rome

549. DONATO BRAMANTE. Original Plan for
St. Peter's, Rome. 1506 (after Geymüller)

550. Plan of S. Lorenzo,
Florence, reproduced to
the same scale as figure 549.

548. Plan of the Tempietto,
with projected courtyard (after Serlio)

551. CARADOSSO. Medal Showing Bramante's Design
for St. Peter's. 1506. British Museum, London

sacred architecture (pages 401–2); based entirely on the
circle and the square, it is so rigidly symmetrical that
we cannot tell which apse was to hold the high altar.
Bramante envisioned four identical façades like that on
the medal of 1506, dominated by the same repertory of
severely classical forms we saw in the Tempietto: domes,
half-domes, colonnades, pediments. These simple geo-
metric shapes, however, do not prevail inside the church.
Here the "sculptured wall" reigns supreme: the plan
shows no continuous surfaces, only great, oddly shaped

"islands" of masonry that have been well described by one critic as giant pieces of toast half-eaten by a voracious space. The actual size of these "islands" can be visualized only if we compare the measurements of Bramante's church with those of earlier buildings. San Lorenzo in Florence, for instance, has a length of 268 feet, less than half that of the new St. Peter's (550 feet). Figure 550, which reproduces the plan of S. Lorenzo on the same scale as Bramante's plan (fig. 549), proves that Bramante's reference to the Pantheon and the Basilica of Constantine was no idle boast; his plan dwarfs these monuments, as well as every Early Renaissance church (each arm of the Greek cross has about the dimensions of the Basilica of Constantine). How did he propose to build a structure of such overwhelming size? Cut stone or brick, the materials favored by medieval architects, would not do, for technical and economic reasons; only construction in concrete, as used by the Romans but largely forgotten during the Middle Ages, was strong and cheap enough to fill Bramante's needs (see page 157). By reviving this ancient technique, he opened a new era in the history of architecture, for concrete permitted designs of far greater flexibility than the building methods of the medieval masons. The possibilities of the material, however, were not fully exploited for some time to come. The construction of St. Peter's progressed at so slow a pace that in 1514, when Bramante died, only the four crossing piers had actually been built. For the next three decades the campaign was carried on hesitantly by architects trained under Bramante, who modified his design in a number of ways. A new and decisive phase in the history of St. Peter's began only in 1546, when Michelangelo took charge; the present appearance of the church (fig. 565) is largely shaped by his ideas. But this must be considered in the context of Michelangelo's career as a whole.

FLORENCE AND ROME: MICHELANGELO

The concept of genius as divine inspiration, a superhuman power granted to a few rare individuals and acting through them, is nowhere exemplified more fully than in the life and work of Michelangelo (1475–1564). Not only his admirers viewed him in this light; he himself, steeped in the tradition of Neo-Platonism, accepted the idea of his genius as a living reality, although it seemed to him at times a curse rather than a blessing. The element that brings continuity to his long and stormy career is the sovereign power of his personality, his faith in the subjective rightness of everything he created. Conventions, standards, and traditions might be observed by lesser spirits; he could acknowledge no authority higher than the dictates of his genius.

Unlike Leonardo, for whom painting was the noblest of the arts because it embraced every visible aspect of the world, Michelangelo was a sculptor—more specifically, a

552. MICHELANGELO. *David*. 1501–4.
Marble, height of figure 13′ 5″. Academy, Florence

carver of marble statues—to the core. Art, for him, was not a science but "the making of men," analogous (however imperfectly) to divine creation; hence the limitations of sculpture that Leonardo decried were essential virtues in Michelangelo's eyes. Only the "liberation" of real, three-dimensional bodies from recalcitrant matter could satisfy his urge (for his procedure, see discussion of *St. Matthew,* page 12). Painting, for him, should imitate the roundness of sculptured forms, and architecture, too, must partake of the organic qualities of the human figure. Michelangelo's faith in the image of man as the supreme vehicle of expression gave him a sense of kinship with Classical sculpture closer than that of any Renaissance artist. Among recent masters he admired Giotto, Masaccio, Donatello, and Jacopo della Quercia more than the men he knew as a youth in Florence. Yet his mind was decisively shaped by the cultural climate of Florence during the 1480s and 90s; both the Neo-Platonism of Marsilio Ficino and the religious reforms of Savonarola profoundly affected him. These conflicting influences reinforced the tensions within Michelangelo's personality, his violent changes of mood, his sense of being at odds with himself and with the world. As he conceived his statues to be bodies released from their marble prison, so the body was the earthly prison of the soul—noble, surely, but a prison nevertheless. This dualism of body and spirit endows his figures with their extraordinary *pathos;* outwardly calm, they seem stirred by an overwhelming psychic energy that has no release in physical action.

The unique qualities of Michelangelo's art are fully present in the *David* (fig. 552), the earliest monumental statue of the High Renaissance. Commissioned of the artist in 1501, when he was twenty-six, the huge figure was designed to be placed high above the ground, on one of the buttresses of the Cathedral. The city fathers chose instead to put it in front of the Palazzo Vecchio, as the civic-patriotic symbol of the Florentine republic (see fig. 415; it has since been replaced by a modern copy). We can well understand their decision. The head of Goliath being omitted, Michelangelo's *David* looks challenging—not a victorious hero but the champion of a just cause. Vibrant with pent-up energy, he faces the world like Donatello's *St. George* (see fig. 490), although his nudity links him to the older master's bronze *David* as well. But the style of the figure proclaims an ideal very different from the wiry slenderness of Donatello's youths. Michelangelo had just spent several years in Rome, where he had been deeply impressed with the emotion-charged, muscular bodies of Hellenistic sculpture. Although the *Laocoön* (fig. 192), shortly to become the most famous work in this style, had not then been discovered, other Hellenistic statues were accessible to him. Their heroic scale, their superhuman beauty and power, and the swelling volume of their forms became part of Michelangelo's own style and, through him, of Renaissance art in general. Yet the *David* could never be taken for an ancient statue. In the *Laocoön* and similar works (compare fig. 190), the

body "acts out" the spirit's agony, while the *David,* at once calm and tense, shows the action-in-repose so characteristic of Michelangelo.

This trait persists in the *Moses* (fig. 553) and the two "slaves" (figs. 554, 555), carved about a decade later. They were part of the vast sculptural program for the tomb of Julius II, which would have been Michelangelo's greatest achievement had he carried it out as originally planned. The majestic *Moses,* meant to be seen from below, has the awesome force which the artist's contemporaries called *terribilità*—a concept akin to the sublime. His pose, both watchful and meditative, suggests a man capable of wise leadership as well as towering wrath. The "slaves" are more difficult to interpret: they seem to have first belonged to a series representing the arts, shackled by the death of their greatest patron; later, apparently, they came to signify the territories conquered by Julius II. Be that as it may, Michelangelo has conceived the two

553. MICHELANGELO. *Moses.* c. 1513–15.
Marble, height 92 1/2". S. Pietro in Vincoli, Rome

right: 554. MICHELANGELO.
"The Dying Slave." 1513–16. Marble,
height 90". The Louvre, Paris

far right: 555. MICHELANGELO.
"The Rebellious Slave."
1513–16. Marble, height 84".
The Louvre, Paris

figures as a contrasting pair, the so-called *Dying Slave* (fig. 554) yielding to his bonds, the *Rebellious Slave* (fig. 555) struggling to free himself. Perhaps their allegorical meaning mattered less to him than their expressive content, so evocative of the Neo-Platonic image of the body as the earthly prison of the soul.

The Sistine Chapel

The tomb of Julius II remained unfinished when the pope interrupted Michelangelo's labors on the project at an early stage, half-forcing, half-cajoling the reluctant artist to fresco the ceiling of the Sistine Chapel (fig. 556). Driven by his desire to resume work on the tomb, Michelangelo completed the entire ceiling in four years, 1508–12. He produced a masterpiece of truly epochal importance. The ceiling is a huge organism with hundreds of figures rhythmically distributed within the painted architectural framework, dwarfing the earlier murals (fig. 538) by its size, and still more by its compelling inner unity. In the central area, subdivided by five pairs of girders, are nine scenes from Genesis, from the Creation of the World (at the far end of the Chapel) to the Drunkenness of Noah. The theological scheme behind

the choice of these scenes and the rich program accompanying them—the nude youths, the medallions, the prophets and sibyls, the scenes in the spandrels—has not been fully explained, but we know that it links the early history of man and the coming of Christ, the beginning of time and its end (the *Last Judgment* on the wall above the altar, although it was painted a quarter of a century later, must have been intended from the start). We do not know how much responsibility Michelangelo had for the program; he was not a man to submit to dictation, and the subject matter of the ceiling as a whole fits his cast of mind so perfectly that his own desires cannot have conflicted strongly with those of his patron. What greater theme could he wish than the Creation of the World, Man's Fall, and his ultimate reconciliation with the Lord? A detailed survey of the Sistine Ceiling would fill a book; we shall have to be content with two of the four major scenes in the center portion. Of these, the *Creation of Adam* (fig. 557) must have stirred Michelangelo's imagination most deeply; it shows not the physical molding of Adam's body but the passage of the Divine spark—the soul—and thus achieves a dramatic juxtaposition of Man and God unrivaled by any other artist. Jacopo della Quercia approximated it (see fig. 495), but without the dynamism of Michelangelo's design that contrasts the earth-bound Adam and the figure of God rushing through the sky. This relationship becomes even more meaningful when we realize that Adam strains not only toward his Creator but toward Eve, whom he sees, yet unborn, in the shelter of the Lord's left arm. *The Fall of Man and the Expulsion from the Garden of Eden* (colorplate 60) shows the cool, subdued tones typical of the whole ceiling. Michelangelo has been called a poor colorist—perhaps unjustly. If he here restricts his palette to "stony" colors,

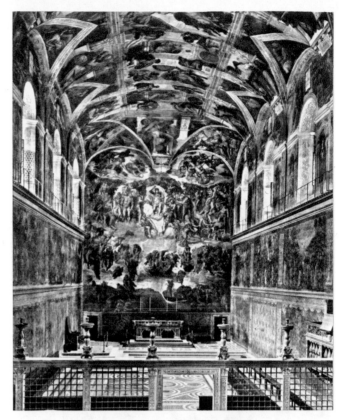

556. Interior of the Sistine Chapel (showing Michelangelo's Ceiling Fresco and *Last Judgment*). The Vatican, Rome

it is to give his figures the quality of painted sculpture and integrate them with their architectural setting. His narrative scenes are the pictorial counterpart of reliefs rather than illusionistic "windows." Within his limited range of hues, the variety of subtle gradations is astonishing: he does not simply color the areas within the contours but builds up his forms from broad and vigorous brush strokes in the tradition of Giotto and Masaccio.

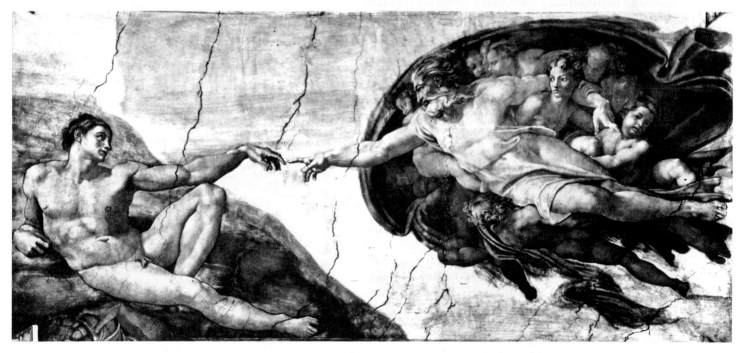

557. MICHELANGELO. *The Creation of Adam*, detail of the Sistine Ceiling. 1508–12

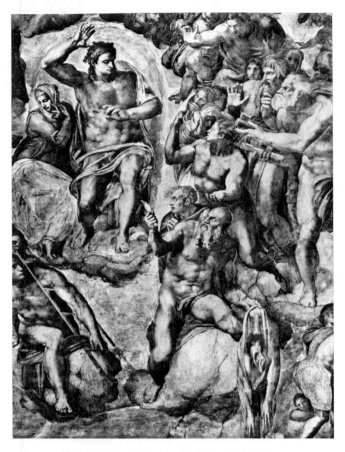

558. MICHELANGELO. *The Last Judgment*
(detail, with self-portrait). 1534–41. Fresco.
Sistine Chapel, The Vatican, Rome

however, is not the saint's but Michelangelo's own. In this grimly sardonic self-portrait (so well hidden that it was recognized only in modern times) the artist has left his personal confession of guilt and unworthiness.

The Medici Chapel

The interval between the Sistine Ceiling and the *Last Judgment* coincides with the papacies of Leo X (1513–21) and Clement VII (1523–34); both were members of the Medici family, and preferred to employ Michelangelo in Florence. His activities centered on S. Lorenzo, the Medici church. A century after Brunelleschi's revolutionary design for the sacristy (see page 388), Leo X decided to build a matching structure—the New Sacristy—to house the tombs of Lorenzo the Magnificent, Lorenzo's brother Giuliano, and two younger members of the family also named Lorenzo and Giuliano. Michelangelo took early charge of this project and worked on it for fourteen

The *Expulsion* is particularly close to Masaccio's (compare fig. 511). Our colorplate also permits us to glimpse the garland-bearing nude youths that accompany the main sections of the ceiling. These wonderfully animated figures, recurring at regular intervals, play an important role in Michelangelo's design; they form a kind of chain linking the Genesis scenes, yet their significance remains uncertain. Are they images of human souls? Do they represent the world of pagan antiquity? Whatever the answer, they seem to belong to the same category of being as the "slaves" from the Tomb of Julius II; again the symbolic intent is overpowered by the wealth of expression Michelangelo has poured into these figures.

When Michelangelo returned to the Sistine Chapel in 1534, over twenty years later, the Western world was enduring the spiritual and political crisis of the Reformation (see page 461). We perceive with shocking directness how the mood has changed as we turn from the radiant vitality of Michelangelo's ceiling fresco to the somber vision of his *Last Judgment*. Mankind, Blessed and Damned alike, huddles together in tight clumps, pleading for mercy before a wrathful God (fig. 558). Seated on a cloud just below the Lord is the Apostle Bartholomew, holding a human skin to represent his martyrdom (he had been flayed). The face on that skin,

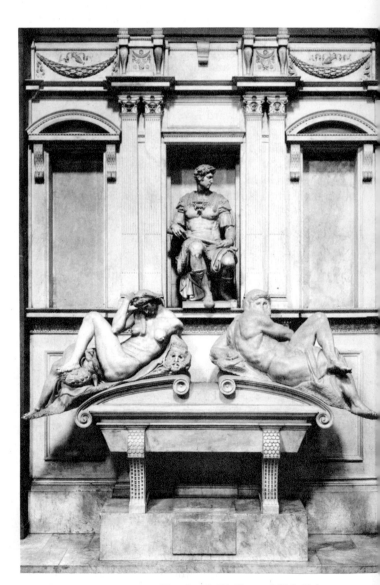

559. MICHELANGELO. Tomb of Giuliano de'Medici.
1524–34. Marble, height of central figure 71″.
New Sacristy, S. Lorenzo, Florence

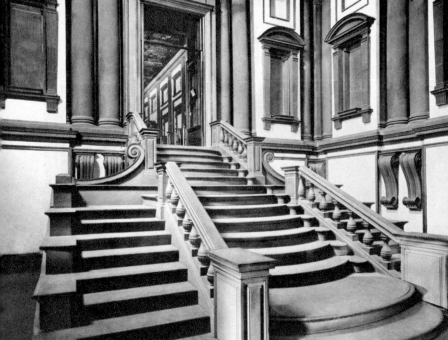

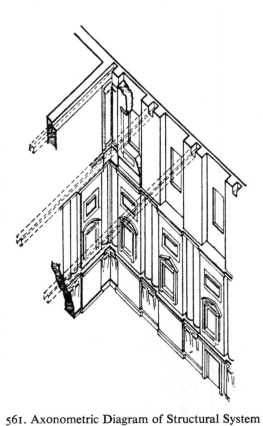

560. MICHELANGELO. Vestibule of the Laurentian Library, Florence. Begun 1524; stairway designed 1558–59

561. Axonometric Diagram of Structural System of the Library Vestibule (after Ackerman)

years, completing the architecture and two of the tombs, those for the lesser Lorenzo and Giuliano (fig. 559). The New Sacristy was thus conceived as an architectural-sculptural ensemble; it is the only work of the artist where his statues remain in the setting planned specifically for them. The design of the two tombs still shows some kinship with such Early Renaissance tombs as that of Leonardo Bruni (see fig. 527), but the differences weigh more heavily: there is no inscription, the effigy has been replaced by two allegorical figures (*Day* on the right, *Night* on the left), and the statue of Giuliano, in classical military garb, bears no resemblance to the deceased. ("A thousand years from now, nobody will want to know what he really looked like," Michelangelo is said to have remarked.) What is the meaning of this triad? The question, put countless times, has never found a satisfactory answer. Michelangelo's plans for the Medici tombs underwent so many changes of form and program while the work was under way that the present state of the monuments can hardly be the final solution; rather, the dynamic process of design was arbitrarily halted by the artist's departure for Rome in 1534. *Day* and *Night* were certainly designed for horizontal surfaces, not the curved, sloping lid of the present sarcophagus. Perhaps they were not even intended for this particular tomb. Giuliano's niche is too narrow and too shallow to accommodate him comfortably. Other figures and reliefs were

planned, but never executed. Was their omission intentional or accidental? Despite all this, the tomb of Giuliano remains a compelling visual unit. The great triangle of the statues is held in place by a network of verticals and horizontals whose slender, sharp-edged forms heighten the roundness and weight of the sculpture. *Giuliano*, the ideal image of the prince, is a younger and more pensive counterpart of the *Moses;* the reclining figures contrast in mood like the "slaves." Derived from ancient river gods (compare figs. 8, 9), they embody the quality of action-in-repose more dramatically than any other works by Michelangelo: in the brooding menace of *Day*, and in the disturbed slumber of *Night*, the dualism of body and soul is expressed with unforgettable grandeur.

Architecture

Concurrently with the New Sacristy, Michelangelo built the Laurentian Library, adjoining S. Lorenzo, to house for the public the vast collection of books and manuscripts belonging to the Medici family. In the vestibule (fig. 560) his full powers as a creator of new architectural forms are displayed for the first time. By the standards of the 1520s, based on the classical ideal of Bramante, everything here is wrong: the pediment above the door is broken; the pilasters of the niches taper downward; the

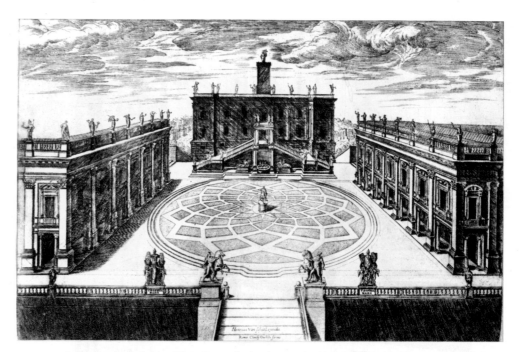

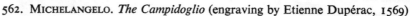

562. MICHELANGELO. *The Campidoglio* (engraving by Etienne Dupérac, 1569)

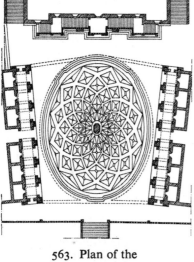

563. Plan of the Campidoglio

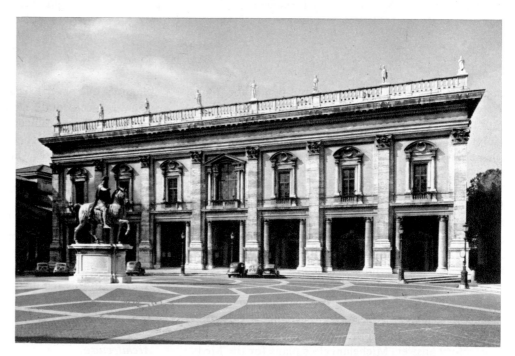

564. MICHELANGELO. The Conservators' Palace, Campidoglio, Rome. Designed c. 1545

columns belong to no recognizable order; the scroll brackets sustain nothing. Most paradoxical, however, from the point of view of established practice, are the recessed columns: though structurally logical—the columns support heavy piers, which in turn support the roof beams (fig. 561)—this feature upsets a hallowed rule of architectural propriety: that in the classical post-and-lintel system the columns (or pilasters) and entablature must project from the wall on which they have been superimposed, to stress their separate identities. The system could be reduced to a linear pattern (as in the Palazzo Rucellai: fig. 517), but no one before Michelangelo had dared to defy it by incorporating columns into the wall. The entire design demonstrates what Vasari, the

artist's friend and biographer, had in mind when he wrote that Michelangelo's architecture "broke the bonds and chains of . . . common usage." The purpose of these innovations is, of course, expressive rather than functional; the walls push inward between the columns to make of the vestibule a kind of "compression chamber" where the beholder experiences an almost physical stress. Our unease is heightened by the blank stare of the empty niches and by the nightmarish stairway, which flows downward and outward so relentlessly that we wonder if we dare brave the current by mounting the steps.

During the last thirty years of his life, architecture became Michelangelo's main preoccupation. In 1537–39, he received the most ambitious commission of his career: to reshape the Campidoglio, the top of the Capitoline Hill, into a square with a monumental frame worthy of this venerable site, once the symbolic center of ancient Rome. At last he could plan on a grand scale, and he took full advantage of the opportunity. Although not completed until long after his death, the project was carried out essentially as he had designed it—the most imposing civic center ever built, and a model for countless others. Pope Paul III took the initiative by transferring the equestrian monument of Marcus Aurelius (see fig. 252) to the Campidoglio, and Michelangelo designed its base; the statue became the focal point of his entire scheme, placed at the apex of a gently rising oval mound. Three sides of the piazza are defined by palace façades, so that the visitor, after ascending the flight of steps on the fourth side, finds himself enclosed in a huge "outdoor room." The effect of the ensemble cannot be rendered by photographs. Even the best view, an engraving based on Michelangelo's design (fig. 562), conveys it very imperfectly: it shows the complete bilateral symmetry of the scheme, and the energetic sense of progression along the main axis toward the Senators' Palace, but it distorts the shape of the piazza, which is not a rectangle but a trapezoid (the flanking façades are divergent: fig. 563). This peculiarity was imposed on Michelangelo by the existing site; the Senators' Palace, and the Conservators' Palace on the right, were older buildings which had to be preserved behind newly designed exteriors, and they were placed at an angle of 80 instead of 90 degrees. But he turned into an asset what would have hindered a less imaginative architect: the divergence of the flanks makes the Senators' Palace look larger than it is, dramatically dominating the piazza. The whole conception has the visual effectiveness of a stage set—note that in the engraving the "New Palace" on the left is a mere show front with nothing behind it. Yet this façade and its twin on the opposite side are not shallow screens but vigorously three-dimensional structures (fig. 564) with the most "muscular" juxtaposition of voids and solids, of horizontals and verticals, of any piece of architecture since Roman antiquity. They share the striking feature of an open portico, which links the piazza and façades as a courtyard is related to the arcades of a cloister. The columns and stone beams of the porticoes are inscribed within a colossal order of pilasters which supports a heavy cornice topped by a balustrade; the entire design is based on the classic post-and-lintel principle. We have encountered these elements on the façades of the Pazzi Chapel and Alberti's S. Andrea, and in the Tempietto of Bramante (see figs. 501, 520, 547), but it remained for Michelangelo to weld them into a coherent system. For the Senators' Palace he employed the colossal order and balustrade above a tall basement which emphasizes the massive quality of the building. The single entrance at the top of the huge double-ramped stairway seems to gather all the spatial forces set in motion by the oval mound and the divergent flanks, and thus provides a dramatic climax for the visitor traversing the piazza.

With the Campidoglio, the colossal order became firmly established in the repertory of monumental architecture. Michelangelo himself used it again on the exterior of St. Peter's (fig. 565), with equally impressive results. The system of the Conservators' Palace, with windows now replacing the open loggias, and an attic instead of the balustrade, could here be adapted perfectly to the jagged contour of the plan; unlike Bramante's many-layered elevation (see fig. 551) the colossal order emphasized the compact body of the structure, thus setting off the dome more dramatically. The same desire for compactness and organic unity led Michelangelo to simplify the interior, without changing its centralized character (figs. 566, 567). He brought the complex spatial sequences of Bramante's plan (see fig. 549) into one cross-and-square, and defined its main axis by modifying the exterior of the eastern apse and projecting a portico for it. This part of his design was never carried out. The dome, however, although built largely after his death, reflects his ideas in every important respect. Bramante had planned his dome as a stepped hemisphere above a narrow drum, which would have seemed to press down on the church below; Michelangelo's conveys the opposite sensation, a powerful thrust that draws energy upward from the main body of the structure. The high drum, the strongly projecting buttresses accented by double columns, the ribs, the raised curve of the cupola, the tall lantern—all contribute verticality at the expense of the horizontals. We may recall the Florence Cathedral dome (see fig. 410), from which Michelangelo borrowed not only the double-shell construction but the Gothic profile. Yet the effects are immensely different: the smooth planes of Brunelleschi's dome give no hint of the internal stresses, while Michelangelo finds a sculptured shape for these contending forces, and relates them to those in the rest of the building (the impulse of the paired colossal pilasters below is taken up by the double columns of the drum, continues in the ribs, and culminates in the lantern). The logic of this design is so persuasive that few domes built from 1600 to 1900 fail to acknowledge it.

Michelangelo's magnificent assurance in handling

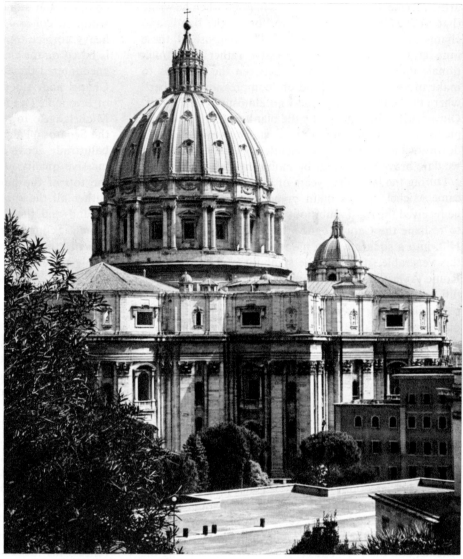

565. MICHELANGELO.
St. Peter's, Rome,
seen from the west.
1546–64 (dome completed by
Giacomo della Porta, 1590)

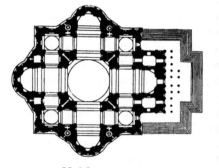

566. MICHELANGELO.
Plan for St. Peter's

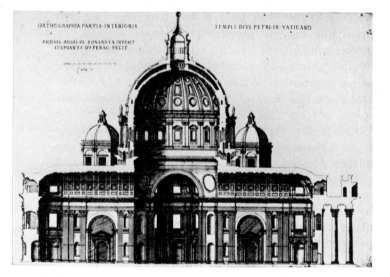

567. Longitudinal Section of St. Peter's
(engraving by Etienne Dupérac, 1569)

such projects as the Campidoglio and St. Peter's seems to belie his portrayal of himself as a limp skin in the *Last Judgment*. It is indeed difficult to reconcile these contrasting aspects of his personality. Did he, perhaps, toward the end of his life, find greater fulfillment in architecture than in shaping human bodies? In his last piece of sculpture, the *Pietà Rondanini* (fig. 568), he is groping for new forms, as if his earlier work had become meaningless to him. The group is a fragment, destroyed partly by his own hand; he was still struggling with it a few days before he died. The theme—especially its emotional content—suggests that he intended it for his own tomb. These two figures have no trace of High Renaissance rhetoric; silently hovering, they evoke the devotional images of medieval art. Like the master's self-portrait (see fig. 551), the *Pietà Rondanini* occupies an intensely private realm. Its plea for redemption is addressed to no human audience, but to God.

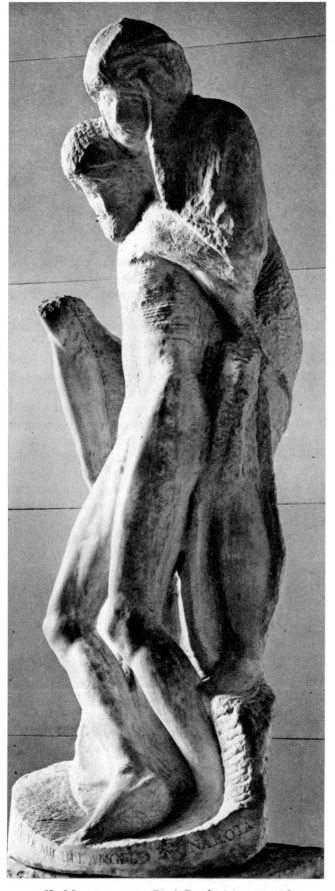

568. MICHELANGELO. *Pietà Rondanini.* c. 1555–64.
Marble, height 77 1/2″. Castello Sforzesco, Milan

ROME: RAPHAEL

If Michelangelo exemplifies the solitary genius, Raphael belongs just as surely to the opposite type: the artist as a man of the world. The contrast between the two was as clear to their contemporaries as it is to us. Although each had his partisans, both enjoyed equal fame. Today our sympathies are less evenly divided—

> In the room the women come and go
> Talking of Michelangelo. (T. S. Eliot)

So do a lot of us, including the authors of historical novels and fictionalized biographies, while Raphael is usually discussed only by historians of art. The younger master's career is too much of a success story, his work too replete with seemingly effortless grace, to match the tragic heroism of Michelangelo. As an innovator, Raphael seems to contribute less than Leonardo, Bramante, and Michelangelo, the three artists whose achievements were basic to his. Yet he is the central painter of the High Renaissance; our conception of the entire style rests more on his work than on any other master's. The genius of Raphael was a unique power of synthesis that enabled him to merge the qualities of Leonardo and Michelangelo, creating an art at once lyric and dramatic, pictorially rich and sculpturally solid. This power is already present in the first works he made in Florence (1504–8), after he completed his apprenticeship with Perugino. The meditative calm of the *Madonna del Granduca* (fig. 569) still reflects the style of his teacher (compare fig. 538). But the forms are ampler and enveloped in Leonardesque *sfumato;* the Virgin, grave and tender, makes us think of the *Mona Lisa* without engendering any of her mystery.

Michelangelo's influence on Raphael asserted itself somewhat later. Its full force can be felt only in Raphael's Roman works. At the time Michelangelo began to paint the Sistine Ceiling, Julius II summoned the younger artist from Florence and commissioned him to decorate a series of rooms in the Vatican Palace. The first room, the Stanza della Segnatura, may have housed the pope's library, and Raphael's cycle of frescoes on its walls and ceiling refers to the four domains of learning—theology, philosophy, law, and the arts. Of these, *The School of Athens* (fig. 570) has long been acknowledged as Raphael's masterpiece and the perfect embodiment of the classical spirit of the High Renaissance. Its subject is "the Athenian school of thought," a group of famous Greek philosophers gathered around Plato and Aristotle, each in a characteristic pose or activity. Raphael must have already seen the Sistine Ceiling, then nearing completion. He evidently owes to Michelangelo the expressive energy, the physical power, and the dramatic grouping of his figures. Yet Raphael has not simply borrowed Michelangelo's repertory of gestures and poses; he has absorbed it into his own style, and thereby given it differ-

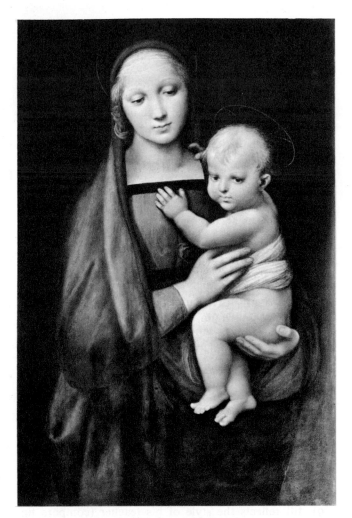

569. RAPHAEL. *Madonna del Granduca*. c. 1505.
Panel, 33 × 21 1/2". Pitti Palace, Florence

stage. To create pictorial space, he relied increasingly on the movement of human figures, rather than perspective vistas. In the *Galatea* of 1513 (fig. 571) the subject is again classical—the beautiful nymph Galatea, vainly pursued by Polyphemus, belongs to Greek mythology—but here the gay and sensuous aspect of antiquity is celebrated, in contrast to the austere idealism of *The School of Athens*. Its composition recalls *The Birth of Venus* (colorplate 58), a picture Raphael knew from his Florentine days, yet their very resemblance emphasizes their profound dissimilarity. Raphael's full-bodied, dynamic figures take on their expansive spiral movement from the vigorous *contrapposto* of Galatea; in Botticelli's picture, the movement is not generated by the figures but imposed on them from without, so that it never detaches itself from the surface of the canvas.

Early in his career Raphael had already shown a special talent for portraiture. It is another tribute to his genius for synthesis that he combined the realism of fifteenth-century portraits (such as fig. 537) with the human ideal of the High Renaissance (which, in the *Mona Lisa*, nearly overpowers the sitter's individuality). Raphael did not flatter or conventionalize his subjects; surely Pope Leo X (colorplate 61) looks here no handsomer than he did in reality. His sullen, heavy-jowled features have been recorded in concrete, almost Flemish detail. Nevertheless, the pontiff has a commanding presence, his aura of power and dignity emanating more from his inner being than from his exalted office. Raphael, we feel, has not falsified the sitter's personality but ennobled and focused it, as if he had been fortunate enough to observe Leo X in his finest hour. The two cardinals, who lack this balanced strength although they are studied with equal care, enhance by contrast the sovereign quality of the main figure. Even the pictorial treatment shows a similar gradation: Leo X has been set off from his companions, his reality heightened by intensified light, color, and texture.

VENICE: GIORGIONE; TITIAN

The distinction between Early and High Renaissance art, so marked in Florence and Rome, is far less sharp in Venice. Giorgione (1478–1510), the first Venetian painter to belong to the new, sixteenth century, left the orbit of Giovanni Bellini only during the final years of his short career. Among his very few mature works, *The Tempest* (colorplate 62) is both the most individual and the most enigmatic. Our first glance may show us little more than a particularly charming reflection of Bellinesque qualities, familiar from the *St. Francis in Ecstasy* (colorplate 57) and the S. Zaccaria Altar (fig. 536). The difference is one of mood—and this mood, in *The Tempest,* is subtly, pervasively pagan. Bellini's landscape is meant to be seen through the eyes of St. Francis, as a piece of God's creation. Giorgione's figures, by con-

ent meaning. Body and spirit, action and emotion, are now balanced harmoniously, and every member of this great assembly plays his role with magnificent, purposeful clarity. The total conception of *The School of Athens* suggests the spirit of Leonardo's *Last Supper* rather than that of the Sistine Ceiling. This holds true of the way Raphael makes each philosopher reveal "the intention of his soul," distinguishes the relations among individuals and groups, and links them in formal rhythm. Also Leonardesque is the centralized, symmetrical design, and the interdependence of the figures and their architectural setting. But compared with the hall of the *Last Supper*, Raphael's classical edifice—its lofty dome, barrel vault, and colossal statuary—shares far more of the compositional burden. Inspired by Bramante, it seems like an advance view of the new St. Peter's. Its geometric precision and spatial grandeur bring to a climax the tradition begun by Masaccio (see fig. 508), continued by Domenico Veneziano and Piero della Francesca, and transmitted to Raphael by his teacher Perugino.

Raphael never again set so splendid an architectural

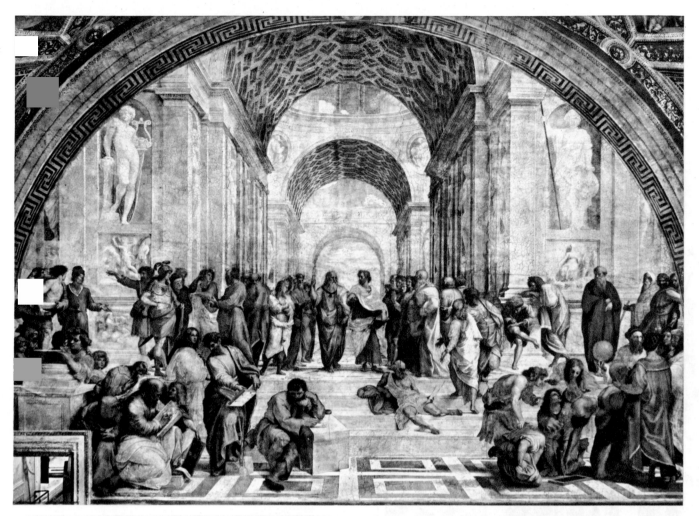

570. RAPHAEL. *The School of Athens*. 1510–11. Fresco. Stanza della Segnatura, Vatican Palace, Rome

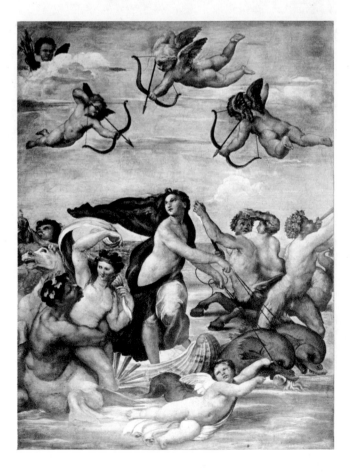

trast, do not interpret the scene for us; belonging themselves to nature, they are passive witnesses—victims, almost—of the thunderstorm about to engulf them. Who are they? So far, the young soldier and the nude mother with her babe have refused to disclose their identity, and the subject of the picture remains unknown. The present title is a confession of embarrassment, yet it is not inappropriate, for the only "action" is that of the tempest. Whatever its intended meaning, the scene is like an enchanted idyl, a dream of pastoral beauty soon to be swept away. Only poets had hitherto captured this air of nostalgic reverie; now, it entered the repertory of the painter. *The Tempest* initiates what was to become an important new tradition.

Giorgione died before he could explore in full the sensuous, lyrical world he had created in *The Tempest*. He bequeathed this task to Titian (1488/90–1576), an artist of comparable gifts who was decisively influenced by Giorgione, and who dominated Venetian painting for the next half-century. Titian's *Bacchanal* of about 1518 (colorplate 63) is frankly pagan, inspired by an an-

571. RAPHAEL. *Galatea*. 1513. Fresco.
Villa Farnesina, Rome

572. TITIAN. *Madonna with Members of the Pesaro Family.*
1526. 16′ × 8′ 10″. Church of the Frari, Venice

flesh and blood. The figures of the *Bacchanal* are idealized beyond everyday reality just enough to persuade us that they belong to a long-lost golden age. They invite us to share their blissful state in a way that makes Raphael's *Galatea* seem cold and remote by comparison.

This quality of festive animation reappears in many of Titian's religious paintings, such as the *Madonna with Members of the Pesaro Family* (fig. 572). Although we recognize the composition as a variant of the *Sacra Conversazione* (compare colorplate 52, fig. 536), Titian has thoroughly transformed it by replacing the familiar frontal view with an oblique one. The Virgin is now enthroned in a great barrel-vaulted hall open on either side, a High Renaissance counterpart of the architecture in Bellini's *Madonna and Saints* in S. Zaccaria (fig. 536); because the view is diagonal, open sky and clouds now fill most of the background. Except for the kneeling donors, every figure is in motion—turning, leaning, gesturing; the officer with the flag seems almost to lead a charge up the steps. Yet the design remains harmoniously self-contained despite the strong element of drama. Brilliant sunlight makes every color and texture sparkle, in keeping with the joyous spirit of the altar. The only hint of tragedy is the cross of the Passion held by two angel-putti, hidden by clouds from the participants in the *Sacra Conversazione* but not from us—a tiny note adding poignancy to the scene.

573. TITIAN. *Man with the Glove.*
c. 1520. 39 1/2 × 35″. The Louvre, Paris

cient author's description of such a revel. The landscape, rich in contrasts of cool and warm tones, has all the poetry of Giorgione, but the figures are of another breed: active and muscular, they move with a joyous freedom that recalls Raphael's *Galatea*. By this time, many of Raphael's compositions had been engraved (see fig. 9), and from these reproductions Titian became familiar with the Roman High Renaissance. A number of the celebrants in his *Bacchanal* also reflect the influence of classical art. Titian's approach to antiquity, however, is very different from Raphael's; he visualizes the realm of classical myths as part of the natural world, inhabited not by animated statues but by beings of

acter also comes out: the tiny figure of the pope, shriveled with age, dominates his tall attendants with awesome authority. Comparing these portraits (figs. 573 and 574), we see that a change of pictorial technique is no mere surface phenomenon. It always reflects a change of the artist's aim. This correspondence is even clearer in *Christ Crowned with Thorns* (fig. 575), a masterpiece of Titian's old age. The shapes emerging from the semi-darkness now consist wholly of light and color; despite the heavy impasto, the shimmering surfaces have lost every trace of material solidity and seem translucent, aglow from within. In consequence, the violent physical action has been miraculously suspended. What lingers in our minds is not the drama but the strange mood of serenity—engendered by deep religious feeling.

574. TITIAN. *Paul III and His Grandsons.* 1546. 6′ 10″ × 5′ 8″. National Museum, Naples

After Raphael's death, Titian became the most sought-after portraitist of the age. His prodigious gifts, evident in the donors' portraits in the altar just discussed, are even more striking in the *Man with the Glove* (fig. 573). The dreamy intimacy of this portrait, with its soft outline and deep shadows, still reflects the style of Giorgione. Lost in thought, the young man seems quite unaware of us; this slight melancholy in his features conjures up the poetic appeal of *The Tempest.* The breadth and power of form, however, goes far beyond Giorgione. In Titian's hands, the possibilities of oil technique—rich, creamy highlights, deep, dark tones that are yet transparent and delicately modulated—now are fully realized; the separate brush strokes, hardly visible before, become increasingly free. We can see the rapid pace of his development when we turn from the *Man with the Glove* to the group portrait *Paul III and His Grandsons* (fig. 574), painted a quarter-century later. The quick, slashing strokes here endow the entire canvas with the spontaneity of a first sketch—some parts of it are, in fact, unfinished—even though the formal composition is derived from Raphael's *Leo X* (colorplate 61). In the freer technique Titian's uncanny grasp of human char-

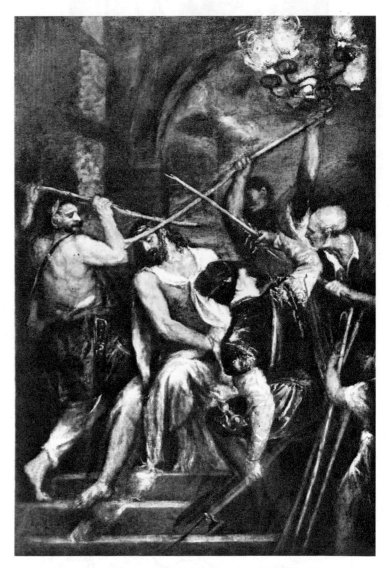

575. TITIAN. *Christ Crowned with Thorns.* c. 1570. 9′ 2″ × 6′. Pinakothek, Munich

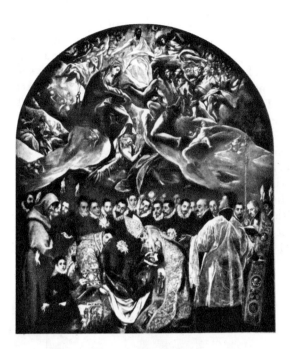

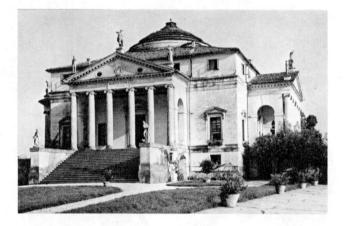

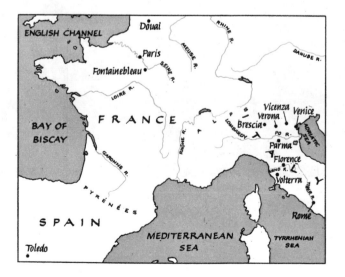

PAINTING
 MANNERISM
 PROTO-BAROQUE AND REALISM

SCULPTURE

ARCHITECTURE

4

MANNERISM
AND OTHER TRENDS

What happened after the High Renaissance? Fifty years ago the question would simply have been answered: after the High Renaissance came the Late Renaissance, which was dominated by shallow imitators of the great masters of the previous generation, and lasted until the Baroque style emerged at the end of the century. Although today we take a far more positive view of the artists who reached maturity after 1520, and generally discard the term Late Renaissance as misleading, we have still to agree on a name for the seventy-five years separating the High Renaissance from the Baroque. Any one label implies that the period has one style, and nobody has succeeded in defining such a style. But if there is no single style in the years 1525–1600, why should this span be regarded as a period at all, except in the negative sense of an interval between two high points, as the Renaissance viewed the Middle Ages? Perhaps this difficulty can be resolved by thinking of this period as a time of crisis that gave rise to several competing tendencies rather than one dominant ideal—or as a time full of inner contradictions, not unlike the present, and thus peculiarly fascinating to us.

PAINTING

MANNERISM

Among the various trends in art after the High Renaissance, that of Mannerism is the most discussed today. But in scope and significance the term remains problematic: its original meaning was narrow and derogatory, designating a group of mid-sixteenth-century painters in Rome and Florence whose self-consciously "artificial," mannered style was derived from certain aspects of Raphael and Michelangelo. More recently, the cold and rather barren formalism of their work has been recognized as a special form of a wider movement that placed "inner vision," however subjective or fantastic, above the twin authority of nature and the ancients; some scholars have broadened the definition of Mannerism to include even the later style of Michelangelo himself—which is rather like calling Phidias a classicist.

576. PONTORMO. *Study of a Young Girl*. c. 1526.
Sanguine drawing. Uffizi Gallery, Florence

577. PARMIGIANINO. *Self-Portrait*. 1524. Panel, diameter 9⅝". Kunsthistorisches Museum, Vienna

578. AGNOLO BRONZINO. *Eleanora of Toledo and Her Son Giovanni de'Medici*. c. 1550. 45¼ × 37¾". Uffizi Gallery, Florence

Rosso; Pontormo

The first indications of disquiet in the High Renaissance appear shortly before 1520, in the work of some young painters in Florence. By 1521, Rosso Fiorentino, the most eccentric member of this group, expressed the new attitude with full conviction in *The Descent from the Cross* (colorplate 64). Nothing has prepared us for the shocking impact of this latticework of spidery forms spread out against the dark sky. The figures are agitated yet rigid, as if congealed by a sudden, icy blast; even the draperies have brittle, sharp-edged planes; the acid colors and the light, brilliant but unreal, reinforce the nightmarish effect of the scene. Here is what amounts to a revolt against the classical balance of High Renaissance art; a profoundly disquieting, willful, visionary style that indicates a deep-seated inner anxiety. Vasari's statement that Rosso committed suicide is probably untrue, yet seems plausible enough as we look at this picture. Pontormo, a friend of Rosso, had an equally strange personality. Introspective and shy, he shut himself up in his quarters for weeks on end, inaccessible even to his friends. His wonderfully sensitive drawings, such as the *Study of a Young Girl* (fig. 576), well reflect these facets of his character; the sitter, moodily gazing into space, seems to shrink from the outer world, as if scarred by the trauma of some half-remembered experience.

Parmigianino; Bronzino

This "anticlassical" style of Rosso and Pontormo, the first phase of Mannerism, was soon replaced by another aspect of the movement. This was less overtly anticlassical, less laden with subjective emotion, but equally far removed from the confident, stable world of the High Renaissance. Parmigianino's *Self-Portrait* (fig. 577) suggests no psychological turmoil; the artist's appearance is bland and well groomed, veiled by a delicate Leonardesque *sfumato*. The distortions, too, are objective, not arbitrary, for the picture records what Parmigianino saw as he gazed at his reflection in a convex mirror. Yet why was he so fascinated by this view "through the looking glass"? Earlier painters who used the same device as an aid to observation had "filtered out" the distortions (as in figs. 466, 475), except when the mirror image was contrasted with a direct view of the same scene (colorplate 48). But Parmigianino substitutes his painting for the mirror itself, even employing a specially prepared convex panel. Did he perhaps want to demonstrate that there is no single, "correct" reality, that distortion is as natural as the normal appearance of things? Characteristically, his scientific detachment soon changed into its very opposite. Vasari tells us that Parmigianino, toward the end of his brief career (he died in 1540 at thirty-seven), was obsessed with alchemy and became

Colorplate 57.
GIOVANNI BELLINI.
St. Francis in Ecstasy.
About 1485.
Panel, 48½ × 55".
The Frick Collection,
New York

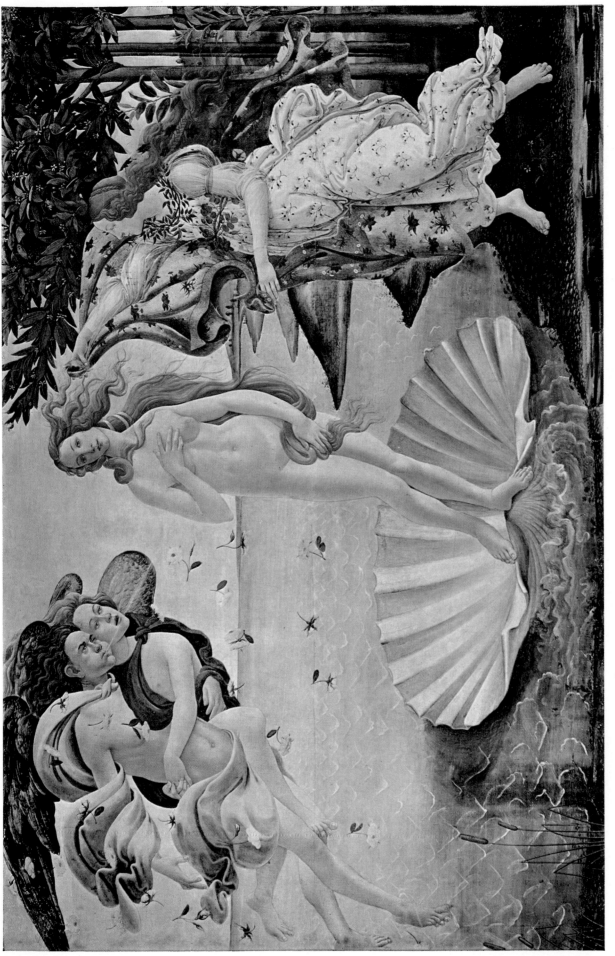

Colorplate 58. SANDRO BOTTICELLI. *The Birth of Venus.* About 1480.
5′ 8⁷/₈″ × 9′ 1⁷/₈″. Uffizi Gallery, Florence

Colorplate 59. PIERO DI COSIMO. *The Discovery of Honey*. About 1498.
Panel, $31 1/4 \times 50 5/8''$. Worcester Art Museum, Massachusetts

Colorplate 60. MICHELANGELO. *The Fall of Man and the Expulsion from the Garden of Eden.*
1508–12. Fresco. Ceiling of Sistine Chapel, The Vatican, Rome

Colorplate 61. RAPHAEL. *Pope Leo X with His Nephews Giulio de'Medici and Luigi de'Rossi.*
About 1518. Panel, 60⁵/₈ × 46⁷/₈″. Uffizi Gallery, Florence

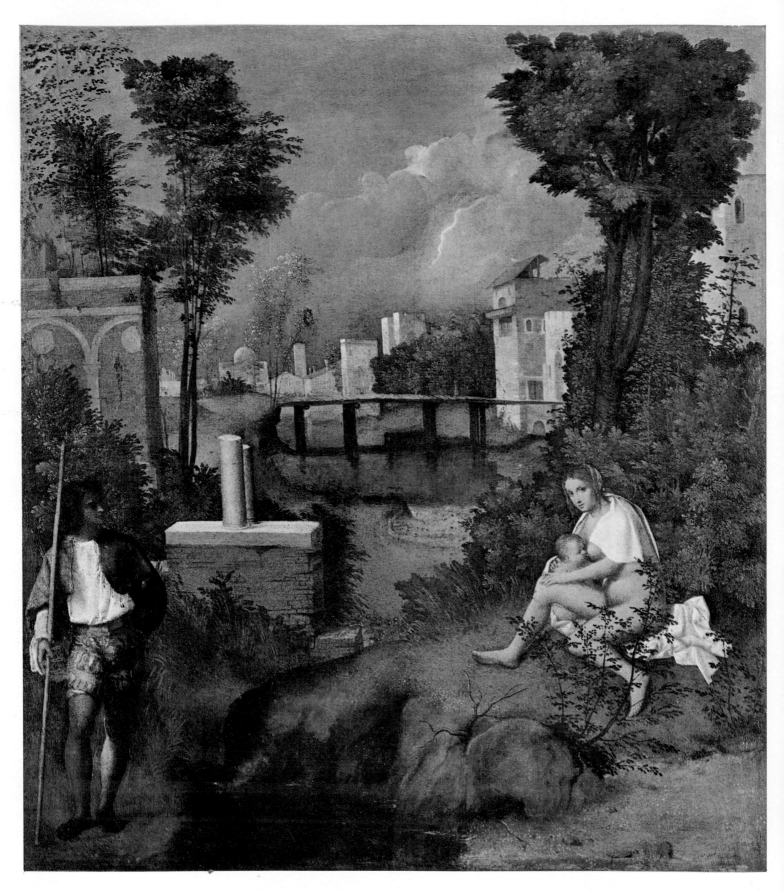

Colorplate 62. GIORGIONE. *The Tempest*. About 1505. 31 1/4 × 28 3/4''. Academy, Venice

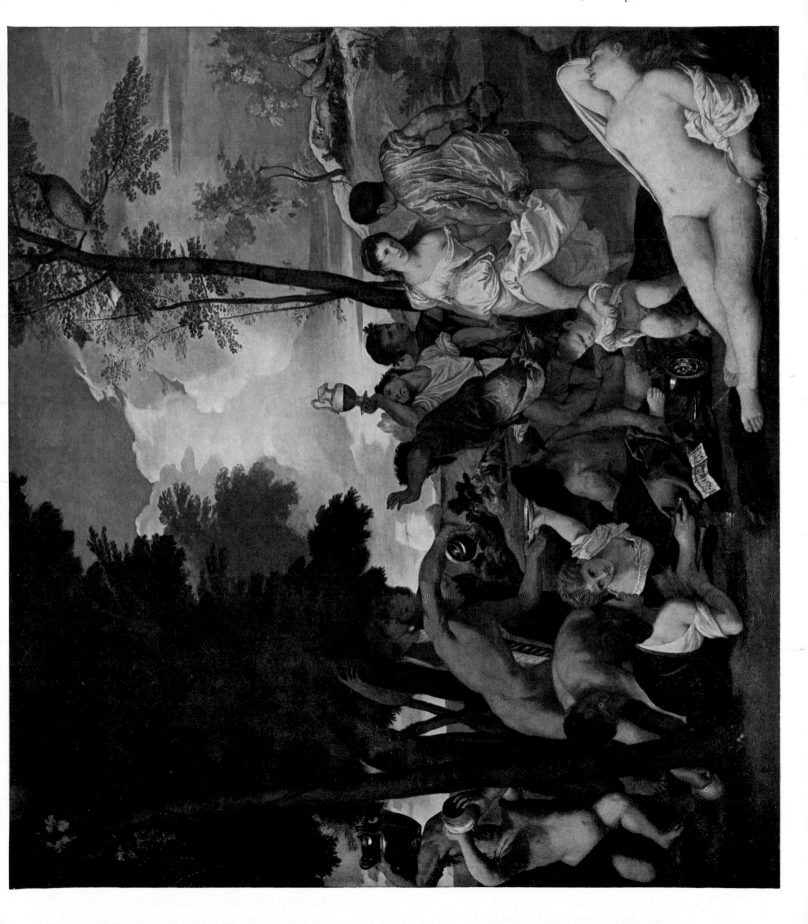

Colorplate 63.
TITIAN. *Bacchanal.*
About 1518.
5′ 8⅞″ × 6′ 4″.
The Prado, Madrid

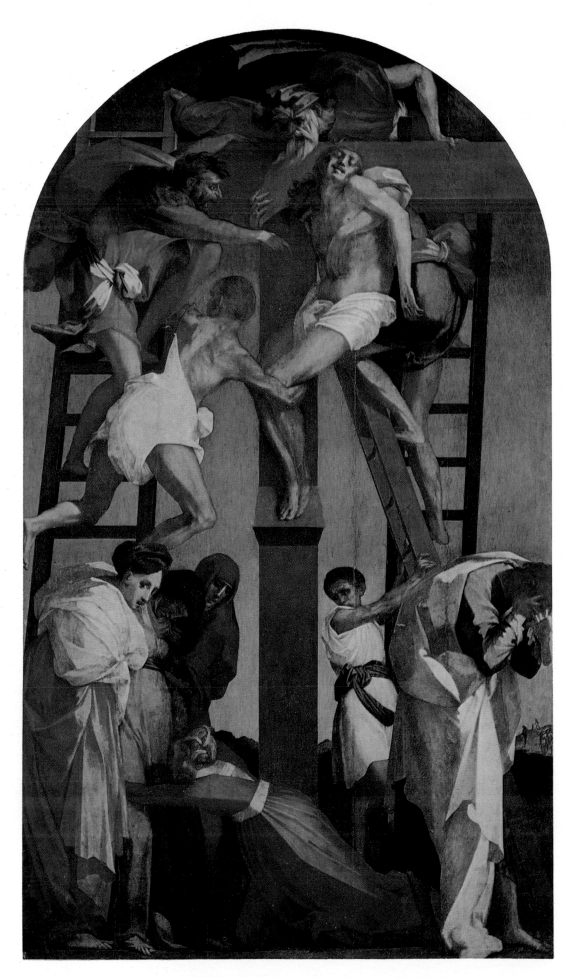

Colorplate 64. ROSSO FIORENTINO. *The Descent from the Cross.*
1521. Panel, 11′ × 6′ 5¹/₂″. Pinacoteca, Volterra

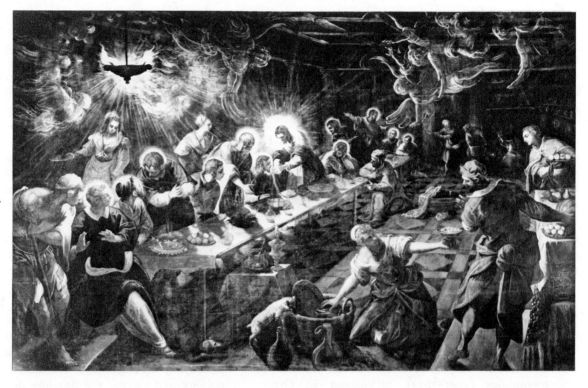

579. TINTORETTO.
The Last Supper. 1592–94.
12′ × 18′ 8″.
S. Giorgio Maggiore,
Venice

"a bearded, long-haired, neglected, and almost savage or wild man." Certainly his strange imagination is evident in his most famous work, *The Madonna with the Long Neck* (colorplate 65), painted after he had returned to his native Parma from several years' sojourn in Rome. He had been deeply impressed with the rhythmic grace of Raphael's art (compare fig. 571), but he has transformed the older master's figures into a remarkable new breed: their limbs, elongated and ivory-smooth, move with effortless languor, embodying an ideal of beauty as remote from nature as any Byzantine figure. Their setting is equally arbitrary, with a gigantic —and apparently purposeless—row of columns looming behind the tiny figure of a prophet; Parmigianino seems determined to prevent us from measuring anything in this picture by the standards of ordinary experience. Here we have approached that "artificial" style for which the term Mannerism was originally coined. *The Madonna with the Long Neck* is a vision of unearthly perfection, its cold elegance no less compelling than the violence in Rosso's *Descent*.

Keyed to a sophisticated, even rarefied taste, the elegant phase of Italian Mannerism appealed particularly to such aristocratic patrons as the Grand Duke of Tuscany and the King of France, and soon became international (see fig. 607). The style produced splendid portraits, like that of Eleanora of Toledo, the wife of Cosimo I de'Medici, by Cosimo's court painter Agnolo Bronzino (fig. 578). The sitter here appears as the member of an exalted social caste, not as an individual personality; congealed into immobility behind the barrier of her lavishly ornate costume, Eleanora seems more akin

to Parmigianino's *Madonna*—compare the hands—than to ordinary flesh and blood.

Tintoretto

Mannerism did not appear in Venice until the middle of the century. Its leading exponent, Tintoretto (1518–94), was an artist of prodigious energy and inventiveness, combining qualities of both its anticlassical and elegant phases in his work. He reportedly wanted "to paint like Titian and to design like Michelangelo," but his relationship to these two masters, though real enough, was as peculiar as Parmigianino's was to Raphael. *Christ Before Pilate* (colorplate 66), one of his many huge canvases for the Scuola di San Rocco, the home of the Confraternity of St. Roch, contrasts tellingly with Titian's *Christ Crowned with Thorns* (fig. 575); the bold brushwork, the glowing colors, and the sudden lights and shadows show what Tintoretto owed to the older artist, and indeed the entire composition recalls the *Madonna with Members of the Pesaro Family* (see fig. 572). Yet the total effect is unmistakably Mannerist: the feverish emotionalism of the flickering, unreal light, and the ghostly Christ, pencil-slim and motionless among the agitated Michelangelesque figures, remind us of Rosso's *Descent*. Even more spectacular is Tintoretto's last major work, *The Last Supper* (fig. 579). This canvas denies in every possible way the classic values of Leonardo's version of the subject, painted almost exactly a century before. Christ, to be sure, still occupies the center of the composition, but now the table is placed at right angles to the picture plane in exaggerated perspec-

tive; His small figure in the middle distance is distinguishable mainly by the brilliant halo. Tintoretto has gone to great lengths to give the event an everyday setting, cluttering the scene with attendants, containers of food and drink, and domestic animals. But this serves only to contrast dramatically the natural with the supernatural, for there are also celestial attendants—the smoke from the blazing oil lamp miraculously turns into clouds of angels that converge upon Christ just as He offers His body and blood, in the form of bread and wine, to the disciples. Tintoretto's main concern has been to make visible the institution of the Eucharist, the transubstantiation of earthly into Divine food; he barely hints at the human drama of Judas' betrayal, so important to Leonardo (Judas can be seen isolated on the near side of the table, but his role is so insignificant that he could almost be mistaken for an attendant).

El Greco

The last—and perhaps the greatest—Mannerist painter was also trained in the Venetian School. Domenikos Theotocopoulos (1541–1614), nicknamed El Greco, came from Crete, which was then under Venetian rule. His earliest training must have been from a Cretan artist still working in the Byzantine tradition. Soon after 1560 El Greco arrived in Venice and quickly absorbed the lessons of Titian, Tintoretto, and other masters. A decade later, in Rome, he came to know the art of Raphael, Michelangelo, and the Central Italian Mannerists. In 1576/77 he went to Spain, settling in Toledo for the rest of his life. Yet he remained an alien in his new homeland; although the spiritual climate of the Counter Reformation, which was especially intense in Spain, may account for the exalted emotionalism of his mature work, contemporary Spanish painting was too provincial to impress him. His style had already been formed before he arrived in Toledo, nor did he ever forget his Byzantine background—until the very end of his career, he signed his pictures in Greek. The largest and most resplendent of El Greco's major commissions is *The Burial of Count Orgaz* (fig. 580, colorplate 67); the huge canvas in the church of Santo Tomé honors a medieval benefactor so pious that St. Stephen and St. Augustine miraculously appeared at his funeral and themselves lowered the body into its grave. The burial took place in 1323, but El Greco represents it as a contemporary event, portraying among the attendants many of the local nobility and clergy; the dazzling display of color and texture in the armor and vestments could hardly be surpassed by Titian himself. Directly above, the count's

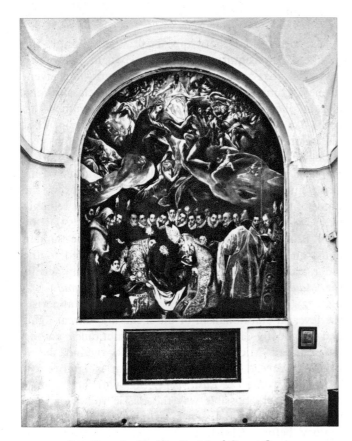

580. Chapel with *The Burial of Count Orgaz*.
1586. S. Tomé, Toledo, Spain (compare colorplate 67)

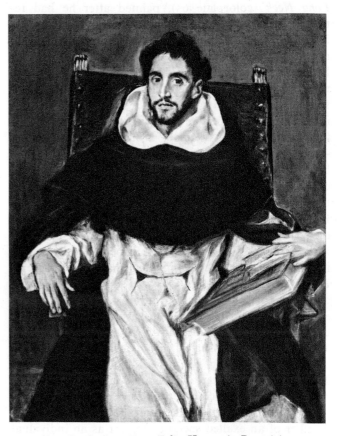

581. EL GRECO. *Fray Felix Hortensio Paravicino*.
c. 1605. 44 1/2 × 33 3/4". Museum of Fine Arts, Boston

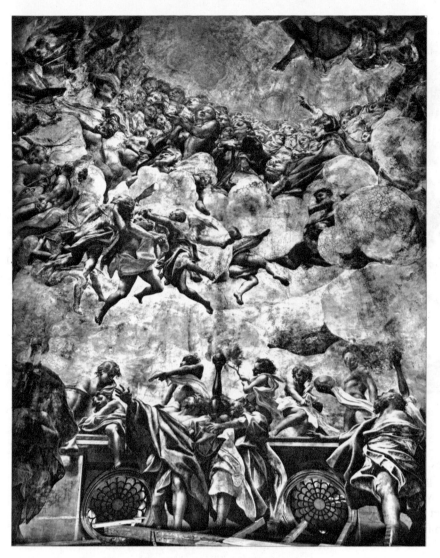

582. CORREGGIO. *The Assumption of the Virgin*
(detail). c. 1525. Fresco. Dome, Parma Cathedral

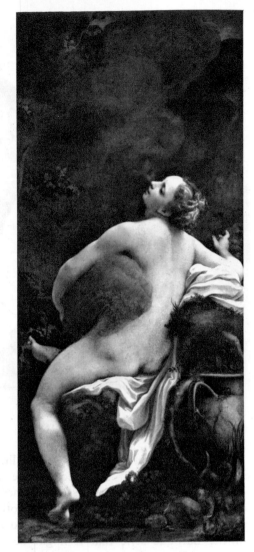

583. CORREGGIO. *Jupiter and Io*. c. 1532.
64 1/2 × 27 3/4″. Kunsthistorisches Museum, Vienna

soul (a small, cloudlike figure like the angels in Tintoretto's *Last Supper*) is carried to Heaven by an angel. The celestial assembly filling the upper half of the picture is painted very differently from the lower half: every form—clouds, limbs, draperies—takes part in the sweeping, flamelike movement toward the distant figure of Christ. Here, even more than in Tintoretto's art, the various aspects of Mannerism fuse into a single ecstatic vision. Its full import, however, becomes clear only when we see the work in its original setting (fig. 580). Like an enormous window, it fills one entire wall of its chapel. The bottom of the canvas is 6 feet above the floor, and as the chapel is only about 18 feet deep, we must look sharply upward to see the upper half of the picture. El Greco's violent foreshortening is calculated to achieve an illusion of boundless space above, while the lower foreground figures appear as on a stage (their feet cut off by the molding just below the picture). The large stone plaque also belongs to the ensemble, representing the front of the sarcophagus into which the two saints lower the body of the count; it thus explains the action within the picture. The beholder, then, per-

ceives three levels of reality: the grave itself, supposedly set into the wall at his eye-level and closed by an actual stone slab; the contemporary re-enactment of the miraculous burial; and the vision of celestial glory witnessed by some of the participants. By sheer chance, El Greco's task here was analogous to Masaccio's in his *Trinity* mural (see fig. 508); the contrast measures the dynamic evolution of Western art since the Early Renaissance.

From El Greco's Venetian training came his mastery of portraiture. We generally know little of his relationship to his sitters, but in his memorable portrait of Fray Felix Hortensio Paravicino (fig. 581) the sitter, an important scholar and poet, was also a friend who praised El Greco's genius in several sonnets. This portrait is an artistic descendant of Titian's *Man with the Glove* (see fig. 573) and the portraits of Pontormo (see fig. 576), yet the mood is one of neither reverie nor withdrawal. Paravicino's frail, expressive hands and the pallid face, with its sensitive mouth and burning eyes, convey a spiritual ardor of compelling intensity. Such, we like to think, were the saints of the Counter Reformation—mystics and intellectuals at the same time.

584. GIROLAMO SAVOLDO.
St. Matthew. c. 1535. 36¾ × 49".
The Metropolitan Museum of Art,
New York (Marquand Fund, 1912)

PROTO-BAROQUE AND REALISM

If Mannerism produced the personalities that today
seem most "modern"—El Greco's fame is greater now
than it ever was before—its dominance was not un-
contested in the sixteenth century. Another trend that
also emerged about 1520 anticipated so many features
of the Baroque style that it might be labeled Proto-
Baroque. Correggio (1489/94–1534), the most important
representative of this trend, was a phenomenally gifted
North Italian painter who spent most of his brief career
in Parma. He absorbed the influence of Leonardo and
the Venetians as a youth, then of Michelangelo and
Raphael, but their ideal of classical balance did not
attract him. His largest work, the fresco of the Assump-
tion of the Virgin in the dome of Parma Cathedral
(fig. 582), is a masterpiece of illusionistic perspective, a
vast, luminous space filled with soaring figures. Although
they move with such exhilarating ease that the force of
gravity seems not to exist for them, they are healthy,
energetic beings of flesh and blood, not disembodied
spirits, and they frankly delight in their weightless con-
dition. For Correggio there was little difference between
spiritual and physical ecstasy, as we see by comparing
the *Assumption of the Virgin* with his *Jupiter and Io*
(fig. 583), one canvas in a series illustrating the Loves of
the Classical Gods. The nymph, swooning in the
embrace of a cloudlike Jupiter, is the direct kin of the
jubilant angels in the fresco. Leonardesque *sfumato,*
combined with a Venetian sense of color and texture,
produces an effect of exquisite voluptuousness that far
exceeds Titian's in his *Bacchanal* (see colorplate 63).
Correggio had no immediate successors nor any lasting
influence on the art of his century, but toward 1600 his

work began to be widely appreciated. For the next
century and a half he was admired as the equal of
Raphael and Michelangelo—while the Mannerists, so
important before, were largely forgotten.

A third trend in sixteenth-century painting in Italy
is to be associated with the towns along the northern edge
of the Lombard plain, such as Brescia and Verona. A
number of artists in that region worked in a style based
on Giorgione and Titian, but with a stronger interest in
everyday reality. One of the earliest and most attractive
of these North Italian Realists was Girolamo Savoldo,
from Brescia, whose *St. Matthew* (fig. 584) must be con-
temporary with Parmigianino's *Madonna with the Long
Neck.* The broad, fluid manner of painting reflects the
dominant influence of Titian, yet the great Venetian
master would never have placed the Evangelist in so
thoroughly domestic an environment. The humble scene
in the background shows the saint's milieu to be lowly in-
deed, and makes the presence of the angel doubly mirac-
ulous. This tendency to visualize sacred events among
ramshackle buildings and simple people had been char-
acteristic of "Late Gothic" painting; Savoldo must have
acquired it from that source. The nocturnal lighting, too,
recalls such Northern pictures as the *Nativity* by Geertgen
tot Sint Jans (fig. 470). But the main source of illumina-
tion in Geertgen's panel is the divine radiance of the
Christ Child, and Savoldo uses an ordinary oil lamp for
his similarly magic and intimate effect.

In the work of Paolo Veronese (1528–88), North Italian
Realism takes on the splendor of a pageant. Born and
trained in Verona, Veronese became, after Tintoretto, the
most important painter in Venice; although utterly un-
like each other in style, both found favor with the public.
The contrast is strikingly evident if we compare Tinto-

retto's *Last Supper* and Veronese's *Christ in the House of Levi* (colorplate 69), both with similar subjects. Veronese avoids all reference to the supernatural. His symmetrical composition harks back to Leonardo and Raphael, the festive mood of the scene reflects Titian's work of the 1520s (compare fig. 572), and at first the picture looks like a High Renaissance work born fifty years too late. Yet we miss one essential: the elevated, ideal conception of man underlying the work of High Renaissance masters. Veronese paints a sumptuous banquet, a true feast for the eyes, but not "the intention of man's soul." Significantly, we are not even sure which event from the life of Christ he originally meant to depict, for he gave the canvas its present title only after he had been summoned by the religious tribunal of the Inquisition, on the charge of filling his picture with "buffoons, drunkards, Germans, dwarfs, and similar vulgarities" unsuited to its sacred character. The account of this trial shows that the tribunal thought the painting represented the Last Supper; Veronese's testimony never made clear whether it was the Last Supper, or the Supper in the House of Simon. To him, apparently, this distinction made little difference; in the end, he settled on a convenient third title, the Supper in the House of Levi, which permitted him to leave the offending incidents in place. He argued that they were no more objectionable than the nudity of Christ and the Heavenly Host in Michelangelo's *Last Judgment,* but the tribunal failed to see the analogy: ". . . in the Last Judgment it was not necessary to paint garments, and there is nothing in those figures that is not spiritual." The Inquisition, of course, considered only the impropriety of Veronese's art, not its unconcern with spiritual depth. His dogged refusal to admit the justice of the charge, his insistence on his right to introduce directly observed details, however "improper," and his indifference to the subject of the picture, spring from an attitude so startlingly "extroverted" that it was not generally accepted until the nineteenth century. The painter's domain, Veronese seems to say, is the entire visible world, and here he acknowledges no authority other than his senses.

SCULPTURE

Italian sculptors of the later sixteenth century fail to match the achievements of the painters. Perhaps Michelangelo's overpowering personality discouraged new talent in this field, but the dearth of challenging new tasks is a more plausible reason. In any case, the most interesting sculpture of this period was produced outside of Italy, and in Florence, after the death of Michelangelo, the leading sculptor was a Northerner. The anticlassical phase of Mannerism, represented by the style of Rosso and Pontormo, has no sculptural counterpart; the work of the Spaniard Alonso Berruguete most closely approaches it. Berruguete had been associated with the founders of the anticlassical trend in Florence around

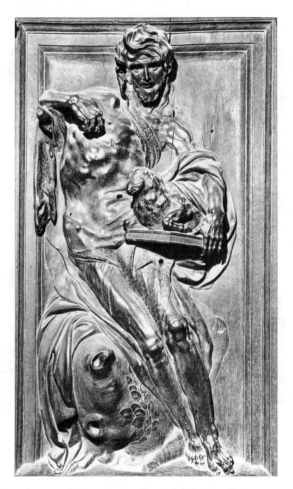

585. ALONSO BERRUGUETE. *St. John the Baptist.* c. 1540. Wood, 31 $\frac{1}{2}$ × 19 $\frac{1}{4}$″. Toledo Cathedral, Spain

1520; his *St. John the Baptist* (fig. 585), one of the reliefs carved twenty years later for the choir stalls of Toledo Cathedral, still reflects this experience. The angular, emaciated body, clawlike hands, and fixed, wide-eyed stare recall the otherworldly expressiveness of Rosso's *Descent* (see colorplate 64). El Greco must have felt a sense of kinship with Berruguete's art.

The second, elegant phase of Mannerism appears in countless sculptural examples in Italy and abroad. The best-known representative of the style is Benvenuto Cellini (1500–71), the Florentine goldsmith and sculptor who owes much of his fame to his picaresque autobiography. The gold saltcellar for King Francis I of France (colorplate 70), Cellini's major work in precious metal to escape destruction, well displays the virtues and limitations of his art. To hold condiments is obviously the lesser function of this lavish conversation piece. Because salt comes from the sea and pepper from the land, Cellini placed the boat-shaped salt container under the guardianship of Neptune, while the pepper, in a tiny triumphal arch, is watched over by a personification of Earth. On the base are figures representing the four seasons and the four parts of the day. The entire object thus reflects the cosmic significance of the Medici Tombs (compare fig. 559), but on this miniature scale Cellini's program turns into playful fancy; he wants to impress us with his

586. FRANCESCO PRIMATICCIO. Stucco Figures.
c. 1541–45. Fontainebleau

ingenuity and skill, and to charm us with the grace of his figures. The allegorical significance of the design is simply a pretext for this display of virtuosity. When he tells us, for instance, that Neptune and Earth each have a bent and a straight leg to signify mountains and plains, we can only marvel at the divorce of form from content. Despite his boundless admiration for Michelangelo, Cellini's elegant figures on the saltcellar are as elongated, smooth, and languid as Parmigianino's (see color-plate 65). Parmigianino also strongly influenced Francesco Primaticcio, Cellini's rival at the court of Francis I. A man of many talents, Primaticcio designed the interior decoration of some of the main rooms in the royal château of Fontainebleau, combining painted scenes and a richly sculptured stucco framework. The section shown in figure 586 obviously caters to the same aristocratic taste that admired Cellini's saltcellar. Although the four maidens are not burdened with any specific allegorical significance—their role recalls the nudes on the Sistine Ceiling—they perform a task for which they seem equally ill-fitted: they reinforce the piers that sustain the ceiling. These willowy caryatids epitomize the studied nonchalance of second-phase Mannerism.

Giovanni Bologna

Cellini, Primaticcio, and the other Italians employed by Francis I made Mannerism the dominant style in mid-sixteenth-century France, and their influence went far beyond the royal court. It must have reached a gifted young sculptor from Douai, Jean de Boulogne (1529–1608), who went to Italy about 1555 for further training and stayed to become, under the Italianized name of Giovanni Bologna, the most important sculptor in Florence during the last third of the century. His over-lifesize marble group, *The Rape of the Sabine Woman* (figs. 587, 588), won particular acclaim, and still has its place of honor near the Palazzo Vecchio. The subject, drawn from the legends of ancient Rome, seems an odd choice for statuary; the city's founders, an adventurous band of men from across the sea, so the story goes, tried vainly to find wives among their neighbors, the Sabines, and resorted at last to a trick: having invited the entire Sabine tribe into Rome for a peaceful festival, they fell upon them with arms, took the women away by force, and thus ensured the future of their race. Considering the nature of the theme, Giovanni Bologna's work tempts us to cite Samuel Johnson's famous remark on women preachers (who reminded him of a dog walking on its hind legs): "It is not done well; but you are surprised to find it done at all." Actually, the artist may not deserve such ridicule, for he designed the group with no specific subject in mind, to silence those critics who doubted his ability as a monumental sculptor in marble. He selected what seemed to him the most difficult feat, three figures of contrasting character united in a common action. Their identities were disputed among the learned connoisseurs of the day, who finally settled on the Rape of the Sabine Woman as the most suitable title. Here, then, is another artist who is noncommittal about subject matter, although his unconcern had a different motive from Veronese's. Giovanni Bologna's self-imposed task was to carve in marble, on a massive scale, a sculptural composition that was to be seen not from one but from all sides; this had hitherto been attempted only in bronze and on a much smaller scale (see figs. 529, 531). He has solved this purely formal problem, but only by insulating his group from the world of human experience. These figures, spiraling upward as if confined inside a tall, narrow cylinder, perform a well-rehearsed choreographic exercise the emotional meaning of which remains obscure. We admire their discipline but we find no trace of genuine *pathos*.

ARCHITECTURE

The concept of Mannerism as a period style, we recall, had been coined for painting. We have encountered little difficulty in applying it to sculpture. Can it usefully be extended to architecture as well? And if so, what qualities must we look for? These questions have arisen only recently, so it is not surprising that we cannot yet answer them very precisely. Some buildings, to be sure, would be called Mannerist by almost everyone today; but this does not give us a viable definition of Mannerism as an architectural period style. Such a structure is the Uffizi in

Florence, by Giorgio Vasari. It consists of two long wings—originally intended, as its name suggests, for offices—facing each other across a narrow court, linked at one end by a loggia (fig. 589). Vasari's inspiration is not far to seek: the "tired" scroll brackets and the peculiar combination of column and wall have their source in the vestibule of the Laurentian Library (on page 431 we cited Vasari's praise for Michelangelo's unorthodox use of the classical vocabulary). Yet his design lacks the sculptural power and expressiveness of its model; rather, the Uffizi loggia forms a screen as weightless as the façade of the Pazzi Chapel (see fig. 501). What is tense in Michelangelo's design becomes merely ambiguous—the architectural members seem as devoid of energy as the human figures of second-phase Mannerism, and their relationships as studiedly "artificial." The same is true of the courtyard of the Palazzo Pitti, by Bartolommeo Ammanati (fig. 590), despite its display of muscularity. Here the three-story scheme of superimposed orders, derived from the Colosseum, has been overlaid with an extravagant pattern of rustication that "imprisons" the columns, reducing them to an oddly passive role. These welts disguise rather than enhance the massiveness of the masonry, the overall corrugated texture making us think of the fancies of a pastry cook.

Palladio

If this is Mannerism in architecture, can we find it in the work of Andrea Palladio (1518–80), the greatest architect of the later sixteenth century, second in importance only to Michelangelo? Unlike Vasari, who was a painter and historian as well as an architect (his artists' *Lives* provide the first coherent account of Italian Renaissance art), or Ammanati, who was a sculptor-architect, Palladio stands in the tradition of the humanist and theoretician Leone Battista Alberti. Although his career centered on his native town of Vicenza, his buildings and theoretical writings soon brought him international status. Palladio insisted that architecture must be governed both by reason and by certain universal rules that were perfectly exemplified by the buildings of the ancients. He thus shared Alberti's basic outlook and his firm faith in the cosmic significance of numerical ratios (see page 390). They differed in how each man related theory and practice. With Alberti, this relationship had been loose and flexible, whereas Palladio believed quite literally in practicing what he preached. His architectural treatise is consequently more practical than Alberti's—this helps to explain its huge success—while his buildings are linked more directly with his theories. It has even been said that Palladio designed only what was, in his view, sanctioned by ancient precedent. If the results are not necessarily classic in style, we may call them "classicistic" (to denote a conscious striving for classic qualities); this is indeed the usual term for both Palladio's work and theoretical attitude.

587, 588. GIOVANNI BOLOGNA. *The Rape of the Sabine Woman*. Completed 1583. Marble, height 13′ 6″. Loggia dei Lanzi, Florence

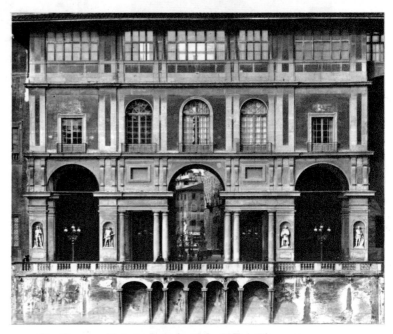

589. GIORGIO VASARI. Loggia of the Uffizi, Florence (view from the Arno). Begun 1560

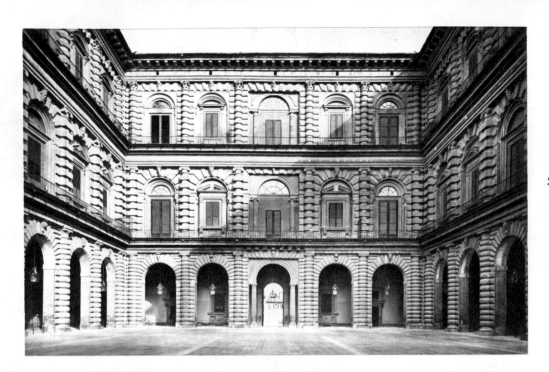

590. BARTOLOMMEO AMMANATI.
Courtyard of the Palazzo Pitti,
Florence. 1558–70

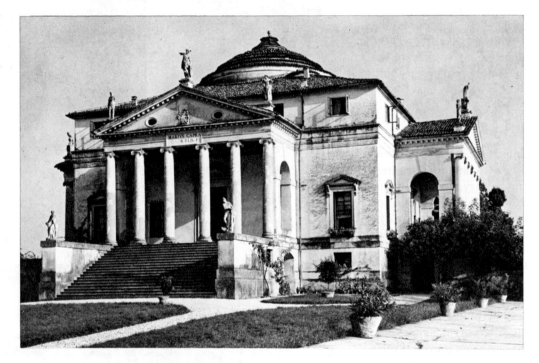

591. ANDREA PALLADIO.
Villa Rotonda,
Vicenza. c. 1567–70

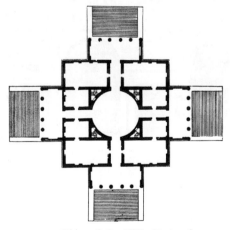

592. Plan of the Villa Rotonda

The Villa Rotonda (figs. 591, 592), one of Palladio's finest buildings, perfectly illustrates the meaning of classicism. An aristocratic country residence near Vicenza, it consists of a square block surmounted by a dome and is faced on all four sides with identical porches in the shape of temple fronts. Alberti had defined the ideal church as such a completely symmetrical, centralized design (pages 401–2); it is evident that Palladio found in the same principles the ideal country house. But how could he justify a context so purely secular for the solemn motif of the temple front? Surprisingly enough, he was convinced, on the basis of ancient literary sources, that Roman private houses had porticoes like these (excavations have since disproved him; see page 164). Yet

Palladio's use of the temple front here is not mere antiquarianism; he probably persuaded himself that it was legitimate because he regarded this feature as desirable for both beauty and utility. In any case, the porches of the Villa Rotonda, beautifully correlated with the walls behind, are an organic part of his design. They lend the structure an air of serene dignity and festive grace that still appeals to us today.

The facade of S. Giorgio Maggiore in Venice (fig. 593), of about the same date as the Villa Rotonda, adds to the same effect a new sumptuousness and complexity. Palladio's problem here was how to create a classically integrated façade for a basilican church. He surely knew Alberti's solution (S. Andrea in Mantua; see fig. 520), a temple front enclosing a triumphal-arch motif; but this design, although impressively logical and compact, did not fit the cross section of a basilica, and really circumvented the problem. Palladio—again following what he believed to be ancient precedent—found a different answer: he superimposed a tall, narrow temple front on another low and wide one to reflect the different heights of nave and aisles. Theoretically, it was a perfect solution. In practice, however, he found that he could not keep the two systems as separate as his classicistic conscience demanded, and still integrate them into a harmonious whole. This conflict makes ambiguous those parts of the design that have, as it were, a dual allegiance; this might be interpreted as a Mannerist quality. The plan (fig. 594), too, suggests a duality: the main body of the church is strongly centralized—the transept is as long as the nave—but the longitudinal axis reasserts itself in the separate compartments for the main altar and the chapel beyond.

Il Gesù

Palladio's immense authority as a designer keeps the conflicting elements in the façade and plan of S. Giorgio from actually clashing. In less assured hands, such a precarious union would break apart. A more generally applicable solution was evolved just at that time in Rome by Vignola and by Giacomo della Porta, two architects who had assisted Michelangelo at St. Peter's and were still using his architectural vocabulary. The church of Il Gesù (Jesus), a building whose importance for subsequent church architecture can hardly be exaggerated, is the mother church of the Jesuits; its design must have been closely supervised so as to conform to the aims of the militant new order. We may thus view it as the architectural embodiment of the spirit of the Counter Reformation. The planning stage of the structure began in 1550 (Michelangelo himself once promised a design, but apparently never furnished it); the present ground plan, by Vignola, was adopted in 1568 (fig. 595). It contrasts in almost every possible respect with Palladio's S. Giorgio: a basilica, strikingly compact, dominated by its mighty nave. The aisles have been replaced by chapels, thus "herding" the congregation quite literally into one large, hall-like space directly in view of the altar; the attention of this "audience" is positively directed toward altar and pulpit, as our view of the interior (fig. 597) confirms. (The painting shows how the church would look from the street if the center part of the façade were removed; for the later, High Baroque decoration of the nave vault, see fig. 629.) We also see here an unexpected feature which the ground plan cannot show: the dramatic contrast be-

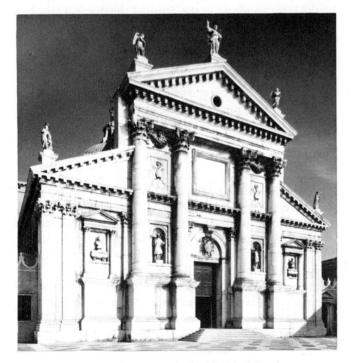

593. ANDREA PALLADIO. S. Giorgio Maggiore, Venice. Designed 1565

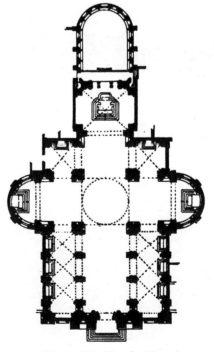

594. Plan of S. Giorgio Maggiore

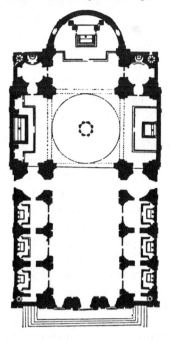

595. GIACOMO VIGNOLA.
Plan of Il Gesù, Rome. 1568

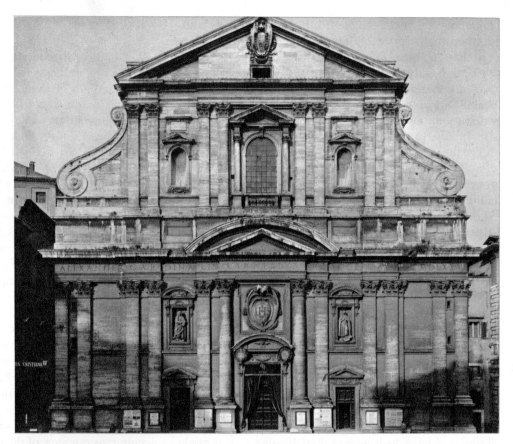

596. GIACOMO DELLA PORTA.
Façade of Il Gesù, Rome. c. 1575–84

597. ANDREA SACCHI and JAN MIEL. *Urban VIII Visiting Il Gesù*. 1639–41. National Gallery, Rome

tween the dim illumination in the nave and the abundant light beyond, in the eastern part of the church, supplied by the large windows in the drum of the dome. Light has been consciously exploited for its expressive possibilities —a novel device, "theatrical" in the best sense—to give Il Gesù a stronger emotional focus than we have yet found in a church interior.

Despite its great originality, the plan of Il Gesù is not entirely without precedent (see fig. 521). The façade, by Giacomo della Porta, is as bold as the plan, although it, too, can be traced back to earlier sources (fig. 596). The paired pilasters and broken architrave of the lower story are clearly derived from Michelangelo's design for the exterior of St. Peter's (compare fig. 565). In the upper story the same pattern recurs on a somewhat smaller scale, with four instead of six pairs of supports; the difference in width is bridged by two scroll-shaped buttresses. A large pediment crowns the façade, which retains the classic proportions of Renaissance architecture (the height equals the width). What is fundamentally new here is the very element that was missing in the façade of S. Giorgio: the integration of all the parts into one whole. Giacomo della Porta, freed from classicistic scruples by his allegiance to Michelangelo, gave the same vertical rhythm to both stories of the façade; this rhythm is obeyed by all the horizontal members (note the broken

entablature), but the horizontal divisions in turn determine the size of the vertical members (hence no colossal order). Equally important is the emphasis on the main portal: its double frame—two pediments resting on coupled pilasters and columns—projects beyond the rest of the façade and gives strong focus to the entire design. Not since Gothic architecture has the entrance to a church received such a dramatic concentration of features, attracting the attention of the beholder outside the building much as the concentrated light beneath the dome channels that of the worshiper inside.

What are we to call the style of Il Gesù? Obviously, it has little in common with Palladio, and it shares with Florentine architecture of the time only the influence of Michelangelo. But this influence reflects two very different phases of the great master's career: the contrast between the Uffizi and Il Gesù is hardly less great than that between the vestibule of the Laurentian Library and the exterior of St. Peter's. If we label the Uffizi Mannerist, the same term will not serve us for Il Gesù. As we shall see, the design of Il Gesù will become basic to Baroque architecture; by calling it "pre-Baroque," we suggest both its seminal importance for the future and its special place in relation to the past.

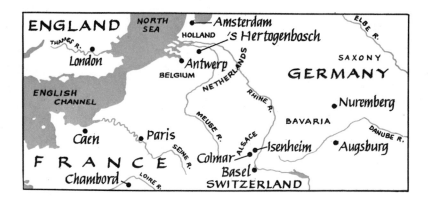

GERMANY

THE NETHERLANDS

FRANCE

 ARCHITECTURE AND SCULPTURE

5

THE RENAISSANCE
IN THE NORTH

North of the Alps, most fifteenth-century artists had remained indifferent to Italian forms and ideas. Since the time of the Master of Flémalle and the Van Eycks they had looked to Flanders, rather than to Tuscany, for leadership. This relative isolation ends suddenly, toward the year 1500; as if a dam had burst, Italian influence flows northward in an ever wider stream, and Northern Renaissance art begins to replace "Late Gothic." That term, however, has a far less well-defined meaning than "Late Gothic," which refers to a single, clearly recognizable stylistic tradition. The diversity of trends north of the Alps is even greater than in Italy during the sixteenth century. Nor does Italian influence provide a common denominator, for this influence is itself diverse: Early Renaissance, High Renaissance, and Mannerist, all in regional variants from Lombardy, Venice, Florence, and Rome. Its effects, too, may vary greatly; they may be superficial or profound, direct or indirect, specific or general. The "Late Gothic" tradition remained much alive, if no longer dominant, and its encounter with Italian art resulted in a kind of Hundred Years' War among styles which ended only when, in the early seventeenth century, the Baroque emerged as an international movement. The full history of this "war" is yet to be written; its major issues are hard to trace through all the battles, truces, and shifting alliances. Its course, moreover, was decisively affected by the Reformation, which had a far more immediate impact on art north of the Alps than in Italy. Our account, then, must be oversimplified, emphasizing the heroic phases of the struggle at the expense of the lesser (but, in the long run, equally significant) skirmishes.

GERMANY

Let us begin with Germany, the home of the Reformation, where the main battles of the "war of styles" took place during the first quarter of the century. Between 1475 and 1500, it had produced such important masters as Michael Pacher and Martin Schongauer (see figs. 479–80, 483), but these hardly prepare us for the astonishing burst of creative energy that was to follow. The range of achievements of this period—comparable, in its brevity and brilliance, to the Italian High Renaissance—is measured by the contrasting personalities of its greatest artists: Matthias Grünewald and Albrecht Dürer. Both died in 1528, probably at about the same age, although we know only Dürer's birth date (1471). Dürer quickly became internationally famous, while Grünewald remained so obscure that his real name, Mathis Gothart Nithart, was discovered only recently.

Grünewald

Grünewald's fame, like that of El Greco, has developed almost entirely within our own century. In the Northern art of his time, he alone, in his main work, the *Isenheim Altarpiece,* overwhelms us with something like the power of the Sistine Ceiling. (Characteristically enough, this extraordinary work was long believed to be by Dürer.) The altarpiece, painted between 1509/10 and 1515 for the monastery church of the Order of St. Anthony at Isenheim, in Alsace, is now in the museum of the nearby town of Colmar. A carved shrine with two sets of movable wings, it has three stages, or "views." The first and outermost, when all the wings are closed, shows *The Crucifixion* (fig. 598)—probably the most impressive ever painted. In one respect it is very medieval: Christ's unbearable agony and the desperate grief of the Virgin, St. John, and Mary Magdalen recall the older German *Andachtsbild* (see fig. 429). But the pitiful body on the cross, with its twisted limbs, its countless lacerations, its rivulets of blood, is on a heroic scale that raises it beyond the merely human, and thus reveals the two natures of Christ. The same message is conveyed by the flanking figures: the three historic witnesses on the left mourn Christ's death as a man, while John the Baptist, on the right, points with calm emphasis to Him as the Saviour. Even the background suggests this duality: this Golgotha is not a hill outside Jerusalem, but a mountain towering above lesser peaks. The Crucifixion, lifted from its familiar setting, thus becomes a lonelye vent silhouetted

against a deserted, ghostly landscape and a blue-black sky. Darkness is over the land, in accordance with the Gospels, yet brilliant light bathes the foreground with the force of sudden revelation. This union of time and eternity, of reality and symbolism, gives Grünewald's *Crucifixion* its awesome grandeur.

When the outer wings are opened, the mood of the *Isenheim Altarpiece* changes dramatically (colorplate 68). All three scenes in this second "view"—the Annunciation, the Angel Concert for the Madonna and Child, and the Resurrection—celebrate events as jubilant in spirit as the Crucifixion is austere. Most striking in comparison with "Late Gothic" painting is the sense of movement pervading these panels—everything twists and turns as though it had a life of its own. The angel of the Annunciation enters the room like a gust of wind that blows the Virgin backward; the Risen Christ shoots from His grave with explosive force; the canopy over the Angel Concert seems to writhe in response to the heavenly music. This vibrant energy has thoroughly reshaped the brittle, spiky contours and angular drapery patterns of "Late Gothic" art. Grünewald's forms are soft, elastic, fleshy. His light and color show a corresponding change: commanding all the resources of the great Flemish masters, he employs them with unexampled boldness and flexibility. His color scale is richly iridescent, its range matched only by the Venetians. And his exploitation of colored light is altogether without parallel at that time. In the luminescent angels of the Concert, the apparition of God the Father and the

Heavenly Host above the Madonna, and, most spectacularly, the rainbow-hued radiance of the Risen Christ, Grünewald's genius has achieved miracles-through-light that remain unsurpassed to this day.

How much did Grünewald owe to Italian art? Nothing at all, we are first tempted to reply. Yet he must have learned from the Renaissance in more ways than one: his knowledge of perspective (note the low horizons) and the physical vigor of some of his figures cannot be explained by the "Late Gothic" tradition alone, and occasionally his pictures show architectural details of Southern origin. Perhaps the most important effect of the Renaissance on him, however, was psychological. We know little about his career, but he apparently did not lead the settled life of a craftsman-painter controlled by the rules of his guild; he was also an architect, an engineer, something of a courtier, and an entrepreneur; he worked for many different patrons and stayed nowhere for very long. He was in sympathy with Martin Luther (who frowned upon religious images as "idolatrous"), even though, as a painter, he depended on Catholic patronage. In a word, Grünewald seems to have shared the free, individualistic spirit of Italian Renaissance artists; the daring of his pictorial vision likewise suggests a reliance on his own resources. The Renaissance, then, had a liberating influence on him but did not change the basic cast of his imagination. Instead, it helped him to epitomize the expressive aspects of the "Late Gothic" in a style of unique intensity and individuality.

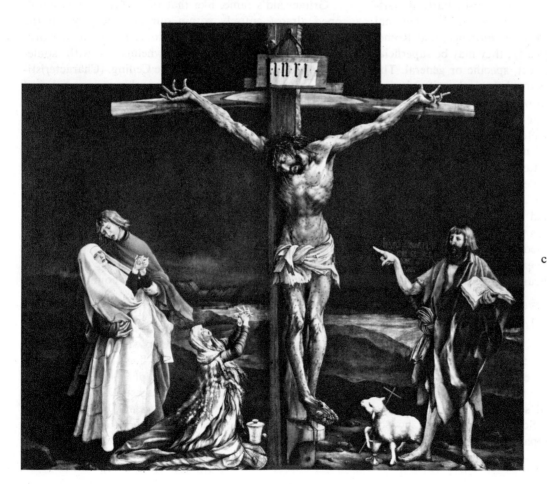

598. MATTHIAS GRÜNEWALD. *The Crucifixion,* from the *Isenheim Altarpiece* (closed). c. 1510–15. Panel, 8′ 10″ × 10′ 1″. Musée Unterlinden, Colmar (see colorplate 68)

599. ALBRECHT DÜRER.
Italian Mountains.
c. 1495. Watercolor.
Ashmolean Museum, Oxford

Dürer

For Dürer (1471–1528) the Renaissance held a richer meaning. Attracted to Italian art while still a young journeyman, he visited Venice in 1494/5 and returned to his native Nuremberg with a new conception of the world and the artist's place in it. The unbridled fantasy of Grünewald's art was to him "a wild, unpruned tree" (he used this phrase for painters who worked by rules-of-thumb, without theoretical foundations) which needed the discipline of the objective, rational standards of the Renaissance. Taking the Italian view that the fine arts belong among the liberal arts, he also adopted the ideal of the artist as a gentleman and humanistic scholar. By steadily cultivating his intellectual interests he came to encompass in his lifetime a vast variety of techniques and subjects. And since he was the greatest printmaker of the time, he had a wide influence on sixteenth-century art through his woodcuts and engravings, which circulated throughout the Western world.

Dürer's youthful copies after Mantegna (see figs. 5, 6) and other Early Renaissance masters show his eager and intuitive grasp of the essentials of their alien style. Even more astonishing are his watercolors made on the way back from Venice, such as the one inscribed "Italian Mountains" (fig. 599). Significantly, Dürer did not record the name of the spot; the specific location had no interest for him. The title he jotted down seems exactly right, for this is not a "portrait," but a "study from the model" perceived in timeless freshness. The calm rhythm of this panorama of softly rounded slopes conveys a view of nature in its organic wholeness that was, in those years, matched only by Leonardo.

After the breadth and lyricism of the *Italian Mountains,*

the expressive violence of the woodcuts illustrating the Apocalypse, Dürer's most ambitious graphic work of the years following his return from Venice, is doubly shocking. The gruesome vision of the *Four Horsemen* (fig. 600)

600. ALBRECHT DÜRER. *The Four Horsemen of the Apocalypse.* c. 1497–98. Woodcut

601. ALBRECHT DÜRER. *Self-Portrait.* 1500.
Panel, 26 1/4 × 19 1/4". Pinakothek, Munich

seems at first to return completely to the "Late Gothic" world of Martin Schongauer (compare fig. 483). Yet the physical energy and solid, full-bodied volume of these figures would have been impossible without Dürer's earlier experience in copying such works as Mantegna's *Battle of Sea Gods.* At this stage, Dürer's style has much in common with Grünewald's. The comparison with Schongauer's *Temptation of St. Anthony,* however, is instructive from another point of view; it shows how thoroughly Dürer has redefined his medium—the woodcut—by enriching it with the linear subtleties of engraving. In his hands, woodcuts lose their former charm as popular art, but gain the precise articulation of a fully matured graphic style. He set a standard that soon transformed the technique of woodcuts all over Europe.

The first artist to be fascinated by his own image, Dürer was in this respect more of a Renaissance personality than any Italian artist. His earliest known work, a drawing made at thirteen, is a self-portrait, and he continued to produce self-portraits throughout his career. Most impressive, and peculiarly revealing, is the panel of 1500 (fig. 601): pictorially, it belongs to the Flemish tradition (compare Jan van Eyck's *Man in a Red Turban,* fig. 466), but the solemn, frontal pose and the Christ-like idealization of the features assert an authority quite beyond the range of ordinary portraits. The picture looks, in

fact, like a secularized icon (see colorplate 25) reflecting not so much Dürer's vanity as the seriousness with which he regarded his mission as an artistic reformer. (One thinks of Martin Luther's "Here I stand; I cannot do otherwise.")

The didactic aspect of Dürer's art is clearest perhaps in the engraving *Adam and Eve,* of 1504 (fig. 602), where the biblical subject serves as a pretext for the display of two ideal nudes: Apollo and Venus in a Northern forest (compare figs. 182, 184). No wonder they look somewhat incongruous; unlike the picturesque setting and its animal inhabitants, Adam and Eve are constructed figures—not the male and female observed from life, but exemplars of what Dürer believed to be perfect proportions. The same approach, now applied to the body of a horse, is evident in *Knight, Death, and Devil* (fig. 603), one of the artist's finest prints. But this time there is no incongruity: the knight on his beautiful mount, poised and confident as an equestrian statue, embodies an ideal both aesthetic and moral. He is the Christian Soldier steadfast on the road of faith toward the Heavenly Jerusalem, undeterred by the hideous horseman threatening to cut him off, or the grotesque devil behind him. The dog, another symbol of virtue, loyally follows his master despite the lizards and skulls in his path. Italian Renaissance form, united with the heritage of "Late Gothic" symbolism (whether open or disguised), here takes on a new, characteristically Northern significance.

The subject of *Knight, Death, and Devil* seems to have been derived from the *Manual of the Christian Soldier* by Erasmus of Rotterdam, the greatest of Northern humanists. Dürer's own convictions were essentially those of Christian humanism; they made him an early and enthusiastic follower of Martin Luther, although, like Grünewald, he continued to work for Catholic patrons. Nevertheless, his new faith can be sensed in the growing austerity of style and subject in his religious works after 1520. The climax of this trend is represented by *The Four Apostles* (colorplate 71), paired panels containing what has rightly been termed Dürer's artistic testament. He presented them in 1526 to the city of Nuremberg, which had joined the Lutheran camp the year before. The chosen Apostles are basic to Protestant doctrine (John and Paul face one another in the foreground, with Peter and Mark behind). Quotations from their writings, inscribed below in Luther's translation, warn the city government not to mistake human error and pretense for the will of God; they plead against Catholics and ultrazealous Protestant radicals alike. But in another, more universal sense, the four figures represent the Four Temperaments (and, by implication, the other cosmic quartets—the seasons, the elements, the times of day, and the ages of man) encircling, like the cardinal points of the compass, the Deity who is at the invisible center of this "triptych." In keeping with their role, the Apostles have a cubic severity and grandeur such as we have not encountered since Masaccio and Piero della Francesca.

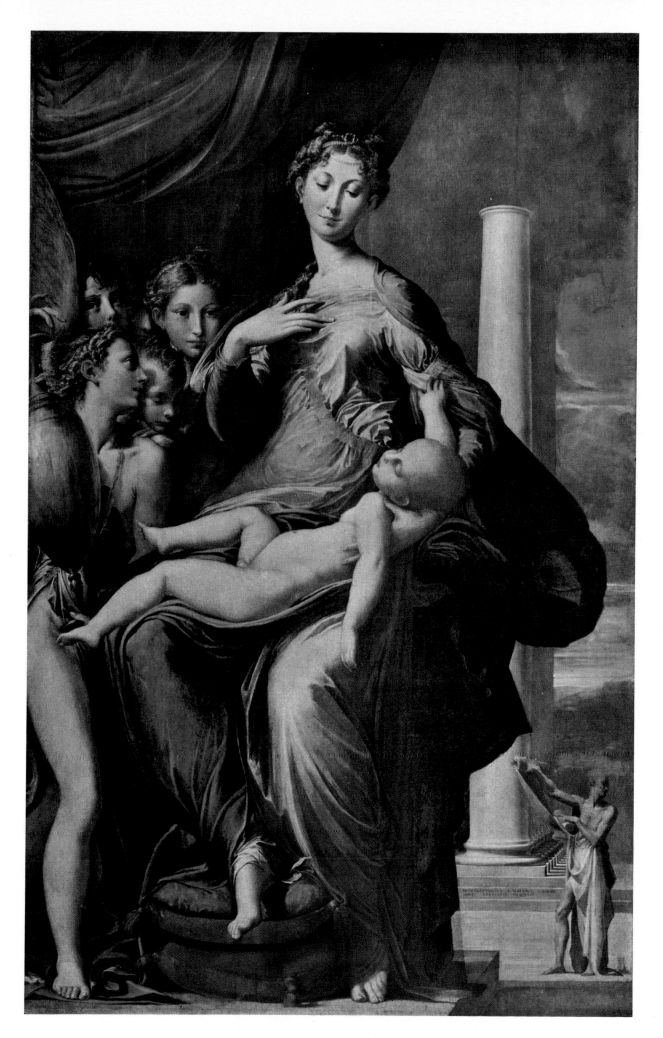

Colorplate 65. PARMIGIANINO. *The Madonna with the Long Neck.*
About 1535. Panel, 7′ 1″ × 4′ 4″. Uffizi Gallery, Florence

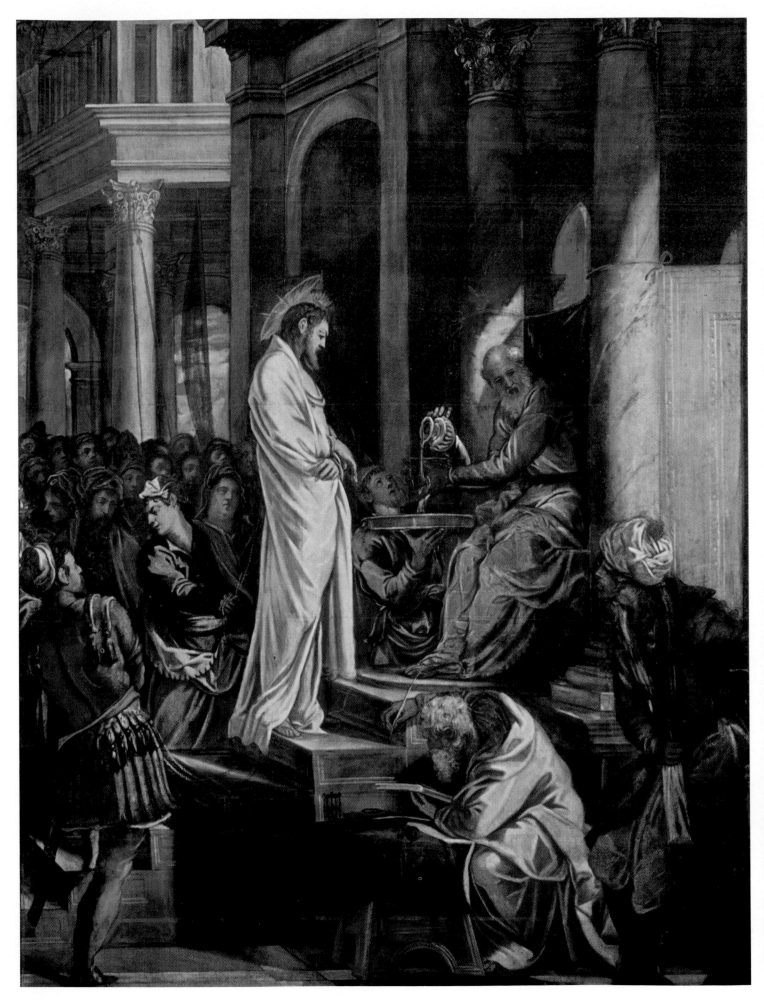

Colorplate 66. TINTORETTO. *Christ Before Pilate*. 1566–67.
About 18′ 1″ × 13′ 3¹/₂″. Scuola di San Rocco, Venice

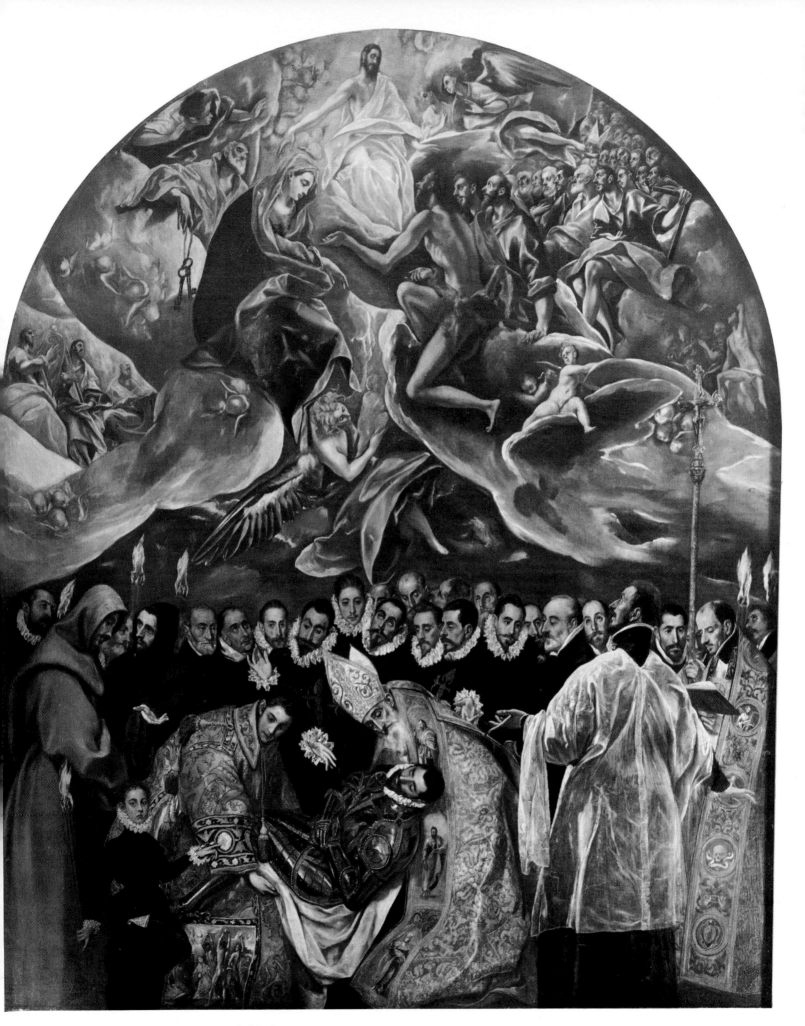

Colorplate 67. EL GRECO. *The Burial of Count Orgaz*. 1586.
16′ × 11′ 10″. Santo Tomé, Toledo, Spain

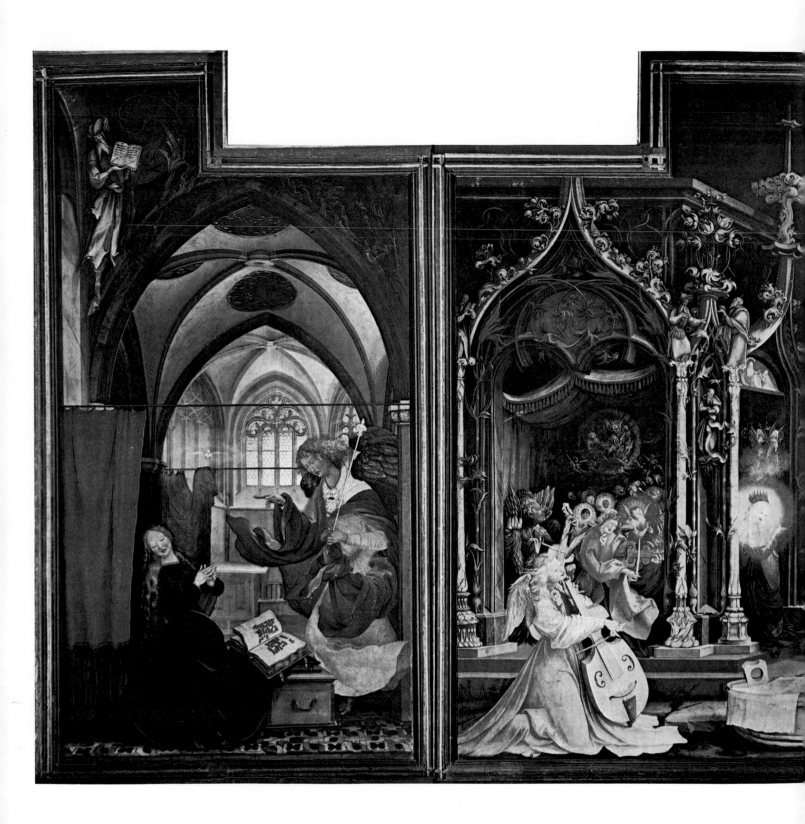

Colorplate 68. MATTHIAS GRÜNEWALD. *The Annunciation; Virgin and Child with Angels; The Resurrection,*
second view of the *Isenheim Altarpiece.* About 1510–15. Panel, each wing 8′ 10″ × 4′ 8″,
central scene 8′ 10″ × 11′ 2 1/2″. Musée Unterlinden, Colmar

Colorplate 69. PAOLO VERONESE. *Christ in the House of Levi.* 1573. 18′ 2″ × 42′. Academy, Venice

Colorplate 70. BENVENUTO CELLINI. *Saltcellar of Francis I*. 1539–43.
Gold with enamel, $10^{1}/_{4} \times 13^{1}/_{8}''$. Kunsthistorisches Museum, Vienna

Colorplate 71. ALBRECHT DÜRER. *The Four Apostles*. 1523–26.
Panel, each 85 × 30″. Pinakothek, Munich

602. ALBRECHT DÜRER. *Adam and Eve.* 1504.
Engraving. Museum of Fine Arts, Boston

603. ALBRECHT DÜRER. *Knight, Death, and Devil.*
1513. Engraving. Museum of Fine Arts, Boston

That the style of *The Four Apostles* has evoked the names of these great Italians is no coincidence, for Dürer devoted a good part of his last years to the theory of art, including a treatise on geometry based on a thorough study of Piero della Francesca's discourse on perspective. Often he went beyond his Italian sources; he invented, for instance, a device for producing an image by purely mechanical means, to demonstrate the objective validity of perspective (fig. 604). Two men "draw" the lute as it would appear to us if we looked at it from the spot on the wall marked by a little hook; the string passing through the hook substitutes for the visual rays. The man on the left attaches it to successive points on the contour of the lute; the other man marks where the string passes through the vertical frame (the picture plane) and makes corresponding dots on the drawing board hinged to the frame. Dürer, of course, knew that such an image was the record of a scientific experiment, not a work of art; neither was he really interested in a method for making pictures without human skill or judgment. Nevertheless, his device, however clumsy, is the first step toward the principle of the photographic camera.

Cranach; Altdorfer

Dürer's hope for a monumental art embodying the Protestant faith remained unfulfilled. Other German painters, notably Lucas Cranach the Elder (1472–1553),

604. ALBRECHT DÜRER. *Demonstration of Perspective,* from
the artist's treatise on geometry. 1525. Woodcut

also tried to cast Luther's doctrines into visual form, but created no viable tradition. Such efforts were doomed, since the spiritual leaders of the Reformation looked upon them with indifference or, more often, outright hostility. Lucas Cranach is best remembered today for his portraits and his delightfully incongruous mythological scenes. In his *Judgment of Paris* (fig. 605) nothing

could be less classical than the three coquettish damsels, whose wriggly nakedness fits the Northern background better than does the nudity of Dürer's *Adam and Eve*. Paris is a German knight clad in fashionable armor, indistinguishable from the nobles at the court of Saxony who were the artist's patrons. The playful eroticism, small size, and precise, miniature-like detail of the picture make it plainly a collector's item, attuned to the tastes of a provincial aristocracy.

As remote from the classic ideal, but far more impressive, is *The Battle of Issus* by Albrecht Altdorfer (c. 1480–1538), a Bavarian painter somewhat younger than Cranach (colorplate 72). Without the text on the tablet suspended in the sky, and the other inscriptions, we could not possibly identify the subject, Alexander's victory over Darius. The artist has tried to follow ancient descriptions of the actual number and kind of combatants in the battle, but this required him to adopt a bird's-eye view whereby the two protagonists are lost in the ant-like mass of their own armies (contrast the Hellenistic representation of the same subject in colorplate 16).

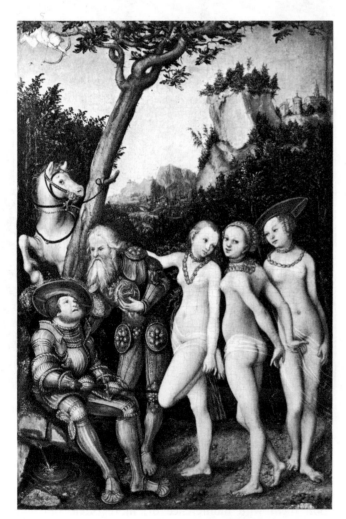

Moreover, the soldiers' armor and the fortified town in the distance are unmistakably of the sixteenth century. The picture might well show some contemporary battle, except for one feature: the spectacular sky, with the sun triumphantly breaking through the clouds and "defeating" the moon. The celestial drama above a vast Alpine landscape, obviously correlated with the human contest below, raises the scene to the cosmic level. This is strikingly similar to the vision of heavenly glory above the Virgin and Child in the *Isenheim Altarpiece* (colorplate 68). Altdorfer may indeed be viewed as a later, and lesser, Grünewald; although he, too, was an architect, well acquainted with perspective and the Italian stylistic vocabulary, Altdorfer's paintings show the unruly imagination already familiar from the work of the older master. But Altdorfer is also unlike Grünewald: he makes the human figure incidental to its spatial setting, whether natural or man-made. The tiny soldiers of the *Battle of Issus* have their counterpart in his other pictures, and he painted at least one landscape with no figures at all—the earliest "pure" landscape (Dürer's sketch, *Italian Mountains*, fig. 599, is not a finished work of art).

Holbein and Portraiture

Gifted though they were, Cranach and Altdorfer both evaded the main challenge of the Renaissance so bravely faced—if not always mastered—by Dürer: the image of man. Their style, antimonumental and miniature-like, set the pace for dozens of lesser masters; perhaps the rapid decline of German art after Dürer's death was due to a failure of ambition, among artists and patrons alike. The career of Hans Holbein the Younger (1497–1543)—the one painter of whom this is not true—confirms the general rule. Born and raised in Augsburg, a center of international commerce in South Germany particularly open to Renaissance ideas, he left at the age of eighteen for Switzerland. By 1520, he was firmly established in Basel as a designer of woodcuts, a splendid decorator, and an incisive portraitist. His likeness of Erasmus of Rotterdam (fig. 606), painted soon after the famous author had settled in Basel, gives us a truly memorable image of Renaissance man: intimate yet monumental, this doctor of humane letters has an intellectual authority formerly reserved for the doctors of the Church. Yet Holbein must have felt confined in Basel, for in 1523–24 he traveled to France, apparently intending to offer his services to Francis I; two years later Basel was in the throes of the Reformation crisis, and he went to England, hoping for commissions at the court of Henry VIII (Erasmus, recommending him to Thomas More, wrote: "Here [in Basel] the arts are out in the cold"). On his return in 1528, he used his English earnings to buy a house for his family. But Basel, becoming meanwhile fanatically Protestant, had iconoclastic riots; despite the entreaties of the city council, Holbein returned to London in 1532. He went

606. HANS HOLBEIN THE YOUNGER. *Erasmus of Rotterdam.*
c. 1523. Panel, 16 1/2 × 12 1/2″. The Louvre, Paris

607. JEAN CLOUET. *Francis I.* c. 1525–30.
Panel, 37 3/4 × 29″. The Louvre, Paris

608. NICHOLAS HILLIARD. *A Young Man Among Roses.*
c. 1588. Parchment, 5 3/8 × 2 3/4″.
Victoria & Albert Museum, London

back to Basel only once, in 1538, while traveling on the Continent as court painter to Henry VIII. The council made a last attempt to keep him at home, but Holbein had become an artist of international fame to whom Basel now seemed provincial indeed. His style, too, had gained an international flavor. The portrait of Henry VIII (colorplate 73) shares with Bronzino's *Eleanora of Toledo* (fig. 578) the immobile pose, the air of unapproachability, and the precisely rendered costume and jewels. While Holbein's picture, unlike Bronzino's, does not yet reflect the Mannerist ideal of elegance—the rigid frontality and physical bulk of Henry VIII create an overpowering sensation of the king's ruthless, commanding presence—both clearly belong to the same species of court portrait. The link between them may be such French works as Jean Clouet's *Francis I* (fig. 607), which Holbein could have seen on his travels. (For Francis I as a patron of Italian Mannerists, see page 454.) The type evidently was coined at the royal court of France, where its ancestry can be traced back as far as Jean Fouquet (see fig. 474). It gained international currency between 1525 and 1550.

609. PIETER AERTSEN.
The Meat Stall. 1551.
Panel, 48 1/2 × 59".
Museum of Art,
Uppsala University, Sweden

Although Holbein's pictures molded British taste in aristocratic portraiture for decades, he had no English disciples of real talent. The Elizabethan genius was more literary and musical than visual, and the demand for portraits in the later sixteenth century continued to be filled largely by visiting foreign artists. The most notable English painter of the period was Nicholas Hilliard (1547–1619), a goldsmith who also specialized in miniature portraits on parchment, tiny keepsakes often worn by their owners as jewelry. These "portable portraits" had been invented in antiquity (see fig. 264) and were revived in the fifteenth century (see fig. 475); Holbein, too, produced miniature portraits, which Hilliard acknowledged to be his model. We see this link with the older master in the even lighting and meticulous detail of *A Young Man Among Roses* (fig. 608), but the elongated proportions and the pose of languorous grace come from Italian Mannerism, probably via Fontainebleau (compare fig. 586). Our lovesick youth also strikes us as the descendant of the fashionable attendants at the court of the Duke of Berry (see fig. 460). We can imagine him besieging his lady with sonnets and madrigals before presenting her with this exquisite token of devotion.

THE NETHERLANDS

The Netherlands in the sixteenth century had the most turbulent and painful history of any country north of the Alps. When the Reformation began, they were part of the far-flung empire of the Hapsburgs under Charles V, who was also king of Spain. Protestantism quickly became powerful in the Netherlands, and the attempts of the Crown to suppress it led to open revolt against foreign rule. After a bloody struggle, the northern provinces (today's Holland) emerged at the end of the century as an independent state, while the southern ones (roughly corresponding to modern Belgium) remained in Spanish hands. The religious and political strife might have had catastrophic effects on the arts, yet this, astonishingly, did not happen. Sixteenth-century Netherlandish painting, to be sure, does not equal that of the fifteenth in brilliance, nor did it produce any pioneers of the Northern Renaissance comparable to Dürer and Holbein. This region absorbed Italian elements more slowly than Germany, but more steadily and systematically, so that instead of a few isolated peaks of achievement we find a continuous range. Between 1550 and 1600, their most troubled time, the Netherlands produced the major painters of Northern Europe, who paved the way for the great Dutch and Flemish masters of the next century.

Two main concerns, sometimes separate, sometimes interwoven, characterize Netherlandish sixteenth-century painting: to assimilate Italian art, from Raphael to Tintoretto (in an often dry and didactic manner), and to develop a repertory supplementing, and eventually replacing, the traditional religious subjects. All the secular themes that loom so large in Dutch and Flemish painting of the Baroque era—landscape, still life, genre (scenes of everyday life)—were first defined between 1500 and 1600. The process was gradual, shaped less by the genius of individual artists than by the need to cater to popular taste as church commissions became steadily scarcer (Protestant iconoclastic zeal was particularly widespread in the Netherlands). Still life, landscape, and genre had been part of the Flemish tradition since the Master of Flémalle and the brothers Van Eyck—we remember the objects grouped on the Virgin's table in the *Merode Altarpiece,* and Joseph in his workshop; or the setting of

the Van Eyck *Crucifixion* (fig. 462, colorplates 46, 47). But they had remained ancillary elements, governed by the principle of disguised symbolism and subordinated to the devotional purpose of the whole. Now they became independent, or so dominant that the religious subject could be relegated to the background. *The Meat Stall* by Pieter Aertsen (fig. 609) is such an essentially secular picture: the tiny, distant figures, representing the Flight into Egypt, are a mere pretext, almost blotted out by the avalanche of edibles in the foreground. We see little interest here in selection or formal arrangement; the objects, piled in heaps or strung from poles, are meant to overwhelm us with their sensuous reality (note the large size of the panel). Aertsen is remembered today mainly as a pioneer of the independent still life, but he seems to have first painted such pictures as a sideline, until he saw many of his altarpieces destroyed by iconoclasts. Perhaps still life assumed a new importance for him when he moved, about 1555, from Antwerp to Amsterdam.

Bruegel

Pieter Bruegel the Elder (1525/30–1569), the only genius among these Netherlandish painters, explored landscape and peasant life. Although his career was spent in Antwerp and Brussels, he may have been born near 's Hertogenbosch; certainly the work of Hieronymus Bosch deeply impressed him and he is in many ways as puzzling to us as the older master. What were his religious convictions, his political sympathies? We know little about him, but his preoccupation with folk customs and

the daily life of humble people seems to have sprung from a complex philosophical attitude. Bruegel was highly educated, the friend of humanists, and patronized by the Hapsburg court. Yet he apparently never worked for the Church, and when he dealt with religious subjects he did so in an oddly ambiguous way. His attitude toward Italian art is also hard to define: a trip to the South in 1552–53 took him to Rome, Naples, and the Strait of Messina, but the famous monuments admired by other Northerners seem not to have interested him; he returned instead with a sheaf of magnificent landscape drawings, especially Alpine views. He was probably much impressed by landscape painting in Venice—its integration of figures and scenery, and the progression in space from foreground to background (see colorplates 62, 63). Out of these memories came such sweeping landscapes in Bruegel's mature style as *The Return of the Hunters* (fig. 610), one of a set depicting the months. Such series, we recall, had begun with medieval calendar illustrations, and Bruegel's winter scene still shows its descent from the February page in the *Très Riches Heures du Duc de Berry* (see fig. 459). Now, however, nature is more than a setting for human activities; it is the main subject of the picture. Men in their seasonal occupations are incidental to the majestic annual cycle of death and rebirth that is the breathing rhythm of the cosmos.

The *Peasant Wedding* (colorplate 74) is Bruegel's most memorable scene of peasant life. These are stolid, crude folk, heavy-bodied and slow, yet their very clumsiness gives them a strange gravity that commands our respect. Painted in flat colors with minimal modeling and no cast

610. PIETER BRUEGEL THE ELDER.
The Return of the Hunters.
1565. Panel, 46 × 63 ³/₄″.
Kunsthistorisches Museum, Vienna

611. PIETER BRUEGEL THE ELDER. *The Blind Leading the Blind.* 1568. 34 × 66″. National Museum, Naples

shadows, the figures nevertheless have a weight and solidity that remind us of Giotto; space is created in assured perspective, and the entire composition is as monumental and balanced as that of any Italian master. Why, we wonder, did Bruegel endow this commonplace ceremony with the solemnity of a biblical event? Was it because he saw in the life of the peasant, free of the ambitions and vanities of city dwellers, the natural, hence the ideal, condition of man? Bruegel's philosophical detachment from religious and political fanaticism also informs one of his last pictures, *The Blind Leading the Blind* (fig. 611). Its source is the Gospels (Matt. 15: 12–19): Christ says, speaking of the Pharisees, "And if the blind lead the blind, both shall fall into the ditch." This parable of human folly recurs in humanistic literature, and we know it in at least one earlier representation, but the tragic depth of Bruegel's large and forceful image gives new urgency to the theme. Perhaps he found the biblical context of the parable specially relevant to his time: the Pharisees had asked why Christ's disciples, violating religious traditions, did not wash their hands before meals; He answered, "Not that which goeth into the mouth defileth a man; but that which cometh out of the mouth." When this offended the Pharisees, He called them the blind leading the blind, explaining that "whatsoever entereth in at the mouth goeth into the belly, and is cast out. . . . But those things which proceed out of the mouth come forth from the heart; and they defile the man. For out of the heart proceed evil thoughts, murders, . . . blasphemies." Could Bruegel have thought that this applied to the controversies then raging over details of religious ritual?

FRANCE

ARCHITECTURE AND SCULPTURE

We have deferred our discussion of sixteenth-century architecture and sculpture north of the Alps because in these fields Italy had no significant influence before the 1520s. France began to assimilate Italian art somewhat earlier than the other countries and was the first to achieve an integrated Renaissance style; we shall therefore confine our discussion to French monuments. As we might expect, architects still trained in the Gothic tradition could not adopt the Italian style all at once; they readily used its classical vocabulary, but its syntax gave them trouble for many years. One glance at the choir of St.-Pierre at Caen (fig. 612), built by Hector Sohier, shows that he follows the basic pattern of French Gothic church choirs (compare fig. 389), simply translating Flamboyant decoration into the vocabulary of the new language: finials become candelabra, pier buttresses are shaped like pilasters, and the round-arched windows of the ambulatory chapels have geometric tracery. The Château of Chambord (fig. 613) is stylistically more complicated. Its plan, and the turrets, high-pitched roofs, and tall chimneys, recall the Gothic Louvre (see colorplate 44); yet the design—greatly modified by later French builders—was originally by an Italian pupil of Giuliano da Sangallo. And his was surely the plan of the center portion (fig. 614), which is quite unlike its French predecessors. This square block, developed from the keep of medieval castles (see page 298), has a central staircase fed by four corridors; these form a Greek cross dividing the interior into four

612. HECTOR SOHIER. Choir of St.-Pierre. 1528–45. Caen

square sections. Each section is further subdivided into one large and two smaller rooms, and a closet—in modern parlance, a suite or apartment. The functional grouping of these rooms, originally imported from Italy, was to become a standard pattern in France. It represents the starting point of all modern "designs for living."

Francis I, who had built Chambord, decided in 1546 to replace the Louvre with a new palace on the old site. He died before the project was more than begun; but his architect, Pierre Lescot, continued it under Henry II, quadrupling the size of the court. This enlarged scheme was not completed for more than a century; Lescot built only the southern half of the court's west side (fig. 615), the finest surviving monument of the French Renaissance in its "classic" phase, so called to distinguish it from the style of such buildings as Chambord. This distinction is well warranted: the Italian vocabulary of Chambord, and St.-Pierre at Caen, is based on the Early Renaissance, while Lescot drew on the work of Bramante and his successors. The details of Lescot's façade have indeed an astonishing classical purity, yet we would not mistake it for an Italian structure. Its distinctive quality comes not from Italian forms superficially applied, but from a genuine synthesis of the traditional château with the

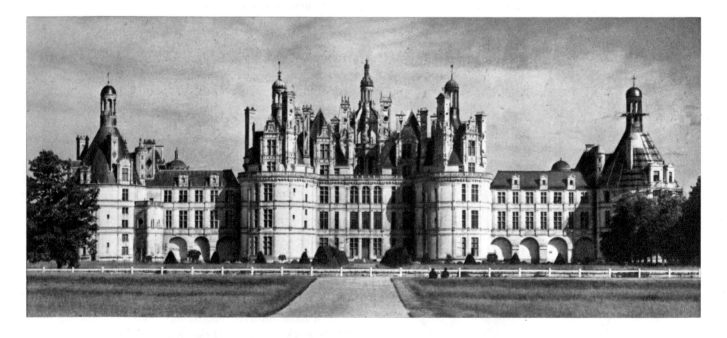

above: 613. The Château of Chambord
(north front). Begun 1519

left: 614. Plan of Center Portion,
Château of Chambord (after Du Cerceau)

615. PIERRE LESCOT. Square Court of the Louvre. Begun 1546. Paris

616, 617. JEAN GOUJON. Reliefs from
the *Fontaine des Innocents*. 1548–49. Paris

Renaissance palace. Italian, of course, are the superimposed classical orders (see figs. 517, 590), the pedimented window frames, and the arcade on the ground floor. But the continuity of the façade is interrupted by three projecting pavilions which have supplanted the château turrets, and the high-pitched roof is also traditionally French. The vertical accents thus overcome the horizontal ones (note the broken architraves), their effect reinforced by the tall, narrow windows. Equally un-Italian is the rich sculptural decoration covering almost the entire wall surface of the third story. These reliefs, admirably adapted to the architecture, are by Jean Goujon, the finest French sculptor of the mid-century. Unfortunately, they have been much restored. To get a more precise idea of Goujon's style we must turn to the relief panels from the *Fontaine des Innocents* (two are shown in figs. 616, 617), which have survived intact, although their architectural framework is lost. These graceful figures recall the mannerism of Cellini (see colorplate 70) and, even more, Primaticcio's decorations at Fontainebleau (see fig. 586). Like Lescot's architecture, their design combines classical details of astonishing purity with a delicate slenderness that gives them a uniquely French air.

A more powerful sculptor—indeed, the greatest of the later sixteenth century—was Germain Pilon (c. 1535–90). In his early years he, too, learned a good deal from Primaticcio, but he soon developed his own idiom by merging the Mannerism of Fontainebleau with elements

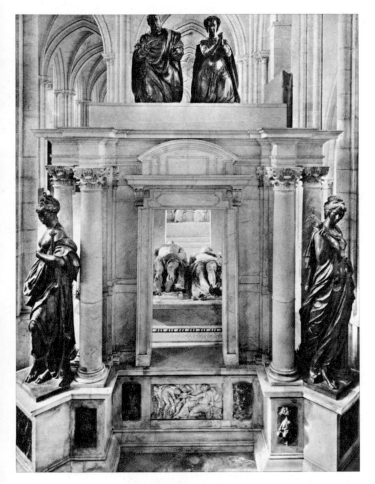

618. FRANCESCO PRIMATICCIO
and GERMAIN PILON.
Tomb of Henry II. 1563-70.
Abbey Church of St.-Denis, Paris

taken from ancient sculpture, Michelangelo, and the Gothic tradition. His main works are monumental tombs, of which the earliest and largest was for Henry II and Catherine de'Medici (fig. 618). Primaticcio built the architectural framework, an oblong, free-standing chapel on a platform decorated with bronze and marble reliefs. Four large bronze statues of Virtues, their style reminiscent of Fontainebleau, mark the corners. On the top of the tomb are bronze figures of the King and Queen kneeling in prayer; inside the chapel, the couple reappear as *gisants,* or nude corpses (fig. 619). This contrast of effigies had been a characteristic feature of Gothic tombs since the fourteenth century: the *gisant* expressed the transient nature of the flesh, usually showing the body in an advanced stage of decomposition, with vermin sometimes crawling through its open cavities. How could this gruesome image take on Renaissance form without losing its emotional significance? Pilon's solution is brilliant: by idealizing the *gisants* he reverses their former meaning. These figures—the recumbent Queen in the pose of a classical Venus, the King in that of the Dead Christ—evoke neither horror nor pity but, rather, the pathos of a beauty that persists even in death. The shock effect of their predecessors has given way to a poignancy that is no less intense. Remembering our earlier distinction between the classical and medieval attitudes toward death (see page 405), this poignancy may be defined: the Gothic *gisant,* which emphasizes physical decay, represents the future state of the body, in keeping with the whole "prospective" character of the medieval tomb; Pilon's *gisants,* however, are "retrospective," yet do not deny the reality of death. In this union of opposites—never to be achieved again, even by Pilon himself—lies the greatness of these figures.

619. GERMAIN PILON.
Gisants of the King and Queen,
detail of the Tomb of Henry II

ROME

 St. Peter's

TURIN

AUSTRIA; SOUTH GERMANY

6

THE BAROQUE
IN ITALY AND GERMANY

Baroque has been the term used by art historians for almost a century to designate the dominant style of the period 1600–1750. Its original meaning—"irregular, contorted, grotesque"—is now largely superseded. It is generally agreed that the new style was born in Rome during the final years of the sixteenth century. What remains under dispute is whether the Baroque is the final phase of the Renaissance, or an era distinct from both Renaissance and modern. We have chosen the first alternative, while admitting that a good case can be made for the second. Which of the two we adopt is perhaps less important than an understanding of the factors that must enter into our decision. And here we run into a series of paradoxes. Thus it has been claimed that the Baroque style expresses the spirit of the Counter Reformation; yet the Counter Reformation, a dynamic movement of self-renewal within the Catholic Church, had already done its work by 1600—Protestantism was on the defensive, some important territories had been recaptured for the old faith, and neither side any longer had the power to upset the new balance. The princes of the Church who supported the growth of Baroque art were known for worldly splendor rather than piety. Besides, the new style penetrated the Protestant North so quickly that we should guard against overstressing its Counter Reformation aspect. Equally problematic is the assertion that Baroque is "the style of absolutism," reflecting the centralized state ruled by an autocrat of unlimited powers. Although absolutism reached its climax during the reign of Louis XIV in the later seventeenth century, it had been in the making since the 1520s (under Francis I in France, and the Medici dukes in Tuscany). Moreover, Baroque art flourished in bourgeois Holland no less than in the absolutist monarchies; and the style officially sponsored under Louis XIV was a notably subdued, classicistic kind of Baroque. We encounter similar difficulties when we try to relate Baroque art to the science and philosophy of the period. Such a link did exist in the Early and High Renaissance: an artist then could also be a humanist and a scientist. But during the

seventeenth century, scientific and philosophical thought became too complex, abstract, and systematic for him to share; gravitation, calculus, and *Cogito, ergo sum* could not stir his imagination. All of this means that Baroque art is not simply the result of religious, political, or intellectual developments. Interconnections surely existed, of course, but we do not yet understand them very well. Until we do, let us think of the Baroque style as one among other basic features—the newly fortified Catholic faith, the absolutist state, and the new role of science—that distinguish the period 1600–1750 from what had gone before.

ROME

Around 1600 Rome became the fountainhead of the Baroque, as it had of the High Renaissance a century before, by gathering artists from other regions to perform challenging new tasks. The papacy patronized art on a large scale, with the aim of making Rome the most beautiful city of the Christian world "for the greater glory of God and the Church." This campaign had begun as early as 1585; the artists then on hand were late Mannerists of feeble distinction, but it soon attracted ambitious younger masters, especially from Northern Italy. These talented men created the new style.

Caravaggio

Foremost among these northerners was a painter of genius, called Caravaggio after his birthplace near Milan (1573–1610), who in 1597–98 did several monumental canvases for a chapel in the church of S. Luigi dei Francesi, among them *The Calling of St. Matthew* (colorplate 75). This extraordinary picture is remote from both Mannerism and the High Renaissance; its only antecedent is the "North Italian realism" of artists like Savoldo (see fig. 584). But Caravaggio's realism is such that a new term, "naturalism," is needed to distinguish it from

620. ANNIBALE CARRACCI. Ceiling Fresco (detail).
1597–1601. Gallery, Palazzo Farnese, Rome

the earlier kind. Never have we seen a sacred subject depicted so entirely in terms of contemporary low life. Matthew, the tax-gatherer, sits with some armed men—evidently his agents—in what is a common Roman tavern; he points questioningly at himself as two figures approach from the right. The arrivals are poor people, their bare feet and simple garments contrasting strongly with the colorful costumes of Matthew and his companions. Why do we sense a religious quality in this scene? Why do we not mistake it for an everyday event? What identifies one of the figures as Christ? Surely it is not the

Saviour's halo (the only supernatural feature in the picture), an inconspicuous gold band that we might well overlook. Our eyes fasten instead upon His commanding gesture, borrowed from Michelangelo's *Creation of Adam* (fig. 557), which bridges the gap between the two groups. Most decisive, however, is the strong beam of sunlight above Christ that illuminates His face and hand in the gloomy interior, thus carrying His call across to Matthew. Without this light—so natural yet so charged with symbolic meaning—the picture would lose its magic, its power to make us aware of the Divine presence. Caravaggio here gives moving, direct form to an attitude shared by certain great saints of the Counter Reformation: that the mysteries of faith are revealed not by intellectual speculation but spontaneously, through an inward experience open to all men. His paintings have a "lay Christianity," untouched by theological dogma, that appealed to Protestants no less than Catholics. This quality made possible his profound—though indirect—influence on Rembrandt, the greatest religious artist of the Protestant North.

Annibale Carracci and His Followers

In Italy, Caravaggio fared less well. His work was acclaimed by artists and connoisseurs, but to the man in the street, for whom it was intended, it lacked propriety and reverence. The simple people resented meeting their likes in his paintings; they preferred religious imagery of a more idealized and rhetorical sort. Their wishes were met by artists less radical—and less talented—than Caravaggio, who took their lead from another newcomer among Roman painters, Annibale Carracci (1560–1609). Annibale came from Bologna, where he and two other members of his family had evolved an anti-Mannerist style since the 1580s. In 1597–1604 he produced his most ambitious work, the ceiling fresco in the gallery of the Far-

621. GUIDO RENI. *Aurora* (ceiling fresco). 1613. Casino Rospigliosi, Rome

622. ANNIBALE CARRACCI.
Landscape with the Flight into Egypt.
c. 1603. 48 ¹/₄ × 98 ¹/₂".
Doria Gallery, Rome

nese Palace, which soon became so famous that it was thought second only to the murals of Michelangelo and Raphael. The historical significance of the Farnese Gallery is indeed great, though our enthusiasm for it as a work of art may no longer be undivided. Our detail (fig. 620) shows Annibale's rich and intricate design: the narrative scenes, like those of the Sistine Ceiling, are surrounded by painted architecture, simulated sculpture, and nude, garland-holding youths. Yet the Farnese Gallery does not merely imitate Michelangelo's masterpiece. The style of the main subjects, the Loves of the Classical Gods, is reminiscent of Raphael's *Galatea* (see fig. 571), and the whole is held together by an illusionistic scheme that reflects Annibale's knowledge of Correggio and the great Venetians. Carefully foreshortened and illuminated from below (note the shadows), the nude youths and the simulated sculpture and architecture appear real; against this background the mythologies are presented as simulated easel pictures. Each of these levels of reality is handled with consummate skill, and the entire ceiling has an exuberance that sets it apart from both Mannerism and High Renaissance art. Annibale Carracci was a reformer rather than a revolutionary; like Caravaggio, with whom he was on the best of terms, he felt that art must return to nature, but his approach was less single-minded, balancing studies from life with a revival of the classics (which to him meant the art of antiquity, and of Raphael, Michelangelo, Titian, and Correggio). At his best, he succeeded in fusing these diverse elements, although their union always remained somewhat precarious. To his disciples, the Farnese Gallery seemed to offer two alternatives: pursuing the Raphaelesque style of the mythological panels, they could arrive at a deliberate, "official" classicism; or they could take their cue from the sensuous illusionism present in the framework. The first choice is exemplified by Guido Reni's *Aurora* (fig. 621), a ceiling fresco showing Apollo in his chariot—the Sun—led by Aurora (Dawn). Despite its rhythmic grace, this relief-like design would seem little more than a pallid reflection of High

Renaissance art were it not for the glowing and dramatic light which gives it an emotional impetus that the figures alone could never achieve. Its very opposite is the *Aurora* ceiling by Guercino (colorplate 76). Here architectural perspective, combined with the pictorial illusionism of Correggio and the intense light and color of Titian, converts the entire surface into one limitless space; the figures sweep past as if propelled by stratospheric winds. With this work, Guercino started what soon became a veritable flood of similar visions (see figs. 629, 645). The most overpowering of these is the ceiling fresco by Pietro da Cortona (1596–1669) in the great hall of the Barberini Palace in Rome, a glorification of the reign of the Barberini pope, Urban VIII (colorplate 77). As in the Farnese Gallery, the ceiling area is subdivided by a painted framework simulating architecture and sculpture, but beyond it we now see the unbounded space of the sky, as in Guercino's *Aurora* (colorplate 76). Clusters of figures, perched on clouds or soaring freely, swirl above as well as below this framework, creating a dual illusion: some figures appear to hover well inside the hall, perilously close to our heads, while others recede into a light-filled, infinite distance. Their dynamism almost literally sweeps us off our feet. Here the Baroque style reaches a thunderous climax.

The sculptured precision of the Farnese Gallery does not do justice to the important Venetian element in Annibale Carracci's style. This is most striking in his landscapes, such as the monumental *Landscape with the Flight into Egypt* (fig. 622). Its pastoral mood and the soft light and atmosphere hark back to Giorgione and Titian (see colorplates 62, 63). The figures, however, play a far less conspicuous role here; they are, indeed, as small and incidental as in any Northern landscape (compare fig. 610). Nor does the character of the panorama at all suggest the Flight into Egypt—it would be equally suitable for almost any story, sacred or profane. Still, we feel that the figures could not be removed altogether (though we can imagine them replaced by others). This is not the untamed nature of Northern landscapes,

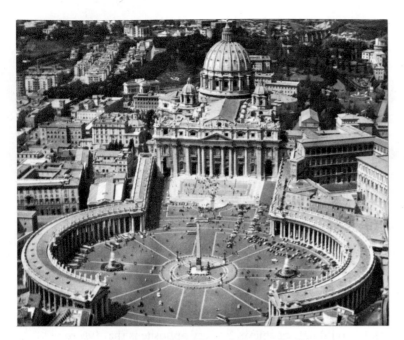

623. Aerial View of St. Peter's, Rome.
Nave and façade by CARLO MADERNO, 1607–15;
colonnade by GIANLORENZO BERNINI,
designed 1657

but a "civilized," hospitable countryside. The old castle, the roads and fields, the flock of sheep, the ferryman with his boat, all show that man has been at home here for a long time. Hence the figures, however tiny, do not appear lost or dwarfed into insignificance, because their presence is implicit in the orderly, domesticated quality of the setting. This firmly constructed "ideal landscape" evokes a vision of nature that is gentle yet austere, grand but not awesome. We shall meet its descendants again and again in the next two centuries.

ST. PETER'S

In architecture, the beginnings of the Baroque style cannot be defined as precisely as in painting. In the vast ecclesiastical building program that got under way in Rome toward the end of the sixteenth century, the most talented young architect to emerge was Carlo Maderno (1556–1629); in 1603 he was given the task of completing, at long last, the church of St. Peter's. The pope had decided to add a nave to Michelangelo's building (fig. 566), converting it into a basilica. The change of plan, which may have been prompted by the example of Il Gesù (see figs. 595, 597), made it possible to link St. Peter's with the Vatican Palace (fig. 623, right). Maderno's design for the façade follows the pattern established by Michelangelo for the exterior of the church—a colossal order supporting an attic—but with a dramatic emphasis on the portals. There is what can only be described as a crescendo effect from the corners toward the center: the spacing of the supports becomes closer, pilasters turn into columns, and the façade wall projects step by step. This quickened rhythm, we recall, had been hinted at a generation earlier, in Giacomo della Porta's façade of Il Gesù (see fig. 596). Maderno made it the dominant principle of his façade designs, not only for St. Peter's but for smaller churches as well; in so doing, he replaced the traditional notion of the church façade as one continuous wall surface—a concept not yet challenged by the façade of Il Gesù—with the "façade-in-depth," dynamically related to the open space before it. The possibilities implicit in this new concept were not to be exhausted until a hundred and fifty years later.

Bernini

The enormous size of St. Peter's made the decoration of its interior a uniquely difficult task—how to relate its chill vastness to the human scale and imbue it with a measure of emotional warmth? That the problem was solved is very largely to the merit of Gianlorenzo Bernini (1598–1680), the greatest sculptor-architect of the century. St. Peter's occupied him at intervals during most of his long and prolific career; he began by designing the huge bronze canopy for the main altar under the dome (fig. 624). The tabernacle is a splendid fusion

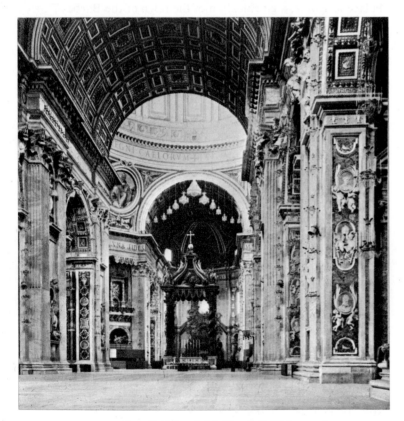

624. Interior (with Bernini's Tabernacle,
1624–33), St. Peter's, Rome

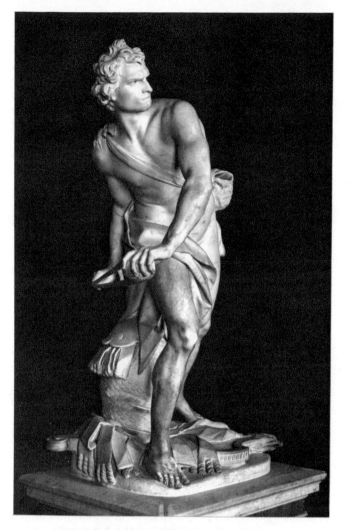

625. GIANLORENZO BERNINI. *David*. 1623.
Marble, lifesize. Borghese Gallery, Rome

of architecture and sculpture. Four ornate, spiral-shaped columns support an upper platform; at its corners are statues of angels, and vigorously curved scrolls which raise high the symbol of the victory of Christianity over the pagan world, a cross above a golden orb. The entire structure is so alive with expressive energy that it strikes us as the very epitome of Baroque style. Yet its most astonishing feature, the corkscrew columns, had been invented in late antiquity, and even employed, on a much smaller scale, in the old basilica of St. Peter's; Bernini could claim the best possible precedent for his own use of the motif. Nor is this the only instance of an affinity between Baroque and ancient art: several monuments of Roman architecture of the second and third centuries A.D. seem to anticipate the style of the seventeenth (see figs. 232–35). A similar relationship can be discovered between Hellenistic and Baroque sculpture. If we compare Bernini's *David* (fig. 625) with Michelangelo's (see fig. 552), and ask which is closer to the Pergamum Frieze or the *Laocoön Group* (see figs. 190, 192), our vote must go to Bernini. His figure shares with the Hellenistic works that unison of body and spirit, of motion and emotion, which Michelangelo so conspicuously avoids. This

does not mean that Bernini is more classical than Michelangelo; it indicates, rather, that both the Baroque and the High Renaissance acknowledged the authority of ancient art, but each period drew inspiration from a different aspect of antiquity.

But Bernini's *David*, obviously, is in no sense an echo of the *Laocoön Group*. If we ask what makes it Baroque, the simplest answer would be: the implied presence of Goliath. Unlike earlier statues of David, Bernini's is conceived not as one self-contained figure but as "half of a pair," his entire action focused on his adversary. Did Bernini, we wonder, plan a statue of Goliath to complete the group? He never did, for his David tells us clearly enough where *he* sees the enemy. Consequently, the space between David and his invisible opponent is charged with energy: it "belongs" to the statue. If we stand directly in front of this formidable fighter, our first impulse is to get out of the line of fire.

Bernini's *David* shows us what distinguishes Baroque sculpture from the sculpture of the two preceding centuries: its new, active relationship with the space it inhabits. It eschews self-sufficiency for an illusion—the illusion of presences or forces that are implied by the behavior of the statue. Because it so often presents an "invisible complement" (like the Goliath of Bernini's *David*), Baroque sculpture has been denounced as a tour de force, attempting essentially pictorial effects that are outside its province. The accusation is pointless, for illusion is the basis of every artistic experience, and we cannot very well regard some kinds or degrees of illusion as less legitimate than others. It is true, however, that Baroque art acknowledges no sharp distinction between sculpture and painting. The two may enter into a symbiosis previously unknown, or, more precisely, both may be combined with architecture to form a compound illusion, like that of the stage. Bernini, who had a passionate interest in the theater, was at his best when he could merge architecture, sculpture, and painting in this fashion. His masterpiece is the Cornaro Chapel, containing the famous group called *The Ecstasy of St. Theresa* (fig. 626), in the church of Sta. Maria della Vittoria. Theresa of Avila, one of the great saints of the Counter Reformation, had described how an angel pierced her heart with a flaming golden arrow: "The pain was so great that I screamed aloud; but at the same time I felt such infinite sweetness that I wished the pain to last forever. It was not physical but psychic pain, although it affected the body as well to some degree. It was the sweetest caressing of the soul by God." Bernini has made this visionary experience as sensuously real as Correggio's *Jupiter and Io* (see fig. 583); the angel, in a different context, would be indistinguishable from Cupid, and the saint's ecstasy is palpably physical. Yet the two figures, on their floating cloud, are illuminated (from a hidden window above) in such a way as to seem almost dematerialized in their gleaming whiteness. The beholder experiences them as visionary. The "invisible comple-

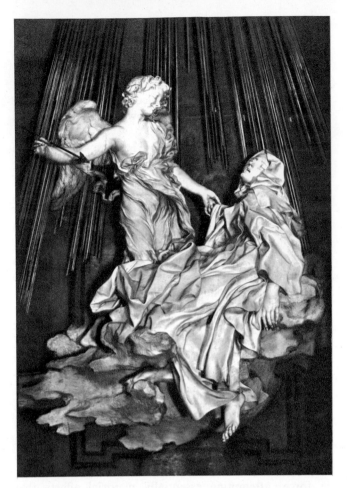

626. GIANLORENZO BERNINI.
The Ecstasy of St. Theresa. 1645–52. Marble, lifesize.
Cornaro Chapel, Sta. Maria della Vittoria, Rome

627. *The Cornaro Chapel.*
Eighteenth-century painting. Museum, Schwerin

ment" here, less specific than David's but equally important, is the force that carries the figures heavenward, causing the turbulence of their drapery. Its nature is suggested by the golden rays, which come from a source high above the altar: in an illusionistic fresco on the vault of the chapel, the glory of the heavens is revealed as a dazzling burst of light from which tumble clouds of jubilant angels (fig. 627). It is this celestial "explosion" that gives force to the thrusts of the angel's arrow and makes the ecstasy of the saint believable. To complete the illusion, Bernini even provides a built-in audience for his "stage": on the sides of the chapel are balconies resembling theater boxes, where we see marble figures—members of the Cornaro family—who also witness the Ecstasy. Their space and ours are the same, and thus part of everyday reality, while the Ecstasy, housed in a strongly framed niche, occupies a space that is real but beyond our reach. The ceiling fresco, finally, represents the infinite, unfathomable space of Heaven. We may recall that *The Burial of Count Orgaz* and its setting also form a whole embracing three levels of reality (see page 451); the reader will be able to analyze for himself the profound difference between Baroque and Mannerism by contrasting these two chapels.

Some years later Bernini created another compound display, on an even grander scale, in the choir of St. Peter's (fig. 624, far background, and fig. 628)—a climax for the visitor at the very end of the church. Again the focus is a burst of heavenly light (through a real window of stained glass) that propels a mass of clouds and angels toward us. These clouds envelop the bronze *Throne of St. Peter,* which hovers weightless in mid-air, anchored to the hands of the Four Fathers of the Church. And the interior decoration of Il Gesù is further evidence of Bernini's imaginative daring (fig. 629), although his role in this case was only advisory. The commission for the ceiling frescoes went to Giovanni Battista Gaulli, his young protégé; a talented assistant, Antonio Raggi, did the stucco sculpture. As we see the nave fresco spilling so dramatically over its frame, then turning into sculptured figures, it is clear that the plan must be Bernini's; here again we sense the spirit of the Cornaro Chapel. While designing the *Throne of St. Peter,* Bernini also conceived as "exterior decoration" the magnificent oval piazza in front of St. Peter's (see fig. 623). It acts as an immense atrium, framed by colonnades which the artist himself likened to the motherly, all-embracing arms of the Church. The basilica integrated with so grandiose a setting of "molded" open space can be compared, for sheer impressiveness, only with the ancient Roman sanctuary at Palestrina (see fig. 214).

Borromini

As a personality, Bernini represents a type we first met among the artists of the Early Renaissance—the self-assured, expansive man of the world. His great rival

Colorplate 72. ALBRECHT ALTDORFER. *The Battle of Issus.* 1529. Panel, 62 × 47″. Pinakothek, Munich

· ANNO · ETATIS · · SVÆ · XLIX ·

Colorplate 73. HANS HOLBEIN THE YOUNGER. *Henry VIII*. 1540.
Panel, 32 1/2 × 29″. National Gallery, Rome

Colorplate 74. PIETER BRUEGEL THE ELDER. *Peasant Wedding*. About 1565. Panel, 44 7/8 × 64". Kunsthistorisches Museum, Vienna

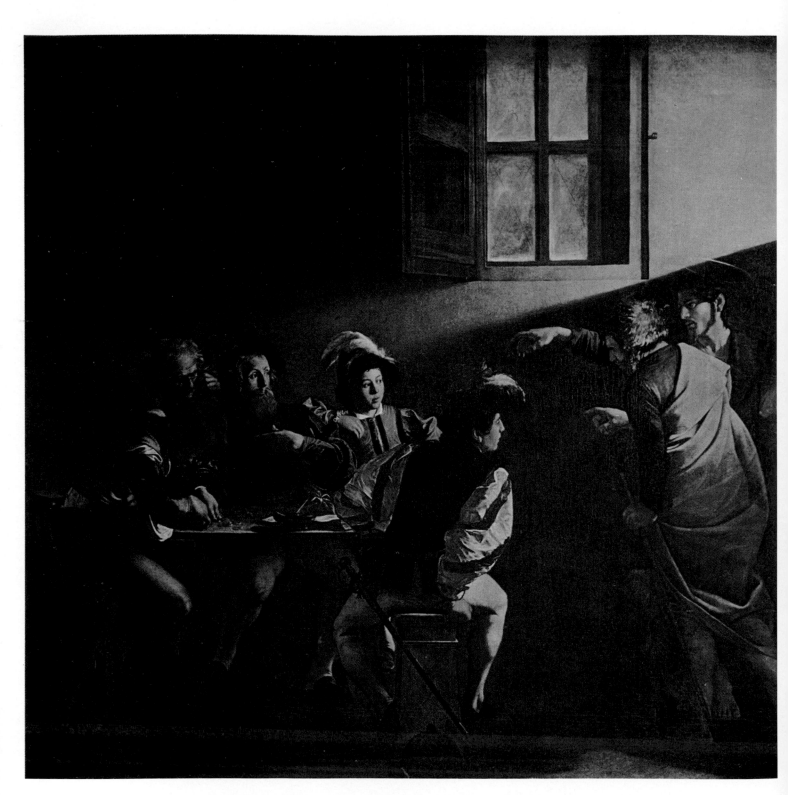

Colorplate 75. CARAVAGGIO. *The Calling of St. Matthew*. About 1597–98.
11′ 1″ × 11′ 5″. Contarelli Chapel, S. Luigi dei Francesi, Rome

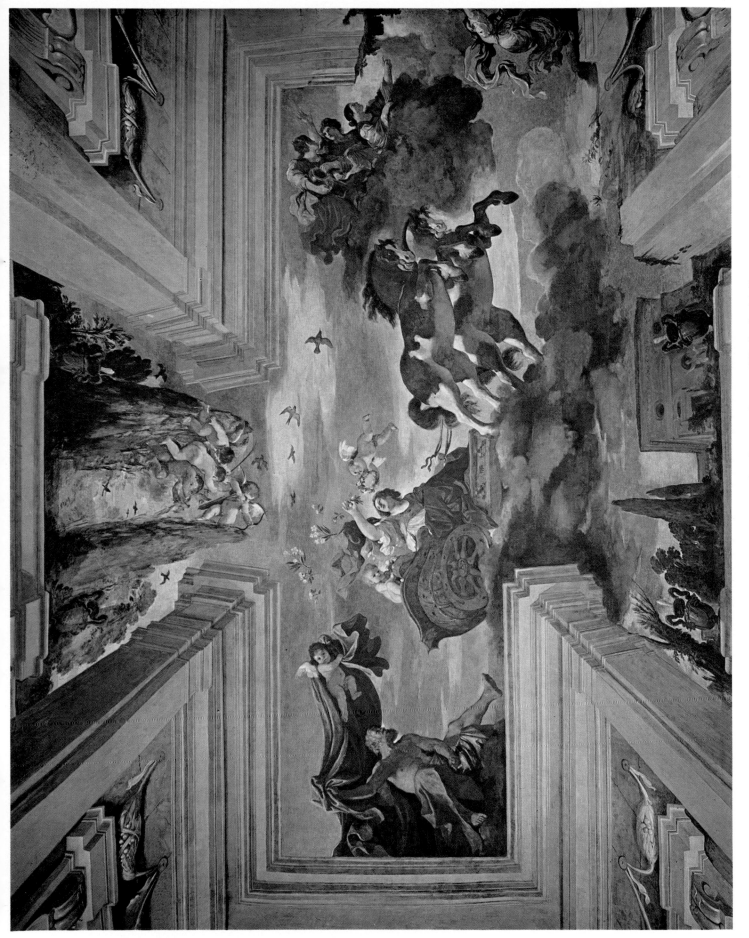

Colorplate 76. GUERCINO. *Aurora*. Ceiling fresco. 1621–23. Villa Ludovisi, Rome

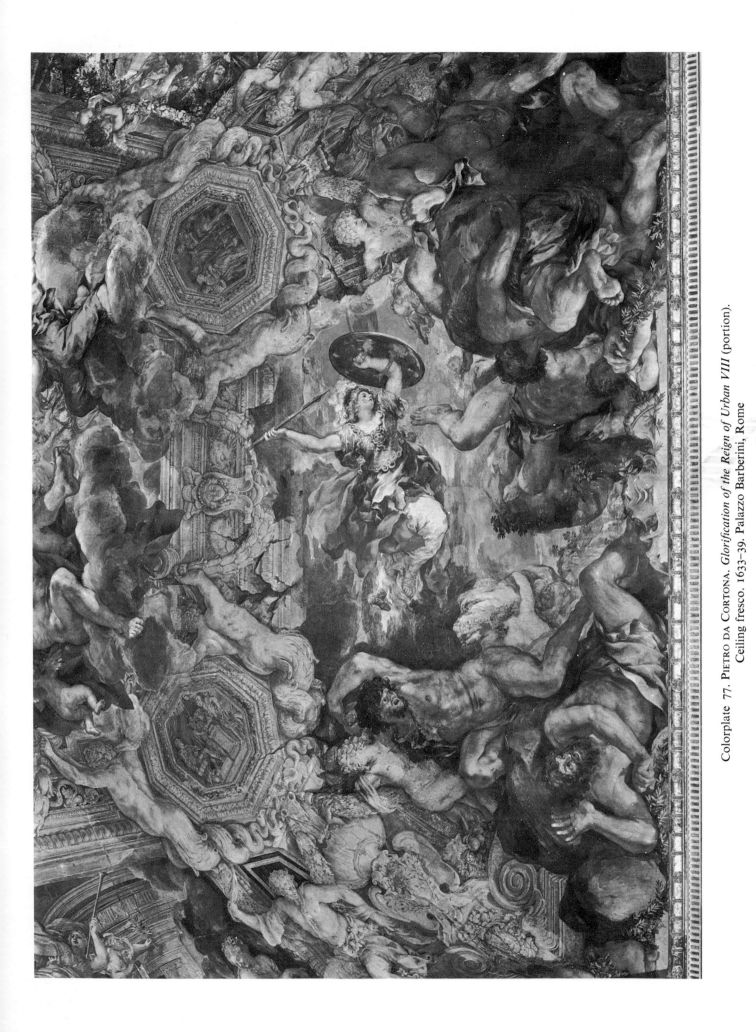

Colorplate 77. PIETRO DA CORTONA. *Glorification of the Reign of Urban VIII* (portion).
Ceiling fresco. 1633–39. Palazzo Barberini, Rome

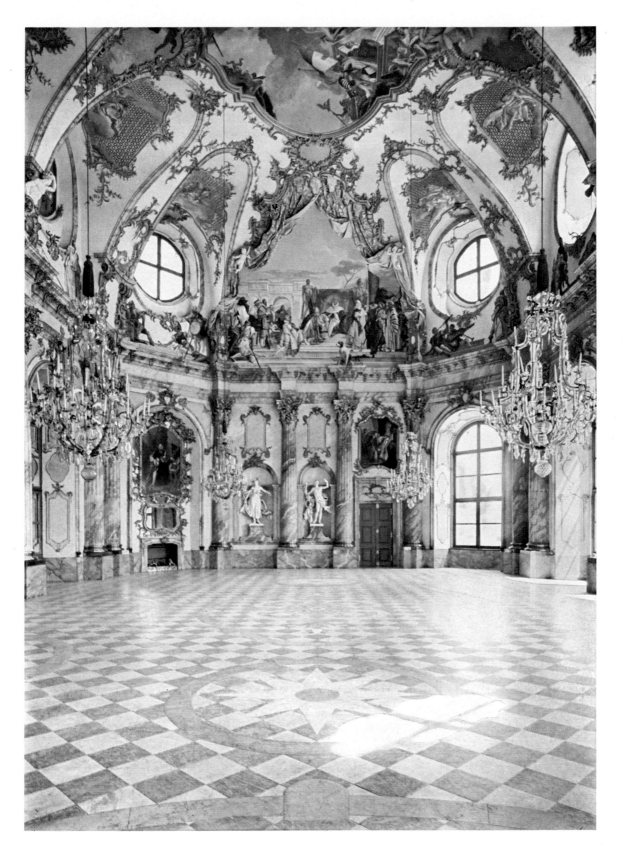

Colorplate 78. BALTHASAR NEUMANN. The Kaisersaal,
Episcopal Palace, Würzburg. 1719–44 (frescoes by GIOVANNI BATTISTA TIEPOLO, 1751)

Colorplate 79. Peter Paul Rubens. *The Garden of Love*. About 1632–34. 6′ 6″ × 9′ 3¹/₂″. The Prado, Madrid

in architecture, Francesco Borromini (1599–1667), was the opposite type: a secretive and emotionally unstable genius, he died by suicide. The temperamental contrast between the two would be evident from their works alone, even without the testimony of contemporary witnesses. Both exemplify the climax of Baroque architecture in Rome, yet Bernini's design for the colonnade of St. Peter's is dramatically simple and unified, while Borromini's structures are extravagantly complex. Bernini himself agreed with those who denounced Borromini for flagrantly disregarding the classical tradition, enshrined in Renaissance theory and practice, that architecture must reflect the proportions of the human body. We understand this accusation when we look at Borromini's first major project, the church of S. Carlo alle Quattro Fontane (figs. 630–32). The vocabulary is not unfamiliar, but the syntax is new and disquieting; the ceaseless play of concave and convex surfaces makes the entire structure seem elastic, "pulled out of shape" by pressures that no previous building could have withstood. The plan is a pinched oval suggesting a distended and half-melted Greek cross, as if it had been drawn on rubber; the inside of the dome, too, looks "stretched"—if the tension were relaxed, it would snap back to normal. The façade was designed almost thirty years later, and the pressures and counterpressures here reach their maximum intensity. Borromini merges architecture and sculpture in a way that must have shocked Bernini; no such fusion had been ventured since Gothic art.

S. Carlo alle Quattro Fontane established Borromini's local and international fame. "Nothing similar," wrote the head of the religious order for which the church was

628. GIANLORENZO BERNINI.
Throne of St. Peter. 1657–66. Gilt bronze, marble, and stucco. Apse, St. Peter's, Rome

629. GIOVANNI BATTISTA GAULLI.
Triumph of the Name of Jesus
(ceiling fresco).
1672–85. Il Gesù, Rome

630. FRANCESCO BORROMINI.
Plan of S. Carlo alle
Quattro Fontane, Rome.
Begun 1638

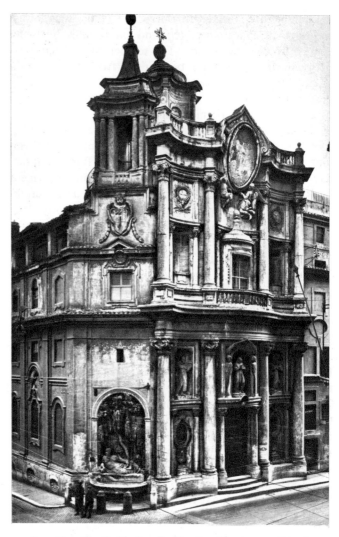

632. Façade, S. Carlo alle Quattro Fontane. 1665–67

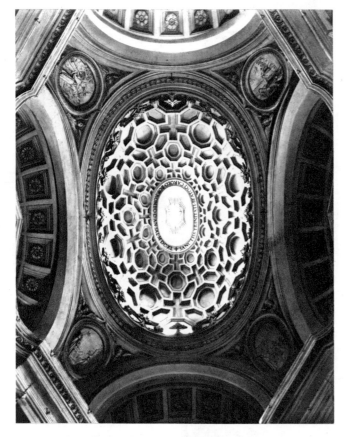

631. Dome, S. Carlo alle Quattro Fontane

built, "can be found anywhere in the world. This is attested by the foreigners who . . . try to procure copies of the plan. We have been asked for them by Germans, Flemings, Frenchmen, Italians, Spaniards, and even Indians. . . ." The design of Borromini's next church, S. Ivo (figs. 633, 634), is more compact and equally daring. Its plan, a star-hexagon, belongs unequivocally to the central type; Borromini may have been thinking of octagonal structures such as S. Vitale, Ravenna (compare figs. 282–85). But he did not subdivide the space into a tall, domed "nave" ringed by an ambulatory or chapels; he covered all of it with one great dome, continuing the star-hexagon pattern up to the circular base of the lantern. Again the concave-convex rhythm dominates the

entire design—the structure might almost be described as a larger version of the Temple of Venus at Baalbek, turned inside out (figs. 233, 234). A third project by Borromini is of special interest as a High Baroque critique of St. Peter's. Maderno had found one problem insoluble: although his new façade forms an impressive unit with Michelangelo's dome when seen from a distance, the dome is gradually hidden by the façade as we approach the church. Borromini designed the façade of S. Agnese in Piazza Navona (fig. 635) with this conflict in mind. Its lower part is adapted from the façade of St. Peter's, but curves inward, so that the dome—a tall, slender version of Michelangelo's—functions as the upper part of the façade. The dramatic juxtaposition of concave and convex, always characteristic of Borromini, is further emphasized by the two towers (such towers were also once planned for St. Peter's), which form a monumental triad with the dome. Once again Borromini joins Gothic and Renaissance features—the two-tower façade and the dome—into a remarkably "elastic" compound.

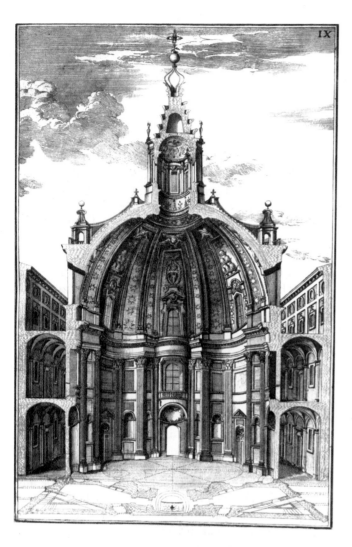

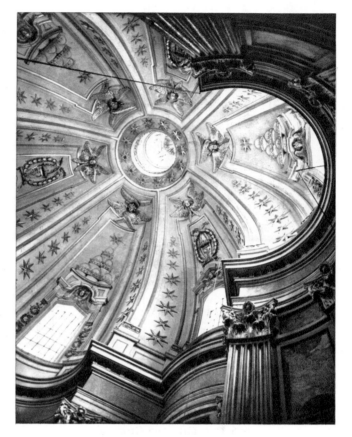

left: 633. FRANCESCO BORROMINI.
Section, S. Ivo, Rome. Begun 1642

below: 634. Dome, S. Ivo

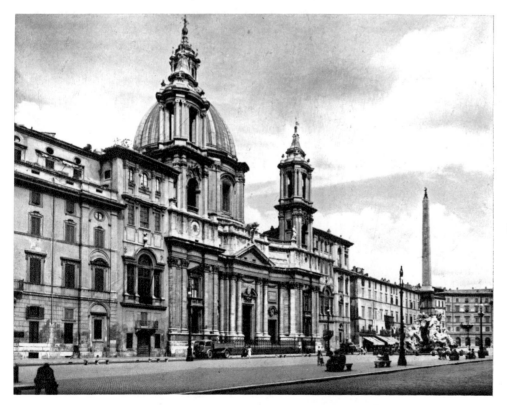

635. FRANCESCO BORROMINI.
S. Agnese in Piazza Navona,
Rome. 1653–63

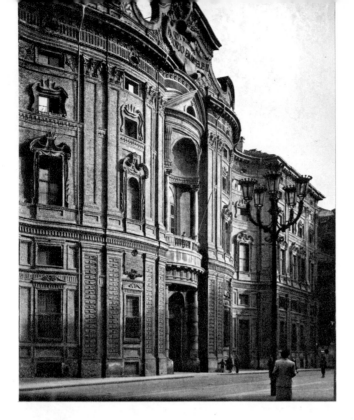

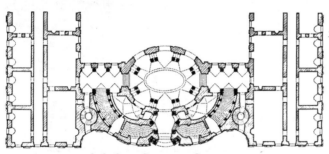

636, 637. GUARINO GUARINI.
Façade and Plan of Palazzo Carignano,
Turin. Begun 1679

The wealth of new ideas that Borromini introduced was to be exploited not in Rome but in Turin, the capital of Savoy, which became the creative center of Baroque architecture in Italy toward the end of the seventeenth century. In 1666, that city attracted Borromini's most brilliant successor, Guarino Guarini (1624–83), a Theatine monk whose architectural genius was deeply grounded in philosophy and mathematics. His design for the façade of Palazzo Carignano (figs. 636, 637) repeats on a larger scale the undulating movement of S. Carlo alle Quattro Fontane (see fig. 632), using a highly individual vocabulary. Incredibly, the exterior of the building is entirely of brick, down to the last ornamental detail. Still more extraordinary is Guarini's dome of the Chapel of the Holy Shroud—a round structure attached to the Cathedral (figs. 639, 640). The tall drum, with alternating windows and tabernacles, consists of familiar Borrominesque motifs, but beyond it we enter a realm of pure illusion. The interior surface of the dome of S. Carlo alle Quattro Fontane, though dematerialized by light and the honeycomb of fanciful coffers, was still recognizable (see fig. 631); but here the surface has disappeared completely in a maze of segmental ribs, and we find ourselves staring into a huge kaleidoscope. Above this seemingly endless funnel of space hovers the dove of the Holy Spirit within a bright, twelve-pointed star. So far as we know, there is only one similar dome anywhere in the history of art: that of the Ulu Mosque at Erzurum in Turkish Armenia, built about 1150 (fig. 638). How could Guarini have known about it? Or did he recapture its effect entirely by coincidence? Guarini's dome retains an old symbolic meaning, that of the Dome of Heaven (see page 403, figs. 522–24). But the objective harmony of the Renaissance has here become subjective,

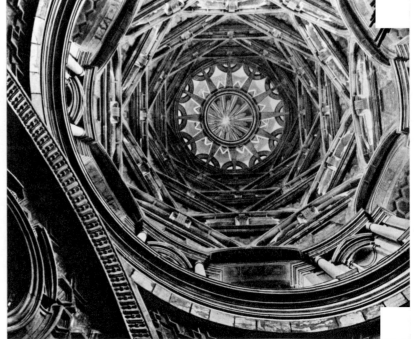

above: 638. Wooden Dome of the Ulu Mosque, Erzurum. Seljuk, c. 1150

right: 639. GUARINO GUARINI. Dome, Chapel of the Holy Shroud, Cathedral, Turin. 1668–94

a compelling experience of the infinite. If Borromini's style at times suggested a synthesis of Gothic and Renaissance, Guarini takes the next, decisive step; in his theoretical writings, he contrasts the "muscular" architecture of the ancients with the opposite effect of Gothic churches—which appear to stand only by means of some kind of miracle—and he expresses equal admiration for both. This attitude corresponds exactly to his own practice; by using the most advanced mathematical techniques of his day, he achieved architectural miracles even greater than those of the seemingly weightless Gothic structures.

AUSTRIA; SOUTH GERMANY

It is not surprising that the style invented by Borromini and furthered by Guarini should achieve its climax north of the Alps, in Austria and Southern Germany, where such a synthesis of Gothic and Renaissance was sure of a particularly warm response. In these countries, ravaged by the Thirty Years' War, the number of buildings remained small until near the end of the seventeenth century; Baroque was an imported style, practiced mainly by visiting Italians. Not until the 1690s did native designers come to the fore. There followed a period of intense activity that lasted more than fifty years and gave rise to some of the most imaginative creations in the history of architecture. We must be content with a small sampling of these monuments, erected for the glorification of princes and prelates who, generally speaking, deserve to be remembered only as lavish patrons of the arts. Johann Fischer von Erlach (1656–1723), the first great architect of the Late Baroque in Central Europe, is linked most directly to the Italian tradition. His

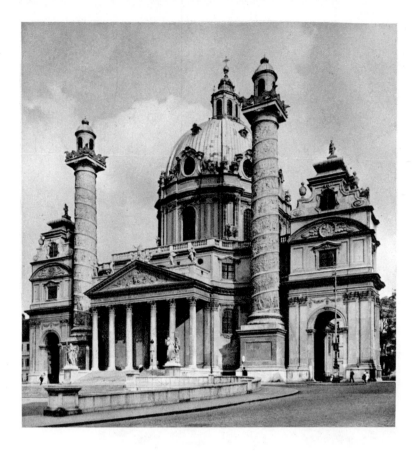

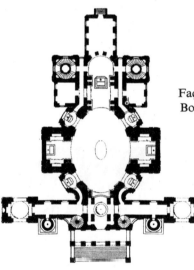

641, 642. JOHANN FISCHER VON ERLACH. Façade and Plan of St. Charles Borromaeus, Vienna. 1716–37

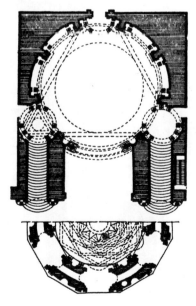

640. Plan of the Chapel of the Holy Shroud, and (below) of the Dome

design for the church of St. Charles Borromaeus in Vienna (figs. 641, 642) combines the façade of Borromini's S. Agnese, and the Pantheon portico (see fig. 221), with a pair of huge columns derived from the Column of Trajan (see fig. 248) which here substitute for façade towers. (The actual façade towers have become corner pavilions, reminiscent of the Louvre court—compare fig. 615.) With these inflexible elements of Roman Imperial art embedded into the elastic curvatures of his church, Fischer von Erlach expresses, more boldly than any Italian Baroque architect, the power of the Christian faith to absorb and transfigure the splendors of antiquity.

Even more monumental, thanks to its superb site, is the Monastery of Melk (fig. 643), by Jakob Prandtauer. The buildings form a tightly knit unit that centers on the church: it occupies the crest of a promontory above the Danube, rising from the rock, not like a fortress but like a vision of heavenly glory. The interior of the church (fig. 644) still reflects the plan of Il Gesù, but the abundant illumination, the play of curves and countercurves, and the weightless grace of the stucco sculpture, give it an airy lightness far removed from the Roman Baroque. The vaults and wall surfaces seem thin and pliable, like membranes easily punctured by the expansive power of space. This tendency is carried even further by the architects of the next generation, among whom Balthasar Neumann (1687–1753) was the most prominent. His largest project, the Episcopal Palace in Würzburg, includes the breath-taking Kaisersaal (colorplate 78), a great oval hall decorated in white, gold, and pastel shades—the favorite color scheme of the mid-eighteenth century. Structural members such as columns, pilasters, architraves are now minimized; windows and vault segments are framed by continuous, ribbon-like moldings, and the white surfaces are spun over with irregular ornamental designs. This repertory of lacy, curling motifs, invented in France about 1700, is the hallmark of the Rococo style (see page 539), which is here happily combined with German Late Baroque architecture. The membrane-like ceiling so often gives way to illusionistic openings of every sort that we no longer feel it to be a spatial boundary. These openings do not, however, reveal avalanches of figures propelled by dramatic bursts of light, like those of Roman ceilings (compare fig. 629),

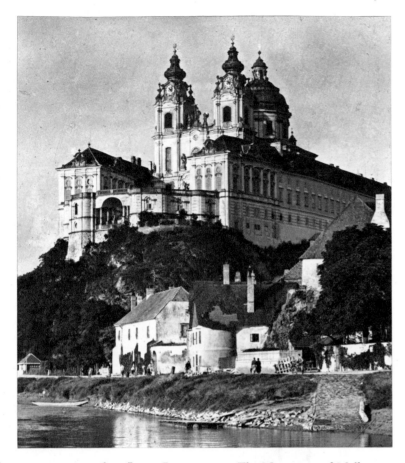

643. JAKOB PRANDTAUER. The Monastery of Melk,
Austria. Begun 1702

644. PRANDTAUER, BEDUZZI,
and MUNGGENAST. Interior,
Monastery Church,
Melk. Completed c.1738

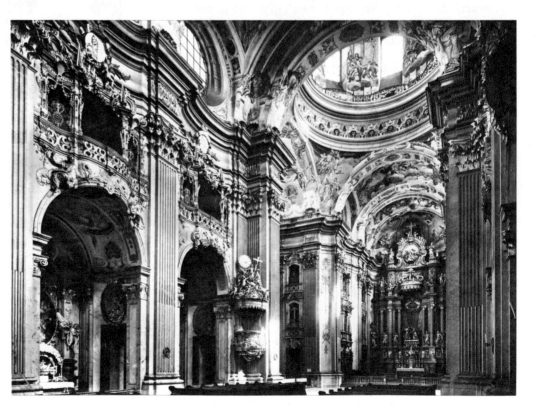

645. GIOVANNI BATTISTA TIEPOLO. Ceiling Fresco
of the Kaisersaal (detail; see colorplate 78).
1751. Episcopal Palace, Würzburg

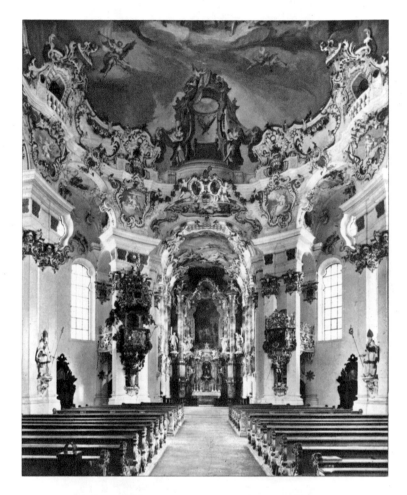

but blue sky and sunlit clouds, and an occasional winged
creature soaring in this limitless expanse. Only along the
edges are there solid clusters of figures (fig. 645). Here
the last, and most refined, stage of illusionistic ceiling
decoration is represented by its greatest master, Gio-
vanni Battista Tiepolo (1696–1770). Venetian by birth
and training, Tiepolo blended the tradition of High Ba-
roque illusionism with the pageantry of Veronese. His
mastery of light and color, the grace and felicity of his
touch, made him famous far beyond his home territory.
In the Würzburg frescoes his powers are at their height.
He was afterward invited to decorate the Royal Palace
in Madrid, where he spent his final years.

A contemporary of Balthasar Neumann, Dominikus
Zimmermann, created what may be the finest spatial de-
sign of the mid-eighteenth century, the Bavarian pilgrim-
age church nicknamed "Die Wies" (figs. 646, 647). The
exterior is so plain that its interior richness seems truly
overwhelming. Like the Kaisersaal, its shape is oval, but
since the ceiling rests on paired, free-standing supports,
the spatial configuration is more complex and fluid;
despite the playful Rococo décor, we are reminded of a
German Gothic *Hallenkirche* (see fig. 405). Here at last
Guarini's prophetic revaluation of Gothic architecture
has become reality.

646, 647. DOMINIKUS ZIMMERMANN.
Interior and Plan of Die Wies,
Upper Bavaria. 1745–54

FLANDERS

HOLLAND

SPAIN

7

THE BAROQUE
IN FLANDERS, HOLLAND,
AND SPAIN

FLANDERS

Rubens

Although Rome was its birthplace, the Baroque style soon became international. Among the artists who helped bring this about, the great Flemish painter Peter Paul Rubens (1577–1640) holds a place of unique importance. It might be said that he finished what Dürer had started a hundred years earlier—the breakdown of the artistic barriers between North and South. Rubens' father was a prominent Antwerp Protestant who fled to Germany to escape Spanish persecution during the war of independence (see page 476); the family returned to Antwerp after his death, when Peter Paul was ten years old, and the boy grew up a devout Catholic. Trained by local painters, Rubens became a master in 1598, but developed a personal style only when, two years later, he went to Italy. During his eight years in the South, he eagerly studied ancient sculpture, the masterpieces of the High Renaissance (see his splendid drawing after Leonardo's *Battle of Anghiari*, fig. 543), and the work of Caravaggio and Annibale Carracci, absorbing the Italian tradition far more thoroughly than had any Northerner before him. He competed, in fact, with the best Italians of his day on even terms, and could well have made his career in Italy—a choice not open to earlier Northern painters. When his mother's illness in 1608 brought him back to Flanders, he meant the visit to be brief. But he received a special appointment as court painter to the Spanish regent, which permitted him to establish a workshop in Antwerp, exempt from local taxes and guild regulations. Rubens thus had the best of both worlds for he was valued at court not only as an artist, but as a confidential adviser and emissary. Diplomatic errands gave him entree to the royal households of the major

powers, where he procured sales and commissions, while he was also free to carry out, aided by a growing number of assistants, a vast volume of work for the city of Antwerp, for the Church, and for private patrons.

The Raising of the Cross (fig. 648), the first major altarpiece Rubens produced after his return, shows strikingly how much he owed to Italian art. The muscular figures, modeled to display their physical power and passionate feeling, recall the Sistine Ceiling and the Farnese Gallery; the lighting suggests Caravaggio's. The panel is more heroic in scale and conception than any previous Northern work, yet Rubens is also a meticulous Flemish realist in such details as the foliage, the armor of the soldier, and the curly-haired dog in the foreground. These varied elements, integrated with sovereign mastery, form a composition of tremendous dramatic force. The unstable pyramid of bodies, swaying precariously, bursts the limits of the frame in a characteristically Baroque way, making the beholder feel that he, too, participates in the action. In the decade of the 1620s, Rubens' dynamic style reached its climax in his huge decorative schemes for churches and palaces. The most famous, probably, is the cycle in the Luxembourg Palace in Paris, glorifying the career of Marie de'Medici, the widow of Henri IV and mother of Louis XIII. Our illustration shows the artist's oil sketch for one episode, the young queen landing in Marseilles (fig. 649). Hardly an exciting subject—yet Rubens has turned it into a spectacle of unprecedented splendor. As Marie de'Medici walks down the gangplank, Fame flies overhead sounding a triumphant blast on two trumpets, and Neptune rises from the sea with his fish-tailed crew; having guarded the queen's journey, they rejoice at her arrival. Everything flows together here in swirling movement: heaven and earth, history and allegory—even drawing and painting, for Rubens used oil sketches like this one to prepare his compositions. Unlike earlier artists, he preferred to design his pictures

648. PETER PAUL RUBENS. *The Raising of the Cross.*
1609–10. Panel, 15′ 2″ × 11′ 2″. Antwerp Cathedral

married a beautiful girl of sixteen (his first wife died in 1626). He also bought a country house, the Château of Steen, and led the leisurely life of a squire. This change induced a renewed interest in landscape painting, which he had practiced only intermittently before. Here, too, the power of his genius is undiminished. In the *Landscape with the Château of Steen* (fig. 650), a magnificent open space sweeps from the hunter and his prey in the foreground to the mist-veiled hills along the horizon. As a landscapist, Rubens is the heir of both Pieter Bruegel and Annibale Carracci (compare figs. 610, 622), again creating a synthesis from his Northern and Southern sources.

Van Dyck

Besides Rubens, only one Flemish Baroque artist won international stature. Anthony van Dyck (1599–1641) was that rarity among painters, an infant prodigy. Before he was twenty, he had become Rubens' most valued assistant. But he lacked the older master's vitality and inventiveness, and his fame is based mainly on his portraits, especially those he painted in England as court painter to Charles I, during 1632–41. Among the most attractive is *Charles I Hunting* (fig. 651), in which the king stands next to a horse and two grooms against a landscape backdrop. Representing the sovereign at ease, it might be called a "dismounted equestrian portrait"—less rigid than a formal state portrait, but hardly less grand. The fluid Baroque movement of the setting contrasts

in terms of light and color from the very start (most of his drawings are figure studies or portrait sketches). This unified vision, adumbrated but never fully achieved by the great Venetians, was Rubens' most precious legacy to subsequent painters.

Around 1630, the turbulent drama of Rubens' preceding work changes to a late style of lyrical tenderness inspired by Titian, whom Rubens rediscovered, as it were, in the royal palace while he visited Madrid. *The Garden of Love* (colorplate 79) is one beautiful result of this encounter, as glowing a tribute to the pleasures of life as Titian's *Bacchanal* (see colorplate 63). But these celebrants belong to the present, not to a golden age of the past, even though they are playfully assaulted by swarms of cupids. To understand the artist's purpose, we must first realize that this subject, the Garden of Love, had been a feature of Northern painting ever since the courtly style of the International Gothic. The early versions, however, merely showed groups of fashionable young lovers in a garden—they were genre scenes pure and simple. By combining this tradition with Titian's classical mythologies, Rubens has created an enchanted realm where myth and reality become one. The picture must have had special meaning for him, since he had just

649. PETER PAUL RUBENS. *Marie de'Medici,
Queen of France, Landing in Marseilles.* 1622–23.
Panel, 25 × 19 3/4″. Pinakothek, Munich

650. PETER PAUL RUBENS. *Landscape with the Château of Steen.* 1636. Panel, 53 × 93". The National Gallery, London

oddly with the self-conscious elegance of the king's pose, which still suggests the stylized grace of Elizabethan portraits (compare fig. 608). Van Dyck has brought the Mannerist court portrait up-to-date, rephrasing it in the pictorial language of Rubens and Titian. He created a new aristocratic portrait tradition that continued in England until the late eighteenth century, and had considerable influence on the continent as well.

HOLLAND

In contrast to Flanders, where all of art was overshadowed by the majestic personality of Rubens, Holland produced a bewildering variety of masters and styles. The new nation was proud of its hard-won freedom. Though the cultural links with Flanders remained strong, several factors encouraged the quick development of Dutch artistic traditions. Unlike Flanders, where all artistic activity radiated from Antwerp, Holland had a number of flourishing local schools; besides Amsterdam, the commercial capital, we find important groups of painters in Haarlem, Utrecht, Leyden, Delft, and other towns. Holland was a nation of merchants, farmers, and seafarers, and its religion the Reformed Protestant faith; Dutch artists had not the large-scale public commissions sponsored by State and Church that were available throughout the Catholic world. While municipal authorities and civic bodies provided a certain amount of art patronage, their demands were limited, so that the private collector now became the painter's chief source

651. ANTHONY VAN DYCK. *Portrait of Charles I Hunting.* c. 1635. 107 × 83 1/2". The Louvre, Paris

652. HENDRICK TERBRUGGHEN. *The Calling of St. Matthew.* 1621. 40 × 54". Centraal Museum, Utrecht

of support. This condition had already existed to some extent before (see page 476), but its full effect can be seen only after 1600. There was no shrinkage of output; on the contrary, the general public developed so insatiable an appetite for pictures that the whole country became gripped by a kind of collector's mania. John Evelyn, during a visit to Holland in 1641, noted in his diary that "it is an ordinary thing to find a common farmer lay out two or three thousand pounds in this commodity. Their houses are full of them, and they vend them at their fairs to very great gain." Pictures had indeed become a commodity, and their trade followed the law of supply and demand. Many artists produced "for the market" rather than for individual patrons. The mechanism of the market has been said to raise a barrier between artist and public, and to degrade or falsify the "true worth" of the work of art. Such charges, however, are unrealistic: the true worth of a work of art is always unstable, and depends on time and circumstance (see our introductory remarks, page 10); even those who believe in timeless values in art will concede that these values cannot be expressed in money. Because the art market reflects the dominant, rather than the most discerning, taste of the moment, works by artists now regarded as mediocre may once have been overpriced; others, highly valued today, seem once to have sold too cheaply. Yet the system in antiquity and the Middle Ages, when artists were paid on standards of craftsmanship, was hardly fairer in rewarding aesthetic merit (except, perhaps, for Alexander the Great, who is said to have ceded his mistress to the painter Apelles as a token of appreciation). The market does form a barrier between artist and patron, but there are advantages in this as well as drawbacks. To subject the artist to the impersonal

pressure of supply and demand in an egalitarian society is not necessarily worse than to make him depend on the favor of princes. The lesser men will tend to become specialists, steadily producing their marketable pictures, while artists of independent spirit, perhaps braving public indifference and economic hardship, will paint as they please and rely for support on the discerning minority. The collector's mania in seventeenth-century Holland caused an outpouring of artistic talent comparable only to Early Renaissance Florence, although many Dutchmen were lured into becoming painters by hopes of success that failed to come true. Even the greatest masters were sometimes hard-pressed (it was not unusual for an artist to keep an inn, or run a small business on the side). Yet they survived—less secure, but freer.

The Baroque style came to Holland from Antwerp, through the work of Rubens, and from Rome, through direct contact with Caravaggio and his followers. Although most Dutch painters did not go to Italy, in the early years of the century there were some who did, principally from Utrecht, a town with strong Catholic traditions. It is not surprising that these artists were more attracted by Caravaggio's realism and "lay Christianity" than by Annibale Carracci's classicism. *The Calling of St. Matthew* by Hendrick Terbrugghen (1588–1629), the oldest of this group (fig. 652), directly reflects Caravaggio's earlier version (colorplate 75): the sharp light, the dramatic timing, and the everyday detail. While the Utrecht School produced no great artists, its members were important for transmitting the style of Caravaggio to other Dutch masters who then made better use of these new Italian ideas.

Hals

One of the first to profit from this experience was Frans Hals (1580/85–1666), the great portrait painter of Haarlem. He was born in Antwerp, and what little is known of his early work suggests the influence of Rubens. His developed style, however, seen in such pictures as *The Jolly Toper* (colorplate 80), combines Rubens' robustness and breadth with a concentration on the "dramatic moment" that must be derived, via Utrecht, from Caravaggio. Everything here conveys complete spontaneity: the twinkling eyes and half-open mouth, the raised hand, the teetering wineglass, and—most important of all—the quick way of setting down the forms. Hals works in dashing brush strokes, each so clearly visible as a separate entity that we can almost count the total number of "touches." With this open, split-second technique, the completed picture has the immediacy of a sketch (compare that by Rubens, fig. 649). The impression of a race against time is, of course, deceptive; Frans Hals spent hours, not minutes, on this lifesize canvas, but he maintains the illusion of having done it in the wink of an eye. These qualities are even more forceful in the *Malle Babbe* (fig. 653), one of the artist's genre pictures. A lower-class

counterpart of *The Jolly Toper,* this folk character, half witch (note the owl), half village idiot, screams invective at other guests in a tavern. Hals seems to share their attitude toward this benighted creature—one of cruel amusement rather than sympathy—but his characterization is masterfully sharp and his lightning-like brushwork has the bravura of incredible skill. In the artist's last canvases these pictorial fireworks are transmuted into an austere style of great emotional depth. His group portrait, *The Women Regents of the Old Men's Home at Haarlem* (fig. 654), the institution where he spent his final years, has an insight into human character matched only in Rembrandt's late style (compare figs. 659, 660). The daily experience of suffering and death has so etched the faces of these women that they seem themselves to have become images of death—gentle, inexorable, and timeless.

Rembrandt

Rembrandt (1606–69), the greatest genius of Dutch art, was also stimulated at the beginning of his career by indirect contact with Caravaggio. His earliest pictures, from his Leyden period (1625–31), are small, sharply lit, and intensely realistic; many, such as *Tobit and Anna with*

653. FRANS HALS. *Malle Babbe.* c. 1650. 29 ¹/₂ × 25″. State Museums, Berlin-Dahlem

654. FRANS HALS. *The Women Regents of the Old Men's Home at Haarlem.* 1664. 67 × 98″. Frans Hals Museum, Haarlem

655. REMBRANDT. *Tobit and Anna with the Kid*. 1626. Panel,
15 1/2 × 11 3/4". Collection Baroness Thyssen-Bornemisza, Lucerne

the Kid (fig. 655), deal with Old Testament subjects—a life-
long preference of the artist's. Even this little panel, filled
with the homely detail of peasant life, has qualities that
distinguish Rembrandt's from earlier Old Testament
scenes; it shows not only his greater realism but his new
emotional attitude. Since the beginning of Christian art,
episodes from the Old Testament had often been repre-
sented for the light they shed on Christian doctrine (the
Sacrifice of Isaac, for example, "prefigured" the sacrificial
death of Christ), rather than for their own sake. This per-
spective not only limited the choice of subjects, it also
colored their interpretation. Rembrandt, by contrast,
viewed the stories of the Old Testament in the same lay
Christian spirit that governed Caravaggio's approach
to the New Testament: as direct accounts of God's ways
with men. How deeply they moved him is evident from
the touching relationship he has created between the
blind Tobit and his wife.

Ten years later, in *The Blinding of Samson* (fig. 656),
Rembrandt had developed a full-blown High Baroque
style. He here visualizes the Old Testament as a world of
oriental splendor and violence, cruel yet seductive. The
sudden flood of brilliant light pouring into the dark tent
is unabashedly theatrical, heightening the drama. Rem-
brandt was at this time an avid collector of Near Eastern
paraphernalia, which serve as props in these pictures. He
was now Amsterdam's most sought-after portrait painter
and a man of considerable wealth. This prosperity petered

out in the 1640s; the turning point may have been his
famous group portrait known as *The Night Watch*
(fig. 657). The huge canvas—originally it was even larger
—shows a military company, whose members had each
contributed toward the cost. But Rembrandt did not do
them equal justice. Anxious to avoid a mechanically
regular design, he made the picture a virtuoso perfor-
mance of Baroque movement and lighting; in the process,
some of the figures were plunged into shadow, some hidden
by overlapping. Legend has it that the people whose por-
traits he had thus obscured were dissatisfied. There is
no evidence that they were; we do know, however, that
the painting was admired even then as a work of art.

Like Michelangelo, Rembrandt has been the subject
(one might say, the victim) of many fictionalized biog-
raphies. In these, the artist's fall from public favor is
usually explained by the "catastrophe" of *The Night
Watch*. Actually, his fortunes declined after 1642 less
suddenly and completely than his romantic admirers
would have us believe. Certain important people in
Amsterdam continued to be his steadfast friends and
supporters, and he received some major public com-
missions in the 1650s and 1660s; his financial difficulties
resulted largely from poor management. Nevertheless,
the years after 1642 were a period of crisis, of inner un-
certainty and external troubles. Rembrandt's outlook
changed profoundly: after about 1650, his style eschews
the rhetoric of the High Baroque for lyric subtlety and
pictorial breadth. Such pictures as *Jacob Blessing the
Sons of Joseph* (colorplate 81) show this new depth of
feeling. Some exotic trappings from the earlier years
remain, but they no longer create an alien, barbarous
world. The golden light filtering from behind the curtain
on the left seems as gentle as the gestures and glances. So
pervasive is the mood of tender silence that the beholder,
watching from the foot of the bed, senses a spontaneous
kinship with this family group—our bond of shared ex-
perience is stronger and more intimate here than in any
earlier work of art.

In his later years, Rembrandt often adapted, in a high-
ly personal way, compositions or pictorial ideas from the
Northern Renaissance: one instance is *The Polish Rider*
(fig. 658). We cannot be sure that the rider is Polish—the
title was given to him later—although his costume is of
the kind worn by the local troops then fighting the Turks
in eastern Europe; nor is Rembrandt's exact meaning
clear. But Dürer's famous engraving, *Knight, Death, and
Devil* (see fig. 603), which Rembrandt surely admired,
may be the key to the picture. Is not *The Polish Rider*
another Christian Soldier bravely making his way through
a perilous world? The dangers in this case are ours to
imagine in the gloomy landscape, but the rider's serious,
alert glance suggests unseen threats. With such a rela-
tionship of form and content, the differences between
the painting and the print make a rewarding study.
Dürer's horseman, boxed into the composition, is
balanced and stationary like an equestrian statue; Rem-

656. REMBRANDT. *The Blinding of Samson*. 1636. 7′ 9″ × 9′ 11″. Staedel Institute, Frankfort

657. REMBRANDT. *The Night Watch (The Company of Captain Frans Banning Cocq)*.
1642. 12′ 2″ × 14′ 7″. Rijksmuseum, Amsterdam

658. REMBRANDT. *The Polish Rider*. c. 1655. 46 × 53″.
The Frick Collection, New York (Copyright)

659. REMBRANDT. *Self-Portrait*. c. 1660.
45 × 38″. The Iveagh Bequest, Kenwood, London

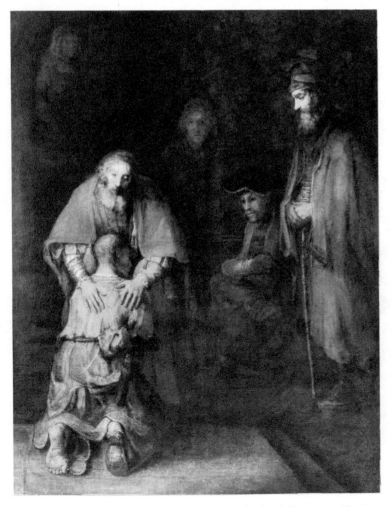

660. REMBRANDT. *The Return of the Prodigal Son*. c. 1665.
8′ 8″ × 6′ 7 ³/₄″. Hermitage Museum, Leningrad

brandt's, slightly foreshortened and off-center, is in motion—urged on, as it were, by the light from the left. The curving path he follows will soon lead him beyond the frame. This subtle imbalance implies a space far vaster than the compass of the picture and stamps Rembrandt's work as Baroque, despite the absence of the more obvious hallmarks of the style. The same is true of the *Self-Portrait* (fig. 659); in the sixty-odd the artist produced during a long career, his view of himself reflects every stage of his inner development—experimental in the Leyden years; theatrically disguised in the 1630s; frank and self-analytical toward the end of his life, as in our example, yet full of simple dignity.

The Return of the Prodigal Son (fig. 660), painted a few years before his death, is perhaps Rembrandt's most moving religious picture. It is also his quietest—a moment stretching into eternity. The sensuous beauty seen in *Jacob Blessing the Sons of Joseph* has now yielded to a humble world of bare feet and ragged clothes, recalling the *Tobit and Anna* painted four decades before. This feeling for the poor and outcast had never disappeared entirely from Rembrandt's work, although during his middle years it survived in his drawings and prints rather than in his paintings. He had a special sympathy for the Jews, as the heirs of the biblical past and as the patient victims of persecution; they were often his models, and among his prints are scenes such as *Christ Preaching* (fig. 661) that seem to take place in

661. REMBRANDT. *Christ Preaching*. c. 1652. Etching.
The Metropolitan Museum of Art, New York (Bequest of Mrs. H. O. Havemeyer, 1929)

some corner of the Amsterdam ghetto. *The Return of the Prodigal Son* is the ultimate fruit of these studies.

Rembrandt's importance as a graphic artist is second only to Dürer's, although we get no more than a hint from this single example. But we must add a word about his medium. By the seventeenth century, the techniques of woodcut and engraving were employed mainly to reproduce other works. The creative printmakers of the day, including Rembrandt, preferred etching, often combined with drypoint (see fig. 484). An etching is made by coating a copperplate with resin to make an acid-resistant "ground," through which the design is scratched with a needle, laying bare the metal surface underneath. The plate is then bathed in an acid that etches (or "bites") the lines into the copper. The depth of these grooves varies with the strength and duration of the bath. The biting is usually by stages: after a brief immersion the etcher will apply a protective coating to the plate in those areas where the lines should be faint: he then immerses the plate until it is time to protect the less delicate lines, and so on. To scratch a design into the resinous ground is, of course, an easier task than to scratch it into the copperplate itself, hence an etched line is smoother and more flexible than a drypoint line. An etched plate is also more durable; like an engraving, it yields a far larger number of prints than a drypoint plate. Its chief virtue is its wide tonal range, including velvety dark shades not possible in other graphic media. No subsequent artist

has ever exploited this tonal quality more subtly than Rembrandt.

Landscape and Still Life Painters

Rembrandt's religious pictures demand an insight that was beyond the capacity of all but a few collectors. Most art buyers in Holland preferred subjects within their own experience—landscapes, architectural views, still lifes, everyday scenes. These various types, we recall, originated in the latter half of the sixteenth century (see page 476);

662. JAN VAN GOYEN. *Fort on a River*. 1644.
Panel, 16 3/4 × 29 3/4". Museum of Fine Arts, Boston

663. JACOB VAN RUISDAEL.
The Jewish Graveyard.
c. 1655. 32 × 37 1/2".
State Picture Gallery, Dresden

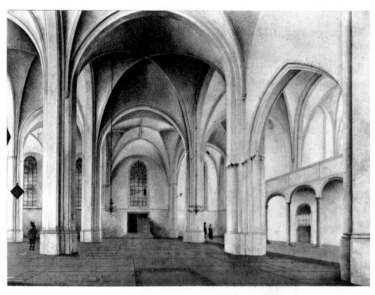

664. PIETER SAENREDAM.
St. Cunera Church, Rhenen. 1655.
Panel, 19 3/4 × 27".
Mauritshuis, The Hague

as they became fully defined, an unheard-of specialization began. The trend was not confined to Holland. We find it everywhere to some degree, but Dutch painting was its fountainhead, both in volume and variety. There were, in fact, so many subtypes within each major division mentioned above that we can illustrate only a small sampling. The *Fort on a River* (fig. 662) by Jan van Goyen represents a new kind of landscape, which enjoyed great popularity because its elements were so familiar; the distant town under a looming gray sky, seen through a moisture-laden atmosphere across an expanse of water— this view is still characteristic of the Dutch countryside today. No one knew better than Van Goyen how to evoke the special mood of these "nether lands," ever threatened by the sea. The awareness of natural forces also dominates *The Jewish Graveyard* (fig. 663) by Jacob van Ruisdael, the greatest Dutch landscape painter. The scene is frankly imaginary: the thunderclouds passing over a wild, deserted mountain valley, the medieval ruin, the torrent that has forced its way between ancient graves, all create a mood of deep melancholy. Nothing endures on this earth, the artist tells us—time, wind, and water grind all to dust, the feeble works of man as well as the trees and rocks. His signature on the gravestone nearest us is a final touch of gloomy irony. Ruisdael's vision of nature in relation to man is thus the exact opposite of

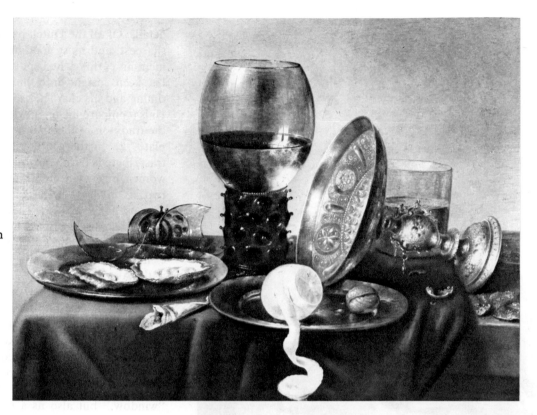

665. WILLEM CLAESZ. HEDA. *Still Life.* 1634. Panel, 17 × 22 1/2″. Boymans-van Beuningen Museum, Rotterdam

Annibale Carracci's (compare fig. 622): it inspires that awe on which the Romantics, a century later, were to base their concept of the Sublime.

Nothing at first seems further removed from *The Jewish Graveyard* than the painstakingly precise architectural interior of *St. Cunera Church, Rhenen* (fig. 664), painted by Pieter Saenredam at exactly the same time. Yet it, too, is meant to invite meditation, rather than serve merely as a topographic record (these views were often freely invented). The medieval structure, stripped of all furnishings and whitewashed under Protestant auspices, is no longer a house of worship. It has become a place for the dead (note the tomb slabs in the floor), and in its crystalline spaciousness we feel the silence of a graveyard. Again we are reminded that All is Vanity. Even still life can be tinged with this melancholy sense of the passing of all earthly pleasures; the message may lie in such established symbols as death's-heads and extinguished candles, or be conveyed by means less direct. Our example (fig. 665) belongs to a widespread type, the "breakfast piece," showing the remnants of a meal. Food and drink are less emphasized than luxury objects—crystal goblets and silver dishes—carefully juxtaposed for their contrasting shape, color, and texture. How different this seems from the piled-up edibles of Aertsen's *Meat Stall* (see fig. 609)! But virtuosity was not the artist's only aim: his "story," the human context of these grouped objects, is suggested by the broken glass, the half-peeled lemon, the overturned silver dish; whoever sat at this table has been suddenly forced to abandon his meal. The curtain that time has lowered on the scene, as it were, invests the objects with a strange *pathos*. The

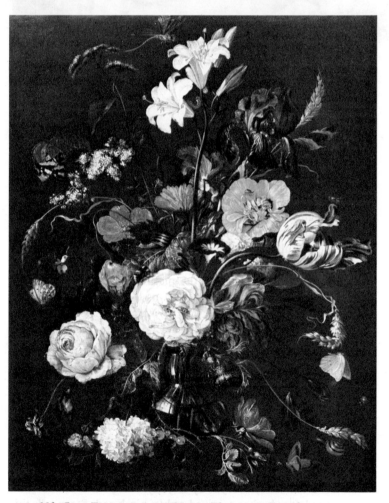

666. JAN DAVIDSZ. DE HEEM. *Flower Still Life.* c. 1665. 21 × 16 1/4″. Ashmolean Museum, Oxford

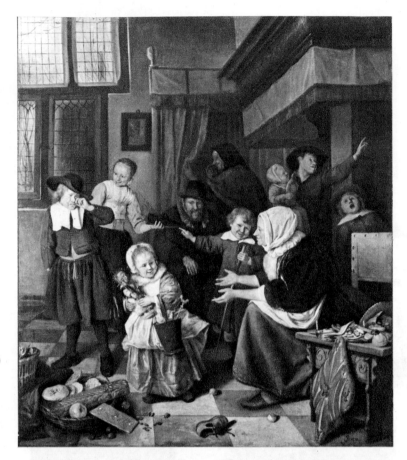

667. JAN STEEN. *The Eve of St. Nicholas.*
c. 1660–65. 32 $^1/_4$ × 27 $^3/_4$″. Rijksmuseum, Amsterdam

disguised symbolism of "Late Gothic" painting lives on here in a new form. Other types of still life, such as flower pieces, can be traced directly to their symbolic origins. How much of the older meaning survives in these examples is still being debated. Was the artist of the beautiful flower piece in figure 666 aware of the significance of each blossom, and of the butterflies, moths, and snails he put into the picture, and did he assemble his bouquet to this end? Or was he content to make it a feast for the eyes? Be that as it may, these flowers have such Baroque vitality that they fairly leap from their vase.

Steen; Vermeer

The vast class of pictures termed genre is as varied as that of landscapes and still lifes: it ranges from tavern brawls to refined domestic interiors. *The Eve of St. Nicholas,* by Jan Steen (fig. 667), is midway between these extremes. St. Nicholas has just paid his pre-Christmas visit to the household, leaving toys, candy, and cake for the children; everybody is jolly except the bad boy on the left, who has received only a birch rod. Steen tells this story with relish, embroidering it with many delightful

details. Of all the Dutch painters of daily life, he was the sharpest, and most good-humored, observer. To supplement his earnings he kept an inn, which perhaps explains his keen insight into human behavior. His sense of timing and his characterization often remind us of Frans Hals (compare fig. 653), while his storytelling stems from the tradition of Pieter Bruegel the Elder (compare colorplate 74). In the genre scenes of Jan Vermeer, by contrast, there is hardly any narrative. Single figures, usually women, engage in simple, everyday tasks; when there are two, as in *The Letter* (colorplate 82), they do no more than exchange glances. They exist in a timeless "still life" world, seemingly calmed by some magic spell. The cool, clear light that filters in from the left is the only active element, working its miracles upon all the objects in its path. As we look at *The Letter,* we feel as if a veil had been pulled from our eyes; the everyday world shines with jewel-like freshness, beautiful as we have never seen it before. No painter since Jan van Eyck *saw* as intensely as this. But Vermeer, unlike his predecessors, perceives reality as a mosaic of colored surfaces—or perhaps more accurately, he translates reality into a mosaic as he puts it on canvas. We see *The Letter* as a perspective "window," but also as a plane, a "field" composed of smaller fields. Rectangles predominate, carefully aligned with the picture surface, and there are no "holes," no undefined empty spaces. These interlocking shapes give to Vermeer's work a uniquely modern quality within seventeenth-century art. How did he acquire it? We know very little about him except that he was born in Delft in 1632 and lived and worked there until his death at forty-three, in 1675. Some of his works show the influence of Carel Fabritius, the most brilliant of Rembrandt's pupils; other pictures suggest his contact with the Utrecht School. But none of this really explains the genesis of his style, so daringly original that his genius was not recognized until a century ago.

SPAIN

Spain is the last country to be surveyed in the present chapter, for Spanish Baroque painting cannot be fully understood without some knowledge of artistic events in Italy and the Netherlands. During the sixteenth century, at the height of its political and economic power, Spain had produced great saints and writers, but no artists of the first rank. Nor did El Greco's presence prove a stimulus to native talent. The stimulus came, rather, from Caravaggio (though we do not know exactly how it was transmitted) and Flemish painting. Soon after Aertsen and his contemporaries in the Netherlands established the field of still life, Spanish masters began to develop their own versions. In the example by Sanchez Cotán (fig. 668), who was an early and remarkable Spanish painter of still life, we see the distinctive character of

668. SANCHEZ COTÁN.
Still Life. c. 1602–5.
25 × 33 ¹/₂″. Museum, Granada

this tradition. In contrast to the lavish display of food or luxury objects in Northern pictures, we here find an order and an austere simplicity that give a new context to these vegetables. They are so deliberately arranged in a star-and-crescent pattern that we cannot help wondering what symbolic significance the artist meant to convey. In any case, the juxtaposition of bright sunlight and impenetrable darkness, of painstaking realism and abstract form, creates a memorable image.

Sanchez Cotán may have been among the very first Spaniards to feel the influence of Caravaggio. During the second decade of the century, this influence became firmly established, especially in Seville, the home of the most important Spanish Baroque painters. Among them, Francisco de Zurbarán (1598–1664) stands out for the quiet intensity of his devotional pictures, such as *St. Serapion* (fig. 669). Although Caravaggesque in style, it is filled with an ascetic piety that is uniquely Spanish, and the very absence of rhetorical *pathos* makes this image of a martyred monk profoundly moving.

Velázquez

Likewise, Diego Velázquez (1599–1660) painted in a Caravaggesque vein during his early years, but his interests centered on genre and still life rather than religious themes. *The Water Carrier of Seville* (fig. 670), which he did at the age of twenty, already shows his genius: his powerful grasp of individual character and dignity in-

669. FRANCISCO DE ZURBARÁN. *St. Serapion*. 1628. 47 ¹/₂ × 40 ³/₄″
Wadsworth Atheneum, Hartford, Connecticut

670. DIEGO VELÁZQUEZ.
The Water Carrier of Seville.
c. 1619. 41 ¹/₂ × 31 ¹/₂".
Wellington Museum, London
(Crown copyright reserved)

vests this everyday scene with the solemn spirit of a ritual. A few years later, Velázquez was appointed court painter and moved to Madrid, where he spent the rest of his life, doing mainly portraits of the royal family. The earlier of these still show the precise division of light and shade and the clear outlines of his Seville period, but after the late 1620s his work acquired a new fluency and richness. Meanwhile he had become a friend of Rubens, who probably helped him to discover the beauty of the many Titians in the king's collection, but did not influence him directly. He also traveled in Italy, where in 1650 he painted the magnificent portrait of Pope Innocent X (fig. 671). The picture is meant to evoke the great tradition of the papal portraits of Raphael (compare colorplate 61) but its fluid brushwork and glowing color derive from Titian. And the sitter's gaze, sharply focused on the beholder, conveys a passionate and powerful personality.

The Maids of Honor (fig. 672, colorplate 83) displays Velázquez' mature style at its fullest, at once a group portrait and a genre scene. It might be subtitled "the artist in his studio," for Velázquez shows himself at work on a huge canvas; in the center is the little Princess Margarita, who has just posed for him, among her playmates and maids of honor. The faces of her parents, the king and queen, appear in the mirror on the back wall. Have they just stepped into the room, to see the scene exactly

671. DIEGO VELÁZQUEZ.
Pope Innocent X. 1650.
55 × 45 ¹/₄". Doria-Pamphili Gallery, Rome

672. DIEGO VELÁZQUEZ.
The Maids of Honor. 1656.
10′ 5″ × 9′.
The Prado, Madrid
(see colorplate 83)

as we do, or does the mirror reflect part of the canvas—presumably a full-length portrait of the royal family—on which the artist has been working? This ambiguity is characteristic of Velázquez' fascination with light. Unlike Rembrandt, he was concerned with its optical rather than its metaphysical mysteries, but these he penetrated more completely than any painter of his time except Vermeer. The varieties of direct and reflected light in *The Maids of Honor* are almost limitless, and the artist challenges us to find them: we are expected to match the mirror image against the paintings on that wall, and against the "picture" of the man in the open doorway. Velázquez could not have known Vermeer's work, for the latter was then only twenty-four, but he may have known scenes of domestic genre by older Dutch painters. Looking at the open, sketchy brushwork in colorplate 83 (about two-thirds the scale of the original), we wonder if he could also have known Frans Hals (compare colorplate 80). Yet Velázquez' technique is far more varied and subtle, with delicate glazes setting off the impasto of the highlights. The colors, too, have a Venetian richness unmatched by Hals. Nor does Velázquez seem interested in catching time on the wing; his aim is not to show figures in motion, but the movement of light itself and the infinite range of its effects on form and color. For Velázquez, light *creates* the visible world. Not until two centuries later shall we meet painters capable of realizing the implications of this discovery.

FRANCE

 PAINTING

 ARCHITECTURE

 SCULPTURE

 THE ROYAL ACADEMY

 THE FRENCH ROCOCO

ENGLAND

 ARCHITECTURE

 PAINTING

8

THE BAROQUE
IN FRANCE AND ENGLAND

FRANCE

PAINTING

Our discussion of Baroque art in Flanders, Holland, and Spain was limited to painting; architecture and sculpture in these countries, although far from negligible, are not of central importance for the history of art, so that we could afford to leave them out of account. But in France the situation is different. Under Louis XIV France became the most powerful nation of Europe, militarily and culturally; by the late seventeenth century, Paris had replaced Rome as the world capital of the visual arts—a position it held for centuries. How did this astonishing change come about? Because of the Palace of Versailles and other vast projects glorifying the king of France, we are tempted to think of French art in the age of Louis XIV as the expression—and one of the products—of absolutism. This is true of the climactic phase of Louis' reign, 1660–85, but by that time French seventeenth-century art already had its distinctive style. Frenchmen are reluctant to call this style Baroque; to them it is the Style of Louis XIV; often they also describe the art and literature of the period as "classic." The term, so used, has three meanings: as a synonym for "highest achievement," it implies that the Style of Louis XIV corresponds to the High Renaissance in Italy, or the age of Pericles in ancient Greece; the term also refers to the emulation of the form and subject matter of classical antiquity; finally, "classic" suggests qualities of balance and restraint, like those of the classic styles of the High Renaissance and of ancient art. The second and third of these meanings describe what could be called, more accurately, "classicism." And since the Style of Louis XIV reflects Italian Baroque art, however modified, we must label it "classicistic Baroque" or "Baroque classicism."

This classicism was the official court style by 1660–85, but its origin was not political. It sprang, rather, from the persistent tradition of sixteenth-century art, which in France was more intimately linked with the Italian Ren-

aissance than in any other northern country (page 454). Classicism was also nourished by French humanism, with its intellectual heritage of reason and Stoic virtue. These factors retarded the spread of the Baroque in France, and modified its interpretation. Rubens' Medici Cycle, for example, had no effect on French art until the very end of the century; in the 1620s, the young painters in France were still assimilating the Early Baroque. Some

673. GEORGES DE LA TOUR. *Joseph the Carpenter.*
c. 1645. 38 1/2 × 25 1/2″. The Louvre, Paris

674. LOUIS LE NAIN.
Peasant Family.
c. 1640. 44 $1/2$ × 62 $1/2''$.
The Louvre, Paris

675. NICOLAS POUSSIN.
Cephalus and Aurora.
c. 1630. 38 × 51''.
The National Gallery,
London

were oriented toward Caravaggio, and developed astonishingly original styles; the importance of one of these men, Georges de La Tour (1593–1652), has been recognized only recently. His *Joseph the Carpenter* (fig. 673) might be mistaken for a genre scene, yet its devotional spirit has the power of Caravaggio's *Calling of St. Matthew* (see colorplate 75). The boy Jesus holds a candle—a favorite device with La Tour—which lights the scene with an intimacy and tenderness reminiscent of Geertgen tot Sint Jans (compare fig. 470). Strangely enough, La Tour

also shares Geertgen's tendency to reduce his forms to geometric simplicity. The Caravaggesque *Peasant Family* (fig. 674) by Louis Le Nain (1593–1648) is equally impressive. Like the peasant pictures of seventeenth-century Holland and Flanders, it stems from a tradition going back to Pieter Bruegel the Elder (see colorplate 74). But the Netherlandish scenes of low life are humorous or satirical (see fig. 653), whereas Louis Le Nain endows them with a human dignity and monumental weight that recall Velázquez' *Water Carrier of Seville* (see fig. 670).

Like Georges de La Tour, Louis Le Nain was also rediscovered in modern times, but he did not have to wait quite so long.

Poussin; Claude

Why were these important painters so quickly forgotten? The reason is simple: the clarity, balance, and restraint of their art, when measured against other Caravaggesque painters, might be termed "classical," but neither was a "classicist"—and after the 1640s, classicism was supreme in France. The artist who did most to bring this about was Nicolas Poussin (1593/94–1665). The greatest French painter of the century, and the earliest French painter in history to win international fame, Poussin nevertheless spent almost his entire career in Rome. His development also was somewhat paradoxical, as we see in figure 675 and colorplate 84: both show his profound allegiance to antiquity, but in style and attitude they are much farther apart than the seven years' difference in date would suggest. *Cephalus and Aurora* is inspired by Titian's warm, rich color and by his approach to classical mythology (compare colorplate 63). Poussin, too, visualizes antiquity here as a poetic dream world, although the unalloyed bliss of Titian's *Bacchanal* is now overcast

with melancholy (his favorite subjects are tales of frustrated love). By contrast, *The Rape of the Sabine Women* must be seen altogether differently. The strongly modeled figures are "frozen in action," like statues, and many are in fact derived from Hellenistic sculpture; behind them Poussin has set reconstructions of Roman architecture that he believed to be archaeologically correct. Emotion is abundantly displayed, yet it so lacks spontaneity that it fails to touch us. Clearly, the attitude here reflected is not Titian's but Raphael's—more precisely, that of Raphael as filtered through Annibale Carracci and his school (compare figs. 620, 621). Venetian qualities have been consciously suppressed for the severe discipline of an intellectual style. Poussin now strikes us as a man who knew his own mind only too well, an impression confirmed by the numerous letters in which he expounded his views to friends and patrons. The highest aim of painting, he believed, is to represent noble and serious human actions. These must be shown in a logical and orderly way—not as they really happened, but as they would have happened if nature were perfect. To this end, the artist must strive for the general and typical; appealing to the mind rather than the senses, he should suppress such trivialities as glowing color, and stress form and composition. In a good picture, the beholder must be

676. NICOLAS POUSSIN. *Landscape with the Burial of Phocion.* 1648. 47 × 70 ¹/₂". The Louvre, Paris

677. CLAUDE LORRAINE. *View of the Campagna.*
c. 1650? Wash drawing. British Museum, London

678. CLAUDE LORRAINE. *A Pastoral.* c. 1650.
Copper, 15 7/8 × 21 5/8″. Yale University Art Gallery,
New Haven, Connecticut

able to "read" the exact emotions of each figure, and relate them to the given event. These ideas were not new—we recall Leonardo's statement that the highest aim of painting is to depict "the intention of man's soul," and the ancient dictum *ut pictura poesis* (see pages 353, 420)—but before Poussin, no one made the analogy between painting and literature so close, nor put it into practice so single-mindedly. His method accounts for the cold and over-explicit rhetoric in *The Rape of the Sabine Women* that makes the picture so much less accessible to us than his earlier *Cephalus and Aurora.* Poussin even painted landscapes according to this theoretical view, with surprisingly impressive results. The *Landscape with the Burial of Phocion* (fig. 676) follows the tradition of Annibale Carracci's "ideal landscapes" (see fig. 622), but the careful order of its spaces is almost mathematically precise. Yet the effect of rational clarity has a somber calm as pervasive as the lyricism of Annibale's country-

side. This mood is attuned to Poussin's theme, the burial of a Greek hero who died because he refused to conceal the truth: the landscape becomes itself a memorial to Stoic virtue. Although we may no longer read the scene so specifically, we still respond to its austere beauty.

If Poussin developed the heroic qualities of the "ideal landscape," the great French landscapist Claude Lorraine (1600–82) brought out its idyllic aspects. He, too, spent almost his entire career in Rome, and explored the country nearby—the Campagna—more thoroughly and affectionately than any Italian. Countless drawings made on the spot, such as the miraculously fresh and sensitive example in figure 677, bear witness to his extraordinary powers of observation. These sketches, however, were only the raw material for his paintings, which do not aim at topographic exactitude but evoke the poetic essence of a countryside filled with echoes of antiquity. Often, as in *A Pastoral* (fig. 678), the compositions are suffused with the hazy, luminous atmosphere of early morning or late afternoon; the space expands serenely, rather than receding step-by-step as in Poussin's landscapes. An air of nostalgia hangs over such vistas, of past experience gilded by memory; hence they appealed especially to northerners who had seen Italy only briefly—or, perhaps, not at all.

ARCHITECTURE

In France itself, meanwhile, the foundations of Baroque classicism in architecture were laid by a group of designers whose most distinguished member was François Mansart (1598–1666). Apparently he never visited Italy, but other French architects had already imported and acclimatized some aspects of the Roman Early Baroque, especially in church design, so that Mansart was not unfamiliar with the new Italian style. What he owed to it, however, is hard to determine; his most important buildings are châteaux, and in this field the French Renaissance tradition outweighed any direct Italian Baroque influences. The Château of Maisons near Paris, built for a newly risen administrative official, shows Mansart's mature style at its best. The vestibule leading to the grand staircase (fig. 679) has a particularly beautiful effect, severe yet festive. On seeing the classically pure articulation of the walls, one first thinks of Palladio, whose treatise Mansart certainly knew and admired. But sculpture is used here in the characteristically French way, as an integral part of architectural design; and the complex curves of the vaulting tell us that this structure, for all its classicism, belongs to the Baroque.

Mansart died too soon to have a share in the climactic phase of Baroque classicism, which began not long after young Louis XIV took over the reins of government in 1661. Colbert, the king's chief adviser, built the administrative apparatus supporting the power of the absolute monarch. In this system, aimed at subjecting the thoughts and actions of the entire nation to strict control from above, the visual arts had the task of glorifying the king,

and the official "royal style," in both theory and practice, was classicism. That this choice was deliberate we know from the history of the first great project Colbert directed, the completion of the Louvre. Work on the palace had proceeded intermittently for over a century, along the lines of Lescot's design (see fig. 615); what remained to be done was to close the square court on the east side with an impressive façade. Colbert, dissatisfied with the proposals of French architects, invited Bernini to Paris, hoping the most famous master of the Roman Baroque would do for the French king what he had already done so magnificently for the Church. Bernini spent several months in Paris in 1665 and submitted three designs, all on a scale that would completely engulf the extant palace. After much argument and intrigue, Louis XIV rejected these plans, and turned over the problem of a final solution to a committee of three: Louis Le Vau, his court architect, who had worked on the project before; Charles Lebrun, his court painter; and Claude Perrault, who was a student of ancient architecture, not a professional architect. All three were responsible for the structure that was actually built (fig. 680), although Perrault is usually credited with the major share. The design in some ways suggests the mind of an archaeologist, but one who knew how to select those features of classical architecture that would link Louis XIV with the glory of the Caesars and yet be compatible with the older parts of the palace. The center pavilion is a Roman temple front, and the wings look like the flanks of that temple folded outward. The temple theme demanded a single order of free-standing columns, yet the Louvre had three stories—a difficulty skillfully resolved by treating the ground story as the *podium* of the temple, and recessing the upper two behind the screen of the colonnade. The entire design combines grandeur and elegance in a way that fully justifies its fame.

The East Front of the Louvre signaled the victory of French classicism over Italian Baroque as the "royal style." Ironically, this great exemplar proved too pure:

679. FRANÇOIS MANSART.
Vestibule, Château of Maisons-Lafitte.
1642–50

Perrault soon faded from the architectural scene, and Baroque features, although not officially acknowledged, reappeared in the king's vastest enterprise, the Palace of Versailles. This shift corresponded to the king's own taste. Louis XIV was interested less in architectural theory and monumental exteriors than in the lavish interiors that would make appropriate settings for himself and his court. The man to whom he really listened, as a result, was not an architect, but the painter Lebrun, who became supervisor of all the king's artistic projects. As chief dispenser of royal art patronage, he commanded so much power that for all practical purposes he was the dictator of the arts in France. Lebrun had spent several years studying under Poussin in Rome. But the great decorative schemes of the Roman Baroque must also have impressed him, for they stood him in good stead twenty years later, both in the Louvre and at Ver-

680. CLAUDE PERRAULT.
East Front of the Louvre, Paris.
1667–70

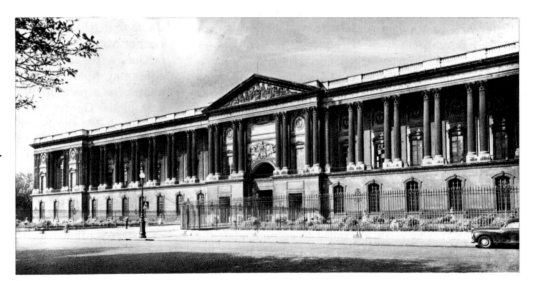

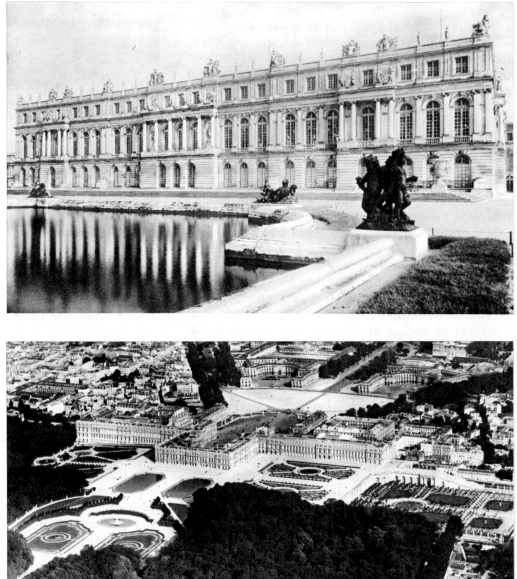

681. LOUIS LE VAU and
JULES HARDOUIN-MANSART.
Garden Front, Center Block,
Palace of Versailles. 1669–85

682. Aerial View of
the Palace of Versailles

sailles. He became a superb decorator, utilizing the combined labors of architects, sculptors, painters, and craftsmen for ensembles of unheard-of splendor, such as the Salon de la Guerre at Versailles (fig. 683). To subordinate all the arts to a single goal—here, the glorification of Louis XIV—was in itself Baroque; if he went less far than Bernini, Lebrun nevertheless drew freely on his memories of Rome. The Salon de la Guerre seems in many ways closer to the Cornaro Chapel than to the vestibule at Maisons (compare figs. 627, 679). And, as in so many Italian Baroque interiors, the separate ingredients are less impressive than the effect of the whole.

The Palace of Versailles, just over eleven miles from the center of Paris, was begun in 1669 by Le Vau, who designed the elevation of the Garden Front (fig. 681). He died within a year, and the entire project, under Jules Hardouin-Mansart (1646–1708), a great-nephew of François Mansart, was vastly expanded to accommodate the ever-growing royal household. The Garden Front, intended by Le Vau to be the principal view of the palace,

was stretched to an enormous length (fig. 681) without modifying the architectural membering; the original façade design, a less severe variant of the East Front of the Louvre, now looks repetitious and out of scale. The whole center block contains a single room, the famous Hall of Mirrors (Galerie des Glaces), with the Salon de la Guerre and its counterpart, the Salon de la Paix, at either end. Apart from its magnificent interior, the most impressive aspect of Versailles is the park extending west of the Garden Front for several miles (the aerial view in fig. 682 shows only a small part of it). Its design, by André Le Nôtre, is so strictly correlated with the plan of the palace that it becomes a continuation of the architectural space. Like the interior of Versailles, these formal gardens, with their terraces, basins, clipped hedges, and statuary, were meant to provide an appropriate setting for the king's appearances in public. They form a series of "outdoor rooms" for the splendid fetes and spectacles that Louis XIV so enjoyed. The spirit of absolutism is even more striking in this geometric regularity imposed

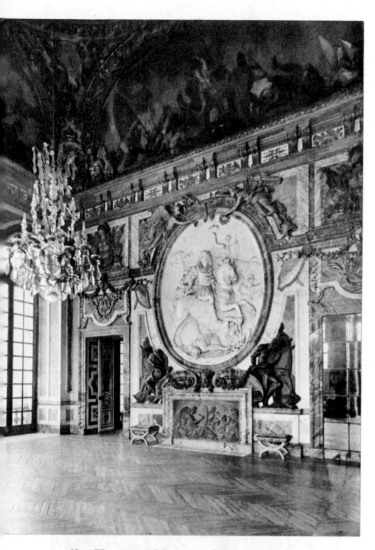

683. HARDOUIN-MANSART, LEBRUN, and COYSEVOX. Salon de la Guerre, Palace of Versailles. Begun 1678.

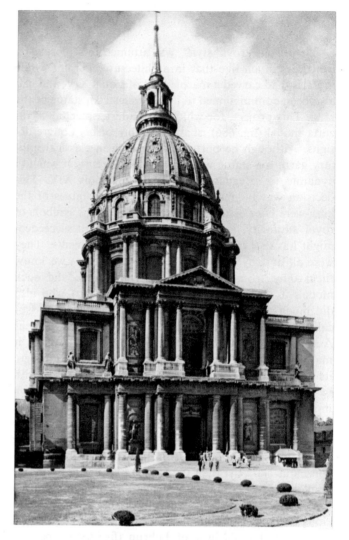

684. JULES HARDOUIN-MANSART. Church of the Invalides, Paris. 1680–91

upon an entire countryside, than it is in the palace itself.

At Versailles, Hardouin-Mansart worked as the member of a team, constrained by the design of Le Vau. His own architectural style can be better seen in the Church of the Invalides (figs. 684, 685), named after the institution for disabled soldiers of which it formed one part. The plan, consisting of a Greek cross with four corner chapels, is based ultimately—with various French intermediaries—on Michelangelo's plan for St. Peter's (see fig. 566); its only Baroque element is the oval choir. The dome, too, reflects the influence of Michelangelo (figs. 565, 567), and the classicistic vocabulary of the façade is reminiscent of the East Front of the Louvre. Yet the exterior as a whole is unmistakably Baroque: the façade breaks forward repeatedly in the crescendo effect introduced by Maderno (see fig. 624); and façade and dome are closely correlated (see fig. 635). The dome itself is the most original, and the most Baroque, feature of Hardouin-Mansart's design; tall and slender, it rises in one continuous curve from the base of the drum to the

685. Plan of the Church of the Invalides

spire atop the lantern. On the first drum rests, surprisingly, a second, narrower drum; its windows provide light for the painted vision of heavenly glory inside the dome, but they themselves are hidden behind a "pseudo-shell" with a large opening at the top, so that the heavenly glory seems mysteriously illuminated and suspended in space; "theatrical" lighting so boldly directed would do honor to any Italian Baroque architect

The official "royal style" was attained in sculpture by a process much like that in architecture. Bernini, while in Paris, had carved a marble bust of Louis XIV, and had also been commissioned to do an equestrian statue of the king. This project, for which he made a splendid terracotta model (fig. 686), shared the fate of his Louvre designs. Although he portrayed the king in classical military garb, the statue was rejected; apparently it was too dynamic to safeguard the dignity of Louis XIV. This decision was far-reaching, for equestrian statues of the king were later erected throughout France as symbols of royal authority, and Bernini's design, had it succeeded, might have set the pattern for these monuments. They were all destroyed in the French Revolution; we know them only from engravings, reproductions, and such models as that by François Girardon (fig. 687), who also did much garden sculpture at Versailles. Characteristically, this is an adaptation of the equestrian Marcus Aurelius on the Capitoline Hill (see fig. 252). While it may look static—lame, in fact—next to Bernini's design, its Baroque qualities show up clearly in comparison with its ancient prototype: the fluid modeling, the wind-blown movement of the king's cloak. There is even a hint at an "invisible complement"—instead of looking at us, the king raises his head and leans back as if communicating with some celestial power. Antoine Coysevox, a less self-conscious classicist than Girardon, was another sculptor employed by Lebrun at Versailles. In his large stucco relief in the Salon de la Guerre (see fig. 683), the victorious Louis XIV retains the pose of Bernini's equestrian statue. Coysevox's bust of Lebrun (fig. 688) repeats—again with a certain restraint—the general outlines of Bernini's bust of Louis XIV. The face, however, shows a realism and a subtlety of characterization that are Coysevox's own. He is the first of a long line of distinguished French portrait sculptors.

Coysevox approached the Baroque in sculpture as closely as Lebrun would permit. Pierre Puget, the greatest and the most Baroque of French seventeenth-century sculptors, had no success at court until after Colbert's death, when the power of Lebrun was on the decline. *Milo of Crotona* (fig. 689), Puget's finest statue, may safely be compared to one by Bernini. Its composition is more contained than that of Bernini's *David* (see fig. 625), yet the agony of the hero has such force that its impact on the beholder is almost physical; the internal tension fills every particle of marble with intense life. The figure also recalls the *Laocoön Group* (see fig. 192). That, one suspects, is what made it acceptable to Louis XIV.

THE ROYAL ACADEMY

Centralized control over the visual arts was exerted by Colbert and Lebrun not only through the power of the purse; it also included a new system of educating artists

686. GIANLORENZO BERNINI. *Model for Equestrian Statue of Louis XIV.* 1670. Terracotta, height 30". Borghese Gallery, Rome

687. FRANÇOIS GIRARDON. *Model for Equestrian Statue of Louis XIV.* 1687? Wax, height 30 1/4". Yale University Art Gallery, New Haven, Connecticut (Gift of Mr. and Mrs. James W. Fosburgh, 1933)

in the officially approved style. Throughout antiquity and the Middle Ages, artists had been trained by apprenticeship, and this time-honored practice still prevailed in the Renaissance. But as painting, sculpture, and architecture gained the status of liberal arts, artists wished to supplement their "mechanical" training with theoretical knowledge. For this purpose, "art academies" were

Colorplate 80. FRANS HALS. *The Jolly Toper*. 1627.
31 $^7/_8$ × 26 $^1/_4$″. Rijksmuseum, Amsterdam

Colorplate 82. JAN VERMEER VAN DELFT. *The Letter*. 1666.
17¹/₄ × 15¹/₄″. Rijksmuseum, Amsterdam

Colorplate 83. DIEGO VELÁZQUEZ. Detail of *The Maids of Honor*. 1656. The Prado, Madrid (see figure 672)

Colorplate 84. Nicolas Poussin. *The Rape of the Sabine Women.* About 1636–37. 61 × 82½″. The Metropolitan Museum of Art, New York (Dick Fund, 1946)

Colorplate 85. ANTOINE WATTEAU. *A Pilgrimage to Cythera*.
1717. 4′ 3″ × 6′ 4¹⁄₂′. The Louvre, Paris

Colorplate 86. JEAN-HONORE FRAGONARD. *Bathers*. About 1765. 25¹/₄ × 31¹/₂″. The Louvre, Paris

Colorplate 87. JEAN-BAPTISTE SIMÉON CHARDIN. *Back from the Market.*
1739. 18 1/2 × 14 3/4″. The Louvre, Paris

688. ANTOINE COYSEVOX. *Charles Lebrun.* 1676.
Terracotta, height 26″. Wallace Collection, London

689. PIERRE PUGET. *Milo of Crotona.* 1671–83.
Marble, height 8′ 10 ¹/₂″. The Louvre, Paris

founded, patterned on the academies of the humanists (the name is derived from the Athenian grove where Plato met with his disciples). Art academies appeared first in Italy, in the later sixteenth century; they seem to have been private associations of artists who met periodically to draw from the model and discuss questions of art theory. These academies later became formal institutions that took over some functions from the guilds, but their teaching was limited and far from systematic. Such was the Royal Academy of Painting and Sculpture in Paris, founded in 1648; when Lebrun became its director, in 1663, he established a rigid curriculum of compulsory instruction in practice and theory, based on a system of "rules"; this set the pattern for all later academies, including their modern successors, the art schools of today. Much of this body of doctrine was derived from Poussin's views (pages 523–24) but carried to rationalistic extremes. The Academy even devised a method for tabulating, in numerical grades, the merits of artists past and present in such categories as drawing, expression, and proportion. The ancients received the highest marks, needless to say, then came Raphael and his school, and Poussin; the Venetians, who overemphasized color, ranked low,

and the Flemish and Dutch lower still. Subjects were similarly classified, from history (classical or biblical) at the top to still life at the bottom.

It is hardly surprising that this strait-jacket system produced no significant artists. Even Lebrun, as we have seen, was far more Baroque in his practice than we would expect from his classicistic theory. The absurd rigidity of the official doctrine generated, moreover, a counter-pressure that vented itself as soon as Lebrun's authority began to decline. Toward the end of the century, the members of the Academy formed two warring factions over the issue of drawing versus color: the conservatives (or "Poussinistes") against the "Rubénistes." The conservatives defended Poussin's view that drawing, which appealed to the mind, was superior to color, which appealed to the senses; the "Rubénistes" advocated color, rather than drawing, as being more true to nature. They also pointed out that drawing, admittedly based on reason, appeals only to the expert few, whereas color appeals to everyone. This argument had revolutionary implications, for it proclaimed the layman to be the ultimate judge of artistic values, and challenged the Renaissance notion that painting, as a liberal art, could be appreci-

690. ANTOINE WATTEAU.
A Pilgrimage to Cythera (detail).
1717. The Louvre, Paris
(see colorplate 85)

ated only by the educated mind. By the time Louis XIV died, in 1715, the dictatorial powers of the Academy had been overcome, and the influence of Rubens and the great Venetians was everywhere.

Watteau

In 1717 the "Rubénistes" scored their final triumph when the painter Antoine Watteau (1684–1721) was admitted to the Academy with his *A Pilgrimage to Cythera* (fig. 690, colorplate 85). This picture violated all academic canons, nor did its subject conform to any established category. But the Academy, now very accommodating, invented for Watteau the new category of *fêtes galantes* (elegant fetes or entertainments). The term refers less to this one canvas than to the artist's work in general, which mainly shows scenes of elegant society, or comedy actors, in parklike settings. He characteristically interweaves theater and real life so that no clear distinction can be made between the two. The *Pilgrimage to Cythera* includes yet another element—classical mythology: these young couples have come to Cythera, the island of love, to pay homage to Venus (whose garlanded image appears on the far right). As the enchanted day draws to a close, they are about to board the boat, accompanied by swarms of cupids, and be transported back to the everyday world. The scene at once recalls Rubens' *Garden of Love* (compare colorplate 79), but Watteau, by depicting the lovers on the point of departure, has added a poignant touch. A sense of the fleeting nature of happiness

pervades all of Watteau's pictures, lending them a poetic subtlety reminiscent of Giorgione (see colorplate 62). His figures, too, have not the robust vitality of Rubens'; slim and graceful, they move with the studied assurance of actors who play their roles so superbly that they touch us more than reality ever could (fig. 690). They recapture in Baroque form an earlier ideal of "mannered" elegance (compare figs. 460, 608).

FRENCH ROCOCO

The work of Watteau gives the signal for a shift in French art and French society. After the death of Louis XIV, the centralized administrative machine that Colbert had created ground to a stop. The nobility, hitherto attached to the court at Versailles, were now freer of royal surveillance. Many of them chose not to return to their ancestral châteaux in the provinces, but to live instead in Paris, where they built elegant town houses, known as *hôtels*. Because these city sites were usually cramped and irregular, they offered scant opportunity for impressive exteriors; the layout and décor of the rooms became the architects' main concern. As state-sponsored building activity was declining, the field of "design for private living" took on new importance. The *hôtels* demanded a style of interior decoration less grandiloquent and cumbersome than Lebrun's—an intimate, flexible style that would give greater scope to individual fancy uninhibited by classicistic dogma. French designers created

the Rococo (or "the Style of Louis XV," as it is often called in France) in response to this need. The name fits well, although it was coined as a caricature of *rocaille* (echoing the Italian *barocco*), which meant the playful decoration of grottoes with irregular shells and stones. Rococo was a refinement in miniature of the curvilinear, "elastic" Baroque of Borromini and Guarini, and thus could be happily united with Austrian and German Late Baroque architecture (colorplate 78, fig. 646). Most French examples of the style, such as the Salon de la Princesse in the Hôtel de Soubise, by Germain Boffrand (fig. 691), are smaller in scale and less exuberant than those in Central Europe; the ceiling frescoes and decorative sculpture in palaces and churches are unsuited to domestic interiors, however, lavish. We must therefore remember that in France, Rococo painting and sculpture were less closely linked with their architectural setting than in Italy, Austria, and Germany, although they reflect the same taste that produced the Hôtel de Soubise. Character-istic of Rococo sculpture are small groups like Clodion's *Satyr and Bacchante* (fig. 692), designed to be viewed at close range. Their coquettish eroticism is another form of "miniature Baroque," a playful echo of the ecstasies of Bernini and Puget (compare fig. 626). The monumental commissions for French Rococo sculptors were few, but the equestrian statue of Peter the Great, made for Cath-erine of Russia by Etienne Maurice Falconet (fig. 693), shows that they could recapture something of Baroque grandeur. This impressive example is a splendidly ener-getic adaptation of Bernini's *Louis XIV* (see fig. 686).

692. CLODION. *Satyr and Bacchante*. c. 1775.
Terracotta, height 23″. The Metropolitan Museum of Art,
New York (Bequest of Benjamin Altman, 1913)

693. ETIENNE MAURICE FALCONET.
Equestrian Monument of Peter the Great.
1766–82. Bronze, over lifesize. Leningrad

Fragonard; Chardin

Much Rococo painting is the counterpart of Clodion's sculpture: intimate in scale and deliciously sensual in style and subject, it lacks the emotional depth that distinguishes Watteau's art. The finest painter in this vein was Jean-Honoré Fragonard (1732–1806); his *Bathers* (colorplate 86) must here suffice to represent its class. A franker "Rubéniste" than Watteau, Fragonard paints with a fluid breadth and spontaneity reminiscent of Rubens' oil sketches (see fig. 649). His figures move with a floating grace that also links him with Tiepolo, whose work he had admired in Italy (compare fig. 645). Fragonard had the misfortune to outlive his era; his pictures became outmoded as the Revolution approached. After 1789 he was reduced to poverty, and he died, forgotten, in the heyday of Napoleon. Yet the style he practiced with such mastery had not been the only alternative open to him and the other French painters of his generation. His art might have been very different had he followed the example of his first teacher, Jean-Baptiste Siméon Chardin (1699–1779), whose style can be called Rococo only with reservations. The "Rubénistes" had cleared the way for a new interest in the Dutch masters as well, and Chardin is the finest painter of still life and genre in this trend. His genre scenes, such as *Back from the Market* (colorplate 87), show life in a Parisian middle-class

household with such feeling for the beauty hidden in the commonplace, and so clear a sense of spatial order, that we can compare him only to Vermeer. But his remarkable technique is quite unlike any Dutch artist's. Devoid of bravura, his brushwork renders the light on colored surfaces with a creamy touch that is both analytical and subtly poetic. His still lifes usually reflect the same modest environment, eschewing the "object appeal" of their Dutch predecessors. In the example shown in figure 694, we see only the common objects that belong in any kitchen: earthenware jugs, a casserole, a copper pot, a piece of raw meat, smoked herring, two eggs. But how important they seem, each so firmly placed in relation to the rest, each so worthy of the artist's—and our—scrutiny! Despite his concern with formal problems, evident in the beautifully balanced design, Chardin treats these objects with a respect close to reverence. Beyond their shapes, colors, and textures, they are to him symbols of the life of the common man. In spirit, if not in subject matter, Chardin is more akin to Louis Le Nain and Sanchez Cotán than to any Dutch painter.

ENGLAND

ARCHITECTURE

We have not mentioned English architecture since our discussion of the Perpendicular style (see fig. 402). This insular form of Late Gothic proved extraordinarily persistent; it absorbed the stylistic vocabulary of the Italian Renaissance during the sixteenth century, but as late as

694. JEAN-BAPTISTE SIMÉON CHARDIN. *Kitchen Still Life.*
c. 1730–35. 12 $\frac{1}{2}$ × 15 $\frac{1}{4}$″. Ashmolean Museum, Oxford

695. INIGO JONES. West Front, Banqueting House,
Whitehall Palace, London. 1619–22

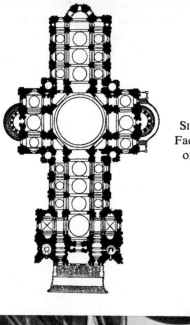

696, 697, 698.
SIR CHRISTOPHER WREN.
Façade, Plan, and Interior
of St. Paul's Cathedral,
London. 1675–1710

1600, English buildings still retained a "Perpendicular syntax"—that is to say, their stage of development corresponded to Chambord, or the choir of St.-Pierre at Caen (see figs. 612, 613). The first architect of the English Renaissance was Inigo Jones (1573–1652). Although he went to Italy about 1600, and again in 1613, he did not bring back the Early Baroque but returned a thoroughgoing Palladian. The Banqueting House he built at Whitehall in London (fig. 695) conforms in every respect to the principles in Palladio's treatise, yet does not copy any specific building by Palladio. Symmetrical and self-sufficient, it is, for its date, more like a Renaissance *palazzo* than any other building north of the Alps. Jones's style, supported by Palladio's authority as a theorist, stood as a beacon of classicist orthodoxy in England for two hundred years. This classicism can be seen in some parts of St. Paul's Cathedral (figs. 696–98) by Sir Christopher Wren (1632–1723), the great English architect of the late seventeenth century: note the second-story windows and, especially, the dome, which looks like a vastly enlarged version of Bramante's Tempietto (see fig. 547). St. Paul's is otherwise an up-to-date Baroque design reflecting a thorough acquaintance with contemporary architecture in Italy and France. Sir Christopher came close to being a Baroque counterpart of the Renaissance artist-scientist. An intellectual prodigy, he first studied anatomy, then physics, mathematics, and astronomy, and was highly esteemed by Sir Isaac Newton. His serious interest in architecture did not begin until he was about thirty. However—and this seems to be characteristic of the Baroque as opposed to the Renaissance—there is apparently no direct link between his scientific and artistic ideas. (It is hard to determine whether his technological knowledge significantly affected the shape of his buildings.) Had not the great London fire of 1666 destroyed the

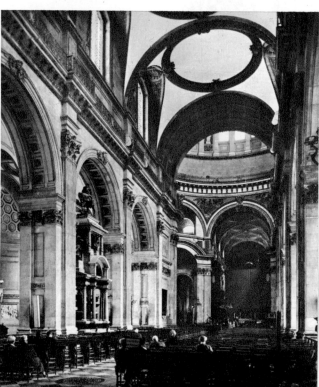

Gothic cathedral of St. Paul, and many lesser churches, Sir Christopher might have remained an amateur architect. But following that catastrophe, he was named to the royal commission for rebuilding the city, and a few years later he began his designs for St. Paul's. The tradition of Inigo Jones did not suffice for this task, beyond providing a starting point. On his only trip abroad, Sir Christopher had visited Paris at the time of the dispute over the completion of the Louvre, and he must have sided with Perrault, whose design for the East Front is clearly reflected in the façade of St. Paul's. Yet, despite his belief that Paris provided "the best school of architecture in Europe," Sir Christopher was not indifferent to the achievements of the Roman Baroque. He must have wanted the new St. Paul's to be the St. Peter's of the Church of England—soberer and not so large, but equally impressive. His dome, like that of St. Peter's, has a diameter as wide as nave and aisles combined, but it rises high above the rest of the structure and dominates even our close view of the façade. The lantern and the upper part of the clock towers also suggest that he knew S. Agnese in Piazza Navona (see fig. 635), probably from drawings or engravings. Italian Baroque elements are still more conspicuous in Blenheim Palace (fig. 699), designed by Sir John Vanbrugh (1664–1726); the grandiose structure was presented by a grateful nation to the victorious Duke of Marlborough. Vanbrugh, like Bernini, had a strong interest in the theater (he was a popular playwright). Their kinship seems even closer when we compare the façade of Blenheim, its colossal order and framing colonnade, with the piazza of St. Peter's (see fig. 623).

PAINTING

The development of English seventeenth-century architecture thus follows the French pattern: toward 1700, the High Baroque wins out over a classicistic tradition. Yet England never accepted the subsequent Rococo. The pomp of Blenheim soon became the object of satire, and the second quarter of the eighteenth century produced a Palladianism more rationalistic than Inigo Jones's and, at that time, unique in all Europe (see fig. 705). But French Rococo painting, from Watteau to Fragonard, had a decisive—though unacknowledged—effect across the Channel and helped, in fact, to bring about the first school of English painting since the Middle Ages that had more than local importance. The earliest of these painters, William Hogarth (1697–1764), made his mark in the 1730s with a new kind of picture, which he described as "modern moral subjects . . . similar to representations on the stage." He wished to be judged as a dramatist, he said, even though his "actors" could only "exhibit a dumb show." These pictures, and the engravings he made from them for popular sale, came in sets, with details recurring in each scene to unify the sequence. Hogarth's "morality plays" teach, by horrid example, the solid middle-class virtues: they show a country girl who succumbs to the temptations of fashionable London; the evils of corrupt elections; aristocratic rakes who live only for ruinous pleasure, marrying wealthy women of lower status for their fortunes (which they soon dissipated). In *The Orgy* (figs. 700, 701), from *The Rake's Progress*, the young wastrel is overindulging in wine and women. The scene is so full of visual clues that a full account

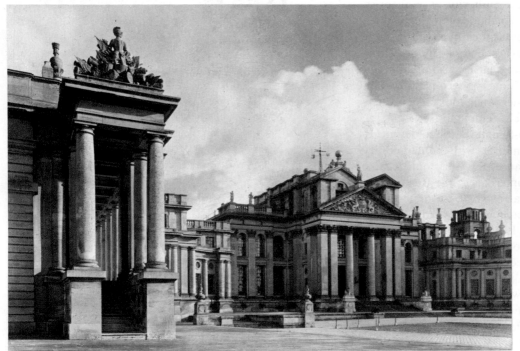

699. SIR JOHN VANBRUGH.
Blenheim Palace, Woodstock.
Begun 1705

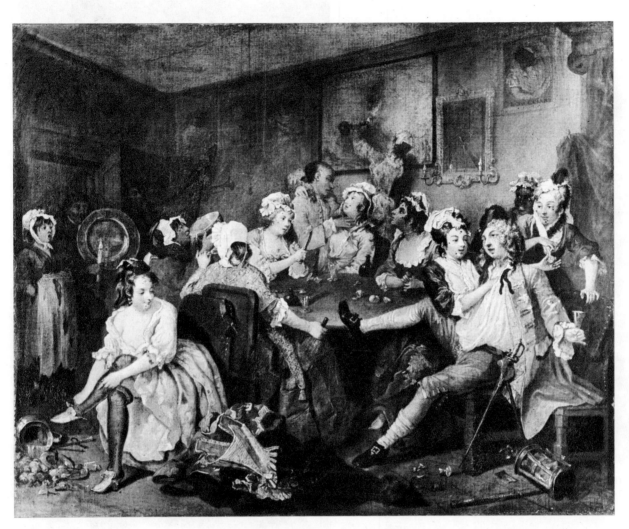

700. WILLIAM HOGARTH. *The Orgy,* Scene III from *The Rake's Progress.* c. 1734. 24 1/2 × 29 1/2".
Sir John Soane's Museum, London

would take pages, plus constant references to the ad-
joining episodes. Yet, however literal-minded, the pic-
ture has great appeal. Hogarth combines some of Wat-
teau's sparkle with Jan Steen's narrative gusto (compare
figs. 690, 667), and so entertains us that we enjoy his
sermon without being overwhelmed by its message. He
is probably the first artist in history to become a social
critic in his own right.

Portraiture remained the only constant source of
income for English painters. Here too, the eighteenth
century produced a style that differed from the continen-
tal traditions that had dominated this field. Its greatest
master, Thomas Gainsborough (1727–88), began by paint-
ing landscapes, but ended as the favorite portraitist of
British high society. His early portraits, such as *Robert
Andrews and His Wife* (colorplate 88), have a lyrical charm
that is not always found in his later pictures. Compared
to Van Dyck's artifice in *Charles I Hunting* (see fig. 651),
this country squire and his wife are naturally, and un-

701. WILLIAM HOGARTH. *He Revels (The Orgy),*
Scene III from *The Rake's Progress.* 1735. Engraving.
The Metropolitan Museum of Art (Harris Brisbane Dick Fund, 1932)

702. THOMAS GAINSBOROUGH. *Mrs. Siddons*. 1785.
49 ¹/₂ × 39″. The National Gallery, London

703. SIR JOSHUA REYNOLDS. *Mrs. Siddons as the Tragic Muse*.
1784. 93 × 57 ¹/₂″. Henry E. Huntington Library
and Art Gallery, San Marino, California

pretentiously, at home in their setting. The landscape, although derived from Ruisdael and his school, has a sunlit, hospitable air never achieved (or desired) by the Dutch masters; and the casual grace of the two figures indirectly recalls Watteau's style. Later portraits by Gainsborough, such as the very fine one of the great actress, Mrs. Siddons (fig. 702), have other virtues: a cool elegance that translates Van Dyck's aristocratic poses into late-eighteenth-century terms, and a fluid, translucent technique reminiscent of Rubens. Gainsborough painted *Mrs. Siddons* in conscious opposition to his great rival on the London scene, Sir Joshua Reynolds (1723–92), who a year before had portrayed the same sitter as the Tragic Muse (fig. 703). Reynolds, the President of the Royal Academy since its founding in 1768, was the protagonist of the academic approach to art, which he had acquired during two years in Rome. Like his French predecessors, he formulated in his famous *Discourses* what he felt were necessary rules and theories. His views were essentially those of Lebrun, tempered by British common sense. Again like Lebrun, he found it difficult to live up to his theories in actual practice. Although he preferred history painting in the grand style, the vast majority of his works are portraits "ennobled," whenever possible, by allegorical additions or disguises like those in his picture of Mrs. Siddons. His style owed a

good deal more to the Venetians, the Flemish Baroque, and even to Rembrandt (note the lighting in *Mrs. Siddons*) than he would concede in theory. The best that can be said of Reynolds is that he almost succeeded in making painting respectable in England as a liberal art (he received an honorary doctorate from Oxford), but at what cost! His *Discourses*, which soon became standard, inhibited the visual capacity of generations of students in England and America. He was generous enough to give praise to Gainsborough, whom he outlived by a few years, and whose instinctive talent he must have envied.

SCULPTURE

English sculpture has not been discussed in these pages since that of the thirteenth century (see fig. 450). During the Reformation, it will be recalled, there was a wholesale destruction of sculpture in England. This had so chilling an effect that for two hundred years the demand for statuary of any kind was too low to sustain more than the most modest local production. With the rise of

a vigorous English school of painting, however, sculptural patronage grew as well, and during the eighteenth century England set an example for the rest of Europe in creating the "monument to genius"—statues in public places honoring culture heroes such as Shakespeare, a privilege hitherto reserved for heads of state. One of the earliest and most ingratiating is that of the great composer George Frederick Handel (fig. 704), by the French-born Louis-François Roubiliac (1702–62). It was also the first statue of a culture hero made within his lifetime (the next to achieve this distinction would be Voltaire in France, a full generation later; see fig. 754). Roubiliac carved the figure in 1743 for the owner of Vauxhall Gardens in London, a pleasure park with dining facilities and an orchestra stand where Handel's music was often performed, so that the statue served two purposes: homage and advertising. Handel is in the guise of Apollo, the god of music, playing a classical lyre; a putto at his feet writes down the divine music. But Handel is a most domestic Apollo, in slippers and a worn dressing gown, a soft beret on his head instead of the then customary wig. Although Roubiliac shows himself in full command of the Baroque sculptural tradition, the studied informality of his deified *Handel* seems peculiarly English: touches such as the right foot resting upon rather than inside the slipper (a hint at the composer's gouty big toe?) suggest that he sought advice from Hogarth, with whom he was on excellent terms. Be that as it may, *Handel* was Roubiliac's first big success in his adopted homeland, and it became the forebear of countless later monuments to culture heroes everywhere (see fig. 783).

704. LOUIS-FRANÇOIS ROUBILIAC. *George Frederick Handel.* 1738. Marble, lifesize. Victoria & Albert Museum, London (Crown copyright reserved)

ILLUSTRATED TIME CHART III

1300

Petrarch, first humanist (1304–74)
Boccaccio (1313–75)

1400

Death of Giangaleazzo Visconti of Milan (1402) removes threat to political independence of Florence
Joan of Arc burned at stake for heresy and sorcery 1431
Council of Florence attempts to reunite Catholic and Orthodox faiths 1439

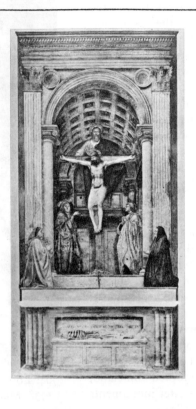

Leonardo Bruni (c. 1374–1444)
Prince Henry the Navigator of Portugal (1394–1460) promotes geographic exploration
Leon Battista Alberti (1404–72): *On Architecture; On Painting*
Earliest record of suction pump c. 1440

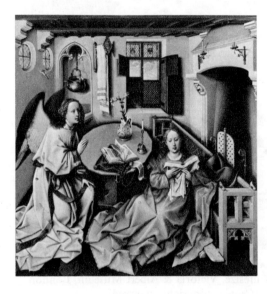

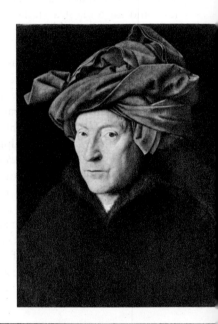

1450

Hapsburg rule of Holy Roman Empire begins 1452
End of Hundred Years' War 1453
Constantinople falls to Turks 1453
Pico della Mirandola (1463–94)
Ferdinand and Isabella unite Spain 1469
Granada, last Moslem stronghold in Spain, falls 1492
Spain and Portugal divide New World 1493–94
Cabot claims eastern North America for England 1497
Charles VIII of France invades Italy 1494–99
Henry VII (r. 1485–1509), first Tudor king of England
Savonarola virtual ruler of Florence 1494; burned at the stake for heresy in Florence 1498

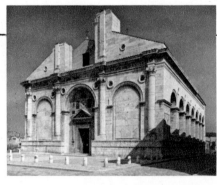

François Villon (born c. 1431)
Marsilio Ficino (1433–99)
Diaz rounds Cape of Good Hope 1486
Columbus discovers America 1492
Sebastian Brant's *Ship of Fools* 1494
Vasco da Gama reaches India, returns to Lisbon 1497–99

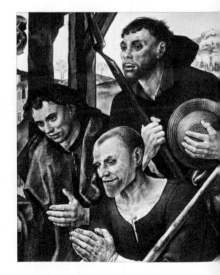

1500

1300

1400

Nanni di Banco, *Four Saints*
Donatello, *St. Mark; St. George*
Brunelleschi begins career as architect 1419;
 Florence Cathedral dome; S. Lorenzo;
 Pazzi Chapel; S. Spirito; Sta. Maria degli
 Angeli
Donatello, *Zuccone; Feast of Herod*
Masaccio, *Trinity* fresco; Brancacci Chapel
 frescoes
Master of Flémalle, *Mérode Altar*
Jacopo della Quercia, portal of S. Petronio,
 Bologna
Donatello, *David*
Jan van Eyck, *Ghent Altar; Wedding Portrait*
Rogier van der Weyden, *Descent from the
 Cross*
Ghiberti, "*Gates of Paradise*"
Luca della Robbia, *Cantoria*
Filippo Lippi, *Madonna*
Fra Angelico, S. Marco frescoes
Witz, *Geneva Altar*
Michelozzo, Palazzo Medici-Riccardi
Domenico Veneziano, *Madonna and Saints*
Donatello, *Gattamelata*
Bernardo Rossellino, Tomb of Leonardo
 Bruni
Castagno, *Last Supper*
Alberti, Palazzo Rucellai

1450

Alberti, S. Francesco, Rimini; S. Andrea,
 Mantua
Donatello, *Magdalen*
Mantegna, Ovetari Chapel frescoes
Antonio Rossellino, *Giovanni Chellini*
Piero della Francesca, Arezzo frescoes
Pollaiuolo, *Battle of Ten Naked Men*, en-
 graving
Pacher, *St. Wolfgang Altar*
Pollaiuolo, *Hercules and Antaeus*
Hugo van der Goes, *Portinari Altar*
Schongauer, *Temptation of St. Anthony*, en-
 graving
Botticelli, *Birth of Venus*
Leonardo, *Adoration of the Magi*
Perugino, *Delivery of the Keys*
Verrocchio, *Colleoni*
Giuliano da Sangallo, Sta. Maria delle
 Carceri, Prato
Giovanni Bellini, *St. Francis*
Leonardo, *Last Supper*
Dürer, *Four Horsemen of the Apocalypse*,
 woodcut

1500

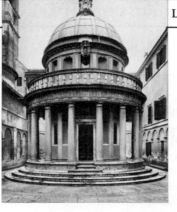

POLITICAL HISTORY, RELIGION

Erasmus of Rotterdam's *Praise of Folly* 1511

Martin Luther (1483–1546) posts theses 1517; excommunicated and outlawed 1521

Charleş V elected Holy Roman Emperor 1519

Cortés wins Aztec empire in Mexico for Spain 1519

Suleiman the Magnificent ascends Turkish throne 1520; threatens Vienna 1525

First printed edition of Machiavelli's *The Prince* 1532

Henry VIII of England (r. 1509–47) founds Anglican Church 1534

Peasants' Revolt in Germany 1524–25

Francis I of France defeated by Charles V at Pavia 1525

Mogul dynasty in India founded 1527

Ignatius of Loyola founds Jesuit order 1534

John Calvin's *Institutes of the Christian Religion* 1536

Wars of Lutheran vs. Catholic princes in Germany; Peace of Augsburg (1555) lets each sovereign decide religion of his subjects

LITERATURE, SCIENCE, TECHNOLOG

Balboa sights Pacific Ocean 1513

Thomas More's *Utopia* 1516

Portuguese reach China 1516; hold trade monopoly in Far East until 1602

First circumnavigation of the globe by Magellan and crew 1520–22

Castiglione's *The Courtier* 1528

Copernicus refutes geocentric view of universe 1543

Paracelsus (1493–1541)

Vesalius' *De Humani Corporis Fabrica* 1543

François Rabelais (1494–1553)

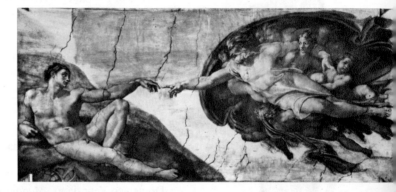

Council of Trent 1545–63

Alexander Knox founds Presbyterian Church 1560

St. Theresa of Avila (1515–82)

Giordano Bruno (1548–1600) burned at the stake for heresy in Venice

Ivan the Terrible of Russia (r. 1547–84)

Charles V retires, divides empire 1556; son Philip II becomes king of Spain, Netherlands, New World; seizes Portugal 1580

Elizabeth I of England (r. 1558–1603)

Turkish sea power crushed at Lepanto 1571

Netherlands revolt against Spain 1568; northern provinces declare independence 1581

Spanish Armada defeated by English 1588

Henry IV of France (r. 1589–1610) ends religious civil war; Edict of Nantes (1598) establishes religious toleration

Lutheranism state religion in Denmark 1560

Montaigne (1533–92)

Cervantes (1547–1616)

Agricola's *De re metallica* 1556

Vasari's *Lives* 1564

Ramelli's *Diverse ed artificiose macchine* 1588

Tycho Brahe (1546–1601)

Francis Bacon (1561–1626)

William Shakespeare (1564–1616)

Sir Philip Sidney (1554–86)

Jamestown, Virginia, founded 1607; Plymouth, Mass., 1620

King James Bible 1611

Romanov dynasty founded in Russia 1613

Thirty Years' War 1618–48

Cardinal Richelieu, adviser to Louis XIII, consolidates power of king 1624–42

Japanese isolation against Europeans begins 1639

Cardinal Mazarin governs France during minority of Louis XIV 1643–61 (Civil War 1648–53)

Charles I of England beheaded 1649; Commonwealth under Cromwell 1649–53

Society of Friends (Quakers) founded 1668

William Gilbert's treatise on magnetism 1600

Napier's treatise on logarithms 1614

Harvey describes circulation of blood 1628

Galileo (1564–1642)

John Donne (1572–1631)

René Descartes (1596–1650)

Pierre Corneille (1606–84)

Torricelli measures pressure of atmosphere 1644

Royal Academy of Paris founded 1648

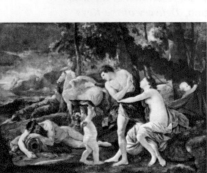

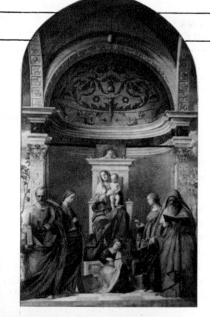

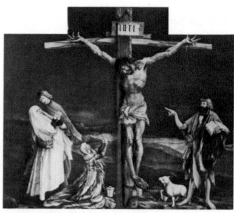

Bosch, *Garden of Delights*
Michelangelo, *David*
Bramante, Tempietto, Rome; new St. Peter's
Leonardo, *Mona Lisa*
Giorgione, *Tempest*
Michelangelo, Sistine ceiling
Raphael, *School of Athens*
Grünewald, *Isenheim Altar*
Michelangelo, *Moses* and two "*Slaves*"
Titian, *Bacchanal*
Château of Chambord
Rosso, *Descent from the Cross*
Michelangelo, Medici tombs
Dürer, *Four Apostles*
Correggio, *Assumption of the Virgin*
Altdorfer, *Battle of Issus*
Parmigianino, *Madonna with Long Neck*
Michelangelo, Laurentian Library vestibule, Florence
Michelangelo, *Last Judgment*
Michelangelo begins Campidoglio replanning 1537–39; architect of St. Peter's 1546
Cellini, Saltcellar of Francis I
Holbein, *Henry VIII*
Titian, *Paul III and Grandsons*
Lescot, Louvre court
Goujon, *Fontaine des Innocents*

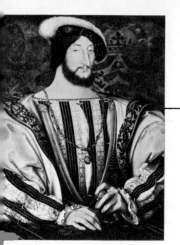

Michelangelo, *Rondanini Pietà* (last work)
Ammanati, Palazzo Pitti courtyard, Florence
Vasari, Uffizi, Florence
Pilon, Tomb of Henry II
Bruegel, *Peasant Wedding*
Palladio, S. Giorgio Maggiore, Venice; Villa Rotonda, Vicenza
Il Gesù, Rome; plan by Vignola; façade by Della Porta
Veronese, *Christ in the House of Levi*
Giovanni Bologna, *Rape of Sabine Woman*
El Greco, *Burial of Count Orgaz*
Tintoretto, *Last Supper*
Caravaggio, *Calling of St. Matthew*
Annibale Carracci, Farnese Gallery ceiling

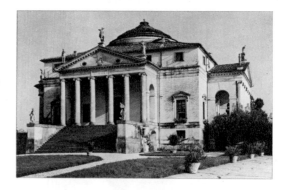

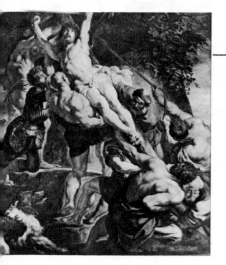

Maderno, nave and façade of St. Peter's; Bernini's colonnade
Rubens, *Raising of the Cross*
Reni, *Aurora*
Jones, Banqueting House, London
Guercino, *Aurora*
Bernini, *David*
Hals, *Jolly Toper*
Pietro da Cortona, Palazzo Barberini ceiling
Van Dyck, *Charles I Hunting*
Borromini, S. Carlo alle Quattro Fontane, Rome, plan
Borromini, S. Ivo, Rome
Rembrandt, *Night Watch*
Mansart, Château of Maisons-Lafitte
Bernini, Cornaro Chapel
Poussin, *Burial of Phocion*

POLITICAL HISTORY, RELIGION	LITERATURE, SCIENCE, TECHNOLOGY	PAINTING, SCULPTURE, ARCHITECTURE
1650		
Charles II restores monarchy in England 1660	Thomas Hobbs' *Leviathan* 1651	Ruisdael, *Jewish Graveyard*
Jacques Bossuet (1627–1704)	Molière (1622–73)	Velázquez, *Maids of Honor*
Spinoza (1632–77)	Pascal (1623–62)	Bernini, *Throne of St. Peter*
Parliament passes Habeas Corpus Act 1679		Rembrandt, *Prodigal Son*
Frederick William, the Great Elector (died 1688) founds power of Prussia		Borromini, S. Carlo alle Quattro Fontane, Rome, façade
Louis XIV absolute ruler of France (r. 1661–1715); revokes Edict of Nantes 1685; France most powerful nation in Europe		Vermeer, *The Letter*
Glorious Revolution against James II of England 1688; Bill of Rights		Perrault, east front of Louvre
		Bernini, Model for equestrian statue of Louis XIV
	Boyle's Law formulated 1660	Guarini, Chapel of Holy Shroud, Turin
	Royal Society, London, founded 1662	Versailles begun 1669
	Isaac Newton (1642–1727)	Puget, *Milo of Crotona*
	John Locke (1632–1704)	Coysevox, *Charles Lebrun*
	Racine (1639–99)	Wren, St. Paul's, London
	Great Fire and Plague of London 1665–66	Le Vau and Hardouin-Mansart, Versailles
	Milton's *Paradise Lost* 1667	Guarini, Palazzo Carignano, Turin
	Bunyan's *Pilgrim's Progress* 1678	
	Leibnitz (1646–1716)	
	Montesquieu (1689–1755)	
1700		
Peter the Great (r. 1682–1725) westernizes Russia, defeats Sweden	Defoe's *Robinson Crusoe* 1719	Prandtauer, Monastery at Melk
English and allies defeat French at Blenheim 1704	Swift's *Gulliver's Travels* 1726	Vanbrugh, Blenheim
Robert Walpole first prime minister 1721–42	John Gay's *The Beggar's Opera* 1728	Fischer von Erlach, St. Charles, Vienna
Wesley brothers found Methodism 1738	Linnaeus' *Systema Naturae* 1737	Watteau, *Pilgrimage to Cythera*
Frederick the Great of Prussia defeats Austria 1740–45	Giovanni Battista Vico (1668–1744)	Neumann, Episcopal Palace, Würzburg
	Alexander Pope (1688–1744)	Boffrand, Hôtel de Soubise
	Voltaire (1694–1778)	Hogarth, *Rake's Progress*
	Charles Du Fay (1698–1739) discovers positive and negative electric charge	Chardin, *Back from the Market*
		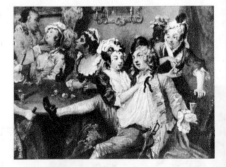
1750		
Seven Years' War (1756–63): England and Prussia vs. Austria and France, called French and Indian War in U.S.; French defeated in battle of Quebec 1769; England greatest colonial and naval power	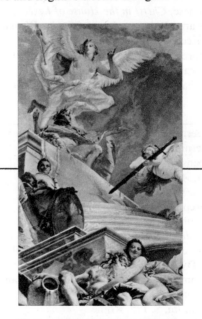	Tiepolo, Würzburg ceiling fresco
Catherine the Great (r. 1762–96) extends Russian power to Black Sea		Fragonard, *Bathers*
Partition of Poland among Russia, Prussia, Austria 1772–95		Falconet, equestrian monument of Peter the Great
		Zimmermann, "Die Wies," Bavaria
		Gainsborough, *Mr. and Mrs. Andrews*
	James Watt patents steam engine 1769	
	Edward Jenner demonstrates smallpox vaccine 1796	

Part Four

THE MODERN
WORLD

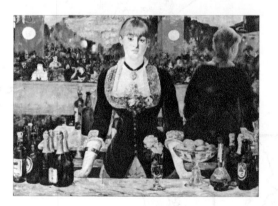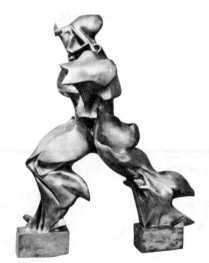

THE WORLD

ARCTIC OCEAN

SIBERIA
U.S.S.R.

GREENLAND

Nome

ALASKA

YUKON R.
Fairbanks

CANADA

Anchorage

KAMCHATKA

ALEUTIAN ISLANDS

VANCOUVER
ISLAND

Seattle

GREAT
LAKES

Quebec
Montreal
Ottawa

NORTH
ATLANTIC
OCEAN

NORTH PACIFIC

OCEAN

MISSOURI R.

Minneapolis

UNITED STATES

GREAT
SALT LAKE

San Francisco
Los Angeles

Chicago
St. Louis

Boston

New York

Kansas City

Washington

Phoenix
Tucson

Dallas

Houston

MISSISSIPPI R.

GULF OF MEXICO

Havana

HAWAII

MEXICO

YUCATÁN

CUBA

Guadalajara

Mexico City

Chichén
Itzá

CARIBBEAN SEA

Uxpanapan

CENTRAL AMERICA

EQUATOR

ECUADOR

Caracas
VENEZUELA

Bogotá
COLOMBIA

CAUCA R.

AMAZON R.

SOUTH PACIFIC

OCEAN

PERU

Machu Picchu
Ollantaytambo
Cuzco

BRAZIL

Lima

Brasília

TAHITI

BOLIVIA

Rio de Janeiro
São Paulo

EASTER
ISLAND

CHILE

ANDES MTS.

PARAGUAY

SOUTH

AMERICA

NEW
ZEALAND

Santiago

ARGENTINA

PARANÁ R.

Buenos
Aires

URUGUAY
Montevideo

LAKE
HURON

Toronto

LAKE ONTARIO

CANADA

Detroit

Rochester

Cambridge

Buffalo

LAKE ERIE

Boston

Cleveland

ALLEGHENY R.

HUDSON R.

Hartford

DELAWARE R.

New Haven

New York

Pittsburgh

Princeton
Merion

UNITED STATES

Philadelphia

OHIO R.

Cincinnati

POTOMAC R.

Baltimore

Washington

ATLANTIC

OCEAN

ADAMS
COUNTY

Charlottesville

palacias

Richmond

 ARCTIC OCEAN

ICELAND

NORWAY
SWEDEN
FINLAND
Oslo
Leningrad
BALTIC SEA
Moscow
VOLGA R.

NORTH SEA
ENGLAND
NETHERLANDS
BELGIUM
FRANCE
BAY OF BISCAY

U. S. S. R.

S I B E R I A

YENISEY R.
OB R.
LENA R.

KAMCHATKA

RUSSIA

Madrid
Spain
Barcelona

ITALY

BLACK SEA

CASPIAN SEA

MONGOLIA

C H I N A

PEKING

KOREA
JAPAN
Kyoto
Tokyo
Nara
Osaka

MEDITERRANEAN SEA

CHIOS

TURKEY

NEAR EAST
SYRIA
JORDAN
ISRAEL

TIGRIS R.
EUPHRATES R.

Teheran

MIDDLE EAST

IRAN

AFGHANISTAN
GANDHĀRA
PAKISTAN

Lahore
Mohenjo-Daro
Mathurā
Sānchī
Sārnāth
Ajantā
Elurā
Calcutta

INDUS R.
GANGES R.

YELLOW (HWANG HO) R.
SZECHWAN
YANGTZE R.

Shanghai

EAST CHINA SEA

TAIWAN

PACIFIC OCEAN

MOROCCO
ALGERIA
LIBYA
EGYPT
Cairo

A F R I C A

AURITANIA
NIGER R.
NIGERIA
Ife
BENIN
GULF OF GUINEA
CAMEROON
GABON
CONGO
ZAÏRE
Kinshasa
CONGO R.

NILE R.

RED SEA

SAUDI ARABIA

PERSIAN GULF

ARABIAN SEA

ETHIOPIA

KENYA
TANZANIA

SOMALIA

INDIA

CEYLON

BAY OF BENGAL

EQUATOR

Hong Kong

VIETNAM

SOUTH CHINA SEA

MALAYSIA

PHILIPPINES

I N D O N E S I A

GAZELLE PENINSULA
NEW BRITAIN
SEPIK R.
NEW GUINEA

SOUTH ATLANTIC OCEAN

ANGOLA
ZAMBIA
MOZAMBIQUE
MADAGASCAR
SOUTH AFRICA

INDIAN OCEAN

WESTERN ARNHEM LAND

A U S T R A L I A

Perth
Sydney
Canberra
Melbourne

SCOTLAND
Glasgow
Edinburgh
Liverpool
Manchester
Amsterdam
Cambridge
The Hague
IRELAND
Birmingham
ENGLAND
London
Twickenham
Brighton

DENMARK
Humlebaek
Copenhagen
Neukirchen
Hamburg
Hanover
Berlin
Dessau
GERMANY
Arnhem
Utrecht
Cologne
Dresden
Weimar
Antwerp
Hanau am Main
Frankfort
Brussels
Ghent
Paris

POLAND

RUSSIA
U.S.S.R.

CZECHOSLOVAKIA
Vienna
HUNGARY
AUSTRIA

ROMANIA

DANUBE

YUGOSLAVIA

Poissy-sur-Seine
Barbizon
Ronchamp
FRANCE
Ornans
Basel Zurich
Lucerne
Bern
Arcole
Milan
SWITZERLAND
LOMBARDY

PROVENCE
Aix Arles
Bordeaux
Montpellier
Marseilles

ATLANTIC OCEAN

BAY OF BISCAY

SPAIN
Guernica

ITALY
Rome

Herculaneum
Pompeii
Paestum

Missolonghi

GREECE
CORFU
Athens

INTRODUCTION

The era to which we ourselves belong has not yet acquired a name of its own. Perhaps this does not strike us as peculiar at first—we are, after all, still in midstream—but considering how promptly the Renaissance coined a name for itself, we may well ponder the fact that no key concept comparable to the "rebirth of antiquity" has emerged in the two hundred years since our era began. It is tempting to make "revolution" such a concept, because rapid and violent change has indeed characterized the modern world. Yet we cannot discern a common impulse behind these developments, for the modern era began with revolutions of two kinds: the industrial revolution, symbolized by the invention of the steam engine, and the political revolution, under the banner of democracy, in America and France. Both revolutions are still going on; industrialization and democracy, as goals, are sought all over the world. Western science and Western political ideology (and, in their wake, all the other products of modern Western civilization, whether food, dress, art, or literature) will soon belong to all mankind. These two movements are so closely linked today that we tend to think of them as different aspects of one process—with effects more far-reaching than any since the Neolithic Revolution ten thousand years ago. Still, the twin revolutions of modern times are not the same; the more we try to define their relationship, and to trace its historic roots, the more paradoxical it seems. Both are founded on the idea of progress, and command an emotional allegiance that once was reserved for religion; but whereas progress in science during the past two centuries has been continuous and palpable, we can hardly make this claim for man's pursuit of happiness, however we choose to define it.

Here, then, is the conflict fundamental to our era. Man today, having cast off the framework of traditional authority which confined and sustained him before, can act with a latitude both frightening and exhilarating. In a world where all values may be questioned, man searches constantly for his own identity, and for the meaning of human existence, individual and collective. His knowledge about himself is now vastly greater, but this has not reassured him as he had hoped. Modern civilization thus lacks the cohesiveness of the past; it no longer proceeds by readily identifiable periods, nor are there clear period styles to be discerned in art or in any other form of endeavor. Instead, we find a continuity of another kind, that of movements and countermovements. Spreading like waves, these "isms" defy national, ethnic, and chronological boundaries; never dominant anywhere for long, they compete or merge with each other in endlessly shifting patterns. Hence our account of modern art will be by movements rather than by countries. Only in this way can we hope to do justice to the fact that modern art, all regional differences notwithstanding, is as international as modern science.

ARCHITECTURE

PAINTING

SCULPTURE

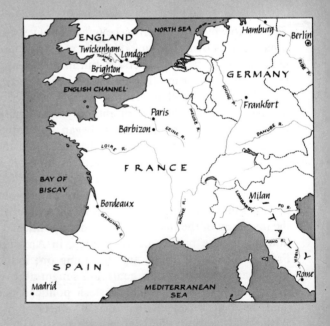

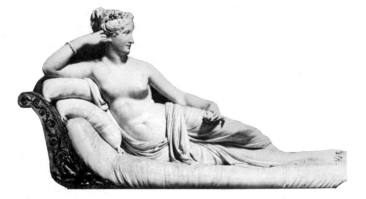

1

NEOCLASSICISM AND ROMANTICISM

The history of the two movements to be dealt with in this chapter covers roughly a century, from about 1750 to 1850. Long regarded as opposites, the two seem today so interdependent that we should prefer a single name for both, if we could find a suitable one. ("Romantic Classicism" has not won wide acceptance.) The difficulty is that the two terms are unevenly matched—like "quadruped" and "carnivore." Neoclassicism is a new revival of classical antiquity, more consistent than earlier classicisms, while Romanticism refers not to a specific style but to an attitude of mind that may reveal itself in any number of ways. Romanticism, therefore, is a far broader concept and correspondingly harder to define. The word derives from the late-eighteenth-century vogue for medieval tales of adventure (such as the legends of King Arthur or the Holy Grail, called "romances" because they were written in a Romance language, not in Latin). But this interest in the long-neglected "Gothick" past was symptomatic of a general revulsion against the established social order and established religion—against established values of any sort—that sprang from a craving for emotional experience. Almost any experience would do, real or imaginary, provided it was sufficiently intense. The declared aim of the Romantics, however, was to tear down the artifices barring the way to a "return to Nature"—nature the unbounded, wild and ever-changing, nature the sublime and picturesque. Were man to behave "naturally," giving his impulses free rein, evil would disappear and his happiness would be perfect. In the name of nature, the Romantic worshiped liberty, power, love, violence, the Greeks, the Middle Ages, or anything that aroused his response, while actually he worshiped emotion as an end in itself. At its extreme, this attitude could be expressed only through direct action, not through works of art. (It has motivated some of the noblest—and vilest—acts of our era.) No artist, then, can be a wholehearted Romantic, for the creation of a work of art demands some detachment and self-awareness. What Wordsworth, the great

Romantic poet, said of poetry—that it is "emotion recollected in tranquillity"—applies also to the visual arts. To cast his fleeting experience into permanent form, the Romantic artist needs a style. But since he is in revolt against the old order, this cannot be the established style of his time; it must come from some phase of the past to which he feels linked by "elective affinity" (another Romantic concept). Romanticism thus favors the revival, not of one style, but of a potentially unlimited number of styles. Revivals, in fact—the rediscovery and utilization of forms hitherto neglected or disliked—became a stylistic principle: the "style" of Romanticism in art (also, to a degree, in literature and music). Neoclassicism, seen in this context, is no more than an aspect of Romanticism. We have put it in the title of the present chapter only because, until about 1800, it loomed larger than the other Romantic revivals.

ARCHITECTURE

Given the individualistic nature of Romanticism, we might expect the range of revival styles to be widest in painting, the most personal and private of the visual arts, and least wide in architecture, the most communal and public. Yet the opposite is true. Painters and sculptors were unable to abandon Renaissance habits of representation, and never really revived medieval art, or ancient art before the classic era. Architects were not subject to this limitation, and the revival styles persisted longer in architecture than in the other arts. Let us then begin our survey with architecture, even though we shall have to omit some of the less significant architectural revivals.

England was the birthplace of Romanticism. The earliest sign of this attitude was the Palladian revival in the 1720s, sponsored by a wealthy amateur, Lord Burlington. Chiswick House (figs. 705, 706), adapted from Villa Rotonda (figs. 591, 592), is compact, simple, and geomet-

705. LORD BURLINGTON and WILLIAM KENT. Chiswick House, near London. Begun 1725

706. Plan of Chiswick House

ric—the antithesis of the Baroque pomp of Blenheim Palace. What distinguishes this style from earlier classicisms is less its external appearance than its motivation: instead of merely reasserting the superior authority of the ancients, it claimed to satisfy the demands of reason, and thus to be more "natural" than the Baroque. This rationalism explains the oddly abstract, segmented look of Chiswick House—the surfaces are flat and unbroken, the ornament is meager, the temple portico juts out too abruptly from the blocklike body of the structure. Should such a villa be set in a geometric, formal garden, like Le Nôtre's at Versailles (see fig. 682)? Indeed not, Lord Burlington and his circle maintained; that would

be unnatural, hence contrary to reason. So they invented what became known all over Europe as "the English landscape garden." Carefully planned to look unplanned, with winding paths, irregularly spaced clumps of trees, and little lakes and rivers instead of symmetrical basins and canals, the "reasonable" garden must seem as unbounded, as full of surprise and variety, as nature itself. It must, in a word, be "picturesque," like the landscapes of Claude Lorraine (which English landscape architects now took as their source of inspiration), and include little temples half concealed by the shrubbery, or artificial ruins, "to draw sorrowful reflections from the soul." Such sentiments were not new; they had often been expressed before in poetry and painting. But to project them onto nature itself, through planned irregularity, was a new idea. The landscape garden, a work of art intended *not* to look like a work of art, blurred the long-established demarcation between artifice and reality, and thus set an important precedent for the revival styles to come. After all, the landscape garden stands in the same relation to nature as a synthetic ruin to an authentic one, an imitation to a genuine folk song, or a Neoclassic or Neo-Gothic building to its ancient or medieval model. When the fashion spread to the other side of the Channel, it was welcomed not merely as a new way to lay out gardens, but as a vehicle of Romantic emotion.

Of all the landscape gardens laid out in England in the mid-eighteenth century, that at Stourhead most nearly retains its original appearance. Its creators, the banker Henry Hoare and the designer Henry Flitcroft, were both enthusiastic followers of Lord Burlington and William Kent; Stourhead is unique not only for its fine pres-

707. HENRY FLITCROFT and HENRY HOARE.
Landscape Garden with Temple of Apollo,
Stourhead, England. 1744–65

ervation but also for the owner's active role in planning every detail of its development. Our view (fig. 707) is across a small lake made by damming the river Stour; high on the far shore is the Temple of Apollo modeled on the Temple of Venus at Baalbek (see fig. 233), which became known in the West only after 1757. Occupying other focal points at Stourhead are a grotto, a Temple of Venus, a Pantheon, a genuine Gothic cross, and a neo-medieval tower built to commemorate King Alfred the Great, "the Father of His People."

The rationalist movement against the Baroque (or, rather, against the Rococo) came somewhat later in France. Its first great monument, the Pantheon in Paris, by Jacques Germain Soufflot (1713–80), was built as the church of Ste-Geneviève, but secularized during the Revolution (fig. 708). Its dome, interestingly enough, is derived from St. Paul's Cathedral in London (see fig. 696), indicating England's new importance for continental architects. The smooth, sparsely decorated surfaces are abstractly severe, akin to those of Chiswick House, while the huge portico is modeled directly on ancient Roman temples. From this coolly precise exterior we would never suspect that Soufflot also had a strong interest in Gothic churches. He admired them, not for the seeming miracles they perform but for their structural elegance —a rationalist version of Guarini's point of view (see fig. 639). His ideal, in fact, was "to combine the classic orders with the lightness so admirably displayed by certain Gothic buildings." Soufflot, however, did not yet study Gothic architecture in detail, as later generations of architects would.

Etienne-Louis Boullée (1728–99) was half a generation younger than Soufflot and far more daring. He built little, but his teaching at the Royal Academy helped to create a tradition of visionary architecture that flourished during the last third of the century and the early years of the next. Boullée's ideal was an architecture of "majestic nobility," an effect he sought to achieve by combining huge, simple masses. Most of his designs were for structures on a scale so enormous that they could hardly be built even today. He hailed the sphere as the perfect form, since no trick of perspective can alter its appearance (except, of course, its apparent size). Thus he projected a memorial to Isaac Newton as a gigantic hollow sphere, mirroring the universe (fig. 709). "O Newton!" he exclaimed, "I conceived the idea of surrounding you with your discovery, and thus, somehow, of surrounding you with yourself." The interior is empty, apart from a sarcophagus at the bottom for the mortal remains of the great man, but the upper half of its surface is pierced by countless small holes, points of light meant to give the illusion of stars. Plans such as this have a utopian grandeur that dwarfs the boldest ambitions of earlier architects. Largely forgotten during most of the nineteenth century, Boullée and his sucessors were rediscovered in the early twentieth, when architects again dared to "think the unthinkable."

Archaeological Excavations

The mid-eighteenth century was greatly stirred by two experiences: the rediscovery of Greek art as the original source of classic style; and the excavations at Herculaneum and Pompeii, which for the first time revealed the

708. JACQUES GERMAIN SOUFFLOT. The Panthéon (Ste-Geneviève), Paris. 1755–92

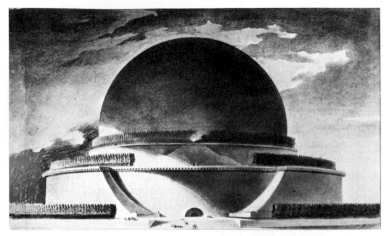

709. ETIENNE-LOUIS BOULLÉE.
Project for a Memorial to Isaac Newton. 1784.
Ink and wash drawing, 15 1/2 × 25 1/2".
Bibliothèque Nationale, Paris

daily life of the ancients and the full range of their arts and crafts. Richly illustrated books about the Acropolis at Athens, the temples at Paestum, and the finds at Herculaneum and Pompeii were published in England and France; archaeology caught everyone's imagination. From this came a new style of interior decoration, seen at its finest in the works of the Englishman, Robert Adam (1728–92), such as the front drawing room at Home House (fig. 710). Adapted from Roman stucco ornament (compare fig. 244), it echoes the delicacy of Rococo interiors but with a characteristically Neoclassic insistence on plane surfaces, symmetry, and geometric precision. Meanwhile, the Palladianism launched by Lord Burlington had spread overseas to the American Colonies, where it became known as the Georgian style; an example of great distinction is Thomas Jefferson's house, Monticello (figs. 711, 712). Built of brick with wooden trim, in design it is not so doctrinaire as Chiswick House (note the less compact plan and the numerous windows), and the use of the Doric order shows its later date. Jefferson still preferred the Roman Doric, although the late eighteenth century came to favor the heavier and more austere Greek Doric. This "Greek revival" phase of Neoclassicism had been pioneered in England, on a small scale; it was quickly taken up everywhere, since it was believed to embody more of the "noble simplicity and calm grandeur" of classic Greece than did the later, less "masculine" orders. Greek Doric was also the least flexible order, hence particularly difficult to adapt to modern tasks even when combined with Roman or Renaissance elements. Only rarely could Greek Doric architecture furnish a direct model for Neoclassic structures: such a case is the Brandenburg Gate in Berlin (fig. 713), derived from the Propylaea (see fig. 155).

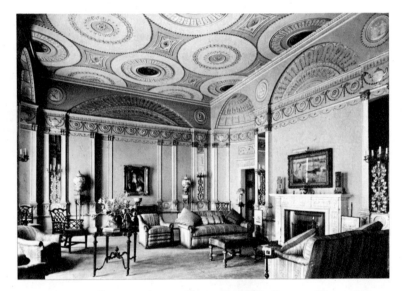

710. ROBERT ADAM. Front Drawing Room, Home House.
20 Portman Square, London. 1772–73

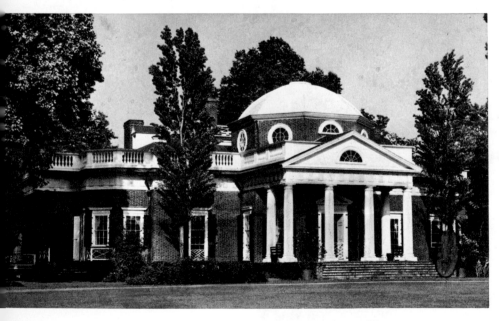

711. THOMAS JEFFERSON. Monticello, Charlottesville,
Virginia. 1770–84; 1796–1806

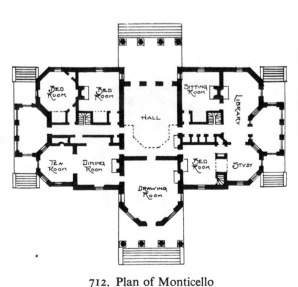

712. Plan of Monticello

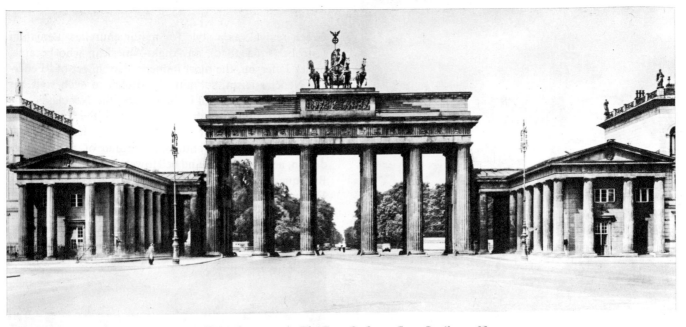

713. KARL LANGHANS. The Brandenburg Gate, Berlin. 1788–91

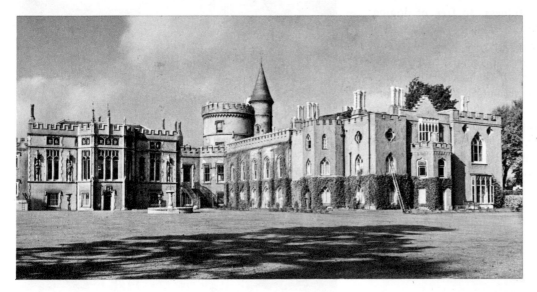

714. HORACE WALPOLE, with
WILLIAM ROBINSON and others.
Strawberry Hill,
Twickenham. 1749–77

715. Interior, Strawberry Hill

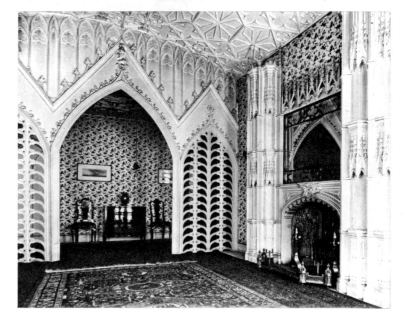

Classic vs. Gothic, and Other Alternatives

While the classic revival between 1750 and 1800 was
becoming increasingly "archaeological," the Gothic re-
vival also got under way, again with the English in the
lead. Gothic architecture had never wholly disappeared
in England—for special purposes, Gothic forms were
used on occasion even by Sir Christopher Wren and Sir
John Vanbrugh, but these were survivals of an authentic
if outmoded tradition. The conscious revival, by contrast,
was linked with the cult of the picturesque, and with the
vogue for medieval (and pseudo-medieval) romances. In
this spirit Horace Walpole, in the third quarter of the
century, enlarged and "gothicized" his country house,
Strawberry Hill (figs. 714, 715). Despite its studied ir-
regularity, the rambling structure has dainty, flat surfaces
that remind us strongly of Robert Adam (compare
fig. 710); the interior looks almost as if decorated with

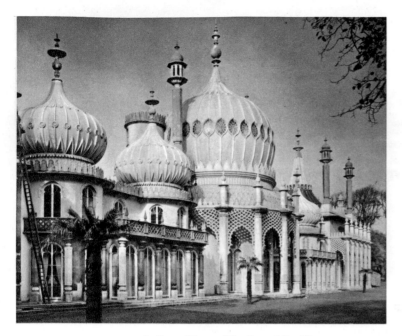

716. JOHN NASH. The Royal Pavilion,
Brighton. 1815–18

lace-paper doilies. This playfulness, so free of dogma, gives Strawberry Hill its special charm. Gothic here is still an "exotic" style; it appeals because it is strange, but for that very reason it must be "translated," like a medieval romance, or the Chinese motifs that crop up in Rococo decoration. The Romantic imagination saw Gothic and the mysterious East in much the same light, as John Nash's Royal Pavilion at Brighton (fig. 716) well demonstrates half a century later. The style of this "stately pleasure dome," a cream-puff version of the Taj Mahal (see fig. 317), was then known as Indian Gothic. It is equally characteristic of Romanticism, however, that by 1800 the Gothic was a fully acceptable alternative to the

Greek revival, as a style for major churches. Benjamin Latrobe (1764–1820), an Anglo-American who became, under Jefferson, the most influential architect of "Federal" Neoclassicism, submitted a design in each style for the Catholic Cathedral in Baltimore; the Neoclassic one was chosen, but it might well have been the Gothic. The exterior of the present building (fig. 717) has walls that resemble Soufflot's Panthéon, a dome of more severe design, a temple front, and bell towers of disguised Gothic-Baroque ancestry (the bulbous crowns are not his work). Far more distinguished is the interior (fig. 718). Inspired by the domed and vaulted spaces of ancient Rome, especially the Pantheon (see fig. 222), Latrobe nevertheless was not interested in archaeological correctness. The

718. Interior, Catholic Cathedral, Baltimore

717. BENJAMIN LATROBE. Catholic Cathedral,
Baltimore, Maryland. Begun 1805

719. BENJAMIN LATROBE. Alternative Design for
the Catholic Cathedral, Baltimore

720. Sir Charles Barry and A. Welby Pugin. The Houses of Parliament, London. Begun 1836

"muscularity" of Roman structures has been suppressed; moldings, profiles, and coffers are no more than linear accents that do not disturb the continuous, abstract surfaces. In this Romantic interpretation, the spatial qualities of ancient architecture become vast, pure, Sublime. The strangely weightless interior presents almost that combination of classic form and Gothic lightness first postulated by Soufflot; it also shows the free and imaginative look of the mature Neoclassic style, when handled by a gifted architect. Had the Gothic design (fig. 719) been chosen, the exterior might have been more striking, but the interior probably less impressive. Like most Romantic architects seeking the Sublime, Latrobe viewed Gothic churches "from the outside in"—as mysterious, looming structures silhouetted against the sky—but nourished his spatial fantasy on Roman monuments. Neo-Gothic interiors are usually disappointing when matched against the best of the Neoclassic.

After 1800, the choice between the classic and Gothic modes was more often resolved in favor of Gothic. Nationalist sentiment, strengthened in the Napoleonic wars, became an important factor, for England, France, and Germany each tended to think that Gothic expressed its particular national genius. Certain theorists, notably John Ruskin, also regarded Gothic as superior for ethical or religious reasons (it was "honest" and "Christian"). All these considerations were conjoined in the design, by Sir Charles Barry and A. Welby Pugin, for the Houses of Parliament in London, the largest monument of the Gothic revival (fig. 720). As the seat of a vast and complex governmental apparatus, but at the same time as a focus of patriotic feeling, it presents a curious mixture—repetitious symmetry governs the main body of the structure, and "picturesque" irregularity its silhouette. Meanwhile the stylistic alternatives were continually increased for architects by other revivals. When, by mid-century, the Renaissance, and then the Baroque, returned to favor, the revival movement

had come full circle: Neo-Renaissance and Neo-Baroque replaced the Neoclassic. This final phase of Romantic architecture, which dominated the years 1850–75 and lingered through 1900, is epitomized in the Paris Opéra (figs. 721–23), designed by Charles Garnier (1825–98). Its Neo-Baroque quality derives more from the profusion of sculpture and ornament than from its architectural vocabulary: the paired columns of the façade, "quoted" from the East Front of the Louvre (see fig. 680), are combined with a smaller order, in a fashion suggested by Michelangelo (see fig. 564). Only the fluid curves of the Grand Staircase recall the High Baroque. The whole building looks "overdressed," its luxurious vulgarity so naïve as to be disarming. It reflects the taste of the beneficiaries of the industrial revolution, newly rich and powerful, who saw themselves as the heirs of the old aristocracy and thus found the pre-revolutionary styles more appealing than classic or Gothic. This "architecture of conspicuous display" was divorced, even more than the previous revival styles, from the practical demands of the industrial age—the factories, warehouses, stores, and city apartments that formed the bulk of building construction.

Industrial Architecture

For it is there, in the world of commercial architecture, that we find after about 1800 the gradual introduction of new materials and techniques that were to have a profound effect on architectural style by the end of the century. The most important was iron, never before used as an actual building material. Within a few decades of its first appearance, iron columns and arches had become the standard means of supporting the roofs over the large spaces required by railroad stations, exhibition halls, and public libraries. A famous early example is the Bibliothèque Ste-Geneviève in Paris, by Henri Labrouste (1801–75): in the reading room a row of cast-

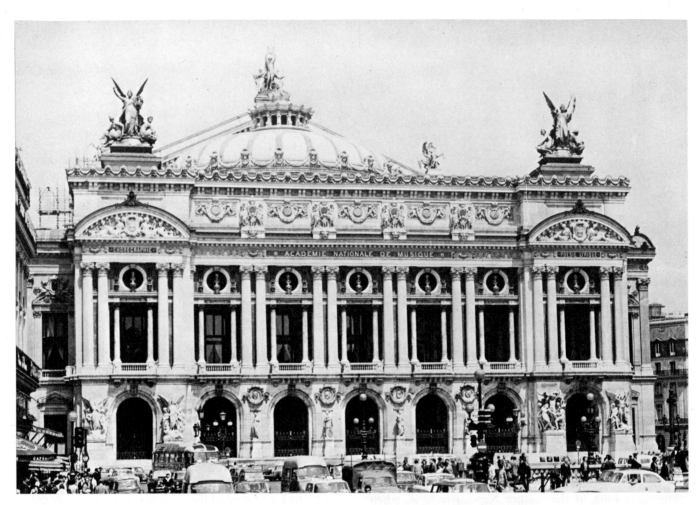

721. CHARLES GARNIER. The Opéra, Paris. 1861–74

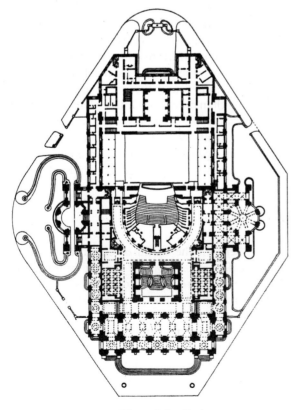

722. Plan of the Opéra

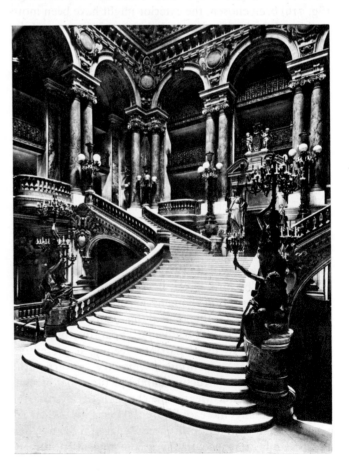

723. Grand Staircase, the Opéra, Paris

iron columns supports two barrel roofs resting on cast-iron arches (fig. 724). Labrouste chose to leave this iron skeleton uncovered, and to face the difficulty of relating it to the massive Renaissance revival style of his building. If his solution does not fully integrate the two systems, it at least lets them coexist. The iron supports, shaped like Corinthian columns, are as slender as the new material permits; their collective effect is that of a space-dividing screen, belying their structural importance. To make them weightier, Labrouste has placed them on tall pedestals of solid masonry, instead of directly on the floor. Aesthetically, the arches presented greater difficulty, since there was no way to make them look as powerful as their masonry ancestors. Here Labrouste has gone to the other extreme, perforating them with lacy scrolls as if they were pure ornament. This architectural—as against merely technical—use of exposed iron members has a fanciful and delicate quality that links it, indirectly, to the Gothic revival. Later superseded by structural steel and ferroconcrete, it is a special and peculiarly appealing chapter in the history of Romantic architecture.

PAINTING

In Romantic painting, as we mentioned previously, the revival of past styles had a far narrower scope than in architecture. Nonetheless, painting remains the greatest creative achievement of Romanticism in the visual arts. Less dependent than architecture or sculpture on public approval, it held a correspondingly greater appeal for the individualism of the Romantic artist; moreover, it could better accommodate the themes and ideas of Romantic literature. Romantic painting was not essentially illustrative. But literature, past and present, now became a more important source of inspiration for painters than ever before, and provided them with a new range of subjects, emotions, and attitudes. Romantic poets, in turn, often saw nature with a painter's eye. Many had a strong interest in art criticism and theory; some, notably Goethe and Victor Hugo, were capable draughtsmen; and Blake cast his visions in both pictorial and literary form. Within the Romantic movement, art and literature have a complex, subtle, and by no means one-sided relationship.

Romantic painting, like architecture, began as a reaction, in the name of reason and nature, against Baroque "artificiality." The first to formulate this view was Johann Winckelmann, the German art historian and theorist who popularized the famous phrase about the "noble simplicity and calm grandeur" of Greek art (in his *Thoughts on the Imitation of Greek Works . . . ,* published 1755). His ideas deeply impressed two painters then living in Rome, the German Anton Raffael Mengs and the Scotsman Gavin Hamilton, as well as the French painter Joseph-Marie Vien. All three had strong anti-

724. HENRI LABROUSTE. Reading Room. Bibliothèque Ste-Geneviève, Paris. 1843–50

quarian leanings but otherwise limited powers—which may be why they accepted Winckelmann's doctrine so readily; their work is less important than their effect as teachers and propagators of the "Winckelmann program," during the 1760s and 70s. To these artists, a return to the classics meant the style and "academic" theory of Poussin, combined with a maximum of archaeological detail newly gleaned from ancient sculpture and the excavations of Pompeii.

America: West; Copley

It may seem surprising that among the first to come under their influence was Benjamin West (1738–1820), who arrived in Rome from Pennsylvania in 1760 and caused something of a sensation, since no American painter had appeared in Europe before. He relished his role of frontiersman—on being shown the *Apollo Belvedere* (see fig. 184), he reportedly exclaimed, "How like a Mohawk warrior!" He also quickly absorbed the lessons of Mengs and Hamilton; when he went to London a few years later, he was in command of the most up-to-date style, and became first a founder-member of the Royal Academy, then, after the death of Reynolds, its president. His career was thus European rather than American. Yet he always took pride in his New World background, and it enabled him to make a contribution to the growth of the Romantic movement that is summed up in his *Death of General Wolfe* (fig. 725).

Wolfe's death, occurring in the siege of Quebec, during the French and Indian War, had aroused considerable feeling in London. When West, among others, decided to represent this event, two methods were open to him: he could give a factual account with the maximum of historic accuracy, or he could use "the grand manner," Poussin's ideal conception of history painting (see page 523), with figures in classical costume. Had West been a European follower of Mengs and Hamilton, he would surely have

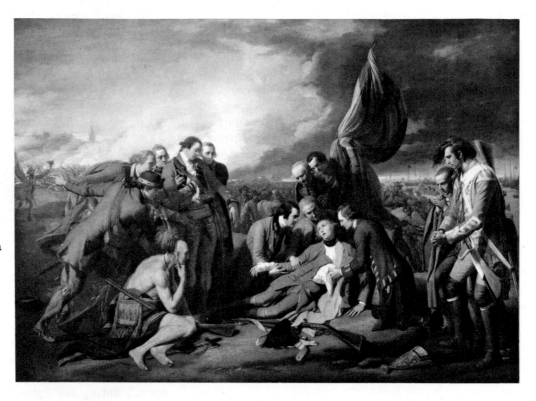

725. BENJAMIN WEST.
The Death of General Wolfe.
1770. 59 ¹/₂ × 84″.
National Gallery of Canada, Ottawa

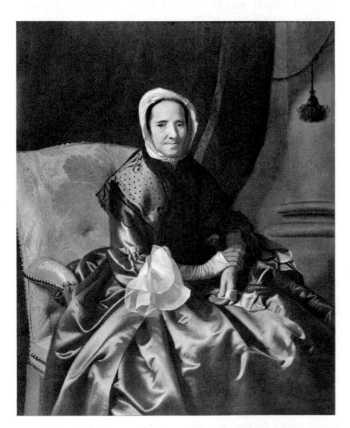

726. JOHN SINGLETON COPLEY. *Mrs. Thomas Boylston.* 1766.
50 ¹/₂ × 40 ¹/₂″. Fogg Art Museum, Harvard University,
Cambridge, Massachusetts

chosen the latter course; however, he knew the American locale of the scene too well for that. He merged the two approaches: his figures wear contemporary dress, and the conspicuous Indian places the event in the New World for those unfamiliar with the subject; yet all the attitudes and expressions are "heroic." The composition, in fact, recalls an old and hallowed theme, the lamentation over the dead Christ (see fig. 450), dramatized by Baroque lighting. West thus endowed the death of a modern military hero both with the rhetorical pathos of "noble and serious human actions," as defined by academic theory, and with the trappings of a real event. He created an image that expresses a phenomenon basic to modern times: the shift of emotional allegiance from religion to nationalism. No wonder his picture had countless successors during the nineteenth century.

West's gifted compatriot, John Singleton Copley of Boston (1738–1815), moved to London just two years before the American Revolution. As New England's outstanding portrait painter, he had adapted the formulas of the British portrait tradition to the cultural climate of his home town. *Mrs. Thomas Boylston* (fig. 726) makes an instructive comparison with Gainsborough's *Mrs. Siddons* (see fig. 702). The framework is much the same (note the curtain), but Gainsborough projects aristocratic coolness and fashionable elegance, while Copley's down-to-earth shrewdness of characterization and soberly exact detail seem more Dutch than English. In Europe, Copley turned to history painting in the manner of West, thus losing his provincial virtues; most mem-

orable as a work of art, and also a model of Romantic imagery, is his *Watson and the Shark* (fig. 727). Watson, attacked by a shark while swimming in Havana harbor, had been dramatically rescued; much later he commissioned Copley to depict this gruesome experience. Perhaps he thought that only a painter newly arrived from America would do full justice to the exotic flavor of the incident; Copley, in turn, must have been fascinated by the task of translating the story into pictorial terms. Following West's example, he made every detail as authentic as possible (here the black has the purpose of the Indian in *The Death of General Wolfe*) and utilized all the emotional resources of Baroque painting to invite the beholder's participation. The shark becomes a monstrous embodiment of evil, the man with the boat hook resembles an Archangel Michael fighting Satan, and the nude youth flounders helplessly between the forces of doom and salvation. Copley may also have recalled representations of Jonah and the Whale: these include the elements of his scene, although the action is reversed (the prophet is thrown overboard into the jaws of the sea monster). This charging of a private adventure with the emotional and symbolic qualities of myth is highly characteristic of Romanticism.

England: Stubbs; Fuseli; Blake; Cozens

The same process recurs in *Lion Attacking a Horse* (colorplate 89) by the Englishman George Stubbs (1724–1806), who painted portraits of race horses—and sometimes their owners—for a living. On a visit to North Africa, he had seen a horse killed by a lion; this experience haunted his imagination, and from it he

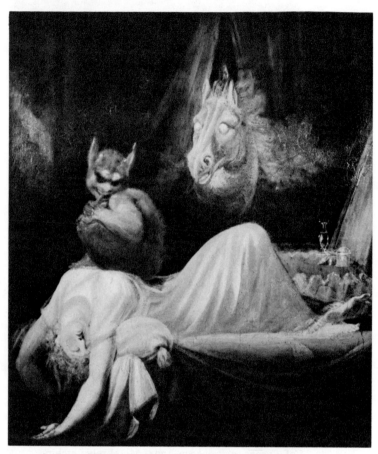

728. JOHN HENRY FUSELI. *The Nightmare.* 1785–90. 29 1/2 × 25 1/4". Goethe Museum, Frankfort

developed a new type of animal picture full of Romantic feeling for the grandeur and violence of nature. Man has no place in this realm, "red in tooth and claw," yet the artist identifies himself emotionally with the horse, whose pure whiteness contrasts so dramatically—and symbolically—with the sinister rocks of the lion's domain. Thunderclouds racing across the sky reinforce the mood of doom; the poor horse, frightened also by the approaching storm, seems doubly defenseless against these forces of destruction. We respond to the horse as to a less fortunate Mr. Watson—with mixed fascination and horror.

But the Romantic quest for terrifying experiences did not pursue only physical violence. It could also lead to the dark recesses of the mind, as in *The Nightmare* (fig. 728) by John Henry Fuseli (1741–1825). This Swiss-born painter—originally named Füssli—had an extraordinary impact on his time, more perhaps because of his adventurous and forceful personality than the merits of his work. Ordained a minister at twenty, he had left the church by 1764, and gone to London in search of freedom. Encouraged by Reynolds, he spent the 1770s in Rome. There he encountered Gavin Hamilton, but Fuseli based his style on Michelangelo and the Mannerists, not on Poussin and the antique. A German acquaintance of those years described him as "extreme in everything—

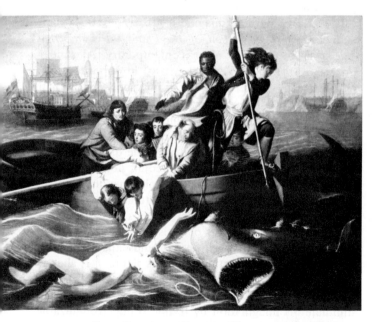

727. JOHN SINGLETON COPLEY. *Watson and the Shark.* 1778. 72 1/2 × 90 1/4". Museum of Fine Arts, Boston

729. WILLIAM BLAKE. *The Ancient of Days*, frontispiece
of *Europe, a Prophecy*. 1794. Metal relief etching,
hand-colored. The Library of Congress, Washington, D.C.
(Lessing J. Rosenwald Collection)

730. TADDEO ZUCCARI. *The Conversion of St. Paul*
(detail). c. 1555. Palazzo Doria-Pamphili, Rome

Shakespeare's painter." Shakespeare and Michelangelo
were indeed his twin gods; he even visualized a Sistine
Chapel with Michelangelo's figures transformed into
Shakespearean characters, where the Sublime would be
the common denominator for "classic" and "Gothic"
Romanticism. In *The Nightmare* we find a similar fusion:
the sleeping woman (more Mannerist than Michelange-
lesque) is Neoclassic, the grinning devil and the lumines-
cent horse come from the demon-ridden world of medieval
folklore. The Rembrandtesque lighting, on the other
hand, reminds us of Reynolds (compare fig. 703).

Later, in London, Fuseli befriended the poet-painter
William Blake (1757–1827), whose personality was even
stranger than his own. A recluse and visionary, Blake
produced and published his own books of poems with
engraved text and hand-colored illustrations. Though he
never left England, he acquired a large repertory of
Michelangelesque and Mannerist motifs from engrav-
ings, and through the influence of Fuseli. He also con-
ceived a tremendous admiration for the Middle Ages,
and came closer than any other Romantic artist to
reviving pre-Renaissance forms (his books were meant
to be the successors of illuminated manuscripts). These
elements are all present in Blake's memorable image of
The Ancient of Days (fig. 729). The muscular figure,
radically foreshortened and fitted into a circle of light,
is derived from Mannerist sources (see fig. 730), while
the symbolic compasses come from medieval representa-
tions of the Lord as Architect of the Universe. With
these precedents, we would expect the Ancient of Days
to signify Almighty God, but in Blake's esoteric mythol-
ogy, he stands rather for the power of reason, which the
poet regarded as ultimately destructive, since it stifles
vision and inspiration. To Blake, the "inner eye" was all-
important; he felt no need to observe the visible world
around him.

It would be hard to imagine a greater contrast than
that between *The Ancient of Days* and the *Landscape*
(fig. 731) by Blake's older contemporary Alexander
Cozens (c. 1717–86). Yet both artists, in opposite ways,
were centrally concerned with inspiration. Cozens had
tired of the idyllic landscapes patterned after Claude
Lorraine which were then so admired. Artists using them
as a model, he felt, could produce only stereotyped
variations on an established theme. The direct study of
nature (important though it was) could not be the new
starting point, for it did not supply the imaginative,
poetic quality that for Cozens constituted the essence of
landscape painting. As a teacher, Cozens developed what
he called "a new method of assisting the invention in
drawing original compositions of landscape" which he
published, with illustrations such as figure 731, shortly
before his death. What was this method? Leonardo da
Vinci, Cozens noted, had observed that an artist could
stimulate his imagination by trying to find recognizable
shapes in the stains on old walls; why not produce such
chance effects on purpose, to be used in the same way?

Colorplate 88. THOMAS GAINSBOROUGH. *Robert Andrews and His Wife*. About 1748–50.
27 1/2 × 47″. The National Gallery, London (Reproduced by courtesy of the Trustees)

Colorplate 89. GEORGE STUBBS. *Lion Attacking a Horse.* 1770. 40$^1/_8$ × 50$^1/_2$″.
Yale University Art Gallery, New Haven, Connecticut

Colorplate 90. GEORGE CALEB BINGHAM. *Fur Traders on the Missouri.* c. 1845. 29 × 36″.
The Metropolitan Museum of Art, New York (Morris K. Jesup Fund, 1933)

Colorplate 91. JEAN-AUGUSTE DOMINIQUE INGRES. *Odalisque*. 1814. 35¼ × 63¾″. The Louvre, Paris

Colorplate 92. FRANCISCO GOYA. *The Third of May, 1808*. 1814–15. 8′ 9″ × 13′ 4″. The Prado, Madrid

Colorplate 93. THÉODORE GÉRICAULT. *Mounted Officer of the Imperial Guard*. 1812. 9′ 7″ × 6′ 4 ¹/₂″.
The Louvre, Paris

Colorplate 94. EUGÈNE DELACROIX. *Greece on the Ruins of Missolonghi*. 1826.
6′ 11¹/₂″ × 4′ 8¹/₄″. Musée des Beaux-Arts, Bordeaux

Colorplate 95. JOSEPH MALLORD WILLIAM TURNER. *The Slave Ship*. 1839. $35^3/4 \times 48''$. Museum of Fine Arts, Boston

Crumple a sheet of paper, smooth it; then, while thinking generally of landscape, blot it with ink, using as little conscious control as possible (our illustration is such an "ink-blot landscape"). With this as the point of departure, representational elements may be picked out in the configuration of blots, and then elaborated into a finished picture. The important difference between the two methods is that Cozens' blots are not a work of nature but a work of art—even though only half-born, they show, if nothing else, a highly individual graphic rhythm. Needless to say, the Cozens method has far-reaching implications, theoretical as well as practical, but these could hardly have been understood by his contemporaries. If they thought Blake was mad, they regarded the "blot-master" as ridiculous. Nevertheless, the "Method" was not forgotten, its memory kept alive partly by its very notoriety. The two great masters of Romantic landscape in England, John Constable and William Turner, both profited from it, although they differed in almost every other way.

731. ALEXANDER COZENS. *Landscape*, from *A New Method of Assisting the Invention in Drawing Original Compositions of Landscape*. 1784–86. Aquatint. The Metropolitan Museum of Art, New York (Rogers Fund, 1906)

England: Constable; Turner

John Constable (1776–1837) admired both Ruisdael and Claude Lorraine, yet he strenuously opposed all flights of fancy. Landscape painting, he believed, must be based on observable facts; it should aim at "embodying a pure apprehension of natural effect." All of his pictures show familiar views of the English countryside. Although he painted the final versions in his studio, he prepared them by making countless oil sketches out-of-doors. These were not the first such studies, but, unlike his predecessors, he was more concerned with the intangible qualities—conditions of sky, light, and atmosphere—than with the concrete details of the scene. Often, as in *Hampstead Heath* (fig. 732), the land serves as no more than a foil for the ever-changing drama of wind, sunlight, and clouds. The sky, to him, was "the key note, the standard scale, and the chief organ of sentiment"; he studied it with a meteorologist's precision, the better to grasp its infinite variety as a mirror of those sweeping forces so dear to the Romantic view of nature. In endeavoring to record these fleeting effects, he arrived at a pictorial technique as broad, free, and personal as that of Cozens' "blotscapes," even though his point of departure was the exact opposite. The full-scale compositions of Constable's final years retain more and more of the quality of his oil sketches; in *Stoke-by-Nayland* (fig. 733), the earth and sky seem both to have become organs of sentiment, pulsating with the artist's poetic sensibility. His contemporary William Turner (1775–1851) had meanwhile arrived at a style which Constable, deprecatingly but acutely, described as "airy visions, painted with tinted steam." Turner began as a watercolorist; the use of translucent tints on white paper may help to explain his preoccupation with colored light. Like Constable, he

made copious studies from nature (though not in oils), but the scenery he selected satisfied the Romantic taste for the Picturesque and the Sublime—mountains, the sea, or sites linked with historic events; in his full-scale pictures he often changed these views so freely that they became quite unrecognizable. Many of his landscapes are linked with literary themes, and bear such titles as *The Destruction of Sodom,* or *Snowstorm: Hannibal Crossing the Alps*, or *Childe Harold's Pilgrimage: Italy*. When they were exhibited, Turner would add appropriate quotations from ancient or modern authors to the catalogue, or he would make up some lines himself and claim to be "citing" his own unpublished poem, "Fallacies of Hope." Yet these canvases are the opposite of history painting as defined by Poussin: the titles indeed indicate "noble and serious human actions," but the tiny figures, lost in the seething violence of nature, suggest the ultimate defeat of all endeavor—"the fallacies of hope." *The Slave Ship* (colorplate 95) is one of Turner's most spectacular visions, and illustrates how he transmuted his literary sources into "tinted steam." First entitled *Slavers Throwing Overboard the Dead and Dying—Typhoon Coming On*, the painting compounds several levels of meaning. It has to do, in part, with a specific incident that Turner had recently read about: when an epidemic broke out on a slave ship, the captain jettisoned his human cargo because he was insured against the loss of slaves at sea, but not by disease. Turner also thought of a relevant passage from *The Seasons*, by the eighteenth-century poet James Thomson, that describes how sharks follow a slave ship during a typhoon, "lured by the scent of steaming crowds, or rank disease, and death." The title of the picture conjoins the slaver's action and the typhoon—but in what relation? Are the dead and dying

732. JOHN CONSTABLE.
Hampstead Heath.
1821. Oil sketch, 10 × 12″.
City Art Galleries, Manchester

733. JOHN CONSTABLE.
Stoke-by-Nayland.
1836. 49¹/₂ × 66¹/₂″.
The Art Institute of Chicago

734. CASPAR DAVID FRIEDRICH.
The Polar Sea.
1824. 38 1/2 × 50 1/2".
Kunsthalle, Hamburg

slaves being cast into the sea against the threat of the storm (perhaps to lighten the ship)? Is the typhoon nature's retribution for the captain's greed and cruelty? Of the many storms at sea that Turner painted, none has quite this apocalyptic quality. A cosmic catastrophe seems about to engulf everything, not merely the "guilty" slaver but the sea itself with its crowds of fantastic and oddly harmless-looking fish. While we still feel the force of Turner's imagination, most of us today, perhaps with a twinge of guilt, enjoy the tinted steam for its own sake, rather than as a vehicle of the awesome emotions the artist meant to evoke. Even in terms of the values he himself acknowledged, Turner strikes us as "a virtuoso of the Sublime," led astray by his very exuberance. He must have been pleased by praise from Ruskin, that protagonist of the moral superiority of Gothic style, who saw in *The Slave Ship,* which he owned, "the true, the beautiful, and the intellectual"—all qualities that raised Turner above older landscape painters. Still, Turner may have come to wonder if his tinted steam had its intended effect on all beholders. Soon after finishing *The Slave Ship*, he could have read in his copy of Goethe's *Color Theory,* recently translated into English, that yellow has a "gay, softly exciting character," while orange-red suggests "warmth and gladness." Would *The Slave Ship* arouse these emotions in a viewer who did not know its title?

Germany: Friedrich

In Germany, as in England, landscape was the finest achievement of Romantic painting, and the underlying ideas, too, were often strikingly similar. When Caspar

David Friedrich (1774–1840), the most important German Romantic artist, painted *The Polar Sea* (fig. 734), he may have known of Turner's "Fallacies of Hope," for in an earlier picture on the same theme, now lost, he had inscribed the name "Hope" on the crushed vessel. In any case, he shared Turner's attitude toward human fate. The painting, as so often before, was inspired by a specific event which the artist endowed with symbolic significance: a dangerous moment in William Parry's Arctic expedition of 1819–20. One wonders how Turner might have depicted this scene—perhaps it would have been too static for him. But Friedrich was attracted by this immobility; he has visualized the piled-up slabs of ice as a kind of megalithic monument to man's defeat built by nature herself. Infinitely lonely, it is a haunting reflection of the artist's own melancholy. There is no hint of tinted steam—the very air seems frozen—nor any subjective handwriting; we look right through the pigment-covered surface at a reality that seems created without the painter's intervention. This technique, impersonal and meticulous, is peculiar to German Romantic painting. It stems from the early Neoclassicists—Mengs, Hamilton, and Vien—but the Germans, whose tradition of Baroque painting was weak, adopted it more wholeheartedly than the English or the French. About 1800, German painters rediscovered what they regarded as their native pictorial heritage: the "medieval" painters of the fifteenth and early sixteenth centuries. This "Gothic Revival," however, remained limited to subject matter and technique; the painstaking precision of the old German masters merely reinforced the Neoclassic emphasis on form at the expense of color. Although in Friedrich's hands this technique yielded extraordinary ef-

fects, it was a handicap for most of his countrymen, who lacked his compelling imagination. Nevertheless, German Romantic painting partially inspired the English Pre-Raphaelite painters, about 1850, and it had influence on America too. *Fur Traders on the Missouri* (colorplate 90) by George Caleb Bingham (1811–79) is a telling example. In the silence of the vast, wide-open spaces, two trappers glide downstream in the misty sunlight, a black fox chained to the prow of their dugout canoe. They remind us of how much Romantic adventurousness went into the westward expansion of the United States.

France: Greuze

We must now catch up with events in France. There, the thinkers of the Enlightenment, who were the intellectual forefathers of the Revolution, strongly fostered the anti-Rococo trend in painting. This reform, at first a matter of content rather than style, accounts for the sudden fame, about 1760, of Jean-Baptiste Greuze (1725–1805): *The Village Bride* (fig. 735), like his other pictures of those years, is a scene of lower-class family life. What distinguishes it from earlier genre paintings (compare fig. 667, colorplate 87) is its contrived, stage-like character, borrowed from the "dumb show" narratives of Hogarth (figs. 700, 701). But Greuze has neither wit nor satire. His pictorial sermon illustrates the social gospel of Jean-Jacques Rousseau: that the poor, in contrast to the immoral aristocracy, are full of "natural"

virtue and honest sentiment. Everything is intended to remind us of this, from the declamatory gestures and expressions of the actors to the smallest detail, such as the hen with her chicks in the foreground: one chick has left the brood and sits alone on a saucer, like the bride who is about to leave *her* "brood." Strangely enough, *The Village Bride* was acclaimed as a masterpiece, and the loudest praise came from Diderot, that apostle of Reason and Nature. Here at last was a painter with a social mission who appealed to the beholder's moral sense instead of merely giving him pleasure, like the frivolous artists of the Rococo! Diderot, in the first flush of enthusiasm, accepted the narrative of Greuze's pictures as "noble and serious human action" in Poussin's sense.

France: David; Gros

He modified his views later, when a far more gifted and rigorous "Neo-Poussinist" appeared on the scene—Jacques Louis David (1748–1825). A disciple of Vien, David had developed his Neoclassic style in Rome during the years 1775–81. In his *Death of Socrates* (fig. 736), of 1787, he seems more "Poussiniste" than Poussin himself (colorplate 84); the composition unfolds like a relief, parallel to the picture plane, and the figures are as solid—and as immobile—as statues. Yet David has added one unexpected element: the lighting, sharply focused and casting precise shadows, is derived from Caravaggio, and so is the firmly realistic detail (note

735. JEAN-BAPTISTE GREUZE.
The Village Bride. 1761.
36 × 46 1/2″. The Louvre, Paris

736. JACQUES LOUIS DAVID.
The Death of Socrates.
1787. 59 × 78″.
The Metropolitan Museum of Art,
New York (Wolfe Fund, 1931)

the hands and feet, the furniture, the texture of the stone surfaces). In consequence, the picture has a quality of life rather astonishing in so doctrinaire a statement of the new ideal style. The very harshness of the design suggests that its creator was passionately engaged in the issues of his age, artistic as well as political. Socrates, about to drain the poison cup, is shown here not only as an example of Ancient Virtue, but also as the founder of the "religion of Reason," a Christ-like figure (there are twelve disciples in the scene). David took an active part in the French Revolution, and for some years he had a power over the artistic affairs of the nation comparable only to Lebrun's a century before. During this time he painted his greatest picture, *The Death of Marat* (fig. 737). David's deep emotion has made a masterpiece from a subject that would have embarrassed any lesser artist: for Marat, one of the political leaders of the Revolution, had been murdered in his bathtub. A painful skin condition caused him to do his paperwork there, with a wooden board serving as his desk. One day a young woman named Charlotte Corday burst in with a personal petition, and plunged a knife into his chest while he read it. David has composed the scene with a stark directness that is truly awe-inspiring. In this canvas, which was planned as a public memorial to the martyred hero, devotional image and historical account coincide. Because Classical art could offer little guidance here, the artist—far more than in *The Death of Socrates*—has drawn again on the Caravaggesque tradition of religious art. It is no accident that his *Marat* reminds us so strongly of Zurbarán's *St. Serapion* (see fig. 669).

After the fall of Robespierre, David was imprisoned

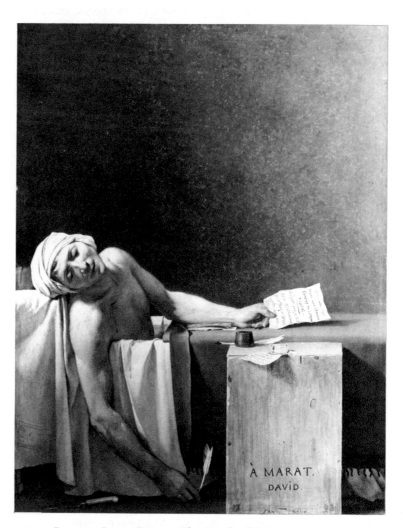

737. JACQUES LOUIS DAVID. *The Death of Marat.* 1793.
65 × 50 ¹/₂″. Royal Museums of Fine Arts, Brussels

for some months in the Luxembourg Palace, and from his cell window painted his first and only landscape (fig. 738). The view of the park was predetermined by chance, and the picture thus has an astonishingly modern, casual look. That he chose to paint it at all, instead of whiling away his time with Neoclassic figure compositions, shows David's deep commitment to direct visual experience. Unencumbered for once by theory, he created a landscape of timeless, lyrical immediacy that only Constable could have rivaled.

When David met Napoleon a few years later, he became an ardent Bonapartist and painted several large pictures glorifying the emperor. But a favorite pupil, Antoine-Jean Gros (1771–1835), partially eclipsed David as the chief painter of the Napoleonic myth. Gros's first portrait of the great general shows him leading his troops at the Battle of Arcole in northern Italy (fig. 739). Painted in Milan, soon after the series of victories that gave the French the Lombard plain, it conveys Napoleon's magic as an irresistible "man of destiny," with a Romantic enthusiasm David could never match. Much as Gros respected his teacher's doctrines, his emotional nature impelled him toward the color and drama of the Baroque. What he accomplished in this case seems especially remarkable if we consider the circumstances, recounted by an eyewitness: Napoleon, too impatient to pose, was made to sit still by his wife, who held him firmly on her lap. David went into exile after the empire collapsed and turned his pupils over to Gros, urging him to return to Neoclassic orthodoxy. But Gros was torn between his pictorial instincts and these academic principles; he never achieved David's authority, and ended by suicide.

739. ANTOINE-JEAN GROS. *Napoleon at Arcole.*
1796. 29 1/2 × 23". The Louvre, Paris

France: Ingres

The mantle of David finally descended upon another pupil, Jean-Auguste Dominique Ingres (1780–1867). Too young to share in the political passions of the Revolution, Ingres never was an enthusiastic Bonapartist; in 1806 he went to Italy and remained for eighteen years. Only after his return did he become the high priest of the Davidian tradition, defending it from the onslaughts of younger artists. What had been a revolutionary style only half a century before, now congealed into rigid dogma, endorsed by the government and backed by the weight of conservative opinion. Ingres is usually called a Neoclassicist, and his opponents Romantics. Actually, both factions stood for aspects of Romanticism: the Neoclassic phase, with Ingres as the last important survivor, and the Neo-Baroque, first adumbrated in Gros's *Napoleon at Arcole.* These two camps seemed to revive the old quarrel between "Poussinistes" and "Rubénistes." The original "Poussinistes" had never quite practiced what they preached, and Ingres' views, too, were far more doctrinaire than his pictures. He always held that drawing was superior to painting, yet a canvas such as his *Odalisque* (colorplate 91) reveals an exquisite sense of color; instead of merely tinting his design, he sets off the petal-smooth limbs of this Oriental Venus ("odalisque" is a Turkish word for a harem slave girl) with a dazzling array of rich tones and textures. The exotic subject, redolent with the enchantment of the *Thousand and One Nights,* is itself characteristic of the

738. JACQUES LOUIS DAVID. *View of the Luxembourg Gardens.*
1794. 21 1/2 × 30". The Louvre, Paris

Romantic movement; it would be perfectly at home in the Royal Pavilion at Brighton (see fig. 716). Despite Ingres' professed worship of Raphael, this nude embodies no classical ideal of beauty. Her proportions, her languid grace, and the strange mixture of coolness and voluptuousness remind us, rather, of Parmigianino (compare colorplate 65).

History painting as defined by Poussin remained Ingres' life-long ambition, but he had great difficulty with it, while portraiture, which he pretended to dislike, was his strongest gift and his steadiest source of income. He was, in fact, the last great professional in a field soon to be monopolized by the camera. Although photography became a practical process only about 1840 (the earliest surviving photograph dates from 1826), its experimental background goes back to the late eighteenth century. The impulse behind these experiments was not so much scientific curiosity as a Romantic quest of the True and Natural. The desire for "images made by Nature" can be seen, on the one hand, in Cozens' ink-blot compositions ("natural" because they were made by chance) and, on the other, in the late-eighteenth-century vogue for silhouette portraits (traced from the shadow of the sitter's profile), which led to attempts to record such shadows on light-sensitive materials. David's harsh realism in *The Death of Marat*, and his fascination with the view from his cell window, also proclaim the standard of unvarnished truth; so does Ingres' *Louis Bertin* (fig. 741), which at first glance looks like a kind of "super-photograph." But this impression is deceptive; comparing it with the preliminary pencil drawing (fig. 740), we realize how much of interpretation the portrait contains. The drawing, quick, sure, and precise, is a masterpiece of detached observation, while the painting, through subtle changes of emphasis and proportion, endows the sitter with a massive force of personality that has truly frightening intensity. Only Ingres could so unify psychological depth and physical accuracy. His followers concentrated on physical accuracy alone, competing vainly with the camera; the Neo-Baroque Romantics, in contrast, emphasized the psychological aspect to such a degree that their portraits tended to become records of the artist's private emotional relationship with the sitter (see fig. 748). Often these are interesting and moving, but they are no longer portraits in the full sense of the term.

Spain: Goya

Before pursuing the Neo-Baroque trend in France, we must take account of the great Spanish painter Francisco Goya (1746–1828), David's contemporary and the only artist of the age who may be called, unreservedly, a genius. When Goya first arrived in Madrid in 1766, he found both Mengs and Tiepolo working there. He was much impressed with Tiepolo, whom he must have recognized immediately as the greater of the two; nor did he respond

740. JEAN-AUGUSTE DOMINIQUE INGRES. *Louis Bertin*. 1832. Pencil drawing. The Louvre, Paris

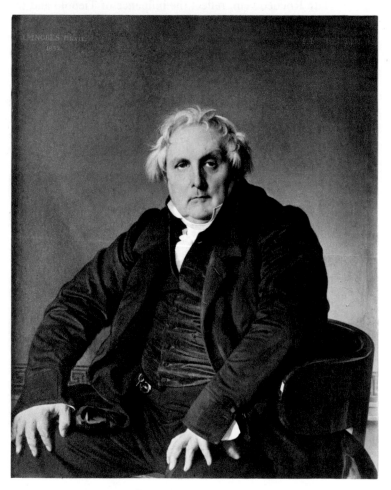

741. JEAN-AUGUSTE DOMINIQUE INGRES. *Louis Bertin*. 1832. 46 × 37 1/2". The Louvre, Paris

742. FRANCISCO GOYA.
The Family of Charles IV.
1800. 9′ 2″ × 11′.
The Prado, Madrid

to the growing Neoclassic trend during his brief visit to Rome five years later. His early works, in a delightful late Rococo vein, reflect the influence of Tiepolo and the French masters (Spain had produced no painters of significance for over a century). But during the 1780s, Goya became more of a libertarian; he surely sympathized with the Enlightenment and the Revolution, and not with the king of Spain, who had joined other monarchs in war against the young French Republic. Yet Goya was much esteemed at court, especially as a portrait painter. He now abandoned the Rococo for a Neo-Baroque style based on Velázquez and Rembrandt, the masters he had come to admire most. *The Family of Charles IV* (fig. 742), his largest royal portrait, deliberately echoes *The Maids of Honor* (see fig. 672): the entire clan has come to visit the artist, who is painting in one of the picture galleries of the palace. As in the earlier work, shadowy canvases hang behind the group and the light pours in from the side, although its subtle gradations owe as much to Rembrandt as to Velázquez. The brushwork, too, has an incandescent sparkle rivaling that of *The Maids of Honor*. Measured against the Caravaggesque Neoclassicism of David, Goya's performance may seem thoroughly "pre-revolutionary," not to say anachronistic. Yet Goya has more in common with David than we might think: he, too, practices a revival style and, in his way, is equally devoted to the unvarnished truth. Psychologically, *The Family of Charles IV* is almost shockingly modern. No longer shielded by the polite conventions of Baroque court portraiture, the inner being of these individuals has been laid bare with pitiless candor. They are like a collection of ghosts: the frightened children, the bloated vulture of a king, and—in a master stroke of sardonic humor—the grotesquely vulgar queen, posed like Velázquez' Princess Margarita (note the left arm, and the turn of the head). How, we wonder today, could the royal family tolerate this? Were they so dazzled by the splendid painting of their costumes that they failed to realize what Goya had done to them?

When Napoleon's armies occupied Spain in 1808, Goya and many of his countrymen hoped that the conquerors would bring the liberal reforms so badly needed. The savage behavior of the French troops crushed these

743. FRANCISCO GOYA. *Bobabilicon (Los Proverbios,* No. 4*)*.
c. 1818. Etching. The Metropolitan Museum of Art,
New York (Dick Fund, 1931)

hopes and generated a popular resistance of equal savagery. Many of Goya's works from 1810–15 reflect this bitter experience. The greatest is *The Third of May, 1808* (colorplate 92), commemorating the execution of a group of Madrid citizens. Here the blazing color, broad fluid brushwork, and dramatic nocturnal light are more emphatically Neo-Baroque than ever. The picture has all the emotional intensity of religious art, but these martyrs are dying for Liberty, not the Kingdom of Heaven; and their executioners are not the agents of Satan but of political tyranny—a formation of faceless automatons, impervious to their victims' despair and defiance. The same scene was to be re-enacted countless times in modern history. With the clairvoyance of genius, Goya created an image that has become a terrifying symbol of our era.

After the defeat of Napoleon, the restored Spanish monarchy brought a new wave of repression, and Goya withdrew more and more into a private world of nightmarish visions such as *Bobabilicon* (Big Booby), an etching from the series *Los Proverbios* (fig. 743). Although suggested by proverbs and popular superstitions, many of these scenes defy exact analysis. They belong to that realm of subjectively experienced horror which we first encountered in Fuseli's *Nightmare*, but are infinitely more compelling. Finally, in 1824, Goya went into vol-

untary exile; after a brief stay in Paris, he settled in Bordeaux, where he died. His importance for the Neo-Baroque Romantic painters of France is well attested by the greatest of them, Eugène Delacroix, who said that the ideal style would be a combination of Michelangelo's art with Goya's.

France: Géricault

But Goya's influence in France began only after his death; the Neo-Baroque trend initiated by Gros had by then aroused the imagination of many talented younger men. *Mounted Officer of the Imperial Guard* (colorplate 93), painted by Théodore Géricault (1791–1824) at the astonishing age of twenty-one, offers the same conception of the Romantic hero as Gros's *Napoleon at Arcole* (see fig. 739), but on a larger scale and with a Rubens-like energy; ultimately, the ancestors of this splendid figure are the equestrian soldiers in Leonardo's *Battle of Anghiari* (see fig. 543). Géricault, himself an enthusiastic horseman, later became interested in the British animal painters such as George Stubbs. But his chief heroes, apart from Gros and the great Baroque masters, were David and Michelangelo. A year's study in Italy deepened his understanding of the nude as an image of expressive power; he was then ready to begin his most ambitious

744. THÉODORE GÉRICAULT. *The Raft of the "Medusa."* 1818–19. 16′ 1″ × 23′ 6″. The Louvre, Paris

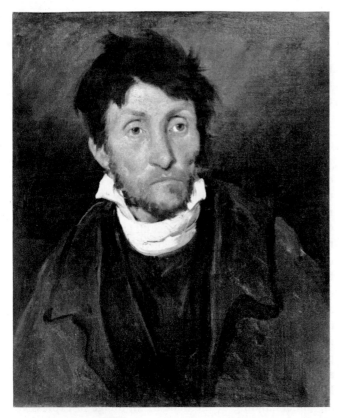

745. THÉODORE GÉRICAULT. *The Madman.* 1821–24. 24 × 20″.
Museum of Fine Arts, Ghent

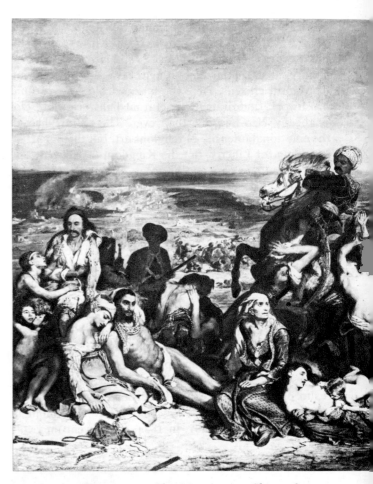

746. EUGÈNE DELACROIX. *The Massacre at Chios.* 1822–24.
13′ 10″ × 11′ 7″. The Louvre, Paris

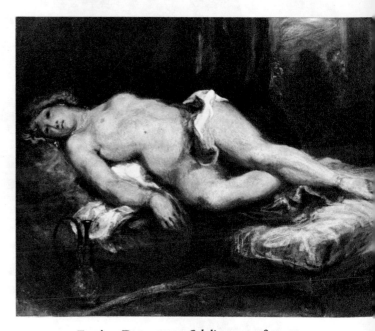

747. EUGÈNE DELACROIX. *Odalisque.* c. 1845–50.
14 7/8 × 18 1/4″. Fitzwilliam Museum, Cambridge

work, *The Raft of the "Medusa"* (fig. 744). The *Medusa,* a
government vessel, had foundered off the West African
coast with hundreds of men on board; only a handful
were rescued, after many days on a makeshift raft. The
event attracted Géricault's attention because it was a
political scandal—like many French liberals, he opposed
the monarchy that was restored after Napoleon—and a
modern tragedy of epic proportions. He went to extra-
ordinary lengths in trying to achieve a maximum of au-
thenticity: he interviewed survivors, had a model of the
raft built, even studied corpses in the morgue. This
search for uncompromising truth is like David's, and
The Raft is indeed remarkable for its powerfully realistic
detail. Yet these preparations were subordinate in the
end to the spirit of heroic drama that dominates the
canvas. Géricault depicts the exciting moment when
the men on the raft first glimpse the rescue ship. From
the prostrate bodies of the dead and dying in the fore-
ground, the composition is built up to a rousing climax
in the group that supports the frantically waving black,
so that the forward surge of the survivors parallels the
movement of the raft itself. Sensing, perhaps, that this
theme of "man against the elements" would have strong
appeal across the Channel (where Copley had painted
Watson and the Shark forty years before; fig. 727),
Géricault took the monumental canvas to England on a
traveling exhibit in 1820. His numerous studies for it had
taught him how to explore extremes of the human con-
dition scarcely touched by earlier artists. He went now

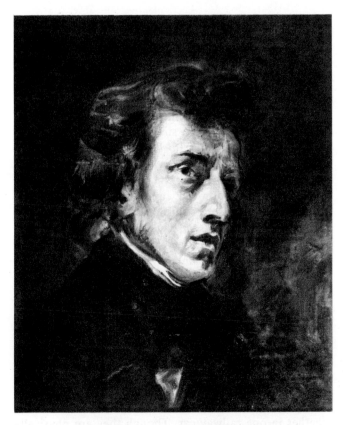

748. EUGÈNE DELACROIX. *Frédéric Chopin.*
1838. 18 × 15″. The Louvre, Paris

not only to the morgue, but even to the insane asylum of
Paris. There he became a friend of Dr. Georget, a pioneer
in modern psychiatry, and painted for him a series of
portraits of individual patients to illustrate various types
of derangement, such as that in figure 745. The conception
and execution of this oil sketch has an immediacy that
recalls Frans Hals, but Géricault's sympathy toward his
subject makes his work contrast tellingly with *Malle Babbe*
(see fig. 653); this ability to see the victims of mental
disease as fellow human beings, not as accursed or be-
witched outcasts, is one of the noblest fruits of the Ro-
mantic movement.

France: Delacroix

The year 1824 was crucial for French painting. Géri-
cault died (in consequence of a riding accident); Ingres
returned to France and had his first public success; the
first showing in Paris of works by Constable was a revela-
tion to many French artists; and *The Massacre at Chios*
(fig. 746) established Eugène Delacroix as the foremost
Neo-Baroque Romantic painter. An admirer of both
Gros and Géricault, Delacroix (1798–1863) had been
exhibiting for some years, but the *Massacre*—conserva-
tives called it "the massacre of painting," others acclaimed

it enthusiastically—made his reputation. For the next
quarter-century, he and Ingres were acknowledged rivals,
and their polarity, fostered by partisan critics, domi-
nated the artistic scene in Paris. Like *The Raft of the
"Medusa,"* the *Massacre* was inspired by a contemporary
event: the Greek war of independence against the Turks,
which stirred a sympathetic response throughout Western
Europe (the full title is *Scenes of the Massacre at Chios:
Greek Families Awaiting Death or Slavery*). Delacroix,
however, aimed at "poetic truth" rather than at recap-
turing a specific, actual event. He shows us an intoxica-
ting mixture of sensuousness and cruelty, but he does not
succeed in forcing us to suspend our disbelief. While we
revel in the sheer splendor of the painting, we do not
quite accept the human experience as authentic; we react,
in other words, much as we do to Turner's *Slave Ship*
(see colorplate 95). One reason may be the discontinuity
of the foreground, with its dramatic contrasts of light
and shade, and the luminous sweep of the landscape
behind (Delacroix is said to have hastily repainted the
latter after seeing Constable's work). Originally, the back-
ground of the *Massacre* was probably like that in
Géricault's *Mounted Officer* (colorplate 93; the Turk-
ish horseman directly recalls Géricault's earlier picture).
Such a dark, stormy sky also appears in Delacroix's final
salute to the Greek cause, *Greece on the Ruins of Misso-
longhi* (colorplate 94). Here the complicated apparatus of
the *Massacre* has been pared down to essentials, with a
great gain in visual and emotional unity: a dead Greek
fighter lies crushed among marble blocks in the fore-
ground; a Moor triumphs; the defenseless maiden is fully
as appealing as a martyred saint. Sonorous color—
creamy whites and flesh tones set off by deep blues and
reds—and the energetically fluid brushwork show Dela-
croix to be a "Rubéniste" of the first order. Contempora-
ry beholders, remembering that Lord Byron had died at
Missolonghi, surely found in the picture a special pathos.

Delacroix's sympathy with the Greeks did not prevent
his sharing the enthusiasm of fellow Romantics for the
Near East. He was enchanted by a visit to North Africa
in 1832, finding there a living counterpart of the violent,
chivalric, and picturesque past evoked in Romantic liter-
ature. His sketches from this trip supplied him with a
large repertory of subjects for the rest of his life—harem
interiors, street scenes, lion hunts. It is fascinating to
compare his *Odalisque* (fig. 747) with Ingres' version (see
colorplate 91): reclining in ecstatic repose, she breathes
passionate abandon and animal vitality—the exact op-
posite of Ingres' ideal. This contrast persists in the por-
traiture of these perennial antagonists. Delacroix rarely
painted portraits on commission; his finest specimens are
of his personal friends and fellow victims of the "Ro-
mantic agony," such as the famous Polish composer
Frédéric Chopin (fig. 748). Here we see the image of the
Romantic hero at its purest: a blend of Gros's *Napoleon*
and Géricault's *Madman,* he is consumed by the fire of
his genius.

749. HONORÉ DAUMIER. *It's Safe to Release This One!*
1834. Lithograph

France: Daumier

The later work of Delacroix reflects the attitude that eventually doomed the Romantic movement: its growing detachment from contemporary life. History, literature, the Near East—these were the domains of the imagination where he sought refuge from the turmoil of the industrial revolution. It is ironical that Honoré Daumier (1808–79), the one great Romantic artist who

did not shrink from reality, remained in his day practically unknown as a painter; his pictures had little impact until after his death. A biting political cartoonist, Daumier contributed satirical drawings to various Paris weeklies for most of his life. He turned to painting in the 1840s, but found no public for his work. Only a few friends encouraged him and, a year before his death, arranged his first one-man show. The neat outlines and systematic crosshatching in Daumier's early cartoons (fig. 749 is a sample) show his conservative training. He quickly developed a bolder and more personal style of draughtsmanship, however, and his paintings of the 1850s and 60s have the full pictorial range of the Neo-Baroque. Their subjects vary widely; many show aspects of everyday urban life that also occur in his cartoons, now viewed from a painter's rather than a satirist's angle. *The Third-Class Carriage* (fig. 750) is such a work. Painted very freely, it must have seemed raw and "unfinished" even by Delacroix's standards. Yet its power is derived from this very freedom, and for this reason Daumier cannot be labeled a realist; his concern is not for the tangible surface of reality but the emotional meaning behind it. In *The Third-Class Carriage* he has captured a peculiarly modern human condition, "the lonely crowd": these people have in common only that they are traveling together in one railway car. Though they are physically crowded, they take no notice of one another—each is alone with his own thoughts. Daumier explores this state with an insight into character and a breadth of human sympathy worthy of Rembrandt, whose work he revered. His feeling for the dignity of the poor also suggests Louis Le Nain, who had recently been rediscovered by French critics (compare fig. 674; the old woman on the left seems

750. HONORÉ DAUMIER.
The Third-Class Carriage.
c. 1862. 26 × 35 1/2".
The Metropolitan Museum of Art,
New York (Bequest of
Mrs. H. O. Havemeyer, 1929.
The H. O. Havemeyer Collection)

751. HONORÉ DAUMIER. *Don Quixote Attacking the Windmills*. c. 1866.
22 1/4 × 33″. Collection Mr. Charles S. Payson, New York

the direct ancestor of the central figure in *The Third-Class Carriage*).

Other paintings by Daumier have subjects more characteristic of Romanticism. The numerous canvases and drawings of the adventures of Don Quixote, from Cervantes' sixteenth-century novel, show the perennial fascination this theme had for him. The lanky knight-errant, vainly trying to live his dream of noble deeds, and Sancho Panza, the dumpy materialist, seemed to embody for Daumier a tragic conflict within human nature that forever pits the soul against the body, ideal aspirations against harsh reality. In *Don Quixote Attacking the Windmills* (fig. 751), this polarity is forcefully realized: the mock hero dashes off in the noonday heat toward an invisible, distant goal, while Panza helplessly wrings his hands, a monument of despair. Again we marvel at the strength, the sculptured simplicity, of Daumier's shapes, and the expressive freedom of his brushwork, which make Delacroix's art seem tame and conventional by comparison.

France: Millet; Corot

If the French public could not accept Daumier's painting style "straight," they nevertheless responded favorably to a diluted and sentimentalized version of it in the work of François Millet (1814–75). Millet was one of the artists of the Barbizon School who had settled in the village of Barbizon, near Paris, to paint landscapes and scenes of rural life. His *Sower* (fig. 752) reflects the

752. FRANÇOIS MILLET. *The Sower*. c. 1850.
40 × 32 1/2″. Museum of Fine Arts, Boston

753. CAMILLE COROT. *Papigno*. 1826. 13 × 15 ³/₄".
Collection Dr. Fritz Nathan, Zurich

SCULPTURE

The development of sculpture, which we must discuss briefly to complete our survey of Romanticism, follows the pattern of painting. We shall find it a good deal less venturesome than either painting or architecture. The unique virtue of sculpture, its solid, space-filling reality (or, if you will, its "idol" quality), was not congenial to the Romantic temperament. The rebellious and individualistic urges of Romanticism could find expression in rough, small-scale sketches but rarely survived the laborious process of translating the sketch into a permanent, finished monument. The sculptor was also overwhelmed by the authority accorded (since Winckelmann) to ancient statues such as the *Apollo Belvedere* (see fig. 184), praised as being supreme manifestations of the Greek genius while in actual fact most of them were mechanical Roman copies after Hellenistic pieces of no great distinction. (When Goethe saw the newly discovered Late Archaic sculpture from Aegina [figs. 143, 144] he pronounced it clumsy and inferior.) How could a

compactness and breadth of Daumier's forms, now blurred in the hazy atmosphere. The "hero of the soil" flavor is somewhat self-conscious and quite alien to Daumier. (Could Millet have known the pathetic sower from the October page of the *Très Riches Heures du Duc de Berry?* Compare colorplate 44.) Another artist linked with the Barbizon School, though not actually a member, was Camille Corot (1796–1875). Today his finest work seems not his late landscapes, misty and poetic; it is the early ones that establish his importance for the development of modern landscape painting. In 1825 he went to Italy for two years and explored the countryside around Rome, like a latter-day Claude. But Corot did not transform his sketches into idealized pastoral visions; what Claude recorded only in his drawings—the quality of a particular place at a particular time (see fig. 677)—Corot made into paintings, small canvases done on the spot in an hour or two. Such a work is his view of Papigno, an obscure little hill town (fig. 753). In size and immediacy, these quickly executed pictures are analogous to Constable's oil sketches (see fig. 732), yet they stem from a different tradition. If Constable's view of nature, which emphasizes the sky as "the chief organ of sentiment," is derived from Dutch seventeenth-century landscapes, Corot's instinct for architectural clarity and stability recalls Poussin and Claude. But he, too, insists on "the truth of the moment"; his exact observation, and his readiness to seize upon any view that attracted him during his excursions, shows the same commitment to direct visual experience as David's *View of the Luxembourg Gardens* (see fig. 738).

754. JEAN ANTOINE HOUDON. *Voltaire*. 1781.
Terracotta model for marble, height 47".
Fabre Museum, Montpellier, France

755. JEAN ANTOINE HOUDON. *George Washington.*
1788–92. Marble, height 74″.
State Capitol, Richmond, Virginia

modern artist rise above the quality of these works, if he was everywhere assured that they were the acme of sculptural achievement? Finally, the new standard of uncompromising, realistic "truth" was embarrassing to the sculptor. When a painter renders clothing, anatomical detail, or furniture with photographic precision he does not produce a duplicate of reality, but a representation of it; while to do so in sculpture comes dangerously close to mechanical reproduction—a hand-made equivalent of the plaster cast. Sculpture thus underwent a crisis that was resolved only toward the end of the century.

Houdon; Canova

As we might deduce from what has just been said, portraiture proved the most viable field for Neoclassic sculpture. Its most distinguished practitioner, Jean Antoine Houdon (1741–1828), still retains the acute sense of individual character introduced by Coysevox (see fig. 688). His fine statue of Voltaire (fig. 754) does full justice to the sitter's skeptical wit and wisdom, and the classical drapery enveloping the famous sage—to stress his equivalence to ancient philosophers—is not disturbing, for he wears it as casually as a dressing gown. Houdon was subsequently invited to America, to portray George Washington; he made two versions, one in classical and one in modern costume. Even the latter (fig. 755), though meticulously up-to-date in detail, has a classical pose and displays the fasces, a bundle of rods that symbolize union. We can feel the chill breath of the *Apollo Belvedere,* as it were, on the becalmed, smooth surfaces.

756. ANTONIO CANOVA. *Pauline Borghese as Venus.* 1808. Marble, lifesize. Borghese Gallery, Rome

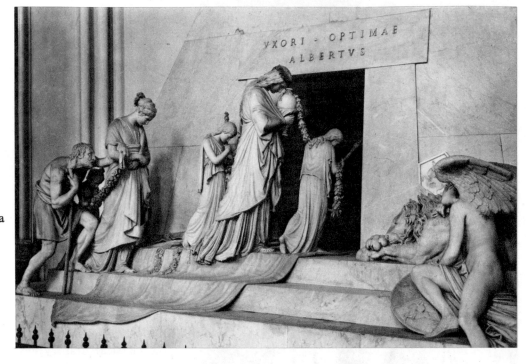

757. ANTONIO CANOVA.
Tomb of the Countess
Maria Christina. 1798–1805.
Church of the Augustinians, Vienna

758. *Canova's Tomb of the Countess Maria Christina*
(painting by Charles Swagers, 1833,
based on an engraving by Pietro Bonato, 1805).
24 1/4 × 28 3/4″. The Art Museum, Princeton University

Still, Washington escaped portrayal in heroic nudity during his lifetime. These representations were not unusual among younger, more doctrinaire Neoclassic sculptors: the most famous of them, Antonio Canova (1757–1822), produced a colossal nude statue of Napoleon, inspired by portraits of ancient rulers whose nudity indicates their status as divinities. Not to be outdone, Napoleon's sister Pauline Borghese permitted Canova to sculpt her as a reclining Venus (fig. 756). The statue is so obviously idealized as to still any gossip. We recognize it as a precursor, more classically proportioned, of Ingres' *Odalisque* (see colorplate 91). Strange to say, *Pauline Borghese* seems the less three-dimensional of the two; she is designed like a "relief in the round," for front and back view only, and her very considerable charm comes almost entirely from the fluid grace of her outlines. Here we also encounter the problem of representation versus duplication, not in the figure itself but in the pillows, mattress, and couch. The same question recurs on a larger scale in Canova's most ambitious work, the Tomb of the Countess Maria Christina (figs. 757, 758). Its design, again essentially linear and relief-like though the statues are carved in the round, has no precedents in earlier tombs: the deceased appears only in a portrait medallion framed by a snake biting its own tail, a symbol of eternity. Presumably, but not actually, the urn carried by the woman in the center contains her ashes. This is an ideal burial service performed by classical figures, mostly allegorical (the group on the left represents the Three Ages of Man), who are about to enter the pyramid-shaped tomb. What troubles us is that this ensemble, in contrast to the tombs of

Colorplate 96. EDOUARD MANET. *The Fifer*. 1866.
63 × 38¼″. The Louvre, Paris

Colorplate 97. CLAUDE MONET. *The River*. 1868. 32 × 39¹/₂″.
The Art Institute of Chicago (Potter Palmer Collection)

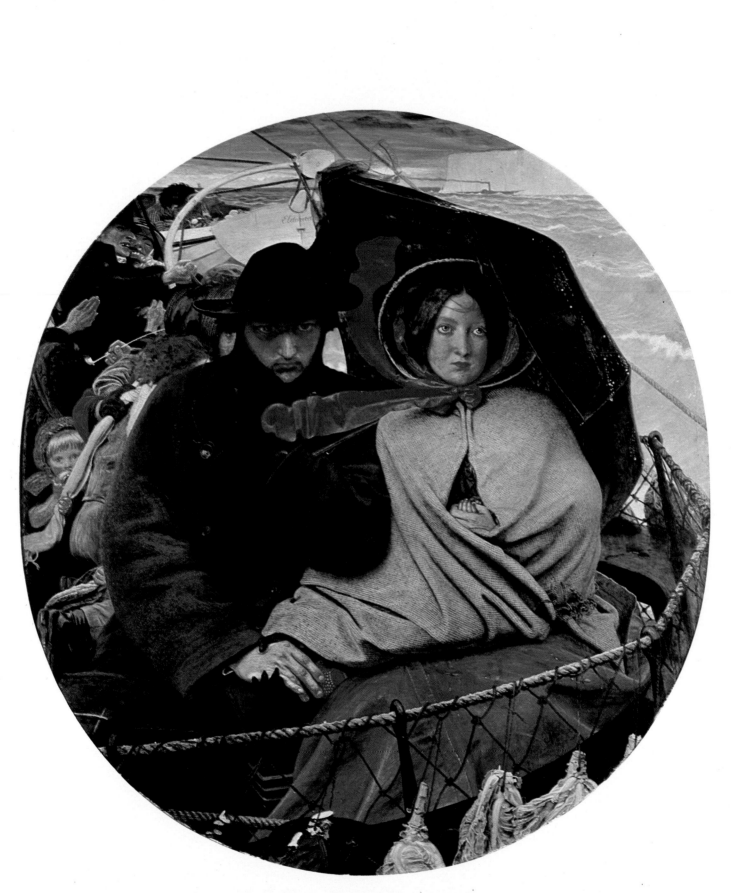

Colorplate 98. FORD MADOX BROWN. *The Last of England*. 1852–55. Panel, $32\frac{1}{2} \times 29\frac{1}{2}''$.
City Museum and Art Gallery, Birmingham, England

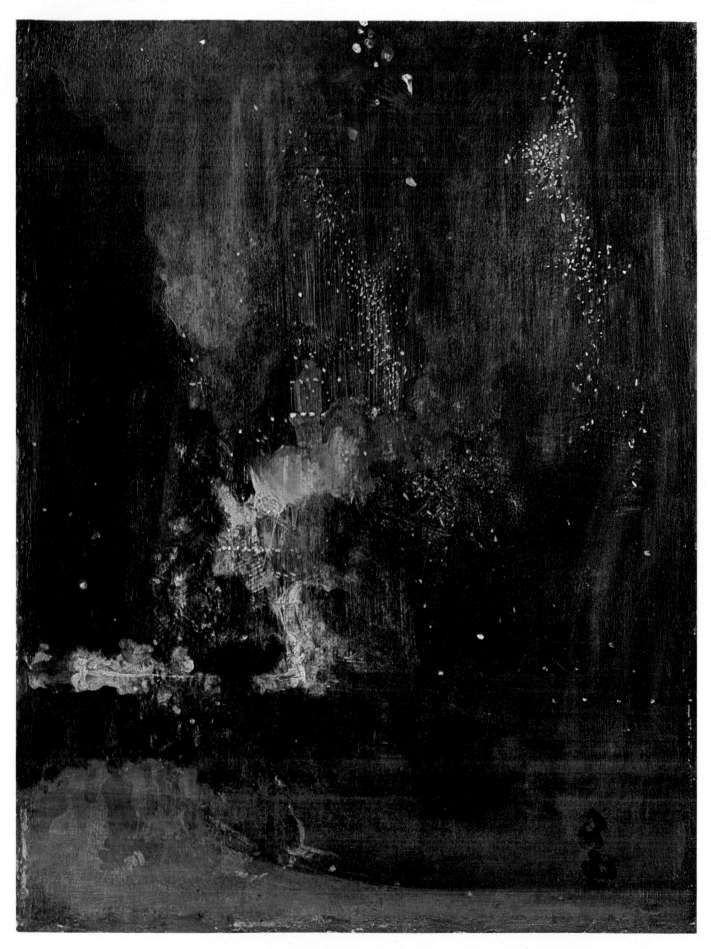

Colorplate 99. JAMES WHISTLER. *Nocturne in Black and Gold: The Falling Rocket*. About 1874. $23^3/_4 \times 18^3/_8''$.
The Detroit Institute of Arts

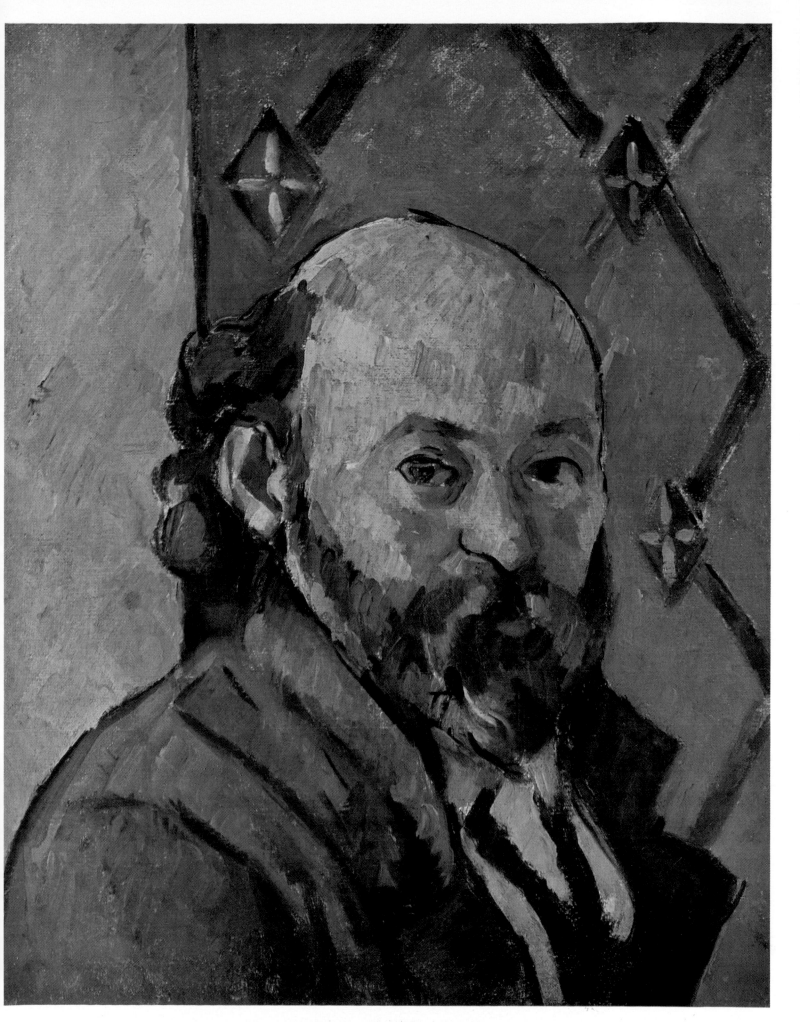

Colorplate 100. PAUL CÉZANNE. *Self-Portrait*. About 1879. $13^{3}/_{4} \times 10^{5}/_{8}''$.
The Tate Gallery, London (By courtesy of the Trustees)

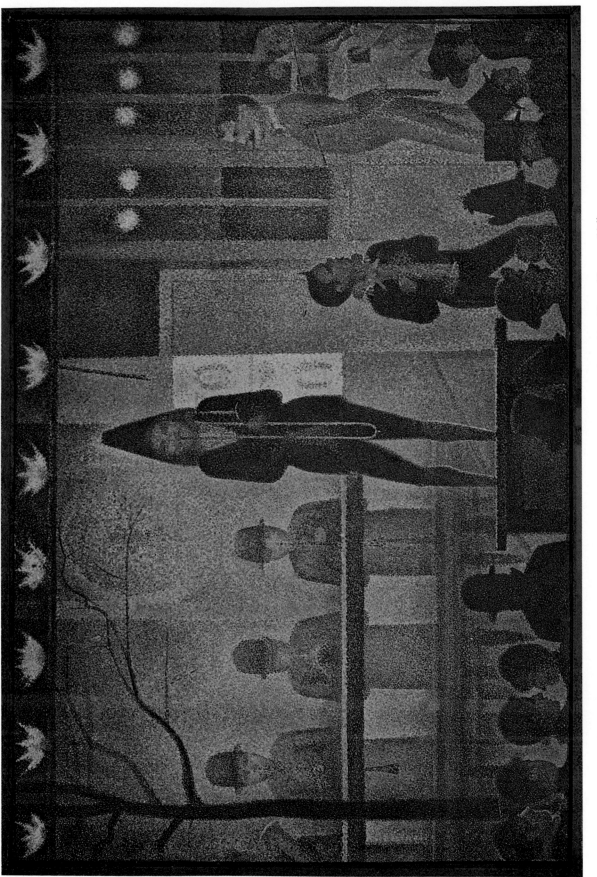

Colorplate 101. GEORGES SEURAT. *Side Show* (*La Parade*). 1887–88. $39^{1}/_{2} \times 59^{1}/_{4}''$.
The Metropolitan Museum of Art, New York (Bequest of Stephen C. Clark, 1960)

Colorplate 102. VINCENT VAN GOGH. *Wheat Field and Cypress Trees*. 1889. 28½ × 36″.
The National Gallery, London (Reproduced by courtesy of the Trustees)

Colorplate 103. PAUL GAUGUIN. *The Vision After the Sermon (Jacob Wrestling with the Angel).* 1888. 28³/₄ × 36¹/₂″. National Gallery of Scotland, Edinburgh

earlier times (such as fig. 527), does not include the real burial place—the pyramid is a sham, a shallow façade built against the wall of the church. But if we must view the monument as a sort of theatrical performance in marble, we expect the artist to characterize it as such by creating a "stage space" that will set it apart from its surroundings (like Bernini's *Ecstasy of St. Theresa*; see fig. 627). Since Canova has not done this, the performance becomes confusingly realistic. Should we join the "actors" on their perfectly real marble steps? No, for we cannot follow them into a mock pyramid. What distinguishes the real from the mock architecture? To what level of reality does the cloth on the steps belong?

Préault; Rude; Barye; Carpeaux

This dilemma could be resolved in two ways: by reviving a pre-classical style sufficiently abstract to restore the autonomous reality of sculpture, or by a return to the frankly theatrical Baroque. Only the latter alternative proved generally feasible at the time, although there were isolated attempts to explore the former. Auguste Préault (1809–79), the boldest sculptor of his day and the one whose personality most closely approached the Romantic ideal, experimented in both directions. His relief *Slaughter* (fig. 759) is brimming with a physical and emotional violence far beyond anything found in Baroque art, yet its expressive distortions, its irrational space filled to the bursting point with writhing shapes, evoke memories of Gothic sculpture (compare fig. 437). In fact, the helmeted knight's face next to that of the screaming mother hints that the subject itself is medieval: some dread apocalyptic event beyond man's control. But in true Romantic fashion Préault does not define this event. He proclaimed, "Je ne suis pas pour le fini. Je suis pour l'infini," a play on words conveying his preference for the unfinished over the finished as well as for the infinite over the finite.

When *Slaughter* was shown to the public in 1834 it found few admirers. One of these must have been the somewhat older sculptor François Rude (1784–1855), as suggested by his own masterpiece, the splendidly rhetorical *Marseillaise* (fig. 760) on one pier of the Arc de Triomphe in Paris. The soldiers, volunteers of 1792 rallying to defend the Republic, are still in classical guise, but the Genius of Liberty above them imparts her great forward-rushing

759. AUGUSTE PRÉAULT. *Slaughter*. 1834. Bronze, 43 × 55″. Museum of Fine Arts, Chartres

760. FRANÇOIS RUDE. *La Marseillaise*. 1833–36.
c. 42 × 26′. Arc de Triomphe, Paris

761. FRANÇOIS RUDE. Monument to Marshal Ney.
1853. Bronze, height 8′ 9″. Paris

762. ANTOINE-LOUIS BARYE.
Jaguar Devouring a Hare. 1850–51.
Bronze, 16 ½ × 37 ½″.
The Louvre, Paris

movement to the entire group. She would not be unworthy of Puget (see fig. 689). Twenty years later, Rude embodied the same *élan* in a single figure; the monument of Marshal Ney (fig. 761) claims a whole army as its invisible complement. Yet the ultimate source of the figure is pictorial (Gros's *Napoleon at Arcole*, fig. 739, and its successors). In a similar way, Stubbs's *Lion Attacking a Horse* (colorplate 89) is the sire of animal groups by Antoine-Louis Barye (1795–1875), the Romantic sculptor closest to Delacroix. The forms of his *Jaguar Devouring a Hare* (fig. 762) have energy and volume; their simplicity, for all the anatomical detail, is rare indeed in mid-nineteenth-century sculpture. However, these qualities can be found only in Barye's smaller pieces; as an architectural sculptor he is disappointingly academic. Rude's real successor in this field was Jean-Baptiste Carpeaux (1827–75), whose famous group for the façade of the Paris Opéra, *The Dance* (fig. 763), perfectly matches Garnier's Neo-Baroque architecture. The plaster model in our illustration is both livelier and more precise than the final stone group (visible in fig. 721, lower right). Its coquettish gaiety derives from small Rococo groups such as Clodion's (see fig. 692), and its sense of scale, too, seems at odds with its size—although the figures look smaller than life, the group is actually 15 feet tall. Nor is this the only discrepancy; Carpeaux's figures, unlike Clodion's, look undressed rather than nude. We cannot accept them as legitimate denizens of the realm of mythology, and they slightly embarrass us, as if "real people" were acting out a Rococo scene. A single leg, detached from this group, might well be mistaken for a cast from nature. "Truth" here has destroyed the ideal reality that was still intact for Clodion a century before.

763. JEAN-BAPTISTE CARPEAUX. *The Dance*. 1867–69. Plaster model, c. 15′ × 8′ 6″. Musée de l'Opéra, Paris

PAINTING
FRANCE
ENGLAND
AMERICA

SCULPTURE

2

REALISM
AND IMPRESSIONISM

PAINTING

FRANCE

"Can Jupiter survive the lightning rod?" asked Karl Marx, not long after the middle of the century. The question sums up the dilemma we felt in Carpeaux's *The Dance*. The French poet and art critic Charles Baudelaire was addressing himself to the same problem when, in 1846, he called for paintings that expressed "the heroism of modern life." At that time only one painter was willing to make an artistic creed of this demand: Baudelaire's friend Gustave Courbet (1819–77).

Courbet and Realism

Proud of his rural background—he was born in Ornans, a village near the French-Swiss border—and a socialist in politics, Courbet had begun as a Neo-Baroque Romantic in the early 1840s; but by 1848, under the impact of the revolutionary upheavals then sweeping over Europe, he had come to believe that the Romantic emphasis on feeling and imagination was merely an escape from the realities of the time. The modern artist must rely on his own direct experience ("I cannot paint an angel because I have never seen one," he said); he must be a Realist. As a descriptive term, "realism" is not very precise. For Courbet, it meant something akin to the "naturalism" of Caravaggio (colorplate 75). As an admirer of Louis Le Nain and Rembrandt he had, in fact, strong links with the Caravaggio tradition, and his work, like Caravaggio's, was denounced for its supposed vulgarity and lack of spiritual content. The storm broke in 1849, when he exhibited *The Stone Breakers* (fig. 764), the first canvas fully embodying his programmatic Realism. Courbet had seen two men working on a road, and had asked them to pose for him in his studio. He painted them lifesize, solidly and matter-of-factly, with none of Millet's overt pathos or sentiment: the young man's face is averted, the old one's half-hidden by a hat. Yet he cannot have picked them casually: their contrast in age is significant—one is too old for such heavy work, the other too young. Endowed with the dignity of their

764. GUSTAVE COURBET.
The Stone Breakers.
1849. 63 × 102".
State Picture Gallery,
Dresden

765. GUSTAVE COURBET. *Interior of My Studio, a Real Allegory Summing Up Seven Years of My Life as an Artist.*
1854–55. 11' 10" × 19' 7". The Louvre, Paris

symbolic status, they do not turn to us for sympathy. Courbet's friend, the socialist Proudhon, likened them to a parable from the Gospels.

At the Paris Exposition of 1855, works by Ingres and Delacroix were prominently displayed, while Courbet failed to gain entry for his pictures. He brought them to public attention by organizing a private exhibition in a large wooden shed and by distributing a "manifesto of Realism." The show centered on a huge canvas, the most ambitious of his career, entitled: *Interior of My Studio, a Real Allegory Summing Up Seven Years of My Life as an Artist* (fig. 765). "Real allegory" is something of a teaser (allegories, after all, are unreal by definition); Courbet meant either an allegory couched in the terms of his particular Realism, or one that does not conflict with the "real" identity of the figures or objects embodying it. The framework is familiar; Courbet's composition clearly belongs to the type of Velazquez' *Maids of Honor* and Goya's *Family of Charles IV* (see figs. 672, 742). But now the artist has moved to the center; his visitors are here his guests, not royal patrons who enter whenever they wish. He has invited them specially, for a purpose that becomes evident only upon thoughtful reflection; the picture does not yield its full meaning unless we take the title seriously and inquire into Courbet's relation to this assembly. There are two main groups: on the left are "the people"—types rather than individuals, drawn largely from the artist's home environment at Ornans:

—hunters, peasants, workers, a Jew, a priest, a young mother with her baby. On the right, in contrast, we see groups of portraits representing the Parisian side of Courbet's life—clients, critics, intellectuals (the man reading is Baudelaire). All of these people are strangely passive, as if they were waiting for we know not what. Some are quietly conversing among themselves, others seem immersed in thought; hardly anybody looks at Courbet. They are not his audience, but a representative sampling of his human environment. Only two of them watch the artist at work: a small boy, intended to suggest "the innocent eye," and the nude model. What is her role? In a more conventional picture, we would identify her as Inspiration, or Courbet's Muse, but she is no less "real" than the others here; Courbet probably meant her to be Nature, or that undisguised Truth which he proclaimed the guiding principle of his art (note the emphasis on the clothing she has just taken off). Significantly enough, the center group is illuminated by clear, sharp daylight and the background and the lateral figures are veiled in semi-darkness, to underline the contrast between the artist—the active creator—and the world around him that waits to be brought to life.

Manet

Courbet's *Studio* helps us to understand a picture that shocked the public even more: Manet's *Luncheon on the*

Grass (fig. 7), showing a nude model accompanied by two gentlemen in frock coats. Edouard Manet (1832–83) was the first to grasp Courbet's full importance—his *Luncheon,* among other things, is a tribute to the older artist. He particularly offended contemporary morality by juxtaposing the nude and clothed figures in an outdoor setting, the more so since the non-committal title offered no "higher" significance. Yet the group has so formal a pose (for its classical source, see figs. 8, 9) that Manet certainly did not intend to depict an actual event. Perhaps the

meaning of the canvas lies in this denial of plausibility, for the scene fits neither the plane of everyday experience nor that of allegory. The *Luncheon,* as a visual manifesto of artistic freedom, is much more revolutionary than Courbet's; it asserts the painter's privilege to combine whatever elements he pleases for aesthetic effect alone. The nudity of the model is "explained" by the contrast between her warm, creamy flesh tones and the cool black-and-gray of the men's attire. Or, to put it another way, the world of painting has "natural laws" that are

766. EDOUARD MANET.
A Bar at the Folies-Bergères.
1881–82. 37 $\frac{1}{2}$ × 51″.
The Courtauld Collection, London

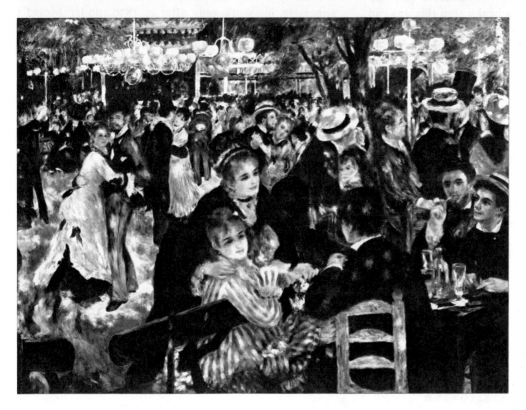

767. AUGUSTE RENOIR.
Le Moulin de la Galette.
1876. 51 $\frac{1}{2}$ × 69″.
The Louvre, Paris

distinct from those of familiar reality, and the painter's first loyalty is to his canvas, not to the outside world. Here begins an attitude that was later summed up in the doctrine of Art for Art's Sake, and became a bone of contention between progressives and conservatives for the rest of the century (see page 613). Manet himself disdained such controversies, but his work attests his lifelong devotion to "pure painting"—to the belief that brush strokes and color patches themselves, not what they stand for, are the artist's primary reality. Among painters of the past, he found that Hals, Velázquez, and Goya had come closest to this ideal. He admired their broad, open technique, their preoccupation with light and color values. Many of his canvases are, in fact, "pictures of pictures"—they translate into modern terms those older works that particularly challenged him. Yet he always took care to filter out the expressive or symbolic content of his models, lest the beholder's attention be distracted from the pictorial structure itself. His paintings, whatever their subject, have an emotional reticence that can easily be mistaken for emptiness unless we understand its purpose.

Courbet is said to have remarked that Manet's pictures were as flat as playing cards. Looking at *The Fifer* (colorplate 96), we can see what he meant. Done three years after the *Luncheon*, it is a painting without shadows (there are a few, actually, but it takes a real effort to find them), hardly any modeling, and no depth. The figure looks three-dimensional only because its contour renders the forms in realistic foreshortening; otherwise, Manet eschews all the methods devised since Giotto's time for transmuting a flat surface into a pictorial space. The undifferentiated light gray background seems as near to us as the figure, and just as solid; if the fifer stepped out of the picture, he would leave a hole, like the cut-out shape of a stencil. Here, then, the canvas itself has been redefined—it is no longer a "window," but a screen made up of flat patches of color. How radical a step this was can be readily seen if we match *The Fifer* against Delacroix's *Greece* (colorplate 94) and a Cubist work such as Picasso's *Three Dancers* of 1925 (colorplate 113). The structure of Manet's painting obviously resembles that of Picasso's, whereas Delacroix—or even Courbet—still follows the "window" tradition of the Renaissance. In retrospect, we realize that the revolutionary qualities of Manet's art were already to be seen, if not yet so obvious, in the *Luncheon*. The three figures lifted from Raphael's group of river gods form a unit nearly as shadowless and stencil-like as the fifer; they would be more at home on a flat screen, for the *chiaroscuro* of their present setting, which is inspired by the landscapes of Courbet, no longer fits them.

Monet and Impressionism

What brought about this "revolution of the color patch"? We do not know, and Manet himself surely did not reason it out beforehand. It is tempting to think that he was impelled to create the new style by the challenge of photography. The "pencil of nature," invented a quarter-century before, had vindicated the objective truth of Renaissance perspective, but it established a standard of representational accuracy that no hand-made image could hope to rival. Painting needed to be rescued from competition with the camera. This Manet accomplished by insisting that a painted canvas is, above all, a material surface covered with pigments—that we must look *at* it, not *through* it. Unlike Courbet, he gave no name to the style he had created; when his followers began calling themselves Impressionists, he refused to accept the term for his own work. The word had been coined in 1874, after a hostile critic had looked at a picture entitled *Impression: Sunrise*, by Claude Monet (1840–1926), and it certainly fits Monet better than it does Manet. Monet had adopted Manet's concept of painting and applied it to landscapes done out-of-doors. Monet's *The River*, of 1868 (colorplate 97), is flooded with sunlight so bright that conservative critics claimed it made their eyes smart; in this flickering network of color patches, the reflections on the water are as "real" as the banks of the Seine. Even more than *The Fifer*, Monet's painting is a "playing card"; were it not for the woman and the boat in the foreground, the picture could hang upside-down with hardly any difference of effect. The mirror image here serves a purpose contrary to that of earlier mirror images (compare fig. 473): instead of adding to the illusion of real space, it strengthens the unity of the actual painted surface. This inner coherence sets *The River* apart from Romantic "impressions" like Constable's *Hampstead Heath* (see fig. 732), or Corot's *Papigno* (see fig. 753), even though all three share the same on-the-spot immediacy and fresh perception. The latter qualities came less easily to the austere and deliberate Manet; they appear in his work only after c. 1870, under Monet's influence. Manet's last major picture, *A Bar at the Folies-Bergères*, of 1881–82 (fig. 766), shows a single figure as calm—and as firmly set within the rectangle of the canvas—as the fifer, but the background is no longer neutral. A huge shimmering mirror image now reflects the whole interior of the night club, but deprives it of three-dimensional reality. (The mirror, close behind the barmaid, fills four-fifths of the picture.) The barmaid's attitude, detached and touched with melancholy, contrasts so poignantly with the sparkling gaiety of her setting, which is not permitted to share. For all its urbanity, the mood of the canvas reminds us oddly of Daumier's *Third-Class Carriage* (see fig. 750).

Renoir; Degas

Scenes from the world of entertainment—dance halls, cafés, concerts, the theater—were favorite subjects for Impressionist painters. Auguste Renoir (1841–1919), an-

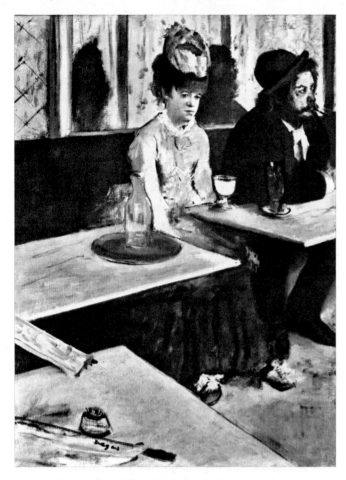

768. EDGAR DEGAS. *The Glass of Absinthe.*
1876. 36 × 27″. The Louvre, Paris

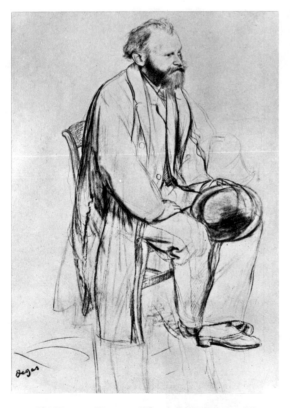

769. EDGAR DEGAS. *Edouard Manet.* c. 1865.
Pencil drawing. The Metropolitan Museum of Art,
New York (Rogers Fund, 1918)

other important member of the group, filled his with the *joie de vivre* of a singularly happy temperament. The flirting couples in *Le Moulin de la Galette* (fig. 767), under the dappled pattern of sunlight and shadow, radiate a human warmth that is utterly entrancing, even though the artist permits us no more than a fleeting glance at any of them. Our role is that of the casual stroller, who takes in this slice of life as he passes. By contrast, Edgar Degas (1834–1917) makes us look steadily at the disenchanted pair in his café scene (fig. 768), but, so to speak, out of the corner of our eye. The design of this picture, at first glance, seems as unstudied as a snapshot, yet the longer we look, the more we realize that everything has been made to dovetail precisely—that the zigzag of empty tables between us and the luckless couple reinforces their brooding loneliness. Compositions as boldly calculated as this set Degas apart from his fellow Impressionists. A wealthy aristocrat by birth, he had been trained in the tradition of Ingres, whom he greatly admired. Degas' portrait drawing of Manet (fig. 769), made soon after they met, recalls Ingres' study of Louis Bertin (see fig. 740); its masterly command of line and its sure grasp of the sitter's personality show that, had times been otherwise, Degas might well have become the greatest professional portraitist of his day. Like Ingres, he despised portraiture as a trade but, unlike him, he acted on his conviction and portrayed only friends and relatives—individuals with whom he had emotional ties. His profound sense of human character lends weight even to seemingly casual scenes such as that in figure 768. When he joined the Impressionists, Degas did not abandon his early allegiance to draughtsmanship. His finest works were often done in pastel (powdered pigments molded into sticks), a medium that had a strong appeal for him since it yielded effects of line, tone, and color simultaneously. *Prima Ballerina* (fig. 770) well demonstrates this flexible technique. The oblique view of the stage, from a box near the proscenium arch, has been shaped into another deliberately off-center composition; the dancer floats above the steeply tilted floor like a butterfly caught in the glare of the footlights. A decade later, *The Tub* (fig. 771) again shows an oblique view, but now the design has grown severe, almost geometric: the tub and the crouching woman, both vigorously outlined, form a circle within a square, and the rest of the rectangular format is filled by a shelf so sharply tilted that it almost shares the plane of the picture; yet on this shelf Degas has placed two pitchers (note how the curve of the small one fits the handle of the other!) that are hardly foreshortened at all. Here the tension between "two-D" and "three-D," surface and depth, comes close to the breaking point.

The Tub is Impressionist only in its shimmering, luminous colors. Its other qualities are more characteristic of the 1880s, the first post-Impressionist decade, when many artists showed a renewed concern with problems of form (see the next chapter). Among the major figures of the movement, Monet alone remained faithful to the Im-

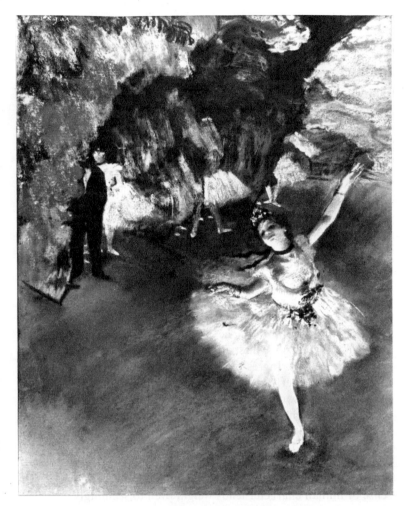

770. EDGAR DEGAS. *Prima Ballerina.* c. 1876.
Pastel, 23 × 16 1/2″. The Louvre, Paris

pressionist view of nature. About 1890, he began to paint pictures in series, showing the same subject under various conditions of light and atmosphere. These tended increasingly to resemble Turner's "airy visions, painted with tinted steam" as Monet concentrated on effects of colored light (see page 577; he had visited London, and knew Turner's work). But Monet never ventured into subjective fantasy, nor did he abandon the basic approach of his earlier work. His *Water Lilies, Giverny* (fig. 772) is a consistent sequel to *The River,* across a span of almost forty years. The pond surface now takes up the entire canvas, so that the effect of a weightless screen is stronger than ever; the artist's brushwork has greater variety and a more personal rhythm; the theme, however, is still the endlessly fascinating interplay of reflection and reality.

ENGLAND

By the time Monet came to admire his work, Turner's reputation was at a low ebb in his own country. Toward 1850, when Courbet launched his revolutionary doctrine of Realism, a concern with "the heroism of modern life" asserted itself quite independently in English painting as well, although the movement lacked a leader of Courbet's stature and assertiveness. Perhaps best known is *The Last of England* (colorplate 98), by Ford Madox Brown (1821–93), a picture that enjoyed vast popularity throughout the latter half of the century in the English-speaking world. The subject—a group of emigrants watching the coast of their homeland disappear as they set out on their long overseas journey—may be less obvious today than it

771. EDGAR DEGAS.
The Tub. 1886.
Pastel, 23 1/2 × 32 1/3″.
The Louvre, Paris

772. CLAUDE MONET. *Water Lilies, Giverny.* 1907.
36 1/2 × 29″. Collection Jocelyn Walker, London

ration from the "primitive" masters of the fifteenth century; to that extent, they belonged to the Gothic revival, which had long been an important aspect of the Romantic movement. What set the Pre-Raphaelites apart from Romanticism pure and simple was an urge to reform the ills of modern civilization through their art; thus the emigrants in *The Last of England* dramatize the conditions that made them decide to leave England. But Rossetti, unlike Brown, was not concerned with social problems; he thought of himself, rather, as a reformer of aesthetic sensibility. His early masterpiece, *Ecce Ancilla Domini* (fig. 773), though realistic in detail, is full of self-conscious archaisms such as the pale tonality, the limited range of colors, the awkward perspective, and the stress on the verticals, not to mention the title in Latin. At the same time, this Annunciation radiates an aura of repressed eroticism that became the hallmark of Rossetti's work and exerted a powerful influence on other Pre-Raphaelites. We can sense it even in the political cartoon (fig. 774) by

once was, and does not carry the same emotional charge. Nonetheless, there can be no question that the artist has treated an important theme taken from modern experience, and that he has done so with touching seriousness. If the pathos of the scene strikes us as a bit theatrical—note the contrast between the brooding young couple in the foreground and the "good riddance" gesture of the man at the upper left—we recognize its source in the "dumb shows" of Hogarth, whom Brown revered (see fig. 700).

Brown's style, however, has nothing in common with Hogarth's; its impersonal precision of detail strikes us as almost photographic; no hint of subjective "handwriting" is permitted to intervene between us and the scene depicted. Brown had acquired this painstaking technique some years earlier, after he met a group of German painters in Rome who practiced what they regarded as a "medieval" style (see above, page 579). He in turn transmitted it to the painter and poet Dante Gabriel Rossetti (1828–82), who in 1848 helped to found an artists' society called the Pre-Raphaelite Brotherhood. Brown himself never actually joined it, but he shared the basic aim of the Pre-Raphaelites: to do battle against the frivolous art of the day by producing "pure transcripts . . . from nature" and by having "genuine ideas to express." As the name of the Brotherhood proclaims, its members took their inspi-

773. DANTE GABRIEL ROSSETTI. *Ecce Ancilla Domini.* 1850. 28 1/2 × 16 1/2″. The Tate Gallery, London

774. WALTER CRANE. Political cartoon from
Cartoons for the Cause. 1886. Woodcut

775. WILLIAM MORRIS. Detail of "Pimpernel" Wallpaper.
1876. Victoria & Albert Museum, London

the illustrator and book designer Walter Crane (1845–1915), which shows another kind of "annunciation"; the genius of Liberty, strongly reminiscent of the style of Botticelli (see colorplate 58), brings the glad tidings of socialism to a sleeping worker who is being oppressed by

776. JAMES WHISTLER. *Arrangement in Black and Gray:
The Artist's Mother.* 1871. 57 × 64 1/2". The Louvre, Paris

Capitalism in the shape of a nightmarish vampire. Shades of Henry Fuseli! (Compare figure 728.)

The link between Rossetti and Crane's cartoon was William Morris (1834–96), who started out as a Pre-Raphaelite painter but soon shifted his interest to "art for use"—domestic architecture and interior decoration such as furniture, tapestries, and wallpapers. He wanted to displace the shoddy products of the machine age by reviving the handicrafts of the pre-industrial past, an art "made by the people, and for the people, as a happiness to the maker and the user." Morris was an apostle of simplicity: architecture and furniture ought to be designed in accordance with the nature of their materials and working processes; surface decoration ought to be flat rather than illusionistic. Our sample of one of his wallpapers (fig. 775) exemplifies the latter principle in its rhythmic movement of fluid, sinuous lines. Despite Morris' self-proclaimed championship of the medieval tradition, this pattern does not represent the revival of any past style but is an independent creation. He invented the first original system of ornament since the Rococo—no small achievement.

Through the many enterprises he sponsored, as well as his skill as a writer and publicist, Morris became a taste-maker without peer in his day. Toward the end of the century, his influence had spread throughout Europe and America. Nor was he content to reform the arts of design alone; he saw them, rather, as a lever by which to reform

modern society as a whole. As a consequence, he played an important part in the early history of Fabian socialism (the gradualist variety invented in England as an alternative to the revolutionary socialism of the Continent). Many of his artist friends, including Walter Crane, came to share his convictions, and some contributed their artistic talents to the cause. Such, then, is the background of our cartoon.

AMERICA

Courbet, during the later years of his life, enjoyed considerable fame and influence abroad; the Impressionists gained international recognition more slowly. Surprisingly, Americans were their first patrons, responding to the new style sooner than Europeans did. At a time when no French museum would have them, Impressionist works entered public collections in the United States, and American painters were among the earliest followers of Manet and his circle. James McNeill Whistler (1834–1903) came to Paris in 1855 to study painting; four years later he moved to London to spend the rest of his life, but he visited France during the 1860s and was in close touch with the rising Impressionist movement. His best-known picture, *Arrangement in Black and Gray: The Artist's Mother* (fig. 776), reflects the influence of Manet in its emphasis on flat areas, and the likeness has the austere precision of Degas' portraits. Its rise to fame as a symbol of our latter-day "mother cult" is a paradox of popular psychology that would have dismayed Whistler: he wanted the canvas to be appreciated for its formal qualities alone. A witty and sharp-tongued advocate of Art for Art's Sake he thought of his pictures as analogous to pieces of music,

calling them "symphonies" or "nocturnes." The boldest example, painted about 1874, is *Nocturne in Black and Gold: The Falling Rocket* (colorplate 99); without an explanatory subtitle, we would have real difficulty making it out. No French painter had yet dared to produce a picture so "non-representational," so reminiscent of Cozens' blot-scapes and Turner's "tinted steam" (see fig. 731, colorplate 95). It was this canvas, more than any other, that prompted Ruskin to accuse Whistler of "flinging a pot of paint in the public's face." Since the same critic had highly praised Turner's *Slave Ship,* we must conclude that what Ruskin really liked was not the tinted steam itself but the Romantic sentiment behind it. During the subsequent suit for libel, Whistler offered a definition of his aims that seems to be particularly applicable to *The Falling Rocket:* "I have perhaps meant rather to indicate an artistic interest alone in my work, divesting the picture from any outside sort of interest. . . It is an arrangement of line, form, and color, first, and I make use of any incident of it which shall bring about a symmetrical result." The last phrase has special significance, since Whistler acknowledges that in utilizing chance effects, he does not look for resemblances but for a purely formal harmony. While he rarely practiced what he preached to quite the same extent as he did in *The Falling Rocket,* his statement reads like a prophecy of American abstract painting today (see colorplate 122).

Whistler's gifted contemporary in America, Winslow Homer (1836–1910), also came to Paris as a young man, but left too soon to receive the full impact of Impressionism. He was a pictorial reporter throughout the Civil War and continued as a magazine illustrator until 1875. Yet he did some of his most remarkable paint-

777. WINSLOW HOMER. *The Morning Bell.*
c. 1866. 24 × 38″.
Yale University Art Gallery,
New Haven, Connecticut
(Stephen C. Clark Collection)

778. THOMAS EAKINS. *The Gross Clinic*. 1875.
96 × 78″. Jefferson Medical College,
Philadelphia

ings in the 1860s. Such a work is *The Morning Bell* (fig. 777); the fresh delicacy of the sunlit scene might be called "pre-Impressionist"—halfway between Corot and Monet (compare fig. 753, colorplate 97). But the picture has an extraordinarily subtle design as well: the dog, the center girl, and those at the right turn the footpath into a seesaw, its upward slant balanced by the descending line of treetops. Thomas Eakins (1844–1916) arrived in Paris from Philadelphia about the time Homer painted *The Morning Bell;* he returned, four years later, with decisive impressions of Courbet, Manet, and Velázquez. Elements from these three artists are combined in *The Gross Clinic* (fig. 778), the most imposing work of American nineteenth-century painting. A powerfully realistic canvas, it is a lifesize view of an operation in progress, glossing over none of the gruesome detail. Conservative critics denounced it as a "degradation of art," but to us it seems a splendid fulfillment of Baudelaire's demand for pictures that express the heroism of modern life.

SCULPTURE

Rodin

Impressionism, it is often said, revitalized sculpture no less than painting. The statement is at once true and misleading. Auguste Rodin (1840–1917), the first sculptor of genius since Bernini, redefined sculpture during the same years that Manet and Monet redefined painting; in so doing, however, he did not follow these artists' lead. How indeed could the effect of such pictures as *The Fifer* or *The River* be reproduced in three dimensions and without color? What Rodin did accomplish is already visible in the first piece he tried to exhibit (it was rejected, as we might expect), *The Man with the Broken Nose* of 1864 (fig. 779). Earlier, he had worked briefly under Barye, whose influence may help to explain the vigorously creased surface (compare fig. 762). These welts and wrinkles produce, in polished bronze, an ever-

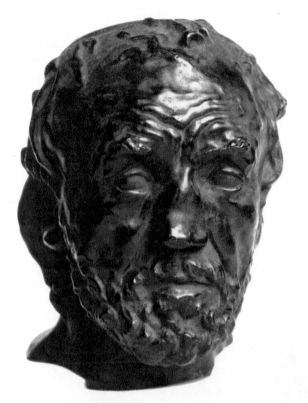

779. AUGUSTE RODIN. *The Man with the Broken Nose.*
1864. Bronze, height 9 ¹/₂″. Rodin Museum,
Philadelphia Museum of Art

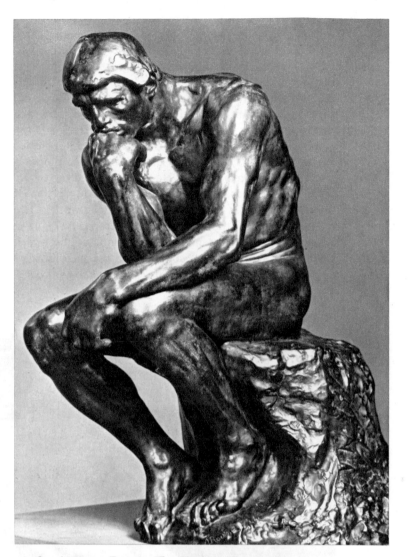

780. AUGUSTE RODIN. *The Thinker*. 1879–89. Bronze,
height 27 ¹/₂″. The Metropolitan Museum of Art,
New York (Gift of Thomas F. Ryan, 1910)

changing pattern of reflections. But is this effect bor-rowed from Impressionist painting? Does Rodin dissolve three-dimensional form into flickering patches of light and dark? These fiercely exaggerated shapes pulsate with sculptural energy, and they retain this quality under whatever conditions the piece is viewed. For Rodin did not work directly in bronze; he modeled in wax or clay. How could he calculate in advance the reflections on the bronze surfaces of the casts that would ultimately be made from these models? He worked as he did, we must assume, for an altogether different reason: not to capture elusive optical effects, but to emphasize the process of "growth" —the miracle of dead matter coming to life in the artist's hands. As the color patch, for Manet and Monet, is the primary reality, so are the malleable lumps from which Rodin builds his forms. And conservative critics re-jected *The Man with the Broken Nose* and Impressionist painting on the same grounds—it was "unfinished," a mere sketch. Sculptors, of course, had always made small, informal sketches (the plastic counterpart of drawings), but these were for the artist's private use, not for public display. Rodin was the first to make of un-finishedness an aesthetic principle that governed both his handling of surfaces and the whole shape of the work (*The Man with the Broken Nose* is not a bust, but a head "broken off" at the neck). By discovering what might be called the autonomy of the fragment, he rescued sculpture from mechanical verisimilitude just as Manet rescued painting from photographic realism.

This sculptural revolution, proclaimed with such dar-

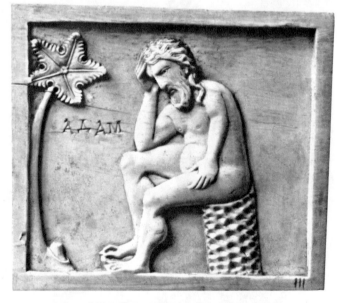

781. *Adam*. Byzantine, 12th century. Ivory.
Walters Art Gallery, Baltimore

ing by Rodin at twenty-four, did not reach full force until the late 1870s. For his living, the young artist had to collaborate with officially recognized sculptors on their public commissions, mostly memorials and architectural sculpture in the Neo-Baroque style of Carpeaux. In 1879 he was at last entrusted with a major task, the entrance of the Museum of Decorative Arts in Paris. Rodin elaborated the commission into an ambitious ensemble called *The Gates of Hell,* its symbolic program inspired by Dante's *Inferno.* He never finished the *Gates,* but they served as a matrix for countless smaller pieces that he eventually made into independent works. The most famous of these autonomous fragments is *The Thinker* (fig. 780), intended for the lintel of the *Gates,* whence the figure was to contemplate the panorama of despair below. The ancestry of *The Thinker* goes back,

indirectly at least, to the beginning phase of Christian art (the brooding Adam of the Byzantine ivory in fig. 781 reflects an Early Christian source); it also includes the action-in-repose of Michelangelo's superhuman bodies (see figs. 555, 559, colorplate 60), the tension in Puget's *Milo* (see fig. 689, especially the feet), and the expressive dynamism of *The Man with the Broken Nose.* Who is *The Thinker?* Partly Adam, no doubt (though there is also a different Adam by Rodin, another "outgrowth" of the *Gates*), partly Prometheus, and partly the brute imprisoned by the passions of the flesh. Rodin wisely refrained from giving him a specific name, for the statue fits no preconceived identity. In this new image of man, form and meaning are one, instead of cleaving apart as in Carpeaux's *Dance.* Carpeaux produced naked figures that pretend to be nude, while *The Thinker,* like the nudes of

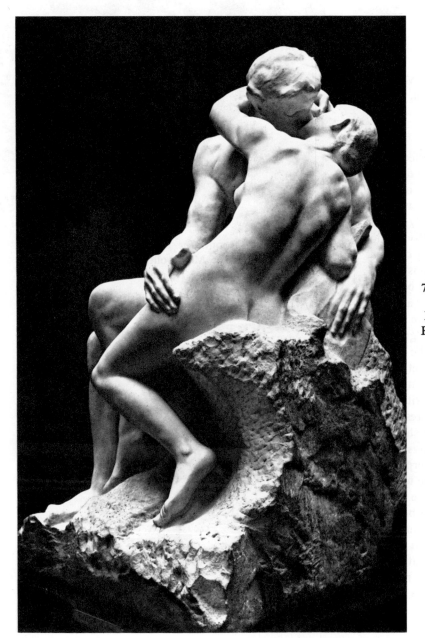

782. AUGUSTE RODIN. *The Kiss.* 1886–98. Marble, over lifesize. Rodin Museum, Paris

783. AUGUSTE RODIN.
Balzac (portion). 1892–97.
Plaster, 9′ 10″.
Rodin Museum, Paris

Michelangelo, is free from subservience to the undressed model.

The Kiss (fig. 782), an over-lifesize group in marble, also derives from the *Gates*. Less powerful than *The Thinker*, it exploits another kind of artful unfinishedness. Rodin had been impressed by the struggle of Michelangelo's "Slaves" against the remnants of the blocks that imprison them; *The Kiss* was planned from the start to include the mass of roughhewn marble to which the lovers are attached, and which thus becomes symbolic of their earthbound passion. The contrast of textures emphasizes the veiled, sensuous softness of the bodies. But Rodin was by instinct a modeler, not a carver like Michelangelo. His greatest works were intended to be cast in bronze. Even these, however, reveal their full strength only when we see them in plaster casts made directly from Rodin's clay originals. The *Balzac Monument*, his most daring creation, remained in plaster for many years, rejected by the committee that had commissioned it (fig. 783). The figure is larger than life, physically and spiritually; it has the overpowering presence of a specter. Like a huge monolith, the man of genius towers above the crowd; he shares "the sublime egotism of the gods" (as the Romantics put it). Rodin has minimized the articulation of the body, so that from a distance we see only its great bulk. As we approach, we become aware that Balzac is wrapped in a long, shroud-like cloak. From this mass the head thrusts upward—one is tempted to say, erupts—with elemental force. When we are close enough to make out the features clearly, we sense beneath the disdain an inner agony that stamps *Balzac* as the kin of *The Man with the Broken Nose*.

PAINTING

SCULPTURE

3

POST-IMPRESSIONISM

PAINTING

In 1882, just before his death, Manet was made a chevalier of the Legion of Honor by the French government. Four years later the Impressionists, who had been exhibiting together since 1874, held their last group show. These two events mark the turn of the tide—Impressionism had gained wide acceptance among artists and the public, but by the same token it was no longer a pioneering movement. The future now belonged to the "Post-Impression-

ists." Taken literally, this colorless label applies to all painters of significance since the 1880s; in a more specific sense, it designates a group of artists who passed through an Impressionist phase but became dissatisfied with the limitations of the style and went beyond it in various directions. As they did not share one common goal, it is difficult to find a more descriptive term for them than Post-Impressionism. In any event, they were not "anti-Impressionists." Far from trying to undo the effects of the "Manet Revolution," they wanted to carry it further; Post-Impressionism is in essence just a later stage—through a very important one—of the development that had begun in the 1860s with such pictures as Manet's *Luncheon on the Grass*.

Cézanne

Paul Cézanne (1839–1906), the oldest of the Post-Impressionists, was born in Aix-en-Provence, near the Mediterranean coast. A man of intensely emotional temperament, he came to Paris in 1861 imbued with

784. PAUL CÉZANNE,
after SEBASTIANO DEL PIOMBO.
Christ in Limbo.
c. 1868–70. 66 × 40".
Collection René Lecomte, Paris

785. SEBASTIANO DEL PIOMBO.
Christ in Limbo.
c. 1530. 89 × 45".
The Prado, Madrid

786. PAUL CÉZANNE.
Fruit Bowl, Glass, and Apples.
1879–82. 18 × 21 1/2".
Collection René Lecomte, Paris

787. PAUL CÉZANNE. *Mont Sainte-Victoire
Seen from Bibemus Quarry*.
c. 1898–1900. 25 1/2 × 32".
The Baltimore Museum of Art
(The Cone Collection)

enthusiasm for the Romantics; Delacroix was his first love among painters, and he never lost his admiration for him. *Christ in Limbo* (fig. 784) has the heavy impasto and highly personal, expressive brushwork of this "Neo-Baroque" phase of Cézanne's development. Yet the painting also shows how well the young artist had grasped the nature of the "Manet Revolution": it is a "picture of a picture" like those Manet had painted, and is based on an Italian sixteenth-century work which Cézanne knew only from a reproduction (fig. 785). What

fascinated him here was the problem of translating the Renaissance composition into the style of Manet's *Fifer* (see colorplate 96): to reconcile, by "closing" the cavernous space, the claims of surface and depth. Like Manet, Cézanne accomplishes this by resolutely refusing to abide by the traditional rules of chiaroscuro: instead of modeling in a continuous scale of tones from dark to light, he treats the shadows as shapes in their own right, solid and clearly bounded. And he is bolder than Manet in his disregard of the logic of external appearance for the sake of the inner logic of the design.

Cézanne soon began to paint bright outdoor scenes, but he never shared his fellow Impressionists' interest in "slice-of-life" subjects, in movement and change. About 1879, when he painted the *Self-Portrait* reproduced in colorplate 100, he had decided "to make of Impressionism something solid and durable, like the art of the museums." His Romantic impulsiveness of the 1860s has now given way to a patient, disciplined search for harmony of form and color: every brush stroke is like a building block, firmly placed within the pictorial architecture; the balance of "two-D" and "three-D" is less harsh than before (note how the pattern of wallpaper in the background frames the rounded shape of the head); and the colors are deliberately controlled so as to produce "chords" of warm and cool tones that reverberate throughout the canvas. In Cézanne's still lifes, such as *Fruit Bowl, Glass, and Apples* (fig. 786), this quest for the "solid and durable" can be seen even more clearly. Not since Chardin have simple everyday objects assumed such importance in a painter's eye. Again the ornamental backdrop is integrated with the three-dimensional shapes, and the brush strokes have a rhythmic pattern that gives the canvas its shimmering texture. We also notice another aspect of Cézanne's mature style that is more conspicuous here than in the *Self-Portrait* and may puzzle us at first: the forms are deliberately simplified,

and outlined with dark contours; and the perspective is "incorrect" for both the fruit bowl and the horizontal surfaces, which seem to tilt upward. The longer we study the picture, the more we realize the rightness of these apparently arbitrary distortions. When Cézanne takes these liberties with reality, his purpose is to uncover the permanent qualities beneath the accidents of appearance (all forms in nature, he believed, are based on the cone, the sphere, and the cylinder). This order underlying the external world was the true subject of his pictures, but he had to interpret it to fit the separate, closed world of the canvas. One detail of our painting is particularly instructive in this respect—the stem of the fruit bowl is slightly off-center, as if the oval shape of the bowl, in response to the pressure of the other objects, were expanding toward the left.

To apply this method to landscape became the greatest challenge of Cézanne's career. From 1882 on, he lived in isolation near his home town, exploring its environs as Claude Lorraine and Corot had explored the Roman countryside. One motif, the distinctive shape of a mountain called Mont Sainte-Victoire, seemed almost to obsess him; its craggy profile looming against the blue Mediterranean sky appears in a long series of compositions, such as the very monumental late work in figure 787. There are no hints of man's presence here—houses and roads would only disturb the lonely grandeur of this view. Above the wall of rocky cliffs that bar our way like a chain of fortifications, the mountain rises in triumphant clarity, infinitely remote yet as solid and palpable as the shapes in the foreground. For all its architectural stability, the scene is alive with movement; but the forces at work here have been brought into equilibrium, subdued by the greater power of the artist's will. This disciplined energy, distilled from the trials of a stormy youth, gives the mature style of Cézanne its enduring strength.

788. GEORGES SEURAT. *Bathers.* 1883–84. 79 1/8 × 118 1/8″. The Tate Gallery, London

Seurat

Georges Seurat (1859–91) shared Cézanne's aim to make Impressionism "solid and durable," but he went about it very differently. His career was as brief as those of Masaccio, Giorgione, and Géricault, and his achievement just as astonishing. Seurat devoted his main efforts to a few very large paintings, spending a year or more on each of them: he made endless series of preliminary studies before he felt sure enough to tackle the definitive version. This painstaking method reflects his belief that art must be based on a system; like Degas, he had studied with a follower of Ingres, and his theoretical interests came from this experience. But, as with all artists of genius, Seurat's theories do not really explain his pictures; it is the pictures, rather, that explain the theories. The subject of his first large-scale composition, the *Bathers* of 1883–84 (fig. 788), is of the sort that had long· been popular among Impressionist painters. Impressionist, too, are the brilliant colors and the effect of intense sunlight. Otherwise, however, the picture is the very opposite of a quick "impression"; the firm, simple contours and the relaxed, immobile figures give the scene a timeless stability that recalls Piero della Francesca (see colorplate 53). Even the brushwork shows Seurat's passion for order and permanence: the canvas surface is covered with systematic, impersonal "flicks" that make Cézanne's architectural brush strokes seem temperamental and dynamic by comparison. In Seurat's later works such as *Side Show* (*La Parade,* colorplate 101), the flicks become tiny dots of brilliant color that were supposed to merge in the beholder's eye and produce intermediary tints more luminous than those obtainable from pigments mixed on the palette. This procedure was variously known as Neo-Impressionism, Pointillism, or Divisionism (the term preferred by Seurat). The actual result, however, did not conform to the theory. Looking at *Side Show* from a comfortable distance (12–15″ for the colorplate, 7–10′ for the original), we find that the mixing of colors in the eye remains incomplete; the dots do not disappear, but remain as clearly visible as the tesserae of a mosaic (compare colorplate 24). Seurat himself must have liked this unexpected effect—had he not, he would have reduced the size of the dots—which gives the canvas the quality of a shimmering, translucent screen. In *Side Show,* the bodies do not have the weight and bulk they had in the *Bathers;* modeling and foreshortening are reduced to a minimum, and the figures appear mostly in either strict profile or frontal views, as if Seurat had adopted the rules of ancient Egyptian art (see page 55). Moreover, they are fitted very precisely into a system of vertical and horizontal coordinates that holds them in place and defines the canvas as a self-contained rectilinear field. Only in the work of Vermeer have we encountered a similar "area-consciousness" (compare colorplate 82).

Van Gogh

While Cézanne and Seurat were converting Impressionism into a more severe, classical style, Vincent van Gogh (1853–90) pursued the opposite direction, for he believed that Impressionism did not provide the artist with enough freedom to express his emotions. Since this was his main concern, he is sometimes called an Expressionist, but the term ought to be reserved for certain later painters (see the next chapter). Van Gogh, the first great Dutch master since the seventeenth century, did not become an artist until 1880; as he died only ten years later,

789. VINCENT VAN GOGH. *The Potato Eaters.* 1885. 32¼ × 45″. Vincent van Gogh National Museum, Amsterdam (V. W. van Gogh Collection)

his career was even briefer than that of Seurat. His early interests were in literature and religion; profoundly dissatisfied with the values of industrial society and imbued with a strong sense of mission, he worked for a while as a lay preacher among poverty-stricken coal miners. This same intense feeling for the poor dominates the paintings of his pre-Impressionist period, 1880–85. In *The Potato Eaters* (fig. 789), the last and most ambitious work of those years, there remains a naïve clumsiness that comes from his lack of conventional training, but this only adds to the expressive power of his style. We are reminded of Daumier and Millet (see figs. 750, 752), of Rembrandt and Louis Le Nain (see figs. 655, 660, 674). For this peasant family, the evening meal has the solemn importance of a ritual.

When he painted *The Potato Eaters,* Van Gogh had not yet discovered the importance of color. A year later in Paris, where his brother Theo had a gallery devoted to modern art, he met Degas, Seurat, and other leading French artists. Their effect on him was electrifying: his pictures now blazed with color, and he even experimented briefly with the Divisionist technique of Seurat. This Impressionist phase, however, lasted less than two years. Although it was vitally important for his development, he had to integrate it with the style of his earlier years before his genius could fully unfold. Paris had opened his eyes to the sensuous beauty of the visible world and had taught him the pictorial language of the color patch, but painting continued to be nevertheless a vessel for his personal emotions. To investigate this spiritual reality with the new means at his command, he went to Arles, in the south of France. It was there, between 1888 and 1890, that he produced his greatest pictures.

Like Cézanne, Van Gogh now devoted his main energies to landscape painting, but the sun-drenched Mediterranean countryside evoked a very different response in him: he saw it filled with ecstatic movement, not architectural stability and permanence. In *Wheat Field and Cypress Trees* (colorplate 102), both earth and sky show an overpowering turbulence—the wheat field resembles a stormy sea, the trees spring flame-like from the ground, and the hills and clouds heave with the same undulant motion. The dynamism contained in every brush stroke makes of each one not merely a deposit of color, but an incisive graphic gesture. The artist's personal "handwriting" is here an even more dominant factor than in the canvases of Daumier (compare figs. 750, 751). Yet to Van Gogh himself it was the color, not the form, that determined the expressive content of his pictures. The letters he wrote to his brother include many eloquent descriptions of his choice of hues and the emotional meanings he attached to them. Although he acknowledged that his desire "to exaggerate the essential and to leave the obvious vague" made his colors look arbitrary by Impressionist standards, he nevertheless remained deeply committed to the visible world. Compared to Monet's *The River* (see colorplate 97), the colors of *Wheat*

790. VINCENT VAN GOGH. *Self-Portrait.* 1889. 22 1/2 × 17″. Collection Mr. and Mrs. John Hay Whitney, New York

Field and Cypress Trees are stronger, simpler, and more vibrant, but in no sense "unnatural." They speak to us of that "kingdom of light" Van Gogh had found in the South, and of his mystic faith in a creative force animating all forms of life—a faith no less ardent than the sectarian Christianity of his early years. The missionary had now become a prophet. We see him in that role in the *Self-Portrait* (fig. 790), his emaciated, luminous head with its burning eyes set off against a whirlpool of darkness. "I want to paint men and women with that something of the eternal which the halo used to symbolize," Van Gogh had written, groping to define for his brother the human essence that was his aim in pictures such as this. At the time of the *Self-Portrait,* he had already begun to suffer fits of a mental illness that made painting increasingly difficult for him. Despairing of a cure, he committed suicide a year later, for he felt very deeply that art alone made his life worth living.

Gauguin

The quest for religious experience also played an important part in the work—if not in the life—of another great Post-Impressionist, Paul Gauguin (1848–1903). He began as a prosperous stockbroker in Paris and an amateur painter and collector of modern pictures (he once owned Cézanne's *Fruit Bowl, Glass, and Apples;* see fig. 786). At the age of thirty-five, however, he became convinced that he must devote himself entirely to art; he

791. PAUL GAUGUIN.
Offerings of Gratitude.
c. 1891–93. Woodcut

abandoned his business career, separated from his family, and by 1889 was the central figure of a new movement called Synthetism or Symbolism. His style, though less intensely personal than Van Gogh's, was in some ways an even bolder advance beyond Impressionism. Gauguin believed that Western civilization was "out of joint," that industrial society had forced men into an incomplete life dedicated to material gain, while their emotions lay neglected. To rediscover for himself this hidden world of feeling, Gauguin left Paris for western France to live among the peasants of Brittany. He noticed particularly that religion was still part of the everyday life of the country people, and in pictures such as our colorplate 103, *The Vision After the Sermon (Jacob Wrestling with the Angel),* he tried to depict their simple, direct faith. Here at last is what no Romantic painter had achieved: a style based on pre-Renaissance sources. Modeling and perspective have given way to flat, simplified shapes outlined heavily in black, and the brilliant colors are equally "un-natural." This style, inspired by folk art and medieval stained glass, is meant to re-create both the imagined reality of the vision, and the trance-like rapture of the peasant women. Yet we sense that Gauguin, although he tried to share this experience, remains an outsider; he could paint pictures *about* faith, but not *from* faith.

Two years later, Gauguin's search for the unspoiled life led him even farther afield. He voyaged to Tahiti as a sort of "missionary in reverse," to learn from the natives instead of teaching them. Although he spent the rest of his life in the South Pacific (he returned home only once, in 1893–95), none of his Tahitian canvases are as daring as those he had painted in Brittany. His strongest works of this period are woodcuts; *Offerings of Gratitude* (fig. 791) again presents the theme of religious worship, but the image of a local god now replaces the biblical subject of the *Vision.* In its frankly "carved" look and its bold white-on-black pattern, we can feel the influences of the native art of the South Seas and of other

non-European styles. The renewal of Western art and Western civilization as a whole, Gauguin believed, must come from "the Primitives"; he advised his fellow Symbolists to shun the Greek tradition and to turn instead to Persia, the Far East, and ancient Egypt. This idea itself was not new. It stems from the Romantic myth of the Noble Savage, propagated by the thinkers of the Enlightenment more than a century before, and its ultimate source is the age-old tradition of an earthly paradise where Man had lived—and might perhaps live again—in a state of nature and innocence. But no one before Gauguin had gone as far to put the doctrine of primitivism into practice. His pilgrimage to the South Pacific had more than a purely private meaning: it symbolizes the end of the four hundred years of colonial expansion which had brought the entire globe under Western domination. The "white man's burden," once so cheerfully—and ruthlessly—shouldered by the empire builders, was becoming unbearable.

Symbolism: the Nabis

Gauguin's Symbolist followers, who called themselves Nabis (from the Hebrew word for "prophet"), were less remarkable for creative talent than for their ability to spell out and justify the aims of Post-Impressionism in theoretical form. One of them, Maurice Denis, coined the statement that was to become the First Article of Faith for twentieth-century painters: "A picture—before being a war horse, a female nude, or some anecdote—is essentially a flat surface covered with colors in a particular order." The Symbolists also discovered that there were some older artists, descendants of the Romantics, whose work, like their own, placed inner vision above the observation of nature. One of these was Gustave Moreau (1826–98), a strange recluse who admired Delacroix yet created a world of personal fantasy that has much in common with the medieval reveries of some of the English Pre-Raphaelites. *The Apparition*

(fig. 792) shows one of his favorite themes: the head of John the Baptist, in a blinding radiance of light, appears to the dancing Salome. Her odalisque-like sensuousness, the stream of blood pouring from the severed head, the vast, mysterious space of the setting—suggestive of an exotic temple rather than of Herod's palace—summon up all the dreams of oriental splendor and cruelty so dear to the Romantic imagination, commingled with an insistence on the reality of the supernatural. Only late in life did Moreau achieve a measure of recognition; suddenly, his art was in tune with the times. During his last six years, he even held a professorship at the conservative École des Beaux-Arts, the successor of the official art academy founded under Louis XIV (see above, pages 528f.). There he attracted the most gifted students, among them such future leaders as Matisse and Rouault.

How prophetic Moreau's work was of the taste prevailing at the end of the century is evident from a comparison with Aubrey Beardsley (1872–98), a talented young Englishman whose elegantly "decadent" black-and-white drawings were the very epitome of that taste. They include a *Salome* illustration (fig. 794) that might well be the final scene of the drama depicted by Moreau: Salome has grasped that head and triumphantly kissed it. Whereas Beardsley's erotic meaning is plain—Salome is passionately in love with John and has asked for his head because she could not have him in any other way—Moreau's remains ambiguous: did his Salome perhaps conjure up the vision of the head? is she, too, in love

793. ODILON REDON. *The Balloon Eye,* from the series *À Edgar Poe.* 1882. Lithograph

with John? Nevertheless, the parallel is striking, and there are formal similarities as well, such as the "stem" of trickling blood from which John's head rises like a flower. Yet Beardsley's *Salome* cannot be said to derive from Moreau's. The sources of his style are English—the graphic art of the Pre-Raphaelites and the curvilinear ornament of William Morris (see figs. 774, 775)—with a strong admixture of Japanese influence (compare fig. 894).

Another solitary artist whom the Symbolists discovered and claimed as one of their own was Odilon Redon (1840–1916). Like Moreau, he had a haunted imagination, but his imagery was even more personal and disturbing. A master of etching and lithography, he drew inspiration from the fantastic visions of Goya (see fig. 743) as well as Romantic literature. The lithograph shown in figure 793 is one of a set he issued in 1882 and dedicated to Edgar Allan Poe. The American poet had been dead for 33 years; but his tormented life and his equally tormented imagination made him the very model of the *poète maudit,* the doomed poet, and his works, excellently translated by Baudelaire and Mallarmé, were greatly admired in France. Redon's lithographs do not illustrate Poe; they are, rather, "visual poems" in their own right, evoking the macabre, hallucinatory world of Poe's imagination. In our example, the artist has revived a very ancient device, the single eye representing

792. GUSTAVE MOREAU. *The Apparition (Dance of Salome).* c. 1876. 21 ¼ × 17 ½". Fogg Art Museum, Harvard University, Cambridge, Massachusetts (Grenville L. Winthrop Bequest)

794. AUBREY BEARDSLEY. *Salome.* 1892. Pen drawing.
Princeton University Library, Princeton, New Jersey

J'AI BAISÉ TA BOVCHE
IOKANAAN
J'AI BAISÉ TA BOVCHE

delicate balance of "two-D" and "three-D" effects, and a quiet magic that makes us think of Vermeer and Chardin (compare colorplates 82, 87), two masters of the past whom Vuillard must have loved. Such economy of means became an important precedent for Matisse a decade later (see colorplate 106). By then, however, Vuillard's own style had grown more conservative. He never recaptured the delicacy and daring of his early canvases.

Toulouse-Lautrec

Van Gogh's and Gauguin's discontent with the spiritual ills of Western civilization was part of a sentiment widely shared at the end of the nineteenth century. A self-conscious preoccupation with decadence, evil, and darkness pervaded the artistic and literary climate. Even those who saw no escape analyzed their predicament in fascinated horror. Yet, somewhat paradoxically, this very awareness proved to be a source of strength (the truly decadent, we may assume, are unable to realize their plight). The most remarkable instance of this strength was Henri de Toulouse-Lautrec (1864–1901); physically an ugly dwarf, he was an artist of superb talent who led a dissolute life in the night spots of Paris and died of alcoholism. He was a great admirer of Degas, and his *At the Moulin Rouge* (colorplate 104) recalls the zigzag form of Degas' *The Glass of Absinthe* (see fig. 768). Yet this view of the well-known night club is no Impressionist "slice of life"; Toulouse-Lautrec sees through

the all-seeing mind of God. But, in contrast to the traditional form of the symbol, Redon shows the whole eyeball removed from its socket and converted into a balloon that drifts aimlessly in the sky. Disquieting visual paradoxes of this kind were to be exploited on a large scale by the Dadaists and Surrealists in our own century (see figs. 821, 822, 826).

Oddly enough, the most gifted member of the Nabis, Edouard Vuillard (1868–1940), was more influenced by Seurat than by Gauguin. In his pictures of the 1890s —mainly domestic scenes, small in scale and intimate in effect, like the *Interior* (fig. 795)—he combines into a remarkable new entity the flat planes and emphatic contours of Gauguin (colorplate 103) with the shimmering Divisionist "color mosaic" and the geometric surface organization of Seurat (see colorplate 101). This seemingly casual view of a corner of the artist's apartment has a

795. EDOUARD VUILLARD. *Interior.* 1898. 19³/₄ × 16¹/₄".
Private Collection, Paris

796. JAMES ENSOR. *Intrigue*.
1890. 35 1/2 × 59".
Royal Museum of Fine Arts, Antwerp

the gay surface of the scene, viewing performers and customers with a pitilessly sharp eye for their character (including his own: he is the tiny bearded man next to the very tall one in the back of the room). The large areas of flat color, however, and the emphatic, smoothly curving outlines, reflect the influence of Gauguin. Although Toulouse-Lautrec was no Symbolist, the Moulin Rouge that he shows here has an atmosphere so joyless and oppressive that we cannot but regard it as a place of evil.

Ensor; Munch; the young Picasso

In the art of the Belgian painter James Ensor (1860–1949), this pessimistic view of the human condition reaches obsessive intensity. *Intrigue* (fig. 796) is a grotesque carnival, but as we scrutinize these masks we become aware that they are the mummers' true faces, revealing the depravity ordinarily hidden behind the façade of everyday appearances. The demon-ridden world of Bosch and Schongauer has come to life again, in modern guise (compare figs. 472, 483). Something of the same macabre quality pervades the early work of Edvard Munch (1863–1944), a gifted Norwegian who came to Paris in 1889 and based his starkly expressive style on Toulouse-Lautrec, Van Gogh, and Gauguin. *The Scream* (fig. 797) shows the influences of all three; it is an image of fear, the terrifying, unreasoned fear we feel in a nightmare. Unlike Fuseli and Goya (see figs. 728, 743), Munch visualizes this experience without the aid of frightening apparitions, and his achievement is the more persuasive for that very reason. The rhythm of the long, wavy lines seems to carry the echo of the scream into every corner of the picture, making of earth and sky one great sounding board of fear. Neither Munch nor Ensor is likely to have known Préault's *Slaughter* (compare fig. 759), yet that remarkable relief, more than half a century earlier, seems strangely prophetic of both.

Young Pablo Picasso (1881–1974), coming to Paris in 1900, felt the spell of the same artistic atmosphere

797. EDVARD MUNCH. *The Scream*. 1893.
36 × 29". National Museum, Oslo

that had generated the style of Munch. His so-called Blue Period (the term refers to the prevailing color of his canvases as well as to their mood) consists almost exclusively of pictures of beggars and derelicts such as *The Old Guitarist* (fig. 798)—outcasts or victims of society whose pathos reflects the artist's own sense of isolation. Yet these figures convey poetic melancholy more than outright despair. The aged musician accepts his fate with a resignation that seems almost saintly, and the attenuated grace of his limbs reminds us of El Greco (compare

798. PABLO PICASSO. *The Old Guitarist*. 1903. Oil on panel, 47 $^3/_4$ × 32 $^1/_2$". The Art Institute of Chicago (Helen Birch Bartlett Memorial Collection)

colorplate 67). *The Old Guitarist* is a strange amalgam of Mannerism and of the art of Gauguin and Toulouse-Lautrec (note the smoothly curved contours), imbued with the personal gloom of a twenty-two-year-old genius.

Rousseau

A few years later, Picasso and his friends discovered a painter who until then had attracted no attention, although he had been exhibiting his work since 1886. He was Henri Rousseau (1844–1910), a retired customs collector who had started to paint in his middle age without training of any sort. His ideal—which, fortunately, he never achieved—was the arid academic style of the followers of Ingres. Rousseau is that paradox, a folk artist of genius. How else could he have done a picture like *The Dream* (colorplate 105)? What goes on in the enchanted world of this canvas needs no explanation, because none is possible, but perhaps for that very reason its magic becomes unbelievably real to us. Rousseau himself described the scene in a little poem:

> Yadwigha, peacefully asleep
> Enjoys a lovely dream:
> She hears a kind snake charmer

> Playing upon his reed.
> On stream and foliage glisten
> The silvery beams of the moon.
> And savage serpents listen
> To the gay, entrancing tune.

Here at last is that innocent directness of feeling which Gauguin thought was so necessary for the age, and traveled so far to find. Picasso and his friends were the first to recognize this quality in Rousseau's work. They revered him, quite justifiably, as the godfather of twentieth-century painting.

SCULPTURE

No tendencies to be equated with Post-Impressionism appear in sculpture until about 1900. Sculptors of a younger generation had by then been trained under the dominant influence of Rodin, and were ready to go their own way. The finest of these, Aristide Maillol (1861–1944), began as a Symbolist painter, although he did not share Gauguin's anti-Greek attitude. Maillol might be called a "classic primitivist"; admiring the simplified strength of early Greek sculpture, he rejected its later phases. The *Seated Woman* (fig. 799) evokes memories of the Archaic and Severe Styles (compare figs. 133, 143–44, 164–68) rather than of Phidias and Praxiteles. The solid forms and clearly defined volumes also recall Cézanne's statement that all natural forms are based on the cone, the sphere, and the cylinder. But the most notable quality of the figure is its harmonious, self-sufficient repose, which the outside world cannot disturb. A statue, Maillol thought, must above all be "static," structurally balanced like a piece of architecture; it must represent a state of being that is detached from

799. ARISTIDE MAILLOL. *Seated Woman (Méditerranée)*. c. 1901. Height 41". Collection Oskar Reinhart, Winterthur, Switzerland

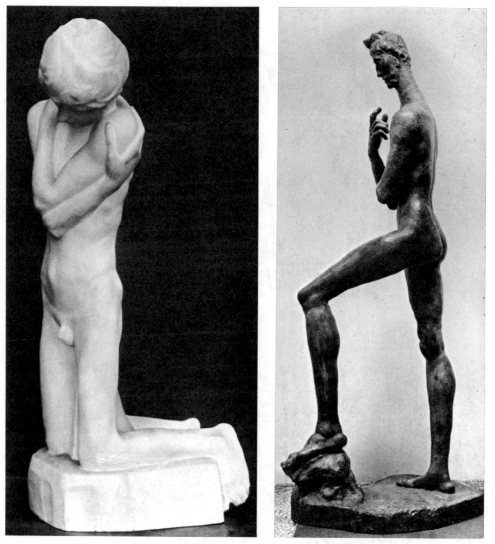

800. ERNST BARLACH. *Man Drawing a Sword*.
1911. Wood, height 31″.
Museum, Cranbrook Academy of Art,
Bloomfield Hills, Michigan

801. GEORGE MINNE.
Kneeling Boy. 1898. Marble, height 31″.
Museum of Fine Arts, Ghent

802. WILHELM LEHMBRUCK.
Standing Youth. 1913. Cast stone, height 92″
The Museum of Modern Art, New York
(Gift of Mrs. John D. Rockefeller, Jr.)

the stress of circumstance, with none of the restless, thrusting energy of Rodin's work. In this respect, the *Seated Woman* is the exact opposite of *The Thinker* (see fig. 780). Maillol later gave it the title *Méditerranée*— The Mediterranean—to suggest the source from which he drew the timeless serenity of his figure.

The *Kneeling Boy* (fig. 801) by the Belgian sculptor George Minne (1866–1941) also shows a state of brooding calm, but the haggard, angular limbs reflect Gothic, not classical, influence and the trance-like rigidity of the pose suggests religious meditation. The statue is part of a fountain design that consists of five identical kneeling boys, grouped around a circular basin as if engaged in a solemn ritual. We must see this figure as one anonymous member of a rhythmically repeated sequence, if we are to understand its mood of ascetic withdrawal. Minne's art attracted little notice in France, but was admired in Germany. Its influence is apparent in the *Standing Youth* (fig. 802) by Wilhelm Lehmbruck (1881–1919); here a Gothic elongation and angularity are conjoined with a fine balance derived from Maillol's art, and also with some of Rodin's expressive energy. The total effect is a looming monumental figure well anchored

in space, yet partaking of that poetic melancholy we observed in Picasso's Blue Period. Ernst Barlach (1870–1938), another important German sculptor who reached maturity in the years before the First World War, seems the very opposite of Lehmbruck; he is a "Gothic primitivist," and more akin to Munch than to the Western Symbolist tradition. What Gauguin had experienced in Brittany and the tropics, Barlach found by going to Russia: the simple humanity of a pre-industrial age. His figures, such as the *Man Drawing a Sword* (fig. 800), embody elementary emotions—wrath, fear, grief—that seem imposed upon them by invisible presences. When they act they are like somnambulists, unaware of their own impulses. Man, to Barlach, is a humble creature at the mercy of forces beyond his control; he is never the master of his fate. Characteristically, these figures do not fully emerge from the material substance (often, as here, a massive block of wood) of which they are made; their clothing is like a hard chrysalis that hides the body, as in medieval sculpture. Barlach's art has a range that is severely restricted in both form and emotion, yet its mute intensity within these limits is not easily forgotten.

4

TWENTIETH-CENTURY PAINTING AND SCULPTURE

PAINTING

In our account of modern art we have already discussed a succession of "isms": Neoclassicism, Romanticism, Realism, Impressionism, Post-Impressionism, Divisionism, Symbolism. There are many more to be found in twentieth-century art—so many, in fact, that nobody has made an exact count. These "isms" can form a serious obstacle to understanding: they may make us feel that we cannot hope to comprehend the art of our time unless we immerse ourselves in a welter of esoteric doctrines. Actually, we can disregard all but the most important "isms"; like the terms we have used for the styles of earlier periods, they are merely labels to help us put things in their proper place. If an "ism" fails the test of usefulness, we need not retain it. This is true of many "isms" in contemporary art; the movements they designate either cannot be seen very clearly as separate entities, or have so little importance that they can interest only the specialist. It has always been easier to invent new labels than to create a movement in art that truly deserves a new name.

Still, we cannot do without "isms" altogether. Since the start of the modern era, the Western world—and, increasingly, the non-Western world—has faced the same basic problems everywhere, and local artistic traditions have steadily given way to international trends. Among these we can distinguish three main currents, each comprising a number of "isms," that began among the Post-Impressionists, and have developed greatly in our own century: Expression, Abstraction, and Fantasy. The first stresses the artist's emotional attitude toward himself and the world; the second, the formal structure of the work of art; the third explores the realm of the imagination, especially its spontaneous and irrational qualities. We must not forget, however, that feeling, order, and imagination are all present in *every* work of art: without imagination, it would be deadly dull; without some degree of order, it would be chaotic; without feeling, it would leave us unmoved. These currents, then, are not mutually exclusive. We shall find them interrelated in many ways, and the work of one artist may well belong to more than one current. Moreover, each current embraces a wide range of approaches, from the realistic to the completely non-representational (or non-objective). Thus these three currents do not correspond to specific styles, but to general attitudes. The primary concern of the Expressionist is the human community; of the Abstractionist, the structure of reality; and of the artist of Fantasy, the labyrinth of the individual human mind.

THE FAUVES; EXPRESSIONISM

The twentieth century may be said, so far as painting is concerned, to have begun five years late. Between 1901 and 1906, several comprehensive exhibitions of the work of Van Gogh, Gauguin, and Cézanne were held in Paris. Thus, for the first time the achievements of these masters became accessible to a broad public. The young painters who had grown up in the "decadent," morbid mood of the 1890s (see page 626) were profoundly impressed, and several of them developed a radical new style, full of violent color and bold distortions. On their first public appearance, in 1905, they so shocked critical opinion that they were dubbed the *Fauves* (the wild beasts), a label they wore with pride. Actually, it was not a common program that brought them together, but their shared sense of liberation and experiment. As a movement, Fauvism comprised numerous loosely related, individual styles, and the group dissolved after a few years.

Matisse; Rouault

Its leading member was Henri Matisse (1869–1954), the oldest of the founding fathers of twentieth-century painting. *The Joy of Life* (fig. 803), probably the most important picture of his long career, sums up the spirit of Fauvism better than any other single work. It obviously derives its flat planes of color, heavy undulating outlines,

803. HENRI MATISSE.
The Joy of Life. 1905–06.
68 1/2 × 93 3/4".
Copyright Barnes Foundation,
Merion, Pennsylvania

and the "primitive" flavor of its forms from Gauguin (see colorplate 103); even its subject suggests the vision of Man in a state of Nature that Gauguin had pursued in Tahiti (see fig. 791). But we soon realize that these figures are not Noble Savages under the spell of a native god; the subject is a pagan scene in the Classical sense—a bacchanal, like Titian's (compare colorplate 63). Even the poses of the figures have for the most part a Classical origin, and in the apparently careless draughtsmanship resides a profound knowledge of the human body (Matisse had been trained in the academic tradition). What makes the picture so revolutionary is its radical simplicity, its "genius of omission": everything that possibly can be, has been left out or stated by implication only, yet the scene retains the essentials of plastic form and spatial depth. Painting, Matisse seems to say, is the rhythmic arrangement of line and color on a flat plane, but it is not *only* that; how far can the image of nature be pared down without destroying its basic properties and thus reducing it to mere surface ornament? "What I am after, above all," he once explained, "is expression . . . [But] . . . expression does not consist of the passion mirrored upon a human face. . . . The whole arrangement of my picture is expressive. The placement of figures or objects, the empty spaces around them, the proportions, everything plays a part." But what, we wonder, does *The Joy of Life* express? Exactly what its title says. Whatever his debt to Gauguin, Matisse was never stirred by the same agonized discontent with the "decadence" of our civilization. He had strong feelings about only one thing—the act of painting: this to him was an experience so profoundly joyous that he wanted to transmit it to the beholder in all its freshness and immediacy. The purpose of his pictures, he always asserted, was to give pleasure.

The radical new balance Matisse struck between the "2-D" and "3-D" aspects of painting is particularly evident in his *Harmony in Red* (colorplate 106); he spreads the same flat blue-on-red pattern on the tablecloth and on the wall, yet he distinguishes the horizontal from the vertical planes with complete assurance. Cézanne had pioneered this integration of surface ornament into the design of a picture (see colorplate 100), but Matisse here makes it the mainstay of his composition. Equally bold— but perfectly readable—is the view of a garden with flowering trees, seen through the window; the house in the distance is painted the same bright pink as the interior, and is thereby brought into relation with the rest of the picture. Likewise the blue of the sky, the greens of the foliage, and the bright yellow dots (for flowers) all recur in the foreground. Matisse's "genius of omission" is again at work: by reducing the number of tints to a minimum, he makes of color an independent structural element. It has such importance that *Harmony in Red* would be meaningless in a black-and-white reproduction.

Another member of the *Fauves*, Georges Rouault (1871–1958), would not have used Matisse's definition of "expression." For him this had still to include, as it had in the past, "the passion mirrored upon a human face"; we need only look at his *Head of Christ* (fig. 804). But the expressiveness does not reside only in the "image quality" of the face. The savage slashing strokes of the brush speak equally eloquently of the artist's rage and compassion. (If we cover the upper third of the picture, it is no longer a recognizable image, yet the expressive effect is hardly diminished.) Rouault is the true heir of Van Gogh's and Gauguin's concern for the corrupt state of the world. He, however, hoped for spiritual

Colorplate 104. HENRI DE TOULOUSE-LAUTREC. *At the Moulin Rouge.* 1892. 48³/₈ × 55¹/₄″.
The Art Institute of Chicago (Helen Birch Bartlett Memorial Collection)

Colorplate 105. HENRI ROUSSEAU. *The Dream*. 1910. 6′ 8¹/₂″ × 9′ 9¹/₂″.
The Museum of Modern Art, New York (Gift of Nelson A. Rockefeller)

Colorplate 106. HENRI MATISSE. *Harmony in Red (Red Room)*. 1908–9. 71¼ × 96⅞″. The Hermitage Museum, Leningrad

Colorplate 107. GEORGES ROUAULT. *The Old King*. 1916–37.
30¼ × 21¼″. Carnegie Institute, Pittsburgh

Colorplate 108. CHAIM SOUTINE. *Dead Fowl*. c. 1926. 38¹/₂ × 24¹/₂″.
The Art Institute of Chicago (Joseph Winterbotham Collection)

Colorplate 109. FRANCIS BACON. *Figure with Meat*. 1954. 50³/₄ × 48″.
The Art Institute of Chicago (Harriott A. Fox Fund)

Colorplate 110. EMIL NOLDE. *The Last Supper*. 1909. 32 1/2 × 41 3/4″. Stiftung Seebüll Ada und Emil Nolde, Neukirchen (Schleswig), Germany

Colorplate III. MAX BECKMANN. *Departure*. 1932–35. Center panel 84³/₄ × 45³/₈″, side panels each 84³/₄ × 39¹/₄″. The Museum of Modern Art, New York (Given anonymously, by exchange)

Colorplate 112. WASSILY KANDINSKY. *Sketch I for "Composition VII."*
1913. $30^{3}/_{4} \times 39^{3}/_{8}''$. Collection Felix Klee, Bern

Colorplate 113. PABLO PICASSO. *Three Dancers*. 1925.
84 1/2 × 56 1/4″. The Tate Gallery, London

Colorplate 114. JOSEPH STELLA. *Brooklyn Bridge*. 1917. 84 × 76″.
Yale University Art Gallery, New Haven, Connecticut (Collection of the Société Anonyme)

Colorplate 115. FERNAND LÉGER. *The City*. 1919. 91 × 117½″. The Philadelphia Museum of Art (The A. E. Gallatin Collection)

Colorplate 116. PIET MONDRIAN. *Composition with Red, Blue, and Yellow.*
1930. 20 × 20″. Collection Mr. and Mrs. Armand P. Bartos, New York

Colorplate 117. GIORGIO DE CHIRICO. *Mystery and Melancholy of a Street*. 1914. 33¹/₂ × 27¹/₄″.
Resor Collection, New Canaan, Connecticut

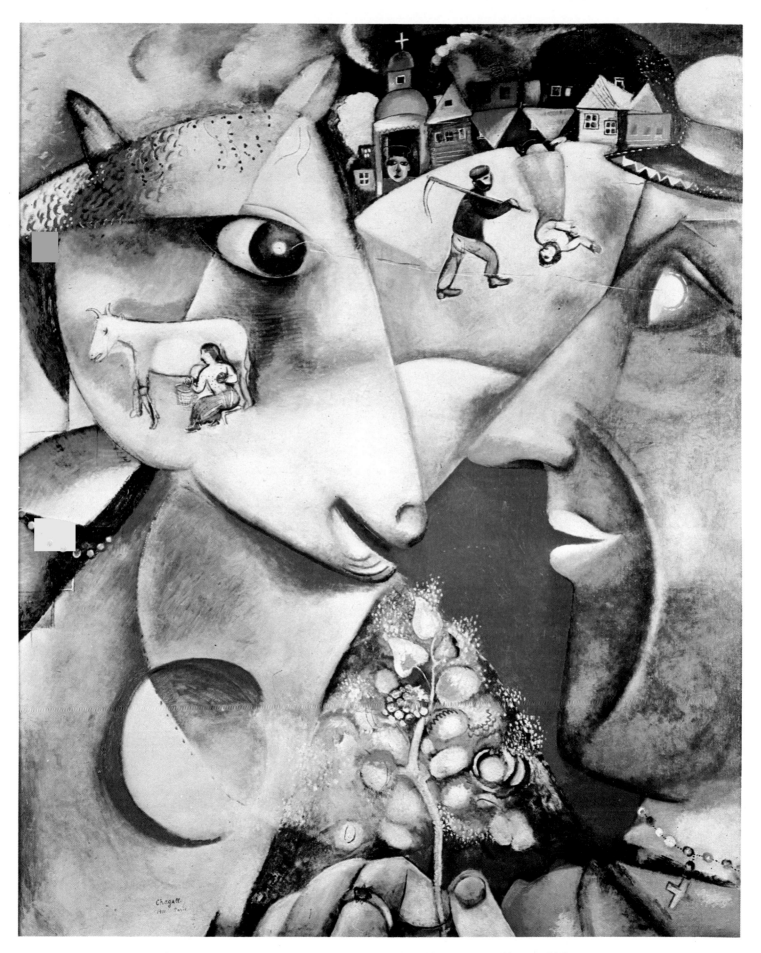

Colorplate 118. MARK CHAGALL. *I and the Village*. 1911. 75¹/₂ × 59¹/₂".
The Museum of Modern Art, New York (Mrs. Simon Guggenheim Fund)

Colorplate 119. PAUL KLEE. *Park near L(ucerne)*. 1938.
39¹/₂ × 27¹/₂″. Klee Foundation, Bern

renewal through a revitalized Catholic faith. His pictures, whatever their subject, are personal statements of that ardent hope. Trained in his youth as a stained-glass worker, he was better prepared than the other *Fauves* to share Gauguin's enthusiasm for medieval art. Rouault's later work, such as *The Old King* (colorplate 107), has glowing colors and compartmented, black-bordered shapes inspired by Gothic stained-glass windows (compare fig. 442). Yet within this framework he retains a good deal of the pictorial freedom we saw in the *Head of Christ*, and the old king's face conveys a mood of resignation and inner suffering that reminds us of Rembrandt and Daumier.

Rouault's expressionism was unique among French painters. The only artist in Paris to follow his lead was Chaim Soutine (1894–1943), an immigrant from Eastern Europe. The rich impasto and the tempestuous, violent brushwork in *The Dead Fowl* (colorplate 108) clearly reflect the older master's influence. Although the picture belongs conventionally to the class of still life, the dead bird is a terrifying symbol of death. As we look at the plucked, creamy-white body, we realize with sudden horror its close resemblance to a human shape. It evokes the earthward plunge of Icarus, or it is, perhaps, a cruelly direct image of Plato's definition of Man as a "featherless biped."

For his power to transmute sheer anguish into visual form, Soutine had no equal among twentieth-century artists unless it be the Englishman Francis Bacon (born 1909). *Figure with Meat* (colorplate 109) reflects Bacon's obsession with Velázquez' *Innocent X* (compare fig. 671), a picture that haunted him for some years. It is, of course, no longer Innocent X we see here but a screaming ghost that is materializing out of a black void in the company of two luminescent sides of beef. The canvas invites comparison with such earlier works as Grünewald's *Crucifixion,* Fuseli's *Nightmare*, Ensor's *Intrigue*, or Munch's *Scream* (see figs. 728, 796, 797), yet none of these really helps us to understand it. Bacon is a compulsive gambler, a taker of risks, in real life as well as in the way he works; he competes with Velázquez here, but on his own terms, which are to set up an almost unbearable tension between the shocking violence of his vision and the luminous beauty of his brushwork. What he seeks are images that, in his own words, "unlock the deeper possibilities of sensation."

Die Brücke

It was in Germany that Fauvism had its most enduring impact, especially among the members of a society called *Die Brücke* (The Bridge), a group of like-minded painters who lived in Dresden in 1905. Their early works, such as Ernst Ludwig Kirchner's *Street* (fig. 805), not only reflect Matisse's simplified, rhythmic line and loud color, but also clearly reveal the direct influence of Van Gogh and Gauguin. *Street* also shows elements derived from Munch

804. GEORGES ROUAULT. *Head of Christ*.
Oil on paper, mounted on canvas. 1905. 45 × 31".
Collection Walter P. Chrysler, Jr., New York

805. ERNST LUDWIG KIRCHNER. *Street*. 1907. 59 1/4 × 78 7/8".
The Museum of Modern Art, New York (Purchase)

(compare fig. 797), who was then living in Berlin and deeply impressed the German Expressionists. One *Brücke* artist, Emil Nolde (1867–1956), stands somewhat apart; older than the rest, he shared Rouault's predilection for religious themes, although he was a far less articulate painter. The thickly encrusted surfaces and deliberately clumsy draughtsmanship of his *Last Supper* (colorplate 110) show that Nolde rejected pictorial refinement in favor of a primeval, direct expression inspired by Gauguin. Ensor's grotesque masks, too, come to mind (see fig. 796), and the mute intensity of Barlach's peasants (see fig. 800). Another artist of highly individual talent, related to the *Brücke* although not a member of it, is the Austrian, Oskar Kokoschka (born 1886). His most memorable works are his portraits painted before the First World War, such as the splendid *Self-Portrait* (fig. 806). Like Van Gogh, Kokoschka sees himself as a visionary, a witness to the truth and reality of his inner experiences (compare fig. 790); the hypersensitive features seem lacerated by a great ordeal of the imagination. It may not be fanciful to find in this tortured psyche an echo of the cultural climate that also produced Sigmund Freud. A more robust descendant of the *Brücke* artists was Max Beckmann (1884–1950), who did not become an Expressionist until after he had experienced the First World War, which left him with a deep despair at the state of modern civilization. *The Dream* (fig. 807) is a mocking nightmare, a tilted, zigzag world crammed with puppet-like figures, as disquieting as those in Bosch's *Hell*

807. MAX BECKMANN. *The Dream*. 1921. 71 × 35".
Collection Morton D. May, St. Louis, Missouri

(see fig. 472). Its symbolism, however, is even more difficult to interpret, since it is necessarily subjective, though no one would deny its evocative power.

How indeed could Beckmann have expressed the chaos in Germany after that war with the worn-out language of traditional symbols? "These are the creatures that haunt my imagination," he seems to say. "They show the true nature of modern man—how weak we are, how helpless against ourselves in this proud era of so-called progress." Many elements from this grotesque and sinister sideshow recur more than a decade later in the lateral panels of Beckmann's triptych, *Departure* (colorplate 111), completed when, under Nazi pressure, he was on the point of leaving his homeland. In the hindsight of today, the topsy-turvy quality of these two scenes, full of mutilations and meaningless rituals, has acquired the force of prophecy. The stable design of the center panel, in contrast, with its expanse of blue sea and its sunlit brightness, conveys the hopeful spirit of an escape to distant shores. After living through the Second World War in occupied Holland, under the most trying conditions, Beckmann spent the final three years of his career in America.

806. OSKAR KOKOSCHKA. *Self-Portrait*. 1913.
32 × 19 ½". The Museum of Modern Art,
New York (Purchase)

Non-objective Painting

But the most daring and original step beyond Fauvism was taken in Germany by a Russian, Wassily Kandinsky (1866–1944), the leading member of a group of Munich artists called *Der Blaue Reiter* (The Blue Horseman). From 1910 on, Kandinsky abandoned representation altogether. Using the rainbow colors and the free, dynamic brushwork of the Paris *Fauves*, he created a completely non-objective style. These works have titles as abstract as their forms; our example, one of the most striking, is called *Sketch I for "Composition VII"* (colorplate 112). Perhaps we should avoid the term "abstract," because it is so often taken to mean that the artist has analyzed and simplified the shapes of visible reality (compare Cézanne's dictum that all natural forms are based on the cone, sphere, and cylinder). This was not the method of Kandinsky. Whatever traces of representation his work contains are quite involuntary—his aim was to charge form and color with a purely spiritual meaning (as he put it) by eliminating all resemblance to the physical world. Whistler, too, had spoken of "divesting the picture from any outside sort of interest"; he even anticipated Kandinsky's "musical" titles (colorplate 99). But it was the liberating influence of the *Fauves* that permitted Kandinsky to put this theory into practice. The possibility was clearly implicit in Fauvism from the start, as shown in our experiment with Rouault's *Head of Christ*: when the upper third of the picture is covered, the rest becomes a non-representational composition strangely similar to Kandinsky's. How valid is the analogy between painting and music? When a painter like Kandinsky carries it through so uncompromisingly, does he really lift his art to another plane? Or could it be that his declared independence from representational images now forces him instead to "represent music," which limits him even more severely? Kandinsky's advocates like to point out that representational painting has a "literary" content, and to deplore such dependence on another art, but they do not explain why the "musical" content of non-objective painting should be more desirable. Is painting less alien to music than to literature? They seem to think music is a higher art than literature or painting because it is inherently non-representational —a point of view with an ancient tradition that goes back to Plato, and includes Plotinus, St. Augustine, and their medieval successors. The attitude of the non-objectivists might thus be termed "secular iconoclasm": they do not condemn images as wicked, but denounce them as non-art. The case is difficult to argue, nor does it matter whether this theory is right or wrong; the proof of the pudding is in the eating, not the recipe. Kandinsky's—or any artist's—ideas are not important to us unless we are convinced of the importance of his pictures. Did he create a viable style? Admittedly, his work demands an intuitive response that may be hard for some of us, yet the painting here reproduced has density and

808. JOSÉ CLEMENTE OROZCO. *Victims* (detail from a mural cycle). 1936. University of Guadalajara, Mexico

vitality, and a radiant freshness of feeling that impresses us even though we are uncertain what exactly the artist has expressed.

Mexico

Americans became familiar with the *Fauves* by exhibitions from 1908 on, and after the First World War there was a growing interest in the German Expressionists as well. American painters, however, were slow to adopt the new movement. During the 1920s and 30s, the center of Expressionism in the New World was Mexico, rather than the United States. The Mexican Revolution began in 1911 with the fall of the dictator Diaz, and continued for more than two decades; it inspired a group of young painters to search for a national style incorporating the great native heritage of pre-Columbian art (figs. 906–8). They also felt that their art must be "of the people," expressing the spirit of the Revolution in vast mural cycles in public buildings. Although each developed his own distinctive style, they shared a common point of

809. PABLO PICASSO.
Les Demoiselles d'Avignon.
1906–7. 96 × 92".
The Museum of Modern Art,
New York (Acquired
through the Lillie P. Bliss
Bequest)

departure: the Symbolist art of Gauguin. This art had shown how non-Western forms could be integrated with the Western tradition, and the flat, decorative quality was moreover particularly suited to murals. The involvement of these artists in the political turmoil of the day often led them to overburden their works with ideological significance. The artist least subject to this imbalance of form and subject matter was José Clemente Orozco (1883–1949), a passionately independent artist who refused to get embroiled in factional politics. Our detail from the mural cycle at the University of Guadalajara (fig. 808) illustrates his most powerful trait, a deep humanitarian sympathy with the silent, suffering masses.

ABSTRACTION

The second of our main currents is the one we called Abstraction. When discussing Kandinsky, we said that the term is usually taken to mean the process (or the result) of analyzing and simplifying observed reality. Literally, it means "to draw away from, to separate." If we have ten apples, and then separate the ten from the

apples, we get an "abstract number," a number that no longer refers to particular things. But "apples," too, is an abstraction, since it places ten apples in one class, without regard for their individual qualities. The artist who sets out to paint ten apples will find no two of them alike, yet he cannot possibly take account of all their differences: even the most painstakingly realistic portrayal of these particular pieces of fruit is bound to be some sort of an abstraction. Abstraction, then, goes into the making of any work of art, whether the artist knows it or not. The process was not conscious and controlled, however, until the Early Renaissance, when artists first analyzed the shapes of nature in terms of mathematical bodies (see page 398). Cézanne and Seurat revitalized this approach and explored it further; they are the direct ancestors of the abstract movement in twentieth-century art. Its real creator, however, was Pablo Picasso.

About 1905, stimulated as much by the *Fauves* as by the retrospective exhibitions of the great Post-Impressionists, Picasso gradually abandoned the melancholy lyricism of his Blue Period for a more robust style. He shared Matisse's enthusiasm for Gauguin and Cézanne, but he

viewed these masters very differently; in 1906–7 he produced his own counterpart to *The Joy of Life*, a monumental canvas so challenging that it outraged even Matisse (fig. 809). The title, *Les Demoiselles d'Avignon* ("The Young Ladies of Avignon"), does not refer to the town of that name, but to Avignon Street in a notorious section of Barcelona; when Picasso started the picture, it was to be a temptation scene in a brothel, but he ended up with a composition of five nudes and a still life. But what nudes! Matisse's generalized figures in *The Joy of Life* (see fig. 803) seem utterly innocuous compared to this savage aggressiveness. The three on the left are angular distortions of classical figures, but the violently dislocated features and bodies of the other two have all the barbaric qualities of primitive art (compare figs. 34–36, 39–42). Following Gauguin's lead, the *Fauves* had discovered the aesthetic appeal of African and Oceanic sculpture, and had introduced Picasso to this material; yet it was he, rather than they, who used primitive art as a battering ram against the classical conception of beauty. Not only the proportions, but the organic integrity and continuity of the human body are denied here, so that the canvas (in the apt description of one critic) "resembles a field of broken glass." Picasso, then, has destroyed a great deal; what has he gained in the process? Once we recover from the initial shock, we begin to see that the destruction is quite methodical: everything—the figures as well as their setting—is broken up into angular wedges or facets; these, we will note, are not flat, but shaded in a way that gives them a certain three-dimensionality. We cannot always be sure whether they are concave or convex; some look like chunks of solidified space, others like fragments of translucent bodies. They constitute a unique kind of matter, which imposes a new integrity and continuity on the entire canvas. The *Demoiselles*, unlike *The Joy of Life*, can no longer be read as an image of the external world; its world is its own, analogous to nature but constructed along different principles. Picasso's revolutionary "building material," compounded of voids and solids, is hard to describe with any precision. The early critics, who saw only the prevalence of sharp edges and angles, dubbed the new style Cubism.

Facet Cubism

That the *Demoiselles* owes anything to Cézanne may at first seem incredible. Nevertheless, Picasso had studied Cézanne's late work (such as fig. 787) with great care, finding in Cézanne's abstract treatment of volume and space the translucent structural units from which to derive the facets of Cubism. The link is clearer in Picasso's portrait of Ambroise Vollard (fig. 810), painted four years later: the facets are now small and precise, more like prisms, and the canvas has the balance and refinement of a fully mature style. Contrasts of color and texture, so pronounced in the *Demoiselles*, are now reduced

to a minimum (the subdued tonality of the picture approaches monochrome), so as not to compete with the design. And the structure has become so complex and systematic that it would seem wholly cerebral if the "imprismed" sitter's face did not emerge with such dramatic force. Of the "barbaric" distortions in the *Demoiselles* there is now no trace; they had served their purpose. Cubism has become an abstract style within the purely Western sense. But its distance from observed reality has not significantly increased—Picasso may be playing an elaborate game of hide-and-seek with nature, but he still needs the visible world to challenge his creative powers. The non-objective realm held no appeal for him, then or later.

Collage Cubism

By 1910, Cubism was well established as an alternative to Fauvism, and Picasso had been joined by a number of other artists, notably Georges Braque (1882–1963), with whom he collaborated so intimately that their work at that time is difficult to tell apart. Both of them—it is not clear to whom the chief credit belongs—initiated the

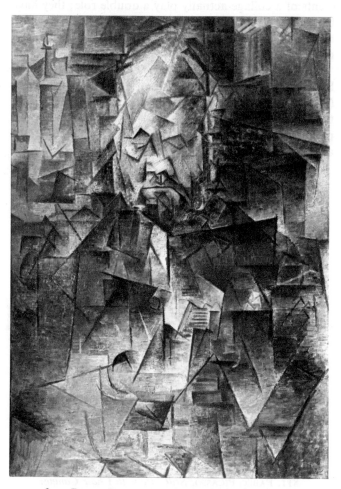

810. PABLO PICASSO. *Ambroise Vollard*. 1909–10.
36 × 25 1/2″. Pushkin Museum, Moscow

next phase of Cubism, which was even bolder than the first. We see its beginnings in Picasso's *Still Life* of 1911–12 (fig. 811). Most of the painting shows the now-familiar facets, except for the letters; these, being already abstract signs, could not be translated into prismatic shapes, but from beneath the still life emerges a piece of imitation chair caning, which has been pasted onto the canvas, and the picture is "framed" by a piece of rope. This intrusion of alien materials has a most remarkable effect: the abstract still life appears to rest on a real surface (the chair caning) as on a tray, and the substantiality of this tray is further emphasized by the rope. Within a year, Picasso and Braque were producing still lifes composed almost entirely of cut and pasted scraps of material, with only a few lines added to complete the design. In one fine example by Braque (fig. 812) we recognize strips of imitation wood graining, part of a tobacco wrapper with a contrasting stamp, half the masthead of a newspaper, and a bit of newsprint made into a playing card (the ace of hearts). The technique came to be known as *collage* (the French word for "paste-up"). Why did Picasso and Braque suddenly prefer the contents of the wastepaper basket to brush and paint? Because, wanting to explore the new concept of the picture-as-a-tray, they found the best way was to put real things on the tray. The ingredients of a collage actually play a double role; they have been shaped and combined, then drawn or painted upon to give them a representational meaning, but they do not lose their original identity as scraps of material, "outsiders" in the world of art. Thus their function is both to *represent* (to be part of an image) and to *present* (to be themselves). In this latter capacity, they endow the collage with a self-sufficiency that no facet-Cubist picture can have. A tray, after all, is a self-contained area, detached from the rest of the physical world; un-

like a painting, it cannot show more than is actually on it. The difference between the two phases of Cubism may also be defined in terms of picture space: facet Cubism retains a certain kind of depth, the painted surface acting as a window through which we still perceive remnants of the familiar perspective space of the Renaissance. Though fragmented and redefined, this space lies behind the picture plane and has no visible limits; potentially, it may contain objects that are hidden from our view. In collage Cubism, on the contrary, the picture space lies in front of the plane of the "tray"; space is not created by illusionistic devices, such as modeling and foreshortening, but by the actual overlapping of layers of pasted materials. When, as in figure 812, the apparent thickness of these materials, and their distance from each other, is increased by a bit of shading here and there, this does not affect the integrity of the non-perspective space. Collage Cubism, then, offers a basically new space concept, the first since Masaccio: it is a true landmark in the history of painting.

Before long Piccaso and Braque discovered that they could retain this new pictorial space without the use of pasted materials; they had only to paint as if they were making collages. Picasso's *Three Musicians* (fig. 813) shows this "cut-paper style" so consistently that we cannot tell from the reproduction whether it is painted or pasted. It is, in any event, one of the great masterpieces of collage Cubism, monumental in size and conception. The separate pieces are fitted together as firmly as architectural blocks, yet the artist's primary concern is not with the surface pattern (if it were, the painting would resemble a patchwork quilt), but with the image of the three musicians, traditional figures of the comedy stage. Their human presence, solemn and even sinister, may be sensed behind the screen of costumes and masks.

811. PABLO PICASSO. *Still Life with Chair Caning.* 1911–12. 10 ½ × 13 ¾″. Collection the artist's estate

812. GEORGES BRAQUE. *Le Courrier.* 1913. Collage, 20 × 22 ½″. The Philadelphia Museum of Art (A. E. Gallatin Collection)

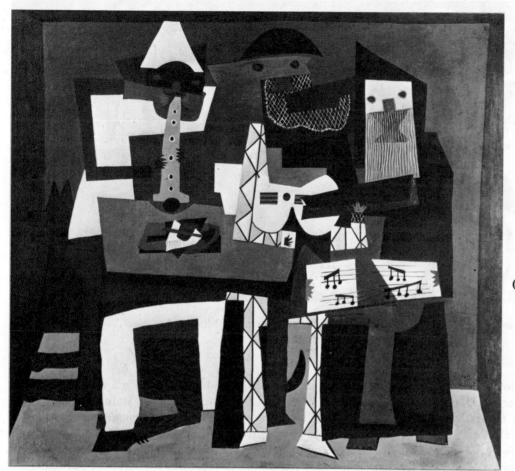

813. PABLO PICASSO.
Three Musicians. 1921.
79 × 87 ³/₄". The Museum of
Modern Art, New York
(Mrs. Simon Guggenheim Fund)

Post-Cubist Picasso

By now, Picasso was internationally famous. Cubism had spread throughout the Western world; it influenced not only other painters, but sculptors and even architects. Picasso himself, however, was already striking out in a new direction. Soon after the invention of collage Cubism, he had begun to do drawings in a painstakingly realistic manner reminiscent of Ingres, and by 1920 he was working simultaneously in two quite separate styles: that of the *Three Musicians,* and a Neoclassic style of strongly modeled, heavy bodied figures such as his *Mother and Child* (fig. 814). To many of his admirers, this seemed a kind of betrayal, but in retrospect the reason for Picasso's double-track performance is clear: chafing under the limitations of collage Cubism, he needed to resume contact with the classical tradition, the "art of the museums." The figures in *Mother and Child* have a mock-monumental quality that suggests colossal statues rather than flesh-and-blood human beings, yet the theme is treated with surprising tenderness. The forms, however, are carefully dovetailed within the frame, not unlike the way the *Three Musicians* is put together. A few years later the two tracks of Picasso's style began to converge, making an extraordinary synthesis that has since become the basis of his art. The *Three Dancers* of 1925 (colorplate 113) shows how he accomplished this seemingly impossible feat. Structurally, the picture is pure collage

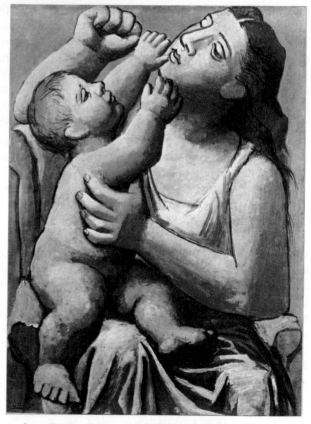

814. PABLO PICASSO. *Mother and Child.* 1921–22.
38 × 28". The Alex L. Hillman Family Foundation,
New York

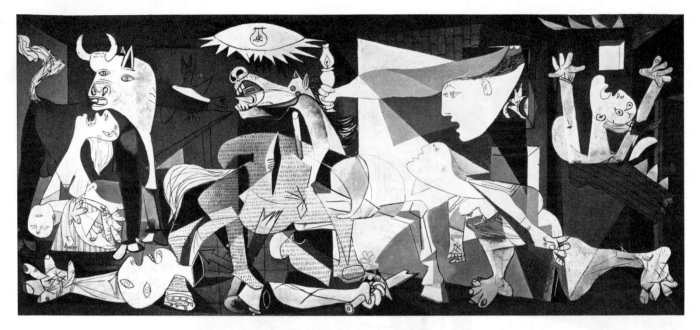

815. PABLO PICASSO. *Guernica*. 1937. 11′ 6″ × 25′ 8″. The Museum of Modern Art, New York
(on indefinite loan from the artist's estate)

Cubism; it even includes painted imitations of specific materials—patterned wallpaper, and samples of various fabrics cut out with pinking shears. But the figures, a wildly fantastic version of a classical scheme (compare the dancers in Matisse's *The Joy of Life*, fig. 803), are an even more violent assault on convention than the figures in the *Demoiselles d'Avignon*. Human anatomy is here simply the raw material for Picasso's incredibly fertile inventiveness; limbs, breasts, and faces are handled with the same sovereign freedom as the fragments of external reality in Braque's *Le Courrier* (fig. 812). Their original identity no longer matters—breasts may turn into eyes, profiles merge with frontal views, shadows become substance, and vice versa, in an endless flow of metamorphoses. They are "visual puns," offering wholly unexpected possibilities of expression—humorous, grotesque, macabre, even tragic. That Picasso's new style may have truly monumental grandeur is evident in his mural, *Guernica* (fig. 815), painted in 1937. As a citizen of a neutral nation, Picasso had been little affected by the First World War, nor did he show any interest in politics during the 1920s. But the Spanish Civil War stirred him to ardent partisanship with the Loyalists. The mural, executed for the Pavilion of the Spanish Republic at the Paris International Exposition, was inspired by the terror-bombing of Guernica, the ancient capital of the Basques in northern Spain. It does not represent the event itself; rather, with a series of powerful images, it evokes the agony of total war. The destruction of Guernica was the first demonstration of the technique of saturation bombing which was later employed on a huge scale in the course of World War II; the mural was thus a prophetic vision of doom—the doom that threatens us even more in this age of nuclear warfare. The symbolism of the scene resists precise interpretation, despite its several traditional elements: the mother and her dead

child are the descendants of the Pietà (see fig. 429), the woman with the lamp recalls the Statue of Liberty, and the dead fighter's hand, still clutching a broken sword, is a familiar emblem of heroic resistance. We also sense the contrast between the menacing, human-headed bull, surely intended to represent the forces of darkness, and the dying horse. These figures owe their terrifying eloquence to what they *are*, not to what they *mean;* the anatomical dislocations, fragmentations and metamorphoses, which in the *Three Dancers* seemed willful and fantastic, now express a stark reality, the reality of unbearable pain. The ultimate test of the validity of collage construction (here in superimposed flat "cutouts" restricted to black, white, and gray) is that it could serve as the vehicle of such overpowering emotions.

Variants of Cubism

As originally conceived by Picasso and Braque, Cubism was a formal discipline of subtle balance applied to traditional subjects—still life, portraiture, the nude. Other painters, however, saw in the new style a special affinity with the geometric precision of engineering that made it uniquely attuned to the dynamism of modern life. The short-lived Futurist movement in Italy exemplifies this attitude; in 1910 its founders issued a manifesto violently rejecting the past, and exalting the beauty of the machine. Their output was more original in sculpture (see fig. 844) than it was in painting. Strong echoes of Futurism appear in *Brooklyn Bridge* (colorplate 114), by the Italo-American Joseph Stella (1880–1946), with its maze of luminescent cables, vigorous diagonal thrusts, and crystalline "cells" of space. Cubism in a dynamized form is also to be seen in the early work of George Grosz (1893–1959), a German painter and graphic artist who had studied in Paris in 1913. At the end of the First

World War, he developed a bitter, savagely satiric style to express the disillusionment of his generation. In *Germany, a Winter's Tale* (fig. 817), the city of Berlin forms a kaleidoscopic—and chaotic—background for several large figures, which are superimposed on it as in a collage: the marionette-like, timid "good citizen" at his table, and the sinister forces that molded him (a hypocritical clergyman, a general, and a schoolmaster). In contrast, *The City* (colorplate 115), by the Frenchman Fernand Léger (1881–1955), is a beautifully controlled industrial landscape that is stable without being static, and reflects the clean geometric shapes of modern machinery. Buoyant with optimism and pleasurable excitement, it conjures up a mechanized utopia. In this instance, the term "abstraction" applies more to the choice of design elements and their manner of combination than to the shapes themselves, since these (except for the two figures on the staircase) are "pre-fabricated" entities.

De Stijl; Mondrian

The most radical abstractionist of our time was, strangely enough, a Dutch painter nine years older than Picasso, Piet Mondrian (1872–1944). He came to Paris in 1912 as a mature Expressionist in the tradition of Van Gogh and the *Fauves*. Under the impact of facet Cubism, his work soon underwent a complete change, as illustrated in *Flowering Trees* (fig. 816). The branches here form a network of dark lines against a background of pinkish and bluish grays compounded of blossoms and sky, which shows a strong tendency to break up into separate cells. The dark lines hold these cells in place as lead frames hold the panes of a stained-glass window. By further simplifying these elements, Mondrian developed within the next decade a completely non-representational style that he called Neo-Plasticism (the movement as a whole is also known as *De Stijl*, after the Dutch magazine advocating his ideas). *Composition with Red, Blue, and Yellow* (colorplate 116) shows Mondrian's style at its most severe: he restricts his design to horizontals and verticals and his colors to the three primary hues, plus black and white. Every possibility of representation is thereby eliminated. Yet Mondrian sometimes gave to his works such titles as *Trafalgar Square*, or *Broadway Boogie-Woogie*, that hint at some degree of relationship, however indirect, with observed reality. Unlike Kandinsky, Mondrian did not strive for pure, lyrical emotion; his goal, he asserted, was "pure reality," and he defined this as equilibrium "through the balance of unequal but equivalent oppositions." Perhaps we can best understand what he meant if we think of his work as "abstract collage" that uses black bands and colored rectangles, instead of recognizable fragments of chair caning and newsprint. He was interested solely in relationships, and wanted no distracting elements or fortuitous associations. But, by establishing the "right" relationship among his

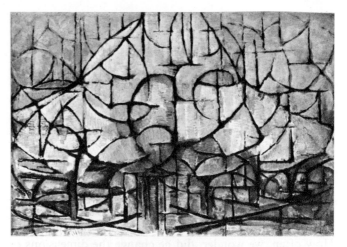

816. PIET MONDRIAN. *Flowering Trees.* 1912. 25 1/2 × 37 3/8". Collection G. J. Nieuwenhuizen Segaar, Nova Spectra Gallery, The Hague

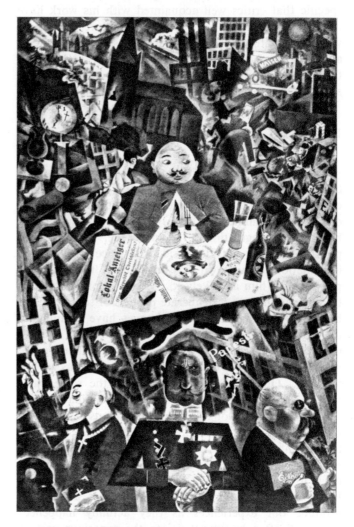

817. GEORGE GROSZ. *Germany, a Winter's Tale.* 1918. Formerly Collection Garvens, Hanover, Germany

bands and rectangles, he transforms them as thoroughly as Braque transformed the snippets of pasted paper in *Le Courrier* (fig. 812). How did he discover the "right" relationship? And how did he determine the shape and number for the bands and rectangles? In

Braque's *Le Courrier*, the ingredients are to some extent "given" by chance; Mondrian, apart from his self-imposed rules, constantly faced the dilemma of unlimited possibilities. He could not change the relationship of the bands to the rectangles without changing the bands and rectangles themselves. When we consider his task, we begin to realize its infinite complexity. Looking again at *Composition with Red, Blue, and Yellow*, we find that when we measure the various units, only the proportions of the canvas itself are truly rational, an exact square; Mondrian has arrived at all the rest "by feel," and must have undergone agonies of trial and error. How often, we wonder, did he change the dimensions of the red rectangle, to bring it and the other elements into self-contained equilibrium? Strange as it may seem, Mondrian's exquisite sense for non-symmetrical balance is so specific that critics well acquainted with his work have no difficulty telling fakes from genuine pictures. Designers who work with non-figurative shapes, such as architects and typographers, are likely to be most sensitive to this quality, and Mondrian has had a greater influence among them than among painters (see the next chapter).

FANTASY

The third current, which we termed Fantasy, follows a course less clear-cut than the other two, since it depends on a state of mind more than on any particular style. The one thing all painters of fantasy have in common is the belief that imagination, "the inner eye," is more important than the outside world. And since every artist's imagination is his own private domain, the images it provides for him are likely to be equally private, unless he subjects them to a deliberate process of selection. But how can such "uncontrolled" images have meaning to the beholder, whose own inner world is not the same as the artist's? Psychoanalysis has taught us that we are not so different from each other in this respect as we like to think. Our minds are all built on the same basic pattern, and the same is true of our imagination and memory. These belong to the unconscious part of the mind where experiences are stored, whether we want to remember them or not. At night, or whenever conscious thought relaxes its vigilance, our experiences come back to us and we seem to live through them again. However, the unconscious mind does not usually reproduce our experiences as they actually happened. They will often be admitted into the conscious part of the mind in the guise of "dream images"—in this form they seem less vivid, and we can live with our memories more easily. This digesting of experience by the unconscious mind is surprisingly alike in all of us, although the process works better with some individuals than with others. Hence we are always interested in imaginary things, provided they are presented to us in such a way that they seem real. What happens in a fairy tale, for

example, would be absurd in the matter-of-fact language of a news report, but when it is told to us as it should be told, we are enchanted. The same thing is true of paintings—we recall *The Dream* by Henri Rousseau (see colorplate 105). But why, we may ask, does private fantasy loom so large in present-day art? We saw the trend beginning at the end of the eighteenth century in the art of Fuseli and Goya (see figs. 728, 743); perhaps they suggest part of the answer. There seem to be several interlocking causes: first, the cleavage that developed between reason and imagination in the wake of rationalism, which tended to dissolve the heritage of myth and legend that had been the common channel of private fantasy in earlier times; second, the artist's greater freedom—and insecurity—within the social fabric, giving him a sense of isolation and favoring an introspective attitude; and, finally, the Romantic cult of emotion that prompted the artist to seek out subjective experience, and to accept its validity. In nineteenth-century painting, private fantasy was still a minor current. After 1900, it became a major one.

Nostalgia: De Chirico; Chagall

The heritage of Romanticism can be seen most clearly in the astonishing pictures painted in Paris just before the First World War by Giorgio de Chirico (born 1888), such as *Mystery and Melancholy of a Street* (colorplate 117). This deserted square with endless diminishing arcades, nocturnally illuminated by the cold full moon, has all the poetry of Romantic reverie. But it has also a strangely sinister air; this is an "ominous" scene in the full sense of that term—everything here suggests an omen, a portent of unknown and disquieting significance. De Chirico himself could not explain the incongruities in these paintings—the empty furniture van, or the girl with the hoop—that trouble and fascinate us. Later, after he had returned to Italy, he adopted a conservative style and repudiated his early work, as if he were embarrassed at having put his dream world on public display. The power of nostalgia, so evident in *Mystery and Melancholy of a Street*, also dominates the fantasies of Marc Chagall (born 1887), a Russian Jew who came to Paris in 1910. *I and the Village* (colorplate 118) is a Cubist fairy tale, weaving dreamlike memories of Russian folk tales, Jewish proverbs, and the look of Russia into one glowing vision. Here, as in many later works, Chagall relives the experiences of his childhood; these were so important to him that his imagination shaped and reshaped them for years without their persistence being diminished.

Klee

The "fairy tales" of the German-Swiss painter Paul Klee (1879–1940) are more purposeful and controlled than Chagall's, although at first they may strike us as more

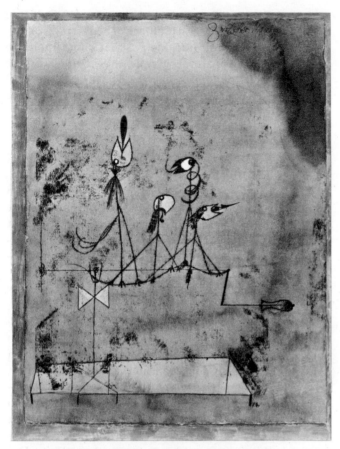

818. PAUL KLEE. *Twittering Machine*. 1922.
Watercolor, pen and ink, 16 ¼ × 12″.
The Museum of Modern Art, New York (Purchase)

819. MARK TOBEY. *1951*. 1951. 43 ¾ × 27 ¾″.
Collection Joseph R. Shapiro, Oak Park, Illinois

childlike. Klee, too, had been influenced by Cubism; but primitive art, and the drawings of small children, held an equally vital interest for him. During the First World War, he molded from these disparate elements a pictorial language of his own, marvelously economical and precise. *Twittering Machine* (fig. 818), a delicate pen drawing tinted with watercolor, demonstrates the unique flavor of Klee's art: with a few simple lines, he had created a ghostly mechanism that imitates the sound of birds, simultaneously mocking our faith in the miracles of the machine age and our sentimental appreciation of bird song. The little contraption (which is not without its sinister aspect: the heads of the four sham birds look like fishermen's lures, as if they might entrap real birds) thus condenses into one striking invention a complex of ideas about present-day civilization. The title has an indispensable role; it is characteristic of the way Klee works that the picture itself, however visually appealing, does not reveal its full evocative quality unless the artist tells us what it means. The title, in turn, needs the picture—the witty concept of a twittering machine does not kindle our imagination until we are shown such a thing. This interdependence is familiar to us from cartoons; Klee lifts it to the level of high art without relinquishing the playful

character of these verbal-visual puns. To him art was a "language of signs," of shapes that are images of ideas as the shape of a letter is the image of a specific sound, or an arrow the image of the command, "This way only." But he also realized that in any conventional system the sign is no more than a "trigger"; the instant we perceive it, we automatically invest it with its meaning, without stopping to ponder its shape. Klee wanted *his* signs to impinge upon our awareness as visual facts, yet also to share the quality of "triggers." Toward the end of his life, he immersed himself in the study of ideographs of all kinds, such as hieroglyphics, hex signs, and the mysterious markings in prehistoric caves—"boiled-down" representational images that appealed to him because they had the twin quality he strove for in his own graphic language. This "ideographic style" is very pronounced in colorplate 119, *Park near L(ucerne)*, which makes a fascinating comparison with Mondrian's *Flowering Trees* (see fig. 816); as a lyric poet may use the plainest words, these deceptively simple shapes sum up a wealth of experience and sensation: the innocent gaiety of spring, the clipped orderliness peculiar to captive plant life in a park. Has it not also a relationship, in spirit if not in fact, with the Romanesque *Spring Landscape* in the manu-

820. MARCEL DUCHAMP. *Nude Descending a Staircase, No. 2.* 1912.
58 × 35″. The Philadelphia Museum of Art
(Louise and Walter Arensberg Collection)

821. MARCEL DUCHAMP. *The Bride.* 1912.
34 ³/₄ × 21 ¹/₂″. The Philadelphia Museum of Art
(Louise and Walter Arensberg Collection)

script of *Carmina Burana* (see colorplate 36)? Only one other painter, the American Mark Tobey (1890–1976), developed a "picture-writing" style comparable to Klee's. His personal ideographs, however, have the fluent character of Chinese calligraphy. In *1951* (fig. 819) these "signs" are suspended in space, like constellations seen against the night sky.

Duchamp; Dada

In Paris on the eve of the First World War, we encounter yet another painter of fantasy, the Frenchman Marcel Duchamp (1887–1968). After basing his early style on Cézanne, he initiated a dynamic version of facet Cubism, similar to Futurism, by superimposing successive phases of movement on each other, as in multiple-exposure photography. (His *Nude Descending a Staircase*, done in this vein, caused a scandal at the Armory Show of modern art in New York in 1913; fig. 820). Very soon, however, Duchamp's development took on a far more disturbing turn. In *The Bride* (fig. 821) we will look in vain for any resemblance, however remote, to the human form; what we see is a mechanism that seems part motor, part distilling apparatus; the antithesis of Klee's twittering machine, it is beautifully engineered to serve no purpose whatever. Its title, which cannot be irrelevant (Duchamp, by lettering it right onto the canvas, has emphasized its importance), causes us real perplexity. Did he intend to satirize the scientific outlook on man, by "analyzing" the bride until she is reduced to a complicated piece of plumbing? If so, the picture may be the negative counterpart of the glorification of the machine, so stridently proclaimed by the Futurists.

It is hardly surprising that the mechanized mass killing of the First World War should have driven Duchamp to despair. Together with a number of others who shared his attitude, he launched in protest a movement called Dada (or Dadaism). The term, meaning "hobbyhorse" in French, was reportedly picked at random from a dictionary, but as an infantile "all-purpose word," it perfectly fitted the spirit of the movement. Dada has often been called nihilistic, and its declared purpose was indeed to make clear to the public at large that all established values, moral or aesthetic, had been rendered meaningless by the catastrophe of the great war. During its short life (c. 1916–22) Dada preached non-sense and anti-art with a vengeance; Duchamp would put his signature, and a provocative title, on ready-made objects such as bottle racks and snow shovels, and exhibit them as works of art; once he "improved" a reproduction of Leonardo's *Mona Lisa* with a mustache and the letters LHOOQ, which, when pronounced in French, make an off-color pun. Not even modern art was safe from the Dadaists' assaults; one of them exhibited a toy monkey inside a frame, entitled "Portrait of Cézanne." On the other hand, they adopted the technique of collage Cubism for their own purposes: figure 822, by the German Dadaist Max Ernst (1891–1976),

822. MAX ERNST. *1 Copper Plate 1 Zinc Plate*
1 Rubber Cloth 2 Calipers 1 Drainpipe Telescope
1 Piping Man. 1920. Collage, 12 × 9″.
Estate of Hans Arp

823. HANS (JEAN) ARP. *Collage with Squares*
Arranged According to the Laws of Chance. 1916–17.
Collage of colored papers, 19 1/8 × 13 5/8″.
The Museum of Modern Art, New York (Purchase)

an associate of Duchamp, is largely composed of snippets from illustrations of machinery. The caption pretends to enumerate these mechanical ingredients, which include (or add up to?) "1 Piping Man." Actually there is also a "piping woman." These offspring of Duchamp's prewar *Bride* stare at us blindly through their goggles.

Yet Dada was not a completely negative movement. In its calculated irrationality there was also liberation, a voyage into unknown provinces of the creative mind. The only law respected by the Dadaists was that of chance, and the only reality, that of their own imaginations. Thus Hans Arp (1887–1966), another early member of the movement, invented a new kind of collage (fig. 823) whose elements—colored pieces of paper that had been shaped by tearing rather than by cutting—were arranged "according to the laws of chance." Arp started these compositions by dropping the bits of paper on a larger sheet, and then cautiously adjusted this "natural" configuration. The artist's task, he believed, was to "court the Muse of Chance," eliciting from her what he called "organic concretions" (he disliked the term "abstraction," which implies discipline and conscious purpose, not reliance on the happy accident). Playfulness and spontaneity are also the impulses behind Duchamp's Ready-Mades, which the artist created simply by shifting

their context from the utilitarian to the aesthetic. They are certainly extreme demonstrations of a principle. But the principle itself—that artistic creation depends neither on established rules nor on manual craftsmanship—is an important discovery, as we recall from our discussion of Picasso's *Bull's Head* in the Introduction (see fig. 1).

Duchamp himself, having made this point, soon withdrew from all artistic activity. Whatever his reason, it certainly was not a lack of ideas. His last major work, a huge canvas with the nonsense title *Tu m'* (fig. 824), was so dazzlingly inventive, so far ahead of its time, that we can judge its full importance only now, more than half a century later. The picture combines—and somehow manages to reconcile—the most varied and contradictory kinds of reality: the background is delicately shaded to suggest empty space, an illusion reinforced by the series of overlapping lozenge-shaped color samples receding toward the upper left-hand corner and by the realistic sign-painter's hand near the center; yet this "space" is also a flat screen on which we see the cast shadows of a bicycle wheel, a corkscrew, and a hat rack. The canvas even has a tear in it, held together with safety pins. But the tear is an imitation—it is only painted—while the pins are

824. MARCEL DUCHAMP. *Tu m'*. 1918. Oil and graphite on canvas, with bottle-brush, safety pins, nut and bolt; 27 1/2 × 122 3/4". Yale University Art Gallery, New Haven, Connecticut (Katherine S. Dreier Bequest)

real. Next to them is a painted white bottle, with a real bottle-brush protruding from it. The two sets of wavy lines—the only element of symmetry in the design—are derived from an experiment akin to Arp's exploration of the laws of chance; Duchamp had repeatedly dropped pieces of string and recorded the exact shape of the curves they made on the floor. This improbable mixture anticipates most of the devices we shall meet in the Pop and Op Art of the 1960s. The idea of a painting with objects that stick out from the picture plane into the spectator's space was, astonishingly enough, suggested as early as 1844 by Grandville, a French Romantic illustrator who boasted a uniquely original and whimsical imagination. In a drawing that pretends to show the official annual art exhibition at the Louvre (fig. 825), he

included, on the left wall, a still life with three-dimensional fruit so real that birds are pecking at it (an all-too-literal version of the ancient Greek story about Apelles, who could paint grapes so realistically that they deceived the birds); across the aisle a battle scene bursts out of its frame in similar fashion, with horses' legs, weapons, and parts of soldiers menacing the beholder. Could Duchamp have been inspired by this drawing? Maybe he knew it and the book in which it appears, for a few years later his fellow Dadaist Max Ernst rediscovered Grandville, acclaiming him as one of his artistic progenitors.

SURREALISM

In 1924, after Duchamp's retirement, a group of his fellow "chance-takers" founded Dada's successor, Surrealism. They defined their aim as "pure psychic automatism . . . intended to express . . . the true process of thought . . . free from the exercise of reason and from any aesthetic or moral purpose." Surrealist theory was heavily larded with concepts borrowed from psychoanalysis, and its overwrought rhetoric is not always to be taken seriously. The notion that a dream can be transposed directly from the unconscious mind to the canvas, by-passing the conscious awareness of the artist, did not work in practice: some degree of control was simply unavoidable. Nevertheless, Surrealism stimulated several novel techniques for soliciting and exploiting chance effects. Max Ernst, the most inventive member of the group, often combined collage with "frottage" (rubbings from pieces of wood, pressed flowers, and other relief surfaces—the process we all know from the children's pastime of rubbing with a pencil on a piece of paper covering a coin). In *Swamp Angel* (fig. 826) he has obtained fascinating shapes and textures by "decalcomania" (the transfer, by pressure, of oil paint to the canvas from some other surface). This procedure is in essence another variant of those recommended by Alexander Cozens and Leonardo da Vinci (see fig. 731), and Ernst has certainly found, and elaborated upon, an extraordinary wealth of images among his stains. The end result does

825. GRANDVILLE. *A View of the Paris Salon of this year and all past and future years*, from *Un autre monde*. 1844. Wood engraving, 5 1/4 × 5 1/8".

have some of the qualities of a dream, but it is a dream born of a strikingly Romantic imagination. The drawing by Salvador Dali (born 1904) reproduced in figure 827 comes even closer to Cozens' ink-blot method: here it yields a landscape with figures that Dali could hardly have "dreamed" without already knowing the Odyssey Landscapes of Roman art (see colorplate 17).

Surrealism, however, has a more boldly imaginative branch: some works by Picasso, such as *Three Dancers* (see colorplate 113), have affinities with it, and its greatest exponent is also Spanish, Joan Miró (born 1893), who painted the striking *Composition* (colorplate 120). His style has been labeled "biomorphic abstraction," since his designs are fluid and curvilinear rather than geometric. Actually, "biomorphic concretion" might be a more suitable name, for the shapes in Miró's pictures have their own vigorous life. They seem to change before our eyes, expanding and contracting like amoebas until they approach human individuality closely enough to please the artist. Their spontaneous "becoming" is the very opposite of abstraction as we defined it above (see page 652), although Miró's formal discipline is no less rigorous than that of Cubism (he began as a Cubist).

SINCE WORLD WAR II

Equally misleading is the term Abstract Expressionism, which is often applied to the style of painting that prevailed for about a dozen years following the end of World War II. Arshile Gorky (1904–48), an Armenian who came to America at sixteen, was the pioneer of the movement and the single most important influence on its other members. It took him twenty years—painting first in the vein of Cézanne, then in that of Picasso—to arrive at his mature style as we see it in *The Liver Is the Cock's Comb* (colorplate 121). The enigmatic title suggests Gorky's close contact with André Breton, the Surrealist poet who found refuge in New York during the war, as well as his own experience in camouflage, gained from a class he conducted earlier. Everything here is in the process of turning into something else. The biomorphic shapes clearly owe much to Miró, while their spontaneous handling and the glowing color reflect Gorky's enthusiasm for Kandinsky (see colorplates 112, 120). Yet the dynamic interlocking of the forms, their aggressive power of attraction and repulsion, are uniquely his own.

Action Painting

Had Gorky lived into the 1950s, he would surely have been the leading figure among the Abstract Expressionists. His principal heir proved to be Jackson Pollock (1912–56), who in 1950 did the huge and original picture entitled *One* (fig. 828) mainly by pouring and spattering his colors, instead of applying them with the brush. The result, especially when viewed at close range (colorplate 122), suggests both Kandinsky and Max Ernst

826. MAX ERNST. *Swamp Angel.* 1940. 26 1/2 × 32 1/2″. Collection Kenneth MacPherson, Rome

827. SALVADOR DALI. *Return of Ulysses.* 1936. Ink blots, brush, and pen drawing, 9 3/8 × 14 1/2″. Private Collection, New York

(compare colorplate 112, fig. 826). Kandinsky's non-representational Expressionism, and the Surrealists' exploitation of chance effects, are indeed the main sources of Pollock's work, but they do not sufficiently account for his revolutionary technique and the emotional appeal of his art. Why did Pollock "fling a pot of paint in the public's face" (as Ruskin had accused Whistler of doing)? Not, surely, to be more abstract than his predecessors, for the strict control implied by abstraction is exactly what Pollock relinquished when he began to dribble and spatter. A more plausible explanation is that he came to regard paint itself, not as a passive substance to be manipulated at will, but as a storehouse of pent-up forces for him to release. The actual shapes visible in our colorplate are largely determined by the internal dynamics of his material and his process: the viscosity of the paint,

828. JACKSON POLLOCK. *One (# 31, 1950)*. 1950. 8′ 10″ × 17′ 5 5/8″ (see detail, colorplate 122).
The Museum of Modern Art, New York (Gift of Sidney Janis)

the speed and direction of its impact upon the canvas, its interaction with other layers of pigment. The result is a surface so alive, so sensuously rich, that all earlier painting looks pallid in comparison. But when he releases the forces within the paint by giving it a momentum of its own—or, if you will, by "aiming" it at the canvas instead of "carrying" it on the tip of his brush—Pollock does not simply "let go" and leave the rest to chance. He is himself the ultimate source of energy for these forces, and he "rides" them as a cowboy might ride a wild horse, in a frenzy of psychophysical action. He does not always stay in the saddle, yet the exhilaration of this contest, that strains every fiber of his being, is well worth the risk. Our simile, though crude, points up the main difference between Pollock and his predecessors: his total commitment to the *act* of painting. Hence his preference for huge canvases that provide a "field of combat" large enough for him to paint not merely with his arms, but with the motion of his whole body. Action Painting, the term coined some years ago for this style, conveys its essence far better than does Abstract Expressionism. To those who complain that Pollock is not sufficiently in control of his medium, we reply that this loss is more than offset by a gain—the new continuity and expansiveness of the creative process that gives his work its distinctive mid-twentieth-century stamp.

Pollock's drip technique, however, was not in itself essential to Action Painting. Willem de Kooning (born 1904), another prominent member of the group and a close friend of Gorky, never abandoned the brush although he is unmistakably an Action Painter. Whether or not De Kooning's work has a recognizable subject,

it always retains a link with the world of images. In some paintings, such as *Woman II* (colorplate 123), the image emerges from the jagged welter of brush strokes as insistently as it does in Rouault's *Head of Christ* (see fig. 804). What De Kooning has in common with Pollock is the furious energy of the process of painting, the sense of risk, of a challenge successfully—but barely—met. Mark Rothko (1903–73) presents a challenge of the opposite kind. In the mid-1940s he too had worked in a style derived from Gorky, yet within less than a decade he subdued the aggressiveness of Action Painting so completely that his pictures breathe the purest contemplative stillness. *Earth and Green* (colorplate 124) consists of two rectangles with blurred edges—one dark red, the other green—on a purplish blue ground; the canvas is very large, over seven and one-half feet tall, and the thin washes of paint permit the texture of the cloth to be seen throughout. But to use such bare factual terms to describe what we see hardly touches the essence of the work, or the reasons for its mysterious power to move us. These are to be found in the delicate equilibrium of the two shapes, their strange interdependence, the subtle variations of hue (note how the dark blue "halo" around the upper rectangle seems to immerse it in the blue ground, while the green rectangle stands out more assertively in front of the blue). Not every beholder responds to the works of this withdrawn, introspective artist; for those who do, the experience is akin to a trancelike rapture.

Action Painting marked the international coming-of-age for American art. The movement had a power-

Colorplate 120. JOAN MIRÓ. *Composition.* 1933. $51^{1}/_{4} \times 63^{1}/_{2}''$. Wadsworth Atheneum, Hartford, Connecticut

Colorplate 121. ARSHILE GORKY. *The Liver Is the Cock's Comb.* 1944. 72 × 98″. The Albright-Knox Art Gallery, Buffalo (Gift of Seymour H. Knox)

Colorplate 122. JACKSON POLLOCK. Detail of *One* (*#31, 1950*). 1950. The Museum of Modern Art, New York (Gift of Sidney Janis) (see figure 828)

Colorplate 123. WILLEM DE KOONING. *Woman II*. 1952. 59 × 43″.
The Museum of Modern Art, New York (Gift of Mrs. John D. Rockefeller, III)

Colorplate 124. MARK ROTHKO. *Earth and Green*. 1955. 90$^1/_4$ × 73$^1/_2''$.
Collection Gallery Beyeler, Basel

Colorplate 125. JEAN DUBUFFET, *Natural History*. 1951. 57 × 45″.
Collection Mr. and Mrs. Ralph F. Colin, New York

Colorplate 126. MORRIS LOUIS. *Beth Feh.* 1958. Acrylic on canvas, 7′ 6″ × 10′ 8″. Collection Andrew Crispo, New York

Colorplate 127. Paul Jenkins. *Phenomena Astral Signal.* 1964. Acrylic on canvas, 9′ 8″ × 6′ 8″.
Collection Mr. and Mrs. Harry W. Anderson, New York (Courtesy of the Martha Jackson Gallery, New York)

ful impact on European art, which in those years had nothing to show of comparable force and conviction. One French artist, however, was of such prodigal originality as to constitute a movement all by himself: Jean Dubuffet (born 1901), whose first exhibition soon after the Liberation electrified—and antagonized —the art world of Paris. As a young man Dubuffet had formal instruction in painting, but he responded to none of the various trends he saw around him nor to the art of the museums; all struck him as divorced from real life, and he turned to other pursuits. Only in middle age did he experience the breakthrough that permitted him to discover his creative gifts: he suddenly realized that for him true art had to come from outside the ideas and traditions of the artistic elite, and he found inspiration in the art of children and of the insane. The distinction between "normal" and "abnormal" struck him as no more tenable than established notions of "beauty" and "ugliness." Not since Marcel Duchamp (see pages 660–62) had anyone ventured so radical a critique of the nature of art. Dubuffet made himself the champion of what he called *l'art brut,* "art-in-the-raw," but he created something of a paradox besides: while extolling the directness and spontaneity of the amateur as against the refinement of professional artists, he became a professional artist himself. Duchamp's questioning of established values had led him to cease artistic activity altogether, but Dubuffet became incredibly prolific, second only to Picasso in output. Compared with Paul Klee, who had first utilized the style of children's drawings (see page 658), Dubuffet's art is "raw" indeed; its stark immediacy, its explosive, defiant presence, are the opposite of the older painter's formal discipline and economy of means. Did Dubuffet perhaps fall into a trap of his own making? If his work merely imitated the *art brut* of children and the insane, would not these self-chosen conventions limit him as much as those of the artistic elite? We may be tempted to think so at our first sight of *Le Metafisyx* (fig. 829) from his *Corps de Dame* series—even De Kooning's wildly distorted *Woman II* (colorplate 123) seems gentle when matched against this shocking assault on our inherited sensibilities. The paint is as heavy and opaque as a rough coating of plaster, and the lines articulating the blocklike body are scratched into this surface like graffiti made by an untrained hand. But appearances can deceive; the fury and concentration of Dubuffet's attack should convince us that his demonic female is not "something any child can do." In an eloquent statement the artist has explained the purpose of images such as this: "The female body . . . has long been associated with a very specious notion of beauty . . . which I find miserable and most depressing. Surely I am for beauty, but not that one. . . . I intend to sweep away everything we have been taught to consider—without question—as grace and beauty [and to] substitute another and vaster beauty, touching all

829. JEAN DUBUFFET. *Le Metafisyx (Corps de Dame).* 1950. 45 ³/₄ × 35 ¹/₄″. Collection Mr. and Mrs. Arnold Maremont, Winnetka, Illinois

objects and beings, not excluding the most despised. . . . I would like people to look at my work as an enterprise for the rehabilitation of scorned values, and . . . a work of ardent celebration." In *Natural History* the woman's flattened body has become a table (colorplate 125), the parts of her anatomy clumps of earth or stones. But these have a rich and mysterious life of their own. The plaster-like surface of the earlier picture has given way to a differentiated relief effect; Dubuffet has used various thick pastes that respond in strange and surprising ways to the application of oil colors. Here, more easily than in his female nude (fig. 829), we sense the artist's successful search for "another and vaster beauty."

After the mid-1950s, Action Painting gradually lost its dominant position, but its force was far from spent. A number of artists who had been in the movement transformed it into a style called color-field painting, in which the canvas is stained with thin, translucent color washes. Among the most gifted of these was Morris Louis (1912– 62). The successive veils of color in his *Beth Feh* (colorplate 126; the title is composed of two Hebrew letters) appear to have been "floated on" without visible marks of the brush, mysteriously beautiful like the aurora bore-

alis. It is their harmonious interaction, their delicately shifting balance, that gives the picture enduring appeal. Younger artists such as Paul Jenkins (born 1923) have developed distinctive variations on the theme of color-field painting. In *Phenomena* (colorplate 127) the liquid medium has been made to flow in currents of varying speed and density. The resulting veils of color may be gossamer-thin or they may have the rich depth of stained glass. No spattering, no dribbling betrays the painter's "action"; the forces that give rise to these shapes seem to be of the same kind as those governing the cloud formations in a wind-swept sky and the pattern of veins in a leaf.

Many artists who came to maturity in the 1950s, however, turned away from Action Painting altogether. The brilliant and precocious Frank Stella (born 1936), having conceived an early enthusiasm for Mondrian, soon evolved a non-figurative style that was even more self-contained; unlike Mondrian (see page 657 and colorplate 116), Stella did not concern himself with the vertical-horizontal balance which relates the older artist's work to the world of nature. Logically enough, he also abandoned the traditional rectangular format, so as to make quite sure that his pictures bore no resemblance to windows. The shape of the canvas now became an integral part of the design (fig. 830). In one of his largest works, the majestic *Empress of India* (colorplate 128), this shape is determined by the thrust and counterthrust of four huge chevrons, identical in size and shape but sharply differentiated in color and in their relationship to the whole. The paint, moreover, contains powdered metal which gives it an iridescent sheen—yet another way to stress the impersonal precision of the surfaces and to remove the work from any comparison with the "hand-made" look of easel pictures. In fact, to speak of *Empress of India* as a picture seems decidedly awkward. It demands to be called an object, sufficient unto itself.

Other artists who made a name for themselves in the

830. Installation view of Frank Stella exhibition at Leo Castelli Gallery, New York, 1962

mid-1950s rediscovered what the layman continued to take for granted despite all efforts to persuade him otherwise: that a picture is not "essentially a flat surface covered with colors" (as Maurice Denis had insisted) but an image wanting to be recognized. If art was by its very nature representational, then the modern movement, from Manet to Pollock, was based on a fallacy, no matter how impressive its achievements. Could it be that painting had been on a kind of voluntary starvation diet for the past hundred years, feeding upon itself rather than on the world around us? Wasn't it time to give in to the "image-hunger" thus built up—a hunger from which the public at large had never suffered, since its demand for images was abundantly supplied by photography, advertising, magazine illustrations, and comic strips? The artists who felt this way seized upon these products of commercial art catering to "low-brow," popular taste. Here, they realized, was an essential aspect of our present-day visual environment that had been entirely disregarded as vulgar and anti-aesthetic by the representatives of "high-brow" culture, and cried out to be examined. Only Marcel Duchamp and some of his fellow Dadaists, with their contempt for all orthodox opinion, had dared to penetrate this realm (see page 660). It was they who now became the patron saints of "Pop Art," as the new movement came to be called.

Pop Art

Pop Art actually began in London in the mid-1950s, but from the very start its imagery was largely based on American mass media, which had been flooding England ever since the end of World War II. It is not surprising, therefore, that the new art had a special appeal for America, and that it reached its fullest development here during the following decade. Unlike Dada, Pop is not motivated by despair or disgust at present-day civilization; it views commercial culture as its raw material, an endless source of pictorial subject matter, rather than as an evil to be attacked. Nor does Pop share Dada's aggressive attitude toward the established values of modern art. It is not "anti-modern," then, but "post-modern." Pop Art in America could also draw upon the tradition of the "Ash Can School," a group of painters concerned with the everyday urban scene. The school flourished in the years just before the First World War but was soon eclipsed by the rush toward a more radical modernism; it got its name because the artists were fascinated with the teeming life of the slums. One of them, however, Edward Hopper (1882–1967), focused on what has since become known as the "vernacular architecture" of American cities—store fronts, movie houses, all-night diners—which no one else had thought worthy of an artist's attention. *Early Sunday Morning* (colorplate 129) distills a haunting sense of loneliness from the all-too-familiar elements of an ordinary street. Its quietness,

831. The Great Uncle and Cousins of Larry Rivers in Poland. c. 1928. Photograph (compare colorplate 130)

we realize, is temporary; there is hidden life behind these façades. We almost expect to see one of the window shades raised as we look at them. But apart from its poetic appeal, the picture also shows an impressive formal discipline: we note the strategy in placing the fireplug and barber pole, the subtle variation in the treatment of the row of windows, the precisely calculated slant of sunlight, the delicate balance of verticals and horizontals. Obviously, Hopper was not unaware of Mondrian.

The transition from Action Painting to Pop in the mid-1950s may be seen in *Europe II* (colorplate 130) by Larry Rivers (born 1923). With its energetic gestures of the brush, its boldly abbreviated shapes, it still speaks a language akin to that of De Kooning. At the same time, however, we sense that the picture is *about* something, that it has been built on an older image which keeps asserting itself underneath. In this instance we happen to to know the image: a photograph taken of members of the artist's family in Poland a generation earlier (fig. 831). Even if we did not, we would recognize its kind, for such frontal, stiffly posed pictures have been made ever since photography was invented, and form part of everyone's

832. ROBERT INDIANA. *The Demuth Five.* 1963. 68″ on each side. Collection Mr. and Mrs. Robert C. Scull, New York

833. ROBERT INDIANA. *Love.* 1966. Aluminum, 12 × 12 × 6″ (edition of 6)

family album. Rivers has taken this visual commonplace seriously; he is moved by its solemn air commemorating some special occasion, now long forgotten, that momentarily brought these people together. In his painting the group has begun to dissolve, the divergent personalities to regain their separateness; the family icon is about to fall apart. Yet it remains a meaningful whole, a shared experience made new by the painter's intense scrutiny of it.

Among the pioneers of Pop Art in America perhaps the most important is Jasper Johns (born 1930), who began by painting, meticulously and with great precision, such familiar objects as flags, targets, numerals, and maps. His *Three Flags* (colorplate 131) presents an intriguing problem: just what is the difference between image and reality? We instantly recognize the Stars and Stripes, but if we try to define what we actually see here, we find that the answer eludes us. These flags behave "unnaturally"—instead of waving or flopping they stand at attention, as it were, rigidly aligned with each other in a kind of reverse perspective. Yet there is movement of another sort: the reds, whites, and blues are not areas of solid color but subtly modulated. Can we really say, then, that this is an image of three flags? Clearly, no such flags can exist anywhere except in the artist's head. And we begin to marvel at the picture as a feat of the imagination—probably the last thing we expected to do when we first looked at it.

Revolutionary though it was, Johns' use of flags, numerals, and similar elements as pictorial themes had to some extent been anticipated thirty years before by another American painter, Charles Demuth (1883–

1935), in such pictures as *I Saw the Figure 5 in Gold* (colorplate 132). The title is taken from a poem by William Carlos Williams, whose name—as "Bill," "Carlos," and "W. C. W."—also forms part of the design. In the poem the figure 5 appears on a red firetruck, while in the painting it has become the dominant feature, thrice repeated to reinforce its persistence in our memory as the firetruck rushes on through the night. Demuth's treatment of the background recalls the Futurism of Joseph Stella (colorplate 114). That *I Saw the Figure 5 in Gold* was an ancestor of Pop is attested by Robert Indiana (born 1928), who paid homage to it in *The Demuth Five* (fig. 832). Here, however, the format has been changed to that of a highway sign connoting danger; the numerals have been superimposed on a five-pointed star suggestive of a sheriff's badge; and the pentagonal field behind the star (a reference to the Pentagon in Washington?) carries five "commands" in big stenciled letters—an indictment of American society in capsule form. Such bitter messages are rare in Pop. Indiana has devised a uniquely effective pictorial code for conveying them. Obsessed with word images, he even gives them three-dimensional shape: *Love* (fig. 833), in gleaming aluminum, is a tribute not only to his formal precision but to his faith in the power of what must be the most abused word in present-day English.

Roy Lichtenstein (born 1923), in contrast, has seized upon comic strips—or, more precisely, upon the standardized imagery of the traditional strips devoted to violent action and sentimental love, rather than those bearing the stamp of an individual creator. His paint-

ings, such as *Girl at Piano* (fig. 834, colorplate 133), are greatly enlarged copies of single frames, including the balloons, the impersonal, simplified black outlines, and the dots used for printing colors on cheap paper. These pictures are perhaps the most paradoxical in the entire field of Pop Art: unlike any other paintings past or present, they cannot be reproduced on the pages of this book, for they then become indistinguishable from the comic strip on which they are based. Only a full-size detail in color enables us to see what the artist has accomplished. Enlarging a design meant for an area about six square inches to one no less than 3264 square inches must have given rise to a host of formal problems that could be solved only by the most intense scrutiny: how, for example, to draw the girl's nose so it would look "right" in comic-strip terms, or how to space the colored dots so they would have the proper weight in relation to the outlines. Clearly, our picture is not a mechanical copy, but an interpretation which remains faithful to the spirit of the original only because of the countless changes and adjustments of detail the artist has introduced. What fascinates Lichtenstein about comic strips—and what he makes us see for the first time—are the rigid conventions of their style, as firmly set and as remote from life as those of Byzantine art. How is it possible for images of this sort to be so instantly communicable? Why are they so "real" to millions of people? In recent years he has applied the same technique to other kinds of images, reinterpreting paintings by Picasso and Mondrian, and even Abstract Expressionist works, in terms of the formal conventions of comic strips. Perhaps these experiments, often astonishingly effective, point the way to an eventual reconciliation between Pop and the classics of modern art.

Environments

Although Pop Art is sometimes referred to as "the new realism," the term hardly seems to fit the painters we have discussed. They are, to be sure, sharply observant of their sources; but the material chosen—flags, numerals, lettering, signs, badges, comic strips—is itself rather abstract. Other artists associated with Pop have a less narrowly selective attitude, and some embrace in their work the entire range of their physical environment, including the people. They usually find the flat surface of a canvas too confining; in order to bridge the gap between image and reality, they often introduce three-dimensional objects into their pictures (we remember Duchamp's bottle-brush in figure 824), or they may even construct full-scale models of everyday things and real-life situations, utilizing every conceivable kind of material. These "environments" or "assemblages" combine the qualities of painting, sculpture, collage, and stagecraft. Robert Rauschenberg (born 1925) pioneered this approach as early

as the mid-1950s. Like a composer making music out of the noises of everyday life, he constructed works of art from the trash of urban civilization. *Odalisk* (colorplate 134) is a box covered with a miscellany of pasted images—comic strips, photos, clippings from picture magazines—held together only by the skein of brush strokes the artist has superimposed on them; the box perches on a foot improbably anchored to a pillow on a wooden platform, and is surmounted by a stuffed chicken. The title, a witty blend of "odalisque" and "obelisk," refers both to the nude girls among the collage of clippings (for the original meaning of "odalisque," see page 582) and to the shape of the construction as a whole: the box shares its verticality and slightly tapering sides with real obelisks, slender four-sided pillars of stone erected by the ancient Egyptians. The Romans brought many obelisks to Italy (one marks the center of the colonnaded piazza of St. Peter's; see fig. 624) and these inspired a number of later monuments in Europe and America. Rauschenberg's unlikely "monument" has at least one element in common with its predecessors—compactness and self-sufficiency. George Segal (born 1924), in contrast, creates "environments,"

834. ROY LICHTENSTEIN. *Girl at Piano.* 1963.
Magna on canvas, 68 × 48″ (see detail, colorplate 133).
Harry N. Abrams Family Collection, New York

lifesize three-dimensional pictures showing real people and real objects in everyday situations, such as *Cinema* (colorplate 135). The subject is ordinary enough to be instantly recognizable: a man changing the letters on a movie theater marquee. Yet the relation of image and reality is far more subtle and complex than the obvious authenticity of the scene suggests. The man's figure is cast from a live model by a technique of Segal's invention, and retains its ghostly white plaster surface. Thus it is one crucial step removed from our world of daily experience, and the neon-lit sign has been carefully designed to complement and set off the shadowed figure. Moreover, the scene is brought down from its natural context, high above the entrance to the theater where we might have glimpsed it in passing, and presented at eye-level, in isolation, so that we grasp it completely for the first time.

Some "environments" can have a shattering impact on the beholder. This is certainly true of *The State Hospital* (colorplate 136) by the West Coast artist Edward Kienholz (born 1927), which shows a cell in a ward for senile patients, with a naked old man strapped to the lower bunk. He is the victim of physical cruelty—his body is little more than a skeleton covered with leathery, discolored skin—which has reduced what little he had in him of mental life almost to the vanishing point:

835. KENNETH J. BUTLER. *Cherrie V.* 1968. Lithograph, 26 × 20″. Private Collection, New York

his head is a glass bowl with live goldfish, of whom we catch an occasional glimpse. The horrifying realism of the scene even has an olfactory dimension: when the work was displayed at the Los Angeles County Museum, it exuded a sickly hospital smell. But what of the figure in the upper bunk? It almost duplicates the one below, with one important difference: it is a mental image, since it is enclosed in the outline of a comic-strip balloon rising from the goldfish bowl. It represents, then, the patient's awareness of himself. The abstract devices of the balloon and the metaphoric goldfish bowl are both alien to the realism of the scene as a whole, yet they play an essential part in it, for they help to break the grip of horror and pity—they make us think as well as feel. Kienholz' means may be Pop, but his aim is that of Greek tragedy. As a witness to the unseen miseries beneath the surface of modern life, he has no equal anywhere today.

The urge to endow works of art with a new authenticity by blurring the distinction between image and reality has produced a number of techniques besides that of "environments." One of the least promising of these is to coat the body of a model with paint and then apply her imprint to the canvas. Even this method, however, can yield impressive results when used with skill and sensitivity, as in *Cherrie V* (fig. 835) by Kenneth J. Butler (born 1937). The title, matter-of-fact like nearly all others in Pop, simply gives the model's name and the serial number of her body print. Here the lithographic ink, more liquid and responsive to pressure than oil paint, records a surprisingly articulate image which the artist has modified and rounded off without changing its essential character. The visual appeal of the strong black-and-white pattern has something in common with that of a photographic negative. Interestingly enough, the idea of body prints probably came to the West from Japan, where the technique has been practiced for centuries (although on fish rather than girls).

Photo Realism

Another, more recent, offshoot of Pop Art is the trend called Photo Realism because of its fascination with camera images. Photographs had been utilized by nineteenth-century painters soon after the invention of the "pencil of nature"—one of the earliest to do so, surprisingly, was Delacroix—but they were no more than a convenient substitute for reality. When Larry Rivers used an old family photograph (fig. 831), he freely translated the camera image into the personal idiom of his brush. For the Photo Realists, in contrast, the photograph itself is the reality on which they build their pictures. At its best, their work, as in *New Shoes for H* by Don Eddy (born 1944; colorplate 137), has a visual complexity that challenges the most acute observer. Eddy grew up in southern California; as a teen-ager he learned to do fancy paint jobs on cars and

836. Don Eddy. Photograph for *New Shoes for H.* 1973.
6 1/4 × 6 1/2″ (see colorplate 137).
The Cleveland Museum of Art (Gift of the artist)

surfboards with an air brush, then worked as a photographer for several years. When he became a painter, he used both earlier skills. In preparing *New Shoes for H,* Eddy took a series of pictures of the window display of a shoe store on Union Square in Manhattan. One photograph (fig. 836) served as the basis for the painting. What intrigued him, clearly, was the way glass filters (and transforms) everyday reality. Only a narrow strip along the left-hand edge offers an unobstructed view: everything else—shoes, bystanders, street traffic, buildings—is seen through two or more layers of glass, all of them at oblique angles to the picture surface. The combined effect of these panes—displacement, distortion, and reflection—is the transformation of a familiar scene into a dazzlingly rich and novel visual experience. Comparing the painting with the photograph, we realize that they are related in much the same way as Lichtenstein's *Girl at Piano* (fig. 834, colorplate 133) is to the comic strip frame from which it derives. Unlike Eddy's photograph, his canvas shows everything in uniformly sharp focus, articulates details lost in the shadows, and, most important of all, gives pictorial coherence to the scene through a brilliant color scheme whose pulsating rhythm plays over the entire surface. At the time he painted *New Shoes for H,* color had become newly important in Eddy's thinking; the H of the title pays homage to Henri Matisse and to Hans Hofmann, the latter a painter linked to Abstract Expressionism whom Eddy had come to admire.

Op Art

Pop Art may be said to have matured within a decade of its inception. Another direction that gathered force about the same time, in the mid-1950s, is still near its infancy: the trend—actually, a whole cluster of related trends—known as "Op Art" because of its concern with optics (that is, the physical and psychological process of vision). There are several reasons for its slower development. Op Art does not have the topical impetus and the emotional appeal of Pop; by comparison it seems overly cerebral and systematic, more akin to the sciences than to the humanities. As a consequence it has attracted less attention and public support. On the other hand, its possibilities appear to be as unlimited as those of science and technology, while Pop is likely to run its course or to transform itself beyond recognition fairly soon. At the same time, because of its very eagerness to take advantage of the new materials and processes constantly supplied by science, Op Art is not fully in command of its own goals. Perhaps that is why so few of its creations have an air of finality about them.

When we use our eyes in everyday life, we take it for granted that the world around us is as we perceive it. Only when we find a discrepancy, when "our eyes deceive us," do we become aware of the complexities of the process, although most of us do not know how to analyze these. In saying that our eyes deceive us, we think of them as an instrument, something like a camera, that supplies images to the mind. But if the eyes are merely a tool, a mechanical device, how can they have a will of their own (which is, after all, what deception implies)? Obviously, we must be using the wrong analogy. A better one, though still inadequate, would be to regard the mind as a computer into which the eyes feed an endless stream of data; perception would then be the answers the computer supplies after analyzing these data. If we could be aware of the images actually projected on the retina, they would tell us nothing—there would be a different one (in fact, two different ones) every fraction of a second. Fortunately, we are not. All we know is the end product of the analysis; this can be our only meaning whenever we speak of seeing, or vision, or perception. If "our eyes deceive us," something has momentarily gone wrong with the process of analysis; the computer has been overtaxed, perhaps by contradictory data or by too many data in quick succession. Because the resulting "optical illusions" may be a danger to life and limb, our visual apparatus tends to resist them. Hence they are surprisingly rare in our contacts with the familiar everyday world. They can also be induced on purpose, however; and to these man-made illusions we react not with fear but with pleasure, whether or not they really succeed in deceiving us. If they don't, we are more than willing to give them the benefit of the doubt. Why this should be so is a difficult question which we must leave to the psychologist, perhaps to the philosopher as well. Suffice it to say that all representational art from the Old Stone Age onward has been involved with optical illusion in one sense or another. What is new

837. VICTOR VASARELY. *Vega*. 1957.
77 × 51″. Collection the Artist

838. FRANÇOIS MORELLET. *Sphere-Web*. 1967. Lattice sphere
of metal rods, diameter 14 ⅛″. Galerie Denise René, Paris

about Op Art is that it is rigorously non-representational, while seeking to extend the realm of optical illusion in every possible way. Much of it consists of constructions or "environments" dependent for their effect on light and motion. These cannot be reproduced in photographs, since they exploit those aspects of our visual apparatus that are least like the camera. We must confine ourselves in this book to the kind of Op Art which does not lose all of its essential qualities when illustrated.

The ancestry of Op Art can be traced back to Mondrian (see page 657). Its present development, however, stems largely from the work of Victor Vasarely (born 1908), a Hungarian long domiciled in France, who has been its chief theoretician as well as its most inventive practitioner. Many of his paintings, drawings, and constructions are in stark black-and-white, such as the large canvas, *Vega* (fig. 837), named after the brightest star in the constellation Lyra. It is a huge checkerboard whose regularity has been disturbed by bending the lines that make the squares. But such a description is no more than a list of ingredients— it does not tell us what we actually see. The size of the standard squares in relation to that of the entire field has been carefully chosen so as to tempt us to link the black squares into a network of diagonals when we view the picture from a certain distance (about 30 in. from our reproduction). But since many of these squares have been subjected to distortion, their sizes vary considerably, the largest having over ten times the area of the smallest. As a consequence, no matter what our viewing distance, our eyes receive contradictory data: we read parts of the field in terms of diagonals, others in terms of verticals and horizontals. The picture thus practically forces us to move back and forth, and as we do so the field itself seems to move, expanding, undulating, contracting. If *Vega* were a three-dimensional object, the variety of effects to be observed as we move in relation to it would be greater still, for we would then receive different sets of contradictory data from each eye. *Sphere-Web* (fig. 838) by François Morellet (born 1926) may serve to suggest some of these possibilities. Op Art, then, involves the beholder with the work of art in a truly novel, dynamic way. In America Josef Albers, who came here after 1933, when Hitler closed the Bauhaus school at Dessau (see page 708), became the founding father of another, more austere kind of Op Art based on subtle color relations among simple geometric shapes. His gifted pupil Richard Anuszkiewicz (born 1930) paints in the same vein, but his self-imposed restrictions are less severe. In *Entrance to Green* (colorplate 138) the ever-decreasing series of rectangles creates a sense of infinite recession toward the center; this is counterbalanced by the color pattern which brings the center close to us by the gradual shift from cool to warm tones as we move inward from the periphery. Surely, Op Art has not yet reached its limits.

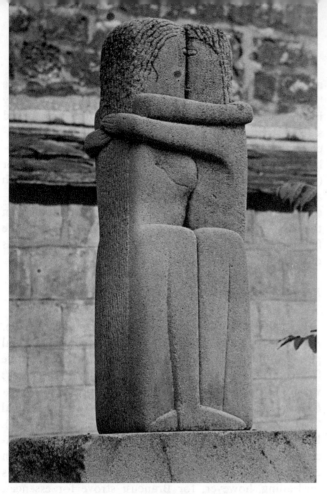

839. CONSTANTIN BRANCUSI. *The Kiss*. 1909.
Height 35 ¹/₄″. Tomb of T. Rachevskaia,
Montparnasse Cemetery, Paris

840. Pottery Figurine Group (Chavinoid),
from Peru. c. 500–100 B.C. Height 6 ¹/₂″.
Private Collection

SCULPTURE

The main currents we have followed in painting may be found also in sculpture. The parallelism, however, should not be overstressed. While painting has been the richer and more adventurous of the two arts, its leadership has not remained unchallenged in the last half-century, and the development of sculpture has often followed its own path.

Brancusi; Moore

Expressionism, for instance, is a much less important current in sculpture than in painting—which is rather surprising, since the rediscovery of primitive sculpture by the *Fauves* might have been expected to evoke a strong response among sculptors. Only one important sculptor shared in this rediscovery: Constantin Brancusi (1876–1957), a Rumanian who came to Paris in 1904. But he was more interested in the formal simplicity and coherence of primitive carvings than in their savage expressiveness: this is evident in *The Kiss* (fig. 839), executed in 1909 and now placed over a tomb in a Parisian cemetery. The compactness and self-sufficiency of this group is a

radical step beyond Maillol's *Seated Woman* (see fig. 799), to which it is related much as are the *Fauves* to Post-Impressionism. Brancusi has a "genius of omission" not unlike Matisse's; to him, a monument is an upright slab, symmetrical and immobile—a permanent marker, like the steles of the ancients—and he disturbs this basic shape as little as possible. The embracing lovers are differentiated just enough to be separately identifiable, and seem more primeval than primitive. They are a timeless symbol of generation, innocent and anonymous— the exact opposite of Rodin's *Kiss* (see fig. 782), where the contrast of flesh and stone mirrors the dualism of guilt and desire. Their nearest relatives are to be found among such works of the remote past as the pre-Columbian pottery figurine group shown in figure 840, which was made more than 2000 years ago (and which Brancusi could not have known, since it is a very recent find). Appropriately, it too was conceived for a cemetery—as a gift to be buried with the deceased.

Brancusi's "Primevalism" was the starting point of a sculptural tradition that still continues today. It has appealed particularly to English sculptors, as we may see in the early works of Henry Moore (born 1898): his majestic *Two Forms* of 1936 (fig. 841) are, as it were, the second-generation offspring of Brancusi's *Kiss*. More

841. HENRY MOORE. *Two Forms*. 1936.
Height c. 42″. Collection Mrs. H. Gates Lloyd,
Haverford, Pennsylvania

abstract and subtle in shape, they are nevertheless "persons," even though they can be called "images" only in the metaphoric sense. This family group—the forked slab evolved from the artist's studies of the mother-and-child theme—is mysterious and remote like the monoliths of Stonehenge, which greatly impressed the sculptor (see fig. 30). His *Recumbent Figure* (fig. 842) retains both a classical motif—one thinks of a reclining river god—and a primeval look, as if the forms had resulted from the slow erosion of a thousand years. The design of the figure is in complete harmony with the natural striations of the stone.

Kinetic Sculpture; Constructivism

Brancusi meanwhile had taken another daring step. About 1910, he began to produce non-representational pieces in marble or metal, reserving his "primeval" style for wood and stone. The former fall into two groups: variations on the egg shape, with such titles as *The Newborn* or *The Beginning of the World;* and soaring vertical "bird" motifs (*Bird in Space,* figure 843, is one of these). Because he concentrated on two basic forms of such uncompromising simplicity, Brancusi has at times been called the Mondrian of sculpture; this comparison is misleading, however, for Brancusi strove for essences, not for relationships. He was fascinated by the antithesis of life as potential and as kinetic energy—the self-contained perfection of the egg, which hides the mystery of all creation, and the pure dynamics of the creature released from this shell. *Bird in Space* is not the abstract

842. HENRY MOORE.
Recumbent Figure. 1938.
Green Hornton stone,
length c. 54″.
The Tate Gallery, London

image of a bird; rather, it is flight itself, made visible and concrete. Its disembodied quality is emphasized by the high polish that gives the surface the transparency of a mirror, and thus establishes a new continuity between the molded space within and the free space without. Other sculptors at that time were tackling the problem of body-space relationships with the formal tools of Cubism. The running figure entitled *Unique Forms of Continuity in Space* (fig. 844), by the Futurist Umberto Boccioni (1882–1916), is as breathtaking in its complexity as *Bird in Space* is simple. Boccioni has attempted to represent not the human form itself, but the imprint of its motion upon the medium in which it moves; the figure remains concealed behind its "garment" of aerial turbulence. The statue recalls the famous Futurist statement that "the roaring automobile is more beautiful than the Winged Victory," although it obviously owes more to the Winged Victory (the *Nike of Samothrace,* fig. 191) than to the design of motor cars (fins and streamlining, in 1931, were still to come). Or perhaps Boccioni's source of inspiration was closer at hand—he could have seen the work of Niccolò dell'Arca (compare fig. 531). Raymond Duchamp-Villon (1876–1916), an elder brother of Marcel Duchamp, achieved a bolder solution in *The Great Horse* (fig. 845). He began with abstract studies of the animal, but his final version is an image of "horsepower," wherein the body has become a coiled spring and the legs resemble piston rods. Because of this very remoteness from their anatomical model, these quasi-mechanical shapes have a dynamism that is more persuasive—if less picturesque—than that of Boccioni's figure.

In facet Cubism, we recall, concave and convex were postulated as equivalents; all volumes, whether positive or negative, were "pockets of space." A group of Russian artists, the Constructivists, applied this approach to sculpture and arrived at what might be called three-dimensional collage. According to them, these constructions were actually four-dimensional: since they implied motion, they also implied time. The movement flowered briefly in Russia (1917–22), but was soon suppressed as "bourgeois formalism." Some of its members turned to applied art; others emigrated to the West and joined forces with De Stijl, the Dutch group. One of them, Antoine Pevsner (1886–1962), returned to Paris, where he had spent some years shortly before the First World War. His *Torso* (fig. 846) combines plastic and copper sheeting into a structure of "space cells" divided by translucent "membranes"—volumes without tangible reality, but nonetheless fully defined. The machine-like precision of the shapes suggests the influence of Marcel Duchamp, whom Pevsner greatly admired.

Surrealism

Dada uncompromisingly rejected formal discipline in sculpture, as it did in the other arts—perhaps even more

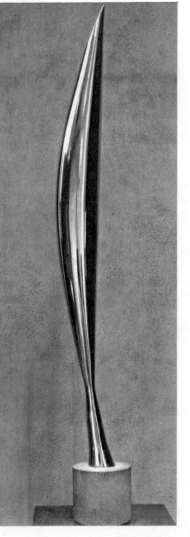

843. CONSTANTIN BRANCUSI. *Bird in Space.* 1919. Bronze, height 54″. The Museum of Modern Art, New York (Anonymous Gift)

844. UMBERTO BOCCIONI. *Unique Forms of Continuity in Space.* 1913. Bronze, height 43 1/2″. The Museum of Modern Art, New York (Acquired through the Lillie P. Bliss Bequest)

845. RAYMOND DUCHAMP-VILLON. *The Great Horse.*
1914. Bronze, height 39 ³/₈″. The Art Institute of Chicago
(Gift of Miss Margaret Fisher)

846. ANTOINE PEVSNER. *Torso.* 1924–26. Plastic and
copper, height 29 ¹/₂″. The Museum of Modern Art,
New York (Katherine S. Dreier Bequest)

so, since only three-dimensional objects could become Ready-Mades, the sculpture of Dada. Some of Duchamp's examples consist of combinations of found objects: these "assisted" Ready-Mades approach the status of constructions, or three-dimensional collage. This technique, recently baptized "assemblage," proved to have unlimited possibilities. It has produced such striking pieces as Picasso's *Bull's Head* (see fig. 1), and numerous younger artists have explored it since, especially in junk-ridden America (see colorplate 139). The Surrealist contribution to sculpture is harder to define: it was difficult to apply the theory of "pure psychic automatism" to painting, but still harder to live up to it in sculpture. How indeed could solid, durable materials be given shape without the sculptor being consciously aware of the process? Thus, apart from the devotees of the Ready-Made, few sculptors were associated with the movement, and the effect produced by those who were cannot be directly compared with Surrealist painting. One of the exceptions is *The Palace at 4 A. M.* (fig. 847), by Alberto Giacometti (1901–66), a Swiss sculptor and painter who lived in Paris. The materials—wood, glass, wire, and string—suggest Constructivism, but Giacometti's concern is not with structural problems. This airy cage is the three-dimensional equivalent of a Surrealist picture; unlike earlier pieces of sculpture, it creates its own spatial environment that clings to it as though this eerie miniature world were protected from everyday reality by an invisible glass bell. The space thus trapped is mysterious and corrosive, and gnaws away at the forms until only their skeletons are left; even they, we feel, will disappear before long. Surrealism may also have contributed to the astonishing sculptural imagination of Julio Gonzalez (1872–1942). Trained as a wrought-iron craftsman in his native Catalonia, Gonzalez had come to Paris in 1900. Although he was a friend of both Brancusi and Picasso, he produced little of consequence until the 1930s, when his creative energies suddenly came into focus. It was Gonzalez who established wrought iron as an important medium for sculpture, taking advantage of the very difficulties that had discouraged its use before. The *Head* (fig. 848) combines extreme economy of form with an aggressive reinterpretation of anatomy that is derived from Picasso's work after the mid-1920s (see colorplate 113, especially the head of the figure on the left): the mouth is an oval cavity with spike-like teeth, the eyes two rods that converge upon an "optic nerve" linking them to the tangled mass of the "brain." Similar gruesomely expressive metaphors have since been created by a whole generation of younger sculptors, in wrought iron and welded steel, as if the violence of their working process mirrored the violence of modern life.

Mobiles

The early 1930s, which brought Giacometti and Gonzalez to the fore, produced still another important

847. ALBERTO GIACOMETTI. *The Palace at 4 A. M.* 1932–33.
Construction in wood, glass, wire, and string, height 25″.
The Museum of Modern Art, New York (Purchase)

848. JULIO GONZALEZ. *Head.* c. 1935.
Wrought iron, height 17 3/4″. The Museum of Modern Art,
New York (Purchase)

development, the mobile sculpture—mobiles, for short—
of the American Alexander Calder (born 1898): these
are delicately balanced constructions of metal wire,
hinged together and weighted so as to move with the
slightest breath of air. They may be of any size, from
tiny tabletop models to the huge *Lobster Trap and Fish
Tail* (colorplate 140). Kinetic sculpture was conceived
by the Constructivists, and their influence is evident in
Calder's earliest mobiles; these were motor-driven, and
tended toward abstract geometric configurations. It was
Calder's contact with Surrealism that made him realize
the poetic possibilities of "natural" rather than fully
controlled movement; he borrowed biomorphic shapes
from Miró, and began to think of mobiles as similes of
organic structures—flowers on flexible stems, foliage
quivering in the breeze, marine animals floating in the
sea. Such mobiles are infinitely responsive to their
environment. Unpredictable and ever-changing, they
incorporate the fourth dimension as an essential element
of their structure. Within their limited sphere, they are
more truly alive than any other man-made thing.

Materials and Assemblage

Pop Art, we recall, has produced not only paintings but
constructions and "environments" (colorplates 135, 136).
Being three-dimensional, the latter two can claim to be
considered sculpture, but the claim rests on a convention
which Pop itself has helped to make obsolete. According
to this convention, a work of art consisting of a flat or
smoothly curved surface covered with colors is a paint-

ing (or, if the surface is not covered, a drawing), while
sculpture is everything else, whether or not the surface
is colored and regardless of the material, size, or degree
of relief (unless we can enter it, in which case we call
it architecture). Our habit of using "sculpture" in this
sense is only a few hundred years old. Antiquity and the
Middle Ages had separate terms to denote various kinds
of sculpture according to the materials and working
processes involved, but no single one to cover them all.
Maybe it is time to revive such distinctions. Let us, then,
modify our all-too-inclusive definition of sculpture by
acknowledging "environments" as a separate category,
distinct from both painting and sculpture in its use of
heterogeneous materials ("mixed mediums") and its
blurring of the borderline between image and reality.
Constructions present a more difficult problem. If we
agree to restrict the term "sculpture" to objects made of
a single substance, then we must put "assemblages" (that
is, constructions using mixed mediums) in a class of their
own—probably a useful distinction, because of their kin-
ship with Ready-Mades. But what of Picasso's *Bull's
Head* (fig. 1)? Is it not an instance of assemblage, and
have we not called it a piece of sculpture? Actually, there
is no inconsistency here; for the *Bull's Head* is a bronze
cast, even though we cannot tell this by looking at a
photograph of it. Had Picasso wished to display the
handlebars and bicycle seat themselves, he would surely
have done so. If he chose to have them cast in bronze, this
must have been because he wanted to "dematerialize" the
ingredients of the work by having them reproduced in a
single material. Apparently he felt it necessary to clarify

849. CÉSAR (BALDACCINI). *The Thumb*. 1966.
Plaster, height 78 ³/₄″. Louisiana Museum of Modern Art,
Humlebaek near Copenhagen

850. AUGUSTE RODIN. *The Secret*. 1910.
Marble, height 35″. Rodin Museum, Paris

851. GRANDVILLE. *The Finger of God*,
from *Un autre monde*. 1844.
Wood engraving, 4 × 4 ³/₄″

the relation of image to reality in this way—the sculptor's way—and the same procedure was his general custom whenever he utilized ready-made objects.

Nevertheless, we must not apply the "single-material" rule too strictly. Calder's mobiles, for instance, often combine metal, string, wood, and other substances, yet they do not strike us as being assemblages, because these materials are not made to assert their separate identities. Conversely, an object may deserve to be called an assemblage even though composed of essentially homogeneous material. Such is often true of the works known as "junk sculpture," made of fragments of old machinery, parts of wrecked automobiles, and similar discards. A most successful example—and a puzzling borderline case—is *Essex* (colorplate 139) by John Chamberlain (born 1927). The title refers to a make of car that has not been on the market for many years, suggesting that the object is a kind of homage to a vanished species. But we may well doubt that these pieces of enameled tin ever had so specific an origin. They have been carefully selected for their shape and color, and composed in such a way that they form a new entity, evoking a gigantic multicolored rose rather than the crumpled automobiles to which they

once belonged. Whether we prefer to call *Essex* assemblage or sculpture is of little importance, but in trying to reach a decision we gain a better insight into the qualities that constitute its appeal.

The New Scale

Sculpture in the sense defined above hardly exists in Pop Art, just as there is little of it—apart from such things as dolls and store dummies—in the world of commercial art from which Pop draws its material. The comic strip has no sculptural counterpart. Still, here and there we do find pieces that bring to mind the artistic problems raised by Roy Lichtenstein. A most impressive example is *The Thumb* (fig. 849) by the French sculptor César (César Baldaccini; born 1921). At first glance, it may look like a plaster cast of an actual thumb, mechanically enlarged; and the point of departure must indeed have been such a thumb (the artist's own, we assume). But once we realize that the rate of enlargement here is about the same as in Lichtenstein's comic-strip works, it becomes clear that there could have been nothing automatic about the process. Every tiny crease of skin, every slight irregularity in the shape of the nail has engaged the artist's attention and has been rendered with so much exactitude and authority that this is indeed not "a thumb" but *the* Thumb. What started César on this enterprise must have been the "autonomous fragments" made by Rodin, who in his later years did several sculptures of hands, with ambitious titles such as *The Secret* (fig. 850). To take the next step, reducing the fragment to a thumb and endowing it with a sense of self-sufficiency, was a special challenge to César's powers. We can hardly deny that he has met it in memorable fashion, even though we find it difficult to imagine how the same principle could be extended any further. Yet César was not the first to conceive an enormous sculptured thumb. It had been done more than a century before by Grandville, that strange draughtsman whom we came to know in connection with Marcel Duchamp and Max Ernst (fig. 851). Grandville's work has been so widely reproduced since the 1930s that César could hardly have escaped knowing it. Still, there is a big difference between merely visualizing a gigantic sculptured thumb and actually making one.

Scale, so important in *The Thumb,* has assumed even greater significance for a recent sculptural movement that extends the scope—indeed, the very concept—of sculpture in a fundamentally new direction. "Primary Structure," the most suitable name so far suggested for this type, conveys its two salient characteristics: extreme simplicity of shapes, and a kinship with architecture. Another term, "Environmental Sculpture" (not to be confused with the mixed-medium "environments" of Pop), refers to the fact that many Primary Structures are designed to envelop the beholder, who is invited to enter or walk through them. It is this space-articulating function that distinguishes Primary Structures from all previous sculpture and relates them to architecture. They

852. MATHIAS GOERITZ.
Steel Structure. 1952–53.
Height 14′ 9″.
The Echo (Experimental
Museum), Mexico City

853. RONALD BLADEN. *The X* (in the
Corcoran Gallery, Washington, D.C.). 1967.
Painted wood, to be
constructed in steel, 22′ 8″ × 24′ 6″ × 12′ 6″.
Fischbach Gallery, New York

854. ROBERT SMITHSON. *Spiral Jetty*. 1970.
Total length 1,500′; width of jetty 15′.
Great Salt Lake, Utah

are, as it were, the modern successors, in structural steel and concrete, to such prehistoric monuments as Stonehenge (see figs. 29, 30). The first to explore these possibilities was Mathias Goeritz (born 1915), a German working in Mexico City. As early as 1952–53, he established an experimental museum, The Echo, for the display of massive geometric compositions, some of them so large as to occupy an entire patio (fig. 852). His ideas have since been taken up on either side of the Atlantic. Often, these sculptors limit themselves to the role of designer and leave the execution to others, to emphasize the impersonality and duplicability of their invention. If no patron is found to foot the bill for carrying out these very costly structures, they remain on paper, like unbuilt architecture. Sometimes they reach the mock-up stage, with painted wood substituting for metal, as in *The X* (fig. 853), by the Canadian Ronald Bladen (born 1918), which was built for an exhibition inside the two-story hall of the Corcoran Gallery in Washington. Its commanding presence, dwarfing the Neoclassic colonnade of the hall, seems doubly awesome in such a setting. The ultimate medium for Environmental Sculpture is the earth itself, since it provides complete freedom from the limitations of the human scale. Some designers of Primary Structures have, logically enough, turned to "Earth Art," inventing projects that stretch over many miles. These latter-day successors to the mound-building Indians of the Neolithic (see fig. 31) have the advantage of modern earth-moving machinery, but this is more than outweighed by the problem of cost and the difficulty of finding suitable sites on our crowded planet. The few projects of theirs that have actually been carried out are mostly found—and the finding is itself often difficult enough—in the more remote corners of western America. *Spiral Jetty,* the work of Robert Smithson (1938–73), juts out into the Great Salt Lake in Utah (fig. 854). Its appeal rests, in part, on the Surrealist irony of the concept: a spiral jetty is as self-contradictory as a straight corkscrew. But it can hardly be said to have grown out of the natural formation of the terrain like the Great Serpent Mound, and one wonders if it will endure as long.

Smith

The American sculptor David Smith (1906–65), whose earlier work had been strongly influenced by the wrought-iron constructions of Julio Gonzalez (see fig. 848), evolved during the last years of his life a singularly impressive form of Primary Structure in his *Cubi* series. Figure 855 shows three of these against the open sky and rolling hills of the artist's farm at Bolton Landing, New York (all are now in major museums). Only two basic components are employed—cubes (or multiples of them) and cylinders—yet Smith has created a seemingly endless variety of configurations. The units which make up

Colorplate 128. FRANK STELLA. *Empress of India*. 1965. Metallic powder in polymer emulsion, 6′ 5″ × 18′ 8″. Collection Irving Blum, Los Angeles

Colorplate 129. EDWARD HOPPER. *Early Sunday Morning*. 1930. 35 × 60″. Whitney Museum of American Art, New York

Colorplate 130. LARRY RIVERS. *Europe II*. 1956. 54 × 48″.
Collection Copyright Mrs. Donald M. Weisberger, New York

Colorplate 131. JASPER JOHNS. *Three Flags*. 1958. Encaustic on canvas, 30$^7/_8$ × 45$^1/_4$″. Collection Mr. and Mrs. Burton Tremaine, Meriden, Connecticut

Colorplate 132. CHARLES DEMUTH. *I Saw the Figure 5 in Gold*. 1928. Composition board, $35^{1}/_{2} \times 30''$.
The Metropolitan Museum of Art, New York (The Alfred Stieglitz Collection, 1949)

Colorplate 133. ROY LICHTENSTEIN. Detail, actual size, of *Girl at Piano*. 1963.
Harry N. Abrams Family Collection, New York (see figure 834)

Colorplate 134. ROBERT RAUSCHENBERG. *Odalisk*. 1955–58. Construction, 81 × 25 × 25″.
Collection Mr. and Mrs. Victor W. Ganz, New York

Colorplate 135. GEORGE SEGAL. *Cinema.* 1963. Plaster, metal, Plexiglas, and fluorescent light, 9′ 10″ × 8′ × 3′ 3″.
The Albright-Knox Art Gallery, Buffalo (Gift of Seymour H. Knox)

the structures are poised one upon the other as if they were held in place by magnetic force, so that each represents a fresh triumph over gravity. Unlike the younger members of the Primary Structure movement, Smith executed these pieces himself, welding them of sheets of stainless steel whose shiny surfaces he finished and controlled with exquisite care. As a result, his work displays an "old-fashioned" subtlety of touch that reminds us of the polished bronzes of Brancusi.

Oldenburg; Newman

Primary Structures are obviously monuments. But just as obviously they are not monuments commemorating or celebrating anything except their designer's imagination. To the man in the street they offer no ready frame of reference, nothing to be reminded of, even though the original meaning of "monument" is "a reminder." Presumably, monuments in this traditional sense died out when contemporary society lost its consensus of what ought to be publicly remembered. Yet the belief in the possibility of such monuments has not been abandoned altogether. One artist,

Claes Oldenburg (born 1929), has proposed a number of unexpected and imaginative solutions to the problem; he is, moreover, an exceptionally precise and eloquent commentator on his ideas. All his monuments are heroic in size, though not in subject matter; all share one common feature, their origin in humble objects of everyday use. Perhaps his most surprising project is a skyscraper in the shape of a colossal clothespin (colorplate 141)—now executed in several versions, one made of two kinds of steel and some 45 feet high. He describes his idea, after explaining why he likes old-fashioned wooden clothespins— "leggy structures" with "human presence": he happened to start playing with such a pin during a flight to Chicago, and "I also had a postcard of the Empire State Building. I made a sketch, superimposing the clothespin on the postcard; then I stuck the clothespin in a wad of gum. . . and placed it on the little table in front of my seat. As our plane came over Chicago, I noticed that the buildings down there looked the same size as the clothespin. Later, back in New York, I worked the pin up as a skyscraper, inspired by recollections of the *Chicago Tribune* Competition of 1922. Among the designs submitted were several

855. DAVID SMITH. *Cubi* Series. Stainless steel. (left) *Cubi XVIII*. 1964. Height 9′ 8″. Museum of Fine Arts, Boston. (center) *Cubi XVII*. 1963. Height 9′. Dallas Museum of Fine Arts. (right) *Cubi XIX*. 1964. Height 9′ 5″. The Tate Gallery, London

versions of a skyscraper in the form of a column . . . ; a building in the form of an Indian with raised tomahawk, and another in the form of Skeezix, the comic-strip character. My clothespin seemed to belong in this company, especially since it had a gothic look—like the winner, still standing, the Tribune Tower." Granted the idea of a skyscraper as a "human presence" suggested by the 1922 competition, Oldenburg's clothespin seems eminently more suitable than an Indian or Skeezix. Its design, modified to fit its new function (the legs are sturdier and farther apart), has great elegance in its sweeping curves. And it is something everybody can relate to. One cannot help rejoicing that it has been built.

Two years later Oldenburg conceived and executed a monument shaped a gigantic ice bag (fig. 856) with a mechanism inside to make it move—"movements caused by an invisible hand," as the artist described them. For a piece of outdoor sculpture he wanted a form that combined hard and soft and did not need a base. An ice bag met these demands, so he bought one and started playing with it. He soon realized, he says, that the object was made for manipulation, "that movement was part of its identity

and should be used." He sent the *Giant Ice Bag* to the U.S. Pavilion at EXPO 70 in Osaka, Japan, where crowds were endlessly fascinated to watch it heave, rise, and twist like a living thing, then relax with an almost audible sigh. Another outdoor monument without a base is in the form of a huge trowel stuck into the ground, made by Oldenburg for Sonsbeek Park at Arnhem, Holland (fig. 857). Although it is anchored in a buried slab of concrete, he wanted it to look "as if it had just dropped out of the sky, like lightning." He also liked the sharp contrast between its "nakedly mechanical form," the violence of its downward thrust, and the aristocratic setting, the park with its tame deer; he noted that *Trowel* is "a hard version of the swans that live in the lagoons of the park." The trowel, then, is as rich in connotations for Oldenburg as the clothespin, and equally pregnant with hidden possibilities. Like the clothespin skyscraper, *Trowel* has a grace no one would have suspected in the simple tool that was its point of origin. What do these monuments celebrate? What is the secret of their appeal? Part of it, which they share with Pop Art, is that they reveal the aesthetic potential of the ordinary and all-too-

856. CLAES OLDENBURG. *Giant Ice Bag.* 1969–70. Plastic and metal, with interior motor, height 15′ 6″, diameter 18′

857. CLAES OLDENBURG. *Sculpture in the Form of a Trowel Stuck in the Ground.* 1971. Metal, height 40′. Kröller-Müller Museum, Otterlo, Holland. (Installation view in Sonsbeek Park, Arnhem)

858. BARNETT NEWMAN.
Broken Obelisk. 1963–67.
Steel, height 25′ 1″.
Institute of Religion
and Human Development, Houston

familiar. But they also have an undeniable grandeur. We might say, with Baudelaire, that they express "the heroism of modern life."

There is one dimension, however, that is missing in Oldenburg's monuments. They delight, astonish, amuse—but they do not move us. Wholly secular, wedded to the here and now, they fail to touch our deepest emotions. In our time, only one monument has succeeded in this: *Broken Obelisk* (fig. 858) by Barnett Newman (1905–70). An artist beset by profound religious and philosophical concerns which he struggled throughout his life to translate into visual form, Newman conceived *Broken Obelisk* in 1963 but could not have it executed until four years later, when he found the right steel fabricator. It consists of a square base plate beneath a four-sided pyramid

whose tip meets and supports that of the up-ended broken obelisk. The two tips have exactly the same angle (53°, borrowed from that of the Egyptian pyramids, which had long fascinated the artist) so that their juncture forms a perfect X. Why this monument has such power to stir our feelings is difficult to put into words. Is it the daring juxtaposition of two age-old shapes that have contrary meanings, the one symbolizing timeless stability, the other a thrust toward the heavens? Surely—but what if the obelisk were intact? Would that not reduce the whole to an improbable balancing feat? The brokenness of the obelisk, then, is essential to the *pathos* of the monument. It speaks to us of our unfulfilled spiritual yearnings, of a quest for the infinite and universal that persists today as it did thousands of years ago.

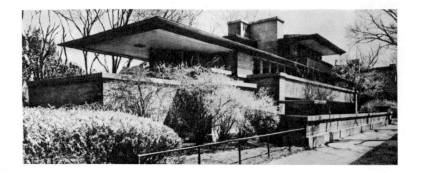

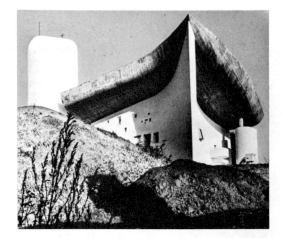

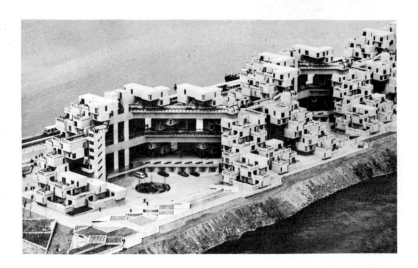

England; U.S.A.
Art Nouveau
Wright
International Style
Urban Planning

5

TWENTIETH-CENTURY ARCHITECTURE

For more than a century, from the mid-eighteenth to the late nineteenth, architecture had been dominated by a succession of "revival styles" (see pages 557–65). This term, we will recall, does not imply that earlier forms were slavishly copied; the best work of the time has both individuality and high distinction. Yet the architectural wisdom of the past, however freely interpreted, proved in the long run to be inadequate for the needs of the present. The authority of historic modes had to be broken if the industrial era was to produce a truly contemporary style.

ENGLAND; U.S.A.

This authority proved extraordinarily persistent. Even a pioneer of cast-iron construction such as Labrouste could not think of architectural supports as anything but columns having proper capitals and bases, rather than as metal rods or pipes (see page 563). It was only in structures which were not considered "architecture" at all that new building materials and techniques could be explored without these inhibitions. Within a year of the completion of the Bibliothèque Ste.-Geneviève there was built in London the Crystal Palace (fig. 859), a pioneering achievement far bolder in conception, designed to house the first of the great international expositions that continue in our own day. Its designer, Sir Joseph Paxton (1801–65), was an engineer and builder of greenhouses; and the Crystal Palace was indeed a gigantic greenhouse—so large that it enclosed some old trees growing on the site—with its iron skeleton freely on display. Still, the notion that there might be beauty, and not merely utility, in the products of engineering made headway very slowly,

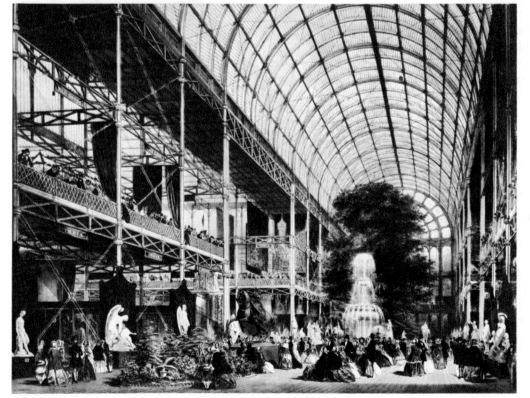

859. SIR JOSEPH PAXTON. The Crystal Palace, interior view looking north. 1851 (Lithograph by Joseph Nash). Victoria & Albert Museum, London (Crown Copyright Reserved)

860. EDWARD WILLIAM GODWIN. Sideboard. c. 1867.
Ebonized wood with silver hardware and imitation leather
panels, height 71″. Victoria & Albert Museum, London
(Crown Copyright Reserved)

861. CARL MICHEL STUDIO. *Jewelry Designs.*
Watercolor. c. 1865. Staatliche Zeichenakademie,
Hanau am Main, Germany

even though the doctrine "form follows function" found
an ever greater number of advocates from the mid-nine-
teenth century on. Among the earliest harbingers of
"machine aesthetic" are certain jewelry designs of the
1860s in France and Germany; these are composed of
screw heads, nuts, bolts, wrenches, and other symbols of
the age (fig. 861). They might have been intended to
appeal to prosperous factory owners, since the materials
indicated are gold and precious stones (the era of cheap
mass-produced "costume jewelry" was yet to come). Be
that as it may, they have a clean-cut, uncluttered quality
that Fernand Léger would have liked (colorplate 113).
In England, in the same decade, the reform ideas of
William Morris began to bear fruit in domestic archi-
tecture and decoration (see page 612). The boldest in-
novations, however, came not from members of his
immediate circle but from Edward William Godwin
(1833–86), a friend of Whistler's, who designed the
remarkable sideboard illustrated in figure 860. Godwin
had been much impressed with the simplicity of Japa-

nese interior furnishings, which he knew mainly from
the colored woodcuts recently available in the West (see
page 724). His sideboard, composed of "boxes" within
a framework of straight "sticks," owes its elegance al-
most entirely to its finely balanced proportions, since
applied ornament has been kept to a bare minimum. At
the same time, it has been planned for ease and low cost
of manufacture (the material is cheap wood, painted
black). In its geometric austerity, it seems oddly prophet-
ic of Mondrian (compare colorplate 116).

Despite such forays into new territory, the search for
a truly modern style did not begin in earnest until
about 1880. It demanded far more than a reform of
architectural grammar and vocabulary: to take advan-
tage of the expressive qualities of the new building
techniques and materials that the engineer had placed at
his disposal, the architect needed a new philosophy.
The leaders of modern architecture have characteristi-
cally been vigorous and articulate thinkers, in whose
minds architectural theory is closely linked with ideas
of social reform. It is equally significant that the move-
ment began in commercial architecture (stores, offices,
apartments), outside the range of established building
types; that its symbol was the skyscraper; and that its
first home was Chicago, then a burgeoning metropolis
not yet encumbered by any allegiance to the styles of the
past. The great Chicago fire of 1870 had opened vast

862. Warehouses on New Quay, Liverpool. 1835–40

863. HENRY HOBSON RICHARDSON. Marshall Field
Wholesale Store (demolished 1930). Chicago. 1885–87

864. LOUIS SULLIVAN. Wainwright Building.
St. Louis, Missouri. 1890–91

opportunities to architects from older cities such as
Boston and New York. Among them was Henry Hobson
Richardson (1838–86), who as a young man had profited
from contact with Labrouste in Paris (see fig. 724).
Most of his work along the Eastern seaboard shows a
massive neo-Romanesque style. There are still echoes of
this in his last major project for Chicago, the Marshall
Field Wholesale Store, designed in 1885 (fig. 863). The
huge structure filled an entire city block. In its symmetry,
and the treatment of masonry, it may remind us of
Italian Early Renaissance palaces (see fig. 507). Yet the
complete lack of ornament proclaims its utilitarian pur-
pose. Warehouses and factories as commercial building
types had a history of their own going back to the later
eighteenth century. Richardson must have been familiar
with this tradition, which on occasion had produced
remarkably impressive "stripped-down" designs such as
those of the warehouses on New Quay, Liverpool (fig.
862). In contrast to these earlier structures, however,
the walls of the Marshall Field Wholesale Store do not
present a continuous surface pierced by windows; ex-
cept for the corners, which have the effect of heavy piers,
they show a series of superimposed arcades, like a Roman
aqueduct (see fig. 217), an impression strengthened by
the absence of ornament and the thickness of the
masonry (note how deeply the windows are recessed).
These arcaded walls are as functional and self-sustaining
as their ancient predecessors. They invest the building

with a strength and dignity unrivaled in any earlier com-
mercial structure. Behind them is an iron skeleton that
actually supports the seven floors, but the exterior does
not depend on it, either structurally or aesthetically. The
Field Store thus stands midway between the old and the
new: it embodies, with utmost severity and logic, a con-
cept of monumentality derived from the past, but its
opened-up walls, divided into vertical "bays," look for-
ward to the work of Louis Sullivan (1856–1924), the first
indisputably modern architect. The Wainwright Building
in St. Louis (fig. 864), Sullivan's first skyscraper, was de-
signed only five years after the Field Store. It, too, is
monumental, but in a very untraditional way. The organ-
ization of the exterior both reflects and expresses the
internal steel skeleton, in the slender, continuous brick
piers that rise between the windows from the base to the
attic. Their collective effect is that of a vertical grating
encased by the corner piers and by the emphatic hori-
zontals of attic and mezzanine. This is, of course, only
one of the many possible "skins" that could be stretched
over the structural frame; what counts is that we imme-
diately feel that this wall is derived from the skeleton
underneath, that it is not self-sustaining. "Skin" is
perhaps too weak a term to describe this brick sheath-
ing; to Sullivan, who often thought of buildings as anal-
ogous to the human body, it was more like the "flesh" and
"muscle" that is organically attached to the "bone" yet
capable of an infinite variety of expressive effects. When

865. LOUIS SULLIVAN. Carson Pirie Scott & Company,
Department Store. Chicago. 1899–1904

866. Detail, Carson Pirie Scott & Company

867. ANTONI GAUDÍ. Casa Milá Apartment House. Barcelona. 1905–7

868. Typical Floor Plan,
Casa Milá

869. CHARLES RENNIE MACKINTOSH. North Façade, Glasgow School of Art. 1896–1910

870. Interior of Library, Glasgow School of Art

he insisted that "form follows function," he meant a flexible relationship, not rigid dependence. The range of his invention becomes evident if we compare the Wainwright Building with his last skyscraper, the department store of Carson Pirie Scott & Company in Chicago, begun nine years later (figs. 865, 866). The sheathing of white terracotta here follows the grid of the steel frame far more closely, and the over-all effect is one of lightness and crispness rather than of harnessed energy. Yet the contrast between the horizontal continuity of the flanks and the vertical accent at the corner has been subtly calculated.

ART NOUVEAU

In Europe, meanwhile, the authority of the "revival styles" was being undermined by a movement now usually called by its French name, *Art Nouveau*, although it was known by various other names as well. It was primarily a new style of decoration, based on linear patterns of sinuous curves that often suggest water lilies. Its ancestor was the ornament of William Morris (see fig. 775). It is also related to the styles of such artists as Gauguin, Beardsley, and Munch (see colorplate 103, figs. 794, 797). During the 1890s and early 1900s its pervasive influence on the applied arts may be seen in wrought-iron work, furniture, jewelry, glass, typography, and even women's fashions; it had a profound effect on public taste, but did not lend itself easily to architectural designs on a large scale. The most remarkable instance is the Casa Milá in Barcelona (figs. 867, 868), a large apartment house by Antoni Gaudí (1852–1926).

It shows an almost maniacal avoidance of all flat surfaces, straight lines, and symmetry of any kind, so that the building looks as if it had been freely modeled of some malleable substance. (The material is not stucco or cement, as we might suppose, but cut stone.) The softly rounded openings anticipate the "eroded" shapes of Henry Moore's sculpture (see fig. 842); the roof has the rhythmic motion of a wave; and the chimneys seem to have been squeezed from a pastry tube. The Casa Milá expresses one man's fanatical devotion to the ideal of "natural" form; it could never be repeated, let alone developed further. Structurally, it is a tour de force of old-fashioned craftsmanship, an attempt at architectural reform from the periphery, rather than from the center. Gaudí and Sullivan stand at opposite poles, although both strove for the same goal—a contemporary style independent of the past.

Gaudí represents one extreme of *Art Nouveau* architecture; the Scotsman Charles Rennie Mackintosh (1868–1928) represents another. His basic outlook is so close to the functionalism of Sullivan that at first glance his work hardly seems to belong to *Art Nouveau* at all. The north façade of the Glasgow School of Art (fig. 869) was designed as early as 1896, but might be mistaken for a building done thirty years later. Huge, deeply recessed studio windows have replaced the walls, leaving only a framework of massive, unadorned cut-stone surfaces except in the center bay; this bay is "sculptured" in a style not unrelated to Gaudí's, despite its preference for angles over curves. Another *Art Nouveau* feature is the wrought-iron grillwork (here with a minimum of ornament). Even more surprising than the exterior is the two-story library (fig. 870), with its rectangular

871. HENRY VAN DE VELDE. Theater, Werkbund Exhibition, Cologne (destroyed). 1914

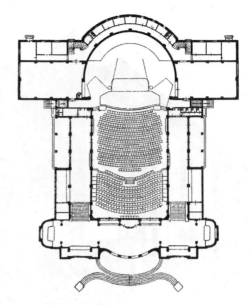

872. Plan of Theater, Werkbund Exhibition, Cologne

wooden posts and lintels supporting the balcony. The entire room has been designed in the spirit of Godwin's sideboard (see fig. 860), as it were, but Mackintosh shows an even finer sense of balance in the matching of voids and solids.

Through architectural magazines and exhibitions, Mackintosh's work came to be widely known abroad. Its structural clarity and force had a profound effect on one of the founding fathers of *Art Nouveau*, the Belgian Henry van de Velde (1863–1957). Trained as a painter, Van de Velde, under the influence of William Morris, had become a designer of posters, furniture, silverware, and glass; after 1900, he worked mainly as an architect. It was he who founded the Weimar School of Arts and Crafts in Germany, which became famous after the First World War as the Bauhaus (see page 708). His most ambitious building (figs. 871, 872), the theater he designed in Cologne for an exhibition sponsored by the Werkbund (arts-and-crafts association) in 1914, makes a telling contrast with the Paris Opéra (figs. 721, 722). Whereas the older building tries to evoke the splendors of the Louvre Palace, Van de Velde's exterior is a tautly stretched "skin" that covers—and reveals—the individual units of which the internal space is composed. It seems almost incredible that the Opéra should have been completed only forty years before.

The Werkbund exhibition of 1914 was a showcase for a whole generation of young German architects who were to achieve prominence after the hiatus of the First World War. Many of the buildings they designed for the fairgrounds anticipate ideas of the 1920s. Among the most adventurous is the staircase of the "Glass House" (fig. 873) by Bruno Taut (1880–1938)—made magically translucent by the use of glass bricks, then a novel material. Its structural steel skeleton is as thin and unobtrusive as the great strength of the metal permits. The total effect suggests Stella's Futurist *Brooklyn Bridge* (colorplate 114) translated into three dimensions.

873. BRUNO TAUT. Staircase of the "Glass House," Werkbund Exhibition, Cologne. 1914

WRIGHT

If Sullivan, Gaudí, Mackintosh, and Van de Velde represent, as it were, the Post-Impressionist stage of modern architecture, Sullivan's great disciple, Frank Lloyd Wright (1867–1959), was the first to reach its

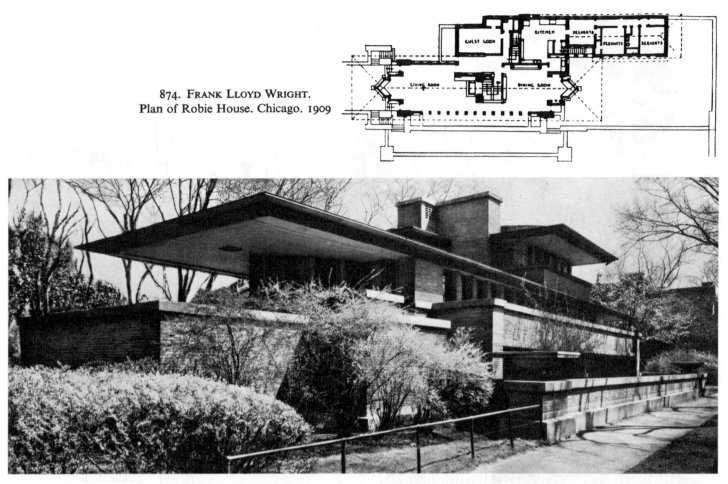

874. FRANK LLOYD WRIGHT.
Plan of Robie House. Chicago. 1909

875. FRANK LLOYD WRIGHT. Robie House

Cubist phase. This is certainly true of his brilliant early style, between 1900 and 1910, which had vast international influence. (His late work, beginning with the 1930s, will be omitted from this account.) During that first decade, Wright's main activity was the design of suburban houses in the Chicago area; these were known as "Prairie Houses," because their low, horizontal lines were meant to blend with the flat landscape around them. The last, and most accomplished, example in this series is the Robie House of 1909 (figs. 874, 875). Its "Cubism" is not merely a matter of the clean-cut rectangular elements composing the structure, but of Wright's handling of space. It is designed as a number of "space blocks" grouped around a central core, the chimney; some of the blocks are closed and others are open, yet all are defined with equal precision. Thus the space that has been architecturally shaped includes the balconies, terrace, court, and garden, as well as the house itself: voids and solids are regarded as equivalents, analogous in their way to facet Cubism in painting, and the entire complex enters into active and dramatic relationship with its surroundings. Wright did not aim simply to design a house, but to create a complete environment. He even took command of the details of the interior, and designed stained glass, fabrics, and furniture. The controlling factor here was not so much the

individual client and his special wishes as Wright's conviction that buildings have a profound influence on the people who live, work, or worship in them, so that the architect is really a molder of men, whether or not he consciously assumes this responsibility.

INTERNATIONAL STYLE

The work of Frank Lloyd Wright had attracted much attention in Europe by 1914. Among the first to recognize its importance were some young Dutch architects who, a few years later, joined forces with Mondrian in the De Stijl movement. The Schröder House in Utrecht (figs. 876, 877), designed in 1924 by Gerrit Rietveld (1888–1964), has a number of Wrightian features—the slablike, overhanging roof and the juxtaposition of closed and open blocks of space—combined with a façade that looks like a painting by Mondrian transposed into three dimensions (compare colorplate 116). At the end of the First World War, the De Stijl group represented the most advanced ideas in European architecture. Its austerely geometric designs, based on Mondrian's principle of an equilibrium achieved through the balance of unequal but equivalent oppositions, had a decisive influence on so many architects abroad that the movement soon became international. The largest and most complex example of

876. GERRIT RIETVELD. Schröder House. Utrecht. 1924

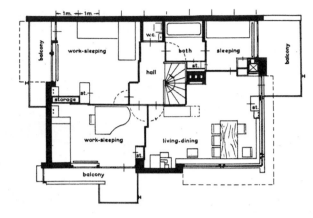

877. Plan of the Schröder House

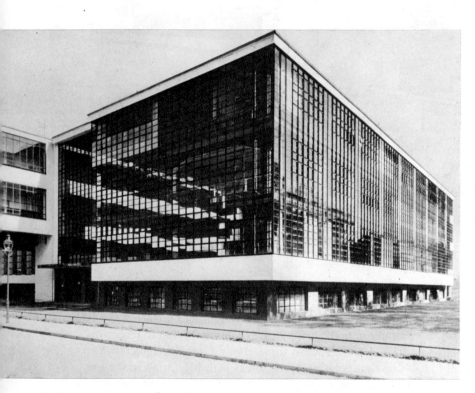

878. WALTER GROPIUS. Shop Block, the Bauhaus. Dessau, Germany. 1925–26

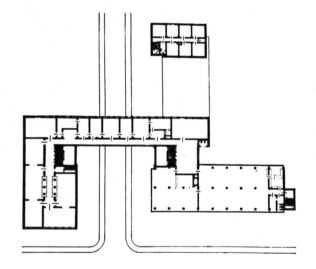

879. Plan, the Bauhaus

this "International Style of the 1920s" is the group of buildings created in 1925–26 by Walter Gropius (1883–1969) for the Bauhaus transferred to Dessau, the famous art school of which he was the director. (Its curriculum embraced all the visual arts, linked by the root concept of "structure," *Bau*.) The plant consists of three major blocks (fig. 879), for classrooms, shops, and studios, the first two linked by a bridge of ferroconcrete containing offices (fig. 878, extreme left). The most dramatic is the shop block, a four-story box with walls that are a continuous surface of glass. This radical step had been possible ever since the introduction of the structural steel skeleton several decades before, which relieved the wall of any bearing function; Sullivan had approached it in the Carson Pirie Scott & Co. store (fig. 865), but he could not yet free himself from the traditional notion of the window as a "hole in the wall." Gropius frankly acknowledges, at last, that in modern architecture the wall is no

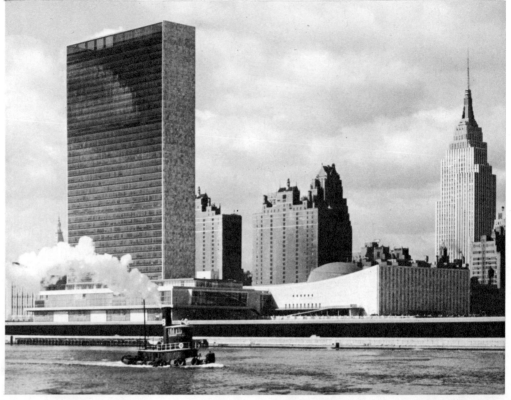

880. WALLACE K. HARRISON and
an International Advisory Committee
of Architects (LE CORBUSIER,
OSCAR NIEMEYER, and others).
United Nations Buildings.
New York. 1949–51.

more than a curtain or climate barrier, which may consist
entirely of glass if maximum daylight is desirable. A
quarter-century later, the same principle was used on a
much larger scale for the two main faces of the great slab
that houses the Secretariat of the United Nations
(fig. 880). The effect is rather surprising: since such walls
reflect as well as transmit light, their appearance depends
on the interplay of these two effects. They respond, as it
were, to any change of conditions without and within,
and thus introduce a strange quality of life into the
structure. (The mirror-like finish of Brancusi's sculpture
serves a similar purpose.)

In France, the most distinguished representative of
the "International Style" during the 1920s was the
Swiss-born architect Le Corbusier (Charles Edouard
Jeanneret, 1886–1965). At that time he built only private
houses—from necessity, not choice but these are as
important as Wright's "Prairie Houses." Le Corbusier
called them *machines à habiter* (machines to be lived in),
a term intended to suggest his admiration for the
clean, precise shapes of machinery, not a desire for
"mechanized living." (The paintings of his friend Fer-
nand Léger during those years reflect the same attitude:
colorplate 115.) Perhaps he also wanted to imply that his
houses were so different from conventional homes as to
constitute a new species. Such is indeed our impression
as we approach the most famous of them, the Savoye
House at Poissy-sur-Seine (fig. 881): it resembles a low,
square box resting on stilts—pillars of reinforced con-
crete that form part of the structural skeleton and
reappear to divide the "ribbon-windows" running along
each side of the box. The flat, smooth surfaces, denying
all sense of weight, stress Le Corbusier's preoccupation

881. LE CORBUSIER. Savoye House.
Poissy-sur-Seine, France. 1929–30

882. Interior, Savoye House

883. George Howe and William E. Lescaze.
Philadelphia Savings Fund Society Building.
Philadelphia. 1931–32

884. Ludwig Mies van der Rohe.
Lake Shore Drive Apartment Houses.
Chicago. 1950–52

885. Le Corbusier.
Unité d'Habitation
Apartment House.
Marseilles. 1947–52

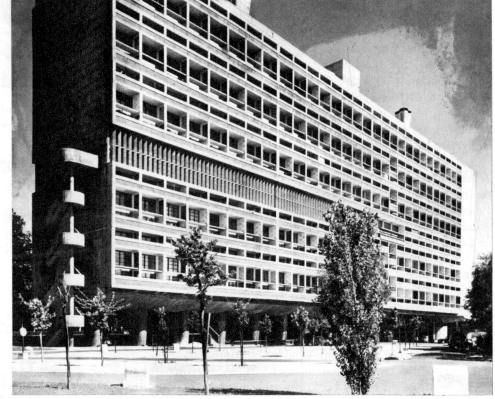

with abstract "space blocks." In order to find out how the box is subdivided, we must enter it (fig. 882): we then realize that this simple "package" contains living spaces that are open as well as closed, separated by glass walls. Within the house, we are still in communication with the outdoors (views of the sky and the surrounding terrain are everywhere to be seen). Yet we enjoy complete privacy, since an observer on the ground cannot see us unless we stand next to a window. The functionalism of the Savoye House thus is governed by a "design for living," not by mechanical efficiency.

America, despite its early position of leadership, did not share the exciting growth that took place in European architecture during the 1920s. The impact of the "International Style" did not begin to be felt on this side of the Atlantic until the very end of the decade. A pioneer example is the Philadelphia Savings Fund Society Building of 1931–32 (fig. 883), by George Howe (1886–1954) and William E. Lescaze (born 1896), a skyscraper in the tradition of Sullivan that incorporates in its design many features evolved in Europe since the end of the First World War. During the following years, the best German architects, whose work Hitler condemned as "un-German," came to this country and greatly stimulated the development of American architecture. Gropius, who was appointed chairman of the architecture department at Harvard University, had an important educational influence; Ludwig Mies van der Rohe (1887–1969), his former colleague at Dessau, settled in Chicago as a practicing architect. The Lake Shore Drive apartment houses (fig. 884), two severely elegant slabs placed at right angles to each other, exemplify Mies van der Rohe's dictum that "less is more." He is the great spiritual heir of Mondrian among contemporary designers, possessed of the same "absolute pitch" in determining proportions and spatial relationships.

Later Work of Le Corbusier

Le Corbusier, in contrast to Mies van der Rohe, abandoned the geometric purism of the "International Style." "His work after the 1930s shows a growing preoccupation with sculptural, even anthropomorphic effects. Thus the Unité d'Habitation, a large apartment house in Marseilles (fig. 885), is a "box on stilts" like the Savoye House, but the pillars are not thin rods; their shape now expresses their muscular strength in a way that makes us think of Doric columns. The exposed staircase on the flank, too, is vigorously sculptural, and the flat plane of the all-glass façade has a honeycomb-screen of louvers and balconies that forms a sun-break but also enhances the three-dimensional quality of the structure. This projecting screen has proved to be an invention of great importance, practically and aesthetically; it is now a standard feature of modern architecture throughout the tropics (Le Corbusier himself introduced it in India and Brazil).

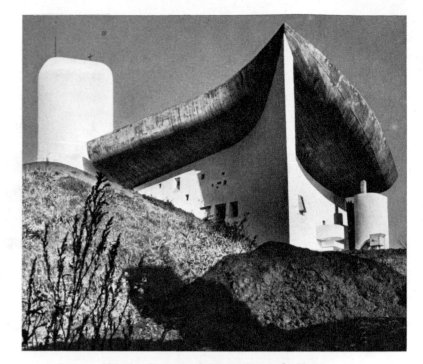

886. LE CORBUSIER. Notre-Dame-du-Haut, from the southeast. Ronchamp, France. 1950–55

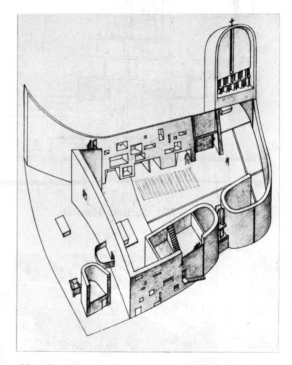

887. Perspective diagram, Notre-Dame-du-Haut, from the northeast

The most revolutionary building of the mid-twentieth century, however, is Le Corbusier's church of Notre-Dame-du-Haut at Ronchamp in eastern France (figs. 886, 887, colorplate 142). Rising like a medieval fortress from a mountain crest, its design is so irrational that it defies analysis, even with the aid of perspective diagrams. The play of curves and countercurves is here as insistent

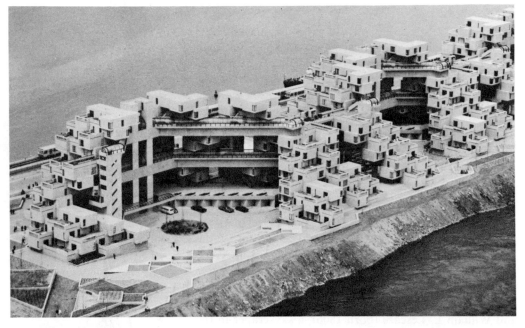

888. MOSHE SAFDIE
and others.
Habitat, EXPO 67,
Montreal. 1967

889. Section, Habitat

890. Detail, Habitat

as in Gaudí's Casa Milá, though the shapes are now simpler and more dynamic: the massive walls seem to obey an unseen force that makes them slant and curl like paper; and the overhanging roof suggests the brim of an enormous hat, or the bottom of a ship split lengthwise by the sharp-edged buttress from which it is suspended. If the Casa Milá brings to mind the "eroded" softness of Henry Moore's *Recumbent Figure,* Ronchamp has the megalithic quality of the same artist's *Two Forms* (see fig. 841). This evocation of the dim, prehistoric past is quite intentional: asked to create a sanctuary on a mountain top, Le Corbusier must have felt that this was the primeval task of architecture, placing him in a direct line of succession with the men who had built Stonehenge, the ziggurats of Mesopotamia, and the Greek temples. Hence, he also consciously avoids any correlation between exterior and interior. The doors are concealed: we must seek them out like clefts in a mountainside, and to pass through them is much like entering a secret—and sacred—cave. Only inside do we sense the specifically Christian aspect of Ronchamp. The light, channeled through stained-glass windows so tiny that they seem hardly more than slits or pinpricks on the exterior, cuts widening paths through the thickness of the wall, and thus becomes once more what it had been in medieval architecture—the visible counterpart of the Light Divine. There is true magic in the interior of Ronchamp, but also a strangely disquieting quality, a nostalgia for the certainties of a faith that is no longer unquestioned. Ronchamp mirrors the spiritual condition of modern man—which is a measure of its greatness as a work of art.

URBAN PLANNING

Le Corbusier belongs to the same heroic generation as Gropius, Rietveld, and Mies van der Rohe, all born in the 1880s. It was these men who in the course of their

Colorplate 136. EDWARD KIENHOLZ. *The State Hospital*. 1966.
Mixed mediums, 8 × 12 × 10′. Museum of Modern Art, Stockholm

Colorplate 137. DON EDDY. *New Shoes for H*. 1973–74. Acrylic on canvas, 44 × 48″.
The Cleveland Museum of Art (Purchased with a grant from the National Endowment for the Arts
matched by gifts from members of The Cleveland Society for Contemporary Art)

Colorplate 138. RICHARD ANUSZKIEWICZ. *Entrance to Green*. 1970. Acrylic on canvas, 108 × 72″.
Collection Sidney Janis Gallery, New York

Colorplate 139. JOHN CHAMBERLAIN. *Essex*. 1960. Automobile parts and other metal, 9′ × 7′ 6″ × 43″ (relief).
The Museum of Modern Art, New York (Gift of Mr. and Mrs. Robert C. Scull and Purchase)

Colorplate 140. ALEXANDER CALDER. *Lobster Trap and Fish Tail* (mobile). 1939. Steel wire and sheet aluminum, c. 8' 6" × 9' 6".
The Museum of Modern Art, New York (Gift of the Advisory Committee)

Colorplate 141. CLAES OLDENBURG. *Late Submission to the Chicago Tribune Architectural Competition of 1922:*
Clothespin (Version Two). 1967. Pencil and colored crayon on paper, 22 × 23¹/₄″.
Des Moines Art Center (Gift of Gardner Cowles by exchange and partial gift of Charles Cowles, 1972)

Colorplate 142. LE CORBUSIER. Interior, toward south. Notre-Dame-du-Haut, Ronchamp, France. 1950–55

Colorplate 143. JAPANESE. *Jigoku Sōshi (Hell Scroll)*. Early Kamakura Period, about 1200 A.D. Paper, height 10″. National Museum, Tokyo

long, fruitful careers coined the language of twentieth-century architecture. Their successors continue to use it, adapting its vocabulary to new building types and materials but not questioning its fundamental logic. To younger architects today, the greatest challenge is not the individual structure but urban design: replacing the slums of our decaying cities with housing that will provide a socially healthful environment for very large numbers of people. Urban planning is probably as old as civilization itself (which, we recall, means "city life"). We have caught only occasional glimpses of it in this book (see pages 152, 157–59, 328), since its history is difficult to trace by direct visual evidence: cities, like living organisms, are ever-changing, and to reconstruct their past from their present appearance is a laborious task. With the advent of the industrial era two centuries ago, cities began to grow explosively, and have continued to do so ever since. Much of this growth was uncontrolled beyond the laying out of a network of streets; housing standards were poor or poorly enforced. The unfortunate result can be seen in the overcrowded, crumbling apartment blocks that are the blight of vast urban areas everywhere. They were taken over by the poor, while those who could afford it fled to the dormitory towns of suburbia. This exodus, accelerated by the automobile, has produced the dangerous tensions that lend urgency to the cry for urban renewal today. Such renewal, needless to say, must involve the political, social, and economic forces of our entire society, rather than the architect alone. Yet the architect has an essential role in the process, for it is he —and he only—who will have to translate the schemes of the planning agencies into reality. One important problem engaging his attention is how to develop an alternative to the conventional high-rise apartment block in densely populated areas: a housing pattern that will be less deadeningly uniform (but no more expensive), and provide more light and air, safer access, and a multitude of other desirable features. One promising solution, by the Israeli architect Moshe Safdie and his associates (figs. 888–90), was recently demonstrated in the Habitat complex at the Montreal EXPO 67. The individual apartments consist of prefabricated "boxes" that can be combined into units of several sizes and shapes, attached to a zigzagging concrete framework which can be extended to fit any site (fig. 889). If the result looks a bit like a Chinese puzzle (fig. 888), this impression disappears as we enter the complex and enjoy its openness, its fascinating variety of perspectives (fig. 890). It is in enterprises like this that the architects of the future may well find their most fruitful fields of endeavor.

The Meeting of East and West

The author of a history of art for the general reader faces one dilemma at the outset: should he proportion his book to give equal weight to every significant area? If not, what should he leave out? Fortunately, perhaps, no one solution to this problem is clearly superior to the others we might think of. Encyclopedic breadth and historic continuity can be balanced against each other in countless ways, and the pattern of the present volume has, like the rest, the defects of its virtues. The purpose of this postscript is to take the reader on a brief excursion through the domains we have so far omitted, and by showing him a small sample of the wealth of material he will find there, to whet his appetite for a longer stay.

Our interest in the past springs from a desire to understand the present. Behind it lies always the question, "how did we get to where we are now?" For the historian of art, "now" means the living art of our century; this art is the product of Western civilization on both sides of the Atlantic. We have, accordingly, discussed in this book only those elements outside Europe and America that have contributed to the growth of the Western artistic tradition: prehistoric and primitive art, as well as the art of Egypt, the ancient Near East, and Islam. Three major areas have been omitted—Indian Asia, China and Japan, and pre-Columbian America—because their indigenous artistic traditions are no longer alive today, and because these styles did not, generally speaking, have a significant influence on the West. But, even if they are not essential for our account, they are nevertheless important in their own right; a book half again as large as this, with three hundred more pages and five hundred more illustrations, would certainly include them. The very fact that the ancient arts of India, the Far East, and America are so admired in the West today suggests their relevance to the modern world. They may yet become a vital source of inspiration for Western art. If they failed to do so in the past, even after the West had learned of their existence, this was not because they were "less advanced." More often, it was because they were "too refined"; their style, the result of many centuries of continuous development, was keyed to special sensibilities alien to the Western tradition.

INFLUENCE OF EAST ON WEST

This is true particularly of the art of the Far East. Printing from wood blocks, we recall, was a Chinese invention taken over by the West (pages 366–67). We do not know which Chinese prints actually reached medieval Europe, but they might have included woodcuts like

891. *Landscape with a Hermit-Priest.* Chinese (from the first printed Buddhist Canon). Northern Sung Dynasty, 971–983 A.D. Woodcut on paper. Fogg Art Museum, Harvard University, Cambridge, Massachusetts

892. FAN K'UAN. *Travelers on a Mountain Path.*
c. 1000 A.D. Hanging scroll, ink and colors on silk,
height 81 1/4". Chinese National Palace Museum,
Taichung, Taiwan

893. *Hunting and Threshing Scene.*
Later Han Dynasty, 25 B.C.–221 A.D. 16 1/2 × 18". Rubbing
from a Tomb Tile from Ch'êng-tu, Szechwan,
China, Richard Rudolph Collection, California

894. Detail of the *Chōjū Giga.* 12th century. Hand
scroll, ink on paper, height 12". Kōzan-ji, Kyoto, Japan

895. *Dragon.* Late Chou Dynasty, 6th–3rd century.
Bronze, height c. 25 1/2". Collection Jacques Stoclet, Brussels

the splendid *Landscape* (fig. 891), from a recently dis-
covered set of four, dated 971–983 A.D. It represents,
skillfully transcribed into black-and-white, the atmos-
pheric style of the great landscape painters of the period,
such as Fan K'uan (fig. 892). Its origins can be traced
back at least eight hundred years (fig. 893). After so long
a period of growth, this art had achieved a poetic vision
of nature that contrasts the majesty of mist-shrouded
mountains with the insignificance of man. Who in the
West could have responded to the pictorial and emotion-
al subtlety of such works? Chinese silks and porcelains,
we know, were greatly admired in the Middle Ages, but
no one, we suspect, could appreciate Chinese landscapes
until the mid-fourteenth century, when Europe re-
established its own tradition of landscape painting. Am-

896. KITAGAWA UTAMARO.
House Cleaning at the End of the Year
(one of five scenes). c. 1800. Colored woodcut.
Nelson Gallery-Atkins Museum, Kansas City, Missouri

897. CH'ÊN JUNG. *Nine Dragon Scroll* (detail).
1244. Ink and slight color on paper, height 18 1/4".
Museum of Fine Arts, Boston

brogio Lorenzetti might be the first (colorplate 41), yet to him, as to the Greeks and Romans, a landscape was "the countryside," the scene of purposeful human action, not lonely, untamed nature. Perhaps Leonardo would have understood the Chinese attitude, and after him Altdorfer, Bruegel, and Ruisdael (see figs. 544, 610, 663, colorplate 72), but all would have wondered at the fact that these landscapes do not tell us where the beholder stands in relation to the view depicted (the Chinese artist assumes that the beholder is *in* the landscape, not looking *at* it from the outside).

Other aspects of Far Eastern painting would have struck a more responsive chord, had they been accessible to the medieval West. The charmingly drawn animals burlesquing human actions in a Japanese scroll of the twelfth century (fig. 894) seem to anticipate the *drôleries* of Gothic illuminated manuscripts (see fig. 457). While not directly related, both works share a common ancestry in the animal fables of ancient Mesopotamia (see fig. 85), which proliferated in India and the Far East as well as in the West. (One collection of Indian animal stories, translated from Sanskrit into Arabic and thence into Latin and the modern languages, was very popular in the later Middle Ages and furnished motifs for *drôleries*.) Heaven and Hell, too, are to be found in both East and West. The Buddhist Hell dramatically visualized in a Japanese scroll of c. 1200 A.D. (colorplate 143) could well be part of a Christian Last Judgment, with its anguished, naked souls and gruesome demons—although no Western artist then knew how to depict flames so vividly. This graphic formula, invented by the Chinese many centuries before, traveled west as far as Persia; we encounter it in the *Ascension of Mohammed* (colorplate 29), a composition that borrows some aspects of the Buddhist Paradise. The last two illustrations represent a Far Eastern tradition of expressive realism that had its final flowering more than five hundred years later in the Japanese color woodcut. Our example (fig. 896), by Kitagawa Utamaro (1753–1806), belongs to a set, *House Cleaning at the End of the Year;* the women are about to "discard" a drowsy young man, left over from the celebration the night before, whom they have found in the course of their cleaning. It was Japanese woodcuts that finally aroused a serious interest in Far Eastern art among Western painters. They began to be imported into Paris soon after trade between Japan and the West had been opened in 1854, and they remained in vogue for more than half a century. Manet was impressed with their bright, flat colors, which corresponded to his own style (see colorplate 96); Whistler liked their decorative effect; Van Gogh, Toulouse-Lautrec, and the Symbolists admired the expressiveness of the simple, smoothly curved outlines. How important these prints were to the development of Impressionism, Post-Impressionism, and *Art Nouveau* is hard to estimate, but their influence is clear in many cases. Ironically, it was their abstractness, not their realism, that made them interesting to Western eyes; no less ironically, they helped pave

898. *Lion Capital,* from a Column erected by King Aśoka. 242–232 B.C. Height 7′. Archaeological Museum, Sārnāth, India

899. *Seated Buddha,* from Gandhāra. 3rd century A.D. Schist, height 36″. Seattle Art Museum

900. *Standing Buddha,* from Mathurā. 5th century A.D. Height 85 1/2″. Indian Museum, Calcutta

the way for the modern artist's rediscovery of medieval stained glass and primitive art.

INFLUENCE OF WEST ON EAST

What of Western influence on the East? Historic—that is, urban—civilization had begun in Mesopotamia about 3500 B.C. (see pages 51–52, 67–68). The earliest urban settlements in India, those at Mohenjo-Daro and Harappa on the Indus River, appeared somewhat later, and the few artistic remains uncovered there indicate early Mesopotamian influences. It may well be that urban civilization spread from the Tigris and Euphrates westward to the Nile and eastward to the Indus and thence to the Yellow River, where Chinese urban settlements began to appear toward 1500 B.C. Contact between the Near East and China continued to be maintained by migratory tribes, although it is sometimes hard to say which way these influences went. Some early Chinese bronzes, such as the magnificent *Dragon* (fig. 895), bring to mind the nomadic "animal style" that ranged, at one time or another, from Siberia to Western Europe and from Iran to Scandinavia (see figs. 98, 99, 326, 327). In our example, the creature already looks as unmistakably Chinese as its descendants fifteen hundred years later (fig. 897). India's link with the West is far more definite. Persian influence prevailed under King Aśoka (272–232 B.C.), the

901. *Yakshī,* East Gate, Stūpa No. 1. Early 1st century B.C. Sānchī, India

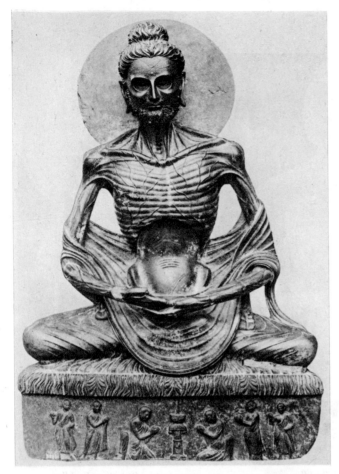

902. *The Fasting Buddha,* from Gandhāra.
2nd or 3rd century A.D. Central Museum, Lahore, Pakistan

903. *Portrait of the Priest Ganjin.* 763–784 A.D.
Dry lacquer, height 32″. Tōshōdai-ji, Nara, Japan

904. *The "Beautiful Bodhisattva" Padmapani*
(detail of wall painting). c. 600–642 A.D.
Cave No. I, Ajantā, India

first Buddhist ruler of Northern India; it is clearly seen in the capitals of the commemorative columns he erected (fig. 898), apparently the earliest Indian sculpture on a monumental scale (compare fig. 101). There was also, however, a native sculptural tradition of soft, sensuously full forms, which can be traced back to the Indus valley settlements. This absorbed the Persian elements, and within two centuries produced its finest monument, the carved gateways of the Great Stūpa at Sānchī (fig. 901; note the winged lions, a Mesopotamian-Persian motif, in the upper left-hand corner). Meanwhile, the extreme northwest region of India—called Bactria in antiquity, later known as Gandhāra, corresponding to modern Afghanistan and a corner of Pakistan—had come under Greek rule as one of the conquests of Alexander the Great (see fig. 197). It remained a focus of Graeco-Roman artistic influence for several centuries. The role of this influence in creating the earliest images of the Buddha (who until the second century A.D. had been represented only through symbols) remains a matter of dispute, but it had an undeniable share in the process. Two distinct types seem to have made their appearance about the same time, both of them meditative and immobile; that from Gandhāra combines the Indian sculptural tradition with Western Classical elements (fig. 899); the other, originating at Mathurā in north central India, represents a purely native style. For two or three centuries they existed side by side, and the Gandhāra style produced such

906. *Wrestler* (Olmec), from Minatitlan. 12th–6th century B.C.(?). Basalt, height 26″. National Museum, Mexico City

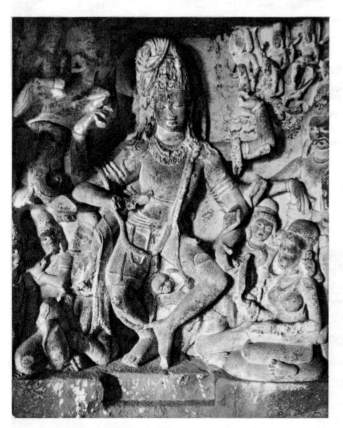

905. *Siva as King of Dancers.* c. 640–675 A.D. Cave No. 21, Elūrā, India

variants as the *Fasting Buddha* (fig. 902), strangely evocative of the emotionalism of Gothic sculpture (see figs. 429, 437). Eventually the two types coalesced (fig. 900) and migrated east as Buddhism expanded into China and Japan. The fine Japanese portrait statue of *Ganjin* (fig. 903), dated 763–784 A.D., still betrays echoes of the Gandhāra style. In India, however, Buddhism had meanwhile been engulfed by the older native religion, Hinduism. The "Beautiful Bodhisattva" (fig. 904), from the great cycle of wall paintings in Cave No. 1 at Ajantā, after 600 A.D., has the swelling, sensuous softness we recall from the sculpture at Sānchī as the ancient heritage of Indian art. We find it again later on in the carvings of the Hindu cave temples at Elūrā (fig. 905).

PRE-COLUMBIAN AMERICA

Of the three major non-Western civilizations, that of pre-Columbian America is by far the youngest. Exactly when man first arrived in the New World—presumably from Siberia by way of Alaska—remains in dispute; it may have been as recently as 10,000 B.C., but much earlier dates have been suggested. In any event, the Neolithic Revolution does not seem to have begun in Central America before c. 3000 B.C., and, in South America, before c. 2000 B.C. The transition from prehistory to

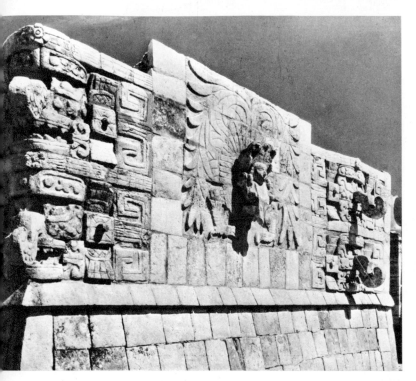

907. Temple of the Warriors (detail). Chichén Itzá, Yucatán. 11th century

history, which took place in Mesopotamia and Egypt between 3500 and 3000 B.C., probably occurred between 1000 B.C. and 1 A.D., but much of the evidence concerning the beginnings of theocratic rule, of literacy, and of monumental architecture is conjectural, and the earliest monuments of historic American civilization brought to light so far belong near the end of the pre-Christian era. Compared to what we know about India and the Far East, our knowledge of pre-Columbian America is limited indeed. Its very isolation from the rest of the world, however, makes its study peculiarly fascinating. Was this isolation, we wonder, really complete, especially during the historic period (c. 1–1500 A.D.)? If so, then the resemblances and analogies between pre-Columbian America and the civilizations of the Old World must result from a parallel evolution of human culture that made the American Indian "re-invent," on his own, many things already invented elsewhere. The

908. *Coatlicue (Goddess of Earth and Death).* Aztec, 15th century. Height 99". National Museum, Mexico City

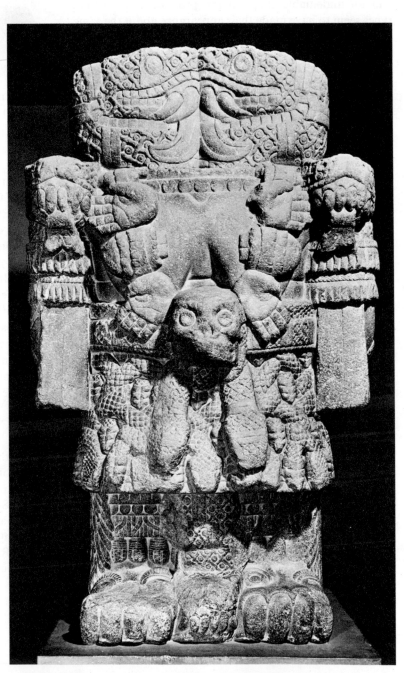

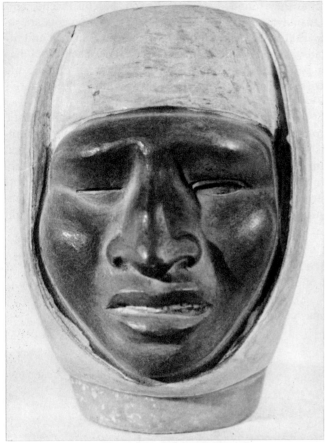

909. Portrait Jar (Mochica). 400–1000 A.D. Clay, height 4 1/8″. Collection Norbert Mayrock, Santiago, Chile

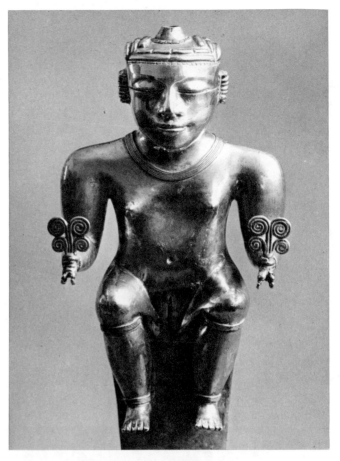

910. *Seated Female Figure* (Quimbaya), from Cauca, Colombia. 11th–14th century. Gold, height 11 1/2″. Museo Arqueológico de América, Madrid

problem will probably be debated for a long time, for both the similarities and the differences are tantalizing. What, for instance, are we to make of the impressive *Wrestler* (fig. 906), produced by the Olmec civilization of southeastern Mexico? Is he really a wrestler? The present name of the figure merely records its striking resemblance to Japanese wrestlers. And why did the Olmecs, alone among pre-Columbian groups, develop so vigorous a three-dimensional and realistic style of sculpture in the round? Elsewhere in Central or South America, monumental stone sculpture is closely bound up with architecture, as in the Temple of the Warriors at Chichén Itzá, Yucatán (fig. 907), where the artistic traditions of the Maya and Toltec peoples are combined. Such temples rise from platforms on top of pyramid-like, stepped mounds that are oddly analogous to the ziggurats of Mesopotamia (see pages 68–69). The highly formalized style of Maya sculpture, its angularity and ornamental symmetry, reappears later in the art of the Aztecs, who rose to power near what today is Mexico City, less than two centuries before the Spanish Conquest. The statue of Coatlícue, the goddess of earth and death (fig. 908), resembles a human figure less than it does a huge architec-

tural block that has been turned into a compound creature of terrifying "otherness." (How restrained the Gorgon from the Artemis Temple on Corfu looks by comparison—see fig. 138.)

The Andean civilization of South America, centered on Peru, had a development roughly parallel to that of Central America. While it produced no stone sculpture comparable to the Olmec *Wrestler*, the anthropomorphic pottery of the Mochica is often even more intensely realistic. The portrait jar in figure 907 has great individuality and expressive power. Andean art also includes masterpieces of jewelry and sculpture in gold. The seated female figure, from a hoard found at Cauca, Colombia (fig. 910), must surely have been a cult object—probably a goddess of fertility. Despite its modest size, the image has extraordinary dignity. It is one of the very few surviving pieces of those legendary treasures of "Inca gold," that were melted down for their material value by the Spanish conquistadors. The Incas themselves had conquered the Peruvian highlands only in the fourteenth century; like the Aztecs, they were warriors rather than artists. Only their architectural achievements were important, and palaces, fortifications, and temples still dominate the

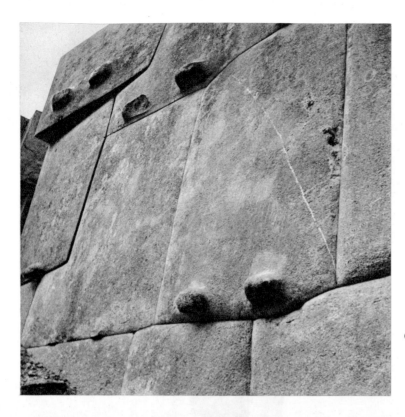

cities they founded, such as Cuzco, Machu Picchu, and Ollantaytambo (figs. 911, 912). These monuments are remarkable for their "sculptured" masonry, shaped and fitted with incredible precision. Sometimes each block has a pair of protuberances, which suggest an organic life within the stone somewhat like that of Henry Moore's *Two Forms* (see fig. 841).

The rapid disappearance of pre-Columbian artistic traditions in the sixteenth century is even more astonishing than the ease with which the Spaniards defeated the Aztec and Inca empires. European artists and collectors admired the technical perfection of the objects brought back by the conquistadors, but were not impressed with their beauty. Only the present has taught us to see them as works of art.

911. Inca Masonry.
Ollantaytambo, Peru. 15th century

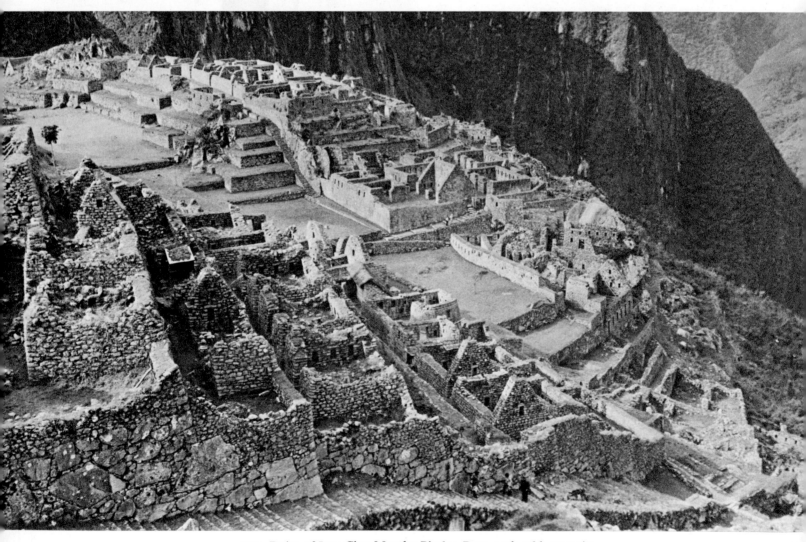

912. Ruins of Inca City, Macchu Picchu, Peru. 15th–16th centuries

ILLUSTRATED TIME CHART IV

POLITICAL HISTORY, RELIGION

LITERATURE, SCIENCE, TECHNOLOGY

PAINTING, SCULPTURE, ARCHITECTURE

Edmund Burke (1729–97)

Gray's *Elegy* 1750
Diderot's *Encyclopedia* 1751–72
Johnson's *Dictionary* 1755
Macpherson's "Ossian" forgeries 1760–63
Rousseau's *Social Contract* and *Emile* 1762
Mechanization of textile spinning 1764–69
Priestley discovers oxygen 1774
Goethe's *Sorrows of Young Werther* 1774
Coke-fed blast furnaces for iron smelting perfected c. 1760–75

Horace Walpole, Strawberry Hill
Soufflot, Panthéon, Paris
Greuze, *Village Bride*
West, *Death of Wolfe*
Stubbs, *Lion Attacking Horse*
Robert Adam, Home House, London

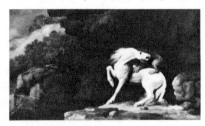

1775

American Revolution 1775–85; Constitution adopted 1789
First British governor general of India appointed 1784
French Revolution 1789–1802; Louis XVI beheaded, Reign of Terror under Robespierre 1793
Consulate of Napoleon 1799–1804

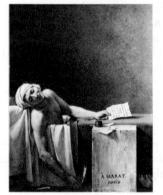

Gibbon's *Decline and Fall of the Roman Empire* 1776–87
Adam Smith's *Wealth of Nations* 1776
Kant's *Critique of Pure Reason* 1781
First aerial crossing of English Channel (in hydrogen-filled balloon) 1785
Paine's *The Rights of Man* 1790
Marquis de Sade's *Justine* 1791
Power loom 1785; cotton gin 1792
Lavoisier (1743–94)
Hutton's *Theory of the Earth* 1795
Laplace's nebular hypothesis 1796
Jenner's smallpox vaccine c. 1798
Wordsworth and Coleridge, *Lyrical Ballads,* 1798

Jefferson, Monticello, Charlottesville
Copley, *Watson and the Shark*
Houdon, *Voltaire*
Cozens, *A New Method . . .*
Fuseli, *Nightmare*
David, *Death of Socrates*
Langhans, Brandenburg Gate, Berlin
Houdon, *Washington*
David, *Death of Marat*
David, *View of Luxembourg Gardens*
Blake, *The Ancient of Days*
Gros, *Napoleon at Arcole*
Canova, Tomb of Maria Christina, Vienna

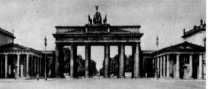

1775

1800

Louisiana Purchase 1803
Napoleon (1769–1821) crowns himself emperor 1804; fails in Russian campaign 1812; beaten at Leipzig, exiled to Elba 1814; defeated at Waterloo, exiled to St. Helena 1815
Revolution in Latin America led by Simon Bolivar (1783–1830) gains independence for Spanish colonies 1822
Greeks declare independence 1822
Monroe Doctrine proclaimed 1823

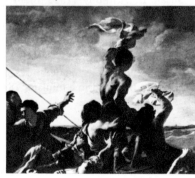

Volta invents electric battery 1800
First voyage of Fulton's steamship 1807; first Atlantic crossing 1819
Hegel (1770–1831) writes *Phenomenology of Mind* 1807
Goethe's *Faust:* Part I, 1808; Part II, 1833
Madame de Staël's *De l'Allemagne* 1810
Byron's *Childe Harold's Pilgrimage* 1812–18
Saint-Simon's ideals for the reorganization of European society 1814
Stephenson's first locomotive 1814
Cuvier's work on paleontology 1815
Shelley (1792–1822) publishes *Adonais* 1821
Faraday discovers principle of electric dynamo 1821
Sir Walter Scott (1771–1832) publishes Waverly novels

Goya, *Family of Charles IV*
Latrobe, Catholic Cathedral, Baltimore
Canova, *Pauline Borghese*
Géricault, *Mounted Officer*
Ingres, *Odalisque*
Goya, *Third of May . . .*
Nash, Brighton Pavilion
Géricault, *Raft of the "Medusa"*
Delacroix, *Massacre at Chios*
Friedrich, *Polar Sea*

1800

1825

1825

Andrew Jackson president 1829–37

July Revolution of 1830 in France

Whigs in England end Tory rule 1830; political and social reforms 1832–35

France conquers Algeria 1830–47

Queen Victoria crowned 1837

British win Hong Kong 1841

U.S. treaty with China opens ports 1844

U.S. annexes western land areas 1845–60

Famine in Ireland, mass emigration 1845

Proudhon founds anarchism 1846

Parliament repeals Corn Laws 1846

Marx and Engels, *Communist Manifesto* 1848

Revolution of 1848: fails in Germany, Hungary, Austria, Italy; France sets up Second Republic (Louis Napoleon)

Erie Canal opened 1825

First railway completed (England) 1825

Pushkin (1799–1837) writes *Eugene Onegin* 1825–31

Grandville (Jean Ignace Isidore Gérard, 1803–47) publishes *Les Métamorphoses du jour* 1828

Stendhal (1783–1842) publishes *The Red and The Black* 1831; *The Charterhouse of Parma* 1839

Victor Hugo (1802–85)

McCormick invents reaper 1831; John Deere perfects steel plow

Gogol (1809–52) writes satirical drama *The Inspector General* 1836

Dickens' *Oliver Twist* 1838

Balzac (1799–1850) writes the 92 novels and stories that comprise *La Comédie Humaine*

Daguerreotype process of photography introduced 1839

Carlyle's *On Heroes, Hero-Worship, and The Heroic in History* 1841

Kierkegaard (1813–55) publishes *Either/Or* 1843

Edgar Allan Poe (1809–49) publishes *The Raven and Other Poems* 1845

Morse perfects telegraph 1844

Joule formulates First Law of Thermodynamics 1847

1850

Louis Napoleon takes title of Napoleon III 1852

Crimean War 1853–55; England and France halt Russia's advance into Balkans

Perry opens Japan 1854

Unification of Italy 1860–70

Russia abolishes serfdom 1861

Frederick Douglass (c. 1817–95) becomes American abolitionist leader

U.S. Civil War (1861–65) ends slavery; Lincoln assassinated 1865

Russia sells Alaska to U.S. 1867

Canada granted dominion status 1867

Marx, *Das Kapital* 1867–94

Susan B. Anthony (1820–1906) organizes National Woman Suffrage Association (with Elizabeth Cady Stanton) 1869

Franco-Prussian War 1870–71; Third Republic in France; Bismarck becomes first chancellor of German empire

Disraeli, British prime minister 1874–80

Tennyson made poet laureate 1850

Lord Kelvin states Second Law of Thermodynamics 1851

Melville's *Moby Dick* 1851

Whitman's *Leaves of Grass* 1855

Flaubert (1821–80) writes *Madame Bovary* 1856

First transatlantic cable laid 1858–66

Darwin publishes *Origin of Species* 1859

First oil well drilled (Pennsylvania) 1859

Bessemer patents tilting converter for steel manufacture 1860

Baudelaire (1821–67) publishes *Les Fleurs du Mal* 1857 (enlarged editions, 1861, 1868)

Pasteur develops germ theory 1864

Tolstoy's *War and Peace* 1864–69

Mendel publishes first experiments in genetics 1865

Lewis Carroll's *Alice in Wonderland* 1865

Dostoyevsky's *Crime and Punishment* 1867

Nobel invents dynamite 1867

First transcontinental railroad completed in America 1869

Suez Canal opened 1869

Maxwell's *Electricity and Magnetism* 1873

1875

Corot, *View of Papigno*
Ingres, *Louis Bertin*
Préault, *Slaughter*
Rude, *La Marseillaise*
Barry and Pugin, Houses of Parliament, London
Constable, *Stoke-by-Nayland*
Turner, *Slave Ship*
Labrouste, Bibliothèque Ste.-Geneviève, Paris
Bingham, *Fur Traders*
Courbet, *Stone Breakers*
Rossetti, *Ecce Ancilla Domini*

Millet, *The Sower*
Barye, *Jaguar and Hare*
Paxton, Crystal Palace, London
Brown, *The Last of England*
Courbet, *Interior of My Studio . . .*
Rude, *Marshal Ney*
Garnier, Opéra, Paris
Daumier, *Third-Class Carriage*
Manet, *Luncheon on the Grass*
Rodin, *Man with Broken Nose*
Homer, *Morning Bell*
Carpeaux, *The Dance*
Monet, *The River*
Whistler, *The Artist's Mother*

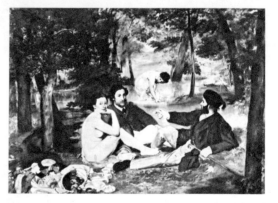

1875

High tide of European colonialism (1876–1914)

Queen Victoria becomes empress of India 1877

Japan defeats China 1894–95

First Zionist Congress called by Theodor Hertzl 1897

Spanish-American War 1898; U.S. gains Philippines, Guam, Puerto Rico, annexes Hawaii

Boxer Rebellion in China, against West 1899–1900

Boer War 1899–1902

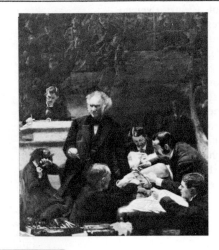

Verlaine, *Romances sans paroles* 1874

Bell patents the telephone 1876

Mark Twain (1835–1910), *Tom Sawyer* 1876

Ibsen (1828–1906), *A Doll's House* 1879

Mallarmé (1842–89)

Edison invents phonograph 1877; electric light bulb 1879

Zola (1840–1902)

Pasteur and Koch prove germ theory of disease 1881

Henry James (1843–1916) publishes *The Portrait of a Lady* 1881

First internal combustion engines for gasoline 1885

Huysmans (1848–1907)

Emily Dickinson (1830–86): two volumes of poetry published 1890, 1891

Oscar Wilde, *Lady Windermere's Fan* 1892

G. B. Shaw (1856–1950), most important British playwright since Shakespeare

Roentgen discovers X rays 1895

W. B. Yeats (1865–1939)

Marconi invents wireless telegraphy (precursor of radio) 1895

Edison invents motion picture 1896

The Curies discover radium 1898

Anton Chekhov, *Uncle Vanya* 1899

1900

Theodore Roosevelt (1901–9) proclaims Open Door policy; carries "Big Stick"; promotes Panama Canal (opened 1914)

William James (1842–1910) publishes *The Varieties of Religious Experience* 1902

Japan defeats Russia 1904–5

Internal strife, reforms in Russia 1905

Triple Entente (Britain, France, Russia) 1907

Revolution in China, republic led by Sun Yat-sen set up 1911

First World War 1914–18; U.S. enters 1917

Bolshevik Revolution 1917; Russia signs separate peace with Germany 1918

Wilson presents 14 Points 1918; armistice signed in West

Paris Peace Conference 1919; League of Nations founded

Gandhi agitates for Indian independence after World War I

Irish Free State established 1921

Mussolini's Fascists seize Italian government 1922

Turkey becomes republic

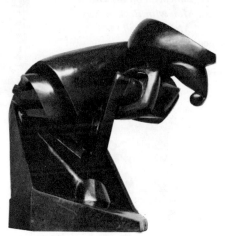

Planck formulates quantum theory 1900

Freud's *Interpretation of Dreams* 1900

Pavlov's first experiments with conditioned reflexes 1900

Wright brothers' first flight with power-driven airplane 1903

Einstein's theory of relativity 1905

Maxim Gorky (1868–1936)

Ford begins assembly-line production 1909

André Gide, *Strait is the Gate* 1909

Gertrude Stein writes *Three Lives* 1909

Russell and Whitehead, *Principia Mathematica* 1910–13

Rutherford's theory of positively charged atomic nucleus 1911

Apollinaire (1880–1918) writes *Alcools* 1913

Marcel Proust (1871–1922) publishes *Remembrance of Things Past* 1913–27

D. H. Lawrence (1885–1930) writes *Sons and Lovers* 1913; *The Rainbow* 1915

James Joyce (1882–1941), *Ulysses* 1914–21

Margaret Sanger (1883–1966) leads the birth-control movement beginning c. 1915

T. S. Eliot (1888–1964), *Prufrock and Other Observations* 1917; *The Waste Land* 1922

John Dewey (1859–1952), instrumentalism affects progressive school movement

First regular radio station broadcasts 1920

Sinclair Lewis, *Main Street* 1920

Maria Montessori (1870–1952) pioneers in early childhood education

1925

1875

Eakins, *Gross Clinic*
Moreau, *The Apparition*
Renoir, *Moulin de la Galette*
Degas, *Glass of Absinthe*
Cézanne, *Fruit Bowl, Glass, and Apples*
Rodin, *The Thinker*
Seurat, *Bathers*
Richardson, Marshall Field Wholesale Store, Chicago
Rodin, *The Kiss*
Gauguin, *Vision after the Sermon*
Van Gogh, *Wheat Field and Cypress Trees*
Sullivan, Wainwright Building, St. Louis
Toulouse-Lautrec, *Moulin Rouge*
Rodin, *Balzac*
Munch, *The Scream*
Mackintosh, Glasgow School of Art
Minne, *Kneeling Boy*
Sullivan, Carson Pirie Scott Building, Chicago

1900

Maillol, *Méditerranée*
Picasso, *Old Guitarist*
Rouault, *Head of Christ*
Matisse, *Joy of Life*
Gaudí, Casa Milá, Barcelona
Picasso, *Les demoiselles d'Avignon*
Mondrian, *Flowering Trees*
Brancusi, *The Kiss*
Nolde, *Last Supper*
Rousseau, *The Dream*
Rodin, *The Secret*
Chagall, *I and the Village*
Barlach, *Man Drawing Sword*
Duchamp, *The Bride; Nude Descending a Staircase, No. 2*
Braque, *Le Courrier*
Kandinsky, *Sketch I for Composition VII*
Lehmbruck, *Standing Youth*
Boccioni, *Unique Forms . . .*
De Chirico, *Mystery and Melancholy . . .*
Duchamp-Villon, *Great Horse*
Van de Velde, Werkbund theater, Cologne
Arp, *Collage with Squares . . .*
Stella, *Brooklyn Bridge*
Duchamp, *Tu m'*
Léger, *The City*
Brancusi, *Bird in Space*
Ernst, *1 Copper Plate . . .*
Picasso, *Mother and Child*
Klee, *Twittering Machine*
Rietveld, Schröder House, Utrecht
Pevsner, *Torso*

1925

1925			1925

POLITICAL HISTORY, RELIGION

Chiang Kai-shek unites Nationalist China 1927–28

Stalin purges rivals 1928; Five-Year Plan

Stock-market crash in U.S. 1929; worldwide depression

Japan invades Manchuria 1931

Spain becomes republic 1931

Reichstag fire, Berlin; Hitler seizes power in Germany 1933

Roosevelt proclaims New Deal 1933

Mussolini conquers Ethiopia 1936

Spanish Civil War 1936–39; won by Franco

Hitler annexes Austria 1938; seizes Czechoslovakia 1939; signs nonaggression pact with Russia

World War II 1939–45

Atomic bomb dropped on Hiroshima 1945

United Nations Charter signed 1945

Fourth Republic founded in France 1946; Germany and Austria divided into occupation zones

British rule ends in India 1947

U.S. starts Marshall Plan 1947

Tito breaks with Stalin 1948

Israel achieves nationhood 1948

NATO founded 1949

West Germany becomes Federal Republic 1949

People's Republic of China founded 1949

Soviets explode atomic bomb 1949

LITERATURE, SCIENCE, TECHNOLOGY

Ezra Pound(1885–1972), *Cantos* 1925–60

Luigi Pirandello (1867–1936) writes *Six Characters in Search of an Author* 1922

Adolf Hitler writes *Mein Kampf* 1924

William Faulkner (1897–1962)

Ernest Hemingway (1898–1961) publishes *A Farewell to Arms* 1929

Margaret Mead (born 1901), *Coming of Age in Samoa* 1928

Eugene O'Neill (1888–1953), *Mourning Becomes Electra* 1931

First regular TV broadcasts in U.S. 1928

Thomas Wolfe (1900–1938) writes *Look Homeward Angel* 1929

Andre Malraux (born 1895), *Man's Fate* 1933

Radar developed, Watson-Watt 1934–35

Berthold Brecht (1898–1956).

Albert Camus (1913–60), *The Stranger* 1942

Atomic fission on laboratory scale 1942

First large-scale atomic explosion, Los Alamos 1943

Jean-Paul Sartre (born 1905) formulates existentialism, *Being and Nothingness* 1943

Penicillin discovered 1943

Computer technology developed 1944

Tennessee Williams (born 1914) writes *The Glass Menagerie* 1945

Xerography invented 1946

Norman Mailer (born 1923) publishes *The Naked and the Dead* 1948

PAINTING, SCULPTURE, ARCHITECTURE

Picasso, *Three Dancers*

Gropius, Bauhaus, Dessau

Demuth, *I Saw the Figure 5 in Gold*

Le Corbusier, Savoye House, Poissy

Howe and Lescaze, Philadelphia Savings Fund Society Building

Giacometti, *Palace at 4 A.M.*

Miró, *Composition*

González, *Head*

Moore, *Two Forms*

Picasso, *Guernica*

Moore, *Recumbent Figure*

Calder, *Lobster Trap and Fish Tail*

Ernst, *Swamp Angel*

Picasso, *Bull's Head*

Le Corbusier, Unité d'Habitation, Marseilles

Harrison, U.N. Buildings, New York

Hopper, *Early Sunday Morning*

Gorky, *The Liver Is the Cock's Comb*

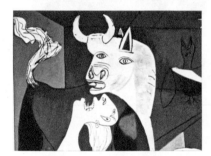

1950			1950

POLITICAL HISTORY, RELIGION

Korean War 1950–53

Japan and U.S. sign peace treaty 1951

Death of Stalin 1953

U.S. Supreme Court outlaws racial segregation in public schools 1954

British evacuate Suez Canal zone 1954

West Germany admitted to NATO 1955

Warsaw pact signed by East European countries 1955

Khrushchev denounces Stalin 1956; Russia crushes Hungarian revolt

Egypt seizes Suez Canal 1956

Common Market established 1957

U.S. tests first ICBM 1957

Fifth Republic, France (De Gaulle) 1958

Seventeen African countries achieve independence 1960

Pope John XXIII convenes Vatican Council II 1962

John F. Kennedy assassinated 1963

U.S. intervention in Vietnam begins 1965

Martin Luther King assassinated 1968

Russia invades Czechoslovakia 1968

Civil war in Pakistan gains independence for People's Republic of Bangladesh 1972–73

Vietnam War ends 1973

Nixon resigns presidency 1974

Death of Franco 1975

LITERATURE, SCIENCE, TECHNOLOGY

Eugene Ionesco (born 1912), *The Bald Soprano* 1950; *The Lesson* 1951

Samuel Beckett, *Waiting for Godot* 1952

Alfred C. Kinsey publishes *Sexual Behavior in the Human Male* 1948; *Female* 1953

Robbe-Grillet (born 1922), *The Erasers* 1953

Genetic code cracked 1953

Saul Bellow (born 1915) writes *The Adventures of Augie March* 1953

First hydrogen bomb (atomic fusion) exploded 1954

Death of Einstein 1955

Oral birth-control pill accepted c. 1955

Sputnik, first satellite, launched 1957

Lawrence Durrell (born 1912) publishes his tetralogy *The Alexandria Quartet* 1957–60

Vladimir Nabokov, *Lolita* 1958

Laser device invented in U.S. 1960

First manned space flight 1961

Solzhenitsyn, *The First Circle* 1964

First kidney transplant 1950; first heart transplant performed 1967

First manned landing on the moon 1969

PAINTING, SCULPTURE, ARCHITECTURE

Pollock, *One*

Dubuffet, *Natural History*

Mies van der Rohe, Lake Shore Drive Apartments, Chicago

De Kooning, *Woman II*

Le Corbusier, Notre-Dame-du-Haut, Ronchamp

Goeritz, *Steel Structure*

Rothko, *Earth and Green*

Bacon, *Figure with Meat*

Robert Rauschenberg, *Odalisk*

Vasarely, *Vega*

Johns, *Three Flags*

Chamberlain, *Essex*

Morris Louis, *Beth Feh*

Lichtenstein, *Girl at Piano*

Indiana, *The Duluth Five*

George Segal, *Cinema*

Barnett Newman, *Broken Obelisk*

Smith, *Cubi* series

Kienholz, *State Hospital*

César, *The Thumb*

Bladen, *The X*

Safdie and associates, Habitat, Montreal

Smithson, *Spiral Jetty*, Great Salt Lake

Oldenburg, *Giant Ice Bag*

Eddy, *New Shoes for H*

1975			1975

A NOTE ON ARCHITECTURAL DRAWINGS

by David G. DeLong

Architectural drawings can show how buildings look, how they function, and how they are constructed. Drawings have served these purposes since the beginnings of monumental architecture in ancient Egypt, and they remain as essential to most architecture as musical notation is for most music. Architects use them to develop and record their concepts and to explain these concepts to assistants. Drawings are also used to communicate certain things about buildings to builders, to clients, and to the general public.

Types of Architectural Drawings

There are various types of architectural drawings. Those still in general use may be grouped into three major categories: sketches, construction drawings, and presentation drawings. Sketches, such as the drawing by Leonardo da Vinci (fig. 546), are generally made by an architect for his own use or to illustrate concepts for his assistants. Construction drawings are rarely published, for they explain technical matters to builders. They may be done by an architect, but more often are by his technical assistants or draftsmen. Presentation drawings are the type most frequently published; they are usually made to show the client or the public how the building will look and how it will function. They are often drawn by a draftsman or by a professional renderer, also called a delineator. Sometimes they are drawn after a building is built, as a record or study tool.

Whether classified as sketches, construction drawings, or presentation drawings, various kinds of drawings record different aspects of a building. These include plans, sections, elevations, isometrics, axonometrics, perspectives, and diagrams. All of these, except for perspectives and diagrams, are usually drawn to a predetermined scale so that each line is related in a set way to the actual dimensions of a building. Thus if a drawing is made to a scale of eight feet to one inch, each linear inch of the drawing represents eight linear feet of the building, one-eighth inch is equal to one foot, one-sixteenth inch equals six inches, etc. The scale of a drawing is sometimes indicated numerically (as $1/8'' = 1'-0''$), but is often shown graphically (as in fig. 80), with a short measuring strip scored like a ruler to indicate the relationship between sizes in the drawing and in the actual building.

Conventions

In preparing architectural drawings, a set of conventions is generally followed to make the drawings easy to understand. These conventions are most consistently applied to plans and sections, both of which show hypothetical cuts through the illustrated building. If a building were sliced horizontally along a plane parallel to and slightly above the floor, the cut face of the lower portion, seen from above, would resemble a plan. And if a building were sliced open along a vertical plane, the face of the exposed cut would resemble a section.

Dark heavy lines usually indicate the solid portions which have been cut, such as walls or pillars in plan, and floors and ceilings in section. Or these elements may be outlined with heavy lines and filled in with hatching or crosshatching—closely spaced parallel lines drawn in one or two directions. Hatching or dotting is also used to represent earth when part of a building is below ground level (figs. 52, 116). Thin single lines can also show other elements which lie beyond or below the cutting plane represented by the plan or section. In plans, these lines can indicate changes of level, including single steps or whole flights of stairs (fig. 163). Such lines can also show patterns in the surface of a floor or wall (fig. 223).

Gaps indicate openings or spaces between the solid elements; thin lines outlining the opening show the exposed edges of that opening. In plans, these edges represent the bottom surfaces of the opening being shown, as the sills of windows and the thresholds of doors. In sections, these edges represent the sides of the opening, as the jambs of windows and doors.

Plans

The simple plan of a Mycenaean megaron (fig. 121) follows these typical conventions. Its rectangular space is enclosed by solid walls which open on one narrow side. The single line along the right, connecting the freestanding ends of the long side walls, shows the step up to the floor level of the porch; the two black circles show the freestanding columns which help support the roof above. Behind the porch, four black rectangles represent the piers which separate the porch from the vestibule; the connecting lines indicate the threshold. Threshold lines are also shown in the single doorway connecting the vestibule to the inner room.

The same conventions are followed in the plan of the much larger Temple of Amen-Mut-Khonsu at Luxor (fig. 72), with its complex spaces and courtyards defined by walls and columns. Within the front pylons, hidden spaces are shown that could not be revealed by elevations or perspective drawings. In the plan of the Imperial Forums at Rome (fig. 216) similar drawing conventions are observed, to show the sequence of spaces of an entire complex of connected, monumental buildings. A portion of the Forum of Augustus is left blank to indicate that this area is not known as certainly as the others.

Indications of different floor levels are particularly important for understanding plans. In the plan of the Altar of Zeus at Pergamum (fig. 189) the single lines around the entire base of the building represent stairs, indicating that the main platform level of the altar area is raised several feet above the adjacent ground level. The uppermost level, that of the altar itself, is reached by climbing the wide flight of stairs which continues up one side of the structure, as indicated in the plan and seen in the illustration (fig. 188). The plan of the "White Temple" on its ziggurat at Uruk (fig. 80) displays a more extensive series of level changes, for it contains both the plan of the temple and that of the mountain top on which it is built. The linear pattern along the left side of the drawing shows the retaining wall built on that side of the mountain; these parallel lines reflect in plan the alternately thick and thin widths of the wall, which leans inward so that its entire face is seen in the drawing. On the right edge of the drawing

the closely spaced lines represent flights of stairs ascending the mountain toward the temple; small arrows point the directions up the stairs and ramp. The large arrow at the upper left of the plan points north, to establish the orientation of the complex. Both types of arrow are typical plan conventions.

Changes of level that are not associated with major ramps or stairs are seen in the plan of the Bauhaus at Dessau (fig. 879): here one wing of the building bridges the road below. While the road at first glance appears to intersect the building near the center of the plan, in actuality the road passes beneath it on a lower level. The lines representing the road are interrupted in the drawing to indicate this fact, while the lines representing the building level are continuous. The bridging element of the building is seen at the far left side of the adjacent illustration (fig. 878).

Unconventional variations in plans and sections may, of course, occur. The hatched lines in the floor plan of the Casa Milá at Barcelona (fig. 868), for example, show open courtyards, not solid walls. Such a variation gives special prominence to an important area of the drawing, but does not always add to its clarity.

Dashed or dotted lines show elements that are not normally visible in an actual view. They are most often used in plans to show elements lying above or below the floor level. One very typical use is to indicate the line of the roof, as seen in the dashed outlines in the plan of the Robie House in Chicago (fig. 872). The sloping outer planes of this roof intersect along the dashed lines inside the dashed rectangular outline and describe a hipped roof, shaped like an extended pyramid.

A more complex series of roof shapes is shown according to typical conventions by the dashed and dotted lines in the plan of the Mosque of Ahmed I at Istanbul (fig. 319). Here each dotted circle represents a dome, each dotted half-circle a half-dome. The pairs of straight dashed lines connecting the solid piers stand for the structural elements that support these domes and half-domes. In this case the supports are round arches but such paired lines can represent many types of support, whether beams, pointed arches, flat arches, or segmental arches which are less than a full half-circle in outline.

A similar combination of dotted circles and half-circles describes in plan the shape of the ceiling of the Pazzi Chapel at Florence (fig. 504). Circles again represent domes; the pattern of radiating lines in the main dome, like spokes of a wheel, stands for the ribs dividing the inner surface of the dome into a series of shapes which appear triangular in plan. The half-circles in this plan are drawn with their bottom diameters lying along an adjacent wall. In this position a dashed or dotted half-circle usually indicates a barrel vault rather than a half-dome, as described above, and a portion of this barrel vault may be seen in the interior view of the chapel (fig. 502).

A barrel vault is frequently used for spanning an interior space, and like a dome, it can be considered as a shape generated by an arch. A round arch rotated, so that its outer ends describe a circle, forms a hemispherical dome; an arch moved along a straight line, so that its outer ends describe two parallel lines, generates a half-cylinder, or barrel vault. Pointed and segmental arches can describe other forms of barrel vaults and domes. And barrel vaults can follow a curved line if the two supporting walls remain a constant diameter apart.

When two barrel vaults intersect at right angles, a groin vault is formed. This type of vault is generally shown in plan by dashed lines which follow the lines of intersection of the two vaults; an X results, its outer tips indicating the low points of the groin vault. The plan of the Abbey Church at Fossanova (fig. 406) shows groin vaults roofing the nave and side aisles. These vaults are seen in the interior view (fig. 407), and also the transverse arches with attached ribs which span the nave. In this position the transverse arches help support

each individual vault, and the ribs help support the arches. Ribs are strengthening elements that stiffen a vault or arch as a buttress stiffens a wall, by making it thicker at certain places. In plan ribs are typically shown by parallel dashed lines, like those for an arch or beam. Sometimes ribs are used to strengthen the lines of intersection which result in the making of a groin vault, as seen in the nave of Durham Cathedral (fig. 357). Ribbed groin vaults are usually shown in plan by paired rather than by single dashed lines, each line representing one side of the rib. This convention is used in the plan of Durham Cathedral (fig. 355).

Other, more elaborate ceiling shapes can also be shown in plan by dashed lines, often requiring individual interpretation. The inward-pointing curved lines in each bay of the side aisles in the plan of S. Lorenzo at Florence (fig. 499) represent segmental domes—curved surfaces which are partial domes as seen in the interior view (fig. 500). Sometimes ceiling patterns, rather than structural shapes, are shown by dashed lines. The recessed panels called coffers which often elaborate a ceiling or the inner face of a dome are sometimes indicated in this manner; the elaborate coffers that we see in the dome of S. Carlo alle Quattro Fontane at Rome (fig. 631) are not included in the plan (fig. 630), for they would have made the drawing too complicated at so small a scale.

Dashed lines are occasionally used to show elements that are not visible but once existed, or that are intended for the future. In the plan of the Acropolis at Athens in 400 B.C. (fig. 154) the old Temple of Athena is shown in this manner; it no longer existed even in 400 B.C., but its location is still important in understanding the planning of the adjacent Erechtheum. And dashed lines may indicate an addition planned for a building, to be constructed later.

Sections

Used in conjunction with plans, sections describe the interior volumes of buildings. These volumes can be small in relation to the total mass of the structure: in the section of the Pyramid of Cheops at Giza (fig. 59) the interior passages are shown in white, the enclosing stone in gray, and the structural layers of the stone are outlined in black.

More extensive interior volumes are seen in the section through Sta. Costanza at Rome (fig. 272): a domed central volume opens through a circular row of columns into a lower barrel-vaulted space. A portion of the porch is at the far left of the drawing, and the vestibule is at the far right; both of these spaces, too, are barrel vaulted. Barrel-vaulted spaces and domed spaces look the same in section, so one must refer to the plan to distinguish between them: short dotted lines at the right and left of the plan of Sta. Costanza (fig. 273) indicate the location of the vertical plane along which the section is cut through the center, and from the shape of the spaces in plan one can deduce that the central circle is domed and that the surrounding spaces are covered by barrel vaults. In this building the barrel-vaulted perimeter space and porch both follow a circle in plan rather than a straight line, forming doughnut-like spaces. The solid elements of the building, heavily shaded in the plan, are heavily outlined in the section, and the delineator has elected to omit indications of the structure between these inner and outer lines. This convention is often followed when the structure is too complicated to explain, or when the inner and outer profiles of a building are known but the actual structure is not.

Elevations

Those portions of Sta. Costanza which lie behind the section plane—including the window openings and the columns—

are seen in elevation. If the section plane were moved to a position outside the building, the exterior would be seen in elevation. In an elevation everything appears approximately as it would to an observer of the building itself, except that the building is shown flat, with none of the converging lines of a perspective drawing. Because an elevation is not distorted to give an impression of depth, and because it is drawn to scale, the height of the building and of its visible parts can be determined from the drawing (fig. 719). Elevations are useful in understanding the appearance of a building, as seen in the reconstruction drawing of the West Front of the Temple of Artemis at Corfu (fig. 139).

When elevations are drawn at a large scale they are useful in explaining details of a building, as seen in that of the Doric and Ionic orders (fig. 146). In this drawing part of the column shafts is cut away, so that the shafts appear shorter than they actually are. Conventionally such cutting is shown by leaving a gap, often with broken or jagged edges, through the entire element that has been shortened, and the device is frequently used in composite and large-scale drawings to save space on the page.

Isometrics, Axonometrics, and Perspectives

Plans, sections, and elevations give measurable indications of only two dimensions at a time (diagrams A, B). Isometric and axonometric drawings give measurable indications of three. To accomplish this, horizontal lines of the building are drawn at an angle to the base line of the drawing, while vertical lines remain vertical (diagram C). This allows length, width, and height to be shown simultaneously in one drawing. Because each line is drawn to scale, the actual size of the object being represented can be determined.

In isometric drawings, all horizontals of the building are usually drawn at an equal angle to the base of the drawing. In an axonometric, horizontals of the building are drawn at different angles to the base so that the interior angle between the horizontals will be the same as the angle shown in plan (diagram D). While an axonometric looks less realistic than an isometric, it has the advantage of showing the true angles of the building. Such drawings are not always easy to comprehend, as seen in the drawing of one corner of the vestibule of the Laurentian Library at Florence (fig. 561), with its horizontal lines drawn at an angle of 45° to the base of the drawing. It shows one corner of the vestibule as if from above, with the roof removed and the beams shown as dashed lines. In the drawing of one bay at St. Sernin at Toulouse, the floor is removed and the view is as if from below (fig. 349). In the axonometric of the Palace Chapel (fig. 332) the building is shown cut open along a jagged line to illustrate two conditions: the central dome (on the left side), and the subsidiary barrel vaults below (on the right).

Axonometric drawings appear unnatural because they have no converging lines, and normally we expect parallel lines of a three-dimensional object to converge near the horizon. Perspective drawings show three-dimensional objects by means of these converging lines and therefore appear more natural. But the visual impression of depth that is created by the converging of all parallel lines means that these lines cannot be drawn to a consistent scale, and perspectives cannot readily be used to determine the actual dimensions of a building. Of all architectural drawings, however, perspectives probably give the most convincing impression of a building's appearance. They can be cast to show the building from any angle, including the informative aerial view used in the drawing of the Citadel of Sargon II at Dur Sharrukin (fig. 92). They can also be drawn with part of the building hypothetically removed, as in the reconstruction of the Basilica of Constantine

A. Plan

Ground Line B. Elevation

120°
30° 30°
Base Line of Drawing C. Isometric

90°
60° 30°
Base Line of Drawing D. Axonometric

at Rome (fig. 226), so that the inside and the outside of a building appear in the same drawing. The same device is used in the drawing of Notre-Dame-du-Haut at Ronchamp (fig. 887), which is shown with the entire roof removed. In the drawing of S. Ivo at Rome (fig. 633), one-half of the building has been removed so that a full section through the building is revealed along with the interior. In this same drawing the plan of the portion cut away has also been shown in front of the perspective (as has the plan in the drawing of the Basilica of Constantine), like a footprint of the missing portion.

Other Diagrams

A final kind of drawing often shows no particular building, but records instead some general concept of organization. The concept can be common to a whole series of similar buildings or explain some abstract element of a single building, such as how people move through it. The plan of a monastery at St. Gall (fig. 335) is really a diagram rather than a plan, for it is not meant to describe the actual forms of a single building but to show the relationships that should be sought in designing any monastery for that religious order. Connecting links are indicated among various elements, but no real corridors or specific architectural shapes are included.

Precisely because of their general nature, such diagrams frequently precede all other architectural drawings and are important to both the architect and the student: by recording general concepts rather than set forms, they deal with an essential aspect of architecture in a way that no other kind of drawing can equal. Taken together with plans, sections, isometrics, and perspectives, they complete the presentation of all aspects of a building so that it can be understood whether one has seen it or not, or even if it has never been built.

GLOSSARY

ABACUS. A slab of stone at the top of a classical CAPITAL, just beneath the ARCHITRAVE (figs. 146, 147).

ABBEY. 1) A religious community headed by an abbot or abbess. 2) The buildings which house the community. An abbey church often has an especially large CHOIR to provide space for the monks or nuns (fig. 384).

ACADEMY. A place of study, the word coming from the Greek name of a garden near Athens where Plato and later Platonic philosophers held philosophical discussions from the 5th century B.C. to the 6th century A.D. The first Academy of Fine Arts, properly speaking, was the Academy of Drawing founded 1563 in Florence by Giorgio Vasari. Important later academies were the Royal Academy of Painting and Sculpture in Paris, founded 1648, and the Royal Academy of Arts in London, founded 1769. Their purpose was to foster the arts by systematic teaching, exhibitions, discussion, and occasionally by financial assistance.

ACANTHUS. 1) A Mediterranean plant having spiny or toothed leaves. 2) An architectural ornament resembling the leaves of this plant, used on MOLDINGS, FRIEZES, and Corinthian CAPITALS (figs. 159, 211).

ACRYLIC. A plastic binder MEDIUM for PIGMENTS that is soluble in water. Developed about 1960 (colorplates 127, 138).

AERIAL PERSPECTIVE. See PERSPECTIVE.

AISLE. See SIDE AISLE.

ALLA PRIMA. A painting technique in which PIGMENTS are laid on in one application with little or no UNDERPAINTING.

ALLAH. The unique and personal God of the MOSLEM faith.

ALTAR. 1) A mound or structure on which sacrifices or offerings are made in the worship of a deity. 2) In a Catholic church, a table-like structure used in celebrating the Mass.

ALTARPIECE. A painted or carved work of art placed behind and above the ALTAR of a Christian church. It may be a single panel (colorplate 45) or a TRIPTYCH or a POLYPTYCH having hinged wings painted on both sides (figs. 463, 465). Also called a reredos or retable.

ALTERNATING SYSTEM. A system developed in Romanesque church architecture to provide adequate support for a GROIN-VAULTED NAVE having BAYS twice as long as the SIDE-AISLE bays. The PIERS of the nave ARCADE alternate in size; the heavier COMPOUND piers support the main nave vaults where the THRUST is concentrated, and smaller, usually cylindrical piers support the side-aisle vaults (figs. 357, 360).

AMAZON. One of a tribe of female warriors said in Greek legend to dwell near the Black Sea (fig. 179).

AMBULATORY. A covered walkway. 1) In a BASILICAN church, the semicircular passage around the APSE (fig. 384). 2) In a CENTRAL-PLAN church, the ring-shaped AISLE around the central space (fig. 282). 3) In a CLOISTER, the covered COLONNADED or ARCADED walk around the open courtyard.

AMPHITHEATER. A double THEATER. A building, usually oval in plan, consisting of tiers of seats and access corridors around the central theater area (fig. 218).

AMPHORA (pl. AMPHORAE). A large Greek storage vase with an oval body usually tapering toward the base; two handles extend from just below the lip to the shoulder (fig. 126).

ANDACHTSBILD. German for devotional picture. A picture with a type of imagery intended for private devotion, first developed in northern Europe.

ANNULAR. From the Latin word for ring. Signifies a ring-shaped form, especially an annular barrel VAULT.

ANTA (pl. ANTAE). The front end of a wall of a Greek temple, thickened to produce a PILASTER-like member. Temples having COLUMNS between the antae are said to be "in antis" (fig. 145).

AQUATINT. A print processed like an ETCHING, except that the ground or certain areas are covered with a solution of asphalt, resin, or salts which, when heated, produces a granular surface on the plate and rich gray tones in the final print (fig. 731). Etched lines are usually added to the plate after the aquatint ground is laid.

APOCALYPSE. The Book of Revelation, the last book of the New Testament. In it St. John the Evangelist describes his visions, experienced on the island of Patmos, of heaven, the future of mankind, and the Last Judgment.

APOSTLE. One of the twelve disciples chosen by Christ to accompany him in his lifetime, and to spread the GOSPEL after his death. The traditional list in Matt. 10: 1–4 includes Andrew, Bartholomew, James the Greater (son of Zebedee), James the Less (son of Alphaeus), John, Judas Iscariot, Matthew, Peter, Philip, Simon the Canaanite, Thaddeus (or Jude), and Thomas (fig. 516). In art, however, the same twelve are not always represented since "apostle" was sometimes applied to other early Christians, such as St. Paul.

APSE. 1) A semicircular or polygonal niche terminating one or both ends of the NAVE in a Roman BASILICA (fig. 229). 2) In a Christian church, it is usually placed at the east end of the nave beyond the TRANSEPT or CHOIR (fig. 268); it is also sometimes used at the end of transept arms.

AQUEDUCT. Latin for duct of water. 1) An artificial channel or conduit for transporting water from a distant source. 2) The overground structure which carries the conduit across valleys, rivers, etc. (fig. 217).

ARCADE. A series of ARCHES supported by PIERS or COLUMNS (fig. 266). When attached to a wall, these form a blind arcade (fig. 367).

ARCH. A curved structure used to span an opening. Masonry arches are built of wedge-shaped blocks, called voussoirs, set with their narrow side toward the opening so that they lock together (figs. 209, 217). The topmost voussoir is called the keystone. Arches may take different shapes as in the pointed Gothic arch (fig. 401), or the STILTED Islamic (fig. 313), but all require support from other arches or BUTTRESSES.

ARCHBISHOP. The chief BISHOP of an ecclesiastical district.

ARCHITRAVE. The lowermost member of a classical ENTABLATURE, i.e., a series of stone blocks which rests directly on the COLUMNS (figs. 146, 147).

ARCHIVOLT. A molded band framing an ARCH, or a series of such bands framing a TYMPANUM, often decorated with sculpture (fig. 372).

ARRICCIO. See SINOPIA.

ATMOSPHERIC PERSPECTIVE. See PERSPECTIVE.

ATRIUM. 1) The central court of a Roman house (fig. 230), or its open entrance court. 2) An open court, sometimes COLONNADED or ARCADED, in front of a church (figs. 268, 359).

ATTIC. A low upper story placed above the main CORNICE or ENTABLATURE of a building, and often decorated with windows and PILASTERS (figs. 565, 681).

AURIGNACIAN. An adjective used for describing artefacts of an Upper PALEOLITHIC culture preceding the MAGDALENIAN; the word comes from Aurignac (Haute-Garonne), a site in southern France where such work was found.

BACCHANT (fem. BACCHANTE). A priest or priestess of the wine god, Bacchus (in Greek mythology, Dionysus), or one of his ecstatic female followers, who were sometimes called maenads (colorplate 63, fig. 279).

BALUSTRADE. 1) A railing supported by short pillars called balusters (fig. 563). 2) Occasionally applied to any low parapet (figs. 175, 329).

BAPTISTERY. A building or a part of a church, often round or octagonal, in which the sacrament of baptism is administered (fig. 367). It contains a baptismal font, a receptacle of stone or metal which holds the water for the rite (fig. 376).

BARREL VAULT. See VAULT.

BASE. 1) The lowermost portion of a COLUMN or PIER, beneath the SHAFT (figs. 146, 160). 2) The lowest element of a wall, DOME, or building, or occasionally of a statue or painting (see PREDELLA).

BASILICA. 1) In ancient Roman architecture, a large, oblong building used as a hall of justice and public meeting place, generally having a NAVE, SIDE AISLES, and one or more APSES (fig. 229). 2) In Christian architecture, a longitudinal church derived from the Roman basilica, and having a nave, apse, two or four side aisles or side chapels, and sometimes a NARTHEX. 3) One of the seven main churches of Rome (St. Peter's, St. Paul Outside the Walls, St. John Lateran, etc.), or another church accorded the same religious privileges.

BATTLEMENTED. Having a notched parapet or

crenelations around the top of a building or fortification wall (fig. 415).

BAY. A subdivision of the interior space of a building, usually in a series bounded by consecutive architectural supports.

BENEDICTINE ORDER. Founded at Subiaco near Rome in 529 A.D. by St. Benedict of Nursia (c. 480–c. 543). Less austere than other early ORDERS, it spread throughout much of western Europe and England in the next two centuries.

BISHOP. The spiritual overseer of a number of churches or a diocese. His throne or cathedra, placed in the principal church of the diocese, designates it as a cathedral.

BLIND ARCADE. See ARCADE.

BLOCKBOOKS. Books, often religious, of the 15th century, containing WOODCUT prints in which picture and text were usually cut into the same block (compare fig. 482).

BODHISATTVA. In Buddhism, one who has reached enlightenment and, postponing Nirvana, helps others attain enlightenment (fig. 904).

BOOK. A written work of some length on consecutive sheets of PAPER, PARCHMENT, etc., fastened or bound together in a volume. See CODEX.

BOOK COVER. The stiff outer covers protecting the bound pages of a BOOK. In the medieval period they may be covered with precious metal and elaborately embellished with jewels, embossed decoration, etc. (colorplate 33).

BOOK OF HOURS. A private prayer book containing the devotions for the seven canonical hours of the Roman Catholic church (matins, vespers, etc.), liturgies for local saints, and sometimes a calendar (colorplate 44). They were often elaborately ILLUMINATED for persons of high rank, whose names are attached to certain extant examples (fig. 457).

BRACKET. A stone, wooden, or metal support projecting from a wall and having a flat top to bear the weight of a statue, CORNICE, beam, etc. (fig. 374). The lower part may take the form of a SCROLL: it is then called a scroll bracket (fig. 560).

BROKEN PEDIMENT. See PEDIMENT.

BRONZE. An alloy of copper and tin, used since early times for sculpture. See BRONZE AGE; CIRE PERDU.

BRONZE AGE. The earliest period in which BRONZE was used for tools and weapons. In the Middle East, the Bronze Age succeeded the NEOLITHIC period in c. 3500 B.C., and preceded the Iron Age, which began c. 1900 B.C.

BRUSH DRAWING. See DRAWING.

BUDDHA. Indian religious leader, 566–480 B.C., founder of Buddhism (figs. 899, 900, 902).

BURIN. See ENGRAVING.

BUTTRESS. 1) A projecting support built against an external wall, usually to counteract the lateral THRUST of a VAULT or ARCH within (fig. 388). 2) FLYING BUTTRESS. An arched bridge above the aisles which reaches from the upper nave wall, where the lateral thrust of the main vault is greatest, down to a solid pier (fig. 389).

BYZANTIUM. City on the Sea of Marmara, founded by the ancient Greeks and renamed Constantinople in 330 A.D. Today called Istanbul.

CAESAR. The surname of the Roman dictator, Caius Julius Caesar, subsequently used as the title of an emperor; hence the German Kaiser, and the Russian czar (tsar).

CALIPH. A Moslem ruler; the first caliph succeeded MOHAMMED and claimed political and religious authority by his descent from the Prophet. Subsequently these caliphates were recognized: Omayyids, Abbasids, and Fatimids.

CALLIGRAPHY. From the Greek word for beautiful writing. 1) Decorative or formal handwriting executed with a quill or reed pen, or with a brush, as in Chinese or Japanese works (colorplates 23, 32, 143; figs. 276, 323). 2) A design derived from or resembling letters, and used to form a pattern (colorplates 30, 31).

CALVARY. The hill originally outside Jerusalem where Christ was crucified, the name being taken from the Latin word calvaris, meaning skull (Golgotha is the Greek transliteration of skull in Aramaic). The hill was thought to be the spot where Adam was buried, and was thus traditionally known as "the place of the skull."

CAMPAGNA. Italian word for countryside. When capitalized, it usually refers to the countryside near Rome.

CAMPANILE. From the Italian word campana meaning bell. A bell tower, either round or square in plan, and sometimes freestanding (figs. 269, 359).

CAMPOSANTO. Italian word for holy field. A cemetery near a church, and often enclosed.

CANOPY. In architecture, an ornamental, rooflike projection or cover above a statue or sacred object (figs. 419, 624).

CAPITAL. The uppermost member of a COLUMN or PILLAR supporting the ARCHITRAVE (figs. 146, 159).

CARDINAL. In the Roman Catholic church, a member of the Sacred College, the ecclesiastical body which elects the Pope and constitutes his advisory council.

CARMELITE ORDER. Originally a 12th-century hermitage claimed to descend from a community of hermits established by the Prophet Elijah on Mt. Carmel, Palestine. In the early 13th century it spread to Europe and England, where it was reformed by St. Simon Stock and became one of the three great mendicant orders (see FRANCISCAN, DOMINICAN).

CARTHUSIAN ORDER. See CHARTREUSE.

CARTOON. From the Italian word cartone, meaning cardboard. 1) A full-scale DRAWING for a picture or design intended to be transferred to a wall, panel, tapestry, etc. (fig. 543). 2) A drawing, usually humorous or satirical, calling attention to some action or person of popular interest (fig. 749).

CARVING. 1) The cutting of a figure or design out of a solid material such as stone or wood, as contrasted to the additive technique of MODELING. 2) A work executed in this technique (figs. 554, 555).

CARYATID. A sculptured female figure used as an architectural support (figs. 141, 160). A similar male figure is an atlas (pl. atlantes).

CASTING. A method of duplicating a work of sculpture by pouring a hardening substance such as plaster or molten metal into a mold. See CIRE PERDU.

CAST IRON. A hard, brittle iron produced commercially in blast furnaces by pouring it into molds where it cools and hardens. Extensively used as a building material in the early 19th century (figs. 724, 859), it was superseded by STEEL and FERROCONCRETE.

CATACOMBS. The underground burial places of the early Christians, consisting of passages with niches for tombs, and small chapels for commemorative services.

CATHEDRA, CATHEDRAL. See BISHOP.

CELLA. 1) The principal enclosed room of a temple, to house an image (fig. 145). Also called the naos. 2) The entire body of a temple as distinct from its external parts.

CENTERING. A wooden framework built to support an ARCH, VAULT, or DOME during its construction.

CENTRAL-PLAN CHURCH. 1) A church having four arms of equal length. The CROSSING is often covered with a DOME. Also called a Greek-cross church. 2) A church having a circular or polygonal plan.

CHALK. Calcium carbonate, either natural or artificially prepared, finely ground to make a white substance used in GESSO. It may be pressed in sticks and used in its white form, or mixed with colored pigments to make PASTELS.

CHANCEL. See CHOIR.

CHAPEL. 1) A private or subordinate place of worship (figs. 501–4). 2) A place of worship that is part of a church, but separately dedicated (fig. 556).

CHARTREUSE. French word for a Carthusian monastery (in Italian, Certosa). The Carthusian ORDER was founded by St. Bruno (c. 1030–1101) at Chartreuse near Grenoble in 1084. It is an eremetic order, the life of the monks being one of silence, prayer, and austerity.

CHASING. 1) A technique of ornamenting a metal surface by the use of various tools. 2) The procedure used to finish a raw bronze cast.

CHÂTEAU (pl. CHÂTEAUX). French word for castle, now used to designate a large country house as well (fig. 614).

CHEVET. In Gothic architecture, the term for the developed and unified east end of a church, including choir, apse, ambulatory, and radiating chapels (fig. 392).

CHIAROSCURO. From the Italian word for light and dark. In painting, a method of modeling form primarily by the use of light and shade (figs. 540, 593).

CHOIR. In church architecture, a square or rectangular area between the APSE and the NAVE or TRANSEPT. It is reserved for the clergy and the singing choir, and is usually marked off by steps, a railing, or a CHOIR SCREEN (fig. 333). Also called the chancel. See PILGRIMAGE CHOIR.

CHOIR SCREEN. A screen, frequently ornamented with sculpture, separating the CHOIR of a church from the NAVE or TRANSEPT (fig. 426). In Orthodox Christian churches it is decorated with ICONS, and thus called an iconostasis (fig. 294).

CIRE-PERDU PROCESS. The lost-wax process of CASTING. A method in which an original is MODELED in wax and covered with clay. When the clay is dry, the wax is melted out, and the resulting mold is filled with molten metal (often BRONZE) or liquid plaster.

CISTERCIAN ORDER. Founded at Cîteaux in France in 1098 by Robert of Molesme with the objective of reforming the BENEDICTINE ORDER, and reasserting its original ideals of a life of severe simplicity.

CITY-STATE. An autonomous political unit comprising a city and the surrounding countryside.

CLERESTORY. A row of windows in the upper part of a wall which rises above an adjoining roof. Used to provide direct lighting in a Roman

BASILICA or Christian church (colorplate 37).

CLOISTER. 1) A place of religious seclusion such as a monastery or nunnery. 2) An open court attached to a church or monastery and surrounded by a covered ARCADED walk or AMBULATORY (fig. 336). Used for study, meditation, and exercise.

CODEX (pl. CODICES). A manuscript in BOOK form made possible by the use of PARCHMENT instead of PAPYRUS. During the 1st to 4th centuries A.D., it gradually replaced the ROLL or SCROLL previously used for written documents.

COFFER. 1) A small chest or casket. 2) A recessed, geometrically shaped panel in a ceiling. A ceiling decorated with these panels is said to be coffered (figs. 222, 631, 718).

COLLAGE. A composition made of cut and pasted scraps of materials, sometimes with lines or forms added by the artist (figs. 812, 823).

COLONNADE. A series of regularly spaced COLUMNS supporting a LINTEL or ENTABLATURE (figs. 71, 623).

COLOSSAL ORDER. COLUMNS, PIERS, or PILASTERS which extend through two or more stories (figs. 518, 563).

COLUMN. An approximately cylindrical, upright architectural support, usually consisting of a long, relatively slender SHAFT, a BASE, and a CAPITAL (figs. 146, 147). When imbedded in a wall, it is called an engaged column (fig. 161). Columns decorated with spiral RELIEFS were used occasionally as free-standing commemorative monuments (figs. 248, 461).

COMPOUND PIER. See PIER.

CONCRETE. A mixture of sand or gravel with mortar and rubble, invented in the ancient Near East and further developed by the Romans (figs. 218, 219). Largely ignored during the Middle Ages, it was revived by Bramante in the early 16th century for St. Peter's (fig. 533). Reinforced concrete: see FERROCONCRETE.

CONFRATERNITY. See SCUOLA.

CONTRAPPOSTO. Italian word for set against. A method developed by the Greeks to represent freedom of movement in a figure. The parts of the body are placed asymmetrically in opposition to each other around a central axis, and careful attention is paid to the distribution of the weight (figs. 164, 165).

CORINTHIAN ORDER. See ORDER, ARCHITECTURAL.

CORNICE. 1) The projecting, framing members of a classical PEDIMENT, including the horizontal one beneath and the two sloping or "raking" ones above (figs. 146, 147). 2) Any projecting, horizontal element surmounting a wall or other structure, or dividing it horizontally for decorative purposes (fig. 507).

COUNTER REFORMATION. The movement of self-renewal and reform within the Roman Catholic church following the Protestant REFORMATION of the early 16th century, and attempting to combat its influence. Also known as the Catholic Reform. Its principles were formulated and adopted at the Council of Trent, 1545–63.

CRAYON. A drawing stick made from PIGMENT mixed with wax or paraffin (colorplate 141).

CRENELATED. See BATTLEMENTED.

CROMLECH. From the Welsh for concave stone. A circle of large upright stones or DOLMENS, probably the setting for religious ceremonies in prehistoric England (figs. 29, 30).

CROSSHATCHING. See HATCHING.

CROSSING. The area in a church where the TRANSEPT crosses the NAVE, frequently em-

phasized by a DOME (fig. 364), or crossing tower (fig. 348).

CROSS SECTION. See SECTION.

CRYPT. In a church, a VAULTED space beneath the CHOIR, causing the floor of the choir to be raised above the level of that of the NAVE (fig. 345).

CUNEIFORM. Describes the wedge-shaped characters written on clay by the ancient Mesopotamians.

CYCLOPEAN. An adjective describing masonry with large, unhewn stones, thought by the Greeks to have been built by the Cyclopes, a legendary race of one-eyed giants (fig. 120).

DEËSIS. From the Greek word for entreaty. The representation of Christ enthroned between the Virgin Mary and St. John the Baptist, frequent in Byzantine MOSAICS (colorplate 25) and depictions of the Last Judgment (colorplate 47); refers to the role of the Virgin Mary and St. John as intercessors for mankind.

DIORITE. An igneous rock, extremely hard and usually black or dark gray in color (fig. 88).

DIPTYCH. 1) Originally a hinged two-leaved tablet used for writing. 2) A pair of ivory CARVINGS or PANEL paintings, usually hinged together (figs. 279, 474).

DIPYLON VASE. A Greek funerary vase with holes in the bottom through which libations were poured to the dead (fig. 125). Named for the cemetery near Athens where the vases were found.

DOLMEN. A structure formed by two or more large, upright stones capped by a horizontal slab; thought to be a prehistoric tomb (fig. 28).

DOME. 1) A true dome is a VAULTED roof of circular, polygonal, or elliptical plan, formed with hemispherical or ovoidal curvature (figs. 279, 548, 631). May be supported by a circular wall or DRUM (fig. 298), or by PENDENTIVES (fig. 281) or related constructions. Domical coverings of many other sorts have been devised (figs. 410, 639, 503).

DOMINICAN ORDER. Founded as a mendicant ORDER by St. Dominic in Toulouse in 1206–16.

DOMUS. Latin word for house. A Roman detached, one-family house with rooms grouped around one, or frequently two, open courts. The first, the ATRIUM, was used for entertaining and conducting business; the second, usually with a garden and surrounded by a PERISTYLE or COLONNADE, was for the private family (fig. 230).

DONJON. See KEEP.

DONOR. The patron or client at whose order a work of art was executed; the donor may be depicted in the work (figs. 462, 474).

DORIC ORDER. See ORDER, ARCHITECTURAL.

DRAWING. 1) A work in pencil, pen and ink, charcoal, etc., often on paper (fig. 794). 2) A similar work in ink or WASH, etc., made with a brush and often called a brush drawing (fig. 677). 3) A work combining these or other techniques (fig. 827).

A drawing may be large or small, a quick sketch or an elaborate work. Among its various forms are: a record of something seen (figs. 422, 543, 576, 769); a study for all or part of another work (figs. 10, 535, 740, colorplate 141; see also OIL SKETCH; SINOPIA); an illustration associated with a text (figs. 443, 545, 894); a technical aid. See the preceding Note on Architectural Drawings.

DRÔLERIES. French word for jests. Used to describe the interlaced animals and small figures

in the margins of medieval manuscripts (fig. 457), and occasionally in wood CARVINGS on furniture.

DRUM. 1) A section of the SHAFT of a COLUMN (figs. 155, 228). 2) A wall supporting a DOME (figs. 296, 565).

DRYPOINT. See ENGRAVING.

ECHINUS. In the Doric or Tuscan ORDER, the round, cushion-like element between the top of the SHAFT and the ABACUS (figs. 146, 148).

ELDERS, TWENTY-FOUR. The twenty-four elders frequently represented on the PORTALS of Romanesque and Gothic churches (fig. 417) are those described by St. John the Evangelist in his vision of heaven, clad in white and seated around the throne of God (Rev. 4: 4, 10).

ELEVATION. An architectural drawing presenting a building as if projected on a vertical plane parallel to one of its sides. See preceding Note on Architectural Drawings. 2) Term used in describing the vertical plane of a building.

ENAMEL. 1) A colored glassy substance, opaque or translucent, applied in powder form to a metal surface and fused to it by firing. The two main techniques developed: "champlevé" (from the French for raised field), in which the areas to be treated are dug out of the metal surface; and "cloisonné" (from the French for partitioned), in which compartments or "cloisons" to be filled are made on the surface with thin metal strips. 2) A work executed in this technique (figs. 326, 383).

ENCAUSTIC. A technique of painting with PIGMENTS dissolved in hot wax (colorplate 20).

ENGAGED COLUMN. See COLUMN.

ENGRAVING. 1) A means of embellishing metal surfaces or gem stones by incising a design on the surface. 2) A PRINT made by cutting a design into a metal plate (usually copper) with a pointed steel tool known as a burin. The burr raised on either side of the incised line is removed; ink is then rubbed into the V-shaped grooves and wiped off the surface; the plate, covered with a damp sheet of paper, is run through a heavy press (fig. 483). The image on the paper is the reverse of that on the plate (figs. 700, 701). When a fine steel needle is used instead of a burin, a drypoint engraving is produced; this technique is characterized by a softer line (fig. 484). 3) These techniques are called respectively engraving and drypoint. 4) Wood engraving, a technique of engraving on a block of wood cut across the grain. Finely detailed prints result from this method, which is relatively rapid of execution (figs. 825, 851).

ENTABLATURE. 1) In a classical order, the entire structure above the COLUMNS; this usually includes ARCHITRAVE, FRIEZE, and CORNICE (figs. 146, 147). 2) The same structure in any building of a classical style (fig. 707).

ENTASIS. A swelling of the SHAFT of a COLUMN (figs. 148, 152).

ETCHING. 1) A PRINT made by coating a copper plate with an acid-resistant resin and drawing through this ground, exposing the metal with a sharp instrument called a STYLUS. The plate is bathed in acid which eats into the lines; it is then heated to remove the resin, and finally inked and printed on paper (fig. 661). 2) The technique itself is also called etching.

EUCHARIST. 1) The sacrament of Holy Communion, the celebration in commemoration of the Last Supper. 2) The consecrated bread and wine used in the ceremony.

EVANGELISTS. Matthew, Mark, Luke, and John, traditionally thought to be the authors of the GOSPELS, the first four books of the New Testament which recount the life and death of Christ. They are usually shown with their symbols, which are probably derived from the four beasts surrounding the throne of the Lamb in the Book of Revelation (4:7) or from those in the vision of Ezekiel (1: 4–14): a winged man or angel for Matthew (fig. 583), a winged lion for Mark (fig. 339), a winged ox for Luke (colorplate 34), and an eagle for John (colorplate 35). These symbols may also represent the Evangelists (colorplate 22, fig. 329).

FAÇADE. The principal face or front of a building.

FALISCAN WARE. Pottery made in the Etruscan city of Falerii (the present Città Castellana), whose inhabitants were the Falisci (fig. 177).

FATHERS OF THE CHURCH. Early teachers and defenders of the Christian faith. Those most frequently represented are the four Latin fathers: St. Jerome, St. Ambrose, and St. Augustine, all of the 4th century, and St. Gregory of the 6th.

FERROCONCRETE. Reinforced CONCRETE, strengthened by STEEL rods and mesh placed inside before hardening. It was introduced in France c. 1900, and is widely used today (colorplate 142, figs. 878, 881, 888).

FIBULA. A clasp, buckle, or brooch, often ornamented.

FINIAL. A relatively small, decorative element terminating a GABLE, PINNACLE, or the like (fig. 612).

FLUTING. In architecture, the ornamental grooves channeled vertically into the SHAFT of a COLUMN or PILASTER (fig. 155). They may meet in a sharp edge as in the Doric ORDER, or be separated by a narrow strip as in the Ionic, Corinthian, and Composite orders.

FLYING BUTTRESS. See BUTTRESS.

FONT. See BAPTISTERY.

FORESHORTENING. A method of reducing or distorting the parts of a represented object which are not parallel to the PICTURE PLANE, in order to convey the impression of three dimensions as perceived by the human eye (colorplate 84, fig. 741).

FORUM (pl. FORA). In an ancient Roman city, the main, public square which was the center of judicial and business activity, and a public gathering place (fig. 216).

FRANCISCAN ORDER. Founded as a mendicant ORDER by St. Francis of Assisi (Giovanni di Bernardone, 1181/82–1226). The monks' aim was to imitate the life of Christ in its poverty and humility, to preach, and to minister to the spiritual needs of the poor.

FRESCO. Italian word for fresh. 1) True fresco is the technique of painting on moist plaster with PIGMENTS ground in water so that the paint is absorbed by the plaster and becomes part of the wall itself (colorplate 39). Fresco secco is the technique of painting with the same colors on dry plaster. 2) A painting done in either of these techniques.

FRIEZE. 1) A continuous band of painted or sculptured decoration (figs. 141, 243). 2) In a classical building, the part of the ENTABLATURE between the ARCHITRAVE and the CORNICE. A Doric frieze consists of alternating TRIGLYPHS and METOPES, the latter often sculptured (fig. 152). An Ionic frieze is usually decorated with continuous RELIEF sculpture (figs. 146, 147).

FROTTAGE. See RUBBING.

GABLE. 1) The triangular area framed by the CORNICE or eaves of a building and the sloping sides of a pitched roof (fig. 342). In classical architecture, it is called a PEDIMENT. 2) A decorative element of similar shape, such as the triangular structures above the PORTALS of a Gothic church (fig. 394), and sometimes at the top of a Gothic picture frame.

GALLERY. A second story placed over the SIDE AISLES of a church and below the CLERESTORY (fig. 386), or, in a church with a four-part ELEVATION, below the TRIFORIUM and above the NAVE ARCADE which supports it on its open side.

GENIUS (pl. GENII). A winged semi-nude figure, often purely decorative (fig. 527) but frequently representing the guardian spirit of a person or place, or personifying an abstract concept (fig. 757).

GENRE. French word for kind or sort. A work of art, usually a painting, showing a scene from everyday life that is represented for its own sake (colorplate 87).

GESSO. A smooth mixture of ground CHALK or plaster and glue, used as the basis for TEMPERA PAINTING and for OIL PAINTING on PANEL.

GILDING. 1) A coat of gold or of some gold-colored substance applied mechanically or chemically to surfaces of a painting, sculpture, or architectural decoration (colorplates 45, 51, 78). 2) The process of applying same.

GISANT. From the French verb *gésir*, meaning to lie helpless or dead. A recumbent statue on a tomb (fig. 619).

GLAZE. 1) A thin layer of translucent oil color applied to a painted surface or to parts of it in order to modify the tone. 2) A glassy coating applied to a piece of ceramic work before firing in the kiln, as a protective seal and as decoration.

GLORIOLE or GLORY. The circle of radiant light around the head or figures of God, Christ, the Virgin Mary, or a saint. When it surrounds the head only, it is called a halo or nimbus (colorplate 42); when it surrounds the entire figure with a large oval (figs. 301, 417), it is called a *mandorla* (the Italian word for almond). It indicates divinity or holiness, though originally it was placed around the heads of kings and gods as a mark of distinction.

GOLD LEAF, SILVER LEAF. 1) Gold beaten into very thin sheets or "leaves," and applied to ILLUMINATED MANUSCRIPTS and PANEL paintings (colorplates 34, 42, 45), to sculpture (colorplate 51), or to the back of the glass TESSERAE used in MOSAICS (colorplates 22, 24). 2) Silver leaf is also used, though ultimately it tarnishes (colorplate 23). Sometimes called gold foil, silver foil.

GOLGOTHA. See CALVARY.

GORGON. In Greek mythology, one of three hideous, female monsters with large heads, and snakes for hair (fig. 138). Their glance turned men to stone, and Medusa, the most famous Gorgon, was killed by Perseus only with help from the gods.

GOSPEL. 1) The first four books of the New Testament. They tell the story of Christ's life and death, and are ascribed to the EVANGELISTS Matthew, Mark, Luke, and John. 2) A copy of these, usually called a Gospel Book, often richly ILLUMINATED (figs. 337, 339).

GRAPHITE. Soft carbon having an iron-gray color and a metallic luster (fig. 824).

GREEK-CROSS CHURCH. See CENTRAL-PLAN CHURCH.

GROIN VAULT. See VAULT.

GROUND PLAN. An architectural drawing presenting a building as if cut horizontally at the floor level. See the preceding *Note on Architectural Drawings.*

GUTTAE. In a Doric ENTABLATURE, small peglike projections above the FRIEZE possibly derived from pegs originally used in wooden construction (figs. 146, 147).

HALL CHURCH, HALL CHOIR. See HALLENKIRCHE.

HALLENKIRCHE. German word for hall church. A church in which the NAVE and the SIDE AISLES are of the same height. The type was developed in Romanesque architecture, and occurs especially frequently in German Gothic churches (figs. 352, 405).

HALO. See GLORIOLE.

HATCHING. A series of parallel lines used as shading in PRINTS and DRAWINGS (fig. 535). When two sets of crossing parallel lines are used, it is called crosshatching (fig. 604).

HIEROGLYPH. A picture of a figure, animal, or object, standing for a word, syllable, or sound. These symbols are found on ancient Egyptian monuments or in their written records (fig. 68).

HIGH RELIEF. See RELIEF.

HÔTEL. French word for hotel, but used also to designate an elegant town house (fig. 691).

ICON. From the Greek word for image. A PANEL painting of one or more sacred personages such as Christ, the Virgin, a saint, etc., particularly venerated in the ORTHODOX Catholic church (colorplate 27).

ICONOSTASIS. See CHOIR SCREEN.

ILLUMINATED MANUSCRIPT. A MANUSCRIPT decorated with drawings (fig. 340) or with paintings in TEMPERA colors (colorplates 34, 35).

ILLUSIONISM. In artistic terms, the technique of manipulating pictorial or other means in order to cause the eye to perceive a particular reality. May be used in architecture (fig. 639) and sculpture (figs. 626, 627), as well as in painting (colorplates 18, 77; figs. 260, 629).

IMPASTO. From the Italian word meaning "in paste." Paint, usually OIL PAINT, applied very thickly (colorplates 83, 100).

IN ANTIS. See ANTA.

INQUISITION. A religious tribunal of the Catholic church for the suppression of heresy, first administered by the DOMINICAN ORDER in the 13th century. In the 16th century the Spanish Inquisition was particularly active, and was controlled independently by the Spanish kings.

IONIC ORDER. See ORDER, ARCHITECTURAL.

ISLAM. The religion of the MOSLEMS, based on the submission of the faithful to the will of ALLAH as this was revealed to the Prophet MOHAMMED and recorded in the KORAN. The adjectival form is Islamic.

INSULA (pl. INSULAE). Latin word for island. 1) An ancient Roman city block. 2) An "apartment house": a large CONCRETE and brick building or chain of buildings around a central court, up to five stories high. The ground floor contained shops, and above were living quarters (fig. 231).

JAMBS. The vertical sides of an opening. In Romanesque and Gothic churches, the jambs of doors and windows are often cut on a slant outward, or "splayed," thus providing a broader surface for sculptural decoration (figs. 417, 418).

JESUIT ORDER. The "Society of Jesus" was founded in 1540 by Ignatius Loyola (1491–1556), and especially devoted to the service of the pope. The order was a powerful influence in the struggle of the Catholic COUNTER REFORMATION with the Protestant REFORMATION, and also very important for its missionary work, disseminating Christianity in the Far East and the New World.

KAABA. An ancient Arabic SANCTUARY in the Great Mosque at Mecca which became the most sacred shrine of the MOSLEMS. The small building in the mosque contains a stone which is said to have been turned black either by the tears of pilgrims, or by the sins of those who have touched it.

KEEP. 1) The innermost and strongest structure or central tower of a medieval castle, sometimes used as living quarters, as well as for defense. Also called a donjon (colorplate 44). 2) A fortified medieval castle.

KEYSTONE. See ARCH.

KORAN. The scriptures of the MOSLEMS, revealed by ALLAH to MOHAMMED at Mecca and Medina, and transcribed by the Prophet himself, or by one of his associates. The text was established 651–52 A.D.

KORE (pl. KORAI). Greek word for maiden. An archaic Greek statue of a clothed, standing female (fig. 137).

KOUROS (pl. KOUROI). Greek word for youth. An archaic Greek statue of a standing, nude youth (fig. 133).

KYLIX. In Greek and Roman antiquity, a shallow drinking cup with two horizontal handles, often set on a stem terminating in a foot (fig. 129).

LABORS OF THE MONTHS. The various occupations suitable to the months of the year. Scenes or figures illustrating these were frequently represented in ILLUMINATED manuscripts (colorplate 44, fig. 459), or, sometimes with the symbols of the signs of the ZODIAC, CARVED around the PORTALS of Romanesque and Gothic churches (figs. 417, 424).

LANTERN. A relatively small structure crowning a DOME, roof, or tower, frequently open to admit light to an enclosed area below (figs. 296, 565).

LAPIS LAZULI. From the Latin for stone of blue. A deep-blue stone used first for ornamental purposes (colorplate 6), or, after the 12th century, for preparing the blue PIGMENT known as ultramarine.

LAPITH. A member of a mythical Greek tribe which defeated the CENTAURS in a battle, scenes from which are frequently represented in painting and sculpture (colorplate 11, fig. 168).

LAY BROTHER. One who has joined a monastic ORDER but has not taken monastic vows, and therefore belongs still to the people or laity as distinguished from the clergy or religious.

LEKYTHOS (pl. LEKYTHOI). A Greek oil jug with an ellipsoidal body, a narrow neck, a flanged mouth, a curved handle extending from below the lip to the shoulder, and a narrow base terminating in a foot. It was used chiefly for ointments and funerary offerings (colorplate 13).

LIBERAL ARTS. Traditionally thought to go back to Plato, they comprised the intellectual disciplines considered suitable or necessary to a complete education, and included Grammar, Rhetoric, Logic, Arithmetic, Music, Geometry, and Astronomy. During the Middle Ages and the Renaissance, they were often represented allegorically in painting and sculpture (fig. 417).

LINTEL. See POST AND LINTEL.

LITHOGRAPHY. A PRINT made by drawing a design with an oily crayon or other greasy substance on a porous stone or, later, a metal plate; the design is then fixed, the entire surface is moistened, and the printing ink which is applied adheres only to the oily lines of the drawing. The design can then be transferred easily in a press to a piece of paper. The technique was invented c. 1796 by Aloys Senefelder, and quickly became popular (figs. 749, 793, 835). It is also widely used commercially, since many impressions can be taken from a single plate.

LOGGIA. A covered GALLERY or ARCADE open to the air on at least one side. It may stand alone or be part of a building (colorplate 68, fig. 589).

LONGITUDINAL SECTION. See SECTION.

LOUVERS. One slat or a series of overlapping boards or slats which can be opened to admit air, but are slanted so as to exclude sun and rain (fig. 885).

LOW RELIEF. See RELIEF.

LUNETTE. 1) A semicircular or pointed wall area, as under a VAULT (fig. 502) or above a door or window. When it is above the PORTAL of a medieval church, it is called a TYMPANUM (fig. 372). 2) A painting (fig. 622), relief sculpture (fig. 526), or window of the same shape (fig. 705).

MADRASAH. A combination of a Mohammedan mosque and theological school, with living quarters for students (fig. 315).

MAESTÀ. Italian word for majesty, applied in the 14th and 15th centuries to representations of the Madonna and Child enthroned, and surrounded by her celestial court of saints and angels (fig. 448).

MAGDALENIAN. An adjective used for describing artefacts of the latest culture of the Upper PALEOLITHIC; the word comes from La Madeleine (Dordogne), a site in southwestern France where such work was found.

MAGNA. Paint in the form of PIGMENT ground in an ACRYLIC resin with solvents and plasticizer (fig. 834, colorplate 133).

MAGUS (pl. MAGI). A member of the priestly caste of ancient Media and Persia. In Christian literature (Matt. 2: 1–12), one of the three Wise Men or Kings who came from the East bearing gifts to the newborn Jesus (colorplate 45).

MANDORLA. See GLORIOLE.

MANUSCRIPT. From the Latin word for handwritten. 1) A document, scroll, or book written by hand, as distinguished from such a work in print (i.e., after c. 1450). 2) A book produced in the Middle Ages, frequently ILLUMINATED.

MASTABA. An ancient Egyptian tomb, rectangular in shape, with sloping sides and a flat roof. It covered a chapel for offerings and a shaft to the burial chamber (fig. 52).

MAUSOLEUM. 1) The huge tomb erected at Halicarnassus in Asia Minor in the 4th century B.C. by King Mausolus and his wife Artemisia (fig. 178). 2) A generic term for any large funerary monument.

MEANDER. From the name Maeander (modern Menderes), a winding river in western Turkey that flows into the Aegean Sea. A decorative motif of intricate, rectilinear character, applied to architecture and painting (figs. 245, 374, 570).

MEDIUM (pl. MEDIA). 1) The material or technique in which an artist works. 2) The liquid or semiliquid vehicle in which PIGMENTS are carried in PAINT, PASTEL, etc.

MEGALITH. A huge stone such as those used in CROMLECHS and DOLMENS.

MEGARON (pl. MEGARONS, or MEGARA). From the Greek word for large. The central audience hall in a Minoan or Mycenaean palace or home (fig. 110).

MESOLITHIC. Transitional period of the Stone Age, between the PALEOLITHIC and the NEOLITHIC.

METOPE. In a Doric FRIEZE, one of the panels, either decorated or plain, between the TRIGLYPHS. Originally it probably covered the empty spaces between the ends of the wooden ceiling beams (figs. 146, 152).

MIHRAB. The small niche which marks the QIBLA wall of a mosque showing the direction of Mecca.

MINARET. A tall, slender tower with balconies from which Moslems are summoned to prayer by the chant of the MUEZZIN (fig. 318).

MINIATURE. 1) A single illustration in an ILLUMINATED manuscript (colorplate 35). 2) A very small painting, especially a portrait on ivory, glass, or metal (figs. 264, 475).

MINOTAUR. In Greek mythology, a monster having the head of a bull and the body of a man, who lived in the Labyrinth of the palace of Knossos on Crete.

MODEL. 1) The preliminary form of a sculpture, often finished in itself but preceding the final CASTING or CARVING (figs. 686, 763). 2) The preliminary or reconstructed form of a building, made to scale (figs. 214, 336). 3) A person who poses for an artist.

MODELING. 1) In sculpture, the building up of a figure or design in a soft substance such as clay or wax (fig. 692). 2) In painting and drawing, producing a three-dimensional effect by changes in color, the use of light and shade, etc.

MOHAMMED (also Muhammad). Arab prophet and the founder of ISLAM (570?–632). His first revelations were c. 610 and continued throughout his lifetime; collected and recorded, these form the basis of the KORAN. Mohammed was forced to flee from Mecca, his birthplace, to Medina in 622; the date of this Hegira marks the beginning of the Islamic calendar.

MOLDING. In architecture, any of various long, narrow, ornamental bands having a distinctive profile, which project from the surface of the structure and give variety to the surface by means of their patterned contrasts of light and shade (figs. 141, 244).

MOSAIC. Decorative work for walls, VAULTS, ceilings, or floors, composed of small pieces of colored materials (called TESSERAE) set in plaster or CONCRETE. The Romans, whose work was mostly for floors, used regularly shaped pieces of marble in its natural colors (colorplate 16). The early Christians used pieces of glass whose brilliant hues, including gold, and slightly irregular surfaces produced an entirely different, glittering effect (colorplates 22, 24). See also GOLD LEAF.

MOSLEM (also Muslim). 1) One who has embraced ISLAM; a follower of MOHAMMED. 2) An adjective for the religion, law, or civilization of Islam.

MOUNDS. Enormous piles of earth erected by the Indians of the central United States, the so-

called Mound Builders, as a grave and/or BASE for a temple or other structure. Sometimes in the form of an animal, presumably the TOTEM of the tribe.

MUEZZIN. In Mohammedan countries a cryer who calls the faithful to prayer from a MINARET or high part of a building.

MURAL. From the Latin word for wall, *murus*. A large painting or decoration either executed directly on a wall or done separately and affixed to it.

MUSES. In Greek mythology, the nine goddesses who presided over various arts and sciences. They are led by Apollo as god of music and poetry, and usually include Calliope, Muse of Epic Poetry; Clio, Muse of History; Erato, Muse of Love Poetry; Euterpe, Muse of Music; Melpomene, Muse of Tragedy; Polyhymnia, Muse of Sacred Music; Terpsichore, Muse of Dancing; Thalia, Muse of Comedy; and Urania, Muse of Astronomy.

NAOS. See CELLA.

NARTHEX. The transverse entrance hall of a church, sometimes enclosed but often open on one side to a preceding ATRIUM (fig. 268).

NAVE. 1) The central aisle of a Roman BASILICA, as distinguished from the SIDE AISLES (fig. 229). 2) The same section of a Christian basilican church extending from the entrance to the APSE or TRANSEPT (fig. 268).

NEOLITHIC. The New Stone Age, thought to have begun c. 9000–8000 B.C. The first society to live in settled communities, to domesticate animals, and to cultivate crops, it saw the beginning of many new skills such as spinning, weaving, and building (fig. 20).

NEW STONE AGE. See NEOLITHIC.

NIKE. The ancient Greek goddess of victory, often identified with Athena, and by the Romans with Victoria. She is usually represented as a winged woman with windblown draperies (fig. 191).

NIMBUS. See GLORIOLE.

OBELISK. A tall tapering, four-sided stone shaft with a pyramidal top. First constructed as MEGALITHS in ancient Egypt (fig. 71); certain examples since exported to other countries (figs. 624, 635).

ODALISQUE. Turkish word for a harem slave girl or concubine (colorplate 91; fig. 747).

OIL. In art, the MEDIUM for pigments used in OIL PAINTING. Among numerous vegetable oils, the traditional favorite is refined linseed oil, which dries to a tough, solid film.

OIL PAINTING. 1) A painting executed with PIGMENTS mixed with OIL, first applied either to a panel prepared with a coat of GESSO (as also in TEMPERA PAINTING), later to a stretched canvas primed with a coat of white paint and glue. The latter method has been usual since the late 15th century. Oil painting also may be executed on paper, parchment, copper, etc. 2) The technique of executing such a painting.

OIL SKETCH. A work in oil painting of an informal character, sometimes preparatory to a finished work (figs. 649, 732, 747).

OLD STONE AGE. See PALEOLITHIC.

ORCHESTRA. 1) In an ancient Greek theater, the round space in front of the stage and below the tiers of seats, reserved for the chorus (fig. 162). 2) In a Roman theater, a similar space usually reserved for important guests.

ORDER, ARCHITECTURAL. An architectural system based on the COLUMN and its ENTABLATURE, in which the form of the elements themselves (CAP-ITAL, SHAFT, BASE, etc.) and their relationships to each other are specifically defined. The five classical orders are the Doric, Ionic, Corinthian, Tuscan, and Composite (fig. 146). See also COLOSSAL ORDER, SUPERIMPOSED ORDER.

ORDER, MONASTIC. A religious society whose members live together under an established set of rules. See BENEDICTINE, CARMELITE, CISTERCIAN, DOMINICAN, FRANCISCAN, JESUIT, THEATINE.

ORTHODOX. From the Greek word for right in opinion. The Eastern Orthodox Church, which split from the Western Catholic Church during the 5th century A.D. and transferred its allegiance from the pope in Rome to the Byzantine emperor in Constantinople and his appointed patriarch. Sometimes called the Byzantine Church.

PAINT. See ACRYLIC, ENCAUSTIC, FRESCO, MAGNA, OIL PAINTING, TEMPERA PAINTING, WATERCOLOR.

PALAZZO (pl. PALAZZI). Italian word for palace (in French, *palais*). Refers either to large, official buildings (fig. 415), or to important private town houses (fig. 507).

PALEOLITHIC. The Old Stone Age: usually divided into Lower, Middle, and Upper (which began about 35,000 B.C.). A society of nomadic hunters who used stone implements, later developing ones of bone and flint. Some lived in caves which they decorated during the latter stages of the age (colorplate 1; fig. 12), at which time they also produced small CARVINGS in bone, horn, and stone (figs. 16, 17).

PALETTE. 1) A thin, usually oval or oblong board with a thumb hole at one end, used by painters to hold and mix their colors. 2) The range of colors used by a particular painter. 3) In Egyptian art, a slate slab, usually decorated with sculpture in low RELIEF. The small ones with a recessed circular area on one side are thought to have been used for eye makeup. The larger ones were commemorative objects (figs. 49, 50).

PANEL. 1) A wooden surface used for painting, usually in TEMPERA and prepared beforehand with a layer of GESSO. Large ALTARPIECES require the joining together of two or more boards (colorplate 49). 2) Recently panels of masonite or other composite material have come into use (colorplate 133).

PANTHEON. A temple dedicated to all the gods (figs. 221, 222), or one housing tombs of the illustrious dead of a nation, or memorials to them (fig. 708).

PANTOCRATOR. A representation of Christ as ruler of the universe which appears frequently in the DOME or APSE MOSAICS of Byzantine churches (fig. 295).

PAPER. General name for a writing material made from various fibrous substances. Invented in China in the 2nd century A.D., it was known in Europe in the Middle Ages, but its possibilities as a cheap substitute for PARCHMENT were not fully realized until the development of printing in northern Europe in the 15th century.

PAPYRUS. 1) A tall aquatic plant which grew abundantly in the Near East, Egypt, and Abyssinia. 2) A paper-like material made by laying together thin strips of the pith of this plant, and then soaking, pressing, and drying the whole. The resultant sheets were used as writing material by the ancient Egyptians, Greeks, and Romans. 3) An ancient document or SCROLL written on this material.

PARCHMENT. From Pergamum, the name of a Greek city in Asia Minor where parchment was invented in the 2nd century B.C. 1) A paper-like material made from thin bleached animal hides, used extensively in the Middle Ages for MANUSCRIPTS (colorplates 32, 34, 35). Vellum is a superior type of parchment, made from calfskin. 2) A document or miniature on this material.

PASSION. 1) In ecclesiastic terms, the events of Christ's last week on earth. 2) The representation of these events in pictorial, literary, theatrical, or musical form (colorplates 39, 40, 49; figs. 516, 575, 648).

PASTEL. 1) A color of a soft, subdued shade. 2) A drawing stick made from PIGMENTS ground with CHALK and mixed with gum water. 3) A drawing executed with these sticks (figs. 770, 771).

PEDESTAL. An architectural support for a statue, vase, etc.

PENDENTIVE. One of the spherical triangles which achieve the transition from a square or polygonal opening to the round BASE of a DOME or the supporting DRUM (figs. 291, 294, 524).

PEDIMENT. 1) In classical architecture, a low GABLE, typically triangular, framed by a horizontal CORNICE below and two raking cornices above; frequently decorated with sculpture (fig. 142). 2) A similar architectural member, either round or triangular, used over a door, window, or niche (fig. 559). When pieces of the cornice are either turned at an angle or broken, it is called a broken pediment (fig. 232).

PEPLOS. An outer garment worn draped in folds about the figure by ancient Greek women (fig. 137).

PERIPTERAL. An adjective describing a building which is surrounded by a single row of COLUMNS or COLONNADE (figs. 145, 152).

PERISTYLE. 1) In a Roman house or DOMUS, an open garden court surrounded by a COLONNADE (fig. 235). 2) A colonnade around the outside of a building or court (figs. 145, 548).

PERSPECTIVE. A technique for representing spatial relationships and three-dimensional objects on a flat surface so as to produce an effect similar to that perceived by the human eye. In "atmospheric" or aerial perspective, this is accomplished by a gradual decrease in the intensity of local color and in the contrast of light and dark, so that everything in the far distance tends toward a light bluish-gray tone (colorplate 47). In one-point linear perspective, developed in Italy in the 15th century, a mathematical system is used, based on orthogonals (parallel lines receding at right angles to the picture plane) that converge on a single vanishing point on the horizon. Since this presupposes an absolutely stationary viewer and imposes rigid restrictions on the artist, it is seldom applied with complete consistency (colorplate 54, fig. 493).

PIAZZA (pl. PIAZZE). Italian word for public square (in French, *place*; in German, *Platz*).

PICTURE PLANE. The flat surface on which a picture is painted.

PICTURESQUE. Visually interesting or pleasing, as if resembling a picture (fig. 707).

PIER. An upright architectural support, usually rectangular, and sometimes with CAPITAL and BASE (fig. 203). When COLUMNS, PILASTERS, or SHAFTS are attached to it, as in many Romanesque and Gothic churches, it is called a com-

pound pier (fig. 357).

PIETÀ. Italian word for both pity and piety. A representation of the Virgin grieving over the dead Christ (fig. 429). When used in a scene recording a specific moment after the Crucifixion, it is usually called a "Lamentation" (fig. 450).

PIGMENT. Colored substances found in organic and inorganic sources; many are now prepared synthetically. 1) Pigment finely divided and suspended in a liquid medium becomes a paint, ink, etc. See OIL PAINTING, TEMPERA PAINTING, WATERCOLOR, FRESCO. 2) Pigment suspended in a solid medium becomes CRAYON, PASTEL, etc.

PILASTER. A flat, vertical element projecting from a wall surface, and normally having a BASE, SHAFT, and CAPITAL. It has generally a decorative rather than structural purpose (figs. 520, 522).

PILGRIMAGE CHOIR. The unit in a Romanesque church composed of the APSE, AMBULATORY, and RADIATING CHAPELS (figs. 347, 385).

PILLAR. A general term for a vertical architectural support which includes COLUMNS, PIERS, and PILASTERS.

PINNACLE. A small, decorative structure capping a tower, PIER BUTTRESS, or other architectural member, and used especially in Gothic buildings (figs. 395, 397).

PLAN. See GROUND PLAN.

PODIUM. 1) The tall base upon which rests an Etruscan or Roman temple (fig. 210). 2) The ground floor of a building made to resemble such a base (fig. 680).

POLYPTYCH. An ALTARPIECE or devotional work of art made of several panels joined together (fig. 463), often hinged.

PORTA. Latin word for door or gate (fig. 209).

PORTAL. A door or gate, usually a monumental one with elaborate sculptural decoration (figs. 417, 430).

PORCH. General term for an exterior appendage to a building which forms a covered approach to a doorway (fig. 394). See PORTICO for porches consisting of columns.

PORTICO. A porch supporting a roof or an ENTABLATURE and PEDIMENT, often approached by a number of steps (figs. 210, 562). It provides a monumental covered entrance to a building, and a link with the space surrounding it.

POST AND LINTEL. A basic system of construction in which two or more uprights, the "posts," support a horizontal member, the "lintel." The lintel may be the topmost element (figs. 29, 30), or support a wall or roof (fig. 120, 870).

PREDELLA. The base of an ALTARPIECE, often decorated with small scenes which are related in subject to that of the main panel or panels (colorplate 45).

PRINT. A picture or design reproduced, usually on paper and often in numerous copies, from a prepared wood block, metal plate, or stone slab. See AQUATINT, ENGRAVING, ETCHING, LITHOGRAPH, WOODCUT.

PRONAOS. In a Greek or Roman temple, an open vestibule in front of the CELLA (fig. 145).

PROPYLAEUM (pl. PROPYLAEA). 1) The entrance to a temple or other enclosure, especially when it is an elaborate structure. 2) The monumental entry gate at the western end of the Acropolis in Athens (fig. 155).

PSALTER. 1) The book of Psalms in the Old Testament, thought to have been written in part by David, King of ancient Israel. 2) A copy of the Psalms, sometimes arranged for liturgical or

devotional use, and often richly ILLUMINATED (colorplate 26).

PULPIT. A raised platform in a church from which the clergyman delivers a sermon or conducts the service. Its railing or enclosing wall may be elaborately decorated (fig. 432).

PUTTO (pl. PUTTI). A small, nude child, usually winged, often represented in classical and Renaissance art (colorplate 76, fig. 532). Also called a cupid or amoretto when he carries a bow and arrow and personifies Love (colorplate 79, fig. 571).

PYLON. From the Greek word for gateway. 1) The monumental entrance to an Egyptian temple or forecourt consisting either of a massive wall with sloping sides pierced by a doorway, or of two such walls flanking a central gateway (fig. 71). 2) A tall structure at either side of a gate, bridge, or avenue, marking an approach or entrance.

QIBLA. The direction of Mecca, toward which Moslems turn when praying. It is indicated in a mosque by the MIHRAB (niche) in the "qibla wall."

QUARTZITE. An extremely compact, granular rock, consisting essentially of quartz (fig. 67).

QUATREFOIL. An ornamental element composed of four lobes radiating from a common center (figs. 424, 440).

RADIATING CHAPELS. Term for CHAPELS arranged around the AMBULATORY (and sometimes the TRANSEPT) of a medieval church (figs. 348, 385, 395).

REFECTORY. 1) A room for refreshment. 2) The dining hall of a monastery, college, or other large institution.

REFORMATION. The religious movement in the early 16th century which had for its object the reform of the Catholic Church, and led to the establishment of Protestant churches. See also COUNTER REFORMATION.

REINFORCED CONCRETE. See FERROCONCRETE.

RELIEF. 1) The projection of a figure or part of a design from the background or plane on which it is CARVED or MODELED. Sculpture done in this manner is described as "high relief" or "low relief" depending on the height of the projection (figs. 51, 243). When it is very shallow, it is called schiacciato, the Italian word for flattened out (fig. 491). 2) The apparent projection of forms represented in a painting or drawing.

RESPOND. A half-PIER, PILASTER, or similar element projecting from a wall to support a LINTEL, or an ARCH whose other side is supported by a free-standing COLUMN or pier, as at the end of an ARCADE (colorplate 22). 2) One of a series of pilasters on a wall behind a COLONNADE (figs. 232, 500) which echo or "respond to" the COLUMNS, but are largely decorative. 3) One of the slender shafts of a COMPOUND PIER in a medieval church which seems to carry the weight of the VAULT (figs. 358, 391).

RHYTON. An ancient drinking horn made from pottery or metal, and frequently having a base in the form of a human or animals head (fig. 103).

RIB. A slender, projecting, archlike member which supports a VAULT either transversally (fig. 350), or at the GROINS, thus dividing the surface into sections (fig. 358). In late Gothic architecture, its purpose is often primarily ornamental (fig. 402).

RIBBED VAULT. See VAULT.

ROLL. A long sheet of PAPYRUS or PARCHMENT with a written text, sometimes illustrated, used as a book before the introduction of the CODEX. Also called a SCROLL, and, in Latin, a rotulus (fig. 202).

ROOD SCREEN. See CHOIR SCREEN.

ROSE WINDOW. A large, circular window with stained glass and stone TRACERY, frequently used on FAÇADES and at the ends of TRANSEPTS of Gothic churches (figs. 388, 390).

ROSTRUM. 1) A beak-like projection from the prow of an ancient warship, used for ramming the enemy. 2) In the Roman FORUM, the raised platform decorated with the beaks of captured ships, from which speeches were delivered (fig. 257). 3) A platform, stage, or the like used for public speaking.

RUBBING. A reproduction of a relief surface made by covering it with paper and rubbing with pencil, chalk, etc. (fig. 893). Also called "frottage."

RUSTICATION. A masonry technique of laying stones with sharply indented joints (figs. 507, 590).

SACRA CONVERSAZIONE. Italian for holy conversation. A composition of the Madonna and Child with Saints in which the figures all occupy the same spatial setting, and appear to be conversing or communing with each other (figs. 536, 572).

SACRISTY. A room near the main altar of a church, or a small building attached to a church, where the vessels and vestments required for the service are kept. Also called a vestry.

SALON. 1) A large, elegant drawing or reception room in a palace or private house (fig. 691). 2) The official government-sponsored exhibition of paintings and sculpture by living artists held in the Louvre at Paris, first biennially, then annually (fig. 825). 3) Any large public exhibition patterned after the Paris Salon.

SANCTUARY. 1) A sacred or holy place or building. 2) An especially holy place within a building, such as the CELLA of a temple, or the part of a church around the altar.

SANGUINE. A reddish-brown CHALK stick used for DRAWING (fig. 576).

SARCOPHAGUS (pl. SARCOPHAGI). A large stone coffin usually decorated with sculpture and/or inscriptions (figs. 200, 277). The term is derived from two Greek words meaning flesh and eating, which were applied to a kind of limestone in ancient Greece, since the stone was said to turn flesh to dust.

SATYR. One of a class of woodland gods thought to be the lascivious companions of Dionysus, the Greek god of wine (or of Bacchus, his Roman counterpart). They are represented as having the legs and tail of a goat, the body of a man, and a head with horns and pointed ears. A youthful satyr is also called a faun (colorplate 59, fig. 186).

SCRIPTORIUM (pl. SCRIPTORIA). A workroom in a monastery reserved for copying and illustrating MANUSCRIPTS.

SCROLL. 1) An architectural ornament with the form of a partially unrolled spiral, as on the CAPITALS of the Ionic and Corinthian ORDERS (figs. 146, 160). 2) A form of written text: see ROLL. 3) A format for Far Eastern painting, either large (fig. 892) or small (fig. 894).

SCROLL BRACKET. See BRACKET.

SCUOLA. Italian word for school. In Renaissance Venice it designated a fraternal organization or

confraternity, dedicated to good works, usually under ecclesiastical auspices.

SECTION. An architectural drawing presenting a building as if cut across the vertical plane, at right angles to the horizontal plane. Cross section: a cut along the transverse axis. Longitudinal section: a cut along the longitudinal axis. See the preceding *Note on Architectural Drawings*.

SEXPARTITE VAULT. See VAULT.

SFUMATO. Italian word meaning gone up in smoke, used to describe very delicate gradations of light and shade in the MODELING of figures; applied especially to the work of Leonardo da Vinci and his followers (fig. 541).

SHAFT. In architecture, the part of a COLUMN between the BASE and the CAPITAL (fig. 146).

SIBYLS. In Greek and Roman mythology, any of numerous women who were thought to possess powers of divination and prophecy. They appear in Christian representations, notably in Michelangelo's Sistine Ceiling, because they were believed to have foretold the coming of Christ.

SIDE AISLE. A passageway running parallel to the NAVE of a Roman BASILICA or Christian church, separated from it by an ARCADE or COLONNADE (figs. 229, 268). There may be one on either side of the nave, or two, an inner and outer.

SILENI. A class of minor woodland gods in the entourage of the wine god, Dionysus (or Bacchus). Like Silenus, the wine god's tutor and drunking companion, they are thick-lipped and snub-nosed, and fond of wine. Similar to SATYRS, they are basically human in form except for their horse tails and ears (colorplate 19).

SILVER LEAF. See GOLD LEAF.

SINOPIA (pl. SINOPIE). Italian word taken from Sinope, the ancient city in Asia Minor which was famous for its brick-red PIGMENT. In FRESCO paintings, a full-sized, preliminary sketch done in this color on the first rough coat of plaster or "arriccio" (fig. 455).

SKENE. See THEATER.

SKETCH. See DRAWING; OIL SKETCH.

SPANDREL. The area between the exterior curves of two adjoining ARCHES, or, in the case of a single arch, the area around its outside curve from its springing to its KEYSTONE (colorplate 56, figs. 256, 280).

SPHINX. 1) In ancient Egypt, a creature having the head of a man, animal, or bird, and the body of a lion; frequently sculpted in monumental form (fig. 60). 2) In Greek mythology, a creature usually represented as having the head and breasts of a woman, the body of a lion, and the wings of an eagle. It appears in classical, Renaissance, and Neoclassical art.

STANZA (pl. STANZE). Italian word for room.

STEATITE. Soapstone, commonly gray or grayish-green in color (fig. 114).

STEEL. Iron modified chemically to have qualities of great hardness, elasticity, and strength. For use in sculpture, see figs. 855, 858. For architectural use, see STRUCTURAL STEEL.

STELE. From the Greek word for standing block. An upright stone slab or pillar with a CARVED commemorative design or inscription (figs. 87, 176).

STEREOBATE. The substructure of a classical building, especially of a Greek temple (fig. 146).

STILTS. Term for pillars or posts supporting a superstructure; in 20th-century architecture, these are usually of FERROCONCRETE (figs. 881, 885). Stilted, as in stilted arches, refers to tall supports beneath an architectural member (fig. 299).

STOA. In Greek architecture, a covered COLONNADE, sometimes detached and of considerable length, used as a meeting place or promenade.

STOIC. A school of philosophy founded by Zeno about 300 B.C., and named after the STOA in Athens where he taught. Its main thesis is that man should be free of all passions.

STRUCTURAL STEEL. STEEL used as an architectural building material either invisibly (fig. 846) or exposed (figs. 873, 880). See FERROCONCRETE.

STUCCO. 1) A CONCRETE or cement used to coat the walls of a building. 2) A kind of plaster used for architectural decorations such as CORNICES, MOLDINGS, etc., or for sculptured RELIEFS (figs. 203, 314).

STUDY. See DRAWING.

STUPA. A large mound-shaped Buddhist shrine, often elaborately decorated with sculpture (fig. 901).

STYLOBATE. A platform or masonry floor above the STEREOBATE forming the foundation for the COLUMNS of a classical temple (fig. 146).

STYLUS. From the Latin word *stilus*, the writing instrument of the Romans. 1) A pointed instrument used in ancient times for writing on tablets of a soft material such as clay. 2) The needle-like instrument used in drypoint or etching. See ENGRAVING, ETCHING.

SUPERIMPOSED ORDERS. Two or more rows of COLUMNS, PIERS, or PILASTERS placed above each other on the wall of a building (figs. 219, 517).

TABERNACLE. 1) A place or house of worship. 2) A CANOPIED niche or recess built for an image (fig. 489). 3) The portable shrine used by the Jews to house the Ark of the Covenant (colorplate 21).

TABLINIUM. From the Latin word meaning writing tablet, or written record. In a Roman house, a small room at the far end of the ATRIUM, or between it and the second courtyard. It was used for keeping family records.

TEMPERA PAINTING. 1) A painting made with PIGMENTS mixed with egg yolk and water. In the 14th and 15th centuries, it was applied to PANELS which had been prepared with a coating of GESSO; the application of GOLD LEAF and of underpainting in green or brown preceded the actual tempera painting (colorplates 40, 45). 2) The technique of executing such a painting.

TERRACOTTA. Italian word for cooked earth. 1) An earthenware, naturally reddish-brown but often GLAZED in various colors and fired. Used for pottery, sculpture, or as a building material or decoration. 2) An object made of this material. 3) The natural color of the material.

TESSERA (pl. TESSERAE). A small piece of colored stone, marble, glass, or gold-backed glass used in a MOSAIC.

THEATER. In ancient Greece, an outdoor place for dramatic performances, usually semicircular in plan and provided with tiers of seats, the ORCHESTRA, and the *skene*, or support for scenery (fig. 162). See also AMPHITHEATER.

THEATINE ORDER. Founded in Rome in the 16th century by members of the recently dissolved Oratory of Divine Love. Its aim was to reform the Church from within, and its members were pledged to cultivate their spiritual lives and to perform charitable works.

THERMAE. A public bathing establishment of the ancient Romans which consisted of various types of baths plus social and gymnastic facilities.

THOLOS. In classical architecture, a circular building ultimately derived from early tombs (fig. 161).

THRUST. The lateral pressure exerted by an ARCH, VAULT, or DOME, which must be counteracted at its point of greatest concentration either by the thickness of the wall or by some form of BUTTRESS.

TOGA. A garment worn by ancient Roman citizens when appearing in public. It consisted of a single, long piece of material which could be draped in a variety of ways (fig. 238).

TOTEM. Among the Indians of North America, a natural object or animal assumed as the emblem of a tribe or family, or the representation of it, such as those CARVED on the posts or "totem-poles" erected in front of their dwellings.

TRACERY. 1) Ornamental stone work in Gothic windows. In the earlier or "plate tracery," the windows appear to have been cut through the solid stone (colorplate 37). In "bar tracery" the glass predominates, the slender pieces of stone having been added within the windows (fig. 395). 2) Similar ornamentation using various materials and applied to walls, shrines, etc. (fig. 479).

TRANSEPT. A cross arm in a BASILICAN church, placed at right angles to the NAVE, and usually separating it from the CHANCEL or APSE (fig. 268).

TREE OF KNOWLEDGE. The tree in the Garden of Eden from which Adam and Eve ate the forbidden fruit which destroyed their innocence (Gen. 2: 9, 17).

TREE OF LIFE. A tree in the Garden of Eden whose fruit was reputed to give everlasting life; in medieval art it was frequently used as a symbol of Christ (Gen. 2: 9; 3: 22).

TREFOIL. An ornamental element with three lobes radiating from a common center (fig. 451).

TRIFORIUM. The section of a NAVE wall above the ARCADE and below the CLERESTORY (colorplate 37). It frequently consists of a BLIND ARCADE with three openings in each bay. When the GALLERY is also present, a four-story ELEVATION results, the triforium being between the gallery and clerestory. It may also occur in the TRANSEPT or CHOIR wall.

TRIGLYPH. The element of a Doric FRIEZE separating two consecutive METOPES, and being divided by channels (or glyphs) into three sections. Probably an imitation in stone of the ends of wooden ceiling beams (figs. 146, 152).

TRIPTYCH. An ALTARPIECE or devotional picture, either CARVED or painted, with one central panel and two hinged wings (figs. 304, 471).

TRIUMPHAL ARCH. 1) A monumental ARCH, sometimes a combination of three arches, erected by a Roman emperor in commemoration of his military exploits, and usually decorated with scenes of these deeds in RELIEF sculpture (fig. 256). 2) The great transverse arch at the eastern end of a church which frames the altar and APSE and separates them from the main body of the church. It is frequently decorated with MOSAICS or MURAL paintings (colorplate 22, fig. 266).

TROPHY. 1) In ancient Rome, arms or other spoils taken from a defeated enemy and

publicly displayed on a tree, PILLAR, etc. 2) A representation of these objects, and others symbolic of victory, as a commemoration or decoration.

TRUMEAU. A central post supporting the LINTEL of a large doorway, as in a Romanesque or Gothic PORTAL, where it was frequently decorated with sculpture (figs. 369, 430).

TRUSS. A triangular wooden or metal support for a roof which may be left exposed in the interior (figs. 266, 408), or be covered by a ceiling (figs. 345, 366).

TUNIC. In classical Greece and Rome, a loose, knee-length garment worn by both sexes. It could have sleeves or not, and was generally worn unbelted.

TURRET. 1) A small tower, part of a larger structure. 2) A small tower at an angle of a building, frequently beginning some distance from the ground.

TYMPANUM. 1) In classical architecture, the recessed, usually triangular area, also called a PEDIMENT, often decorated with sculpture (fig. 147). 2) In medieval architecture, an arched area between an ARCH and the LINTEL of a door or window, frequently carved with RELIEF sculpture (figs. 372, 420).

UNDERPAINTING. See TEMPERA PAINTING.

VAULT. An arched roof or ceiling usually made of stone, brick, or CONCRETE. Several distinct varieties have been developed; all need BUTTRESSING at the point where the lateral THRUST is concentrated. 1) A barrel vault is a semicylindrical structure made up of successive ARCHES (fig. 352). It may be straight or ANNULAR in plan (fig. 271). 2) A groin vault is the result of the intersection of two barrel vaults of equal size which produces a BAY of four compartments with sharp edges, or "groins" where the two meet (fig. 220). 3) A ribbed groin vault is one in which RIBS are added to the groins, for structural strength and for decoration (fig. 357). 4) A sexpartite vault is a

ribbed groin vault in which each bay is divided into six compartments by the addition of a transverse rib across the center (fig. 358). 5) A fan vault is an elaboration of a ribbed groin vault, with elements of TRACERY using cone-like forms. It was developed by the English in the 15th century, and was employed for decorative purposes (figs. 403, 404).

VELLUM. See PARCHMENT.

VESTRY. See SACRISTY.

VICES. Often represented allegorically in conjunction with the seven VIRTUES, they include Pride, Avarice, Wrath, Gluttony, Unchastity (Luxury), Folly, and Inconstancy, though others such as Injustice are sometimes substituted.

VILLA. Originally a large country house (fig. 591), but in modern usage, also a detached house or suburban residence.

VIRTUES. The three theological virtues, Faith, Hope, and Charity, and the four cardinal ones, Prudence, Justice, Fortitude, and Temperance, were frequently represented allegorically, particularly in medieval manuscripts and sculpture.

VOLUTE. A spiral architectural element found notably on Ionic and Composite CAPITALS (figs. 160, 210), but also used decoratively on building FAÇADES and interiors (figs. 596, 641).

VOUSSOIR. See ARCH.

WASH. A thin layer of translucent color or ink used in WATERCOLOR PAINTING and BRUSH DRAWING (fig. 677), and occasionally in OIL PAINTING.

WATERCOLOR PAINTING. Painting, usually on paper, in PIGMENTS suspended in water (figs. 599, 818).

WESTWORK. From the German word *Westwerk*. In Carolingian, Ottonian, and German Romanesque architecture, a monumental western front of a church, treated as a tower or combination of towers, and containing an entrance and vestibule below, and a CHAPEL and GALLERIES above. Later examples often added

a TRANSEPT and a CROSSING tower (fig. 342).

WING. The side panel of an ALTARPIECE which is frequently decorated on both sides, and also hinged, so that it may be shown either open or closed (figs. 463, 465).

WOODCUT. A PRINT made by carving out a design on a wood block cut along the grain, applying ink to the raised surfaces which remain, and printing from those (figs. 481, 600, 604). The spaces between the lines may be colored by hand, or, as is the case with many Japanese woodcuts, by using separate blocks for one or more colors (figs. 891, 896).

WOOD ENGRAVING. See ENGRAVING.

WROUGHT IRON. A comparatively pure form of iron which is easily forged and does not harden easily, so that it can be shaped or hammered by hand (fig. 848), in contrast to molded CAST IRON.

YAKSHI. A tree-nymph or local fertility spirit occurring in Buddhist and Hindu art and religion (fig. 901).

ZIGGURAT. From the Assyrian word *ziqquratu* meaning mountain top or height. In ancient Assyria and Babylonia, a pyramidal tower built of mud brick and forming the BASE of a temple; it was either stepped or had a broad ascent winding around it which gave it the appearance of being stepped (figs. 79, 82).

ZODIAC. 1) An imaginary belt circling the heavens, including the paths of the sun, moon, and major planets, and containing twelve constellations and thus twelve divisions called signs, which have been associated with the months. The signs are: Aries the ram, Taurus the bull, Gemini the twins, Cancer the crab, Leo the lion, Virgo the virgin, Libra the balance, Scorpio the scorpion, Sagittarius the archer, Capricorn the goat, Aquarius the water-bearer, and Pisces the fish. They are frequently represented around the PORTALS of Romanesque and Gothic churches in conjunction with the LABORS OF THE MONTHS (figs. 372, 424).

This list includes the most recent and comprehensive studies that are available in English. Books with material relevant to several chapters are cited under the first heading only. Many of these works contain bibliographies that may be consulted for information on more specialized topics. Two excellent general bibliographies are Guide to Art Reference Books by Mary W. Chamberlin (American Library Association, 1959), and Art Books: A Basic Bibliography by E. Louise Lucas (New York Graphic Society, 1968). Asterisks (*) indicate that titles are available in paperback. For publishers and dates, consult Paperbound Books in Print.

INTRODUCTION:
THE ARTIST AND HIS PUBLIC

*ARNHEIM, RUDOLF, Art and Visual Perception, University of California Press, Berkeley, 1974

*———, Visual Thinking, University of California Press, Berkeley, 1971

*———, Toward a Psychology of Art, University of California Press, Berkeley and Los Angeles,1966

BAUMGART, FRITZ, A History of Architectural Styles, Praeger, New York, 1970

BERNHEIMER, RICHARD, The Nature of Representation, New York University Press, 1961

*DEINHARD, HANNA, Meaning and Expression: Toward a Sociology of Art, Beacon Press, Boston, 1970

*ELSEN, ALBERT E., Purposes of Art, 3rd ed., Holt, Rinehart and Winston, New York, 1972

*FOCILLON, HENRI, The Life of Forms in Art, 2nd English ed., enlarged and revised, Wittenborn, New York, 1958

*GOLDWATER, ROBERT, and TREVES, MARCO, Artists on Art, 3rd ed., Pantheon Books, New York, 1958

*GOMBRICH, ERNST H., Art and Illusion, 4th ed., Pantheon Books, New York, 1972

———, HOCHBERG, JULIAN, and BLACK, MAX, Art, Perception and Reality, Johns Hopkins University Press, Baltimore, 1973

*KUBLER, GEORGE, The Shape of Time, Yale University Press, New Haven, 1962

*PANOFSKY, ERWIN, Meaning in the Visual Arts, Anchor Books, Garden City, 1955

READ, HERBERT E., Art and Alienation: The Role of the Artist in Society, Horizon, New York, 1967

*———, Art and Society, 2d ed., Pantheon Books, New York, 1950

*———, Icon and Idea, Schocken Books, New York, 1965

*ROSENBERG, HAROLD, The Anxious Object: Art Today and Its Audience, 2nd ed., Horizon, New York, 1966

PART ONE

THE ANCIENT WORLD

I. MAGIC AND RITUAL—
THE ART OF PREHISTORIC MAN

BLACK, GLENN A., Angel Site, 2 vols., Indiana Historical Society, Indianapolis, 1967

*BOAS, FRANZ, Primitive Art, new ed., Dover, New York, 1955

*BURKITT, MILES C., The Old Stone Age, 4th ed., Atheneum, New York, 1963

*CHILDE, VERE GORDON, The Dawn of European Civilization, 6th ed., Knopf, New York, 1958

CLARK, JOHN GRAHAME D., The Stone Age Hunters, McGraw-Hill, New York, 1967

CORNET, JOSEPH, Art of Africa, Phaidon, New York, 1971

DAVIES, OLIVER, West Africa Before the Europeans: Archaeology and Prehistory, Methuen, London, 1967

FROBENIUS, LEO, and FOX, D. C., Prehistoric Rock Pictures in Europe and Africa, Museum of Modern Art, New York, 1937

GRAZIOSI, PAOLO, Paleolithic Art, McGraw-Hill, New York, 1960

GUIART, JEAN, The Arts of the South Pacific, tr. by Anthony Christie, Golden Press, New York, 1963

*LAUDE, JEAN, The Arts of Black Africa, University of California Press, Berkeley, 1971

LEROI-GOURHAN, ANDRÉ, Treasures of Prehistoric Art, Abrams, New York, 1967

LLOYD, SETON, Mounds of the Near East, Edinburgh University Press, 1963

LOMMEL, ANDREAS, Shamanism, the Beginnings of Art, McGraw-Hill, New York, 1967

MEGAW, J. V. S., Art of the European Iron Age, Harper and Row, New York, 1970

MELLAART, JAMES, Catal Hüyük: A Neolithic Town in Anatolia, McGraw-Hill, New York, 1967

PERICOT-GARCIA, LUIS, GALLOWAY, JOHN, and LOMMEL, ANDREAS, Prehistoric and Primitive Art, Abrams, New York, 1967

*POWELL, THOMAS G. E., Prehistoric Art, Praeger, New York, 1966

SANDARS, NANCY K., Prehistoric Art in Europe, Pelican History of Art, Penguin Books, Baltimore, 1968

*SILVERBERG, ROBERT, Mound Builders of Ancient America: The Archeology of a Myth, New York Graphic Society, Greenwich, 1968

*WAAGE, FREDERICK, Prehistoric Art, W. C. Brown, Dubuque, 1967

*WILLETT, FRANK, African Art, Praeger, New York, 1971

*WINGERT, PAUL S., Primitive Art: Its Traditions and Styles, Oxford University Press, New York, 1962

———, The Sculpture of Negro Africa, Columbia University Press, New York, 1950

2. EGYPTIAN ART

ALDRED, CYRIL, Akhenaten and Nefertiti, Viking Press, New York, 1973

———, Art of Ancient Egypt, 3 vols., Transatlantic, New York, 1974

———, Development of Ancient Egyptian Art from 3200 to 1315 B.C., Transatlantic, New York, 1975

BADAWY, ALEXANDER, A History of Egyptian Architecture, Vol. I, Sh. Studio Misr., Giza, 1954; Vols. II–III, University of California Press, Berkeley, 1966–68

*FAKHRY, AHMED, The Pyramids, 2nd ed., University of Chicago Press, 1962

GROENEWEGEN-FRANKFORT, HENRIETTE A., Arrest and Movement, University of Chicago Press, 1951

HAYES, WILLIAM C., The Scepter of Egypt, 2 vols., Harper, in cooperation with the Metropolitan Museum of Art, New York, 1953–59

LANGE, KURT, and HIRMER, MAX, Egypt, 4th ed., Phaidon, London, 1968

MICHALOWSKI, KAZIMIERZ, Art of Ancient Egypt,

Abrams, New York, 1969

*PANOFSKY, ERWIN, Tomb Sculpture: Its Aspects from Ancient Egypt to Bernini, Abrams, New York, 1969

PORTER, BERTHA, and MOSS, ROSALIND L.B., Topographical Bibliography of Ancient Egyptian Hieroglyphic Texts, Reliefs and Paintings, 7 vols., Oxford University Press, New York, 1927–51; 2nd ed., Vols. I (2 parts), 2–3, 1960–74

POULSEN, VAGN, Egyptian Art, New York Graphic Society, Greenwich, 1968

SCHAFER, HEINRICH, Principles of Egyptian Art, tr. by Emma Brunner-Traut, Clarendon Press, Oxford, 1974

SMITH, WILLIAM STEVENSON, The Art and Architecture of Ancient Egypt, reprinted with corrections, Pelican History of Art, Penguin Books, Baltimore, 1965

WOLDERING, IRMGARD, The Art of Egypt, Greystone, New York, 1963

WOLF, WALTHER, The Origins of Western Art: Egypt, Mesopotamia, the Aegean, Universe Books, New York, 1971

3. THE ANCIENT NEAR EAST

AKURGAL, EKREM, Art of the Hittites, Abrams, New York, 1962

*EHRICH, ROBERT W., ed., Chronologies in Old World Archeology, University of Chicago Press, 1965

*FRANKFORT, HENRI, The Art and Architecture of the Ancient Orient, rev. ed., Pelican History of Art, Penguin Books, Baltimore, 1971

*———, The Birth of Civilization in the Near East, Williams & Norgate, London, 1951

GHIRSHMAN, ROMAN, The Arts of Ancient Iran from Its Origins to the Time of Alexander the Great, tr. by Stuart Gilbert and James Emmons, Golden Press, New York, 1964

*GROENEWEGEN-FRANKFORT, HENRIETTE A., and ASHMOLE, BERNARD, Art of the Ancient World, Abrams, New York, 1975

———, and YALOURIS, NICHOLAS, Persian Art: The Parthian and Sassanian Dynasties, 249 B.C.–A.D. 651, tr. by Stuart Gilbert and James Emmons, Golden Press, New York, 1962

*LLOYD, SETON, The Art of the Ancient Near East, Praeger, New York, 1961

———, MÜLLER, HANS W., and MARTIN, ROLAND, Ancient Architecture: Mesopotamia, Egypt, Greece, Abrams, New York, 1974

*MELLAART, JAMES, Earliest Civilizations of the Near East, McGraw-Hill, New York, 1965

MOORTGAT, ANTON, The Art of Ancient Mesotamia, Phaidon, New York, 1969

PARROT, ANDRÉ, The Arts of Assyria, Braziller, New York, 1961

———, Sumer: The Dawn of Art, tr. by Stuart Gilbert and James Emmons, Golden Press, New York, 1961

ROSTOVTZEFF, MIKHAIL I., Iranians and Greeks in South Russia, repr. ed., Russell and Russell, New York, 1969

*SAGGS, H. W. F., The Greatness That Was Babylon, Praeger, New York, 1968

SMITH, WILLIAM STEVENSON, Interconnections in the Ancient Near East, Yale University Press, New Haven, 1965

STROMMENGER, EVA, and HIRMER, MAX, 5000 Years of the Art of Mesopotamia, tr. by Christina

Haglund, Abrams, New York, 1964

*WOOLLEY, CHARLES L., Ur of the Chaldees, Norton, New York, 1965

4. AEGEAN ART

BLEGEN, CARL W., and RAWSON, MARION, eds., The Palace of Nestor at Pylos in Western Messenia, 3 vols., Princeton University Press, 1966–73

*CROON, J. H., ed., The Encyclopedia of the Classical World, tr. by J. Muller, Van Santen and Claire Jones, Prentice-Hall, Englewood Cliffs, 1965

DEMARGNE, PIERRE, Aegean Art: The Origins of Greek Art, tr. by Stuart Gilbert and James Emmons, Golden Press, New York, 1964

*GRAHAM, JAMES WALTER, The Palaces of Crete, Princeton University Press, 1962

*HIGGINS, REYNOLD, Minoan and Mycenean Art, Praeger, New York, 1967

MARINATOS, SPYRIDON N., and HIRMER, MAX, Crete and Mycenae, Abrams, New York, 1960

MYLONAS, GEORGE E., Mycenae and the Mycenaean Age, Princeton University Press, 1966

NILSSON, MARTIN P., Minoan,Mycenaean Religion, 2nd rev. ed., Gleerup, Lund, 1968

*TAYLOUR, WILLIAM, The Mycenaeans, Ancient Peoples and Places Series, Praeger, New York, 1964

*VERMEULE, EMILY, Greece in the Bronze Age, University of Chicago Press, 1972

5. GREEK ART

ADAM, SHEILA, The Technique of Greek Sculpture in the Archaic and Classical Periods, Thames and Hudson, London, 1967

ARIAS, PAOLO E., and HIRMER, MAX, A History of 1000 Years of Greek Vase Painting, Abrams, New York, 1963

ASHMOLE, BERNARD, Architect and Sculptor in Classical Greece, New York University Press, 1972

———, and YALOURIS, NICHOLAS, Olympia: The Sculptures of the Temple of Zeus, Phaidon, London, 1967

BEAZLEY, JOHN D., Attic Black-Figure Vase-Painters, Clarendon Press, Oxford, 1956

———, Attic Red-Figure Vase-Painters, 2nd ed., 3 vols., Oxford University Press, London, 1963

———, and ASHMOLE, BERNARD, Greek Sculpture and Painting to the End of the Hellenistic Period, Cambridge University Press, 1966

BERVÉ, HELMUT, GRUBEN, GOTTFRIED, and HIRMER, MAX, Greek Temples, Theatres, and Shrines, Abrams, New York, 1963

BIEBER, MARGARETE, Laocoön: The Influence of the Group Since Its Rediscovery, Wayne State University Press, Detroit, 1967

———, The Sculpture of the Hellenistic Age, rev. ed., Columbia University Press, New York, 1961

BLUEMEL, KARL, Greek Sculptors at Work, 2nd. English ed., Phaidon, New York, 1969

*BOARDMAN, JOHN, Athenian Black-Figure Vases, Oxford University Press, New York, 1974

*———, Greek Art, rev. ed., Praeger, New York, 1973

*———, Pre-Classical: From Crete to Archaic Greece, Penguin Books, Baltimore, 1967

BRILLIANT, RICHARD, Arts of the Ancient Greeks, McGraw-Hill, New York, 1973

BUNDGAARD, JENS ANDREAS, Mnesicles, a Greek Architect at Work, Scandinavian University Books, Copenhagen, 1957

CARPENTER, RHYS, *The Architects of the Parthenon*, Penguin Books, Baltimore, 1970

CHARBONNEAUX, JEAN, MARTIN, ROLAND, and VILLARD, FRANÇOIS, *Archaic Greek Art*, Braziller, New York, 1971

*COOK, ROBERT M., *Greek Art: Its Development, Character and Influence*, Farrar, Straus and Giroux, New York, 1973

DEMARGNE, PIERRE, *The Birth of Greek Art*, Braziller, New York, 1975

HAVELOCK, CHRISTINE M., *Hellenistic Art*, New York Graphic Society, Greenwich, 1970

KRAAY, COLIN M., and HIRMER, MAX, *Greek Coins*, Abrams, New York, 1966

LAWRENCE, ARNOLD W., *Greek Architecture*, 2nd ed., Pelican History of Art, Penguin Books, Baltimore, 1967

*LULLIES, REINHARD, and HIRMER, MAX, *Greek Sculpture*, Abrams, New York, 1960

PFUHL, ERNST, *Masterpieces of Greek Drawing and Painting*, tr. by John Beazley, Macmillan, New York, 1955

POLLITT, JERRY J., *The Ancient View of Greek Art: Criticism, History and Terminology*, Yale University Press, New Haven, 1974

_____, *The Art of Greece: Sources and Documents*, Prentice-Hall, Englewood Cliffs, 1965

RICHTER, GISELA M. A., *Archaic Greek Art Against Its Historical Background*, Oxford University Press, New York, 1949

_____, *A Handbook of Greek Art*, 6th ed., redesigned, Phaidon, London, 1969

_____, *Kouroi*, 3rd ed., Phaidon, New York, 1970

_____, *The Sculpture and Sculptors of the Greeks*, 4th ed., rev., Yale University Press, New Haven, 1970

ROBERTSON, C. M., *History of Greek Art*, 2 vols., Cambridge University Press, 1975

*SCRANTON, ROBERT L., *Greek Architecture*, Braziller, New York, 1962

STOBART, JOHN C., *The Glory that Was Greece*, 4th ed., Praeger, New York, 1971

*WHITE, JOHN, *The Birth and Rebirth of Pictorial Space*, 2nd ed., Boston Book and Art Shop, 1967

WYCHERLEY, RICHARD E., *How the Greeks Built Cities*, 2nd ed., Macmillan, London, 1962

6. ETRUSCAN ART

*BOETHIUS, AXEL, and WARD-PERKINS, JOHN B., *Etruscan and Roman Architecture*, Pelican History of Art, Penguin Books, Baltimore, 1970

MORETTI, MARIO, *New Monuments of Etruscan Painting*, tr. by Dawson Kiang, Pennsylvania State University Press, University Park, 1970

PALLOTTINO, MASSIMO, *Etruscan Painting*, Skira, Geneva, 1952

_____, and HÜRLIMANN, MARTIN, *Art of the Etruscans*, Vanguard, New York, 1955

RICHARDSON, EMELINE, *The Etruscans: Their Art and Civilization*, University of Chicago Press, 1964

RIIS, POUL J., *An Introduction to Etruscan Art*, Munksgaard, Copenhagen, 1953

7. ROMAN ART

BIANCHI-BANDINELLI, RANUCCIO, *Rome: The Late Empire, A.D. 200–400*, Braziller, New York, 1971

_____, *Rome: The Center of Power*, Braziller, New York, 1970

*BROWN, FRANK E., *Roman Architecture*, Braziller, New York, 1961

CHARLES-PICARD, GILBERT, *Roman Painting*, Pallas Library of Art, New York Graphic Society, Greenwich, 1970

*HANFMANN, GEORGE M. A., *Roman Art*, New York Graphic Society, Greenwich, 1964

HEINTZE, HELGA VON, *Roman Art*, Universe Books, New York, 1971

KÄHLER, HEINZ, *The Art of Rome and Her Empire*, tr. by J. R. Foster, Crown, New York, 1963

KRAUS, THEODOR, and VON MATT, LEONARD, *The Miracle of Pompeii and Herculaneum*, Abrams, New York, 1962

*L'ORANGE, HANS P., *Art Forms and Civic Life in the Late Roman Empire*, Princeton University Press, 1965

McDONALD, ALEX H., *Republican Rome*, Praeger, New York, 1966

MacDONALD, WILLIAM L., *The Architecture of the Roman Empire*, Vol. I, Yale University Press, New Haven, 1965

MAIURI, AMEDEO, *Roman Painting*, Skira, Geneva, 1953

NASH, ERNEST, *Pictorial Dictionary of Ancient Rome*, 2 vols., 2nd ed., rev., Praeger, New York, 1968

*POLLITT, JERRY J., *The Art of Rome and Late Antiquity: Sources and Documents*, Prentice-Hall, Englewood Cliffs, 1966

STRONG, DONALD E., *Roman Imperial Sculpture: An Introduction to the Commemorative and Decorative Sculpture of the Roman Empire down to the Death of Constantine*, Tiranti, London, 1961

TOYNBEE, JOCELYN M. C., *The Art of the Romans*, Praeger, New York, 1965

_____, *The Hadrianic School*, Cambridge University Press, 1934

VERMEULE, CORNELIUS, *European Art and the Classical Past*, Harvard University Press, Cambridge, 1964

WARD-PERKINS, JOHN B., *Roman Architecture*, Abrams, New York, 1977

*WHEELER, ROBERT ERIC MORTIMER, *Roman Art and Architecture*, Praeger, New York, 1964

8. EARLY CHRISTIAN AND BYZANTINE ART

BECKWITH, JOHN, *Coptic Sculpture, 300–1300*, Tiranti, London, 1963

_____, *Early Christian and Byzantine Art*, Pelican History of Art, Penguin Books, Baltimore, 1970

DEMUS, OTTO, *Byzantine Art and the West*, New York University Press, 1970

GOODENOUGH, ERWIN R., *Jewish Symbols in the Graeco-Roman Period*, 13 vols., Pantheon Books, New York, 1953–68

GRABAR, ANDRÉ, *The Beginnings of Christian Art, 200–395*, tr. by Stuart Gilbert and James Emmons, Thames and Hudson, London, 1967

_____, *Byzantium: Byzantine Art in the Middle Ages*, tr. by Betty Forster, Methuen, London, 1969

_____, *Christian Iconography: A Study of Its Origins*, Princeton University Press, c. 1968

_____, *Early Christian Art*, Braziller, New York, 1971

_____, *The Golden Age of Justinian, from the Death of Theodosius to the Rise of Islam*, tr. by Stuart Gilbert and James Emmons, Braziller, New York, 1971

HAMILTON, GEORGE HEARD, *Art and Architecture of Russia*, Pelican History of Art, Penguin Books, Baltimore, 1954

HUTTER, IRMGARD, *Early Christian and Byzantine Art*, Universe Books, New York, 1971

KÄHLER, HEINZ, and MANGO, CYRIL, *Hagia Sophia*, Praeger, New York, 1967

*KRAUTHEIMER, RICHARD, *Early Christian and Byzantine Architecture*, Pelican History of Art, Penguin Books, Baltimore, 1965

_____, *Studies in Early Christian, Medieval and Renaissance Art*, New York University Press, 1969

*LOWRIE, WALTER, *Art in the Early Church*, Norton, New York, 1969

*MANGO, CYRIL, *The Art of the Byzantine Empire, 312–1453: Sources and Documents*, Prentice-Hall, Englewood Cliffs, 1972

_____, *Byzantine Architecture*, Abrams, New York, 1976

MATHEWS, THOMAS J., *Byzantine Churches of Istanbul: A Photographic Survey*, Pennsylvania State University Press, University Park, 1976

MOREY, CHARLES RUFUS, *Early Christian Art*, 2nd ed., Princeton University Press, 1953

PERKINS, ANN, *The Art of Dura Europas*, Clarendon Press, Oxford, 1973

*RICE, DAVID TALBOT, *Art of the Byzantine Era*, Praeger, New York, 1966

SMITH, EARL BALDWIN, *The Dome*, Princeton University Press, 1950

VOLBACH, WOLFGANG, and HIRMER, MAX, *Early Christian Art*, Abrams, New York, 1962

WEITZMANN, KURT, *Studies in Classical and Byzantine Manuscript Illumination*, University of Chicago Press, 1971

ZARNECKI, GEORGE, *Art of the Medieval World*, Abrams, New York, 1976

PART TWO

THE MIDDLE AGES

1. ISLAMIC ART

BUSSAGLI, MARIO, *Oriental Architecture*, Abrams, New York, 1976

CRESWELL, KEPPEL ARCHIBALD C., *Early Muslim Architecture*, 2 vols., 3 parts, reprint of 1932 ed.,

Hacker, New York, 1976

_____, *A Short Account of Early Muslim Architecture*, Penguin Books, Baltimore, 1958

_____, *Muslim Architecture in Egypt*, 2 vols., reprint of 1952–59 ed., Hacker, New York, 1976

*DIMAND, MAURICE S., *A Handbook of Muhammadan Art*, 3rd ed., rev. and enl., Metropolitan Museum of Art, New York, 1958

ETTINGHAUSEN, RICHARD, *Arab Painting*, Skira, Geneva, 1962

GOODWIN, GODFREY, *A History of Ottoman Architecture*, Johns Hopkins University Press, Baltimore, 1971

GRABAR, OLEG, *The Formation of Islamic Art*, Yale University Press, New Haven, 1973

*HOAG, JOHN D., *Western Islamic Architecture*, Braziller, New York, 1963

İPSIROGLU, MAZHAR Ş., *The Painting and Culture of the Mongols*, Abrams, New York, 1966

POPE, ARTHUR UPHAM, *Masterpieces of Persian Art*, Dryden Press, New York, 1945

_____, *Persian Architecture: The Triumph of Form and Color*, Braziller, New York, 1965

UNSAL, BECHET, *Turkish Islamic Architecture in Seljuk and Ottoman Times*, St. Martin's Press, London and New York, 1973

2. EARLY MEDIEVAL ART

BACKES, MAGNUS, and DÖLLING, REGINE, *Art of the Dark Ages*, Abrams, New York, 1971

BUSCH, HARALD, and LOHSE, BERND, *Pre-Romanesque Art*, Macmillan, New York, 1966

*CONANT, KENNETH J., *Carolingian and Romanesque Architecture, 800–1200*, 3rd ed., Pelican History of Art, Penguin Books, Baltimore, 1973

*DAVIS-WEYER, CAECILIA, *Early Medieval Art: 300–1150: Sources and Documents*, Prentice-Hall, Englewood Cliffs, 1971

GRABAR, ANDRÉ, and NORDENFALK, CARL, *Early Medieval Painting*, Skira, Geneva, 1957

*GROHSKOPF, BERNICE, *The Treasure of Sutton Hoo: Ship-Burial for an Anglo-Saxon King*, Atheneum, New York, 1970

*HENDERSON, GEORGE DAVIS S., *Early Medieval*, Style and Civilization, Penguin Books, Baltimore, 1972

HENRY, FRANÇOISE, *Irish Art During the Viking Invasions, 800–1020 A.D.*, Cornell University Press, Ithaca, 1967

_____, *Irish Art in the Early Christian Period, to 800 A.D.*, Cornell University Press, Ithaca, 1965

*HINKS, ROGER P., *Carolingian Art*, University of Michigan Press, Ann Arbor, 1962

HUBERT, JEAN, PORCHER, JEAN, and VOLBACH, W. F., *Europe of the Invasions*, Braziller, New York, 1969

_____, *The Carolingian Renaissance*, Braziller, New York, 1970

KENDRICK, THOMAS D., *Anglo-Saxon Art to A.D. 900*, Barnes and Noble, New York, 1972

KIDSON, PETER, *The Medieval World*, McGraw-Hill, New York, 1967

*KITZINGER, ERNST, *Early Medieval Art in the British Museum*, Indiana University Press, Bloomington, 1964

LASKO, PETER, *Ars Sacra, 800–1200*, Pelican History of Art, Penguin Books, Baltimore, 1972

*MARTINDALE, ANDREW, *The Rise of the Artist in the Middle Ages and Early Renaissance*, McGraw-Hill, New York, 1972

OAKESHOTT, WALTER F., *Classical Inspiration in Medieval Art*, Chapman & Hall, London, 1959

PALOL SALELLAS, PEDRO DE, and HIRMER, MAX, *Early Medieval Art in Spain*, Abrams, New York, 1967

*PEVSNER, NIKOLAUS, *An Outline of European Architecture*, 6th ed., Penguin Books, Baltimore, 1960

RUSSELL, JEFFREY B., *Dissent and Reform in the Early Middle Ages*, University of California Press, Berkeley, 1965

*SAALMAN, HOWARD, *Medieval Architecture*, Braziller, New York, 1962

3. ROMANESQUE ART

BOLOGNA, FERDINANDO, *Early Italian Painting: Romanesque and Early Medieval Art*, D. Van Nostrand, Princeton, 1964

BRAUNFELS, WOLFGANG, *Monasteries of Western Europe: the Architecture of the Orders*, 3rd ed., Princeton University Press, 1972

COLLON-GEVAERT, SUZANNE, LEJEUNE, JEAN, and STIENNON, JACQUES, *A Treasury of Romanesque Art, Metalwork, Illumination and Sculpture from the Valley of the Meuse*, Phaidon, New York, 1972

COURTENS, ANDRÉ, *Romanesque Art in Belgium*, M. Vokaer, Brussels, 1969

DEMUS, OTTO, *Romanesque Mural Painting*, Abrams, New York, 1971

DODWELL, CHARLES R., *Painting in Europe: 800–1200*, Pelican History of Art, Penguin Books, Baltimore, 1971

FARRAR, CLARISSA P., *Bibliography of English Translations from Medieval Sources*, Records of Civilization Sources and Studies, Columbia University Press, New York, 1946

FERGUSON, MARY ANNE, *Bibliography of English Translations from Medieval Sources, 1943–67*, Records of Civilization Sources and Studies, Columbia University Press, New York, 1974

FOCILLON, HENRI, *The Art of the West in the Middle Ages*, ed. by Jean Bony, tr. by Donald King, 2 vols., Phaidon, New York, 1963

FORSYTH, GEORGE H., *The Church of St. Martin at Angers*, Princeton University Press, 1953

GRABAR, ANDRÉ, *Romanesque Painting from the Eleventh to the Thirteenth Century: Mural Painting*, tr. by Stuart Gilbert, Skira, Geneva, 1958

GRIVOT, DENIS, and ZARNECKI, GEORGE, *Gislebertus, Sculptor of Autun*, Orion, New York, 1961

KUBACH, HANS ERICH, *Romanesque Architecture*, Abrams, New York, 1975

KÜNSTLER, GUSTAV, *Romanesque Art in Europe: Architecture and Sculpture*, New York Graphic Society, Greenwich, 1969

MARLE, RAIMOND VAN, *The Development of the Italian Schools of Painting*, 19 vols., reprint of 1923–38 ed., Hacker, New York, 1971

MÜLLER-WIENER, WOLFGANG, *Castles of the Crusaders*, McGraw-Hill, New York, 1966

PÄCHT, OTTO, *The Rise of Pictorial Narrative in Twelfth Century England*, Clarendon Press, Oxford, 1962

RICKERT, MARGARET, *Painting in Britain in the Middle Ages*, 2nd ed., Pelican History of Art, Penguin Books, Baltimore, 1965

SAXL, FRITZ, *English Sculptures of the Twelfth Century*, ed. by Hanns Swarzenski, Faber & Faber, London, 1954

STONE, LAWRENCE, *Sculpture in Britain: The Middle Ages*, 2nd ed., Pelican History of Art, Penguin Books, Baltimore, 1972

*SWARZENSKI, HANNS, *Monuments of Romanesque Art: The Art of Church Treasuries in North-Western Europe*, 2nd ed., University of Chicago Press, 1967

*TIMMERS, J. J. M., *A Handbook of Romanesque Art*, Macmillan, New York, 1969

WEBB, GEOFFREY F., *Architecture in Britain: The Middle Ages*, 2nd ed., Pelican History of Art, Penguin Books, Baltimore, 1965

ZARNECKI, GEORGE, *Romanesque Art*, Universe History of Art, Universe Books, New York, 1971

4. GOTHIC ART

Abbot Suger on the Abbey Church of St.-Denis and Its Art Treasures, tr. by Erwin Panofsky, Princeton University Press, 1946

AUBERT, MARCEL, *The Art of the High Gothic Era*, Crown, New York, 1965

BATTISTI, EUGENIO, *Cimabue*, tr. by Robert and Catherine Enggass, Pennsylvania State University Press, University Park, 1967

*BOWIE, THEODORE, ed., *The Sketchbook of Villard de Honnecourt*, 3rd ed., Indiana University Press, Bloomington, 1968

*BRANNER, ROBERT, *Chartres Cathedral*, Norton, New York, 1969

_____, *St. Louis and the Court Style in Gothic Architecture*, Zwemmer, London, 1965

DEUCHLER, FLORENS, *Gothic Art*, Universe Books, New York, 1973

DuPONT, JACQUES, and GNUDI, CESARE, *Gothic Painting*, Skira, Geneva, 1954

EVANS, JOAN, *Art in Medieval France*, Oxford University Press, New York, 1952

FRANKL, PAUL, *Gothic Architecture*, tr. by Dieter Pevsner, Pelican History of Art, Penguin Books, Baltimore, 1962

*FRISCH, TERESA G., *Gothic Art: 1140–1450: Sources and Documents*, Prentice-Hall, Englewood Cliffs, 1971

GALL, ERNST, *Cathedrals and Abbey Churches of the Rhine*, Abrams, New York, 1963

GRODECKI, LOUIS, *Gothic Architecture*, Abrams, New York, 1977

HENDERSON, GEORGE DAVID SMITH, *Chartres*, Style and Civilization, Penguin Books, Baltimore, 1968

_____, *Gothic*, Style and Civilization, Penguin Books, Baltimore, 1967

*HOLT, ELIZABETH GILMORE, ed., *A Documentary History of Art:* Vol. 1, *The Middle Ages and the Renaissance,* 2nd ed., Doubleday, Garden City, 1957

*JANTZEN, HANS, *High Gothic: The Classic Cathedrals of Chartres, Reims and Amiens,* tr. by James Palmes, Pantheon Books, New York, 1962

*KATZENELLENBOGEN, ADOLF, *The Sculptural Programs of Chartres Cathedral,* Johns Hopkins University Press, Baltimore, 1959

*MÂLE, EMILE, *The Gothic Image: Religious Art in France of the Thirteenth Century,* tr. by Dora Nussey, Harper, New York, 1958

*MARTINDALE, ANDREW, *Gothic Art,* Praeger, New York, 1967

*MEISS, MILLARD, *Painting in Florence and Siena after the Black Death,* Princeton University Press, 1951

*PANOFSKY, ERWIN, *Gothic Architecture and Scholasticism,* Archabbey Press, Latrobe, Pennsylvania, 1951

POPE-HENNESSY, JOHN W., *Italian Gothic Sculpture,* 2nd ed., Phaidon, New York, 1970

PORCHER, JEAN, *Medieval French Miniatures,* tr. by Julian Brown, Abrams, New York, 1960

SAUERLÄNDER, WILLIBALD, *Gothic Sculpture in France,* Abrams, New York, 1973

*SIMSON, OTTO G. VON, *The Gothic Cathedral: Origins of Gothic Architecture and the Medieval Concept of Order,* 2nd ed., Princeton University Press, 1974

*STODDARD, WHITNEY S., *Monastery and Cathedral in France,* Wesleyan University Press, Middletown, 1966

TINTORI, LEONETTO, and BORSOOK, EVE, *Giotto: The Peruzzi Chapel,* Abrams, New York, 1965

*WATSON, P., *Building the Medieval Cathedrals,* Cambridge University Press, 1976

PART THREE

THE RENAISSANCE

1. "LATE GOTHIC" PAINTING, SCULPTURE, AND THE GRAPHIC ARTS

BALDASS, LUDWIG, *Jan van Eyck,* Phaidon, London, 1952

*CUTTLER, CHARLES D., *Northern Painting: From Pucelle to Bruegel,* Holt, Rinehart and Winston, New York, 1968

DAVIES, MARTIN, *Rogier van der Weyden, an Essay with a Critical Catalogue of Paintings,* Phaidon, New York, 1972

*DUMONT, GEORGES HENRI, *Memling,* Barnes and Noble, New York, 1967

EICHENBERG, FRITZ, *The Art of the Print: Masterpieces, History, and Techniques,* Abrams, New York, 1976

FRIEDLÄNDER, MAX J., *Early Netherlandish Painting,* 14 vols., tr. by Heinz Norden, Praeger, New York, 1967–73

*_____, *From Van Eyck to Bruegel: Early Netherlandish Painting,* Phaidon, New York, 1969

FRINTA, MOJMÍR S., *The Genius of Robert Campin,* Mouton & Co., The Hague, 1966

GIBSON, WALTER S., *Hieronymus Bosch,* Praeger, New York, 1973

*HIND, ARTHUR M., *History of Engraving and Etching,* 3rd ed., rev., Houghton, Mifflin, Boston, 1923

_____, *An Introduction to a History of Woodcut,* 2 vols., Houghton, Mifflin, Boston, 1935

*IVINS, WILLIAM M., JR., *How Prints Look,* Metropolitan Museum of Art, New York, 1943

KOCH, ROBERT A., *Joachim Patinir,* Princeton University Press, 1968

LANDOLT, HANSPETER, *German Painting: The Late Middle Ages: 1350–1500,* Skira, Geneva, 1968

MCFARLANE, K. B., *Hans Memling,* Oxford University Press, New York, 1972

MEISS, MILLARD, *French Painting in the Time of Jean de Berry: The Late Fourteenth Century and the Patronage of the Duke,* 2 vols., Phaidon, London, 1967

*PANOFSKY, ERWIN, *Early Netherlandish Painting,* 2 vols., Harvard University Press, Cambridge, 1958

PUYVELDE, LEO VAN, *Flemish Painting from the van Eycks to Metsys,* McGraw-Hill, New York, 1970

REUTERSWÄRD, PATRICK, *Hieronymus Bosch,* Norstedt and Söner, Stockholm, 1970

VENTURI, LIONELLO, *Italian Painting,* 3 vols., Skira, Geneva, 1950–52

WHITE, JOHN, *Art and Architecture in Italy, 1250–1400,* Pelican History of Art, Penguin Books, Baltimore, 1966

ZUPNICK, IRVING L., *Bruegel,* McGraw-Hill, New York, 1970

2. THE EARLY RENAISSANCE IN ITALY

*ALAZARD, JEAN, *The Florentine Portrait,* Schocken Books, New York, 1969

*ALBERTI, LEON BATTISTA, *On Painting and On Sculpture,* Phaidon, New York, 1972

_____, *Ten Books on Architecture,* ed. by Joseph Rykwert, Tiranti, London, 1955

*ANTAL, FREDERICK, *Florentine Painting and Its Social Background,* Boston Book and Art Shop, 1965

*AVERY, CHARLES, *Florentine Renaissance Sculpture,* Harper & Row, New York, 1970

*BAXANDALL, MICHAEL, *Painting and Experience in Fifteenth-Century Italy,* Clarendon Press, Oxford, 1972

BERENSON, BERNARD, *The Drawings of the Florentine Painters,* 3 vols., repr. ed. of 1938 ed., University of Chicago Press, 1973

*_____, *Italian Painters of the Renaissance,* rev. ed., Phaidon, London, 1967

_____, *Italian Pictures of the Renaissance, Central and North Italian Schools,* 3 vols., Phaidon, London, 1968

_____, *Italian Pictures of the Renaissance: Florentine School,* 2 vols., Phaidon, London, 1963

*BLUNT, ANTHONY, *Artistic Theory in Italy, 1450–1600,* Oxford University Press, New York, 1956

BORSOOK, EVE, *The Mural Painters of Tuscany,* Phaidon, London, 1960

*BURCKHARDT, JAKOB C., *The Civilization of the Renaissance in Italy,* tr. by S. G. C. Middlemore, 3rd rev. ed., Phaidon, London, 1950

*CENNINI, CENNINO, *The Craftsman's Handbook (Il Libro dell'Arte),* tr. by Daniel V. Thompson, Jr., Dover, New York, 1954

CHASTEL, ANDRÉ, *The Age of Humanism: Europe, 1480–1530,* tr. by Katherine Delavenay and E. M. Gweyer, McGraw-Hill, New York, 1964

_____, *Studios and Styles of the Italian Renaissance, 1460–1500,* Braziller, New York, 1971

CLARK, KENNETH M., *Piero della Francesca,* 2nd ed., Phaidon, London, 1969

DEWALD, ERNEST T., *Italian Painting, 1200–1600,* Holt, Rinehart and Winston, New York, 1961

GILBERT, CREIGHTON, *History of Renaissance Art Throughout Europe: Painting, Sculpture, Architecture,* Abrams, New York, 1973

*GOMBRICH, ERNST H., *Norm and Form: Studies in the Art of the Renaissance,* Phaidon, London, 1966

HARTT, FREDERICK, *History of Italian Renaissance Art,* Abrams, New York, 1969

HENDY, PHILIP, *Piero della Francesca and the Early Renaissance,* Macmillan, New York, 1968

JANSON, HORST W., *The Sculpture of Donatello,* 2 vols., Princeton University Press, 1963

KRAUTHEIMER, RICHARD, and KRAUTHEIMER-HESS, TRUDE, *Lorenzo Ghiberti,* 2nd ed., Princeton University Press, 1970

LARNER, JOHN, *Culture and Society in Italy, 1290–1420,* Scribner's, New York, 1971

LEE, RENSSELAER W., *Ut Pictura Poesis: The Humanistic Theory of Painting,* Norton, New York, 1967

*LOWRY, BATES, *Renaissance Architecture,* Braziller, New York, 1962

MANETTI, ANTONIO DE TUCCIO, *The Life of Brunelleschi,* ed. by Howard Saalman, Pennsylvania State University Press, University Park, 1970

*MEISS, MILLARD, *Giotto and Assisi,* Norton, New York, 1967

MURRAY, PETER, *Renaissance Architecture,* Abrams, New York, 1976

PAATZ, WALTER, *The Arts of the Italian Renaissance: Painting, Sculpture, Architecture, Decorative Arts,* Abrams, New York, 1976

*PANOFSKY, ERWIN, *Renaissance and Renascences in Western Art,* Humanities Press, New York, 1970

POPE-HENNESSY, JOHN, *Fra Angelico,* Phaidon, London, 1952

_____, *Italian Renaissance Sculpture,* Phaidon, New York, 1971

_____, *Paolo Uccello: Complete Edition,* 2nd ed., Phaidon, New York, 1969

SEYMOUR, CHARLES, JR., *Sculpture in Italy, 1400–1500,* Pelican History of Art, Penguin Books, Baltimore, 1966

*SEZNEC, JEAN, *The Survival of the Pagan Gods,* tr. by Barbara F. Sessions, reprint by Bollingen Foundation and Pantheon Books, Princeton University Press, 1972

SINGLETON, CHARLES S., ed., *Art, Science and History in the Renaissance,* Johns Hopkins University Press, Baltimore, 1967

TIETZE-CONRAT, ERICA, *Mantegna: Paintings, Drawings, Engravings: Complete Edition,* Phaidon, London, 1955

TURNER, ALMON R., *The Vision of Landscape in Renaissance Italy,* Princeton University Press, 1966

*WIND, EDGAR, *Pagan Mysteries in the Renaissance,* rev. ed., Barnes and Noble, New York, 1968

3. THE HIGH RENAISSANCE IN ITALY

*ACKERMAN, JAMES S., *The Architecture of Michelangelo,* rev. ed., Viking Press, New York, 1966

_____, *Palladio's Villas,* J. J. Augustin, Locust Valley, New York, 1967

CLARK, KENNETH M., *Leonardo da Vinci,* rev. ed., Penguin Books, Baltimore, 1967

DE TOLNAY, CHARLES, *Michelangelo,* 2nd ed., rev., 5 vols., Princeton University Press, 1969–71

FISCHEL, OSKAR, *Raphael,* tr. by Bernard Rackham, 2 vols. in 1, Spring Books, London, 1964

*FREEDBERG, SYDNEY J., *Painting in Italy, 1500–1600,* Pelican History of Art, Penguin Books, Baltimore, 1971

*_____, *Painting of the High Renaissance in Rome and Florence,* 2 vols., Harvard University Press, Cambridge, 1961

HARTT, FREDERICK, *Michelangelo,* 3 vols., Abrams, New York, 1965–76

*KLEIN, ROBERT, and ZERNER, HENRI, *Italian Art, 1500–1600: Sources and Documents,* Prentice-Hall, Englewood Cliffs, 1966

*LEONARDO DA VINCI, *The Notebooks,* tr. by Edward MacCurdy, 2 vols., Harcourt, Brace, New York, 1938

*LEVEY, MICHAEL, *High Renaissance,* Style and Civilization, Penguin Books, Baltimore, 1975

*PANOFSKY, ERWIN, *Studies in Iconology,* Oxford University Press, New York, 1939

PIGNATTI, TERISIO, *Giorgione,* Phaidon, New York, 1971

POPE-HENNESSY, JOHN, *Italian High Renaissance and Baroque Sculpture,* 3 vols., Phaidon, London, 1963

_____, *Raphael,* New York University Press, 1970

SCHULZ, JUERGEN, *Venetian Painted Ceilings of the Renaissance,* University of California Press, Berkeley, 1968

TIETZE, HANS, and TIETZE-CONRAT, ERICA, *The Drawings of the Venetian Painters in the 15th and 16th Centuries,* J. J. Augustin, Locust Valley, New York, 1944

*VASARI, GIORGIO, *The Lives of the Painters, Sculptors and Architects,* tr. by Gaston Du C. De Vere, 4 vols., Abrams, New York, 1977

WETHEY, HAROLD E., *The Paintings of Titian: Complete Edition,* 2 vols., Phaidon, London, 1969–71

*WITTKOWER, RUDOLF, *Architectural Principles in the Age of Humanism,* Random House, New York, 1965

*WÖLFFLIN, HEINRICH, *Classic Art: An Introduction to the Italian Renaissance,* 3rd ed., Phaidon, New York, 1968

4. MANNERISM AND OTHER TRENDS

BOUSQUET, JACQUES, *Mannerism, the Painting and Style of the Late Renaissance,* tr. by S. W. Taylor, Braziller, New York, 1964

BRIGANTI, GIULIANO, *Italian Mannerism,* tr. by Margaret Kunzle, VEB Edition, Leipzig, 1962

*CELLINI, BENVENUTO, *Autobiography,* ed. by John Pope-Hennessy, Phaidon, London, 1960

FREEDBERG, SYDNEY J., *Parmigianino,* Harvard University Press, Cambridge 1950

*FRIEDLAENDER, WALTER F., *Mannerism and Anti-Mannerism in Italian Painting,* Columbia University Press, New York, 1957

*HOLT, ELIZABETH GILMORE, ed., *A Documentary History of Art,* Vol. II, *Michelangelo and the Mannerists: The Baroque and the Eighteenth Century,* 2nd ed., Doubleday, Garden City, 1957

*SHEARMAN, JOHN K. G., *Mannerism,* Style and Civilization, Penguin Books, Baltimore, 1967

SMYTH, CRAIG H., *Mannerism and Maniera,* J. J. Augustin, Locust Valley, New York, 1963

TIETZE, HANS, *Tintoretto: The Paintings and Drawings,* Phaidon, London, 1948

WETHEY, HAROLD E., *El Greco and His School,* 2 vols., Princeton University Press, 1962

WÜRTENBERGER, FRANZSEPP, *Mannerism, the European Style of the Sixteenth Century,* tr. by Michael Heron, Holt, Rinehart and Winston, New York, 1963

5. THE RENAISSANCE IN THE NORTH

*BENESCH, OTTO, *The Art of the Renaissance in Northern Europe,* rev. ed., Phaidon, London, 1965

_____, *German Painting from Dürer to Holbein,* tr. by H. S. B. Harrison, Skira, Geneva, 1966

*BLUNT, ANTHONY, *Art and Architecture in France, 1500–1700,* 2nd ed., Pelican History of Art, Penguin Books, Baltimore, 1970

GANZ, PAUL, *The Paintings of Hans Holbein the Younger,* 1st complete ed., Phaidon, London, 1956

GROSSMANN, F., ed., *Bruegel: The Paintings: Complete Edition,* 2nd rev. ed., Phaidon, London, 1966

LEYMARIE, JEAN, *Dutch Painting,* tr. by Stuart Gilbert, Skira, Geneva, 1956

OSTEN, GERT VON DER, and VEY, HORST, *Painting and Sculpture in Germany and the Netherlands, 1500–1600,* Pelican History of Art, Penguin Books, Baltimore, 1969

PANOFSKY, ERWIN, *Albrecht Dürer,* 2 vols., 3rd ed., Princeton University Press, 1948

PEVSNER, NIKOLAUS, and MEIER, MICHAEL, *Grünewald,* Abrams, New York, 1958

ROTHENSTEIN, JOHN K. M., *An Introduction to English Painting,* 5th rev. ed., Cassell, London, 1965

SCHOENBERGER, GUIDO, *The Drawings of Mathis Gothart Nithart Called Grünewald,* Bittner, New York, 1948

STECHOW, WOLFGANG, *Pieter Bruegel the Elder,* Abrams, New York, 1969

*_____, *Northern Renaissance Art, 1400–1600: Sources and Documents,* Prentice-Hall, Englewood Cliffs, 1966

*SUMMERSON, JOHN N., *Architecture in Britain, 1530–1830,* 4th rev. ed., Pelican History of Art, Penguin Books, Baltimore, 1969

WATERHOUSE, ELLIS K., *Painting in Britain, 1530–1790,* 3rd ed., Pelican History of Art, Penguin Books, Baltimore, 1969

6. THE BAROQUE IN ITALY AND GERMANY

ENGGASS, ROBERT, and BROWN, JONATHAN, *Italy and Spain, 1600–1750: Sources and Documents,* Prentice-Hall, Englewood Cliffs, 1970

*FRIEDLAENDER, WALTER F., *Caravaggio Studies,* Princeton University Press, 1955

HELD, JULIUS, and POSNER, DONALD, *Seventeenth and Eighteenth Century: Baroque Painting, Sculpture, Architecture,* Abrams, New York, 1971

HEMPEL, EBERHARD, *Baroque Art and Architecture in Central Europe,* Pelican History of Art, Penguin Books, Baltimore, 1965

*HIBBARD, HOWARD, *Bernini,* Penguin Books, Baltimore, 1966

_____, *Carlo Maderno and Roman Architecture: 1580–1630,* Pennsylvania State University Press, University Park, 1971

HINKS, ROGER P., *Michelangelo Merisi da Caravaggio,* Faber & Faber, London, 1953

KEUTNER, HERBERT, *Sculpture: Renaissance to Rococo,* Vol. III, *A History of Western Sculpture,* New York Graphic Society, Greenwich, 1969

LEVEY, MICHAEL, *Painting in XVIII Century Venice,* Phaidon, London, 1959

MAHON, DENIS, *Studies in Seicento Art and Theory,* Warburg Institute, London, 1947

*MILLON, HENRY A., *Baroque and Rococo Architecture,* Braziller, New York, 1961

MOIR, ALFRED, *The Italian Followers of Caravaggio,* 2 vols., Harvard University Press, Cambridge, 1967

MORASSI, ANTONIO, *Complete Catalogue of the Paintings of G. B. Tiepolo,* Phaidon, London, 1962

NORBERG-SCHULZ, CHRISTIAN, *Baroque Architecture,* Abrams, New York, 1972

_____, *Late Baroque and Rococo Architecture,* Abrams, New York, 1974

POSNER, DONALD, *Annibale Carracci,* 2 vols., Phaidon, London, 1971

*WATERHOUSE, ELLIS K., *Italian Baroque Painting,* 2nd ed., Phaidon, New York, 1969

*WITTKOWER, RUDOLF, *Art and Architecture in Italy, 1600–1750*, 3rd ed., Pelican History of Art, Penguin Books, Baltimore, 1973
_____, *Gian Lorenzo Bernini, The Sculptor of the Roman Baroque*, 2nd ed., Phaidon, London, 1966
*WÖLFFLIN, HEINRICH, *Principles of Art History*, tr. by Mary D. Hottinger, Holt, New York, 1932

7. THE BAROQUE IN FLANDERS, HOLLAND, AND SPAIN

BENESCH, OTTO, ed., *Rembrandt: Collected Writings*, Vol. I, Praeger, New York, 1970
BERGSTROM, INGVAR, *Dutch Still Life Painting*, tr. by Christine Hedström and Gerald Taylor, Yoseloff, New York, 1956
BERNT, WALTHER, *The Netherlandish Painters of the Seventeenth Century*, Vol. III, Phaidon, New York, 1970
BROWN, JONATHAN, *Zurbarán*, Abrams, New York, 1974
GERSON, HORST, and TER KUILE, E. H., *Art and Architecture in Belgium, 1600–1800*, Pelican History of Art, Penguin Books, Baltimore, 1960
GOLDSCHEIDER, LUDWIG, *Vermeer: The Paintings: Complete Edition*, 2nd ed., Phaidon, London, 1967
KUBLER, GEORGE A., and SORIA, MARTIN, *Art and Architecture in Spain and Portugal and their American Dominions, 1500–1800*, Pelican History of Art, Penguin Books, Baltimore, 1959
LOPEZ-REY, JOSÉ, *Velázquez' Work and World*, New York Graphic Society, Greenwich, 1968
NICOLSON, BENEDICT, *Hendrick Terbrugghen*, Lund Humphries, London, 1958
ROSENBERG, JAKOB, *Rembrandt, Life and Work*, rev. ed., Phaidon, London, 1964
_____, SLIVE, SEYMOUR, and TER KUILE, E. H., *Dutch Art and Architecture, 1600–1800*, rev. ed., Pelican History of Art, Penguin Books, Baltimore, 1972
SLIVE, SEYMOUR, *Frans Hals*, 3 vols., Phaidon, New York, 1970–74
STECHOW, WOLFGANG, *Dutch Landscape Painting of the Seventeenth Century*, Phaidon, London, 1966
_____, *Rubens and the Classical Tradition*, Harvard University Press, Cambridge, for Oberlin College, Oberlin, 1968
SWILLENS, P. T. A., *Johannes Vermeer, Painter of Delft, 1632–1675*, tr. by C. M. Brueningh Williamson, Spectrum, Utrecht and New York, 1950
THUILLIER, JACQUES, and FOUCART, JACQUES, *Rubens' Life of Marie de Medici*, Abrams, New York, 1970
WHITE, CHRISTOPHER, *Rembrandt as an Etcher*, 2 vols., Pennsylvania State University Press, University Park, 1969
_____, *Rubens and His World*, Viking Press, New York, 1964

8. THE BAROQUE IN FRANCE AND ENGLAND

ANTAL, FREDERICK, *Hogarth and His Place in European Art*, Routledge & Kegan Paul, London, 1962
BLUNT, ANTHONY, *The Paintings of Nicolas Poussin*, Phaidon, London, 1966
BURKE, JOSEPH, and CALDWELL, COLIN, *Hogarth, The Complete Engravings*, Abrams, New York, 1968
FRIEDLAENDER, WALTER F., *Nicolas Poussin, A New Approach*, Abrams, New York, 1966
GAUNT, WILLIAM, *The Great Century of British Painting: Hogarth to Turner*, Phaidon, London, 1971
HERRMANN, LUKE, *British Landscape Painting of the 18th Century*, Oxford University Press, New York, 1974
HUYGHE, RENÉ, *Watteau*, Braziller, New York, 1970
*PAULSON, RONALD, *Hogarth, His Life, Art and Times*, 2 vols., Yale University Press, New Haven, 1971
*REYNOLDS, JOSHUA, *Discourses on Art*, ed. by Robert R. Wark, Huntington Library, San Marino, 1959
SOEHNER, HALLDOR, and SCHÖNBERGER, ARNO, *The Rococo Age: Art and Civilization of the 18th Century*, McGraw-Hill, New York, 1960
WILDENSTEIN, GEORGES, and WILDENSTEIN, DAVID, *Chardin*, rev. and enl. ed., New York Graphic Society, Greenwich, 1969
_____, ed., *The Paintings of Fragonard: Complete Edition*, Phaidon, London, 1960

PART FOUR
THE MODERN WORLD

1. NEOCLASSICISM AND ROMANTICISM

ADHÉMAR, JEAN, *Honoré Daumier*, English ed., P. Tisné, New York and Basel, 1954
BARKER, VIRGIL, *American Painting, History and Interpretation*, Bonanza, New York, 1960
BERGER, KLAUS, *Géricault and His Work*, University of Kansas Press, Lawrence, 1955
BOIMÉ, ALBERT, *The Academy and French Painting in the 19th Century*, Phaidon, New York, 1970
CLARK, KENNETH M., *The Gothic Revival*, Humanities Press, New York, 1970
CRAVEN, WAYNE, *Sculpture in America*, Crowell, New York, 1968
EITNER, LORENZ, *Géricault's Raft of the Medusa*, Phaidon, London, 1972
*_____, *Neoclassicism and Romanticism, 1750–1850: Sources and Documents*, 2 vols., Prentice-Hall, Englewood Cliffs, 1970
FINBERG, ALEXANDER J., *The Life of J. M. W. Turner*, R. A., 2nd rev. ed., Clarendon Press, Oxford, 1961
*FRIEDLAENDER, WALTER F., *From David to Delacroix*, Harvard University Press, Cambridge, 1952
GAUNT, WILLIAM, *The Restless Century: Painting in Britain, 1800–1900*, Phaidon, London, 1972
GERNSHEIM, HELMUT and ALISON, *The History of Photography from the Camera Obscura to the Beginning of the Modern Era*, 2nd ed., McGraw-Hill, New York, 1969
GUDIOL I RICART, JOSÉ, *Goya*, Abrams, New York, 1965
HAMILTON, GEORGE HEARD, *Nineteenth and Twentieth Century Art: Painting, Sculpture, Architecture*, Abrams, New York, 1970
*HAMLIN, TALBOT F., *Greek Revival Architecture in America*, Oxford University Press, New York, 1944
HERRMANN, LUKE, *Ruskin and Turner*, Praeger, New York, 1969
*HITCHCOCK, HENRY-RUSSELL, *Architecture: Nineteenth and Twentieth Centuries*, 2nd ed., Pelican History of Art, Penguin Books, Baltimore, 1971
HOFMANN, WERNER, *The Earthly Paradise: Art in the Nineteenth Century*, tr. by Brian Battershaw, Braziller, New York, 1961
*HONOUR, HUGH, *Neoclassicism*, Style and Civilization, Penguin Books, Harmondsworth, 1968
LAFUENTE-FERRARI, ENRIQUE L., ed., *Goya: His Complete Etchings, Aquatints and Lithographs*, Abrams, New York, 1962
LICHT, FRED, *Sculpture, 19th and 20th Century*, New York Graphic Society, Greenwich, 1967
MEEKS, CAROL L. V., *Italian Architecture, 1750–1914*, Yale University Press, New Haven, 1966
*NOVOTNY, FRITZ, *Painting and Sculpture in Europe, 1780–1880*, Pelican History of Art, Penguin Books, Baltimore, 1960
RAINE, KATHLEEN, *William Blake*, Praeger, New York, 1971
RHEIMS, MAURICE, *Nineteenth Century Sculpture*, Abrams, New York, 1976
ROSENBLUM, ROBERT, *Jean-Auguste-Dominique Ingres*, Abrams, New York, 1967
*_____, *Transformations in Late Eighteenth Century Art*, Princeton University Press, 1967
*THOMAS, HUGH, *Goya: The Third of May, 1808*, Viking Press, New York, 1973
WILDENSTEIN, GEORGES, *Ingres*, 2nd rev. ed., Phaidon, London, 1956
WINCKELMANN, JOHANN JOACHIM, *Winckelmann's Writings on Art*, ed. by David Erwin, Phaidon, London, 1972

2. REALISM AND IMPRESSIONISM

*ELSEN, ALBERT EDWARD, *Auguste Rodin: Readings on His Life and Work*, Prentice-Hall, Englewood Cliffs, 1965
*_____, *Rodin*, Doubleday, Garden City, for the Museum of Modern Art, New York, 1963
FLEMING, GORDON H., *Rossetti and the Pre-Raphaelite Brotherhood*, Hart-Davies, London, 1967
*GOODRICH, LLOYD, *Winslow Homer*, Macmillan for the Whitney Museum of American Art, New York, 1944
GREENFIELD, HOWARD, *The Impressionist Revolution*, Doubleday, Garden City, 1972
*HAMILTON, GEORGE HEARD, *Manet and His Critics*, Yale University Press, New Haven, 1954
HENDRICKS, GORDON, *Thomas Eakins*, Viking Press, New York, 1974
*HILTON, TIMOTHY, *The Pre-Raphaelites*, Abrams,

New York, 1971
*HUNTER, SAM, *Modern French Painting, 1855–1956*, Dell, New York, 1956
KELDER, DIANE, *The French Impressionists and Their Century*, Praeger, New York, 1970
*KLINGENDER, FRANCIS D., *Art and the Industrial Revolution*, rev. and enl. ed., Evelyn, Adams and Mackay, Chatham, 1968
*McCOUBREY, JOHN, *American Art, 1700–1960: Sources and Documents*, Prentice-Hall, Englewood Cliffs, 1965
*NOCHLIN, LINDA, *Impressionism and Post Impressionism, 1874–1904: Sources and Documents*, Prentice-Hall, Englewood Cliffs, 1966
*_____, *Realism and Tradition in Art, 1848–1900: Sources and Documents*, Prentice-Hall, Englewood Cliffs, 1966
PACH, WALTER, *Pierre Auguste Renoir*, Abrams, New York, 1950
REWALD, JOHN, *The History of Impressionism*, 4th rev. ed., New York Graphic Society for the Museum of Modern Art, New York, 1973
REYNOLDS, GRAHAM, *Victorian Painting*, Macmillan, New York, 1966
SEITZ, WILLIAM C., *Claude Monet*, Abrams, New York, 1960
*SLOANE, JOSEPH C., *French Painting Between the Past and the Present*, Princeton University Press, 1951

3. POST-IMPRESSIONISM

*ANDERSEN, WAYNE, *Gauguin's Paradise Lost*, Viking Press, New York, 1971
BADT, KURT, *The Art of Cézanne*, tr. by Sheila A. Ogilvie, University of California Press, Berkeley, 1965
BOURET, JEAN, *The Life and Work of Toulouse-Lautrec*, Abrams, New York, 1966
CHASSÉ, CHARLES, *The Nabis and Their Period*, tr. by Michael Bullock, Praeger, New York, 1969
*CHIPP, HERSCHEL B., *Theories of Modern Art*, University of California Press, Berkeley, 1968
COOPER, DOUGLAS, *The Cubist Epoch*, Phaidon, New York, 1971
CRESPELLE, JEAN-PAUL, *The Fauves*, New York Graphic Society, Greenwich, 1962
GOGH, VINCENT VAN, *The Complete Letters of Vincent Van Gogh*, tr. by Mrs. J. Van Gogh-Bonger and C. de Dood, 3 vols., New York Graphic Society, Greenwich, 1958
GOLDWATER, ROBERT, *Paul Gauguin*, Abrams, New York, 1957
HUISMAN, PHILIPPE, and DORTU, M. G., *Toulouse-Lautrec*, Doubleday, Garden City, 1973
*MADSEN, STEPHAN T., *Art Nouveau*, McGraw-Hill, New York, 1967
*MULLER, JOSEPH-EMILE, *Fauvism*, Praeger, New York, 1967
NOVOTNY, FRITZ, *Toulouse-Lautrec*, Phaidon, New York, 1969
PERRUCHOT, HENRI, *Edouard Manet*, Barnes and Noble, New York, 1962
REWALD, JOHN, *Post-Impressionism from Van Gogh to Gauguin*, 2nd ed., Museum of Modern Art, New York, 1962
RHEIMS, MAURICE, *The Flowering of Art Nouveau*, tr. by Patrick Evans, Abrams, New York, 1966
*ROOKMAAKER, HENDRIK R., *Gauguin and 19th Century Art Theory*, Swets & Zeitlinger, Amsterdam, 1972
_____, *Synthetist Art Theories: Genesis and Nature of the Ideas on Art of Gauguin and His Circle*, Swets & Zeitlinger, Amsterdam, 1959
ROSKILL, MARK, *Van Gogh, Gauguin, and the Impressionist Circle*, New York Graphic Society, Greenwich, 1970
*RUSSELL, JOHN, *Seurat*, Praeger, New York, 1965
_____, *Vuillard*, New York Graphic Society, Greenwich, 1971
SCHAPIRO, MEYER, *Paul Cézanne*, 3rd ed., Abrams, New York, 1962
_____, *Vincent Van Gogh*, Abrams, New York, 1950
SCHMUTZLER, ROBERT, *Art Nouveau*, tr. by Edouard Roditi, Abrams, New York, 1962
*SELZ, PETER, and CONSTANTINE, MILDRED, eds., *Art Nouveau: Art and Design at the Turn of the Century*, Doubleday, Garden City, for the Museum of Modern Art, New York, 1960

4. TWENTIETH-CENTURY PAINTING AND SCULPTURE

ARGAN, GIULIO CARLO, *Henry Moore*, tr. by Daniel Dichter, Abrams, New York, 1973
ARNASON, H. H., *Calder*, D. Van Nostrand, Princeton, 1966

_____, *History of Modern Art: Painting, Sculpture, Architecture*, 2nd ed., Abrams, New York, 1977
ARP, HANS, *Arp on Arp: Poems, Essays, Memories*, ed. by Marcel Jean, Viking Press, New York, 1972
BARR, ALFRED H., JR., ed., *Cubism and Abstract Art*, reprint of 1936 ed. of the Museum of Modern Art, Arno Press, New York, 1966
_____, ed., *Fantastic Art, Dada, Surrealism*, reprint of 1936 ed. of the Museum of Modern Art, Arno Press, New York, 1969
*_____, *Matisse, His Art and His Public*, reprint of 1951 ed. of the Museum of Modern Art, Arno Press, New York, 1966
*_____, *Picasso, Fifty Years of His Art*, reprint of 1946 ed. of the Museum of Modern Art, Arno Press, New York, 1966
*BATTCOCK, GREGORY, ed., *Minimal Art: A Critical Anthology*, Dutton, New York, 1968
*_____, *The New Art: A Critical Anthology*, rev. ed., Dutton, New York, 1973
BLUNT, ANTHONY, and POOL, PHOEBE, *Picasso, the Formative Years: A Study of His Sources*, New York Graphic Society, Greenwich, 1962
BOECK, WILHELM, and SABARTÉS, JAIME, *Picasso*, Abrams, New York, 1955
BOWNESS, ALAN, *Modern European Art*, Harcourt, Brace, Jovanovich, New York, 1972
*BROWN, MILTON W., *American Painting from the Armory Show to the Depression*, Princeton University Press, 1955
*BURNHAM, JACK, *Beyond Modern Sculpture*, Braziller, New York, 1968
*_____, *Great Western Saltworks: Essays on the Meaning of Post-Formalist Art*, Braziller, New York, 1974
DAIX, PIERRE, and BOUDAILLE, GEORGES, *Picasso: The Blue and Rose Periods*, New York Graphic Society, Greenwich, 1967
*DAVIS, DOUGLAS M., *Art and the Future: A History/Prophecy of the Collaboration Between Science, Technology and Art*, Praeger, New York, 1973
DOESBURG, THEO VAN, *Principles of Neo-Plastic Art*, New York Graphic Society, Greenwich, 1968
*DUTHUIT, GEORGES, *The Fauvist Painters*, Wittenborn, Schultz, New York, 1950
*FINCH, CHRISTOPHER, *Pop Art: The Object and the Image*, Dutton, New York, 1968
FRIEDMAN, B. H., *Jackson Pollock: Energy Made Visible*, McGraw-Hill, New York, 1972
FRY, EDWARD F., *Cubism*, McGraw-Hill, New York, 1966
_____, *David Smith*, Solomon R. Guggenheim Museum, New York, 1969
GEIST, SIDNEY, *Brancusi: The Sculpture and Drawings*, Abrams, New York, 1975
*GELDZAHLER, HENRY, *American Painting in the Twentieth Century*, Metropolitan Museum of Art, New York, 1965
*GOLDING, JOHN, *Cubism: A History and an Analysis, 1907–1914*, rev. ed., Boston Book and Art Shop, 1968
*GOLDWATER, ROBERT J., *Primitivism in Modern Art*, rev. ed., Vintage Books, New York, 1967
GORDON, DONALD E., *Ernst Ludwig Kirchner*, Harvard University Press, Cambridge, 1968
*GRAY, CAMILLA, *The Russian Experiment in Art, 1863–1922*, Abrams, New York, 1970
GRAY, CHRISTOPHER, *Cubist Aesthetic Theories*, Johns Hopkins University Press, Baltimore, 1953
GROHMANN, WILL, *Paul Klee*, Abrams, New York, 1955
*HAFTMANN, WERNER, *Painting in the Twentieth Century*, expanded ed., 2 vols., Praeger, New York, 1965
*HERBERT, ROBERT L., ed., *Modern Artists on Art*, Prentice-Hall, Englewood Cliffs, 1965
HILL, ANTHONY, *Data: Directions in Art Theory and Aesthetics*, New York Graphic Society, Greenwich, 1969
*HODIN, JOSEPH PAUL, *Edward Munch*, Praeger, New York, 1972
HUNTER, SAM, and JACOBUS, JOHN, *American Art of the Twentieth Century: Painting, Sculpture, Architecture*, Abrams, New York, 1973
JAFFE, HANS L. C., *De Stijl*, Abrams, New York, 1971
*_____, *De Stijl, 1917–1931: The Dutch Contribution to Modern Art*, Meulenhoff, Amsterdam, 1956
KAHNWEILER, DANIEL-HENRY, *Juan Gris: His Life and Work*, rev. ed., Abrams, New York, 1969

KOZLOFF, MAX, *Jasper Johns*, Abrams, New York, 1972

KUH, KATHERINE, *Leger*, Art Institute of Chicago, 1953

*KUHN, CHARLES L., *German Expressionism and Abstract Art: The Harvard Collection*, Harvard University Press, Cambridge, 1957

KULTERMANN, UDO, *The New Sculpture, Environments and Assemblages*, Praeger, New York, 1968

LALIBERTE, NORMAN, and MOGELON, ALEX, *Collage, Montage, Assemblage: History and Contemporary Techniques*, Van Nostrand-Reinhold, New York, 1972

*LIPPARD, LUCY R., *Pop Art*, Praeger, New York, 1966

*——, *Surrealists on Art*, Prentice-Hall, Englewood Cliffs, 1970

LÖVGREN, SVEN, *The Genesis of Modernism*, rev. ed., Indiana University Press, Bloomington, 1971

MARTIN, MARIANNE W., *Futurist Art and Theory, 1909–1915*, Clarendon Press, Oxford, 1968

MATTHEWS, J. H., *An Introduction to Surrealism*, Pennsylvania State University Press, University Park, 1965

MELVILLE, ROBERT, *Henry Moore: Sculpture and Drawings, 1921–1969*, Abrams, New York, 1970

MONDRIAN, PIET C., *Plastic Art and Pure Plastic Art*, Wittenborn, New York, 1945

*MONTE, JAMES K., *22 Realists*, Whitney Museum of American Art, New York, 1970

MOTHERWELL, ROBERT, *The Dada Painters and Poets*, Wittenborn, Schultz, New York, 1951

*NADEAU, MAURICE, *The History of Surrealism*, Macmillan, New York, 1965

New Art Around the World, texts by Sam Hunter and others, Abrams, New York, 1966

Phaidon Dictionary of Twentieth-Century Art, Phaidon, New York, 1973

POGGIOLI, RENATO, *The Theory of the Avant-Garde*, Harvard University Press, Cambridge, 1968

POPPER, FRANK, *Origins and Development of Kinetic Art*, tr. by S. Bann, New York Graphic Society, Greenwich, 1968

*READ, HERBERT E., *Henry Moore*, Praeger, New York, 1965

*RICHARDSON, EDGAR P., *Painting in America*, 4th printing, Crowell, Collier, Macmillan, New York, 1965

RICHTER, HANS, *Dada: Art and Anti-Art*, McGraw-Hill, New York, 1965

RICKEY, GEORGE, *Constructivism: Origins and Evolution*, Braziller, New York, 1967

ROETHEL, HANS KONRAD, *The Blue Rider . . . in the Municipal Gallery, Munich*, Praeger, New York, 1971

ROH, FRANZ, *German Art in the 20th Century*, New York Graphic Society, Greenwich, 1968

*ROSE, BARBARA, *American Art Since 1900*, rev. ed., Praeger, New York, 1975

*ROSENBLUM, ROBERT, *Cubism and Twentieth-Century Art*, Abrams, New York, 1966

ROTERS, EBERHARD, *Painters of the Bauhaus*, Praeger, New York, 1969

RUBIN, WILLIAM, *Dada and Surrealist Art*, Abrams, New York, 1968

RUSSELL, JOHN, *Max Ernst: Life and Work*, Abrams, New York, 1967

SCHMALENBACH, FRITZ, *Oskar Kokoschka*, New York Graphic Society, Greenwich, 1967

*SEITZ, WILLIAM C., *The Responsive Eye*, Museum of Modern Art, New York, 1965

*SELZ, PETER, *German Expressionist Painting*, University of California Press, Berkeley, 1957

*SPIES, WERNER, *Max Ernst*, Abrams, New York, 1969

SYLVESTER, DAVID, *Henry Moore*, Praeger, New York, 1968

TAYLOR, JOSHUA C., *Futurism*, Museum of Modern Art, New York, 1961

TRIER, EDWARD, *Form and Space: The Sculpture of the Twentieth Century*, rev. ed., Praeger, New York, 1968

TUCHMAN, MAURICE, *Chaim Soutine*, New York Graphic Society, Greenwich, for the Los Angeles County Museum of Art, 1968

VASARELY, VICTOR, *Vasarely*, intro. by Marcel Joray, tr. by Jaakon Chevalier, Editions du Griffon, Neuchatel, 1965

5. TWENTIETH-CENTURY ARCHITECTURE

BANHAM, REYNER, *The New Brutalism: Ethic or Aesthetics*, Reinhold, New York, 1966

*BAYER, HERBERT, *Bauhaus 1919–1928*, New York Graphic Society, Greenwich, for the Museum of Modern Art, New York, 1976

*BLASER, WERNER, *Mies van der Rohe*, rev. ed., Praeger, New York, 1972

BOESIGER, WILLY, ed., *Le Corbusier*, Praeger, New York, 1972

*CHOAY, FRANÇOISE, *Le Corbusier*, Braziller, New York, 1960

*COLLINS, GEORGE R., *Antonio Gaudi*, Braziller, New York, 1960

*COLLINS, PETER, *Changing Ideas in Modern Architecture, 1750–1950*, Faber & Faber, London, 1965

*DREXLER, ARTHUR L., *Ludwig Mies van der Rohe*, Braziller, New York, 1960

Encyclopedia of Modern Architecture, Abrams, New York, 1964

*EVENSON, NORMA, *Le Corbusier: The Machine and the Grand Design*, Braziller, New York, 1970

FITCH, JAMES MARSDEN, *American Building*, 2nd ed., 2 vols., Houghton, Mifflin, Boston, 1966–72

*——, *Walter Gropius*, Braziller, New York, 1960

GIEDION, SIGFRIED, *Space, Time and Architecture*, 5th rev. and enl. ed., Harvard University Press, Cambridge, 1967

*GROPIUS, WALTER, *Scope of Total Architecture*, Harper, New York, 1954

*HITCHCOCK, HENRY-RUSSELL, *The Architecture of H. H. Richardson and His Times*, rev. ed., MIT Press, Cambridge, 1966

*——, *In the Nature of Materials: The Buildings of Frank Lloyd Wright, 1887–1941*, reprint, Da Capo Press, New York, 1973

*——, *Architecture: Nineteenth and Twentieth Centuries*, Pelican History of Art, Penguin Books, Baltimore, 1971

*——, and JOHNSON, PHILIP, *The International Style*, Norton, New York, 1966

*MORRISON, HUGH, *Louis Sullivan*, Norton, New York, 1962

*PAPADAKI, STAMO, *Oskar Niemeyer*, Braziller, New York, 1960

*PETER, JOHN, *Masters of Modern Architecture*, Braziller, New York, 1958

*PEVSNER, NIKOLAUS, *Pioneers of Modern Design*, 2nd ed., Museum of Modern Art, New York, 1949

SAARINEN, ALINE B., ed., *Eero Saarinen On His Work*, rev. ed., Yale University Press, New Haven, 1968

SHARP, DENNIS, *Modern Architecture and Expressionism*, Braziller, New York, 1966

——, *Sources of Modern Architecture: A Bibliography*, Lund Humphries, London, 1967

TAFURI, MANFREDO, *Contemporary Architecture*, Abrams, New York, 1977

TUNNARD, CHRISTOPHER, *The City of Man*, 2nd ed., Scribner, New York, 1970

POSTSCRIPT

THE MEETING OF EAST AND WEST

Lee, Sherman E., *A History of Far Eastern Art*, rev. ed., Abrams, New York, 1974

INDIA

BACHHOFER, LUDWIG, *Early Indian Sculpture*, reprint, Hacker, New York, 1972

*COOMARASWAMY, ANANDA K., *History of Indian and Indonesian Art*, Dover, New York, 1972

KARL, OWEN C., *Buddhist Cave Temples of India*, International Publishing Co., New York, 1976

KRAMRISCH, STELLA, *The Art of India*, Phaidon, London, 1954

MOOKERJEE, AJITCOOMAR, *The Arts of India from Prehistoric to Modern Times*, rev. ed., Tuttle, Rutland, 1966

RANDHAWA, MOHINDER S., and GALBRAITH, JOHN K., *Indian Painting: The Scene, Themes and Legends*, Houghton, Mifflin, Boston, 1966

*ROWLAND, BENJAMIN, *The Art and Architecture of India: Buddhist, Hindu, Jain*, 3rd rev. ed., Pelican History of Art, Penguin Books, Baltimore, 1967

SINGH, MADANJEET, *Ajanta: Ajanta Painting of the Sacred and the Secular*, Macmillan, New York, 1965

SIVARAMAMURTI, C., *The Art of India*, Abrams, New York, 1977

*WHEELER, ROBERT ERIC MORTIMER, *The Indus Civilization*, 3rd ed., Cambridge University Press, 1968

CHINA

BUHOT, JEAN, *Chinese and Japanese Art*, Praeger, New York, 1967

CHANG, KWANGH-CHIH, *The Archaeology of Ancient China*, rev. ed., Yale University Press, New Haven, 1968

LOEHR, MAX, *Ritual Vessels of Bronze Age China*, New York Graphic Society, Greenwich, for the Asia Society, New York, 1968

RUDOLPH, RICHARD, *Han Tomb Art of West China*, University of California Press, Berkeley, 1951

*SICKMAN, LAWRENCE, and SOPER, ALEXANDER, *The Art and Architecture of China*, 3rd ed., Pelican History of Art, Penguin Books, Baltimore, 1968

SULLIVAN, MICHAEL, *The Arts of China*, new & rev. ed. of *A Short History of Chinese Art*, University of California Press, Berkeley, 1973

——, *The Birth of Landscape Painting in China*, University of California Press, Berkeley, 1962

YUTANG, LIN, *The Chinese Theory of Art*, G. P. Putnam's, New York, 1967

WILLETTS, WILLIAM, *Chinese Art*, 2 vols., Penguin Books, Baltimore, 1958

*WU, NELSON I., *Chinese and Indian Architecture*, Braziller, New York, 1963

JAPAN

*ALEX, WILLIAM, *Japanese Architecture*, Braziller, New York, 1963

KIDDER, JONATHAN EDWARD, JR., *Japanese Temples: Sculpture, Paintings, Gardens, and Architecture*, Abrams, New York, 1967

NOMA, SEIROKU, *The Arts of Japan: Ancient and Medieval*, 2 vols., Kodansha International, Tokyo, and Japan Publications, Rutland, 1966–67

Pageant of Japanese Art, ed. by Staff Members of the Tokyo National Museum, 6 vols., Toto Bunka Co., Tokyo, 1952–54

*PAINE, ROBERT T., and SOPER, ALEXANDER, *The Art and Architecture of Japan*, 2nd ed., Pelican History of Art, Penguin Books, Baltimore, 1974

SECKEL, DIETRICH, *Emakimono: The Art of the Japanese Painted Scroll*, Pantheon Books, New York, 1959

SMITH, BRADLEY, *Japan: A History in Art*, Doubleday, Garden City, 1971

SOPER, ALEXANDER, *The Evolution of Buddhist Architecture in Japan*, Princeton University Press, 1942

*WARNER, LANGDON, *The Enduring Art of Japan*, Harvard University Press, Cambridge, 1952

YASHIRO, YUKIO, *2000 Years of Japanese Art*, Abrams, New York, 1958

PRE-COLUMBIAN AMERICA

BLISS, ROBERT WOODS, *Pre-Columbian Art: The Robert Woods Bliss Collection in the National Gallery of Art*, by Samuel K. Lothrop, W. E. Foshag, and J. Mahler, Phaidon, London, 1957

*BUSHNELL, GEOFFREY H. S., *The Ancient Arts of the Americas*, Praeger, New York, 1965

*COE, MICHAEL D., *The Maya*, Praeger, New York, 1966

CRAVEN, ROY C., JR., et al., *Ceremonial Centers of the Maya*, The University Presses of Florida, Gainesville, 1974

GENDROP, PAUL, and HEYDEN, DORIS, *Pre-Columbian Architecture of Mesoamerica*, Abrams, New York, 1976

KUBLER, GEORGE, *The Art and Architecture of Ancient America*, Pelican History of Art, Penguin Books, Baltimore, 1962

LAPINER, ALAN, *Pre-Columbian Art of South America*, Abrams, New York, 1976

*MORLEY, SYLVANUS G., *The Ancient Maya*, 3rd ed., Stanford University Press, 1956

PROSKOURIAKOFF, TATIANA A., *A Study of Classic Maya Sculpture*, Carnegie Institute, Washington, D.C., 1950

*ROBERTSON, DONALD, *Pre-Columbian Architecture*, Braziller, New York, 1963

THOMPSON, JOHN E., *The Rise and Fall of Maya Civilizations*, 2nd ed., University of Oklahoma Press, Norman, 1966

WINNING, HASSO VON, *Pre-Columbian Art of Mexico and Central America*, Abrams, New York, 1968

*WOLF, ERIC R., *Sons of the Shaking Earth*, University of Chicago Press, 1959

Page numbers are in roman type. Figure numbers of black-and-white illustrations are in *italic* type. Colorplates are designated cp. Names of artists and architects are in CAPITALS. Titles of works are in *italics*.

Würzburg, Episcopal Palace, Kaisersaal, *see* Neumann; Tiepolo

X

X, The, see Bladen
Xerxes, king of Persia, 78

Y

Yakshī, see Sānchī
Young Man Among Roses, NICHOLAS HILLIARD, 608
Youth and Demon of Death, cinerary container, Etruscan, 149, 151; *202*

Z

Zeus, Altar of, *see* Pergamum
Zeus, Temple of, *see* Olympia
ziggurat, 68, 74, 712; of King Urnammu, *see* Ur; "White Temple," *see* Uruk
ZIMMERMANN, DOMINIKUS, 503, 539; "Die Wies,"

pilgrimage church, Upper Bavaria, *646, 647*
Zoroaster, 79
Zoser, king of Egypt, 56; Funerary District of; Step Pyramid of, *see* Saqqara
Zuccone, see Donatello
ZUCCARI, TADDEO, 568; *Conversion of St. Paul, 730*
ZURBARÁN, FRANCISCO DE, 517, 581; *St. Serapion, 669*

LIST OF CREDITS

Frankfort: 656; State Museums, Berlin East: 75, 188, 190, 307, 487; *7*; State Museums, Berlin West: 474, 653; Stearn and Sons, Cambridge, England: 747; Stoedtner, Dr. Franz, Düsseldorf: 141; Stratton, A., from *Life . . . Wren:* 697; Studio R. Rémy, Dijon: *43*; Studios Puytorac, Bordeaux: 668; Studly, Adolph, Pennsburg, Pa.: 800; Sunami, Soichi, N.Y.: 33, 823; Sybel, Von (after): 288; The Tate Gallery, London: 773, 788; *100*; Thames and Hudson, Ltd., London: 104, from Costa and Lockhart, *Persia;* Thomas, J.W., Oxford: 425; Thyssen-Bornemiza Collection, Lucerne: 655; Tiers, from Monkmeyer Press Photo Service, N.Y.: 317; Tiranti, London, from B. Unsal, *Turkish Islamic Ar-*

chitecture: 319; Ubbelohde-Doering, Santiago, Chile: 909, 911; UNESCO, from UNESCO World Art Series, *Australia*, plate XXII: 18; Uppsala University, Sweden: 609; United Nations, N.Y.: 880; University Museum, Philadelphia: 85; *6*; University of Oxford, Copyright Reserved: 694; University of Utrecht, Library: 340; Vatican Archives, Vatican Museum, Rome: 182, 184, 185, 192, 239, 240, 253; Vatican Library, Rome: 276; Versnel, Jan, Amsterdam: 876, 877; Vertut, Jean, from *Préhistoire de l'Art Occidental* by André Leroi-Gourhan, courtesy Editions d'Art Lucien Mazenod, Paris: *1*; Victoria and Albert Museum, London, Crown Copyright: 279, 305, 378, 528, 608, 704,

859, 860; Vincent, John B., Berkeley, Calif.: 518, 564, 595, 596; Vizzanova, Paris: 681, 683, 776, 783, 786; Von Matt, Leonard, Buochs, Switzerland: 107; Wadsworth Atheneum, Hartford: 669; *120*; Wallace Collection, London: 688; Walters Art Gallery, Baltimore: 781; Warburg Institute, University of London: 377; Ward, Clarence, Oberlin: 387, 388, 391; Ware (after): 592; Webb, John, London: *48, 54, 88, 102, 113*; Wehmeyer, Hildesheim: 346; Wellington Museum, London, Crown Copyright: 670; Wiegand, T. (after): 234; Whitaker Studios, Richmond: 755; Whitney Museum of American Art, N.Y.: *129*; Witty, Derrick E., Sunbury-on-Thames: 775; Worcester Art Museum,

Mass.: *59*; Yale University Art Gallery, New Haven: 678, 687, 777, 824; *89, 114*; Yan, Photo Reportage, Toulouse: 14, 348; Yugoslav State Tourist Office, N.Y.: 235; Zwemmer, A., Ltd., London, from J.S. Ackerman, *The Architecture of Michelangelo:* 561.

Acknowledgment is made with thanks to Harcourt, Brace & Jovanovich, Inc., for permission to use the quotation on page 433 from "The Love Song of J. Alfred Prufrock" by T.S. Eliot from his volume *Collected Poems 1909–1935*, copyright, 1936, by Harcourt, Brace & World, Inc.

COMPARATIVE VIEWS OF THE HISTORY OF ART

III 1000 A.D.–1976 Unit of time: 50 years

1000 A.D.	1050	1100	1150	1200	1250	1300	1350	1400	1450

Ottonian

ROMANESQUE

GOTHIC: England

GOTHIC: France

GOTHIC: Italy

International Style

"LATE GOTHIC

EARLY RENAISS
Italy

GOTHIC: Germany

ISLAM

Late Byzantine

INDIA Medieval *(Hindu)*

CHINA Sung

Marco Polo

JAPAN Kamakura

Mu

AMERICAS Pre-Columbian